Customised Books in Early Modern Europe and the Americas, 1400–1700

Intersections

INTERDISCIPLINARY STUDIES IN EARLY MODERN CULTURE

General Editor

Karl A.E. Enenkel (*Chair of Medieval and Neo-Latin Literature*
Universität Münster
e-mail: kenen_01@uni_muenster.de)

Editorial Board

W. de Boer (*Miami University*)
S. Bussels (*University of Leiden*)
A. Dlabačová (*University of Leiden*)
Chr. Göttler (*University of Bern*)
J.L. de Jong (*University of Groningen*)
W.S. Melion (*Emory University*)
A. Montoya (*Radboud University Nijmegen*)
R. Seidel (*Goethe University Frankfurt am Main*)
P.J. Smith (*University of Leiden*)
J. Thompson (*Queen's University Belfast*)
A. Traninger (*Freie Universität Berlin*)
C. Zittel (*Ca' Foscari University of Venice / University of Stuttgart*)
C. Zwierlein (*Berlin*)

VOLUME 86 – 2024

The titles published in this series are listed at *brill.com/inte*

Customised Books in Early Modern Europe and the Americas, 1400–1700

Intersections

INTERDISCIPLINARY STUDIES IN EARLY MODERN CULTURE

General Editor

Karl A.E. Enenkel (*Chair of Medieval and Neo-Latin Literature
Universität Münster*
e-mail: kenen_01@uni_muenster.de)

Editorial Board

W. de Boer (*Miami University*)
S. Bussels (*University of Leiden*)
A. Dlabačová (*University of Leiden*)
Chr. Göttler (*University of Bern*)
J.L. de Jong (*University of Groningen*)
W.S. Melion (*Emory University*)
A. Montoya (*Radboud University Nijmegen*)
R. Seidel (*Goethe University Frankfurt am Main*)
P.J. Smith (*University of Leiden*)
J. Thompson (*Queen's University Belfast*)
A. Traninger (*Freie Universität Berlin*)
C. Zittel (*Ca' Foscari University of Venice / University of Stuttgart*)
C. Zwierlein (*Berlin*)

VOLUME 86 – 2024

The titles published in this series are listed at *brill.com/inte*

Customised Books in Early Modern Europe and the Americas, 1400–1700

Edited by

Christopher D. Fletcher
Walter S. Melion

BRILL

LEIDEN | BOSTON

Cover illustrations: (central image) "Kings and Princes Coming to Troy to Assist King Priam", in The Hague, National Library of the Netherlands, KW 1900 A 008, fol. 48v. Folio size 200 × 140 mm. Public domain. Wikimedia Commons; (background image) Hans Schrotbanck (designer), Christ's passion is our redemption; detail from *Magnencii Rabani Mauri de laudi[bus] Sanctae Crucis opus* (Pforzheim, Thomas Anshelm – Jakob Wimpfeling: 1503), fol. i iv v. Woodcut, 310 mm (fol.). Atlanta, Pitts Theollogy Library, Candler Theology School, Emory University, 1503 HRAB. Creative Commons 0 License.

The Library of Congress Cataloging-in-Publication Data is available online at https://catalog.loc.gov
LC record available at https://lccn.loc.gov/2023047111

Typeface for the Latin, Greek, and Cyrillic scripts: "Brill". See and download: brill.com/brill-typeface.

ISSN 1568-1181
ISBN 978-90-04-68055-5 (hardback)
ISBN 978-90-04-68056-2 (e-book)
DOI 10.1163/9789004680562

Copyright 2024 by Koninklijke Brill NV, Leiden, The Netherlands.
Koninklijke Brill NV incorporates the imprints Brill, Brill Nijhoff, Brill Schöningh, Brill Fink, Brill mentis, Brill Wageningen Academic, Vandenhoeck & Ruprecht, Böhlau and V&R unipress.
All rights reserved. No part of this publication may be reproduced, translated, stored in a retrieval system, or transmitted in any form or by any means, electronic, mechanical, photocopying, recording or otherwise, without prior written permission from the publisher. Requests for re-use and/or translations must be addressed to Koninklijke Brill NV via brill.com or copyright.com.

This book is printed on acid-free paper and produced in a sustainable manner.

Contents

Acknowledgements IX
List of Figures X
Notes on the Editors XXXI
Notes on the Contributors XXXII

PART 1
Introduction

1 Kinds and Degrees of Customisation in Early Modern Book Production and Reception 3
 Walter S. Melion

2 The Customising Mindset in the Fifteenth Century: The Case of Newberry Inc. 1699 41
 Christopher D. Fletcher

PART 2
Customisation across Media

3 A Late Medieval Multi-Text Manuscript and Its Printed Precedents 67
 Britt Boler Hunter

4 Reforming Hrabanus: Early Modern Iterations of *In honorem sanctae crucis* 92
 Kelin Michael

5 A Customized Housebook of Repurposed Prints: the *Liber Quodlibetarius, c.* 1524 137
 Stephanie Leitch

PART 3
Communal Customising

6 How to Talk about Burgundian Books You Could Not Read 169
 Bret L. Rothstein

7 Customizing for the Community: The Wiesbaden Manuscript
 (Hauptstaatsarchiv 3004 B 10) and the Late Medieval Church 186
 Geert Warnar

8 A Medical Anthology Customised 'for the Consolation of the Sick' in a
 Brussels Convent 227
 Andrea van Leerdam

9 Custom Made by Antonio Ricardo: Peru's First Printer and His
 Illustrations in Jerónimo de Oré's *Symbolo Catholico Indiano* (1598) 248
 Tom Cummins

PART 4
Individual Customisers

10 From Proud Monument to Ill-Marked Tomb: Tommaso Schifaldo in a
 Sicilian Humanist Miscellany 289
 Paul F. Gehl

11 Customization of a Latin Emblem Book by a Vernacular Owner:
 Unknown German Poems to a Copy of Vaenius's *Emblemata Horatiana*
 (first edition, 1607) 325
 Karl A.E. Enenkel

12 Picture Bound: Customized Books of Prints and the Myth of the
 Ideal Series 372
 Shaun Midanik

13 Customizing an Emblem Book as an *album amicorum*: Valentin
 Ludovicus' Entry in the *Stammbuch* of Christian Weigel 402
 Mara R. Wade

CONTENTS VII

PART 5
Editorial Customisation

14 A Play of Continuity and Difference: A Book of Fortune-telling Adapted
 from the Kingdom of Poland to Southeastern Europe 425
 Justyna Kiliańczyk-Zięba

15 Shifting Perspectives: Changing Optical Theory in the Printed Works of
 Jean-François Niceron 452
 Brent Purkaple

16 Venice as a Musical Commodity in Early Modern Germany:
 A Frontispiece Collage, *c.* 1638 475
 Jason Rosenholtz-Witt

17 Vaenius in Ireland: An Eighteenth-Century Customization of the
 Emblemata Horatiana 492
 Simon McKeown

PART 6
Visual Customisation

18 Frames, Screens and Urns: Customisation and Poetics in the 1495 Aldine
 Theocritus painted by Albrecht Dürer for Willibald Pirckheimer 525
 Jakub Koguciuk

19 Compiled Compositions: The *Kattendijke Chronicle* (*c.* 1491–1493) and
 Late Medieval Book Design 547
 Anna Dlabačová

20 Interpolated Prints as Exegetical Meditative Glosses in a Customized
 Copy of Franciscus Costerus's Dutch *New Testament* 600
 Walter S. Melion

21 'By the Genius of the Indians': The Customization of Nieremberg's *De la
 Diferencia* in Guarani (Loreto, Juan Bautista Neumann et alii: 1705) 684
 Pedro Leal

 Index Nominum 771

Acknowledgements

This volume consists of essays redacted from papers originally delivered at the colloquium, *Customised Books in Early Modern Europe and the Americas, 1400–1700*, held at Emory University on October 14–16, 2021. Organised under the aegis of the Art History Department's Lovis Corinth Endowment, the colloquium was the eleventh in the ongoing series of such events convened annually at Emory. Kay Corinth and her sister Mary Sargent established the endowment to honor the memory of Kay's father-in-law, the celebrated painter Lovis Corinth. The Corinth Colloquia provide an interdisciplinary forum for the comparative study of early modern northern art. Dr. Lia Markey, Director of The Newberry Library's Center for Renaissance Studies, offered unstinting support for this project. I am especially grateful to the Center's Assistant Director, Christopher Fletcher, who co-organised the three-day colloquium and, over the next year and a half, co-edited the ensuing volume. Sarah McPhee, Samuel Candler Dobbs Professor of Art History and Chair of the Art History Department, encouraged and facilitated *Customised Books in Early Modern Europe and the Americas* amidst the many complications attendant upon a post-pandemic conference. Corinth Graduate Associates Annie McEwen Maloney and Alexandra Zigomalas assisted in preparing and implementing the colloquium, and Ms. Zigomalas served afterward as an ideal editorial assistant. For her administrative support, I am beholden to Blanche Barnett, Academic Department Administrator. I also want to thank Chris Sawula, the department's former Visual Resources and Spatial Art History Librarian, for consulting with the IT team tasked with managing the colloquium. Finally, an immeasurable debt of thanks is owed to Linnea Harwell, Graduate Program Coordinator in Art History, the person without whom the colloquium could never have been realised, who took matters great and small in hand and managed them with consummate grace, skill, intelligence, and savoir faire.

Desidero eam corona immortalitatis gratiarum cingere.

Walter S. Melion

Figures

1.1 Jan Wierix after Bernardino Passeri, *Annunciation*, plate 1 of the image sequence tracking the life of Christ, illustration to chapter 107 of the liturgical sequence, in Jerónimo Nadal, *Adnotationes et meditationes in Evangelia* (Antwerp, Martinus Nutius: 1595). Engraving, 233 × 146 mm 13

1.2 Jan Wierix after Bernardino Passeri, *The Universal Judgment*, plate 98 of the image sequence tracking the life of Christ, illustration to chapter 1 of the liturgical sequence, in Jerónimo Nadal, s.j., *Adnotationes et meditationes in Evangelia* (Antwerp, Martinus Nutius: 1595). Engraving, 233 × 145 mm 14

1.3 Theodoor and Cornelis, Emblem 15: "Hominis vere Christiani descriptio" ("Description of a truly Christian man"), engraving, ca. 1601. In Jan David, s.j., *Veridicus Christianus* (Antwerp: Ex officina Plantiniana, 1606), quarto 16

1.4 Theodoor and Cornelis Galle, *Orbita probitatis ad Christi imitationen* (*Orbit of Probity for the Imitation of Christ*), engraving, ca. 1601. Appendix to Jan David, s.j., *Veridicus Christianus* (Antwerp: Ex officina Plantiniana, 1606), quarto 21

1.5 Hector van Aytta, "Dant Dura Dulcia", in *Album amicorum of Cornelis a Blyenburch*: page 113 of Paradin Claude – Symeoni Gabriele, *Heroica symbola* (Antwerp, Christopher Plantin: 1562), in-octavo 27

1.6 Theodoor, Cornelis, and/or Jan Galle, *Vita S. Joseph beatissimae Virginis sponsi patriarcharum maximi iconibus delineata ac versiculis ornata* (Life of St. Joseph, husband of the most blessed Virgin, greatest of the patriarchs, portrayed in images and ornamented with Verses) (Antwerp, Theodoor Galle: ca. 1601–1633). Engraving, 101 × 60 mm 31

1.7 Antoon II Wierix, *Cor Iesu amanti sacrum* (Heart sacred to the loving Jesus / Heart of Jesus sacred to the one who loves him) (Antwerp, Antoon II Wierix: before 1604), title-page. Engraving, 91 × 56 mm 32

1.8 Ferrar / Collet Family, *Of the Lord's Supper: The Sacrament of Continuance in the Convenant of Grace* [...] *in which are to be considered the Sacramental Relation of the visible signe* [...] *and the invisible Grace*, page 231 in *The Prince of Wales's Concordance*, ca. 1640. Cut and pasted engravings and letterpress, in-grand folio 35

1.9 Ferrar / Collet Family, "Certain women, which had been healed of evil spirits and infirmities [...]", page 66 in *M O N O T E Σ Σ A P O N or The Actions Doctrine and Other Passages Touching Our Lord and Saviour Iesus Christ*, 1640. Private collection. Source: Gaudio M., *The Bible and the Printed Image in Early Modern England* (Abingdon – New York: 2017) 57 36

FIGURES

XI

2.1 Title page of *Ein ware nachuolgung Cristi*. (Augsburg: Anton Sorg, 1486). Chicago, Newberry Library, Inc. 1699 44

2.2 Incipit of devotional manuscript in Inc. 1699. Chicago, Newberry Library, Inc. 1699, fol. 193r 45

2.3 Decorative border around a pre-existing torn corner. Chicago, Newberry Library, Inc. 1699, fol. 229v 47

2.4 Wax dripping in *Ein ware nachuolgung Cristi*. (Augsburg: Anton Sorg, 1486). Chicago, Newberry Library, Inc. 1699, fol. XVII r 48

2.5 Two *Priameln*. Chicago, Newberry Library, Inc. 1699, fol. 227r 53

3.1 Final scene of *Revelation* (above) and scenes from the "Life of John" (below). Ink and color wash on parchment, 324 × 238 mm, ca. 1470. London, British Library, Additional Manuscript 19896, picture-book Apocalypse, fol. 23v 72

3.2 Final scene of *Revelation* (above) and scenes from the "Life of John" (below). Handcolored woodcut print, 275 × 190 mm, ca. 1470. Cambridge, Trinity College Library, Inc.3[4245], *Apocalypsis Sancti Johannis cum figuris*, fol. 46v 73

3.3 Detail of "John witnessing the rise of the Beast from the Sea". Ink and color wash on vellum, 40 × 30 cm, ca. 1470. London, Wellcome Library MS 49, *Wellcome Apocalypse*, lower miniature of fol. 15r 74

3.4 "Dying man with vision of Trinity, Virgin, and St. Anthony" from the *Ars Moriendi*. Ink and color wash on vellum, 40 × 30 cm, ca. 1470. London, Wellcome Library MS 49, *Wellcome Apocalypse*, lower left miniature of fol. 30r 77

3.5 "Dying man with vision of Trinity, Virgin, and St. Anthony". Hand colored woodcut print, 150 × 105 mm, ca. 1475. Washington D.C., Library of Congress, Incun. x. P27, *Ars Moriendi*, Schreiber edition XII, pg. 15 78

3.6 End of the post-Apocalyptic "Life of John" and beginning of the *Ars Moriendi*. Ink and color wash on vellum, 40 × 30 cm, ca. 1470. London, Wellcome Library MS 49, *Wellcome Apocalypse*, lower left miniature of fols. 28v to 29r 80

3.7 Concluding scenes of the *Ars Moriendi*, the *Ad mortem festinamus* and "Wheel of Fortune". Ink and color wash on vellum, 40 × 30 cm, ca. 1470. London, Wellcome Library MS 49, *Wellcome Apocalypse*, lower left miniature of fol. 30v 82

3.8 "Life of Antichrist". Ink and color wash on parchment, 285 × 215 (260 × 190) mm, ca. 1470. London, British Library, Additional Manuscript 19896, picture-book Apocalypse, fols. 8v to 9r 84

3.9 "Antichrist's failed ascension into heaven from the Mount of Olives". Ink and color wash on vellum, 40 × 30 cm, ca. 1470. London, Wellcome Library MS 49, *Wellcome Apocalypse*, lower left miniature of fol. 13r 86

3.10	Antichrist performing marvels. Ink and color wash on vellum, 40 × 30 cm, ca. 1470. London, Wellcome Library MS 49, *Wellcome Apocalypse*, lower left miniature of fol. 10v 87
4.1	*Crucified Christ, c.* 825–850 CE; detail from Hrabanus Maurus's *In honorem sanctae crucis*, fol. 8v. Tempera and ink on parchment, 365 × 295 mm. Rome, Biblioteca Apostolica Vaticana, Reg. Lat. 124 93
4.2	*Crucified Christ; c.* 1600 CE; detail from Hrabanus Maurus's *In honorem sanctae crucis*, fol. 9v. Tempera, gold, and ink on parchment, 350 × 298 mm. Paris, Bibliothèque nationale de France, Bibliothèque d'Arsenal, Ms-472 94
4.3	Dedication Image, *c.* 825–850 CE; detail from Hrabanus Maurus's *In honorem sanctae crucis*, fol. 2v. Tempera and ink on parchment, 365 × 295 mm. Rome, Biblioteca Apostolica Vaticana, Reg. Lat. 124 110
4.4	Hans Schrotbanck (designer), Dedication Image; detail from *Magnencii Rabani Mauri de laudi[bus] Sanctae Crucis opus* (Pforzheim, Thomas Anshelm – Jakob Wimpfeling: 1503), fol. Aa v r. Woodcut, 310 mm (fol.); Atlanta, Pitts Theology Library, Candler Theology School, Emory University, 1503 HRAB 111
4.5	Dedication Image, *c.* 1490 CE; detail from Hrabanus Maurus's *In honorem sanctae crucis*, fol. 1v. Tempera, ink, and gold on parchment. Stuttgart, Württembergische Landesbibliothek, Cod. Theol. et philos. 2° 122 112
4.6	Hans Schrotbanck (designer), *Crucified Christ;* Woodcut; detail from *Magnencii Rabani Mauri de laudi[bus] Sanctae Crucis opus* (Pforzheim, Thomas Anshelm – Jakob Wimpfeling: 1503), fol. a i v. Woodcut, 310 mm (fol.); Atlanta, Pitts Theology Library, Candler Theology School, Emory University, 1503 HRAB 114
4.7	Hans Schrotbanck (designer), *Hrabanus Praying*; detail from *Magnencii Rabani Mauri de laudi[bus] Sanctae Crucis opus* (Pforzheim, Thomas Anshelm – Jakob Wimpfeling: 1503), fol. k iii v. Woodcut, 310 mm (fol.). Atlanta, Pitts Theology Library, Candler Theology School, Emory University, 1503 HRAB 115
4.8	Hans Schrotbanck (designer), Christ's passion is our redemption; detail from *Magnencii Rabani Mauri de laudi[bus] Sanctae Crucis opus* (Pforzheim, Thomas Anshelm – Jakob Wimpfeling: 1503), fol. i iv v. Woodcut, 310 mm (fol.). Atlanta, Pitts Theology Library, Candler Theology School, Emory University, 1503 HRAB 116
4.9	Hans Schrotbanck (designer), *Crucified Christ*; detail from *Magnencii Rabani Mauri de laudi[bus] Sanctae Crucis opus* (Pforzheim, Thomas Anshelm – Jakob Wimpfeling: 1503), fol. a i v. Woodcut, 310 mm (fol.). Boston, Boston Public Library, G.H01.72 119

FIGURES XIII

4.10 Albrecht Dürer (designer), *Hrotsvitha presenting her work to Otto I*; detail
 from *Opera Hrosvite, illustris virginis et monialis Germane, gente Saxonica
 orte, nuper a Conrado Celte inventa* (Nuremberg, Conrad Celtis: 1501), a i v.
 Woodcut, 310 mm (fol). Los Angeles, Getty Research Institute, PA8340.A12
 1501; © Getty Research Institute 120

4.11 Dedication Image, *c.* 1600 CE; detail from Hrabanus Maurus's *In
 honorem sanctae crucis*, fol. 3v. Tempera, gold, and ink on parchment,
 350 × 298 mm. Paris, Bibliothèque nationale de France, Bibliothèque
 d'Arsenal, Ms-472 123

4.12 *Louis the Pious, c.* 825–850 CE; detail from Hrabanus Maurus's *In honorem
 sanctae crucis*, fol. 4v. Tempera and ink on parchment, 365 × 295 mm. Rome,
 Biblioteca Apostolica Vaticana, Reg. Lat. 124 130

4.13 *Louis the Pious; c.* 1600 CE; detail from Hrabanus Maurus's *In honorem
 sanctae crucis*, fol. 5v. Tempera, gold, and ink on parchment, 350 × 298 mm.
 Paris, Bibliothèque nationale de France, Bibliothèque d'Arsenal, Ms-472 131

5.1 Master WR, "Noah's Ark", illumination, in Benedictus Rughalm,
 Liber Quodlibetarius, fol. 9v–10r. Erlangen, Universitätsbibliothek
 Erlangen-Nuremberg (inv. no. Ms. B 200) 140

5.2 Master WR, "The Fifth Day", illumination, in Benedictus Rughalm, *Liber
 Quodlibetarius*, fol. 4r. Erlangen, Universitätsbibliothek Erlangen-Nuremberg
 (inv. no. Ms. B 200) 142

5.3 Master WR, "Head Brace", illumination, in Benedictus Rughalm,
 Liber Quodlibetarius, fol. 68r. Erlangen, Universitätsbibliothek
 Erlangen-Nuremberg (inv. no. Ms. B 200) 146

5.4 Master WR, section devoted to "Physiognomy", illumination, in Benedictus
 Rughalm, *Liber Quodlibetarius*, fol. 80r. Erlangen, Universitätsbibliothek
 Erlangen-Nuremberg (inv. no. Ms. B 200) 149

5.5 Anon., sets of "Foreheads", woodcut, in Bartolommeo Cocles, *Ein kurtzer
 bericht der gantzen Phisionomey und Ciromancy* (Strassburg, Johann
 Grüninger: 1524). Sig. W 8 Philos. 959 150

5.6 Erhard Reuwich, for Bernard von Breydenbach, *Peregrinatio in Terram
 Sanctam* (Mainz, Schöffer: 1486) 152

5.7 Master WR, "Exotic Animals", illumination, in Benedictus Rughalm,
 Liber Quodlibetarius, fol. 89v. Erlangen, Universitätsbibliothek
 Erlangen-Nuremberg (inv. no. Ms. B 200) 154

5.8 Master WR, "Various Herbs", illumination, in Benedictus Rughalm, *Liber
 Quodlibetarius*, fol. 56r. Erlangen, Universitäsbibliothek Erlangen-Nuremberg
 (inv. no. Ms. B 200) 157

5.9 Master WR, "Which fish are healthy", illumination, in Benedictus
 Rughalm, *Liber Quodlibetarius*, fol. 117v. Erlangen, Universitätsbibliothek
 Erlangen-Nuremberg (inv. no. Ms. B 200) 158

XIV FIGURES

5.10 Master WR, "How to catch birds", illumination, in Benedictus Rughalm,
 Liber Quodlibetarius, fol. 87r. Erlangen, Universitätsbibliothek
 Erlangen-Nuremberg (inv. no. Ms. B 200) 160

5.11 Master WR, "Horses", illumination, in Benedictus Rughalm,
 Liber Quodlibetarius, fol. 91r. Erlangen, Universitätsbibliothek
 Erlangen-Nuremberg (inv. no. Ms. B 200) 161

6.1 Netherlandish artisan (possibly Rogier van der Weyden), Jean Wauquelin
 Presenting His Translation of the *Croniques de Hainaut* to Philip the
 Good, frontispiece to Jacques de Guise, *Chroniques de Hainault* (*Annales
 historiae illustrium principum Hannonniae*), 1447–1448 (Part I). Tempera on
 parchment, 43.9 × 31.6 cm (folio) 171

6.2 Anonymous, Swan Mazer, before 1384. Silver-gilt and maple wood,
 7.0 × 12.7cm. Corpus Christi College, Cambridge University 180

7.1 Ms. Wiesbaden, Hessisches Hauptstaatsarchiv, 3004 B 10, fol. 61r. Page with
 pasted drawings 188

7.2 Ms. Wiesbaden, Hessisches Hauptstaatsarchiv, 3004 B 10, fol. 2v. Table of
 contents, verses on borrowing the book and pasted drawing 192

7.3 Ms. Wiesbaden, Hessisches Hauptstaatsarchiv, 3004 B 10, fol. 14v. Pasted
 drawing of Saint George fighting the dragon 205

7.4 Ms. Wiesbaden, Hessisches Hauptstaatsarchiv, 3004 B 10, fol.151v.
 Saint George 207

7.5 St George by Alexandre Hannotiau; copy ca. 1900 of the wall painting in
 Saint Martin's (now disappeared) 208

7.6 Ms. Wiesbaden, Hessisches Hauptstaatsarchiv, 3004 B 10, fol. 24v. Adoration
 of the Magi, set of pasted drawings 209

7.7 Three Magi Sculpture St. Martin's Church Halle (Belgium) 209

7.8 Ms. Wiesbaden, Hessisches Hauptstaatsarchiv, 3004 B 10, fol. 126r. Three
 dead rising from their graves 211

7.9 Ms. Wiesbaden, Hessisches Hauptstaatsarchiv, 3004 B 10, fol. 118v. Mary and
 Jesus with saints Catherine and Barbara 213

7.10 Ms. Wiesbaden, Hessisches Hauptstaatsarchiv, 3004 B 10, fol. 14r. Pasted
 drawings of St. Martin and the beggar with Jesus in the clouds 215

7.11 Ms. Wiesbaden, Hessisches Hauptstaatsarchiv, 3004 B 10, fol. 1v. Salvator
 mundi with accompanying text 216

7.12 Ms. Wiesbaden, Hessisches Hauptstaatsarchiv, 3004 B 10, fol. 45r. Moses
 receiving the ten commandments 219

7.13 Ms. Wiesbaden, Hessisches Hauptstaatsarchiv, 3004 B 10, fol. 110v. Monk and
 nun in dialogue 222

8.1 Title page with owners' inscription of the Poor Clares in Brussels, dated 1555.
 Sylvius Petrus, *Tfundament der Medicinen ende Chyrurgien* (Antwerp, Willem

FIGURES

XV

Vorsterman: 1540), Washington D.C., Library of Congress, Rosenwald 1159, fol. A i r 230

8.2 Instances of censorship in text and image, folio number written and corrected by a single hand, parchment tabs added to the side. Sylvius, *Tfundament*, Library of Congress, Rosenwald 1159, fols. P iii v–P iiii r 233

8.3 Trace of a pin next to a recipe 'against all kinds of fevers'. Sylvius, *Tfundament*, Library of Congress, Rosenwald 1159, fol. [2]C ii v 235

8.4 A pin next to a recipe 'against too much blood'. Sylvius, *Tfundament* (Antwerp, Willem Vorsterman: 1532), Copenhagen, Det Kgl. Bibliotek, Fol. Pat. 19840, fol. O iii v 237

8.5 Hand-coloured urine flasks. Sylvius, *Tfundament* (1530), The Hague, KB National Library of the Netherlands, KW 228 A 10, fol. D v r 240

8.6 Hand-coloured urine flasks. Sylvius, *Tfundament* (1530), Ghent University Library, BIB.ACC.008275, fol. D v r 240

8.7 Hand-coloured urine flasks. Sylvius, *Tfundament* (1540), Bethesda, MD, National Library of Medicine, HMD collection, WZ 240 S985f 1540, fol. D v r 241

8.8 Hand-coloured urine flasks. Sylvius, *Tfundament* (1532), Copenhagen, Det Kgl. Bibliotek, Fol. Pat. 19840, fol. D v r 241

9.1 Bishop Zumárraga, "Title Page" of *Dotrina Breve p[ro]uechosa de las cosas q[ue] p[er]tenecen a la fe catholica* […] (Gran Ciudad Tenochitlan Mexico de Nueva España, Juan Cromberger (Juan Pablos): 1544). Harvard University, Houghton Library, pga_typ_100_544-METS 251

9.2 Juan de La Cruz, "The final part of the fourteen articles of faith or liturgical acts that enact that faith, and Moses receives the Ten Commandments that then follow," *Doctrina christiana en la lengua guasteca co[n] la lengua castellana* (Mexico City, Pedro Ocharte: 1571), fols. 13v–14r 252

9.3 "Title Pages" to Alonso de la Vera Cruz, *Physica speculatio* (Mexico City, Juan Pablos: 1554) and Maturino Gilberti, *Diálogo de doctrina christiana en la lengua de Mechuacan* (Mexico City, Juan Pablos: 1559) 253

9.4 Alonso de Molina, "Profile Portrait of Christ," in *Confesionario mayor, en lengua mexicana y castellana* (Mexico City, Pedro Brilli: 1578) 29 255

9.5 "Profile Portrait of Christ" with text 'Ego sum veritas, Jesu Cristo Nazareno', in Alonso de Molina, *Confesionario mayor, en lengua mexicana y castellana* (Mexico City, Antonio Espinosa: 1565) 27, 68, and in the frontispiece of Friar Juan Baptista, *Sermonario en la Lengua Mexicana* (Mexico City, Diego Lopez Daualos: 1606) 256

9.6 Alonso de Molina, "Title Page" with "Profile Portrait of Christ," in *Doctrina Christiana, en lengua mexicana* […] (Mexico, En Casa de Pedro Ocharte: 1578) 257

9.7	Antonio Ricardo, "Title Pages" of *Doctrina Christiana y catecismo para instruccion de los Indios* (1585); *Tercero catecismo y exposicion de la doctrina christiana, por sermones* (1585); and *Confessionario para los curas de Indios* (Ciudad de Los Reyes, Antonio Ricardo Primero Impressor en estos Reyenos del Piru: 1584–1585) 261
9.8	Antonio Ricardo, "The Last Supper". Woodcut in *Doctrina Christiana y catecismo para instruccion de los indios* (Lima, Antonio Ricardo primero impressor en estos Reynos del Peru: 1584), fol. 45r 262
9.9	Antonio Ricardo, "Profile Portrait of Christ". Woodcut in "Catecismo Mayor", in *Doctrina Christiana y catecismo para instruccion de los Indios* (Lima, Antonio Ricardo primero impressor en estos Reynos del Peru: 1585), fol. 83v 263
9.10	Antonio Ricardo, "Double Vignette of the Trinity and Coronation of the Virgin". Woodcut at the end of "Catecismo breve", in *Doctrina Christiana y catecismo para instruccion de los Indios* (Lima, Antonio Ricardo primero impressor en estos Reynos del Peru: 1585), fol. [18r] 265
9.11	Sacristy of San Peter in Lima with Bernardo Bitti, "Coronation of the Virgin" at the eastern end. Oil on canvas, 1580 267
9.12	Bernardo Bitti, "Coronation of the Virgin". Oil on canvas, 1580. San Pedro, Lima 268
9.13	Antonio Ricardo (?), "Portrait of Pedro de Oña". Woodcut, in Pedro de Oña, *Arauco Donado* (Lima, Antonio Ricardo: 1578), fol. 3r 269
9.14	Jerónimo Luis de Oré, "Title Page" and final page, in *Symbolo Catholico Indiano* (Lima, Antonio Ricardo: 1598) 271
9.15	Jerónimo Luis de Oré, "Crucifixion of Christ", in *Symbolo Catholico Indiano* (Lima, Antonio Ricardo: 1598), fol. 124v 273
9.16	Jerónimo Luis de Oré, "The Trinity", in *Symbolo Catholico Indiano* (Lima, Antonio Ricardo: 1598), fol. 66r 275
9.17	Jerónimo Luis de Oré, "Portrait of Christ", in *Symbolo Catholico Indiano* (Lima, Antonio Ricardo: 1598), fols. 66v and 67r 276
9.18	Hans Burkmair, "Salvator Mundi" with the text of the so called *Lentulus* Letter. Woodcut, 32.3 × 22.7 cm, ca. 1511 278
10.1	Newberry Library, MS 71.5, fol. 3r. Schifaldo, *Carmen bucolicum*, written in Cesare Zizo's formal hand 297
10.2	Newberry Library, MS 71.5, fol. 21r. Pseudo-Pliny, *De viris illlustribus* (Venice: 1486), with marginal note at bottom in the hand of Cesare Zizo concerning a Sicilian campaign. Note his correction to the spelling of 'Lilybeo' (Marsala, his hometown and Schifaldo's) 299
10.3	Newberry Library, MS 71.5, fol. 107r, Pontano, *Parthenopaeus* I 6, with annotations by the scribe of the text, including one on the legend of Empedocles 308

FIGURES

XVII

11.1a Vaenius, *Emblemata Horatiana*, Engraving to E. 16, "Voluptatum usurae, morbi et miseriae" (p. 39) 332

11.1b German poem to emblem 16 (p. 38) 332

11.1c Engraving to emblem 17, "Crapula ingenium offuscat" 333

11.2 Engraving to emblem 11, "Animi servitus" 334

11.3a Vaenius, *Emblemata Horatiana*, Engraving to E. 10, "Amor virtutis" 336

11.3b German verses to emblem 10 (p. 26) 336

11.4a Detail of Fig. 11.3A 338

11.4b Personification of Nemesis or 'Rach'. Illustration to Andrea Alciato, *Emblematum liber*, ed. Held (Frankfurt a.M.: 1567), no. 71, "Nec verbo nec facto quenquam laedendum" 338

11.4c Bernard Salomon, Nemesis, 1551. Woodcut to Alciato's emblem "Nec verbo nec facto quenquam laedendum" 339

11.4d Medieval scourge from 1493 339

11.4e Engraving to emblem 87, "Culpam Poena premit comes" (p. 180). The German poet took the female figure to the left to be Serapis 341

11.4f The Fury Tisiphone, by Antonio Tempesta, 1606. Engraving, illustration to Ovid's *Metamorphoses* 342

11.4g (*left*) The Graeco-Egyptian god Serapis. Sculpture from the Serapeum of Alexandria. Roman copy from a Greek original from the 4th century BC. Vatican Museums; (*right*) Serapis. Illustration to Vincenzo Cartari, *Imagines deorum, qui ab antiquis colebantur* [...] (Lyon, Bartolomaeus Honoratus: 1581), p. 55 343

11.4h Page 180 of the German poet's copy of the *Emblemata Horatiana* (1607) 345

11.5a Detail of Vaenius's image to E. 1, "Virtus inconcussa" (p. 9) 347

11.5b Personification of Constantia by Philip Galle, 1585–1590. Engraving, 15.2 × 8.7 cm 347

11.5c Personification of Fortitudo with the lion by Marco Dente da Ravenna, 1515–1520 (possibly after a design by Giulio Romano). Engraving, 17.9 × 27.9 cm 347

11.6a Engraving to emblem 64 of Vaenius, *Emblemata Horatiana* (Antwerp: 1607), p. 135 348

11.6b Johannes Wierix after Chrispijn van den Broeck (died 1591), *Hercules at the crossroads*, standing between the personifications of Labor and Voluptas, engraving, second half of the 16th century 349

11.6c Attributed to Jacob Matham, after Hendrik Goltzius, personification of Avarita, from the series *The Seven Vices* (1587). https://commons.wikimedia.org/wiki/File:Avarice_-_Jacob_Matham.jpg 350

11.6d Detail of Fig. 11.6A 350

11.6e German poem to Emblem 64 (p. 134) 352

11.7a	Engraving to emblem 8, "Virtus in actione consistit" 355
11.7b	German poem to emblem 8 355
11.8a	Engraving to emblem 2, "Virtutis Gloria" 357
11.8b	Relief with the Triumph of Marcus Aurelius, 2nd century BC. Part of the triumphal arch of Constantine, now in the Palazzo dei Conservatori, Rome 360
11.8c	Nicolas Beatrizet (died 1565), Triumph of Marcus Aurelius, ca. 1550. After the relief on the triumphal arch of Constantine 360
11.8d	German poem to Emblem 4 (p. 10) 360
11.9a	Engraving to emblem 14 of Vaenius, *Emblemata Horatiana* (Antwerp: 1607), p. 35 364
11.9b	German poem to emblem 14 (p. 34) 365
11.10a	Engraving to emblem 81 "Tempera te tempori" 369
11.10b	German poem to emblem 81 (p. 168) 369
12.1	Jan van Troyen, Frontispiece. Etching, book height 44 cm, made in 1673 after a painting by David Teniers the Younger. From: *Davidis Teniers Antverpiensis pictoris, et a cvbicvlis ser.mis principibvs Leopoldo Gvil. archidvci, et Ioanni Austriaco Theatrum Pictorium* [...] (Antwerp, Jacobus Peeters: 1673) 373
12.2	Jan van Troyen, Frontispiece. Detail, vignette below the plate. Etching, book height 44 cm, after a painting by David Teniers the Younger. From: *Davidis Teniers Antverpiensis pictoris, et a cvbicvlis ser.mis principibvs Leopoldo Gvil. archidvci, et Ioanni Austriaco Theatrum Pictorium* [...] (Antwerp, Jacobus Peeters: 1673) 374
12.3	Paulo Henoch, *Alla Serenissima altezza del dvca di Parma e Piacenza*. Letterpress, 1617. From: *Descrizione del Sacro Monte della Vernia* (Florence, Paulo Henoch (?): 1612/17) 393
12.4	Lino Moroni (?), *Defcriuefi nella feguente profpettiua la moftra* [...]. Letterpress, 1612. From: *Descrizione del Sacro Monte della Vernia* (Florence, s.n.: 1612) 394
13.1	'C.W.C.S.' and '1613', Cover, Achillis Bocchi, *Symbolicarum quæstionum* (Bologna, apud Societatem Typographiæ Bononiensis: 1574); *Stammbuch* Christian Weigel. Cod. Guelf. 225 Noviss. 8 405
13.2	Emblem 108, Achillis Bocchi, *Symbolicarum quæstionum* (Bologna, apud Societatem Typographiæ Bononiensis: 1574). http://emblematica.library.illinois.edu/detail/emblem/E020865 407
13.3	Emblem 108, Ludovicus entry, *pictura*, Bocchi, *Symbolicarum quæstionum; Stammbuch* Christian Weigel. Herzog August Bibliothek (HAB), Wolfenbüttel, Cod. Guelf. 225 Noviss. 8 408
13.4	Emblem 108, Ludovicus entry, text, Bocchi, *Symbolicarum quæstionum; Stammbuch* Christian Weigel. Herzog August Bibliothek (HAB), Wolfenbüttel, Cod. Guelf. 225 Noviss. 8 409

FIGURES

XIX

13.5 Emblem 108, Ludovicus entry, opening, Bocchi, *Symbolicarum quæstionum; Stammbuch* Christian Weigel. Herzog August Bibliothek (HAB), Wolfenbüttel, Cod. Guelf. 225 Noviss. 8 413

13.6 Emblem 108 verso, Roman Ludwig entry, opening, Bocchi, *Symbolicarum quæstionum; Stammbuch* Christian Weigel. Herzog August Bibliothek (HAB), Wolfenbüttel, Cod. Guelf. 225 Noviss. 8 417

14.1 "Fortuna-Occasio". Woodcut illustration, ante 1532 (1531?). Title page of Stanisław z Bochnie, *Fortuna albo Szczęście* (Kraków, Łazarz Andrysowic: [post 1561]). Munich, Bayerische Staatsbibliothek, call no. Res. 2 Phys.m.7 430

14.2 "Chart with a Rooster". Woodcut illustration, ante 1532 (1531?). In Stanisław z Bochnie, *Fortuna albo Szczęście* (Kraków, Łazarz Andrysowic: [post 1561]), fol. C ii r. Munich, Bayerische Staatsbibliothek, call no. Res. 2 Phys.m.7 431

14.3 "Chart with a Rabbit". Woodcut illustration, ante 1532 (1531?). In Stanisław z Bochnie, *Fortuna albo Szczęście* (Kraków, Łazarz Andrysowic: [post 1561]), fol. D vi v. Munich, Bayerische Staatsbibliothek, call no. Res. 2 Phys.m.7 432

14.4 "Oracles of Sybilla Kumana". Woodcut illustration, ante 1532 (1531?). In Stanisław z Bochnie, *Fortuna albo Szczęście* (Kraków, Łazarz Andrysowic: [post 1561]), fol. H iii r. Munich, Bayerische Staatsbibliothek, call no. Res. 2 Phys.m.7 433

14.5 "Oracles of Sybilla Samia". Woodcut illustration, ante 1599. In *Fortuna* (Cluj-Napoca, The Heltai Press, ca 1599–1601). Budapest, Országos Széchényi Könyvtár, call no RMK I. 361b 438

14.6 "Oracles of Sybilla Samia". Woodcut illustration, ca 1616. In *Fortuna* (Bardejov, Jakob Klöss (Junior), ca 1616). Budapest, Országos Széchényi Könyvtár, call no RMK I. 350 439

14.7 "Fortuna-Occasio". Woodcut illustration, ante 1599. Title page of *Fortuna* (Cluj-Napoca, The Heltai Press, ca 1599–1601). Budapest, Országos Széchényi Könyvtár, call no RMK I. 361b 440

14.8 "Chart with a Wolf". Watercolour on paper, ante 1664. In *Sibila Katarine Zrinske* (northern Croatia, ante 1664). Zagreb, Knjižnica Zagrebačke nadbiskupije (Metropolitana), call no. MR 157 444

14.9 "Oracles of Sybilla Persica". Watercolour on paper, ante 1664. In *Sibila Katarine Zrinske* (northern Croatia, ante 1664). Zagreb, Knjižnica Zagrebačke nadbiskupije (Metropolitana), call no. MR 157 445

14.10 Gerhard Altzenbach, *Twelve Sybillen*. Engraving, 36.6 × 29.1 cm. Cologne, 1620–1672. Braunschweig, Herzog Anton Ulrich-Museum, call no GAltzenbach AB 3.14 446

15.1 Michel Lasne, engraved portrait of Jean-François Niceron. In Niceron Jean-François, *La perspective curieuse* (Paris, François Langlois: 1652) 453

15.2	Engraving of cylindrical anamorphosis sketched by Jean-François Niceron. In Niceron Jean-François, *La perspective curieuse* (Paris, Pierre Billaine: 1638) plate 19. Source gallica.bnf.fr / Bibliothèque nationale de France 456
15.3	Engraving designed by Jean-François Niceron depicting Louis XIII seen using a faceted crystal. In Niceron Jean-François, *La perspective curieuse* (Paris, Pierre Billaine: 1638) plate 24. Source gallica.bnf.fr / Bibliothèque nationale de France 461
15.4	Jean Blanchin, engraving of quadrangle optical projection. In Niceron Jean-François, *La perspective curieuse* (Paris, Pierre Billaine: 1638) plate 18. Source gallica.bnf.fr / Bibliothèque nationale de France 462
15.5	Engraving of camera obscura. In Niceron Jean-François, *Thaumaturgus opticus* (Paris, François Langlois: 1646) plate 2 466
15.6	Engraving of 'scenographum catholicum'. In Niceron Jean-François, *Thaumaturgus opticus* (Paris, François Langlois: 1646) plate 37 468
16.1	Index, Cod. Guelf. 323 Mus. Hdschr, Wolfenbüttel, Herzog August Bibliothek 476
16.2	Title page, *Fasciculus Secundus* (Goslar, 1637). Krakow, Biblioteka Jagiellońska, Mus.ant.pract. D 600 483
16.3	*Verleih uns Frieden*, in *Fasciculus Secundus* (Goslar: 1637). Cantus partbook. Krakow, Biblioteka Jagiellońska, Mus.ant.pract. D 600 484
16.4	Cover page with collaged frontispiece, Cod. Guelf. 323 Mus. Hdschr., Wolfenbüttel, Herzog August Bibliothek 487
16.5	Detail, Scotto press device, Cod. Guelf. 323 Mus. Hdschr., Wolfenbüttel, Herzog August Bibliothek 489
17.1a	Cornelis Galle or Cornelis Galle (engravers) and Otto Vaenius (designer), "Vis Institutionis". Sample of *loci communes*. From: Vaenius Otto, *Q. Horatii Flacci emblemata* (Antwerp, P. Lisaert: 1612) 496
17.1b	Cornelis Galle or Cornelis Galle (engravers) and Otto Vaenius (designer), "Vis Institutionis". Engraving, 16.1 × 13.1cm. From: Vaenius Otto, *Q. Horatii Flacci emblemata* (Antwerp, P. Lisaert: 1612) 497
17.2	Pierre Daret (engraver) and Otto Vaenius (designer), "La Nourriture Peut Tout". Engraving, 18 × 14.5cm. From: Le Roy, Marin, Sieur de Gomberville, *La doctrine des moeurs* (Paris, P. Daret – L. Sevestre: 1646) 498
17.3	Pierre Daret (engraver) and Otto Vaenius (designer), "Education Can Do All Things". Engraving, 18 × 14.5cm. From: Gibbs Thomas Mannington, *Moral Virtue Delineated* (London, J. Darby – A. Bettesworth – F. Fayram – J. Pemberton – J. Hooke – C. Rivington – F. Clay – J. Batley – E. Symon: 1726) 499
17.4	Robert Williams (engraver) and Godfrey Kneller (painter), "Portrait of Mary Butler, Duchess of Ormonde, with Thomas, Earl of Ossory," *c.*1693. Mezzotint, 34.3 × 25cm 500

FIGURES

XXI

17.5 Edmund Arwaker, *Pia desideria: or, Divine Addresses in Three Books* (London, Henry Bonwicke: 1686), with a frontispiece by John Sturt (engraver) and Boëtius Bolswert (designer) 501

17.6 Stefano Mulinari (engraver) and Otto Vaenius (designer), "Tempora Mutantur, Et Nos Mutamus In Illis." Engraving, 17 × 13.8cm. From: Otto Vaenius – Stefano Mulinari, *Q. Horati Flacci emblemata/Emblemi Di Q. Orazio Flacco* (Florence, S. Mulinari: 1777) 507

17.7 J. Ford (engraver) and F.R. West, Otto Vaenius, and Stefano Mulinari (designers), "La Forza dell'Educazione." Engraving, 17.7 × 14.8cm. From: Elizabeth Grattan, *The First Number of a Translation from the Italian of the Morals of Horace, with Notes from the Principal Greek and Latin Historians and Poets* (Dublin, D. Graisberry: 1785) 508

17.8 W.P. Carey (engraver) and F.R. West, Otto Vaenius, and Stefano Mulinari (designers), "La Filosofia Maestra della Vita Umana." Engraving, 18.1 × 14.8cm. From: Elizabeth Grattan, *The First Number of a Translation from the Italian of the Morals of Horace, with Notes from the Principal Greek and Latin Historians and Poets* (Dublin, D. Graisberry: 1785) 510

17.9 J. Ford (engraver) and Otto Vaenius, and Stefano Mulinari (designers), "Conviene Alternare Il Contegno Grave Con La Piacevolezza." Engraving, 18.8 × 14.8cm. From: Elizabeth Grattan, *The First Number of a Translation from the Italian of the Morals of Horace, with Notes from the Principal Greek and Latin Historians and Poets* (Dublin, D. Graisberry: 1785) 511

17.10 J. Ford (engraver) and F.R. West, Otto Vaenius, and Stefano Mulinari (designers), "La Natura Ottima Moderatrice." Engraving, 18.1 × 14.9cm. From: Elizabeth Grattan, *The First Number of a Translation from the Italian of the Morals of Horace, with Notes from the Principal Greek and Latin Historians and Poets* (Dublin, D. Graisberry: 1785) 514

17.11 J. Ford (engraver) and F.R. West, Otto Vaenius, and Stefano Mulinari (designers), "Chi E Ricco? Chi Nulla Desidera." Engraving, 18 × 14cm. From: Elizabeth Grattan, *The First Number of a Translation from the Italian of the Morals of Horace, with Notes from the Principal Greek and Latin Historians and Poets* (Dublin, D. Graisberry: 1785) 515

17.12 J. Ford (engraver) and F.R. West, Otto Vaenius, and Stefano Mulinari (designers), "La Potesta Soggetta Ad Altra Maggior Potesta." Engraving, 18 × 14.7cm. From: Elizabeth Grattan, *The First Number of a Translation from the Italian of the Morals of Horace, with Notes from the Principal Greek and Latin Historians and Poets* (Dublin, D. Graisberry: 1785) 516

18.1 Albrecht Dürer, *A Pastoral Landscape with Shepherds Playing a Viola and Panpipes*. Painted illumination on a printed sheet, 31 × 20.3 cm. From: Theocritus, *Idylls and Other Texts*. (Venice, Aldus Manutius: 1495/6) 528

18.2	Albrecht Dürer, *A Pastoral Landscape with Shepherds Playing a Viola and Panpipes* (detail) 529
18.3	Albrecht Dürer, *Joachim and the Angel* (detail), ca. 1504. Woodcut, sheet: 29.4 × 21 cm. Yale University Art Gallery, 1956.16.2c 531
18.4	Ovid, *Opera* (Venice, Aldus Manutius: 1502–1503. Manchester, The John Rylands University Library, Spencer 3366, (illumination attributed to Benedetto Bordon) 533
18.5	Albrecht Dürer, *A Pastoral Landscape with Shepherds Playing a Viola and Panpipes* (detail) 533
18.6	Albrecht Dürer, *A Pastoral Landscape with Shepherds Playing a Viola and Panpipes* (detail) 535
18.7	Choir screen at Santa Maria Gloriosa dei Frari, Venice, ca. 1475. Photo: "The Choir Screen" by Slices of Light (marked CC BY-NC-ND 2.0). Available at: https://flic.kr/p/2hPhQcn To view the terms, visit https://creativecommons.org/licenses/by-nd-nc/2.0/jp/?ref=openverse 536
19.1	"David of Burgundy", in the *Kattendijke Chronicle*. The Hague, National Library of the Netherlands, KW 1900 A 008, fol. 530v. Folio size 200 × 140 mm 550
19.2	"Emperor Louis", in The Hague, National Library of the Netherlands, KW 1900 A 008, fol. 152v. Folio size 200 × 140 mm 552
19.3a	"Kings and Princes Coming to Troy to Assist King Priam", in The Hague, National Library of the Netherlands, KW 1900 A 008, fol. 48v. Folio size 200 × 140 mm 554
19.3b	Detail of "Kings and Princes Coming to Troy to Assist King Priam", in The Hague, National Library of the Netherlands, KW 1900 A 008, fol. 48v. Folio size 200 × 140 mm 555
19.4	"Christians in Jerusalem Seeing Signs in Heaven", in *Historie van hertoghe Godevaert van Boloen* ([Gouda, Printer of Godevaert van Boloen (Collaciebroeders?): about 1486–87]). Woodcut. Leiden, University Library, shelf mark THYSIA 2259A, fol. p3v 555
19.5a–b	Reconstruction of the cutting and pasting process using a modern printout of the woodcut from the *Historie van hertoghe Godevaert van Boloen* ([Gouda, Printer of Godevaert van Boloen (Collaciebroeders?): about 1486–87]) 556
19.6	Detail of "Troy under Siege", in The Hague, National Library of the Netherlands, KW 1900 A 008, fol. 55v 557
19.7a	"Dirc III, Count of Holland", The Hague, National Library of the Netherlands, KW 1900 A 008, fol. 173v. Folio size 200 × 140 mm 560

FIGURES

XXIII

19.7b "Knight", in *De ludo scachorum* in Dutch (Delft, Jacob Jacobszoon van der Meer: 14 Feb. 1483). Woodcut. Oxford, Bodleian Library, shelf mark Auct. 2Q 5.7, fol. e<5>v 561

19.8 Anonymous Master (School of the Master of the Playing Cards), "Four of Birds". Copper engraving, plate 6.9 × ca. 9.2 cm, sheet 9.6 × 14.1 cm. Vienna, Albertina, inv. no. DG1926/639 563

19.9a "Margaret II of Hainault and Banner Bearer" in The Hague, National Library of the Netherlands, KW 1900 A 008, fol. 311v. Folio size 200 × 140 mm 564

19.9b Detail of "Margaret II of Hainault and Banner Bearer" in The Hague, National Library of the Netherlands, KW 1900 A 008, fol. 311v. Folio size 200 × 140 mm 565

19.10 Anonymous Master (School of the Master of the Playing Cards), "Eight of Birds". Copper engraving, plate 13.5 × 9.9 cm. Vienna, Albertina, inv. no. DG1926/645 566

19.11 Reconstruction of "Margaret II of Hainault's Banner Bearer", in The Hague, National Library of the Netherlands, KW 1900 A 008, fol. 311v and Vienna, Albertina, inv. no. DG1926/645 567

19.12a Master of the Berlin Passion, *A Swan, a Stork, and an Ostrich*. Copper engraving, sheet 8.7 × 6.9 cm. Vienna, Albertina, inv. no. DG1926/832 568

19.12b Reconstruction of the "Banner Bearer of Floris II", in The Hague, National Library of the Netherlands, KW 1900 A 008, fol. 189v and Vienna, Albertina, inv. no. DG1926/832 569

19.13 Master E.S., retouched by Israhel van Meckenem, *Six of Beasts*. Copper engraving, plate 9.7 × 6.7 cm. Vienna, Albertina, inv. no. DG1926/792 570

19.14 "Count Willem V of Holland with Banner Bearer", in The Hague, National Library of the Netherlands, KW 1900 A 008, fol. 321v. Folio size 200 × 140 mm 571

19.15 "Emperor Octavian Augustus and Banner Bearer", in The Hague, National Library of the Netherlands, KW 1900 A 008, fol. 101v. Folio size 200 × 140 mm 572

19.16 "Christ and the Woman of Samaria", in *Tboeck vanden leven Jhesu Christi* (Delft, [Christiaen Snellaert]: 22 May 1488). Woodcut, hand coloured. Nijmegen, University Library, shelf mark Inc 40 nr.1, fol. n1r 573

19.17 "Dirc II, Count of Holland", in The Hague, National Library of the Netherlands, KW 1900 A 008, fol. 167v. Folio size 200 × 140 mm 574

19.18 "Christ Disrobed", in *Tboeck vanden leven Jhesu Christi* (Delft, [Christiaen Snellaert]: 22 May 1488). Woodcut, hand coloured. Liège, University Library, shelf mark XV.B228, fol. gg1v 575

19.19	Reconstruction of "Dirc II's Banner Bearer", The Hague, National Library of the Netherlands, KW 1900 A 008, fol. 167v and Liège, University Library, shelf mark XV.B228, fol. gg1v 576
19.20	Reconstruction of "Philip of Burgundy's Banner Bearer", in The Hague, National Library of the Netherlands, KW 1900 A 008, fol. 514v and figure cut from *Historie van hertoghe Godevaert van Boloen* ([Gouda, Printer of Godevaert van Boloen (Collaciebroeders?): about 1486–87]). Woodcut. Leiden, University Library, shelf mark THYSIA 2259A, fol. k2r 577
19.21	"Forest without Mercy", in The Hague, National Library of the Netherlands, KW 1900 A 008, fol. 111v. Folio size 200 × 140 mm 580
19.22	"The Soul with a Hound on a Leash", in *Van die gheestlike Kintscheÿt ihesu ghemoraliseert* (Antwerp, Gerard Leeu: 16 Feb. 1488). Woodcut. The trees on the top right were cut and pasted behind the remains of dragon-like figure (engraving) in the bottom half of the *Forest without Mercy* (Fig. 19.21). Washington D.C., LoC, Incun. 1488 .V3, fol. h2r. Library of Congress, Rare Book and Special Collections Division 581
19.23	"Miracle of Loosduinen", in The Hague, National Library of the Netherlands, KW 1900 A 008, fol. 226v. Folio size 200 × 140 mm 583
19.24	"Circumcision", in *Tboeck vanden leven Jhesu Christi* (Delft, [Christiaen Snellaert]: 22 May 1488). Woodcut, hand coloured. Liège, University Library, shelf mark XV.B228, fol. e3v 584
19.25	"Christ preaching and a woman in the crowd raising her voice", in *Tboeck vanden leven Jhesu Christi* (Antwerp, Gerard Leeu: 3 Nov. 1487). Woodcut, hand coloured. Liège, University Library, XV.C164, fol. v2r 588
19.26	Master of the Ten Thousand Martyrs, *Nativity*, in Prayerbook, Dutch, after *c.* 1485, paper, ca. 130 × 90 mm. Copper engraving. Vienna, Österreichische Nationalbibliothek, Ms. Series Nova 12909, fol. 17v 589
19.27	"Godfrey Crowned King of Jerusalem", in *Historie van hertoghe Godevaert van Boloen* ([Gouda, Printer of Godevaert van Boloen (Collaciebroeders?): about 1486–87]). Woodcut. Leiden, University Library, shelf mark THYSIA 2259A, fol. k5v 591
19.28	"King Eson Announces his Last Will", in Raoul Lefèvre, *Historie van den vromen ridder Jason* (Haarlem, Jacob Bellaert: [about 1483–85]). Woodcut, hand coloured. Washington, Library of Congress, fol. a2v 592
19.29a–b	"The Elder and the Soul", in Otto von Passau, *Dat boeck des gulden throens* (Utrecht, [Printer with the Monogram], 30 Mar. 1480). Woodcut, hand coloured. Utrecht, University Library, shelf mark E fol 153 (Rariora) dl 1, fols. 9v and 18r 596
20.1	*Het Nieu Testament onses Heeren Iesu Christi, met korte uytlegghinghen door Franciscum Costerum, Priester der Societeyt Iesu* (Antwerp, Ioachim Trognaesius: 1614), title-page. Engraving, in folio 601

FIGURES

XXV

20.2 Matthew 3:11–24, with scriptural glosses in the narrow outer margins at left and far right and Costerus's glosses in the wide column at right, from Costerus Franciscus, s.j., *Het Nieu Testament onses Heeren Iesu Christi* (Antwerp, Ioachim Trognaesius: 1614) 3 602

20.3 Acts 1:4–11, with cut and pasted-in *Garland and Holy Spirit*, and sewn-in *Ascension* by Gaspar Huybrechts, from *Het Nieu Testament onses Heeren Iesu Christi* (Antwerp, Ioachim Trognaesius: 1614) 370–371. Engraving, inserted in folio 604

20.4 James 5:13–20, with cut and pasted-in *Death of a Sick Man, with Monks, Lay People, and the Devil at his Bedside*, and cut and pasted-in *Saint Aloysius Gonzaga in Prayer*, from *Het Nieu Testament onses Heeren Iesu Christi* (Antwerp, Ioachim Trognaesius: 1614) 866–867. Engraving, inserted in folio 606

20.5 Luke 18:14–27, with sewn-in *Suffer the Children to Come unto Me*, from *Het Nieu Testament onses Heeren Iesu Christi* (Antwerp, Ioachim Trognaesius: 1614) 238–239. Engraving, inserted in folio 607

20.6 "Tot den Godtvruchtighen leser", from *Het Nieu Testament onses Heeren Iesu Christi* (Antwerp, Ioachim Trognaesius: 1614), fol. **3 recto 608

20.7 Matthew 28:17–20, with cut and pasted-in *Saints Ignatius and Francis Xavier Flanking the Virgin and Child*, from *Het Nieu Testament onses Heeren Iesu Christi* (Antwerp, Ioachim Trognaesius: 1614) 100–101. Engraving, inserted in folio 614

20.8 "Van de Catholiicke oft canoniicke brieven", with cut and pasted-in *Blesseds Aloysius Gonzaga and Stanislaus Kostka*, and *Francis Borgia Kneeling before the Trinity, the Virgin, and Saints Ignatius and Francis Xavier*, from *Het Nieu Testament onses Heeren Iesu Christi* (Antwerp, Ioachim Trognaesius: 1614) 844–845. Engraving, inserted in folio 617

20.9 Matthew 23:16–29, with cut and pasted-in *Christ the Judge* and *Kneeling Votary*, from *Het Nieu Testament onses Heeren Iesu Christi* (Antwerp, Ioachim Trognaesius: 1614) 71. Engraving, inserted in folio 620

20.10 Matthew 23:30–35, with cut and pasted-in *God the Father*, from *Het Nieu Testament onses Heeren Iesu Christi* (Antwerp, Ioachim Trognaesius: 1614) 72. Engraving, inserted in folio 622

20.11 Mark 15:12–17, with cut and pasted-in *Crucifixion with Mary and John*, and sewn-in *Ecce Homo* by Alexander Voet, from *Het Nieu Testament onses Heeren Iesu Christi* (Antwerp, Ioachim Trognaesius: 1614) 152–153. Engraving, inserted in folio 624

20.12 Mark 15:28–41, with sewn-in *Crucifixion, Sixth to Ninth Hours*, from *Het Nieu Testament onses Heeren Iesu Christi* (Antwerp, Ioachim Trognaesius: 1614) 152–153. Engraving, inserted in folio 626

20.13	Mark 15:28–41, with cut and pasted-in *Crucified Christ Flanked by Angels* and *Centurion / Longinus Piercing the Side of Christ*, from *Het Nieu Testament onses Heeren Iesu Christi, met korte uytlegghinghen door Franciscum Costerum, Priester der Societeyt Iesu* (Antwerp, Ioachim Trognaesius: 1614) 153. Engraving, inserted in folio 628
20.14	Luke 22:41–55, with cut and pasted-in *Agony in the Garden*, from *Het Nieu Testament onses Heeren Iesu Christi* (Antwerp: Ioachim Trognaesius, 1614) 254. Engraving, inserted in folio 630
20.15	Luke 22:44–56, with cut and pasted-in *Christ Crucified* and *Virgin of Sorrow Mourning the Entombment*, from *Het Nieu Testament onses Heeren Iesu Christi* (Antwerp, Ioachim Trognaesius: 1614) 260–261. Engraving, inserted in folio 631
20.16	Luke 22:56–69, with sewn-in *Penitent Saint Peter* by Alexander Voet, from *Het Nieu Testament onses Heeren Iesu Christi* (Antwerp, Ioachim Trognaesius: 1614) 254–255. Engraving, inserted in folio 633
20.17	Luke 22:11–26, with sewn-in *Christ Bound to the Column* by Maarten van den Eenden, from *Het Nieu Testament onses Heeren Iesu Christi* (Antwerp, Ioachim Trognaesius: 1614) 256–257. Engraving, inserted in folio 634
20.18	Luke 22:11–26, with cut and pasted-in *Christ Scourged and Bleeding from many Wounds* and *Virgin of Sorrows Meeting Christ on the Road to Calvary*, from *Het Nieu Testament onses Heeren Iesu Christi* (Antwerp, Ioachim Trognaesius: 1614) 257. Engraving, inserted in folio 637
20.19	Luke 22:27–31, with cut and pasted-in *Angel Exhibiting the Sudarium*, from *Het Nieu Testament onses Heeren Iesu Christi* (Antwerp, Ioachim Trognaesius: 1614) 258. Engraving, inserted in folio 639
20.20	Luke 22:27–31, with sewn-in *Carrying of the Cross* by Gaspar Huybrechts, from *Het Nieu Testament onses Heeren Iesu Christ* (Antwerp, Ioachim Trognaesius: 1614) 258–259. Engraving, inserted in folio 642
20.21	Luke 22:27–31, with cut and pasted-in *Carrying of the Cross with Virgin of Sorrows*, from *Het Nieu Testament onses Heeren Iesu Christi* (Antwerp, Ioachim Trognaesius: 1614) 258–259. Engraving, inserted in folio 644
20.22	Luke 22:27–31, with sewn-in *Holy Face with the Crown of Thorns* by Gaspar Huybrechts, from *Het Nieu Testament onses Heeren Iesu Christi* (Antwerp, Ioachim Trognaesius: 1614) 258–259. Engraving, inserted in folio 645
20.23	Luke 22:32–43, with sewn-in *Crucified Christ with Arma Christi and Ecclesia Lodged in the Sacred Heart*, from *Het Nieu Testament onses Heeren Iesu Christi* (Antwerp, Ioachim Trognaesius: 1614) 258–259. Engraving, inserted in folio 647
20.24	Luke 22;32–43, with cut and pasted-in *Virgin of Sorrows Gazes at the Crucified Christ* and *Virgin of Sorrows Meditates on the Passion*, from *Het Nieu*

FIGURES XXVII

Testament onses Heeren Iesu Christi (Antwerp, Ioachim Trognaesius: 1614)
259. Engraving, inserted in folio 648

20.25 John 20:29–31, with sewn-in *Effigy of the Risen Christ* and *Effigy of the
 Virgin* (*Apparition of Jesus to Mary*), by Pieter de Bailliu after Theodoor
 van Thulden, from *Het Nieu Testament onses Heeren Iesu Christi* (Antwerp,
 Ioachim Trognaesius: 1614) 364–365. Engraving, inserted in folio 652

20.26 John 20:1–13, cut and pasted-in *Salome and Mary of James / Joanna and Mary
 of James Bear Witness to the Resurrection* and sewn-in *Resurrection*, from
 Het Nieu Testament onses Heeren Iesu Christi (Antwerp, Ioachim Trognaesius:
 1614) 360–361. Engraving, inserted in folio 657

20.27 John 20:1–13, sewn-in *Apparition of the Risen Christ to the Magdalene*, and cut
 and pasted-in *Mary Magdalene*, from *Het Nieu Testament onses Heeren Iesu
 Christi* (Antwerp, Ioachim Trognaesius: 1614) 360–361. Engraving, inserted
 in folio 658

20.28 John 18:1–13, cut and pasted-in *Agony in the Garden*, and sewn-in *Agony in
 the Garden* by Alexander Voet, from *Het Nieu Testament onses Heeren Iesu
 Christi* (Antwerp, Ioachim Trognaesius: 1614) 352–353. Engraving, inserted
 in folio 660

20.29 John 18:14–23, cut and pasted-in *Penitent Saint Peter*, from *Het Nieu
 Testament onses Heeren Iesu Christi* (Antwerp, Ioachim Trognaesius: 1614)
 353. Engraving, inserted in folio 662

20.30 John 18:14–23, sewn-in *Christ before Caiaphas* by Gaspar Huybrechts, from
 Het Nieu Testament onses Heeren Iesu Christi (Antwerp, Ioachim Trognaesius:
 1614) 352–353. Engraving, inserted in folio 664

20.31 John 18:24–36, sewn-in *Christ before Pontius Pilate* by Gaspar Huybrechts,
 from *Het Nieu Testament onses Heeren Iesu Christi* (Antwerp, Ioachim
 Trognaesius: 1614) 354–355. Engraving, inserted in folio 665

20.32 John 19:1–6, sewn-in *Flagellation* by Alexander Voet, from *Het Nieu Testament
 onses Heeren Iesu Christi* (Antwerp, Ioachim Trognaesius: 1614) 354–355.
 Engraving, inserted in folio 668

20.33 John 19:1–6, sewn-in *Christ Kneels to Retrieve his Robe after the Scourging
 at the Pillar* by Alexander Voet, from *Het Nieu Testament onses Heeren Iesu
 Christi* (Antwerp, Ioachim Trognaesius: 1614) 354–355. Engraving, inserted in
 folio 669

20.34 *Christ Mocked and Crowned with Thorns*, from *Het Nieu Testament onses
 Heeren Iesu Christi* (Antwerp, Ioachim Trognaesius: 1614) 354–355. Engraving,
 inserted in folio 670

20.35 John 19:7–12, sewn-in *Ecce Homo* by Gaspar Huybrechts, from *Het Nieu
 Testament onses Heeren Iesu Christi* (Antwerp, Ioachim Trognaesius: 1614)
 356–357. Engraving, inserted in folio 671

XXVIII

FIGURES

20.36 John 19:13–24, sewn-in *Carrying of the Cross* by Gaspar Huybrechts, from *Het Nieu Testament onses Heeren Iesu Christi* (Antwerp, Ioachim Trognaesius: 1614) 356–357. Engraving, inserted in folio 672

20.37 John 19:25–33, sewn-in *Crucifixion* by Gaspar Huybrechts, from *Het Nieu Testament onses Heeren Iesu Christi* (Antwerp, Ioachim Trognaesius: 1614) 358–359. Engraving, inserted in folio 673

20.38 John 19:25–33, sewn in *Deposition* by Gaspar Huybrechts, from *Het Nieu Testament onses Heeren Iesu Christi* (Antwerp, Ioachim Trognaesius: 1614) 358–359. Engraving, inserted in folio 674

20.39 John 19:34–42, sewn-in *Entombment* by Gaspar Huybrechts, from *Het Nieu Testament onses Heeren Iesu Christi* (Antwerp, Ioachim Trognaesius: 1614) 358–359. Engraving, inserted in folio 675

21.1 Preface page from Nicolás del Techo, *Historia Provinciae Paraquariae Societatis Iesu* [p. 8], late 17th centuryW 691

21.2 Spanish titlepage from *Edvcacion Christiana: y buena criança de los niños guaranis*, 1713 692

21.3 Guarani titlepage from *Edvcacion Christiana: y buena criança de los niños guaranis*, 1713 693

21.4 Bernardino de Cerbín's approbation, Archivum Romanum Societatis Iesu, 1700, VL Paraquaria 01.1 699

21.5 First state, page 4 from Juan Eusebio Nieremberg, *De la Diferencia* (Doctrinas [Loreto, Juan Bautista Neumann]: 1705) 700

21.6 Second state, *c.* 1700, page 4 from Juan Eusebio Nieremberg, *De la Diferencia* (Doctrinas [Loreto, Juan Bautista Neumann]: 1705) 701

21.7 Plate 9 from Jeremias Drexel's *Infernus, damnatorum carcer et rogus* (Monaco, Cornelius Leysser: 1631) 182 704

21.8 Gaspar Bouttats, plate 453 from Juan Eusebio Nieremberg's *De la Diferencia* (Antwerp, Verdussen: 1684) 705

21.9 Boetius à Bolswert, "Image of the World". Engraving. 1616 706

21.10 Gaspar Bouttats, plate 21 from Juan Eusebio Nieremberg's *De la Diferencia* (Antwerp, Verdussen: 1684) 707

21.11 Emblem *Mortis Formido* from Otto Vaenius, *Quinti Horatij Flacci Emblemata* (Antwerp, Phillipe Lisaert: 1612) 75 708

21.12 Gaspar Bouttats, plate 122 from Juan Eusebio Nieremberg's *De la Diferencia* (Antwerp, Verdussen: 1684) 709

21.13 Titlepage, Guarani edition of Juan Eusebio Nieremberg's *De la Diferencia* (Loreto, Juan Bautista Neumann et alii: 1705) 710

21.14 Gaspar Bouttats, plate 309 from Juan Eusebio Nieremberg's *De la Diferencia* (Antwerp, Verdussen: 1684) 712

FIGURES XXIX

21.15 Juan Yaparí (attributed to), plate 31 from Juan Eusebio Nieremberg's *De la Diferencia* (Doctrinas [Loreto, Juan Bautista Neumann]: 1705) 713

21.16 Gaspar Bouttats, plate iii from Juan Eusebio Nieremberg's *De la Diferencia* (Antwerp, Verdussen: 1684) 716

21.17 Plate 17 from Juan Eusebio Nieremberg's *De la Diferencia* (Loreto, Juan Bautista Neumann et alii: 1705) 717

21.18 Gaspar Bouttats, plate 122 (detail) from Juan Eusebio Nieremberg's *De la Diferencia* (Antwerp, Verdussen: 1684) 718

21.19 Plate 23 from Juan Eusebio Nieremberg's *De la Diferencia* (Loreto, Juan Bautista Neumann et alii: 1705) 718

21.20 Detail from plates 18 (2.8); 19 (2.12); 21 (2.20), 23 (2.30), 24 (2.44), from Juan Eusebio Nieremberg's *De la Diferencia* (Loreto, Juan Bautista Neumann et alii: 1705) 720

21.21 Maria Eugenia de Beer, frontispiece for Francisco Aguado's *Sumo Sacramento de la fe* (Madrid, Franco Martinez: 1640) 721

21.22 Plate 2 from Juan Eusebio Nieremberg's *De la Diferencia* (Loreto, Juan Bautista Neumann et alii: 1705) 722

21.23 Frontispiece and engravings from Giovanni Pietro Pinamonti's *L'Inferno aperto al cristiano perche non v'entri* (Bologne, heirs of Antonio Pisarri: 1689) 724

21.24 Plates 34–41 from Juan Eusebio Nieremberg's *De la Diferencia* (Loreto, Juan Bautista Neumann et alii: 1705) 725

21.25 Emblems 48, 122 and 113 from Andrea Alciato's *Emblematum libri duo* (Lyon, Jean de Tournes: 1547) 728

21.26 Plate 13 from Juan Eusebio Nieremberg's *De la Diferencia* (Loreto, Juan Bautista Neumann et alii: 1705) 729

21.27 Plate 23 from Juan Eusebio Nieremberg's *De la Diferencia* (Loreto, Juan Bautista Neumann et alii: 1705). Detail from Figure 21.19 (Image © Museo Colonial e Histórico de Luján); and Boetius a Bolswert, eighteenth image [*decimaoctava imago*] from Antoine Sucquet's *Via Vitae Aeternae* (Antwerp, Martinus Nutius: 1620). Detail (Image © Getty Research Institute) 733

21.28 Plate 22 from Juan Eusebio Nieremberg's *De la Diferencia* (Loreto, Juan Bautista Neumann et alii: 1705. Detail 736

21.29 Gaspar Bouttats (after Joseph Lamorlet), "El Emperador Carlos v. renuncia en Brusselas todos sus Estados de Flandes [...]". Detail. Engraving from Prudencio de Sandoval's *Historia de los Hechos del Emperador Carlos V* (Antwerp, Verdussen: 1681). Image © Universidad Complutense de Madrid 737

21.30 Plate 16 from Nieremberg's *De la Diferencia*. Detail. (Doctrinas [Loreto, Juan Bautista Neumann]: 1705) 738

XXX FIGURES

21.31 Antonio Tempesta, "Aul[us] Vitellius Aug[ustus]", engraving from the series
 The First Twelve Roman Caesars (1596) (Image © Metropolitan Museum);
 Mathäus Merien, "Aul[us] Vitellius Aug[ustus]" after Tempesta (1616) (Image
 © Metropolitan Museum); Gaspar Bouttats after Joseph Lamorlet, engraving
 from Prudencio de Sandoval's *Historia de los Hechos del Emperador
 Carlos V*. Detail. (Antwerp, Verdussen: 1681) (Image © Universidad
 Complutense de Madrid) 739
21.32 Plate 24 from Juan Eusebio Nieremberg's *De la Diferencia*. Detail. (Loreto,
 Juan Bautista Neumann et alii: 1705) (Image © Museo Colonial e Histórico
 de Luján); and Hieronymus Wierix (engraver), *Ingressus solemnis in
 ciuitatem*, plate 87 from Jeronimo Nadal's *Evangelicae Historiae Imagines*,
 Antwerp, 1593. The arrows are mine and indicate 'points of interest' for
 comparison 747
21.33 Plate 4 from Juan Eusebio Nieremberg's *De la Diferencia* (Loreto, Juan
 Bautista Neumann et alii: 1705) 750
21.34 Juan Yapari (attributed to), plate 11 from Juan Eusebio Nieremberg's
 De la Diferencia (Loreto, Juan Bautista Neumann et alii: 1705) 751
21.35 A graph showing the number of plates based on their iconographic
 group 758

Notes on the Editors

Christopher D. Fletcher
is the Assistant Director of the Center for Renaissance Studies at the Newberry Library in Chicago. A medieval historian by training, his research focuses on the relationship between religion and public communication technology before 1800. He has published articles on letter-writing in the Middle Ages, emblems, and the digital humanities. His current book project, *Public Engagement in the Middle Ages: Medieval Solutions to a Modern Crisis*, explores how medieval practices of public engagement can inform modern scholars' public outreach efforts.

Walter S. Melion
is Asa Griggs Candler Professor of Art History at Emory University in Atlanta, where he directs the Fox Center for Humanistic Inquiry (Emory's institute for advanced study in the humanities). He is author of three monographs and a critical edition of Karel van Mander's *Foundation of the Noble, Free Art of Painting*, co-author of two exhibition catalogues, editor or co-editor of more than twenty-five volumes, and has published more than eighty articles. Melion is editor of two book series: Brill's *Studies on Art, Art History, and Intellectual History* and *Lund Humphries' Northern Lights*. He was elected Foreign Member of the Royal Netherlands Academy of Arts and Sciences in 2010. He is president emeritus of the Sixteenth Century Society, current president of the Historians of Netherlandish Art, and a board member of the Print Council of America.

Notes on the Contributors

Britt Boler Hunter
is the Instruction and Reference Librarian at the Florida State University College of Law Research Center and was formerly a Patricia Rose Teaching Fellow at the Florida State University Department of Art History, where she completed her Ph.D. in summer 2022. Hunter's research centers on the construction of visual information and visual exegesis in late medieval manuscripts and early printed books. She is particularly interested in Apocalypse iconography, narrative picture cycles, and the *compilatio* of illustrations and diagrams in medieval encyclopedias. Hunter co-authored the 2020 facsimile commentary volume *Picture Book of the Life of St. John and the Apocalypse* with Richard K. Emmerson and Peter Kidd.

Tom Cummins
is Dumbarton Oaks Professor of the History of Pre-Columbian and Colonial Art in the Department of the History of Art and Architecture at Harvard University since 2002, and Director of Dumbarton Oaks since 2019. In 2011, he was awarded La Orden "Al Mérito por Servicios Distinguidos En el Grado de Gran Cruz" by the Republic of Peru. He is a member of the American Academy of Art and Science.

Anna Dlabačová
is a University Lecturer at the Leiden University Centre for the Arts in Society where she teaches in the MA program Book and Digital Media Studies. Her research focuses on the late medieval Low Countries and her research interests include late medieval spiritual literature, prayer culture, the transmission of texts, and the role of the printing press in the dissemination of texts and images. In 2023 she hopes to commence her ERC-Starting Grant project "Pages of Prayer: The Ecosystem of Vernacular Prayer Books in the Late Medieval Low Countries, *c.* 1380–1550".

Karl A.E. Enenkel
is Professor of Medieval Latin and Neo-Latin at the University of Münster (Germany). Previously he was Professor of Neo-Latin at Leiden University (Netherlands). He is a member of the *Royal Netherlands Academy of Arts and Sciences*. Among his major book publications are *Francesco Petrarca: De vita solitaria, Buch 1.* (1991); *Die Erfindung des Menschen. Die Autobiographik des frühneuzeitlichen Humanismus von Petrarca bis Lipsius* (2008); *Die Stiftung*

NOTES ON THE CONTRIBUTORS

von Autorschaft in der neulateinischen Literatur (ca. 1350–ca. 1650) (2015); *The Invention of the Emblem Book and the Transmission of Knowledge, ca. 1510–1610* (2019), and *Ambitious Antiquities, Famous Forebears. Constructions of a Glorious Past in the Early Modern Netherlands and Europe* (with Koen Ottenheym, 2019). He has (co)edited and co-authored some 40 volumes on a variety of topics; key topics are addressed in *Modelling the Individual. Biography and Portrait in the Renaissance* (1998), *Recreating Ancient History* (2001), *Mundus Emblematicus. Studies in Neo-Latin Emblem Books* (2003), *Cognition and the Book* (2004), *Petrarch and his Readers* (2006), *Early Modern Zoology* (2007), *The Authority of the Word* (2011), *The Reception of Erasmus* (2013), *Transformation of the Classics* (2013), *Neo-Latin Commentaries and the Management of Knowledge* (2013), *Beiträge zu Boccaccios lateinischen Werken und ihrer Wirkung* (2015), *Discourses of Anger in the Early Modern Period* (2015), *Jesuit Image Theory* (2016), *Emblems and the Natural World* (2017), *The Figure of the Nymph in Early Modern Culture* (2018), *Solitudo. Spaces, Places, and Times of Solitude in Late Medieval and Early Modern Cultures* (2018), *Artes Apodemicae and Early Modern Travel Culture, 1550–1700*, and *Reinventing Ovid's Metamorphoses. Pictorial and Literary Transformation in Various Media, 1500–1800*. He has founded the international series *Intersections. Studies in Early Modern Culture* (Brill); *Proteus. Studies in Early Modern Identity Formation*; *Speculum Sanitatis: Studies in Medieval and Early Modern Medical Culture* (500–1800) (both Brepols), and *Scientia universalis*.

Paul F. Gehl

is Curator Emeritus at the Newberry Library, Chicago, where he served for some thirty years as Custodian of the John M. Wing Foundation on the History of Printing and George A. Poole III Curator of Rare Books. He is an historian of education, printing, and design, the author of *A Moral Art: Grammar, Culture and Society in Trecento Florence* (1993); *Humanism For Sale: Making and Marketing Schoolbooks in Italy 1450–1650* (2008); *A Meditation in Rome* (2012); and *Chicago Modernism and the Ludlow Typograph: Douglas C. McMurtrie and Robert Hunter Middleton at Work* (2020).

Pedro Leal

currently serves as Associate Director for Digital Asset Management at the John Carter Brown Library at Brown University. Previously he was Assistant Professor in Portuguese and Hispanic Studies at the University of Glasgow, and held research and teaching positions in Brazil, Spain, Belgium, Germany, and Scotland. Leal was recently appointed Editor in Chief of *Emblematica: Essays in Word and Image* (Droz).

Leal's research interests lie in emblem studies and intermediality in the early modern period. His current work focuses on the role of books and prints in the clash between Indigenous and colonial visual cultures in the Americas. He edited *Emblems in Colonial Ibero-America* (Glasgow Emblem Studies, 2017); co-edited, with José Julio García Arranz, *Jeroglíficos en la Edad Moderna* (Janus, 2020) and, more recently, co-edited a special issue of Early Modern Digital Review, *Digital Emblematica* (2022), with Mara Wade.

Justyna Kiliańczyk-Zięba

is an assistant professor at the Jagiellonian University in Krakow, Poland. She is the author of *Jan Januszowski – pisarz, tłumacz, wydawca* (2007), a book about a printer-intellectual active in Krakow in the sixteenth century, and *Sygnety drukarskie w Rzeczypospolitej XVI wieku. Źródła ikonograficzne i treści ideowe* (2015), a monograph on printers' devices in early modern Poland-Lithuania. She has published a number of articles on book history, emblematics and history of ideas, as well as edited extensive sixteenth-century texts.

Jakub Koguciuk

graduated from the Ph.D. program in History of Art and Renaissance Studies at Yale University in 2019. His thesis explores the artistic impact of Jacopo Sannazaro's *Arcadia* and the evolution of pastoral motifs in the arts of the period. He is working on a book-length study of Italian Renaissance pastoral in literature and the visual arts. He is interested in the Renaissance in Venice and the Veneto as well as the development of Early Modern print culture and the history of the environment.

Andrea van Leerdam

is a book historian with a particular interest in the intersections of materiality, images, and reading practices in the early period of print. She completed her dissertation *Woodcuts as Reading Guides. How Images Shaped Knowledge Transmission in Medical-Astrological Books in Dutch (1500–1550)* at Utrecht University in 2022, funded by the Dutch Research Council NWO. She graduated in Medieval and Renaissance Studies in 2005 at Utrecht University and has worked as a Humanities communication advisor. In 2022–2023, she is a post-doctoral researcher in a digital humanities project on *The European Dimensions of Popular Print Culture* led by Dr Jeroen Salman at Utrecht University.

NOTES ON THE CONTRIBUTORS

Stephanie Leitch

is associate professor of Art History at Florida State University, where she teaches early modern art and the history of printmaking. She is the author of *Mapping Ethnography in Early Modern Germany: New Worlds in Print Culture* (2010) and many articles about the intersection of printmaking with knowledge-based pursuits. Her current book project, *The Art of Observation in the Early Modern Print*, explores how the visual accompaniments of how-to genres sharpened visual acuity, cued observation, and calibrated sightings.

Simon McKeown

is Head of the History of Art Department, Marlborough College, U.K. He serves as General Editor of the *Imago Figurata* series for Brepols publishers, Associate Editor of *Emblematica: Essays in Word and Image*, and as Chair of the International Society for Emblem Studies. His publications include *Emblematic Paintings from Sweden's Age of Greatness: Nils Bielke and the Neo-Stoic Gallery at Skokloster* (2006); *The Emblem in Scandinavia and the Baltic* (2006, ed. with Mara Wade); *Reading and Writing the Swedish Renaissance* (2009); *The International Emblem from Incunabula to the Internet* (2010); *Otto Vaenius and his Emblem Books* (2012); *Emblems and Impact* (2017, ed. with Ingrid Höpel); and *Sacred Emblems in Western Sweden* (2021).

Kelin Michael

is currently a doctoral candidate in Art History at Emory University and the project manager for the J. Paul Getty Museum upcoming special exhibition *Lumen: The Art and Science of. Light*. She was also the 2021–2022 Graduate Curatorial Intern in Manuscripts at the Getty Museum. She specializes in medieval manuscripts, focusing on the relationship between text and image. Her interests involve reception and copying practices, particularly how illuminators altered images in later copies of medieval manuscripts to reflect contemporary social contexts. Kelin also works to bridge the gap between academia, the museum world, and the public through her work.

Shaun Midanik

is a doctoral candidate at the University of Toronto in the Department of Art, with a collaborative specialization in Book History and Print Culture. His research connects the fields of Art History and Book History through his study of Italian books of prints, bound groups of printed pictures that emerged as a new medium in the early modern period. As part of his dissertation project, he established the Books of Prints Cataloging Project (booksofprints.omeka.net), which aims to record books of prints as the basis for developing a new

cataloguing standard. His focus on a more dynamic early modern print culture has led to a diverse set of research interests related to books of prints, including virtual pilgrimage, drawing manuals, and emblem books.

Brent Purkaple

is a historian of premodern science, book history, and the history of science and religion. He received his Ph.D. from the Department of the History of Science, Technology, and Medicine at the University of Oklahoma in 2022. He is currently a visiting professor of history at Grand Valley State University, in Allendale, Michigan.

Jason Rosenholtz-Witt

is Visiting Assistant Professor of Musicology and Double Bass at Western Kentucky University. Previously, he was Visiting Assistant Professor and Music Program Coordinator at Oxford College of Emory University, where he also directed the chamber ensemble. He specializes in music and politics in Northern Italy during the sixteenth and seventeenth centuries, extending into German-speaking lands and England. His secondary interests include American experimentalism (1960s–80s) and jazz during the Civil Rights era.

Bret L. Rothstein

a scholar of visual and material cultures of play – is Ruth N. Halls Professor in the Department of Art History at Indiana University, Bloomington. He is the author of *Sight and Spirituality in Early Netherlandish Painting* (Cambridge, 2005) and *The Shape of Difficulty: A Fan Letter to Unruly Objects* (Penn State, 2019), as well as essays in *American Quarterly*, *Art History*, the *Journal of Early Modern Cultural Studies*, *Renaissance Quarterly*, RES: *Anthropology and Aesthetics*, *Word & Image*, and *Zeitschrift für Kunstgeschichte*.

Mara R. Wade

is professor emerita of Germanic Languages & Literatures, University of Illinois at Urbana-Champaign. She is the immediate past president of the Renaissance Society of America. She has held visiting professorships at the University of Göttingen; the Hochschule für Musik, Theater und Medien, Hannover; University of Stockholm; University of Erlangen-Nürnberg, and University of Heidelberg. She currently serves, by appointment of the State of Lower Saxony, on the academic Advisory Board of the Herzog August Bibliothek, Wolfenbüttel.

Her research focuses on emblems, court studies of Germany and Scandinavia, gender studies, and German literature and the arts in the early modern period. She is the editor-in-chief of *Emblematica: Essays in Word and Image*

NOTES ON THE CONTRIBUTORS

and the PI for *Emblematica Online*. She was awarded a senior research prize from the Alexander von Humboldt Foundation, a lifetime achievement award. *She is currently completing the monograph Early Modern Intellectual Networks: Emblems as Open Sources* that explores social practices of emblematics. With Christopher Fletcher she is editing *Emblems and Empire*, which focuses on the Nürnberg town hall emblems.

Geert Warnar

is a senior lecturer of the Leiden University Centre for the Arts in Society. He teaches Dutch medieval literature and dialogue studies, which are also the main themes of his current research and recent publications. These concern in particular the most popular Dutch epic romance (*Roman van Limborch*) in a European context and Dutch dialogues (1300–1600): *Lezen als een luistervink. De dialoog in de Nederlandse literatuur van Maerlant tot Coornhert* (Leiden: 2022).

PART 1

Introduction

CHAPTER 1

Kinds and Degrees of Customisation in Early Modern Book Production and Reception

Walter S. Melion

Art historians, codicologists, and historians of the book have increasingly come to recognise that printed books, like other categories of book, such as codices, were 'permeable' rather than 'fixed' objects. Just as manuscripts were mutable, their material form and constituent parts manipulable, so too, printed books could be adapted to need or use, their format altered to fit a wide spectrum of functions, in response to contingent circumstances of all kinds, not least their owners' desire to mark a book as theirs. As bibliographers and book historians have amply documented, early modern printers and publishers often produced variable copies of the books they propagated.[1] Patrons and proprietors, either at the production stage, the time of purchase, or later in the life of the book, could intervene in the process of assembling or reassembling the book's materials, thereby altering its format and function, manner and meaning. The kinds of variation *Customised Books in Early Modern Europe and the Americas* explores involve alterations to the physical structure of the book – through insertion or interpolation, subtraction or deletion, adjustments in the ordering of folios or quires, amendments of image or text. Although our primary interest is in printed books and print series bound like books, we also consider selected manuscripts since meaningful alterations made to incunabula and early printed books often followed the patterns such changes took in late fourteenth- and fifteenth-century codices. Throughout *Customised Books* the emphasis falls on the hermeneutic functions of the modifications made by makers and users to the structure of meaning of their manuscripts and books.

The book of hours, one of the most popular types of prayerbook fabricated for the laity in the fifteenth century, set the habit of modifying books to desire, in ways befitting a reader's priorities, requirements, and sense of self. In the great Netherlandish centers of book production, such as the secular workshops

1 See, for example, Maclean I., *Learning and the Market Place: Essays in the History of the Early Modern Book*, Library of the Written Word 9 – The Handpress World 6 (Leiden – Boston: 2009), esp. 1–24, 107–130; and Pettegree A., *The Book in the Renaissance* (New Haven – London: 2010).

of Bruges and the convents and monasteries of Amsterdam, Delft, and Haarlem, as Pamela Robinson, Peter Gumbert, and especially Kathryn M. Rudy have demonstrated so compellingly, the assembly of manuscripts 'articulated in blocks' 'built up out of independent units', or as Rudy aptly puts it, composed of 'modules', facilitated indeed invited the assembly of a specific kind of customised book.[2] These were 'assembly-line' books penned by multiple hands trained to write in a corporate style, comprising a book of hours' essential component parts – Calendar, Hours of the Virgin, Seven Penitential Psalms and Litany, Vigil for the Dead – supplemented by additional elements selected by the book's purchaser for insertion at chosen junctures: Hours of the Cross, of Eternal Wisdom, of the Holy Spirit, and/or of All Saints, Prayers for the Sacrament, and various Suffrages and Indulgenced Prayers.[3] Each auxiliary element filled one or more quires, always starting on the quire's first recto and usually ending in blank lines or pages; the quires could be slotted in wherever and whenever required, a process which sometimes necessitated rebinding. Furthermore, the blanks could be filled in at the buyer's request with supplemental prayers, such as the *Salve Regina*, the *Magnificat*, or the indulgenced *Ave, sanctissima virgo Maria*, and single folios inscribed with longer prayers (say, a suffrage to Saint Christopher) or decorated on the verso with a full-page

2 See Robinson P.R., "The 'Booklet': A Self-Contained Unit in Composite Manuscripts", *Codicologica: Towards a Science of Handwritten Books* 3 (1980) 46–47; Gumbert J.P., *The Dutch and their Books in the Manuscript Age* (London: 1990); idem, "Codicological Units: Towards a Terminology for the Stratigraphy of the Non-Homogeneous Codex", *Segno e testo* 2 (2004) 17–42; idem, "Codicologische eenheden – opzet voor een terminologie", *Koninklijke Nederlandse Akademie van Wetenschappen. Mededelingen van de Afdeling Letterkunde, nieuwe reeks* 67.2 (2004) 5–38; Rudy K., *Postcards on Parchment: The Social Lives of Medieval Books* (New Haven – London: 2015); and eadem, "Sewing the Body of Christ: Eucharist Wafer Souvenirs Stitched into Fifteenth-Century Manuscripts, Primarily in the Netherlands", *Journal of Historians of Netherlandish Art* (2016), n.p. Also see Kwakkel E., "The Cultural Dynamics of Medieval Book Production", in Biemans J.A.A.M. – Hoek K. van der – Rudy K. – Vlist E. van der (eds.), *Manuscripten en miniaturen: Studies aangeboden aan Anne S. Korteweg bij haar afscheid van de Koninklijke Bibliotheek*, Bijdragen tot de geschiedenis van de Nederlandse boekhandel (Zutphen: 2007) 243–254; and idem, "Towards a Terminology for the Analysis of Composite Manuscripts", *Gazette du livre medieval* 41 (2002) 12–19.

3 On the prevailing divisions and standardised production of books of hours, see Delaissé L.M.J., "The Importance of Books of Hours for the History of the Medieval Book", in McCracken U.E. – Randall L.M.C. – Randall R.H. (eds.), *Gatherings in Honor of Dorothy E. Miner* (Baltimore: 1974) 203–225; Farquhar J.D., "The Manuscript as a Book", in Hindman S. – Farquhar (eds.), *Pen to Press: Illustrated Manuscripts and Printed Books in the First Century of Printing* (College Park: 1977) 11–99; Saenger P.H., "Books of Hours and the Reading Habits of the Later Middle Ages", in Boureau A. – Chartier R. (eds.), *The Culture of Print: Power and the Uses of Print in Early Modern Europe* (Princeton: 1989) 141–173; and Reinburg V., *French Books of Hours: Making an Archive of Prayer, c. 1400–1600* (Cambridge, U.K. – New York: 2012).

CUSTOMISATION IN EARLY MODERN BOOK PRODUCTION AND RECEPTION 5

illumination matching an incipit on the facing folio recto could be sewn in (by means of a stub). The illumination, more often than not, might consist of a single-leaf image painted on spec for the purpose of being acquired and interpolated into a prayerbook as a paratextual illustration. (Rudy calls such images 'postcards'.[4])

The modular assembly of these prefabricated books of hours, far from pre-cluding various kinds and degrees of individuated intervention, appears to have emboldened their relatively affluent and literate owners to particularise their prayerbooks through the addition of prayers, images, and objects such as pilgrimage badges, gathered into the *locus libri* to protect the user, secure her/his salvation, and/or memorialise signal events of personal importance.[5] One famous codicological example is the rebinding of the *Grandes Heures* of Philip the Bold by Jean Miélot and Dreux Jehan under the direction of Philip the Good ca. 1450–1451.[6] Quires were unbound and restitched, new quires and folios interpolated, parchment paintings glued or sewed in, and badges and other tokens from pilgrimage shrines affixed. (Parchment paintings, unlike illuminations, first circulated independently of any book, though many even-tually found their way into codices wherein they were added by processes of accretion or substitution.) These new elements changed the *horae*-missal's form, function, and meaning: liturgies of little interest to Philip the Bold but important to his successor, such as the Mass of Pentecost, were introduced, and novel liturgies, such as the Mass of the Visitation (instituted in 1441), were newly comprised. Badges and other traces of Philip the Good's frequent pilgrimages and visitations to shrines now testified to his fervent piety and, in particular, to his enthusiasm for localised cults and suffrages. Conversely, selected satirical *bas de-pages* offensive to devotional decorum were deleted or erased, and certain prayers were overlaid with parchment sheets featuring alternative images or prayers. These changes, taken together, allowed Philip more fully to invest in forms of devotion associated with his expanding ter-ritories and to enhance his reputation as a paragon of Burgundian religiosity.

Aggregative addenda such as these established a template for the inventive incursions later made into printed books in the sixteenth and seventeenth cen-turies. In her study of British Library Add. Ms. 24332, a book of hours compiled by the beghards of Maastricht ca. 1500 at their House of Saints Bartholomew

4 See Rudy, *Postcards on Parchment*, esp. 1–17, 73–155.
5 On the modular system of book manufacture devised specially for the production of books of hours, see Rudy K., *Piety in Pieces: How Medieval Readers Customized their Manuscripts* (Cambridge, U.K.: 2016) 1–57.
6 On the *horae*-missal known as the *Grandes Heures* and the emendations and amendments commissioned by Philip the Good, see ibid. 176–184.

and Michael, Kathryn Rudy, building on the scholarship of Ursula Weekes, identifies another type of customisation that would have far-reaching consequences for the embellishment of printed prayerbooks.[7] The beghards, perhaps under the direction of the scribe Jan van Emmerick, gathered large quantities of pre-coloured prints prior to the composition of Add. 24332 and then used them to illuminate the manuscript as it was being written, adjusting from image to text as well as from text to image, trimming the smaller prints to ornament columns of texts, cutting out circular prints to embed in historiated initials, or binding in the larger printed sheets to serve as folios (in which case either the folio recto or verso could be used for writing).[8] In this two-way process, printed images were adapted to the various text formats, and conversely, text layouts were adapted to the size and shape of the pasted- or bound-in images. Whereas previously, as Rudy points out with reference to producers of single-leaf miniatures, such as the Masters of the Pink Canopies, scribe-copyists would determine the design of a page and the illuminations would then be added, now the pasted-in prints tended increasingly to dictate the page design, with words, more often than not, making way for the pictorial inserts.[9] Moreover, since it was usually the copyist who dictated where to place the images, s/he began jointly to take over what had been the discrete functions of scribe, designer, and illuminator (in the sense of finding and placing the pre-coloured prints). In turn, the copyist responded to the specific requirements of the person or persons for whom the manuscript was assembled, here likely the beghards' own house.[10]

7 On the beghards of Maastricht and their compilatory books, of which Add. 24332 was the first manuscript built around prints, see Rudy K., *Image, Knife, and Gluepot: Early Assemblage in Manuscript and Print* (Cambridge, U.K.: 2019), esp. 1–166, 197–243. On the use of cut and pasted-in prints to illustrate manuscript prayerbooks, see Weekes U., *Early Engravers and their Public: The Master of the Berlin Passion and Manuscripts from Convents in the Rhine-Maas Region, ca. 1450–1500* (London: 2004), esp. 101–185, 202–213.

8 On Van Emmerick, see Deschamps J., "De herkomst van het Leidse Handschrift van de Sint-Servatiuslegende van Hendrik van Veldeke", *Handelingen van de Koninklijke Zuidnederlandse Maatschappij voor Taal- en Letterkunde en Geschidenis* 12 (1958) 65–66, no. 9; and Rudy, *Image, Knife, and Gluepot* 15, 24–25, 34–36, 163, 189–193.

9 Ibid. 300–306 and, with specific reference to the Masters of the Pink Canopies, 109, 301. Also see Smeyers M., *Vlaamse miniaturen voor van Eyck, ca. 1380–1420*, exh. cat., Cultureel. Centrum Romaanse Poort, Corpus of Illuminated Manuscripts 6 (Leuven: 1993) 4–12; and Hindman S., *The Robert Lehman Collection. IV: Illuminations* (New York – Princeton: 1997) 53–60.

10 The distinctive *modus operandi* developed by the beghards in constructing Add. 24332 allowed them to adapt the manuscript to their specific needs, on which see Rudy, *Image, Knife, and Gluepot* 108–110, 162–166, 303–304. The book's novel calendar, which doubles as

For the purposes of customisation, book printer-publishers exercised the full range of options discernible in Add. 24332. Take incunabula such as the *Book of Hours* printed by the Dutch publisher Wolfgang Hopyl in Paris in 1500, three exemplars of which survive, an uncoloured one on paper (Brussels KBR, Inc. A2188) and two on vellum (The Hague, KB, 172 C 21, and Paris BNF, Vélins 1684), both of them richly coloured and illuminated.[11] The methods whereby these three copies were differentiated are closely analogous to those used by the beghards for their manuscript. Hopyl, whose name and witty motto appear in the colophon, 'Be happy if you wish to live long / Live well if you wish to be happy forever', made use of the second series of woodcut illustrations designed and executed by the publisher Simon Vostre and printer Philippe Pigouchet for the embellishment of their books of hours. Hopyl borrowed fifteen of the twenty full-page woodcuts, rendered in the style of the Master of the Apocalypse Rose of Sainte-Chapelle, as well as numerous smaller cuts, including calendar illustrations and decorated initials. Texts were typeset to conform to the size and shape of the woodblocks. As in the case of modular manuscripts, the miniatures serve to mark key gatherings and call attention to major prayers, with full-page images printed on versos facing the incipits. Envisioning two communities of users, Hopyl printed some copies on paper – the Brussels exemplar is one such copy – and some on vellum for more affluent clientele. Customers then had the option of sending their prayerbooks to an illuminator's workshop for further enhancements: the owner of the Paris copy had the full-page woodcuts finely coloured with gold highlights; decorated letters were converted either into champie initials (gold on a coloured field) or coloured initials (colour on a golden field). The majority of red-printed initials were also adorned with gilding. To augment the effect of richness, decorative borders were painted in the outermost vertical margin of the full page miniatures, and starting with the Hours of the Cross, L-shaped borders were added to the bottom corners of the full-page miniatures and the incipit pages. The illumination of The Hague copy is equally rich though more subtle: trompe-l'oeil borders strewn with flowers on a yellow-gold ground, in the Ghent-Bruges style, replace the white, Italianate vine tendrils seen in the Paris copy, and the full-page miniatures, the calendar images, and the saints' images accompanying

a table of contents and assists the reader to find substitute prayers for various feast days, likewise served the beghard's spiritual requirements; see ibid. 167–195.

11 On Hopyl's Dutch Book of Hours, see Delft M. van, "Illustrations in Early Printed Books and Manuscript Illumination: The Case of a Dutch Book of Hours Printed by Wolfgang Hopyl in Paris in 1500", in Wijsman H. – Kelders A. – Speakman Sutch S. (eds.), *Books in Transition at the Time of Philip the Fair: Manuscripts and Printed Books in the Late Fifteenth- and Early Sixteenth-Century Low Countries* (Turnhout: 2010) 131–164.

the suffrages are more elaborately painted, so that the woodcut lines are no longer clearly evident beneath semi-transparent washes of colour. Marieke van Delft in her study of Hopyl's *Book of Hours* ascribes the painting of the copies in Paris and The Hague to workshops based in the Southern Netherlands.[12]

As Hopyl's *Book of Hours* makes apparent, the individuation of incunabula and post-incunabula occurred in two stages or registers: that of the printer-publisher working for a specific patron or with a hypothetical community of users in view, and that of the purchaser keen to align a book with her/his social station and aspirations. With respect to the former, there are innumerable examples of the customisation of page layout, typeface, illustration, and content dating from after the post-incunabula period (1500–1530/40). Three examples, two liturgical, the third polemical, should suffice to make this point: first, the publication of *Missalia Romana* for export in cities such as Venice where the printing House of Giunta was one of the chief purveyors of missals designed more for private prayer than liturgical ceremonial.[13] The Giunta, to appeal to the devout laity, reduced the book's size from the large folio format best suited for priestly celebration of the Mass, to the more portable quarto or octavo. One of the last Giunta editions, the *Missale Romanum* of 1598, although it sports a title-page and opening papal letter ("Pius episcopus servus servorum Dei") printed in humanist roman and italic typefaces, hallmarks of Venetian pressworks that claimed an implicit lineage from the *officina* of Aldus Manutius, is otherwise mostly printed in black-letter Italian gothic, with only headings and initial capitals, along with some display lines of section titles, likewise printed in roman. Full-page woodcut illustrations decorate the bifolio openings introducing the "Propium Missarium de tempore", the "Canon Missae", the "Proprium Missarum de sanctis", and the "Commune sanctorum", and quarter-page illustrations the openings to the "Proprium Missarum pro defunctis" and months of the "Elucidatio kalendarii". Finally, fifty-eight fully notated pages of musical chant are printed in red and black with annotations in gothic. The Giunta incorporated these features, as Caroline Archer and Barry McKay plausibly hypothesise, so as to make the book appealing to buyers in northern Europe or the British Isles where the market for Catholic religious works remained strong in spite of adverse conditions.[14] The Giunta, in a word, were expert at strategic customisation.

12 See ibid. 144–156, esp. 156.

13 On the Giunta *Missale Romanum* customised for export to England and elsewhere, see Archer C. – McKay B., "A Black Letter Volume from the Home of the Roman Letter: A Venetian *Missale Romanum* of 1597 – A Case Study of the Archer Copy", in Archer – Peters L. (eds.), *Religion and the Book Trade* (Newcastle upon Tyne: 2015) 29–44.

14 See ibid. 41.

CUSTOMISATION IN EARLY MODERN BOOK PRODUCTION AND RECEPTION 9

The Officina Plantiniana, chief supplier of missals and breviaries to Spain between 1571 and 1576 by virtue of a non-exclusive agreement signed with the Spanish crown, provides a second example of customisation from the publisher's side.[15] The Spanish theologian Benito Arias Montano, in his letter recommending Plantin to Philip II's secretary Gabriel de Zayas, touts the printer-publisher's ability to customise as one of his foremost virtues; having enumerated the advantages of hiring Plantin for this job, he assures De Zayas that the Officina Plantiniana will deliver other useful benefits (*invenciones*, inventive features, and *aprovechamientos*, advantages) over and above those pertaining to a breviary:

> And I shall make known other inventive features, the advantages of which, alongside the breviary, will necessarily make people more eager to buy the breviaries. The same will be true for the missals, which will come from here with the greatest expediency.[16]

For his part, Philip II wrote frequently to Plantin, insisting that he customise the missals and breviaries for the Spanish clergy. Benito Rial Costas, in his study of Plantin's efforts to print the newly promulgated *Tridentine Missal* and *Breviary* even while accommodating to the local needs of the Spanish clergy, cites numerous royal missives asking for such accommodations:

15 On Plantin's production of missals and breviaries customised for the Spanish clergy, see Rial Costas B., "International Publishing and Local Needs: The Breviaries and Missals Printed by Plantin for the Spanish Crown", in McLean M. – Barker S. (eds.), *International Exchange in the Early Modern World*, Library of the Written Word 51, The Handpress World 38 (Leiden – Boston: 2016) 15–30. Also see Bowen K.L., *Christopher Plantin's Books of Hours: Illustration and Production*, Bibliotheca Bibliographica Neerlandica 32 (Nieuwkoop: 1997); Bowen K.L. – Imhof D., *Christopher Plantin and Engraved Book Illustrations in Sixteenth-Century Europe* (Cambridge, U.K.: 2008) 122–162; Bowen K.L., "Royal Books of Hours with Local and International Appeal: An Examination of Jan Moretus's 1600/1601 and 1609 Editions of the *Officium Beatae Mariae Virginis*", *The Library* 15.2 (2014) 158–184; and eadem, "Christopher Plantin, Philip II, and the Vatican: Negotiating between Personal Preferences and Pragmatic Considerations When Designing the Antwerp Editions of the New Tridentine Missal", *De gulden passer* 92 (2014) 31–52.

16 Cited in Rial Costas, "International Publishing and Local Needs" 19. See Letter of Benito Arias Montano to Gabriel de Zayas, 9 October 1570, in Fernández Navarrete et al. (eds.), *Colección de documentos inéditos para la historia de España, Vol. 41* (Madrid: 1842–1896) 184–185: 'Y yo daré invenciones con que allende del breviario haya otros aprovechamientos que necesariamente acrecienten la codicia de comprar los breviarios. Lo mismo será de los misales que saldrán de aquí con gradisima ventaja'.

[1 February 1571]
Regarding the quires that are tied apart, which are of the Order of St. Jerome, I do not know if it would be good to make a division because not all clerics may want to pray that Order and its Holy Days but only those of this Kingdom; and if you agree, they could be divided into two quires: one with only the Saint of the Kingdom, the most general, for the clerics to pray if they wish; and the other with the Order's Holy Days for the exclusive use of the Order's members.[17]

[19 June 1575]
Having given it more thought, I think it better not to put [a picture of Saint Jerome amongst the first pages of the missal], since many of these missals must serve for other orders that ignorant of the reason for including it and thinking the missal belongs to the Order of Saint Jerome will have misgivings about using it. [...] I believe that the same would occur in many bishoprics, and for this reason it appears better to me that the title alone go at the front [of the missal], with no picture, seeing as the book, being general, ought to be useful to everyone; or that it bear the picture of the patron saint of each order or of the principal church of the bishopric, as appropriate.[18]

17 Cited in Rial Costas, "International Publishing and Local Needs" 21. See Fernández Navarrete et al., "Advertimientos de mano de S.M.d sobre los que había hecho el Padre Villalba para la impression de los breviaries, diurnale y misales romanos nuevos", in *Colección, Vol. 41* 199: 'De los cuadernos que están atados aparte, que son los de la Orden de San Jerónimo, no se si sería bueno hacer una división; porque quizá no todos los clérigos querrán rezar aquello y las fiestas de la orden, sino las destos reinos; y pareciendo bien, se podrían divider aquellos en dos cuadernos, uno de solos los santos destos reinos los más generales, para que esto pudiesen rezar los clérigos si quisiesen, y otro de las fiestas de la Orden, para que este sirva solamente para los religiosos dellas'.

18 Cited in Rial Costas, "International Publishing and Local Needs" 20–21. See Fernández Navarrete et al., "Lo que S.M.d ha avertido de su mano sobre la impresión del missal", in *Colección, Vol. 41* 246–247: 'Habiéndolo pensado más me parece que no se ponga porque como muchos de estos misales han de server para otras órdenes, creo que a los de ellas, no entendiendo la causa que hay para ello, sino pareciendole quel missal al tener aquella imagen es de la Orden de San Jerónimo como los de hasta aquí se les hara el mal el tomarlo. Y así me parece que ésto sería de inconveniente, y lo mismo creo que sería en muchos obispados; y por esto me parece que en il principio no fuese imagen sino el título del libro pues es general y podría servir para todos o que llevase al principio para cada libro la imagen del santo de cada Orden o de la iglesia principal del obispado para donde hubiese de ser'.

CUSTOMISATION IN EARLY MODERN BOOK PRODUCTION AND RECEPTION 11

[July 1572]
The rubrics of the missal must be set with the same letter used in the text of the missal and not with the letter of the gloss, since the red texts, being set with a small letter, read very badly. And if Rome asks or has asked that the rubrics be set with letters smaller than the text or with the letters of the gloss, this can be respected in missals printed for Rome, but in missals printed for Spain, the rubrics must be set with the same letter as in the text.[19]

Philip II and his advisors ordered Plantin to print breviaries in one rather than two volumes, since Spanish priests and monks clearly preferred that more compact format. The king also paid very close attention to page layout, requesting that the space filled by the glosses be commensurate with that taken up by the text proper; this could be achieved, states Philip, if the space between lines of gloss were made greater than those between lines of text. Text and gloss, even while remaining clearly differentiated, would thus become maximally legible. Philip even monitored the inking, admonishing Plantin to make certain that the blacks were sufficiently dark and the reds bright enough to be legible by night. The emphasis on materials and typography rather than content testifies to the king's two preoccupations: on one hand, he wished to convince Spanish clergy throughout the empire to adopt the new missals and breviaries; on the other hand, he needed to acclimatise the Spanish market, used as it was to the rites and customs of Elna, Lleida, and Santiago, as well as Toledo, to the Roman liturgy. However, bowing to local pressure, he instructed Plantin to include in his breviaries the prayer of St. Louis found in the breviaries of Venice and to insert a quire with the five holy days of the saints of Spain.

Patterns of customisation could just as well be used to telegraph quite different intentions, of course. The eleven polemical pamphlets produced by the Protestant printer John Day in London between 1553 and 1554, soon after the ascension of Mary Tudor to the English throne, were regularised to indicate to

19 Cited in Rial Costas, "International Publishing and Local Needs" 24. See "Respuesta de las dudas de Cristóforo Plantino acerca de la impresión de los mismales con el canto español para España", in Plantin-Moretus Museum Arch. 122: *Missale et Breviarium 1572–1576* 75: 'Las rúbricas del misal han de ser de la misma letra que es el texto del misal y no de la letra de la glosa porque lo colorado siendo de letra pequeña se lee muy mal. Y si de roma piden o han pedido que las rubricas sean de letra menor que el texto o de la letra de la glosa esto se podra guardar en los misales que para roma se imprimieren mas en los misales que han de ser para españa las rubricas han de ser de la misma letra del texto'.

potential readers that they constitute a common set.[20] All carry the false colophon 'Roane, by Michael Wood', all use the same roman font, all display ample fields of white space on their title-pages, and all share a distinctive orthography, such as the preference for 'i' rather than 'y' endings. These features, as Cathy Shrank notes in her study of the mis-en-page of English printers such as Day, function as markers of these pamphlets' shared purpose: together they wage a unified campaign against the Roman Catholic priorities of the new Marian government.

Variations in the bound versions of one and the same edition of a text, either predetermined by the publisher or requested by a purchaser after s/he had acquired the unbound folios, constitute another type of customisation. Some copies of the 1595 edition of Jerónimo Nadal's *Adnotationes et meditationes in Evangelia* (Antwerp, Martinus Nutius), for example, contained illustrations, others not, and amongst the illustrated copies, the sequence of 153 engravings could be galleried either before or after the treatise proper, or again, dispersed within the treatise, one image per chapter, either as an opening exordium or closing excursus.[21] The galleried images usually appear in chronological order, tracking key events from the life of Christ and layering that temporal order onto the textual chapters, which were generally printed in liturgical order, starting not with the *Annunciation*, image 1 of the pictorial series, but with "Dominica prima adventus: quae iudicium proxime praecedent" [Figs. 1.1 & 1.2]. When the engravings are interspersed amongst the chapters, the liturgical calendar takes clear precedence over the sequence of the *vita Christi*, which is, so to speak, 'disordered' to match the Church's ceremonial calendar. However, if the reader instead chose to follow the image sequence, this would 'disorder' the liturgical sequence: starting with the *Annunciation* print then entails jumping three-quarters of the way through the *Adnotationes et meditationes* to chapter 107, "De annuntiatione". Where the images were located thus changed how the text was read, as well as the reader's sense of the cognitive and mnemonic value

20 On Day's illicit publications customised for co-religionists, see Shrank C., "Mis-en-page, 'The Authors Genius', 'The Capacity of the Reader', and the Ambition of 'A Good Compositer'", in Archer – Peters (eds.), *Religion and the Book Trade* 66–82, at 81–82. On Day's repurposing of Catholic martyrologies for an Anglican reader-viewership, see Engel W., *The Printer as Author in Early Modern England: John Day and the Fabrication of a Protestant Memory Art* (New York: 2022) 103–138.

21 On the complex production history of Nadal's *Adnotationes et meditationes*, see "'Quis non intelliget hoc voluisse Christu': The Significance of the Redacted Images in Jerónimo Nadal's *Adnotationes et meditationes in Evangelia* of 1595," in *Jerome Nadal, Annotations and Meditations on the Gospels, Cumulative Index*, prep. J.P. Lea (Philadelphia: 2014), 1–99; and Bowen K.L. – Imhof D., "Publishing and Selling Jerónimo Nadal's Trend-Setting *Evangelica historiae imagines* and *Adnotationes et meditationes in Evangelia*: Dealings with the Moretuses, 1595–1645", *The Library* 20.3 (2019) 307–339.

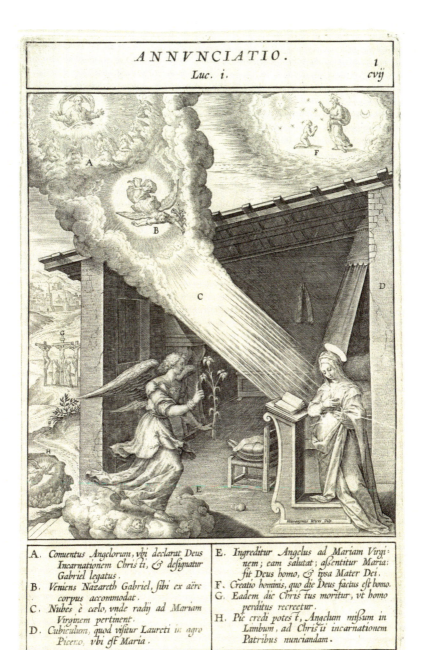

FIGURE 1.1 Hieronymus Wierix after Bernardino Passeri, *Annunciation*, plate 1 of the image sequence tracking the life of Christ, illustration to chapter 107 of the liturgical sequence, in Jerónimo Nadal, *Adnotationes et meditationes in Evangelia* (Antwerp, Martinus Nutius: 1595). Engraving, 233 × 146 mm
AMSTERDAM, RIJKSMUSEUM RP-P-OB-67.130

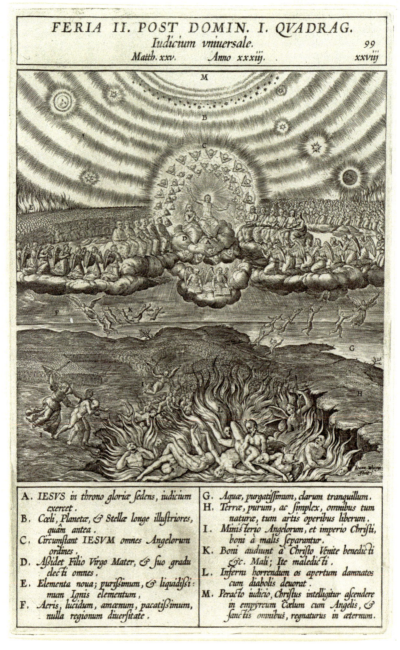

FIGURE 1.2 Jan Wierix after Bernardino Passeri, *The Universal Judgment*, plate 98 of the image sequence tracking the life of Christ, illustration to chapter 1 of the liturgical sequence, in Jerónimo Nadal, s.j., *Adnotationes et meditationes in Evangelia* (Antwerp, Martinus Nutius: 1595). Engraving, 233 × 145 mm
AMSTERDAM, RIJKSMUSEUM RP-P-OB-67.222

CUSTOMISATION IN EARLY MODERN BOOK PRODUCTION AND RECEPTION 15

of Nadal's texts and images in concert. In copies of the book without pictures, Nadal's texts, especially his descriptive *adnotationes*, perform the task of generating the requisite images, doing so *prima facie*, rather than mediating the effect of the pictorial *imagines*. The positioning of the images also affects the reader's sense of Nadal's image-based theology as it relates to his account of the mysteries of the Incarnation, Passion, and Resurrection.

Another example of a variable edition is Joannes David, s.j.'s catechetical emblem book, *Veridicus Christianus*, published in 1601 in three versions – one consisting solely of 100 engraved plates inscribed with dialogic texts in Latin, Dutch, and French, issued by the print publisher Philips Galle under the title *Icones ad Veridicum Christianum*; another comprising 100 chapters of Latin text without pictures; and a third of the full text together with the concomitant plates usually inserted as frontispieces to the book's catechetical-meditative chapters.[22] Having originally written his book as a collection of 100 Dutch distichs, titled *Wijsheyt der simpel christenen* (Brussels, Rutger Velpius: 1593), and then greatly expanded it, David then rewrote a version in Latin, much amplified through the addition of scriptural references and exegetical arguments suitably engaging to a Latinate audience (the ideal readers being young men educated in one of the Society's colleges). As the book's format changes, so too does the complexity of its allegorical arguments: the *Icones* consists of *picturae* bracketed by a titular motto (above) and catechism-like questions and answers inscribed on the plates in three languages (below), so that the pictorial image illustrates both the *titulus* and the *subscriptio*, bodying forth the former descriptively by means of personification and prosopopoeia, and animating the latter by means of richly particularised narrative allegory enacted by *dramatis personae* set in richly detailed environs. Take Emblem 15, "Hominis vere Christiani description" (Description of a truly Christian man) and its three subscriptions [Fig. 1.3]:

> [Latin:] Say then: Who is worthy of the august name of Christian?
> He who fulfills the power of his name in Word and Deed.
> [Dutch]: Now say, who is it exactly who holds the Name of Christian.
> He who professes and lives the Teaching and the law of Christ.

22 On the gestation and production history of the *Veridicus Christianus*, see Imhof D., *Jan Moretus and the Continuation of the Plantin Press*, Bibliotheca Bibliographica Neerlandica, Series Major, Volume III, 2 vols. (Leiden: 2014) 1:231–232; and Waterschoot W., "*Veridicus Christianus* and *Christeliicken Waerseggher* by Joannes David", in Dekoninck R. – Guiderdoni-Bruslé (eds.), *Emblemata sacra: rhétorique et herméneutique du discours sacré dans la littérature en images / Emblemata sacra: The Rhetoric and Hermeneutics of Illustrated Sacred Discourse*, Imago figurata 7 (Turnhout: 2007) 527–534.

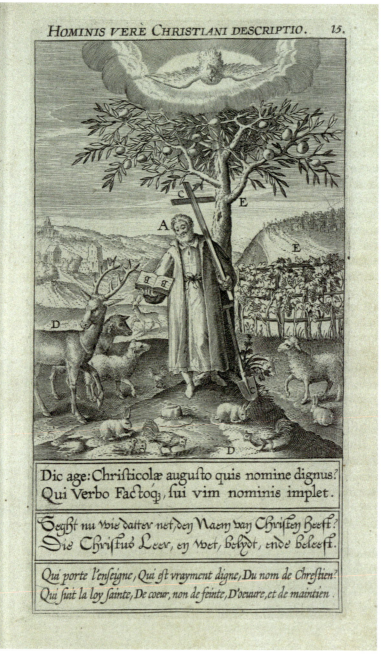

FIGURE 1.3 Theodoor and Cornelis Galle, Emblem 15: "Hominis vere Christiani descriptio" ("Description of a truly Christian man"), engraving, ca. 1601. In Jan David, s.j., *Veridicus Christianus* (Antwerp, Ex officina Plantiniana: 1606), quarto
STUART A. ROSE ARCHIVE, MANUSCRIPTS, AND RARE BOOK LIBRARY, EMORY UNIVERSITY

[French]: Who bears the ensign, who is truly worthy of the name of Christian?

He who at heart, not feigning, follows the holy law, in deed, in safekeeping.[23]

The *pictura* centers on the personified figure of 'Bonus Christianus' (Good Christian) who, true to his name, shoulders the cross of Christ and both reflects upon and shows forth the book of Scripture, under the radiant and, as the fruit-laden tree indicates, fruitful guidance of the Holy Spirit. The Latin distich, read together with the image, invites us to infer that the man, who not only dwells on the Word but actively imitates Christ by bearing the cross, exemplifies David's eponymous true Christian ('Veridicus Christianus'). The Dutch distich specifies that the man also teaches the law of Christ, presumably preaching it to the flock of animals gathered around him (as if he were a second St. Francis). The French distich, playing upon an evident pun (*enseigne* = 'teaches' or 'ensign'), characterises the man as an epitome of heartfelt sincerity who teaches by example, that is, by taking up the burden of the cross, preserving the message of Christ's gospel not only in word but also in deed ('D'oeuvre, et de maintien').

For readers who had access only to David's text, the opening line of chapter 15 makes clear that it now falls to them to visualise an image true to the allegorical argument David's words vividly evoke; referring to the previous thirteen emblems on heresy, David states: 'After we have now depicted an heretical man as if with a brush after the life, so that anyone who holds dear the salvation of his soul might easily recognise and shun him, it remains to hear who ought to be called Christian and who is worthy of that name'.[24] The image to be fashioned in the mind's eye, apprises David, must illustrate Acts 11:15–16, in which Peter, having entered Jerusalem, defends his conviction that the Gospel, being universal, encompasses both Jews and Gentiles: 'And when I had begun to speak, the Holy Ghost fell upon them, as upon us also in the beginning.

23 David Joannes, s.j., *Veridicus Christianus* (Antwerp, Ex officina Plantiniana: 1601):
 'Dic age: Christicolae augusto quis nomine dignus?
 Qui Verbo Factoque, sui vim nominis implet'.
 'Seght nu wie datter net, den Naem van Christen heeft?
 Die Christus Leer, en wet, belydt, ende beleeft'.
 'Qui porte l'enseigne, Qui est vrayment digne, Du nom de Chrestien?
 Qui suit la loy sainte, De Coeur, non de feinte, D'oeuvre, et de maintien'.
24 Ibid. 44: 'Postquam iam haereticum hominem ita penicillo ad vivum depinximus, ut quivis eum facile dignoscat; et quantum animae salus ei cara est devitet: restat, ut quis sit dicendus Christianus, quisque eo nomine dignus sit audiamus'.

And I remembered the word of the Lord, how that he said: "John indeed baptised with water, but you shall be baptised with the Holy Ghost".[25]

Only for reader-viewers with an illustrated copy of the *Veridicus Christianus* in hand, would the full force David's verbal-visual apparatus have become fully evident. With reference to the letters 'A'–'E' that correlate key components of the emblematic *pictura* to specific places in the text of chapter 15, they would have realised that the 'Good Christian' is preaching to animals that signify a Christian congregation: the deer of Psalm 41:1 ('As the hart panteth after the fountains of water; so my soul panteth after thee, o God'), the sheep of John 10:1–21 ('[...] and there shall be one fold and one shepherd'), and the hens of Luke 13:34 ('[...] how often would I have gathered thy children as the bird doth her brood under her wings'). They would also have recognised that the hares – identified as unclean in Leviticus 11:6 – stand for the Gentiles, i.e., the uncircumcised, whose conversion to the faith Peter boldly endorses in Acts 11:6, citing his vision of 'fourfooted creatures of the earth, and beasts'. Extrapolating from these symbolic devices, they would have gone on to connect the shovel, labeled 'C', and the fruit-laden tree and vines, both labeled 'E', with well-known scriptural passages that compare Christ (and his Christian ministers) to husbandmen and vintners:

> [Isaiah 5:1–2:] My beloved had a vineyard on a hill in a fruitful place. And he fenced it in, and picked the stones out of it, and plated it with the choicest vines [...]: and he looked that it should bring forth grapes.

> [Matthew 21:33:] There was a man an householder, who planted a vineyard, and made a hedge round about it, and dug in it a press [...].

> [Luke 13:8:] Sir, let [the fig tree] alone for one more year, until I dig around it and put manure on it.

Having discussed the essential constituents of emblem 15, David then qualifies his reading of the *pictura*, arguing that it chiefly represents the *imitatio Christi*. To bolster his case, he cites the Pseudo-Cyprian and the Pseudo-Augustine, in particular the former's definition in *De duodecim abusivis saeculi* of a truly Christian man as any person who conforms his behavior to that of Christ, and the latter's complementary definition in *De vita christiana* of the Christian as the person who imitates Christ above all. A marginal gloss – 'Christiani, ut

25 Unless otherwise noted, biblical citations come from *The Holy Bible Translated from the Latin Vulgate, Douay Rheims Version*, ed. R. Challoner (Rockford: 1989).

CUSTOMISATION IN EARLY MODERN BOOK PRODUCTION AND RECEPTION 19

pictores, Christi imitatores' (Christians, like painters, [are] imitators of Christ) – makes apparent that he conceives of imitation as a visual process reliant upon images, produced either verbally and pictorially.[26] David enlarges upon this apothegm, as follows: 'For what does it serve for someone to be called a carpenter, farmer, or merchant, nay rather, a knight, commander, king, or emperor in name only, and to be none of them in substance. But let us look a little more closely at that indignity, whereby marked by the name of Christian, we least do what we hear [ourselves called]. Let us suppose we are painters, and not only in the saying: for we are said to be Christians, and we are that; and imitators of Christ, but not properly'.[27] David at this point launches into a remarkably detailed ekphrasis, visualising in words what he means by the bipartite analogy of Christians to painters, Christian behavior to painting. This allegorical word-picture or, better, word-painting supplements the emblematic "Description of a truly Christian man" supplied by the *pictura*; the verbal and pictorial images are intended to operate in tandem, which is to say trans-medially, so that the two allegories come to function as a two-way system of mutual reference. Moreover, the verbal allegory proves to be reflexive of the pictorial one, in that it focuses on the action of picturing Christ, i.e., painting oneself in his image. As David makes clear, there are proper and improper ways of doing this:

> Imagine that we are painters, let this be more than something merely said: for we are called Christians, and so we are; imitators of Christ, [yet] not properly. And so, represent [to yourself] very many painters sitting at their panels, casting their eyes at Christ, in order to shadow him forth in the proper colours: whether dwelling in holiness on earth, or praying in the garden, or again, scourged, bearing the cross, or indeed affixed to the cross: and meanwhile, in place of the things just said, other painters paint Christ adored by the Magi, changing water into wine, multiplying the loaves, or having entered Jerusalem in triumph, or radiant on Mount Thabor in the splendour of glory, and [otherwise] splendid, graceful, pleasurable in this way; in which things many are more pleased to imitate him, than in contempt, poverty, the disgrace of the Passion, and patience; still others, which is worse, delineate the betrayer Judas, portraying him in place of Christ; others (I shudder to write it) do not blush when they

26 David, *Veridicus Christianus* 45.
27 Ibid. 44–45: 'Quid enim hoc alicui conferat, quod faber, agricola, vel mercator vocetur; immo, quod Comes, Dux, Rex, Imperator, solo sit nomine, et nihil eorum sit in re? Verum ut paulo penitius indignitatem istam intueamur, qua Christiani nomine insigniti, nihil minus quam quod audimus facimus: Pictores nos esse puta, non iam dici tantum: quia Christiani dicimur, et sumus; Christique imitatores, sed non recti'.

depict on the tablet of the heart an evil spirit instead of Christ, even while contemplating his example, in the manner of painters who preparing to portray someone are wont to inspect the living prototype. But among them, he who portrays Christ the best, is he who must be judged the best painter in this wise. Otherwise, he would deserve to be chastised by the harsh censure of Saint Augustine, when he says: 'Christian, may you be caught, Christian, faithful in name, [yet] in deed showing something else. And so, let us be faithful imitators, according to the apostle's admonition: 'Looking at Jesus, the author and furnisher of faith'.[28]

Remarkably, David and his designer-engravers Theodoor and Cornelis Galle later provide a pictorial image of this ekphrasis: it appears on the title-page of the book's appendix, "Orbita probitatis ad Christi imitationem Veridico Christiano subserviens" (Wheel of probity serving the True Christian for the imitation of Christ) [Fig. 1.4]. This engraving allows the reader-viewer retrospectively to assay her/his verbally generated image of the *imitatio Christi* and to triangulate amongst the ekphrasis and the two *picturae* ("Hominis vere Christiani descriptio" and "Orbita probitatis"). The three versions of the *Veridicus Christianus* – the engraved series *Icones ad Veridicum Christianum*, consisting of tripartite emblems (motto, picture, epigram), the text-only publication (an example of the emblematic genre known as *emblemata nuda*, emblems shorn of pictures), and the full-fledged emblem book (engraved motto, picture, and epigram amplified by an extensive commentary keyed to lettered elements in the *pictura*)—allow us to consider how David's emblems

28 Ibid., 45: 'Pictores nos esse puta, non iam dici tantum: quia Christiani dicimur, & sumus; Christique imitatores, sed non recti. Effinge itaque pictores plurimos ad tabellas suas sedere, & in Christum oculos coniicere, ut debitis eum coloribus adumbrent; sive sancte in terris conversantem, sive orantem in horto, sive denique flagellatum, crucem gestantem, aut etiam Cruci affixum: interim, pictorum alij, loco iam dictorum, pingerent Christum vel adoratum a magis, vel aquam in vinum mutantem, vel multiplicantem panes, vel ingressu Hierosolymitano triumphantem, vel in monte Thabor splendore gloriae radiantem, & eiusmodi speciosa, grata, placentia; in quibus libentius multi eum, quam in contemptu, paupertate, & passionis opprobrio, & patientia imitentur: alij, quod peius est, pro Christo Judam proditorem delineent & effingant: alij (horreo scribens) etiam cacodaemonem in cordis sui tabella, pro Christo, depingere non erubescant, interim Christi exemplar contemplantes; ut pictores effigiem cuiuspiam efficturi, vivum solent prototypon inspicere. Qui vero horum omnium Christum optime expresserit, ille optimus eiusmodi pictor & Christianus censendus est. Alioqui, dignus sit, qui hac severa D. Augustini censura verberetur. Dum ait: Deprehenderis, & detegeris Christiane: quando aliud agis, & aliud profiteris: Fidelis in nomine, aliud demonstrans in opere. Itaque iuxta Apostoli monitum: *Aspicientes in auctorem fidei, & consummatorem Jesum*; fideles ipsius simus imitatores'.

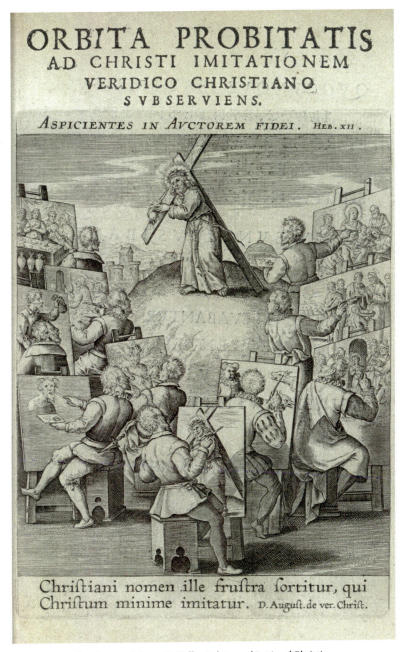

FIGURE 1.4 Theodoor and Cornelis Galle, *Orbita probitatis ad Christi imitationen* (*Orbit of Probity for the Imitation of Christ*), engraving, ca. 1601. Appendix to Jan David, s.j., *Veridicus Christianus* (Antwerp, Ex officina Plantiniana: 1606), quarto
STUART A. ROSE ARCHIVE, MANUSCRIPTS, AND RARE BOOK LIBRARY, EMORY UNIVERSITY

operate differently under varying conditions of image and text mediated by three registers of customisation dictated by the marketplace. As Dirck Imhof has ascertained, copies of the *Veridicus Christianus* without plates sold for 35 stuivers, whereas fully illustrated copies cost 5 florins; more ornate copies with ornamental vignettes and borders, presumably engraved, printed on larger sheets and gilt-edged were occasionally sold for as much as 10 florins.[29]

Broadly speaking, early modern consumers of printed books customised them in one of three ways. First, they made edits in pen and ink, crossing out lines, inserting marginal or interlinear glosses, adding signage such as manicula, asterisks, or other marks, and/or appending handwritten notes on pasted-in sheets. Second, as in the case of emblem books converted into *alba amicorum*, they interleaved blank folios or sheets pre-illuminated and -inscribed, with images and texts designed to memorialise the signatories and their shared networks of sociability. This method of customisation involved binding or re-binding the newly augmented book. Third, a more radical form of customisation involved disarticulating a printed book's text and images and reassembling them into a novel configuration of parts. The resulting codex, though it might imitate the look and feel of a printed book, was in fact a hybrid entity, neither wholly manuscript nor typographical. Whereas the first type of customisation is often minimally invasive, type two involves a restructuring of the book's form and function, and type three, the most extreme, entirely subtracts the original codex and replaces it with a substitute book.

The various editions of Giorgio Vasari's *Vite de' piu eccellenti pittori, scultori et architettori* (editio princeps, Florence, Lorenzo Torentino: 1550; second ed., Florence, Appresso i Giunti: 1568) postillated by non-Tuscan painters provide a good example of the first type. The annotations added to a copy of the 1550 edition now housed at the Beinecke Library, Yale University, by an artist or amateur in the circle of the Paduan painter-printmaker Domenico Campagnola, are typical; the two annotators contest Vasari's claims for the superiority of Tuscan *disegno*, instead following art theorists such as Lodovico Dolce, who had praised Venetian *colorito* in his treatise *Dialogo della pittura, intitolato l'Aretino* (Venice, Gabriel Giolito de' Ferrari: 1557), stating his preference for oil-based painting and its affective qualities of *grazia* (grace) and *sprezzatura* (nonchalance).[30] Characteristic is this irritable remark appended at the end of the book, in the form of a summary judgment: 'See how this good man [...] Giorgio Aretino reports in these lives some of his opinions that not even the

29 Imhof, *Jan Moretus* 1:231.

30 On this Paduan copy of Vasari's *Vite*, see Ruffini M., "Sixteenth-Century Paduan Annotations to the First Edition of Vasari's *Vite* (1550)", *Renaissance Quarterly* 62 (2009) 748–808.

mouth of an oven would say. And he neglects important things, so much that nobody ever saw so much praise of one country and blame of another as this radish head gives; for he exalts his own Florentines so much and blames the others so much, not seeing, poor man, that the true virtue and spirit of painting is oil painting, and that it came from these regions'.[31] With regard to the foremost exponent of *colorito*, the Venetian master Titian, a pair of annotators writing about twenty years apart, the first before the painter's death in 1576, the other after, covered the recto of the first flyleaf before the back cover with a brief encomium of the artist, followed by a long, partial list of his works: 'Since I am readily writing about painters, let me write about that one who is the wonder of the world and the true imitator of nature; and the antique painters will forgive me, for they, when compared to this one, did not know what they were doing. I am here referring to Titian, so celebrated in Europe for his lavish works [...]'.[32] Marco Ruffini, in his study of these Paduan *postille* to Vasari, points out that the first annotator began by listing prestigious commissions outside Venice, then major Venetian commissions, both secular and sacred, before mentioning an early work, while the second annotator reversed this order. This effect of reverse symmetry indicates that the process of annotation, though effected by multiple hands, was to some extent systematic rather than haphazard.[33]

Yet more systematic are the *postille* interpolated into the margins of a copy of the 1568 edition of the *Vite* formerly owned by the Carracci – Ludovico, Agostino, and Annibale – and most likely annotated by all three working in concert to shore up the reform principles enshrined in the curriculum of their Bolognese Academy.[34] Their postils are an epideictic exercise in canon-formation, as witness the vituperative tone of the following assessment of Titian and his contemporaries:

> O listen to the malignant Vasari, he says that the rivals of Titian were not men of valour when these were Giorgione, Pordenone, Tintoretto, Giuseppe Salviati, Veronese, and Palma Vecchio, all of whom were

31 Vasari, *Vite* (Beinecke Rare Book and Manuscript Library, Yale University) 552. Cited in Ruffini, "Sixteenth-Century Paduan Annotations" 765.

32 Vasari, *Vite* (Beinecke Library), flyleaf recto in front of back cover. Cited in Ruffini, "Sixteenth-Century Paduan Annotations" 770.

33 Ibid. 769–770. Ruffini further surmises, in ibid. 785–786, that the annotators had access only to first and second parts of the *Vite*, on the first and second ages, and that annotator one read the text discontinuously.

34 On the Carracci postils, see Dempsey C., "The Carracci Postille to Vasari's *Lives*", *The Art Bulletin* 68 (1986) 72–76.

painters of great importance; yet Titian overcame them all, while if he had to compete against the Ghirlandaios, Bronzinos, Lippis, Soggis, Lappos, Gengas, Bugiardinis, and others of Vasari's Florentines with names as obscure as their works, he could easily have beaten them painting with his feet, excepting, however, the divine Michelangelo and Andrea del Sarto.[35]

Written by Hand A (either Ludovico or Annibale), these remarks arise from the same person's earlier observation that Titian's *disegno* eclipses that of the Tuscans: 'Note well that whosoever follows Titian in such things must needs have great *disegno*, something one never finds in the works of the Florentines'.[36] Hand A, as Charles Dempsey adverts in his classic study of the Carracci *postille*, also praised Titian for making full use of the affordances of *disegno* to produce colouristic effects of 'lifelikeness and naturalism', and for choosing as his principal object of imitation the 'primary and principal things in life' rather than 'secondary sources in the antique'.[37] Statements such as these hijack Vasari, turning the *Vite* into a disputatious, multi-voice dialogue about the rivalrous relation between the *maniera Toscana* and the *maniera Lombarda*.

The *postille* added by El Greco to his 1568 edition of the *Vite* sometime between 1577, when he moved to Toledo, and his death in 1614, follow suit, but this time in defence of the Byzantine manner of painting, known as the *maniera Greca*, deprecated by Vasari. Written in El Greco's idiosyncratic Castillian, with letter-forms resembling his native Greek, the most interesting of these *postille*, as adduced by Nico Hadjinicolaou in a recent article, assorts the Greek manner above that of Giotto: 'If [Vasari] truly knew that Greek manner about which he speaks, he would have treated it otherwise than he does, [for] I say that comparing it with what Giotto did, this is simple in comparison with that, inasmuch as the Greek manner teaches about / displays ingenious difficulties'.[38] El Greco ascribes to the Byzantines a manner of painting more ingenious in its mastery of the difficulties of art than that of the master who, according to Vasari, displayed an incomparable command of such *difficultà*, principally

35 Vasari, *Vite* (Bologna, Biblioteca Communale dell'Archiginnasio) 814. Cited in Dempsey, "Carracci *Postille*" 75.

36 Vasari, *Vite* (Bologna, Biblioteca Communale) 814. Cited in Dempsey, "Carracci *Postille*" 75–76.

37 See ibid. 76.

38 See Hadjinicolaou N., "La defensa del arte bizantino por El Greco: Notas sobre una paradoja", *Archivo español de arte* 81.323 (2008) 217–232, at 222: 'Si [Vasari] supiera lo que es verdaderamente aquella manera griega de la que habla, de otra suerte la trataría en lo que dice, digo que comparándola con lo que hizo Giotto, ésta es simple en comparación de aquélla, por lo que la manera griega enseña de dificultades ingeniosas'.

CUSTOMISATION IN EARLY MODERN BOOK PRODUCTION AND RECEPTION 25

based on his studies after nature. As El Greco would have known from his reading of the "Life of Giotto", Vasari had panegyrised the lifelike poses and gestures of Giotto's volumetric figures, the variety of their costumes, and the expressive clarity and persuasiveness of the emotions they convey.[39] On the contrary, El Greco situates not Giotto but the Greeks at the fountainhead of a progressive history of art that culminates, it may be presumed, with the Venetian-inflected *disegno* and *colorito* of El Greco himself.

Printed books could also be repurposed through the implantation of extraneous elements that complexly interact with the extant material they colonise. A typical example is the *album amicorum* of the Catholic Bürgermeister of Vienna Johann von Thau, compiled between 1578 and 1598, which consists of the 1565 edition of Virgil Solis's *Biblische Figuren des alten Testaments* (Frankfurt, Johannis Wolffius), combined with the 1569 edition of Johann Posthius's *Tetrasticha in Ovidii Metamorphoseon lib. XV* (Frankfurt, Georgius Corvinus—Sigismund Feyerabend), likewise illustrated by Solis, the whole interleaved with blank folios and bound with Von Thau's arms stamped on the outside cover.[40] Von Thau circulated the book amongst a circle of acquaintances he wished to declare as friends, using the *album amicorum* to construct a network of elite contacts whose professional and affective ties to himself are both advertised and commemorated. The book, far from merely documenting this social circle, declares and constitutes it. Viennese notables such as Ulrich II Molitor, Abbot of Heiligenkreuz (1558–1585), Lorenz II Reiss, Abbot of Lilienfeld (1587–1601), Johann IX Schretel, Abbot of the Scots Monastery, Vienna (1562–1583), and Georg Ludwig Wehe embellished the blanks with their signatures, portraits, and/or coats-of-arms, and also inscribed their names and titles. Unsurprisingly, given that the majority of signatories were churchmen, the entries mainly cluster amongst Solis's biblical prints of the Old Testament. Von Thau's 'friends' selected episodes of special interest to them, spinning webs of typological analogy discernible to their fellow signatories.

More accessible is the *Album amicorum* of Cornelis à Blyenburch, originally from Dordrecht, who rose to the position of city magistrate in The Hague. He circulated his album between 1563 and 1569, having compiled it from the 1562 Latin edition of Claude Paradin and Gabriele Simeoni's *Heroica symbola* (Antwerp, Christopher Plantin) interleaved with blank folios, onto which

39 On these qualities of Giotto's art, see, for instance, Vasari G., "Giotto, pittore, scultore e architetto fiorentino", in *Le vite de' più eccellenti pittori, scultori ed architettori, tomo I*, ed. G. Milanesi (Florence: 1906) 377–378.

40 On the *Album amicorum Von Thau*, see Rosenheim M., *The Album Amicorum* (Oxford: 1910) 273–275. The professional illuminators hired by Von Thau's *amici* to give form to their clever conceits also added colours to the respective interleaf's adjacent printed image, thus making clear on which biblical or Ovidian scene they were commenting.

'friends' inscribed 58 entries, including two gouaches, one pen-and-ink drawing, and 31 brightly coloured coats of arms. The entry by Hector van Aytta (Ayttalus), Councilor Ordinary of the Court of Friesland, plays wittily upon the contiguous emblem, inverting the argument put forth by its interlocking parts: the motto "Superstitio religioni proxima" (Superstition most near to religion), the *pictura* of a sharp knife cutting cleanly through a whetstone, and the explanatory epigram, which reads [Fig. 1.5]:

> This is the earnest desire of the ancient enemy, of Satan, that whensoever he wishes to spread abroad in the world some signal error or impiety, according to his cunning and perversity, he strives ever to cover over that selfsame most illicit falsehood with an image or shadow of truth. Although that whole overlay is nothing other than a mere imposture, trick, and beguilement. Which selfsame thing he formerly accomplished when first he brought to pass the superstition of divination and augury, persuading King Priscus Tarquinius and the Roman people that that adamantine whetstone had indeed been cut in half with a sharp knife.[41]

The epigram refers to a story told in Livy, *Ab urbe condita* 1.36: having decided to increase the ranks of equestrian centuries – the Ramnes, Titienses, and Luceres – with squadrons of cavalry named after himself, Tarquinius finds himself blocked by the renowned augur Attus Navius who prevents him from proceeding unilaterally; only after a priest has first taken the auspices and duly consulted the omens, will the king be empowered to act. Celebrated by Livy as a priestly curb upon royal power, the anecdote is instead read by Paradin and Simeoni as a glaring example of ancient Roman superstition. The cunning falsehoods of Satan himself lurk behind the religious customs of ancient Rome, declare Paradin and Simeoni.

Van Aytta, perhaps seeing in the nearly homonymic Attus a conciliar namesake, restores Livy's positive reading of the encounter between king and

41 Paradin Claude – Simeoni Gabriele, *Symbola heroica* (Antwerp, Christopher Plantin: 1562) 113, in *Album amicorum of Cornelis a Blyenburch* (The Hague, Koninklijke Bibliotheek 130 E 28) 113: 'Hoc est antiqui hostis, et Sathanae studium, ut quoties insignem errorem, aut impietatem aliquam in hunc mundum spargere cupit, quae sua vafrities est, ac perversitas, illud ipsum vel falsiss[imum] commentum suum aliquae semper Veritatis specie atque umbra conetur obvelare. Quamquam aliud nihil sit totum illud involucrum, quam mera impostura, praestigiumque, ac fascinatio. Quod ipsum luculenter olim effecit, quando primum divinandi, augurandique superstitionem invexit, a Decio Navio augure ipsam cotem etiam durissimam novacula bipartitam esse, Prisco Tarquinio Regi, populoque Rom[ano] persuadens'.

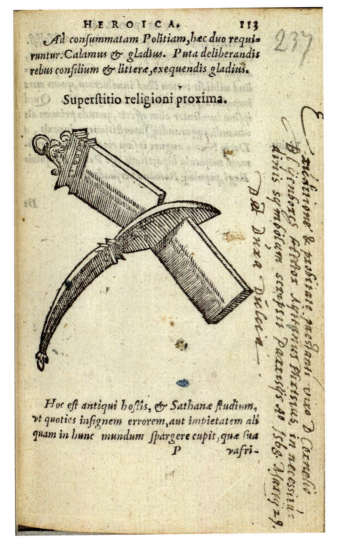

FIGURE 1.5

Hector van Aytta, "Dant Dura Dulcia", in *Album amicorum of Cornelis a Blyenburch*: page 113 of Paradin Claude – Symeoni Gabriele, *Heroica symbola* (Antwerp, Christopher Plantin: 1562), in-octavo
THE HAGUE, KONINKLIJKE BIBLIOTHEEK 130 E 28

augur. Writing in a clear hand that mimics the emblem book's italic typeface, he asseverates:

> The Frisian Hector Ayttanus has written on the image of necessity for Master Cornelis à Blyenburch, a man excellent in erudition and probity. Paris, 29 March 1568. Harsh things produce sweet ones.[42]

42 Ibid.: 'Eruditione et probitate praestanti viro D. Cornelio Blijenborcs Hector Aijttanus Phrisius, in necessitudinis symbolum scripsit Parrisijs Ao. 1568 Martij 29. Dant Dura Dulcia'.

By construing the sharp cut of the knife as an allegory of necessity, Van Aytta implies that the augur-counsellor's intervention was exigent rather than fraudulent. He further intimates that this should be apparent to any man as learned and upright as is Blyenburch. The motto, 'Dant Dura Dulcia', celebrates Attus's stern reprimand from which a sweet outcome issued: Livy asserts that Attus, having once read the omens as positive, ultimately sanctioned the king's plan, and that as a result, Tarquinius vanquished the Sabines. Read in this light, the emblem becomes an exemplum of the power of religion to sway royal policy (and curb the preemptive exercise of royal prerogatives) through the wise exercise of divinely sanctioned counsel. That Van Aytta's alternative epigram and motto are written in slanting letters, at ninety degrees to the printed text and image, as if flowing in the same direction as the cutting blade that slices through the whetstone, encourages the reader-viewer to appreciate how his postscript bifurcates the emblem, cutting through and reorientating it. Printed at the top of page 113, the closing sentences of the previous emblem, "Police souvereine" (Sovereign state), in that they describe the sword as the instrument whereby counsel is converted into practical action may have inspired Van Aytta's reading of "Superstitio religioni proxima": 'These two, the reed pen and the sword, are required for perfected statecraft. Namely, counsel and letters are for the deliberation of things, the sword for executing them'.[43]

Editions of Andrea Alciato's *Emblematum liber* were amongst the emblem books most commonly augmented for use as *alba amicorum*. A prime example is the *Album amicorum* of the humanist medical doctor Arnold Manlius, which consists of a German edition of Alciato (Frankfurt am Main, Sigismund Feyerabend for Georg Raben and Simon Hüter: 1567) interleaved with 127 additional folios, some with printed frames.[44] Personal physician to the imperial ambassador Karl Rym, Manlius accompanied him during his nearly four year-long embassy to Constantinople between May 1570 and December 1574. Once there, he ranged far beyond the German House, the Constantinopolitan headquarters of the ambassador and his retinue, searching for signatures from noblemen, theologians, and fellow humanists belonging to other embassies, to the Greek Orthodox Patriarchate, and to the local fraternity of translators, known as dragomans, trained to write in Persian, Arabic, and Ottoman Turkish. Manlius used Alciato's emblems like commonplace heads around which he clustered complementary signatures: three musicians – Gibertus Vigarannus,

43 Ibid.: 'Ad consummatam Politiam, haec duo requiruntur: Calamus et gladius. Puta deliberandis rebus consilium et litterae, exequendis gladius'.

44 On this and related *alba amicorum* compiled on mission to the Sublime Porte, see Radway R.D., "Three *Alba Amicorum* from the Habsburg Netherlands: Manlius, Wijts, and Huenich in the Ottoman Empire", *Early Modern Low Countries* 6 (2022) 103–126.

CUSTOMISATION IN EARLY MODERN BOOK PRODUCTION AND RECEPTION 29

Simeon Strats, and Franciscus Mergot, were invited to sign in the vicinity of the emblem "Musicam Diis curae esse" (The gods care for music).[45]

By incorporating their inscriptions, Manlius attested to his cosmopolitan bona fides, but as Robyn Dora Radway has lately argued, he nevertheless found ways of affirming his imperial loyalties and Christian orthodoxy.[46] Amongst the most remarkable of his signatories was the Christian apostate and Muslim convert Murad Bey, whose elaborate, multi-part inscription displays his command of Ottoman Turkish and Hungarian, and middling Latin. Murad signed next to Alciato's emblem "Vino prudentiam augeri" (Prudence is amplified through wine), an adaptation of Erasmus, *Adagia* 1.vii.17, "In vino veritas".[47] He thus shows himself to espouse Alciato's view that wine, if drunk moderately, enhances wit and wisdom with good cheer. But he tempers Alciato's admonition to marry the virtues of Minerva and Bacchus, by opening his page with the motto, 'It is better to have an enemy than to have a friend who has no sympathy for you'.[48] Responding to this motto, Manlius penned a very long commentary on the facing folio recto, in which he demonstrates how Murad was more a sympathetic enemy than a superficial friend. Telling of a time when their conversation turned from the subject of Christian and Muslim mores, especially as regards marriage, divorce, and circumcision, to matters of religion, he describes how they nearly came to blows when Murad trumpeted the inevitable triumph of Islam and he retorted by insulting the Prophet Mohammed. Manlius reinscribes confessional lines that brook no crossing, but does so in a way that affirms that he and Murad are good enemies rather than bad, lukewarm friends. The heated climax of their mutual argument, nearly reminiscent of a bar-room brawl, also implicitly warns against drinking too much wine when conversing on disputatious topics.

Within this category of customisation, another type of variation consists of books and print series that have been disassembled, reconfigured, and further modified through the interpolation of elements from other books and

45 See Alciato, "Emblema XXXII", in *Album amicorum Arnold Manlius* (Heidelberg University Library); and Radway, "Three *Alba Amicorum*" 108. On the Feyerabend printing of Alciato's *Emblemata*, see Green H., *Andrea Alciati and his Book of Emblems: A Biographical and Bibliographical Study* (London: 1872) 74; Landwehr J., *German Emblem Books, 1531–1888: A Bibliography* (Utrecht: 1972) 29; Daly P.M. (ed.), *Andrea Alciato, Jeremias Held, Held's Translation of Alciato's Emblematum Liber (1566). Facsimile Edition Using Glasgow University Library SM 45*, Imago Figurata Editions 4 (Turnhout: 2007); and Höpel I., *Emblem und Sinnbild. Vom Kunstbuch zum Erbauungsbuch* (Frankfurt am Main: Athenäum, 1987) 57–66.

46 Radway, "Three *Alba amicorum*" 109–110.

47 See Alciato, *Emblema XXXIX*, in *Album amicorum Arnold Manlius* (Heidelberg University Library); and Radway, "Three *Alba amicorum*" 109.

48 Ibid.

series. A prime example is the *Vita sancti Iosephi* of ca. 1601–1633, which comprises two primary components: the print series *Vita sancti Ioseph beatissimae Virginis sponsi patriarcharum maximi* of ca. 1600 (Life of Saint Joseph, spouse of the most holy Virgin, greatest of the patriarchs), published and engraved by Theodoor, Cornelis, and/or Jan Galle, and the *Cor Iesu amanti sacrum* of ca. 1600 (Heart sacred to the loving Jesus / Heart of Jesus sacred to the one who loves him), designed, engraved, and published by Antoon II Wierix [Figs. 1.6 & 1.7].[49] The latter series has been inserted midway through the first, at a key juncture – between the antecedent image *Nocturna hospitatio* (Noctural lodging), which shows Joseph preparing a place of rest for Mary and Jesus during the flight into Egypt, and *In caelis gloriosa sessio* (Glorious seating in heaven) and *Egypti commoratio* (Egyptian sojourn), which respectively show the holy family glorified in heaven, and Joseph in Egypt, keeping watch at home, Mary and Jesus beside him. Positioned between domestic scenes of the holy family, in heaven and on earth, the *Cor Iesu amanti sacrum*'s meaning changes: Wierix's series plots the story of the heart's transformation as it opens to receive Jesus, then changes in form and function, shifting from cluttered workshop to painter's studio where Christ's lineaments are portrayed, from throne room where Jesus sits in state to oratory where one reposes with/in Christ; in its new context, the series becomes a stepwise chronicle of the transformation of Joseph's heart into a dwelling-place for Jesus, a true *hospitium Christi* (place of hospitality for Christ). The spiritual glorification of Joseph is seen to arise from the indwelling of Christ, whose presence conversely informs, indeed motivates, the domestic and artisanal scenes of the holy family's day-to-day life that follow. Positioned just before the close of the *Vita sancti Ioseph*, these scenes include *Pueri ad Ioseph subiectio* (The Son's subjection to Joseph) and *Sollicita manuum operatio* (Solicitous operation of the hands), both of which portray Jesus labouring under the guidance of Mary and Joseph in their home cum carpenter's workshop. Here, as elsewhere, the juxtaposition of two discrete series mutually alters their respective significance.

In the case of the gospel harmonies and bible concordances manufactured by the Ferrar / Collet family at Little Gidding in Huntingdonshire the linked processes of dis- and rearticulation were taken to the furthest extreme. Michael Gaudio, in his monograph on the Collet sisters' artisanal-exegetical labour of bible reading, refers to their method of cutting and pasting printed texts and

49　On this hybrid book, see Melion W.S., "Jesus, Mary, and Joseph as Artisans of the Heart and Soul in Manuscript MPM R 35, *Vita S. Ioseph beatissimae Virginis sponsi* of ca. 1600", in Dekoninck R. – Guiderdoni A. – Melion (eds.), *Quid est secretum: Visual Representation of Secrets in Early Modern Europe, 1500–1700*, Intersections 65.2 (Leiden – Boston: 2020) 37–144.

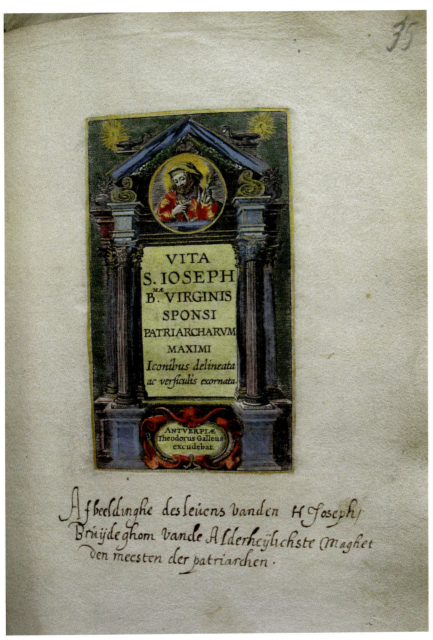

FIGURE 1.6 Theodoor, Cornelis, and/or Jan Galle, *Vita S. Joseph beatissimae Virginis sponsi patriarcharum maximi iconibus delineata ac versiculis ornata* (Life of St. Joseph, husband of the most blessed Virgin, greatest of the patriarchs, portrayed in images and ornamented with Verses) (Antwerp, Theodoor Galle: ca. 1601–1633). Engraving, 101 × 60 mm
ANTWERP, PLANTIN MORETUS MUSEUM, MPM R 35

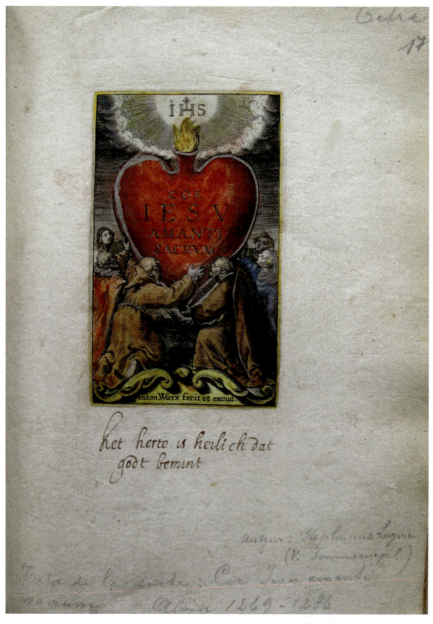

FIGURE 1.7 Antoon II Wierix, *Cor Iesu amanti sacrum* (Heart sacred to the loving Jesus / Heart of Jesus sacred to the one who loves him) (Antwerp, Antoon II Wierix: before 1604), title-page. Engraving, 91 × 56 mm
ANTWERP, PLANTIN MORETUS MUSEUM, MPM R 35

CUSTOMISATION IN EARLY MODERN BOOK PRODUCTION AND RECEPTION 33

images as 'patchwork': by this he means that they harvested textual and visual fragments as if they were pieces of cloth, sewing them into meaningful patterns resembling a quilt, its constituent elements tightly coordinated even while the seams across which they are joined remain visible.[50] Their scrapbook harmonies and concordances – the first made for their own use, the ensuing volumes for luminaries such as Charles I (the "King's Concordance"), the Prince of Wales (the "Pentateuch Concordance"), and poet George Herbert – consist of passages cut from multiple copies the King James Bible, rearranged so that texts in roman type, which add up to the continuous, 'full and Cleare Narration of all that was sayde or donn', alternate with texts in black letter, which compile scriptural variants and/or provide exegetical particulars that allow the biblical stories to be contextualised.[51] The sisters often supplemented these textual snippets with handwritten notes that refer the reader to cognate scriptural passages. Roman capitals, generally A-C, in the margins indicate the biblical source texts, such as the synoptic Gospels. Simultaneously, excerpts from multiple prints were collaged to illustrate the episodes recounted in the adjacent texts and to comment upon them. For instance, at the top of page 50 in a Gospel harmony compiled in 1640, *M O N O T E Σ Σ A P O N: The Actions and Doctrine and Other Passages Touching Our Lorde and Saviour Iesus Christ*, the sisters collaged the figure of John the Baptist over Jan Collaert's *Adonijah Requesting Solomon's Maidservant as his Wife*, expropriated from Gerard de Jode's *Thesaurus sacrarum historiarum Veteris Testamenti* of 1585.[52] This overlay allowed for a reinterpretation of Collaert's print: viewed in conjunction with the relevant passages from Matthew 14, Mark 6, and Luke 9, pasted just below in two columns, it now illustrates *John the Baptist's Testimony against Herod and Herodias.*

In one of the most sophisticated of Little Gidding's books, the *Prince of Wales's Concordance* created for the future Charles II, the juxtaposition of text and image serves to elaborate reflexively upon the signifying functions of scriptural media, textual and pictorial. Page 231, "The Ceremoniall Law", contains an amalgam of at least five cut and pasted prints – the *Name of God in Hebrew, Greek, and Latin*; *Moses and Aaron*; the *Celebration of Passover*; the *Last Supper*; and *Of the Lord's Supper: The Sacrament of Continuance in the*

50 See Gaudio M., *The Bible and the Printed Image in Early Modern England: Little Gidding and the Pursuit of Scriptural Harmony*, Visual Culture in Early Modernity 52 (London – New York: 2017) 35–59.

51 Ibid. 30.

52 Ibid. 28.

Convenant of Grace [...] in which are to be considered the Sacramental Relation of the visible signe [...] and the invisible Grace – that forms part of a protracted exegesis of the typological analogy between Passover and the Eucharist [Fig. 1.8]. Excerpts from key biblical passages prefiguring the Eucharist under the Old Law and instituting it under the New – amongst which, Exodus 12, 1 Corinthians 11:[20–29], 2 Corinthians 5:7, Ephesians 4:10, and Revelation 14:13 – alternate with long extracts from William Guild's *Moses Unvailed; or, those figures which served unto the patterne and shadow of heavenly things, pointing out the Messiah Christ Jesus* [...] (London, G.P. for J. Budge: 1620). The visual-verbal apparatus constitutes a statement of image doctrine that reconciles or perhaps blurs the distinction between the exegetical properties of the scriptural word and the scriptural image. The reader-viewer is urged to view letters (both typeset and engraved) as if they were images and to read images as if they were texts. The mutual implication of scriptural work and scriptural image adumbrates or signifies the mysterious nature of the Eucharist in which the 'visible signe', partaking of the 'type and figure in the works of man' joins with the 'invisible Grace and trueth figured in the works of God'.[53]

For the Collet sisters, who cut and pasted under the direction of their uncle and spiritual advisor Nicholas Ferrar, the spiritual exercise of rearranging scriptural particles in word and image had deeply personal significance, as one of the most poignant pages in *MONOTEΣΣAPON* reveals. The top of page 66 contains eight prints in a symmetrical arrangement infixed within a lightly scribed latticework of double-ruled red lines: above at center appears Boëtius à Bolswert's print, extracted from chapter 26 of Johannes Bourgesius, s.j.'s, *Vitae, Passionis et mortis Jesu Christi Domini nostri mysteria* (Antwerp, Henricus Aertssius: 1622): Christ sends the twelve apostles forth to preach (Matthew 10 and Luke 6), promulgates the commandment of love (Matthew 22 and Mark 12), and recounts the parable of the Good Samaritan (Luke 10) in the form of an image in the image, unscrolled and held aloft by an angel hovering over the Lord [Fig. 1.9].[54] Two half-length cut-outs of Mary Magdalene flank this print, and five small

53 Ferrar and Collett Families, *The Prince of Wales's Concordance* (Little Gidding: ca. 1640) 231: 'The Sacrament of Continuance is the Covenant of Grace whereby our Comunion with the Father, Sonne,and holy Ghost[,] and so the faithfull with our growth and preservation in Christ is sealed unto us. In which are to be considered the Sacramentall Relation of The visible signe, type and figure in the works of man [and] The invisible Grace and trueth figured in the works of God'.

54 On this page, the assembly of which Gaudio compares to an embroiderer's grid, see *Bible and the Printed Image* 56–57, Fig. 1.26. Here the Collet sisters, ever striving to harmonise their sources, adaptively appropriate nunnish Catholic imagery but embed it within a patchwork pattern of diverse shapes, scales, and media that insists on the mediated, discontinuous nature of any human knowledge of God.

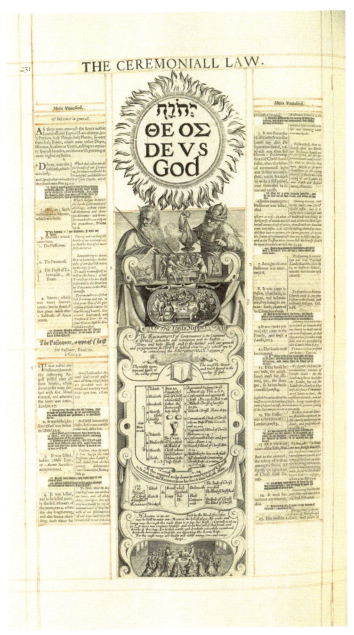

FIGURE 1.8 Ferrar / Collet Family, *Of the Lord's Supper: The Sacrament of Continuance in the Convenant of Grace* [...] *in which are to be considered the Sacramental Relation of the visible signe* [...] *and the invisible Grace*, page 231 in *The Prince of Wales's Concordance*, ca. 1640. Cut and pasted engravings and letterpress, in-grand folio
WINDSOR, THE ROYAL COLLECTION

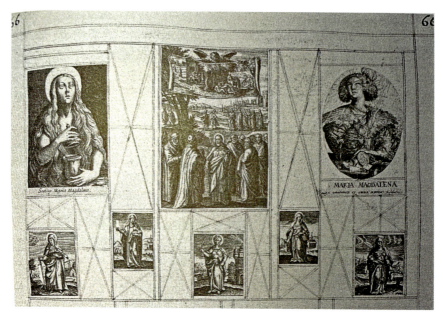

FIGURE 1.9 Ferrar / Collet Family, "Certain women, which had been healed of evil spirits and infirmities [...]", page 66 in *MONOTEΣΣAPON or The Actions Doctrine and Other Passages Touching Our Lord and Saviour Iesus Christ*, 1640. Private collection. Source: Gaudio M., *The Bible and the Printed Image in Early Modern England* (Abingdon – New York: 2017) 57.

full-length effigies of virgin martyrs are ranged below in a battlement pattern. This constellation of cut and pasted-in images illustrates Luke 8:2–3: 'And certain women who had been healed of evil spirits and infirmities; Mary who is called Magdalen, out of whom went seven devils, and Joanna the wife of Chuza, Herod's steward, and Susanna, and many others, which ministered unto him of their substance'.[55] The decision to devote a full page to this heretofore unillustrated passage, and the visual amplification of it surely speak to the Little Gidding women's sense of the evangelical affordances of their patchwork labour: through their print ministry, they could be said to go forth into the world, in imitation of the apostles, their labor testifying to their love of God and their fellow men. The page itself, in bearing witness to their pious practice of customisation, certifies their firm adherence to the commandment of love. Just as Christ generates the parable of the Good Samaritan in the angelically mediated form of an image in the image, so too, the Colets have fashioned a scriptural image signifying their embrace of divine love as an urgent requirement of the Christian life. The fact that the Colets, after fabricating their pages,

55 *The English Bible: King James Version*, eds. H. Marks – G. Hammond – A. Busch (New York: 2012).

pressed them in a large book press to give them the flattened appearance of a printed page, speaks to their sense that they were producing a species of printed book, hybrid to be sure, but nonetheless authoritative in appearance, texture, and format.[56] It makes sense, then, to think of the codices they lovingly manufactured as the most customised of printed books.

The nineteen essays that follow explore these and other kinds of customisation. The authors aim to understand how changes to the fabric of printed and variously bound *opera* altered, inflected, and/or transformed their functions, their ways of producing meaning and knowledge, in the process testifying to the dynamic, complex, agentive relation between reader-viewers and their treasured books. After commencing with the current essay, the collection continues with a second introductory essay, by co-editor Christopher Fletcher, which in its examination of the 'customising mindset' raises important collateral issues. Next comes "Customisation Across Media", the first of five thematic subdivisions. The three essays (Hunter, Michael, and Leitch) deal with the translation of printed material into manuscript and vice-versa as methods of customisation. The four essays in "Communal Customising" (Rothstein, Warnar, Van Leerdam, Cummins) examine shared modes of customisation, including those practised by courtly elites and by printers, artists, and patrons construed loosely as a community. The four essays in "Individual Customisers" (Gehl, Enenkel, Midanik, Wade) take stock of variously personal approaches to customisation, from the efforts of a devoted student to fashion a literary monument for his teacher, to the appropriation of emblems for a *Stammbuch*. The four essays in "Editorial Customisation" (Koguciuk, Dlabacova, Melion, Germano Leal) focus on the creation of new editions from already printed works. Finally, the four essays in "Visual Customisation" investigate how pictorial images were used to emend, amend, and, occasionally, transmogrify printed books.

Bibliography

Album amicorum of Cornelis à Blyenburch (The Hague, Koninklijke Bibliotheek).
Album amicorum Arnold Manlius (Heidelberg University Library).
Album amicorum Johan von Thau (British Library, London).
Alciato Andrea, *Emblemata* (Frankfurt am Main, Sigismund Feyerabend for Georg Raben and Simon Hüter: 1567).
Archer C. – McKay B., "A Black Letter Volume from the Home of the Roman Letter: A Venetian *Missale Romanum* of 1597 – A Case Study of the Archer Copy", in

56 On the Collet sisters' efforts to press their fabricated pages flat, giving them the appearance of printed book pages, see Gaudio, *Bible and the Printed Image* 30–31.

Archer – Peters L. (eds.), *Religion and the Book Trade* (Newcastle upon Tyne: 2015) 29–44.

Bowen K.L. *Christopher Plantin's Books of Hours: Illustration and Production*, Bibliotheca Bibliographica Neerlandica 32 (Nieuwkoop: 1997).

Bowen K.L., "Royal Books of Hours with Local and International Appeal: An Examination of Jan Moretus's 1600/1601 and 1609 Editions of the *Officium Beatae Mariae Virginis*", *The Library* 15.2 (2014) 158–184.

Bowen K.L., "Christopher Plantin, Philip II, and the Vatican: Negotiating between Personal Preferences and Pragmatic Considerations When Designing the Antwerp Editions of the New Tridentine Missal", *De gulden passer* 92 (2014) 31–52.

Bowen K.L., – Imhof D., *Christopher Plantin and Engraved Book Illustrations in Sixteenth-Century Europe* (Cambridge, U.K.: 2008).

Bowen K.L., – Imhof D., "Publishing and Selling Jerónimo Nadal's Trend-Setting *Evangelica historiae imagines* and *Adnotationes et meditationes in Evangelia*: Dealings with the Moretuses, 1595–1645", *The Library* 20.3 (2019) 307–339.

Daly P.M. (ed.), *Andrea Alciato, Jeremias Held, Held's Translation of Alciato's Emblematum Liber (1566). Facsimile Edition Using Glasgow University Library SM 45*, Imago Figurata Editions 4 (Turnhout: 2007).

David Joannes, s.J., *Veridicus Christianus* (Antwerp, Ex officina Plantiniana: 1601).

Delaissé L.M.J., "The Importance of Books of Hours for the History of the Medieval Book", in McCracken U.E. – Randall L.M.C. – Randall R.H. (eds.), *Gatherings in Honor of Dorothy E. Miner* (Baltimore: 1974) 203–225.

Delft M. van, "Illustrations in Early Printed Books and Manuscript Illumination: The Case of a Dutch Book of Hours Printed by Wolfgang Hopyl in Paris in 1500", in Wijsman H. – Kelders A. – Speakman Sutch S. (eds.), *Books in Transition at the Time of Philip the Fair: Manuscripts and Printed Books in the Late Fifteenth- and Early Sixteenth-Century Low Countries* (Turnhout: 2010) 131–164.

Dempsey C., "The Carracci Postille to Vasari's *Lives*", *The Art Bulletin* 68 (1986) 72–76.

Deschamps J., "De herkomst van het Leidse Handschrift van de Sint-Servatiuslegende van Hendrik van Veldeke", *Handelingen van de Koninklijke Zuidnederlandse Maatschappij voor Taal- en Letterkunde en Geschidenis* 12 (1958).

Engel W., *The Printer as Author in Early Modern England: John Day and the Fabrication of a Protestant Memory Art* (New York: 2022).

Farquhar J.D., "The Manuscript as a Book", in Hindman S. – Farquhar (eds.), *Pen to Press: Illustrated Manuscripts and Printed Books in the First Century of Printing* (College Park: 1977) 11–99.

Gaudio M., *The Bible and the Printed Image in Early Modern England: Little Gidding and the Pursuit of Scriptural Harmony*, Visual Culture in Early Modernity 52 (London – New York: 2017).

Green H., *Andrea Alciati and his Book of Emblems: A Biographical and Bibliographical Study* (London: 1872).

Gumbert J.P., *The Dutch and their Books in the Manuscript Age* (London: 1990).

Gumbert J.P., "Codicological Units: Towards a Terminology for the Stratigraphy of the Non-Homogeneous Codex", *Segno e testo* 2 (2004) 17–42

Gumbert J.P., "Codicologische eenheden – opzet voor een terminologie", *Koninklijke Nederlandse Akademie van Wetenschappen. Mededelingen van de Afdeling Letterkunde, nieuwe reeks* 67.2 (2004) 5–38.

Hindman S., *The Robert Lehman Collection. IV: Illuminations* (New York – Princeton: 1997).

Höpel I., *Emblem und Sinnbild. Vom Kunstbuch zum Erbauungsbuch* (Frankfurt am Main: Athenäum, 1987).

Imhof D., *Jan Moretus and the Continuation of the Plantin Press*, Bibliotheca Bibliographica Neerlandica, Series Major, Volume III, 2 vols. (Leiden: 2014).

Kwakkel E., "The Cultural Dynamics of Medieval Book Production", in Biemans J.A.A.M. – Hoek K. van der – Rudy K. – Vlist E. van der (eds.), *Manuscripten en miniaturen: Studies aangeboden aan Anne S. Korteweg bij haar afscheid van de Koninklijke Bibliotheek*, Bijdragen tot de geschiedenis van de Nederlandse boekhandel (Zutphen: 2007) 243–254.

Kwakkel E., "Towards a Terminology for the Analysis of Composite Manuscripts", *Gazette du livre medieval* 41 (2002) 12–19.

Landwehr J., *German Emblem Books, 1531–1888: A Bibliography* (Utrecht: 1972).

Maclean I., *Learning and the Market Place: Essays in the History of the Early Modern Book*, Library of the Written Word 9 – The Handpress World 6 (Leiden – Boston: 2009).

Melion W.S., "'Quis non intelliget hoc voluisse Christum': The Significance of the Redacted Images in Jerónimo Nadal's *Adnotationes et meditationes in Evangelia* of 1595," in *Jerome Nadal, Annotations and Meditations on the Gospels, Cumulative Index*, prep. J.P. Lea (Philadelphia: 2014) 1–99.

Melion W.S., "Jesus, Mary, and Joseph as Artisans of the Heart and Soul in Manuscript MPM R 35, *Vita S. Ioseph beatissimae Virginis sponsi* of ca. 1600", in Dekoninck R. – Guiderdoni A. – Melion (eds.), *Quid est secretum: Visual Representation of Secrets in Early Modern Europe, 1500–1700*, Intersections 65.2 (Leiden – Boston: 2020) 37–144.

Nadal Jerónimo, *Adnotationes et meditationes in Evangelia* (Antwerp, Martinus Nutius: 1595).

Navarrete F. et al. (eds.), *Colección de documentos inéditos para la historia de España, Vol. 41* (Madrid: 1842–1896).

Paradin Claude – Simeoni Gabriele, *Symbola heroica* (Antwerp, Christopher Plantin: 1562).

Pettegree A., *The Book in the Renaissance* (New Haven – London: 2010).

Posthius Johann, *Tetrasticha in Ovidii Metamorphoseon lib. XV* (Frankfurt, Georgius Corvinus – Sigismund Feyerabend: 1569).

Radway R.D., "Three *Alba Amicorum* from the Habsburg Netherlands: Manlius, Wijts, and Huenich in the Ottoman Empire", *Early Modern Low Countries* 6 (2022) 103–126.

Robinson P.R., "The 'Booklet': A Self-Contained Unit in Composite Manuscripts", *Codicologica: Towards a Science of Handwritten Books* 3 (1980).

Reinburg V., *French Books of Hours: Making an Archive of Prayer, c. 1400–1600* (Cambridge, U.K. – New York: 2012).

Rial Costas B., "International Publishing and Local Needs: The Breviaries and Missals Printed by Plantin for the Spanish Crown", in McLean M. – Barker S. (eds.), *International Exchange in the Early Modern World*, Library of the Written Word 51, The Handpress World 38 (Leiden – Boston: 2016) 15–30.

Rosenheim M., *The Album Amicorum* (Oxford: 1910).

Rudy K., *Postcards on Parchment: The Social Lives of Medieval Books* (New Haven – London: 2015).

Rudy K., "Sewing the Body of Christ: Eucharist Wafer Souvenirs Stitched into Fifteenth-Century Manuscripts, Primarily in the Netherlands", *Journal of Historians of Netherlandish Art* (2016), n.p.

Rudy K., *Piety in Pieces: How Medieval Readers Customized their Manuscripts* (Cambridge, U.K.: 2016).

Rudy K., *Image, Knife, and Gluepot: Early Assemblage in Manuscript and Print* (Cambridge, U.K.: 2019).

Ruffini M., "Sixteenth-Century Paduan Annotations to the First Edition of Vasari's *Vite* (1550)", *Renaissance Quarterly* 62 (2009) 748–808.

Saenger P.H., "Books of Hours and the Reading Habits of the Later Middle Ages", in Boureau A. – Chartier R. (eds.), *The Culture of Print: Power and the Uses of Print in Early Modern Europe* (Princeton: 1989) 141–173.

Shrank C., "Mis-en-page, 'The Authors Genius', 'The Capacity of the Reader', and the Ambition of 'A Good Compositer'", in Archer C.– Peters L. (eds.), *Religion and the Book Trade* (Newcastle upon Tyne: 2015) 66–82.

Smeyers M., *Vlaamse miniaturen voor van Eyck, ca. 1380–1420*, exh. cat., Cultureel. Centrum Romaanse Poort, Corpus of Illuminated Manuscripts 6 (Leuven: 1993).

Solis Virgil, *Biblische Figuren des alten Testaments* (Frankfurt, Johannis Wolffius: 1565).

Vasari Giorgio, *Le vite de' piu eccellenti pittori, scultori et architettori* (Florence, Lorenzo Torentino: 1550). (Postillated copy: Beinecke Rare Book and Manuscript Library, Yale University.)

Vasari Giorgio, *Le vite de' piu eccellenti pittori, scultori et architettori* (Florence, Appresso i Giunti: 1568). (Postillated copies: Biblioteca Communale dell'Archiginnasio, Bologna; formerly Fundación Xavier de Salas, Trujillo, Cáceres.)

Vasari Giorgio, "Giotto, pittore, scultore e architetto fiorentino", in *Le vite de' più eccellenti pittori, scultori ed architettori, tomo 1*, ed. G. Milanesi (Florence: 1906) 369–428.

Waterschoot W., "*Veridicus Christianus* and *Christeliicken Waersegger* by Joannes David", in Dekoninck R. – Guiderdoni-Bruslé (eds.), *Emblemata sacra: rhétorique et herméneutique du discours sacré dans la littérature en images / Emblemata sacra: The Rhetoric and Hermeneutics of Illustrated Sacred Discourse*, Imago figurata 7 (Turnhout: 2007) 527–534.

Weekes U., *Early Engravers and their Public: The Master of the Berlin Passion and Manuscripts from Convents in the Rhine-Maas Region, ca. 1450–1500* (London: 2004).

CHAPTER 2

The Customising Mindset in the Fifteenth Century: The Case of Newberry Inc. 1699

Christopher D. Fletcher

1 Introduction

Information culture in the early twenty-first century is defined by an over-abundance, to say the least. Today, more people have access to more information in more formats than at any point in human history, which has created a constantly and rapidly shifting information culture that can be unwieldy and confusing. Such a culture has consequences; in the past few years, it has contributed to the erosion of trust in facts and institutions, a rise in cybercrime and cyberterrorism, and direct threats to democracy, none of which seem to be going away anytime soon.[1]

In light of this, it is essential for both institutions and individuals to be able to confidently participate in information culture by analyzing its capabilities, identifying its shortcomings, and mitigating its dangers. Considering the speed at which technology currently develops, this task can be daunting, so it is useful to begin by looking to the past. How did individuals and institutions in earlier periods engage with information culture? How did they analyze, interrogate, and use the various communication technologies available to them, and to what purpose? Finally, what can we learn from their experience?

Answering these questions allows us to identify particular patterns of thought and behavior that effectively respond to rapid changes in information culture. These patterns are much easier to isolate and analyze in these earlier periods, thanks to the comparative dearth of technology. As such, the ways in

1 For general introductions to each of these threats and information culture's role within them, see Flintham Martin – Karner Christian – Bachour Khaled – Creswick Helen – Gupta Neha – Moran Stuart, "Falling for Fake News: Investigating the Consumption of News via Social Media", in *Proceedings of the 2018 CHI Conference on Human Factors in Computing Systems* (Montreal: 2018) 1–10; Worth Robert, "Terror on the Internet: The New Arena, The New Challenges", *New York Times Book Review* 21 5 December 2016; and Liam Hanlon – Welle Jud – Nawrocki Scott, "January 6 and Beyond: Understanding the New Social Media Landscape", March 24, 2021 https://www.nardelloandco.com/insights/january-6-and-beyond/# (accessed 3/17/22).

© KONINKLIJKE BRILL NV, LEIDEN, 2024 | DOI:10.1163/9789004680562_003

which humans reacted to new communication technologies in the past can reveal a model for effectively engaging with it now and in the future.

Few historical moments are more useful for this purpose than the latter half of the fifteenth century in Europe, the age of the *incunabulum*. Scholars and authors have frequently pointed to this era as a major turning point in intellectual and technological history, a time when traditional European modes of communication and dissemination of information were gradually re-shaped by the technology of print, a process that in turn created new technologies and new forms of media.[2] At least in Europe, this period marked the first time that information consumers could choose between different forms of technology – that is, manuscript and print – in order to access, process, and share the information at their disposal.

In this essay, I will argue that exploring how and why late medieval individuals chose to use these two technologies in the ways that they did can illuminate best practices for navigating our hyper-technological information culture. As I will show, the key to understanding these practices is found in the late medieval practice of *customisation*. Widely shared by authors, bookmakers, and consumers, the customising mindset encouraged fifteenth-century readers to master the capabilities of the available information technologies and adapt them to meet their needs and interests.

Contrary to earlier studies highlighting competition between manuscript and print, scholars have more recently come to understand that late medieval readers frequently chose to use *both* technologies together, compiling volumes that included printed and manuscript material.[3] These hybrid volumes, which were far more numerous than the surviving record indicates, are the clearest manifestation of the customising mindset.[4] By understanding how the multiple technologies interact within these volumes, we can retrace how

2 Useful overviews of fifteenth-century book culture include McKitterick David, *Print, Manuscript and the Search for Order, 1450–1830* (Cambridge, 2003); Bühler Curt, *The Fifteenth-Century Book: The Scribes, the Printers, the Decorators* (Philadelphia: 1960); Dane Joseph, *What is a Book? The Study of Early Printed Books* (Notre Dame: 2012); Neddemeyer Uwe, *Von der Handschrift zum gedruckten Buch: Schriftlichkeit und Leseinteresse im Mittelalter und in der frühen Neuzeit: quantitative und qualitative Aspekte* (Wiesbaden: 1998); and Schmitz Wolfgang, *Grundriss der Inkunabelkunde: Das gedruckte Buch im Zeitalter des Medienwechsels* (Stuttgart: 2018).

3 McKitterick, *Print, Manuscript, and the Search for Order* 48–52.

4 Nineteenth-century librarians, booksellers, and bibliophiles frequently dismembered hybrid volumes in order to separate manuscript from printed books. McKitterick, *Print, Manuscript, and the Search for Order* 50.

CUSTOMIZING MINDSET: THE CASE OF NEWBERRY INC. 1699

late medieval users shaped information culture by customising books that were personal and practically useful.

In this chapter, I will trace out the contours of the customising mindset through the witness of a fifteenth-century hybrid volume in the collection at the Newberry Library in Chicago, where it is cataloged as Inc. 1699.[5] This book combines an *incunabulum* and a manuscript miscellany, both of which are in German. As we shall see, codicological evidence suggests that an early owner – quite probably the *first* owner – consciously chose to combine these two forms of media in a single volume. By teasing out the functional relationship between the technologies it contains, I argue that this humble volume can show us how the late medieval customising mindset created certain patterns of interaction with the material forms of information culture that resonated through later centuries down to the present.

2 The Volume

Inc. 1699 is quarto volume produced on chancery paper, now bound in a fragment from a fourteenth-century liturgical manuscript. The host work in the volume is a nearly complete copy of *Ein ware nachuolgung Cristi*, the first German edition of Thomas of Kempen's *Imitatio Christi*, which was printed in Augsburg by Anton Sorg in 1486 [Fig. 2.1]. Bound with it is a thirty-two folio manuscript on paper, containing dozens of discrete texts in German, copied in two hands, one of which was clearly that of a professional scribe [Fig. 2.2].[6]

Both sections of the book are modest in terms of their quality and appearance. The *Nachuolgung* edition is fairly plain, with only a series of ten-line *Maiblumen* and 4-line outline and ornamental woodcut initials as decorations. It is, therefore, a typical example of the inexpensive vernacular editions Augsburg printers were known for producing during the fifteenth century.[7]

5 Chicago, Newberry Library, Inc. 1699. The Newberry acquired the volume in 1901 with the purchase of the library of Prince Louis-Lucien Bonaparte. See Collins Victor, *Attempt at a Catalog of the Library of the Late Prince Louis-Lucian Bonaparte*. 4 vols. (London: 1894). The volume is also described in Selmer Carl – Goedsche C.R., "The *Priamel* Manuscript of the Newberry Library, Chicago", *PMLA* 53.1 (1938) 64–77.

6 Kempen Thomas von, *Ein ware nachuolgung Cristi* (Augsburg, Anton Sorg: 1486). In what follows, citations from the printed *Nachuolgung* will use Sorg's pagination, while citations from the manuscript will use the modern foliation.

7 On early print culture in Auguburg, see Künast Hans-Jörg, *'Getruckt zu Augspurg': Buchdruck und Buchhandel in Augsburg zwischen 1468 und 1555* (Tübingen: 1997).

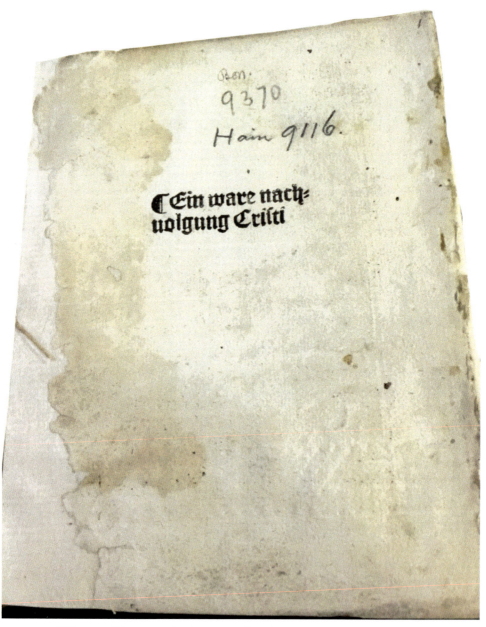

FIGURE 2.1 Title page of *Ein ware nachuolgung Cristi*. (Augsburg: Anton Sorg, 1486). Chicago, Newberry Library, Inc. 1699

FIGURE 2.2 Incipit of devotional manuscript in Inc. 1699. Chicago, Newberry Library, Inc. 1699, fol. 193r

The manuscript too shows signs of having been produced on a budget. The paper is decent but somewhat ragged, and seems to have been so at the time of copying, considering the initials and decorations made around a torn-off corner [Fig. 2.3]. Though the manuscript has been trimmed, the margins are fairly small, and care seems to have been taken to write on as much of the page as possible. Finally, some of the rubrics and initials bear a grayish tint, suggesting that the scribe was not constantly working with a pure batch of red ink.[8]

Modest as it may look, there is no doubt that Inc. 1699 was used. There is an abundance of material evidence in the book suggesting active engagement from readers as early as the time of its creation. Marginal notations, a manicule, and pastedown paper tabs throughout the book testify to early owners' direct and active engagement with its content. More than this, smudges, stains, tears, and thumbprints throughout the volume give a sense of how often it was opened. Rusty stains in the gutter could have been made by small objects used to mark important passages or to hold a place in between readings, suggesting that readers frequently returned to their reading. Moreover, this reading seems to have happened throughout the day; faint reddish stains throughout the book suggest that it was open near the owner's meals or daily work, while the presence of what appears to be hardened wax here and there indicates that the book was read by candlelight [Fig. 2.4].

The most important codicological evidence for our purposes, however, is the binding. According to Lesa Dowd, the former Director of Conservation Services at the Newberry Library, the split thong sewing connecting the *Nachuolgung* to the manuscript appears to be older than the parchment waste cover, which was likely added in the sixteenth century. The reason for this is that the sewing supports attached to the text block and the thread connecting them to the cover predate the sewing supports on the cover itself. This is crucial for us, because it strongly indicates that the *Nachuolgung* and the manuscript were intentionally bound together very early in the volume's life, very likely in the late fifteenth century. Based on this evidence, it seems plausible that the decision to combine two information technologies in a single, cohesive volume was made by its original owner.

8 Clemens Raymond – Graham Timothy, *Introduction to Manuscript Studies* (Ithaca: 2007) 24–25.

CUSTOMIZING MINDSET: THE CASE OF NEWBERRY INC. 1699

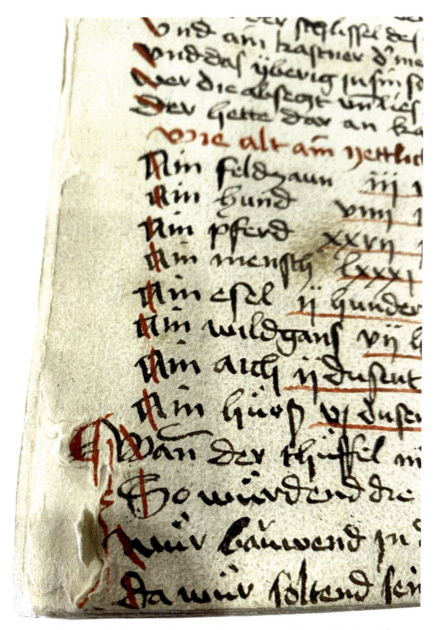

FIGURE 2.3 Decorative border around a pre-existing torn corner. Chicago, Newberry Library, Inc. 1699, fol. 229v.

⸿Das xvii. plat

sich selb jn keinen dingen·vnd begert dz die
ere gotes beschehe jn allen dingen·auch haß
set der keinen menschen der jm selber kein be=
sunder freüd wünscht denn allein jn got säli
ge zewerden·vnd er leget niemant kein güt
tat zü·wann er keret es gancz zü got võ dez
alle ding seind vrsprünglichen außgangen·
vnd jn dem all heiligen zum letsten säliklich
rüwendt·wer ein füncklin warer liebe hett·
der empfund on zweifel das all jrdische di
ge wol seind eytelkeyt vnd üppigkeyt·

⸿Von vertragen vnnd über
setzen still　⸿Das xvi·Capitel

Er mensch sol gedultiklich leiden
was er an jm vnd an andern mē
schen nit gebessern mag bis das
got etwas ordnet·vnd gedeck dz
es villeicht also besser ist vmb dz dz du wer
dest bewärt vnd gedult lernest on die vnn
ser verdienen nit groß zeschäczen ist· Doch
soltu bitten für söllich jrsal das dir gott be
gnad zehelffen·das mügest gütlichen tragē

FIGURE 2.4　Wax dripping in *Ein ware nachuolgung Cristi*. (Augsburg: Anton Sorg, 1486). Chicago, Newberry Library, Inc. 1699, fol. XVII r

3 Two Technologies and the Customising Mindset

Combining printed and manuscript works in a single volume would hardly have seemed odd in the fifteenth century. Long before Inc. 1699 was produced, customisation had become ingrained in how Europeans engaged with their books. Beginning in the fourteenth century, the combination of growing lay literacy and the increasing availability of paper as a writing support steadily diversified the reading public, allowing new groups of readers to bring their own interests, needs, and intellectual approaches the books they commissioned, purchased secondhand, or made themselves.[9] When print became more widely available in the middle of the century, it entered into an already sophisticated information culture, one in which individuals of various backgrounds and skill levels confidently and proactively participated.[10] As such, far from completely changing everything, print took its place as another technological option for recording and conveying information. This, in turn, created new possibilities for customisation.

Late medieval readers understood that manuscript and print were *distinct* information technologies that worked differently. Manuscripts were unique, handmade objects that were always produced (at least initially) for a specific owner, who could play a significant role in shaping the size, appearance, quality, and content of the finished product. Manuscripts were also inherently malleable; it was always possible to annotate, rearrange, or remove a manuscript's texts, or add in entirely new ones. The miscellaneous, constantly in-progress nature of manuscript technology conditioned late medieval readers to be rarely satisfied with their books as they received them. Whether they received a manuscript directly from a scribe or secondhand, owners actively rethought, reshaped, and redefined the contents and physical forms of their books.[11]

Print technology, on the other hand, was mechanical and standardised. Its mode of production was considerably faster than manuscript, making works

9 Cf. Parkes M.B., *Scribes, Scripts, and Readers: Studies in the Communication, Presentation, and Dissemination of Medieval Texts* (London: 1991) 275–297; and Kwakkel Erik, "A New Type of Book for A New Type of Reader: The Emergence of Paper in Vernacular Book Production", *The Library*, 7th ser., 4 (2003) 219–248.

10 Curt Bühler referred to this phenomenon as 'the "every man his own scribe" movement.' *The Fifteenth-Century Book* 22.

11 Johnston Michael – Van Dussen Stephen, "Introduction," in Johnston Michael – Van Dussen Stephen (eds.), *The Medieval Manuscript Book: Cultural Approaches* (Cambridge: 2015) 5–10.

available in far greater quantities than before. To do that, however, printers (and occasionally authors) had to make the critical decisions about the physical characteristics of a given work, which led to editions that were more uniform in their text and physical appearance than manuscripts.[12] Except in rare cases, printers could not be certain exactly who would buy or use what they printed; success in the industry depended on producing material that met the specific needs of either well-established audiences (such as scholars) or that would appeal to as broad an audience as possible.[13]

Yet, at the same time, it is crucial to note that printed books were (again, with rare exceptions) naturally *incomplete* when they came off the press. Whatever the work, spaces were usually left for rubrics, illustrations, capitals, and other elements to be added by hand (i.e., by manuscript technology).[14] In other words, the distinctions between manuscript and print did not mean that the two communication technologies were incompatible for late medieval readers. In fact, hybrid volumes like Inc. 1699 clearly show the *complementary* relationship between the two. The respective technical qualities of each – one personal and specific, the other impersonal and general – created new possibilities for customisation, allowing late medieval readers and bookmakers to produce volumes that drew on the strengths of both. Inc. 1699, I suggest, was one of these.

4 The Content of Inc. 1699

Already in the fifteenth century, printers understood that the most profitable product was something that was already appealing to a broad audience, and few works fit that bill better than the host text in Inc. 1699.[15] Thomas of Kempen's *Imitatio Christi* was unquestionably one of the most popular works of spiritual instruction in the later Middle Ages, beloved by highly-trained intellectuals as well as ordinary laypeople.[16] Completed in the early fifteenth

12 On the persistent instability of printed works, see Johns Adrian, *The Nature of the Book: Print and Knowledge in the Making* (Chicago: 1998).

13 Pettegree Andrew, *The Book in the Renaissance* (New Haven: 2010) 65–90.

14 Schmitz, *Grundriss der Inkunablekunde* 19.

15 On the inherent conservatism of fifteenth-century printers, see Cuijpers Peter M.H., *Teksten als koopwaar: Vroege drukkers verkennen de markt* (Amsterdam: 1998).

16 For a general overview, see Bodemann Ulrike – Staubach Nikolaus (eds.), *Aus dem Winkel in die Welt: Die Bücher des Thomas von Kempen und ihre Schicksale* (Frankfurt am Main: 2006).

century, the *Imitatio* almost immediately became an incredible success, with over 700 manuscripts in several languages surviving from the fifteenth and early sixteenth centuries. Not surprisingly, the widespread fame of Thomas's masterwork made it a very appealing text for early printers, who went on to produce tens of thousands of copies in Latin and various vernaculars before the Reformation.[17]

The *Imitatio* was so successful because it dispensed simple and clear advice for achieving one of the central goals of late medieval devotion: overcoming the distractions of the secular world to pursue a virtuous, spiritual life that led to salvation.[18] As the owner of the *Nachuolgung* would have read, the work aimed to facilitate 'die verwandlung d(er) sitten unnd ein gancze ertoetung gepraestlicher naigung die machen einen waren geisliche(n) menschen' ('the conversion of one's life and a complete destruction of the desire for pleasurable things that make one a true Religious)'.[19] Through its four books, the *Imitatio* mapped out a practical approach to pursing the 'inner life' that could be followed (though not without difficulty) by anyone, even if they did not belong to vowed religious community.

In other words, one of the strengths of any version of the *Imitatio* was its generality. Any devout Christian – rich or poor, religious or lay, urban or rural, highly or modestly literate, etc. – could follow the 'inner life' it described. Yet, while the *Imitatio* provided a clear idea of what the virtuous life should look like, it was not entirely specific about how to achieve it. To give just one example, Thomas encouraged those pursuing the inner life to 'Pÿß nimmer müssig eintwed(er) schreib od(er) liß, bett betracht od(er) arbeit etw(a)z and(er)s für die gemei(n)dz nücz seÿ' (Never be idle; either write or read, pray or do some useful work for the benefit of others)'.[20] The lack of detail here is notable. Thomas says nothing here about *what* readers should read or write, *how* they should pray, on *what* they should meditate, or *what* kind of work they might do. Rather than get into specifics, Thomas chose instead to prioritise devotional flexibility:

17 Neddermeyer Uwe, "*Radix studii et speculum vitae*: Verbreitung und Rezeption der Imitatio Christi in Handschriften und Drucken bis zur Reformation", in Helmrath Johannes (ed.), *Studien zum 15. Jahrhundert: Festschrift für Erich Meuthen* (Munich: 1994) I: 457–481.

18 Late medieval devotion occupies a rich vein of scholarship, but an excellent overview that considers the Modern Devout perspective is Van Engen John, *Sisters and Brothers of the Common Life: The Devotio Moderna and the World of the Later Middle Ages* (Philadelphia: 2008).

19 Kempen, *Nachuolgung*, fol. XVIII v.

20 Kempen, *Nachuolgung*, fol. XXII r.

Auch gefallent maingerleÿ uebung dem menschen nach zÿmmlicheÿt der zeit als etliche ding schmecken einem an dem wercktag un(d) andere am feÿrtag. Andere ding bedürffen wir in d(er) zeite der anuechtungn, und andere zů der zeÿt d(er) rů vnd des frides vns gelustet andere dinge zů gedencken so wir bekoert werden, und andere so wir frölich seind in dem herrn.

Also different exercises strike us as appropriate at particular times: some are good for working days, others for festival days. Some exercises should be used at times of great trial, others at times of peace and tranquility. Still other exercises are useful when our thoughts make us sad, others when we are joyful in the Lord.[21]

In other words, Thomas's work supplied only a basic road map for following the inner life; it was left up to the individual reader to plot their own journey, using whatever specific practices or methods worked best for them. In this, the *Imitatio* in any language was perfectly suited for print technology. The inherent generality of the work made it appealing to a diverse range of audiences, so printers could feel confident that they would be able to sell whatever copies they produced. At the same time, the inherent incompleteness of printed works built off of the *Imitatio*'s invitation for readers to flesh out its general framework with their own experience. Anyone willing to accept that invitation would naturally turn to manuscript technology, just as, it seems, the owner of Inc. 1699 decided to do.

The manuscript in Inc. 1699 contains eleven distinct texts or groups of mostly devotional texts, the majority of which are, so far as I have been able to find, unedited. In order, they are a commentary on the *Salve Regina* attributed to Bernard of Clairvaux; a partial translation of the *De divinis moribus*, a short devotional treatise attributed to Thomas Aquinas; an anonymous meditation on the Five Wounds of Christ; an anonymous poem on dying well; versified quotations from theological authorities (Albert the Great, Augustine of Hippo, Bernard); a series of anonymous devotional poems; a taxonomy of different virtues, vices, and characteristics of human behavior; an anonymous work on the legend of Bernard of Clairvaux's eight psalm verses; and a series of eighteen short, vernacuclar poems, known as *Priameln*.

21 Kempen, *Nachuolgung*, fol. XXII v.

FIGURE 2.5 Two *Priameln*. Chicago, Newberry Library, Inc. 1699, fol. 227r

Most of the manuscript texts fit perfectly with the devotional program of the *Nachuolgung*; any one of them would be a good candidate for the 'different devotions' Thomas encouraged his readers to use. In that light, Inc. 1699 seems like a fairly routine, yet still illuminating, case of customisation, that is, a devout reader compiling a series of devotional texts to help follow the spiritual plan Thomas laid out.

However, I suggest that we can learn more about the first owner's customising mindset by looking carefully at the only texts that do not, at first glance, appear very devotional at all: the *Priameln*. Contrary to the interior-facing, spiritual focus of the other texts in the volume, most of these poems were deeply tied to the hustle and bustle of secular life. Very popular in the fifteenth century, *Priameln* were usually humorous and satirical takes on everyday life, focusing especially on the good and bad behavior of different trades and social classes, and the examples in Inc. 1699 follow this pattern.[22] To be sure, it is clear that the *Priameln* were not a haphazard or casual addition to Inc. 1699. They were copied from an exemplar by the same professional scribe responsible for the devotional texts, and feature the same sort of rubricated initials and red slashes at the beginning of lines as the other texts in the manuscript [Fig. 2.5].[23] Moreover, there are considerably fewer poems in Inc. 1699 compared to other surviving *Priamel* manuscripts from the fifteenth century, indicating that those in Inc. 1699 were selected specifically for the volume.[24] As such, understanding why these secular-oriented texts were included in an otherwise devotional book provides perhaps the clearest window onto the customising mindset of Inc. 1699's owner, allowing us to see how they deployed print and manuscript to accomplish the central goal of devotional life.

5 Pursuing the 'Inner Life' in an Urban Context

Making sense of the *Priameln* in Inc. 1699 begins with *where* the volume was produced and used. Although the book lacks any clear provenance information, evidence suggests the volume was most likely compiled in or near Augsburg. The *Nachuolgung* was obviously printed there, and the manuscript shows signs

22 Selmer – Goedsche, "The *Priamel* Manuscript" 64. On *Priameln* and their development, see Kiepe H., *Die Nürnberger Priameldichtung. Untersuchungen zu Hans Rosenplüt und zum Schreib- und Druckwesen im 15. Jahrhundert* (PhD dissertation, Ludwig-Maximilians-Universität, 1984).

23 Selmer – Goedsche, "The *Priamel* Manuscript" 67–68. The only exception is the material on fol. 229 r, which has no colouring of any kind, despite a space being left for a red initial.

24 Selmer – Goedsche, "The *Priamel* Manuscript" 68 n. 7.

CUSTOMIZING MINDSET: THE CASE OF NEWBERRY INC. 1699

of having been made in the vicinity of the Swabian capital, as well. The scribe wrote in a Swabian dialect (e.g., using 'kon' instead of 'kann', or 'liecht' instead of 'licht'), indicating that they had at least grown up in the region.[25] Augsburg also seems like a likely home for the owner of Inc. 1699; as a major urban trading center, Augsburg boasted a flourishing book culture that was sustained by a substantial population of literate readers with the necessary income to buy printed books and manuscripts.[26]

The likely urban setting for Inc. 1699 is crucial for understanding its content. Like all urban environments, Augsburg was a difficult place in which to pursue the inner life; the city housed a high concentration of innumerable distractions that could interrupt, delay, or completely derail one's devotional journey. For instance, unlike monks in a remote religious community, city-dwellers would, in the course of their day, inevitably interact with many people for business or social reasons. The *Priameln* in Inc. 1699 give a sense of this varied social landscape, mentioning government officials (judges, watchmen, tax collectors), various tradesmen (carpenters, butchers, tailors, millers, etc.), and ecclesiastical professionals (priests, sacristans, confessors).

There was nothing wrong, of course, with human interaction in the pursuit of the inner life, provided that this was done with other devout people.[27] One could not always be sure that was the case in a place like Augsburg. The poems give a sense of this by humorously and satirically commenting on how these urban professionals did their respective jobs. To give one example, *Priamel* 12 asserts that individuals in particularly messy professions (butchers, carpenters, charburners, wagoners, etc.) who fail to clean themselves up after work should be considered 'ain schande [...] [Der wirt gar selten] für ain wisen [in ain rat gewelt]' (a disgrace whose opinion is almost never worth anything).[28]

Although it was clearly meant to be a joke, the notion of commenting on the behavior of others did not fit with the program Thomas described in the *Nachuolgung*. On the contrary, he suggested *ignoring* other people as much as possible:

> Was geet dich das od(er) dyß an ... ob diser seÿ ein soellicher od(er) ein
> soellicher od(er) das der also würcket und redet. Du bedarffestt nichssen

25 Kauffmann Friedrich, *Geschichte der schwäbischen Mundart im Mittelalter und in der Neuzeit, mit Textproben und einer Geschichte der Schriftsprache in Schwaben* (Strasbourg: 1890).

26 See Neddemeyer, *Von der Handschrift*. For Augsburg specifically, see Künast, *Getruckt zu Augspurg*.

27 Van Engen, *Sisters and Brothers of the Common Life* 162–199.

28 Inc. 1699, fol. 229 r; Selmer – Goedsche 75.

antwurten für dÿe annderen. Aber für dÿch selber würßt und műßt du geben antwurt und rechnung.

What does it matter to you whether a person is good or evil, or even what they say or do? You will not be required to answer for others, but you must answer and give account for only yourself.[29]

Focusing on oneself was much more easily done within a religious community, but what of the devout individuals who still lived in the world? What chance did they have to pursue the inner life with all the distractions around them? This issue is not addressed in great detail in the *Nachuolgung*, but the *Priameln* speak to it directly. Amid the wit and sarcasm, the poems express a desire for an urban environment centered on the pursuit of the inner life while actively participating in secular life. A clear example is *Priamel* 6, which insists that a judge looking to do his job well must incorporate devotional acts like following the Ten Commandments and undertaking arduous pilgrimages.[30]

That spiritual orientation comes out strongest in the final two poems, which scholars have, evidently, not considered proper *Priameln*, as they have not been included in any edited collection of which I am aware.[31] They are, to be sure, much more explicitly devotional than the other poems, and less concerned with the secular world. Indeed, the final poem in the manuscript could almost be considered a brief synopsis of the entire *Nachuolgung Cristi*:

Hab gott liebe vo(n) dine(n) hertze(n) gentzlich / Vnd vo(n) diner gantzer diner sele susigklich / Vnd allen dinen krafften vestenklich / Diene im mit fliß getrülich / Des gottes wartt hoerne volgigklich / Verschmeche die welt gentzlich / Sprich dein gebett andaechtiglich / Schütt dein wort flissiklich / Leyd ungumach Dultiklich / Verzere dein zitt nützlich / Vor müssikait hütt dich staettiklich / Mit boessen gedencke(n) verwür dich nit williglich / Deins libß notturf enpfauch messiglich / Deins libß gemach sůch nit uberflüssiglich / Biß niema(n)t nit haimlich unnützlich / Biß schaemig offenbar und heÿmlich / Halt deine glider züchtiklich / Mit deine(n) neste(n) lob fridlich / Mit dine(n) underthon güttlich / Mit dine(n) obresten gehorsamklich.'

29 Kempen, *Nachuolgung*, fol. xcvi r.
30 Inc. 1699, fol. 227 v.
31 Selmer and Goedsche left them out of their edition of the *Priameln*, with no explanation.

CUSTOMIZING MINDSET: THE CASE OF NEWBERRY INC. 1699 57

> Keep the love of God in your heart completely / and in the depths of
> your soul sweetly / and with all of your might resolutely / serve Him with
> full effort truly. / Proclaim the Word of God loudly / Languish through
> this world fully / Say your prayers piously / Mind your own words assid-
> uously / Suffer hardship patiently / Use your time productively / From
> idleness defend yourself warily / Entangle yourself in wicked thoughts
> unwillingly / Ask for what your body needs moderately / Seek your own
> health not overzealously / Be of help for anyone presently / Be humble
> and reserved publicly / With your friends behave modestly / To your fam-
> ily give praise joyfully / With your servants behave respectfully / With
> your superiors behave obediently.[32]

Far from commenting on the foibles of secular professions, this poem reminds
the reader to maintain the proper attitude towards the secular world, that is, as
something to 'languish through' (*Verschmeche*) rather than enjoy. At the same
time, it also acknowledges the reader's place within a complex secular society;
it encourages them to show their humility publicly and treat those below and
above them in the social hierarchy with modesty, respect, and obedience.[33]

 This sense becomes even clearer in light of the penultimate poem in the
manuscript, which places the satirical and moral work of the *Priameln* into the
context of the pursuit of the inner life:

> Ach wierser ist zů fürchtend der man / Der falsch ist und wol reden kan /
> Sein zung und sein falster můt / Oft schaden und groß übel tůtt / An man-
> ichem schlechten biderman / Der nitht gedenckt der list die er k[on]. Vor
> zitten güngend die frum(m)en herz[en] / Dic schelitz můstend hinder
> die thü[ren] / So stand es in allen landen woll / Nyemant sich bößhait
> troesten sol / Eß würt noch komen die zitt / Das frümkait gewinnet de(n)
> stritt / So würt es in der welt under gůtt / Das bedenckt ier frum(m)en
> un(d) habet gůtte(n) můtt.

> Ah, truly to feared is the man / Who is false yet can speak well. / His
> tongue and his lying mouth / Often do great harm and evil / On certain
> unfortunate goodmen / Who without thinking let him do what he can. /
> Long ago the pious hearts went / And had to shut themselves off behind
> closed doors / So is the case in every land there is / No one should trust

32 Inc. 1699, fol. 230 v.

33 For example, multiple poems praise a judge who treats poor and rich exactly the same.
 Inc. 1699, fols. 227 r–227 v.

the wicked / The time will surely come / That piety will win the day / So shall it be in the world under God / Think on that, ye devout, and take heart.[34]

This poem is blunt about the fallenness of the secular world, and we can imagine the reader thinking back on the miscreants described in the preceding *Priameln* as they considered who the 'wicked' might be. Importantly, though, this poem is quite specific about the type of evildoer most responsible for the struggles of 'the pious hearts': a false man who speaks well, using that skill to bring 'shame and evil' to good people who fail to see past their deceptions. This is such a problem, the poem insists, that the best course was to shut oneself off from the world entirely, as religious people had done for centuries.

The critical point here, however, is that this was what pious individuals did *in the past*. By including that point, *Priamel* 19's message for its contemporary readers seems to be that shutting oneself away from the secular world was impossible, especially in an urban setting like Augsburg, where one could not completely avoid these deceptive troublemakers. Crucially, though the poem explicitly encourages devout people to patiently wait for the time when 'piety will win the day,' it also subtly criticises the 'goodmen' whose ignorance, naïveté, or overly-trusting nature allows the 'false man' to do them harm.

This notion casts the more secularly-oriented *Priameln* that came before in a different light. Framed in this way, between the explicitly devotional manuscript material and these final poems, the *Priameln* offer something more spiritually useful than just humorous observations on city life: taken together, they help the reader identify the dangerous 'false men' by breaking down the urban environment into categories of professions and individual behaviors that a 'goodman' should avoid. That sentiment is reinforced by *Priamel* 10, which describes a person who values (*würt*) various sorts of deceitful and terrible people, from a nefarious tax collector to a priest willing to excommunicate someone to escape a debt. The focus of the poem's ire, however, is not so much on the rogues' gallery it describes, as it is on the person who considers them worthy of respect, support, or patronage: 'Wer dem dar zů boesse iar gan / Der thett gar nachent ain thaeglich sind dar an (For him there will be evil days all year long, because he acts like a fool every day)'.[35] What is condemned here, in other words, is not the failure to avoid these deceitful characters, but the failure to see what they really are.

Thus, the role of the *Priameln* in the devotional program of Inc. 1699 comes into clearer focus: their purpose is to help the user effectively *read* the urban

34 Inc. 1699, fols. 230 r–230 v.

35 Inc. 1699, fol. 228 v.

CUSTOMIZING MINDSET: THE CASE OF NEWBERRY INC. 1699 59

environment around them in order to maintain the spiritual focus necessary to pursue the inner life. The poems lay out the landscape of different individuals and professions that a late medieval city-dweller would likely encounter in the course of their daily life, and the visible behaviors that determined whether they should be welcomed or avoided. This was a volume made by a person who could not, for whatever reason, separate themselves from the secular life as much as the *Nachuolgung* recommended, but still wanted to apply the spiritual lessons in Thomas's text to their own life.

By combining these poems with the other devotional material in the manuscript and the collected advice in the *Nachuolgung* itself, Inc. 1699's owner thus created a complete devotional guide for successfully pursuing the inner life in a bustling urban center. The categorizing specificity of the poems supplied key information about warily navigating the secular world that was deliberately left out of Thomas's work. By doing so, the owner transformed satirical, secular poetry into 'useful devotions' that were essential for reaching their spiritual goals.

To customise a volume like Inc. 1699, the owner required manuscript *and* print technology. The *Nachuolgung*, like most all early printed texts, is a highly general work, designed to be appealing to a broad and largely undefined audience. The manuscript, on the other hand, is highly specific, reflecting the wants and needs of the book's owner. By putting the two of them together in the same volume, the owner used the manuscript texts (especially the *Priameln*) to *complete* the necessarily *incomplete* edition of Thomas of Kempen's work that came off Anton Sorg's presses.

6 The Customisation of Inc. 1699

To better understand the customising mindset behind this volume, it may be useful to attempt to retrace, conjecturally yet as plausibly as we can, how this process may have unfolded. The process mostly likely began when the owner heard the news about Anton Sorg's intention to print *Ein ware Nachuolgung Cristi* in early 1486. Word of the edition spread quickly throughout the city's reading community through multiple channels, including, perhaps, the thriving community of Modern Devout in and around the city,[36] the monastery who supplied the manuscript exemplar used for printing,[37] and Sorg himself,

36 On the formative role the Modern Devout played in the growth of book culture, see Kock T., *Die Buchkultur der Devotio moderna: Handschriftenproduktion, Literaturversorgung und Bibliotheksaufbau im Zeitalter des Medienwechsels* (Frankfurt: 1999).

37 Neddemeyer, *Von der Handschrift* 353.

priming the market for his product.[38] The news was particularly exciting for the owner, who yearned to seek the inner life, but did not have the wherewithal to join a religious community or the education to read the Latin edition of the *Imitatio* Günther Zainer had printed nearly fifteen years earlier.[39]

Even though Sorg's edition was months away, however, the owner already knew that the printed text would not be entirely complete. Based on their previous experience with both the content of Thomas's text and the many vernacular books printed in Augsburg, they knew quite well that the printed *Nachuolgung* would only be a generalised framework for following the inner life. More specific, personalised content would be needed to fill it out, which could only be done with a manuscript. With that in mind, the owner paid a visit to their local scribe, who commonly copied vernacular manuscripts for lay clients in between commissions for the city's government and religious institutions.[40] The owner commissioned the scribe to create a modest copy of several 'useful devotions' that would augment the *Nachuolgung*, asking the scribe to include some important devotional texts of his choice along with some specific requests. The latter included texts they had learned about through conversations with neighbors, followers of the Modern Devout, and their parish priest over the years.[41] Knowing full well the challenges of pursuing the inner life in a place like Augsburg, the owner especially requested that the scribe copy some of their favorite *Priameln*, which spoke most clearly to their life in the city.

It took some time for the scribe to produce the manuscript, as they usually waited until the end of the workday to copy it, but it was ready by the time Sorg's edition came off the presses in November. The owner was so excited to purchase a copy from the local bookseller that they forgot to check for all the leaves, not realizing that one was missing. Undeterred, the owner quickly took both the printed book and the devotional manuscript to a bookbinder recommended by the scribe. The binder carefully sewed the two paper texts together, making sure that the *Nachuolgung* appeared first, and (since the owner had

38 Pettegree, *The Book in the Renaissance* 75–78.

39 On this Latin edition, see Cheng Jane, *Imitation as Innovation: The* Imitatio Christi, *1450–1550* (Cambridge, MA: 2009) 22–31.

40 On the decentralised nature of vernacular manuscript production, see Doyle A.I. – Parkes M.B., "The Production of Copies of the Canterbury Tales and the *Confessio Amantis* in the Early Fifteenth Century", in Parkes M.B. – Watson A.G. (eds.), *Medieval Scribes, Manuscripts, and Libraries: Essays Presented to N.R. Ker* (London: 1978) 163–210.

41 On the production of manuscript miscellanies, see Boffey J. – Thompson J.J., "Anthologies and Miscellanies: Production and Choice of Texts", in Griffiths Jeremy – Pearsall Derek (eds.), *Book Production and Publishing in Britain, 1375–1475* (Cambridge: 1989) 403–432.

spent most of their budget on acquiring the two texts), attached a piece of parchment waste (which would need to be replaced eventually) lying around the shop as the cover. The owner returned home with their personalised devotional guide, which they took out to read whenever they could, usually at the end of the day, while they were working or by candlelight before turning in at night.

We cannot, of course, know for certain exactly how Inc. 1699 came to be, but the above sketch seems plausible enough. What we do know is that a modestly educated layperson in Augsburg would surely have had the motive, means, and opportunity to use late medieval information culture in this way. We also know that hybrid volumes like Inc. 1699 are the physical record of that customising process.

7 Implications of the Late Medieval Customising Mindset

Inc. 1699 stands as a clear witness to the customising mindset in the late fifteenth century, and the ways in which it promoted engagement with late medieval information culture. As we have seen, the volume's owner skillfully drew on a number of cultural influences – their interest in late medieval devotion, their experience living in an urban environment, and their knowledge of the complementary qualities of print and manuscript technology – to create the sort of volume that best suited their needs. Readers and bookmakers rarely, if ever, commented on this process openly; they simply took for granted that customisation was the best way to participate in the information culture of their day.

The stories of customisation preserved in Inc. 1699 and other hybrid books have much to tell us not only about the reading culture that produced them, but also about how we might manage the hyper-technological information culture we know today. In particular, tracing out the customising process behind Inc. 1699 has allowed us to isolate certain best practices of late medieval information culture that can be adapted to our current moment.

First, the example of Inc. 1699 shows us that fifteenth-century information consumers were technologically literate. As we have seen, they understood that print and manuscript were two different forms of technology, each with its own advantages and disadvantages. Second, this high degree of literacy made late medieval information consumers confident manipulators of information technology. Whether they were an elite, professional intellectual or an ordinary layperson, information consumers freely deployed multiple technologies at once, using one to make up for the shortcomings of the other, in order to

produce outcomes (in this case, hybrid volumes) that enhanced the value of both. Finally, based on this, late medieval readers were highly goal-oriented. That is, they embraced the individualised and miscellaneous character at the heart of medieval manuscript culture not necessarily to push boundaries, but precisely because they intended to produce innovative, multimedia volumes that worked for them. That practice, in turn, influenced the work of printers and professional scribes, who were compelled to respond to the wants and needs of their consumers as they further refined and developed their respective technologies.

These practices, of course, cannot map neatly onto the situation in the twenty-first century, but they do offer a framework for how we might start to prepare ourselves and others to be responsible and effective participants in contemporary information culture. In particular, we might characterise that preparation as training people how to develop a customising mindset. Just as that mindset encouraged late medieval readers to understand the intricacies of communication technology and proactively manipulate them for their own purposes, so too can it help teach how to manage the overwhelming volume, speed, and scope of information culture today.

Perhaps most importantly, the late medieval customising mindset empowers individuals, institutions, and communities to be *proactive* users of information culture. The example of Inc. 1699 shows how information consumers forced technology developers to respond to them, rather than passively waiting to receive whatever technology developers decided they needed. While we cannot know exactly how late medieval readers acquired the sort of expertise that led to volumes like Inc. 1699, we can use their witness to reverse-engineer best practices that can become part of a formal, institutionalised training (one that includes analog technologies like manuscript) to be a responsible participant in information culture. The goal of this training would be to develop a customising mindset that is informed by the past in order to meet the challenges and needs of the present.

That mindset is not as remote as one might think. Customisation is clearly visible in the age of the *incunabula*, but it remained a central part of information culture for centuries to come. As the other essays in this volume attest, information consumers skillfully and eagerly deployed all the technology available to them to create new and re-create older forms of books and other media to respond to the demands of their day. The long record of human experience recorded in customised volumes like Inc. 1699 and its successors, if nothing else, can still be used to set us on a firmer ground as we look to an uncertain technological future.

Bibliography

Bodemann Ulrike – Staubach Nikolaus (eds.), *Aus dem Winkel in die Welt: Die Bücher des Thomas von Kempen und ihre Schicksale* (Frankfurt am Main: 2006).

Boffey J. – Thompson J.J., "Anthologies and Miscellanies: Production and Choice of Texts", in Griffiths Jeremy – Pearsall Derek (eds.), *Book Production and Publishing in Britain, 1375–1475* (Cambridge: 1989) 403–432.

Bühler Curt, *The Fifteenth-Century Book: The Scribes, the Printers, the Decorators* (Philadelphia: 1960).

Clemens Raymond – Graham Timothy, *Introduction to Manuscript Studies* (Ithaca: 2007)

Collins Victor, *Attempt at a Catalog of the Library of the Late Prince Louis-Lucian Bonaparte*. 4 vols. (London: 1894).

Cuijpers Peter M.H., *Teksten als koopwaar: Vroege drukkers verkennen de markt* (Amsterdam: 1998).

Dane Joseph, *What is a Book? The Study of Early Printed Books* (Notre Dame: 2012).

Doyle A.I. – Parkes M.B., "The Production of Copies of the Canterbury Tales and the *Confessio Amantis* in the Early Fifteenth Century", in Parkes M.B. – Watson A.G. (eds.), *Medieval Scribes, Manuscripts, and Libraries: Essays Presented to N.R. Ker* (London: 1978) 163–210.

Johnston Michael – Van Dussen Stephen (eds.), *The Medieval Manuscript Book: Cultural Approaches* (Cambridge: 2015).

Kauffmann Friedrich, *Geschichte der schwäbischen Mundart im Mittelalter und in der Neuzeit, mit Textproben und einer Geschichte der Schriftsprache in Schwaben* (Strasbourg: 1890).

Kiepe H., *Die Nürnberger Priameldichtung. Untersuchungen zu Hans Rosenplüt und zum Schreib- und Druckwesen im 15. Jahrhundert* (PhD dissertation, Ludwig-Maximilians-Universität, 1984).

Kock T., *Die Buchkultur der Devotio moderna: Handschriftenproduktion, Literaturversorgung und Bibliotheksaufbau im Zeitalter des Medienwechsels* (Frankfurt: 1999).

Künast Hans-Jörg, *'Getruckt zu Augspurg': Buchdruck und Buchhandel in Augsburg zwischen 1468 und 1555* (Tübingen: 1997).

Kwakkel Erik, "A New Type of Book for A New Type of Reader: The Emergence of Paper in Vernacular Book Production", *The Library*, 7th ser., 4 (2003) 219–248.

McKitterick David, *Print, Manuscript and the Search for Order, 1450–1830* (Cambridge: 2003).

Neddemeyer Uwe, "*Radix studii et speculum vitae:* Verbreitung und Rezeption der Imitatio Christi in Handschriften und Drucken bis zur Reformation", in Helmrath Johannes (ed.), *Studien zum 15. Jahrhundert: Festschrift für Erich Meuthen* (Munich: 1994) I: 457–481.

Neddemeyer Uwe, *Von der Handschrift zum gedruckten Buch: Schriftlichkeit und Lese-interesse im Mittelalter und in der frühen Neuzeit: quantitative und qualitative Aspekte* (Wiesbaden: 1998).

Parkes M.B., *Scribes, Scripts, and Readers: Studies in the Communication, Presentation, and Dissemination of Medieval Texts* (London: 1991).

Pettegree Andrew, *The Book in the Renaissance* (New Haven: 2010).

Schmitz Wolfgang, *Grundriss der Inkunabelkunde: Das gedruckte Buch im Zeitalter des Medienwechsels* (Stuttgart: 2018).

Selmer Carl – Goedsche C.R., "The *Priamel* Manuscript of the Newberry Library, Chicago", *PMLA* 53.1 (1938) 64–77.

Van Engen John, *Sisters and Brothers of the Common Life: The Devotio Moderna and the World of the Later Middle Ages* (Philadelphia: 2008).

PART 2

Customisation across Media

∵

CHAPTER 3

A Late Medieval Multi-Text Manuscript and Its Printed Precedents

Britt Boler Hunter

The Wellcome Library MS 49, known as the *Wellcome Apocalypse*, is a multi-text manuscript produced in southern Germany circa 1470 and named for the Apocalypse in picture-book style on the first twenty-eight folios.[1] The manuscript is an elaborate and complexly illustrated compendium comprising almost 300 individual images and 100 textual sources across only sixty-nine folios.[2] Although the complexity of the manuscript's *compilatio*, or strategic arrangement of compiled material, is too elaborate to describe here, it is important to understand that the *Wellcome Apocalypse* has perceived thematic groupings that form three general sections – eschatology, medicine/science, and moralisations – which are all linked through the visual consistency and apparent didactic function of the manuscript.[3] The first section is made up of three quires consisting of popular religious texts, images, verses, and symbols all dealing with eschatological themes. These themes cover a broad range, from the universal eschatology of the end of the world according to the *Book of Revelation* to a personal, individual eschatology based on contemplation of one's own end and deathbed, as exemplified in the *Ars moriendi*.[4] This section

1 London, Wellcome Library MS 49. See Emmerson R.K. and Lewis S., "Census and Bibliography of Medieval Manuscripts Containing Apocalypse Illustrations, ca. 800–1500" *Traditio* 42 (1986) 448; and Seebohm A., *Apokalypse, ars moriendi, medizinische Traktate, Tugend- und Lasterlehren: die erbaulich-didaktische Sammelhandschrift London, Wellcome Institute for the History of Medicine, Ms. 49* (Munich: 1995). While earlier scholarship dates the *Wellcome Apocalypse* to 1420, the formal evidence presented in this essay clearly supports redating the *Wellcome Apocalypse* with a terminus post quem of circa 1470 to coincide with the general period of production for the blockbooks discussed here.

2 Seebohm, *Apokalypse, ars moriendi, medizinische Traktate, Tugend- und Lasterlehren* 7.

3 These three groupings are explored in my dissertation, *The Wellcome Apocalypse: Innovating Pictorial Traditions in the Ordinatio of a Late Medieval Multi-Text Manuscript* (Ph.D. dissertation, Florida State University: 2022).

4 For universal and individual eschatologies see Emmerson R.K., "Imagining and Imaging the End: Universal and Individual Eschatology in Two Carthusian Illustrated Manuscripts [1999]", in Donoghue D. – Simpson J. – Watson N. (eds.), *The Morton W. Bloomfield Lectures 1989–2005* (Kalamazoo: 2010) 165–166.

© KONINKLIJKE BRILL NV, LEIDEN, 2024 | DOI:10.1163/9789004680562_004

contains the three iconographic cycles that are the focus of this essay, through which I will demonstrate that the manuscript's creator used contemporary popular media of the late fifteenth century as an available source of model imagery that readily lent itself to customisation. The specific popular media consist of the xylographic printed blockbooks of the Apocalypse, *Ars moriendi* and Life of Antichrist, which were marketed to the general reading public.[5]

Amid this dynamic period of robust image-making, the blockbooks stand out as works that combined recognisable imagery with accessible religious themes to create a wide readership. Despite the challenges of precise dating and locating the place of production, their circulation was clearly high enough to account for the numerous surviving copies. One reason for the popularity of the blockbooks is their subject matter, which often focuses on practical piety and moral teaching.[6] The *Biblia pauperum*, for example, was based on the popular medieval book type characterised by a didactic *ordinatio* comparing parallel themes across the Old and New Testaments. This sort of typological comparison that relies fundamentally on visualisation of two narratives supplemented by minimal text appealed to lay readers who sought Christian moralisation. By the time the *Biblia pauperum* was translated into a blockbook format, the visual conventions for typology had been firmly established; the new printed edition was likely intended to help parish priests compose sermons – although it was certainly popular with lay readers as well.[7] In fact, the short and simple inscriptions and captions have been cited as evidence of an increasing literacy, particularly among the lower and middle classes.[8] The transition of manuscript to print did not just go in one direction, however. Printed books were themselves new sources and inspirations for increased manuscript activity.

The phenomenon of printed images being reproduced as hand-drawn images is important for the study of late medieval books. Manuscript illustrators are known to have copied printed images in Breydenbach's *Peregrinationes in terram sanctam* and Werner Rolevinck's *Fasciculus temporum*, among other

5 Febvre L. – Martin H., "The Technical Problems and Their Solution", in *The Coming of the Book: The Impact of Printing 1450–1800* (London: 1979) 47. For the purpose of this essay I have cited readily available blockbook images from German editions, but I do not suggest that these specific copies were the models used by the manuscript's creator.

6 Hindman S. – Farquhar J.D., *Pen to Press: Illustrated Manuscripts and Printed Books in the First Century of Printing* (College Park: 1977) 109–110.

7 Stevenson A., "The Problem with Blockbooks", in Sabine Mertens (ed.) *Blockbücher des Mittelalter: Bilderfolgen als Lektüre* (Mainz: 1991) 246.

8 Nellhaus T., "Momentos of Things to Come: Orality, Literacy, and Typology in the *Biblia Pauperum*", in Hindman S. (ed.), *Printing the Written Word: The Social History of Books, c. 1450–1520* (Ithaca: 1991) 317.

examples.[9] Indeed, the preference for manuscript books in England was so strong that at least one hundred manuscript copies of William Caxton's printed books have been identified.[10] Evidence of Cistercian nuns in Frankfurt and Nonnberg using single-sheet prints as exemplars for their illustrated manuscripts has been discovered by Jeffrey Hamburger.[11] Even artistic media beyond books were affected by the iconographic and compositional models provided by fifteenth-century prints. Seven of the eight panels comprised by the altarpiece from the Swabian Abbey of Heggbach were copied after pictorial inventions by Martin Schongauer, as well as Rogier van der Weyden and Dirc Bouts.[12] These are just some of numerous examples of the rich interconnectedness of print and manuscript in late medieval Europe.

This essay focuses on just one manuscript which demonstrates the crucial role of printed images during this time. The aim here is to demonstrate that the creator of the *Wellcome Apocalypse* used no fewer than three printed sources, and by extension bring attention to the complex process of book production climate in the late Middle Ages, when manuscript, xylographic, and typographic books overlapped for many years. The 1470s, in particular, saw the convergence of several striking shifts: the decline of manuscript production, the increase in typographic production, and the increase in the use of woodcut images to illustrate typographic books.[13] Although such data would suggest an overall decline in older methods of book production, it must be remembered that manuscripts allowed for the highest degree of customisation; so, it is possible that the decline in manuscript production in the 1470s overall was a result of a shift in priorities that reserved manuscript media for the most customizable book commissions.[14] Moreover, recent trends in scholarship have convincingly argued against the interpretation of printing technologies as revolutionary, stressing instead that mechanical methods replaced manual methods rather slowly.[15] Suffice it to say that in such an image and information

9 Nellhaus "Momentos of Things to Come" 102.

10 Bühler C., *The Fifteenth Century Book: The Scribes, the Printers, The Decorators* (Philadelphia: 1960) 12.

11 Hamburger J., "'In gebeden und in bilden geschriben': Prints as Exemplars of Piety and the Culture of the Copy in Fifteenth-Century Germany", in Parshall P.W. (ed.), *The Woodcut in Fifteenth-Century Europe* (Washington D.C.: 2009) 162–163.

12 Hamburger, "'In gebeden und in bilden geschriben'" 156.

13 Needham P., "Prints in the Early Printing Shop", in Parshall P.W. (ed.), *The Woodcut in Fifteenth-Century Europe* (Washington D.C.: 2009) 42.

14 See the essay by Stephanie Leitch in this volume for another highly idiosyncratic manuscript produced during the incunabular age of print.

15 Schmidt P., "The Multiple Image: The Beginnings of Printmaking, between Old Theories and New Approaches", in Parshall P.W. – Schoch R. (eds.), *Origins of European Printmaking:*

rich environment, the *Wellcome Apocalypse*'s creator benefited from the availability of more book formats, as he made use of three of the most easily accessible image cycles, adapting them to inform the manuscript's reader-viewers of the most current knowledge about death and the end times. Although the manuscript itself seems to have been produced for a learned cleric, the inclusion of popular content, I contend, was a didactic choice for the purposes of educating students. To do so, the creator took advantage of a period of shifting communication patterns emphasizing shared visual literacy and profound access to images.

1 Apocalypse

The blockbook Apocalypse derived from a well established category of manuscripts called picture-book Apocalypses that originally date to mid-thirteenth century England, but were replicated prolifically in manuscript workshops throughout Europe in the subsequent centuries.[16] Because of its standardised image cycle, double half-page miniatures, and minimal use of inscriptions, the picture-book was a logical model for woodcut reproduction in what would become one of the most popular blockbook cycles of the late fifteenth century, resulting in six different print editions.[17] This clearly indicates that the popularity of the illustrated Apocalypses remained high enough by the late fifteenth century to warrant their mass production through printing methods. In fact, there are a total of sixty-one extant blockbook Apocalypses, which almost rivals the total number of extant Anglo-French Apocalypse manuscripts at seventy-nine.[18] The key difference is that the woodcut medium seems more targeted at a merchant or middle-class audience of new lay readers than to

 Fifteenth-Century Woodcuts and Their Public (Washington D.C.: 2005) 39. Whereas early scholarship suggested that xylographic printing logically developed into typographic printing, Needham has convincingly shown that the craft of woodcutting remained quite separate from early typographers who belonged to metal-working fields.

16 For picture-book apocalypses see Emmerson R.K., *Apocalypse Illuminated: The Visual Exegesis of Revelation in Medieval Illustrated Manuscripts* (University Park: 2018) 83–160.

17 Schreiber W.L., *Manuel de l'amateur de la gravure sur bois et sur métal au XVe siècle, 4, Un catalogue des livres xylographiques et xylo-chirographiques indiquant les différences de toutes les éditiones existantes* (Leipzig: 1902) 160–162.

18 Purpus E., "Die Blockbücher der Apokalypse", in Mertens S. (ed.), *Blockbücher des Mittelalters: Bilderfolgen als Lektüre* (Mainz: 1991) 81. Purpus notes that not all of the sixty-one extant blockbooks are complete, but even fragments obviously must derive from complete books, as I am not aware of picture-book iconography being used for single sheet prints.

A LATE MEDIEVAL MULTI-TEXT MANUSCRIPT & ITS PRINTED PRECEDENTS 71

the original aristocrats of the mid-thirteenth century.[19] Early scholarship on the *Wellcome Apocalypse* by Gertrude Bing connected the manuscript with the blockbooks as an intermediary between the earlier picture-books and the later prints.[20] Her suggestion correctly situates the *Wellcome Apocalypse* within the picture-book mileu, but it falls victim to the assumption that book production proceeded along an evolutionary track whereby manuscripts unidirectionally influence print.[21] Part of the confusion surrounding which came first has to do with the unique customisation visible in the *Wellcome Apocalypse*: the textual passages were expanded to the point of obscuring the double half-page miniature layout. Close scrutiny of the iconography, however, shows that the blockbooks must have come first. Thus we see a cycle in which the picture-book iconography that originated in manuscript form in the mid-thirteenth century, was later transmitted through blockbooks in the mid-fifteenth century, and then appeared in manuscript again as early as circa 1470.

The *Wellcome Apocalypse* is certainly not the first example of a manuscript following a printed model. A compelling example of such transmission is cited in an analysis of another later German picture-book Apocalypse now in the British Library.[22] Kathryn Henkel's argument regarding this manuscript is contingent on the size and inscription of select placards. Take, for example, the scene of John's last vision of Christ (*Rev.* 22:12–13) on the top of folio 23v in the British Library manuscript with the equivalent scene on the top of folio 46v of the sixth-edition blockbook now in Cambridge, Trinity College Library [Figs. 3.1–3.2].[23] The compositions are identical: on the left John, his hands raised in prayer, kneels before the blessing figure of Christ. Taking up the remaining two-thirds of the respective images are massive placards containing Christ's pronouncements. Interestingly, the size of the inscription does not condition the size of the placard, even when the copied text is dramatically truncated.[24] The allocation of so much space for so little text, therefore, suggests that the manuscript's creator used the printed image as a source model.[25]

19 Febvre – Martin, "The Technical Problems and Their Solution" 47.

20 Bing G., "Apocalypse Block-Books and Their Manuscript Models", *Journal of the Warburg and Courtauld Institute* 5 (1942) 144.

21 Ibid., 157. Bing claimed that the simpler *mise-en-page* of the blockbooks was an artistic rejection of the crowded text and image formation of the Wellcome Apocalypse. It should be stressed that, writing under the constraints of World War II, Bing had limited access to comparanda in European and American libraries.

22 London, British Library, Add. 19896. Emmerson – Lewis, "Census" 127, 448.

23 Cambridge, Trinity Library Inc.3[4245].

24 Hunter B.B., "Fifteenth-Century Picture-Book Apocalypses", *The Illustrated Life of Saint John and Picture-Book Apocalypse*, (Barcelona: 2020), vol. 2, 103–104.

25 Henkel K. – Denny D. (eds.), *The Apocalypse*, exh. cat., University of Maryland Art Gallery (College Park: 1973) 34–35.

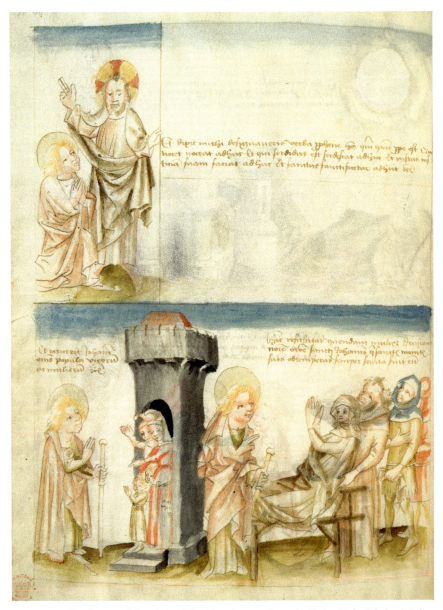

FIGURE 3.1 Final scene of *Revelation* (above) and scenes from the "Life of John" (below). Ink and color wash on parchment, 324 × 238 mm, ca. 1470. London, British Library, Additional Manuscript 19896, picture-book Apocalypse, fol. 23v
PUBLIC DOMAIN

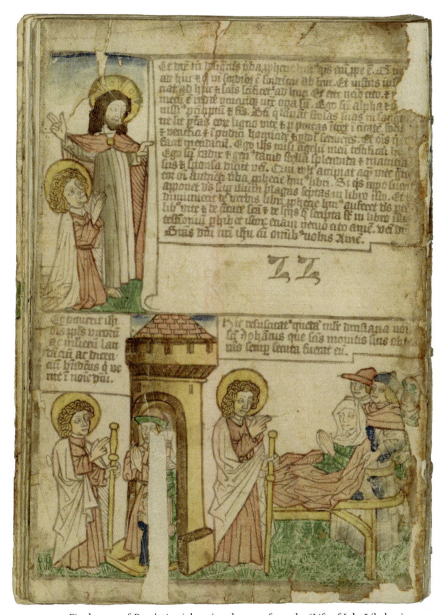

FIGURE 3.2 Final scene of *Revelation* (above) and scenes from the "Life of John" (below). Handcolored woodcut print, 275 × 190 mm, ca. 1470. Cambridge, Trinity College Library, Inc.3[4245], *Apocalypsis Sancti Johannis cum figuris*, fol. 46v

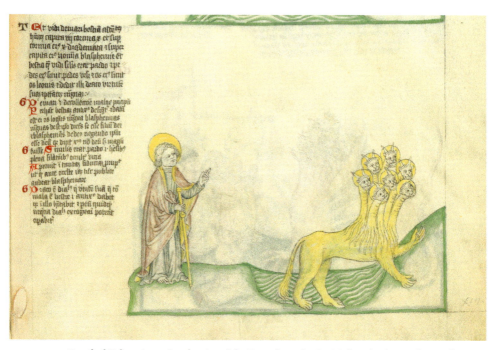

FIGURE 3.3 Detail of "John witnessing the rise of the Beast from the Sea". Ink and color wash on vellum, 40 × 30 cm, ca. 1470. London, Wellcome Library MS 49, *Wellcome Apocalypse*, lower miniature of fol. 15r
PUBLIC DOMAIN

A comparable instance of blank space in the *Wellcome Apocalypse* occurs in the lower register of folio 15r where John beholds the seven-headed Beast from the Sea as it steps out onto a steep bank (*Rev.* 13:1–2) [Fig. 3.3]. John raises his index finger to point not at the Beast but at the void before him. Within the lightly framed miniature, John directs our attention toward this empty space; it is further highlighted by the chunky block of text that fills the left side of the page, its black and red ink juxtaposed to the translucent brightness of the miniature's negative space. The woodcut version of this image demonstrates that the biblical text and coordinating commentary were once inscribed on the placard and banderole in the middle of the miniature, but the designer of the *Wellcome Apocalypse* reorganised this text into a neat column in the margin and left the center of the miniature empty.[26] Most importantly, John points only in the

26 A ca. 1470 blockbook now in Cambridge is fully digized online and presents an excellent example of the type of printed model the *Wellcome Apocalypse* designer would have most likely based his composition on. See Cambridge, Trinity Library Inc.3[4245].

printed image. Earlier picture-book manuscripts, like the one Bing used as her primary Apocalypse manuscript (Oxford, Bodleian Library, Auct. D.4.17), show John leaning on his staff instead of pointing at the biblical inscription in the center of the miniature. It stands to reason then that among the models used for the *Wellcome Apocalypse*, at least one was a blockbook Apocalypse.

In addition to the transmission of iconography from print to manuscript, a liberal customisation of the Apocalypse's commentary in the *Wellcome Apocalypse* combine to amplify the book's idiosyncratic appearance. The manuscript's compiler seems to demonstrate an encyclopedic impulse by expanding quotations of biblical verses with large blocks of annotations derived from two different commentaries: the Berengaudus commentary, which had typically accompanied picture-book style Apocalypses since the mid-thirteenth century, and the *Glossa ordinaria*, the standard biblical commentary of the Middle Ages that was not typically used in illustrated Apocalypse inscription.[27] This emphasis in the *Wellcome Apocalypse* on more complete biblical and exegetical references often manifests in full marginal text columns or even more invasive passages that distort the equal ratio of double-half page miniatures. In fact, the manuscript's designer frequently manipulates textual passages throughout all sections of the book, not just the Apocalypse. The adding or subtracting of passages, and their expansion or truncation, occurs most commonly in the compilatory final section of the manuscript, which consists of sermon exempla.[28] This textual manipulation parallels the expanded commentary in the Apocalypse, which together convey how the *Wellcome Apocaplypse* resulted from a truly bespoke process of compilation. The many instances of distorted page layouts in the Apocalypse complicates the clearly image-focused effect of the original picture-book archetypes. It would not be accurate, however, to suggest that the *Wellcome Apocalypse* reduces the significance of the images; even though the manuscript's designer is forced to reconcile the centrality of the images with the expanded co-texts, the imagery throughout the manuscript – especially in the Apocalypse – remains central to the folios' design. The final result is a unique presentation of a highly conventional iconographic cycle that had

27 The Berengaudus commentary is an ecclesiological and prophetic exegesis on *Revelation* with strong moral and historical interpretations attributed to a late eleventh-century Benedictine named Berengaudus. See Emmerson, *Apocalypse Illuminated* 112. The commentary has been misattributed to Ambrose in the Patrologia Latina. See *Expositio super septem visions libri Apocalypsis*, PL 17:765–970. For the *Glossa ordinaria* see Smith L., *Glossa Ordinaria: The Making of a Medieval Bible Commentary* (Boston: 2014).

28 Seebohm, *Apokalypse, Ars moriendi, Medizinische Traktate* 14. For medieval sermons and sermon exempla see Wenzel S., *Medieval 'Artes Praedicandi': A Synthesis of Scholastic Sermon Structure* (Toronto: 2015).

been reproduced faithfully in manuscript and print for nearly two centuries. Unlike the printed models, the *Wellcome Apocalypse* made innovative custom adjustments that merged wordier text blocks and additional glosses with the image-focused layouts of the picture-books.[29] Why the creator would want to emphasize both familiar iconography and expanded textual explanation is not clear, but might suggest a mnemonic function of the imagery, perhaps to be recalled when composing sermons or tutorial lessons.

2 *Ars moriendi*

The *Ars moriendi* (Art of Dying Well) was first composed as an unillustrated treatise in the early fifteenth century. A shorted narrative version appeared around the year 1450; it was subsequently adapted into a very popular blockbook with eleven full page woodcut plates. This instructive moralising text found success as a blockbook in the mid- to late fifteenth century when its numerous editions were almost exclusively printed in Germany.[30] It would seem that one of these later, German blockbooks – perhaps close to the twelfth edition – was copied into the *Wellcome Apocalypse*. As such, this provides a fascinating example of the concurrent production of manuscripts alongside printed books in the late fifteenth century, and how the migration of images from blockbooks to manuscript occurred naturally in that process.[31] The first to observe that the miniatures in the *Wellcome Apocalypse* derive from the woodcuts in the *Ars moriendi* was Sandra Hindman, who rightly noted their nearly identical compositions.[32] Consider the *Wellcome Apoclaypse* and blockbook images of the dying man confronted by visions of Heaven and Hell [Figs. 3.4–3.5]. The hellmouth with burning souls is positioned just to the side of the bed in the foreground of both images. Likewise, the vision of the Trinity and the Virgin is situated at the top of the image between Saint Anthony at the foot of the bed and the angel holding the scroll above the dying man's head. Finally, both images feature two attendant angels who confront the dying man in the foreground, one gesturing

29 The result is what Bing characterises as a crowded derivation from the original models. Bing, "Apocalypse Block-Books and Their Manuscript Models" 144–145.

30 With one or two potential early Netherlandish exceptions, the thirteen distinct editions of the *Ars moriendi* were exclusively produced in fifteenth-century Germany, according to Hind A.M., *An Introduction to a History of Woodcut, with a Detailed Survey of Work Done in the Fifteenth Century* (New York: 1973) 224–225. For *Ars Moriendi* blockbooks see Conway W.M., *The Woodcutters of the Netherlands in the Fifteenth Century* (Hildesheim: 1964). For the *Ars Moriendi* see Beaty N.L., *The Craft of Dying: A Study in the Literary Tradition of the Ars Moriendi in England* (New Haven: 1970).

31 Hindman – Farquhar, *Pen to Press* 110.

32 Idem.

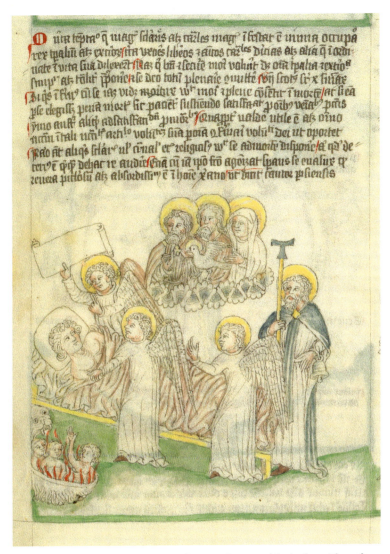

FIGURE 3.4 "Dying man with vision of Trinity, Virgin, and St. Anthony" from the *Ars Moriendi*. Ink and color wash on vellum, 40 × 30 cm, ca. 1470. London, Wellcome Library MS 49, *Wellcome Apocalypse*, lower left miniature of fol. 30r
PUBLIC DOMAIN

toward heaven, the other toward hell. Although the demon next to the hell-mouth is omitted in the *Wellcome Apocalypse*, as is the mock-text on the angel's scroll, the striking similarity between the two compositions remains apparent. It should be stressed that in contrast to the manipulation of iconography the liberal addition of supplementary texts in the Apocalypse section of the

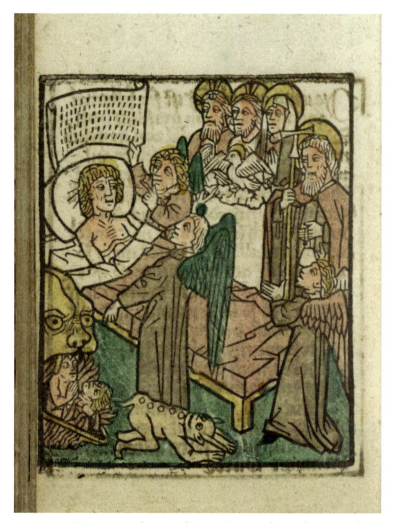

FIGURE 3.5 "Dying man with vision of Trinity, Virgin, and St. Anthony". Hand colored woodcut print, 150 × 105 mm, ca. 1475. Washington D.C., Library of Congress, Incun. x. P27, *Ars Moriendi*, Schreiber edition XII, pg. 15
LIBRARY OF CONGRESS, RARE BOOK AND SPECIAL COLLECTIONS DIVISION. PUBLIC DOMAIN

manuscript, the eleven miniatures of the *Ars moriendi* across folios 29r to 30v more faithfully replicate the printed model. I suggest this is likely because the *Ars moriendi* was a much more recent text and image cycle, and therefore lacked additional exegetical and devotional material from which the *Wellcome Apocalypse*'s compiler could draw. This does not mean that the compiler did not

exert authorial control over the material, though.[33] On the contrary, it seems clear that the compiler used the *Ars moriendi* as a thematic link between the Apocalypse's concluding scene of John's death and the morality texts on folios 30v–31r. While John's exemplary death is a paragon of Christian death, it is the *Ars moriendi* and the practical moral wisdom appended to it, that the pupils of the *Wellcome Apocalypse* can more realistically replicate at their own deaths, as described below.

In a further development of Hindman's formal observations, I focus attention on the significance of the altered *mise-en-page* and the contextualisation within the multi-text *compilatio*. The *Ars moriendi* begins on folio 29r, directly after the conclusion of the Apocalypse section at the bottom of 28v [Fig. 3.6]. Save for a slightly enlarged rubricated initial Q at the top of 29r, the only major cue that visually signals the beginning of a new, distinct text is the shift in page layout, namely, from double half-page miniatures to two columns of text. All eleven images derived from the blockbooks are inserted after their coordinating texts within the double columns. Interestingly, this *mise-en-page* diverges from the text and image layout of the blockbooks, whose full-page illustrations generally face a full page of text to form an opening consisting of one image and the start of its related description. The two-column format in the manuscript likely resulted from the size of the *Wellcome Apoclaypse*, which, at a massive forty by thirty centimeters, was considerably larger than the handheld size of the xylographic booklets. The format also conforms to the general double-column page layout of the compiled allegorical, pastoral, and instructive material in the later quires of the manuscript. It is possible that the designer employed this specific layout not only to accommodate the larger page, but also to indicate a subtle shift in genre as the manuscript transitions from the end of John's post-Apocalypse hagiography to the beginning of the *Ars moriendi*'s instructive text on morality. Conversely, the shift in subject is not presented in a way that detracts from the thanatological link between

33 The medieval understanding of authorial roles is complex and perhaps best exemplified by Bonaventure's mid-thirteenth-century commentary on Peter Lombard's *Sentences* that outlines a 'fourfold way of making a book', which defines the scribe (*scriptor*), the compiler (*compilator*), the commentator (*commentator*), and the author (*auctor*). Although the compiler is the individual who writes the words of other people, scholars have noted that the compiler also generates meaning – or authorial control – by positioning and shaping the authorities of the *auctor*. See Kraebel A., "Modes of Authorship and the Making of Medieval English Literature", in Berensmeye I. – Buelens G. – Demoor M. (eds.), *The Cambridge Handbook of Literary Authorship* (Cambridge: 2019) 98–114; and Minnis A., *Medieval Theory of Authorship: Scholastic Literary Attitudes in the Later Middle Ages* (Philadelphia: 2012).

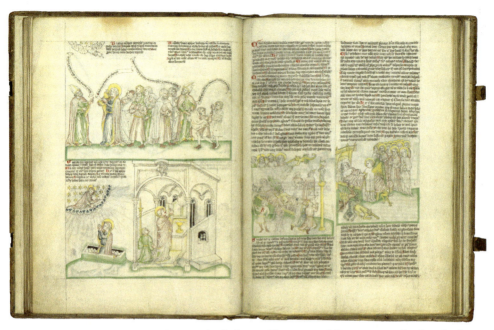

FIGURE 3.6　End of the post-Apocalyptic "Life of John" and beginning of the *Ars Moriendi*. Ink and color wash on vellum, 40 × 30 cm, ca. 1470. London, Wellcome Library MS 49, *Wellcome Apocalypse*, lower left miniature of fols. 28v to 29r
PUBLIC DOMAIN

St. John's exemplary "good death" at the bottom of 28v, to the instruction on dying well in the *Ars moriendi*.

The last scene in John's hagiography is the bottom half-page illustration of folio 28v, which depicts John consecrating the host before an altar on the right and kneeling in prayer in his grave on the left. According to the *Legenda aurea*, John's final actions in life were to perform the sacrament of the Eucharist and then, kneeling inside his tomb, to surrender himself to Christ, who had called him, body and soul, to Heaven.[34] The legend functions to show the inextricable link between the Eucharist and salvation, an important theological lesson underscoring how Christ's gifts lead to eternal life. This miniature is also significant because it typically occurs in the picture-book Apocalypses as the concluding miniature. Its moralizing purpose is thus also imbued with the eschatological exegesis that precedes it. In the *Wellcome Apocalypse*, the

34　The *Legenda Aurea* (Golden Legend) or Lives of the Saints was compiled by Jacobus de Voragine, Archbishop of Genoa, in 1275. Jacobus de Voragine – Ryan W.G. (trans.) *The Golden Legend: Readings on the Saints*, 2 vols. (Princeton: 1995).

lesson taught by the image echoes with the following two folios which provide detailed instructions on maintaining one's faith on one's deathbed. All of the miniatures in the *Ars moriendi* show the dying man surrounded by temptations and describe his pious responses, as described in each section of the instructional text. The scenes alternate between exemplifying good and evil, but the dying man is always depicted prone in his bed at the center of the scene.

The analogous visualisation of narrative episodes in this opening invites reader-viewers to transition from one text to the next without interruption. The text enhances this connection between imminent death, as demonstrated by scenes from the "Life of John", and the ideal way to die so as to achieve eternal salvation in heaven. Reader-viewers, when encountering the five temptations of the *Ars moriendi*, would have the pious, exemplary death of John in mind to guide them through the moralizing images of human death that follow. Indeed, the ideal of a death anticipated, prepared for, and carefully managed – deaths such as the ones illustrated in the *Wellcome Apocalpyse* – was deeply entrenched medieval culture. Both romances and hagiographies portray figures, from Lancelot to Francis of Assisi, who not only undergo but perform their own deaths, even choosing details of costume and setting.[35] Carolyn Walker Bynum has convincingly shown that medieval deaths were carefully staged and 'even controlled and willed by the dying person'.[36] It follows that reader-viewers would see the transition from John's death to the dying man's death as coherent, in that both men foresaw what is needful for salvation, having prepared rightly and piously to die. The images of death that follow in the *memento mori* section are a further extension of this thanatological lesson. Reader-viewers were taught that in facing their own individual eschatologies, they should recall these exemplars of 'good deaths'.

A comparable thematic transition between compiled materials likewise occurs at the end of the *Ars moriendi* on folio 30v, where the designer has carefully organised the page layout to transition into several *memento mori* subjects on the successive folios [Fig. 3.7]. The page seems to maintain its apparent two-column layout with roughly quarter-page miniatures, but in fact, a subtle layout shift has occurred. The conclusion of the *Ars moriendi* comprises only the top half of the folio; in a standard double-column format, the reader-viewer would normally be expected to proceed through the full length of the left column before reading the top of the second column on the right side of the page. Instead, in the *Wellcome Apocalypse*, we see a hybrid format;

35 Bynum C.W., "Death and Resurrection in the Middle Ages: Some Modern Implications", in *Proceedings of the American Philosophical Society* 142 (1998) 592.

36 Ibid. 590.

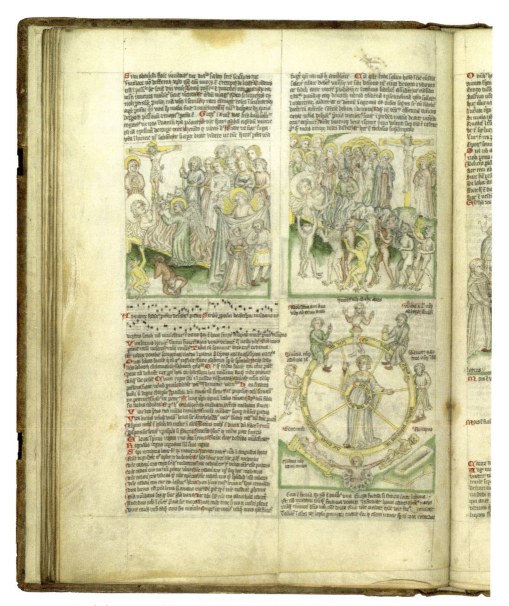

FIGURE 3.7 Concluding scenes of the *Ars Moriendi*, the *Ad mortem festinamus* and "Wheel of Fortune". Ink and color wash on vellum, 40 × 30 cm, ca. 1470. London, Wellcome Library MS 49, *Wellcome Apocalypse*, lower left miniature of fol. 30v
PUBLIC DOMAIN

A LATE MEDIEVAL MULTI-TEXT MANUSCRIPT & ITS PRINTED PRECEDENTS 83

the page is divided into four equal segments, indicated by the lead point ruling of four quadrants. In this format, the reader-viewer moves from the top half of the left column to the top half of the right column before returning to read the bottom half of the left column and then the bottom half of the right column. The four quadrants of the page lack typical markers, such as large, ornamented initials, text headings, or sufficient line breaks to signify separation. Instead, the presence of newly compiled material is subtly suggested by the musical notation directly below the *Ars moriendi* miniature of the dying man preparing to leave his family and worldly possessions to follow Christ in death. Indeed, the top line of the musical staff is actually connected to the miniature as the lead point line that demarcates the bottom of the miniature frame also serves as the top of the musical staff.

Not only are the image and notation visually linked together on this folio, but their respective subjects are intertwined, as well. The music and verses here are from a popular pilgrim's tune called *Ad mortem festinamus*, about avoiding sin and the inevitability of death, which was composed around the year 1400 at the Spanish Monastery of Monserrat.[37] After the musical notation and inscribed reprise, the song includes the subsequent eleven lines of text with intermittent rubricated initials that direct the reader to sing the reprise. The song is then immediately followed by more passages and verses about death. The lower right quadrant of folio 30v contains the image of the Wheel of Fortune, the first miniature in the appended *memento mori* content. The image matches the size and inter-columnar location of the previous *Ars moriendi* miniatures, contributing to the visual continuity of the compiled material on this folio. Like the continuation from the "Life of John" to the *Ars moriendi*, the transition from the *Ars moriendi* to the *Ad mortem festinamus* blurs the borders between two thanatological texts, creating a coherent, uniform section on dying well.

3 Antichrist

Unlike the Apocalypse and *Ars moriendi* in the *Wellcome Apocalypse*, the Life of Antichrist and its assimilation of iconography from blockbooks illustrating

37 *Ad mortem festinamus* was first inscribed in 1399 in the Llibre Vermell de Montserrat at the Monastery of Montserrat near Barcelona, where the manuscript still remains. Florence Whyte argues that the *Ad mortem festinamus* was one of several songs created by the Montserrat monks to replace the inappropriate songs they heard pilgrims singing. She also notes that several of the verses can be found in a 1267 *Contemptus mundi*. Whyte F., *The Dance of Death in Spain and Catalonia* (New York: 1977) 38–40, 43.

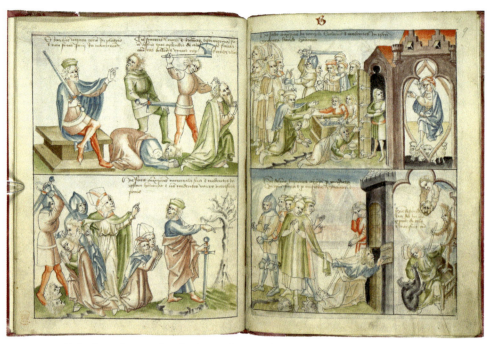

FIGURE 3.8 "Life of Antichrist". Ink and color wash on parchment, 285 × 215 (260 × 190) mm, ca. 1470. London, British Library, Additional Manuscript 19896, picture-book Apocalypse, fols. 8v to 9r
PUBLIC DOMAIN

the Life of Antichrist has yet to be considered by scholars; the sequence interrupts the Apocalypse midway, from folios 10v to 13r. Careful iconographic analysis does indeed suggest that, again, blockbooks offered a pictorial model, but this time the relationship is much more complex. The inclusion of a Life of Antichrist in the middle of an Apocalypse picture book was not uncommon; it normally occurred around *Revelation* 11:7, when the Two Witnesses are killed by the Beast that rises from the Abyss, a passage that had long been explained as a symbol of Antichrist, as appears in later copies such as the British Library's later fifteenth-century German picture-book Apocalypse (Add. 19896). There, in a single opening from folio 8v to 9r [Fig. 3.8], the four miniatures detail the killing of the Two Witnesses; Antichrist performing marvels and having faithful Christians executed; the bribing or persecution of further faithful Christians; and the final demise of Antichrist who is slain by the Breath of Christ's Mouth – an allusion to *2 Thessalonians*: 2:8.[38] These four miniatures

38 'And then that wicked one shall be revealed whom the Lord Jesus shall kill with the spirit of his mouth; and shall destroy with the brightness of his coming, him' (*2 Thess*. 2:8).

constitute the entirety of the Antichrist cycle in the standard picture-book Apocalypses and represent the narrative arc of Antichrist as described in the *Book of Revelation*; as such, their insertion serves to emphasise Antichrist's present danger as taught by the Apocalypse. The Antichrist cycle in the *Wellcome Apocalypse* contains an astounding eighteen miniatures arranged in three-layer registers with all of the textual descriptions and citations relegated to the internal margin, a text-image format consistent with the surrounding Apocalypse folios, as described above. The *Wellcome Apocalypse*'s Antichrist cycle diverges from the rest of the exegetical picture-book, in that it exemplifies a different literary genre: the inverted or parodic hagiography that dates back to the tenth-century *Libellus de Antichristo* by Abbot Adso of Montier-en-Der.[39] We again see the *mise-en-page* shift significantly from one layout (double half page miniatures) to another (three registers of miniatures), and this cues reader-viewers that an intentional change in subject has occurred. Furthermore, the rejection of the traditional four-miniature cycle in favor of the longer inverted hagiography goes back to the widely popular Antichrist blockbooks. By the later fifteenth century, these blockbooks were the most widely available pictorial source in Germany for Antichristian iconography.

The blockbooks were not the only source on Antichrist. In fact, legendary accounts and prophecies of Antichrist's evil deeds were legion in medieval Europe, to such an extent that the compiler of the *Wellcome Apocalypse* surely had a plethora of additional visual, textual, and even oral traditions from which to draw.[40] For example, we know that the most important textual source for the *Wellcome Apocalypse*'s Antichrist Vita was the *Compendium theologicae veritatis* by Hugh Ripelin of Strasbourg, because it is frequently quoted verbatim in the marginal passages.[41] Although the *Compendium theologica* is unillustrated, the Antichrist blockbooks offer the most reliable visual parallel to its text since they share the same narratological structure.[42] By incorporating them, the

39 For Antichrist as parody of Christ see Emmerson R.K., "Antichrist as Anti-Saint: The Significance of Abbot Adso's *Libellus de Antichristo*", *American Benedictine Review* 30 (1979) 175–190.

40 For Antichrist sources and medieval representations see Emmerson R.K., *Antichrist in the Middle Ages: A Study of Medieval Apocalypticism, Art, and Literature* (Seattle: 1981) and McGinn B., *Antichrist: Two Thousand Years of the Human Fascination with Evil* (New York: 2000).

41 Cermanová P., "The Life of Antichrist in the Velislav Bible", in Panusšková L. (ed.), *The Velislav Bible, the Finest Picture-Bible of the Late Middle Ages: Biblia Depicta as Devotional, Mnemonic and Study Tool* (Amsterdam: 2018) 148.

42 Horníčková K., "The Antichrist Cycle in the Velislav Bible and the Representation of the Intellectual Community", in Panusšková L. (ed.), *The Velislav Bible, the Finest Picture Bible of the Late Middle Ages* (Amsterdam: 2018) 184. Other pictorial Antichrist cycles based on

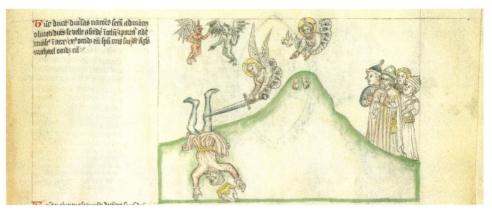

FIGURE 3.9 "Antichrist's failed ascension into heaven from the Mount of Olives". Ink and color wash on vellum, 40 × 30 cm, ca. 1470. London, Wellcome Library MS 49, *Wellcome Apocalypse*, lower left miniature of fol. 13r
PUBLIC DOMAIN

Wellcome Apocalypse's Antichrist Vita becomes a sort of visual representation of the major narrative episodes described in Hugh Ripelin's *Compendium*. The *Wellcome Apocalypse* even replicates Antichrist's method of death as pictured in the blockbooks, rejecting the death described in 2 *Thessalonians* 2, which was most often rendered in the picture-book Apocalypses. The *Wellcome Apocalypse*'s Antichrist is struck down by a sword-weilding Archangel Michael as he endeavors to ascend to heaven from the Mount of Olives, a parody of Christ's ascension [Fig. 3.9]. To accommodate the narrow horizontal miniature, the artist creatively reoriented the composition from the vertical, full-page woodcut model, centering the peak of the mount which bears Christ's footprints and shifting the inverted, condemned Antichrist to the left, thus emphasising not only his failed ascension but also his descent into a subterranean hell.

The strongest evidence that the Antichrist blockbooks served as the model for the *Wellcome Apocalypse*'s Antichrist Vita appears in the bottom miniature of folio 10v [Fig. 3.10]. This peculiar scene of marvels shows Antichrist suspending a castle on a thread, calling a hart to leap from a stone, and hatching a giant from an egg. Also depicted are a false Pentecost, indicated by the bands of fire

the *Compendium theologica*, like the mid-fourteenth century Velislav Bible, reorganise the narrative structure for individual exegetical emphasis. Horníčková argues that the placement of the burning books towards the end of the narrative in the Velislav is significant because it places the scholars and theologians as the last holdouts who refuse to convert, claiming that the episode depicts an act of retaliation against the learned clerical community.

A LATE MEDIEVAL MULTI-TEXT MANUSCRIPT & ITS PRINTED PRECEDENTS 87

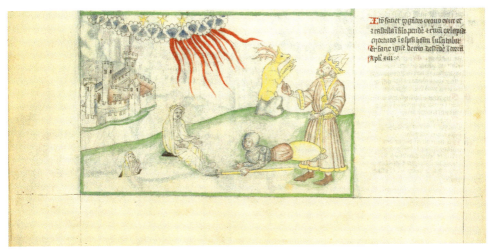

FIGURE 3.10 Antichrist performing marvels. Ink and color wash on vellum, 40 × 30 cm, ca. 1470. London, Wellcome Library MS 49, *Wellcome Apocalypse*, lower left miniature of fol. 10v
PUBLIC DOMAIN

streaming from Heaven, and a fake resurrection of the dead. The significance of the marvels of the castle, hart, and giant marvel is that a pictorial representation of this trick does not appear anywhere before the first editions of the Antichrist blockbooks. The sequence was apparently invented by the original designer of the Antichrist blockbook, as argued first by Christoph Peter Burger and later Bernard McGinn.[43] The replication of this scene in the *Wellcome Apocalypse* most likely indicates that the blockbooks were one of the iconographic sources for the book's illustrator. Although the blockbooks dedicate a single full-page image to the triple marvel, the *Wellcome Apocalypse* compresses the iconography, combining it with Antichrist's other false Pentecost and resurrection into a single miniature adapted to the horizontal layout. Nevertheless, in its effect of narrative progression, the composition still relies on the blockbook models for specific iconographic elements.

43 Burger C.P., "Endzeiterwartung im späten Mittelalter", in Boveland K. – Burger C.P. – Steffen R. (eds.), facsimile of *Der Antichrist und die Fünfzehn Zeichen vor dem Jüngsten Gericht* (Hamburg: 1979) 41. Burger says, 'In dieser Ausschmückung mag der Verfasser des Bildertextes originell gewessen sein'. Also see McGinn, *Antichrist: Two Thousand Years of the Human Fascination with Evil* 195. It is impossible to know if the miracles of the castle, hart, and giant were originally in the Velislav Bible since sixteen miniatures are missing, but it seems unlikely if we accept Horníčková's argument that the order of conversion was arranged hierarchically, with the miracles among the lower level stratagems.

The triple marvel demonstrates Antichrist's power over the natural world, and is just one scene from of a longer series of eight marvels described as 'wonders of impossibility' by Tina Boyer.[44] Pictured together in the *Wellcome Apocalypse*, the wonders contribute to the concept of the 'world turned upside down' as an essential feature of Antichrist's reign. Indeed, his most important quality is his comprehensive ability to imitate Christ's life, as demonstrated by his attempted ascension into heaven. Moreover, Antichrist's pretended omnipotence is portrayed as frightening to reader-viewers, as exemplified by Boyer's argument that the detail of the castle suspended on a thread is a representation of the court and the center of power and that its presence exhibits Antichrist's ability to exert authority over earthly politics[45] It is likely that the castle would have been seen as a symbol of power in the late Middle Ages, but I suggest that this detail is also a parody of the New Heaven described in John's vision in *Revelation* 21:2 ('The holy city, the new Jerusalem, coming down out of heaven from God, prepared as a bride adorned for her husband') and featured in the *Wellcome Apocalypse* on folio 26r. Because the image on folio 10v illustrates the deception performed by Antichrist rather than the true miracle of the New Jerusalem, the rendering of the thread indicates not only the falseness of Antichrist's conjurings but also the precarious and unsafe condition into which he forces all humanity. The threat to humanity is underscored by the giant hatching from an egg, which might signify unholy warriors such as Gog and Magog, the prophesied armies of Antichrist (*Rev.* 20:4). Medieval exegesis describes Gog and Magog as barbarous peoples, or as giants unleashed to fight at the battle of Armageddon.[46]

Although the designer of the *Wellcome Apocalypse* clearly relied on the blockbook's narrative sequence and pictorial details for the Antichrist Vita, his fascinating interpretation of late medieval Antichrist lore is exhibited in the codicological contextualisation of the cycle. The inverted hagiography of Antichrist is inserted into the context of the Apocalypse exactly where the four-miniature biblical exegesis of Antichrist that emphasises his role in salvation history would normally be. Thus, the *Wellcome Apocalypse*'s artist has essentially synthesised the two Antichristian traditions into one new eschatological

44 Boyer T., "The Miracles of Antichrist", in Hintz E.R. – Pincikowski S.E. (eds.), *The End-Times in Medieval German Literature: Sin, Evil, and the Apocalypse* (Cambridge: 2019) 244.

45 Ibid. 245.

46 This is especially emphasised by Pseudo-Methodius, who claims that Gog and Magog were barbaric cannibals locked in the Caucasus Mountains by Alexander the Great. See Alexander P.J., *The Byzantine Apocalyptic Tradition* (Berkeley: 1985) 147.

presentation. In fact, all three printed models discussed here have been recontextualised due to the cohesiveness of their shared artistic style and visual language which asserts their combined function as instructional material. These picture cycles have been imbued with a new, united meaning as they elegantly transition across the breadth of eschatology (i.e., from universal to personal) in this first codicological unit of the *Wellcome Apocalypse*.

4 Conclusion

The Apocalypse, *Ars moriendi*, and Life of Antichrist blockbooks were among the most popular and readily available books in fifteenth-century Germany. Like most contemporary blockbooks, all are highly illustrated and deal with accessible religious themes while simultaneously providing instruction of existential concern to late medieval reader-viewers.[47] It follows, then, that these books were used as sources, either because they were easier to obtain than high quality manuscript models, or because their imagery had become familiar due to their reproducibility. Each unit image and text was carefully compiled, curated to fit together and effect a smooth transition from one block of text to another; these printed precedents and their replication in the *Wellcome Apolcaypse* helps us better understand the fluid dynamics of media modalities in the world of late medieval book culture.

Despite these conclusions, questions about the *Wellcome Apocalypse* still linger. Although the specific provenance of the manuscript has resisted being revealed, the presence of the printed models discussed in this essay firmly situate the manuscript in the 1470s. The custom arrangement of image cycles and inclusion of additional texts indicates the manuscript's production in a center of learning, but the manuscript has yet to be linked to a recognizable workshop, artist, or scribal hand. The topics featured throughout the whole manuscript indicate clerical interests, but the the reliance on recognizable imagery perhaps suggests lay students as well. These issues taken together suggest to me that the *Wellcome Apocalypse* is perhaps more than a testament to shifting book production methods, but also a testament to a shifting culture in which books of all kinds increased their visual components to meet the educational and aesthetic expectations of the reading public.

47 Hindman – Farquhar, *Pen to Press* 109–110.

Bibliography

Alexander P.J. *The Byzantine Apocalyptic Tradition*. (Berkeley: 1985).

Beaty N.L., *The Craft of Dying: A Study in the Literary Tradition of the Ars Moriendi in England* (New Haven: 1970).

Bing G., "Apocalypse Block-Books and Their Manuscript Models", *Journal of the Warburg and Courtauld Institute* 5 (1942) 143–158.

Boyer T., "The Miracles of Antichrist", in Hintz E.R. – Pincikowski S.E. (eds.), *The End-Times in Medieval German Literature: Sin, Evil, and the Apocalypse* (Cambridge: 2019)

Bühler C., *The Fifteenth Century Book: The Scribes, the Printers, The Decorators* (Philadelphia: 1960).

Burger C.P., "Endzeiterwartung im späten Mittelalter", in Boveland K. – Burger C.P. – Steffen R. (eds.), facsimile of *Der Antichrist und die Fünfzehn Zeichen vor dem Jüngsten Gericht* (Hamburg: 1979).

Bynum C.W., "Death and Resurrection in the Middle Ages: Some Modern Implications", *Proceedings of the American Philosophical Society* 142 (1998).

Cermanová P., "The Life of Antichrist in the Velislav Bible", in Panussková L. (ed.), *The Velislav Bible, the Finest Picture-Bible of the Late Middle Ages: Biblia Depicta as Devotional, Mnemonic and Study Tool* (Amsterdam: 2018).

Conway W.M., *The Woodcutters of the Netherlands in the Fifteenth Century* (Hildesheim: 1964).

Emmerson R.K., "The Epitome of Apocalypse Illustration: The Anglo-French Tradition," in *Apocalypse Illuminated* (University Park: 2018).

Emmerson R.K., "Imagining and Imaging the End: Universal and Individual Eschatology in Two Carthusian Illustrated Manuscripts [1999]", in Donoghue D. – Simpson J. – Watson N. (eds.), *The Morton W. Bloomfield Lectures 1989–2005* (Kalamazoo: 2010).

Emmerson R.K. – Lewis S., "Census and Bibliography of Medieval Manuscripts Containing Apocalypse Illustrations, ca. 800–1500", *Traditio* 42 (1986).

Febvre L – Martin H., "The Technical Problems and Their Solution", in *The Coming of the Book: The Impact of Printing 1450–1800* (London: 1979) 45–76.

Hamburger J., "'In gebeden und in bilden geschriben': Prints as Exemplars of Piety and the Culture of the Copy in Fifteenth-Century Germany," in Parshall P.W. (ed.), *The Woodcut in Fifteenth-Century Europe* (Washington D.C.: 2009) 155–90.

Henkel K. – Denny D. (eds.), *The Apocalypse*, exh. cat., University of Maryland Art Gallery (College Park: 1973).

Hind A.M., *An Introduction to a History of Woodcut, with a Detailed Survey of Work Done in the Fifteenth Century* (New York: 1973).

Hindman S. – Farquhar J.D., *Pen to Press: Illustrated Manuscripts and Printed Books in the First Century of Printing* (College Park: 1977).

Horníčková K., "The Antichrist Cycle in the Velislav Bible and the Representation of the Intellectual Community", in Panussková L. (ed.), *The Velislav Bible, the Finest Picture Bible of the Late Middle Ages* (Amsterdam: 2018).

Hunter B.B., "Fifteenth-Century Picture-Book Apocalypses," *The Illustrated Life of Saint John and Picture-Book Apocalypse*, 2 vols. (Barcelona: 2020).

Hunter B.B., *The Wellcome Apocalypse: Innovating Ordinatio and Pictorial Traditions in a Late Medieval Multi-Text Manuscript* (Ph.D. dissertation, Florida State University: 2022).

Kraebel A., "Modes of Authorship and the Making of Medieval English Literature", in Berensmeye I. – Buelens G. – Demoor M. (eds.), *The Cambridge Handbook of Literary Authorship* (Cambridge: 2019) 98–114.

McGinn B., *Antichrist: Two Thousand Years of the Human Fascination with Evil* (New York: 2000).

Minnis A., *Medieval Theory of Authorship: Scolastic Literary Attitudes in the Later Middle Ages* (Philadelphia: 2012).

Needham P., "Prints in the Early Printing Shop," in Parshall P.W. (ed.), *The Woodcut in Fifteenth-Century Europe* (Washington D.C.: 2009).

Nellhaus T., "Momentos of Things to Come: Orality, Literacy, and Typology in the *Biblia Pauperum*," in Hindman S. (ed.), *Printing the Written Word: The Social History of Books, c. 1450–1520* (Ithica: 1991) 292–322.

Purpus E., "Die Blockbücher der Apokalypse" in Mertens S. (ed.), *Blockbücher des Mittelalters: Bilderfolgen als Lektüre* (Mainz: 1991) 81–97.

Voragine Jacobus de, *The Golden Legend: Readings on the Saints*, trans. W.G. Ryan, 2 vols. (Princeton: 1995).

Schmidt P., "The Multiple Image: The Beginnings of Printmaking, between Old Theories and New Approaches" in Parshall P.W. – Schoch R. (eds.), *Origins of European Printmaking: Fifteenth-Century Woodcuts and Their Public* (Washington D.C.: 2005) 37–56.

Schreiber W.L., *Manuel de l'amateur de la gravure sur bois et sur métal au XVᵉ siècle*, 4, *Un catalogue des livres xylographiques et xylo-chirographiques indiquant les differences de toutes les éditiones existantes* (Leipzig: 1902).

Seebohm A., *Apokalypse, ars moriendi, medizinische Traktate, Tugend- und Lasterlehren: die erbaulich-didaktische Sammelhandschrift London, Wellcome Institute for the History of Medicine, Ms. 49* (Munich: 1995).

Smith L., *Glossa Ordinaria: The Making of a Medieval Bible Commentary* (Boston: 2014).

Stevenson A., "The Problem with Blockbooks", in *Blockbücher des Mittelalter: Bilderfolgen als Lektüre* (Mainz: 1991) 229–62.

Whyte F., *The Dance of Death in Spain and Catalonia* (New York: 1977).

CHAPTER 4

Reforming Hrabanus: Early Modern Iterations of *In honorem sanctae crucis*

Kelin Michael

Hrabanus Maurus composed *In honorem sanctae crucis*, his collection of twenty-eight *carmina figurata*, or 'figured poems', in the early ninth century, during the height of the Carolingian Renaissance. As the title suggests, the collection of poems honors the holy cross. The twenty-eight poems make up one macro-poem in which Christ is portrayed as the key to decoding the universe and, within it, the signs of holy history.[1] The poems focus on Christ as a mediator between the earthly and heavenly realms, highlighting that, through the Passion and his dual nature, Christ became the Savior in a world over which he rules [Fig. 4.1].[2] The poems fall into three categories: those with geometric designs (e.g. lines, simple geometric shapes), those with complex geometric forms (e.g. Greek letters), and those with fully figural images (e.g. Louis the Pious, Christ, flowers, Evangelist symbols). The category of fully figural poems form 'iconotexts', works that make text and pictorial image inextricable.[3] These iconotexts became the loci for meaningful interventions in subsequent copies of the work, from the medieval era to the beginning of the Baroque period.

Due to the complexity of the poems, *In honorem* was an incredibly tricky text to reproduce in any medium, so tricky, in fact, that the process naturally opened the door to forms of customization. Over the course of seven centuries, changes were made to the script, color, image style, and collated materials of *In honorem* as nearly 100 copies were created across Europe. These changes made to the pictorial *carmina figurata* reflected and participated in larger political and religious shifts. In this essay, I focus on various attempts in the early modern period to reproduce *In honorem* in both print and manuscript formats, including how creators and owners of these books customized them.

1 Perrin M.J.-L., "La Représentation Figurée de César-Louis le Pieux chez Raban Maur en 835: Religion et Idéologie", *Francia*, Band 24.1 (1997) 41.

2 Perrin, "La Représentation Figurée" 41.

3 I turn here to Michael Squire's use of 'iconotextual'. See Squire M., "POP Art: The Optical Poetics of Publilius Optatianus Porfyrius", in Elsner J. – Hernández J. (eds.), *Towards a Poetics of Late Latin Literature*, (New York: 2016) 72.

© KONINKLIJKE BRILL NV, LEIDEN, 2024 | DOI:10.1163/9789004680562_005

REFORMING HRABANUS: ITERATIONS OF *IN HONOREM SANCTAE CRUCIS*

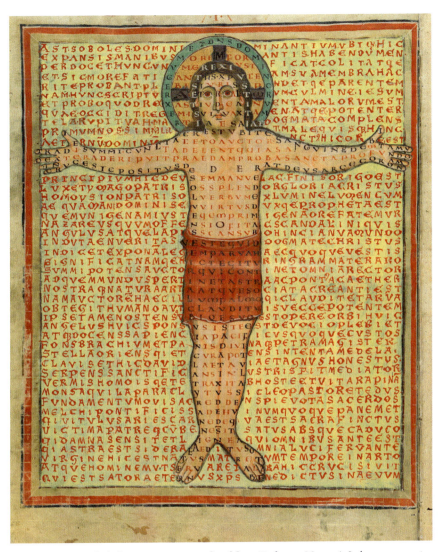

FIGURE 4.1 *Crucified Christ*, c. 825–850 CE; detail from Hrabanus Maurus's *In honorem sanctae crucis*, fol. 8v. Tempera and ink on parchment, 365 × 295 mm. Rome, Biblioteca Apostolica Vaticana, Reg. Lat. 124
© BIBLIOTECA APOSTOLICA VATICANA

I focus on the efforts of the contributors to the first printed edition (Jakob Wimpfeling; Pforzheim: Thomas Anshelm, 1503), as well as three specific copies of the book from Emory University's Pitts Theology Library, the Boston Public Library, and the Folger Shakespeare Library to showcase added

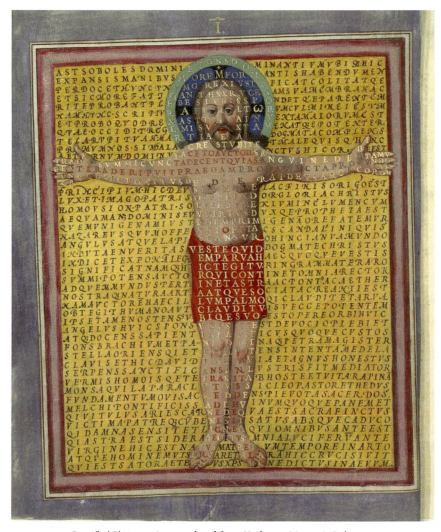

FIGURE 4.2 *Crucified Christ*; c. 1600 CE; detail from Hrabanus Maurus's *In honorem sanctae crucis*, fol. 9v. Tempera, gold, and ink on parchment, 350 × 298 mm. Paris, Bibliothèque nationale de France, Bibliothèque d'Arsenal, Ms-472
© BIBLIOTHÈQUE NATIONALE DE FRANCE [FAIR USE POLICY]

elements such as hand coloring, inscriptions, and collations.[4] Additionally, I compare this printed version of *In honorem* to a subsequent copy commissioned by Holy Roman Emperor Rudolf II for his *Kunstkammer* in 1600; the return to the manuscript format at this juncture was meaningful and requires

4 Pitts Theology Library 1503 HRAB, Boston Public Library G.H01.72, and Folger Shakespeare Library cs1828.

close study [Fig. 4.2]. Analyzing why Rudolf chose to return to manuscript demonstrates that customization of certain works did not work better with a switch to print, especially with works containing highly illustrative images. In Hrabanus's *In honorem*, text and image become immutable, which limits the print medium's ability to support a true intervention within the work itself. In the 1503 edition, contributors were instead forced into more of a supplemental dialogue with the work. Following the shift of *In honorem* from manuscript to print and back again, offers a striking example of the complexity of both mediums, and highlights their strengths and weaknesses in terms of customization.

1 How to Read Hrabanus's *Carmina figurata*

Why was Hrabanus's *In honorem* so difficult to customize? The answer lies in the complex function of the iconotextual poems. Before delving into early modern alterations made to the work as whole, it is crucial to illustrate how one of Hrabanus's iconotextual poems functions. There are several ways to approach each *carmen figuratum*, textually and visually. Examining the crucified Christ poem, which appears near the beginning of the work, helps illustrate these complexities [Figs. 4.1, 4.2]. The first approach is simply to read from left to right, following the lines of characters as one would sentences in a book. This process produces a poem which consists of the entire field of characters in the grid. The resulting poem describes the power of Christ and the people's rightful celebration of the Savior who suffered on the cross for humanity's sins, reinforcing the concept of Christ's dual nature by describing him as the light and image of the Father. This textual designation of Christ as the image of the Father allows for the formation of an integral relationship between the text and image in this pictorial *carmen figuratum*. Additionally, the beginning of the explanation of the poem – a *declaratio* which appears on the facing page of each poem – reads: 'The image of Christ extends his arms on the cross and his names express his simultaneously divine and human nature'. In this description, Hrabanus's language signals his intent to place the dual nature of Christ at the center of the dialogue concerning text and image.

The second way to approach the poem is through the ten *versus intexti* that appear throughout Christ's body, effectively revealed by examining the pictorial components of the poem. For instance, one verse appears along the contours of Christ's proper right arm, while another appears in his loincloth. Each verse conforms and relates to the area of the body in which it appears, serving to reinforce the themes of Christ's ruling power and dual nature. The verse along Christ's right arm provides a prime example of this relationship. The text reads, 'Jesus created all things as/by the right hand of the most supreme

God'.[5] In this case, not only does the text directly refer to the part of the body it helps form, but it also alludes to the action that body part takes theologically. Because this verse, and the other nine *versus intexti* are tailored to the areas in which they appear, the relationship Hrabanus creates between text and image becomes reciprocal and inextricable, forming an iconotext.

A reading of the imagery itself reinforces this reciprocal relationship of text and image. Here, because we see Christ depicted *as* the cross and not *on* the cross, Hrabanus simultaneously reveals Christ as God and man. Here, although Christ appears crucified (as a man, he died for everyone's sins), he also appears triumphant in death (as God, he overcomes death through the Resurrection). Looking closer, we can see that Christ's fingers and halo breach the frame of the poem, drawing the eye to the fingers of Christ's proper right hand, where the first *versus intextus* begins. The fact that the poem includes a frame draws attention to its status as *image*, rather than as pure text. Furthermore, the piercing of the frame by the fingers and halo both highlights the frame and declares Christ's status as an image that is not bound by that frame. He is something more than inscribed image or text, depicted here as human and divine. Supporting this quality of the image is Hrabanus's understanding of poetry as the pure embodiment of the Word of God.

Here, Peter Godman provides a translation of Hrabanus's poem "On writing":

> As God's kindly law rules in absolute majesty over the wide world,
> it is an exceedingly holy task to copy the law of God.
> This activity is a pious one, unequalled in merit
> by any other which men's hands can perform.
> **For the fingers rejoice in writing, the eyes in seeing,**
> **and the mind at examining the meaning of God's mystical words.**
> No work sees the light which hoary old age
> does not destroy or wicked time overturn:
> **only letters are immortal and ward off death,**
> **only letters in books bring the past to life.**
> Indeed God's hand carved letters on the rock
> that pleased Him when He gave His law to the people,
> and these letters reveal everything in the world that is,
> has been or may chance to come in the future.[6]

5 All translations, unless otherwise noted, are my own. Hrabanus Maurus, *In honorem sanctae crucis*, Carmen figuratum B1, Versus intextus 1: 'Dextra dei summi cuuncta creavit iesus'.

6 Latin transcription in Godman P., *Poetry of the Carolingian Renaissance* (London, 1985) 249.

In this short collection of verses, Hrabanus speaks volumes. He views the act of writing as something holy and pious. He also delineates a tripartite structure to the significance of writing, mentioning how the figures rejoice in the physical act, the eyes in seeing, and the mind in comprehending the meaning of God's Word. These three stages correspond to the levels of contemplation completed by monks. The first remains rooted in the physical world, the second, walks the line between the physical world and the internal world (the act of seeing through visualizing), and the third leaves the physical world behind and achieves an understanding of God.[7] Hrabanus then describes the legacy of writing, one that is immortal and reveals to the world God's intentions. Through words, one can ward of death and convey the Word of God.

Not only did Hrabanus view writing as a holy act, but he had a specific interest in poetry and metrics. He composed a treatise, *Excerptio de arte grammatica Prisciani*, that compiled presentations of prosody from Priscian, Diomedes, Isidore, Donatus, and Bede to standardize the teaching of metrics in Carolingian schoolrooms.[8] Michele Ferrari describes how Hrabanus understood the poet to be a *vates*, a divinely inspired mouthpiece for God.[9] Creating a poem was thus a religious experience for Hrabanus. By creating a *carmen figuratum* of Christ – the quintessential iconotext as the Word of God incarnate – Hrabanus deliberately uses the medium of poetry to draw attention to Christ's iconotextual nature by creating an iconotext himself.[10]

As debates about the appropriate veneration of holy images within a religious context often used Christ's dual nature as a justification for the use of these images, the purpose of Hrabanus's opus situates his *carmina figurata* within the contemporary deliberations concerning text and image. Copies made from 900–1500 CE exhibit a multitude of changes, some of which include: the addition of a cross behind the figure of the crucified Christ, changes in the clothing of the Louis the Pious figure, the extraction of certain pictorial poems, and the pairing of *In honorem* with other texts. Hrabanus's iconotextual poems implicitly challenge the predominant Carolingian stance on the superiority of

7 For an understanding of how Carolingian art could have functioned similarly when used correctly, see Kessler H., ""Facies bibliothecae revelata": Carolingian Art as Spiritual Seeing," in *Spiritual Seeing: Picturing God's Invisibility in Medieval Art* (Philadelphia, 2000) 149–189.

8 Heikkinen S., "Re-classicizing Bede?: Hrabanus Maurus on prosody and meter", *Philological Quarterly* 94:1–2 (2015) 1–4.

9 Ferrari M., "Dichtung und Prophetie bei Hrabanus Maurus", in Felten F. – Nichtweiß B. (eds.), *Hrabanus Maurus, Gelehrter, Abt von Fulda und Erzbischof von Mainz* (Mainz, 2006) 71–91.

10 A general understanding across the literature is that the Latin of these poems is of lesser quality than Hrabanus's non-*carmina figurata* poems, indicating that the image is in some way dictating the outcome of the text.

98 MICHAEL

text over image and, in doing so, form a work that succeeded in garnering long-sustained interaction.

2 Jakob Wimpfeling and the 1503 Printed Edition

The desire to create the first printed edition of *In honorem* was born out of conditions supported by the ideals of German humanism. German humanism, broadly defined, sought the general spread of intelligence with a goal to reach "the fountains of the Christian system."[11] There was also a large focus on translation, with figures such as Erasmus emphasizing the role of the reader in understanding texts for themselves. However, unlike the Italians, the Germans focused more on biblical texts, rather than Greek and Roman classics. A tension between two camps of humanism existed in Germany, a more conservative, scholastic-based humanism, and a more liberal humanism, closer in tone to that of the Italians. In fact, some figures, like Wimpfeling, vehemently opposed the use of pagan authors, especially in an educational context, and openly criticized the Italians for holding them in such high regard. Here, I provide a brief introduction of the collaborators, as well as an inventory of their additions and how they related to German humanism.

In his preface to the 1503 printed edition Jakob Wimpfeling greets 'lovers/ enthusiasts of beautiful letters' by writing, 'I beg you, then, kind reader, everyone who is truly Christian, make this book your own [...]'.[12] In doing so, he encouraged readers to create an intimate relationship with *In honorem* and its contents. Making alterations, either slight or considerable, was not a novelty when it came to Hrabanus's collection of *carmina figurata*. In fact, it was common practice. However, in the seven centuries from 810 to 1503, these changes were made almost solely to the images during the copying process. Printed copies allowed for new and different interactions with Hrabanus's poems – including a shift from a primarily monastic audience to a lay audience – but the shift to print also introduced many challenges and limitations in terms of customization. By adding curated introductory and concluding material to *In honorem* – namely, a preface, several laudatory poems, and a *peroracio* (closing speech) – editor Wimpfeling primed reader-viewers for Hrabanus's main

11 Schaff P. – Schley Schaff D., *History of the Church, Volume 5, Part 2* (University Park, PA, 1924), 619.

12 Maurus H., *Magnencij Rabani Mauri de laudi[bus] Sanctae Crucis opus* (Pforzheim, Wimpfeling: 1503), fol. Aa i r.: 'vniuersis bonarum litterarum amatoribus' and 'Fac igitur peculiarem hunc librum tibi candide lector obsecro. quisquis vere christianus es [...]'.

content, preparing them to engage with a book that was 'splendid and worthy of all veneration'.[13] However, because of print's nature as a mass-reproductive medium, Wimpfeling was forced to create a dialogue with Hrabanus's poems, rather than a direct intervention into their visual components. For example, Wimpfeling had the freedom to add information (e.g. his preface and *perora-cio*), but could not change the structure, content or image within each *carmen figuratum*. In addition, Wimpfeling brought a new approach to *In honorem*, that of a German humanist scholar. In doing so, he situated Hrabanus's work within a German understanding of the region's legacy as one of continuous power, reaching back from the Hapsburgs, to the Ottonians, Carolingians, and finally to Antiquity.[14] Wimpfeling's approaches contrasted with the several centuries' worth of manuscript producers before them.

Wimpfeling and Thomas Anshelm (c. 1470–1522/1524) were the two main figures that brought the print version of *In honorem* to fruition.[15] Anshelm had established the first printer's shop in Pforzheim, Germany in 1496 and Wimpfeling was a theologian from Sélestat who had studied at multiple universities before settling in 1501 in Strasbourg, a city not far from Anshelm's shop. In the colophon to *In honorem*, Anshelm labels himself as the printer of the work and, over the course of his career, he became known for publications containing large amounts of woodcuts. Although the edition does not expressly denote a publisher, Anshelm is the likely candidate, especially in light of complimentary comments directed towards him in the added introductory material. Wimpfeling, on the other hand, is traditionally labeled as the editor of the work and is regarded as such largely due to his contribution of a lengthy preface and closing speech. It is also typically agreed that he was the instigator for the collection of the other prefatory materials.

While Anshelm and Wimpfeling were the most crucial contributors, and those whose names are officially attached to the edition in catalogues today, they were not the only individuals who had a hand in producing *In honorem*'s first printed edition. A group of humanists, including Johannes Reuchlin (c. 1455–1522), Nikolaus Keinbös (active late 15th–early 16th century CE),

13 Maurus, *Magnencij Rabani Mauri*, fol. Aa i r.: 'preclarum et omni veneratione dignum opus [...]'

14 Woods C.S., *Forgery, Replica, Fiction: Temporalities of German Renaissance Art* (Chicago, 2008) esp. 61–71.

15 Most scholars agree that Wimpfeling was the instigator of the 1503 edition. However, Johannes Reuchlin also had several interpersonal connections with the collaborators for *In honorem*. Gábor Endrődi makes a strong case for his role as editor. Endrődi G., "'Damit siegt Hrabanus mühelos über Apelles': Johannes Reuchlins Interesse an den Figurengedichten von Hrabanus Maurus", *Daphnis* 51 (2023) esp. 6, n. 23 and 24.

Sebastian Brant (c. 1458–1521), Jodocus Gallus (c. 1459–1517), Theodore Dietrich Gresemundus (the Younger, c. 1477–1512), Johannes Gallinarius (c. 1475–1516), and Georg Simler (c. 1477–1536) all contributed to the volume and exchanged ideas through their participation in the same humanist circles.

Each was tied to the humanist circle in Heidelberg, more specifically to Wimpfeling, and their varying specialties – grammar, Greek and Hebrew, Latin poetry, and theology – were all needed to handle a work like Hrabanus's, which included complex theological concepts, embedded numerology, Greek phrases, and figural Latin poetry. In addition to the skills they brought with them, these humanists read and formed a connection with Hrabanus's *carmina figurata*. When combined with Wimpfeling's editorial expertise and Anselm's printing experience, these scholars produced a version of *In honorem* that reflected their intimate engagement with the volume in a way that distinguished the printed edition from previous manuscript copies. The material each produced for the introduction of *In honorem* showcased their nuanced responses to the Carolingian work in the context of early sixteenth-century German humanism.

Wimpfeling was an Alsatian priest, poet, pedagogue, and historian.[16] He was one of the more conservative German humanists at the time *In honorem* was published, but his ideas concerning priestly reform, focused in moral purity and patriotism, influenced his circle of colleagues, and even reached a young Martin Luther (c. 1483–1546).[17] Over the course of his life, Wimpfeling wrote over one hundred of his own titles – including discourses, prefaces, pamphlets, poems, letters, and treatises dealing with questions of religion, education, history, and politics. Most of these publications contributed to his program for the *restitutio Christianismi* (restoration of Christianity), a concept that was prevalent in the writings of Renaissance humanism and often dealt with the return to original or pristine sources of Christianity (such as evangelical and apostolic sources) as a way to rid the religion of corruption and restore it.[18] Wimpfeling provides a preface and closing speech (*peroracio*) in *In honorem* – both addressed to the reader – as well as a list of laudatory references from previous authors, such as Vincent de Beauvais, who mention Hrabanus' work. He

16 For more on Wimpfeling, see Mertens D., "Jakob Wimpfeling (1450–1528). Pädagogischer Humanismus", in Schmidt P.G. (ed.), *Humanismus im Deutschen Südwesten. Biographische Profile* (Sigmaringen, 1993) 35–57, Knepper J., *Jakob Wimpfeling (1450–1528): Sein Leben Und Seine Werke* (Freiburg: 1902) and Spitz L.W., *The Religious Renaissance of German Humanists* (Cambridge, MA: 1963) 41–60.

17 Spitz, *The Religious Renaissance*, 41, 17.

18 Spitz, *The Religious Renaissance*, 41–42, 203–204.

uses these additions to reflect how *In honorem* and the work of other Christian poets are useful in the restoration of Christianity.

Reuchlin, an avid scholar of Latin, Greek and Hebrew, was born in Pforzheim, and had strong connections to humanist circles in Heidelberg.[19] As Reuchlin and Anshelm were both from the south-German town, it is likely that Reuchlin was the one to reach out to the fledgling printer to publish the edition of *In honorem*.[20] Reuchlin was also "a pioneer in Hebrew studies and built up a constructive philosophy based on Neoplatonism and the Jewish Cabala."[21] He wanted the Bible to become better known, not just through the Vulgate, but through careful study of original source material, in this case, the Hebrew Bible and the accompanying grammatical and exegetical traditions.[22] While *In honorem* is not written in Hebrew, it does contain Greek and takes great care to unfold the mysteries of Christ and the cross throughout its twenty-eight *carmina figurata*. It makes sense that Reuchlin would see the value of the work to access knowledge from the Bible. Reuchlin was deeply aware of the humanist interests in Italy, yet still saw Hrabanus as special, a man who created a work which worked both as poetry and exegesis.[23] Reuchlin adds a poem to the edition, addressed to Thomas Anshelm, that praised the printer and the original offer for their skills and contributions.

Brant studied philosophy and then law at the University of Basel, but what ultimately drew him into humanist circles was his Neo-Latin poetry.[24] He eventually transitioned to translating his own and others' works into German and is best known for his vernacular work *Das Narrenschiff* (c. 1494), an allegorical

19 Perrin M.J.-L., "Dans les marges de l'editio princeps du *De laudibus sanctae crucis* de Hraban Maur (Pforzheim 1503: un aperçu de l'humanisme rhénan vers 1500", in Lehmann, Y. – Freyburger, G. – Hirstein, J. (eds.), *Antiquité tardive et humanism: de Tertullien à Beatus Rhenanus. Mélanges offerts à François Heim à l'occasion de son 70e anniversaire* (Turnhout: 2005) 339; Schmitz W., "'O preclarum et omni veneration Dignum opus'... Zur Drucklegen von Hrabans 'Liber de laudibus sanctae crucis' im Jahre 1503", in Ernst U. – Sowinski B. (eds.), *Architectura poetica: Festschrift für Johannes Rathofer zum 65. Geburtstag*, Kölner Germanistische Studien 30 (Cologne – Vienna: 1990) 392.

20 Schmitz, "O preclarum," 394. Although Schmitz also concedes that Anshelm could have been recommended by Keinbös who came from the neighboring town of Durlach.

21 Spitz, *The Religious Renaissance*, 17–18. For more on Reuchlin, see Spitz, *The Religious Renaissance*, 61–80 and Schmidt P.G., *Humanismus Im Deutschen Südwesten. Biographische Profile* (Sigmaringen: 1993) 59–75.

22 Chisholm H., "Reuchlin, Johann", in *Encyclopædia Britannica: A Dictionary of Arts, Sciences, Literature and General Information, Volume 23* (11th ed.) (New York, 1911) 203.

23 Ferrari, "Dichtung und Prophetie" 91.

24 For more on Sebastian Brant, see Schmidt et al., *Humanismus*, 77–104. For the relationship between Reuchlin and Brant, see Zeydel E.H., "Johann Reuchlin and Sebastian Brant: A Study in Early German Humanism", *Studies in Philology* 67.1 (1970) 117–138.

102 MICHAEL

exploration of the weaknesses and vices of his time. At the time of the edition, Brant worked in Strasbourg and had known Reuchlin and Wimpfeling for a long time. As a strong advocate for German cultural nationalism, as was Wimpfeling, Brant's interest in *In honorem* makes sense. However, returning to a work which could not be translated into the vernacular demonstrates how *In honorem*'s structure did not allow for certain forms of customization. Brant writes verses recommending Hrabanus's work and mentions Nikolaus Keinbös's involvement.[25]

Gallus (aka Jost Hahn) belonged to a circle of humanists surrounding Johann van Dalberg (c. 1445–1503). He was a student of Wimpfeling's, sharing his teacher's disdain for the corruption of the Church, and held a master's degree from Heidelberg, specializing in Aristotle.[26] His affinity for Hrabanus's work was likely comparable to Wimpfeling's, in that he saw the poems as a way to encourage a moral life rooted in Christ. Gallus adds a quatrain addressed to Christians, as well as a poem praising Thomas Anshelm.

Gresemundus was first educated at Erfurt, eventually impressing the likes of Wimpfeling, Adam Werner von Themar (c. 1462–1537), and Abbot Johannes Trithemius (aka Johann Heidenberg, c. 1462–1516) with his writing, publishing his first work in 1494 at the age of seventeen.[27] After studying in Italy, he became a law professor and humanist poet, exhibiting close ties with the circle in Heidelberg since 1499 (including Reuchlin and Wimpfeling).[28] Although Gresemundus was studying antiquities in Rome in 1501 and had a hobby of collecting ancient coins and inscriptions, and thus was familiar with the Italian form of humanism, he left the city after he wrote two scathing epigrams about Pope Alexander VI (c. 1431–1503) and called for the rehabilitation of the clergy. Considering his poetic inclinations and criticisms of the Church, Gresemundus's contribution to Wimpfeling's edition makes sense. Gresemundus writes two poems on the glory of Hrabanus's work.

As a student and friend of Wimpfeling (and perhaps also a relative), Gallinarius first attended university at Heidelberg in 1495 and eventually became a professor there. Focused on grammar and rhetoric, he was

25 In his dedication, Brant writes, "Quod mihi nuper opus Rabani Nicolae sacrata/ De Cruce misisti deque decore Crucis." Schmitz, "O preclarum," 393, n.17, 394. Keinbös was a Johanniter from Durlach and it is confirmed that he was an editor of Sebastian Brant's texts. Perrin, "Dans les marges," 339.

26 Blundo G., "Gallus, Jodokus", *Neue Deutsche Biographie* 6 (1964): 55; Schmitz, 'O preclarum," 393; Perrin, "Dans les marges," 339.

27 Grimm H., "Gresemund, Theoderich der Jüngere", *Neue Deutsche Biographie* 7 (1966): 48.

28 Schmitz, 'O preclarum," 393; Perrin, "Dans les marges," 340.

enthusiastic about humanistic endeavors and often contributed verses to Wimpfeling's publications.[29] Gallinarius contributes two elegiac poems, one recommending Hrabanus's work to those who love Christ, and another asking the Muses to adorn Hrabanus with a crown (he also writes six short lines in that same vein).

Simler was a well-educated humanist and connoisseur of Greek who, at the time, upon Reuchlin's recommendation, was the principal of the Pforzheim Latin School.[30] He also served as a proofreader for Anshelm's printshop in Pforzheim.[31] He shared a desire for reform with Wimpfeling and had come to Pforzheim from Heidelberg, which explains his connection to the circle of humanists involved in the creation of this edition of *In honorem*. With an admiration for Latin and his job as a proofreader (likely for this publication), Simler's balanced understanding of the construction and aesthetics of Hrabanus's *carmina figurata* is reflected in his own poetry. Simler adds a laudatory poem addressed to Hrabanus, an additional quatrain on the same subject, and the initials "G:S" also appear at the bottom of a new eight-lined poem under the image of the intercession of Alcuin on Hrabanus's behalf.

New textual material prepared by each collaborator customized Hrabanus's original content by nuancing the intended purpose of *In honorem* to 'properly' educate German humanists against the morally dangerous pagan influences of Italian humanism. The additions also reflected the collaborators' individual relationships with the iconotextual nature of the *carmina figurata*, with each focusing on different visual and textual aspects of the poems in their laudatory verses. In creating a printed edition of *In honorem*, supplemented by their own writing, this group of humanists both encouraged and enacted Wimpfeling's invitation for reader-viewers to "make this book [their] own" (Aa i,v). It is illuminating to consider how the transition from a manuscript format to a printed format allowed for this type of customization. For the sake of brevity, I will focus on a few examples that capture this complex relationship between original and added materials.

29 Franck J., "Gallinarius, Johannes", *Allgemeine Deutsche Biographie* 8 (1878): 336–338; Schmitz, "O preclarum," 393; Perrin, "Dans les marges," 340.

30 This school had become quite famous in southern Germany. Schmitz, "O preclarum," 394; Horawitz A. – Harttfelder K., *Briefwechsel Des Beatus Rhenanus* (Leipzig: 1886) 41.

31 Schmitz, "O praeclarum," 399. Later, Simler became best known as the teacher of Philipp Melanchthon. Schmitz, "O preclarum," 394.

3 Content of the Added Text

Johannes Reuchlin, in his poem addressed to Thomas Anshelm, compares *In honorem*'s power to that of the Brazen Serpent (Numbers 21: 8–9).[32] He suggests that although the Brazen Serpent had the power to heal, Hrabanus's work, conveyed to reader-viewers through their edition, does so in superior fashion, or to a higher degree.[33] For the reader-viewer of the edition, comparing the salvific power of *In honorem* to that of the Brazen Serpent had the effect of solidifying the book's reputation as a legitimate theological and educational tool. These lines of Reuchlin's poem mirror a list given by Wimpfeling in his *peroracio* which offers Christian substitutions for pagan authors. It is impossible to know, but, because Reuchlin and Wimpfeling were contemporaries, Reuchlin likely had input in, or at the very least was aware of, the list. In this context, the reader-viewer substitutes the edition of *In honorem* for the Brazen Serpent, as if it were the antitype to a famous Old Testament typological symbol. By reading and viewing Hrabanus's work, Reuchlin implies, one will be able to recognize and correct one's sins. The reference to the Brazen Serpent here is inherently visual, indeed pictorial. In the original narrative, the Israelites were not saved by reading a text; they were saved by viewing the serpent that Moses had constructed and placed on a pole. In this way, Reuchlin draws focus to the pictorial nature of Hrabanus's *carmina figurata* while advocating for their efficacy as salvific teaching tools.

Reuchlin reinforces this idea in another section of the poem where he writes, 'This cross of Hrabanus shines brighter than Constantine's vision / Once painted in celestial letters'.[34] These lines refer to the vision, sent by God, which appeared to Constantine as a "cross of light in the heavens," before the Battle at the Milvian Bridge (c. 312 CE).[35] When Constantine defeated his enemy the next day, he attributed the victory to the God of the Christians. As this was seen by many to be a landmark moment in the shift from paganism to Christian worship, to say that Hrabanus's cross shines brighter than Constantine's vision is a grand statement of endorsement for the work's theological relevance. It also

32 For an examination of how imagery of the Brazen Serpent is integral to a typological understanding of Christian images, see Kessler H., "'They preach not by speaking out loud but by signifying': Vitreous Arts as Typology", *Gesta* 51.1 (2012) 55–70.

33 Maurus, *Magnencij Rabani Mauri*, fol. Aa ii r: 'Aerea serpentis potuit sanare figura/ Fixa cruci, nostra tu mage tutus eris'. For an expansive analysis of Reuchlin's reasoning behind these comparisons, see Endrődi G., "'Damit siegt Hrabanus" esp. 6, n. 23 and 24.

34 See Perrin, "Dans les marges" 343. Maurus, *Magnencij Rabani Mauri*, fol. Aa ii r: 'Crux haec plus Rabani: quam Constantiniana splendet/ Quondam sidereis visio picta notis'.

35 Eusebius, *The Life of Constantine* (London, 1847) 26.

underscores Wimpfeling's commitment to studying Christian poets such as Hrabanus in lieu of pagan ones, a direct contest to the type of humanism practiced by contemporary Italians. By evoking a visual sign given to Constantine (*visio*) and by using terms such as *picta* to insist on the pictorial nature of the vision, Reuchlin continues to emphasize the visual efficacy of Hrabanus's visual-textual *carmina*.

Furthermore, Reuchlin writes, 'The series scatters finely formed colored marks / In various directions, so that the order inscribes the cross', and goes on to remark upon Hrabanus's superiority to famous visual artists of antiquity (Apelles, Parrhasius, and Zeuxis).[36] The language Reuchlin uses conjures the image of Apelles, who threw a paint-soaked sponge against one of his murals in progress thus producing the extemporaneous effect of a horse's foaming mouth.[37] The lines of poetry also have an ekphrastic quality to them, walking the reader through the construction of Hrabanus's *carmina figurata* as well as descriptively comparing them to works of ancient artists, objects, and events. Reuchlin's descriptions play with the comparison between painting and poetry, encompassed in the phrase *ut pictura poesis*.[38] By referring to the equivalence between painting and poetry, Reuchlin adds another layer of complexity to a long-standing debate about the superiority of text over image, as well as the appropriate use of pictorial images; through his own poetry (*poesis*), which focuses on visual/pictorial subjects (*pictura*), he crafts a description of Hrabanus's own poems (*poesis*), which are inherently pictorial (*pictura*). In this way, Reuchlin mirrors the iconotextual quality of Hrabanus's *carmina figurata* through his pictorially-focused yet still textual description.

Not all collaborators focused as strongly on the pictorial qualities of Hrabanus's poems as did Reuchlin. Some, such as Sebastian Brant, focused more on their textual genius. His poem, one of the longest contributions, is addressed to Nikolaus Keinbös, the parish priest of Durlach, as the friend who originally recommended *In honorem* to him.[39] In the first two lines of his

36 Thank you to Walter Melion, Annie Maloney, and Cody Houseman for help with this translation. Maurus, *Magnencij Rabani Mauri*, fol. Aa ii r: 'Formosas spargit series maculosa lituras/ Partibus in variis, ut notet ordo crucem'.

37 Empiricus S., *Outlines of Pyrrhonism*, Bury R.G. (trans.) (Cambridge: 1933) 19.

38 Here, I turn to Kennedy D. – Meek R., *Ekphrastic Encounters: New Interdisciplinary Essays on Literature and the Visual Arts* (Manchester: 2019) 1–15 for ideas concerning the nature and importance of *ekphrasis* and the conversation revolving around *ut pictura poesis*. On ancient conceptions of *ekphrasis*, see Webb R., *Ekphrasis, Imagination and Persuasion in Ancient Rhetorical Theory and Practice* (London: 2009), and Eck C. van, *Art, Agency and Living Presence: From the Animated Image to the Excessive Object* (Leiden: 2015).

39 Keinbös's name translates to "not evil", and Brant takes the opportunity to create instances of word play within his verses. Additionally, there is a Nikolaus Keubsch (or Kenbsch) of

poem, he writes, 'Nikolas, you recently sent me the work of Hrabanus / That of the sacred cross, and of the beauty of the cross'.[40] Although the last half of the poem is primarily dedicated to complimenting Keinbös and his position within the church, Brant focuses on the salvific and educational textual nature of *In honorem* in the first half of the poem. He refers to it as a poem (*carmine*) and Hrabanus as the best author (*optimus auctor*), rather than choosing a term which more directly connotes a visual artist. He also comments on the fact that he himself needed to read and study the poem multiple times in order fully to appreciate its complexities. He goes on to praise the variety of the poems (*vario carminis*) in *In honorem*, and he describes how Hrabanus has succeeded where others had fallen short, in his ability to use language (*lingua*) to sing the praises of Christ and of the cross in a way that effectively conveys their power and importance. Through his verses, Brant acknowledges the power of genius (*ingenii vis*) behind Hrabanus's *carmina figurata*, which is visible in their complexity, their validity, and their author's linguistic acumen.

Further contributions focus neither on the pictorial nor textual qualities of Hrabanus's work, instead detailing the amount of skill and virtue it took to make the book, both on Hrabanus's part, and on Anshelm's. Still others focus equally on both qualities, balancing references to Hrabanus's skill as a poet and visual artist. Altogether, the textual additions, written from various cultural positions and perspectives, provided a well-rounded reflection on the skill it took to create the iconotextual *In honorem*, both in its original form and in its new printed format.

This additional content cued reader-viewers to the humanists' contemporary pedagogical goals of directing their audiences toward what they viewed as true and correct Christian devotional study. This approach did not depart entirely from the theological objective of Hrabanus's complex contemplative work and framed it for a more diverse audience. Originally intended for monks and for a few select lay patrons (e.g. Emperor Louis the Pious), *In honorem*'s audience expanded to a lay elite with Wimpfeling's edition. In humanist circles, the work could be discussed, alongside the new framing materials. Additionally, the added material re-situated Hrabanus's content in terms of what Wimpfeling et al. thought constituted correct devotional study. Hrabanus, in his *Excerptio de arte grammatica Prisciani*, worked to marry Bede's *De arte metrica*, which excised pagan authors from the study of prosody,

the Order of Saint John and city priest of Durlach recorded in 1502. This figure is likely the Keinbös referred to in this edition. Schmitz "'O preclarum'" 393, n. 17.

40 Maurus, *Magnencij Rabani Mauri*, fol. Aa ii v: 'Quod mihi nuper opus Rabani, Nicolae, sacrata/ De cruce misisti, deque decore crucis ...'.

with the rising Carolingian interest in the works of pagan authors.[41] In contrast, Wimpfeling returns towards Bede's anti-pagan stance by offering his list of substitutions in his framing materials. By customizing *In honorem*, the collaborators which took part in creating the edition succeeded in retaining the essence of Hrabanus's original work, but recontextualized it for a modern audience.

4 Creating and Interacting with a Printed *In honorem*

Aside from the added textual content, when sixteenth-century audiences interacted with Wimpfeling's printed edition, their experience remained fairly similar to engaging with a manuscript copy. The structure of the publication adhered to Hrabanus's original. Each *carmen figuratum* was followed by its *declaratio* and then Book II provided Hrabanus's commentary on each poem. Wimpfeling et al. contributed added prefatory and closing material as well as a full transcription of each *carmen figuratum* text before the *declaratio*. This addition demonstrates another way in which Wimpfeling attempted to customize Hrabanus's original work for an extended lay audience. With the new transcription of each poem, audiences had another layer of didactic material to walk them through the contemplative process of digesting Hrabanus's complex work.

Outside of the new didactic material, the content of the text remained the same, as it must, to retain the coherency and legibility of each poem, as well as the work as a whole. Before this, new commentaries were almost never produced. Berthold of Nuremburg in the fourteenth century was an exception, but his commentary was not interwoven with Hrabanus's text; it was appended at the end.[42] After the tenth and eleventh century many more manuscript copies of *In honorem* were compiled with other works, but many were miscellanies and, besides the fact that the included works might be thematically related, the texts were not typically altered to create a stronger link between the separate works. Wimpfeling et al. did not compile *In honorem* with other publications and thus retained a similar format to the earliest manuscript copies. These choices make sense, as German humanists of this time looked to demonstrate the continuity of German glory from antiquity through to the present (including

41 Heikkinen, "Re-classicizing Bede" 4.
42 Hamburger J., *Diagramming Devotion: Berthold of Nuremberg's Transformation of Hrabanus Maurus's Poems in Praise of the Cross* (Chicago: 2020).

108 MICHAEL

through the Carolingian Empire).[43] In another form of customization, by keeping *In honorem* as close to its original form as they could, Wimpfeling et al. translated the work into print in a way which provided the most 'authentic' collection of Hrabanus's poems while catering to their new audience.

This process involved working from multiple manuscript copies during the editorial process instead of from one exemplar, as would likely have been done in earlier centuries when creating new manuscript copies.[44] In fact, in a letter to Johannes Trithemius, sent from Speyer on September 17, 1492, Wimpfeling explicitly writes that he had read *De dominicae crucis laudibus*, a poem 'without any kind of imitation'. In describing the poem in this way (*sine cuiusquam imitacione*), Wimpfeling coveys his awe to Trithemius, suggesting that this was likely the beginning of his desire to create a printed volume. He also notes that he viewed the work in Mainz and other Rhenish monasteries in the vicinity, implying that he had set eyes on more than one copy.[45] Based on these words and on the quality of the final product, it is extremely likely that those involved in the process of translating from manuscript to print consulted multiple exemplars for the work, which differed from the typical print tradition of referencing one exemplar.

Wimpfeling must have had access to a copy, or to a combination of copies, which included the following: the intercession of Alcuin for Hrabanus (Perrin's A2), the dedication to Pope Gregory (A3), the Louis the Pious *carmen* (A5), and Hrabanus's signature poem (A8).[46] Of the manuscript copies that survive today, Reg. Lat. 124 [Figs. 4.1, 4.3] was in Mainz at the time of Wimpfeling's visit and contains all the aforementioned materials. It thus serves as a possible ninth-century exemplar for the 1503 printed edition.[47] The manuscript would

43 Woods, *Forgery* 63–71.

44 For a detailed analysis of this topic see Endrődi, '"Damit siegt Hrabanus" 4, n. 15–18.

45 Johannes Trithemius, a German Benedictine abbot, was known as a cryptographer and occultist. Wimpfeling likely thought he would be interested in Hrabanus's *magnum opus*, especially in the poems for their cryptographic quality. See Letter 33 in Herding O. – Mertens D., *Jakob Wimpfeling-Briefwechsel, Erster Teilband* (Munich: 1990) 201–209, esp. 205: 'Testis est, qui sanctum et admirabile opus *De dominice crucis laudibus carmine sine cuiusquam imitacione conscripsit.* Testimonium prebent ornatissima vetustissimaque diuresis in locis epigrammata, que hodie extant, que in Magunciaco cenobiisque plurimis Rheno finitimis nosipsi summa cum iucunditate vidimus et lectitauimus'. Herding and Mertens remark that although such an early stay in Mainz is not directly attested, it was most likely connected to the trial of Johannes von Wesel (d. 1481 in Mainz); see 202, n. 2.

46 See Perrin, M.J.-L., *L'iconographie de la Gloire à la sainte croix de Raban Maur* (Turnhout: Brepols, 2009) for this numbering.

47 Spiller notes that the copy in Turin (Biblioteca Nazionale Universitaria, K.II.20 (R 1456)) contains the dedication to Gregory IV, but does not mention if it contains the intercession

have been a treasured possession at Mainz (where Hrabanus was Archbishop from 847 to 856). It also makes sense that Wimpfeling would want to reference a manuscript copy tied as closely as possible to Hrabanus, both to achieve accuracy in his edition and to patriotically imbue the print copy with the prestige of the famed and admired German archbishop.[48]

Another possible exemplar is a manuscript much like Österreichische Nationalbibliothek MS 652 Theol. 39. Although this copy is thought to have been in Würzburg beginning in the fourteenth century, the influence of a similar exemplar is likely due to a specific detail found in the poem containing the four evangelist symbols and the Agnus Dei.[49] In this manuscript, as well as in Wimpfeling's edition, the Agnus Dei's head is shown in profile, with only one eye visible. In Reg. Lat. 124, the Agnus Dei appears with three visible eyes. The majority of ninth-century manuscript copies do not contain a three-eyed Angus Dei, which demonstrates that a second ninth-century copy was consulted, or that Wimpfeling and/or the woodblock artist chose not to include the third eye. Furthermore, while Wimpfeling's edition does not include a specific dedication (e.g. to Otgar, Archbishop of Mainz, the Abbey of St. Denis, etc.), as do other ninth-century copies, this does not mean that he did not reference a manuscript containing such a dedication. He may simply have decided to omit material of such a specific nature to fulfill his aim of creating a print copy that was useful for a wider audience. Ultimately, a combination of exemplars makes sense. Wimpfeling would have wanted to consult multiple copies overseen by Hrabanus to ensure that his printed edition was the most accurate it could be.

Considering the dedicatory images from both ninth century and later manuscript copies reveals that the woodcut artist may have consulted different copies of *In honorem* to create the images for the printed edition. These images in ninth-century copies, like the ones Wimpfeling would have seen in Rhenish monasteries, appear two-dimensional and sparsely populated [Fig. 4.3]. To produce a woodcut image like the one in the printed edition [Fig. 4.4], another, later exemplar – one that contained architectural frameworks and additional details – such as Cod. Theol. et philos. 2° 122, now in Stuttgart (c. 1490 CE),

image or that of Louis the Pious. Additionally, if it is, as Spiller suspects, the copy made for Eberhard, Margrave of Friuli, then the manuscript would not have remained in Fulda. See Spilling H., *Opus Magnentii Hrabani Mauri in honorem sanctae crucis conditum. Hrabans Beziehung zu seinem Werk* (Frankfurt am Main: 1992) 69–70.

48 Reg. Lat. 124 contains marginal notes made in Hrabanus' own hand.

49 Hermann H.J., *Die frümittelalterlichen Handschriften des Abendlandes (Beschreibendes Verzeichnis der illuminierten Handschriften in Österrich. I. Band: Die illuminierten Handschriften und Inkunabeln der Nationalbibliothek in Wien)* (Leipzig, 1923), b88.

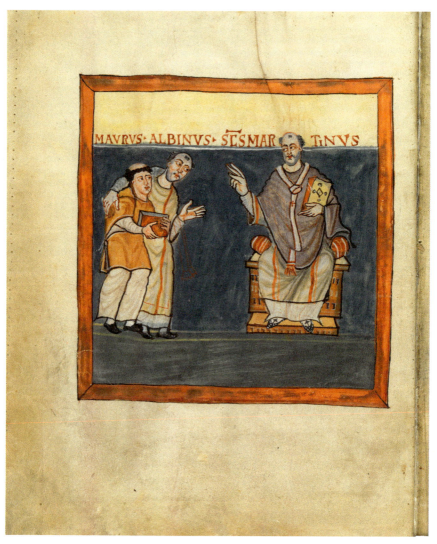

FIGURE 4.3 Dedication Image, c. 825–850 CE; detail from Hrabanus Maurus's *In honorem sanctae crucis*, fol. 2v. Tempera and ink on parchment, 365 × 295 mm. Rome, Biblioteca Apostolica Vaticana, Reg. Lat. 124
© BIBLIOTECA APOSTOLICA VATICANA

would have needed to be consulted [Fig. 4.5]. As Wimpfeling's goal was to create a version of Hrabanus's work that celebrated German heritage while appealing to a contemporary audience, it makes sense that the artist fashioned the woodcuts from more contemporary-styled miniatures, taking advantage of the increase of manuscript production of *In honorem* that took place in fifteenth-century Germany.

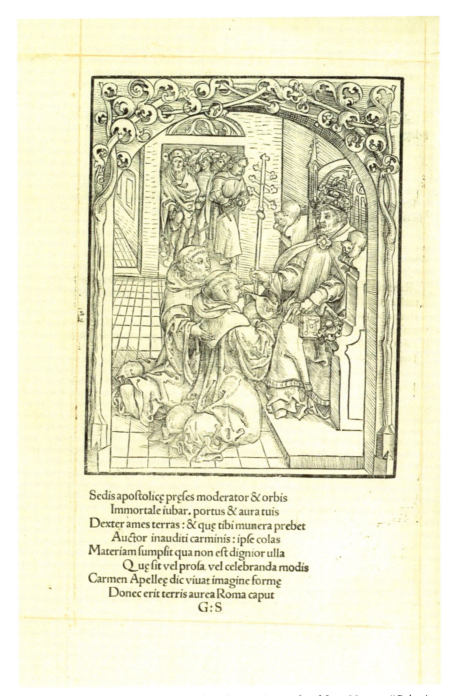

FIGURE 4.4 Hans Schrotbanck (designer), Dedication Image; detail from *Magnencii Rabani Mauri de laudi[bus] Sanctae Crucis opus* (Pforzheim, Thomas Anshelm – Jakob Wimpfeling: 1503), fol. Aa v r. Woodcut, 310 mm (fol.); Atlanta, Pitts Theology Library, Candler Theology School, Emory University, 1503 HRAB
CREATIVE COMMONS 0 LICENSE

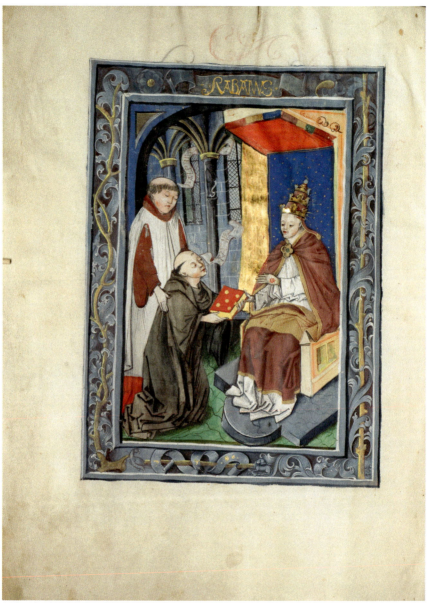

FIGURE 4.5 Dedication Image, c. 1490 CE; detail from Hrabanus Maurus's *In honorem sanctae crucis*, fol. 1v. Tempera, ink, and gold on parchment. Stuttgart, Württembergische Landesbibliothek, Cod. Theol. et philos. 2° 122
© WÜRTTEMBERGISCHE LANDESBIBLIOTHEK. PUBLIC DOMAIN

In addition to the dedication images, the woodcut draftsman, who recent research has shown to be Hans Schrotbanck, played a further role in customizing the Wimpfeling's printed edition of *In honorem*.[50] He faced a number of challenges to do this, the most important of which were: printing in both red and black, printing poems with a combination of organic and geometric pictorial elements, and maintaining the outlines of the *versus intexti* in order to retain the legibility of both the hidden verses and the text of each *carmen figuratum* as a whole.[51] Three different strategies were devised to navigate these challenges: creating completely xylographic prints, where the entire poem was carved into a printing block [Fig. 4.6]; partially xylographic prints, where portions of the poem were carved into printing blocks and others were made using movable type [Fig. 4.7]; and prints made completely from movable type with small woodcut accents [Fig. 4.8]. When analyzing the distribution of these three types of prints, what stands out is that the *carmina figurata* that include more organic lines (pictorial images), such as the crucified Christ, are completed either fully, or at least partially, through xylographic printing. Creating several folio-sized woodblocks that included textual and pictorial mixed elements, with no room for error would have been incredibly time-consuming and expensive. The distribution of techniques also demonstrates the difficulty of printing a work as complicated as *In honorem* and highlights the amount of labour expended to embed the *carmina figurata* containing complex geometric and pictorial forms, within the larger publication. The amount of work put into these prints is made even more astonishing by the fact that Wimpfeling and Anshelm's edition only saw a single print run.

This being said, this print publication of *In honorem* allowed a wider lay audience (reflecting Wimpfeling's invitation to "everyone who is truly Christian") to read the *carmina figurata* of a celebrated German archbishop without the prerequisite of being a member of the monastic or upper-elite classes. Wimpfeling likely had a literate, educated audience in mind, considering that the entire work (including the paratextual components) is in Latin.[52] Although

50 Endrődi G., "Hans Schrotbanck", in *Allgemeines Künstler-Lexikon. Die bildenden Künstler aller Zeiten und Völker, Bd. 102* (Berlin: 2019) 227; Endrődi included a long description of these prints in his 2017 presentation, "Ein Zeitgenosse Dürers neu entdeckt: Der Straßburger Künstler Hans Schrotbanck", Zentralinstitut für Kunstgeschichte (Munich: May 3, 2017). I owe him a debt of thanks for supplying me with his transcript and slides.

51 Perrin M.J.-L., "Un nouveau regard jeté par Jakob Wimpfeling (1450–1528) sur la culture antique et chrétienne [Quelques réflexions en marge de l'édition du *De laudibus sanctae crucis* de Raban Maur (Pforzheim 1503)]", *Bulletin de l'Association Guillaume Budé*, 1 (1992) 74.

52 One might compare this to Brant's *Das Narrenschiff* (1494) which was published in German and was clearly supposed to reach a broader lay audience.

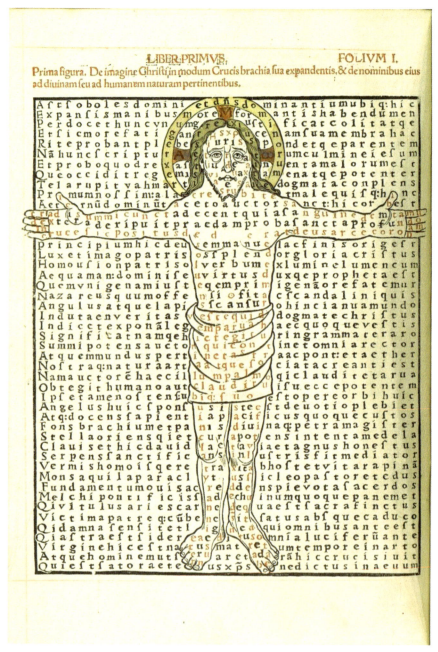

FIGURE 4.6 Hans Schrotbanck (designer), *Crucified Christ;* Woodcut; detail from *Magnencii Rabani Mauri de laudi[bus] Sanctae Crucis opus* (Pforzheim, Thomas Anshelm – Jakob Wimpfeling: 1503), fol. a i v. Woodcut, 310 mm (fol.); Atlanta, Pitts Theology Library, Candler Theology School, Emory University, 1503 HRAB
CREATIVE COMMONS 0 LICENSE

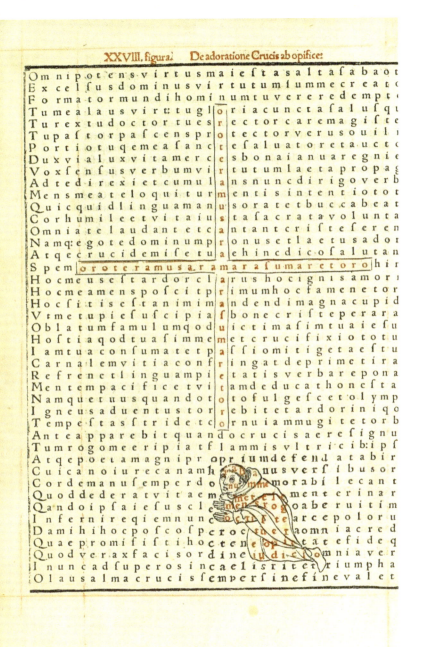

FIGURE 4.7 Hans Schrotbanck (designer), *Hrabanus Praying*; detail from *Magnencii Rabani Mauri de laudi[bus] Sanctae Crucis opus* (Pforzheim, Thomas Anshelm – Jakob Wimpfeling: 1503), fol. k iii v. Woodcut, 310 mm (fol.). Atlanta, Pitts Theology Library, Candler Theology School, Emory University, 1503 HRAB
CREATIVE COMMONS 0 LICENSE

XXVI figura. De prophetarum fentenciis. quę ad paffionem Chrifti.
et ad noftram redemptionem pertinet.

```
Ergoprophetarumbene  e  tecruxfamenhonorat
Praedicatexaltatre   f  onattuafactafutura
Infpiratafacrotunc   p  lebsqodprotulitore
Spiritusetfanctufi   l  lismandaueratintus
Omniacumcriftumrepa  a  rareloqunturetinte
Confixumdominumcon   c  edereregnabenignis
Dauidperfofasillih   i  epalmaquepedesque
Dixeratatqecibofelt  t  radietpoculoacetum
Dequetuolignoregema  a  fferitomnibusipfum
Huicpuerohumeriseff  f  eimperiuoratefayas
Corpuspercuffummanu  u  umextenfumorebeato
Confputamfaciemperp  p  endensfunufetaftum
Atq: leuatamadtedifpe r rfoscurrereifrahel
Hieremiasagnumdefcr  i  ribitceuholocauftum
Adtractumfinevocepi  i  umlignoquecibandum
Hiezechielcernitvis  u  utaugrammatefignum
Eruereplebematq:cruc c  isducentisadinftar
Sictufanctafalusvir  r  tusesvifaprophetis
Esplacitafuperifcru  u  xhuicesnauitamundo
Namdanielcriftumdix  x  ithicplebeabiniqua
Multandumetfinemdeh  h  incnoxiatotatenere
Ofeefaluandumpopulu  u  mmortisquoquemorte
Praedicatatqeiohel   i  illapraedixerathora
Etlolemetftellasluc  c  emnonfundereterris
Hocidemetinfauftaf   e  ftapraedixeratamos
Abdiasinfidiasiona   s  quoquefunerafinxit
Michadeimontemnaum   n  untiatultioquidfit
Cornuafanctacrucis   a  bbacucpraedicatore
Sofoniasquediemdud   u  mdominiauditamaram
Aggeushincqepolosd   i  xitterramquemoueri
Zachariasiefumreno   t  atperfordidaveftis
Plagasinmanibusfix   a  splangerequemultos
Malachiascernitfum   m  umdominarepeorbem
Ardentiquerogomund   u  metfudareminiftros
Haectuafactaprobie   n  dicebantorepriores
Cruxalmavateshaece   d  iditauctorinhifque
Tupiaconplerashaec   o  omniapaffiochrifti
```

FIGURE 4.8 Hans Schrotbanck (designer), Christ's passion is our redemption; detail from
Magnencii Rabani Mauri de laudi[bus] Sanctae Crucis opus (Pforzheim, Thomas
Anshelm – Jakob Wimpfeling: 1503), fol. i iv v. Woodcut, 310 mm (fol.). Atlanta,
Pitts Theollgy Library, Candler Theology School, Emory University, 1503 HRAB
CREATIVE COMMONS 0 LICENSE

it is impossible to know who owned most copies of this edition, a few prominent humanists left an *ex libris* or mentioned *In honorem* in personal correspondence. In a letter to Reuchlin, dated October 1, 1503, Conradus Mutianus (aka Konrad Mutian, c. 1470–1526) writes about anticipating the new edition of Hrabanus's work.[53] Other prominent humanists such as Beatus Rhenanus (c. 1485–1547), who, like Wimpfeling, came from Schlettstad (Sélestat), and Hartmann Schedel, the author of the Nuremberg Chronicle, also acquired copies of the work once it was printed.[54] In fact, Schedel mentions *In honorem* in his famous 1493 text, writing, "Hrabanus, a monk and German abbot of Fulda, later archbishop. Of Mainz, and a very famous and distinguished theologian and poet, at this time through the greatness of his intelligence wrote many excellent books, especially that miraculous work On the Praises of the Holy Cross".[55] The anticipation for the printed edition and the reverence held for Hrabanus's *In honorem*, even before 1503, demonstrates that Wimpfeling had a humanist market in mind for his edition and was more than likely speaking primarily to them in his added material in order to form, in his eyes, a reformed, more moral set of scholars than the Italians or French.

This expanded audience then took the customization of the work into their own hands by adding hand-coloring and inscriptions, and by pairing *In honorem* with other printed works. The copy of *In honorem* held at Emory University's Pitts Theology Library offers examples of hand colored illustrations [Fig. 4.6]. Although the shift in medium resulted in the loss of the colorful, sometimes opulent, decoration that was characteristic of earlier manuscript copies, owners could add their own elements of decoration that were no less meaningful. What is most interesting, however, is *where* they chose to add color. The pigment is placed largely within the most visually pictorial examples of the *carmina figurata* (e.g., Louis the Pious, Christ, the angels and seraphim, the Agnus Dei and Evangelist symbols, and floral motifs). As in the manuscript copies,

53 "Emi Rabanum tuum, Germanorum eruditissime, tuum iure dixi, quem et urbs tua patria quasi ab inferis revocavit et tu bene tornato ac mire gravi sanctoque poemate illustrasti." Letter 2 in Rufus C.M., *Der briefwechsel des Conradus Mutianus*, Hendel O. (ed.) (1890), 2.

54 Beatus Rhenanus's personal library, as well as many books of Wimpfeling's, were acquired by the Humanist Library of Sélestat. Beatus Rhenanus's copy of *In honorem* remains there today (Cote: K 1012a). Schedel's copy of *In honorem* is in the Bayerische Staatsbibliothek (BSB-ID 1780319).

55 "Rabanus monachus natione Germanus, abbas Fuldensis, postea Maguntinus archiepiscopus, theologus quidem praeclarissimus, ac insiguis poeta, per hoc tempus in prosa et carmine plurimum valuit; qui ex ingenii sui magnitudine multos edidit libros, praecipua opus mirandum de Laudibus sanctae Crucis ..." Schumuch W.W. and Hadavas K., *First English edition of the Nuremberg chronicle: being the Liber chronicarum of Dr. Hartmann Schedel ...* (Madison 2010) folio CLXIX recto.

changes to the copies of the printed edition cluster at these poems, suggesting that their iconotextual properties particularly appealed to reader-viewers.

The copy held at the Boston Public Library includes an inscription which demonstrates which part of the volume the owner considered most important [Fig. 4.9]. The only handwritten text in the volume, it appears above the figured poem of the crucified Christ: *Huius imagines duo oculi duo O esse debent et faciunt dictionem sexti versus oro cum R in naso* (The two images of an eye should be two Os and they make, with the R in the nose, the term 'oro' of the sixth line). The scripted interpolation refers to the pictorial and textual nature of the poem and to the owner's own attempts to uncover the layered messages of Hrabanus's poem. The owner uses the terms *imagines, dictionem, sexti versus*; *imagines* (image) refers to the pictorial nature of the eyes in the poem; *dictionem* (term) delineates a word (*oro*) that is revealed from the understanding of the eyes functioning as letter *O*s alongside a clearly textual letter *R* that appears in the nose of Christ; and *versus* (line/verse) acknowledges the textual poetic nature of the work while noting where this particular term (*oro*) appears. In this way, the marginal notation acts as a window through which we can observe the owner's contemplative and multi-modal interaction with the work.

Finally, a copy from the Folger Shakespeare Library is combined with Hrotsvitha of Gandersheim's *Liber Secundus (Book of Drama)*, published by Conrad Celtis (c. 1459–1508) in 1501, just two years before Wimpfeling's *In honorem*. Hrotsvitha, the first known female writer from German lands, was a secular canoness known for her dramas and poems.[56] The choices of collated publications, such as *In honorem* and *Liber Secundus*, and the manner of their interaction, can lend insight into how the owner understood the assembled works, both separately and as complements. The book begins with two woodcuts by Albrecht Dürer, one that shows Celtis presenting the publication to the Elector of Saxony, and another that shows Hrotsvitha presenting her work to Emperor Otto [Fig. 4.10]. Peter Bloch writes about how the format of Hrabanus's dedication images from *In honorem* served as a template for similar images across several centuries.[57] By combining these two printed texts into one volume, the owner created a visual juxtaposition emphasizing the continuation of this tradition.

56 Frankforter D.A., "Hrotswitha of Gandersheim and the Destiny of Women", *The Historian*, 1.2 (1979) 295–314.

57 Bloch P., "Zum Dedikationsbild Im Lob Des Kreuzes Des Hrabanus Maurus", in Elbern V.H. (ed.) *Das Erste Jahrtausend. Kultur und Kunst im werdenden Abendland an Rhein und Ruhr, Textband 1* (Dusseldorf: 1962) 493–494.

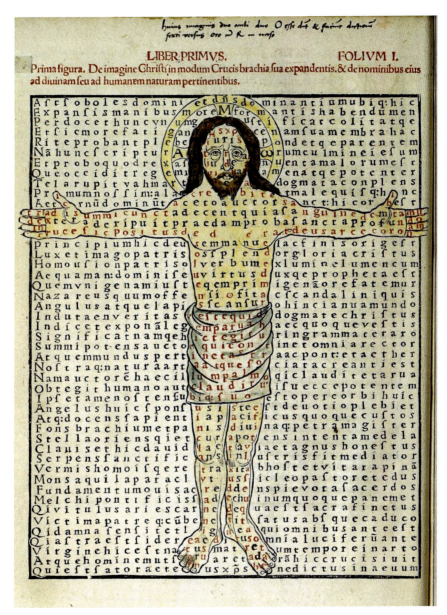

FIGURE 4.9 Hans Schrotbanck (designer), *Crucified Christ*; detail from *Magnencii Rabani Mauri de laudi[bus] Sanctae Crucis opus* (Pforzheim, Thomas Anshelm – Jakob Wimpfeling: 1503), fol. a i v. Woodcut, 310 mm (fol.). Boston, Boston Public Library, G.H01.72

PUBLIC DOMAIN

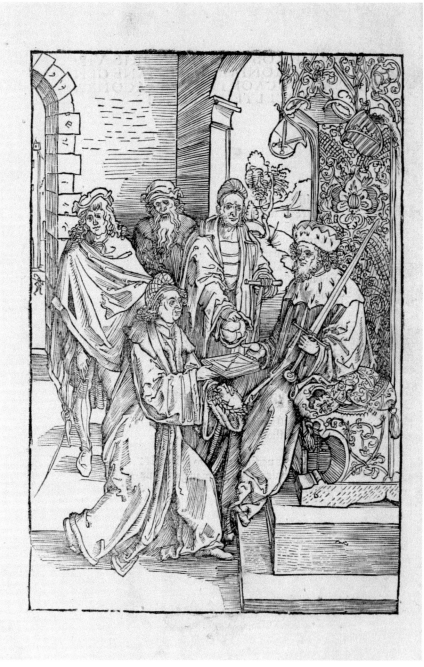

FIGURE 4.10 Albrecht Dürer (designer), *Hrotsvitha presenting her work to Otto I*; detail from *Opera Hrosvite, illustris virginis et monialis Germane, gente Saxonica orte, nuper a Conrado Celte inventa* (Nuremberg, Conrad Celtis: 1501), a i v. Woodcut, 310 mm (fol). Los Angeles, Getty Research Institute, PA8340.A12 1501
© GETTY RESEARCH INSTITUTE. PUBLIC DOMAIN

Hrotsvitha's text consists of six plays conceived of as love dialogues. Just as Wimpfeling highlights the dangers of pagan material in his preface to *In honorem*, Hrotsvitha, in her *Liber Secundus*, contrasts the chastity and perseverance of Christian women to the emotional and weak Roman women portrayed by Terence.[58] In her preface to her plays, she writes:

> There are many Catholics, and we cannot entirely acquit ourselves of the charge, who, attracted by the polished elegance of the style of pagan writers, prefer their works to the holy scriptures. There are others who, although they are deeply attached to the sacred writings and have no liking for most pagan productions, make an exception in favour of the works of Terence, and, fascinated by the charm of the manner, risk being corrupted by the wickedness of the matter. Wherefore I, the strong voice of Gandersheim, have not hesitated to imitate a poet [Terence] whose works are so widely read, my object being to glorify, within the limits of my poor talent, the laudable chastity of Christian virgins in that self-same form of composition which has been used to describe the shameless acts of licentious women.[59]

Just as Wimpfeling understood Hrabanus's *In honorem* as more moral and cleverer than efforts by pagan poets, Hrotsvitha, nearly five centuries before, already proclaimed herself to be undertaking a similar mission. The owner of the Folger copy likely understood Hrotsvitha's work as a complement to Hrabanus's since she, too, offers moral guidance. Furthermore, based on the specificity of the nature of the content, the owner may have even been a woman herself. Thus, not only would the reader-viewer be able to connect the two works in terms of visual content, but there was a strong textual and thematic bridge between them as well.

Between the release of the 1503 printed edition and the year 1600, no other printed editions were published. Additionally, recent research on the print techniques used for Wimpfeling's edition suggests that the woodblocks would have been rendered unusable after a single print run. For any poem comprised of a woodblock print which included red letters enclosed within black lines (e.g., Louis the Pious and the Crucified Christ), the printing technique used required a first printing pass (for red ink) where the black portions of the block would be covered with vellum or paper, and a second (for black ink) where the red letters would be cut away beforehand, rendering the blocks unusable

58 Frankforter, "Hroswitha" 295–314.
59 Rudolph A.K., "*Ego Clamor Validus Gandeshemensis* Hrotsvitha of Gandersheim: Her Sources, Motives, and Historical Context", Magistra 20.2 (2014) 58–90.

122 MICHAEL

afterwards.[60] Unlike other major printing endeavors, such as the Nuremberg Chronicle, which depended heavily on woodcuts that could be reused multiple times, an attempt to recreate Wimpfeling's edition of *In honorem* was likely too time-consuming and expensive.

While the printed edition expanded the audience for Hrabanus's work and produced a new type of intimate interaction with it, some qualities of the manuscript copies, such as the symbolic importance of color and the use of opulent materials like gold leaf, were lost. Additionally, the purpose of several manuscripts made prior to 1500 – to impress and honor their individual recipients – was also replaced. The combination of the loss of manuscript-specific elements and the difficulties in printing a new edition created a situation where, if someone wanted another copy of *In honorem*, a manuscript stood as the better option. Thus, with the appearance of a single manuscript made in 1600 in Prague [Fig. 4.2], the question arises, for whom was this last known manuscript copy of *In honorem* created, and why?

5 Rudolf II and *In honorem*: His *Kunstkammer* and *Studiolo*

The differences in the goals of the print and manuscript mediums were likely a factor when Holy Roman Emperor Rudolf II commissioned a manuscript copy of *In honorem* in the years leading up to 1600 [Figs. 4.2, 4.11]. To enhance the impressiveness of his copy, Rudolf wrote to the monastery at Fulda, where Hrabanus had created *In honorem*, and requested to borrow the ninth-century manuscript (now Vatican Reg. lat. 124) that contained examples of Hrabanus's own handwriting, the same copy that Wimpfeling likely consulted a century earlier [Figs. 4.1, 4.3].[61] Unlike Wimpfeling, the compilers of Rudolph's edition consulted only this single original manuscript, evidence of which can be seen in the return to the layouts of the ninth-century dedication images [Figs. 4.3, 4.11] as well as the text format of the Fulda copy.

The archive at Fulda contains the letter from Rudolf to Johann von Westernach (secretary to Archduke Ernest of Austria), written on June 15th, 1598, which requests the loan of the *In honorem* manuscript to Prague.[62]

60 Endrődi, "Damit siegt Hrabanus" 2, n. 6 and 7.

61 Perrin M.J.-L., "Le De laudibus sanctae crucis de Raban Maur et sa tradition manuscrite au IXᵉ siécle", *Revue d'histoire des textes* 19 (1989) 202. Perrin concludes that Reg. Lat. 124 is the copy that was borrowed from Fulda, citing very specific variations of the text that are only common to these two manuscripts.

62 Schlosser J. von, *Eine Fulder Miniaturhandschrift* [*De laudibus sanctae crucis*] (Vienna: 1892) 29.

FIGURE 4.11 Dedication Image, c. 1600 CE; detail from Hrabanus Maurus's *In honorem sanctae crucis*, fol. 3v. Tempera, gold, and ink on parchment, 350 × 298 mm. Paris, Bibliothèque nationale de France, Bibliothèque d'Arsenal, Ms-472
© BIBLIOTHÈQUE NATIONALE DE FRANCE [FAIR USE POLICY]

Another letter, dated August 4th, 1598, now in the archives in Vienna, confirms the receipt of the manuscript by Rudolf and reads:

> Recipisse an den von Westernach pro überschickt buech Rabani Mauri. Rudolf etc. Ersamer Lieber andechtiger. Wir haben das begerte alte geschribne buech Rabani Mauri aus dem stift Fulda, so du uns zuwegenbracht und zukommen lassen, wol empfangen und gern gesehen […][63]

63 Schlosser, *Eine Fulder Miniaturhandschrift* 30, n. 1.

124 MICHAEL

> Receipt for the book of Rabanus Maurus sent by von Westernach. Rudolf
> (etc.) to the most honorable reader. We have well received and gladly
> seen the desired old, handwritten book of Rabanus Maurus from the
> monastery of Fulda, that you have sent and had delivered to us.

The manuscript seems never to have been returned to Fulda, as was typi-
cal under Rudolf; it was likely then taken to Sweden as war booty by Queen
Christina in 1648. An inventory confirms that other manuscripts were seized
at this time, and although *In honorem* is not specifically listed, its presence at
the Vatican Library – where Christina sent much of her collection when she
travelled from Sweden to Rome in 1654–55 – suggests that it almost certainly
met the same fate.[64]

It is illuminating to consider not only why Rudolf would want a manuscript
copy of *In honorem* for his collection, but why he would specifically request that
the manuscript be copied from a ninth-century exemplar, one with direct ties
to Fulda and Hrabanus. Rudolf most certainly could have acquired a printed
copy of the work for his collection, but returning to the medium of manu-
script clearly appealed to him. Scholars have suggested, based on descriptions
of similar objects in an inventory of Rudolf's collections from 1607–1611, that
the manuscript was intended for Rudolf's *Kunstkammer*.[65] Rudolf had one of
the most extensive *Kunstkammern* north of the Alps and, through symbolic
arrangement and display, he used it to demonstrate his magnificence and
power to prominent visitors. However, recent scholarship has investigated the
purpose and contents of Rudolf's *studiolo* at Prague Castle – another potential
location of his copy of *In honorem* – examining how this more intimate space

64 Perrin, "Tradition manuscrite" 202. *In honorem* was indeed in her collection at this time.
 An inventory of Christina's book and manuscript collections, made by Isaac Vossius's
 in c. 1653, mentions 'Eiusdem [Rhabani Mauri] de Sancta Cruce'. Rome, Biblioteca
 Apostolica, Vat.lat.817, fol. 211r.
65 Bauer R. – Haupt H., "Die Kunstkammer Kaiser Rudolfs II. in Prag, ein Inventar aus den
 Jahren 1607–1611", *Jahrbuch der Kunsthistorischen Sammlungen in Wien* 72 (1976) 1–37.
 A vague inventory entry on a manuscript in the inventory may even refer directly to
 a copy of *In honorem*, although the evidence is tangential at best. See 131, entry f. 377,
 2585: 'In folio: ein philosophisch alt geschriben buch mit figurn und ein copey uff perga-
 men geschriben vom Mathes Dörrer, ungebunden, welchs nit gantz beysamen und Herr
 Hayden auß bevelch I. Mt: etliche bletter davon genommen'. (In folio: a philosophical, old,
 handwritten book with drawings and a copy on parchment by Mathes Dörer, not bound,
 not completely collated and of which Mr. Hayden removed some leaves on order of his
 majesty'.) Another possibility may be entry 2591 on the same page: 'In folio und überlengt:
 Allerley künstliche schrifften uff pergamen'. (In folio and larger: All kinds of artistic writ-
 ings on parchment.)

interacted with and complemented the more public *Kunstkammer*.[66] Both of these spaces may have housed this manuscript and it is worth briefly addressing each of them in turn.

The origins of *studioli* trace back to the papal palace in Avignon in the late fourteenth century. Even from this early date, the *studiolo* existed as an attachment to the main library where the pope's collection was housed, indicating a separate purpose for the room, and this became a model that other prominent Europeans began to adopt in their own living spaces.[67] For example, Antonio Montecatini, an ambassador from Ferrara, famously wrote in 1480 about Lorenzo de' Medici's visit to Piero de' Medici's *studiolo*. His description marks the *studiolo* as a place where impressive objects (including books) were used for study, but also as representations of the owner's "discriminating taste, and perhaps most notably, of his wealth".[68] The *studiolo* served as a place for contemplation, even relaxation, and was accessible only to the owner of the collection and those within their closest circle.

From their inception, the practice of housing illuminated manuscripts in *studioli* was common. To give another example among many, the old Medici Palace in Florence, founded by Cosimo the Elder in the fifteenth century, held illuminated manuscripts in its *studiolo*.[69] The practice of collecting manuscripts and eventually printed books in medieval and early modern libraries fed into the development of these more intimate study spaces.[70] Books were the major component of early *studioli* and contributed to the heavily curated collections of scores of high-profile individuals, such as Rudolf.

In fact, in 1464, Filarete included an account of Piero's *studiolo* in his *Treatise on Architecture*. He writes:

66 Fornasiero A. – Zlatohlávková E., "The *Studiolo* of Rudolf II at Prague Castle", *Journal of the History of Collections* 32.2 (2020) 239–244; Fornasiero A. – Zlatohlávková E. – Kindl M., *From Studiolo to Gallery: Secular Spaces for Collections in the Lands of the Bohemian Crown on the Threshold of the Early Modern Era* (Prague: 2020).

67 Kerscher G., Architektur als Repräsentation: Spätmittelalterliche Palastbaukunst zwischen Pracht und zeremoniellen Voraussetzungen. Avignon – Mallorca – Kirchenstaat (Tübingen – Berlin: 2000) 91–92. The first secular studiolo was that of King Charles V of France, who ruled between 1364 and 1380.

68 Campbell S., *The Cabinet of Eros: Renaissance Mythological Painting and the Studiolo of Isabella d'Este* (New Haven: 2006) 30; Syson L. – Thornton D., *Objects of Virtue: Art in Renaissance Italy* (London: 2001) 81–82; Hatfield R., "Some Unknown Descriptions of the Medici Palace in 1459", *Art Bulletin* 52 (1970) 232–249.

69 Fornasiero – Zlatohlávková – Kindl, *From Studiolo to Gallery* 31.

70 Fornasiero – Zlatohlávková – Kindl, *From Studiolo to Gallery* 53–54.

He has himself carried into a studio ... When he arrives there, he looks at his books. They seem like nothing but solid pieces of gold. They are most noble within and without, in Latin and in the vernacular to suit man's delight and pleasure. Sometimes he reads on or the other or has them read. He has so many different kinds that not one day but more than a month would be required to see and understand their dignity ... He has honored them, as you have understood, with fine script, miniatures, and ornaments of gold and silk, as a man who recognizes the dignity of their authors and through love of them has wished to honor them in this manner.[71]

This description could easily be of the luxury copy of *In honorem* commissioned by Rudolf. With its red velvet cover, richly saturated miniatures, and copious amounts of gold and silver gilding, not to mention the meticulously neat scripts, Arsenal Ms. 472 certainly reflects the type of reverence and honor for the book itself, but also for its author, that Filarete highlights.

As the practice of creating *studioli* continued, art objects were gradually added, first as study tools, and then as objects in their own right.[72] Stephen Campbell details that towards the end of the fifteenth century, the *studiolo* in the Medici palace was transformed from a private chamber to a space of luxury, one that had properties of a domestic treasury and a proper library. He writes that:

What distinguishes the study from these other spaces ... is a particular selectiveness and calculated presentation, the sense that these are objects with a particular closeness to their owner, which can thus stand as a synecdochic representation of the principal occupant. This relation to an owner is sustained because the contents of the *studiolo* are conceived as objects for that owner's use, as extensions of himself ...[73]

In their private, designated study spaces, owners could reflect on these luxury objects, illuminated manuscripts, and printed books, in order to construct an internal version of themselves through introspection and one for visitors cultivated through presentation and performance. Filarete's account demonstrates how books and precious objects complemented one another in this

71 Filarete, *Treatise on Architecture*, Spencer J. (trans.), 2 vols. (New Haven – London: 1965) I, 320.
72 Fornasiero – Zlatohlávková – Kindl, *From Studiolo to Gallery* 35–38.
73 Campbell, *The Cabinet of Eros* 31.

endeavor, a practice Rudolf II surely cultivated. To avoid criticism of irreverent opulence, however, the collection and use of the *studiolo* needed to adhere to the Christian ideological model of 'studious solitude', that of a 'paradigmatic scholar-saint'.[74]

By ordering the production of his own luxury *In honorem* manuscript, Rudolf had the opportunity to replicate and add to the lavish nature of earlier copies. His manuscript would function both as a book and as an object. It would portray Rudolf as a man of power and wealth to special visitors to the *studiolo* and would serve as a contemplative tool for the emperor himself.

Kunstkammern in turn developed out of the *studioli* and reflected the 'humanistic emphasis on the individual' and a desire for study and knowledge of the new world.[75] It thus makes sense that *Kunstkammern* contained many of the same types of objects as *studioli* – including illuminated manuscripts – in addition to an expanded range of objects, ordered by type and function. Eliška Zlatohlávková eloquently describes both the difference and overlap between *Kunstkammer* and *studiolo*:

> *Studioli*, originally designed as spaces for education and meditation, used to house mainly books, while artworks served as complements to reading. On the contrary, artworks (along with various natural-material rarities and *objets d'art*) were the cornerstone of the furnishing of *Kunstkammern*, while books could not usually be found in these rooms at all, with some honourable exemptions. Libraries were separated from other collections in the 16th century and placed in special rooms, often in immediate proximity to the *Kunstkammer*.[76]

Both types of collections often existed simultaneously, nearly sharing the same space. For example, the Dresden *Kunstkammer*, founded by Elector Augustus of Saxony in 1560, not only contained a specialized library of nearly 300 volumes but also Augustus's private *studiolo* that formed part of the greater, more public *Kunstkammer*.[77] Owners of the collections now had multiple modes with which to convey their messages to various audiences, not only to their inner selves and inner circles, but also to a slightly wider, yet still exclusive circle of visitors.

74 Campbell, *The Cabinet of Eros* 32.
75 Fornasiero – Zlatohlávková – Kindl, *From Studiolo to Gallery* 111.
76 Fornasiero – Zlatohlávková – Kindl, *From Studiolo to Gallery* 111; Busch R. von, *Studien zu deutschen Antikesammlungen des 16. Jahrhunderts* (Ph.D. dissertation, University Tübingen: 1978) 78–79.
77 Fornasiero – Zlatohlávková – Kindl, *From Studiolo to Gallery* 115–116.

Thomas DaCosta Kaufmann has thoroughly examined how Rudolf II used his own *Kunstkammer* as a form of *representatio*, both publicly (when hosting important diplomatic visitors) and privately (as a refuge for contemplation).[78] When ambassadors visited Prague, Rudolf would have them brought through his *Kunstkammer* to make specific political points (depending on the visitor), conveyed through the items in his collection.[79] Dignitaries such as Cardinal Alessandro D'Este, Duke Maximilian I of Bavaria, Elector Duke Christian II, Archduke Maximilian III, Grand Master of the Teutonic Knights and Regent of the Tyrol, and Venetian ambassador Piero Duodo are known to have visited Rudolf's collection.[80] Rudolf saw his *Kunstkammer* as a way to express his *virtus* (worth) and as Holy Roman Emperor, his collection needed to be extravagant in order to confirm his power. Furthermore, DaCosta Kaufmann suggests that Rudolf, who was known to have been fascinated with the occult, may have understood the objects in his collection as talismans with which he could extend his power through the practices associated with memory theatres.[81] Rudolf commissioned many of the objects displayed in his *Kunstkammer*, and his manuscript copy of *In honorem* could have been one such exhibition piece.

As Rudolf likely kept possession of the Fulda copy (Reg. Lat. 124), he would have had the opportunity to study and/or display both copies of *In honorem*, advertising the link to the powerful figure of Hrabanus himself – and by extension, the Carolingian Empire – as well as the time and effort that had gone into the creation of his singular copy. The opulent use of color, shading, script, and gilding would have seemed an enrichment of the ninth-century exemplar. The enhanced modeling of the figures did more than simply bring Hrabanus's work stylistically into the seventeenth century. The figure of Christ seems to protrude into the reader-viewer's space, in a visual allusion (and enactment) of *John* 1:14: 'The Word became flesh and made his dwelling among us'. Thus, even if the visitors had seen a print or manuscript copy of *In honorem* before, they were unlikely to have seen anything like Rudolf's lavishly ornamented and, in this sense, amplified copy. Conceptually, Rudolf's copy of *In honorem* makes sense both within the context of the *studiolo* and that of the *Kunstkammer*. So, are we able to further determine in which context the manuscript was used?

The inventory made by Daniel Fröschl between 1607 and 1611 reveals the systematic way in which Rudolf's collection was organized and listed the objects that resided in the main *Kunstkammer*. However, three rooms, known as the

78 DaCosta Kaufmann T., "Remarks on the Collections of Rudolf II: The *Kunstkammer* as a Form of *Representatio*", *Art Journal* 38.1 (1978) 22.
79 DaCosta Kauffmann, "Remarks on the Collections of Rudolf II" 22.
80 DaCosta Kauffmann, "Remarks on the Collections of Rudolf II" 22.
81 DaCosta Kauffmann, "Remarks on the Collections of Rudolf II" 25.

Vordere Kunstkammer (front *Kunstkammmer*) were not included.[82] As some manuscripts were known to be stored in the *Kunstkammer*, this gap in the inventory leaves room for the possibility that *In honorem* was included in these three rooms at this point in time. However, there remain other possibilities for its location, including the library, which was likely its own separate room, and, as already discussed, the *studiolo*, which may have been a more logical placement for a luxurious manuscript with a contemplative focus.[83]

The general iconographic language of Rudolf's collection uses objects and images to form a microcosm of the world, situating man (in this case the emperor) as controller of that world.[84] The pictorial and textual imagery of *In honorem* (most prominently in poem A5) depicts the emperor as the right hand of Christ, through whom God exercises just rule. Additionally, a level of customization was already at play when Hrabanus created this poem for Louis the Pious. He wrote at the very end of this poem, '… a little while ago I wrote a book for the glory of Christ in verses and prose, which now for you, holy emperor … I offer, the image of whom goes before the beginning, standing in the armor of faith, it shows [you] in victory everywhere'.[85] Although Hrabanus crafted this figure as Louis the Pious, the original recipient of Reg. Lat. 124, in 1600, Louis's role would have been projected onto Rudolf as the patron of Arsenal Ms. 472 [Figs. 4.12 and 4.13]. This projection of identity would have supported and strengthened any claims that Rudolf made linking his Habsburg lineage with that of the Carolingians.[86]

The textual imagery also attests to the emperor's (Caesar/Augustus) right to rule. In Louis's halo the words TV HLVDOVVICUM CRISTE CORONA (You, Christ, crown Louis) appear. The cross in Louis proper right hand holds the message, IN CRUCE XRISTE TVA VICTORIA VERA SALUSQ: OMNIA RITE REGIS (In the cross, Christ is your true victory and salvation, According to the cross of Christ, you solemnly rule with your triumphant truth and salvation). The

82 Fornasiero – Zlatohlávková – Kindl, *From Studiolo to Gallery* 120.

83 Fornasiero – Zlatohlávková – Kindl, *From Studiolo to Gallery* 121; Fučiková E., "The Collection of Rudolf II at Prague: Cabinet of Curiosity or Scientific Museum?", in Impey O. – MacGregor A. (eds.), *The Origins of Museums* (Oxford: 1987) 47–53.

84 Fornasiero – Zlatohlávková – Kindl, *From Studiolo to Gallery* 84.

85 Conscripsi dudum nam Christi laude labellum/Versibus et prosa, tibi quem nunc, inde imperator,/offero, sancta, libens, cujus praecedit imago/stans armata fide victorm monstrat ubique. Translation provided by Dr. Jennifer Awes Freeman.

86 The Habsburgs often attempted to link their heritage to prominent historical, biblical, and mythological figures, such as the Carolingians. Niederstätter A., *Die Herrschaft Österreich: Fürst und Land im Spätmittelalter. Österreichische Geschichte 1278–1411* (Vienna: 2004) 63–67; Lhotsky A., "Apis Colonna: Fabeln und Theorien über die Abkunft der Habsburger. Ein Exkurs zur Cronica Austrie des Thomas Ebendorfer", *Mitteilungen des Instituts für Österreichische Geschichtsforschung* 55, JG (1944) 171–246.

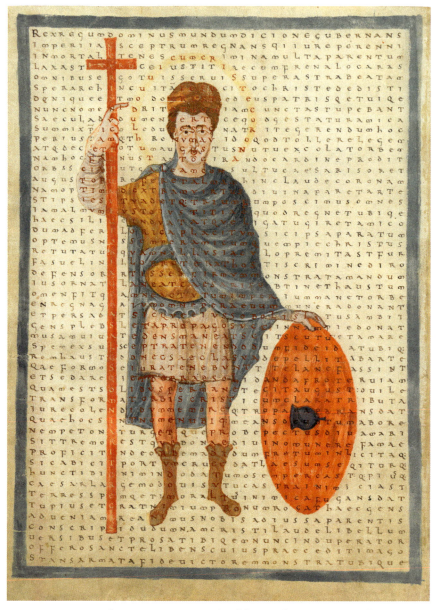

FIGURE 4.12 *Louis the Pious*, c. 825–850 CE; detail from Hrabanus Maurus's *In honorem sanctae crucis*, fol. 4v. Tempera and ink on parchment, 365 × 295 mm. Rome, Biblioteca Apostolica Vaticana, Reg. Lat. 124
© BIBLIOTECA APOSTOLICA VATICANA

REFORMING HRABANUS: ITERATIONS OF *IN HONOREM SANCTAE CRUCIS* 131

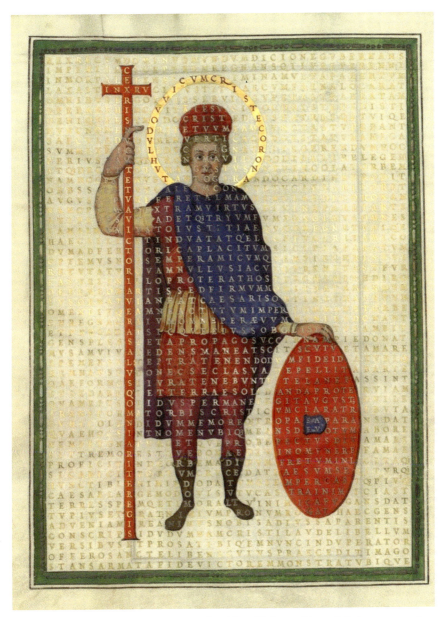

FIGURE 4.13 *Louis the Pious*; c. 1600 CE; detail from Hrabanus Maurus's *In honorem sanctae crucis*, fol. 5v. Tempera, gold, and ink on parchment, 350 × 298 mm. Paris, Bibliothèque nationale de France, Bibliothèque d'Arsenal, Ms-472
© BIBLIOTHÈQUE NATIONALE DE FRANCE [FAIR USE POLICY]

remainder of the *versus intexti* hold similarly themed messages, as does the entirety of the main poem's text. Situated in Rudolf's *studiolo, In honorem* would have served as a contemplative tool for the emperor as he ruminated on how to be a just and pious ruler, following in Louis the Pious's footsteps. Additionally, although there is no evidence that the monastic devotional context of *In honorem* was retained in this case, the manuscript was still used in a contemplative, devotional fashion by the Holy Roman Emperor, as it would have been in one of its original contexts at the Carolingian court.

This reminder to maintain just and pious rule, made up of pictorial and textual components, aligned the iconotextual strengths of Hrabanus's *In honorem* with Rudolf's aim to portray himself as an all-powerful Holy Roman Emperor to visiting diplomats, and to himself. The pictorial and textual images in Rudolf's manuscript highlight its dual functions: to serve as a Mirror of Princes (as it did for Louis the Pious), perhaps for use in his *studiolo*, but also as a magnificent piece of art, potentially for a more public display in his *Kunstkammer*.[87] Anyone who saw its pages would have been impressed by the extravagance of its materials and workmanship, with its themes of divinely sanctioned rule, and with its ties to an important historical figure, Hrabanus Maurus. Furthermore, displaying the original ninth century copy with Hrabanus's handwriting alongside his early modern copy, would have showcased Rudolf's ties to the Carolingians while emphasizing the levels of customization he achieved with *In honorem*.

6 Conclusion

After nearly seven centuries of an established manuscript tradition, the spread of *In honorem* in the early modern period was facilitated by the translation of the work to the medium of print in 1503. This translation, however, was not without challenges and it required significant levels of customization, especially within the image-making process. As there was not another printed edition attempted until 1605, which even then was a verbatim copy of Wimpfeling's edition, *In honorem* offers an opportunity to understand what can happen when a complex iconotextual work like Hrabanus's enters into a more diverse media climate.

Wimpfeling and his collaborators used print to frame Hrabanus's *carmina figurata* in a way that served their ideological purposes – using Christian poets, in lieu of pagan ones, to support a humanistic, moral education in opposition to Italian and French humanism. They simultaneously reflected the

87 The lack of indications of use (e.g. faded pigments, smudges on the margins) support some sort of display function.

iconotextual nature of *In honorem*'s poems in their prefatory textual contributions. The transition to print also allowed for the customization and spread of individual copies of the work, showcasing the multitude of ways in which its new lay reader-viewers interacted with its contents. However, the amount of customization that was required at the level of print production (i.e., woodcuts) helps us think more carefully about the limits of print, even at a time when it had become the dominant mode of production.

Rudolf's return to the medium of manuscript not only made a statement about the idiosyncrasy that a handcrafted manuscript could provide, but it also indirectly reflected the possibility that, in the case of *In honorem*, the level of customization required to produce a printed edition was not practical. Instead of spearheading a new, complex printed edition of Hrabanus's collection of poems, he commissioned a copy of *In honorem* to be made from an original ninth-century copy of the work, one touched by Hrabanus himself. In doing so, instead of using Hrabanus's *carmina figurata* for a broad, ideological purpose, Rudolf formed a specialized object for use in his *studiolo* and/or *Kunstkammer* that allowed him to simultaneously reflect on what it took to be a just and pious leader and to showcase his prestige and power to a more public audience.

Even though the scripted and printed early modern versions of *In honorem* were customized to different ends, both forms of the book succeeded in forging intimate connections with their creators and reader-viewers. In part, the iconotextual nature of Hrabanus's *carmina figurata* allowed them to be employed both within a humanistic pedagogical sphere as well as one centered around imperial reflection and performance. Because the text of *In honorem* is immutable, the challenge became how to alter the materials and effectively supplement the content of the work within these contexts. Considering the few editions and copies of *In honorem* made after the spread of print in Europe, it seems clear that this challenge of customization was too great for early modern bookmakers to overcome.

Bibliography

Bauer R. – Haupt H., "Die Kunstkammer Kaiser Rudolfs II. in Prag, ein Inventar aus den Jahren 1607–1611", *Jahrbuch der Kunsthistorischen Sammlungen in Wien* 72 (1976) 1–37.

Bloch P., "Zum Dedikationsbild Im Lob Des Kreuzes Des Hrabanus Maurus", in Elbern V.H. (ed.,) *Das Erste Jahrtausend. Kultur und Kunst im werdenden Abendland an Rhein und Ruhr, Textband 1* (Dusseldorf: 1962) 471–494.

Blundo G., "Gallus, Jodokus", *Neue Deutsche Biographie* 6 (1964) 55.

Campbell S., *The Cabinet of Eros: Renaissance Mythological Painting and the Studiolo of Isabella d'Este* (New Haven: 2006).

Chisholm H., "Reuchlin, Johann", in *Encyclopædia Britannica: A Dictionary of Arts, Sciences, Literature and General Information* 23 (New York: 1911) 203.

DaCosta Kaufmann T., "Remarks on the Collections of Rudolf II: The Kunstkammer as a Form of Representatio", *Art Journal* 38.1 (1978) 22–28.

Eck C. van, *Art, Agency, and Living Presence: From the Animated Image to the Excessive Object* (Leiden: 2015).

Endrődi G., "'Damit siegt Hrabanus mühelos über Apelles': Johannes Reuchlins Interesse an den Figurengedichten von Hrabanus Maurus", *Daphnis* 51 (2023).

Endrődi G., "Ein Zeitgenosse Dürers neu entdeckt: Der Straßburger Künstler Hans Schrotbanck", Zentralinstitut für Kunstgeschichte (Munich, Institut für Kunstgeschichte: May 3, 2017).

Endrődi G., "Hans Schrotbanck", in Allgemeines Künstler-Lexikon. Die bildenden Künstler aller Zeiten und Völker, Bd. 102 (Berlin: 2019) 227.

Eusebius, *The Life of Constantine* (London: 1845).

Ferrari M., "Dichtung und Prophetie bei Hrabanus Maurus", in Felten F. – Nichtweiß B. (eds.), *Hrabanus Maurus, Gelehrter, Abt von Fulda und Erzbischof von Mainz* (Mainz, 2006) 71–91.

Filarete, *Treatise on Architecture*, Spencer J. (trans.), 2 vols. (New Haven – London: 1965).

Fornasiero A. – Zlatohlávková E., "The *Studiolo* of Rudolf II at Prague Castle", *Journal of the History of Collections* 32.2 (2020) 239–244.

Fornasiero A. – Zlatohlávková E. – Kindl M., *From Studiolo to Gallery: Secular Spaces for Collections in the Lands of the Bohemian Crown on the Threshold of the Early Modern Era* (Prague: 2020).

Franck J., "Gallinarius, Johannes", *Allgemeine Deutsche Biographie* 8 (1878) 336–338.

Frankforter D.A., "Hroswitha of Gandersheim and the Destiny of Women", *The Historian*, 1.2 (1979) 295–314.

Fučiková E., 'The Collection of Rudolf II at Prague: Cabinet of Curiosity or Scientific Museum?', in Impey O. – MacGregor A. (eds.), *The Origins of Museums* (Oxford: 1987) 47–53.

Greschat M., *Martin Bucer, Strasbourg et l'Europe. Exposition à l'occasion du 500e Anniversaire du Réformateur Strasbourgeois Martin Bucer 1491–1991. Strasbourg, Église Saint-Thomas, 13 Juillet-19 Octobre 1991* (Strasbourg: 1991).

Grimm H., "Gresemund, Theoderich Der Jüngere", *Neue Deutsche Biographie* 7 (1966) 48.

Hamburger J., *Diagramming Devotion: Berthold of Nuremberg's Transformation of Hrabanus Maurus's Poems in Praise of the Cross* (Chicago: 2020).

Hatfield R., "Some Unknown Descriptions of the Medici Palace in 1459", *Art Bulletin* 52 (1970) 232–249.

Heikkinen S., "Re-classicizing Bede?: Hrabanus Maurus on prosody and meter", *Philological Quarterly* 94:1–2 (2015) 1–22.

Herding O. – Mertens D., Jakob Wimpfeling-Briefwechsel, Erster Teilband (Munich: 1990).

Herding O. – Mertens D., *Jakob Wimpfeling-Briefwechsel, Zweiter Teilband* (Munich: 1990).

Horawitz A. – Harttfelder K., *Briefwechsel Des Beatus Rhenanus* (Leipzig: 1886).

Kennedy D. – Meek R., Ekphrastic Encounters: New Interdisciplinary Essays on Literature and the Visual Arts (Manchester: 2019).

Kerscher G., Architektur als Repräsentation: Spätmittelalterliche Palastbaukunst zwischen Pracht und zeremoniellen Voraussetzungen. Avignon – Mallorca – Kirchenstaat (Tübingen – Berlin: 2000).

Kessler H., "'They preach not by speaking out loud but by signifying': Vitreous Arts as Typology", *Gesta* 51.1 (2012) 55–70.

Knepper J., *Jakob Wimpfeling (1450–1528): Sein Leben Und Seine Werke* (Freiburg: 1902).

Lhotsky A., "Apis Colonna: Fabeln und Theorien über die Abkunft der Habsburger. Ein Exkurs zur Cronica Austrie des Thomas Ebendorfer", *Mitteilungen des Instituts für Österreichische Geschichtsforschung* 55, JG (1944) 171–246.

Maurus Hrabanus, "De Laudibus Sanctae Crucis", in Colvener G. (ed.,) *Magnentii H-Rabani Mauri, ex Abate Fuldensi, Achiepiscopi Sexti Moguntini, Opera quae reperiri potuerunt, omnia in sex tomos distincta, Tome I* (Cologne, Antonii Hierarati: 1627) 273–348.

Maurus Hrabanus, *Magnencij Rabani Mauri De laudi[bus] Sancte Crucis opus* (Pforzheim, Thomas Anshelm – Jakob Wimpfeling: 1503).

Maurus Hrabanus, *Magnencij Rabani Mauri De laudib[us] Sancte Crucis opus* (Augsburg, Jakob Wimpfeling – Marc Velser: 1605).

Niederstätter A., *Die Herrschaft Österreich: Fürst und Land im Spätmittelalter. Österreichische Geschichte 1278–1411* (Vienna: 2004).

Perrin M.J.-L., "Dans les marges de l'editio princeps du *De laudibus sanctae crucis* de Hraban Maur (Pforzheim 1503: un aperçu de l'humanisme rhénan vers 1500", in Lehmann, Y. – Freyburger, G. – Hirstein, J. (eds.), *Antiquité tardive et humanisme: de Tertullien à Beatus Rhenanus. Mélanges offerts à François Heim à l'occasion de son 70e anniversaire* (Turnhout: 2005) 337–375.

Perrin M.J.-L., *L'iconographie de La Gloire à la Sainte Croix de Raban Maur* (Turnhout: 2009).

Perrin M.J.-L., "La Représentation figurée de César-Louis le Pieux chez Raban Maur en 835: Religion et idéologie", *Francia, Band 24/1* (1997) 39–64.

Perrin M.J.-L., "Le De laudibus sanctae crucis de Raban Maur et sa tradition manuscrite au IXe siécle", *Revue d'histoire des textes* 19 (1989) 191–251.

Perrin M.J.-L., *Rabani Mauri, In honorem Sanctae Crucis* (Turnhout: 1997).

Perrin M.J.-L., "Un nouveau regard jeté par Jakob Wimpfeling (1450–1528) sur la culture antique et chrétienne [Quelques réflexions en marge de l'édition du *De laudibus sanctae crucis* de Raban Maur (Pforzheim 1503)]", *Bulletin de l'Association Guillaume Budé*, 1 (1992) 73–86.

Rudolph A.K., "*Ego Clamor Validus Gandeshemensis* Hrotsvitha of Gandersheim: Her Sources, Motives, and Historical Context", Magistra 20.2 (2014) 58–90.

Rufus C.M., *Der Briefwechsel des Conradus Mutianus* (O. Hendel: 1890).

Schaff P. – Schaff D.S., *History of the Church*, Vol. 5, Part 2 (University Park, PA: 1924).

Schmidt P.G., *Humanismus Im Deutschen Südwesten. Biographische Profile* (Sigmaringen: 1993).

Schmitz W., "'O preclarum et omni veneration Dignum opus' [...] Zur Drucklegen von Hrabans 'Liber de laudibus sanctae crucis' im Jahre 1503", in Ernst U. – Sowinski B. (eds.), *Architectura poetica: Festschrift für Johannes Rathofer zum 65. Geburtstag*, Kölner Germanistische Studien 30 (Cologne – Vienna: 1990) 389–402.

Schumuch W.W. and Hadavas K., First English edition of the Nuremberg chronicle: being the Liber chronicarum of Dr. Hartmann Schedel ... (Madison 2010) folio CLXIX recto.

Spilling H., Opus Magnentii Hrabani Mauri in honorem sanctae crucis conditum. Hrabans Beziehung zu seinem Werk (Frankfurt am Main: 1992).

Spitz L.W., *The Religious Renaissance of German Humanists* (Cambridge, MA: 1963).

Squire M., "POP art: The optical poetics of Publilius Optatianus Porfyrius", in Elsner J. – Hernández J. (eds.), *Towards a Poetics of Late Latin Literature*, (New York: 2016) 23–100.

Syson L. – Thornton D., *Objects of Virtue: Art in Renaissance Italy* (London: 2001).

Trithemius Johannes, *Liber de Scriptoribus Ecclesiasticis* (Basileae, Johannes Amerbach: 1494).

Vincent de Beauvais, *Speculum Historiale* (Venetiis, Hermmanus Liechtenstein: 1494).

Busch R. von, *Studien zu deutschen Antikesammlungen des 16. Jahrhunderts* (Ph.D. dissertation, University Tübingen: 1978).

Schlosser J. von, Eine Fulder Miniaturhandschrift [De laudibus sanctae crucis] (Vienna: 1892) 29.

Webb R., Ekphrasis, Imagination and Persuasion in Ancient Rhetorical Theory and Practice (London: 2009).

Zeydel E.H., "Johann Reuchlin and Sebastian Brant: A Study in Early German Humanism", *Studies in Philology* 67.1 (1970) 117–138.

CHAPTER 5

A Customized Housebook of Repurposed Prints: the *Liber Quodlibetarius, c.* 1524

Stephanie Leitch

As illustrations in printed books increasingly took over the burden of a text's didactics in the sixteenth century, the images themselves began to establish a secondary market for their stand-alone visual content. Their growing sovereignty poised images on the brink of new epistemological work. The common epistemic thrust of these printed images can be tracked in a manuscript that collected them from diverse sources. The *Liber Quodlibetarius*, a codex produced in the opening decades of the sixteenth century and preserved today in the University Library in Erlangen, took many images circulating in printed texts and juxtaposed them on the strength of the commonality of their visual programs and their kindred epistemic aims. This essay focuses on several images from these represented genres that attempted to distill the content of those printed books and adjust that knowledge to the collectible nature of a picture encyclopedia. Images generated by the printing press were customized by the codex's compilers and set into new knowledge frameworks.

The profusion of concise illustrated vernacular texts that descended on the print market in the first few decades of the sixteenth century established a repertoire of increasingly recognizable images. Images in these printed texts spurred both rising visual literacy and how-to knowledge as images took over the instructional function and visual program of the book. Indeed, printed images had already adopted the mantle of knowledge-based agency through their technical reproducibility, but as they came to carry the burden of instruction, epistemic practices began to crop up around the images themselves.[1] The degree to which these books' didactics became visualized can even be seen in handmade codices in the age of print; these are among the best places to search for marks of visualized instruction. The compiler of the picture codex *Liber Quodlibetarius* collected images from printed books into a database of

1 For a cogent review of developments in the discourse on, as well as the uses and limits of, epistemic images, see Marr A., "Knowing Images: A Review Essay", *Renaissance Quarterly* 69.3 (2016) 1000–1013.

© KONINKLIJKE BRILL NV, LEIDEN, 2024 | DOI:10.1163/9789004680562_006

sovereign images and repurposed them.[2] In the context of the codex, images adopted different roles in their new environment. One factor contributing to their easy incorporation into other contexts was their ability to travel without precise textual moorings but remained legible. So tenacious was the sovereignty of these images that they could read as well in how-to manuals as in chronicles and travel accounts. This essay will juxtapose the content of the Erlangen codex with its printed sources in order to show how these prints begin to structure the format, and in some cases, the prerogatives, of the book. When transferred into a scribal context, printed images were creatively repurposed; this essays argues that the *Liber Quodlibetarius* was a manuscript customized by the print market.

1 An Ark of Visualized Knowledge

The codex *Liber Quodlibetarius* (Ms. B 200), widely referred to as a pictorial encyclopedia or housebook in the secondary literature, resides today in the University Library in Erlangen.[3] Of the codex's 288 folios of images, many are sourced from contemporary printed books. It is difficult to assign this role of collector to a particular agent. On fol. 86v, the manuscript bears the date 1524 as well as the monogram 'WR' which may or may not identify the cleric, 'Benedictus Rughalm patavius pfaff' (fol. 164r), as the scribe.[4] The Rughalm family can be traced to Passau, a town today in lower Bavaria. Around 1500, Benedictus and Wolfgangus Rughalm (probably his brother) were enrolled at

2 For an overview of the content, see Rudolph P., "Hausbücher. ›Bayerische Bild-Enzyklopädien‹ (Nr. 49a.5.1.)", in Bodemann, U. et al. (eds.), *Katalog der deutschsprachigen illustrierten Handschriften des Mittelalters (KdiH), Bd. 6*. (Munich: 2015) 466–473. For the entry in the manuscript census, see also https://handschriftencensus.de/24571. For a link to the manuscript, see /webclient/DeliveryManager?custom_att_2=simple_viewer&pid=5281832. For partial identification of the selection of the printed templates, see Lutze E., *Die Bilderhandschriften der Universitätsbibliothek Erlangen* (Wiesbaden: 1971) 58–70.
3 Ferrari M.C., "Le monde en images: Deux encyclopédies manuscrites à Erlangen et à Cracovie", in *Art de l'enluminure* 76 (Dijon: 2021) 4–29. The manuscript is the topic of a research team (Prof. Dr. Michele C. Ferrari, Dr. Manuel Teget-Welz, and Dr. Stefan Weber) at the Friedrich-Alexander Universität Erlangen-Nürnberg that investigates early modern illustrated encyclopedias, *Bildenzyklopädien des frühen 16. Jahrhunderts*.
4 The illustrator's monogram 'WR' can be found on fol. 86v. Labels of some drawings are also from Benedictus Rughalm. UB Erlangen-Nürnberg, MS. B 200: http://digital.bib-bvb.de/view /bvbmets/viewer.0.6.4.jsp?folder_id=0&dvs=1605197036959~61&pid=5281832&locale=de&u sePid1=true&usePid2=true.

the University of Vienna.[5] The compilation demonstrates the high level of erudition of the compiler, who collected images from a variety of printed genres, and refashioned them into manuscript form.[6] A related codex, preserved today in the Jagiellonian library and likely produced around the same time, has been treated in the secondary literature as a 'Housebook of medieval knowledge'.[7] It is beyond the scope of this paper to discuss the various aspects that relate these two codices, but the Erlangen codex depends more heavily on printed sources than does the codex in Cracow. Additionally, handwritten canons at the rear of the *Liber Quodlibetarius* frequently point to applications of the material found on specific pages of the book. For example, several folios carry instructions that refer the reader to a specific page in the canons, text assembled at the back of the book that attempts to explain material related to the images. This cross-referencing is absent from the Cracow codex, whose images are also less concerned with invoking the printed prototypes that probably served as a common sources for both codices. Although a short span of time likely separates the production of the books from each other, the intervention of printed sources that governed the knowledge collected in the Erlangen codex helped to determine its pictorial program.

Certainly the idea of the *Liber Quodlibetarius*'s capacity for storage was reinforced by an image of the Ark of Noah that forms a double folio spread (folios 9v–10r) announcing the wonders of both heaven and earth [Fig. 5.1]. As God's first storage vessel, the wooden Ark was a container of processed and replicable data; so in some sense, this pictured ark delivers the conceptual aims of the entire codex. Instead of seeking exclusively specimens of the natural world to reproduce, however, the compiler of the Erlangen codex sourced much of that knowledge of that world in the medium of print.

The illuminator's act of inserting pictorial data culled from the print market asks us to consider the *Liber Quodlibetarius* as a customized book that recapitulated previously packaged knowledge. The practicalities of setting woodblocks into the form of the printing press separately from lead type may have played

5 Identified in Bodemann, *Katalog der deutschsprachigen illustrierten Handschriften des Mittelalters* 470.

6 For this practice in the sixteenth century, see Pettegree A., "The Renaissance Library and the Challenge of Print", in Crawford A. (ed.), *The Meaning of the Library: A Cultural History* (Princeton: 2015) 72–102, esp. 75; Jordanova L., *The Look of the Past: Visual and Material Evidence in Historical Practice* (Cambridge: 2012).

7 While the Jagiellonian codex provides content similar to the *Liber Quodlibetarius*, the latter distinguishes itself through its reliance on printed image to structure its content formally. For the codex preserved today in Cracow in the Biblioteka Jagiellon'ska (Rkp. Przyb. 35/64 (49a.5.2.)), see https://jbc.bj.uj.edu.pl//dlibra/results?action=AdvancedSearchAction&type=-3&val1=dig:NDIGORP009564.

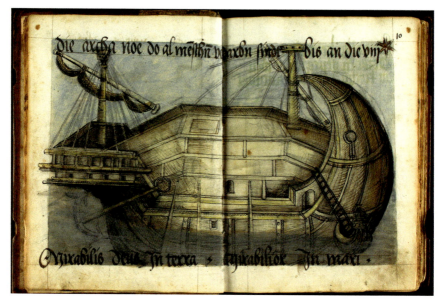

FIGURE 5.1 Master WR, "Noah's Ark", illumination, in Benedictus Rughalm, *Liber Quodlibetarius*, fol. 9v–10r. Erlangen, Universitätsbibliothek Erlangen-Nuremberg (inv. no. Ms. B 200)
IMAGE © UNIVERSITÄTSBIBLIOTHEK ERLANGEN-NUREMBERG

a considerable role in establishing an assembly-line look to many sixteenth-century printed books, especially those genres that took knowledge acquisition as their directive. In the bed of the press, the block was neatly constrained by type, spacers and furniture in the printing form, but it was easily removed. The very detachability of many of the moveable woodblocks from the printing form made it easier for woodblocks to be reused and, in the process, to wander into pastures for which they were not originally designed. The images became free-floating visual data that could be deployed into new knowledge structures. Sovereign printed images hailed the new agency of the viewer whose attentiveness to their interactive potential was awakened by books that increasingly addressed the reader as a user.[8] We can think of the illuminator's transformation of these prints in the *Liber Quodlibetarius* as a microhistory of reception. Through the codex's re-presentation of printed knowledge, we can detect in an abbreviated shape the kinds of disciplinary formation exerted by printed images on nascent fields of instruction, for example, print's ambition to fix the approach and parameters of emergent disciplines, such as those of

8 Karr Schmidt S.K., *Interactive and Sculptural Printmaking in the Renaissance* (Leiden – Boston: 2017).

botany and anatomy.[9] The new content areas produced by the creative reuse of prints thus intersects with the discourse on their knowledge-making properties, or their epistemic prompts.[10]

If the Ark was a metaphor for the container, the codex also alluded not only to knowledge of the world, but also established both biblical and historical time. The book begins with a creation sequence: the story of the Creation, the great Flood, and the Wonders of the World. The illuminator of the *Liber Quodlibetarius* formatted the opening sequence in the way that many other printed books did: the sequential development of the creation narrative as divisions of matter that results in the accumulation of stuff in the world. Previous manuscripts and printed books, like Hartmann Schedel's *Liber chronicarum* (Koberger: Nuremberg, 1493), presented those historical and material passages in a roundel format, an easily repeatable formula.[11] This roundel established a program of graphic design that would be reprised throughout the *Liber Quodlibetarius*: a few lines of text headlining the folio with the explanatory picture in the roundel below. Schedel's chronicle may also have provided a model for the visual passages of the creation narrative.[12] The Erlangen illuminator borrowed content for the roundels from the *Liber chronicarum* in several key visual vignettes, one of which is a visual explication of *Genesis* 1:20: God's creation of swarms of living creatures on the fifth day (fol. 4r) [Fig 5.2]. In Schedel's scene, the illuminator saw the animals of the earth and sea expressed as an arrangement of diverse data. The liberty that he took adding birds to the formula supplied by his model's tree indicates that he interpreted it as an armature for biodiversity. Schedel's roundel was a data set that could be amplified in the new configuration. Later images would crib from this diversity; the illuminator stocked the *Liber Quodlibetarius* with images of related fish and birds, later reusing them to introduce methods of fishing and birding. Thus, the

9 Kusukawa S., *Picturing the Book of Nature: Image, Text, and Argument in Sixteenth-Century Human Anatomy and Medical Botany* (Chicago: 2011); Ogilvie B., *The Science of Describing: Natural History in Renaissance Europe* (Chicago: 2006).

10 The array of images that serviced knowledge-based pursuits in early modern print culture can be found in succinct categories in Dackerman S., *Prints and the Pursuit of Knowledge in Early Modern Europe* (Cambridge-New Haven: 2011).

11 For use of the roundel format in manuscripts such as the *Liber Floridus*, see Vorholt H., *The Shaping of Knowledge: The Transmission of the 'Liber Floridus'* (London: 2018). Many thanks to Britt Hunter Boler for discussing manuscript precedents with me.

12 See e.g., Schedel Hartmann, *Registrum huius operis libri cronicarum: cu[m] figuris et ymagi[ni]bus ab inicio mu[n]di* (Nuremberg, Anton Koberger for Sebald Schreyer and Sebastian Kammermeister: 1493), with woodcuts by Michael Wohlgemut, Wilhelm Pleydenwurff, and Albrecht Dürer. See ISTC https://data.cerl.org/istc/is00307000, with links to several electronic facsimiles.

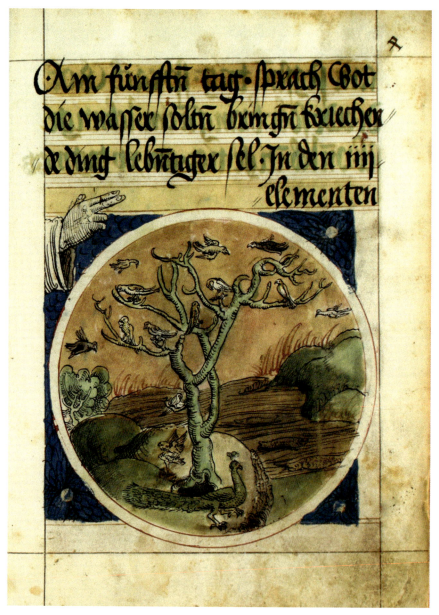

FIGURE 5.2 Master WR, "The Fifth Day", illumination, in Benedictus Rughalm, *Liber Quodlibetarius*, fol. 4r. Erlangen, Universitätsbibliothek Erlangen-Nuremberg (inv. no. Ms. B 200)
IMAGE © UNIVERSITÄTSBIBLIOTHEK ERLANGEN-NUREMBERG

HOUSEBOOK OF REPURPOSED PRINTS: THE *LIBER QUODLIBETARIUS* 143

images would build cognitive bridges to new epistemic practices. Within the format of the Creation roundel, the illuminator already heralds his interest in the natural world as significant data for his book.

In other forms of creative interpolation of images, the illuminator established new meanings for the repurposed material. The "marvelous peoples", or the Marvels of the East, frequently featured on margins of maps in the manuscript tradition. While they sometimes appeared uncomfortably cramped into small cells of the *oikumene* in manuscript maps, the marvels were disciplined into boxed sets of taxonomic specimens in Schedel's chronicle.[13] The *Liber Quodlibetarius* introduces the marvels by way of a roundel that announces the section as: 'various animals of the earth'. In the seven-page section that follows, the marvelous beings are restricted to an upper border that conceptually serves as a continuous coastline, with inscriptions that give a nod to their locations. The illuminator chose to package references to geography, the metadata that traditionally located the marvels, into the accompanying text rather than in a series of roundels that instead portrayed visual previews of exotic encounters.

Maps, ships, and exotic sights form the content of the roundels for this section. Ocean vessels, shipmates, in addition to images of camels and a war elephant, are drawn from a sixteenth-century travel account of Ludovico de Varthema, whose travels took him from Bologna to the Near East and Southeast Asia.[14] Although the illustrations for Varthema's account printed in 1515 by the Augsburg printmaker Jörg Breu were full of stereotypes of peoples of these regions, Varthema would become a source for visual pilfering by later printmakers to represent peoples whose demographic would expand from Java and Brazil to Sweden.[15] In the diverse material pulled together in the *Liber*

13 For the instability of the term race in scholarship on the marvels, where the term is primarily used to designate a collection, see Mittman A., "Are the 'Monstrous Races' Races?", *Postmedieval* 6 (2015) 36–51.

14 Varthema Ludovico de, *Die Ritterlich Und Lobwirdig Rayß Des Gestrengen Und Über All Ander Weyt Erfarnen Ritters Und Lantfarers Herren Ludowico Vartomans von Bolonia Sagent von Den Landen Egypto Syria von Bayden Arabia Persia Jndia Und Ethiopia von Den Gestalten Syten Und Dero Menschen ...* – *Deutsche Digitale Bibliothek*, trans. Michael Herr (Augsburg, Miller: 1515), https://www.digitale-sammlungen.de/en/view/bsb00011589?page=,1.

15 For illustrations by Jörg Breu, see "Recuperating the Eyewitness: Jörg Breu's Images of Islamic and Hindu Culture in Ludovico de Varthema's *Travels* (Augsburg: 1515)", in Leitch S., *Mapping Ethnography in Early Modern Germany: New Worlds in Print Culture* (Basingstoke, UK: 2010) 101–145. For Breu's images as a rich source of copies in early modern published travel narratives, see Voigt L. – Brancaforte E., "The Traveling Illustrations of Sixteenth-Century Travel Narratives", *PMLA* 129.3 (2014) 365–398.

Quodlibetarius, we can perhaps see why Breu's images were frequently packaged for transport to other locations.

These copies of Breu's prints in the Erlangen codex proves what a reliable source of "eyewitness" information his images were considered to be. For instance, the roundel on fol. 7r presumably recapitulates Varthema's voyage around the Cape of Good Hope, but the image here stands in for a sea-voyage generally. It was likely recommended by the suggestion of foreign lands inspired by the marvels above it, but the scene also provided a fertile canvas for sea monsters that were flights of the illuminator's fancy. Likewise, the roundel featuring exotic animals, a camel and a war elephant, on fol. 8r, repurposed data from two distinct pages of Varthema's text (the camel on fol. 11r; the elephant on 32r). Separated from the narrative events of Varthema's journey that mentioned sights worth seeing in faraway places, Breu's illustrations provided the illuminator with serviceable visual prototypes for showing mankind's mastery over exotic animals. In the *Liber Quodlibetarius*, the illuminator featured Breu's mammals in their useful guises: an elephant outfitted for war and a camel laden with goods. While far from delivering what was promised by the section header 'various animals of the earth', the section welded together from Breu's images nevertheless supplies a fitting bridge from the prior section (the Ark as data collection) to the one that follows it, images about human ingenuity as manifested in a sequence on the man-made wonders of the world. Breu's ships, camels and elephants suitably expressed distance for the purposes of announcing the phenomenon of marvels.

2 Learning through Roundels: Dial up Ingenuity

Sequences that open with the creation story, the flood, and the man-made structures of the ancient world were common ways to introduce historical causation into texts. In some chronicles, they also provided a preface to the idea of secular time; in the *Liber Quodlibetarius*, they seem to introduce the notion of timekeeping generally. Much of the observation of heavenly bodies by astrologers and astronomers in the sixteenth century was undertaken to determine correct schedules for seasonal routines and predictions about the weather and human nature. The following section's roundels present instrument dials, or images that can function as instruments to help schedule such practices. Packaging astral observations, horoscope recommendations, and bloodletting tables, these dials are both influenced by and respond to a contemporary cosmographic text, Peter Apian's *Cosmographicus Liber* (Landshut: Weyssenburger, 1524), and the printed works of Johannes Regiomontanus from

which some of Apian's own precepts were drawn.[16] Astronomical and astrological dials could be constructed on the basis of Apian's data: in some cases, the Erlangen codex extrapolates information from Apian's book and expands it into new tools and gauges.[17] The organizing principle of the roundel is now replaced by a dial, either functioning or fictional. These dials show the reader/user how to organize knowledge derived from the stars. The many different kinds of judgments that could be made from the stars in judicial astrology featured here show the ever expanding (and almost limitless) computing potential of such instruments. Also embedded in these dials is information from calendar publications: pithy pamphlets that provided eclipse schedules, time tables for sowing and harvesting, and recommended appropriate locations on the body for seasonal bloodletting.[18] In this manuscript, Apian's prints provided the impetus for new ways of formatting searchable information.

After the section on these dials of astral influence, we see the roundel format increasingly used as a window to the pictured instruments themselves. In other words, in the place of functioning dials, the reader now encounters images of other types of instruments. A large section on internal medicine borrows material that circulated in contemporary calendar publications and almanacs which included diagrams for bloodletting and zodiac men. This section stretches from fol. 63r to fol. 79r and ranges from visual explanations of how to take a pulse and compare the color of urine samples to bloodletting diagrams. Bundled into this 'calendar' section are images from a popular manual for battlefield surgery, the *Feldtbuch der Wundarzney* (Strasbourg, Schott: 1517), with images attributed to Hans Wechtlin.[19] While the iconography for the visual aids produced in Johann Schott's print shop ranged from devotional material to flat arrays of tools seen from above, Wechtlin endeavored to make his images useful to users by connecting specific tools to particular types of

16 For the productions of Apian's shop, see Grimm H., *Peter und Georg Apian, Buchdrucker zu Ingolstadt und Landshut* (Mainz: 1961).

17 For Apian's dials, see Vanden Broecke S., "The Use of Visual Media in Renaissance Cosmography: The Cosmography of Peter Apian and Gemma Frisius", *Paedagogica Historica* 36.1 (2000) 130–150; Gaida M., "Reading Cosmographia: Peter Apian's Book-Instrument Hybrid and the Rise of the Mathematical Amateur in the Sixteenth Century", *Early Science and Medicine* 21.4 (2016) 277–302.

18 Johnston S.M., "Printing the Weather: Knowledge, Nature, and Popular Culture in Two Sixteenth-Century German Weather Books", *Renaissance Quarterly* 73.2 (2020) 391–440.

19 Gersdorff Hans von, *Feldtbuch der Wund-Artzney, sampt vilen Instrumenten der Chirurgey*. (Strassburg: Johann Schott 1517), provides several prints as templates, see http://mdz-nbn -resolving.de/urn:nbn:de:bvb:12-bsb00010085-8 (BSB Munich). Also see Panse M., *Hans von Gersdorffs Feldbuch der Wundarznei: Produktion, Präsentation und Rezeption von Wissen* (Wiesbaden: 2012).

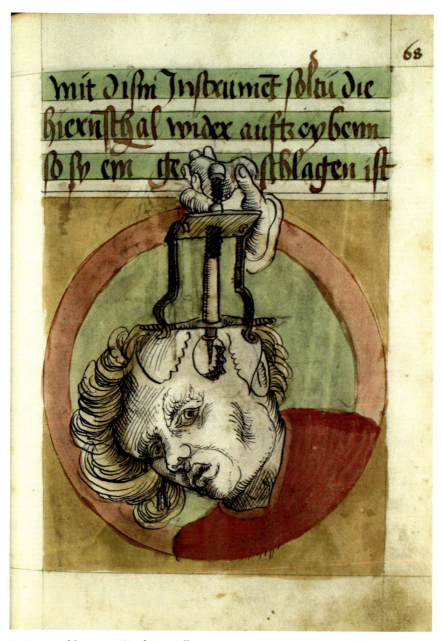

FIGURE 5.3 Master WR, "Head Brace", illumination, in Benedictus Rughalm, *Liber Quodlibetarius*, fol. 68r. Erlangen, Universitätsbibliothek Erlangen-Nuremberg (inv. no. Ms. B 200)
IMAGE © UNIVERSITÄTSBIBLIOTHEK ERLANGEN-NUREMBERG

medical procedures. The visual armature of the book featured searchability. The illuminator intuited Wechtlin's aims and extended them by systematically formatting images from the printed text into roundels showcasing the instrument-like properties of the devices they contain. For example, a head-brace similar to the kind used for trepanation that assumes a full-page format in Schott's text appears in a roundel at fol. 68r [Fig. 5.3]. The accompanying inscription indicates that this is the tool for attending to certain battle wounds to the head, and that it could be used to retrieve bits of skull that have caved in. Instruments for stabilizing injured heads, straightening legs, and immobilizing arms appear in similar round windows. The *Liber Quodlibetarius* enables readers to mount searches for the content within the roundels, which in this context have become spaces for information-laden tools. Organizing this material into easily searchable formats, the images of the codex can be thought of as a type of extended table of contents for the book itself. Page numbers often appear on folios that refer the reader to the canons at back of the book for additional information.

3 Reading Palms and Faces

Widely-circulating imagery in several popular how-to genres permitted common practices to develop around them; such as palm reading, scanning the forehead for wisdom lines, or guidelines for playing musical instruments. The collective viewing that accrued around these images, and the consensus that developed as a result, helped to cement several popular avenues to practical knowledge.[20] New questions in the scholarship on types of epistemic images, such as diagrams and technical images, encourage scholars to reflect on 'the means by which images persuade us that a particular kind of knowledge is reliable'.[21] Two assurances about reliability in the early modern press come in the form of repetition and recognizability. In other words, the repetition of images and formatting practices across a variety of different genres of how-to knowledge played a role in making certain sets of images recognizable and authoritative.

20 Leitch S., "Getting to How-to: Chiromancy, Physiognomy, Metoscopy and Prints in Secrets' Service", in Dekoninck R. – Guiderdoni, A. – Melion, W.S. (eds.) *Quid Est Secretum? Visual Representations of Secrets in Early Modern Europe, 1500–1800* (Leiden – Boston: 2020) 635–659.

21 Marr A. – Heuer C.P., "Introduction: The Uncertainty of Epistemic Images", *21: Inquiries into Art, History, and the Visual* 1.2 (2020) 251–255; esp. 255.

Among the tenacious visual models carried over from printed books into the *Liber Quodlibetarius* were formulas for comparison, which were used in those editions to coach the reading of profiles and hands. Known as physiognomies and chiromancies respectively, or collectively as complexion books, sometimes these genres related to natural astrology asked readers to compare features and thus set up their diagnoses along poles of contrast in linear formats that would facilitate comparative study. A page in the *Liber Quodlibetarius*'s spread of physiognomic information on fol. 8or [Fig. 5.4] carries the same set of paired profiles that could be found in editions of a complexion book circulating in the German-speaking realm [Fig. 5.5] that also reconciled them to a common baseline.[22] Eliminating the interstitial text that provided the physiognomic analysis, the Erlangen illuminator imported the images, leaving just a trace of the textual apparatus of the printed volumes in the captions that snake through the profiles. Presented here are only the heads that serve the instrumental aspect of the physiognomist's art. In published complexion books, this repertoire of heads indicated physiognomic analysis writ large. Generic heads reproduced in printed physiognomies could be moved around to stand in for character traits, and these images were often shuffled around to be used broadly to signal shady characters or reliable employees. Similarly modularized information can also be detected in other astrological genres that treated the body as a database of decipherable signs, such as in the pages of palms that the *Liber Quodlibetarius* splays out in ten folios beginning on 8ir (fols. 8ir–85r). The connection of images to character traits is also evident in ten folios of elaborately wrought horse bits (fols. 58r–62v). Bridle bits are visualized as tools by which unruly horses can be restrained, but they are also images that point to an assessment of the horse's character. In the circulation of such books in print in the following decades, the images of horse bits presented in printed bit-books would also come to have a practical function insofar as their publishers would advertise them as templates for spurmakers or blacksmiths.[23] The Erlangen codex follows this model of importing sovereign images to stand in for modes of diagnosis and also the potential of these designs as models for fabrication.

22 Cocles Bartolommeo, *Ein kurtzer bericht der gantzen Phisionomey und Ciromancy* (Strassburg, Johann Grüninger: 1524). I am grateful to Johanna Wittstatt for calling my attention to this volume.

23 Cuneo, P., "Just a Bit of Control: The Historical Significance of Sixteenth- and Seventeenth-Century German Bit-Books," in Raber, K. – Tucker, T. (eds.), *The Culture of the Horse: Status, Discipline, and Identity in the Early Modern World* (New York – 2005), 141–173, esp. 150. This practical use is implicit in passages that encourage readers to fashion their own bridle bits by copying designs found in the books.

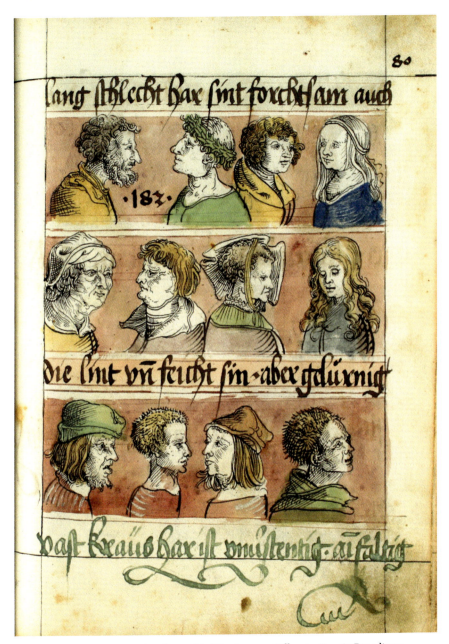

FIGURE 5.4 Master WR, section devoted to "Physiognomy", illumination, in Benedictus Rughalm, *Liber Quodlibetarius*, fol. 80r. Erlangen, Universitätsbibliothek Erlangen-Nuremberg (inv. no. Ms. B 200)
IMAGE © UNIVERSITÄTSBIBLIOTHEK ERLANGEN-NUREMBERG

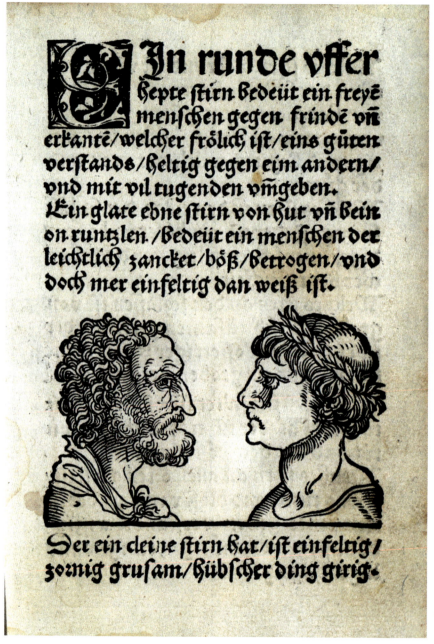

FIGURE 5.5 Anon., sets of "Foreheads", woodcut, in Bartolommeo Cocles, *Ein kurtzer bericht der gantzen Phisionomey und Ciromancy* (Strassburg, Johann Grüninger: 1524). Sig. W 8 Philos. 959
IMAGE © UNIVERSITÄTSBIBLIOTHEK, LUDWIG-MAXIMILIANS-UNIVERSITÄT, MUNICH

HOUSEBOOK OF REPURPOSED PRINTS: THE *LIBER QUODLIBETARIUS* 151

Clearly the Housebook's organizer tried to implement a sustainable image policy by sourcing many of its designs from printed manuals, such as books on astronomy, surgery, distillation, cosmography, and physiognomy, to name just a few. Many of these were imported into the picture codex in recognizable and also detachable formats, easy to arrange into other compositions. Other handmade and customized books around this time (*alba amicorum*, prayerbooks, books of relics (*Heiltumbücher*), and zoological inventories, for example) relied on printed sources for inspiration in their efforts to catalogue collectible information.[24] We might ask ourselves what kinds of new cognitive connections images spurred in their readers simply by virtue of their juxtaposition in the catalogue. The Erlangen codex seems to offer a low-tech solution for organizing material abundance, but do the images stop there in their epistemological work?

4 Taming Printed Animals

Some sections of the Erlangen codex function more as repositories of information than those in which images are recommended for their instrumental function. Folios devoted to animals constitute one of these sections that serve as a type of visual menagerie which groups together collected animals. One printed work that inspired the formal set up of the *Liber Quodlibetarius*'s pages of zoological material was Bernhard von Breydenbach's *Peregrinatio in Terram Sanctam* (Mainz, Schöffer: 1486) [Fig. 5.6]. For this account of Breydenbach's travels to the Holy Land, the artist Erhard Reuwich reformatted the supporting visual material in travel narratives and in encyclopedic natural histories, like Bartholomeus Anglicus's *De Proprietatibus Rerum*, to help explain the sights that a group of European pilgrims encountered in the Holy Land. Many of the formal conventions that Breydenbach established for images were replicated

24 Among recent scholarship that treat manuscripts produced in the age of print and respond to their pictorial schemes, see Dlabacova A., "Religious Practice and Experimental Book Production. Text and Image in an Alternative Layman's 'Book of Hours' in Print and Manuscript", *Journal of Historians of Netherlandish Art* 9.2 (2017) 1–41, esp. 29 and note 64; Cashion D.T., "The Art of Nikolaus Glockendon: Imitation and Originality in the Art of Renaissance Germany", in *Journal of Historians of Netherlandish Art*, 2.1–2 (2010); Egmond F., *Eye for Detail: Images of Plants and Animals in Art and Science, 1500–1630* (London: 2017). Anna Dlabacova argues in this present volume that the visual program of the fifteenth century chronicle of Kattewijke, for instance, consisted of fragments of prints pasted in new arrangements into the manuscript itself. For codices of relics and their relationship to printed editions, see Cárdenas L., *The Texture of Images: the Relic Book in Late-Medieval Religiosity and Early Modern Aesthetics* (Leiden – Boston: 2021), 82–114.

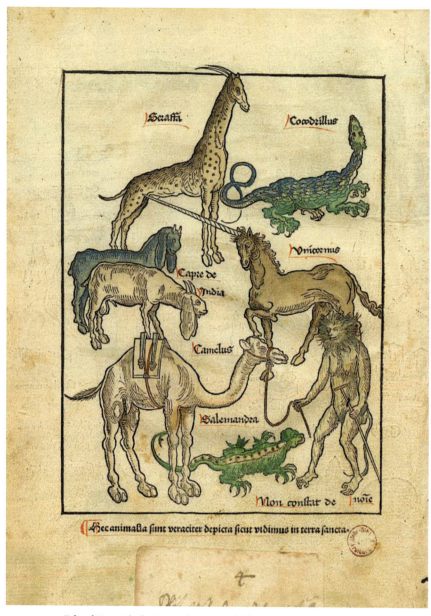

FIGURE 5.6 Erhard Reuwich, for Bernard von Breydenbach, *Peregrinatio in Terram Sanctam* (Mainz, Schöffer: 1486)

HOUSEBOOK OF REPURPOSED PRINTS: THE *LIBER QUODLIBETARIUS* 153

in the next generation of encyclopedic books, such as Hartmann Schedel's *Liber chronicarum* or Sebastian Münster's *Cosmographia universalis* (Basel: Petri, 1559). So, too, did the compiler of the *Liber Quodlibetarius* reproduce images from Breydenbach for a section of the codex about animals on fol. 89v [Fig. 5.7]. In the codex, this menagerie of animals from the Holy Land floats in a space whose background no longer alluded to a pilgrim's itinerary, but referred only to the page of the book itself.[25] This setup was itself inherited from printed encyclopedias that tended to group their sparse illustrations at the end of chapter sections, in which all the creatures mentioned in the book assumed their places.[26] Rather than systematic inquiry of a field of study, handmade compilations in the age of the printing press, per Ann Blair, were 'driven by supply of information from their sources'.[27] To compilers such as ours, empirically encountered specimens were less important than the ones sourced from the printed page. But our compiler did exercise some judgment that suggested a weighing of these printed facts against animals that might actually be encountered. He edited the unicorn and the salamander out of Breydenbach's collection, two traditional favorites from bestiaries whose existence was perhaps too clouded by legend to permit their appearance here. Whereas those specimens were popular in other books that borrowed their imagery, the housebook's illuminator seems skeptical about including them.[28] Could it have been the scribe or illuminator who chose to omit elements of fables and legends in a book that was increasingly designed as a reference volume for the reader's interface with the natural world?

25 The German edition did not include the text that accompanied the animals in the Latin edition, which incorporates the caption: 'Haec animalia sunt veraciter depicta sicut vidimus in terra sancta'. William Ivins, in "A First Edition of Breydenbach's Itinerary", *The Metropolitan Museum of Art Bulletin* (1919) 217, translates: 'These animals are veraciously depicted just as we saw them in the Holy Land'. All animals are labeled in the Latin edition except for monkey, underneath which we find the caption: 'Non constat de nomine' (We don't know its name).

26 For instance, only a handful of illustrations appear in printed editions of Bartholomaeus Anglicus's *De Proprietatibus Rerum* and Konrad von Megenberg's *Buch der Natur*. Natural histories of the late 15th century tend to be sparingly illustrated. The pressures of expedient letterpress printing dictated the graphic design of books; incorporating woodblocks encouraged the printer to group content discussed in the text at convenient visual junctures, such as at section breaks.

27 Blair A. – Duguid P. – Goeing A.S. – Grafton A., *Information: A Historical Companion* (Princeton: 2021) 79.

28 This spare visual field prepared those same animals for transfer to other venues, one of which may have been Adriaen Coenen's *Visboek*, which re-catalogued Breydenbach's salamander among other specimens of sea monsters that could be found near Scheveningen.

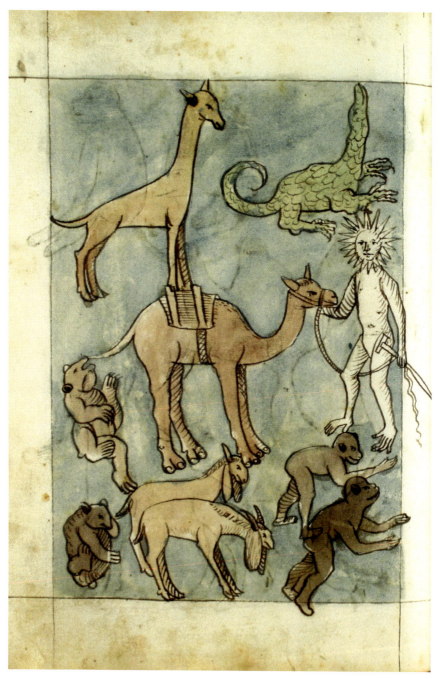

FIGURE 5.7 Master WR, "Exotic Animals", illumination, in Benedictus Rughalm, *Liber Quodlibetarius*, fol. 89v. Erlangen, Universitätsbibliothek Erlangen-Nuremberg (inv. no. Ms. B 200)
IMAGE © UNIVERSITÄTSBIBLIOTHEK ERLANGEN-NUREMBERG;

5 Prints from Nature

Another tradition of printing inspired at least one other knowledge-making gesture that ran tangent to the data-gathering from printed books in the *Liber Quodlibetarius*'s epistemology. Specimens from the natural world function similarly in the data displays, and nature-printing belongs to a set of artisanal practices that produced new types of books including commonplace books and *florilegia*.[29] But there were also other collections of hand-made botanical books generated from printed dried and inked plants, or *Naturselbstdrücke*, that presented them as fragile fragments of the natural world.[30] Epistemic guarantees provided by specimens with analogues in the natural world can also be inferred from the range of uses exhibited by nature prints that appear throughout the housebook: marginalia, decoration, and informational displays of herbs. In some cases, the impression served as an index of the living plant.

While they serve as mnemonic reminders of the natural world, nature specimens actually have a range of functions, both decorative and indexical. The variety of information on which impressions of leaves and plants left their mark causes us to reflect on how the act of commonplacing can generate new knowledge structures. The cognitive dissonance that Ann Blair proposes as an important tolerance of commonplacing can perhaps be seen in the range of operations which nature prints perform in both the Erlangen and the Jagiellonian manuscripts.[31]

The use of nature prints in the *Liber Quodlibetarius*'s sister manuscript in Cracow appears to be mostly decorative. Nature prints sometimes appear as impressed afterthoughts, especially when placed on top of other images, such as atop the dial that scheduled bathing and bloodletting according to star signs on fol. 19v of the Jagiellonian manuscript.[32] While the poor quality of the impressions might challenge our modern notion of decoration,

29 Cave R., *Impressions of Nature: A History of Nature Printing* (London: 2010).

30 Olariu D., *The Misfortune of Philippus de Lignamine's Herbal or New Research Perspectives in Herbal Illustrations from an Iconological Point of View* (Berlin: 2015).

31 Ann Blair has shown how similar acts of knowledge collecting, such as Jean Bodin's commonplace book *Universae naturae theatrum* (1596), represented important reference material for subsequent generations of German natural philosophers. See Blair A., "Humanist Methods in Natural Philosophy: The Commonplace Book", *Journal of the History of Ideas* 53.4 (1992); Blair A., *Too Much to Know: Managing Scholarly Information before the Modern Age* (New Haven: 2011). See also Moss A., "Locating Knowledge", in Enenkel, K.A.E. – Neuber, W. (eds.), *Cognition and the Book: Typologies of Formal Organisation of Knowledge in the Printed Book of the Early Modern Period* (Leiden – Boston: 2005).

32 Jagiellonian Ms. Acc. 35-64, fol. 19v. For the Jagiellonian codex, see https://jbc.bj.uj.edu.pl//dlibra/results?action=AdvancedSearchAction&type=-3&val1=dig:NDIGORP009564.

such *Naturselbstdrücke* appear to have no other discernible relationship to the volvelle. In the context of manuscripts whose content does not otherwise explicitly try to replicate the natural world indexically, the random placement of many nature impressions might recall the practice of pressing leaves or flowers into books, an act that breathed inspiration into manuscript marginalia that mimicked the look of pressed flowers.[33]

While prints of leaves appear scattered throughout both the Erlangen and Cracow manuscripts, one folio of the Erlangen codex (fol. 56r) devoted solely to nature prints shows sixteen deliberately placed and carefully inked herbs and leaves [Fig. 5.8]. The accompanying inscription designates the impressions as 'various herbs and spices' and refers the reader back to a lengthier explanation at the end of the book; although, in this particular case, the page number is missing.[34] Thus, the nature impressions in the codex, as well as the text suggesting uses for these plants, support the idea of building mnemonic bridges between the image and the function of the actual specimen. The measuring gauge placed at the bottom of the page functions like a ruler that invites the reader to consider these impressed leaves indexically by providing a framework for the image that might enable interactive empirical investigations like measuring and comparing. Such self-referential methods of commentary provide an example of how new knowledge schemas cropped up around natural impressions.

Around some of the nature prints in the Erlangen codex, however, we see new cognitive links being built by the images. On a later folio (117v), leaf prints surround several fishes, including an impression made by a sage leaf [Fig. 5.9]. The captioned text promises to show 'which fish are healthy or useful, and how to catch them [...] also how to preserve them'.[35] In the canons on fol. 157r to which this image refers, we find the description of fishing bait and methods. Sage, an herb recalled by a familiar impression of the leaf, is also mentioned for use in fishing. Dominic Olariu has suggested that the repetition of impressions of herbs like sage throughout the text after the initial summary on this folio build the reader's skills in identifying the plant.[36] Such hyperlinking of the leaf to information about how to use it as bait for fish adds another layer

33 Kaufmann T.D., *The Mastery of Nature: Aspects of Art, Science, and Humanism in the Renaissance* (Princeton: 1993) 22. See, for example, works by the Master of Mary of Burgundy and the later experiments of Joris Hoefnagel.

34 *Liber Quodlibetarius* fol. 56r.

35 *Liber Quodlibetarius*, fol. 117v.

36 Olariu D., "Herbs under Pressure: Plant Illustrations and Nature Printing in the first half of the Fifteenth Century," in Felfe R. – Saß M. (eds.), *Naturalismen: Kunst, Wissenschaft und Ästhetik* (Berlin: 2019) 22–23.

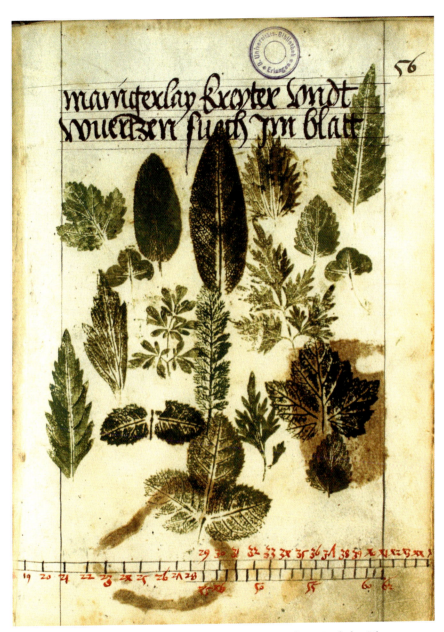

FIGURE 5.8 Master WR, "Various Herbs", illumination, in Benedictus Rughalm, *Liber Quodlibetarius*, fol. 56r. Erlangen, Universitätsbibliothek Erlangen-Nuremberg (inv. no. Ms. B 200)
IMAGE © UNIVERSITÄTSBIBLIOTHEK ERLANGEN-NUREMBERG

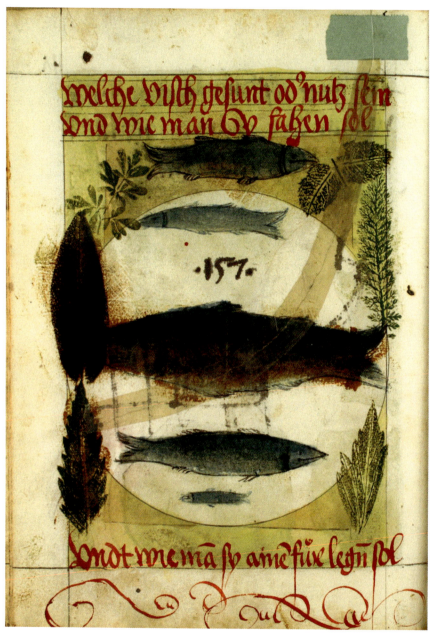

FIGURE 5.9 Master WR, "Which fish are healthy", illumination, in Benedictus Rughalm, *Liber Quodlibetarius*, fol. 117v. Erlangen, Universitätsbibliothek Erlangen-Nuremberg (inv. no. Ms. B 200)
IMAGE © UNIVERSITÄTSBIBLIOTHEK ERLANGEN-NUREMBERG

HOUSEBOOK OF REPURPOSED PRINTS: THE *LIBER QUODLIBETARIUS* 159

of skill that can be developed around the plant's identification. The indexical function of the leaf in this context perfectly fits Lorraine Daston's categorization of an epistemic image as one that replaces the object which it signifies.[37] Such nature impressions are exemplary for the general autonomy of images in this book, a sovereignty built by the images borrowed from ancestors in printed books.

A similar type of hyperlinking of a sovereign image to a procedure appears on a folio (87r) devoted to birds [Fig. 5.10], where we find an inscription that relates to their trapping: 'You will find how to catch birds on folio 157'.[38] This section seems to source animals from pre-existing printed contexts, perhaps even motifs from a model sheet or a deck of fifteenth-century playing cards, and applies purposes to those images.[39] The visual fields of the series of pages that follow compress animals into them, among them the giraffe, crocodile and a monkey guiding a camel that we know the compiler to have sourced from Breydenbach's travels. The caption about bird-catching, applied to what appears to be an assortment of birds from unrelated printing contexts, demonstrates how tenacious the idea of the utility of the image becomes, but also its limits. One of the primary objectives seems to be to index the image, leaving room for connections to practical purposes that might arise later. Thus, the utility of the image had to compete with the illuminator's mandate to control an unwieldy amount of information.

Indeed, even the birds seem to extend beyond the borders erected by the ruled lines. Some of the lines appear to have been drawn in after the birds themselves, perhaps in the hopes that this method of containment could bring some measure of order to the randomness of the specimens.[40] This avian display is disciplined *ex post facto* by the formatting of the ruled lines. The scribe's attempt to contain this display of visualized data is itself a move to impart some order to the page, condensing the birds into orderly arrangements, as

37 Daston L. "Epistemic Images", in Payne A. (ed.), *Vision and Its Instruments: Art, Science, and Technology in Early Modern Europe* (University Park, Penn.: 2015) 17–18. For Daston, 'A successful epistemic image becomes a working object of science, a stand-in for the too plentiful and too various objects of nature, and one that can be shared by a dispersed community of naturalists who do not all have direct access to the same flora and fauna'.

38 *Liber Quodlibetarius*, fol 87r: 'Wie man vogl sol vahen vindest am 157 blat'.

39 For popular motifs used in model sheets for playing cards, see Van Buren A. – Edmunds S., "Playing Cards and Manuscripts: Some Widely Disseminated Fifteenth-Century Model Sheets," *The Art Bulletin* 56.1 (March 1974) 12–30. I thank Anna Dlabacova for sharing this source with me.

40 I thank Julia Little this astute observation.

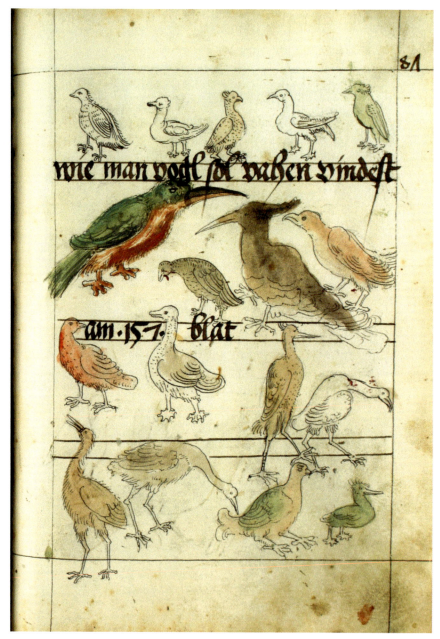

FIGURE 5.10 Master WR, "How to catch birds", illumination, in Benedictus Rughalm, *Liber Quodlibetarius*, fol. 87r. Erlangen, Universitätsbibliothek Erlangen-Nuremberg (inv. no. Ms. B 200)
IMAGE © UNIVERSITÄTSBIBLIOTHEK ERLANGEN-NUREMBERG

HOUSEBOOK OF REPURPOSED PRINTS: THE *LIBER QUODLIBETARIUS* 161

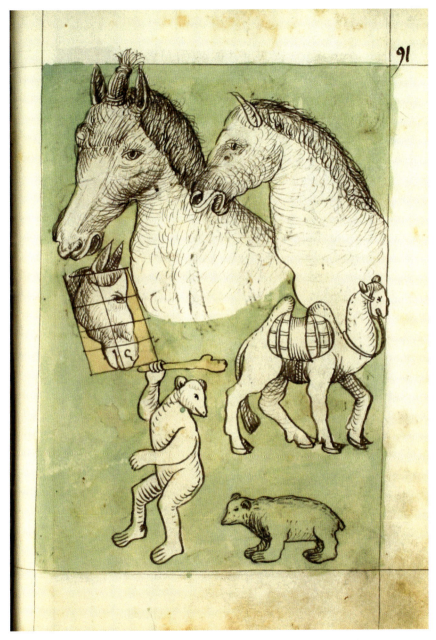

FIGURE 5.11　Master WR, "Horses", illumination, in Benedictus Rughalm, *Liber Quodlibetarius*, fol. 91r. Erlangen, Universitätsbibliothek Erlangen-Nuremberg (inv. no. Ms. B 200)
IMAGE © UNIVERSITÄTSBIBLIOTHEK ERLANGEN-NUREMBERG

Noah might have done in order to load his ark. The idea that the reader might take instruction about how to catch birds or fish from this folio suggests an overarching impulse to link an epistemic function to images that are sometimes derived from genres governed by more of a knowledge-making bent than others.

But it is this very idea of usefulness that corrals together a selection of horses presented across folios 90v–91r. The poses of recumbent horses on folio 90v are followed by a folio of naturalistically rendered horse profiles that awkwardly share the page with a horse head locked in a grid (fol. 91r) [Fig. 5.11]. Such a grid recalled those used by artists for the purposes of establishing ratios and transferring designs. The one in the Erlangen codex likely derived from a model book that instructed artists how to draw horses and mannequins, such as Erhard Schön's manual *Unterweisung der Proportion und Stellung der Possen* (Nuremberg, Christoph Zell: 1538). Such a page must have signaled utility to artists, perhaps even ones tasked with the illustration of books like these.

In conclusion, even when the strict utility of visualized data found in the *Liber Quodlibetarius* goes out of focus, an overarching emphasis remains on the effort to collect specimens from printed sources. By analogy, the compiler also relates material that may not have originally appeared in print to a standard of usefulness by connecting them back to the act of making an impression. Handmade compilations in the age of the press often interfaced both with the ample supply of visual information that print sent into circulation, as well as some organizational principles of the printed book. In the *Liber Quodlibetarius*, many of the images and formats were sifted out from the sediment of the printed page. Images whose genealogies were routed through the printing press established the foundation of the Erlangen codex's collecting practices. The detachable nature of the *Liber Quodlibetarius*'s images allows us to see through the page and back to the woodblock itself. Among the moveable types created by the press were images that were easily unhinged from the textual struts that secured them in their printed editions. Creators of books like the *Liber Quodlibetarius* repurposed images found in printed books and then customized new cognitive contexts for them. One of the lasting results of that detour through the press was the compiler's imperative to make some of that data useful. That usefulness spurred the organization of other less utilitarian data into seemingly useable content. The page became a fluid medium that could accept impressions of cosmographic and anatomical knowledge, snapshots from travel journals, species of birds and animals, and even inked herbs. In this prodigious ark of a book, these images could be measured, used for self-care, fishing, or as substitutions for the natural world.

Bibliography

Blair A., "Humanist Methods in Natural Philosophy: The Commonplace Book", *Journal of the History of Ideas* 53.4 (1992).

Blair A., *Too Much to Know: Managing Scholarly Information before the Modern Age* (New Haven: 2011).

Blair A. – Duguid P. – Goeing A.S. – Grafton A., *Information: A Historical Companion* (Princeton: 2021).

Bodemann U., et al. (eds.), *Katalog der deutschsprachigen illustrierten Handschriften des Mittelalters (KdiH), Bd. 6* (Munich: 2015) 466–473.

Van Buren A. – Edmunds S., "Playing Cards and Manuscripts: Some Widely Disseminated Fifteenth-Century Model Sheets," *The Art Bulletin* 56.1 (March 1974) 12–30.

Cárdenas L., *The Texture of Images: the Relic Book in Late-Medieval Religiosity and Early Modern Aesthetics* (Leiden – Boston: 2021).

Cashion D.T., "The Art of Nikolaus Glockendon: Imitation and Originality in the Art of Renaissance Germany", *Journal of Historians of Netherlandish Art* 2.1–2 (2010).

Cave R., *Impressions of Nature: A History of Nature Printing* (London: 2010).

Dackerman S., *Prints and the Pursuit of Knowledge in Early Modern Europe* (Cambridge – New Haven: 2011).

Daston L., "Epistemic Images", in Payne A., *Vision and Its Instruments: Art, Science, and Technology in Early Modern Europe* (University Park, Penn.: 2015) 17–18.

Dekoninck R. – Guiderdoni, A. – Melion, W.S. (eds.), *Quid Est Secretum? Visual Representations of Secrets in Early Modern Europe, 1500–1800* (Leiden – Boston: 2020)

Dlabacova A., "Religious Practice and Experimental Book Production: Text and Image in an Alternative Layman's 'Book of Hours' in Print and Manuscript", *Journal of Historians of Netherlandish Art* 9.2 (2017) 1–41.

Egmond F., *Eye for Detail: Images of Plants and Animals in Art and Science, 1500–1630* (London: 2017).

Felfe R. – Saß M., *Naturalismen: Kunst, Wissenschaft und Ästhetik* (Berlin: 2019).

Ferrari M.C., "Le monde en images: Deux encyclopédies manuscrites à Erlangen et à Cracovie", *Art de l'enluminure* 76 (Dijon: 2021) 4–29.

Gaida M., "Reading Cosmographia: Peter Apian's Book-Instrument Hybrid and the Rise of the Mathematical Amateur in the Sixteenth Century", *Early Science and Medicine* 21.4 (2016) 277–302.

Grimm H., *Peter und Georg Apian, Buchdrucker zu Ingolstadt und Landshut* (Mainz: 1961).

Ivins W., "A First Edition of Breydenbach's Itinerary", *The Metropolitan Museum of Art Bulletin* (1919) [full pages nos.].

Johnston S.M., "Printing the Weather: Knowledge, Nature, and Popular Culture in Two Sixteenth-Century German Weather Books", *Renaissance Quarterly* 73.2 (2020).

Jordanova L., *The Look of the Past: Visual and Material Evidence in Historical Practice* (Cambridge: 2012).

Karr Schmidt, S.K., *Interactive and Sculptural Printmaking in the Renaissance* (Leiden – Boston: 2017).

Kaufmann T.D., *The Mastery of Nature: Aspects of Art, Science, and Humanism in the Renaissance* (Princeton: 1993).

Kusukawa S., *Picturing the Book of Nature: Image, Text, and Argument in Sixteenth-Century Human Anatomy and Medical Botany* (Chicago: 2011).

Leitch S., *Mapping Ethnography in Early Modern Germany: New Worlds in Print Culture* (Basingstoke, UK: 2010).

Leitch S., "Getting to How-to: Chiromancy, Physiognomy, Metoscopy and Prints in Secrets' Service", in Dekoninck R. – Guiderdoni, A. – Melion, W.S. (eds.), *Quid Est Secretum? Visual Representations of Secrets in Early Modern Europe, 1500–1800* (Boston: 2020) 635–659.

Lutze E., *Die Bilderhandschriften der Universitätsbibliothek Erlangen* (Wiesbaden: 1971) 58–70.

Marr A., "Knowing Images: A Review Essay", *Renaissance Quarterly* 69.3 (2016) 1000–1013.

Marr A. – Heuer C.P., "Introduction: The Uncertainty of Epistemic Images", *21:Inquiries into Art, History, and the Visual* 1.2 (2020) 251–255.

Moss A., "Locating Knowledge", in Enenkel, K.A.E. – Neuber, W., *Cognition and the Book: Typologies of Formal Organisation of Knowledge in the Printed Book of the Early Modern Period* (Leiden – Boston: 2005).

Mittman A., "Are the 'monstrous races' races?" *Postmedieval* 6 (2015) 36–51.

Ogilvie B., *The Science of Describing: Natural History in Renaissance Europe* (Chicago: 2006).

Olariu D., *The Misfortune of Philippus de Lignamine's Herbal or New Research Perspectives in Herbal Illustrations From an Iconological Point of View* (Berlin: 2015).

Olariu D., "Herbs under Pressure: Plant Illustrations and Nature Printing in the first half of the Fifteenth Century", in Felfe R. – Saß M. (eds.), *Naturalismen: Kunst, Wissenschaft und Ästhetik* (Berlin: 2019) 22–23.

Panse M., *Hans von Gersdorffs Feldbuch der Wundarznei: Produktion, Präsentation und Rezeption von Wissen* (Wiesbaden: 2012).

Pettegree A., "The Renaissance Library and the Challenge of Print", in Crawford A. (ed.), *The Meaning of the Library: A Cultural History* (Princeton: 2015).

Raber K. – Tucker T. (eds.), *The Culture of the Horse: Status, Discipline, and Identity in the Early Modern World* (New York – 2005) 141–173.

Vanden Broecke S., "The Use of Visual Media in Renaissance Cosmography: the Cosmography of Peter Apian and Gemma Frisius", in *Paedagogica Historica* 36.1 (2000) 130–150.

Voigt L. – Brancaforte E., "The Traveling Illustrations of Sixteenth-Century Travel Narratives", in *PMLA* 129.3 (2014) 365–98.

Vorholt H., *The Shaping of Knowledge: The Transmission of the 'Liber Floridus'* (London: 2018).

PART 3

Communal Customising

∵

CHAPTER 6

How to Talk about Burgundian Books You Could Not Read

Bret L. Rothstein

This essay is a study of the social value of books in early modern Burgundy, and it focuses on the circulation and appraisal of lavish manuscripts in Philip the Good's court, with particular attention to the duke's chateau at Hesdin during the second quarter of the fifteenth century. However, this essay also is a materialist study of a category rather than an object, and it pertains to a book that probably was not a book at all but was instead a building (or, more accurately, part of a building). I have in mind a supposed *estaplel ouquel a ung livre de balades* ('lectern on which sits a book of ballads'), to quote a 1433 record of alterations to the fabric of the chateau. Far from rewarding the would-be reader, the *estaplel ouquel a ung livre de balades* assaulted anyone who drew near. My analysis of this item (and I do believe it was one, not two) constitutes an attempt to begin understanding what a 'book' might not have been for people at that time and in that place. I also want to give readers sense of a circumstance in which making even basic kinds of sense was open to question.

Hence my decision to write about an architectural feature[1] for a volume about customized books: that feature provides a limit case for the category of books. The limit case in question demonstrates not a set of concrete boundaries, a simple taxonomic formula on which one could rely, but rather the opposite. Presenting visitors with something that was only superficially book-like, the *estaplel ouquel a ung livre de balades* rebuffed anyone who approached it with the act of reading, or at the very least bibliophilic appraisal, in mind. To use that thing intelligently was therefore to remain analytically supple, in this case by differentiating the qualities of a legible book from the simple appearance of a book in circumstances that were, one might hasten to add, uncertain. Someone whose skills had become sclerotic, by contrast, fell prey to its

1 To refer to the *estaplel ouquel a ung livre de balades* as an architectural feature is not to deny the possibility of the lectern and book having been an actual lectern and an actual book. It is simply to acknowledge that the location of the *estaplel ouquel a ung livre de balades* was dictated by the plumbing that soiled and soaked the would-be reader. Plumbing, lectern, and book were entangled by design and, thus, formed a composite entity that was primarily an extension of the chateau – i.e., an architectural feature.

© KONINKLIJKE BRILL NV, LEIDEN, 2024 | DOI:10.1163/9789004680562_007

unreliability.[2] Mapping this limit case can help us better understand just how elastic the category of the book, and thus the scope of customization, could be.

1 How to Talk About Books

Imagine a first-time visitor to the chateau at Hesdin in northeast France in, say, 1440. A guest of the Valois duke Philip the Good of Burgundy, this person would have found themselves in the company of a fifteenth-century taste-maker whose rule was shaped by significant political frustration. Unable to occupy the French throne, Philip sought to display a magnificence that would express the authority he could never wield.[3] Hence the show of visual force associated with him: the establishment of intricate courtly rituals that became famous throughout the continent, the founding of noble organizations such as the Order of the Golden Fleece, and of course extensive patronage of the arts.[4] At first blush, one might envy our hypothetical courtier, since that person stood at an epicenter of artistic innovation, including (most notably for our purposes) the production of often lavish manuscripts that subsequently drove courtly tastes.[5] The person who found themselves in that milieu would have needed to be able to talk intelligently about books [Fig. 6.1]. And to do that, they would have had to know what books were.

The suggestion that courtiers "had to know what books were" might seem a bit much. Surely anyone in the Valois orbit knew a book when they saw one. After all, manuscripts were seemingly everywhere, a component of courtly life so central, so prominent that having to name them categorically would probably have struck any reasonable person as silly. But just because you think you know a book when you see one does not guarantee this is the case. The

2 For more on the punishment of skills gone stale, see Rothstein B.L., *The Shape of Difficulty: A Fan Letter to Unruly Objects* (University Park: 2019) esp. 126–129.

3 The classic study is Vaugh R., *Philip the Good: The Apogee of Burgundy* (Harlow: 1970; reprint London: 2002). The reprint includes an introductory essay by Graeme Small that addresses more recent contributions.

4 See, for instance, Brown A. – Small G., *Court and Civic Society in the Burgundian Low Countries c. 1420–1530* (Manchester – New York: 2007); cf. Arnade P., *Realms of Ritual: Burgundian Ceremony and Civic Life in Medieval Ghent* (Ithaca, NY: 1996). On the entanglement of arts at court, see Normore C., *A Feast for the Eyes: Art, Performance, and the Late Medieval Banquet* (Chicago: 2015).

5 See, for instance, Wijsman H., "Patterns in Patronage: Distinction and Imitation in the Patronage of Painted Art by Burgundian Courtiers in the Fifteenth and Early Sixteenth Centuries", in Gunn S.J. – Janse A. (eds.), *The Court as a Stage: England and the Low Countries in the Later Middle Ages* (Woodbridge: 2006) 53–69. See also Smith J.C., *The Artistic Patronage of Philip the Good, Duke of Burgundy, 1419–1467* (Ph.D. dissertation, Columbia University: 1981).

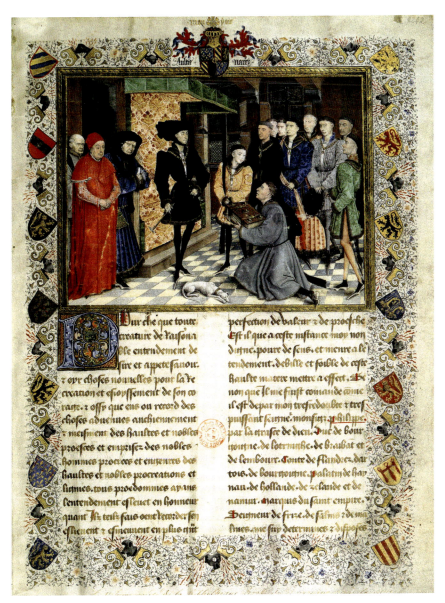

FIGURE 6.1 Netherlandish artisan (possibly Rogier van der Weyden), *Jean Wauquelin Presenting His Translation of the* Croniques de Hainaut *to Philip the Good*, frontispiece to Jacques de Guise, *Chroniques de Hainault* (*Annales historiae illustrium principum Hannonniae*), 1447–1448 (Part I). Tempera on parchment, 43.9 × 31.6 cm (folio)
BRUSSELS, BIBLIOTHÈQUE ROYALE DE BELGIQUE, MS. 9242.
PHOTO © ART RESOURCE

act of naming is powerful, setting us on a particular mental trajectory, but it also is distressingly arbitrary. Meaning is, after all, use. (To reach for a pencil in order to jot something down is to have identified a particular object as such, which is just a degenerate form of naming.) But activating an object is always an expression of hermeneutic trust – trust not only in the object, but also in one's interpretative communities – and that trust rests on shaky foundations. Ask anyone who, as a child, reached for a stick of chewing gum offered by a prankster. Readers coming out of later twentieth-century American culture will likely recall the sting of a spring-loaded trap that snapped shut on their finger as they pulled that misleading object from its faux pack. A cheap gag, to be sure, but one that summons the methodological ghost haunting this volume. To customize objects belonging to a particular category – sticks of gum, boutonnieres, books – is to assign that category a considerable degree of stability from which the customized object might then be said to depart.

Most of the time, that stability obtains, which is all to the good, since trying to live any other way would be exhausting. I extend what I call my hand toward an eye-catching board-bound rectangular object that appears to contain what look like sheets of paper, pull that object from the surface I call a shelf, rotate the object toward me, perform an act commonly known as 'opening it', and understandably expect to find images, perhaps even some text, on its anticipated pages. However, that cascade of expectations has its limits, particularly when other people are involved, since people make mistakes, do their work poorly, fail to follow through on promises, or get up to mischief. The resulting problem touches on customization, but it also extends beyond that phenomenon, since the idea of customization depends on there being 'books' to customize in the first place. But what if there is a thing that does not provide the affordances a book would and yet nonetheless lurks in a place where I might customarily find books and where the people around me have a reputation for bibliophilia? And what if that thing has been crafted to look as much like a book as possible? This exact situation arose with at least some frequency in Philip the Good's court starting in the early fifteenth century. And in so doing, it cast the category called 'books' into question.

2 Controlling Chaos

Built around 1300, the chateau at Hesdin became renowned for an array of what Ellie Truitt has called medieval robots.[6] The automata that made Hesdin

6 Truitt E.R., *Medieval Robots: Mechanism, Magic, Nature, and Art* (University Park, PA: 2015), esp. 122–137. See also Eamon W., "Technology as Magic in the Late Middle Ages and

HOW TO TALK ABOUT BURGUNDIAN BOOKS YOU COULD NOT READ 173

famous were initially concentrated in a garden, where one could marvel at, among other things, a group of mechanical monkeys covered in badger fur. Such was the impact of this garden that it even made its way into Guillaume de Machaut's *Remede de Fortune*, where the character of the Lover names it as a spur to poetic invention.[7] Hesdin had fallen into disrepair by the turn of the fifteenth century, but Philip reinvested in it on a grand scale and made the residence a regular stop on his travels – an average of two visits per year, according to Werner Paravicini.[8] Most important, the 1433 record of alterations tells us that Philip did not just renovate existing structures; he also added to them, increasing the number of automata for which the site had become famous and moving the building's center of levity from the garden to the interior, where one now found various new attractions, to borrow a term from Tom Gunning.[9]

To judge from that record, this is where the trouble would have started. Many of the attractions at Hesdin turn out to have been what we would now call assaults, though it is by no means clear that visitors would have thought of them that way at the time. Indeed, it is conceivable that being put in harm's way might even have read as an expression of royal favor.[10] Either way, in one particular gallery at Hesdin the entanglement of people and machines took the form of farce as those machines repeatedly upended the expectations – real or rehearsed – of their people. Most of the attractions in the gallery were of a sort one might expect to find in a contemporary funhouse, but that space also contained the *estaplel ouquel a ung livre de balades*. As a result, the 1433 record provokes a sense of jarring contrast with a lone book-like object sitting

 the Renaissance", *Janus* 70 (1983) 171–212, Franke B., "Gesellschaftsspiele mit Automaten – 'Merveilles' in Hesdin", *Marburger Jahrbuch für Kunstwissenschaft* 24 (1997) 135–158.

7 Van Buren A.H., "Reality and Literary Romance in the Parc of Hesdin", in MacDougall E.B. (ed.), *Medieval Gardens*, Dumbarton Oaks Colloquia on the History of Landscape Architecture 9 (Washington D.C.: 1986) 117 n. 123; Truitt, *Medieval Robots* 128–129. See also Farmer S., "Aristocratic Power and the 'Natural' Landscape: The Garden Park at Hesdin, ca. 1291–1302", *Speculum* 88.3 (2013) 644–680.

8 Truitt, *Medieval Robots* 130–131. Regarding Philip's visits to Hesdin, see Paravicini W., "Die Residenzen der Herzöge von Burgund, 1363–1477", in Patze H. – Paravicini W. (eds.), *Fürstliche Residenzen im spätmittelalterlichen Europa* Vorträge und Forschungen 36 (Sigmaringen: 1990) 218.

9 Gunning T., "The Cinema of Attraction[s]: Early Film, Its Spectator, and the Avant-Garde", *Wide Angle* 8.3–4 (1986) 63–70. Another formative influence on my thinking has been idem, "Crazy Machines: Mischief Gags and the Origins of American Film Comedy", in Karnick K.B. – Jenkins H. (eds.), *Classical Hollywood Comedy* (London: 1995) 87–105.

10 Franke, "Gesellschaftsspiele" 140–141 suggests jesters might have been deployed in lieu of courtiers. Truitt, *Medieval Robots* 134, by contrast, notes that there may have been incentives for people of higher rank to undergo some of the assaults at Hesdin. On the aesthetics and ethics of participation in courtly spectacles, see Normore, *A Feast for the Eyes*, esp. 60–73.

on a lectern and surrounded by trap doors, distorting mirrors, automata that might speak to or even strike a visitor, and pipes that might squirt water up one's dress or drench one in ink or soot. Needless to say, surprise seems to have played an important role in the gallery. With that in mind, it is perhaps worth introducing the *estaplel ouquel a ung livre de balades* amidst the wonders with which it would have competed at the time.

Imagine yourself in an ornate gallery lined with beautiful paintings set against large, costly expanses of mirrors and occupied by several automata.[11] Like anyone with an ounce of self-respect in Philip's orbit, you have come prepared with an opinion or two about paintings, tapestries, and sculpture, as well as perhaps a few casual observations in your pocket concerning the particular skill of an artisan named Colart le Voleur, who you have been told executed the paintings on display.[12] Approach one of the automata, a wooden figure called the Hermit, and it will speak to you, providing additional opportunities to celebrate the artisanal skill at Philip's disposal. Looking into an adjacent space, you see another figure above a window. Walk in and ask that figure a question; it will answer, perhaps even making an amusing face as it does so.

As you move throughout the gallery, more and more objects offer themselves for appraisal. Your attention split among so many candidates for the display of discernment, you finally alight on what might well be the *pièce de résistance*. To one side, you see a pretty book of ballads on a lectern, a little gem that someone with a lesser eye might miss amidst the wealth of showy mechanical wonders. Although not so ostentatious as those paintings in the gallery or the Hermit or that figure above the window, it will undoubtedly still be a feast for the eyes, since Philip's love of fine books is well known. Plus, singing is a fashionable courtly diversion.[13] Given all this, only a fool would not venture over to have a look, perhaps even recite a verse or two.[14] After all, even the simplest book of ballads in Philip's court would have been an exercise in customization (the finest materials, the most sophisticated ornamentation, the wittiest selection and

11 This narrative of the gallery builds on the 1433 record as transcribed in Truitt, *Medieval Robots* 262–263 n. 60. Unless otherwise stated, all translations are mine.

12 It is worth recalling the observation by Franke, "Gesellschaftsspiele" 140 that performative 'commentators' activated painted monuments for their fellow visitors to Hesdin. See also Normore, *A Feast for the Eyes*, as in note 4 above.

13 See, for instance, Wright C.M., *Music at the Court of Burgundy, 1364–1419: A Documentary History*, Musicological Studies 28 (Henryville, PA: 1979); Sosson, J.-P., "Chantiers urbains, chantiers ducaux dans les anciens Pays-Bas méridionaux (XIVe–XVe s.): deux univers de travail différents?", in Cauchies J.-M. (ed.) *A la cour de Bourgogne: Le Duc, son entourage, son train*, Burgundica 1 (Turnhout: 1998) 127–136; Strohm R. *Music in Medieval Bruges* (Oxford: 1991) 74–101.

14 Franke, "Gesellschaftsspiele" 140.

juxtaposition of texts, etc.) Indeed, such a book became something of a proxy for its owner and his renowned tastes, and it rarely hurts to pay a compliment.

With the benefit of hindsight, one might be forgiven for thinking that *only* a fool would do any of that. According to the account from 1433, '[...] y a ung estaplel ouquel a ung livre de balades que, quant l'en y vault lire, les gens se treuvent tous broulliez de moir et tantost qu'ilz regardent dedans aussi sont ilz moulliez d'eaue quant on vault [....]' (there is a lectern on which sits a book of ballads that, if one wishes to read it, that person finds themselves completely soiled, and those who [still] wish to look within [the book] are also drenched with water).[15] Note how both assaults are attuned specifically to interest.[16] They are even scaffolded, with one punishment for the casual observer and a second one for the die-hard. Having invited assessment, the item ruins your clothes and perhaps even stains your skin. And yet, despite this, you persist, aiming to turn a page or read a bit of text, but in return for your pains all you get is a thorough drenching. The situation is a dramatic bait-and-switch, blemishing you in the midst of your attempt to appraise, as well as to vocalize and perhaps enact, beauty. Caught off guard, you step back to gather your wits. However, that part of the floor is rigged to blast soot from below. Move to your left, and water falls from the ceiling, matting your hair and saturating your clothes. Perhaps it is time to assess the damage and gather your wits: you turn to a mirror near the lectern, and it douses you with flour, which joins the soot and water to make a nasty grey paste on your expensive clothes. You might be tempted to try again, using those mirrors in the gallery, but they are essentially funhouse mirrors that will emphasize your dirtiness and distort your features. Better to open a window and get a bit of fresh air while you try to sort a reasonably dignified way forward.

Not so fast, though. A mechanical figure next to that window slams it shut, but only after squirting you with water once more. Seeing your fate, another member of your group sticks close to a different wall, only to find the floor give way, dropping them unceremoniously onto a sack filled with feathers. Retreat to the gallery and stand by a cluster of sculpted figures, where you hope to find a safe space. (After all, what patron in his right mind would risk soaking expensive sculptures?) You are wrong, but not in the way you expected: the figures turn out to be automata that beat you about the head and shoulders. A voice finally calls for everyone to leave the room. Do as you are told, and you

15 I am working from the transcription in Truitt, *Medieval Robots* 263 n. 60. Regarding the substance that soils one's clothing, soot gets the vote in idem 132, while Franke, "Gesellschaftsspiele" 140 favors ink.

16 Franke, "Gesellschaftsspiele" 139–140.

176 ROTHSTEIN

get soaked once again and then dropped through the false floor of a bridge into a pond. But if you lag, you will be thoroughly drenched once more.

3 An Architectural Anglerfish

This – and more – was what awaited visitors to Hesdin after 1433, when Philip paid Colart le Voleur not only to execute the gallery's cycle of paintings but also to oversee renovation and mechanical enhancement of the room and its adjoining spaces. The basic implications of Philip's enterprise seem clear enough. The automata provided multiple opportunities for courtiers to exercise a kind of amateur reverse engineering, which enabled people to sort degrees of understanding and, thus, belonging in a highly competitive environment.[17]

I doubt, however, that every one of the attractions at Hesdin functioned in the same fashion. It is one thing to try explaining how, say, the Hermit worked. It is another thing altogether to parse that supposed opportunity to read. The Hermit raises vexing mechanical questions; the *estaplel ouquel a ung livre de balades* does not. (One would have to be quite dense indeed not to understand how water and ink or soot could be moved around.) To be sure, I am inclined to agree with Franke, who suggests that the automata one found in the gallery, among other spaces, served not to enhance or shore up notions of order, but rather to generate acceptable sorts of chaos.[18] And that chaos undoubtedly created a ludic zone where one could play through knowledge hierarchies and aspects of courtly belonging. But in the case of the *estaplel ouquel a ung livre de balades*, the sort of play in question revolved less around how the thing worked than around why one managed to miss the warning signs.[19]

To put it another way, the automata initiated a comedy of errors by driving their people to take ever less effective and ever more frenzied action. In the course of doing so, they also activated a fifteenth-century Burgundian counterpart to the operational aesthetic, that peculiarly American obsession with being able to explain everything all the time.[20] The *estaplel ouquel a ung livre de balades*, by contrast, initiated a comedy of *category* errors, quietly inviting a measured, erudite response that it subsequently undercut. Of course, there would have been commonalities among these attractions even beyond their

17 This is the central argument in Truitt, *Medieval Robots*. Franke, "Gesellschaftsspiele" takes a similar approach but allows for a broader range of interests.

18 Franke, "Gesellschaftsspiele" 140.

19 Cf. Rothstein, *Shape of Difficulty* 106–108 regarding the likelihood that curiosity followed surprise for first-time users of the Swan Mazer.

20 Harris N., *Humbug: The Art of P.T. Barnum* (Chicago: 1973).

capacity for inflicting both insult and injury. The ensemble would undoubtedly have provoked curiosity about its mechanisms, curiosity that may have been quite pronounced. That staging of its assaults would suggest as much: the amateur engineer, not just the would-be reader, got a shower that their stained but more circumspect compatriot did not. But it was not a mechanical imitation of a natural form, in the manner of the apes or birds in the garden, or of the Hermit next door. It was a manufactured thing that masqueraded as merely a manufactured object – i.e., part of a building that looked like a book and supporting apparatus but was in fact the lure that brought one into a trap.[21]

It is tempting to write off the *estaplel ouquel a ung livre de balades* as a bit player, a mere rhetorical flourish that supported the more prominent features around it. But I suspect this particular attraction would have stood out precisely because it was not a sculpted figure, a funhouse mirror, a large and elaborate painting, or a captivating automaton. Placed amidst florid marvels, it undoubtedly would have provoked a lesser sort of interest. And yet, it would have provoked interest nonetheless, especially for someone attuned to the subtler side of Burgundian tastes. After all, from early on Philip had gained a reputation as an extravagant bibliophile. For the refined courtier, especially one with a literary or musical bent, Hesdin's *estaplel ouquel a ung livre de balades* would initially have scanned as an expression of the duke's fondness for books and song. Consequently, even in the early days of Philip's patronage, anyone with an ounce of social sense would have approached a book-like object as the opportunity to curry ducal favor by praising its material and technical qualities or by selecting and perhaps reciting a witty passage.

Who indeed would have walked heedlessly past an attractive, well-made manuscript?[22] In the Burgundian court, the appearance of a book often occasioned performative judgment: gathering around, admiring the book in the company of others, dipping into it wisely, complementing the owner on their fine taste, and so on.[23] In such cases, the aim was not only to glean wisdom from a codex, but also to jockey for social advantage around a familiar and highly coded object, one so ubiquitous as to become both unremarkable (the category itself) and at the same time noteworthy (each individual example). But because it encompassed both extremes, 'book' as a category was in truth marked by considerable ambiguity. That is where the Hesdin *estaplel ouquel a*

21 Regarding the contrast between objects and things, see Brown B.C., "Thing Theory", *Critical Inquiry* 28.1 (2001) 1–22.

22 Franke, "Gesellschaftsspiele" (as in note 18 above).

23 Buettner B., "Profane Illuminations, Secular Illusions: Manuscripts in Late Medieval Courtly Society", *The Art Bulletin* 74.1 (1992), esp. 76–78.

ung livre de balades gained special force. Distracting ornamentation and tricky plumbing masqueraded as an unremarkable object of remarkable beauty. In so doing, it caught out those whose grasp of what books were and could be was superficial and insufficiently flexible.

4 The Subtlety of Unuseless Things

We find another parodic response to such charged familiarity in a prank the Limbourg brothers played in 1410, when they presented Jean de Berry with what a later document describes as:

> Item, un livre contrefait d'une pièce de bois paincte en semblance d'un livre, où il n'a nuls fueillets ne riens escript; convert de veluiau blanc, à deux fermouers d'argent dorez, esmaillez aux armes de Monseigneur [....]

> a book fashioned from a piece of wood painted in the likeness of a book, though there are neither pages nor anything written [on them]; covered in white velvet with two gilded silver clasps enameled with the arms of my lord [....][24]

As Brigitte Buettner has observed, the prank appealed to a courtly taste for strange and surprising objects.[25] It also did something more, though. Reducing the category of the book to pure ornamentation and eliding textual content altogether, the Limbourg brothers' non-book brilliantly skewered a materialistic bent that often threatened to obscure the informational utility of books. And from what we can tell, their gag seems to have worked beautifully: that description comes from a 1413 inventory of Jean de Berry's *library*, where the non-book evidently landed after its initial presentation, most likely as a playful trap for visitors who thought they knew books when they saw them.[26]

As was the case in Jean de Berry's court, so visitors to Hesdin often would have deployed literacy, visual acuity, and a sensitivity to the disposition of materials as social currencies, not just intellectual tools. Anyone who approached a book of ballads in Philip's orbit knew they would have to expend those currencies

24 As transcribed in Guiffrey J., *Inventaires de Jean duc de Berry (1401–1416)* (Paris: 1894), vol. 1, article 994.

25 Buettner B., "Past Presents: New Year's Gifts at the Valois Courts, ca. 1400", *The Art Bulletin* 83.4 (2001) 604–606; Buettner describes the object in question as a box, not a solid block. Cf. Franke, "Gesellschaftsspiele" 140.

26 Rothstein, *Shape of Difficulty* 116–117.

in a way that matched the refinement of the object. And that refinement, through the subtle customization it evinced, provided the index of an ideal – i.e., Philip's own skills and expectations, as well as the money and connections he could deploy in service of them. Provoked by the skillfulness of the artisans who wrote script, rubricated pages, and assembled boards, leather, clasps, and gems into bindings, the courtier's critical skills had to rise to the occasion. In the case of Hesdin, subtlety would likely have been the order of the day. Placed where it was, as it was, the *estaplel ouquel a ung livre de balades* initially would have seemed a poor neighbor to the automata, paintings, and distorting mirrors nearby – making no promise to speak, offering no large-scale iconographical program. And yet, it also seemed to promise just the sort of pleasure one might reasonably expect in a bibliophilic court. Until the full nastiness of the gallery and its adjacent spaces was set in motion, that non-book would have provided a spot of marked understatement, one best met sensitively.

Consequently, the punishment meted out by that *estaplel ouquel a ung livre de balades* came in response not simply to curiosity, but to *subtle and refined* curiosity. To grasp the sharpness of that punishment, it helps if we spend a moment on the communication strategies that governed tricky objects and spaces in the later fourteenth and early fifteenth centuries. A good example would be the Swan Mazer, a French cup that eventually made its way to Corpus Christi College at Cambridge University [Fig. 6.2]. As the *estaplel ouquel a ung livre de balades* likely was, so this cup is not especially beautiful. I mean, it is fine; it is even *nice*. But that is precisely the point: it is *just nice*, which distracts us from the fact that it is also *naughty*. For the person unfamiliar with this object's behavior, it looks like nothing more than a mid-level drinking vessel, when it is in fact something else. Fill it part-way, and everything goes fine: drink at will. But fill it to its namesake (that bird needs a pond, after all), and it will immediately drain through its foot and onto your clothes. To put it another way, the Swan Mazer is not really a cup in the strictest sense of the word (meaning something that only holds liquid in between sips). It is an *if-then* function designed to sort those who look at fancy objects from those who actually see them.[27] That function's efficacy relies on meticulous de-emphasis, with the relative simplicity of gilt silver metalwork providing just enough points of interest to distract you from the drainage mechanism, part of which is in fact

27 *If* you fill the Swan Mazer a little, *then* it will work without incident; *if* you fill it fully, *then* it will drain. What seems like misbehavior – evacuating between sips – is in fact entirely predictable, even desirable, provided you are perspicacious and cautious enough to have sorted the underlying mechanism. See Rothstein, *Shape of Difficulty* 8–10 and 106–107.

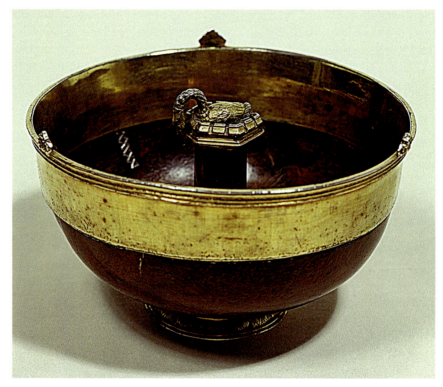

FIGURE 6.2 Anonymous, Swan Mazer, before 1384. Silver-gilt and maple wood, 7.0 × 12.7cm.
Corpus Christi College, Cambridge University
PHOTO COURTESY OF THE PARKER LIBRARY, CORPUS CHRISTI COLLEGE,
CAMBRIDGE UNIVERSITY

visible if you know how and where to look.[28] Here, too, we find a machine for interrogating category errors; thinking you know what a cup is and could be was no substitute for close observation and rigorous consideration.

A similar strategy governed Hesdin's unreliable spaces, which made consistent use of de-emphasis in, for example, the automata and quasi-funhouse mirrors. These dazzled the eye and appealed boldly to one's analytical skills, all the while drawing attention away from the mechanisms that would eventually come into play elsewhere in the room. For example, the apertures that emitted water, flour, and soot or ink would necessarily have been visible, much in the manner of the Swan Mazer's mechanism. But an aperture is hard to spot when flanked by all manner of ornate sculptural details, lavish paintings, distorting mirrors, and mechanical wonders. The floor that would drop one onto that

28 For a fuller discussion of de-emphasis, see idem, especially Chapter 3.

HOW TO TALK ABOUT BURGUNDIAN BOOKS YOU COULD NOT READ

sack of feathers and the bridge that would send people into water below arguably belong in the same category, their seams and hinges more overshadowed than hidden by the decoration surrounding them.

A notable exception to this was that *estaplel ouquel a ung livre de balades*, which I would describe as an exercise not only in de-emphasis but also misdirection.[29] The apparatus provided visual details that competed with information of genuine relevance, but it also indicated the potential for an experience that was ultimately not available. What we have, then, is another non-book that destabilized the very idea of what a book was or could be.[30] In the context of Hesdin, this distinction comes with a difference. The chateau's de-emphasized traps interrogated your ability to sort mechanisms that detectably hid within animatronic figures or that governed mirrors. By contrast, the *estaplel ouquel a ung livre de balades* lied outright. It masqueraded as part of a fashionable, important, and entirely familiar category of objects (lavishly customized books) to which it subsequently and quite bluntly gave the lie. There was no mystery, not like one would have encountered with, say, the Hermit – or even, for that matter, the Swan Mazer.[31] There was only surprise of a decidedly unsubtle kind.

But unsubtlety was the point. The *estaplel ouquel a ung livre de balades* benefited from the fact that it initially was in the aesthetic minority. Looking like a relatively modest and familiar kind of object was what allowed it to do its work in the first place. And I do believe 'first' is the applicable term here. The gallery at Hesdin undeniably worked in a comedic tone, with knowledge being the central topic of interrogation. (One thinks of Cicero's observation that, '[...] scitis esse notissimum ridiculi genus, cum aliud exspectamus, aliud dicitur. Hic nobismet ipsis noster error risum movet [...]' (you know already that the best-known type of joke is when we expect one thing and another is said. With this, our own error moves us to laugh).[32]) Upending expectations, the gallery's attractions spurred visitors to play the vicissitudes of knowing something versus merely *thinking* you know something. But timing was a central factor in that play, with surprises being sprung on visitors in sequence. In that context, it is worth asking who in the world would take the time to examine a book of ballads when being sprayed with water or beaten by an automaton. It seems

29 See idem, especially Chapter 5.

30 Even if Philip had someone place an actual book of ballads atop that lectern, the object in question was then no longer a book in any functional sense, since it was in a context designed to thwart attempts at reading. And is something unreadable still a book?

31 See Rothstein, *Shape of Difficulty* 8–10.

32 Cicero Marcus Tullius, *De Oratore*, trans. E.W. Sutton – H. Rackham, 2 vols. (Cambridge, MA: 1942), II, chapter 63.

likely that the *estaplel ouquel a ung livre de balades* might have coexisted with more congenial attractions, such as the Hermit, but preceded others. Indeed, the presentation of a book of ballads – even a fake one – presumes relative calm in which to engage with and begin vocalizing text. With that in mind, I imagine that unassuming apparatus initiated a broader and increasingly frenetic erosion of physical and cultural conventions. Ensconced well within the unreliable spaces around the Hermit, it would be a perfect lure for the incautious visitor.

In sum, then, the Hesdin *estaplel ouquel a ung livre de balades* punished category error that derived, ironically, from accomplishment. In the process, it revealed the contingency of what fifteenth-century 'books' were and could be. Unlike the surrounding attractions, which had a kind of reach, meeting you where you stood, it drew you out, inviting you to step forward and delve into its contents the same way you would when presented with the opportunity to peruse one of the duke's custom-made books – had it been a book in the first place, that is. But it was not a book; it was merely book-like, with the subversion of that book-likeness temporarily invalidating the hard-won sensibilities of anybody who sought to read it. In so doing, it set bibliophilia and erudition in play by undercutting the knowledge on which the contemporaneous culture of books depended. After all, everyone in Philip's milieu would have known a good book when they saw it, except when they suddenly did not, as at Hesdin. But that was the point of having an entire cluster of rooms revolve around a lone non-book.

Philip was a big-spending bibliophile, but he also frequently was a nonreading one, at least in the modern sense of silent, private reading. According to the courtier David Aubert, Philip preferred to have others vocalize books for him.[33] In such an environment, the relationship between textual content and the means for conveying it was attenuated, admitting of ambiguity. Perhaps that was a determining factor in why, to borrow a formulation from Pierre Bayard, Burgundian bibliomania could revolve around knowing how to talk about books you had not read.[34] To be sure, under most circumstances, literacy and an appreciation for nice things were basic qualifications for courtly competency. And yet, manuscripts in the Burgundian court were also a political currency – signifiers of wealth and erudition to be exchanged; they were means for building or modifying power relationships. This matters, especially with respect to the chateau at Hesdin, because we are accustomed to thinking

33 Doutrepont G., *La littérature française a la cour des Ducs de Bourgogne, Philippe le Hardi, Jean Sans Peur, Philippe le Bon, Charles le Téméraire* (Paris, 1909) 467.

34 Bayard P., *How to Talk About Books You Haven't Read*, trans. J. Mehlman (London: 2008).

about Philip's artistic patronage as an exercise in generating iconographies of power, expressing a grandeur and suggesting a nobility the duke could never actually possess. However, the Hesdin *estaplel ouquel a ung livre de balades* suggests something more peculiar: the desire to command not just the imagery of authority, but the very categories on which that imagery might depend in the first place. As such an exercise, the first-timer's visit to Hesdin would have taught one how to talk about non-books you *could not possibly read* because they were not really books in the first place.

We should bear in mind that Philip saw himself as the ultimate author of the wonders at Hesdin.[35] Recognizing this casts the question of customized Burgundian books in a new light. The chateau began as an expression of his forebears' ambitions, but in the early fifteenth century it came to exemplify his own. That exemplarity included elements of courtly life that have become *de rigeur* in the literature: exclusive noble orders, intricate rituals, and elegant outfits; exquisite meals, elaborate entertainments, and of course beautifully customized books. All of these modes of cultural production generated iconographies of authority, which is why they figure so prominently in scholarship on the Burgundian courts. However, they also did something more peculiar. They made *customization itself* into a barometer of economic, political, and social power. Hence Philip's fondness for Hesdin: it provided a calculatedly idiosyncratic environment in which his emblems, his courtiers, his servants, his accoutrements, and his visitors all nested, intertwined, and overlapped entirely according to his pleasure. In that idiosyncratic environment, the *estaplel ouquel a ung livre de balades* provided a specifically bookish demonstration of Philip's privilege of seemingly total customization.

Bibliography

Arnade P., *Realms of Ritual: Burgundian Ceremony and Civic Life in Medieval Ghent* (Ithaca, NY: 1996).

Bayard P., *How to Talk About Books You Haven't Read*, trans. J. Mehlman (London: 2008).

Brown A. – Small G., *Court and Civic Society in the Burgundian Low Countries c. 1420–1530* (Manchester – New York: 2007).

Brown B.C., "Thing Theory", *Critical Inquiry* 28.1 (2001) 1–22.

Buettner B., "Past Presents: New Year's Gifts at the Valois Courts, ca. 1400", *The Art Bulletin* 83.4 (2001) 598–625.

35 Franke, "Gesellschaftsspiele" 139.

Buettner B., "Profane Illuminations, Secular Illusions: Manuscripts in Late Medieval Courtly Society", *The Art Bulletin* 74.1 (1992) 75–90.

Van Buren A.H., "Reality and Literary Romance in the Parc of Hesdin", in MacDougall E.B. (ed.), *Medieval Gardens*, Dumbarton Oaks Colloquia on the History of Landscape Architecture 9 (Washington D.C.: 1986) 117–134.

Cicero Marcus Tullius., *De Oratore*, trans. E.W. Sutton – H. Rackham, 2 vols. (Cambridge, MA: 1942).

Doutrepont G., *La littérature française a la cour des Ducs de Bourgogne, Philippe le Hardi, Jean Sans Peur, Philippe le Bon, Charles le Téméraire* (Paris, 1909).

Eamon W., "Technology as Magic in the Late Middle Ages and the Renaissance", *Janus* 70 (1983) 171–212,

Farmer S., "Aristocratic Power and the 'Natural' Landscape: The Garden Park at Hesdin, ca. 1291–1302", *Speculum* 88.3 (2013) 644–680.

Franke B., "Gesellschaftsspiele mit Automaten – 'Merveilles' in Hesdin", *Marburger Jahrbuch für Kunstwissenschaft* 24 (1997) 135–158.

Guiffrey J., *Inventaires de Jean duc de Berry (1401–1416)*, 2 vols. (Paris: 1894).

Gunning T., "The Cinema of Attraction[s]: Early Film, Its Spectator, and the Avant-Garde", *Wide Angle* 8.3–4 (1986) 63–70.

Gunning T., "Crazy Machines: Mischief Gags and the Origins of American Film Comedy", in Karnick K.B. – Jenkins H. (eds.), *Classical Hollywood Comedy* (London: 1995) 87–105.

Harris N., *Humbug: The Art of P.T. Barnum* (Chicago: 1973).

Normore C., *A Feast for the Eyes: Art, Performance, and the Late Medieval Banquet* (Chicago: 2015).

Paravicini W., "Die Residenzen der Herzöge von Burgund, 1363–1477", in Patze H. – Paravicini W. (eds.), *Fürstliche Residenzen im spätmittelalterlichen Europa*, Vorträge und Forschungen 36 (Sigmaringen: 1990) 207–63.

Rothstein B.L., *The Shape of Difficulty: A Fan Letter to Unruly Objects* (University Park, PA: 2019).

Smith J.C., *The Artistic Patronage of Philip the Good, Duke of Burgundy, 1419–1467* (Ph.D. dissertation, Columbia University: 1981).

Sosson J.-P., "Chantiers urbains, chantiers ducaux dans les anciens Pays-Bas méridionaux (XIVe-XVe s.): deux univers de travail différents?", in Cauchies J.-M. (ed.), *A la cour de Bourgogne: Le Duc, son entourage, son train*, Burgundica 1 (Turnhout: 1998) 127–136.

Strohm R., *Music in Medieval Bruges* (Oxford: 1991).

Truitt E.R., *Medieval Robots: Mechanism, Magic, Nature, and Art* (University Park, PA: 2015).

Vaugh R., *Philip the Good: The Apogee of Burgundy* (Harlow: 1970; reprint, London: 2002).

Wijsman H., "Patterns in Patronage: Distinction and Imitation in the Patronage of Painted Art by Burgundian Courtiers in the Fifteenth and Early Sixteenth Centuries", in Gunn S.J. – Janse A. (eds.), *The Court as a Stage: England and the Low Countries in the Later Middle Ages* (Woodbridge: 2006) 53–69.

Wright C.M., *Music at the Court of Burgundy, 1364–1419: A Documentary History*, Musicological Studies 28 (Henryville, PA: 1979).

CHAPTER 7

Customizing for the Community: The Wiesbaden Manuscript (Hauptstaatsarchiv 3004 B 10) and the Late Medieval Church

Geert Warnar

Can the idea of customized books be separated from the mechanized production of the printing press and applied to medieval manuscripts? The question may sound strange: the individual book as research object (instead of the text or texts it transmits) lies at the heart of approaches like the New Philology or *Überlieferungsgeschichte*, that focus on the materiality of literary communication in manuscript cultures.[1] Yet manuscripts have not received as much attention as printed books, perhaps because each handwritten medieval codex has so many individual characteristics that its uniqueness is axiomatic. In other words, every manuscript was always customized. The same might be said for the texts – medieval literature was often aimed at a specific audience, whether addressed in person as a patron(ess) or in the social and religious categories of lay man or woman, sinner, contemplative, aristocrat or citizen. Leaving aside these issues of literary culture, codicologists that advocate a cultural approach to the medieval book propose studying the manuscript not as a product but as a process, full of rearrangements, additions or unforeseen decisions by scribes, readers and owners that may have changed any original or revised plan.[2] The making of a manuscript depends on forms of direct contact with the material text in which it is difficult to decide where the production stops and customizing begins. This is different from the mechanical (re)production of printed material in a fixed format with identical copies that could be customized in later stages. A scribe's individual treatment of her or his *exemplar*, the decision

1 For a state of the art on the study of medieval literature in a manuscript culture in the Low Countries (significant for this article), see the contributions in Besamusca A.A.M. – Pratt K. – Meyer M. – Putter A. (eds.), *The Dynamics of the Medieval Manuscript: Text Collections from a European Perspective* ([NP]: 2017). How *Überlieferungsgeschichte* and New Philology work in practice is demonstrated perfectly in Dlabacova A., *Literatuur en observantie. De Spieghel der volcomenheit van Hendrik Herp en de dynamiek van laatmiddeleeuwse tekstverspreiding* (Hilversum: 2014) (with reference to earlier research on Dutch literature).

2 Johnston M. – Van Dussen M., "Introduction: Manuscripts and Cultural History", in Johnston M. – Van Dussen M. (eds.), *The Medieval Manuscript Book: Cultural Approaches* (Cambridge: 2015) 1–16.

© KONINKLIJKE BRILL NV, LEIDEN, 2024 | DOI:10.1163/9789004680562_008

CUSTOMIZING FOR THE COMMUNITY: THE WIESBADEN MANUSCRIPT

whether or not to collect accompanying texts and the choice of these texts might result in a book that changes in appearance and function over time, as texts and notes are added, or new quires attached. This can be an ongoing process, during which various owners and users leave their traces, until the life cycle of a manuscript comes to an end in the well-protected environment of an institutional library, such as the Hessisches Hauptstaatsarchiv in Wiesbaden, Germany.

The library preserves, under shelf mark 3004 B 10, a Dutch manuscript from the first decade of the fifteenth century that lends itself perfectly to an in-depth discussion of the problems and possibilities that research on the customization of medieval handwritten books raises.[3] The problems in this particular case have to do with the scarcity of information on origins, ownership and history of the manuscript; the potential lies in the interpretation of a miscellany as a customized book. The Wiesbaden manuscript contains over seventy texts, written by at least nine hands (not necessarily nine persons), distributed over at least four codicological units, to which have been added thirty-seven contemporary drawings, partly pasted on leaves that were inserted into the book [Fig. 7.1]. The texts and drawings cover a wide range of religious subject matter, including exegesis and exhortation, prayer and saints, didactics and devotion, confession and contemplation. All the texts (except for some Latin notes) are written in the Dutch vernacular; apparently the Wiesbaden manuscript reflects the religious interests of the laity – laity referring to those that did not read or understand Latin, but also to those who did not count as clergy in the ecclesiastical sense.[4]

For the practical purpose of understanding the Wiesbaden codex, it is useful to distinguish customizing from actively contributing to the scribal work of copying texts or the artistic work of illustrating texts. Customizing will refer to any arrangement or rearrangement after these primary stages of production. Although this distinction is not drawn from the codicologist's conventional terminology, the idea that customizing happens at a different moment in the

3 A fully edited version of the manuscript appears in Kienhorst H. – Schepers K. – Berteloot A. (eds.), *Het Wiesbadense handschrift: Hs. Wiesbaden, Hessisches Hauptstaatsarchiv, 3004 B 10* (Hilversum: 2009), here referred to as "the Wiesbaden edition". The Introduction surveys everything known about the manuscript, as well as all published research on it. I have relied on this introductory study for codicological information (hands, quires etc.), in particular, 21–99. For quotations from the manuscript, the text-page number is cited, followed by the line numbers, as recorded in the Wiesbaden edition. Transcriptions of texts on the drawings have been given a letter rather than a number. A pdf-file of the edition can be downloaded at https://www.textualscholarship.nl/?p=7016.

4 Wackers P. *Terug naar de bron* (Utrecht: 2002).

FIGURE 7.1 Ms. Wiesbaden, Hessisches Hauptstaatsarchiv, 3004 B 10, fol. 61r. Page with pasted drawings

life of a manuscript is crucial for decoding the complex assemblage of the Wiesbaden codex.

The drawings were probably added after the copying process was largely finished.[5] The pasting and insertion of the drawings certainly fall under the customizing part of the process. One of the main questions I want to pose is what it means for the use and interpretation of texts and images in the Wiesbaden manuscript that they were bound together. The purpose of adding drawings to a book that consisted primarily of written texts, must be different from illustrating a manuscript according to a preconceived plan. The Wiesbaden manuscript is best understood as a miscellany in which texts and images function together, next to each other but also on their own, just as paintings in a church could be observed one by one, in the specific context of an altar or chapel but also within the greater whole of the church. The comparison is inspired by the pictures in the Wiesbaden manuscript with portraits of saints, disciples and other biblical figures, or standard scenes like Last Judgement or the three dead kings rising from their graves: devotional imagery of this type would have been regularly encountered in churches. But the idea of the Church – not only as a sacred building, but as a religious institution and a Christian community at the heart of late medieval society – provides a context that will prove important for understanding the Wiesbaden manuscript and its pictorial customization.

The drawings were at first believed to have been inserted into the manuscript only to ensure their preservation. Martha Renger, who has published much of the best work on the images in the Wiesbaden codex, speaks of them as 'the most extensive collection of fourteenth-century north European drawings still existing [...] [that] witness to the range of styles current in the late fourteenth-century Netherlands where so few larger works of art exist today'. Renger was also the first to shift the focus from preservation of the drawings to their integration in the book: 'The Wiesbaden manuscript is the earliest example known to me of an entire manuscript containing mounted and framed drawings intended to accompany, if not to illustrate texts'.[6] Thus, the pasted

5 Martha Renger's dissertation on the manuscript was followed by two important articles: see Renger M.O., "The Wiesbaden Drawings", *Master Drawings* 25 (1987) 390–410; and eadem, "Wiesbaden 3004 B 10: More than a Manuscript", in Smeyers M. – Cardon B. (eds.), *Flanders in a European Perspective. Manuscript Illumination around 1400 in Flanders and Abroad* (Louvain: 1995) 207–217.

6 See Renger, "The Wiesbaden Drawings" 390 for both quotations. See also Kienhorst H. – Schepers K., "Het hele plaatje zien. De toevoeging van tekeningen in de codex Wiesbaden, Hessisches Hauptstaatsarchiv, 3004 B 10", in Schepers K. – Hendrickx F. (eds.), *De letter levend maken. Opstellen aangeboden aan Guido de Baere bij zijn zeventigste verjaardag* (Louvain: 2010) 371–400.

insertion of the images should be thought of as an intentional customizing of the codex. The reasons why the drawings were used in this way remain a mystery, especially since literary interest in the Wiesbaden manuscript has thus far been quite limited. A substantial number of the book's texts survive only in this manuscript, and of these, only two have been edited separately: a set of questions and answers (in the form of *quaestiones*) on the theory and practice of the mystical life and a dialogue between a nun and a secular priest, whose ecclesiastical authority is challenged to such a degree that the editor considers the text anti-hierarchal.[7] Even if this is true of this particular *disputacie*, the rest of the manuscript has a different character, indicating that it was possibly produced and customized with a much broader readership in mind than some of its supposedly 'radical' texts would suggest. More recent research on the selection of texts in the Wiesbaden manuscript as a whole simply labels the content as 'verzamelde vroomheid' (collected piety).[8]

It was the emerging interest in material philology that moved the codex from the periphery of Dutch medieval literature to a more prominent position. This shift can be linked directly to the launch of the series *Middelnederlandse verzamelhandschriften* (Medieval Dutch miscellanies), that provided editions of complete collections of texts in specific manuscripts.[9] The aim of the series, deeply influenced by the New Philology, was to study medieval literature in the material context of its text transmission. Within a single manuscript, various texts interacted as a result of the compiler's ideas, the scribe's interests or the commissioner's wishes, generating new meanings and interpretations that can never be grasped by treating the individual texts as authorial products. The Wiesbaden codex was immediately identified as a perfect showcase for these dynamics of interpretation. Publication of an edition of the Wiesbaden manuscript in the *Middelnederlandse verzamelhandschriften* was considered a *desideratum* almost from the start, but its complexity (change of hands, inserted quires and the numerous drawings) presented a major challenge – and required a full research project. The edition of Hans Kienhorst and Kees Schepers (completed in 2007) is impressive and has laid the groundwork for any future study of the Wiesbaden manuscript. The detailed codicological description, which reads like a forensic report, has proved indispensable for

7 An edition of this anti-hierarchal tekst appears in Lievens R. "Een antihiërarchische disputatie uit de veertiende eeuw', *Sacris Erudiri* 25 (1982), 167–201. For the other separate text edition, see Lievens R. "Questien van eenen goeden simpelen mensche", in Coun Th. (ed.), *Hulde-album Dr. F. Van Vinckenroye* (Hasselt: 1985) 187–208. These are texts 42 and 33 in the Wiesbaden edition.

8 Wackers, *Terug naar de bron.*

9 The papers for the conference / launch event are collected in Sonnemans G. (ed.), *Middeleeuwse verzamelhandschriften uit de Nederlanden. Congres Nijmegen 14 oktober 1994* (Hilversum: 1996).

CUSTOMIZING FOR THE COMMUNITY: THE WIESBADEN MANUSCRIPT 191

my article and effort to develop a new account of the use and function of the manuscript and its customization. The editors' codicological and philological work inevitably focused on the material text and the manuscript as a product; the somewhat more speculative arguments presented here focus instead on the process of customization, situating it within the larger contexts of religious and literary culture. Starting with a slightly updated sketch of what can be said about the origins of the Wiesbaden manuscript and various stages in the history of its production, this contribution explores how the drawings enriched the book and its use.

1 'After this book has been read'

The Wiesbaden manuscript betrays nothing of its ownership, its origins or the identity of the scribes. Before moving to the archives in Wiesbaden, the book was kept in the Norbertine monastery of Arnstein an der Lahn (near Koblenz) where it must have arrived before the end of the sixteenth century. There is no indication that the book came to Arnstein through a Norbertine connection, although there were several abbeys of the order in the Duchy of Brabant, where the manuscript must have originated. Similar watermarks have also been found in documents from Malines, Ghent and Brussels dating from the first decade of the fifteenth century. This dating corresponds to the year 1410 written under a short rhyme on returning the book to its rightful owner [Fig. 7.2]. Apparently, the codex could be borrowed for reading:

> After this book has been read (read includes silently / privately read and
> read publicly / aloud)
> Then give it back to him who owns the book.
> Then one will borrow it to you
> The next / second time, this I know.
> If one were not to do this (= returning the book)
> And asked for it again
> He (=the owner) would be unprepared (to lend it again)
> This says the one who knows.[10]

10 'Alse desen boec ghelesen es, Waermen des oec niet en dade
 Soe gheeften weder dies hi es. Ende men ne anderwerven bade
 Soe sal menne u ten anderen male Hi soude wesen ongehereet;
 Gherne leenen, dat weet ic wale. Dat seghet deghene diet wel weet'
 (Wiesbaden edition nr.4).

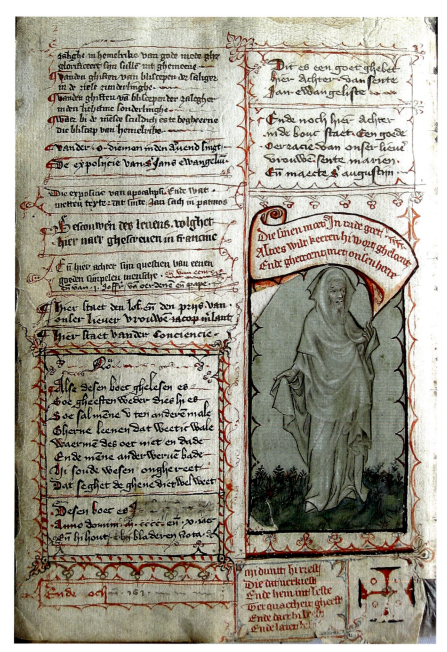

FIGURE 7.2 Ms. Wiesbaden, Hessisches Hauptstaatsarchiv, 3004 B 10, fol. 2v. Table of contents, verses on borrowing the book and pasted drawing

CUSTOMIZING FOR THE COMMUNITY: THE WIESBADEN MANUSCRIPT

The verses suggest an individual but not necessarily private (male) owner or bookkeeper and some sort of communal use of the manuscript, but we have no information about the community in which the manuscript likely circulated. The person who wrote the note must have been responsible for the book and loaning it out. Although he uses the first person in the note and talks about the manuscript's owner in the third person, the last line betrays that it is one and the same man. He is one of the main characters in the history of the manuscript, as his hand reappears in all sections of the manuscript. This 'Hand 7', as the anonymous scribe is referred to in the edition, wrote the texts on the last quires, but added short dicta and statements throughout the manuscript and even on some of the drawings. He must have been the person who finally customized the book after other scribes had contributed to its production. Hand 7 thus was personally involved in the manuscript's making, its use and its circulation. A name under the verses on borrowing has been erased so carefully that this possible clue to previous ownership had already disappeared in the fifteenth century.

It is unclear who could consult the manuscript or under what circumstances. Only very few other Dutch manuscripts have notes on borrowing, although that practice must have been more common than the rare data might lead us to assume.[11] The available information mainly concerns books from institutional libraries such as those in monasteries, convents and religious houses, but notes on borrowing (and returning!) were particularly relevant when books could leave the place where they were kept. A Dutch manuscript of 1428 containing a set of devotional treatises offers a glimpse of the practice in question. The scribe was the priest Johannes van Wederden (Wierden in the Northern part of the Netherlands), and his colophon expresses his hope to share in the benefits that anyone may obtain by reading this book. He adds the warning that one should be careful lending this book 'out of the house' to worldly people (*werlike lude*) as they do not take good care of books.[12] A similar note in a monastic

11 Wranovix M., "Common Profit Books in Ulrich Pfeffel's Library: Parish Priests, Preachers, and Books in the Fifteenth Century", *Speculum* 87 (2012) 1125–1155.

12 Ms. Leiden, University Library Ltk 351. See Lieftinck G.I. *Codicum in finibus Belgarum ante annum 1550 conscriptorum qui in bibliotheca universitatis asservantur* (*Bibliotheca universitatis Leidensis*, Codices manuscripti V) pars I, (Leiden: 1948), 198–200: "Inden jaeren ons heren dusent vier hondert ende achtentwintich is dit boeck ghescreven vermids heren Johanne van wederden preister uutgheseget een deel wat van den lesten Ende hevet dit van mynnen ghescreven. begherende mede deelachtich te werden alder vruchten die yemant lesende uut desende boke vercrighen mach ende datmen voer em bidden wille onsen heren. Voertmer datmen mit aller vlite dit boeck waer. wanttet cranc van stove is. ende men niet lichtelike uuten hues en leene in werliker lude hande. went si quelicke pleghen die boeke te waren".

manuscript (1480) with a commentary on the *Song of Songs* in Dutch is more enthusiastic about lending out the book for studying and copying within the convent, but also to other groups (*vergaderinge*, literally 'gatherings') who desire to disdain temporal things and live for eternal things. Those who have not (yet) turned from the flesh to the spirit should find support in books that discuss the four last things or the fundamentals of (practicing) virtue.[13]

The Wiesbaden note neither mentions 'worldly people' as potential borrowers nor implies that the book circulated in a specific community or 'gathering' of like-minded persons, but it still reflects the late medieval practice of making common-profit books containing informative reading material for a diversity of individuals available in parishes and churches. Such books also modeled organized forms of lay devotion used by guilds and confraternities.[14] A shred of evidence for this *Sitz im Leben* of the Wiesbaden manuscript is a reminder in verse (written on the final leaves of the book) to think of God and be modest when seated for dinner:

> When you are seated at the table
> where you will drink or eat,
> think of God who grants it all.
> Speak moderately what you (really) mean
> And think about the poor in the street
> Who would gladly eat with you.[15]

13 Ms. Olim Louvain, University Library G74. See Schepers K., *Bedudinghe op Cantica Canticorum. Vertaling en bewerking van Glossa Tripartita super Cantica* (Louvain: 2006) 386–387: "Die dit boec screef ende gaf van mynnen. den cloester van den berge. die war sine meninge dat mens mildelike solde lenen enich van onsen cloesteren. om uut te scriven ofte studeren. of oec enige ander vergaderinge die daer nae hongeren ende begeren die tijtlike dinge te versmaden ende ewighe dinge te mynnen dese sel mens sonderlinge geerne lenen. ende dat ander stucke van desen. Mer die den vleysche meer volgen dan den geest die sel ment weygeren. ende wisen se totten vier utersten ende tot ander boeken die vanden doechden spreken in mynre volkomenheit".

14 Corbellini S. – Hoogvliet M., "Late medieval urban libraries as a social practice: miscellanies, common profit books and libraries (France, Italy, the Low Countries)", in Speer A. – Reuke L. (eds), *Die Bibliothek -- The Library -- La Bibliothèque: Denkräume und Wissensordnungen*. Miscellanea Mediaevalia: Veröffentlichungen des Thomas-Instituts der Universität Köln 41 (Berlin: 2020) 379–398.

15 Als ghi ter tafelen zijt gezeten,
daer ghi drincken sult oft eten,
dan denct op gode, diet al verleent.
Sprect met maten dat ghi meent,
ende denct om die arme opter straten,
dat zij gheerne met u aten'.
(Wiesbaden edition, T)

CUSTOMIZING FOR THE COMMUNITY: THE WIESBADEN MANUSCRIPT

A similar reminder, with exactly the same opening line, hung on the wall in the chamber of the Malines Guild of the Bowmen, urging the members to commemorate their fellow bowmen who had died in battle.[16]

A sense of communal devotion also presents itself in the Wiesbaden manuscript in texts that were meant to be read in public meetings; these texts used the language of charters to address all who would see or hear them.[17] A more substantial form of interaction is found in the exegetical analysis of the pericope of Christ hiding himself (John 8:59), that is read on Passion Sunday. The text combines the liturgical context of a sermon with the informal setting of a conversation in which the person speaking is reminded of what he said on a previous occasion, when preaching about the Annunciation. The preacher responds by quoting a *meester der postillen*, probably the Franciscan theologian Nicholas of Lyra, before moving on to the theme and topics of his sermon: six meanings of Christ hiding himself. Apparently, the theology is beyond the capacities of the preacher's audience, as they ask for further clarification: 'Good sir, now we would gladly ask – because we are small in intellect – that you clarify for us these six intricate points. For even were we logicians and [university] students in Paris, we would have to study hard on these points.' The answer is very accommodating: 'Now, you gentlemen, because of your courtly request and for the praise of our Lord and your instruction and edification, I will do my best gladly and out of love'.[18]

These traces of a dialogue evince a professional cleric, who is familiar with both the practices of Church life and its theological concepts and methods. He is communicating with unschooled but highly interested lay men. The slightly dialogic exposition demonstrates a form of interaction that could apply to the making and use of the Wiesbaden manuscript as a whole: with clerics involved in the production (as compilers, scribes, authors and bookkeepers, like the man behind Hand 7), and a readership of laymen engaged in forms of religious life beyond merely attending Mass on Sundays. Both parties were committed to the joined goal of 'instruction and edification' (*instructie ende*

16 Danis M.C.H., *Opkomst en bloei van het Christendom in Mechelen, Vol. 1* (Malines: 1857) 242: 'Als ghy ter taefelen syt geseten'.

17 Wiesbaden edition nrs. 55/170, 184 and 186; 68/84.

18 Wiesbaden edition nr. 57/25 for the reference to the sermon on the Annunciation, 31 for the master of the postillae and 137–144 for the question and answer: 'Goede heere, nu wilden wi u gherne bidden, om dat wi in verstannessen cleene zijn, dat ghi ons dese vi subtile pointe verclaret. Want al waren wi logiciene ende studente van Parijs, so zijn zij ons studiens ghenouch'. 'Nu, ghi heeren, om de hovessche manighe van hu lieden ende omme den lof ende prijs ons heeren, ende om uwer lieder instructie of ghestichtichede, soe willic mi van minnen gherne daer toe pinen' (my quotation marks).

ghestichtichede). Although we cannot extrapolate the character of this particular text to the rest of the manuscript with complete certainty, there is nothing in the codex that suggests it was *not* the work of clerics writing for the laity. Moreover, the customizations made to the Wiesbaden manuscript would also have been considered part of providing reading material for audiences in ways beyond composing new works, such as donating and loaning books, or placing texts and images on display in public spaces like church interiors.[19] Supply and demand of religious knowledge could take on many forms, and the Wiesbaden manuscript is a great example of these late medieval devotional dynamics, in which the church parish was pivotal as a (public) space for many practices in religious culture.

To understand this diversity as characteristic of both the Wiesbaden manuscript itself and contemporary visions of devotional life, the book must be contextualized in the 'world of the fifteenth-century Church' as articulated by John Van Engen.[20] This period, as Van Engen shows, saw a considerably more active, widespread and variegated participation in religious practice across all levels of society. First, devotional energies and community-formation in fifteenth-century parishes are to be construed as signs of a growing religious awareness – not necessarily only within movements such as the *devotio moderna* but also in confraternities. Second, to the extent that diverse texts consider specific aspects or functions of religious life, they do so without making the (implicit) assumption that their readers know only one dimension of spiritual devotion. The mixtures of themes and texts in miscellanies demonstrate that the reader who is addressed as a sinner in one text may be invited to meditate in the next or introduced to the afterlife. Third, the multiple options for practicing the religious life, even though they sometimes appear contradictory, should not be seen as mutually exclusive. Although the professed, the clergy and the laity were associated with specific duties, expectations and life styles, the fifteenth century witnessed growing efforts to appropriate religious practices across these categories. The laity in particular explored new domains of religion, ranging from the acquisition of personalized prayer books and the commissioning of prestigious illustrated Bible manuscripts, to attending monastic *collationes* and setting up confraternities.[21]

19 Corbellini – Hoogvliet, "Late medieval urban libraries".

20 See Van Engen J., "Multiple Options: The World of the Fifteenth-Century Church", *Church History* 77, (2008) 257–284.

21 Cf. Warnar G. "Het verlossende word. De Utrechtse bijbels (ca. 1430–1480) in context", *Ons geestelijk erf* 83 (2012) 264–284; and Boonstra P., *Reading by Example: The Communication of Religious Knowledge in the Collationes of the Brothers of the Common Life* (Groningen: 2021).

CUSTOMIZING FOR THE COMMUNITY: THE WIESBADEN MANUSCRIPT 197

These multiple options are so characteristic for the Wiesbaden manuscript, that they resist earlier hypotheses on its production and circulation among beghards or similar groups of artisans who combined traits of a religious order and a professional guild.[22] Some texts refer to forms of lay mysticism that was associated with beghards and their supposedly controversial spirituality thought to be informed by the teachings of Meister Eckhart. This fourteenth-century Dominican was accused of preaching potentially heretical views to lay people, sometimes more specifically described as beghards. A few Eckhart-dicta in the Wiesbaden manuscript have recently been identified as excerpts from sermons that were also cited in the official accusations against the mystic.[23] However, the excerpts themselves do not show any trace of unorthodox thinking, presenting Eckhart's views on the benefits of humility in the face of God. The Eckhart references could have been a matter of personal interest, as the hand that wrote these excerpts also added a short dialogue between Meister Eckhart and an unspecified lay person, who explains to the mystic the nature of true spiritual poverty, again in a way that is rather different from Eckhart's own famously controversial ideas on this issue.[24]

The role switching with the lay man teaching the master is not uncommon in this mystical type of exemplary narrative, for which anti-intellectual is a more adequate term than anti-hierarchal.[25] The texts support the engaged laity, but this does not mean that the scribe copied them to question clerical authority. Immediately preceding the Eckhart dialogue is a poem that describes a contest between the great philosophers Albertus Magnus and Henry of Ghent with the Dutch vernacular author Jacob van Maerlant. His learned opponents acknowledge Maerlant's mastership in singing the praises of the Virgin Mary.[26]

22 On this hypothesis, see Kienhorst – Schepers, "Het hele plaatje zien".

23 Vinzent M. "'Meine Demut gibt Gott seine Gottheit' (Meister Eckhart, Predigt 14) – neue handschriftliche Zeugnisse und eine neue Edition", in Haustein J. (ed.), *Traditionelles und Innovatives in der geistlichen Literatur des Mittelalters*. Meister-Eckhart-Jahrbuch. Beihefte 7 (Stuttgart: 2019) 63–85, esp. 65–69.

24 Ubbink R.A., *De receptie van Meister Eckhart in de Nederlanden gedurende de middeleeuwen. Een studie op basis van middelnederlandse handschriften* (Amsterdam: 1978) 204–207.

25 Survey in Vooys C.G.N. de, *Middelnederlandse legenden en exempelen* (Groningen – The Hague: 1926) 332–349.

26 Warnar G., "Lodewijk van Velthem, de *Spiegel historiael* en *Den lof van Maria*. Van handschrift Wroclaw, Universiteitsbibliotheek IV F88e-11 naar het bewustzijn van een Nederlandse literatuur in de veertiende eeuw", in Kiedrón S. – Kowalska-Szubert A.(eds.) *Thesaurus polyglottus et flores et flores quadrilingues. Festschrift für Stanislaw Predota* (Wroclaw: 2004) 709–722.

That vernacular devotion is presented as superior to the learning of the *doctores*, testifies to the laity's growing religious consciousness, a trend that would only grow stronger throughout the fifteenth century, taking shape in the 'multiple options' of late medieval religious culture.

2 Multiple Options in Context

The varieties of spiritual guidance found in the devotional literature of the later Middle Ages should not be considered a historiographical problem to be solved but as evidence for the wide range of religious practices within reach of anyone; this was increasingly a matter of personal choice. This quotation from Van Engen's survey of the 'multiple options' brings it all together:

> More, beyond duties and expectations people were also cracking open niches across a wide and diverse spectrum, finding ways to appropriate religion for themselves. This requires historical explanation, even definition. In medieval categories religion meant strictly the estate of the professed, then the estate of the clergy, next the 'good' (that is, practicing, engaged) laity, and lastly all the baptized. To appropriate religion meant that people in the third category took on practices and aspirations generally considered the domain of the first or second. Acts largely accounted clerical, or aspirations associated with the religious, increasingly were undertaken by interested laypeople.[27]

Turning from these general observations to the specific mixture of texts and images in the Wiesbaden manuscript, we see the idea of multiple options take shape from the opening text onwards. The *Wech der sielen salicheit* [= Path of the soul's salvation], a manual of religious instruction, introduces already in its fourth chapter multiple states of salvation (*behoudenissen*), and their ways of life: the state of innocence of newborn children, the state of penitence for those who partake of the sacraments, the state of justice for those who are concerned with their fellow Christians and the state of perfection for the contemplatives. Each of these categories has its set of sacraments, virtues and ideals to pursue. Together these states of life offer a wide spectrum of religious

27 Van Engen, "Multiple options" 269.

CUSTOMIZING FOR THE COMMUNITY: THE WIESBADEN MANUSCRIPT

practices and formations – providing evidence that the multiple options were indeed conceptualized in religious writing.[28]

This may also be said for the texts in the Wiesbaden manuscript, even apart from their combination with the drawings. The texts cover most medieval models for a Christian life, from collective confession to personal prayer. However, there is an emphasis on the traditional practices of the Church and the (Sunday) sermon.[29] Whereas the ten commandments are explained for the salvation of the souls of simple Christian folk (*zalicheit der zielen des simpels kerstens volcs*) who 'do not often hear additional sermons', the previously mentioned discussion of 'Christ hiding himself' is aimed at laymen for whom the sermon alone did not suffice as the sole source of religious instruction.[30] The religious life envisioned for these lay readers is not governed by the vows or rules of the religious orders. Accordingly, the Wiesbaden manuscript shows hardly any traces of the rich mystical and monastic literature of Jan van Ruusbroec and his circle, although these texts came from the same Brabantine regions where the book was produced.[31] Some texts, such as a translation of Bede's exposition of the *Apocalypse* or a letter in verse on the conditions of the contemplative life, presuppose a religiously informed readership, but the Wiesbaden manuscript started as a manual for pastoral care.[32]

The work on the manuscript began with the transcription of a work of practical theology, which the colophon calls 'the mirror of Christian faith'. The text survives in other (fragments of) manuscripts and was eventually printed

28 On this chapter from the *Wech* (Wiesbaden edition 5/147–211), see Warnar G., "Biecht, gebod en zonde. Middelnederlandse moraaltheologie voor de wereldlijke leek", in Mertens Th. et al., *Boeken voor de eeuwigheid. Middelnederlands geestelijk proza* (Amsterdam: 1993) 40.

29 See Van Engen, "Multiple options", 259, for the concept of traditional religion and its practices, as introduced by Duffy E., *The Stripping of the Altars: Traditional Religion in England 1400–1580* (New Haven: 1992).

30 Wiesbaden edition nrs.7 and 57.

31 Both of the other complete manuscript copies of the *Wech der sielen salicheit* (the first text in the Wiesbaden manuscript) were accompanied by Ruusbroec texts:. Ms. Brussels, Royal Library, II 280 and ms. Gent, University Library, 1291–1293. Descriptions of both manuscripts can be found through a shelfmark search of the Bibliotheca Neerlandica Manuscripta (https://bnm-i.huygens.knaw.nl/).

32 On the *Apocalypse* commentary, see Schepers K., "Kortsluiting tussen Wearmouth-Jarrow en Vlaanderen. De Apocalyps in het Middelnederlands", *Queeste* 15 (2008) 97–119. On the rhymed letter, see Wackers, P., "Een berijmde brief over het volmaakte leven", in Schepers K. – Hendrickx F. (eds.), *De letter levend maken. Opstellen aangeboden aan Guido de Baere bij zijn zeventigste verjaardag* (Louvain: 2010) 629–651.

as the *Wech der sielen salicheit*, a general introduction to everything a devout Christian needed to know: the seven deadly sins and the ten commandments, the sacraments, the virtues, and the gifts of the Holy Spirit; the text concludes with a detailed treatment of eschatological matters.[33] The *Wech* was based on the standard textbooks for teaching the laity: the *Compendium theologicae veritatis* by Hugo Ripelin of Strassbourg and the *Summa de vitiis et virtutibus* by Guillelmus Peraldus. The anonymous author of the *Wech* makes himself known as a Flemish priest; he claims to have provided religious instruction for 'simple people' out of charity (*ter leeringhen van simpelen menschen uut minnen*). These words from the colophon echo the prologue, where the author, justifying his use of the mother tongue, talks about the need to familiarize simple people with the basic knowledge they need to live as children of the Holy Church.[34]

This reference (by a priest) to writing for the benefit of the children of the Holy Church typifies the Wiesbaden manuscript as a religious manual for the secular laity. This function applies, too, to another copy of the *Wech*, produced in the Brabantine monastery of Zevenborren at this time (more precisely, in 1413) for a certain Amant Mannoet, whose payment for the codex is registered in the colophon. In Mannoet's manuscript, the *Wech* is complemented by Jan van Ruusbroec's exposition of the creed and a meditative exercise on the seven prayers encompassed by the Pater Noster.[35] Likewise, the first Wiesbaden scribe added to the *Wech* texts that treat Christian topics of common concern, including an explanation of the ten commandments (translated from Jean Gerson's French *Miroir de l'ame*) and some prayers from the standard repertoire.[36] The next scribes added material that explored themes related to (or only addressed briefly in) the *Wech*, starting with a rhymed exposition of *John* 1:1–14.[37] The author, the poet Augustijnken, avers that his exposition is meant to strengthen

33 For a detailed treatment of the *Wech*, see Schepers K., "Judgment, Damnation, and Salvation in *Wech van Salicheit*, *Tafel vanden kersten ghelove*, and in Ruusbroec's Works – Apocalyptic Eschatological Concepts in Middle Dutch Texts and in Their Latin Sources", *Queeste* 21 (2014) 1–22.

34 Wiesbaden edition nr.5/17–21.

35 [Ampe A. et al.] *Jan van Ruusbroec (1293–1381). Tentoonstellingscatalogus* (Brussels: 1981), nr.74.

36 Wiesbaden edition nrs. 7 and 9–11. On the Gerson translation, see Schepers K., "Het Opus tripartitum van Jean Gerson in het Middelnederlands", *Ons geestelijk erf* 79 (2005–2008) 146–188.

37 See Bouwmeester G., *Receptiegolven. De primaire, secundaire en tertiaire receptie van Augustijnkens werk (1358–2015)* (PhD dissertation, Utrecht University, 2016); and Warnar G., "Augustijnken in Pruisen. Over de drijfveren van een Middelnederlandse dichter en literatuur binnen de Duitse Orde", *Jaarboek voor Middeleeuwse Geschiedenis* 8 (2005), 101–139.

CUSTOMIZING FOR THE COMMUNITY: THE WIESBADEN MANUSCRIPT

the Christian reader's faith, although his poem is intellectually more demanding than the preceding works in prose. John's words lead to a profound discussion of incarnation theology, but the liturgy remains a primary point of reference; Augustijnken focuses his discussion on those verses from the Gospel comprised by the Mass (which were also copied into most Books of Hours). Next comes a poem on confession and penitence, sacramental themes already dealt with in the *Mirror* that must have been important in the context of the Wiesbaden codex. A model confession on a separate parchment leaf bound at the end of the book, also points to sacramental religion and its practices.[38]

After the pastoral character of the first section, the contents of the miscellany become more diverse and intellectually more ambitious. The third hand was responsible for the longest text in the manuscript – the somewhat mysteriously chosen commentary on the *Apocalypse*.[39] As a translation of Bede's Latin original, this work seems to have been a failed experiment that left no other traces. Within the Wiesbaden manuscript the exegetical commentary is a departure from the teaching of traditional religion in the *Wech* and consecutive texts. Hand 3 shows a stronger interest in texts that bring professional theology within reach of vernacular readers; the Eckhart excerpts and Augustynken's theological poetry were also copied by him. With this thematic reorientation, the anticipated readership of the texts changes. The prologue to Bede's commentary greets 'dear sisters and brothers' and wishes them to remain *bemuert* forever in Holy Writ against all temptations of the world; *bemuert* literally means 'walled in', hence, protected, supported and even empowered.[40] These might be the original words of the translator; the scribe adds to the prologue some advice (within a separate frame) for a more general readership, who are told to 'read this text and understand it with your heart / And remember it; then it will be for your benefit (*Leset dese scrifte ende verstaet met uwer herten wel / Ende onthoudet, so macht u vromen wel*). These verses are very similar to a short rhyme that Hand 7 wrote four folia earlier: 'Reading, praying and contemplating; these three have no worth without understanding' (*Lesen, beden ende contempleren; dese III en doghen niet sonder verstaen*).[41]

The verb and noun *verstaen* relate to understanding as the intellectual work of the mind but also to the inner formative work of the heart. These mental activities give rise to the processes of instruction and edification mentioned before. The two accidental *sententia* recorded by the principal scribes betray

38 Wiesbaden edition nr.17 (the rhymed text on confession) and nr.770 (model confession)
39 Wiesbaden edition nr.26. See Schepers K., "Kortsluiting".
40 Wiesbaden edition nr.26/7–10.
41 Wiesbaden edition nrs.27 and 13.

some of the criteria applied to the choice of texts in Wiesbaden manuscript. The function and significance of the texts consist in instilling knowledge of the religious life in all its late medieval diversity; they also aim to improve religious understanding (*verstaen*), which in medieval Dutch is etymologically close to *verstannissen*, the intellect – one of the seven gifts of the Holy Spirit, as listed in the *Wech*.[42] Improving *verstaen* may be a common feature in medieval religious writing *tout court*, but comes to the fore with special prominence in the Wiesbaden manuscript, most obviously in a set of questions on mystical theology in the tradition of the *Lehrgespräch*. Here meaning and understanding arise directly from the language use of the speaker and the addressee, although the heading suggests a meditative inner dialogue: 'These are the questions (quaestiones) of a good, simple person, whereupon the supreme king gives answers to his (= the person's) soul' (*Dit sijn questien van eenen goeden simpelen mensche, daer die opperste coninc ziere zielen op antwoert*). The text itself reads like a lecture with the same 'I' asking the questions and responding.[43]

These questions, together with a long letter in verse (addressed to a lady) on the conditions and preparation for a contemplative life, were copied in a separate parchment booklet that was obtained from elsewhere and integrated in the Wiesbaden codex by one of its scribes (probably Hand 3) further to expand the options for understanding the religious life.[44] The same is true of the texts in the last units of the codex, which offer orderly schemata for contemplation, like the four lights of nature, grace, faith and glory, or a ladder with thirty rungs of the Old and New Testament (texts 44, 52). A separate discussion of the seven deadly sins as offences against the Holy Spirit reads like the record of a public lecture in which each sin is discussed with three arguments, followed by an equally systematic treatment of the seven gifts of the Holy spirit as an antidote. In conclusion, all who have seen or heard these texts are invited to join in a final prayer.[45]

As the manuscript becomes more personal (or less professional, as the editors suspect), the copied texts show a growing emphasis on the exhortative rhetoric of sermons. When Hand 7 works on his own in the last quires, he starts with an exposition of *Romans* 14:17 that incorporates short mosaic texts on threats to the true spiritual life and on the need for critical investigation of

42 Wiesbaden edition 5/2260. On the (speaker's) meaning and the (addressee's) understanding, see Clark H., *Using language* (Cambridge: 1996) 12–14.

43 Wiesbaden edition nr.34. The text is discussed in Warnar G., "Eckhart und der Laie als Lehrgespräch. Versuch einer Rehabilitierung?" *Meister Eckhart-Jahrbuch* 7 (2013) 181–194.

44 The letter is particularly complex in its interaction between speaker / sender and addressee. See Wackers, "Een berijmde brief".

45 Wiesbaden edition nrs. 44, 52 and 55.

CUSTOMIZING FOR THE COMMUNITY: THE WIESBADEN MANUSCRIPT

one's own struggle with earthly vanities.[46] The later sections of the Wiesbaden manuscript share characteristics with the *collationales* of the Modern Devotion in the Northern Low Countries: religious textbooks in the vernacular that were compiled to be read and discussed at informal meetings with lay people on Sundays after church.[47] These *collationales* closely followed the liturgical pericopes read on Sundays. Several Wiesbaden texts are copies of sermons, and others also start with a biblical theme and could easily be read out during meetings similar to the *collationes*. The text on Christ hiding himself (providing 'instruction and edification') reflects a similar context, with strong connections to the liturgical calendar as the theme and argument develop from the pericope (*John* 8:59) to be read on the Passion Sunday. The following sermon starts with *Song of Songs* 4:12, introduced as an antiphon in honor of Mary.[48] These liturgical references appear throughout the Wiesbaden manuscript and are found from the start: the *Wech* draws the central idea of its Prologue (God has called upon all humans to 'possess' the eternal life) from the liturgical collect *Deus auctor pacis etc.* 'as our mother the Holy Church proclaims' (*also onse moeder die heilighe kerke orcond*). Moreover, the translation of Bede's commentary on the *Apocalypse*, opens with a Prologue that refers to the O-Antiphons sung during Advent (*Clavis David*).[49]

Connections to the liturgy seem so natural to late medieval religious writing that its significance in this case is easily overlooked. The Wiesbaden codex is not organized around the Hours like a prayer book nor does it follow the liturgical calendar like a sermon collection for Sundays and specific Saints' days. Given the diversity of the texts, the recurring references to liturgy and the cyclical life of the Church become meaningful for deducing the milieu in which the texts were collected and the manuscript was customized. Readers were constantly being reminded of their attachment to the Church. Hand 7 makes this particularly explicit in what he wrote to fill a blank space after the conclusion of the *Wech*. Perhaps inspired by the Advent-antiphon mentioned in the *Apocalypse* commentary, he added a short reflection on Church life that he rubricated as "On the [capital] O that one sings in the Advent" (*Vander O diemen inden advent singt*). The O of the antiphon signifies the calling and longing of the Old Testament prophets and fathers who sat in the darkness of original sin before Jesus saved them. Their tears and suffering should awaken

46 Wiesbaden edition nr.60. From l.140 on, there follows a set of excerpts that are also found in other manuscripts.

47 Boonstra P., *Reading by Example: the Communication of Religious Knowledge in the Collationes of the Brothers of the Common Life* (Groningen, 2021).

48 Wiesbaden edition nrs. 57 and 58.

49 Wiesbaden edition 5/1–4 and 26/1–6.

the 'us' addressed in this short text, which regrets that Christmas is celebrated without due devotion:

> When Christmas Eve passes, one sings and calls out *Puer nobis* from the joy of all blessed creatures in heaven and on earth and in hell. Oh, how all divine hearts cry out now when they see this beloved feast pass in such great idleness. Old and young now behave as if they have lost their senses. What devotion learn the young from the old? Alas, how little they care about God? Therefore, the state of the holy Church is bitter. Because humility, mercy, loyalty, truth, charity, penitence, chastity, true faith, true hope; it all has declined in the holy place. And [this is] because everyman loves himself and looks for his own profit as far as he may. Nota bene.[50]

It is difficult to establish whether this is the lament of the man behind Hand 7, or if he is copying a complaint with which he agreed. Rhetorical usage and the sense of communicating with an audience make it more than a personal note. Even though Hand 7 is filling a blank space, the concluding 'nota bene' and a reference in the table of contents give these words extra emphasis. Catching a glimpse of the man behind Hand 7, who remained responsible for the Wiesbaden manuscript after completing it, we see that he was familiar with the ecclesiastical office and was concerned with the state of religious life and the Church – both the institution and the community, and, if we take the added drawings into account, possibly also the sacred (public) space.

3 The Images and the Church

The idea that the Wiesbaden manuscript reflects the religious culture of a parish church might be developed further by looking at the drawings. They were not made to be inserted into the manuscript. Martha Renger argued that the

50 Wiesbaden edition 6: 'Alse kersavont lijdt, soe singtmen ende roept luyde Puer nobis van bliscapen die alle zaleghe creatueren hadden in den hemel ende opder erden ende inder hellen. Ach, hoe zeere jammert nu allen godliken herten, als si horen ende sien dit minlike hoghetijt met soe groter ydelheit begaen. Oude ende jonghe, die ghelaten nu of si zinneloes waren. Wat devocyen leeren die jonghe nu ane doude? Ach, lacen, hoe cleyne es die gode ontfermnysse? Hier omme moet van node bitterlec staen in die heileghe kerke. Want oetmoedicheit, ontfermherticheit, trouwe, waerheit, broederlike minne, penytencie, reyn leven, gherecht gheloeve, gherecht hope, dit es zeere vergaen inder heilegher stat. Ende want elc mint hem selven ende soect sijn eyghen vordeel in al dat hi vermach. Nota bene'.

CUSTOMIZING FOR THE COMMUNITY: THE WIESBADEN MANUSCRIPT 205

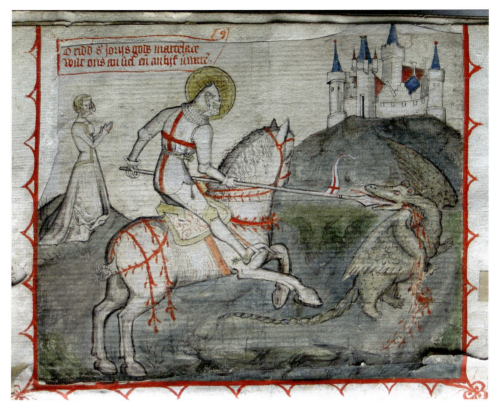

FIGURE 7.3 Ms. Wiesbaden, Hessisches Hauptstaatsarchiv, 3004 B 10, fol. 14v. Pasted drawing of Saint George fighting the dragon

drawings, some of which must have been cut from model sheets, originally may have served as patterns for (mural) paintings, tapestry, statues or stained glass windows.[51] Kienhorst and Schepers pointed out other parallels with pictorial imagery in (Low German) church interiors: a *Salvator mundi*, a last judgement scene, the Annunciation, Saint Martin and the beggar and Saint George fighting the dragon [Fig. 7.3].[52] Further evidence that the Wiesbaden drawings are related to church imagery are the two large murals of ca. 1400 discovered in the Church of Saint John the Evangelist and John the Baptist in Malines.[53]

51 Renger, "The Wiesbaden drawings".
52 Kienhorst – Schepers, "Het hele plaatje zien".
53 Bergmans, A. – Buyle M., "'Internationale Stijl' in Mechelen: Ontdekking, Conservatie en Onderzoek van de Muurschilderingen van rond 1400 in de Toren van de Sint-Janskerk," *RELICTA (BRUSSEL)* 10 (2013) 129–207.

One of these paintings depicts a similar scene of Saint George that we find in the Wiesbaden codex, with the saint on horseback slaying the dragon to save the princess who, according to the traditional narrative in the *Legenda aurea*, was about to be sacrificed to a monstrous dragon. The other mural portrays Saint Christopher, who once was also present in the Wiesbaden manuscript, although this drawing has been removed.[54]

The Malines paintings are close to the Wiesbaden manuscript in space and time, but the images are not directly related. A second image of Saint George in the Wiesbaden manuscript, pasted onto the last leaf of the final quire, bears a much greater resemblance with a mural in the Church of Saint Martin in Halle (southwest of Brussels) [Figs. 7.4–7.5].[55] There is more to connect the Wiesbaden drawings to this church. When Renger developed the hypothesis that the drawings were originally used to plot compositions, she pointed especially to four separate drawings that together represent the Adoration of the Magi [Fig. 7.6].[56] Support for Renger's hypothesis might be found in the portal of St. Martin's in Halle, where a sculpted scene of the Adoration of the Magi is similarly composed [Fig. 7.7]. Two kings turn toward each other as if they were having a conversation, with the king closest to Mary and the Christ child (although the king in the portal does not kneel, he doffs his crown like the king in the Wiesbaden drawing).[57] A short poem written in the voice of the three kings addressing the child Jesus accompanies the drawing of the *Magi* in the Wiesbaden codex. The same poem appears in a contemporary manuscript with a text collection that probably originated in the parish church of Molenbeek near Brussels.[58] The manuscript also contains a copy of the poem in praise of Mary that appears in the Wiesbaden codex.[59]

If the Church of Halle is relevant for understanding the drawings in the Wiesbaden manuscript, this is perhaps mainly, but not only, because few other churches in the Brabantine area (where the book can be located on linguistic grounds) have retained so many medieval art works that give an impression

54 Wiesbaden edition Pl.IV and VII.

55 Bergmans, A. – Buyle M., "'Internationale Stijl' in Mechelen" 171, with an image of the 19th century reproduction of the mural that does not longer exist.

56 Renger, "The Wiesbaden drawings" 394–395.

57 Steyaert J.W., *The Sculpture of St. Martin's in Halle and Related Netherlandish Works* (PhD dissertation, University of Michigan, 1974) 92–100.

58 Wiesbaden edition H; the accompanying editorial commentary mentions the other copy. On the manuscript and its origins, see Brinkman H., "Het wonder van Molenbeek. De herkomst van de tekstverzameling in het handschrift-Van Hulthem" *Nederlandse Letterkunde* 5 (2000) 21–46.

59 Wiesbaden edition nr.28, and the introduction 104 for other copies.

CUSTOMIZING FOR THE COMMUNITY: THE WIESBADEN MANUSCRIPT

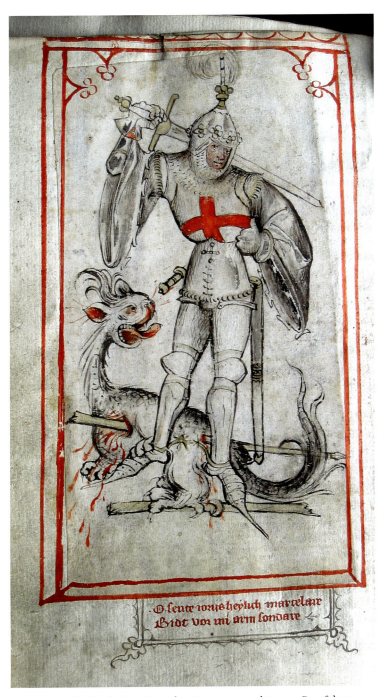

FIGURE 7.4 Ms. Wiesbaden, Hessisches Hauptstaatsarchiv, 3004 B 10, fol.151v. Saint George

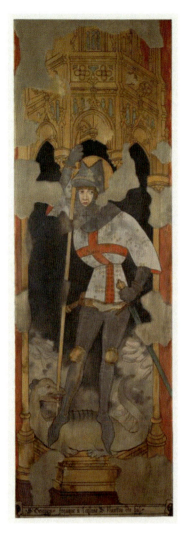

FIGURE 7.5
St George by Alexandre Hannotiau; copy ca. 1900 of the wall painting in Saint Martin's (now disappeared)

of church decoration in the Low Countries around 1400.[60] The paintings and sculpture in the Halle church reveal how close the Wiesbaden drawings must have been to the art that decorated other religious establishments as well. Based on shared iconographical conventions, these similarities go beyond them. Apart from the pictures of Saint George and the Adoration of the Magi, the manuscript contains drawings of the three patron saints of the church: the Virgin Mary, Martin of Tours, and Catherine of Alexandria. The drawing of the

60 See the two issues of *Monumenten en Landschappen* 19/5–6 (2000) that consist of contributions on (the restauration of) the art in St. Martin's.

CUSTOMIZING FOR THE COMMUNITY: THE WIESBADEN MANUSCRIPT 209

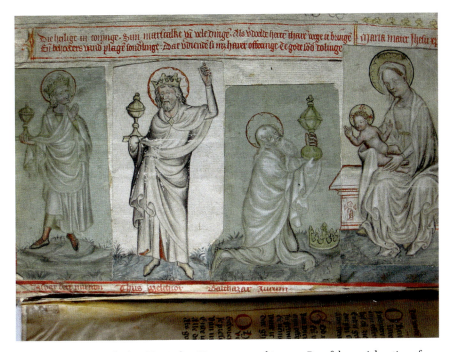

FIGURE 7.6 Ms. Wiesbaden, Hessisches Hauptstaatsarchiv, 3004 B 10, fol. 24v. Adoration of the Magi, set of pasted drawings

FIGURE 7.7
Three Magi Sculpture St. Martin's Church Halle (Belgium)

three dead kings (the living kings are not depicted) corresponds to sculptures in the arches of one of the chapels of St. Martin's. The figures, though they diverge in some respects, remain thematically analogous: one body decayed, the other draped in a sheet and rising from the coffin, the third still dressed, having only just passed away [Fig. 7.8].[61] Like the drawings of the Magi, the three dead men in the Wiesbaden manuscript may also have served as a model for new compositions that did not strictly imitate it.

Without overemphasizing these parallels, we might well consider the Halle church and its parish community as the (public) place and milieu where the Wiesbaden manuscript circulated. Work on the church's sculpture and interior decoration took place in the early years of the fifteenth century, closely corresponding to the date of the Wiesbaden manuscript, which must have been completed in or shortly after 1410. The church of Halle was (newly) dedicated in 1410.[62] Work on the church continued afterwards, but the moment is remarkable in light of the hypothesis that the Wiesbaden drawings were added to the manuscript after they had ceased to be used as compositional models.

Someone who must have been familiar with this use of model drawings was the Tournai painter Henri le Kien, who had worked in 1407–1408 on five 'tableaux' for the church in Halle. The painter was also involved in the design and execution of murals for the chapel of Saint Nicholas in the Church of Saint Jacques in Tournai. He would, of course, have been intimately familiar with the use of compositional models. There are similarities in manner between the decoration of the Tournai chapel and paintings of approximately the same date in the church of Halle. The statute book of the Confraternity of Our Lady of Halle, a manuscript containing statutes, a membership roll and a list of Marian miracles, partly in verse, which was kept at the church, is illuminated in the style of the Tournai artist Jean Semont.[63]

The Halle church of Saint Martin with its interior decoration and resident confraternity offers a wonderful context for the Wiesbaden codex; indeed, the

61 Wiesbaden edition Pl.xxiv. On the church, see Louis A. "La decoration sculpturale des chapelles du choeur à l'eglise Saint Martin à Hal. i: La rencontré des tois morts et des trois vifs", *Revue Belge d'Archéologie et d'Histoire de l'Art* 4 (1936) 13–30. On the significance of the ways in which the three dead men were portrayed, see Reilly C.A. "Bonne de Luxembourg's Three Living and Three Dead: Abnormal Decomposition", *Inquiries Journal/Student Pulse* 3.07 (2011). <http://www.inquiriesjournal.com/a?id=555>.

62 Steyaert, *The Sculpture of St. Martin's* 3.

63 See Vanwijnsberghe D., *'Moult bons et notables': l'enluminure tournaisienne à l'époque de Robert Campin (1380–1430)* (Paris et al.: 2007), especially 217–218 on Tournai illumination and Halle, and 272–274 on Henri le Kien.

CUSTOMIZING FOR THE COMMUNITY: THE WIESBADEN MANUSCRIPT

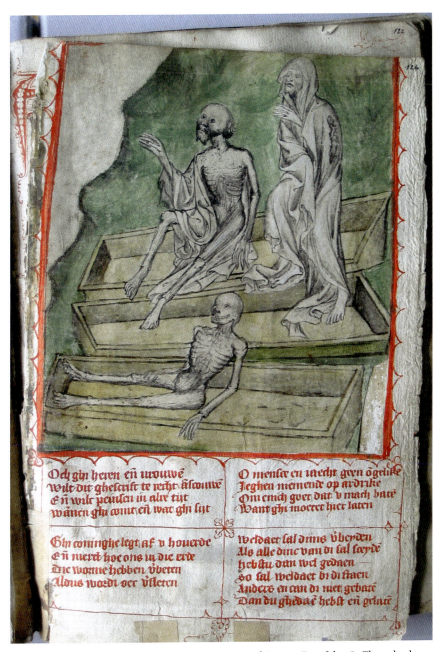

FIGURE 7.8 Ms. Wiesbaden, Hessisches Hauptstaatsarchiv, 3004 B 10, fol. 126r. Three dead rising from their graves

miracle book of Our Lady of Halle supplies the parallel of another manuscript owned by a lay religious community.[64] Even more than the Wiesbaden codex this manuscript has largely escaped the notice of scholars, even though the miracle stories in verse demonstrate an interest in literature, poetic performance and Marian devotion that matches contemporary texts, such as the poets' contest in praise of Mary that survives in the Wiesbaden manuscript. Here Hand 7 pays attention to Our Lady at the end of the first quire: he pasted a drawing of Mary with the child Jesus and Saints Catherine and Barbara, accompanied by Marian prayers [Fig. 7.9]. One pleads for mercy, reminding Mary *also alstu mi broederscap kenst*, 'as you know me, a brother in a confraternity', but the Middle Dutch *broederscap* signifies both the confraternity as a community and the bond between Christians on which the idea of confraternities was based. The prayers are followed by an excerpt from the (pseudo-)Anselm's *Admonitio morienti*, a set of questions for someone on his deathbed, who is addressed here repeatedly as *broeder*. Near the end of the manuscript, Hand 7 copied the sermon of the Dominican Henry of Louvain, which Mary, according to legend, ultimately delivered in his place: *dit sermoen preecte ons vrouwe voer broeder Heinrike vander Calstren te Colne*. The rubric suggests that the audience was familiar with the story; the scribe, moreover, appears to know Henry's family name.[65] This record of a Marian miracle coincides with the accounts of Mary's interventions in the Miracle book.

Still, there is no definitive evidence that places the Wiesbaden codex in Halle (even though the editors locate the manuscript's origins in the same region of Brabant on account of key linguistic features). Analogies between the Wiesbaden drawings and art work in St. Martin's add considerable weight to the hypothesis that the manuscript circulated in the context of church life. Its illustrations were models for or reflections of the many public images painted to enhance church worship and devotion. If the texts in the Wiesbaden manuscript offered instruction and edification to all who (according to the Prologue of the first text in the manuscript) wished to live as 'children of the Holy Church', the images served as the visual counterpart to those written texts, in counterpoint with which they heightened religious awareness, engagement and sentiments.

64 On the (contents of the) Miracle book, see Mulder J. van, "Lieve Jehan, goede vrient. Visioenen in het mirakelboek van Halle", *Ons geestelijk erf* 81 (2010) 311–338. The manuscript can be consulted online at http://balat.kikirpa.be/object/28570.

65 Wiesbaden edition nr.62. On the author, see Scheepsma W.F., "Hendrik van Leuven: Dominican, Visionary and Spiritual Leader of Beguines", in Griffith F. – Hotchin J. (eds.): *Brothers and Sisters in Christ: Men, Women, and the Religious Life in Germany, 1100–1500* (Louvain: 2014) 271–302.

CUSTOMIZING FOR THE COMMUNITY: THE WIESBADEN MANUSCRIPT

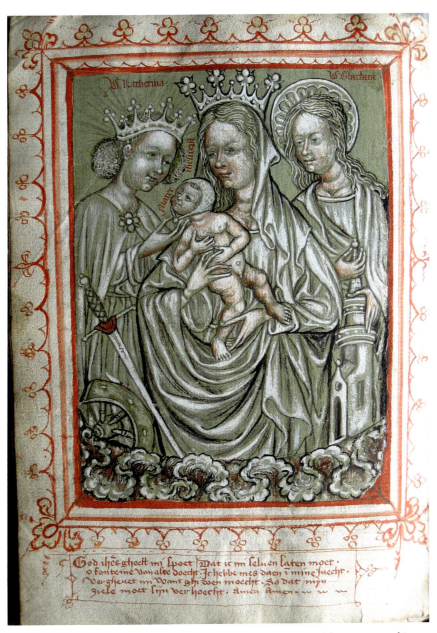

FIGURE 7.9 Ms. Wiesbaden, Hessisches Hauptstaatsarchiv, 3004 B 10, fol. 118v. Mary and Jesus with saints Catherine and Barbara

New purposes were attached to the drawings as the context in which they were viewed changed; the images certainly became devotional objects after being integrated into the codex, and may have been used as such even earlier. Some drawings were rearranged or combined with short texts and framed like visual units, changes that conferred a primary meditative function on them. Scrolls with short rhyming texts and an image of Christ amidst clouds were added to the drawing *St. Martin and the Beggar*, converting it into conversation between Christ, the saint and the beggar [Fig. 7.10]. Martin repeats Christ's words adjuring the saint to serve him faithfully (Christ: *die my mit trouwen dient*; Martin: *wie Cristum met trouwen dient*), and promises to come to the Lord's assistance (*soe sal ic u in staden staen*). These last words are repeated by the beggar in his plea to Martin to help him (*om gods wil, staet mi in staden*).[66]

The full-page *Salvator mundi* image was customized in a similar way, by adding a schematic text in the voice of Christ urging the reader to respond to the Saviour's many virtues:

> As I am so beautiful, why don't you love me?
> As I am so rich, why don't you ask me?
> As I am so strong, why don't you fear me?
> As I am so merciful, why don't you come to me?
> As I am so just, why don't you shun your sins [Fig. 7.11].

Compared to other renderings of this text, the rhetoricized version in the Wiesbaden manuscript is more intense, because it addresses the reader so directly, adapting Christ's words to an argumentative structure that gives the addressee no other choice than to respond.[67] This message (in which the text is also schematically visualized) and the adjacent picture of Christ would work just as effectively if they were transplanted to a public setting where everyone that passed by could feel He was speaking to them. The drawing's placement on the book's first flyleaf altered even while enhancing its communicative potential: the image, in agreement with the other collected texts, now expresses the need attentively to approach and embrace Christ the Saviour.

66 Wiesbaden edition C and Pl.III.
67 Wiesbaden edition A1 and Pl.I. In other copies of this text, Jesus does not address an audience (see the BNM-I website, keyword phrase: 'normalised title: Ic ben schoen ende men mynt mi niet').

CUSTOMIZING FOR THE COMMUNITY: THE WIESBADEN MANUSCRIPT

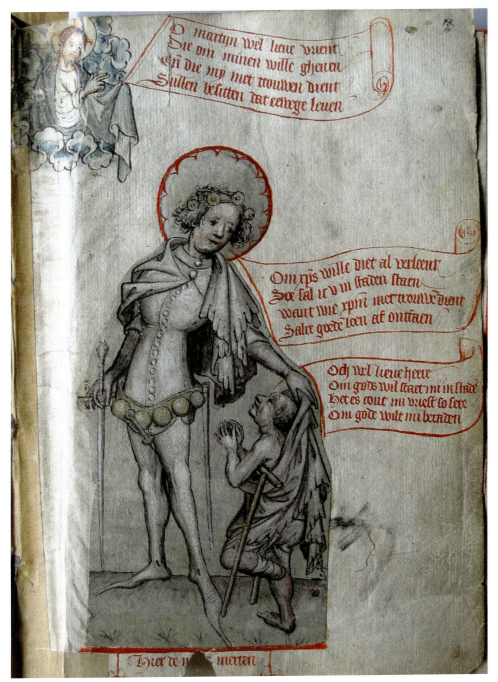

FIGURE 7.10 Ms. Wiesbaden, Hessisches Hauptstaatsarchiv, 3004 B 10, fol. 14r. Pasted drawings of St. Martin and the beggar with Jesus in the clouds

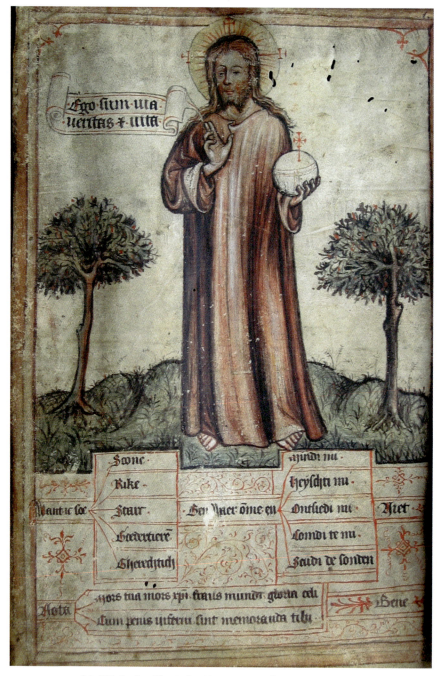

FIGURE 7.11 Ms. Wiesbaden, Hessisches Hauptstaatsarchiv, 3004 B 10, fol. 1v. Salvator mundi with accompanying text

CUSTOMIZING FOR THE COMMUNITY: THE WIESBADEN MANUSCRIPT

The hand that added the texts on these two drawings was not involved in the scribal work.[68] This suggests that the images were already customized before being pasted into the manuscript, but they became part of the miscellany after being inserted, interacting with the other texts. The image of Martin and the beggar is placed close to a discussion of almsgiving (a chapter in the *Wech*).[69] It is not an illustration, but a devotional object in its own right, communicating a message both visually and in conjunction with the text. Like someone who views a mural image of Saint Martin and recalls his vita and reputation, the reader of the Wiesbaden codex is invited closely to look at the drawing and read the spoken words of Christ, the Saint and the beggar. The exposition of alms and their sacramental meaning operate in tandem with the devotional image's exhortative function. Similarly, the Salvator Mundi drawing, together with Christ's words, could very well function on its own as an object of devotion, urging the believer directly to turn toward her / his Saviour; within the manuscript, however, the image also assists the reader to adopt a proper attitude, as a prelude to the introductory section of the first text, which presents itself as an antidote to the fact that 'so few creatures seek to know the truth of what God is or serve / worship (*dienen*) the goodness that God is'.[70]

Other drawings with accompanying texts were likewise turned into separate units within frames that keep words and image together. Rhymed prayers address depicted saints as if they were images painted in churches or displayed in houses.[71] The image of the three dead is accompanied by an invitation in verse to meditate upon the fleeting nature of wealth and beauty: 'O, you lords and ladies, behold this depiction well, and always think / take notice of from whence you come, and what you are' [Fig. 7.8].

> Och ghi heren ende vrouwen,
> Wilt dit ghescrift te recht anscouwen,
> Ende wilt peinsen in alre tijt
> Wannen ghi comt ende wat ghi sijt.[72]

68 The Introduction to the Wiesbaden edition, 86–98, gives a very detailed account of the hands that can be distinguished in the texts and the drawings. It should be noted that different 'hands' do not necessarily mean different persons. On customization of the drawings, also see Renger "The Wiesbaden Drawings" 394–395, 402.

69 Wiesbaden edition 5/1246–1331.

70 Wiesbaden edition 5/6–7.

71 Wiesbaden edition Pl.XVII.

72 Wiesbaden edition N and plate XXIV.

These verses demonstrate that the purpose of the image is the same in the codex as in a church mural; the medieval Dutch *ghescrift* (translated here as 'depiction') is related to the verb *scriven* (to write) but also refers to 'what is painted' (or drawn), certainly in combination with *anscouwen* (to behold). The reader is invited to use the image as if it were a *memento mori*, the starting point for meditation on *death*. The theme comes up again near the end of the codex, where Hand 7 copied an excerpt on death from the Dutch version of Gerard van Vliederhoven's *Cordiale de quatuor novissimus*.[73]

The drawings operated together with the texts, rather than illustrating them. The images brought more miscellaneous material to a collection that already was rather diverse. This diversity should not be seen as symptomatic of a lack of coherence. Customization acknowledged the need for multiple options of reading and viewing. The images work in tandem with the extensive expository texts, by layering upon them the meditative potential of devotional imagery which is, in turn, enhanced and particularized by the exhortative messages, often in direct speech, of the depicted figures with their speech scrolls.

4 Hand 7: Customizing for the Community

This deliberate new use of the drawings as part of the miscellany was probably only envisioned when the codex acquired its definitive form. No longer in use as models, the drawings were now manipulated by the person who customized the book, Hand 7, with different ends in view. He was the last person to copy texts for the Wiesbaden manuscript. He also wrote short notes, verses and *dicta* in every section of the book, even on the leaves with drawings. On the full-page drawing of *Moses Receiving the Ten Commandments*, he connected the image to the following text (Gerson's exposition of the commandments) but also emphasized the need to obey the commandments in order to achieve eternal salvation [Fig. 7.12].[74] The message is clearly pastoral, as might be expected of a 'man of the Church' with clerical responsibilities, someone with access to the

73 Wiesbaden edition nr.75. Cf. the Introduction 111.

74 Wiesbden edition 1 and Pl.XI: 'Dit sijn die helighe x ghebode, die God Moyses gaf opten berch van Sinay, hier na betughet metter scrifturen, daer ons alle volcomenheyt kerstens gheloves in gheleert wort ende alle sonden ende ghebreclicheit in verboden es. Ende wiese houdt metten werken ende metten levene, die blijft behouden; ende wie datse breect ende die also sterft, die wert verdoemt ende van gode eewelic vermalendijt'.

CUSTOMIZING FOR THE COMMUNITY: THE WIESBADEN MANUSCRIPT 219

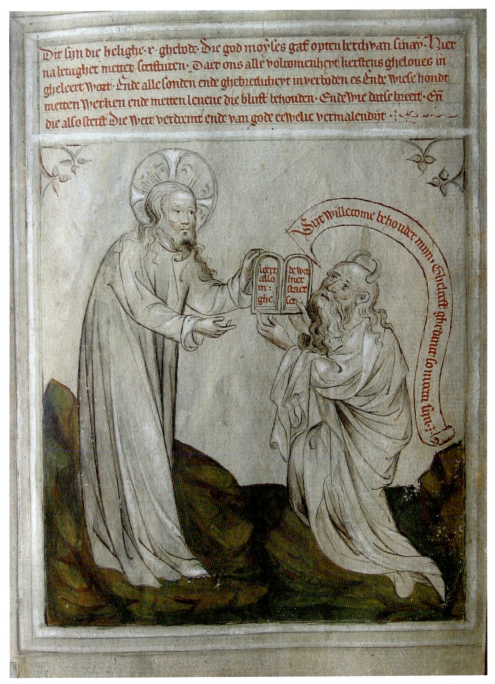

FIGURE 7.12 Ms. Wiesbaden, Hessisches Hauptstaatsarchiv, 3004 B 10, fol. 45r. Moses receiving the ten commandments

drawings used by painters to model their mural projects for clerical patrons. He was familiar with preaching and providing additional homiletic 'instruction and edification' for interested laymen. Finally, he was the keeper of a manuscript that perhaps was produced in collaboration with colleagues who shared his interests and concerns. We cannot be sure that Hand 7 of the Wiesbaden codex, like his fellow scribes, was affiliated with a particular church (let alone St. Martin's in Halle), he was certainly no stranger to ecclesiastical offices and pastoral responsibilities. The text on the commandments is only one example among many of the 'traditional religion', traces of which are constitutive of the manuscript in word and image. But the manuscript as a whole is more complex than this, and so, too, was the man behind Hand 7.

Repeatedly, he is very critical toward practices in the Church and the professional clergy. His lament on the lack of devotion has been cited, but elsewhere in the manuscript, Hand 7 is even more sharply outspoken:

> The clergy, as I see it, do not follow holy Scripture; neither do holy people follow the clergy, whatever ensues. But they (the holy people) follow the words of our Lord that they (the clergy) teach and preach to us. Their (again, the clergy) equals and servants follow them and are on their side; those who love God, follow God and follow his commandments gladly.[75]

The distinction, if not opposition, between the clergy and the 'holy people' who truly follow the words of the Lord returns in the first text copied (at least partly) by Hand 7, a disputation between two persons in religious orders, one male, the other female.[76] The question being discussed is proposed by the woman: what is the highest work a human being can perform? For the priest the answer is celebrating mass, but the woman disagrees: a mass may be celebrated by a sinful priest, whereas the work of divine love and divine unity is

75 Wiesbaden edition nr.25:
 'De papen, alsic versta,
 En volghen der heligher scriften niet na;
 Noch heilighe lieden, wats ghesciet,
 en volghen oec den papen niet.
 Maer si volghen den woerde ons heeren,
 Dat si ons predeken ende leeren.
 Hoer ghelike, hoer meysniede,
 volghen hem ende sijn hoerliede;
 Die gode minnen volghen gode
 Ende doen gaerne sine ghebode'.
76 Wiesbaden edition nr 42.

beyond sin. Rapidly the debate shifts to a conversation about the state of the Church and its clergy in particular. The woman is superior to the priest in her argumentation, in her analysis of religious life and even in her command of scriptural knowledge, when the discussion focuses on the Holy Church and the voluntary poverty of Christ and Saint Peter. He, not silver or gold or the riches of the world, was the rock upon which the Church was built.[77]

The woman is the dominant voice in the debate, which may lead readers to conclude that the disputation itself is directed against ecclesiastical professionals who do not meet the requirements of true religion. This may have been the original aim of the anonymous author, but any new reader or scribe could decide for him- or herself with which speaker to identify. The dialogue form places the reader in the position of a bystander who may choose to side with one of the participants.[78] It is possible to interpret the anticlericalism in the dialogue as a lesson to be learned by those who hold positions similar to that of the priest. The conversation would then be a 'reality check' concerning his ecclesiastical office and practices; accordingly, he must search his soul and alter his patterns of thought and behavior. The woman reminds the priest of the 'state of the holy on which the Holy Church was founded' (*staet der heilighen daer die heilighe kerke op gesticht es*) and the distance between it and the current state of affairs among a clerical elite obsessed with wealth, riches and rich patrons, at the expense of their pastoral duties or the salvation of the poor.[79] It is this distinction on which Hand 7 dwells in his short poem on the clergy and (again) 'holy people'.

His own concerns about the ordained clergy, experienced at first hand, might very well be what motivated Hand 7 to add the disputation to the manuscript. The rubricated introduction states that one should 'hear / listen to the disputation between the two of them because truth is often countered and contradicted in favor of (personal) profit'.[80] The 'two of them' must refer to the figures in the facing-page drawing, since only later does the text proper designate the interlocutors [Fig. 7.13]. This drawing depicts a scene that looks more conversational than disputatious.[81] A monk and a nun (whose halo, out of

77 Wiesbaden edition nr 42/272 ff.
78 On the reader of a dialogue as bystander, see Warnar G. *Lezen als een luistervink. De dialoog in de Nederlandse literatuur van Maerlant tot Coornhert* (Leiden: 2022).
79 Wiesbaden edition nr.42/286 ff.
80 Wiesbaden nr.42/1–3.
81 Wiesbaden edition Pl.xix.

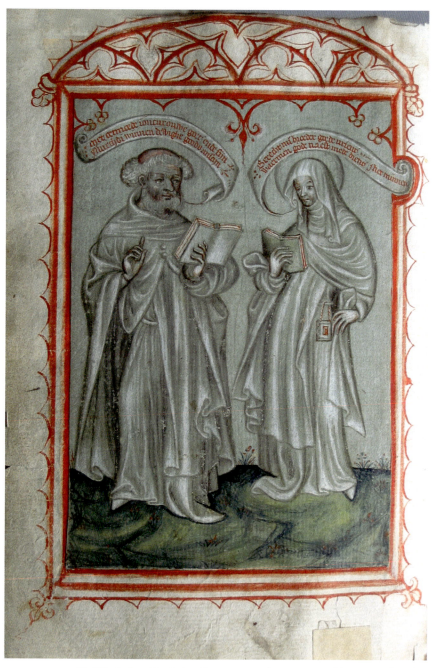

FIGURE 7.13 Ms. Wiesbaden, Hessisches Hauptstaatsarchiv, 3004 B 10, fol. 110v. Monk and nun in dialogue

CUSTOMIZING FOR THE COMMUNITY: THE WIESBADEN MANUSCRIPT 223

place in this context, may imply sanctity) hold forth, both with a book in hand. The gesture of the monk seems to indicate that he is teaching or explaining. His rhyming words, written on the scroll, read: 'With humility, good and pure lady, will you gain the face of the eternal God' (*Met oetmoede, joncfrouwe goet ende fijn, muechdi winnen dewighe goods anscijn*). The nature and tone of the nun's response suggests she and the monk are anything but opposed: 'Explain to me, friar / brother, dear friend, by what means one serves God best' (*Berecht mi broeder, goede vrient, Waermen gode naest mede dient*).

The drawing and the scroll texts reflect exemplify the giving and receiving of spiritual guidance in good harmony: the speaker's meaning and the listener's reception thereof appear entirely concordant. Important to note is that the inscriptions were added by Hand 7, who also chose to position the drawing immediately before the disputation. Was he attempting to reconcile its anti-clericalism with the (or specifically his) pastoral work of spiritual direction? This intervention would coincide with the prior texts: the rhymed letter on the mystical life addressed to a *joncvrouwe* (which could mean a noble young lady and / or a religious woman), and the series of questions and answers on the religious life. The two texts (copied by two scribes) belong to the same unit, as they were copied together on two parchment quires added later to the Wiesbaden codex. Thematically, the texts were also deliberately paired, as the *Questien* offers a more systematic survey of the issues discussed in the letter. Moreover, both texts share dialogic features that aim to enhance the informative function of these works. The drawing of the nun and the priest seems to be part of this cluster focusing on spiritual direction. It was pasted onto the last page of leaves that 'embraced' the two quires not initially produced for the Wiesbaden manuscript; obtained later, they were inserted before the disputation was added.[82]

The customizing of these units in the Wiesbaden manuscript is different from the collecting of miscellaneous material for a pastoral manual. If that was the original aim of the first scribe(s), who copied complete texts that discussed the foundations of the religious life, things had changed by the time Hand 7 entered the scene. The nature of the texts had already shifted toward more demanding forms of theology and contemplation (thanks to Hand 3, who also probably prepared the appended parchment quires), but Hand 7 was the principal character in the story of the customization of the Wiesbaden manuscript. He turned the book into a mirror of the late medieval Church – textually by

82 Wiesbaden edition nrs.33 and 34. Cf. the Introduction 41–42; and Wackers "Een berijmde brief".

broadening its scope to include shorter expositions and sermons, along with critical observations, practical guides (like the model confession), poetry and prayers; visually by giving a new life and function to discarded drawings that yet maintained their devotional purpose of creating and fostering religious engagement. All in all, the Wiesbaden manuscript documents in a unique way how the multiple options in the early fifteenth-century Church were made available to many parties. Without knowing who the people were that borrowed the book, without any clue about the man behind Hand 7, we may still conclude he customized for the community, turning manuscript Wiesbaden 3004 B 10 into a treasure exemplary of the multiple options discernible in late medieval religious literature and culture in the Low Countries.

Bibliography

[Ampe A. et al.] *Jan van Ruusbroec (1293–1381). Tentoonstellingscatalogus* (Brussels: 1981).

Besamusca A.A.M. – Pratt K. – Meyer M. – Putter A. (eds.), *The Dynamics of the Medieval Manuscript: Text Collections from a European Perspective* ([NP]: 2017).

Boonstra P., *Reading by Example: the Communication of Religious Knowledge in the Collationes of the Brothers of the Common Life* (Groningen: 2021).

Clark H., *Using language* (Cambridge: 1996).

Bouwmeester G., *Receptiegolven. De primaire, secundaire en tertiaire receptie van Augustijnkens werk (1358–2015)* (PhD dissertation, Utrecht University, 2016).

Brinkman H., "Het wonder van Molenbeek. De herkomst van de tekstverzameling in het handschrift-Van Hulthem", *Nederlandse Letterkunde* 5 (2000) 21–46.

Corbellini S. – Hoogvliet M., "Late Medieval Urban Libraries as a Social Practice: Miscellanies, Common Profit Books and Libraries (France, Italy, the Low Countries)", in Speer A. – Reuke L. (eds.), *Die Bibliothek – The Library – La Bibliothèque: Denkräume und Wissensordnungen. Miscellanea Mediaevalia: Veröffentlichungen des Thomas-Instituts der Universität Köln* 41 (Berlin: 2020) 379–398.

Dlabacova A., *Literatuur en observantie. De Spieghel der volcomenheit van Hendrik Herp en de dynamiek van laatmiddeleeuwse tekstverspreiding* (Hilversum: 2014).

Duffy E., *The Stripping of the Altars: Traditional Religion in England 1400–1580* (New Haven: 1992).

Johnston M. – Van Dussen M., "Introduction: Manuscripts and Cultural History", in Johnston M. – Van Dussen M. (eds.), *The Medieval Manuscript Book: Cultural Approaches* (Cambridge: 2015) 1–16.

Kienhorst H. – Schepers K. – Berteloot A. (eds.), *Het Wiesbadense handschrift: Hs. Wiesbaden, Hessisches Hauptstaatsarchiv, 3004 B 10* (Hilversum: 2009).

Kienhorst H. – Schepers K., "Het hele plaatje zien. De toevoeging van tekeningen in de codex Wiesbaden, Hessisches Hauptstaatsarchiv, 3004 B 10", in Schepers k. – Hendrickx F. (eds.), *De letter levend maken. Opstellen aangeboden aan Guido de Baere bij zijn zeventigste verjaardag* (Louvain: 2010) 371–400.

Lieftinck G.I., *Codicum in finibus Belgarum ante annum 1550 conscriptorum qui in bibliotheca universitatis asservantur (Bibliotheca universitatis Leidensis, Codices manuscripti v) pars I* (Leiden: 1948).

Louis A., "La decoration sculpturale des chapelles du choeur à l'eglise Saint Martin à Hal. I: La rencontré des tois morts et des trois vifs", *Revue Belge d'Archéologie et d'Histoire de l'Art* 4 (1936) 13–30.

Monumenten en Landschappen 19/5–6 (2000).

Mulder J. van, "Lieve Jehan, goede vrient. Visioenen in het mirakelboek van Halle", *Ons geestelijk erf* 81 (2010) 311–338.

Reilly C.A., "Bonne de Luxembourg's Three Living and Three Dead: Abnormal Decomposition", *Inquiries Journal/Student Pulse* 3.07 (2011) <http://www.inquiriesjournal.com/a?id=555>

Renger M.O., "The Wiesbaden Drawings", *Master Drawings* 25 (1987) 390–410.

Renger, M.O., "Wiesbaden 3004 B 10: more than a manuscript", in Smeyers M. – Cardon B. (eds.), *Flanders in a European perspective. Manuscript illumination around 1400 in Flanders and abroad* (Louvain: 1995) 207–217.

Scheepsma W.F., "Hendrik van Leuven. Dominican, Visionary and Spiritual Leader of Beguines", in Griffith F. – Hotchin J. (eds.): *Brothers and Sisters in Christ: Men, Women, and the Religious Life in Germany, 1100–1500.* (Louvain: 2014) 271–302.

Schepers K., *Bedudinghe op Cantica Canticorum. Vertaling en bewerking van Glossa Tripartita super Cantica* (Louvain: 2006).

Schepers K., "Het Opus tripartitum van Jean Gerson in het Middelnederlands", *Ons geestelijk erf* 79 (2005–2008) 146–188.

Schepers K., "Kortsluiting tussen Wearmouth-Jarrow en Vlaanderen. De Apocalyps in het Middelnederlands', *Queeste* 15 (2008), 97–119.

Schepers K., "Judgment, Damnation, and Salvation in *Wech van Salicheit, Tafel vanden kersten ghelove*, and in Ruusbroec's Works – Apocalyptic Eschatological Concepts in Middle Dutch Texts and in Their Latin Sources", *Queeste* 21 (2014) 1–22.

Steyaert J.W., *The Sculpture of St. Martin's in Halle and Related Netherlandish Works* (PhD dissertation University of Michigan, 1974).

Ubbink R.A., *De receptie van Meister Eckhart in de Nederlanden gedurende de middeleeuwen. Een studie op basis van middelnederlandse handschriften* (Amsterdam: 1978).

Van Engen J., "Multiple Options: The World of the Fifteenth-Century Church", *Church History* 77, (2008) 257–284.

Vanwijnsberghe D., *'Moult bons et notables' : l'enluminure tournaisienne à l'époque de Robert Campin (1380–1430)* (Paris et al.: 2007).

Vinzent M., ""Meine Demut gibt Gott seine Gottheit" (Meister Eckhart, Predigt 14) – neue handschriftliche Zeugnisse und eine neue Edition", in Haustein J. (ed.), *Traditionelles und Innovatives in der geistlichen Literatur des Mittelalters*. Meister-Eckhart-Jahrbuch. Beihefte 7 (Stuttgart: 2019) 63–85.

Vooys C.G.N. de, *Middelnederlandse legenden en exempelen* (Groningen – The Hague: 1926).

Wackers P., *Terug naar de bron* (Utrecht: 2002).

Wackers P., "Een berijmde brief over het volmaakte leven", in Schepers K. – Hendrickx F. (eds.), *De letter levend maken. Opstellen aangeboden aan Guido de Baere bij zijn zeventigste verjaardag* (Louvain: 2010) 629–651.

Warnar G., "Biecht, gebod en zonde. Middelnederlandse moraaltheologie voor de wereldlijke leek", in Mertens Th. et al.: *Boeken voor de eeuwigheid. Middelnederlands geestelijk proza*. (Amsterdam: 1993) 36–51.

Warnar G., "Lodewijk van Velthem, de *Spiegel historiael* en *Den lof van Maria*. Van handschrift Wroclaw, Universiteitsbibliotheek IV F88e–11 naar het bewustzijn van een Nederlandse literatuur in de veertiende eeuw", in: Kiedrón S. – Kowalska-Szubert A. (eds.), *Thesaurus polyglottus et flores et flores quadrilingues. Festschrift für Stanislaw Predota* (Wroclaw: 2004) 709–722.

Warnar G., "Augustijnken in Pruisen. Over de drijfveren van een Middelnederlandse dichter en literatuur binnen de Duitse Orde", *Jaarboek voor Middeleeuwse Geschiedenis* 8 (2005) 101–139.

Warnar G., "Het verlossende woord. De Utrechtse bijbels (ca. 1430–1480) in context", *Ons geestelijk erf* 83 (2012) 264–284.

Warnar G., "Eckhart und der Laie als Lehrgespräch. Versuch einer Rehabilitierung?" *Meister Eckhart-Jahrbuch* 7 (2013) 181–194.

Warnar G., *Lezen als een luistervink. De dialoog in de Nederlandse literatuur van Maerlant tot Coornhert* (Leiden: 2022).

Wranovix M., "Common Profit Books in Ulrich Pfeffel's Library: Parish Priests, Preachers, and Books in the Fifteenth Century", *Speculum* (2012) 87, 1125–1155.

CHAPTER 8

A Medical Anthology Customised 'for the Consolation of the Sick' in a Brussels Convent

Andrea van Leerdam

In the first half of the sixteenth century, the book market in the Low Countries comprised a growing range of medical and astrological works in the vernacular, ranging from almanacs to surgery handbooks.[1] Many surviving copies were customised to some extent by early modern users. Often, however, we are left to guess precisely who these users were, and their traces of use often provide only circumstantial evidence of their interests and their reasons for owning a medical book in the vernacular. In this essay, I focus on a customised copy of a richly illustrated medical anthology in Dutch, printed in 1540, with an inscription that exceptionally specifies not only who owned the volume early on, but also for what purpose. The work is titled *Tfundament der Medicinen ende Chyrurgien* (The Foundations of Medicine and Surgery) and this particular copy is now kept in the Library of Congress in Washington D.C.[2] I will briefly refer to it here as *Tfundament*. In 1555, the copy was kept in the infirmary of the Poor Clares in Brussels.

After briefly introducing the book, I examine the inscription of ownership and relate it to the physical modifications to the volume that pertain especially to censorship and navigation. I will contextualise particularities of this copy in the light of other copies of *Tfundament* and other contemporary medical works. My aim is to demonstrate that an examination of multiple copies is crucial for uncovering patterns in customisation practices. As we shall see,

1 The findings presented here are part of my PhD research at Utrecht University, The Netherlands, funded by the Dutch Research Council NWO. These findings also appear in my dissertation, *Woodcuts as Reading Guides. How Images Shaped Knowledge Transmission in Medical-Astrological Books in Dutch (1500–1550)*, defended on 21 October 2022. Autopsy of the original copy of *Tfundament der Medicinen ende Chyrurgien* discussed in this article, in the Library of Congress in Washington D.C., was made possible by short-term fellowships granted by the Renaissance Society of America and the Bibliographical Society of America.

2 Sylvius Petrus, *Tfundament der Medicinen ende Chyrurgien* (Antwerp, Willem Vorsterman: 1540), copy Washington D.C., Library of Congress, shelfmark Rosenwald 1159, full scan available at https://lccn.loc.gov/65058993.

© KONINKLIJKE BRILL NV, LEIDEN, 2024 | DOI:10.1163/9789004680562_009

Tfundament is an exemplary case that raises particular questions about hand-colouring and the use of pins to modify pages.

1 Medical Instruction in Word and Image for Novice Professionals

Tfundament der Medicinen ende Chyrurgien is a folio volume of highly varie-gated medical and astrological content. It was written, or rather compiled, by a Petrus Sylvius from Antwerp, who identifies himself in the preface. He must have been a medical professional, but nothing is known about him. The first edition was printed by Willem Vorsterman in Antwerp in 1530. Vorsterman reprinted the work in 1532 and 1540 with hardly any changes, so it must have sold well in this form.[3] The copy under scrutiny here is from the third edition.

The book's target audience, as Petrus Sylvius states in the preface, are nov-ice physicians, surgeons and apothecaries, and Sylvius states that the work is intended 'for the common profit'.[4] It covers much of the available contem-porary medical-astrological knowledge, including such topics as letting blood, the influence of the planets and zodiac signs on human life, uroscopy, herbal remedies, distilled waters, women's and children's diseases, plague and syphilis (*pocken*), surgery (including horse surgery and field surgery), and recipes for beneficial waters for other than medicinal purposes (including an ink that will prevent mice from eating the paper).

3 Sylvius Petrus, *Tfundament der Medicinen ende Chyrurgien* (Antwerp, Willem Vorsterman: 1530), USTC 437521, NK 1971, NB 28786. Sylvius, *Tfundament der Medicinen ende Chirurgien* (Antwerp, Willem Vorsterman: 1532), USTC 425753, NK 3914, NB 28787. Sylvius, *Tfundament der Medicinen ende Chyrurgien* (Antwerp, Willem Vorsterman: 1540), USTC 438121, NK 1972, NK 01135, NB 28788. Only one later – and smaller, quarto size – edition of *Tfundament* is known: *t Fvndament der medicynen ende chyrvrgien* (Rotterdam, Matthijs Bastiaensz: 1622), USTC 1011167. It contains fewer woodcuts than the sixteenth-century editions. Secondary lit-erature on this title is scant: Gysel C., "De Antwerpse uitgaven van *Den Herbarius in Dyetsche* en *Tfundament der medicinen* (1540)", in Gerritsen W.P. – Gijsen A. van – Lie O.S.H. (eds.), *Een school spierinkjes: kleine opstellen over Middelnederlandse artes-literatuur* (Hilversum: 1991) 83–84; Nave F. de –Schepper M. De (eds.), *De geneeskunde in de Zuidelijke Nederlanden (1475–1660)*, exh. cat., Museum Plantin-Moretus and Stedelijk Prentenkabinet (Antwerp: 1990) 101; Vermeulen Y.G., *'Tot profijt en genoegen': Motiveringen voor de produktie van Nederlandstalige gedrukte teksten 1477–1540* (Groningen: 1986) 139; Dongen J.A. van, "De Incunabelen en Postincunabelen in de Bibliothkeek van de Maatschappij (XII)", *Medisch contact* 20:36 (1965) 730–733; Post W. – Pennink R. – Cockx-Indestege E., *Oude drukken uit de Nederlanden: boeken uit de collectie Arenberg, thans in de verzameling Lessing J. Rosenwald*, exh. cat., The Hague, Museum Meermanno-Westreenianum/Brussels, Albert I Bibliotheek (The Hague: 1960) nr. 156.

4 Sylvius, *Tfundament* (1540), fol. A ii r.

MEDICAL ANTHOLOGY CUSTOMISED 'FOR THE CONSOLATION OF THE SICK' 229

Tfundament also shows great variety in its images. Many of its woodcuts are copied or reused from earlier works. They include epistemic images of plants, surgical instruments, and anatomical diagrams, but also more narrative images including several half figures copied after Hartmann Schedel's *Nuremberg Chronicle* (1493; see Fig. 8.2);[5] a generic image of a scholar in his study that is used three times within the book;[6] an image of Job sitting on the dung heap with his wife rebuking him, attributed to Jan Swart van Groningen and reused from Vorsterman's 1528 Bible edition, the so-called *Vorstermanbijbel*;[7] and a distillation scene reused from *Dit is die rechte conste om alderhande wateren te distilleren* (published by Vorsterman around 1520) and copied after Thomas van der Noot's *Tscep vol wonders*.[8]

2 A Donation to the Infirmary of the Poor Clares

Because of all its textual and visual variety, *Tfundament* allows for many types of use. It is therefore singularly fortunate that a copy survives which specifies its designated users and use so explicitly [Fig. 8.1]. The inscription on the title page of the Library of Congress copy consists of multiple elements, embedded in the printed title page layout. Its various elements are written inside two printed roundels with woodcut half figures representing scholars, in the empty shield that is printed between these roundels, and in the bottom margin. The full inscription reads, in translation:

> [*upper roundel, above the scholar figure:*]
> In the sick room should this book remain
>
> [*upper roundel, below the scholar figure:*]
> Monastery of the sisters of St. Clare in Brussels
> near the beguinage

5 Schedel Hartmann, *Liber chronicarum* (Nuremberg, Anton Koberger for Sebald Schreyer and Sebastian Kammermeister: 1493).

6 This woodcut was used earlier on the title page of *De virtutibus quarundam herbarum* (i.e. *Liber aggregationis*) attributed to Pseudo-Albertus Magnus (Leiden, Jan Seversz: s.d.); NAT VIII, 20.

7 *Den Bibel. Tgeheele Oude ende Nieuwe Testament met grooter naersticheyt naden Latijnschen text gecorrigeert* (Antwerp, Willem Vorsterman: 1528), fol. Ff vi v. On the attribution of the image of Job to Jan Swart, see Post et al., *Oude drukken uit de Nederlanden* nr. 156.

8 The distillation scene is reproduced in Wittop Koning D.A., *Dit is die rechte conste om alderhande wateren te distilleren (Antwerp, ca. 1520): Facsimile with an Introduction* (Ghent: 1976). Noot Thomas van der, *Tscep vol wonders* (Brussels, Thomas van der Noot: 1514), fol. g iii v.

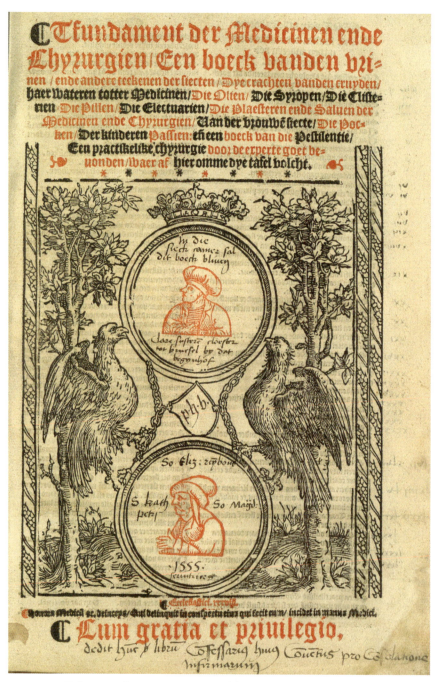

FIGURE 8.1 Title page with owners' inscription of the Poor Clares in Brussels, dated 1555. Sylvius Petrus, *Tfundament der Medicinen ende Chyrurgien* (Antwerp, Willem Vorsterman: 1540), Washington D.C., Library of Congress, Rosenwald 1159, fol. A i r

MEDICAL ANTHOLOGY CUSTOMISED 'FOR THE CONSOLATION OF THE SICK' 231

[*in the empty shield:*]
p.h.b.

[*lower roundel, three abbreviated names surrounding the scholar figure:*]
Sister Eliz[abeth] Reynbout
Sister Kath[arina] Petri
Sister Magd[alena]

[*lower roundel, below the scholar figure:*]
·1555·
seruitrices

[*bottom margin, in Latin:*]
This book was given by the confessor of this convent for the consolation of the sick[9]

Thus, the inscription neatly specifies what, where, who, when, and why. As the date of 1555 is just fifteen years after this edition was published, this copy offers insight into one of its earliest contexts of use. The location of use is also specified in detail: the infirmary of the monastery of the Poor Clares in Brussels. Their house, called Bethlehem, was established next to the Great Beguinage in the second half of the fifteenth century by a group of lay sisters of the third order of Saint Francis of Assisi.[10] In 1501 they adopted the stricter rule of Saint Clare as reformed by Saint Colette, and thus became Poor Clares. It seems peculiar that the location 'near the beguinage' would require specification in a volume that was not to leave the convent's sick room. An explanation may be that it served to distinguish the convent of the Poor Clares from that of the Rich Clares (who followed a slightly less strict rule that allowed for joint possessions), and therefore, that it functioned not so much as a geographic marker but rather as a marker of identity.[11]

9 Fol. A i r: 'In die sieck camer sal dit boeck bliuen | Clare sustere[n] cloester tot bruesel by dat begynhof | p.h.b. | So Eliz[abeth] rey[n]bout | S kath[arina] petrj | So Magd[alena] | .1555. seruitrices | dedit hu[n]c libru[m] Co[n]fessari[us] hui[us] Co[n]ue[n]tus pro Co[n]solatione Infirmarum'.

10 Henne A. – Wauters A., *Histoire de la ville de Bruxelles*, vol. III (Brussels: 1845) 538. The name Bethlehem is also mentioned in one of the manuscripts donated by the confessor Henricus of Beringhen; see below, note 13.

11 On marks of ownership as socially embedded expressions of identity, see Wakelin D., "'Thys ys my boke': Imagining the Owner in the Book", in Flannery M.C. – Griffin C. (eds.), *Spaces for Reading in Later Medieval England* (Houndmills: 2016) 13–33.

The title page inscription also reveals how the sisters came to possess this book, and for what purpose: it was donated by their confessor for the consolation, or relief, of the sick.[12] We may assume that the three sisters whose names are inscribed were the ones who used the book as *servitrices* or nurses in the infirmary. We can even identify their confessor: I propose that the initials *p.h.b.* stand for *pater henricus de beringhen*. I found his name inscribed in several books that he donated to the Poor Clares, though I have not found any biographical details about him. The books he donated include two fifteenth-century manuscripts with sermons by Bernard of Clairvaux (1090–1153), and another medical work, a herbal in Dutch printed in 1547, titled *Den groten herbarius*.[13] The latter contains an inscription with a request to pray for him, *Confessario huius conventus*, a phrase that implies that the herbal was kept inside the convent. We can imagine it served a similar practical function in the sick room of the Clares, and that perhaps it was used by the same three *servitrices*.[14] Henricus apparently was a steady supplier of books, providing the sisters not only with spiritual care but also with means for physical healthcare.

3 A Chastened and Searchable Work of Reference

Let us now take a closer look at how the Poor Clares used *Tfundament* in their infirmary. The volume hardly shows any signs of wear, and the paper is clean and sturdy. The sisters must have treated it with care. The volume contains early modern modifications that are all applied with evident care, too. As I will discuss, they pertain, firstly, to censorship, and secondly to navigation. They form coherent clusters, not only in terms of purpose but also in their layout and handwriting. Both clusters fit the designated use to such an extent that

12 The Dutch word for consolation, *troost*, could also mean aid, counsel, or benefit (MNW, WNT). I assume the Dutch-speaking annotator had such a meaning in mind when writing the Latin term *consolatione*.

13 Both manuscripts are mentioned in Gheyn J. van den, *Catalogue des manuscrits de la Bibliothèque royale de Belgique*, 13 vols. (Brussels: 1901–1948), vol. 2 (1902) nr. 1464 and vol. 3 (1903) nr. 1874 (inscribed *Den Clare susteren van bethleem tot bruesel*). The herbal is *Den groten herbarius met al sijn figueren der Cruyden* (Antwerp, Symon Cock: 1547), copy held in Antwerp, Museum Plantin-Moretus, shelfmark R 44.7. It is a translation of Cuba Johannes de, *Gart der Gesundheit* (first published Mainz, Peter Schöffer: 1485).

14 The copy of *Den groten herbarius* in Museum Plantin-Moretus contains an annotation on fol. q iiii v in evidently the same hand as that on the title page of the Poor Clares' copy of *Tfundament* in the Library of Congress; see also below.

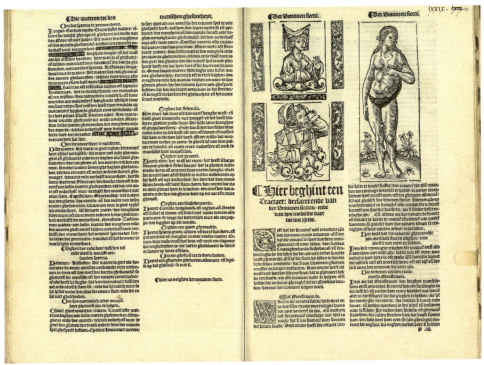

FIGURE 8.2 Instances of censorship in text and image, folio number written and corrected by a single hand, parchment tabs added to the side. Sylvius, *Tfundament*, Library of Congress, Rosenwald 1159, fols. P iii v–P iiii r

I would argue that all of these modifications were made by the Poor Clares.[15] Together these instances of customisation shed light on how the sisters purposely prepared the volume for use as a work of reference.

The first cluster of modifications for use in the infirmary testifies to a concern with inappropriate content. In the woodcut of a naked woman that marks the start of the section on women's diseases, a veil is drawn in dark ink to cover her genitals [Fig. 8.2]. Moreover, several words related to genitals and procreation have been struck through in the same dark ink. Notably, only these specific words have been manipulated, very carefully, while the rest of the

15 Although we cannot rule out the possibility that the confessor Henricus of Beringhen made (part of) the modifications, I believe it is more likely that (one of) the sisters did so. I base this on the combined presence of specific phrasings in the title page inscription: the use of the perfect tense *dedit* (the confessor *has given* the volume), the three names of the *servitrices*, and the reference to the confessor in the third person. Even if the modifications were made by Henricus, he likely did so with a view to the book's donation to the sisters.

text is untouched.[16] This brings to mind how curse words are bleeped out in present-day videos: the bleep primarily serves to convey that an inappropriate expression is being used, while it often remains relatively easy to deduce from the context what is being said. Rather than entirely removing the licentious content, the sisters preferred these chastening interventions, which apparently served as a less constraining advice to skip a certain part of the book. The book was thus kept intact and it could continue to be used within the religious community.

The second cluster of modifications consists of a coherent but slightly awkward set of navigational aids. Evidently the printed navigational aids (which include a table of contents, running titles, headings, and curiously inconsistent folio numbering[17]) did not meet the sisters' needs for referencing. They numbered all leaves by hand in Roman numerals, and in the printed table of contents the same hand wrote the relevant folio numbers next to the printed entries. It seems telling that no numbers are added in this table of contents for the parts of the volume that pertain to surgery, which start at the bottom of the left column and take up the entire right column: it is conceivable that surgical interventions were beyond the medical expertise of the *servitrices* and that they therefore did not make much use of this part of the work. They also attached eye-catching and indeed tactile parchment tabs to the side of various pages to mark the start of a new section (see Figs. 8.2 and 8.3). The folio numbers are written on both sides of each tab, thus facilitating navigation back and forth through the book.

Although all numbers – both in the table of contents, on the folios, and on the tabs – are written very neatly, this great care did not prevent various mistakes in the Roman numerals. On several pages these errors are corrected (apparently in the same hand that wrote the initial numbering), or at least noted, such as on fol. L1r with the comment 'twice' (*tweemael*) where two consecutive pages have been given the same number. We get the impression that the annotating sisters were not very experienced in writing these numbers,

16 Similarly, in another copy of *Tfundament* (of the 1530 edition, Ghent University Library BHSL.RES.1944/-1 v.2), in the chapters pertaining to the male genitals only the chapter titles have been struck through with neat lines, while the texts themselves have not been censored. Similar instances of censorship were also found in Andreas Vesalius' *De fabrica corporis humana*: Margócsy D. – Somos M. – Joffe S.N., *The* Fabrica *of Andreas Vesalius. A Worldwide Descriptive Census, Ownership, and Annotations of the 1543 and 1555 Editions* (Leiden: 2018) 122. They also note that the censored passages are often still perfectly legible and that the black strokes even draw extra attention to these passages (some of which are indeed marked by a manicule).

17 Whereas the 1532 edition has printed folio numbers throughout, the editions of 1530 and 1540 have printed folio numbers on just a few pages.

MEDICAL ANTHOLOGY CUSTOMISED 'FOR THE CONSOLATION OF THE SICK' 235

FIGURE 8.3 Trace of a pin next to a recipe 'against all kinds of fevers'. Sylvius, *Tfundament*, Library of Congress, Rosenwald 1159, fol. [2]C ii v

nor in Latin for that matter. This suggestion is reinforced by a tiny mistake in the inscription on the title page. In the phrase *dedit hunc librum* in the bottom margin, a *b* has been struck through before *librum*. It seems that the annotator accidentally started writing the Dutch word *boeck* rather than the Latin *librum*. The mother tongue of the Dutch vernacular was evidently more top of mind than Latin.

The sisters' endeavours to tackle the challenges of navigation also come to the fore from an annotation in the printed herbal *Den groten herbarius* which their confessor Henricus of Beringhen also donated to them. The annotation is written at the top of a topical index, clearly in the same hand as that of the title page of *Tfundament der medicinen*.[18] It reads as follows:

> *dese tafel dient op den herbarius dat eerste boeck,*
> *om te vinden dij virtuten oft crachten der cruden oft substantien.*
> *Ende elck cruijt oft substantie is een capittel, die paragraphus is ¶ [paraph sign]*

this table serves the first book of the herbal, to find the virtues or powers of the herbs and substances. And each herb or substance is a chapter, and the paragraph is ¶ [paraph sign]

18 *Den groten herbarius* (copy Museum Plantin-Moretus) fol. q iiii v.

In this volume, too, then, we see a concern with navigation but also a certain struggle with its conventions: the sisters apparently felt a need for additional explanation on how to use the index.

The copy of *Tfundament* of the Poor Clares testifies to a further type of customisation that may be related to navigation, yet which now easily tends to be overlooked. The volume contains various traces of pins that were once attached to the pages. The actual pins are no longer there, but their shape is still recognisable, imprinted in the paper and offset on the opposite page, and there are tiny, aligned holes in the paper [Fig. 8.3]. As I have argued elsewhere, the application of pins in early modern books seems to have been much more common than book historians have acknowledged.[19] This practice emerges as a pattern only once we start looking for its inconspicuous remainders across volumes, the tiny rows of punches in the pages that are sometimes connected by a rusty stripe, and indeed the actual pins that are preserved in rare cases.

The functions of pins in early modern books are not self-evident. Close attention to their positioning is key to uncovering how they functioned. One possibility is that they were used to attach something to the page, such as a written note.[20] But in most cases where I found pins to be still present, nothing is attached to them, or not anymore.[21] A copy of the 1532 edition of *Tfundament*, now held at the Royal Library of Denmark in Copenhagen, provides telling examples of the use of pins.[22] The volume still contains three actual pins, in addition to many pin holes [Fig. 8.4]. Equally fascinating, it also includes several pieces of thread sown onto the pages in a few crude stitches, sometimes right through the printed text. If we look at how and where the pin holes are positioned in the Copenhagen copy, and their similar appearance in the copy of *Tfundament* of the Poor Clares, it is plausible that the pins functioned in these

19 Leerdam A.E. van, "Popularising and Personalising an Illustrated Herbal in Dutch", *Nuncius* 36.2 (2021) 378–380.

20 Volumes where I found pins that hold inserted pieces of paper include Fuchs Leonhart, *Den nieuwen herbarius* (Basel, Michael Isingrin: 1545 or later), copy Utrecht University Library, shelfmark ALV 162–459, and the sixteenth-century medical miscellany MS E 64 at the National Library of Medicine, Bethesda, MD. On the early modern use of pins as tools for flexible ordering: Giscombe J., "The Use of Pins in Early Modern England (1450–1700)", blog *The Book & Paper Gathering* (2018), https://thebookandpapergathering .org/2018/05/31/the-use-of-pins-in-early-modern-england-1450-1700/ (accessed 30 April 2022); Leong E., "Read. Do. Observe. Take Note!", *Centaurus* 60.1–2 (2018) 96–98; Walsby M., "Cheap Print and the Academic Market: The Printing of Dissertations in Sixteenth-Century Louvain", in Pettegree A. (ed.), *Broadsheets: Single-sheet Publishing in the First Age of Print* (Leiden: 2017) 371–373.

21 I discuss these cases in my dissertation *Woodcuts as Reading Guides* (forthcoming).

22 *Tfundament* (1532), copy Copenhagen, Det Kgl. Bibliotek, shelfmark Fol. Pat. 19840.

MEDICAL ANTHOLOGY CUSTOMISED 'FOR THE CONSOLATION OF THE SICK' 237

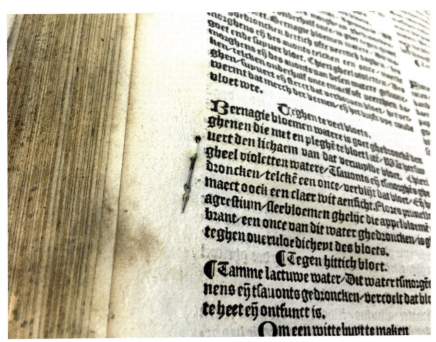

FIGURE 8.4 A pin next to a recipe 'against too much blood'. Sylvius, *Tfundament* (Antwerp, Willem Vorsterman: 1532), Copenhagen, Det Kgl. Bibliotek, Fol. Pat. 19840, fol. O iii v

cases to mark specific remedies. The holes are notably present in text sections with medicinal recipes, and the pins – and perhaps also the threads in the Copenhagen copy – may have been used in similar ways as drawn maniculae (pointing hands) or underlining. They are mostly positioned in the margins, pinned vertically right along a recipe, or horizontally next to the heading for a recipe. In the copy of the Poor Clares, there are vertically aligned pin holes: for example, next to a recipe 'against all kinds of fevers'[23] (see Fig. 8.3) and next to a recipe 'against deafness of the ears'.[24] The Poor Clares' copy of *Den groten herbarius* also contains traces of a similarly positioned pin, vertically next to a passage with recipes containing *alsen* (*absinthium*, i.e., wormwood), one to prevent pollution of the blood and one to prevent books from being eaten by mice and worms.[25] In all cases, it requires careful examination to determine which passage a pin may have marked, as the pin holes are obviously present

23 Fol. [2]C ii v.
24 Fol. [2]E iii v.
25 *Den groten herbarius* (1547, copy Museum Plantin-Moretus), fol. B iii v.

on both sides of the paper. The side where the pin head was located (which can be identified from the imprint it left) was plausibly the page that the reader had before her when she attached the pin.

The pins' three-dimensionality may have made them more easily retrievable, so perhaps for the Poor Clares the pins functioned as another three-dimensional navigational aid, somewhat similar to the parchment tabs, though a bit more hazardous. In Copenhagen I almost pricked my finger on one of the pins as I was not expecting it to be there. As this experience reveals, pins encourage users to handle the book with extra care, for the book's sake as well as their own. In that sense, the application of pins by the Poor Clares would be quite consistent with their careful treatment of their volume.

4 Custom or Pre-sale Colouring?

The volume of the Poor Clares not only deserves our attention for the ways in which it has been customised, but curiously also for a particular feat of customisation that is lacking, namely hand-colouring. That this is noteworthy becomes apparent – just as in the case of the pins – only when we compare this copy to others. I examined nine out of fourteen surviving copies of *Tfundament* (1530, 1532, and 1540 editions).[26] I would like to focus on questions raised by the presence – or absence – of colour in the section of *Tfundament* that deals with uroscopy, or establishing diagnoses on the basis of the colour of a patient's urine. The uroscopy treatise comprises five pages with illustrations. Each woodcut showing a urinal is preceded by a heading that briefly describes the urine's colour, and followed by a more detailed discussion of the colour and the ailments it indicates. The section closes with a sort of visual summary of all the urinals together, in six rows of three [Figs. 8.5–8.8]. The text emphatically points to the didactic and diagnostic function of the images, referring to them as 'a resource for those aspiring to the aforementioned honourable art [of medicine]' and explaining how they serve for comparison to real urine samples from patients.[27] The printed text thus clearly anticipates the manual addition of colour in the urine flasks, and so does the visual arrangement of the flasks in a grid.

26 In the context of my PhD research, I have been able to localise fourteen copies in public collections, of which I have consulted nine: see below, note 28. Van Leerdam, *Woodcuts as Reading Guides* (forthcoming).

27 *Tfundament* (1530), fol. D iii r: 'een toevlucht […] den aencomenden totter voorseyder eerweerdiger conste'; fol. D v r: 'so suldy die vrinen waer af hier die vrinalen metten gedaenten volghen, contempleren ende aensien tegen ende by die Vrine die v voren comen mach'.

Anticipation turns into fact in a substantial number of cases: seven out of the nine copies of *Tfundament der medicinen* I examined have coloured urinals.[28] Indeed, in six of these copies, the urinals are the only coloured woodcuts. What stands out immediately upon comparison is the striking turquoise-greenish tone used in all coloured copies to represent the colour of the glass. This raises a rather fundamental question: who did the colouring? A common option was that books were coloured *after* they were sold, by a professional colourist at the request of an owner, or – less frequently addressed in scholarship – by owners themselves. There are indeed various indications that we see different colourists at work here. There is considerable variation in how the shades and substances of the urines have been represented across copies, not only in the colours but also in the patterns of dots and layers in the flasks.[29] Moreover, the striking green-blue colour of the glass is applied in different tones, in different degrees of opacity, and with varying applications of shading, across copies. For example, the flasks in the copies in The Hague (1530) [Fig. 8.5] and Ghent (1530) [Fig. 8.6] display a more sophisticated suggestion of depth through the application of shading than in the other copies.[30] In the copy in The Hague, the shadows are applied on the left side of the flasks, while in the Ghent copy they are on the right. In the copy in Bethesda, MD (1540) the green-blue paint is markedly opaque compared to the other copies [Fig. 8.7].

28 *Tfundament* (1530) The Hague, KB National Library of the Netherlands KW 228 A 10 (volume coloured throughout);

 Tfundament (1530) Ghent, University Library BHSL.RES.1944/-1 v.2;

 Tfundament (1530) Ghent, University Library BIB.ACC.008275 (the library catalogue lists this copy as the 1540 edition but it is the 1530 edition);

 Tfundament (1532) Copenhagen, Det Kgl. Bibliotek Fol. Pat. 19840;

 Tfundament (1532) New Haven, CT, Yale University, Beinecke Library, call number 16th cent. (composite copy: quire D, with the section on uroscopy, is from the 1530 edition);

 Tfundament (1540) Amsterdam, Allard Pierson/University of Amsterdam OTM: Ned. Inc. 106;

 Tfundament (1540) Bethesda, MD, National Library of Medicine, HMD collection WZ 240 S985f 1540.

 A further copy of the 1540 edition with coloured urinals was auctioned at Marc Van De Wiele in Bruges on 9–10 October 2015, lot 879; the auction catalogue includes a picture of the urinals on p. 72 (https://issuu.com/uitgeverijvandewiele/docs/catalogus_okt15_lr, accessed 30 April 2022). Uncoloured copies:

 Tfundament (1540) Washington, D.C., Library of Congress Rosenwald 1159 (the Poor Clares' copy);

 Tfundament (1540) Antwerp, Hendrik Conscience Heritage Library J 23176 [C2-516 c].

29 On variation in the colouring of urine charts across different works on uroscopy, see also Stolberg M., *Uroscopy in Early Modern Europe* (London: 2016) 36–38.

30 The Ghent copy with shelfmark BIB.ACC.008275; see above, note 28.

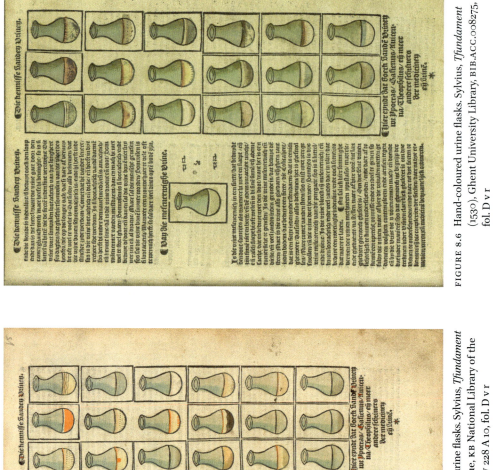

FIGURE 8.5 Hand-coloured urine flasks. Sylvius, *Tfundament* (1530), The Hague, KB National Library of the Netherlands, KW 228 A 10, fol. D v r

FIGURE 8.6 Hand-coloured urine flasks. Sylvius, *Tfundament* (1530), Ghent University Library, BIB.ACC.008275, fol. D v r

MEDICAL ANTHOLOGY CUSTOMISED 'FOR THE CONSOLATION OF THE SICK' 241

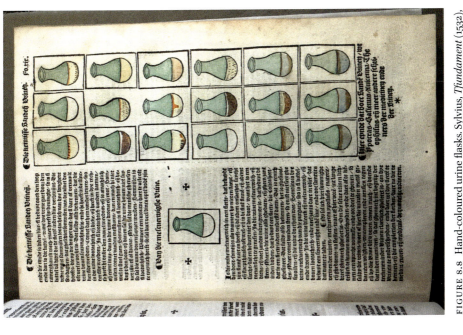

FIGURE 8.7 Hand-coloured urine flasks. Sylvius, *Tfundament* (1540), Bethesda, MD, National Library of Medicine, HMD collection, WZ 240 S985f 1540, fol. D v r

FIGURE 8.8 Hand-coloured urine flasks. Sylvius, *Tfundament* (1532), Copenhagen, Det Kgl. Bibliotek, Fol. Pat. 1984o, fol. D v r

However, if we assume that all copies were coloured separately, then how do we account for the fact that in so many copies these urinals are the only coloured woodcuts, and that all of them have this similar, eye-catching green-blue colour? A comparison with hand-coloured urinals in contemporary works on uroscopy suggests that it was not a widespread convention to render the glass flasks in this colour: in many copies with hand-colouring, only the different types of urine are coloured and not the glass of the vessels.[31] Therefore, the presence of these green-blue flasks in no fewer than seven copies of *Tfundament* does not seem to be a mere coincidence.

Alternatively, the flasks may have been coloured, at least for a portion of each print run, *before* the copies were sold, under the auspices of the printer. The practice of offering part of a print run pre-coloured was not unusual, though I have not found any other examples of it in contemporary Dutch medical-astrological works.[32] It seems unusual, however, to find only part of a book coloured in advance, in this case only the urinals. Moreover, this scenario would not explain the differences in urine shades across copies. While the question remains unanswered for now, this case nevertheless demonstrates how important it is to closely study multiple copies to gain an appreciation of colouring as a customisation practice that bears on the production as well as reception of illustrated books.

31 Using the USTC, Google, and resources from my PhD research, I consulted a total of some 30 digitised copies of three works that include woodcuts showing urine flasks: Ketham (attr.), *Fasciculus medicinae* (various editions in Latin, Italian, Dutch printed between 1491–1529, with one or two urine wheel diagrams per edition), *Hortus sanitatis* (Mainz, Jakob Meydenbach: 1491; a scene depicting the teaching of uroscopy, with urinals standing on a shelf, on fol. i v at the start of the *Tractatus de Urinis*), and Pinder Ulrich, *Epiphanie medicorvm. Speculum videndi vrinas hominum* [...] (Nuremberg, Ulrich Pinder: 1506; urine wheel on fol. [1]v, overview of flasks on fol. A ii r, woodcuts of single flasks throughout the book). A rare case of green-coloured flasks can be found in *Fasciculus medicine: similitudo complexionum & elementorum* (Venice, Giovanni and Gregorio De'Gregorii: 1500) copy New York Academy of Medicine, call number FOLIO INCUNABULA, https://digital collections.nyam.org/islandora/object/facendoillibro%253A174 (accessed 4 May 2022). Stolberg, *Uroscopy* plate 14 shows another case (in a copy of *Hortus sanitatis* 1491), though without source reference.

32 Cases of pre-sale colouring include the *Herbarius Latinus* (Mainz, Peter Schöffer: 1484) and Belon Pierre, *Histoire de la nature des oyseaux* (Paris, Benoît Prévost: 1555), as described, respectively, by Rautenberg U., "Das Buch als Artefakt und kommunikatives Angebot. Die Exemplargeschichte des 'Herbarius latinus' (Mainz: Peter Schöffer, 1484) aus der Bibliothek des Christoph Jacob Trew", in Gleixner U. – Baum C. – Münkner J. – Rößler H. (eds.), *Biographien des Buches* (Göttingen: 2018) 57; and Chatelain J.M. – Pinon L., "Genres et fonctions de l'illustration au XVIᵉ siècle", in Martin H.J. (ed.), *La naissance du livre moderne. Mise en page et mise en texte du livre français (XIVᵉ–XVIIᵉ siècles)* (Paris: 2000) 259–261.

Although colour was a 'key diagnostic indicator' in uroscopy, as Mary Fissell has described it, and the addition of colour was clearly envisaged by *Tfundament*'s author Petrus Sylvius, not all readers seem to have felt a practical need for coloured images.[33] A substantial number of copies of urine treatises are uncoloured; whereas my sample of *Tfundament* contains only two such copies, many uncoloured urinals can be found in other contemporary medical works. For example, in my PhD research I also examined nine copies of the Dutch translation of *Fasciculus medicine* (Antwerp, Claes de Grave: 1512 and 1529), which contains two urine wheels (diagrams with flasks of different types of urine arranged in a circle); only one of these nine copies has a bit of colour, in just three of the urine flasks.[34] Indeed, many early printed works on uroscopy are not even illustrated at all.[35] Several of the uncoloured copies, such as the volume of the Poor Clares, do contain early modern traces of use, so we can assume that they were indeed read.[36] Possibly the textual descriptions of urine were sufficient for some readers. For other readers, coloured images may have worked as a mnemonic aid or an additional reassurance for identification, and they may even have been useful as a means of clarification in conversations between healers and patients.[37]

We can only speculate as to why the Poor Clares did not deem hand-colouring necessary for their specific purposes. It is noteworthy that their copy of *Den groten herbarius*, also donated to them by their confessor, is not

33 Fissell M., "Popular Medical Writing", in Raymond J. (ed.), *The Oxford History of Popular Print Culture*, vol. 1: Cheap Print in Britain and Ireland to 1660 (Oxford: 2011) 419. On hand-colouring uroscopy charts, see Hentschel K., *Visual Cultures in Science and Technology: A Comparative History* (Oxford: 2014) 348–349; Dackerman S. (ed.), *Prints and the Pursuit of Knowledge in Early Modern Europe*, exh. cat., Harvard Art Museums (Cambridge, MA: 2011) 56–57.

34 Ketham Johannes de (attr.), *Fasciculus medicine* (Antwerp, Claes de Grave: 1512), copy Copenhagen, Det Kgl. Bibliotek, call number 40 Med. 50850, barcode 20002334, fol. s i r.

35 For example, the lavishly illustrated herbal *Den groten herbarius* contains an unillustrated uroscopy treatise attributed to Arnaldus de Villanova (in the 1547 edition: fols. q ii v–q iiii r). The *Tractatus de Urinis* in the *Hortus sanitatis* (1491, fols. i r-x r) is similarly unillustrated, apart from the uroscopy scene at the beginning.

36 The other copy without coloured urinals I examined of *Tfundament* (1540, copy Antwerp, Hendrik Conscience Heritage Library, J 23176 [C2-516 c]) also contains early modern traces of use. A similar phenomenon may be observed for early printed herbals, where uncoloured copies often also contain a variety of users' traces; Van Leerdam, *Woodcuts as Reading Guides* (forthcoming).

37 On the role of medical books in doctor-patient interactions, see Strådal S.Ö., "Medieval Medical Diagrams: Meanings, Audiences, and Functions", *Hektoen International. A Journal of Medical Humanities* 5.3 (2013), https://hekint.org/2017/01/24/medieval-medical-diagrams-meanings-audiences-and-functions/ (accessed 4 May 2022).

coloured either, whereas colouring was a common means in herbals to make the depicted plants more easily recognisable. Perhaps Henricus of Beringhen preferred not to make additional expenses or efforts for his donations. Perhaps the sisters did not perform uroscopy themselves – the lack of colour might have similar reasons as the lack of handwritten folio numbers in the table of contents' section on surgery. Or perhaps, conversely, the sisters' practical experience was such that the textual indications of colour provided them with enough guidance.

5 Conclusion

In conclusion, the case of *Tfundament der medicinen* brings important issues to the fore regarding early modern book ownership, use, and customisation. First, the ownership note and modifications by the Poor Clares in Brussels jointly enable us to reconstruct a concrete situation of use for a vernacular medical book. The case makes clear that works like *Tfundament* could find an even wider audience than the novice professionals that the author Petrus Sylvius envisioned. While the three *servitrices* of the Poor Clares inscribed on the title page were certainly medical practitioners, in the monastery's sick room, they were not part of the target group of novice physicians, surgeons, and apothecaries, and nor was their confessor Henricus of Beringhen who donated the book. For the designated use in the convent's sick room, the sisters customised the book into a more practically useful work of reference. The use of tabs and pins made referencing into a truly three-dimensional process. Moreover, their approach to referencing involved not only facilitating navigation, but also visually warning against inappropriate content.

Secondly, this case study has stressed the importance of comparing traces of use in multiple copies. Even though customisation is by definition individualised, there are certainly patterns to be discovered. The use of pins is a compelling example of a versatile practice that was more common among early modern readers than scholarship has acknowledged.

Finally, the comparison of multiple copies of *Tfundament* problematises the role of colour in practices of customisation. How did the presence or absence of colour affect – or reflect – the ways in which a book was used? A comparative view evinces that we need to pay particular attention to whether colour was added before or after a book was sold, and whether it was done by a professional or by readers themselves. Should we consider hand-colouring as customisation at all when the author already anticipated it, or when it was done at the request of a printer rather than a buyer/owner? Hand-colouring

thus forcefully challenges distinctions between production and reception, as it urges us to think carefully about *who* were involved in customising the early printed book and indeed about what customisation actually means.

Bibliography

Abbreviations

MNW Verwijs E. – Verdam J. et al., *Middelnederlandsch Woordenboek* (1885–1929), https://gtb.ivdnt.org/search.

NAT Nijhoff W., *L'art typographique dans les Pays-Bas pendant les années 1500 à 1540*, 3 vols (The Hague: 1926–1935).

NB Walsby M. – Pettegree A., *Netherlandish Books. Books Published in the Low Countries and Dutch Books Published Abroad before 1601* (Leiden: 2010).

NK Nijhoff W. – Kronenberg M.E., *Nederlandsche bibliographie van 1500 tot 1540*, 3 vols. (The Hague: 1923–1971).

USTC *Universal Short Title Catalogue*, https://www.ustc.ac.uk.

WNT *Woordenboek der Nederlandsche Taal* (1864–1998), https://gtb.ivdnt.org/search/.

Primary Sources

Den Bibel. Tgeheele Oude ende Nieuwe Testament met grooter naersticheyt naden Latijnschen text gecorrigeert (Antwerp, Willem Vorsterman: 1528).

Cuba Johannes de, *Den groten herbarius met al sijn figueren der Cruyden* (Antwerp, Symon Cock: 1547).

Fuchs Leonhart, *Den nieuwen herbarius* (Basel, Michael Isingrin: 1545 or later).

Hortus sanitatis (Mainz, Jakob Meydenbach: 1491).

Ketham Johannes de (attr.), *Fasciculus medicinae* [Latin] (Venice, Giovanni and Gregorio De'Gregorii: 1491).

Ketham Johannes de (attr.), *Fasciculus medicinae* [Italian] (Venice, Giovanni and Gregorio De'Gregorii: 1494).

Ketham Johannes de (attr.), *Fasciculus medicine: similitudo complexionum & elementorum* [Latin] (Venice, Giovanni and Gregorio De'Gregorii: 1500).

Ketham Johannes de (attr.), *Fasciculus medicine* [Dutch] (Antwerp, Claes de Grave: 1512).

Ketham Johannes de (attr.), *Fasciculus medicine* [Dutch] (Antwerp, Claes de Grave: 1529).

Noot Thomas van der, *Tscep vol wonders* (Brussels, Thomas van der Noot: 1514).

Pinder Ulrich, *Epiphanie medicorvm. Speculum videndi vrinas hominum* [...] (Nuremberg, Ulrich Pinder: 1506).

Schedel Hartmann, *Liber chronicarum* (Nuremberg, Anton Koberger for Sebald Schreyer and Sebastian Kammermeister: 1493).

Sylvius Petrus, *Tfundament der Medicinen ende Chyrurgien* (Antwerp, Willem Vorsterman: 1530).

Sylvius Petrus, *Tfundament der Medicinen ende Chirurgien* (Antwerp, Willem Vorsterman: 1532).

Sylvius Petrus, *Tfundament der Medicinen ende Chyrurgien* (Antwerp, Willem Vorsterman: 1540).

Sylvius Petrus, *t Fvndament der medicynen ende chyrvrgien* (Rotterdam, Matthijs Bastiaensz: 1622).

Secondary literature

Chatelain J.M. – Pinon L., "Genres et fonctions de l'illustration au XVIe siècle", in Martin H.J. (ed.), *La naissance du livre moderne. Mise en page et mise en texte du livre français (XIV e -XVII e siècles)* (Paris: 2000) 236–269.

Dackerman S. (ed.), *Prints and the Pursuit of Knowledge in Early Modern Europe*, exh. cat., Harvard Art Museums (Cambridge, MA: 2011).

Dongen J.A. van, "De Incunabelen en Postincunabelen in de Bibliotheek van de Maatschappij (XII)", *Medisch contact* 20:36 (1965) 730–733.

Fissell M., "Popular Medical Writing", in Raymond J. (ed.), *The Oxford History of Popular Print Culture*, vol. 1: Cheap Print in Britain and Ireland to 1660 (Oxford: 2011) 417–430.

Gheyn J. van den, *Catalogue des manuscrits de la Bibliothèque royale de Belgique*, 13 vols. (Brussels: 1901–1948).

Giscombe J., "The Use of Pins in Early Modern England (1450–1700)", blog *The Book & Paper Gathering* (2018), https://thebookandpapergathering.org/2018/05/31/the -use-of-pins-in-early-modern-england-1450–1700/ (accessed 30 April 2022).

Gysel C., "De Antwerpse uitgaven van *Den Herbarius in Dyetsche* en *Tfundament der medicinen* (1540)", in Gerritsen W.P. – Gijsen A. van – Lie O.S.H. (eds.), *Een school spierinkjes: kleine opstellen over Middelnederlandse artes-literatuur* (Hilversum: 1991) 83–84.

Henne A. – Wauters A., *Histoire de la ville de Bruxelles*, vol. III (Brussels: 1845).

Hentschel K., *Visual Cultures in Science and Technology: A Comparative History* (Oxford: 2014).

Leerdam A.E. van, "Popularising and Personalising an Illustrated Herbal in Dutch", *Nuncius* 36.2 (2021) 356–393.

Leerdam A.E. van, *Woodcuts as Reading Guides. How Images Shaped Knowledge Transmission in Medical-Astrological Books in Dutch (1500–1550)* (forthcoming, Amsterdam: 2024).

Leong E., "Read. Do. Observe. Take Note!", *Centaurus* 60.1–2 (2018) 87–103.

Margócsy D. – Somos M. – Joffe S.N., *The* Fabrica *of Andreas Vesalius. A Worldwide Descriptive Census, Ownership, and Annotations of the 1543 and 1555 Editions* (Leiden: 2018).

Nave F. de – Schepper M. De (eds.), *De geneeskunde in de Zuidelijke Nederlanden (1475–1660)*, exh. cat., Museum Plantin-Moretus and Stedelijk Prentenkabinet (Antwerp: 1990).

Post W. – Pennink R. – Cockx-Indestege E., *Oude drukken uit de Nederlanden: boeken uit de collectie Arenberg, thans in de verzameling Lessing J. Rosenwald*, exh. cat., The Hague, Museum Meermanno-Westreenianum/Brussels, Albert I Bibliotheek (The Hague: 1960).

Rautenberg U., "Das Buch als Artefakt und kommunikatives Angebot. Die Exemplargeschichte des 'Herbarius latinus' (Mainz: Peter Schöffer, 1484) aus der Bibliothek des Christoph Jacob Trew", in Gleixner U. – Baum C. – Münkner J. – Rößler H. (eds.), *Biographien des Buches* (Göttingen: 2018) 39–87.

Stolberg M., *Uroscopy in Early Modern Europe* (London: 2016).

Strådal S.Ö., "Medieval Medical Diagrams: Meanings, Audiences, and Functions", *Hektoen International. A Journal of Medical Humanities* 5.3 (2013), https://hekint.org/2017/01/24/medieval-medical-diagrams-meanings-audiences-and-functions/ (accessed 4 May 2022).

Vermeulen Y.G., *'Tot profijt en genoegen': Motiveringen voor de produktie van Nederlandstalige gedrukte teksten 1477–1540* (Groningen: 1986).

Wakelin D., "'Thys ys my boke': Imagining the Owner in the Book", in Flannery M.C. – Griffin C. (eds.), *Spaces for Reading in Later Medieval England* (Houndmills: 2016) 13–33.

Walsby M., "Cheap Print and the Academic Market: The Printing of Dissertations in Sixteenth-Century Louvain", in Pettegree A. (ed.), *Broadsheets: Single sheet Publishing in the First Age of Print* (Leiden: 2017) 355–375.

Wittop Koning D.A., *Dit is die rechte conste om alderhande wateren te distilleren (Antwerp, ca. 1520): Facsimile with an Introduction* (Ghent: 1976).

CHAPTER 9

Custom Made by Antonio Ricardo: Peru's First Printer and His Illustrations in Jerónimo de Oré's *Symbolo Catholico Indiano* (1598)

Tom Cummins

1 Introduction

One cannot imagine the 'New World' without the printing press in Europe and America.[1] The printing of specialized volumes and even new genres was instrumental to the Spanish imperial project in terms of administrative, financial, religious, and legal affairs.[2] We therefore tend to think of the establishment of printing presses solely in terms of the production of books, pamphlets, and other ephemera (such as indulgences) in the New World. The establishment of the first press in America was also the initiation of the first global conglomerate business enterprise that involved mining and other ventures.[3] Global mercantile capital, colonisation, and bookmaking are inextricably intertwined. Nonetheless, book printing in America was first and foremost in the service of the evangelical mission of the Catholic Church and most specifically the pastoral needs of the Franciscans, Augustinians, Dominicans, and eventually the Jesuits when they arrived beginning in the last quarter of the sixteenth century. This essay will therefore not address customised books in the same sense as other essays in this volume. Rather, it addresses the process of customization of printed books. These are books that were created for the new needs of the evangelical mission, a process that required close collaboration between printers, authors, and patrons. It will ultimately focus on an analysis of a specific

1 The first part of this essay is based on my essay "Writ Large: Printing, Painting and Conversion in Sixteenth-Century America", in Wilkinson A.S. (ed.), *Typography, Illustration and Ornamentation in the Early Modern Iberian Book World, 1450–1800* (Leiden: 2021) 315–349.

2 The critical importance of the printing press in the transformation of the New World is still not well understood and has not found a solid foothold in the general scholarship on the history of printing; so, for example, the printing press in sixteenth-century America has no place in Eisenstein E.L., *The Printing Press as an Agent of Change*, vol. 1 (Cambridge: 1979) or Dackerman S. (ed.), *Prints and the Pursuit of Knowledge in Early Modern Europe* (New Haven, 2011).

3 See Griffin C., *The Crombergers of Seville: The History of a Printing and Merchant Dynasty* Oxford: 1988) 94–97.

© KONINKLIJKE BRILL NV, LEIDEN, 2024 | DOI:10.1163/9789004680562_010

text-image relationship in a unique late sixteenth-century book published in the Viceroyalty of Peru.

As we shall see, Antonio Ricardo, Peru's first printer, came to Lima from Mexico City and almost immediately began work on publishing specific evangelical projects that would shape religious teaching in Peru for the next three hundred years. This essay will discuss some of the few images used in that printing project so as to eventually focus on a very idiosyncratic book written by a Peruvian-born author and the use of images in it. This book is Jerónimo de Oré's *Symbolo catolico indiano*, printed by Antonio Ricardo in 1598. It is a truly remarkable book for a variety of reasons,[4] not the least of which is the layout of some of the printed woodblock images in relation to the Latin, Spanish, and Quechua printed texts. Because the prints seem to be randomly placed and are also radically different in terms of styles, they have drawn little scholarly attention. Scholars have generally focused on studying the texts in the volume or the history of the author and considered the prints to be merely decorative and incidental.[5] However, a closer look at the relationship of some images to adjacent texts implies that there may have been a calculated intent to make various visual and textual connections within the book. As shall be seen, my argument ultimately will be based on an absent ekphrastic text and its image and their underlying demonstration of the Athanasian Creed as a defense of the Doctrine of the Trinity and, more generally, Christological Doctrine as it was translated into Quechua. In this sense, the prints make visible what is proclaimed to be true in the text.

2 From Mexico City to Lima

American printing in any sustained form began in the viceroyalty of New Spain (Mexico, Central America, and the Philippines). The first Bishop of Mexico City, Fray Juan Zumárraga, a Franciscan, raised the necessity of having a press with the Council of the Indies, the colonial governing body in Madrid. Printing therefore became firmly established first in Mexico City with the contract signed between Juan Cromberger and Juan Pablos in Seville in 1539, on the understanding that the Italian Juan Pablos (born in the region of Brescia around

4 See Andrango-Walker C., *El Símbolo católico indiano (1598) de Luis Jerónimo de Oré: Saberes coloniales y los problemas de la evangelización en la región andina* (Madrid: 2018) 31.

5 Ibid. Also see Tord LE, "Luis Jerónimo de Oré y *El Symbolo Catolico Inidiano*" and Cook N.D., "Luis Jeonimo: una aproximación", in Tibsar A. (ed.), *Symbolo Catholico Indiano, Fray Luis Jerónimo de Oré, 1598 Edicion facsimilar* (Lima: 1992) 15–34, 35–62.

1500) would travel to New Spain (Mexico) with the necessary equipment.[6] The intent in bringing a printer to Mexico City was to arm the church with the necessary equipment to effect the systematic evangelisation of New Spain only ten years after the defeat of the Aztec empire and the destruction and rebuilding of their capitol. It is no surprise, therefore, that the first known book to be published in America is the 1544 *Dotrina Breve p[ro]uechosa de las cosas q[ue] p[er]tenecen a la fe catholica* composed by Bishop Zumárraga and printed by Juan Pablos under the name of Juan Cromberger [Fig. 9.1].

The text is a simplified version of Erasmus's *Paraclesis*, with the idea of teaching Christian doctrine in a straightforward, plain way for the people of Mexico.[7] Quickly, however, printing in Mexico City turned to producing critically important new meta-texts such as bilingual dictionaries and grammars in many of the various Indigenous languages.[8]

The production of specialized books for missionaries in the field as well as books for students at the newly-created university in Mexico City required both the importation of paper and printing equipment and the reuse of whatever was already at hand. Since there were multiple languages that needed to be translated into Latin and Spanish, the printing of books as well as more ephemeral material grew rapidly in sixteenth-century Mexico City. These new books allowed the missionaries to learn local languages or, at least, to be able to read catechetical teachings and preach sermons in Maya, Nahuatl, Zapotec, and other languages. Some of these texts were extensively illustrated so that they could visually teach doctrine to the new converts. The style and compositional and iconographic complexity of the images can vary greatly in the same volume, such as in Pedro de Feria's *Doctrina Christiana en lengua Castellana y Çapoteca* published by Pedro Ocharte in 1567, as well as in Juan de la Cruz's *Doctrina christiana en la lengua guasteca co[n] la lengua castellana*, published in 1571 [Fig. 9.2]. In this latter publication, woodcut images appear interspersed with the texts in Spanish and Guasteca that, for example, are either direct illustrations of the fourteen articles of faith in the text or refer to liturgical acts that enact that faith. Unlike the discrete vertical columns of parallel texts, the

6 See Griffin, *The Crombergers* 1988.

7 Egío J.L., "Pragmatic or Heretic? Editing Catechisms in Mexico in the Age of Discoveries and Reformation (1539–1547)", in Duve T. – Danwerth O. (eds.), *Knowledge of the Pragmatici: Legal and Moral Theological Literature and the Formation of Early Modern Ibero-America* (Leiden: 2020) 243ff.

8 For metalinguistic works, see Hanks W., *Converting Word: Maya in the Age of the Cross* (Berkeley – Los Angeles – London: 2010) 10–11, 207–208; and Durston A., *Pastoral Quechua: The History of Christian Translation in Colonial Peru 1550–1650.* (Notre Dame, IN: 2007) 271–302.

CUSTOM MADE BY ANTONIO RICARDO: PERU'S FIRST PRINTER

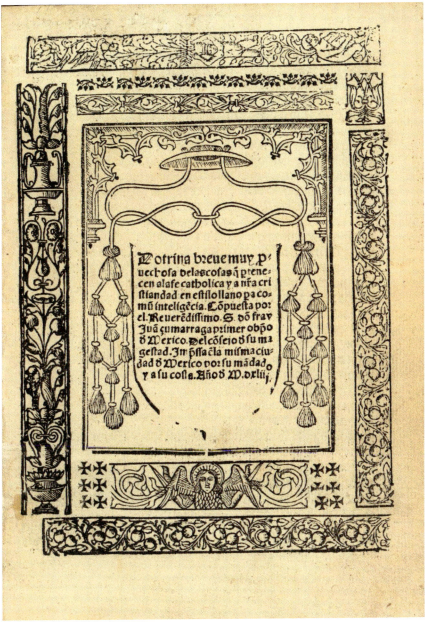

FIGURE 9.1 Bishop Zumárraga, "Title Page" of *Dotrina Breve p[ro]uechosa de las cosas q[ue] p[er]tenecen a la fe catholica* [...] (Gran Ciudad Tenochitlan Mexico de Nueva España, Juan Cromberger (Juan Pablos): 1544). Harvard University, Houghton Library, pga_typ_100_544-METS

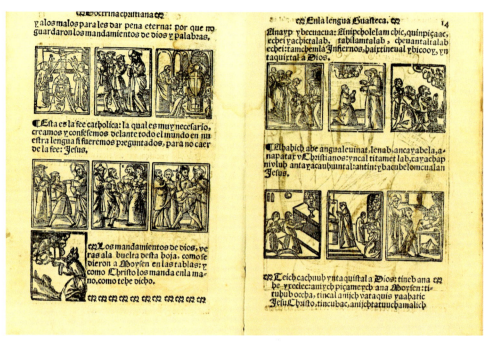

FIGURE 9.2 Juan de La Cruz, "The final part of the fourteen articles of faith or liturgical acts that enact that faith, and Moses receives the Ten Commandments that then follow," *Doctrina christiana en la lengua guasteca co[n] la lengua castellana* (Mexico City, Pedro Ocharte: 1571), fols. 13v–14r

images run horizontally across the two facing pages in a single continuous narrative, thereby uniting or bridging the two different linguistic columns of the same text. Here we can see, through the very composition of the printed page, how critical images were in the greater catechetical mission in which the visual component crosses horizontally between the two languages, creating mutual intelligibility and uniting the common meaning expressed in the parallel horizontal columns of two unrelated languages.[9]

Block prints were not always specific to the texts, and they could be used for frontispieces in which different titles were framed. For example, the Augustinian friar Alonso de la Vera Cruz's 1554 *Physica speculatio* treats the study or 'investigation' of physics based on Aristotle's *Physica*. This book was intended for use in the new University of Mexico, and its main divisions corresponds to

9 Images were used in New Spain to act as a kind of go-between for texts in Indigenous and European languages; see Cummins T., "From Lies to Truth: Colonial Ekphrasis and the Act of Crosscultural Translation", in Farago C. (ed.), *Cultural Migrations: Reframing the Renaissance*. (New Haven: 1995) 152–174; 326–329.

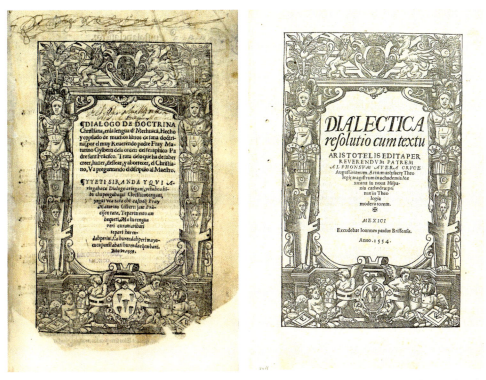

FIGURE 9.3 "Title Pages" to Alonso de la Vera Cruz, *Physica speculatio* (Mexico City, Juan Pablos: 1554) and Maturino Gilberti, *Diálogo de doctrina christiana en la lengua de Mechuacan* (Mexico City, Juan Pablos: 1559)

earlier editions of Aristotle's work. The same frontispiece matrix was used five years later for an entirely different kind of book: *Diálogo de doctrina christiana en la lengua de Mechuacan* by the French Franciscan Maturino Gilberti, who had earlier written a grammar of the language and published a vocabulary in 1559 with Juan Pablos [Fig. 9.3].[10] Except for the titles, the only difference between the two frontispieces is the emblematic sign in the escutcheon indicating the monastic order of each author. The point here is rather simple: the needs of the very different reading communities (Indigenous and European) were addressed specifically in the texts, but the same images seemed to be

10 The woodcut title page was first cut in London for *The Book of Common Prayer* printed by Edward Whirechurch in 1549, see Boston Public Library, https://archive.org/details/bookeofcommonpraoochur_1/page/n9/mode/2up. On this first title page, the initials of the printer and royal coat of arms appear in the cartouche.

used for both, at times seemingly indiscriminately.[11] This was not always the case, however, and I will discuss in the last part of this essay a case in which plates were chosen precisely according to the author's intention to address the desires and aims of evangelisation. In a very rare Peruvian book, the use of images within a very heterogeneous text can only be understood by reference to an internal dialogic context among images, spatial layout, and text. This extremely rare case appears in Jerónimo de Oré's *Símbolo católico indiano*, printed in 1598 by Antonio Ricardo in Lima, the first printer in the viceroyalty of Peru.

Before discussing Oré's book and Antonio Ricardo's image/text layout, it is important to set the scene by looking at two other sixteenth-century Mexican printers and the specific illustrations they chose to use (and re-use). For example, the second printer in Mexico, Antonio Espinosa, who worked with Juan Pablos until 1559, printed Alonso de Molina's bilingual Spanish-Nahua *Confesionario en la lengua mexicana y castellana* in 1569. Like many polyglot publications, its texts are laid out in corresponding columns with sections left for woodblock prints to be added. These are stock images brought from Spain or re-carved in America that appear time and again both in Mexican and then in Peruvian books, as we shall see. In the case of Molina's book, the images often illustrate the narrative of the text, but one image, the profile bust portrait of Christ [Fig. 9.5], repeatedly appears as the indexical presence of Christ, often in relation to the feasts that were to be celebrated in the liturgical year, as can be seen in the later (1578) edition published by Pedro Balli [Fig. 9.4].

The most common image, however, is a woodcut of Christ in a roundel with the Latin text 'Ego sum veritas' from the gospel of John. The same image appears three times in the 1565 edition of *Confesionario mayor, en lengua mexicana y castellana*, and again in Friar Juan Bapista's *Sermonario en la Lengua Mexicana* published by Diego Lopez Dau(v)alos in 1606.

In one example, however, the text surrounding the roundel has changed to 'Speciosus forma prae filiis hominum' (Thou art beautiful above the sons of men) from *Psalm* 44 [Fig. 9.6]. This same text appears in the frontispiece of Molina's *Doctrina Christiana, en lengua mexicana* printed by Pedro Ocharte in 1578.

11 Based on a comparison of the three title pages Antonio Rodíguez-Buckingham states that 'it seems logical to infer that the Mexican initials and the frontispiece were copied from the European editions by well-trained local laborers, probably on the very site of the printing shop. Like the well-trained metal or wood engravers of Europe, the Mexican workers were undoubtedly instructed to copy faithfully what they saw'. See Rodíguez-Buckingham A., "Monastic Libraries and Early Printing in Sixteenth-Century Spanish America", *Libraries & Culture* 24.1 (1989) 33–56.

❧ En lengua Mexicana y Castellana. 29

missa, yniquac tictequipa-
noua ynizquitlamantli o-
nicteneub, ca amo yctitla-
tlacoua. Yece motechmo-
nequi in ticmolnamiquiliz
yn moteoub ynmotlatoca
ub, cenca timocnelilmatiz,
ynipampa amo çanquex-
quich yc omitzmocnelili.

ber) quando entiendes en
todas estas cosas que te he
dicho ni cometes peccado
alguno. Empero cõuiene,
que entonces te acuerdes
de tu dios y señor, hagas
muchas grãs, por las innu
merables mercedes y bene
ficios que te ha hecho.

¶ Izcatqui ym-

pieloni ylhuitl, yn quipiez
que naturales nicã nueua
España tlaca: aub yntla
quitlacozã, yc ypã vetziz
que temictiani tlatlacolli.

¶ Siguense las

fiestas ó guardar, las qua
les solamente obligan a
los naturales desta nue-
ua España, so pena de pec
cado mortal.

¶ Ytlacatilitzi
yn totecuiyo
Jesu christo, in
moteneua Pas
cua ó nauidad.
¶ Circuncisió,
ym moteneua
yancuic xiuitl,
Año nueuo.
¶ Epiphania,
eintintlatoque
ymilhuitzin, in
moteneua Pas
cua delos reyes.
¶ Ynezcalilitzin totecui-

¶ La natiui-
dad de nro se-
ñor Jesu xpo,
q se llama pas-
cua ó nauidad.
¶ La circunci
sió, q dezimos
ollamamos A
ño nueuo.
¶ La epipha-
nia, que es la
fiesta ó los tres
Reyes, que se
llama Pascua ó los reyes.
¶ La resurrection de nue
stro

FIGURE 9.4 Alonso de Molina, "Profile Portrait of Christ," in *Confesionario mayor, en lengua mexicana y castellana* (Mexico City, Pedro Brilli: 1578) 29

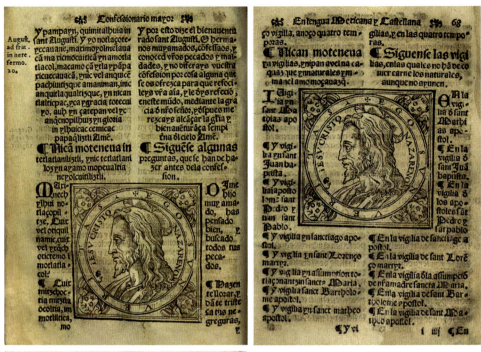

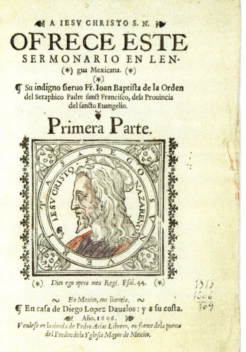

FIGURE 9.5
"Profile Portrait of Christ" with text 'Ego sum veritas, Jesu Cristo Nazareno', in Alonso de Molina, *Confesionario mayor, en lengua mexicana y castellana* (Mexico City, Antonio Espinosa: 1565) 27, 68, and in the frontispiece of Friar Juan Baptista, *Sermonario en la Lengua Mexicana* (Mexico City, Diego Lopez Daualos: 1606)

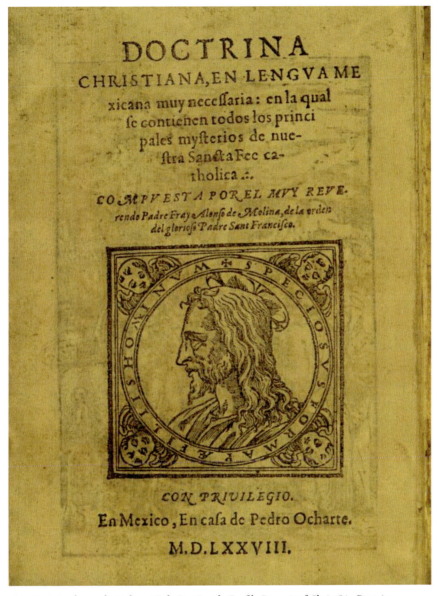

FIGURE 9.6 Alonso de Molina, "Title Page" with "Profile Portrait of Christ," in *Doctrina Christiana, en lengua mexicana* [...] (Mexico, En Casa de Pedro Ocharte: 1578)

Pedro Ocharte, like many of the printers who came to the viceroyalties of New Spain and Peru, was not Spanish; he was born in Rouen and came to New Spain as a merchant in 1548. He entered into relations with Juan Pablos and became so close to the family that Pablos' widow asked Ocharte to serve as a witness for a power of attorney after Pablos passed away. Later, he married Pablos's daughter, María de Figueroa in 1561 or 1562, and eventually signed a contract with Jerónimo Gutiérrez to rent Pablos's press in 1563. As can be seen, therefore, the first four printers in Mexico – Juan Pablos, Antonio Espinosa, Pedro Brilli, and Pedro Ocharte – developed very close personal and professional relationships with each other. A fifth printer, Antonio Ricardo, received the royal cédula in 1570 to travel to New Spain where he set to work, probably first in the workshop of Pedro Ocharte, whom he already had met in Lyon. After the arrival of the first Jesuits in Mexico City, he soon set up shop in their Colegio de San Pedro y San Pablo.[12]

Like Pedro Ocharte (French) and Juan Pablos (Italian), Antonio Ricardo was not Spanish.[13] He was born Antonio Ricciardi in Turin in 1532, and although he hispanized his name, he would print his place of birth in several of his Peruvian publications. Ricardo's close connection with the Jesuits meant that he almost immediately received their patronage, producing several books for them in New Spain.[14] More importantly, this work may have induced the Jesuits in Peru to call him to Lima in 1580, in anticipation of their needs there.[15] Whatever the case, Ricardo immediately began to work in close collaboration with them, even before receiving official permission to do so. The need for printing was already great; though the Jesuits had recently arrived in Lima, they provided the driving intellectual force behind the Third Council of Lima (1582–1583),

12 Cid-Carmona V.J., "Antonio Ricardo: aportaciones a la tipografía médica mexicana del siglo XVI", *Boletín Mexicano de Historia y Filosofía de la Medicina* 8.2 (2005) 40.

13 Many of the printers in Spain and later in America did not come from Spain. Thus, one can trace the lineage of the first printer in New Spain from Poland. Estanislao Polono worked in Seville in the late fifteenth and early sixteenth centuries, and his press and typographical material were inherited by his colleague, the German immigrant printer Jacobo Cromberger, who in his turn bequeathed them to his son Juan who in turn contracted the Italian, Juan Pablos, to begin printing in Mexico City in 1539. Pedro Ocharte (Pierre Ochart from Normandy) became the son-in-law of Juan Pablos and eventually bought his house and press after his death.

14 See, for example, Fernández de Zamora R.M., *Los impresos mexicanos del siglo XVI. Su presencia en el patrimonio cultural del nuevo siglo* (Mexico City: 2009); and Cid-Carmona, "Antonio Ricardo: aportaciones a la tipografía médica mexicana" 40–45.

15 It has been suggested that Ricardo left for Lima in order to take advantage of the great wealth being generated there and to avoid the increased competition in Mexico City; see Rodriguez-Buckingham A., *Colonial Peru and the Printing Press of Antonio Ricardo* (Ph. D. dissertation, University of Michigan: 1977) 89.

officially called by archbishop Toribio Alfonso de Mogrovejo, which would produce a set of texts that would dominate catechetical instruction in Peru for the next three hundred years.[16] Even before the council met, it was clear that a printer in Lima was desperately needed to print these works, virtually as soon as they were written in manuscript. Whatever the reasons were for Ricardo to go to Lima, his colleagues, Pedro Ocharte and Antonio Espinosa, lent him both the equipment and money to establish his press in Lima. In the role of guarantor, he left his wife in Mexico City as he took up his new enterprise in Lima. The issues of debt were a constant for many of the early printers as Ricardo's own will attests. He both owed a great deal of money to lenders and was owed money that he had lent.

The first text that Ricardo published was the *Pragmatica*, a four-page edict on the new Gregorian calendar in 1584. Almost immediately afterward, he published three volumes of catechetical texts developed at the Third Council of Lima. The texts were quickly conceived and written as trilingual (Spanish, Aymara, and Quechua), and Ricardo began printing them within a year. The first of the three, *Confessionario para los curas de Indios*, appeared in 1584 and the other two volumes, *Doctrina Christiana y catecismo para instruccion de los Indios* and *Tercero catecismo y exposicion de la doctrina christiana, por sermons*, appeared less than a year later in 1585. These critical volumes were quickly followed by the sort of meta-text these polyglot volumes required, namely, the first printed Spanish-Quechua dictionary in Lima in 1586, entitled *Arte, y vocabulario en la lengua general del Perú, llamada Quichua*. This dictionary was quickly reprinted several times.

As the Jesuits knew, Lima was the only place where volumes like these could be printed, 'because there were no proofreaders capable of reading the Quechua and Aymara texts in Mexico and Spain'.[17] Furthermore, although these texts had circulated in manuscript, the printed volumes were understood to be the only official volumes for use by the clergy and missionaries. At that point, both the ecclesiastical and civil authorities almost immediately banned the manuscript forms, because only the printed texts could ensure that the consistency and orthodoxy of the text were protected from scribal errors or, even worse, intentional unauthorized changes.[18]

The three Lima volumes all have the same basic layout, which is different from the standard composition of the Mexican bi-lingual volumes, namely, two vertical facing columns of Spanish or Latin on the left and Indigenous

16 See Durston, *Pastoral Quechua* 103–104.
17 Ibid 100.
18 Ibid. 101.

language text on the right. As the Lima volumes are trilingual, Ricardo needed a different format in order to accommodate the smaller typefaces. The page layout most often begins with either the Spanish or Latin text arranged horizontally across the entire page, with two vertical columns of Quechua and Aymara translations arranged below. The frontispieces of the three Lima volumes also have the same basic layout [Fig. 9.7]; all affirm that they were printed with the license of the Real Audiencia of Lima, and, most significantly in terms of Antonio Ricardo's self-fashioning, announce that they were printed 'en la ciudad de los Reyes por Antonio Ricardo primero impressor en estos Reynos del Peru'. That is, he self-identifies as being the first printer in Peru. This claim was a novelty in New Spain; nothing like it appears in any of the books printed by Juan Pablos. This suggests, then, that Ricardo arrived in Lima and set up his shop *before* the crown officially acknowledged his right to print.[19] However, he continued to assert this original claim in the title pages of most of the books that he published thereafter.

The emphasis of the three volumes from the Third Lima Council was to incorporate the pronouncements of the Council of Trent into the evangelical mission in Peru.[20] One of the delicate issues was to confirm the orthodoxy of religious images and the meaning of the veneration of Christian images as enunciated in the twenty-fifth meeting of December 1563, the text of which was copied almost verbatim. Missionaries in Peru were well aware of the urgent need for this guidance, as they were currently engaged in a simultaneous campaign to extirpate idolatry and its particular forms as practiced in Peru. This overriding concern appears multiple times in a text that came out of the Third Council, the *Confesionario para curas de indios con la instrucción contra ritos y exhortaciones para ayuda a bien morir*; religious images were adduced apropos of many confessional questions, and the book also included of a summary of Polo de Ondegardo's *Tratado y averiguación sobre los errores y supersticiones de los indios* (1559–1561).[21] Aside from historiated letters that begin new sections, Ricardo uses very few pictorial woodcuts. They appear either to announce the next section of the book, such as the image of the "Last Supper" that precedes

19 Cid-Carmona, "Antonio Ricardo: aportaciones a la tipografía médica" 41.
20 For the Provisón Real of Philip II's that called for the establishment of the Council for 'el bien de los naturales de estos Reinos del Piru [...] por decreto del santo Concilio de Trento', see Toribio Medina J., *La Imprenta en Lima*, 4 vols. (Santiago de Chile: 1904) I 5–6. For the Council of Trent see N.P. Tanner *Decrees of the Ecumenical Councils*, 1 vols., (Washington DC: 2017) 2.
21 Polo de Ondegardo "Los Errores y supersticiones de los Indios sacados del Tratado y averiguacion que hizo el Licenciado Polo," in *Confesionario para los Curas de Indios* (Lima: 1585) 7r–16v.

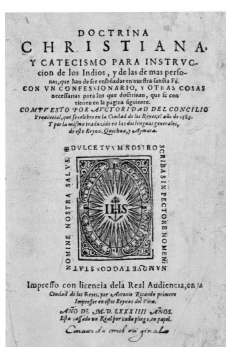
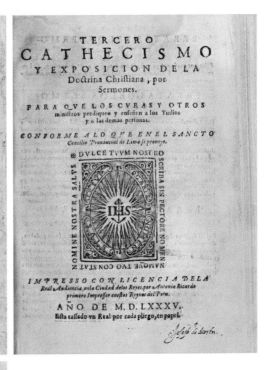

FIGURE 9.7

Antonio Ricardo, "Title Pages" of *Doctrina Christiana y catecismo para instruccion de los Indios* (1585); *Tercero catecismo y exposicion de la doctrina christiana, por sermones* (1585); and *Confessionario para los curas de Indios* (Ciudad de Los Reyes, Antonio Ricardo Primero Impressor en estos Reyenos del Piru: 1584–1585)

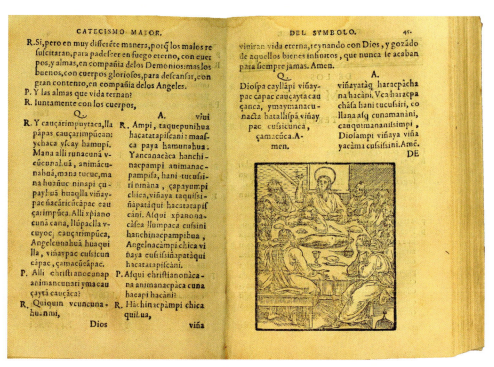

FIGURE 9.8 Antonio Ricardo, "The Last Supper". Woodcut in *Doctrina Christiana y catecismo para instruccion de los indios* (Lima, Antonio Ricardo primero impressor en estos Reynos del Peru: 1584), fol. 45r

the section in the "Catecismo mayor" on the sacraments in *Doctrina Christiana y catecismo para instruccion de los indios* [Fig. 9.8], or to mark the end of a section, such as the "Profile Portrait of Christ" at the end of the *Catecismo Mayor* [Fig. 9.9)].

Ricardo, unsurprisingly, employed some of the same woodblocks that he and other printers had used in Mexico. For example, the woodblock print of the profile bust "Portrait of Christ" framed by a double oval was used in New Spain by Antonio de Espinosa in the 1565 edition of Alonso de Molina's *Confesionario Mayor* and was repeatedly re-used for later volumes such as Juan de Córdova's *Vocabulario de lengua çapoteca* published by Pedro Ocharte and Antonio Ricardo in Mexico City [Fig. 9.5].[22] These examples are inscribed with 'Jesus Christo Nazareno' in the inner text, and 'Ego sum veritas' in the outer

22 Rodriguez-Buckingham A. "English Motifs in Mexican Books: A Case of Sixteenth-Century Information Transfer", in Williams J.M. – Lewis R. (eds.), *Early Images of the Americas: Transfer and Invention* (Tuscon – London: 1993) 287–304, at 297–299.

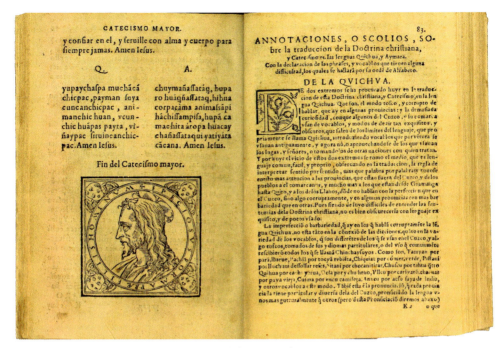

FIGURE 9.9 Antonio Ricardo, "Profile Portrait of Christ". Woodcut in "Catecismo Mayor", in *Doctrina Christiana y catecismo para instruccion de los Indios* (Lima, Antonio Ricardo primero impressor en estos Reynos del Peru: 1585), fol. 83v

text. Pedro Ocharte also uses the same profile of Christ for the title page of his 1578 publication of Molina's *Doctrina christiana en lengua Mexicana*, although with a different surrounding text ('Speciosus forma prae filiis hominum').

The same woodcut of Christ's profile appears in Antonio Ricardo's 1585 publication of the *Catecismo* in Lima, printed below "Fin del Catecismo Mayor" on folio 83v [Fig. 9.9]. The Latin text surrounding the image indicates that Ricardo was using Ocharte's woodcut, which he likely had brought to Lima with him [Fig. 9.6].[23] Yet, it is also evident that Ricardo did not bring very many pictorial woodblocks with him, and the need to print the books quickly meant there was little time to create very many new ones and insert them into the matrix. There is, then, a clear distinction between the extensively illustrated

23 The Latin text is from *Psalm* 44: 'Thou art beautiful above the sons of men'. The passage is sung on the feast of Transfiguration (August 6th). Ricardo Estarbis Cárdenas argues that this is a new woodblock print after Ocharte's, and of better quality than his; see Estarbis Cárdenas R., *El Grabado en Lima: Documento histórico y artístico* (*Siglos XVI al XIX*) (Lima: 2002) 97.

books of the same genre printed in New Spain and those from Peru, as can be seen by comparing the three books Ricardo printed in Lima with Juan de la Cruz's *Doctrina christiana en la lengua guasteca co[n] la lengua castellana* printed by Pedro Ocharte [Fig. 9.4]. That very few illustrations appear in Ricardo's volumes is understandable given the conditions under which they were produced, but it is important to note that no books subsequently printed in Peru during the viceregal period were ever as intensively illustrated as those printed in New Spain.[24] Here, one might ask about the possible differences between New Spain and Peru in terms of catechetical texts and their use in instruction. Was there greater emphasis on text and image as a means of communicating doctrine in New Spain than in Peru? Certainly, images were used in Peru for teaching doctrine, but these seem to be murals and paintings in churches as well as prints, as alluded to in sermons, and not printed images in bilingual books.

The blocks for illustrations, initials, and letters were brought to Lima from Mexico, and Ricardo's enterprise in Peru demonstrates how woodblock printing was slowly transferred from Spain throughout America.[25] However, not all woodblock prints were simply transferred from one place to the next, and while some of Ricardo's woodblock illustrations were clearly based on his work in Mexico, a few clearly were not, as we can see in a pair of small images that mark the end of the *Catecismo Breve* [Fig. 9.10].

The first of the pair depicts the "The Trinity", and it is clearly the same image as "The Trinity" found on folio IIv in Ocharte's 1578 edition of Molina's *Doctrina*. In fact, we know that this print as well as Ricardo's "Profile of Christ" [Fig. 9.9] were made from the same blocks that Ocharte used, because each has the same imperfections [Fig. 9.6].[26] This is no surprise since, as already noted, the two

24 There is a concomitant disparity between the number of illustrated manuscripts in New Spain and the very few illustrated manuscripts in Peru; see Cummins T., "El mundo y vida de las imágenes en las paginas peruanas de los siglos XVI–XVII: el contexto virreinal de las obras de Martín de Murúa, Guaman Poma y otros", in Michaud C. (ed.), *Escritura e imagen en Hispanoamérica: De la crónica ilustrada al cómic* (Lima: 2015) 21–64.

25 The first two centuries of printing in the Viceroyalty of Peru took place almost entirely in Lima. José Toribio Medina's early twentieth-century publications on this subject have not been surpassed by Peru; see, for example, his *La Imprenta en Lima*. In many ways, these early to mid-twentieth-century volumes on Mexican and Peruvian printing and printed editions are still the best for an overall understanding of the history of printing in America. See also González Sánchez C.A., *Los mundos del libro: medios de difusión de la cultura occidental en las Indias de los siglos XVI y XVII*. (Seville: 2001).

26 It has been suggested that Ocharte used Ricardo's equipment and letters while Ricardo was in Mexico City, and that Ricardo had brought some historiated letters from Spain and then took them with him to Lima, see Rodriguez-Buckingham A, "Monastic Libraries" 51.

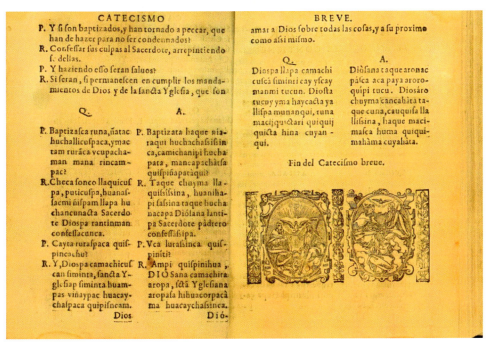

FIGURE 9.10 Antonio Ricardo, "Double Vignette of the Trinity and Coronation of the Virgin". Woodcut at the end of "Catecismo breve", in *Doctrina Christiana y catecismo para instruccion de los Indios* (Lima, Antonio Ricardo primero impressor en estos Reynos del Peru: 1585), fol. [18r]

printers worked closely together in Mexico, and Ocharte actively supported Ricardo by lending him money and equipment to begin printing in Lima.[27]

The second vignette is new, however. It represents the "Coronation of the Virgin" and has a composition similar to the first vignette, showing God the Father, Christ, and the Holy Spirit. As far as I can discern, this image does not appear in any Mexican edition. The presumably new "Coronation" woodcut mirrors the triangular composition of the "Trinity" vignette, but the forms of the figures and the cartouche are different. God the Father, Christ, and the Holy Spirit are reduced in scale so that the figure of Mary can appear below as they bend forward to crown her. Moreover, the cartouche in which they are framed

27 In 1571, Ocharte published a large print of "Our Lady of the Rosary" with a quatrain considered heretical. He was investigated by the Inquisition and remained in its jails for at least a year (July of 1571 to May of 1572); in March 1573, he was accused and imprisoned again, though eventually acquitted. Thus, before Ricardo left for Peru, he and Ocharte worked together, between 1576 and 1578, printing both the *Graduale dominicale* and Fray Juan de Córdova's *Vocabulario çapoteco*. Ricardo was later investigated by the Inquisition in Lima. It seems that their non-Spanish identities made them more suspect by the Inquisition.

is slightly larger to accommodate the more complex figural arrangement. The two vignettes are similar enough that their pairing seems to be compositionally consistent as a whole. The question then becomes, why would Ricardo cut a new image that really does not have much to do with the text of this part of the volume? What would cause such a seemingly idiosyncratic printing gesture? The inclusion of the "Coronation of the Virgin" makes sense, however, if one enters into the specificity of the Jesuits' intellectual leadership at the Third Council of Lima and recognizes Ricardo's first three volumes as part of an overall Jesuit evangelical strategy. To understand this relationship, we must take a closer look at the overarching Jesuit visual program in Lima during the 1580s.

Painting and music had already been understood as a necessary set of tools in the evangelization of New Spain,[28] and they remained fundamental to the Jesuits' mission as they arrived in Peru. Thus, the first Peruvian Jesuit General, Fray Bracomante, characterized the beauty in painting as a functional cultural tool, like many others, in the Andean campaign of evangelization. Before arriving in Peru, he wrote to Rome, asking that a significant artist be dispatched to Lima; they needed 'images that represent with majesty and beauty what they signify because the people of this nation are led by such things'.[29] The artist chosen to go to Lima was the Jesuit painter Democrito Bernardo Bitti, another Italian who was born in Camerino, Italy in 1548. He was ordered to fulfill the mission in 1571 and arrived in Lima in 1575, just five years before Ricardo set up his printing press. Bitti immediately began to paint for the Jesuits in Lima before he traveled to Cuzco, Arequipa, and elsewhere in the high sierras. But before that, Bitti's largest and most famous painting, entitled "Coronation of the Virgin", was commissioned for the Jesuit church, San Pedro, where it is now placed at the eastern end of the sacristy [Fig. 9.11]. The composition is based

28 Based on Saint Gregory's letter to Bishop Serenus of Marseilles, in which Gregory tells him that images are for those who cannot read, 'so that persons ignorant of letters may have something whereby they may gather knowledge of the story [...].' Cited in Chazelle C.M., "Pictures, Books, and the Illiterate: Pope Gregory I's Letters to Serenus of Marseilles", *Word and Image* 6.2 (1990) 139–140. Images were crucial for teaching doctrine in the sixteenth century and were understood to be licit, based upon Gregory and then the reaffirmation by the Council of Trent. See, for example, Valades Diego, *Rhetorica Cristiana* (Perugia, Apud Petrumiacobum Petrutium: 1579) and his discussion of the use of painting for doctrinal instruction of Mexicans.

29 Anónimo, *Historia General de la Compañía de Jesús en la Provincia del Perú* (1600), vol. 1, *lib. 1*, ed. F. Mateos F. Matos (ed.), (Madrid: 1954) 245: 'lo mucho que pueden para indios las cosas exteriores, e suerte que cobren estima de las espirtuales, conforme ven las señales externas y el mucho provecho que sacarían de ver imágenes que representasen con majestad y hermosura lo que significaban, porque la gente de aquella nación va mucho tras estas cosas'.

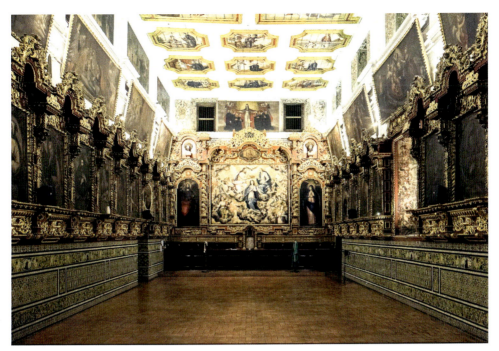

FIGURE 9.11 Sacristy of San Peter in Lima with Bernardo Bitti, "Coronation of the Virgin" at the eastern end. Oil on canvas, 1580

on a central triangular arrangement of the four main protagonists: Mary in the center, flanked by God the Father and Christ with the Holy Spirit (as a dove) above her crowned head [Fig. 9.12]. The crisp lines of the folds, strong contours, elongated thin bodies, and pinks and blues are fully within the mannerist style that was then prominent in Italy. The repose of these central figures is animated by the dynamic figures of the heavenly choir and angels that encircle them amidst clouds.

Bitti painted this majestic work for the Jesuits just as the Third Council of Lima was being convened. This convergence of painter, printer, and doctrinal edicts is not coincidental; after all, the same Jesuits were responsible for calling both Bitti and Ricardo to Lima.[30] Therefore, it may be suggested that the single new print of the "Coronation of the Virgin" that appears at the end of the "Catecismo breve" was inspired in some way by Bitti's painting. At the very least, the two images are linked through Jesuit image theory in the context of conversion. If so, then this is also an example of a reverse process of

30 See Durston, *Pastoral Quechua* 100–101.

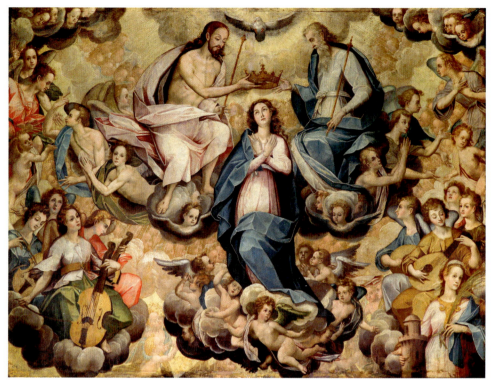

FIGURE 9.12 Bernardo Bitti, "Coronation of the Virgin". Oil on canvas, 1580. San Pedro, Lima

image-making in America, as normal paintings in Mexico and New Spain were usually based on prints made in Europe.[31]

The composition of Ricardo's print and Bitti's painting is not precisely the same. Most striking is the reversal of positions of the figures of Christ and God. Most often, though not always, God is on the viewer's right and Christ is on the viewer's left, as they are in Bitti's painting. However, it is clear that this is not a faithful copy of the painting; for example, Mary's hands are clasped in prayer in the print whereas they are crossed over her chest in Bitti's painting. On the other hand, the handling of the figures and the drapery are similar in the painting and print. It would seem that Ricardo was inspired by Bitti or was even commissioned to engage with the theme. It certainly would have been in the

31 See, for example, Hyman A., *Rubens in Repeat: The Logic of the Copy in Colonial Latin America* (Los Angles: 2021), or the valuable website *Pessca Project on the Engraved Sources of Spanish Colonial Art* https://colonialart.org/front_page.

FIGURE 9.13 Antonio Ricardo (?), "Portrait of Pedro de Oña". Woodcut, in Pedro de Oña, *Arauco Donado* (Lima, Antonio Ricardo: 1578), fol. 3r

Jesuits' interests to add the image of the "Coronation of the Virgin" to the book, considering the order's devotion toward Mary and their earlier commission of Bitti's greatest painting for their home church in Lima. Any semi-educated Spaniard or *Criollo* (a European born in Peru) in late sixteenth-century Lima would probably have seen the relationship if they paid a mind to it.

It is clear that only Ricardo or someone he specifically commissioned would have been capable of producing an original print for one of his publications. This is certainly the case for the author portrait that appears in Pedro de Oña's epic poem *Arauco Domado*, published by Ricardo in 1597. The poem gives a heroic account of the 1557 expedition into Chile to wage battle against the Mapuche/Arucanians who fought the Spaniards to a near standstill. The bust portrait of Pedro de Oña on folio 3r is rather rudimentary [Fig. 9.13]; the roughly oval double-lined frame gives his name and age, and the cursory facial features and crosshatching are crudely done, suggesting that whoever cut the block had very little skill. From this, we can assume that there were different artists involved in making the woodblocks for illustrated books; the "Coronation of the Virgin", by contrast, demonstrates much greater skill.

After the publication of Pedro de Oña's epic poem, Antonio Ricardo, in 1598 published a truly unique book: Luis Jerónimo de Oré's *Symbolo Catholico Indiano*. Singular for several reasons, it qualifies as a custom-made book. Written by the Peruvian-born Franciscan, the book is partially bilingual, divided into several interrelated parts that are all ultimately directed toward the evangelization of Peruvians. Significantly, one part is dedicated to the subject of the aesthetics of conversion.[32] The significance of the book has been more or less ignored in comparison to other chronicles, doctrinal texts (especially Ricardo's publication of the Third Council of Lima's books), and manuscripts (especially the invaluable illustrated manuscripts of Martin de Murúa's *Historia General del Piru*, begun ca. 1589, and Guaman Poma de Ayala's *Nueva coronica i buen gobierno* of ca.1615). Oré's impact on the latter two authors is clear. For example, Martín de Murúa, the Mercadarian friar whose *Historia General del Piru* is the basis for Guaman Poma de Ayla's manuscript, writes on a folio, whose text is now hidden as it is pasted against a blank folio, that the three volumes of the Third Council of Lima and the *Symbolo Catholico Indiano* were important sources for him.[33] He also cites Oré's book.

The *Symbolo Catholico Indiano* is a bilingual (Spanish-Quechua) compilation of theological doctrine, catechetical teaching, canticles for preaching, and a brief history of the Inca and cultural forms of Andean memorial techniques such as the khipu and textiles.[34] It is thought that Oré was a member of the translation team for the Third Council of Lima, as he had studied theology in Lima and was ordained a priest in 1582, just as the council began.[35] Like the other volumes that came out of the council, the *Symbolo Catholico Indiano* is a text that had a long effect in the Andes, and its printed images, too, have not been studied. In part, this is because there are only five figural prints of either Mary, Jesus, or the Trinity, in addition to foliated initial letters. Although there are only five prints, they are stylistically very heterogeneous, as can be seen in the book's first and final Marian images [Fig. 9.14]. The first image appears on

32 Chan-Rodríguez R., "Luis Jeónimo de Oré y la poesía de su *Símbolo católico indiano* (1598)", *Allipanchis* 44.83/83,(2019) 149–170.

33 Murúa Martín de, *Historia y Genealogía Real de los Reyes Incas del Perú, de sus hechos, costumbres, trajes y manera de Gobierno*, Collection of Sean Galvin, Dublin, Manuscript, fol. sn: 'porque los primeros libros que uvo en el piru ympresos fueron el vocabulario catecismos y sermonmarios en la lengua quechua y española de un padre muy ... y de la compania de jesus que fue religioso y otro libro que se yntitula el Catholico indianoescribio otro religioso muy docto de la orden del serafico padre nro. San francisco [...]'.

34 A facsimile edition was published in 1993: *El Symbolo Catholico indiano de Luis Jerónimo de Oré, 1598*, ed. A. Tibsear, OFM (Lima 1993).

35 Andrango-Walker C., *El Símbolo católico indiano (1598) de Luis Jerónimo de Oré: Saberes coloniales y los problemas de la evangelización en la región andina* (Madrid: 2018) 33.

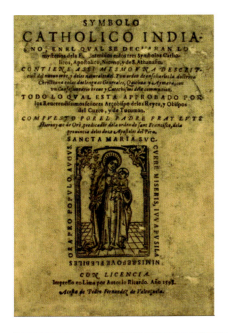

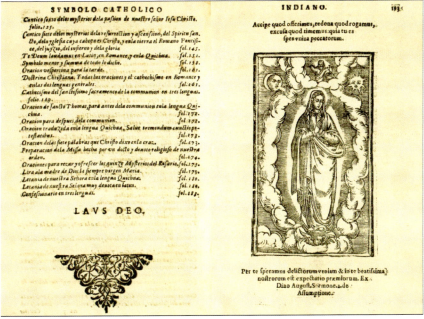

FIGURE 9.14 Jerónimo Luis de Oré, "Title Page" and final page, in *Symbolo Catholico Indiano* (Lima, Antonio Ricardo: 1598)

the title page: Mary holds the Christ child, enclosed within an architectural frame; suggestive of an interior with a tiled floor, crisscrossing orthogonal lines recede into space. The figures, set against a white background, are defined basically by thick contour lines; deeply carved zones of darkness describe Mary's hair and the folds of her garment. The last image in the book depicts "The Assumption of Mary"; softer curving contour lines and shading give the slimmer figure much greater volume and dynamism, recalling Bitti's figures. The variation in depth and length of the line also creates a greater energy in the image. This movement is further animated by the undulating outline of the surrounding clouds. The point here is that one encounters in the very first and last images very different visual handlings of the same biblical figure. However, they are to be seen in relation to each other if one reads their accompanying text. Around the Virgin and Child, on the title page, one reads: 'Sancta Maria suc. Curae miseris, iuva pusillanimes refove E(sic)lebiles ora pro populo. August' (Holy Mary, succor the miserable, help the fainthearted, comfort the sorrowful, pray for thy people,]. The text above and below the final image in the book, "The Assumption of the Virgin", reads: 'Accipe quod offerimus, redona quod rogamus, excusa quod timemus: quia tu es spes unica peccatorum. Per te speramus veniam delictorum et in te, beatissima, nostrorum est expectatio praemiorum. Ex Dino August, Semone, 2/z de Assumptione'. (Accept our offering, grant us our requests, obtain pardon for what we fear, for thou art the sole hope of sinners. Through thee we hope for the remission of our sins, and in thee, O blessed Lady, is our hope of reward.) These Latin passages link the two radically different versions of Mary, which is all the more interesting since they come from the same sermon attributed to Saint Augustine, whose name appears after each passage[36] In other words, the placement of images in relation to texts is not random or accidental; rather, it is meaningfully thought-out even though the images and their associated texts appear at the beginning and end of the book. It seems clear that Oré as author and Ricardo as printer were

36 The Latin passages contextualize the images; however, they are out of order: 'Accipe quod offerimus [...]' appears first in the sermon and is followed by 'Sancta Maria, succurre miseris [...]'. The latter is said to derive either from the prayer "O Beato Virgo Maria" or from "Sermo IX, De Annuntiatione Dominica" (Sermon IX, On the Annunciation), now attributed to Bishop Fulbert of Chartes Cathedral (ca 951–ca1029). However, in the collected works of Saint Augustine, it appears in Book 10, as part of "Sermon 18, De sanctis"; see http://www.preces-latinae.org/thesaurus/BVM/OBeataVM.html (accessed 3 May 2022). Hence the final sentence in the book, in attributing the passage to Saint Augustine, misidentifies its source as his sermon is on the Assumption of the Virgin. What is unclear here is whether the image determined the change from "The Annunciation" to "The Assumption of the Virgin", or the image was created to illustrate the misidentification.

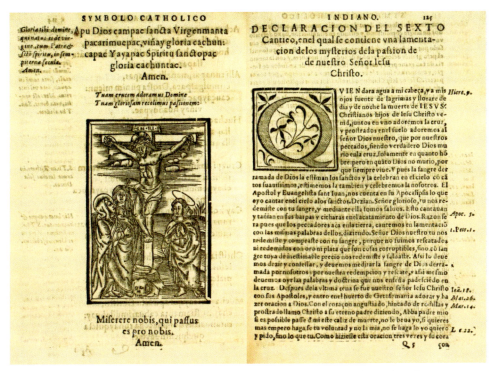

FIGURE 9.15 Jerónimo Luis de Oré, "Crucifixion of Christ", in *Symbolo Catholico Indiano* (Lima, Antonio Ricardo: 1598), fol. 124v

working closely together to ensure that these images and texts conformed to an overall vision of what was to be conveyed.[37]

The relationship between text and image occurs elsewhere, as well. For example the image of of the "Crucifixion" on folio 124v comes between the end of the fifth Canticle and the beginning of the sixth canticle on folio 125r [Fig. 9.15]. The sixth canticle is entitled "Declaracion del Sexto Cantico, en el qual se contiene una lamentacion de los mysterios de la pasion de nuestro señor Jesu Cristo". Indeed, Oré exhorts his listeners repeatedly to dwell on Christ's Passion and especially on the blood shed by Christ for the salvation

37 Oré also published an important book, *Corona de la Sacratissima Virgen Maria Madre de Dios nuestra Señora: en que se contienen ochenta meditaciones de los principios cristianos de la Fè, que corresponden a setenta y tres Aue Marias y ocho vezes el Pater noster* [...] (Madrid, Por la viuda de Cosne Delgado: 1619). In their mutual relation Ricardo's "Coronation of the Virgin" based on Bitti's painting [Figures 10 & 12] may be linked to the miraculous sculpture of the Virgin at Copacabana (1582), as Oré's book, as stated in the title page, is 'Dedicada a la misma Virgen Sacrosanta, Concebida sin pecado orignal, en su Imagen y Santuario de Copacabana'.

of the sinner: 'Señor glorioso tu nos redemiste con tu sangre, y mediante ella somos salvos [...]. Señor Dios nuestro tu nos redemiste con tu sangre, porque no fuimos reseatados ni redemidos con oro ni plata que son cosas corruptibles, sino con sangre tuya de inestimable precio nos redemiste y salvaste'.[38] Salvation is repeatedly promised to mankind through Christ's blood sacrifice -- four more times on the page. In the facing image, one sees large drops of blood dripping profusely from Christ's hands nailed to the cross, alongside the gaping, crescent-shaped side wound.

Andrango-Walker has posited that part of the iconography of the "Crucifixion" (which includes the Virgin Mary, Mary Magdalen, and Mary la Betania at the base of the cross) visualises the text of Mary's own vision: 'la Virgen María, nuestra única señora viendo muerto a Jesús su hijo, sin consuelo alguno y sin descanso hizo llanto congran amagura al pie de la cruz donde estaba con Maria Magdalena y con otras mujeres que habian venido siguiendo a Jesus [...]'.[39] The relationship between this text not on the facing page and the woodcut of the "Crucifixion" is more than a mere case of congruous iconography: that is, the text does more than enunciate the protagonists seen by the viewer. Instead, it unites Mary, who sees the death of Christ as she gazes upward, with the viewer, who also sees the Crucifixion on the page just before. Both she and we become ocular witnesses to Christ's death.

If these three images are so strategically placed in the book, then one might ask, too, about the other two images Ricardo uses, which appear on either side of the same opening (fols. 66r–66v), and what they might mean. The first image, a vignette of the "Trinity" [Fig. 9.16], also appears in the *Catecismo breve* in *Doctrina Christiana y catecismo para instruccion de los Indios*, on folio 18r [Fig. 9.9]. As we have seen, Ricardo had brought with him from New Spain. Still, it was not chosen randomly: the text above the image ends the section, adduced from the *Symbolo*, affirms the Church's absolute belief in the doctrine of the Trinity, as enjoined by the Council of Trent. This is then made manifest by the reused vignette of the "Trinity", now framed by the Latin and Quechua phrase, 'Holy Trinity one God Have mercy on us' ('Sancta Trinitas unus Deus: Misere nobis'; 'Sancta Trinitad huc çappallan Dios: cuyapapaya huaycu').

As one turns the page, the full-page print of the profile of Christ begins a new section of the book, on folio 67r, facing toward the adjacent page that

38 Oré *Symbolo Catholico* folio 125r.

39 Oré Fray Luis Jerónimo de, *Symbolo Catholico Indiano* (Lima, Antonio Ricardo: 1598), fol. 126r. See Andrango-Walker, *El Símbolo católico indiano* 185.

INDIANO. 66

ra y correction de nueſtra ſancta madre ygleſia, ca
tholica Romana; Apoſtolica, columna y regla de
verdad: cuya fè y doctrina proteſto guardar, y con
fieſſo tener ſentir y creer, y enella viuir y morir, aſ-
ſi como toda la vniuerſal ygleſia catholica, y los
concilios plenarios y generales conuocados y có-
firmados por el ſanctiſsimo Pontifice Romano lo
abraçan, ſienten, tienen, y creen en vn ſolo Dios
verdadero, Padre, Hijo, y Eſpiritu ſancto, vno en
eſſencia y trino en perſonas. Al qual ſea gloria y
honra, bendicion, y claridad, ſabiduria y ha-
zimiento de gracias, honor, virtud y
fortaleza por todos los ſiglos
delos ſiglos. Amen.
(.?.) I 2

Sancta Trinitas vnus Deus: Miſere nobis.

Sancta Trinidad huc çapallan Dios:
cuyapaya huaycu.

FIGURE 9.16 Jerónimo Luis de Oré, "The Trinity", in *Symbolo Catholico Indiano* (Lima, Antonio Ricardo: 1598), fol. 66r

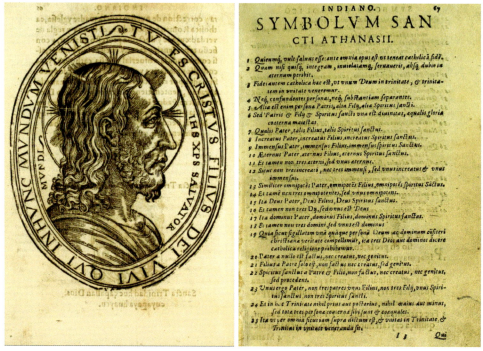

FIGURE 9.17 Jerónimo Luis de Oré, "Portrait of Christ", in *Symbolo Catholico Indiano* (Lima, Antonio Ricardo: 1598), fols. 66v and 67r.

begins the Athanasian Creed. [Fig. 9.17].[40] This is the largest print that Ricardo produced for any of his publications. The block may have been cut in Mexico and brought to Lima by Ricardo, but I doubt it. As I will argue, the way in which it makes Christ's human nature visible suggests that it was custom-made for this publication as this is the central Christological teaching in Oré's book aimed at Andean converts.

It, therefore, is significant that Ricardo does not copy the previous, much used profile of Christ that appeared in several Mexican books [Figs. 9.5 & 9.6], and which, as been argued, was then brought to Peru by Ricardo and used as an illustration in "Catecismo Mayor" of the *Doctrina Christiana y catecismo para*

40 The few extant copies in libraries are incomplete, such as the one in the Library of Congress in which folio 66 has been removed, along with the image of the "Trinity" and the "Portrait of Christ"; see https://www.loc.gov/resource/gdcwdl.wdl_13749/?sp=3 [insert 'accessed, etc.']. The copy in Lima's Biblioteca Nacional del Peru has been rebounded, so that folio 66 faces folio 71; see https://archive.org/details/simbolo-catholico-indiano-peru/page/n151/mode/2up [insert 'accessed, etc.'].

instruccion de los Indios [Fig. 9.9].[41] This change becomes evident from the difference in the texts that accompany the images. In Oré's portrait, one reads, 'IHS XPS SALVATOR MUNDI' around Christ's head, and another the text within the frame: 'TU ES CHRISTUS FILIUS DEI VIVA QUI IN HUNC MUNDUM VENIST'. These texts do not appear in any of the Mexican versions. Furthermore, Oré's figure of Christ has a different profile contour, a bifurcated beard, hair parted in the middle, and a larger halo, flat against the picture plane.

The key questions remain: why did Ricardo use/make this new image of Christ, and is there a source for it? More importantly, does this image have any relation to the *The Athanasian Creed* which it faces? If we take into account that the four other images in the manuscript are not incidentally placed and that they interact with the adjoining texts in some fashion or other, then it can be assumed that this full folio image, too, is strategically placed, as it looks toward a text that explains the nature of the Trinity. I will in fact suggest that the image fulfills a kind of deictic function as well as plays an autoptic role.

Ricardo's image came from a complex early sixteenth-century German broadsheet created by Hans Burgkmair ca. 1511, a "Salvator Mundi" accompanied by the text of the so-called Lentulus Letter [Fig. 9.18].[42]

There are minor and major differences between Burgkmair's print and Ricardo's, as shall be discussed, but it is also clear that Burgkmair's woodcut is the originating source for Ricardo's Christ figure. The texts surrounding the two images are the same (IHS XPS SALVATOR MUNDI, TU ES CHRISTUS FILIUS DEI VIVA QUI IN HUNC MUNDUM VENIST), as are renderings of the halo, beard, hair, etc. Before detailing the differences and what they mean for Oré's book, it is important to understand what Burgkmair's woodcut is about, and how that might have impacted Ricardo's choice to use it as his model.

Two different texts frame Burgkmair's image of Christ. The most significant of the two historically is the shorter one beneath Christ, which is first glossed by the Latin declarative sentence printed in larger, bold letters: 'Incipit epistola Lentuli de dispositione et qualitate facei Jesu Chisiti' (The letter of Lentulus

41 Ricardo Estarbis Cárdenas states unequivocally that Christ's image in Oré's *Symbolo* is simply a reworking of this earlier profile "Portrait of Christ" in "Catecismo Mayor" of the *Doctrina Christiana y catecismo para instruccion de los Indios* (Lima, Antonio Ricardo primero impressor en estos Reynos del Peru: 1585), fol. 83v. This is clearly not the case. See Estarbis Cárdenas R. *El Grabado en Lima: Documento histórico y artístico (Siglos XVI al XIX)* (Lima: 2002) 97.

42 Burkmair created three different prints of Christ's profile with the Lentulus text. Each Christ is different from the other. Stephanie Leitch 'Visual Acuity and the Physiognomer's Art of Observation,' *Oxford Art Journal* 38. 2 2015: 204. See also Joseph Leo Koerner, *The Moment of Self-Portraiture in German Renaissance Art* (Chicago: 1993), 116.

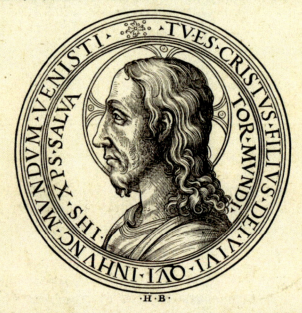

FIGURE 9.18 Hans Burkmair, "Salvator Mundi" with the text of the so-called *Lentulus* Letter. Woodcut, 32.3 × 22.7 cm, ca. 1511
THE ALBERTINA MUSEUM, VIENNA

CUSTOM MADE BY ANTONIO RICARDO: PERU'S FIRST PRINTER

begins with the character and quality of the face of Jesus Christ). This passage is then followed by the letter itself:

> Lentulus, the Governor of the Jerusalemites to the Roman Senate and People, greetings. There has appeared in our times, and there still lives, a man of great power (virtue), called Jesus Christ. The people call him prophet of truth; his disciples, son of God. He raises the dead, and he heals infirmities. He is a man of medium size ('stature procerus, mediocris et spectabilis'); he has a venerable aspect, and his beholders can both fear and love him. His hair is of the color of the ripe hazel-nut, straight down to the ears, but below the ears wavy and curled, with a bluish and bright reflection, flowing over his shoulders. It is parted in two on the top of the head, after the pattern of the Nazarenes. His brow is smooth and very cheerful with a face without wrinkle or spot, embellished by a slightly reddish complexion. His nose and mouth are faultless. His beard is abundant, of the color of his hair, not long, but divided at the chin. His aspect is simple and mature, his eyes are changeable and bright. He is terrible in his reprimands, sweet and amiable in his admonitions, cheerful without loss of gravity. He was never known to laugh, but often to weep. His stature is straight, his hands and arms beautiful to behold. His conversation is grave, infrequent, and modest. He is the most beautiful among the children of men.[43]

This letter is an ekphrastic text that accompanies the visual image of Christ above. However, the text does not altogether conform to the print that one sees. Rather, it is to be read as a historical description by an eyewitness of how Christ appeared to him. Lentulus details Christ's height ('stature'), his eyes, the color and length of his hair and beard, as well as his characteristic expression, both by face and speech. Color and speech cannot be conveyed in the black and white print, nor can the profile bust portrait convey his stature. However, the image precisely describes his hair as 'straight down to the ears, but below the ears wavy and curled [...] flowing over his shoulders', 'parted in two on the top of the head, after the pattern of the Nazarenes'. His beard is also illustrated as described: 'abundant [...] not long, but divided at the chin'. All these described characteristics are present in the image. In these respects, the print visually confirms the autoptic text of Lentulus.

43 Translation of the Latin from Maas A.J., "Publius Lentulus", in *Catholic Encyclopedia, Volume 9*; see https://en.wikisource.org/wiki/Catholic_Encyclopedia_(1913)/Publius_Lentulus (accessed May 3 2022).

The source for the printed image, however, is not the Lentulus text itself. Rather, Burgkmair's image is based on an effigy that came from Jerusalem. This history appears in the text printed above Christ's head. It details how the woodcut image is based on a bronze image that had been brought back from Constantinople by a German Pilgrim.[44] The bronze bust portrait in turn is said to have been based on a portrait painted from life. So, two independent forms of evidence are cited that confirm that the print that one sees is based on two different eyewitness sources. Furthermore, the historical description authenticates the human nature and physical presence of Christ which the pictorial likeness further substantiates.

Ricardo either cut the new block based on this print or had in his possession an unknown block that traveled with him from Mexico. Whatever the case, for reasons that will become clear, Ricardo, if the block was newly cut, did it himself or had someone else do it, an artisan more skilled than whoever cut the block for Oña's portrait. In making the copy, Ricardo altered Burgkmair's broadsheet, eliminating the two texts. Only the figure of Christ remained; moreover, Ricardo has also changed the direction that Christ faces, so that he now looks leftward. Looking toward the facing page, he is thus joined to a different text, one Oré is likely to have considered as more important. The change in orientation of the image does not seem to have been accidental, as becomes apparent if we consider what the text that originally accompanied Burgkmair's print implied, and also what the print first meant in relation to the content of the Athanasian Creed. The Creed begins with an explanation of the Trinity; the first 28 lines begin:

> Whosoever will be saved, before all things it is necessary that he hold the Catholic faith. Which faith except everyone do keep whole and undefiled, without doubt he shall perish everlastingly. And the Catholic Faith is this: that we worship one God in Trinity, and Trinity in Unity. Neither confounding the Persons, nor dividing the Substance. For there is one Person of the Father; another of the Son; and another of the Holy Ghost.[45]

Oré's title, *Symbolo Cathólico Indiano*, takes its name in part from the first three Latin words that initiate the text of the "Symbolum Sancti Anthanasii". As already mentioned, the doctrine of the Trinity was integral to Oré's book.

44　Burgkmair created three different single-sheet woodcuts of Christ's profile with the Lentulus letter; see Wood C. *Forgery, Replicas, Fiction: Temporalities of German Renaissance Art* (Chicago: 2008) 160.

45　"The Athanasian Creed", in *The Catholic Encyclopedia* https://www.newadvent.org/cathen /02033b.htm (accessed 17 May 2022).

CUSTOM MADE BY ANTONIO RICARDO: PERU'S FIRST PRINTER 281

Indeed, the Athanasian Creed was a major iconographic source for many Peruvian colonial paintings, especially those painted in Cuzco, that feature the triangular blazon of the Trinity. In Peru, Oré's text was read and sung for almost three hundred years. But in Ricardo's edition, it is Christ's portrait that looks in the direction of the Trinitarian text, pointing to it as if to say 'look, read here, and believe'. As respects the text, the image of Christ performs a deictic gesture, cuing the viewer; it also bears autoptic witness to human nature as stressed in the Creed. The visual emphasis Christ gives to the text by staring at it has its counterpart in a common deictic device whereby readers underline a significant textual passage – the term 'ojo', which signifies 'look'.

The second section of the "Symbolum Sancti Anthasii", lines 29 through 44, addresses the issue of the nature of Christ, and here the absent ekphrastic text of Burgkmair's woodblock seems to reappear in the words of St. Athanasius. This section begins with a statement of Christological dogma:

> Furthermore, it is necessary to everlasting salvation; that he also believe rightly [in] the Incarnation of our Lord Jesus Christ. For the right Faith is, that we believe and confess; that our Lord Jesus Christ, the Son of God, is God and Man; God, of the Substance of the Father; begotten before the worlds; and Man, of the Substance of his Mother, born in the world. Perfect God; and perfect Man, of a reasonable soul and human flesh subsisting. Equal to the Father, as touching his Godhead; and inferior to the Father as touching his Manhood. Who although he is God and Man; yet he is not two, but one Christ.[46]

One can finally understand the reason for the transformation of Burgkmair's print by Ricardo, and why it was chosen as his source. Christ turns now to face the critical text that structures a good part of the *Symbolo Catholico Indiano*.[47] The visual image of Christ, adapted from Burgkmair's print, can be seen actively to substantiate the dogmatic mysteries of the Trinity and of the Incarnation. The other woodblock prints of Christ's profile that repeatedly appear in books printed in New Spain and in Peru did not need to have those rhetorical qualities. The image in *Symbolo Catholico Indiano* has a provenance that guarantees authenticity, for it was thought to have originated in an eyewitness description and to be in a lineage of historical transmission from a portrait made after the life. The print therefore confirms, phenomenologically, a historical

46 Ibid.

47 The seven canticles in Quechua are placed immediately after the Quechua translation of the Creed, in close relation to it. These canticles are still sung today in Quechua; see Durston, *Pastoral Quechua* 150.

experience of the human nature of the Trinity in Christ. This experience is first made manifest by Oré/Ricardo not verbally but visually, in an image not a text.[48] Underscoring Trinitarian doctrine was critical so as to distinguish the Holy Mystery of the Christian Trinity from the idolatrous Andean religious beliefs. This dialectical position (extirpation/evangelization) was central to the Church's mission in the Andes, a mission Oré was fully supported, both as a pastoral minister and as an author whose works were composed to aid others in their efforts to convert and care spiritually for Andeans.

3 Conclusion

As with several other printers, the efforts of Antonio Ricardo were subject to the Inquisition as well as to financial difficulties.[49] Making books, many unusual and some one of a kind, such as Oré's *Symbolo Cathólico*, required imagination and physical and intellectual effort. Printing was almost always a difficult enterprise, politically and financially. All the paper and most of the machinery had to be brought from Europe, and the printers themselves came from all over Europe. Moreover, printing was unidirectional in terms of vice-regal society. The books produced were to be used either in the new universities of Mexico City and Lima or for translating Christian doctrine into native languages for the purposes of conversion. In this sense, printing was as great a tool as the sword in the concerted attempt to bend native beliefs and identities to Spanish political, social, and religious authority.

The utility of these purposes is evident, but within the prevailing conditions, printers sometimes displayed collaborative creativity with the authors in how they used text and images. This creativity may not be evident at first glance: as the need for printed texts far exceeded the capacity to produce them, so the images that appear in many of them may appear rather undistinguished and repetitive. Typeset, including historiated letters, is fairly uniform and thus traceable from book to book, and so, it is what has mainly interested

48 Burgkmair's interest in autoptic images predates the woodcut of Christ; see Leitch S., "Burgkmair's Peoples of Africa and India (1508) and the Origins of Ethnography in Print", *The Art Bulletin* 91.2 (2009) 134–159. With regard to Ricardo's use of Burgkmair's woodcut "Portrait of Christ", it is perhaps more than coincidental that this 1508 print was the source for the first European image of the Inca; see Cummins T.B.F., "The Indulgent Image: Prints, Natives and the New World", in Katzew I. (ed.), *Contested Visions 1*. (Los Angeles: 2011) 214–218.

49 See Rodriguez-Buckingham A., *Colonial Peru and the Printing Press of Antonio Ricardo* (Ann Arbor: 1977) [page nos.?]; and Griffin, *The Crombergers of Seville* 126–128.

CUSTOM MADE BY ANTONIO RICARDO: PERU'S FIRST PRINTER

scholars of American printing.[50] The heterogeneity and reuse of images may seem simply to mark the expediency of book production. Yet, closer examination suggests that within their limited resources printers, patrons, and authors sometimes attempted to insert images in ways specific to their adjacent texts, as well as to the places in which they were to be seen and the of their reader-viewers. There have been some basic studies of American printed books in the sixteenth and seventeenth centuries. Yet the nature of printing in America, what it was, and what it accomplished, has still to be fully explored.[51] By looking at a unique book composed by Luis Jerónimo de Oré, I have tried to demonstrate that Antonio Ricardo, 'primero impressor en estos Reynos del Peru', as his financially and politically difficult career advanced, proved capable of working with a subtlety very much in keeping with the nature and quality of Oré's book.[52] We will probably never know who owned the Burgkmair print, or who decided to use it as a source. If it was Oré, then his Latinitity would have allowed him fully to understand the broadsheet's implications and the lineage of its featured image. Regardless, there was a clear relationship between printer and author that manifested itself in the way text and image were utilized in the *Symbolo Indiano*. The result of Oré's and Ricardo's collaboration was a book as unique as it was multifaceted. *Symbolo Indiano*, I would argue, is then a custom book in that it is comprised of several different genres. But more importantly, it is composed of a set of heterogeneous textual and visual elements in terms of languages, styles and audience. On reading it, one moves from descriptive narratives of Andean history before and after the arrival of the Europeans, to personal experiences of the author as he traversed the Andes in a missionizing effort, to catechetical texts to prayers and statements of Catholic dogma. History and personal experience were intended for his Spanish readers, be they Europeans, Criollos, Mestizos, or Andeans. The Catechetical texts are in Latin, Spanish, and Quechua. They were meant for Catholic clergy and Andean peoples. Like the various texts, the images are drawn from different sources

50 For the sources and uniformity of letterforms, see ibid.; and Rodriguez-Buckingham, "Monastic Libraries" 33–56.

51 Anglophone America, which after the founding of the United States of America, believed there to be two Americas, did not use images at all. For example, the Algonquin Bible (*Mamusse wunneetupanatamwe Up-Biblium God naneeswe Nukkone Testament kah wonk VVusku Testament*) was printed some 120 years after the first American texts, assiduously eschews images, based as it is on Puritanical beliefs.

52 The sobriquet 'primero impressor [...]' appears on the title page of *Symbolo Indiano*. The New York Public Library holds a series of documents that include information about Ricardo's debts and difficulties with the Inquisition, as well as his contracts with pressmen and bookbinders. It also preserves an inventory of his workshop, compiled as part of the negotiations to sell its contents to Francisco del Canto. See NYPL, The Edward S. and Mary Stillman Harkness Collection, MssCol 6129.

and seem unrelated to one another. There is nothing like this book in the history of publishing in the Viceroyalty of Peru. Moreover, it is critical to its understanding to recognize that there is a common subtext for both the images and texts which is the autoptic. The act of witnessing and recording, either at the time of Christ in Jerusalem or at the present time in Peru, is used by Oré to suture the disparate elements of experience and belief into an overarching set of texts and illustrations intended for a specific evangelical purpose. Unlike all the other books that Ricardo published, this is an idiosyncratic and customized creation that captured and made palpable the spirit of the author's intentions.

Bibliography

Andrango-Walker C., *El Símbolo católico indiano (1598) de Luis Jerónimo de Oré: Saberes coloniales y los problemas de la evangelización en la región andina* (Madrid: 2018).

Anónimo, *Historia General de la Compañía de Jesús en la Provincia del Perú (1600), vol. 1, lib. 1*, ed. F. Mateos (Madrid: 1954).

Chan-Rodríguez R., "Luis Jeónimo de Oré y la poesía de su *Símbolo católico indiano* (1598)", *Allipanchis* 44.83/84 (2019) 149–170.

Cid-Carmona V.J., "Antonio Ricardo: aportaciones a la tipografía médica mexicana del siglo XVI", *Boletín Mexicano de Historia y Filosofía de la Medicina*. 8.2 (2005) 40–45.

Cook D., "Luis Jeronimo: una aproximación", in Tibsar A. (ed.), *Symbolo Catholico Indiano, Fray Luis Jerónimo de Oré, 1598. Edicion facsimilar* (Lima: 1992) 35–62.

Cummins T.B.F., "From Lies to Truth: Colonial Ekphrasis and the Act of Crosscultural Translation", in Farago C. (ed.), *Cultural Migrations: Reframing the Renaissance* (New Haven: 1995) 152–174, 326–329.

Cummins T.B.F., "The Indulgent Image: Prints, Natives and the New World", in Katzew I. (ed.), *Contested Visions* (Los Angeles: 2011) 214–218.

Cummins T.B.F., "El mundo y vida de las imágenes en las paginas peruanas de los siglos XVI–XVII: el contexto virreinal de las obras de Martín de Murúa, Guaman Poma y Otros", in Michaud C. (ed.), *Escritura e imagen en Hispanoamérica: De la crónica ilustrada al cómic* (Lima: 2015) 21–64.

Cummins T.B.F., "Writ Large: Printing, Painting and Conversion in Sixteenth-Century America", in Wilkerson A.S. (ed.), *Typography, Illustration and Ornamentation in the Early Modern Iberian Book World, 1450–1800* (Leiden: 2021) 315–349.

Dackerman S. (ed.), *Prints and the Pursuit of Knowledge in Early Modern Europe* (New Haven: 2011).

Durston A., *Pastoral Quechua: The History of Christian Translation in Colonial Peru 1550–1650*. (Notre Dame, IN: 2007).

Egío J.L., "Pragmatic or Heretic? Editing Catechisms in Mexico in the Age of Discoveries and Reformation (1539–1547)", in Duve T. – Danwerth O. (eds.), *Knowledge of*

the *Pragmatici: Legal and Moral Theological Literature and the Formation of Early Modern Ibero-America*, (Leiden: 2020) 243–281.

Eisenstein E.L., *The Printing Press as an Agent of Change*, 2 vols., (Cambridge: 1979).

Estarbis Cárdenas R., *El Grabado en Lima: Documento histórico y artístico Siglos XVI al XIX* (Lima: 2002).

Fernández de Zamora, R.M. *Los impresos mexicanos del siglo XVI. Su presencia en el patrimonio cultural del nuevo siglo*. (Mexico City: 2009).

Griffin C., *The Crombergers of Seville: The History of a Printing and Merchant Dynasty* (Oxford: 1988).

González Sánchez C.A., *Los Mundos del Libro: Medios de Difusión de la Cultura Occidental en las Indias de los Siglos XVI y XVII*. (Sevilla: 2001).

Hanks W., *Converting Word: Maya in the Age of the Cross* (Berkeley – Los Angeles – London: 2010).

Hyman A., *Rubens in Repeat: The Logic of the Copy in Colonial Latin America* (Los Angeles: 2021).

Leitch S., "Burgkmair's Peoples of Africa and India (1508) and the Origins of Ethnography in Print," *The Art Bulletin* 91.2 (2009) 134–159.

Murúa. M. de, *Historia y Genealogía Real de los Reyes Incas del Perú, de sus hechos, costumbres, trajes y manera de Gobierno*, Collection of Sean Galvin, Dublin, Manuscript 1590–1615.

Medina J.T., *La Imprenta en Lima, vol. 1*, (Santiago de Chile: 1904).

Oré Luis Jerónimo, *Symbolo Catholico Indiano* (Lima, Antonio Ricardo: 1598).

El Symbolo Catholico indiano de Luis Jerónimo de Oré, 1598, ed. A. Tibsear (Lima: 1992).

Corona de la Sacratissima Virgen Maria Madre de Dios nuestra Señora: en que se contienen ochenta meditaciones de los principios cristianos de la Fè, que corresponden a setenta y tres Aue Marias y ocho xpos el Pater noster [...] (Madrid, Por la viuda de Cosne Delgado: 1619).

Rodriguez-Buckingham A., *Colonial Peru and the Printing Press of Antonio Ricardo* (Ph. D. dissertation, University of Michigan: 1977).

Rodriguez-Buckingham A., "Monastic Libraries and Early Printing in Sixteenth-Century Spanish America", *Libraries & Culture* 24.1 (1989) 33–56.

Rodriguez-Buckingham A., "English Motifs in Mexican Books: A Case of Sixteenth-Century Information Transfer", in Williams J.M. – Lewis R. (eds.), *Early Images of the Americas: Transfer and Invention* (Tucson and London: 1993) 287–304.

Tord L.E, "Luis Jerónimo de Oré y *El Symbolo Catolico Inidiano*", in Tibsar A. (ed.), *Symbolo Catholico Indiano, Fray Luis Jerónimo de Oré, 1598, Edicion facsimilar* (Lima: 1992) 15–34.

Valades Diego, *Rhetorica Cristiana* (Perugia, Apud Petrumiacobum Petrutium: 1579).

Wood C., *Forgery, Replicas, Fiction: Temporalities of German Renaissance Art* (Chicago: 2008).

PART 4

Individual Customisers

∴

CHAPTER 10

From Proud Monument to Ill-Marked Tomb: Tommaso Schifaldo in a Sicilian Humanist Miscellany

Paul F. Gehl

Everyone who studies Renaissance humanism in books of the period encounters manuscript miscellanies, and many of these contain both printed and manuscript works.[1] These collections, custom-made for preservation, betray notions of permanence that differ from our own. Their ubiquity also addresses a recurrent theme of our Lovis Corinth volume, the permeability of print and manuscript in early modern European codices. Just as humanist scholars offered manuscript models to printers, humanist miscellanies frequently combined printed and manuscript objects or enacted new, printerly ideals using manuscript practices. Not rarely, however, miscellanies are marked or labeled in a way that obscures their contents and meaning.

This essay analyzes one such miscellany from Sicily and suggests how it evidences personal study habits, academic *pietas*, and a prideful creative and preservationist impulse that we may perhaps call *sicilianità*.[2] It is also badly mislabeled, effectively burying its real subject. The miscellany contains three incunabula and five distinct manuscript sections in three hands, comprising in all some two dozen texts as shown in the accompanying Table. It is currently housed at the Newberry Library.[3] Scholars have carefully studied one

1 On the form: Friedrich M. – Schwarke C., *One-volume Libraries. Composite and Multiple-text Manuscripts* (Berlin – Boston: 2016) 8–11; Fletcher J., *Collection-level Cataloging: Bound-with Books* (Santa Barbara: 2010) 1–19, 35–36. Research help in this time of pandemic was provided by Edoardo Barbieri, Karen-edis Barzman, Marina Beer, Maurizio Campanelli, Rob Carlson, Allison DeArcangelis, JoEllen Dickie, Lesa Dowd, Alison Frazier, László Jankovits, Megan Kelly, Alan Leopold, Lia Markey, Edward Muir, Monique O'Connell, John Powell, Diana Robin, Robert Williams, Demetrio Yocum. My Lovis Corinth Colloquium colleagues also contributed. I thank them all.

2 A deliberate anachronism on my part as explained below; the term is first attested in 1886. See Fatta I., "Insularità: Note sul rapporto fra gli scrittori siciliani e la loro terra", *Carte italiane* 2 (2015) 171–189 at 178–179; Orioles V., "Tra Sicilianità e Sicilitudine", *Linguistica* 49 (2009) 227–234 at 227–229.

3 Newberry Library, Case MS 71.5, purchased in 1975 from the Chicago antiques dealer John A. Sisto, who was discovered in 2007 to have been in receipt of many stolen books. The status of the present volume is under investigation as I write.

© KONINKLIJKE BRILL NV, LEIDEN, 2024 | DOI:10.1163/9789004680562_011

manuscript section that provides unique evidence for the grammatical scholarship of Sicilian humanist Tommaso Schifaldo, O.P. (ca. 1430–ca. 1500).[4] Other manuscript portions have been described in literary and paleographical terms, and most of the unique texts have been edited.[5] There is consensus that the Newberry manuscript is the single most important source for the political dimension of Schifaldo's life and thought, but it has been exploited for this purpose only occasionally.[6]

Three manuscript sections of the book were copied by a schoolmaster, Cesare Zizo (or Zizzo or Lo Zizo, fl. 1490–1523), who describes himself as a devoted follower of Schifaldo.[7] One other, not in Zizo's hand, must also come from Schifaldo's immediate circle. To date, however, scholars have not taken account of the three incunabula interspersed with the works of Schifaldo or the manuscript copy of poetry by Schifaldo's contemporary Giovanni Pontano (1429–1503) written in a third hand. One writer has described the book as 'una sorta di antologia, tutta riconducibile allo scrittoio di Schifaldo' (an anthology of sorts, the whole traceable to the desk of Schifaldo); another sees it as a collection of precious relics of a revered schoolmaster.[8] These scholars are on

4 The basic work on Schifaldo is still Cozzucli G., *Tommaso Schifaldo umanista siciliano del saec. XV. Notizie e scritti inediti* (Palermo: 1897). For the Newberry manuscript: Tramontana A., "Nelle scuole siciliane di Tommaso Schifaldo", in Gargan L. – Mussini Sacchi M.P. (eds.), *I classici e l'università umanistica* (Messina: 2006) 673–692; Bommarito D., "Tommaso Schifaldo e il MS. 71.5 della Newberry Library di Chicago: aspetti paleografici e storici", *Siculorum gymnasium*, n.s. 54 (2001) 3–41; Tramontana A., *In Sicilia a scuola con Persio. Le lezioni dell'umanista Tommaso Schifaldo* (Messina: 2000) 13–19; Kristeller P.O., *Iter Italicum*, vol 6: *Italia III etc.* (Leiden: 1990) 244; Noakes S.J., "A Grammatical Treatise by Tommaso Schifaldo Discovered in Chicago", *Archivum Fratrum Praedicatorum* 53 (1983) 293–300; Noakes S.J. – Kaster R., "Tommaso Schifaldo's *Libellus de indagationibus grammaticis*", *Humanistica Lovaniensia* 32 (1983) 108–156.

5 Bommarito, "Tommaso Schifaldo e il MS. 71.5" 9–18, 27–41; Cherchi P., "Uno smarrito carme bucolico di Tommaso Schifaldo", in Bugliani A. (ed.), *The Two Hesperias: Literary Studies in Honor of Joseph G. Fucilla* (Madrid: 1977) 121–127.

6 Tramontana, *In Sicilia* 13–16, 49–55; idem, "Nelle scuole" 673–675; Bommarito, "Tommaso Schifaldo e il MS. 71.5" 9–15. A recent contribution that does not make use of the Newberry volume: Maltempi A., *We Are the Kingdom of Sicily: Humanism and Identity Formation in the Sicilian Renaissance* (Ph.D. dissertation, University of Akron: 2020) 110–120.

7 Zizo is an obscure figure. He is listed in the index to Vintimiglia Giovanni, *De' poeti siciliani libro primo* (Naples, S. d'Alecci: 1663), but his poems do not appear in the only volume of that anthology to appear. He was a native of Marsala according to Di Giovanni V., *Filologia e letteratura siciliana*, 2 vols. (Palermo: 1871–1897; reprint Bologna: 1968) II 247. Bommarito, "Tommaso Schifaldo e il MS. 71.5" 23, suggests that he was born around 1475 at Salemi, a hill town east of Marsala; a single archival document records him as a schoolteacher at Trapani in 1523.

8 Tramontana, *In Sicilia* 13; Bommarito, "Tommaso Schifaldo e il MS. 71.5" 7.

the right track, but the details of the book's assembly reveal a more complex reality, which this essay will explicate. The miscellany evidences several mechanisms through which Schifaldo promoted humanist culture in Sicily across a half-century of teaching Latin, and his student Zizo emerges as the crucial figure preserving his work, the customizer of this book.

1 Content and Structure

The collection is mixed, indeed motley, in terms of genre. Besides political and bucolic poetry of Schifaldo, erotic verses of Pontano, and a single gender-bending poem claimed for Antonio Beccadelli (1394–1471), there are two biographical compendia, one ancient and secular, the other modern and religious; a learned Good Friday sermon; some of Schifaldo's orations and letters; his grammatical treatise; and the popular pseudonymous epistles of Sultan Mehmed II. The miscellany hangs together slightly better in terms of what we might call 'Sicilian interest'. Schifaldo and Beccadelli were notable Sicilians; the author of the sermon served as an inquisitorial official in Sicily; other texts treat Sicilian matters at least in passing. An anomaly on this criterion is the poetry of Pontano, since he does not seem ever to have visited Sicily, and copies of his works are rare on the island. We can find real unity only under the equally vague category of humanist Latin stylistics, since all these works could contribute in that regard. Still, the Newberry collection seems at first more like a rummage sale table than a useful anthology.

The structure of the volume offers better clues to its meaning. Three of the five manuscript sections, including the first and last, are in the hand of Cesare Zizo. These sections definitely represent a Schifaldo anthology of sorts, written out by this one individual. The papers and inks vary, so the process likely took place across some time. Domenico Bommarito, the scholar who worked most closely with the book, assumed that Zizo was also responsible for the ordering of the collection. He noted that it runs in roughly reverse chronological order, though in fact there are exceptions.[9] Still, this much of the collection can be thought of as a career retrospective assembled by a disciple for his own use from materials available to him after Schifaldo's death (after February 1500). Bommarito's scheme make sense for the four codicological units that directly concern Schifaldo, including the three Zizo copied and the other that contains works by Schifaldo. It does not account for the three incunabula or the manuscript of Pontano. Bommarito suggested that the printed Pseudo-Pliny, heavily

9 Ibid. 22.

292 GEHL

annotated, might have been a study copy that belonged to Schifaldo or some-
one in his school. The other incunabula and the Pontano manuscript could
also have belonged to the master, but in all four cases it is hard to assert this
with any degree of confidence.

TABLE Contents of Newberry Library Case ms 71.5

Folio numbers are those assigned by library staff to the volume as a whole in Septem-
ber 2020, to which compare variously erroneous numbers in Kristeller, *Iter italicum*
244, Tramontana, *In Sicilia* 13–14, and Bommarito, "Tommaso Schifaldo e il MS 71.5"
6–7. The divisions indicated with roman numerals are mine to indicate codicological
units; they reflect the units described in the online catalog of the Newberry.

I. (12 leaves, a^{12}, in hand A, that of Cesare Zizo)

fols. 1–2r	Cesare Zizo, short texts about Tommaso Schifaldo
fol. 2v	blank
fols. 3r–5r	Tommaso Schifaldo, *Carmen bucolicum*
fols. 5v–6r	blank
fols. 6v–8r	Cesare Zizo, verses addressed to Andrea Loredan
fols. 8v–12v	blank

II. (18 leaves, a–b^8, printed, plus two leaves in manuscript)

fols. 13–28	Pseudo-Pliny the Younger, *De viris illustribus Romae* (Venice, no printer named: 1486)
fols. 29–30	inserted leaves containing an index to Pseudo-Pliny (in an unre-lated hand)

III. (22 leaves, a^8 b^6 c^8, printed)

fols. 31–52	Laudivio Zacchia, *Epistolae magni Turci*, with Pseudo-antonio Beccadelli, *De hermaphrodito* (Treviso, Gerardus de Lisa: 1475)

IV. (40 leaves, a–e^8, hand of Cesare Zizo)

fols. 53–88r	Schifaldo, *De viris illustribus Ordinis Praedicatorum*
fols. 88v–92v	Schifaldo, *Oratio de laudibus iustitiae*

V. (8 leaves, a^8, in hand B)

fol. 93	blank
fols. 94r–96v	Schifaldo, Letter to Ferdinando Acuña on the secret workings of nature
fols. 97r–99v	Schifaldo, Thirteen fictive letters in Ciceronian style
fol. 100	blank

TOMMASO SCHIFALDO IN A SICILIAN HUMANIST MISCELLANY 293

TABLE Contents of Newberry Library Case ms 71.5 (*cont.*)

VI.	(39 leaves, a–c^{10} d$^{10\ minus\ 1}$, in hand C)
fol. 101	blank
fols. 102r–135r	Giovanni Gioviano Pontano, *Parthenopaeus. Pruritus. Elegia.*
fols 135v–139v	blank
unnumbered	stub after fol. 139
VII.	(8 leaves, a^8, printed)
fols. 140–147	Rodrigo Fernández de Santaella, *Oratio in die Parasceve* (Rome, no printer named: 1477)
VIII.	(40 leaves, a–c^{12} d^6, hand of Cesare Zizo)
fols. 148r–183v	Schifaldo, *De indagationibus grammaticis*
fols. 184r	Schifaldo, three short poems
fols. 184v–185v	Schifaldo, *Carmen lyricum* [...] *de victoria Bethycae*
fols. 186r	'Salomonis dictum' in Sicilian dialect (an addition in an unrelated hand)
fols. 186v–188	blank
[unnumbered]	two endleaves (pastedowns) conjugate with fols. 185 and 186

We can add some detail by examining the book codicologically. Its contents are summarized in the Table. Units I and VIII are written on the same paper stock and, except for a few annotations, are all in the hand of Cesare Zizo, though some parts (notably the bucolic poem and the grammatical treatise) are more carefully written out than others. The other Schifaldo units (IV and V) are on two different paper stocks. That of Unit IV is similar but not identical to that of Units I and VIII, while that of Unit V, not in Zizo's hand, is unrelated. The incunabula date from the 1470s and 1480s, and all arrived from outside Sicily; they cannot be related to the rest of the miscellany except in terms of content, as discussed below.

The same is true for the four gatherings that comprise the Pontano unit (VI); these are on a paper stock and written in a hand that can be assigned with some certainty to the middle of the fifteenth century. There is a stub at the end of this section, the remains of a leaf that was removed and its conjugate sewn back in. Soiling on the stub suggests that this unit was sewn up and stood alone for some time before being included in the miscellany, as confirmed by the fact that it is the only part of the volume that evidences resewing. Soiling and wear on the first leaf of Unit I suggest the same fate for that section. Units I and VI, then, were almost surely stored separately before the assembly of the

whole. We also know that the last leaf of Unit VIII (at present a pastedown) was the outside leaf either of that unit alone or of the miscellany once assembled, because there is a pencil note ('29') presumably an old shelf mark, on the bottom (outermost) side of that leaf. Similarly, a note on fol. 1r referring to the second incunabulum (Unit III) means that the first three units (and probably all of them) stood as a collection in early modern times.

The present binding offers additional clues. It is modern and heavily reworked, perhaps in several moments. The text block is sewn on three split-leather bands that are long enough to have accommodated additional gatherings, but the unused ends are not visible, so we cannot say if other material once accompanied the present collection. There is no evidence that the text block (except for Unit VI) was ever resewn, so this sewing (of the whole miscellany) predates the modern casing. The cover consists of two layers of parchment over pulp boards. The outer layer is an addition, consisting of the reused grey parchment cover of an older, larger binding. It was glued down over a lower, yellow parchment case with large-diameter endcaps. The endbands are laced into the boards from the outside through both vellum layers; the grey vellum was trimmed around these laces at the top of the spine but not at the bottom. The present spine title was inked onto the reused grey vellum cover after the binding was reworked. The same is true of the inked shelf mark, though the hand is not the same as that of the spine title.

There are several ways to explain the resulting pastiche binding but the most likely is that an early modern binding, perhaps no more than a wrapper around sewn gatherings, was reworked for the rearrangement of a library. The early modern assembly was newly cased, and supplied with new endbands, spine title, and shelf mark. At two different moments, owners of the book labeled its contents. After bundling but long before the present casing, a sixteenth- or seventeenth-century reader noted on the first leaf, '*Epistolae Magni Turci infra*' (Letters of the Grand Turk within), to which another hand has added, '*Secundum procul*' (in third place). Later the book in its present covers was labeled as containing a text by Pliny the Younger, an incorrect reading of an erroneous attribution for the second item in the miscellany. Neither of these owners, apparently, were much interested in Schifaldo.[10]

10 The book bears no marks of ownership except for a shelf mark. We should, of course, allow for the possibility that this curious binding was an elaborate ruse to disguise the actual nature of the book so that it could be sold on improperly. In such a scenario the old grey parchment and inaccurate spine title would have served to make the book look old but unsuspicious.

It is clear nonetheless that the primary logic of the collection that has come down to us has to do with Schifaldo, a minor humanist but one who had a significant impact on Latin studies in his native Sicily.[11] Alas, his biography sheds little direct light on the assembly of the miscellany. Born in Marsala and educated in Catania, he did university studies in Siena in the 1450s. He apparently spent some time in Rome between 1457 and 1461, probably at the Dominican house of studies at Sta. Maria Sopra Minerva.[12] After returning to Sicily, he taught at Messina, Palermo, and finally for some twenty years in his home province (at Marsala, Mazara, and Trapani). In Messina he certainly encountered a tradition of Greek learning as well as the great Greek scholar and teacher Constantine Lascaris, but there is no evidence that Schifaldo studied Greek.[13] Although he joined the Dominican order early in life and is referred to in documents as *theologiae professor,* few of his works are religious. His surviving pedagogical texts concern the field of grammar as understood by humanists to include literary appreciation and criticism. Beyond the classroom he was an accomplished poet and rhetorician who composed the kinds of Latin treatises, orations, and verse for political occasions and patrons that were typical of humanists all over Italy, including many members of religious orders. In later years he also served as inquisitor and vicar general of the Dominican order in Sicily.[14] Except for his university studies and a period in Rome immediately afterwards, his life was spent entirely on the island of Sicily with its unique blend of Greek, Arabic, Latin, Jewish, Spanish, Catalan, Ligurian, and (deeply submerged) indigenous

11 Correnti S., *La Sicilia del Quattrocento. L'umanesimo mediterraneo* (Catania: 1992) 165–167.

12 Bommarito D., "Tommaso Schifaldo e la sua grammatica filosofica", *Interpres* 27 (2008) 97–143 at 100–102.

13 Tramontana A., "L'eredità di Costantino Lascari a Messina nel primo '500", in Lipari G. (ed.), *In nobili civitate messanae: contributi alla storia dell'editoria e della circolazione del libro antico in Sicilia* (Messina: 2013) 121–163; idem, *In Sicilia* 36–38; idem, "Nelle scuole" 687; Correnti, *Sicilia del Quattrocento* 107–118; Bianca C., *Stampa cultura e società a Messina alla fine del Quattrocento* (Palermo: 1988) 12–15.

14 Details of Schifaldo's life are disputed but the uncontroversial facts are provided with clarity and full documentation by Tramontana A., "Schifaldo, Tommaso", *Dizionario biografico degli italiani* 91 (Rome: 2018): https://www.treccani.it/enciclopedia/tommaso-schifaldo_%28Dizionario-Biografico%29/. For Dominican humanists: Frazier A.K., *Possible Lives: Authors and Saints in Renaissance Italy* (New York: 2005) 18–19, 187–192, 335–337; Dollo C., "Cultura del Quattrocento in Sicilia. Alle origini del Siculorum Gymnasium", *Rinascimento* n.s. 39 (1999) 227–292 at 268–271; Kristeller P.O., "The Contribution of Religious Orders to Renaissance Thought and Learning", in *Medieval Aspects of Renaissance Learning. Three Essays by Paul Oskar Kristeller* (New York: 1992) 93–114 at 108–112. For Sicilian political humanism: Tramontana, "Nelle scuole" 673–684; Bianca, *Stampa cultura* 15–23.

cultures.[15] His surviving works are all in vigorous humanist Latin and address international ecclesiastical, pious, and humanist themes, but commentators have found traces of this more complex insular setting in his works. The same may be said of the Newberry miscellany if we examine its contents closely. Indeed, the miscellany adds depth to our understanding of Schifaldo's career as a Sicilian in the service of the Aragonese regime.

The analysis below follows the numbering of the codicological units as they appear in the Table, concentrating on printed and manuscript materials that have not been much discussed in previous literature. It is worth noting at the outset that the Schifaldo anthology assembled by Zizo occupies four sections, two at the center (Units IV–V) and two forming a frame for the miscellany as a whole (Units I and VIII). Of these, all but Unit V are in the hand of Cesare Zizo. The central place is occupied by eight leaves containing particularly accomplished prose works by Schifaldo written in a different hand. Counting only the Schifaldo materials, fifty two leaves precede these eight, and forty follow. As an assembled whole, including non-Schifaldo texts, exactly ninety-two leaves precede this gathering and ninety follow it. Such symmetry is striking in so miscellaneous a volume. It seems clear, therefore, that the Schifaldo collection had a symmetrical structure devised by Zizo and, although the other units (II, III, VI and VII) are *prima facie* insertions if not also intrusions, their placement deliberately reinforced the symmetry.

1.1 Unit I. *Schifaldo miscellany*

The volume opens with verse and prose penned by Cesare Zizo that has loosely to do with Tommaso Schifaldo. Zizo may have put together this single gathering with the intention of an introduction to his anthology in the making. The single hand varies considerably. At the center is a bucolic poem by Schifaldo carefully written out in a staid, upright version of Zizo's hand with its distinctive approach strokes and descenders; it likely was transcribed first [Fig. 10.1]. The pages preceding it are crowded and written more loosely, while those that follow are largely blank. This unit as it has come down to us was very likely intended as front matter for something more substantial; the intrusion of texts unrelated to Schifaldo reinforces this impression. On fol. 1r, Zizo placed a Latin poem of his own addressed to *Franciscus librarius*, identified by two marginal notes as Francesco Palumbo, *librarius et biblyopola Neapolitanus*, otherwise

15 Abulafia D., *The Western Mediterranean Kingdoms 1200–1500: The Struggle for Dominion* (London – New York: 1997) 5–8, 16–17, 60–74; Correnti, *Sicilia del Quattrocento* 82–90, 207–223, 272–274; Sammartano G., *Umanisti marsalesi: T. Schifaldo e V. Colocasio* (Marsala: 1969) 3–6.

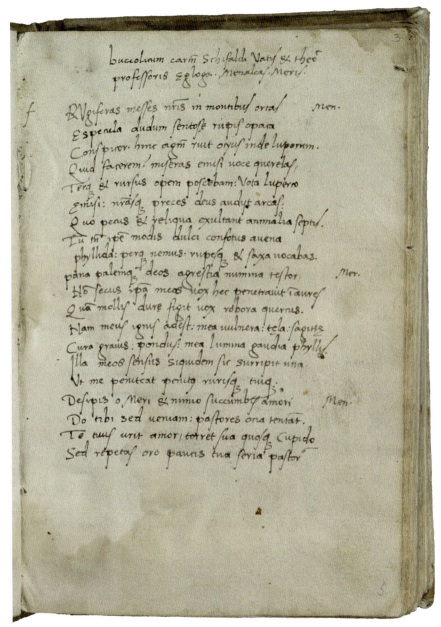

FIGURE 10.1 Newberry Library, MS 71.5, fol. 3r. Schifaldo, *Carmen bucolicum*, written in Cesare Zizo's formal hand

unknown. Below this, inserted into space originally left blank, is a love poem in Sicilian dialect, also by Zizo. On the verso and following leaves stand a letter to Schifaldo and then a poem praising him. In the letter, Zizo evokes the model of Cleanthes who preserved the works of his master Zeno.[16]

Thus far, the start of our miscellany vaguely resembles that of a printed volume, a collection of short pieces relating to the project of an anthology. Prefacing a volume with a poem addressed to a bookseller is a print convention, but there was apparently no attempt to provide a title page or even a caption title, as would have been expected if the anthology were intended to mimic a printed book. Moreover, after the poem by Schifaldo, Zizo placed another poem of his own addressed to a Venetian patrician, Andrea Loredan, praising his patronage and that of his wife Maria.[17] This is a working copy of the poem, with changes and rewrites to several lines. It makes no reference to Schifaldo. Conceivably it was meant to be a second dedication or presentation of a larger volume Zizo planned, but if so the lack of reference to Schifaldo is curious. More likely it was inserted much later onto conveniently blank leaves and has no connection to Schifaldo at all. The next four leaves are also blank and may have been intended to carry additional works of Schifaldo or commendatory texts of the sort that commonly preface humanist works in print. Were the main part of the manuscript anthology to follow immediately, there would be some logic to this 'front matter'. Even that slender logic is disrupted immediately because two of the three incunabula in our miscellany stand next.

1.2 Unit II. *Pseudo-Pliny,* On Illustrious Men of Rome

The first printed piece is a digest of biographies of famous ancient Romans, running roughly chronologically from Proca, legendary king of Alba Longa, to Pompey the Great (d. 48 BCE). In the later Middle Ages, this popular text was attributed to Pliny the Younger, as reported in the caption title of all incunabular editions, including this one.[18] For humanist audiences, this text was

16 Bommarito, "Tommaso Schifaldo e il MS. 71.5" 29.

17 Ibid. 22, 30–31. There are several candidates for this dedicatee. For the tangled genealogy, see Cicogna E.A., *Delle inscrizioni veneziane* vol. 6, part 1: *Inscrizioni nella chiesa di S. Andrea di Venezia detto de Zirada* (Venice: 1853) 119–125; Kohl B.G. – Mozzato A. – O'Connell M., *The Rulers of Venice, 1332–1524, rulersofvenice.org* (New York, ACLS Humanities E-Book: 2013-).

18 Pseudo-Pliny the Younger, *C. Plinii secundi iunioris Liber illustrium virorum* (Venice, no printer named: 1486); Sage M.M., "The De Viris Illustribus: Authorship and Date", *Hermes* 108 (1980) 83–100 at 85–92; Sweeny R.D., "The Ascription of a Certain Class of MSS. of the *De viris illustribus* of the Pseudo-Aurelius Victor", *Rheinisches Museum für Philologie* n.s. 111 (1968) 191–192.

FIGURE 10.2 Newberry Library, MS 71.5, fol. 21r. Pseudo-Pliny, *De viris illlustribus* (Venice: 1486), with marginal note at bottom in the hand of Cesare Zizo concerning a Sicilian campaign. Note his correction to the spelling of 'Lilybeo' (Marsala, his hometown and Schifaldo's)

300 GEHL

primarily of antiquarian interest, a study guide to names that appear in other ancient works.

The individual biographies in the collection are brief and summary, typically including notes on military careers and political offices. The narratives embrace the entire arc of Roman republican history and include events that span the Mediterranean world. There are ten specific mentions of Sicily. The author rehearses some rhetorical commonplaces: Sicily's natural beauty and wealth of resources, its conglomeration of Greek city states gradually brought under peaceful and profitable Roman rule, the subsequent faithfulness of its people to the growing Roman empire, its strategic location for Roman control of the Mediterranean. There is passing mention too of the ways in which Roman magistrates exploited the province. Pseudo-Pliny thus offers a conventional Sicily, but one that could nourish humanist literary and historical thinking about the island.

This copy shows signs of serious study. Two early readers made index notes in the margins; one of them foliated the booklet and created an alphabetical table of contents with clear and accurate references to the folio numbers. Cesare Zizo also made a few marginal notes, largely concerned with Sicilian matters [Fig. 10.2]. All ten earlier editions were ascribed to Pliny the Younger. The attribution, prominent on the first page of the imprint and repeated in the colophon, also appears on the spine of the book as it has come down to us, though mistakenly. The label reads *Plinij Iunioris Historia*, probably by confusion with the *Historia Naturalis* of Pliny the Elder.

1.3 Unit III. *Pseudo-Mehmed II*, Letters of the Grand Turk

A second printed booklet follows immediately. It contains the fictional diplomatic correspondence of Sultan Mehmed the Conqueror followed by a brief epigram *De hermaphrodito* ascribed to Antonio Beccadelli.[19] The letters were composed by a peripatetic humanist who identifies himself as Laudivio Zacchia, Knight of Jerusalem.[20] In the mid-1470s, Zacchia corresponded with Cardinal Jacopo Piccolomini-Ammannati (1422–1479), whose patronage of

19 Zacchia Laudivio, *Epistolae Magni Turci* (Treviso, Gerardus de Lisa: ca. 1475). On the epigram, see Beccadelli Antonio, *Antonii Panhormitae Hermaphroditus*, ed. D. Coppini (Rome: 1990) cix–cx, cxiii, clxxxiv; and Alton E.H., "Who Wrote the Hermaphroditus?", *Hermathena* 21 (1931) 136–148 at 140–141.

20 Coleman J.K., "Forging Relations Between East and West. The Invented Letters of Sultan Mehmed II", in Stephens W. – Havens E.A. – Gomez J.E. (eds.), *Literary Forgery in Early Modern Europe, 1450–1800* (Baltimore: 2019) 118–134 at 118–119; Zacchia Laudivio, *De captivitate ducis Iacobi*, ed. A. Grisafi (Florence: 2013) xii–xiv; Frazier, *Possible Lives* 492.

humanists we will meet later in the Newberry miscellany.[21] Over twenty editions of this collection were printed before 1500, offering examples of fine epistolary style, for Zacchia's sultan was an accomplished disciple of Cicero. These letters also echoed the real fear Italians felt about the Turkish threat. As recent historians note, Mehmed's victories in the Balkans and the eastern Mediterranean effectively 'turned Sicily and Southern Italy into frontier regions'.[22]

The printed collection includes supposed exchanges of the sultan with all the political powers of the Mediterranean world.[23] Of particular interest in the context of our miscellany are letters addressed to groups of Sicilians, accusing them of plotting against the sultan and threatening their destruction; the replies defy the tyrant. The few Sicilians who appear in the collection are courageous, at least on paper. Thus, the literary connection to Sicily is slender and, as with Pseudo-Pliny, conventional. Taken together, these two small incunabula might be thought of as guides to ancient and contemporary commonplaces about Sicily (among other things), useful as such for humanists studying and writing on the island.

This copy of the letters is supplied with careful and neatly written marginalia in an upright hand. The annotator was particularly interested in stylistic matters and such themes as friendship, love of fatherland, and generosity. In one case he remarks Zacchia's source, Valerius Maximus, and elsewhere he indexes Sicilian subjects, e.g., Hiero of Syracuse and Phalaris of Agrigento. These notes align closely with matters Tramontana says characterized Schifaldo's mid-career teaching in the 1470s, and it is tempting to think these might be his notes or those of a student of his, but we are hampered in such speculation by the lack of known autographs of Schifaldo.[24]

It is not clear why this particular Treviso edition of Pseudo-Mehmed found its way to Sicily. There were earlier editions at Naples and Padua and later ones

21 Zacchia, *De captivitate* xiv.

22 Zeldes N., *"The Former Jews of This Kingdom": Sicilian Converts after the Expulsion, 1492–1516* (Leiden: 2003) 8. Compare Coleman "Forging Relations" 119; Meserve M., *Empires of Islam in Renaissance Historical Thought* (Cambridge – London: 2008) 228–229.

23 For the wider historiographical and propagandistic context of this collection see ibid. 65–69, 223–228.

24 Tramontana, "Nelle scuole" 684–690. There are no confirmed autographs of Schifaldo. A few facsimile pages are offered by Tramontana, *In Sicilia* tav 2 for the text of Persius that she suggests was brought from Siena by Schifaldo and annotated by him. That notula hand does not match any in the Newberry manuscript. The same is true for the unique copy of Schifaldo's commentary on Horace, for which see Bottari G., "Tommaso Schifaldo e il suo commento all'*Arte poetica* di Orazio", in Franchini R. (ed.), *Umanità e storia. Scritti in onore di Adelchi Attisani*, vol. 2: *Letteratura e Storia* (Messina: 1971) 221–259.

302 GEHL

at Rome and Brescia, all issued well before the likely assembly of the Newberry miscellany. Most early editions survive in only a few copies. This one, however, is known in a remarkable fifty-six copies, more than any other pre-1500 edition. The print run must have been large, and this copy of Pseudo-Mehmed could have arrived in Sicily in the luggage of any Latinist. However, like all the printed items in the Newberry volume, it was published well after Schifaldo returned definitively to Sicily, so even if these little booklets belonged to him, he surely did not bring them from the mainland himself.

1.4 Unit IV. *Schifaldo,* On Illustrious Sicilian Dominicans and Oration in Praise of Justice

After these two printed items, we find two manuscript sections that together resume the logic of a Schifaldo anthology. The first contains copies of two accomplished works: a significant historical contribution and a lengthy oration on justice.

Schifaldo's *De viris illustribus Ordinis Praedicatorum* is a compendium of short biographies of members of the Dominican order completed in early 1487. It was analyzed in detail by Anne Huijbers who sees it as a significant departure in biographical writing about religious orders. Schifaldo's directness in inserting himself pridefully into the work is unusual, as are his inclusion of still-living figures, and his rather purple prose. He frequently begins one of his biographical vignettes with a flowery reference to the remembrance of good men, a habit that places him in the mendicant tradition of pious *legenda.* Schifaldo's was a panegyric style of history, concerned to create specimens of humanist Latin.[25]

Several important details about this work stand out. The introduction and closing *peroratio* of the treatise are addressed directly to Cardinal Oliviero Carafa (1430–1511), protector and vicar general of the Dominican order at the time of its compilation. Schifaldo tells us that Carafa encouraged him to write about Sicilian members of the order. He indulges in a little antiquarian flourish by referring to this subject as Dominicans born in Sicily 'quam Tucydides et post eum graeci poetae Trinacriam, latini vero triquetram (si Plinio credimus) appellarunt' (which Thucydides and after him the Greek poets called Trinacria,

25 Huijbers A., *Zealots for Souls. Dominican Narratives of Self-Understanding During Obser-
 vant Reforms* (Berlin – Boston: 2018) 285–292; idem, "*De viribus illustris Ordinis Praedic-
 torum.* A 'Classical' Genre in Dominican Hands", *Franciscan Studies* 71 (2013) 297–324 at
 310–322. Huijbers' opinion of its originality contrasts with the more traditional judgment
 of Ferraù G., *La Cultura in Sicilia nel Quattrocento* (Rome: 1982) 27.

TOMMASO SCHIFALDO IN A SICILIAN HUMANIST MISCELLANY 303

that is, 'three-cornered' in Latin if we are to believe Pliny).[26] This citation of Pliny (*Hist. Nat.* III, viii) is curious because it is incomplete. Thucydides (VI, ii, 2) actually called the island both Sicania and Trinacria and provided a fanciful explanation of why the former replaced the latter. Pliny ascribed only Sicania to the Greek historian, saying specifically that Trinacria was employed by others; so it is merely Pliny's etymology of the term that Schifaldo is citing with feigned skepticism. Schifaldo's information on Trinacria would seem to be a claim that he knew Thucydides' text directly, which he could have done in Lorenzo Valla's recently published Latin translation.[27] He is telling his readers both that he has ancient authority for writing history in specifically Sicilian terms and also that he is up to date on humanist scholarship that concerns the island.

Huijbers and others also remark a passage in which Schifaldo vindicates his authorship of readings and hymns for the office of the newest Dominican saint, Catherine of Siena.[28] Schifaldo was justly proud of this elegant and novel work, which Pope Pius II had chosen from among several offered him at the time of Catherine's canonization in 1461.[29] It was the only work of Schifaldo to see print in his own day, but it is not attributed to him in the early editions.[30] He reports that he presented the work to the pope who authorized its publication; and authorship was then attributed to Pius. Schifaldo insists that it is manifestly the fruit of his own Sicilian humanist learning: 'Quis est in Sicilia qui Schifaldi peculiaria verba, suo lepore, suis salibus, sua eloquendi arte predita non liquido dignoscat?' (Who in Sicily does not recognize the characteristic diction of Schifaldo, outstanding for beauty, liveliness, and smooth art of

26 Cozzucli, *Tommaso Schifaldo* 60. Schifaldo addresses the naming of Sicily elsewhere in his *De viris*, ibidem 63, and also in his commentary on Persius, Tramontana, *In Sicilia* 52–54 and 160–161.

27 The first and only incunabular edition was Thucydides, *Historia belli Pelonponnensiaci* (Treviso, Jacobus Rubeus Vercellensis: 1483), ISTC it00359000, five copies now in Palermo. Valla's text was also widely copied in manuscript after its creation in 1448, but no known manuscript copies have identifiable Sicilian provenance; Pade M., "La traduzione di Tucidide. Elenco dei manoscritti e bibliografia", in Regoliosi M. (ed.), *Pubblicare il Valla* (Florence: 2008) 437–452 at 440–450.

28 Huijbers, *Zealots* 289–290; Frazier A.F., "Humanist Lives of Catherine of Siena: Latin Prose Narratives on the Italian Peninsula (1461–1505)", in Hamburger F. – Signori G. (eds.), *Catherine of Siena: The Creation of a Cult* (Turnhout: 2013) 109–134 at 116.

29 Frazier A.K., "Liturgical Humanism: Saints' Offices From the Italian Peninsula in the Fifteenth Century", in Berger A.M.B. – Rodin J. (eds.), *Cambridge History of Fifteenth-Century Music* (Cambridge: 2015) 311–329 at 318–320; idem, "Humanist Lives" 114–115.

30 For the tangled early bibliography, Frasier, "Liturgical Humanism" 319; idem, "Humanist Lives" 116.

eloquence?)[31] This is a remarkable claim in a number of ways, not least that it presumes a coherent Sicilian public (in 1487) that knew and would recognize Schifaldo's learned Latin compositions (of 1461) by their style.

The Newberry copy of this compendium is a personal one, in the hand of Cesare Zizo. One other manuscript is known, a handsome formal copy that eventually belonged to the Dominican house in Bologna but which was still in Sicily in 1547 when a gift note was inserted.[32] One would expect there to have been a presentation copy intended for Cardinal Carafa, but that manuscript does not seem to survive.

The biographical compendium is followed by an oration on the dignity of the magistrate. It contains a reference to Schifaldo's assuming an office, which some scholars speculate was his investiture as inquisitor.[33] The text was edited in full by Bommarito and is a thoughtful address to the role of the judge in maintaining a just society. The judge must be ready to grant pardons but prepared to pronounce a death sentence. These themes are humanist and his *exempla* are classical ones; they have nothing in particular to do with the work of the inquisition, which at this date in Sicily was concerned mostly with non-capital offences.[34]

The two texts in this unit are penned in Cesare Zizo's distinctive hand and the paper is similar to that in units I and VIII. However, Zizo employed a broader pen point and darker ink than for other texts he wrote out for the miscellany, and he seems to have been working in some haste. Elsewhere his hand is formal, mannered, and a little precious. Here the text is clear and accurate, but there are cross-outs and corrections made during copying and some common letters and letter combinations were written very rapidly. Conceivably he had the use of his exemplar for only a limited time; almost certainly he was working from a copy of these works in a Dominican library.

31 Cozzucli, *Tommaso Schifaldo* 93.

32 Bologna, Universitaria Ms 1678; Cozzucli, *Tommaso Schifaldo* 59n. Mongitore Antonino, *Bibliotheca sicula, sive de scriptoribus siculis, qui tum vetera, tum recentiora saecula illustrarunt*, 2 vols. (Palermo, Ex typographia Didaci Bua: 1708 – Ex typographia A. Felicella: 1714) II 263 seems to refer to a third manuscript.

33 Bommarito, "Tommaso Schifaldo e il MS. 71.5" 11–15 and Tramontana, *In Sicilia* 14 place this event in 1497. Cozzucli, *Tommaso Schifaldo* 21 says it took place in 1489, which seems more likely.

34 Zeldes N., "Christians, Jews, and Hebrew Books in Fifteenth-Century Sicily: Between Dialogue and Dispute", in Yuval I.J. – Ben-Shalom R. (eds.), *Conflict and Religious Conversation in Latin Christendom* (Turnhout: 2014) 191–220 at 199–208; Zeldes, *Former Jews* 19–20; Bevilacqua Krasner M., "Re, regine, francescani, domenicani ed ebrei in Sicilia nel XIV e XV secolo. Potere politico, potere religioso e comunita' ebraiche in Sicilia", *Archivio storico siciliano* ser. 4, 24 (1998) 61–91 at 83–89.

TOMMASO SCHIFALDO IN A SICILIAN HUMANIST MISCELLANY

1.5 Unit V. *Schifaldo,* Letters

The fifth codicological unit contains the only known copy of letters in Ciceronian style written in a hand distinct from the others in the miscellany and on paper that also differs. The single, densely written gathering has a blank leaf at the start and again at the end. Thus, even though it appears to continue the larger anthology of works by Schifaldo, we may conclude that it was confected as a unit that existed separately before the miscellany was assembled.

The first letter is an epistolary essay on the inscrutability of the world addressed by Schifaldo to Ferdinando Acuña y de Herrera (ca. 1456–1495), Viceroy of Sicily from 1489 until his death. It was edited by Bommarito, who dates it to the first half of 1492.[35] The unknowable in human affairs is demonstrated by miracles; Schifaldo adduces examples drawn from his home province of Trapani. Bommarito rightly calls it a jewel of humanist Latin. As such Zizo may have considered it a fitting centerpiece to the anthology. The remaining thirteen letters have never been published. They are anonymous, but apparently were composed by Schifaldo as exercises in Latin *sermo humilis.* They contain predictable echoes of Cicero, Horace, Ovid, Vergil, and Seneca as well as legal Latin; like the letter to Acuña, they include topical references to Sicilian locales and affairs.

All the letters in this section are exercises in fine style. Together with the poem on the fall of Granada at the end of the miscellany, they evidence Schifaldo's active participation in the political culture of Aragonese Sicily, something historians of the island tell us was typical of intellectuals in general and Dominicans in particular.[36] These were years of triumph for the Spanish royals but crisis for the Neapolitan branch of the family. Tommaso Schifaldo lived through decades of unsettled politics from the distance of western Sicily, but he was closely connected to the Spanish regime as orator and poet.

1.6 Unit VI. *Giovanni Gioviano Pontano,* Parthenopaeus. Pruritus. Elegia

This copy of Pontano's youthful erotica deserves a study unto itself since it offers interesting variant readings and was annotated by more than one contemporary. It is written in a fifteenth-century hand earlier than any other in the

35 Bommarito, "Tommaso Schifaldo e il MS. 71.5" 9–11, 35–37; compare Tramontana, *In Sicilia* 14–15. The popular and respected Acuña was the dedicatee of other humanist works; Giurato S., *La Sicilia di Ferdinando il Cattolico. Tradizioni politiche e conflitto tra Quattrocento e Cinquecento (1468–1523)* (Soveria Mannelli: 2003) 146–159.

36 Dollo, "Cultura" 268–271.

miscellany on paper that also differs. It was a previously existing manuscript, as confirmed by the resewn state of the last leaf, described above.

Pontano was a leading light of the South Italian Renaissance, indeed the single most important humanist at the court of Naples in Schifaldo's day.[37] His works were widely diffused in manuscript during his lifetime. Although there are hundreds of manuscripts of Pontano's works, it is surprising to meet the particular selection we find here. These are youthful poems that imitate Catullus closely, though Pontano's verses are much more explicit sexually than those of his model. Pontano wrote many works on serious and moralizing themes, but this early collection is not in the least edifying. In it, Pontano employs what Marco Santoro calls 'whimsical intellectual play' entirely in the service of 'thoughtless gaiety'. It is actually more accurate to characterize the content, with Walther Ludwig, as 'krasse und derbe Obszönität' (blatant, crude obscenity).[38] Pontano himself called these verses 'nequitiae procaxque lusus' (naughtiness and wanton play).[39] That these poems turn up in the Newberry miscellany amidst stolidly more respectable works suggests more than general esteem for Pontano; it represents a deliberate decision to own and preserve his Catullan erotica. Its placement here, submerged amidst unrelated works, may also suggest a desire to hide it.

The history of these early poems is complex. None was printed until 1498, but several collections representing successive authorial revisions circulated in manuscript.[40] The details are disputed, but scholars believe that Pontano's first poetry collection, entitled *Pruritus* (Titillation[41]), was dedicated around 1449 to

37 Furstenberg-Levi S., *The Accademia Pontaniana. A Model of a Humanist Network* (Leiden: 2016) 22–31; Bentley J.H., *Politics and Culture in Renaissance Naples* (Princeton: 1987) 127–137, 176–194.

38 Santoro M., "Humanism in Naples" in Rabil A. (ed.), *Renaissance Humanism. Foundations, Forms, and Legacy*, vol. 1: *Humanism in Italy* (Phildelphia: 1988) 296–331 at 314–315; Ludwig W., *Litterae Neolatinae: Schriften zur neulateinischen Literatur* (Munich: 1989) 177. Compare the 'foulmouthed intonations' of Iacono A., "Descrivere il corpo dell'amata: Giovanni Gioviano Pontano, *Parthenopaeus* 1.2 tra disinibizione giovanile e senile compostezza", *Atlante. Revue d'études romanes* 5 (2016) 12–39 at 29.

39 Trans. Gaisser J.H., "Pontano's Catullus", in Kiss D. (ed.), *What Catullus Wrote: Problems in Textual Criticism, Editing and the Manuscript Tradition* (Swansea: 2015) 53–91 at 56.

40 Soranzo M., "'Umbria pieridum cultrix' (*Parthenopaeus* 1.18): Poetry and Identity in Giovanni Gioviano Pontano (1429–1503)", *Italian Studies* 67 (2012) 23–36 at 24–30; Ludwig, *Litterae Neolatinae* 173n47, 177–178; Parenti G., *Poëta proteus alter: forma e storia di tre libri di Pontano* (Florence: 1985) 115–119.

41 Trans. Gaisser, "Pontano's Catullus" 54. For the sources in Martial and Catullus, Ludwig W., "The Origin and Development of the Catullan Style in Neo-Latin Poetry", in Goldwin P. – Murray O. (eds.), *Latin Poetry and the Classical Tradition. Essays in Medieval and Renaissance Literature* (Oxford: 1990) 183–197 at 190.

TOMMASO SCHIFALDO IN A SICILIAN HUMANIST MISCELLANY 307

his near contemporary Leonte Tomasello, a young enthusiast for Catullus. That dedication survives in the Newberry manuscript. By 1451 they are dedicated to a different acquaintance of the author.[42] Pontano omitted the raciest poems of the *Pruritus* in the first versions of a new collection, the *Parthenopaeus*, which date from around 1457.[43] Some of these obscene poems were included again in still later versions, though it is unclear whether by Pontano or by other collectors.[44] As Paolo Cherchi noted when he announced its acquisition by the Newberry, this manuscript contains a combination of poems that appears in a Cortona manuscript that scholars now consider an autograph of Pontano. Two other manuscripts have related redactions.[45] This version seems to represent a very early arrangement of the collection, definitely preceding a more careful one worked by Pontano in an attempt to leave behind his reputation as a courtly rake.[46]

The script of the Pontano manuscript is a mid-fifteenth century humanist cursive, careful and clear but not professional. The poems were copied into a notebook of forty leaves in four gatherings of ten with a handsome watermark of a rooster.[47] The scribe left the first leaf blank, presumably intending it for a cover. The poetry of Pontano occupies the following thirty-three leaves, and then there are five blanks and a stub which would have been the last, fortieth leaf. The scribe may have intended to add other texts on the remaining blanks, but the collection is complete as it stands, corresponding closely to the contents of the Cortona manuscript which must have been a source of the Newberry manuscript.[48]

42 Iacono A., "Pruritum ferit hic novus libellus. Appunti su una raccolta di carmi giovanili di Giovanni Gioviano Pontano", in Conti Bizzaro F. – Lamagna M. – Massimilla G. (eds.), *Studi greci e latini per Giuseppina Matino* (Naples: 2020) 159–172 at 165–167.

43 Gaisser, "Pontano's Catullus" 54–56; Marsh D., "Lasciva Est Nobis Pagina, Vita Proba: Martial and Morality in the Quattrocento", *Memoirs of the American Academy in Rome* 51/52 (2006) 199–209 at 206–208; Ludwig, "Origin" 191.

44 Iacono, "Descrivere il corpo" 15–16, 31–32; Soranzo M., *Poetry and Identity in Quattrocento Naples* (Farnham – Burlington: 2014) 13–14, 20, 30–32; Ludwig, "Origin" 191–192; Ludwig, *Litterae Neolatinae* 172–177.

45 Cherchi P., "Un distico inedito di Pontano", *Forum Italicum* 10 (1976) 398–399; Pontano G.G., *Ioannis Ioviani Pontani carmina*, ed. B. Soldati, 2 vols. (Firenze: 1902) I xlii–xliii, xlviii–l. The Newberry manuscript includes one poem that does not occur in the Cortona manuscript, a fact as yet unexplained by experts on the evolution of Pontano's collection, but see Iacono, "Pruritum ferit" 159, 164n25; idem, "Descrivere il corpo" 15–16; Parenti, *Poëta proteus alter* 116–117.

46 Soranzo, *Poetry and Identity* 30–32, 39–45, 60–61; compare Iacono, "Pruritum ferit" 167.

47 Not located in the standard repertories.

48 There is no reason to believe that the copying was interrupted as Tramontana speculated, *In Sicilia* 13n.

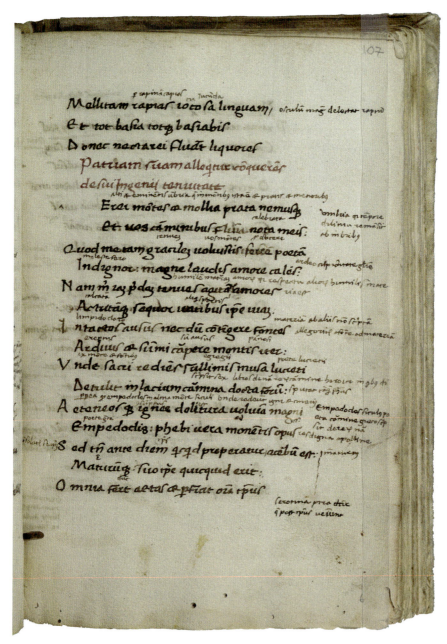

FIGURE 10.3 Newberry Library, MS 71.5, fol. 107r, Pontano, *Parthenopaeus* I 6, with annotations by the scribe of the text, including one on the legend of Empedocles

TOMMASO SCHIFALDO IN A SICILIAN HUMANIST MISCELLANY 309

The Newberry manuscript is annotated, betraying serious study. At least three hands have added notes. A first layer, in a tiny *notula* by the scribe of the text, includes interlinear notes of a grammatical sort, including identifications for historic and mythological figures. Sicilian matters receive particular attention. For example, Pontano's mention of the fate of Empedocles on Mt. Etna (*Parth* I.6, lines 9–12) is glossed with notes about the legends of the poet's demise [Fig. 10.3].[49] As is common for this kind of annotation, it is thorough in the first few leaves and rare later on. The combination of text and glosses in a single, non-professional hand suggests that the booklet was a personal study copy. A second, larger hand has added a few corrections in the margin, while a third reader, identifiable as the annotator of the Pseudo-Mehmet letters, has marked notabilia with manicules and brackets. Thus, the personal copy was passed on to others for reading and study.

Although it is speculation, we can most easily explain the date and structure of this little manuscript and its presence in the Newberry miscellany if we assume, as Bommarito suggested, that the manuscript had belonged to Schifaldo and was preserved by Cesare Zizo because it was a relic of his relationship to the master. If this supposition is true, the manuscript might have been acquired by Schifaldo during his youthful sojourn in peninsular Italy in the late 1450s, just in the midst of Pontano's early notoriety and at exactly the period when this version of the collected poetry was likely assembled.[50] It is tempting to speculate further that either the hand of the text and *notula* or the second annotating hand are Schifaldo's own, but the scripts cannot be identified with any others in manuscripts of his works. Nor do these hands appear elsewhere in the Newberry miscellany.

1.7 Unit VII. *Rodrigo Fernández de Santaella,* Good Friday Sermon

The third printed item in the miscellany is a Latin sermon on the passion of Christ pronounced in the presence of Pope Sixtus IV on Good Friday, 1477 by Spanish humanist Rodrigo Fernández de Santaella (1444–1509).[51] It is a pamphlet of a sort that would become common in Rome as the market for print

49 Fol. 107r. This passage is an early variant, as indicated by Soldati, *Ioannis Ioviani Pontani carmina* II 64, and remarked by Parenti, *Poëta proteus alter* 12. Schifaldo uses Empedocles as an exemplum elsewhere: Cozzucli, *Tommaso Schifaldo* 91; Tramontana, "Nelle scuole" 686–687n.

50 Bommarito "Tommaso Schifaldo e il MS. 71.5" 7; it seems likely that he brought other manuscripts back to Sicily too; Tramontana, *In Sicilia* 20–21.

51 Fernández de Santaella, Rodrigo, *Elegantissima oratio habita* [...] *coram Sixto iiii* [...] *in magna cardinalium prelatorumque frequentia in die Parasceve* A.D. MCCCC *septuagesimo septo* (Rome, no printer named: 1477).

developed there.[52] The author was a 34-year-old secular cleric in the service of Cardinal Jacopo Piccolomini-Ammannati, and he was clearly a man on the make. Santaella was given the privilege of preaching this learned Holy Week sermon just two weeks after the pope had granted him the first of many benefices. We know that he had been at work on it for some months in anticipation of the honor.[53] There were at least two editions of the sermon. The one at the Newberry was probably printed within days of the event for a readership that would have included those present on the occasion and others for whom it could be a small souvenir of the learned culture of the papal capital. The printer is not named and is known to have printed only one other work. Such learned Roman ephemera served to promote the careers of their authors, but they were also pious tourist items.[54]

A second edition of this text appeared at Rome sometime in the 1480s, this time from the most prolific printer of humanist sermons in pamphlet form, Stephan Plannck.[55] Although survival rates offer tricky evidence, the pattern for these two incunabula give a further clue in our investigation of the Schifaldo miscellany. The later printing is widely held in Italy, Austria, Spain and further afield, to a total of over seventy copies, most of which can be traced to monasteries or other religious foundations suppressed in the eighteenth and nineteenth centuries. The earlier edition at the Newberry is much rarer. Only ten copies are known, none in Spain or Sicily, and only that in the Vatican survives on the Italian peninsula. The broad diffusion of the later edition means that it was valued and collected as an edifying specimen of humanist sacred oratory, marketed as such by an established printer to an international public hungry for elegant Latin prose.[56] The rarity of the first edition suggests that it was more truly an ephemerum, very possibly subsidized by the author

52 Bianca C., "Le orazioni a stampa", in Chiabò M. (ed.), *Roma di fronte all'Europa al tempo di Alessandro VI*, 3 vols. (Rome: 2001) II 441–467 at 449–450; Scapecchi P., "Savonarola e la stampa", in ibid. II 399–407 at 399–400; Hilliard D., "Discours et sermons imprimés à Rome à la fin du XV^e siècle à travers deux recueils de la Bibliothèque nationale de France", *Bulletin du bibliophile* (2001) 36–57 at 40–49.

53 Pascual Barea J., "Rodrigo de Santaella en la Roma humanista de Sixto IV (1475–1480)", in Maestre J.M. et al. (eds.), *Humanismo y pervivencia del mundo clásico: Homenaje al profesor Juan Gil*, 5 vols. (Madrid: 2015) I 2215–2228 at 2219–2221; O'Malley J.W., *Praise and Blame in Renaissance Rome. Rhetoric, Doctrine, and Reform in the Sacred Orators of the Papal Court, 1450–1521* (Durham: 1979) 18–23.

54 Scapecchi, "Savonarola" 400; O'Malley, *Praise and Blame* 22.

55 Pontecorvi A., "Alcune note sul catalogo di Stephan Plannck", in Farenga P. (ed.), *Editori e edizioni a Roma nel Rinascimento* (Rome: 2005) 91–118 at 111–112; Scapecchi, "Savonarola" 399.

56 Hilliard, "Discours et sermons" 47–49.

TOMMASO SCHIFALDO IN A SICILIAN HUMANIST MISCELLANY

or his patron to mark the occasion and distributed through their networks of friendship and clientage. This would not have been the case for the later edition since Piccolomini-Ammannati died before it was printed and Santaella was by then back in Spain.[57]

We know the Newberry copy of Santaella's sermon was in Sicily when the Newberry miscellany was assembled, so we may well ask what accounts for its anomalous presence there. The explanation may have to do with Schifaldo's personal relationships. Santaella was sent to Sicily as an inquisitorial official in the mid-1490s. Schifaldo served as inquisitor too, so the two clerics may have worked together. A copy of Santaella's sermon could well have served as a sort of calling card or token of professional esteem. It could also have been the gift of another Spanish cleric who knew of Schifaldo's interest in sacred oratory, or even of Cardinal Piccolomini-Ammannati, whom Schifaldo had likely met in his Roman years.

None of the three printed items in the Newberry miscellany came from Neapolitan presses. At the very least this is a bit of evidence for the limited export of Naples imprints to Sicily by comparison to those aggressively marketed from Rome, Venice, and even Treviso. It also throws into question the commonplace that Naples was the major center of diffusion of humanism to the Aragonese Kingdom of Sicily.[58] In the case of the Santaella piece, a product of patronage never published in Naples, it is likely that personal contacts were more important than marketing. Pseudo-Pliny and Pseudo-Mehmed, on the other hand, were fully commercial products, and both texts were printed in Naples within Schifaldo's lifetime, though members of his circle in Sicily owned the other editions now in Chicago.

1.8 Unit VIII. *Schifaldo,* Grammatical Investigations and Song on the Victory at Granada

The final section of the Newberry miscellany contains a grammatical treatise and a lengthy poem by Schifaldo. This is the only known copy of either piece; the hand and paper are the same as in Unit I, so this section can be attributed to Cesare Zizo. The grammatical treatise (*De indagationibus grammatice*) was published in full with a commentary by Susan Noakes and Robert Kaster who point out that its most original feature is Schifaldo's address to the philological methods of Lorenzo Valla. They note that Schifaldo admired Valla but had

57 On this humanist patron, Cherubini P., "Giacomo Ammanati Piccolomini: Libri, biblioteca, e umanisti", in Miglio M. (ed.), *Scrittura, biblioteche e stampa a Roma nel Quattrocento* (Vatican City: 1985) 175–256.

58 Santoro, "Humanism" 309–310.

reservations about some of his conclusions. Domenico Bommarito offered additional insights in three articles that credit Schifaldo with a more substantial critique of Valla.[59]

Schifaldo's treatment of Valla is not systematic. The treatise draws on many sources, and there are echoes of Valla's *Elegantiae* throughout. Schifaldo is concerned to defend the grammatical opinions of Priscian and the usage of St. Jerome against Valla's complaints that they were unfaithful to the Latin of the best authors. Schifaldo expresses a proper humanist concern for the recovery of pure Latin, but he complains that Valla was too content to treat Cicero and Quintilian as arbiters of usage when in fact neither author was a grammarian with a systematic approach to language. Schifaldo adds that it is impossible for any modern reader to know all of ancient Latin well enough to pontificate the way Valla did. Schifaldo prefers to trust Priscian, 'vir graecus a patre tamen romano oriundus utriusque linguae peritissimus' (a Greek but with a Roman father, most learned in both languages). Priscian, he seems to say, was at least as learned and certainly more cosmopolitan than Valla.[60]

Appended to the grammatical treatise, in fact merely inserted to fill out the blank leaves left at the end of the fourth gathering, stands a poem praising the fall of Granada in 1491–1492.[61] Although the eventual expulsion of the Moors from Spain had been a foregone conclusion for most of Schifaldo's lifetime, the symbolic importance of this event for the entire Mediterranean world cannot be overstated. In view of the ongoing threat from the Ottomans, the victory over the Muslims in Spain was a heartening moment. For the Aragonese royals in Naples and Sicily, it would offer short-lived pleasure, for a French invasion threw the Neapolitan regime into a crisis that occupied the last years Schifaldo's life. The accomplished Sapphics of this poem on the end of the siege make no mention of these later events, so we can guess that it was composed before the French arrived in Southern Italy in late 1494.

59 Noakes – Kaster, "Tommaso Schifaldo's *Libellus*" 112–115; Bommarito D., "Tommaso Schifaldo contro Lorenzo Valla: Storia di una controversia grammaticale", *Filologia e critica* 30 (2005) 34–71; idem, "Tommaso Schifaldo e la sua grammatica" 97–143; idem, "La *Controversia in Vallam* di Tommaso Schifaldo. Divergenze e convergenze grammaticali e concettuali", in Regogliosi M. – Marsico C. (eds.), *La Diffusione Europea del pensiero di Lorenzo Valla* (Florence: 2013) 449–476.

60 Noakes – Kaster, "Tommaso Schifaldo's *Libellus*" 132, 152–154; Tramontana, *In Sicilia* 49–52; idem, "Nelle scuole" 691–692; Bommarito, "Tommaso Schifaldo e la sua grammatica" 118–134, 142; idem, "La *Controversia*" 461–464.

61 For the celebratory literature, Hillgarth J.N., *The Spanish Kingdoms*, vol. 2.: *1410–1516, Castilian Hegemony* (Oxford: 1978) 370–374, 529.

2 Assembly and Meaning

Weighing the combined evidence of all eight codicological entities, what can we conclude about the assembly of the Newberry miscellany? The individual parts of the volume can be dated across several decades, so we must assume that what survives was a conscious assembly by someone who had in mind that it was all material that came from the circle of the revered Tommaso Schifaldo. The man who owned such *pietas* was Cesare Zizo, whose hand is identifiable throughout the book.

The four parts of the miscellany that do not directly concern Schifaldo existed as unities well before its assembly. Unit VI is a mid-fifteenth-century manuscript that may have belonged to Schifaldo; he may even have brought it from the mainland when he returned to Sicily in 1462. The incunabula (datable to 1475, 1477, and 1486) were by definition free-standing items, and there is no reason to believe that they were united to the rest of the contents of the book before its assembly. Unit V, Schifaldo's Ciceronian letters, probably also existed separately from all the rest, though this copy cannot have been made before the early 1490s, when its one identifiable addressee held office. All these pre-existing units can be understood as examples of fine Latin style. They have that logic as a collection in themselves, though as we will see, there are other unifying factors too.

This leaves us with Units I, IV, and VIII– a frame and central piece all in the hand of Cesare Zizo, and on similar paper stocks. The manner in which these units frame the others implies a clear plan. We cannot be absolutely certain that the final ordering was Zizo's since the binding is modern and the sewing, though much older, cannot be dated. Still, it would make little sense for a later binder to create a symmetrically arranged collection of these particular items since so many units have no obvious relationship to Schifaldo or to each other.

Over and above these bare (and somewhat speculative) facts of the assembly of the Newberry miscellany, can we say anything more about its meaning? As noted several times in this essay, one way of understanding the unity of the volume is in terms of the 'Sicilian interest' of many of the individual pieces. However, beyond Schifaldo's works the Sicilian content is not extensive. For example, the work by Santaella has a Sicilian tie only in terms of its author's visit to the island. Pseudo-Pliny and Pontano treat Sicily as a subject, but in both cases in conventional terms in only a few lines. In this regard 'Schifaldo interest' would be as substantive as 'Sicilian' to describe the book, since we can be reasonably sure that the Dominican humanist knew or at least knew of Pontano, Beccadelli, and Santaella and would have had literary interest in the other works. Schifaldo's unique career suggests that we should perhaps

overlay these two interests and look for something peculiarly Sicilian about his humanism and the tradition that Cesare Zizo inherited from him.

Scholars now recognize that there were significant regional variations in fifteenth-century humanism.[62] Schifaldo's life, spent almost entirely on the island and largely at its extreme Western end, invites us to think about marginality if not also pride of place. Outside of humanism's Italian heartland, humanists were rather lonely figures, constituting 'a fairly clear-cut small group of cultivated persons acutely conscious of forming an *avant-garde* opposed to the still-prevalent weight of tradition'.[63] In the older, Italocentric historiography, humanism flourished across central Italy, but it was a cultural export to most areas.[64] Thus, Tommaso Schifaldo of Marsala might be considered a provincial sort of fellow even though he had a solid humanist education.

Only a few scholars view Sicilian humanism as having deep local roots.[65] Recent studies emphasize Naples as a major cultural center but present Sicily as provincial within the two kingdoms (dynastic control of which changed several times in Schifaldo's lifetime), or else they omit the island and its humanists entirely.[66] In this view, Schifaldo studied at Siena and Rome but returned home and dedicated his professional life to communicating the new, soon-to-be European worldview to his provincial students. This much would embrace

62 Furstenberg-Levi, *Accademia Pontaniana* 4–5, 12–14; Baker N.S. – Maxson B. (eds.), *After Civic Humanism. Learning and Politics in Renaissance Italy* (Toronto: 2015) 22–23; Helmrath J., *Wege des Humanismus. Studien zu Praxis und Diffusion der Antikeleidenschaft im 15. Jahrhundert* (Tübingen: 2013) 213–237; Dollo, "Cultura" 227–228; Bentley, *Politics and Culture* 288–299.

63 Hillgarth, *Spanish Kingdoms* 171; idem, *Readers and Books in Majorca 1229–1550*, 2 vols. (Paris: 1991–1992) I 55–62, 117–122, 133–137 develops this notion further by contrasting the provincial humansims of Sicily and Majorca, both Aragonese crown possessions in the fifteenth century.

64 This older view is well summarized in Santoro, "Humanism", with only passing mention of Sicily; compare Bentley, *Politics and Culture* 253–287.

65 The only extensive treatments are Correnti S., *La Sicilia del Cinquecento. Il nazionalismo isolano* (Milano: 1980) and idem, *Sicilia del Quattrocento*. Compare Bottari S., *Messina tra umanesimo e Rinascimento. Il "caso" Antonello, la cultura, le élites politiche, le attività produttive* (Soveria Mannelli: 2010) 56–62; Dollo, "Cultura" 227–228, 266–271; Bianca, *Stampa cultura* 34–35, 170–172; Trasselli C., *Mediterraneo e Sicilia all'inizio dell'epoca moderna (ricerche quattrocentesche)* (Cosenza: 1977) 74–80; Giunta F., "Documenti sugli umanisti Tommaso Schifaldo e Cataldo Parisio", *Bollettino del Centro di Studi filologici e linguistici siciliani* 13 (1977) 429–434 at 429; Cozzuci, *Tommaso Schifaldo* 28–30.

66 Summary in Abulafia D., "The Diffusion of the Italian Renaissance: Southern Italy and Beyond", in Woolfson J. (ed.), *Palgrave Advances in Renaissance Historiography* (Houndmills – New York: 2005) 34–43; compare Helmrath, *Wege des Humanismus* 53–70; Rundle D., "Humanism Across Europe: The Structures of Contacts", in idem (ed.), *Humanism in Fifteenth-Century Europe* (Oxford: 2012) 307–335 at 307–320; Galasso G., *Il Regno di Napoli. Il Mezzogiorno angioino e aragonese (1266–1494)* (Turin: 1992) 760–775.

TOMMASO SCHIFALDO IN A SICILIAN HUMANIST MISCELLANY

Pontano and Pliny, Beccadelli and Santaella, as well as the epistolary models elsewhere in our miscellany. All of those texts actually, physically arrived from outside, so they effectively reflect the crossroads nature of Sicily, its marginality, and its provincial brand of humanism. Alessandra Tramontana sees a similar provincialism in Schifaldo's work, remarking that he often made reference to Sicilian settings and themes but rarely engaged contemporary humanist controversies, perhaps because he had limited access to humanist books.[67]

In fact, Schifaldo's original literary productions do not imagine a humanism centered elsewhere; they are fully humanist but also strikingly Siculo-centric. It is an attitude that many writers and critics today call *sicilianità*.[68] Can this concept be usefully applied to Schifaldo and Zizo? *Sicilianità* consists first in the native Sicilian's sense of living at an unfortunate crossroads of civilizations. To this point, Giuseppe Tomasi di Lampedusa (1896–1957) is much-quoted:

> Sono venticinque secoli almeno che portiamo sulle spalle il peso di magnifiche civiltà eterogenee, tutte venute da fuori già complete e perfezionate, nessuna germogliata da noi stessi, nessuna a cui abbiamo dato il 'la'.

> For at least twenty-five centuries, we have carried on our backs the weight of differing, magnificent civilizations, all of them brought fully developed from outside, not a one we ourselves nurtured, none we can call our own.[69]

67 Tramontana, *In Sicilia* 15–16, 33, 44–54; idem, "Nelle scuole" 674–675, 686–687, 690–692. Local pride was a general tendency among Sicilian humanists; Pulejo E., *Un'umanista siciliano della prima metà del secolo XVI (Claudio Mario Aretio)* (Acireale: 1902) 16–17; Zeldes, "Christians, Jews" 193–196; Bianca, *Stampa cultura* 164–188; Correnti, *Sicilia del Cinquecento* 6–7, 144–161, 167–177; Bottari "Tommaso Schifaldo" 256–257.

68 For a summary history of the concept: Goddeeris I., "The Flexibility of European Identities: East-West and North-South Juxtapositions in Past and Present", *Politeja* 37 (2015) 9–24 at 18–19. Linguistic commentary: Orioles "Tra Scililianità e Sicilitudine" 227–229. Historians of early modern Sicily typically prefer other terms. Correnti, *Sicilia del Cinquecento* 5–7 uses 'nazionalismo isolano'; Trasselli, *Mediterraneo* 75–78 says 'patriottismo siciliano'; Fasoli G., "L'unione della Sicilia all'Aragona", *Rivista storica italiana* 65 (1953) 297–325 at 321 has 'aspirazioni indipendentiste isolane'. But, even in the context of other Italian regionalisms, these terms are too narrowly political for our purposes. An excellent recent examination using the broader notion of *isolarità* is Fatta, "Insularità". Critical literary and intellectual notions of *sicilianità* must also be distinguished from its occasional use, particularly in the nineteenth century, as a racially loaded stereotype, for which see Dickie J., *Darkest Italy. The Nation and Stereotypes of the Mezzogiorno, 1860–1900* (New York: 1999) 100–107.

69 Tomasi di Lampedusa G., *Il Gattopardo* (Milan: 2002) 178, my translation, on which Reimann H., "Tomasi di Lampedusa's Sicily: The Construction of Reality Through

This is a very old sentiment; historians document a comparable nostalgic regret in fourteenth-century Sicily.[70] Another great Sicilian writer, Leonardo Sciascia (1921–1989), makes a leap to a positive literary psychology, calling *sicilianità* 'quella nozione della Sicilia che è insieme luogo comune, "idea corrente", e motivo di univoca e profonda ispirazione nella letteratura e nell'arte' (the notion that Sicily is at once a commonplace, a general understanding, and the cause of profound, unique inspiration in literature and the arts).[71] For these modern writers *sicilianità* is a state of unquiet creative tension. Fatalism is balanced by native arrogance, resulting in a stubborn resistance to being defined as anything but proudly Sicilian.[72] The result, Sciascia insists, is that the subject of Sicilian cultural work is always the island itself, even if the ostensible topic is something larger or somewhere else. Her native authors claim to find in the idea of Sicily an understanding of all humanity.[73]

Sicilianità of this sort is a slippery concept at best, and clearly an anachronism for us. The term first occurs in the nineteenth century, though scholars now trace similar kinds of rhetorically constructed regionalisms in Italy, including *toscanità*, to the sixteenth century.[74] But *sicilianità* does have the interpretive value of a kind of insular catholicity. It fits the politics of Schifaldo's lifetime well, for Sicily was juridically a distinct kingdom but had become an overseas possession of Spanish kings who rarely visited it. Its delegated overlords and much of its economy were Catalan, Aragonese, Castilian.[75] In this context, just as today, *sicilianità* as an analytical concept would include both cultural baggage brought from outside and ambitions to creativity at home. Events, ideas, and practices (like humanism) that arrived in Sicily could be subsumed, Sicilianized if you will. Individuals could be subaltern to outside influences while embracing them avidly as their own.[76]

Narrative Fiction", *Journal of Mediterranean Studies* 4 (1994) 83–96. On variants within this passage: Dipace A., *Questione delle varianti del Gattopardo* (Rome: 1971) 113–114.

70 D'Alessandro V., *Politica e società nella Sicilia aragonese* (Palermo: 1963) 310–313.

71 Quoted by Fatta, "Insularità" 179, my translation.

72 Reimann, "Tomasi di Lampedusa's Sicily" 90; Orioles, "Tra Scililianità e Sicilitudine" 229.

73 Sciascia L., *La corda pazza. Scrittori e cose della Sicilia* (Turin: 1970) 17.

74 Tribby J., "Dante's Restaurant. The Cultural Work of Experiment in Early Modern Tuscany", in Bermingham A. – Brewer J. (eds), *The Consumption of Culture 1600–1800. Image, Object, Text* (London – New York: 1995) 319–337 at 320–325. Venice developed a self-referential kind of humanism analogous in some ways to the Sicilian case though writ larger on the Italian stage; see King M.L., "The Venetian Intellectual World", in Dursteler E.R. (ed.), *A Companion to Venetian History, 1400–1797* (Leiden: 2013) 571–614 at 571–585. As in Sicily, *venezianità* was a coinage of the nineteenth century.

75 Zeldes, *Former Jews* 5–7; Abulafia, *Western Mediterranean* 262; Ryder A., *Alfonso the Magnanimous, King of Aragon, Naples, and Sicily, 1396–1458* (Oxford: 1990) 194–199; Hillgarth, *Spanish Kingdoms* 243–244.

76 Fatta, "Insularità" 175–176, 179–180; Dollo, "Cultura" 268–271.

TOMMASO SCHIFALDO IN A SICILIAN HUMANIST MISCELLANY

Tramontana used the term *sicilianità* narrowly in discussing Schifaldo's pride in finding Sicilian references in classical literature.[77] The concept has also been used broadly with reference to the multicultural Greek and Arabic dimensions of Sicilian intellectual work.[78] But those strains are not strong in Schifaldo's writings. If *sicilianità* is to be useful for understanding the Newberry miscellany, it must apply more specifically to a personally developed worldview that Schifaldo communicated to those followers of his who created the volume that survives. The key work is his *On Illustrious Sicilian Dominicans*. The Newberry copy was carefully written out by Cesare Zizo, and it is the longest work in the miscellany. As we have seen, it was commissioned by a non-Sicilian, and the subject connects it to two international phenomena, Dominican spirituality and humanist learning. But Schifaldo's treatise is in fact both highly personal in form and rhetoric and entirely centered on Sicily. It is a near-perfect example of prideful, self-absorbed *sicilianità*.

When Zizo came to praise his master in the letter and poems with which he prefaced the anthology, he displayed a similar mentality. He stressed Schifaldo's Sicilian reputation as if this were sufficient fame for any man. He asks, 'Nam quis est in Sicilia qui Schifaldum [...] officiis laudibusque non prosecuturus sit?' (Who after all is there in Sicily who does not lavish Schifaldo with honors and praise?). Zizo here echoes Schifaldo's own rhetorical question, words Zizo himself had copied: 'Quis est in Sicilia qui Schifaldi peculiaria verba [...] non [...] dignoscat?' (Who in Sicily does not recognize the characteristic diction of Schifaldo?). Schifaldo employed these notions of Sicilian fame and Sicilian audience throughout his *De viris illustribus*. Zizo adds (in verse) that Sicily honors Schifaldo who brought honor to Sicilians.[79]

Another self-described disciple of Schifaldo, the prominent physician and geographer Gian Giacomo Adria (1485–1560), also specified Sicily as his grammar master's theater of influence; he says, 'Tempore Schifaldi omnes Siculi, legis doctores et vates, discipuli erunt Schifaldi' (In Schifaldo's day, all Sicilians, doctors of law and poets, were his students).[80] As we have seen, Schifaldo's own works – including the letters and poems in the miscellany, his critique of Valla, his occasional pieces in the service of the Aragonese regime – betray this same complex and reflexive worldview. They express a sense that crossroads Sicily is a worthy cultural theater, agora, and marketplace, which accepts ideas from outside but claims them as its own and indeed transforms them into

77 Tramontana, "Nelle scuole" 686.
78 Maltempi, *We Are the Kingdom of Sicily* 10–15, 38–57.
79 Bommarito, "Tommaso Schifaldo e il MS. 71.5" 28–29; Cozzucli, *Tommaso Schifaldo* 68, 70, 71, 73, 92, 93.
80 Mongitore, *Bibliotheca sicula* 263; Correnti, *Sicilia del Quattrocento* 166; compare Tramontana, "Nelle scuole" 673–674.

something uniquely Sicilian. Even humanist Latin becomes a Sicilian achievement. This stance was echoed by Cesare Zizo as a collector. Thus, although the term is strictly speaking anachronistic, *sicilianità* usefully characterizes this view of Sicily as a cultural theater, its literary expression in Schifaldo's works, and the anthology that survives at the Newberry.

3 Conclusion

Still, I would like to conclude by suggesting that the Newberry miscellany does not have a single principle of unity. It must be understood as the result of a gradual process by which its contents changed meaning across the time of its assembly. Schifaldo flourished within it, and then became obscured.

Cesare Zizo's own words make it clear that the project for an anthology was a matter of personal *pietas* and that he dealt directly with Schifaldo to get some material:

> Litteras tuas, praeceptor unice et mihi colendissime, quas ad me dedisti, quanto desiderio quantave cum cupiditate exoptas perlegerim, non modo non scriptis, sed ne verbis quidem et in presentia exprimere unquam possem.

> O singular and most beloved teacher, I have read and reread the longed-for pages of yours that you gave me more eagerly and greedily than I will ever be able to express either in writing or verbally.[81]

We know that in further pursuit of this *pietas* Zizo diligently copied out a number of Schifaldo's longest works himself (Units IV and VIII). He apparently located or commissioned a copy of shorter works (Unit V). We may think of this as a first stage, a personal collection in separate booklets or notebooks that may not have had ambitions beyond the disciple's own use. It is a first stage conceptually, however, not necessarily chronologically. Indeed, the varying hand, inks, and paper stocks make it likely that these three units were created at different times and brought together only later.

Probably separately and at different times, Zizo seems to have acquired other pieces from Schifaldo, perhaps only after his death. These included three study copies, Pontano in manuscript (Unit VI), and the first two incunabula (Units II

81 Bommarito, "Tommaso Schifaldo e il MS. 71.5" 28, my translation.

TOMMASO SCHIFALDO IN A SICILIAN HUMANIST MISCELLANY

and III), as well as the other incunabulum (Unit VII), which has no annotation. Two of the incunabula were connected with the patronage of Cardinal Jacopo Piccolomini-Ammannati, and if they belonged to Schifaldo (and also if they did not) they may have been humanist gift exchanges. All these texts can be connected to Schifaldo only if we assume he owned, studied, or taught them, but not otherwise. So, if their inclusion was intended by Zizo – not intruded by a later owner of the material – he must have thought they came from Schifaldo.

On this reading, the miscellaneous material in Unit I was the last addition, again conceptually if not also chronologically. The several components are all in Zizo's hand but were written at different times, most of them informally and confusedly. The single poem by Schifaldo was carefully transcribed and may have been intended as another part of the personal collection in progress, what we have called its first stage. The other pieces vary in level of care, and some do not relate to the rest of the anthology. This suggests that the project was interrupted for some time, perhaps temporarily abandoned and taken up years later.

It does seem that the order we now have was Zizo's doing. It is unlikely that anyone else would have brought this highly miscellaneous material together in this particular order, with works by Schifaldo symmetrically framing other items he apparently owned. Assuming that this assembly stage was in fact accomplished later than most of the material was transcribed and collected, it could have happened any time within Zizo's lifetime. We know he taught school into the 1520s at least. What Zizo started as an active project of devotion may in the end have simply been a conservation measure, a bundling to keep things together and avoid their dispersal. Such bundling, conceivably including the present sewing (though not the modern binding), might have been Zizo's work or that of someone who acquired the materials from him.

However we reconstruct the assembly, it is clear that the Newberry miscellany is a complex of textual objects that individually changed meaning across time. Study copies were created or acquired and passed from hand to hand. New transcriptions were made from various sources and combined in ways their exemplars had not done. Some booklets likely changed hands by gift or inheritance. We cannot measure or characterize the level of interest involved in most of these individual exchanges, but eventually the *pietas* of Cesare Zizo brought these materials together. At that moment, the diverse meanings of the individual components coalesced into a sort of monument to Tommaso Schifaldo. The bundling represents an attempt at conservation. The early sewing and modern binding were further preservationist acts. The final labeling of the assembly as Pliny effectively entombed Schifaldo under a false epitaph, only to be exhumed once the book was cataloged, announced in the

professional literature, and utilized by a variety of scholars. My hope is that this essay reclaims at least some of the many meanings the customized book has had.

Bibliography

Abulafia D., *The Western Mediterranean Kingdoms 1200–1500: The Struggle for Dominion* (London – New York: 1997).

Abulafia D., "The Diffusion of the Italian Renaissance: Southern Italy and Beyond", in Woolfson J. (ed.), *Palgrave Advances in Renaissance Historiography* (Houndmills – New York: 2005).

Alton E.H., "Who Wrote the Hermaphroditus?", *Hermathena* 21 (1931) 136–148.

Baker N.S. – Maxson B. (eds.), *After Civic Humanism. Learning and Politics in Renaissance Italy* (Toronto: 2015).

Bentley J.H., *Politics and Culture in Renaissance Naples* (Princeton: 1987).

Bevilacqua Krasner M., "Re, regine, francescani, domenicani ed ebrei in Sicilia nel XIV e XV secolo. Potere politico, potere religioso e comunità ebraiche in Sicilia", *Archivio storico siciliano* ser. 4, 24 (1998) 61–91.

Bianca C., *Stampa cultura e società a Messina alla fine del Quattrocento* (Palermo: 1988).

Bianca C., "Le orazioni a stampa", in Chiabò M. (ed.), *Roma di fronte all'Europa al tempo di Alessandro VI*, 3 vols. (Rome: 2001) II 441–467.

Bommarito D., "Tommaso Schifaldo e il MS. 71.5 della Newberry Library di Chicago: aspetti paleografici e storici", *Siculorum gymnasium*, n.s. 54 (2001) 3–41.

Bommarito D., "Tommaso Schifaldo contro Lorenzo Valla: Storia di una controversia grammaticale", *Filologia e critica* 30 (2005) 34–71.

Bommarito D., "Tommaso Schifaldo e la sua grammatica filosofica", *Interpres* 27 (2008) 97–143.

Bommarito D., "La *Controversia in Vallam* di Tommaso Schifaldo. Divergenze e convergenze grammaticali e concettuali", in Regogliosi M. – Marsico C. (eds.), *La Diffusione Europea del pensiero di Lorenzo Valla* (Florence: 2013) 449–476.

Bottari G., "Tommaso Schifaldo e il suo commento all'*Arte poetica* di Orazio", in Franchini R. (ed.), *Umanità e storia. Scritti in onore di Adelchi Attisani*, vol. 2: *Letteratura e Storia* (Messina: 1971) 221–259.

Bottari S., *Messina tra umanesimo e Rinascimento. Il "caso" Antonello, la cultura, le élites politiche, le attività produttive* (Soveria Mannelli: 2010).

Cherchi P., "Un distico inedito di Pontano", *Forum Italicum* 10 (1976) 398–399.

Cherchi P., "Uno smarrito carme bucolico di Tommaso Schifaldo", in Bugliani, A. (ed.), *The Two Hesperias: Literary Studies in Honor of Joseph G. Fucilla* (Madrid, 1977) 121–127.

Cherubini P., "Giacomo Ammanati Piccolomini: Libri, biblioteca, e umanisti", in Miglio M. (ed.), *Scrittura, biblioteche e stampa a Roma nel Quattrocento* (Vatican City: 1985) 175–256.

Cicogna E.A., *Delle inscrizioni veneziane*, vol. 6, part 1: *Inscrizioni nella chiesa di S. Andrea di Venezia detto de Zirada* (Venice: 1853).

Coleman J.K., "Forging Relations Between East and West. The Invented Letters of Sultan Mehmed II", in Stephens W. – Havens E.A. – Gomez J.E. (eds.), *Literary Forgery in Early Modern Europe, 1450–1800* (Baltimore: 2019) 118–134.

Beccadelli Antonio, *Antonii Panhormitae Hermaphroditus*, ed. D. Coppini (Rome: 1990).

Correnti S., *La Sicilia del Cinquecento. Il nazionalismo isolano* (Milano: 1980).

Correnti S., *La Sicilia del Quattrocento. L'umanesimo mediterraneo* (Catania: 1992).

Cozzucli G., *Tommaso Schifaldo umanista siciliano del saec. XV. Notizie e scritti inediti* (Palermo: 1897).

D'Alessandro V., *Politica e societa' nella Sicilia aragonese* (Palermo: 1963).

Di Giovanni V., *Filologia e letteratura siciliana*, 3 vols. (Palermo: 1871–1876; reprint Bologna: 1968).

Dickie J., *Darkest Italy. The Nation and Stereotypes of the Mezzogiorno, 1860–1900* (New York: 1999).

Dipace A., *Questione delle varianti del Gattopardo* (Rome: 1971).

Dollo C., "Cultura del Quattrocento in Sicilia. Alle origini del Siculorum Gymnasium", *Rinascimento* n.s. 39 (1999) 227–292.

Fasoli G., "L'unione della Sicilia all'Aragona", *Rivista storica italiana* 65 (1953) 297–325.

Fatta I., "Insularità: Note sul rapporto fra gli scrittori siciliani e la loro terra", *Carte italiane* 2 (2015) 171–189. Online: https://escholarship.org/uc/item/6mm5x563

Fernández de Santaella, Rodrigo, *Elegantissima oratio habita […] coram Sixto iiii […] in magna cardinalium prelatorumque frequentia in die Parasceve A.D. MCCCC septuagesimo septo* (Rome, no printer named [but Printer of the Antoninus "De censura"]: 1477). ISTC is00123000.

Ferraù G., *La Cultura in Sicilia nel Quattrocento*, exh. cat., Messina Salone del Comune (Rome: 1982).

Fletcher J., *Collection-level Cataloging: Bound-with Books* (Santa Barbara: 2010).

Frazier A.K., *Possible Lives: Authors and Saints in Renaissance Italy* (New York: 2005).

Frazier A.K., "Humanist Lives of Catherine of Siena: Latin Prose Narratives on the Italian Peninsula (1461–1505)", in Hamburger F. – Signori G. (eds.), *Catherine of Siena: The Creation of a Cult* (Turnhout: 2013) 109–134.

Frazier A.K., "Liturgical Humanism: Saints' Offices From the Italian Peninsula in the Fifteenth Century", in Berger A.M.B. – Rodin J. (eds.), *Cambridge History of Fifteenth-Century Music* (Cambridge: 2015) 311–329.

Friedrich M. – Schwarke C. (eds.), *One-volume Libraires: Composite and Multiple-text Manuscripts* (Berlin – Boston: 2016).

Furstenberg-Levi S., *The Accademia Pontaniana. A Model of a Humanist Network* (Leiden: 2016).

Gaisser J.H., "Pontano's Catullus", in Kiss D. (ed.), *What Catullus Wrote: Problems in Textual Criticism, Editing and the Manuscript Tradition* (Swansea: 2015) 53–91.

Galasso G., *Il Regno di Napoli. Il Mezzogiorno angioino e aragonese (1266–1494)* (Turin: 1992).

Giunta F., "Documenti sugli umanisti Tommaso Schifaldo e Cataldo Parisio", *Bollettino del Centro di Studi filologici e linguistici siciliani* 13 (1977) 429–434; reprint, idem, *L'Ultimo medio evo* (Rome: 1981) 118–125.

Giurato S., *La Sicilia di Ferdinando il Cattolico. Tradizioni politiche e conflitto tra Quattrocento e Cinquecento (1468–1523)* (Soveria Mannelli: 2003).

Goddeeris I., "The Flexibility of European Identities: East-West and North-South Juxtapositions in Past and Present", *Politeja* 37 (2015) 9–24.

Helmrath J., *Wege des Humanismus. Studien zu Praxis und Diffusion der Antikeleidenschaft im 15. Jahrhundert* (Tübingen: 2013).

Hillgarth J.N., *The Spanish Kingdoms*, vol. 2.: *1410–1516, Castilian Hegemony* (Oxford: 1978).

Hillgarth J.N., *Readers and Books in Majorca 1229–1550*, 2 vols. (Paris: 1991–1992).

Hilliard D., "Discours et sermons imprimés à Rome à la fin du XVe siècle à travers deux recueils de la Bibliothèque nationale de France", *Bulletin du bibliophile* (2001) 36–57.

Huijbers A., "*De viribus illustris Ordinis Praedictorum*. A 'Classical' Genre in Dominican Hands", *Franciscan Studies* 71 (2013) 297–324.

Huijbers A., *Zealots for Souls. Dominican Narratives of Self-Understanding During Observant Reforms* (Berlin – Boston: 2018).

Iacono A., "Descrivere il corpo dell'amata: Giovanni Gioviano Pontano, *Parthenopaeus* I.2 tra disinibizione giovanile e senile compostezza", *Atlante. Revue d'études romanes* 5 (2016) 12–39. Open access: https://atlante.univ-lille.fr/02-descrivere-il-corpo-dellamata-giovanni-gioviano-pontano-parthenopeus-i-2-tra-disinibizione-giovanile-e-senile-compostezza.html

Iacono A., "Pruritum ferit hic novus libellus: Appunti su una raccolta di carmi giovanili di Giovanni Gioviano Pontano", in Conti Bizzaro F. – Lamagna M. – Massimilla G. (eds.), *Studi greci e latini per Giuseppina Matino* (Naples: 2020) 159–172. Open access: http://www.fedoabooks.unina.it/index.php/fedoapress/catalog/book/204.

King M.L., "The Venetian Intellectual World", in Dursteler E.R. (ed.), *A Companion to Venetian History, 1400–1797* (Leiden: 2013) 571–614.

Kohl B.G. – Mozzato A. – O'Connell M., *The Rulers of Venice, 1332–1524, rulersof venice.org* (New York, ACLS Humanities E-Book: 2013-ongoing).

Kristeller P.O., *Iter Italicum*, vol 6: *Italia III etc.* (Leiden: 1990).

Kristeller P.O., "The Contribution of Religious Orders to Renaissance Thought and Learning", in *Medieval Aspects of Renaissance Learning. Three Essays by Paul Oskar Kristeller* (New York: 1992) 93–114.

Ludwig W., *Litterae Neolatinae: Schriften zur neulateinischen Literatur* (Munich: 1989).

Ludwig W., "The Origin and Development of the Catullan Style in Neo-Latin Poetry", in Goldwin P. – Murray O. (eds.), *Latin Poetry and the Classical Tradition. Essays in Medieval and Renaissance Literature* (Oxford: 1990) 183–197.

Maltempi A., *We Are the Kingdom of Sicily: Humanism and Identity Formation in the Sicilian Renaissance* (Ph.D. dissertation, University of Akron: 2020).

Marsh D., "Lasciva Est Nobis Pagina, Vita Proba: Martial and Morality in the Quattrocento", *Memoirs of the American Academy in Rome* 51/52 (2006) 199–209.

Meserve M., *Empires of Islam in Renaissance Historical Thought* (Cambridge – London: 2008).

Mongitore Antonino, *Bibliotheca sicula, sive de scriptoribus siculis, qui tum vetera, tum recentiora saecula illustrarunt*, 2 vols. (Palermo, Didaci Bua: 1708 – A. Felicella: 1714).

Noakes S.J., "A Grammatical Treatise by Tommaso Schifaldo Discovered in Chicago", *Archivum Fratrum Praedicatorum* 53 (1983) 293–300.

Noakes S.J. – Kaster R., "Tommaso Schifaldo's *Libellus de indagationibus grammaticis*", *Humanistica Lovaniensia* 32 (1983) 108–156.

O'Malley J.W., *Praise and Blame in Renaissance Rome. Rhetoric, Doctrine, and Reform in the Sacred Orators of the Papal Court, 1450–1521* (Durham: 1979).

Orioles V., "Tra Scililianità e Sicilitudine", *Linguistica* 49 (2009) 227–234.

Pade M., "La traduzione di Tucidide. Elenco dei manoscritti e bibliografia", in Regoliosi M. (ed.), *Pubblicare il Valla* (Florence: 2008) 437–452.

Parenti G., *Poëta proteus alter: forma e storia di tre libri di Pontano* (Florence: 1985).

Pascual Barea J., "Rodrigo de Santaella en la Roma humanista de Sixto IV (1475–1480)", in Maestre J.M. et al. (eds.), *Humanismo y pervivencia del mundo clásico: Homenaje al profesor Juan Gil*, 5 vols. (Madrid: 2015) I 2215–2228.

Pontecorvi A., "Alcune note sul catalogo di Stephan Plannck", in Farenga P. (ed.), *Editori e edizioni a Roma nel Rinascimento* (Rome: 2005) 91–118.

Pseudo-Pliny the Younger, *De viris illustribus Romae* (Venice, no printer named [but Giovanni and Gregorio de' Gregori]: 1486). ISTC ia01389000.

Pulejo E., *Un'umanista siciliano della prima metà del secolo XVI (Claudio Mario Aretio)* (Acireale: 1902).

Reimann H., "Tomasi di Lampedusa's Sicily: The Construction of Reality Through Narrative Fiction", *Journal of Mediterranean Studies* 4 (1994) 83–96.

Rundle D., "Humanism Across Europe: The Structures of Contacts", in Rundle D. (ed.), *Humanism in Fifteenth-Century Europe* (Oxford: 2012) 307–335.

Ryder A., *Alfonso the Magnanimous, King of Aragon, Naples, and Sicily, 1396–1458* (Oxford: 1990).

Sage M.M., "The De Viris Illustribus: Authorship and Date", *Hermes* 108 (1980) 83–100.

Sammartano G., *Umanisti marsalesi: T. Schifaldo e V. Colocasio* (Marsala: 1969).

Santoro M., "Humanism in Naples". in Rabil A. (ed.), *Renaissance Humanism. Foundations, Forms, and Legacy*, vol. 1: *Humanism in Italy* (Phildelphia: 1988) 296–331.

Scapecchi P., "Savonarola e la stampa", in Chiabò M. (ed.) *Roma di fronte all'Europa al tempo di Alessandro VI*, 3 vols. (Rome: 2001) II 399–407.

Sciascia L., *La corda pazza. Scrittori e cose della Sicilia* (Turin: 1970; reprint, Milan: 1991).

Pontano Giovanni Gioviano, *Ioannis Ioviani Pontani carmina*, ed. B. Soldati, 2 vols. (Firenze: 1902).

Soranzo M., "'Umbria pieridum cultrix' (*Parthenopaeus* I. 18): Poetry and Identity in Giovanni Gioviano Pontano (1429–1503)", *Italian Studies* 67 (2012) 23–36.

Soranzo M., *Poetry and Identity in Quattrocento Naples* (Farnham – Burlington: 2014).

Sweeny R.D., "The Ascription of a Certain Class of MSS. of the *De viris illustribus* of the Pseudo-Aurelius Victor", *Rheinisches Museum für Philologie* n.s. 111 (1968) 191–192.

Thucydides, *Historia belli Pelonponnensiaci* (Treviso, Jacobus Rubeus Vercellensis: 1483). ISTC it00359000.

Tomasi di Lampedusa G., *Il gattopardo* (Milan: 2002).

Tramontana A., *In Sicilia a scuola con Persio. Le lezioni dell'umanista Tommaso Schifaldo* (Messina: 2000).

Tramontana A., "Nelle scuole siciliane di Tommaso Schifaldo", in Gargan L. – Mussini Sacchi M.P. *I classici e l'università umanistica* (Messina: 2006) 673–692.

Tramontana A., "L'eredità di Costantino Lascari a Messina nel primo '500", in Lipari G. (ed.), *In nobili civitate messanae: contributi alla storia dell'editoria e della circolazione del libro antico in Sicilia* (Messina: 2013) 121–163.

Tramontana A., "Schifaldo, Tommaso", *Dizionario biografico degli italiani* 91 (Rome: 2018): https://www.treccani.it/enciclopedia/tommaso-schifaldo_%28Dizionario -Biografico%29/

Trasselli C., *Mediterraneo e Sicilia all'inizio dell'epoca moderena (ricerche quattrocente-sche)* (Cosenza: 1977).

Tribby J., "Dante's Restaurant. The Cultural Work of Experiment in Early Modern Tuscany", in Bermingham A. – Brewer J. (eds), *The Consumption of Culture 1600–1800. Image, Object, Text* (London – New York: 1995) 319–337.

Vintimiglia Giovanni, *De' poeti siciliani libro primo* (Naples, S. d'Alecci: 1663).

Zacchia Laudivio, *Epistolae magni Turci* (Treviso, Gerardus de Lisa: 1475). ISTC im00059000.

Zacchia Laudivio, *De captivitate ducis Iacobi*, ed. A. Grisafi (Florence: 2013).

Zeldes N., *'The Former Jews of This Kingdom': Sicilian Converts after the Expulsion, 1492–1516* (Leiden: 2003).

Zeldes N., "Christians, Jews, and Hebrew Books in Fifteenth-Century Sicily: Between Dialogue and Dispute", in Yuval I.J. – Ben-Shalom R. (eds.), *Conflict and Religious Conversation in Latin Christendom* (Turnhout: 2014) 191–220.

CHAPTER 11

Customization of a Latin Emblem Book by a Vernacular Owner: Unknown German Poems to a Copy of Vaenius's *Emblemata Horatiana* (first edition, 1607)

Karl A.E. Enenkel

How does the customization of books affect their use, reception, reading, and interpretation? Manuscript additions to printed books are, of course, of paramount interest because they may contain important information about the ways and methods in which owners (or customizers) of books used, read, and interpreted them.[1] Latin emblem books are of special interest because Alciato (together with his early printers Heinrich Steyner and Chrestien Wechel) designed the genre originally as a combination of Latin texts and images, while the illustrated book had deep roots in vernacular literature.[2] It is no surprise that the *Emblematum libellus* was soon embraced by vernacular readers; a couple of years after its first edition, Wechel published Alciato's emblem book equipped with a French translation (made by Jehan Le Fevre), together with the Latin epigrams, under the new title *LIVRET des Emblemes de maistre Andre Alciat mis en rime francoyose et presente a Monseigneur Ladmiral de France* (Paris: 1536).[3] Thus, from the first phase on, the emblem book represents an interesting case of a crossover of Latin and vernacular literature, of poetry and the visual arts, and of popular and learned literature, and this remains true for the emblem production of the sixteenth and seventeenth centuries. When Latin emblem books appeared, they almost immediately drew the attention of vernacular readers too, and frequently they were (re)published with vernacular emblematic poems, sometimes as bilingual (Latin and vernacular) editions, sometimes as multilingual ones. Because in the sixteenth and seventeenth centuries the number of vernacular readers was ever-growing, it is not hard

1 For technical help with the illustrations I am grateful to Lukas Reddemann, for the correction of my English to Meredith MacGroarty.

2 For these aspects, cf. Enenkel K.A.E., *The Invention of the Emblem Book and the Transmission of Knowledge, ca. 1510–1610* (Leiden – Boston: 2019) 3–230, with further literature.

3 Cf. Green H., *Andrea Alciati and his Books of Emblems: A Biographical and Bibliographical Study* (New York: 1872) no. 10, p. 126–129.

© KONINKLIJKE BRILL NV, LEIDEN, 2024 | DOI:10.1163/9789004680562_012

to understand that interest in the vernacularization of emblem books was so conspicuous. This was surely enhanced by another phenomenon, a peculiarity of emblematic images: from the very first appearance of emblem books, the images did not speak for themselves and did not have fixed and stable meanings. This means that vernacular readers who had difficulty understanding the images in Latin emblem books, critically required vernacular explanatory poems.

All this goes for Otho Vaenius's *Emblemata Horatiana*, which appeared in 1607 in Antwerp,[4] and one may say *a fortiori*, because Vaenius envisioned a very particular and demanding type of reader engagement that transcended the standard parameters of the emblem book. The *Emblemata Horatiana* did not contain proper emblematic epigrams, but instead offered a combination of textual fragments from Horace's *Opera*, and likewise other classical Latin (and even Greek) authors, poets, and prose writers, plus *apophthegmata*, proverbs, and Latin *sententiae*, with engraved images. Another difficulty was that the images were not meant to illustrate simply a certain poem by Horace, but a philosophical *locus communis* (commonplace).[5] Vaenius must have been well

4 *Q. Horati Flacci Emblemata. Imaginibus in aes incisis Notisque illustrata, studio Othonis Vaenii Batavolugdunensis* [...] *Auctoris aere et cura* (Antwerp, Hieronymus Verdussen: 1607).

5 For a close analysis of these aspects, cf. my "The Transmission of Knowledge via Pictorial Figurations: *Vaenius' Emblemata Horatiana* (1607) as a Manual of Ethics", in Enenkel, *The Invention of the Emblem Book* 365–438, and my "Horaz als Lehrmeister der Ethik: Vaenius' *Emblemata Horatiana*", in Laureys M. – Dauvois N. – Coppini D. (eds.), Non omnis moriar. *Die Horaz-Rezeption in der neulateinischen Literatur vom 15. Bis zum 17. Jahrhundert* [...], Noctes Neolatinae 35, 1 (Hildesheim – Zurich – New York: 2020), vol. 2, 1243–1305; on the *Emblemata Horatiana*, especially its interpretation as a Neo-Stoic manifesto, cf. Gerards-Nelissen I., "Otto van Veen's *Emblemata Horatiana*", *Simiolus* 5 (1971) 20–63; Forster L., "Die *Emblemata Horatiana* des Otho Vaenius", *Wolfenbüttler Forschungen* 12 (1981) 117–128; Mayer R., "Vivere secundum Horatium: Otto Vaenius' *Emblemata Horatiana*", in Houghton L.B.T. – Wyke M. (eds.), *Perceptions of Horace. A Roman Poet and His Readers* (Cambridge: 2009) 200–218; and Ludwig W., "Die *Emblemata Horatiana* des Otho Vaenius", *Neulateinisches Jahrbuch* 15 (2013) 219–229. As I have shown in "Horaz als Lehrmeister der Ethik" and "The Transmission of Knowledge via Pictorial Figurations", only a certain part of the *Emblemata Horatiana* can be labelled as 'Neo-Stoic'; the others contain other topics, tendencies, and perspectives of ethical advice, arranged in ethical commonplaces.

This method of composition, i.e. the arrangement of the *Emblemata Horatiana* under commonplace headers, is mirrored by the *inventio* of the various *lemmata* and the quotes from Horace. Margit Thoefner thought that Vaenius's *inventiones* are the result of a complete reading of all of Horace's poems, which lasted nine years (??), and thus he illustrated Horace's verse on the basis of an intense reading process (cf. Thoefner M., "Making a Chimera: Invention, Collaboration and the Production of Otto Vaenius' *Emblemata Horatiana*", in Adams A. – van der Weij M. [eds.], *Emblems of the Low Countries: A Book Historical Perspective*, Glasgow Emblem Studies 8 [Glasgow: 2003] 17–44); in my "Horaz als Lehrmeister der Ethik"

CUSTOMIZATION OF A LATIN EMBLEM BOOK BY A VERNACULAR OWNER 327

aware, first, of the importance of vernacular audiences because he worked in the polyglot town of Antwerp,[6] and second, of the fact that many of his potential readers would be unable to understand his new and demanding emblem book. Therefore, already during the preparation of the Latin edition he ordered Dutch and French quatrains, which he published in an extended edition of the *Emblemata Horatiana* that appeared in the same year, 1607. In a recent study, Paul Smith and I tried to define the function of the Dutch and French poems and to tease out in what ways these textual additions affected the interpretation and reception of the emblems.[7]

This contribution focusses on a copy of the first (Latin) edition of Vaenius's *Emblemata Horatiana* from 1607, which was customized by an early seventeenth-century German owner, who added poems in his own hand to the

I have demonstrated that Vaenius worked in a much different way: that he used intensively a collection of commonplaces of Roman poets, the *Sententiae et proverbia ex Latinis poetis* of 1547 (and other editions).

Marc van der Poel was interested in the material fragmentation of the classical poet Horace and the lesser importance of the fragments in the later editions (the 1612 edition, and Gomberville's and Leclerc's works); cf. Poel M. van der, "Venius' *Emblemata Horatiana*: Material Fragmentation of a Classical Poet", in idem (ed.), *Neo-Latin Philology: Old Tradition, New Approaches* (Leuven: 2014) 131–164. Van der Poel rightly assumes that Vaenius composed his texts on the basis of a commonplace book; in his conclusion, he states that the *Emblemata Horatiana* 'was originally an illustrated commonplace book and it developed' 'into a book of moral emblems' (149). In our view the process of the 'development' of the *Emblemata Horatiana* seems to be more complex and complicated than that: actually, both aspects, the illustrated commonplace book and the 'book of moral emblems', are there in the very first edition, and in the later editions as well. For example, Gomberville's version of 1646 is no less a commonplace book than Vaenius's original Latin edition of 1607, the augmented edition with the Dutch and French quatrains of 1607, or the multilingual edition of 1612. Van der Poel does not study the Dutch and French quatrains of the 1607 edition; he is certainly right with stating that 'the various editions of the *Emblemata Horatiana* need to be studied in more detail'.

It is a nice circumstance that almost the complete album of Vaenius's preparatory drawings is preserved in the Pierpont Morgan Library in New York; see Stampfle F., *Netherlandish Drawings of the Fifteenth and Sixteenth Centuries and Flemish Drawings of the Seventeenth and Eighteenth Centuries in the Pierpont Morgan Library* (New York: 1991) 65–99 (nos. 113–215).

6 Cf. Blanco M., "L'emblématique plurilingue à Anvers: Otto van Veen (1557–1626) et l'"humanisme vernaculaire"", in Béhar R. – Blanco M. – Hafner J. (eds.), *Villes à la croisée des langues (XVIᵉ–XVIIᵉ siècles). Anvers, Hambourg, Milan, Naples et Palerme / Städte im Schnittpunkt der Sprachen (16.-17. Jahrhundert). Antwerpen, Hamburg, Mailand, Neapel und Palermo* (Geneva: 2018) 713–738.

7 Enenkel K.A.E. – Smith P.J., "Vaenius's Pluri-Medial Horace: Images for Contemplation, Primer of Philosophy, Iconological Templates for Artists, Latin Commonplace Book, and Vernacular Emblem Book", in Enenkel K.A.E. – Laureys M. (eds.), *Horace Across the Media* (Leiden – Boston: 2022) 212–331 Intersections 82. For the multilingual edition of 1607, cf. https://reader.digitale-sammlungen.de/de/fs1/object/display/bsb11347961_00012.html.

Latin text. When I bought the book, I first supposed that the German verses had been copied in from one of the later printed editions of the *Emblemata Horatiana* that contain German poems – such as the ones by Philipp von Zesen from 1656 (in German and Latin)[8] or Anthonis Jansen van Tergoes from 1684 (in four languages).[9] However, it turned out that no printed version of these verses could be found. It is not self-evident what their status is. For example, they might presage a projected bilingual edition of the *Emblemata Horatiana* (Latin and German) similar to the trilingual edition Vaenius himself published in Antwerp in 1607. If this was the case, the writer did not succeed. After the first sixteen emblems, he stopped systematically adding poems, and he picked out only seven more emblems to equip with his German verses. It seems that these emblems discussed topics that were particularly appealing to him, viz., they reflected his personal interests.[10] However, the form of the verses suggests that their author was not a trained writer or professional poet, and nor do they indicate that he had a clear literary concept in mind. It is remarkable in this respect that the length and rhyme scheme of the verses are conspicuously varied, whereas the vernacular poems in the plurilingual editions either edited by Vaenius himself, in 1607 and 1612, or made by others, such as Philipp von Zesen, are composed according to a certain metrical scheme with the same number of verse lines. For example, the Dutch and French poems of the 1607 edition are all quatrains, and the second Dutch and French poems are all eight-liners (and so are the Italian stanzas). In comparison: some of the 23 German poems in our copy are four-liners (8), some five-liners (3), some six-liners (8), and others contain seven verses (2), or eight, nine, or even eleven lines.[11] This amounts

8 von Zesen Philipp, *Moralia Horatiana – das ist horatzische Sitten-Lehre. Aus der Ernst-sittigen Geselschaft der Alten Weise-meistern gezogen* [...] *Und mit 113 in Kupfer gesto-chenenn Sinn-Bildern und eben so viel Erklärungen und andern Anmärkungen vorgestellet: Itzung aber mit neuen Reim-Bänden geziret und in reiner Hochdeutschen Sprache zu Lichte gebracht durch Filip von Zesen* (Amsterdam, Cornelis Dankers Kornelis de Bruyn: 1656). Cf. von Zesen Philipp, *Sämtliche Werke*, unter Mitwirkung von U. Maché und V. Meid ed. F. van Ingen, vol. XIV (Berlin – New York: 1997), and the facsimile edition, ed. W. Bauer, 2 vols. (Wiesbaden: 1963).

9 *Othonis Vaenii Emblemata Horatiana, imaginibus in aes incisis atque Latino, Germanico, Gallico et Belgico carmine illustrata* (Amsterdam, Henricus Wetstenius: 1684).

10 E. 64, "Paupertatis incommoda" (p. 134); E. 65, "Nil ego contulerim iocundo sanus amico" (p. 136); E. 80, "Ex vino sapienti virtus" (p. 166); E. 81, "Tempera te tempori" (p. 168); E. 82, "Tempus rite impensum sapiens non revocat" (p. 170); E. 83, "Post mortem cessat invidia" (p. 172); and E. 87, "Culpam poena premit comes" (p. 180).

11 Four verses in E. 1, "Virtus inconcussa" (p. 8); E. 2, "Virtutis gloria" (p. 10); E. 4, "Virtus immortalis" (p. 14); E. 6, "In medio consistit virtus" (p. 18); E. 7, "Medio tutissimus ibis" (p. 20); E. 65, "Nil ego contulerim iocundo sanus amico" (p. 136); E. 81, "Tempera te tem-pori" (p. 168); E. 82, "Tempus rite impensum sapiens non revocat" (p. 170); 5 verses in E. 5,

CUSTOMIZATION OF A LATIN EMBLEM BOOK BY A VERNACULAR OWNER 329

to seven different poetic forms for only twenty-three poems. The sequence of rhymes is a bit monotonous (if not clumsy) in a couple of the poems; for example, the four repetitions of the same rhyme in the four-liner to emblem 7 (A-A-A-A),[12] the six-liner to emblem 16,[13] and the eleven-liner to emblem 87.[14] All this suggests that the composition of the German poems in the said copy have a more spontaneous and personal character, and that the author-owner likely customized it with poems for his private use, i.e., for private reading and meditation.

His customization of the *Emblemata Horatiana* was triggered by the complex composition of the texts and the images, the demanding compilation of the various topics (*loci*) from numerous textual fragments, the learned discourse of both texts and images, and not least by the Latin language, which is especially demanding both because of the complexity of Horace's poetry and because of the fact that his poems were presented only in a fragmentary state. The unknown German owner of our copy surely had no access to either Vaenius's plurilingual editions of the *Emblemata Horatiana* of 1607 (Latin, Dutch and French) or 1612 (Latin, Dutch, French, Spanish, and Italian), Philipp von Zesen's *Moralia Horatiana – das ist horatzische Sitten-Lehre* of 1656, or Anthonis Jansen van Tergoes's *Othonis Vaenii Emblemata Horatiana* of 1684, which could have helped him to understand the sense of the emblems. A close reading and comparison with the vernacular poems in these editions show that there are no borrowings in the German poems of our copy.

There is no owner's entry in our copy, nor is there any other evidence that could lead to a personal identification of the author of the poems (as far as I can see). However, there are certain indications that allow us to draw a kind of profile of the author. First, it is almost certain that he must have been a man (which is probably no surprise, but of course, women were owners of emblem books as well). The poem to emblem 16, "Voluptatum usurae, morbi

"Virtuti Sapientia comes" (p. 18); E. 8, "Virtus in actione consistit" (p. 22); E. 80, "Ex vino sapienti virtus" (p. 166); 6 verses in E. 3, "Naturam Minerva perficit" (p. 12); E. 9, "Virtus invidiae scopus" (p. 24); E. 11 "Animi servitus" (p. 28), 13 "Vis institutionis" (p. 32), 15 "Fructus laboris gloria" (p. 36), 16 "Voluptatum usurae, morbi et miseriae" (p. 38); E. 64, "Paupertatis incommoda" (p. 134); E. 83, "Post mortem cessat invidia" (p. 172); 7 verses in E. 12, "Animi servitus perpetua" (p. 30); E. 14, "Incipiendum aliquando" (p. 34); 8 verses in E. 10, "Amor virtutis" (p. 26); 9 verses in E. 17, "Crapula ingenium offuscat" (p. 40); and even 11 verses in E. 87, "Culpam poena premit comes" (p. 180). A translation on a verse of Horace's odes on p. 204 is added by another hand.

12 See p. 20.

13 Emblem 16, p. 38: A-A-A-A-B-B (übt – liebt – verfürt – disponirt).

14 Emblem 87, p. 180: A-A-A-A-B-B-C-C-C-D-D (Nacht – auffwacht – umbracht – gedacht – wol – ein mohl – ebe – lebe – ergebe – buß – fuß).

et miseriae", is clearly written from a male perspective. The Latin texts advise the reader to refrain from sensual pleasures because they bring about 'dolor' ('sorrow, grief, remorsefulness'), make one an addict and slave ('servus'), and (as the title of the emblem has it) because they cause misery ('miseriae') and 'illnesses' ('morbi'). The Antwerp emblematist interpreted the final effects of the *voluptates* above all as mental pain ('droefheyt' – 'sorrow, grief' – and 'ber-ouw' – 'contrition, remorsefulness'), as the accompanying philosophical texts (by Seneca the Younger and a certain 'Democrates') demonstrate (they address the Stoic *passiones animi*),[15] as also does Vaenius's Dutch epigram, which he added in the 1612 edition of the *Emblemata Horatiana*:

> Wilt van de quade wellust vluchten,
> Want *lang bedroeft* haer korte vreught.
> Haer woecker is een deerlijk suchten.
> Seer dier becopt men haer geneucht [...]
> Na wellust *droefheyt* haestich groeyt,
> Die langher duert met *swaer berouwen* (p. 38).

> Avoid evil lust,/ Because her short pleasure causes long sorrow./ Her interest is a pitiful moaning./ After lust sorrow quickly grows,/ That lasts much longer and brings about contrition.

The concepts of sorrow and contrition suggest that Vaenius himself included the perspective of Christian meditation. Although the Antwerp emblematist regarded the awful results of lust in the first place as mental pain and disease ('droefheit'), he also expressed physical symptoms in the image: He depicted an ill man in his bed with a medical doctor and his weeping wife [Fig. 11.1A, right upper corner].

The German author's male perspective appears from the way in which he conceived sensual pleasures: *to drink too much alcohol* ('zuviel sauffen') and *to have sex with prostitutes* ('gredlin lieben ahn hertz'): 'Wer in wollust sich täglich übt,/ Frißt, saufft zuviel, das Gredlin liebt/ Ahn hertz [...]' (p. 38) [Fig. 11.1B].[16] 'Gredlin' (or 'gretlin', 'Grete') is a contemptuous word for a woman, with the denotation of 'harlot, trull, prostitute, slut' and negative associations, such as morally reprehensible behaviour, depravity, and a lack of chastity.[17] Thus,

15 Vaenius quotes fragments from *Epistulae ad Lucilium* 51, 5; 39, 5, and 51, 8.

16 'Who on a daily basis exercises himself in lechery/ and gluttony, who drinks too much, and has too much sex with a trull [...]'.

17 Cf. *Frühneuhochdeutsches Wörterbuch* (https://www.fwb-online.de/lemma/grete.s.1f), s.v. "grete": 'abwertend für: "Mädchen, Frau"; speziell: "schlechte, unsittliche Frau, Dirne"'.

in a marked difference from Vaenius's vernacular epigram, the German poet addresses his moral warning exclusively to men: What happens to a man 'who has sex with a trull'? He falls ill with sexual diseases and is forced to undergo medical treatment, in 'the hospital or the pox house': 'Der Leib (wird) so übel disponiert,/ Daß ihn zuletzt muß fegen auß/ Der Arzt, Spithal und Blaterhauß' – 'The body gets in such a terrible disorder,/ that it must be purged/ By a doctor, in the hospital or pox house' (p. 38) [Fig. 11.1B]. Also, 'zu viel sauffen' was a typically male behaviour, *a fortiori* among the German nobility, and it was discussed many times in sixteenth- and seventeenth-century moral literature. Apparently, the author of the German poems was especially interested in this topic, as he composed poems to two other Horatian emblems which deal with drinking habits (E. 17 and 80). Emblem 17 is about a terrible hangover after drinking too much wine, and is again written from a male perspective; it shows 'Ein Mann, der aller sinn beraubt,/ Kranck ist von hertzen, hirn und haupt' – 'a man who has totally lost his mind,/ and is ill in his heart, his brains, and his head' (p. 40). The image shows a man who seems to have lost consciousness and suffers from a terrible headache [Fig. 11.1C].[18] In emblem 80, "Ex vino sapienti virtus" – "The Wise man gains virtue from wine", Horace (actually in a drinking song, *Odes* I, 7) and Vaenius advise a dear friend (Horace) or the Wise man (Vaenius) to relax, enjoy life, and drink (p. 167–168).[19] As Vaenius puts it in his 1612 epigram: 'Soo set bij wijlen ook ter zijden/ Den arbeyt en des droefheyts pijn/ Met wijn die 'therte doet verblijden [...]' – 'Thus, brush aside at times/ The pain of labour and sadness/ With wine that makes your heart happy [...]' (p. 166). However, in a marked difference from Horace, the German poet's advice boils down to be very cautious and moderate when drinking, and to imbibe for a short period only – otherwise the person in question will act like a fool: 'ein zeijtlang: Nimbt doch sie in acht:/ Ein Narr es aber übermacht,/ Biß er sich hatt umb alles bracht' – 'But he (the Wise man) keeps carefully in mind: only for a while./ Because, a fool, he overdoes,/ Until he has lost everything' (p. 166).

In emblem 11, our poet identifies with the patrician or nobleman who returns home and discovers that he has been cuckolded by his wife and her

18 Also in his description of the iconography, Vaenius states that the emblem is about a male person: 'Hic crapula et vino obrutus [...] nihil differt ab insano' – 'This man who is totally swept away by a hangover because of drinking too much wine [...] does not differ at all from an insane person'.

19 For an in-depth analysis of this emblem cf. my "The Transmission of Knowledge via Pictorial Figurations" 374–379, and section 3, "Antiquarian Learning, Emblematic Intertextuality, and Christian Messages: The Construction of Horatian Emblems in Icon, Commonplace, and Vernacular Poems" of Enenkel – Smith, "Vaenius's Pluri-Medial Horace".

FIGURE 11.1A Vaenius, *Emblemata Horatiana*, Engraving to E. 16, "Voluptatum usurae, morbi et miseriae" (p. 39)

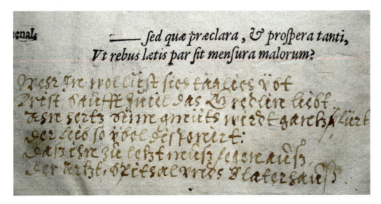

FIGURE 11.1B German poem to emblem 16 (p. 38)
PRIVATE COLLECTION KARL ENENKEL

FIGURE 11.1C Engraving to emblem 17, "Crapula ingenium offuscat"

lover [Fig. 11.2]. In his verses he seems to be pleased that the adulterer, 'bekompt ein solchen lohn/ De hie empfecht uff frischer that,/ Der eims Ehbett besudelt hatt' – 'is paid back in such a way,/ And, having gotten caught red-handed, receives here his reward,/ He who soiled one's marriage bed' (p. 28). The expression 'soiled one's marriage bed' seems to indicate that the author of the poem identified with the married man who wields a sword. Thus, it is clear that the author was no cleric (which other remarks also make apparent); he was probably a married man, too, and, as we will see below, it is likely that he was a nobleman.

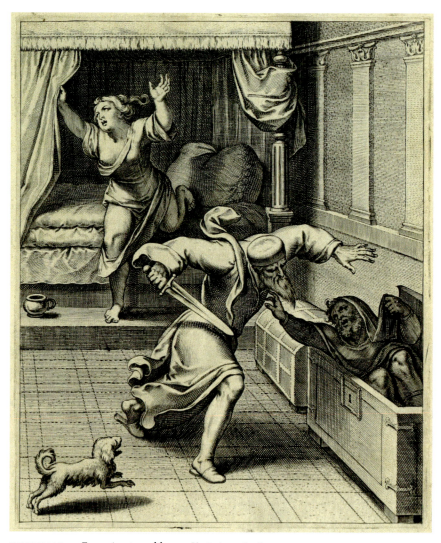

FIGURE 11.2 Engraving to emblem 11, "Animi servitus"

Almost as a matter of course, the author of the poems was a 'pious' Christian 'man'. In his poem to emblem 10, "Amor virtutis", he composed a moral which was not formulated as such in any of the Latin texts: *'Ein fromer Mann* ohn scheuw und schlecht,/ Auß Lieb zur tugend thut was recht' – '*A pious man* without evil or fear/ Acts righteously, just because of his love for virtue' (p. 26). It is noteworthy that emblem 10 is not specifically about religion or piety, but about *sola virtute* as the principle of ethical behaviour: Good people do the

CUSTOMIZATION OF A LATIN EMBLEM BOOK BY A VERNACULAR OWNER 335

right thing not because they are constrained by laws or terrified by punishments, but simply because of their love for virtue. There is nothing specifically Christian in Vaenius's emblem, neither in the texts nor in the image [Fig. 11.3A, emblem 10].[20] The image shows a scene that seems to take place in antiquity (cf. the classicizing architecture, the antique vessels on the table, the bearded heads of the two men in the middle, the Minerva-like goddess in the background [actually *Virtus*]), and Vaenius's explanatory text[21] expresses the Stoic thought that the good man ('vir bonus') acts righteously just because of his love for virtue.[22] However, our German poet had no affinity with Stoicism, and maybe for that reason he interpreted the emblem in a Christian way. In general – as we will see – our poet had little interest in ancient philosophy, whereas Vaenius had conceived his *Emblemata Horatiana* (among other things) as a primer in philosophy.[23] This is a phenomenon of appropriation one can detect in almost all customized emblems by the German owner: The poems rarely address the philosophical concepts and thoughts offered by Vaenius, but break them down into physical and practical advice, popular wisdom, or common Christian morals.

The owner of our copy had certainly mastered Latin, although he was not a brilliant Latinist. In his poems, he did not try to translate any of the Horatian fragments with their demanding choice, combination (*callida iunctura*), and order of words (*positio verborum*), and their sublime stylistic subtlety. In general, he avoided translating the texts offered by Vaenius in any literal or direct manner. Rather, he preferred to compose his poems as descriptions and interpretations of Vaenius's engraved images. Although he did not understand the emblems he customized exactly in the same way as Vaenius, this does not mean that he was an uneducated man. Most noteworthily, he had some understanding of emblems, and he felt able to identify emblematic figures, or, more generally, personifications of virtues and vices. For example, in his poem to emblem 10, "Amor virtutis" (p. 26), he identified the terrifying female personification to the left [Fig. 11.3A] as 'Raach' (Vengeance) [Fig. 11.3B], although Vaenius did not designate her as such in his explanatory text,[24] but as 'Poena', i.e., the personification of Punishment. That Vaenius certainly meant this female figure to represent Poena becomes evident from the fact that he

20 Accordingly, in his Dutch epigram, Vaenius talks solely about 'deught' (p. 26, virtus) in a general sense, without any bias to Christian piety.

21 'Pravus, instigante natura […] amplectentes'.

22 See below.

23 For this aspect, cf. my remarks in: Enenkel – Smith, "Vaenius's Pluri-Medial Horace".

24 'Pravus […] amplectentes' (p. 26).

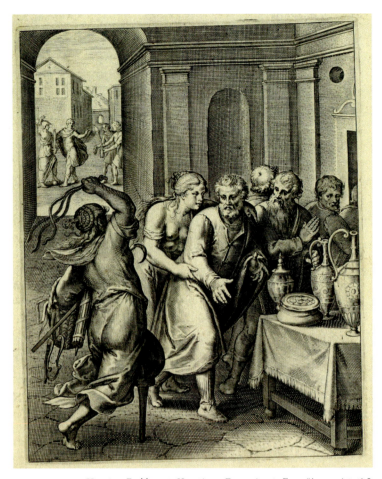

FIGURE 11.3A Vaenius, *Emblemata Horatiana*, Engraving to E. 10, "Amor virtutis"

FIGURE 11.3B German verses to emblem 10 (p. 26)
PRIVATE COLLECTION KARL ENENKEL

construed her as an image to Horace, *Odes* III, 2, 29–32: 'Raro antecedentem scelestum/ Deseruit pede Poena claudo' – 'Rarely does peg-legged Poena leave alone/ A criminal who is haunted by her'.[25] Accordingly, in his Dutch epigram to the 1612 edition, Vaenius called her 'Straffe' – 'Punishment'. The German poet, however, interpreted her as a personification of Vengeance ('Raach'). His poem is construed as an ekphrasis of Vaenius's engraved image (ll. 1–6), followed by a concise moral (ll. 7–8):

> Nimb war, wie hier d'Natur weist ahn
> Zum Angriff unnd Tiebstal ein Mann.
> Davon ihn nicht thut halten ab,
> Daß er dazu nicht willen hab,
> Sondern weil er *die Raach* erplickt
> Die vor ihm steht, ihm drauwt den Strick.
> Ein fromer Mann ohn scheuw und schlecht,
> Auß Lieb zur tugend thut was recht (p. 26) [Fig. 11.3B].

> Look, how here (in the image) the personification of Nature incites/ a man to attempt theft./ He is not deterred from the crime,/ because he did not want to commit it,/ but because he discerns the personification of Vengeance/ standing in front of him and threatening him with the rope/ A pious man without evil or fear/ Acts righteously, just because of his love of virtue.

The German poet identified the figure to the left [Fig. 11.4A] as 'Raach', or Nemesis, because he was acquainted with Alciato's emblem 71 in Jeremias Held's German translation (in Sigmund Feyerabend's edition) [Fig. 11.4B]:[26]

> Die unbarmhertzig *Göttin der Rach* (Goddess of Vengeance)
> Volgt dem Menschen auff dem Fuß nach.
> Den Arm hebt sie mit einer Handt
> In der andern ein Zaum (bridle) und Bandt (rein).
> Damit gibt sie uns zu verstohn,
> Das keiner soll sein nechsten thon

25 Cf. emblem 87 discussed below.

26 For this edition of the *Emblematum liber* cf. Green, *Andrea Alciati*, no. 74, p. 189–190; Landwehr J., *German Emblem Books 1531–1888. A Bibliography* (Utrecht: 1972) 29; Daly P.M. (ed.), *Andrea Alciato, Jeremias Held, Held's translation of Alciato's Emblematum Liber (1566). Facsimile Edition Using Glasgow University Library SM 45*, Imago Figurata Editions 4 (Turnhout: 2007); Höpel I., *Emblem und Sinnbild. vom Kunstbuch zum Erbauungsbuch* (Frankfurt a.M.: 1987) 57–66.

FIGURE 11.4A Detail of Fig. 11.3A

FIGURE 11.4B Personification of Nemesis or 'Rach'. Illustration to Andrea Alciato, *Emblematum liber*, ed. Held (Frankfurt a.M.: 1567), no. 71, "Nec verbo nec facto quenquam laedendum"

> Bleidigen weder mit that noch mundt,
> Sonder halt maß zu aller stundt.

Vaenius had indeed used the same source; he construed his personification of Poena not only after Horace's description in *Odes* III, 29, 29–32 ('pede Poena claudo' – 'peg-legged Poena'), but also after Alciato's Nemesis emblem and its accompanying image designed by Virgil Solis for Sigmund Feyerabend's edition (1567 etc.) [Figs. 11.4A and 11.4B].[27] From Solis's *inventio* Vaenius derived two attributes which were not part of Alciato's original iconography (i.e., the bridle and the yardstick):[28] the *scourge* (in the right hand) and the *crook* (in

27 For the attribution of the Feyerabend woodcuts to Virgil Solis cf. Green, *Andrea Alciati*, no. 74, p. 190.
28 Alciato's iconography contained only two attributes: the bridle ('frena') and the yardstick ('cubitus'). The yardstick disappeared because Chrestien Wechel and his illustrator misunderstood the Latin word 'cubitus' (yardstick) as meaning 'elbow'. Alciato had drawn a yardstick and bridle as Nemesis's attributes from two epigrams in the *Anthologia Graeca* (XVI, 223 and 224). Nemesis was venerated as a goddess in antiquity: Her attributes, however, e.g., in the important cult of Rhamnus in Attica, were different – Pheidias's cult statue held an apple branch (κλάδος μυλέας) and an offering cup (φιάλη) in her hands.

FIGURE 11.4C
Bernard Salomon, Nemesis, 1551. Woodcut to Alciato's emblem "Nec verbo nec facto quenquam laedendum"

FIGURE 11.4D
Medieval scourge from 1493

the left hand). Both are based on Vaenius's misunderstanding of Solis's image: Solis had depicted Jeremias Held's 'Bandt' ('rein'), i.e., another instrument for controlling the horse [Fig. 11.4B], whereas Vaenius thought it was a crook[29] (an instrument to arrest a criminal). Also, Vaenius mistook the part of the braid (hairband) Solis's figure held in her right hand as a scourge. Solis equipped her with such a long braid in imitation of Bernard Salomon's image [Fig. 11.4C]. Vaenius, however, transformed the braid into a medieval scourge or whip [Fig. 11.4D], which was meant as an instrument of punishment.[30] Our German poet, however, took the scourge as 'den strick' ('the rope'): 'Den Strick' does not denote a whip, but the rope of the hangman.

Interestingly, like the German poet of our copy, Philipp von Zesen interpreted Poena (Punishment) as a personification of Vengeance ('Raecherin'): 'Es ist diese hinkende alsgöttin, die sie verfolget. Diese unversuenliche Raecherin, die mit allerhand ruestung zur abstraffung der laster beladen, peitschet sie tapfer davon weg' – 'It is this limping pseudo-goddess who pursues him. This unforgiving and implacable avengeress (Rächerin), who is equipped with all kinds of instruments of punishment, vigorously lashes him and keeps him away'.[31]

Vaenius's personification of Poena (Punishment) appears a second time in the *Emblemata Horatiana*, in emblem 87, "Culpam Poena premit comes", with slight variations [Fig. 11.4E]. Poena is peg-legged, as in the description by Horace in *Odes* III, 29 (which is the first textual fragment of the emblem), but now her scourge has turned into snakes, which is reminiscent of the snakes in the iconography of the Furiae or Erinyes, the Graeco-Roman goddesses of Vengeance. One may compare, for example, the Fury Tisiphone in the *inventio* by Antonio Tempesta [Fig. 11.4F]. Also, Vaenius's Poena has wings, maybe after

Pausanias I, 33, 2–3: '(in Rhamnus) a little way inland is the sanctuary of Nemesis, the most implacable deity to men of violence. It is thought that the wrath of this goddess fell also upon the foreigners who landed in Marathon [...] (and) were bringing a piece of Parian marble. [...] Of this marble Pheidias made a statue of Nemesis, and on the head of the goddess is a crown with deer and small images of Victory. In her left hand she holds an apple branch, in her right hand a cup on which are wrought Aethiopians' (transl. by W.H.S. Jones, Loeb, Pausanias, vol. I [1959], 179). For the antique goddess or personification Nemesis cf. Stenger J., "Nemesis", in *Der Neue Pauly* 8 (2000), cols. 818–819. The early modern mythographer Cartari included Pheidias's statue (with the drinking cup with the Aethiopians and the crown) in his description (p. 309), but ascribed to it a branch of an ash (instead of apple) tree, and added that the image was not winged. Two pages earlier, however, he had stated that antique statues of Nemesis had wings, in order to express the deity's velocity ('Pennas huic Deae ideo vetustas aptavit, ut adesse velocitate voluci cunctis existimaretur'). Cf. Cartari Vincenzo, *Imagines deorum, qui ab antiquis colebantur* [...] (Lyon, Bartolomaeus Honoratus: 1581), p. 307.

29 Cf. also Felice Stampfle's description of the image, *Sixteenth-Century Netherlandish Drawings* 71: 'Nemesis carries [...] a crook'.

30 Cf. ibidem: 'Nemesis [...] stands ready to flog him with her whip'.

31 Philipp von Zesen, *Sämtliche Werke*, vol. XIV (Berlin – New York: 1997) 60.

CUSTOMIZATION OF A LATIN EMBLEM BOOK BY A VERNACULAR OWNER 341

FIGURE 11.4E Engraving to emblem 87, "Culpam Poena premit comes" (p. 180). The German poet took the female figure to the left to be Serapis

the example of Dürer's Nemesis. Notwithstanding these two additional attributes, the figure certainly represents Poena, as indicated in the texts.[32]

32 Stampfle, *Sixteenth-Century Netherlandish Drawings* 94, correctly thinks that the wings symbolize that the figure will 'overtake the guilty', as it is described in Horace, *Odes* III, 2, 29–32. However, Stampfle erroneously identifies the figure as 'Nemesis' or 'Vengeance': The figure must represent Poena, as the emblematic texts, especially the Horatian text fragment require ('pede Poena claudo').

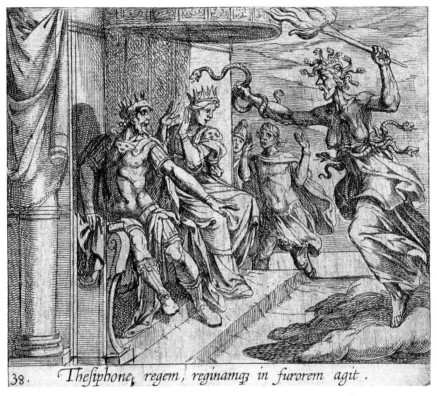

FIGURE 11.4F The Fury Tisiphone, by Antonio Tempesta, 1606. Engraving, illustration to Ovid's *Metamorphoses*

Interestingly, this time the German poet identified the image of Poena [Fig. 11.4E] as the Egyptian 'goddess' ('Göttin') Serapis (p. 180). In the engraving, this is the female figure to the left. He supposed (which was in itself correct) that the image depicted [Fig. 11.4E] the story narrated in the fourth text fragment [see below, Fig. 11.4H]: The story tells us of a murderer who, saved by Serapis, thought that the god favoured him, and in grateful recompense offered a sacrifice. Serapis, however, had only saved him to have him punished by crucifixion,[33] and this is what is represented by the personification of 'Poena' and the wheel in the background. This story from an anonymous Greek poem was transmitted in in Stobaeus's *Florilegium* (*sermo* IX, s.v. "iustitia"), which was available from 1535 in Conrad Gesner's Latin translation.[34] However,

33 'cruci te scias asservari'.
34 For example, Stobaeus Ioannes, *Sententiae ex thesauris Graecorum delectae, quarum autores circa ducentos et quinquaginta citat, in sermones sive locos communes digestae* [...] (Zurich, Christoph Froschauer: 1543, = 2nd edition); and *Epitome Ioannis Stobaei*

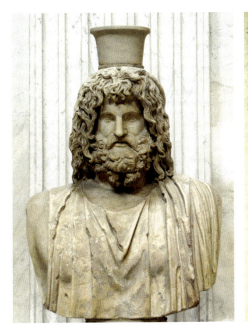 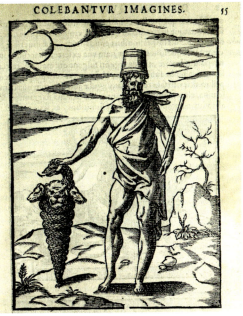

FIGURE 11.4G (*left*) The Graeco-Egyptian god Serapis. Sculpture from the Serapeum of Alexandria. Roman copy from a Greek original from the 4th century B.C. Vatican Museums; (*right*) Serapis. Illustration to Vincenzo Cartari, *Imagines deorum, qui ab antiquis colebantur* [...] (Lyon, Bartolomaeus Honoratus: 1581), p. 55

Vaenius picked it up from one of the later editions of Mirabellius's *Polyanthea seu Florilegium magnum* of ca. 1600 (s.v. "iustitia"), as can be demonstrated by a collation of the texts.[35]

Thus, in the German poem Serapis became a female goddess, although it was actually an important Graeco-Egyptian male god who was usually depicted as a bearded man with a basket of grain on his head[36] [Fig. 11.4G, left and right]. In the 16th and 17th centuries the god Serapis, with his names, iconography, and cult, was well known mainly to learned humanists. Serapis was described

Sententiarum Sive Locorum Communium ex Graecis autoribus [...] *iuxta Conradi Gesneri versionem* [...] *edita per Conradum Lycosthenem* [...] (Basel, Nicolaus Bryling: 1557) p. 107–108.

35 Vaenius's text is identical to *Polyanthea, hoc est, Opus suavissimis floribus celebriorum sententiarum tam Graecarum quam Latinarum exornatarum* [...] *summa fide collegere ad communem studiosae iuventutis utilitatem eruditissimi viri Dominicus Nanus Mirabellius, Bartholomaeus Amantius et Franciscus Tortius* [...] (Lyon, Heirs of Eustathius Vignon: 1600) p. 454, s.v. "iustitia".

36 Serapis was identified with Zeus/Iupiter, Hades/Pluto, Dionysos/Bacchus, and Asclepius/ Aesculapius; cf. Takac S.A., "Serapis", *Der Neue Pauly* 11 (2001), cols. 445–449.

in detail, for example, by Lilio Gregorio Giraldi in his *De deis gentium varia et multiplex historia* of 1548,[37] and in Vicenzo Cartari's *Immagini de i dei* of 1556. Cartari's book provided a clear image of the god: an old bearded man with a basket on his head [Fig. 11.4G, right image]. Our German poet had no access to works such as Giraldi's or Cartari's scholarly mythographies, and therefore had no idea who Serapis really was, or how the deity would look.

> Ein (= einen) Mörder warnet in der Nacht
> Die (*sic*; she) Serapis, daß er (sc. the murderer) auffwacht,
> Ehe er vom einfall würd umbracht
> Eins alten hauß. Drumb er gedacht
> Todschlag gefiel den göttern wol:
> Die Göttin (*sic*) aber noch ein mohl
> Vor ihm erschien, bericht ihn (= ihm) ebe
> Das sie in (= ihn) drumb hett laßen lebe
> Weil er wehr (= wäre) Galgen und drad ergebe,
> Drauff zu empfahen seine buß:
> Der schuldt die straff folgt auff dem fuß [Fig. 11.4H].

> Serapis, she alarmed a murderer in the middle of the night/ and told him to wake up,/ Before he was killed/ By a collapsing house. Therefore, he thought/ That the gods were pleased by murder:/ But the goddess (*sic*) appeared/ Another time To him, just to tell him/ That she had saved his life only/ Because he was destined to receive/ His punishment on the wheel and on the gallows./ Punishment follows hot on the heels of guilt.

We have here the curious customization of Vaenius's Poena as the 'Göttin' Serapis. Although the German poet has here construed a mythological rarity, I doubt that he was motivated by antiquarian interest; anyway, it is clear that he was not equipped with much antiquarian knowledge, and he probably did not have much interest in antiquarian issues either. It is characteristic of his method of customization that he did not pay attention to the Horatian Ode quoted by Vaenius: there he could have found the identification of the depicted personification, i.e., Poena: 'Raro antecedentem scelestum/ Deseruit pede Poena claudo' – 'Rarely does peg-legged Poena leave alone/ A criminal who is haunted by her'.[38]

37 (Basel, Ioannes Oporinus: 1548) p. 271–273.
38 *Odes* III, 2, 31–32.

CVLPAM POENA PREMIT COMES.

——————sæpe Diespiter
Neglectus, incesto addidit integrum:
Rarò antecedentem scelestum
Deseruit pede pœna claudo.

Sequitur superbos vltor à tergo Deus.

Lento gradu ad vindictam sui diuina procedit ira: tàrditatemq́;
supplicij grauitate compensat.

Homicidæ ruinosum iuxta murum dormienti,
Nocte astitisse aiunt Serapin in insomnijs,
Et vaticinatum fuisse: iacens tu surge,
Et iace mutatus ô miserabilis alió.
Hic autem excitatus, mutauit locum: marcidus autem ille
Murus derepentè statim iacuit humi.
Tunc manè sacrificauit Dijs, illos putans delectari homicidis:
Sed Serapis rursus vaticinatus per noctem astans,
Si non permisi te mori, mortem quidem sine tristitia
Nunc effugisti, cruci scias te asseruari.

Ah miser, & si quis primò periuria celat;
Sera tamen tacitis pœna venit pedibus.

Prima peccantium est pœna peccasse. Nec yllum scelus, licèt illud
fortuna exornet muncribus suis, licèt tueatur, ac vindicet, impuni-
tum est: quoniam sceleris in scelere supplicium est.

PRIN-

FIGURE 11.4H Page 180 of the German poet's copy of the *Emblemata Horatiana* (1607)
PRIVATE COLLECTION KARL ENENKEL

Peculiar interpretations of Vaenius's personifications occur frequently in the customizations of the German poet. For example, in his poem to emblem 1, "Virtus inconcussa", he independently interpreted the personifications of virtues depicted in the engraving: The putto with the column (to the right) he identified as 'Standhafftigkeit', the one with the lion (to the left) as 'sterck' [Fig. 11.5A]. This means that he must have been acquainted with the iconography of Constantia with a column which actually existed, e.g., in an engraving by Philipp Galle [Fig. 11.5B], and the one of Fortitudo with the lion, of which there are examples, e.g., by Marco Dente da Ravenna [Fig. 11.5C], Sebald Beham, or Jan Collaert. However, as his Latin description of the iconography demonstrates, Vaenius meant the putto with the column to represent Fortitudo, and the one with the lion to represent Magnanimitas; Constantia is not mentioned by him at all: 'Suntque eius (sc. Virtutis) species variae: Pietas, Iustitia, Prudentia, *Fortitudo, Magnanimitas*, Temperantia' (p. 8). The fact that the German poet did not pay attention to Vaenius's precise descriptions of the iconography means that he felt confident (and maybe also free) to identify emblematic figures.

This appears also from his customization of emblem 64, "Paupertatis incommoda", or "The Disadvantages of Poverty" [Fig. 11.6A].[39] From the accompanying fragment of a Horatian *Ode* (III, 24, 42–44) one can deduce that the 'steep path of virtue' is depicted in the engraving, and that the character of poverty plays an important role: 'Magnum Pauperies opprobrium, iubet/ Quidvis et facere et pati:/ Virtutisque viam deserit arduae' – 'Poverty, that huge disgrace, makes people do and suffer anything and abandon the steep path of virtue'.[40] Vaenius translated the abstract notions of 'pauperies' and 'virtus' into images by conceiving them as personifications: poverty as the female figure (foreground left), who drives forth the Poor Man (foreground middle), and Virtue as the statue in front of the hilltop temple [Fig. 11.6A]. Vaenius himself equipped the emblem with a clear explanation of the iconography: 'Miser hic ad Virtutis atque Honoris templum vix audit vultum attollere, dura ac dira Paupertate rectam ipsi semitam praecludente atque impediente' – 'This miserable man [= here, in the image] hardly dares to raise his face to the temple of Virtus

39 For an in-depth interpretation of this emblem with further bibliographical references, see Enenkel – Smith, "Vaenius's Pluri-Medial Horace", section 3: "Antiquarian Learning, Emblematic Intertextuality, and Christian Messages: The Construction of Horatian Emblems in Icon, Commonplace, and Vernacular Poems".

40 It is noteworthy that this does not reflect Horace's personal opinion, but that of his contemporaries, which he criticizes in the poem. Vaenius did not register this because he picked up the fragment from a commonplace book, and erroneously thought that it represented a philosophical wisdom.

CUSTOMIZATION OF A LATIN EMBLEM BOOK BY A VERNACULAR OWNER 347

FIGURE 11.5A Detail of Vaenius's image to E. 1, "Virtus inconcussa" (p. 9)

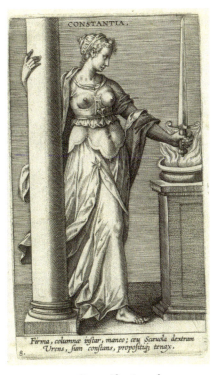

FIGURE 11.5B Personification of Constantia by Philip Galle, 1585–1590. Engraving, 15.2 × 8.7 cm

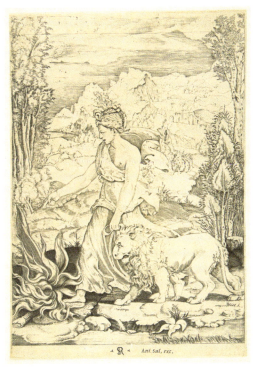

FIGURE 11.5C Personification of Fortitudo with the lion by Marco Dente da Ravenna, 1515–1520 (possibly after a design by Giulio Romano). Engraving, 17.9 × 27.9 cm
TEYLERS MUSEUM HAARLEM

FIGURE 11.6A Engraving to emblem 64 of Vaenius, *Emblemata Horatiana* (Antwerp: 1607), p. 135

and Honos, because hard, bitter Poverty is cutting him off and holding him back from the straight path'.[41] Thus, it is clear that the building on the hilltop is the *temple of Virtus and Honos*. This temple reflects antiquarian scholarship Vaenius picked up from the learned emblematist Sambucus.[42] In Republican Rome, a 'twin-temple' of Virtue and Honour did actually exist, which was

41 On page 134.
42 For the details of is aspect see my remarks in "Vaenius's Pluri-Medial Horace", section 3.

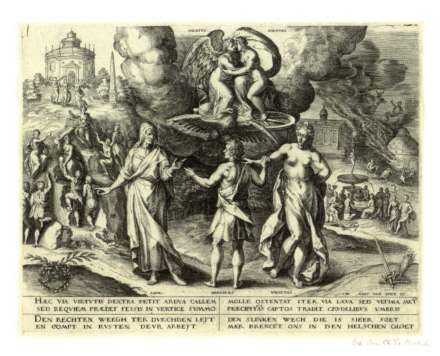

FIGURE 11.6B Johannes Wierix after Chrispijn van den Broeck (died 1591), *Hercules at the crossroads*, standing between the personifications of Labor and Voluptas, engraving, second half of the 16th century
PUBLIC DOMAIN

originally built by Q. Fabius Maximus Verrucosus in 234 B.C. after his war with the Ligurians, in the neighbourhood of the Porta Capena.[43] In his description of the iconology, Vaenius identifies the path leading to the hilltop as the 'straight path', picking up on the concept of the 'steep path' mentioned in Horace's *Ode*; in doing so he refers implicitly to the Christian concept of the steep path to heaven through religious devotion, Christian love, and excellent moral conduct. This Christian concept Vaenius combined with a Christian reading of the myth of Hercules at the crossroads, as it had been presented, among others, by Johannes Wierix and Chrispijn van den Broeck [Fig. 11.6B].

Notwithstanding the antiquarian Roman temple, Vaenius's emblem 64 has a genuine Christian message: The image was designed to stimulate Christian

43 For the building history of the temple see Schaffner B., "Honos", *Der neue Pauly* 5 (1998), col. 713; Platner S.B., *A Topographical Lexicon of Ancient Rome* (Oxford: 1929) 258–260, "Honos et Virtus, aedes", https://penelope.uchicago.edu/Thayer/E/Gazetteer/Places/Europe/Italy/Lazio/Roma/Rome/_Texts/PLATOP*/Honos_et_Virtus.html.

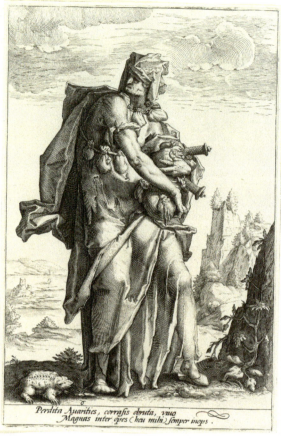

FIGURE 11.6C Attributed to Jacob Matham, after Hendrik Goltzius, personification of Avarita, from the series *The Seven Vices* (1587). https://commons.wikimedia.org/wiki/File:Avarice_-_Jacob__Matham.jpg

FIGURE 11.6D Detail of Fig. 11.6A.

misericordia and trigger acts of charity, such as giving alms. Vaenius depicts the Poor Man as a victim, and he calls him 'miserable'; in the image, his body language radiates oppression and humility. This image of misery Vaenius contrasts with the huge old woman who drives him relentlessly onwards with a bone in her right hand. Interestingly, *Paupertas* is not represented as a figure of misery, but one of aggression and sin. Vaenius produced this effect by giving her the features of the Christian deadly sin of Avarice (Greed), as depicted by Goltzius in the print series *The Seven Vices* [Fig. 11.6C]. The features of the face, the facial expression, and the dress are very similar [Figs. 11.6C and 11.6D]. Actually, the idea of combining *Paupertas* with *Avaritia* already appears in the epigram to Goltzius's *Avarities*:

Perdita Avarities corrasis obruta vivo
 Magnas inter opes (heu mihi) semper inops.

I, doomed Avarice, overmastered by the riches I scraped together,/ Live amidst my wealth – woe is me – always staying *poor*.[44]

The Christian message of the emblem also becomes visible through the scene in the middle ground at left: two beggars are sitting along the way, begging for alms; a patrician walking the path of virtue takes another beggar by the hand and helps him to get up [Fig. 11.6D].

Although Vaenius gave a clear description of the iconography, and although the German poet could have easily incorporated it into his poem (as Vaenius later did in his Dutch verses), he came up with a different interpretation of the emblem, and central to this, I believe, was the process of customization. The poet operated from a perspective that made it difficult for him to either identify with the poor man or evoke the emotion of misericordia. Rather, the image reminded him of the social reality in which he lived. For him, honour was first and foremost a knightly virtue; the knightly status required wealth, military power, and a castle. And thus, he interpreted the twin-temple on the hilltop as a medieval castle [Fig. 11.6E]:

Den Armen blödt der Mangel macht:
Der wirdt von Jederman veracht.
Die Oohnmach ihn treibet immerforth,
Darff auch nicht wol ahnsehn den Ort,
Der vesten hochcrhabnen statt,
Da Würd und Ehr ihr auffkehr hatt. [Fig. 11.6E]

Deficiency makes the poor man a passive coward:/ he is despised by everyone./ *Impotence* (lack of power) drives him forth before her;/ nor may he really look up to the place,/ *to the elevated castle*,/ where dignity and honour dwell.

The medieval castle ('vesten statt, vesten')[45] on an elevated spot functions as a paradigm for the dignity of noblemen. The concept of Paupertas (Poverty) in itself was not very interesting for the German poet, who was probably a

44 Emphasis mine.
45 *Frühneuhochdeutsches Wörterbuch*, https://www.fwb-online.de/search?q=Veste&type =&search: 309a, 36 (nobd., 2. H. 15. Jh.) 'Dar nach fur der kung dar fur die slos, purg und veste [...]'.

FIGURE 11.6E German poem to Emblem 64 (p. 134)
PRIVATE COLLECTION KARL ENENKEL

nobleman. He was more inclined to think in terms of military and political power. And thus, he identified Vaenius's Paupertas as 'Oohnmach', *Impotence* (lack of power). This was the worst nightmare of a nobleman: the loss of power, 'Würd' (dignity), and 'Ehr' (honour), being regarded as a coward ('blöd') and prevented from taking possession of a castle. The principal values of social dignity and honour cause the German poet to break down the concept of virtue to its outward aspects, such as social respect or disrespect: as he puts it, paupers are cowards who will never achieve honour and dignity because *'everybody despises them'*. In his poem, the German owner customized the emblem in a way that made it applicable to himself. This is the reason why he ignored all the other aspects addressed by Vaenius, such as Christian *misericordia* and charity, the concept of the steep and straight path, the moral crossroads, and antiquarian knowledge.

Emblem 8, "Virtus in actione consistit" – "Virtue consists essentially of action" [Fig. 11.7A][46] – offers a moral that is actually very close to the values of nobility. Knights considered themselves as persons who are supposed to show virtue in military action and demonstrate their fortitude and bodily strength. Vaenius had (once more) explained the iconography of the image

46 For an in-depth analysis of this emblem with bibliographical references cf. Enenkel – Smith, "Vanius's Multi-medial Horace", section 7, "The Translation of Horatian Common-Sense Wisdom into Didactic Plates of a Philosophical Primer, and of the Didactic Plates into Vernacular Poems".

CUSTOMIZATION OF A LATIN EMBLEM BOOK BY A VERNACULAR OWNER 353

and identified its personifications, i.e., Virtus (the female figure to the left) and Inertia (Idleness, the old, sleeping man with the donkey): 'Vides hic Virtutem et Inertiam. Illa huic similis videtur, nisi in actionem exsurgat; sine qua nullus ex ipsa fructus redundat, estque veluti nuda sui umbra' – 'Here (in the image) you see Virtue and Idleness. She seems similar to Idleness, except that she comes into action. Without action she bears no fruit and is only something like a bare shade of herself' (p. 22). Both the applicability of the thought and Vaenius's clear description of the image made it comparatively easy for the German poet to customize this emblem:

> Daß Tugend nicht gewinn ein schein
> Der Tregkeitt, soll mans üben fein.
> Ein schiff ohn Ruder, ein Leijr ohn clang
> Pleiben ohn nutz Ihr Leben langh:
> Den Vogel kennt man ahn seim gsang (p. 22) [Fig. 11.7B].

In order to avoid virtue giving the impression of laziness,/ One should very much exercise virtue./ A ship without a rudder, a lute without sound/ Remain useless all their life long:/ A bird is recognized through its song.

There were other elements in Vaenius's emblem, expressed both in the text and in the image, which the German poet did not include in his customization: first, antiquity's concept of fame and glory achieved through praise in literature and the collateral notion that the poet's task is to memorialize virtuous behaviour and transmit it to posterity; second, a comparison of the values of the contemplative versus the active life; third, the dependence of intellectuals (especially poets and philosophers) on their audience: if the audience does not acknowledge them, they remain unheard, as if they did not exist. Vaenius quotes verses from Plautus's *Captivi* and Persius's *Satires* as evidence; Persius: 'scire tuum nihil est, nisi te scire hoc sciat alter' – 'Your knowledge does not count, unless other people know that you are in possession of it';[47] Plautus: 'Saepe summa ingenia in occulto latent' – 'Often the greatest geniuses remain

47 *Satires* 1, 27. Actually, Vaenius did not quote this line in the sense intended by the Roman poet. Persius formulated it as a rhetorical question that was meant as a criticism of the contemporary poets' boundless desire for fame and glory. In the framework of an imaginative dialogue, Persius asks such a poet: 'Does your knowledge really mean nothing to you, except another one knows that you have it?' Vaenius came to this misunderstanding because he had picked up the line from the *Sententiae et proverbia ex Latinis poetis* (p. 121), where it is indeed presented as a statement.

354 ENENKEL

hidden in obscurity'.[48] Fourth, the image also contains a couple of antiquarian elements, such as the ancient Roman tomb with its inscription 'D[is] M[anibus] SR [sacrum]' [Fig. 11.7A], the obelisk, and the Roman book scroll (*volumen*) in the right hand of the poet.[49] The thought that everlasting fame and glory can be achieved (only) through praise in literature is ubiquitous in antiquity, but it is especially stressed by the poets of the age of Augustus (Horace, Virgil, Ovid). Vaenius quotes *Ode* IV, 9, in which Horace promises to make the addressee, Lollius, famous through his verses. Horace argues that heroic deeds do not get recognition if they are not praised by a 'sacred poet'. Vaenius derived the image from Horace's lines 'Paullum sepultae distat inertiae/ Celata virtus' – 'Concealed virtue hardly differs from entombed idleness',[50] by way of rendering virtue and idleness as personifications. The personification of *Inertia*, a man with a donkey,[51] is lying in its tomb, actually an ancient Roman grave tomb (such as those alongside the Via Appia) [Fig. 11.7A]. In the same tomb Virtue (indicated by her symbols of sword, helmet, and pike) is sitting, hidden in the dark. Behind the grave stands a bearded poet equipped with pen and paper, obviously keen to write something, but he is not able to discern Virtue because she is hidden in the grave.

It is essential for the customization of this emblem that the German owner was not particularly interested in the function, value, task, and social position of the intellectual. He did not consider himself a writer, philosopher, or representative of the contemplative life. Furthermore, he was obviously not interested in publishing texts or in living in posterity through the praise of literary works. This is why he did not pick up on the relevance of the main quote, Horace's 'Concealed virtue hardly differs from entombed idleness', nor of the figure of the writer in the image who, adorned with pen and paper, tries to discern Virtue in order to praise her [Fig. 11.7A].

Instead of philosophical thoughts on the active versus the contemplative life, and literary reflections on the role of poetry, poets, and their audience, the author of the German poem reduced the meaning of the emblem to the precept that Virtue must be actively enacted. Instead of arguments, he preferred proverbial expressions: 'the ship without rudder', 'the lute without sound'

48 *Captivi* 165.

49 For the formular, cf. e.g. Sandys J.E., *Latin Epigraphy: An Introduction to the Study of Latin Inscriptions*, 2nd ed. by S.G. Campbell (Chicago: 1971) 62–63.

50 *Odes* IV, 9, 29–30.

51 Vaenius represents Sloth with a donkey (e.g., emblem 5) or a person with a donkey (emblem 8) or just the head of a donkey (emblem 22). For the donkey as an animal accompanying *Sloth*, cf. Blöcker, *Studien zur Ikonographie* 95; Dittrich S. – Dittrich L., *Lexikon der Tiersymbolik. Tiere als Sinnbilder in der Malerei des 14.–17. Jahrhunderts* (Petersberg: 2004).

CUSTOMIZATION OF A LATIN EMBLEM BOOK BY A VERNACULAR OWNER 355

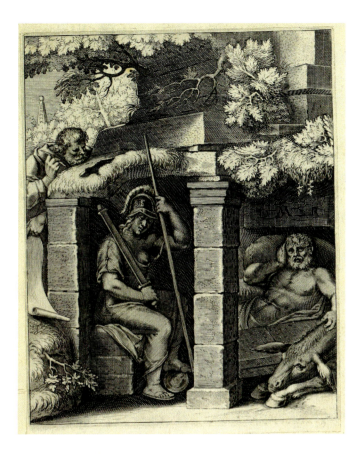

FIGURE 11.7A
Engraving to emblem 8, "Virtus in actione consistit"

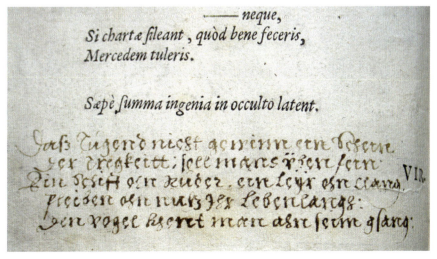

FIGURE 11.7B German poem to emblem 8
PRIVATE COLLECTION KARL ENENKEL

(excerpted from the quote from Claudianus's *De consulatu Honorii*),[52] and 'Am Gesang kennt man den Vogel'. The last one he applied in an unusual way. The proverb is properly used with respect to the *recognition* of things via their characteristics (e.g., donkeys via their long ears); it does not mean, the 'use', raison d'être, or virtue of birds is their song. Probably, the German poet landed upon the addition of 'Den Vogel kennt man ahn seim gsang' [Fig. 11.7B] because this proverb was traditionally part of a series of sayings that contained other recognizable subjects, e.g.: 'Am Gesang (er)kennt man den Vogel,/ den Baum an den Früchten,/ den Narren am Kopf,/ am Klange den Topf'.[53] Some variations of the multiple proverb work with the rhyme words 'Klang' – 'Gesang', e.g.: 'Man kennt den Topf am Klange,/ den Vogel am Gesange,/ den Esel an den Ohren,/ an den Worten den Thoren'.[54] I suspect that the Claudianus fragment 'lyra quae reticet' – 'ein Leijr ohn clang' reminded the German poet of 'den Vogel kennt man am Gesang'.

Interestingly, Philipp von Zesen's epigram is construed according to a very similar pattern: he invokes proverbial expressions instead of teasing out the complex thoughts suggested the textual fragments or describing the allegorical image with its antiquarian elements. Von Zesen used different proverbs; rather than 'Ein schiff ohn Ruder, ein Leijr ohn clang' and 'ein Vogel ohn gesang' he applied 'a lute without strings', 'a rusty rifle', and 'a bow without tension'.[55] The 'eingeruste schus' is a seventeenth-century customization which refers to contemporary artillery. These proverbial expressions serve in Von Zesen's epigram as the decisive argument for the precept 'You should not be lazy':

> Was nuetzt die Laute doch mit seiten nicht bezogen?
> Der eingeruste schus, das pfeil auf schlappem bogen
> Was haben die vor kraft? Sol unsre tugend tuegen,
> So muss sie taetig sein und nicht in schlummer liegen.[56]

52 VIII, 223–224: 'veluti sine remige puppis,/ Vel lyra quae reticet vel qui non tenditur arcus'.

53 Von Düringsfeld I. – Von Reinsberg-Düringsfeld O. Freiherr, *Sprichwörter der germanischen und romanischen Sprachen* (Leipzig: 1872) 210, no. 416 "Erkennen": 'Am Gesang kennt man den Vogel; an den Federn erkennt man den Vogel; den Baum erkennt man an den Früchten [...]'.

54 Ibidem.

55 Von Zesen picked out two of his three images from Claudian, *De consulatu Honorii* VIII, 223–224. Interestingly, Vaenius himself used them in his Dutch poem of the 1612 edition: 'De deught die nimmermeer en blijckt,/ D'ontspannen boogh' of luyt gelijckt,/ Die aen den haeck altijd blijft hangen' – 'Concealed virtue resembles an unbended bow or a lute/ that always stays hung up'.

56 Philipp von Zesen, *Sämtliche Werke*, vol. XIV (Berlin – New York: 1997) 31.

CUSTOMIZATION OF A LATIN EMBLEM BOOK BY A VERNACULAR OWNER 357

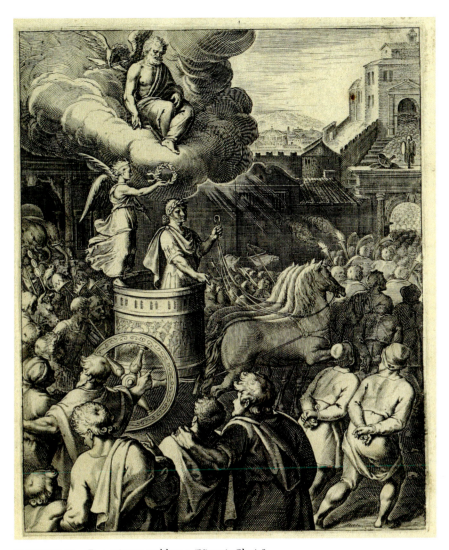

FIGURE 11.8A Engraving to emblem 2, "Virtutis Gloria"

The German poet's lack of interest in antiquarian knowledge and genuine Roman thought appears conspicuously from his customization of emblem 2, "Virtutis Gloria" (p. 10). Vaenius's engraving displays an impressively ekphrastic and very detailed depiction of a Roman triumph [Fig. 11.8A]: a Roman imperator, adorned with the laurel wreath of victory (*corona triumphalis*), stands in a richly decorated carriage drawn by four horses, on the way to the Capitolium (the temple of Jupiter Optimus Maximus), accompanied by the Goddess Victoria, conquered people, and everything that belongs to a Roman

triumph.[57] In front of the imperator are marching first the horn blowers (*cornices*), then the war prisoners (right side); behind the carriage are the kings of the conquered peoples, the bull to be offered at the altar of Jupiter, and war elephants as part of the booty (left side). The procession moves along the Via Sacra, crosses the Forum Romanum, and then ascends the Capitoline Hill (right upper corner). Jupiter with his eagle and thunderbolt is depicted on a cloud (left upper corner), for he is the god in charge of Roman triumphs. The triumph is the ultimate reward for a Roman politician, and his reward of fame and glory: For him it signifies 'touching heaven, the sky, the clouds or the throne of Jupiter',[58] i.e., 'being one of the gods' or achieving eternal glory.

Vaenius's ekphrastic image is carefully constructed, probably after early modern images of a Roman triumph, e.g., drawn or printed copies of the impressive relief of Marcus Aurelius's triumph from the arch of Constantine the Great [Fig. 11.8B], such as the engraving by Nicolas Beatrizet of ca. 1550 [Fig. 11.8C]. On the relief the emperor is depicted in the same way as in Vaenius's engraving, standing on a richly ornamented carriage drawn by four horses, while the goddess Victoria decorates him with a laurel wreath. Moreover, Vaenius has composed a prose ekphrasis to his image, with a careful description of the antiquarian details, such as the 'ivory carriage' ('currus eburneus') of the *triumphator*, the colour of the horses (white), the palm twig, and the laurel wreath. Indeed, the round *currus triumphalis* was also called *currus eburn(e)us* because of the ornamentation made from ivory.[59] The antiquarian details of the ivory carriage and the white horses were derived from Tibullus's *Elegies*, which incorporate a concise image of Messalla's triumph held on 25 September 27 BC.[60] Vaenius explained the iconography in this way:

57 For the Roman triumph cf., i.a., Beard M., *The Roman Triumph* (Cambridge, Mass.: 2007); I. Östenberg, *Staging the world. Spoils, captives, and representations in the Roman triumphal procession* (Oxford: 2009); Künzl E., *Der römische Triumph. Siegesfeiern im antiken Rom* (Munich: 1988); Ehlers W., "Triumphus", in *Realencyclopädie der classischen Altertumswissenschaft* (RE), VII A, 1 (1939), cols. 493–511.

58 Vaenius derived the idea for the image from Horace, *Epistles* I, 17, 33–34: 'To perform great deeds, to present the captivated enemies to the people (of Rome) / That touches Jupiter's throne and reaches the sky' – 'Res gerere et captos ostendere civibus hostes,/ Attingit solium Iovis et caelestia tentat'. Not coincidentally, this is the first text fragment Vaenius added to the image.

59 Ovid, *Epistulae ex Ponto* III, 4, 35; *Tristia* IV, 2, 62.

60 Tibullus, *Elegiae* I, 7, 7–8: 'At te victrices lauros, Messalla, gerentem/ Portabat nitidis currus eburnus equis' – 'The ivory carriage drawn by white horses carried you, Messalla, decorated with the laurels'.

CUSTOMIZATION OF A LATIN EMBLEM BOOK BY A VERNACULAR OWNER 359

'*parcere subiectis et debellare superbos*',[61] recta semita virtutis est: qua quis triumphans, eburneo curru, niveisque vectus equis, Capitolium conscendit, cui palmam ac lauream Victoria tribuit: sicque nubes ac *solium Iouis*[62] vertice quasi *tangit*, famamque inclytis extendit factis, quae nec eripi nec surripi potest umquam neque naufragio neque incendio amitti.

'*To spare the defeated and battle down the rebellious*' (sc. foreign peoples): This is the straight path of virtue. When somebody ascends this path in a triumph to the Capitolium, in the ivory carriage drawn by white horses, he is adorned by Victoria with the palm twig and the laurel wreath, and seems to touch with his crown the clouds with the throne of Jupiter, and to spread his fame with illustrious deeds: No one can ever take or steal them away from him, nor can he lose them in shipwreck or fire.

It is remarkable that the German poet neither mentions the impressive image of the Roman triumph nor picks up the famous formula of Rome's historical mission as expressed in Virgil's *Aeneid* – '*To spare the defeated and battle down the rebellious*' – or the meaning of the Roman triumph Vaenius gave in his prose comment: the Roman idea of becoming immortal through the performance of great deeds. It seems as if the German poet had a very general but knightly 'love of virtue' in mind that leads somehow to 'honour' (in terms of social recognition), and to a curious heavenly reward ('radiation from heaven' – a ray of light or something else? approval by God?):

> Wer liebt unnd ehrt die Tugend schon,
> Dem wirdt Lob Preiß und Ehr zum Lohn
> Und auffgesetzt der Ehren Krantz.
> Sein Haupt noch kürt deß hemels Glantz (p. 10) [Fig. 11.8D].

Whoever loves and venerates beautiful virtue,/ Will receive as a reward praise and honour/ And the wreath of honour, and/ A ray from Heaven[63] will decorate his head.

The German poet's complete disregard of the Roman triumph and the mission of the Roman Empire is noteworthy. It is true that there is a tendency

61 Virgil, *Aeneid* VI, 853.
62 Horace, *Epistles* I, 17, 33–34.
63 The German poet may have alluded to the rays of light which in Vaenius's image come up just under the cloud.

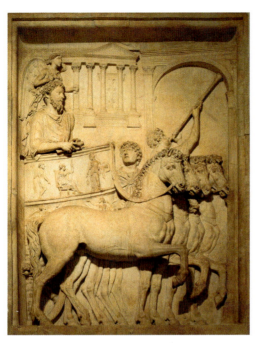

FIGURE 11.8B Relief with the Triumph of Marcus Aurelius, 2nd century BC. Part of the triumphal arch of Constantine, now in the Palazzo dei Conservatori, Rome

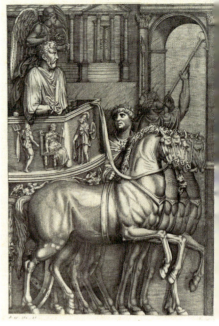

FIGURE 11.8C Nicolas Beatrizet (died 1565), Triumph of Marcus Aurelius, ca. 1550. After the relief on the triumphal arch of Constantine

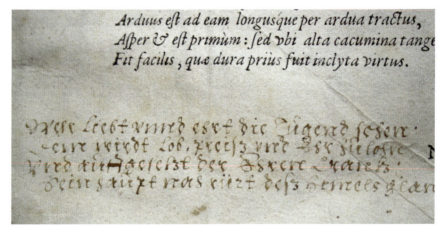

FIGURE 11.8D German poem to Emblem 4 (p. 10)
PRIVATE COLLECTION KARL ENENKEL

CUSTOMIZATION OF A LATIN EMBLEM BOOK BY A VERNACULAR OWNER 361

in vernacular emblem poems to display less interest in antiquarian matters. But the general phenomenon of the (Roman) triumph and the idea of the empire were, of course, widely known. Vaenius's own Dutch epigram in the 1612 edition shows that this kind of thing could easily be presented to a vernacular audience:

Die in triomph' aen't volck vertoont
Den vyanden gheboeyt oneerlijck,
Raeckt Jupiters ghestoelt en heerlijck
Met Godlijck' eere wert gheloont:
'Tverwonnen volck de schult vergheven,
D'oproerders treden mette voet,[64]
Te straffen 'tquaet, te lonen 'tghoet,
Des menschen naem doet eeuwigh leven (p. 10).

Who presents to the people in triumph/ The dishonoured enemies in chains,/ He touches Jupiter's throne and will be/ Splendidly rewarded with divine honour:/ To forgive the defeated people their guilt,/ To trample the rebellious under foot,/ To punish evil, to reward the good,/ That makes a man's name immortal.

Philipp von Zesen's German poem, in fact, contains the same elements as Vaenius's Dutch epigram:

Wer ritterlich mit helden-hand
Sich waget für sein Vaterland,
Die Bürger schützt, den Aufruhr dämpfet,
Des frommen schont, den trotz bekämpfet,
Ja in verdienter sieges-pracht
Den feind gefesselt zeigt dem volke;
Der hat sich göttlich selbst gemacht
Und reicht bis an die höchste Wolke.[65]

Philipp von Zesen's version demonstrates that it was quite possible to present Virgil's idea of Empire ('Des frommen schont, den trotz bekämpfet') in a vernacular poem, and moreover, that one could adapt it easily to knightly values ('ritterlich'). In his prose explanation, Von Zesen even gave an extended

64 This is actually the Dutch translation of *Aeneid* VI, 853.
65 Philipp von Zesen, *Sämtliche Werke*, vol. XIV (Berlin – New York: 1997) 237.

ekphrasis of the Roman triumph depicted in Vaenius's engraving.[66] Thus, it could well be that the German poet's choice to disregard these elements is significant: he may have belonged to the German nobility that was hostile to the empire of the Habsburgs, and to one of the many Protestant dominions of seventeenth-century Germany. In all probability, he composed his poems under Rudolph II (–1612), Mathias (1612–1619), or Ferdinand II (1619–1639). On the other hand, the authors who subscribed to the idea of the empire were not hostile to the Habsburgs: Vaenius lived in the Spanish Netherlands and had even dedicated his *Emblemata Horatiana* to the Habsburg Archduke Albert of Austria;[67] it is very likely that he designed this specific emblem as a mirror of princes,[68] and Philipp von Zesen followed him. He addresses his emblematic poem to one who will 'protect the citizens' and 'supress rebellion' (l. 3), thus to a prince, or the emperor. Von Zesen himself was grateful to Emperor Ferdinand III, who elevated him to the nobility in the 1650s before he published his emblem book (1656).

Instead of antiquarian knowledge, acknowledgement of the Roman empire, or a humanist interest in genuine Roman thought, the author of the German poems had a preference for proverbial wisdom; luckily, the *Emblemata Horatiana* are rich in this respect because Vaenius himself had selected various proverbs from Horace's collected *sententiae*. One of many instances is emblem 14, "Incipiendum aliquando" (p. 35), in which Vaenius presented two proverbs from Horace's *Epistula* I, 2, 'Dimidium facti qui coepit, habet' – 'Well begun is half done' (line 40)[69] – and 'Rusticus exspectat, dum defluat amnis' – 'the fool[70]

66 Ibidem 235: 'Daruem zeiget er (sc. the artist Vaenius in the image) einen der alten ueber-winder, welcher im vollen sieges-gepraenge sich in die Keiserin der staedte, das damahlige sieges-prangende Rohm, begiebet. Er stehet auf einem sieges- und ehrenwagen von gold und elfenbein; sein haeupt ist mit lorbeerzweigen gekröhnet, die ihm seiner eigenen haende sieg selbsten geflochten; und vor ihm her ziehet ein hauffen kriegs-leute, welche den raub der ueberwundenen feinde samt den ruemlichen zeuchen der freigebigkeit des Siegesfürsten mit großer pracht tragen. Ein große Anzahl gefangener uemringen seinen wagen'. Actually, three quarters of Zesius's prose explanation is dedicated to the ekphrasis of the triumph.

67 The extended 1612 edition in five languages Vaenius dedicated again to Albert of Austria.

68 Ineme Gerards-Nelissen has interpreted the complete *Emblemata Horatiana* as a mirror of princes ("Otto van Veen's *Emblemata Horatiana*" 20–63). There are a couple of emblems which can be interpreted in this way, but they represent no more than about 11 per cent of the whole work, as I have shown elsewhere. Cf. Enenkel, "Horaz als Lehrmeister der Ethik" 1246–1251.

69 Otto, *Die Sprichwörter*, no. 557, s.v. 'dimidium': 'Guter Anfang ist halbe Arbeit'.

70 Horace uses 'rusticus' here in its metaphorical sense of 'fool', 'bumpkin', 'idiot'.

CUSTOMIZATION OF A LATIN EMBLEM BOOK BY A VERNACULAR OWNER 363

waits until the river stops flowing' (line 43).[71] Horace used these proverbs as a teacher of moral philosophy; he insists on the importance of moral improvement and urges his readers not to forestall, but to start *right now*. Otherwise, he says, you are like the fool who waits until the river stops flowing. The idea behind this saying is that if one wants to cross a river, it is necessary to jump into the water, rather than foolishly hesitating: the river will never go dry.

Neither proverb could easily be transferred into a *pictura*: the first offers no image at all, the second only that of a river and an indefinite person – but how to depict something like 'until the river stops flowing'? In fact, Vaenius built his *inventio* on a misunderstanding of 'rusticus' as 'farmer' instead of 'fool' [Fig. 11.9A]. The proverb is now no longer about a person crossing a river (a fool), but about a farmer who is procrastinating with regard to his labour. Departing from this idea, Vaenius understands 'well begun is half done' also as farm work. He himself gives a clear explanation of the iconography:

> Agricolam hic vides ignavum, qui laborem differt suum, donec fluminis scilicet cesset cursus; alios vero sedulo intentos operi: quorum hic fundamenta domus iacit, alter aratro boves iungit […]

> Here (in the image) you see a lazy farmer who is procrastinating in his work until the river stops flowing; but you also see other farmers who dedicate themselves industriously to their work: the one lays the foundation of a house, the other hitches the cattle to the plough […].[72]

Actually, the entire iconography is based on Vaenius's imagination: none of the three farm workers is present in Horace's poem.

The German poem is composed as an ekphrasis of Vaenius's image (ll. 1–6); interestingly, the poet customized the emblem by identifying the landscape with his homeland and the river with the Rhine:

> Der Treg *hie* (in the image) lehnt sich uff den Spahd,
> Biß trucken leg *der Rhein* das Gstahd
> Sieht underdeß der arbeit zu,
> hatt langeweil, und schafft ihm rhu:

71 Otto, *Die Sprichwörter*, no. 674, s.v. 'flumen', section 2: 'Es ist thöricht zu warten und die Gelegenheit vorübergehen zu lassen, anstatt eine Sache […] energisch anzugehen'. The lines are in the *Sententiae et proverbia ex poetis Latinis* (Venice, Giovanni Padovano: 1547, p. 108). However, *Epist.* I, 2, offers in itself a collection of Roman proverbial expressions.

72 *Emblemata Horatiana*, emblem 14 (p. 34).

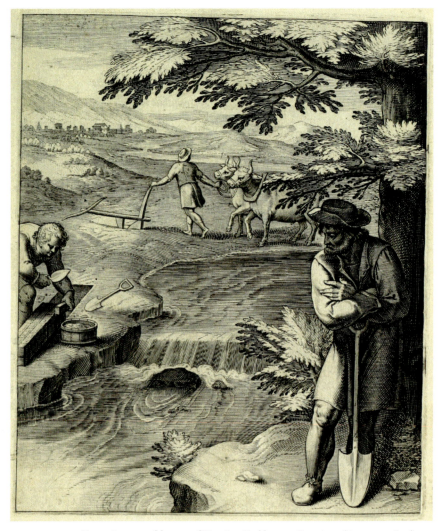

FIGURE 11.9A Engraving to emblem 14 of Vaenius, *Emblemata Horatiana* (Antwerp: 1607), p. 35

Aber der Flusß laufft immer vort
Und last den Esel ahn seim ort
Biß ihm durchs ohr der pfrimen bohrt [Fig. 11.9B].

The lazy man here leans on his spade,/ Until the ford of the Rhine goes dry./ He watches the others working,/ Gets bored and takes his rest./ However, the river keeps on flowing/ and lets this donkey stay where he is,/ Until the awl pricks through his ear.

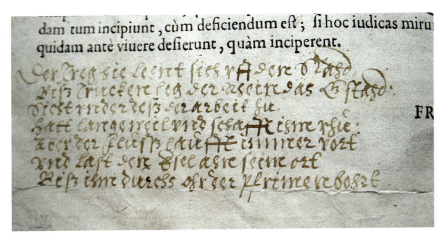

FIGURE 11.9B German poem to emblem 14 (p. 34)
PRIVATE COLLECTION KARL ENENKEL

'Der Treg *hie* lehnt sich auff den Spahd' – this is exactly what one sees in the image, the characteristic gesture of the lazy worker. In the lines quoted from Horace's poem, it is clear that the advice 'incipiendum aliquando' refers to moral improvement; this connection is left out in the German verses: apparently, the poet did not register it. In his customization, the German owner of the copy had worldly things in mind: lazy people will not prevail; they are like donkeys, condemned to hard labour – *never ending hard work in the service of other people* – yet lazy. In order to emphasize this aspect, the poet applied a German proverbial metaphor ('Esel'), and a biblical proverbial expression ('Biß ihm durchs ohr der pfrimen bohrt') from *Exodus* 21:6. This passage offers the Jews laws for slave keeping: after seven years of service a servant should be set free; but if the servant decides himself to stay in the house of his master, he will be a slave forever. This will be ritually confirmed by pricking his ear upon the master's door frame. Thus, in the interpretation of the German user, laziness will lead to eternal dependence: He applies the biblical proverb as an argument against laziness. The identification with the river Rhine is also an important feature of customization: He customized the emblem by incorporating it into his personal experience, and the region in which he lived.

Vaenius sometimes worked in an ekphrastic manner, translating Horace's lines into stunning images. Emblem 81, "Tempora te tempori", represents such a case. The lines quoted and pictured by the Antwerp emblematist are from *Odes* III, 29, a drinking song addressed to Maecenas. Horace invites the statesman to his country estate in the Licenza Valley at Mount Lucretilis, and asks him to interrupt his continuous engagement in affairs of the Roman empire, especially his anxious care for foreign policy, and his continual efforts to

foresee what the Chinese, the Bactrians (Bactria being a remote region in inner Asia, north of the Hindu Kush mountain range, today's Afghanistan), and the seditious people of the Don were up to (ll. 25–28). Horace's *Ode* contains a mixture of Stoic and Epicurean ethics, addressing the philosophical ideal of the tranquillity of the mind (*tranquillitas animi*) and equanimity (being 'aequus'); its central message is the advice (to Maecenas and the reader) not to care anxiously about the uncertain future, focusing on earthly matters which are subject to fortune (a reference to the Stoic doctrine of the *adiaphora*), but instead to focus on the present day with *aequanimitas* (again Stoic), and to enjoy it (implicitly related to the Epicurean formula 'Carpe diem', coined by Horace). Horace says:

> Quod adest memento
>
> Componere aequus; cetera fluminis
> Ritu feruntur, nunc medio alveo
> Cum pace delabentis Etruscum
> In mare, nunc lapides adesos
>
> Stirpesque raptas et pecus et domos
> Volentis una, non sine montium
> Clamore vicinaeque silvae,
> Cum fera diluvies quietos/
>
> inritat amneis (III, 29, 32–41).
>
> Remember to settle/ with equanimity what is present. – All other things are swept along as if in a river,/ Which sometimes glides peacefully/ In its proper riverbed into the Tus-/ can Sea, sometimes violently rolls together worn-away rocks,// Uprooted trees, cattle and houses,/ Its terrible roar echoed by the mountains and/ the neighbouring woods,// when the furious deluge/ Stirs up the peaceful streams.

Vaenius has composed an impressive image of a river violently overflowing, swollen by terrible thunderstorms, which comes rushing down from the mountains in a cascade that rips away everything in its path: houses, trees, and cattle. In the centre of the image houses collapse and tumble into the river, and a tree falls into the water, while cows and sheep, their head just visible, are carried away, jostled in the flood along with wooden bars and stones [Fig. 11.10A]. In his Dutch poem Vaenius focuses on the advice to preserve *aequanimitas* under all circumstances, to stay 'ghelijckmoedigh', as the Wise man ('de wijse')

CUSTOMIZATION OF A LATIN EMBLEM BOOK BY A VERNACULAR OWNER 367

does.[73] Vaenius also refers explicitly to his stunning image, to the 'vloet' ('flood') which 'het onderst boven drijven doet', and the 'onweder woedig' ('furious thunderstorm'):

Den tijd wilt soo hij comt ontfanghen.
Voeght u na hem. Onset u niet
Door crijgh, beroert' of door verdriet.
Laet alle dinghen gaen haar ganghen,
Ofschoon 'tgheval ghelijck een vloet
Het onderst boven drijven doet.
In schoon weer oft' onweder woedigh
Sijt met de wijse ghelijckmoedigh.[74]

Welcome Time kindly when it comes./ Adapt yourself to it. Do not lose control/ Because of war, riot, or sorrow./ Let all things go the way they are going,/ Even though an incident – like the flood – may turn everything upside down./ If the sun is shining or a thunderstorm raging:/ Preserve equanimity, like the Wise man.

In the image Vaenius has also exemplified the admonition, 'Welcome Time kindly when it comes'. The Wise man (left) receives the personification of Time – an old, bearded, winged man with a scythe – whom he invites to be his guest and to whom he opens the door of his house [Fig. 11.10A]. The idea derives from Domenicus Lampsonius's epigram: 'Invisens hilari Tempus te suscipe vultu,/ Hospitioque fove [...]' – 'If Time visits you, receive it with a joyous face/ And foster it with your hospitality [...]' (p. 168).

The German poet [Fig. 11.10B] was not inspired by the stunning engraved imagery of the Horatian *Ode*, nor was he interested in the philosophical ideal of *aequanimitas* and *tranquillitas animi*; and nor did he understand the philosophical attitude of dealing with time, expressed by Lampsonius and Vaenius ('Tempera te tempori' – 'Adapt yourself to time'). The author of the poem excelled neither in literary virtuosity nor cultivated deep philosophical thoughts. He tried to make sense of the emblem, and he found a message that fit his mindset, which was more familiar with practical life and social reality. Thus, he interpreted 'Tempera te tempori' in the sense of the proverbial piece of wisdom, 'Don't put off till tomorrow what you can do today', or 'Auf morgen

73 In the concluding line of the poem. With 'met de Wijse' Vaenius also refers to the Wise man in the image who is gladly receiving Tempus, the personification of time [Fig. 11.10A].

74 *Emblemata Horatiana* of 1612, p. 168.

368 ENENKEL

spare nicht, was du heute thun kannst'.[75] In sixteenth-century Germany, this was a common and widespread bit of wisdom, with a number of variants, e.g., 'Das Heute muss dem Morgen nichts borgen',[76] 'Man muss nicht auf morgen verschieben, was man heute thun kann', or 'Was du heute kannst besorgen, das verschiebe nicht auf morgen'.[77] The second line of the German poem is actually another variant of the same proverb: 'Heuth ist die zeitt, morn nimmer, dein'. 'Don't put off till tomorrow what you can do today'. In fact, it contains nothing more than advice to avoid laziness and not to procrastinate when things need to be done. The German poem runs:

> Nicht spahr biß morn wz (=waz) heuth khan sein:
> Heuth ist die zeitt, morn nimmer, dein.
> Versaumst dieselb, der gwinn ist klein
> Und schweerlig wider z'pringen ein [Fig. 11.10B].

> Don't put off till tomorrow what you can do today:/ Today you are in possession of the time, tomorrow you never are./ If you miss it, your gains are poor,/ and it is difficult bring 'em in again.

In this case the German poet did not address the image at all. His poem mentions 'die zeitt', but there is no evidence that he conceived of it as personification. Moreover, there is no real equivalent of 'Nicht spahr biß morn wz (= waz) heuth khan sein' in the Latin texts offered by Vaenius. The customization of the emblem consists of an effort to assimilate it to popular wisdom.

In conclusion, the author of the German poems customized Vaenius's Latin emblem book of 1607 in a particular way: For his private use of the *Emblemata Horatiana* he excluded everything that had to do with ancient philosophy, philosophical or theoretical discussions, antiquarian knowledge, philology, and genuine Horatian poetics. Instead, he focused on popular and proverbial wisdom, the values of the nobility, physical and practical aspects, and common-sense ethical precepts. He approved of Vaenius's method of presenting *loci communes* in terms of personifications, and he had some knowledge in this field. He was acquainted with Alciato's *Emblematum liber* (in the German edition by Sigmund Feyerabend), and with the general poetics of emblematic

75 Körte W., *Die Sprichwörter und sprichwörtlichen Redensarten der Deutschen* [...] (Leipzig: 1861), no. 5401 (p. 323). Cf. ibidem: 'Nichts auch werde verschoben vom morgenden Tag und darüber,/ Denn kein säumiger Mann wird je anfüllen die Scheuer'.

76 Körte, *Die Sprichwörter und sprichwörtlichen Redensarten der Deutschen* [...] (1861), no. 3533 (p. 216); cf. also no. 3538 (ibidem): 'Besser heute als morgen'; no. 3537 (ibidem): 'Wenn Gott sagt "heute", sagt der Teufel "morgen!"'.

77 Cf. Röhrich L., *Lexikon der sprichwörtlichen Redensarten* (Freiburg i. Br.: 2001), vol. 2, 711.

CUSTOMIZATION OF A LATIN EMBLEM BOOK BY A VERNACULAR OWNER 369

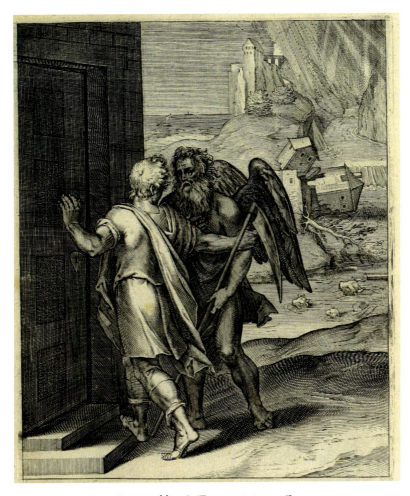

FIGURE 11.10A Engraving to emblem 81 "Tempera te tempori"

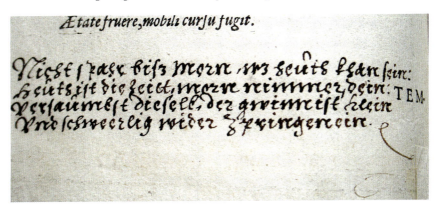

FIGURE 11.10B German poem to emblem 81 (p. 168)
PRIVATE COLLECTION KARL ENENKEL

epigrams, e.g., with respect to ekphrasis, dichotomous structure (with a descriptive and an evaluative part), and the moral (conclusion). An important goal of his customization was to create a better and more direct access to the emblems, especially to the engraved images, which for him usually meant reducing the complexity generated by Vaenius's reading of disparate text fragments. Although some of his interpretations are not identical to Vaenius's, and some are even bluntly incorrect, he generally succeeded, especially in poems which are construed as ekphrases of Vaenius's engravings. Our poetic author had mastered Latin, but he was certainly no theologian, cleric, professional writer, scholar, or learned man. Many adaptations reveal the vernacular complexion of his mindset. There were various vernacular discourses, of course; for example, it was possible either to include or exclude humanism in vernacular emblematic poetry. The Dutch poems Vaenius composed himself and Von Zesen's German poems may be labelled as humanist. However, the author of our customized emblem book excluded humanism. He probably lived in one of the Rhine regions, and looked with disfavor at the German empire of the Habsburgs.

Bibliography

Blanco M., "L'emblématique plurilingue à Anvers: Otto van Veen (1557–1626) et l'"humanisme vernaculaire"", in Béhar R. – Blanco M. – Hafner J. (eds.), *Villes à la croisée des langues (XVIe–XVIIe siècles). Anvers, Hambourg, Milan, Naples et Palerme / Städte im Schnittpunkt der Sprachen (16.-17. Jahrhundert). Antwerpen, Hamburg, Mailand, Neapel und Palermo* (Geneva: 2018) 713–738.

Blöcker S., *Studien zur Ikonographie der Sieben Todsünden in der niederländischen und deutschen Malerei und Graphik von 1450–1560* (Münster: 1993).

Enenkel K.A.E., "Horaz als Lehrmeister der Ethik: Vaenius' *Emblemata Horatiana*", in Laureys M. – Dauvois N. – Coppini D. (eds.), Non omnis moriar. *Die Horaz-Rezeption in der neulateinischen Literatur vom 15. bis zum 17. Jahrhundert* [...], Noctes Neolatinae 35, 1 (Hildesheim – Zurich – New York: 2020), vol. 2, 1243–1305.

Enenkel K.A.E., *The Invention of the Emblem Book and the Transmission of Knowledge, ca. 1510–1610* (Leiden – Boston: 2019).

Enenkel K.A.E., "The Transmission of Knowledge via Pictorial Figurations: Vaenius' *Emblemata Horatiana* (1607) as a Manual of Ethics", in idem, *The Invention of the Emblem Book and the Transmission of Knowledge, ca. 1510–1610* (Leiden – Boston: 2019) 365–438.

Forster L., "Die *Emblemata Horatiana* des Otho Vaenius", *Wolfenbüttler Forschungen* 12 (1981) 117–128.

Gerards-Nelissen I., "Otto van Veen's *Emblemata Horatiana*", *Simiolus* 5 (1971) 20–63.

Henkel A. – Schöne A. (eds.), *Emblemata. Handbuch zur Sinnbildkunst des XVI. und XVII. Jahrhunderts* (Stuttgart: 1967/1996).

Le Roy Marin, Sieur de Gomberville, *La Doctrine des mœurs* (Paris, Louis Sevestre for Pierre Daret: 1646) (other editions 1681, 1682, 1683, 1684, 1685, and 1688).

Ludwig W., "Die Emblemata Horatiana des Otho Vaenius", *Neulateinisches Jahrbuch* 15 (2013) 219–229.

Mayer R., "Vivere secundum Horatium: Otto Vaenius' *Emblemata Horatiana*", in Houghton L.B.T. – Wyke M. (eds.), *Perceptions of Horace: A Roman Poet and His Readers* (Cambridge: 2009) 200–218.

McKeown S. (ed.), *Otto Vaenius and his Emblem Books*, Glasgow Emblem Studies 15 (Glasgow: 2012).

Panofsky E., *Hercules am Scheidewege und andere antike Bildstoffe in der neueren Kunst* (Leipzig – Berlin: 1930).

Poel M. van der, "Venius' *Emblemata Horatiana*: Material Fragmentation of a Classical Poet", in idem (ed.), *Neo-Latin Philology: Old Tradition, New Approaches* (Leuven: 2014) 131–164.

Porteman K., "Miscellanea emblematica", *Spiegel der letteren* 17 (1975) 161–193.

Sambucus Ioannes, *Emblemata* (Antwerp, Christopher Plantin: 1564).

Stampfle F., *Netherlandish Drawings of the Fifteenth and Sixteenth Centuries and Flemish Drawings of the Seventeenth and Eighteenth Centuries in the Pierpont Morgan Library* (New York: 1991).

Tergoes Anthonis Jansen van, *Zinnebeelden, getrokken uit Horatius Flaccus, naar een geestrijke vinding van den geleerden Otto van Veen* (ed. pr. Amsterdam, Justus Dankerts: 1683).

Teyssandier B., *Le Prince à l'école des images:* La Doctrine des mœurs *de Marin Le Roy, Sieur de Gomberville*, Ph.D. dissertation (University of Paris IV – Sorbonne: 2004).

Thoefner M., "Making a Chimera: Invention, Collaboration and the Production of Otto Vaenius' *Emblemata Horatiana*", in Adams A. – van der Weij M. (eds.), *Emblems of the Low Countries: A Book Historical Perspective*, Glasgow Emblem Studies 8 (Glasgow: 2003) 44–66.

Vaenius Otho, *Q. Horati Flacci Emblemata. Imaginibus in aes incisis Notisque illustrata. Studio Othonis Vaenii Batavolugdunensis* [...] *Auctoris aere et cura* (Antwerp, Hieronymus Verdussen: 1607); facsimile edition Emblematisches Kabinett 3 (Hildesheim – Zurich – New York: 1996).

Vaenius Otho, *Quinti Horatii Flacci Emblemata. Imaginibus in aes incisis Notisque illustrata. Studio Othonis Vaeni Batavolugdunensis Auctoris aere et cura* (Antwerp, Otho Vaenius and Philippus Lisaert: 1612).

Von Monroy E.F., *Embleme und Emblembücher in den Niederlanden 1560–1630. Eine Geschichte der Wandlungen ihres Illustrationsstils* (Utrecht: 1964).

CHAPTER 12

Picture Bound: Customized Books of Prints and the Myth of the Ideal Series

Shaun Midanik

Consider the frontispiece of Jacobus Peeters' 1673 edition of the *Theatrum Pictorium* [Fig. 12.1], a bound collection of 246 prints that remediate Italian paintings in the possession of Archduke Leopold Wilhelm of Austria. The *Theatrum* is an important example of a new form of book that emerged in the early modern period: a book of prints, which is a bound collection of printed pictures. At the bottom of the frontispiece [Fig. 12.2], Peeters advertises his Antwerp print shop in four languages where more bound pictures may be purchased, variously describing these works as *Print-Boecken* ('print books') in Dutch, *livres de taille douce* ('books of intaglio') in French, or simply *libri* and *libros* in Latin and Spanish. Four languages lead to three different senses of books of printed pictures.[1]

Definitions of the book of prints are as malleable as the books themselves. In 1684, Peeters printed a new edition of the *Theatrum* to reach a different community of users. Whereas the 1673 edition targeted a polyglot audience, the 1684 printing, with introductory text published only in Latin, addressed

1 As I explain shortly, there are many descriptors for bound groups of pictures. I refer to the medium in this essay as 'books of prints' in accordance with Antony Griffiths' use of the term. Griffiths separates 'series' (also called 'sets', 'cycles', etc.) of prints from books of prints, with the latter containing a title-page and prefatory text. However, I have avoided this distinction since groups of prints did not require a frontispiece or preface to be bound. A division between bound 'series' of prints and books of prints was, to my knowledge, not made by early modern users and printmakers. Indeed, Griffiths himself acknowledges the overlap in his nomenclature when discussing books of prints by Pietro Santi Bartoli: '[Bartoli's books of prints] are usually thought of as books. But in important ways they behave like sets of plates: it was possible to buy just the plates and omit the text'. I identify the book of prints not by the presence of a preface or a title-page, but instead as a distinct medium – a form of communication primarily through bound pictures, which are sometimes accompanied by supplementary text (i.e. letterpress). Griffiths again assists us here: 'However difficult it is to define the type, [the book of prints] was certainly recognized by contemporaries'. The book of prints resists our best efforts at definition, yet was a widely acknowledged medium throughout early modernity. For his definition of the book of prints and the above quotes, see Griffiths A., *The Print before Photography: An Introduction to European Printmaking 1550–1820* (London: 2016) 175–176.

© KONINKLIJKE BRILL NV, LEIDEN, 2024 | DOI:10.1163/9789004680562_013

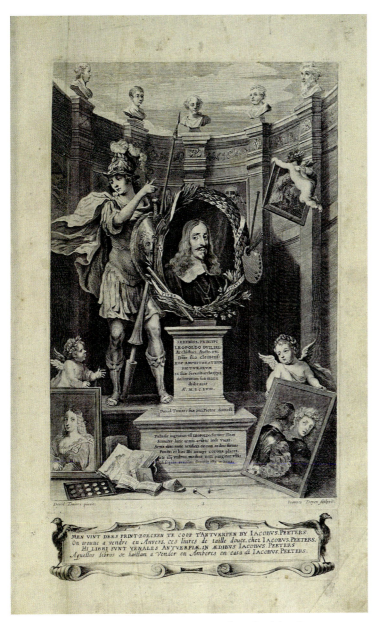

FIGURE 12.1 Jan van Troyen, Frontispiece. Etching, book height 44 cm, made in 1673 after a painting by David Teniers the Younger. From: *Davidis Teniers Antverpiensis pictoris, et a cvbicvlis ser. mis principibvs Leopoldo Gvil. archidvci, et Ioanni Austriaco Theatrum Pictorium* [...] (Antwerp, Jacobus Peeters: 1673)
LOS ANGELES, GETTY RESEARCH INSTITUTE. PUBLIC DOMAIN. INTERNET ARCHIVE

FIGURE 12.2 Jan van Troyen, Frontispiece. Detail, vignette below the plate. Etching, book height 44 cm, after a painting by David Teniers the Younger. From: *Davidis Teniers Antverpiensis pictoris, et a cvbicvlis ser.mis principibvs Leopoldo Gvil. archidvci, et Ioanni Austriaco Theatrum Pictorium* [...] (Antwerp, Jacobus Peeters: 1673)
LOS ANGELES, GETTY RESEARCH INSTITUTE. PUBLIC DOMAIN. INTERNET ARCHIVE

an elite clientele.[2] The new edition excludes the vignette advertising Peeters' books of prints, which is no longer found in subsequent print runs. Changes to the *Theatrum* were sometimes made to individual copies over the following centuries. As is so common with books of prints, one iteration at the British Museum was disbound in the 1870s. The prints were dispersed throughout the British Museum's printroom and the accompanying letterpress bound into its own book. The prints and text were reassembled as loose sheets within its own solander box in 2019.[3]

The *Theatrum* serves as a useful starting point for considering the fluidity of books of prints, both in early modernity and today. The British Museum reunited the prints so as to offer a 'complete' presentation of the *Theatrum* as Peeters envisioned. The online catalogue assures us that the prints and supplementary texts were brought together again so that '[t]he book was reconstituted as one in 2019'.[4] The presumption is that a return to its complete condition in a solander box is a move closer to its 'original' form, but is that necessarily so? Solander boxes after all do not bring us any closer to the initial moment of

2 For an overview of the *Theatrum*'s publication history, see Klinge M., "David Teniers and the Theatre of Painting", in Vegelin van Claerbergen E. (ed.), *David Teniers and the Theatre of Painting*, exh. cat., Courtauld Institute of Art Gallery (London: 2006) 32–37.
3 British Museum, *Theatrum Pictorium*, https://www.britishmuseum.org/collection/object/P_A-8-1 (accessed 26 April 2022).
4 Ibid.

CUSTOMIZED BOOKS OF PRINTS AND THE MYTH OF THE IDEAL SERIES 375

creation for print media, but alter how we store and access them. In a solander box, the loose sheets of the *Theatrum* may shift after every use, leaving a fleeting palimpsest of its most recent user. Institutions regularly describe books of prints under nomenclature that obscures questions of media: common terms to designate them today – such as a series, set, cycle, or suite of prints – mask that these artefacts are, in fact, books. Although these works were described by many terms across early modernity, the most common descriptor up until the eighteenth century was simply the 'book'.[5]

The prevailing view is that books of prints are not books at all: a 'real' book must contain text. Francis Haskell's *The Painful Birth of the Art Book*, a foundational work on the medium, epitomizes this strict definition of the book.[6] In defining his 'art book', Haskell distances his category from previous illustrated books (and indeed all print media): 'this is to be about books devoted to art and not primarily about the reproduction of works of art'.[7] Haskell contends that the creation of the first art book, the *Recueil Crozat* (1729), a book of prints that remediates the Italian paintings and drawings owned by Pierre Crozat and those held in the French royal collections, marked a departure from earlier assemblages of prints. It was, he argues, 'designed to be a book and not just a collection of related illustrations'.[8] By separating books of aesthetic value from works which merely 'reproduce' paintings, Haskell defines a new category that surpasses print media prior to the *Recueil*: 'What essentially distinguishes a book from a collection of prints, whether pasted into albums or kept in portfolios, is the presence of a text'.[9] The *Recueil* represents a new form of book, in Haskell's mind, because of the inclusion of text.[10]

5 The terms series, set, cycle, and suite were used increasingly in the eighteenth century. On some of the terms employed in eighteenth century France, see Leca B., "An Art Book and its Viewers: the 'Recueil Crozat' and the Uses of Reproductive Engraving", *Eighteenth-Century Studies* 38.4 (2005) 629.

6 Ibid. 623–649. "Collections of essays on art books include" Hattori C. – Leutrat E. – Meyer V. (eds.), *À l'origine du Livre d'art: les Recueils d'estampes comme entreprise éditoriale en Europe, XVIe–XVIIIe siècle*. (Milan: 2010); and Palmer R. – Frangenberg T. (eds.), *The Rise of the Image: Essays on the History of the Illustrated Art Book* (Aldershot: 2003).

7 Haskell F., *The Painful Birth of the Art Book* (London: 1987) 7.

8 Ibid. 8, 45–46.

9 Ibid. 46.

10 To be more precise, Haskell argues that while there is sometimes text present in earlier collections of prints, the text in the *Recueil* is novel since it focuses on painters' styles rather than the content of the illustrations. A shift towards the image serving text is integral to distinguishing the art book from earlier print media, in which text serves the image. This makes it a book proper. See Ibid. '[...] for [the *Recueil*] takes a decisive step away from the interest in what is painted to an interest in who painted it and how it is painted'.

This chapter recognizes early modern books of prints as books and explores the multitude of ways in which contemporaries made books through pictures. Rather than interpreting these works as static series of prints, it demonstrates the malleability of bound pictures through their varied material configurations. I contend that customization defined the book of prints for both early modern makers and users. In arguing for the flexibility of the medium, I have two goals. First, I aim to draw prints more broadly to the attention of historians of the book who have long emphasized the materiality of text without analyzing how changes to pictures affect the early modern book.[11] Second, I hope to demonstrate how book historical approaches can shed new light on artefacts normally within the purview of art historians. Customization has often run counter to the art historical 'series' of prints, typified by producer-focused *catalogues raisonnés* that describe such works as best in a complete and ordered form.[12] As I demonstrate, the customization of books of prints was not understood negatively as it often is today, but was expected by early modern makers, sellers, and collectors alike.

This chapter analyzes four themes on the customization of books of prints, each of which connects to key issues on the makeup of the early modern book. I begin by examining the 'ideal series', the complete and immaterial creation by the artist that I define in relation to the descriptive bibliographic notion of the 'ideal copy'. With the ideal series as our foundation, this chapter explores three further themes on the malleability of the book of prints. The following section considers *Sammelbände* of pictures, which are compilations containing multiple books of prints bound together. I continue by analyzing books of prints 'assembled in parts'; that is, new books formed out of the 'fragments' of ostensible wholes. The chapter concludes by investigating what I call the 'parapicture' – the malleable paratextual features within a book of prints. In each section, I explore how the book historical topic alters our understanding of the medium. The principal goal is to show the various benefits of a bookish reimagining of the print series: a recognition of the plasticity of the book of prints forces us to reconsider what pictures *do* in the early modern book.

11 While the field of book history since the 1980s has demonstrated that alterations to textual media are the norm in this period, little work has been undertaken on how changes to early modern prints impacted our notion of the book. Key works on the materiality of text include Grazia M. de – Stallybrass P., "The Materiality of the Shakespearian Text", *Shakespeare Quarterly* 44.3 (1993) 255–83; McGann J.J., *The Textual Condition* (Princeton: 1991) 3–16; and Kastan D.S., "Shakespeare and the Book" (Cambridge: 2001) 1–13.

12 Other related art historical examples are the Hollstein and Illustrated Bartsch reference books, which similarly present 'series' of prints in standard orders with prescribed contents.

1 The Myth of the Ideal Series

Catalogue entries of books of prints, both online and in print, deemphasize the materiality of pictures. Records focus on a book of prints' 'original' condition by cataloguing its producer(s), ordering, and date of printing, yet often do not describe whether they are books at all.[13] In describing the single point of creation, cataloguers regularly compare their exemplar to a mythical prototype – the complete and orderly series of prints, as its makers envisioned it to be.[14] Libraries and print collections regularly describe a series as 'lacking', 'wanting' or 'imperfect' if a plate is out of place or missing altogether. Such nomenclature not only offers a belief that series are complete (or not), it also mistakenly categorizes all groups of prints together: a series of prints pasted into an album can be indistinguishable from a series of loose prints or a series of bound pictures. This is sometimes impossible to notice because of digital reproductions which homogenize the experience of viewing these works. Catalogues of series collapse all related print media upon each other, establishing an immaterial entity that dismisses customization as a mistake unintended by its makers.

I refer to this phenomenon as the 'ideal series' to connect it to descriptive bibliography's notion of the ideal copy. The New Bibliographers of the first half of the twentieth century attempted to define a standard text by which booksellers, cataloguers, and scholars could compare their individual copies.[15] The most cited definition of ideal copy is by Fredson Bowers, who describes its central role in bibliography:

> A description is constructed for an ideally perfect copy, not for any individual copy, because an important purpose of the description is to set up a standard of reference whereby imperfections may be detected and properly analyzed when a copy of a book is checked against the bibliographical description. [...] Thus an *ideal copy* is a book which is complete in all its leaves as it ultimately left the printer's shop in perfect condition and in the complete state that he considered to represent the final and most perfect state of the book.[16]

13 This problem is particularly acute in print collections rather than libraries.

14 As indicated earlier, the series in this paper encompasses a number of synonymous terms such as 'set', 'cycle', or 'suite'.

15 On the history of New Bibliography, see Murphy A., *Shakespeare in Print: A History and Chronology of Shakespeare Publishing* (Cambridge: 2003; reprint ed., 2021) 258–290.

16 Bowers F., *Principles of Bibliographical Description* (Princeton: 1949) 113.

Bibliographic description was, in Bowers' mind, the pursuit of a complete, total book. The 'content' of a book consists solely of the text chosen by the printer, with each record containing the history of the text in its best possible state – the platonic form of the book.[17] Thomas Tanselle, in his analysis of Bowers, admits that an ideal copy 'may be an abstraction, for no such actual copy may be known to exist'.[18] The goal of the bibliographer was to form an historical reconstruction of the book as supposedly intended, induced by examining as many copies as possible of a given title. Bibliographers were instructed by Bowers not to worry themselves with the book as it is today, but rather to envisage it at its printing. Binding and the addition of plates are secondary concerns to the ideal copy since they too were typically added after leaving the printer's shop.[19]

New Bibliography emerged out of modernist presumptions that the solitary artist would not busy themselves with the trivial concerns of printing. Bowers' ultimate goal was to study the book's form in order to move past its materiality and reach the text's essence.[20] Other early bibliographers pursued a mythical, authentic text to serve as a descriptive standard: A.W. Pollard, for example, divided quartos attributed to Shakespeare into 'good' and 'bad' texts, those he believed were authorial originals from non-authorial derivatives; R.B. McKerrow defined the 'original draft' of Pollard's 'good' text as the one first brought to the printer; and W.W. Greg, elaborating on McKerrow, referred to 'foul papers' as the authorial final draft behind the earliest editions.[21] The foundation of New Bibliography was thus established as the pursuit of an ideal authorized text that was corrupted by centuries of handling as well as by transmission. External agents (printers, compositors, editors, etc.) had gradually worsened the true text.[22] Bibliographers were tasked with reconstructing the

17 Grazia M. de, "The Essential Shakespeare and the Material Book", *Textual Practice* 2.1 (1988) 69–71.

18 Tanselle T., "The Concept of Ideal Copy", *Studies in Bibliography* 33 (1980) 2.

19 Bowers, *Principles* 122. On Bowers and issues of ideality, see Dane J. "'Ideal Copy' versus 'Ideal Texts': The Application of Bibliographical Description to Facsimiles", *Papers of the Bibliographical Society of Canada* 33.1 (1995) 35–41.

20 Leah Marcus observes this in Bowers. See Marcus L., *Unediting the Renaissance: Shakespeare, Marlow, Milton* (London: 1996) 21–22, 30.

21 For an important summary of New Bibliography's search for "original" Shakespearian texts, see Werstine P., "Narratives About Printed Shakespeare Texts: 'Foul Papers' and 'Bad' Quartos", *Shakespeare Quarterly* 41 (1990) 65–75.

22 On the problems of asserting an 'authentic' text: Grazia M. de, *Shakespeare Verbatim: The Reproduction of Authenticity and the 1790 Apparatus* (Oxford: 1991) 49–93; Orgel S., "The Authentic Shakespeare", *Representations* 21 (1988) 1–25; and idem, "What is a Text?", in

CUSTOMIZED BOOKS OF PRINTS AND THE MYTH OF THE IDEAL SERIES 379

earliest literary works by attaching them to the authors who wrote them in order to understand their intentions.

Book historians have since rejected the idea that a 'best' text ever existed. The focus on the ideational text by a genius author was replaced in the 1980s and 1990s by a methodological shift towards the material forms of texts, constructed and disseminated by multiple agents involved in the printing process.[23] Early texts are not fixed or original but have extended lives beyond their initial authors and sites of creation. Bibliography retains a foundational role in book history, but its toolkit has been repurposed to question the very features the New Bibliographers claimed as the basis of their 'scientific' pursuit, such as authorship and editorial practices.[24] While book history has questioned the imposition of these twentieth century modes of textuality on the treatment of early modern books, the field has not yet reckoned with the printed pictures on their leaves.

In what follows, I argue that an ideal series, likewise, does not exist. By affirming an immaterial standard to which all manifestations must adhere, the series obscures any account of their materiality. Any work deviating from this standard is considered imperfect. According to this thinking, printmakers are presumed to have had a precise vision of how many plates completed their series. This presumption deviates markedly from early modern thinking about the issue of finality: most series were not conceived as complete artefacts upon printing.[25] Nor were series closed off from consumers, who could pick and choose which prints from a series they wished to purchase. The presumption that a series must be purchased whole or not at all converts buyers into passive recipients of the artist's inventions. This simply does not represent the relationship between buyer and seller in an early modern print or book shop. Numerous forms were available to patrons after purchasing series in a print shop, whether kept loose, pasted into albums, inserted into portfolios, or assembled into books of prints. As Peter Stallybrass succinctly puts it: 'Printers do not print books. They print sheets of paper'.[26] Buyers were as integral to

Kastan D.S. – Stallybrass P. (eds.), *Staging the Renaissance: Reinterpretations of Elizabethan and Jacobean Drama* (New York – London: 1991) 83–87.

23 Stallybrass P. – Chartier R., "Reading and Authorship: the Circulation of Shakespeare 1590–1619", in Murphy A. (ed.), *A Concise Companion to Shakespeare and the Text* (Oxford: 2007) 35–56.

24 For instance, see McKitterick D., *Print, Manuscript and the Search for Order, 1450–1830* (Cambridge: 2003) 1–10.

25 Griffiths A., *The Print before Photography: An Introduction to European Printmaking 1550–1820* (London: 2016) 173.

26 Stallybrass P., "Printing and the Manuscript Revolution", in Zelizer B. (ed.), *Explorations in Communication and History* (London – New York: 2008) 111.

defining form as printmakers, with the book of prints but one possibility in a diverse print media ecosystem centred upon the user as much as the producer. The ideal series obscures all these formal questions. It is telling that many catalogue entries do not even describe whether they are bound or not; their bookish features are largely irrelevant to the incorporeal series.

Recognizing the ideal series forces us to revisit the canonical cycles of prints from the early modern period, many of which underwent significant alterations after their initial realization that demonstrate their bookish qualities. Albrecht Dürer's *Engraved Passion* (c. 1510), one of the earliest intaglio books of prints, was commonly bound by contemporaries despite his apparent intention to keep its plates separate.[27] Stradanus' *Nova Reperta* (c. 1600) was reprinted in 1638 as part of an anthology of thirty books of prints called the *Speculvm diversarvm imaginvm specvlativarvm*. While the *Nova Reperta* on its own celebrated the greatest inventions of the 'modern' age, it took on new life as part of a compendium dedicated to encyclopedic knowledge of the natural world.[28] Piranesi developed new books of prints out of his previous editions, such as his *Antichità Romane* (1756) which drastically increased the number of plates from his earlier *Antichità Romane de' tempi della Repubblica* (1748).[29] When we describe a series by a single title, we characterize all the related groups of prints under one name, without consideration of the diverse forms available after initial production. The ideal series offers a restrictive view of artistic creation that is total, complete, and singularly produced in the mind of the draughtsman. An attention to the book's material form instead makes room for the continuous reconstructions of the artist and their designs across their extended publication histories.

There are also decidedly 'mixed' printings of books of prints in which plates are moved from one publication to the next, further questioning the fixity of the ideal series. Pietro Bartoli first published his 81-plate *Admiranda Romanarvm* antiqvitatvm around 1666, before adding two plates inspired by

27 Hass A., "Two Devotional Manuals by Albrecht Dürer: The 'Small Passion' and the 'Engraved Passion'. Iconography, Context and Spirituality", *Zeitschrift für Kunstgeschichte* 63 (2000) 214–216.

28 Fuhring P., "The Stocklist of Joannes Galle, Print Publisher of Antwerp, and Print Sales from Old Copperplates in the Seventeenth Century", *Simiolus* 39.3 (2017) 229–230; and Fuhring P., "Speculum diversarum insignium speculativum, à variis viris doctis ad inventarum, atque ab insignibus pictoribus ac sculptoribus delineatarum, 1638", in Bass M. – Wyckoff E. (eds.), *Beyond Bosch: The Afterlife of a Renaissance Master in Print*, exh. cat., St Louis Art Museum (St Louis: 2015) 218–223.

29 Yerkes C. – Minor H.H., *Piranesi Unbound* (Princeton – Oxford: 2020) 2–8.

CUSTOMIZED BOOKS OF PRINTS AND THE MYTH OF THE IDEAL SERIES 381

the ancient Roman fresco known as the *Aldobrandini Wedding* in 1677.[30] A new edition in 1693, the famed *Admiranda vestigia*, replaced 31 plates with new ones, some of which were reversed copies from François Perrier's *Icones et segmenta*.[31] The 31 plates that had been removed from the 1693 edition were now used for another of Bartoli's books of prints, the *Veteres arcvs Avgustorvm trivmphis insignes* (1690). In addition to the *Admiranda*, the *Veteres* also borrowed plates from Joseph Marie Suarès' *Arcvs L. Septimii Severi Avg. anaglypha* (1676) and new prints based on the designs of the Sangallo family.[32] A third book of prints called *Übrig gebliebene Merkzeichen von den Römischen Antiquitäten* (1692), printed by Johann Jacob von Sandrart in Nuremberg, is likewise composed of 'recycled' Bartoli prints, and Bartoli is cited on the title page. The initial 29 plates primarily come from the *Veteres*, and its remaining 50 plates from the *Admiranda*.[33] Bartoli and Sandrart certainly did not believe their works had to remain tied to a single title after their initial printing as they continuously tinkered with the plates available to patrons. The second edition of the *Admiranda*, *Veteres*, and *Übrig* seem all to have been printed within a few years of each other, revealing a temporally and geographically dynamic publishing history.

While in some books of prints we find an extended genealogy emerging from a single edition, others lack a coherent prototype. Take as an example of the latter scenario the *Scuola Perfetta*, a collectible drawing manual first printed in the early seventeenth century. The *Scuola*, which never had a stable order across its over two hundred years of publication, may have emerged as a combination of two groups of prints by Luca Ciamberlano and Francesco Brizio.[34] Despite attempts by Bartsch and others to define an 'original' *Scuola* series from which all others derived, there likely is no such thing. Although previous scholarship suggested the *Scuola* was advertised across Europe as the drawings of the Carracci, recent work has demonstrated that a connection to the family was brought to prominence only in the late seventeenth century.[35]

30 Iusco A.G., "Note all'INDICE del 1735 e alle Tavole Sinottiche", in Iusco A.G. (ed.), *Indice delle Stampe de' Rossi: Contributo alla storia di una Stamperia romana* (Rome: 1996) 381.

31 Ibid.

32 Savage N., *Early Printed Books, 1478–1840: Catalogue of the British Architectural Library, Early Imprints Collections* (London: 1994) 123.

33 Schreurs A. (ed.), *Unter Minervas Schutz: Bildung durch Kunst in Joachim von Sandrarts Teutscher Academie* (Wolfenbüttel: 2012) 203–204.

34 Donati L., "Proposte per una datazione della Scuola perfetta: le series incisorie nelle raccolte romane", *Rivista dell'Istituto Nazionale d'Archaeologia e Storia dell'Arte* 57 (2002) 343.

35 Greist A., *Learning to Draw, Drawing to Learn: Theory and Practice in Italian Printed Drawing Books, 1600–1700* (Ph.D. Dissertation, University of Pennsylvania, 2011) 193; Heilmann M. – Nanobashvili N. – Pfisterer U. – Teutenberg T. (eds.), *Punkt, Punkt, Komma,*

Across its many publications, various printmakers would take on a set of core plates or create their own, and then add or remove their own prints. The titles of these editions varied dramatically (*Livre de Portraiture d'Anib. Carracche, Alli nobilissimi amatori del disegno*, etc) and the arrangement and choice of prints frequently differ from one iteration to the next.[36] By all accounts, the *Scuola* was never intended to be an ordered or complete series but rather a composite collection of prints. It was, to a degree, individualized for each owner under the auspices of the printmaker – similar to Antonio Lafreri's *Speculum Romanae magnificentiae* or Matthew Lowne's 'build-it-yourself editions' of Edmund Spenser's folios.[37] The concept of the ideal series limits our understanding of the *Scuola* as fixed or best in its 'original' state. Rather than continuing to search for its earliest printing – a pursuit rooted in the bibliographic reverence for first editions – we must study its numerous and diverse bookish forms.[38] For the remainder of the paper, I will consider some of the most frequent ways in which early modern makers and users customized books of prints.

2 *Sammelbände* of Pictures

In the 1800s, books of prints were frequently rebound on their own to accord with collectors' tastes for slim and independent volumes, remaking books of prints to approximate singularly bound novels. Although overlooked because of these nineteenth century alterations, individual books of prints were commonly brought together throughout early modernity to form multibook compilations, demonstrating some of the ways in which early modern users and makers customized their material artefacts. *Sammelbände* were formed by binding books of prints together, establishing idiosyncratic associations between discrete editions. While the practice was common throughout the early modern period, there is little written about the binding of books of prints

 Strich: Zeichenbücher in Europa, ca. 1525–1925 (Passau: 2014) 202–204; and Nanobashvili N., *Das ABC des Zeichnens. Die Ausbildung von Künstlern und Dilettanti* (Petersberg: 2018) 89–90.

36 Greist, *Learning to Draw* 193.

37 On the *Speculum*, see Parshall P., "Antonio Lafreri's 'Speculum Romanae Magnificentiae'", *Print Quarterly* 23.1 (2006) 3–28; and Zorach R., *The Virtual Tourist in Renaissance Rome: Printing and Collecting the Speculum Romanae magnificentiae* (Chicago: 2008). On Spenser, see Galbraith S.K., "Spenser's First Folio: the Build-It-Yourself Edition", *Spenser Studies* 21.1 (2006) 21–49.

38 On the connection between new bibliographers and "original" books, see Loewenstein J., *The Author's Due: Printing and the Prehistory of Copyright* (Chicago: 2002) 260–262.

CUSTOMIZED BOOKS OF PRINTS AND THE MYTH OF THE IDEAL SERIES 383

with each other.[39] There has been a sustained effort in book history, however, to look at *Sammelbände* of text, which offer important parallels to what we witness with the assembly of books of prints.[40] As with letterpress production, books of prints were commonly sold in paper wrappers or stab-stitched (meaning the sheets were held together by a thread sewn near the spine edge).[41] If they decided to bind them, it was more economical for owners to assemble their books of prints together given the considerable cost of binding in the period. *Sammelbände* could be formed at the point of sale or sent to a binder at a later point, and the contents could shift from one compilation to another after initial binding.[42]

The assembly of books of prints with each other is not solely a result of the expense of binding. Jeffrey Todd Knight refers to the possibilities of a 'material intertextuality' that considers the relatedness of texts within the same *Sammelband*.[43] Books of prints derive meaning from each other when bound together, making every *Sammelband* of pictures a distinct creation. Books of prints are not simply 'reproduced' but provoke a unique experience across every compilation in which they appear. *Sammelbände* of pictures reveal that printmakers and users alike thought in parts. Every book of prints presented itself as a possible building block for a new, larger book of prints. A single edition, itself often a mixed collection of disparate plates, offered potentially endless relationships with other books. The 'material intertextuality' of a book of prints was dynamic rather than fixed.

There were diverse motivations behind each *Sammelband*. Many books of prints were collected together because they shared the same artist. An exemplar at the Kupferstichkabinett in Berlin contains three books of prints

39 Analysis of the binding of books of prints overall is lacking. One exception is Stijnman A. *Engraving and Etching 1400–2000: A History of the Development of Manual Intaglio Printmaking Processes* (London: 2012) 338–341.

40 The research by Alexandra Gillespie, Seth Lerer, Jeffrey Todd Knight, and others over the past twenty years has significantly expanded our understanding of *Sammelbände*. See Gillespie A., "Poets, Printers, and Early English *Sammelbände*" *Huntington Library Quarterly* 67.2 (2004) 189–214; Lerer S., "Medieval Literature and Early Modern Readers: Cambridge University Library Sel. 5.51–5.63", *Papers of the Bibliographical Society of America* 97 (2003) 311–332; and Knight J.T., *Bound to Read: Compilations, Collections, and the Making of Renaissance Literature* (Philadelphia: 2013).

41 Griffiths, *Print before Photography* 170; Pearson D., *English Bookbinding Styles, 1450–1800: a Handbook* (London – New Castle: 2005) 148–150; and Pratt A.T., "Stab-Stitching and the Status of Early English Playbooks as Literature", *The Library* 16.3 (2015) 304–328.

42 Gillespie, "Poets, Printers" 207–208.

43 Knight, *Bound to Read* 82.

designed by Jacques Callot.[44] Each of the three editions was printed by Israël Henriet in Nancy in the early to mid-1630s. The *Sammelband* was formed with a focus on devotional imagery by Callot, and would presumably have been assembled from the stock of available books of prints within Henriet's shop. Other *Sammelbände* were arranged by theme. A collection of books of prints at the British Library contains six drawing manuals from Paris in the mid-1600s, printed by Pierre Mariette.[45] Unlike the Callot *Sammelband*, they were bound with each other not to unite the works of a single artist, but because they were all examples from the same genre – model books. By bringing them together, the early owner possessed a unique book of drawing manuals that oscillates between art collection and educational tool.

The motives for binding books of prints together, then, were based on the interests of their owner and quite frequently on the parameters established by the printmaker.[46] Although rarely noted today, stocklists indicate that print shops commonly pre-assembled books of prints with each other.[47] These bound collections are examples in book of prints form of what Greg calls a 'nonce collection', ready-made *Sammelbände* containing different editions brought together under a new title.[48] The motivation for these works was to provide a pre-assembled compilation of books on a given theme or artist – akin to a compilation album of related genres, singers, or tracks.

Three books of prints based on drawings by Giovanni Battista Montano and printed by Giovanni Battista Soria – the *Scielta d. varii tempietti antichi* (1624) *Diversi Ornamenti* (1625), *Tabernacoli Diversi* (1626/8) – were sold together with either Soria or the printer Carlo Ferrante's edition of the *Architettura con diversi Ornamenti* (1624/36).[49] The ordering of the four books across early

44 1) *Règles de la Congrégation Nostre Dame* (1634), 2) *Vita et historiae Beatae Mariae Virginis Matris Dei* (1633), 3) *Martyrivm Apostolorvm* (1632). Kupferstichkabinett Berlin, Sign. 2135.

45 1) *Livre de portraiture de Io. François Barbier* (1642); 2) *Le livre original de la portraiture* (1644); 3) [Untitled Book of Fourteen Anatomical Studies] (c. 1645); 4) *Libro novo da dissegnare* (1650); 5) *Livre de portraiture recueilly des oeuvre de J. de Rivera* (1650); 6) *A Monseigneur le Duc Danguien* (1650s?). British Library, 638.e.22.(1–6).

46 Alexandra Gillespie similarly speaks of 'the "balance" between the impulses of the producer ... and those of consumers'. See Gillespie "Poets, Printers" 203.

47 On this understudied topic, see Fuhring P., "From Commerce to Fashion: the Architecture à la mode or an Ornament Encyclopedia of the Louis XIV Period", in Ouwerkerk A. (ed.), *Het Nederlandse binnenhuis gaat zich te buiten: internationale invloeden op de Nederlandse wooncultuur* (Leiden: 2007) 154–157.

48 Greg W.W., *A Bibliography of the English Printed Drama to the Restoration* (1939–59), 4 vols. (London: 1962) 4:xxx–xxxii.

49 After 1638, an issue of the *Sammelband* would typically include Ferrante's *Raccolta de' tempij* (1638). See Fowler L.H. *The Fowler Architectural Collection of the Johns Hopkins University* (Baltimore: 1961) 168.

CUSTOMIZED BOOKS OF PRINTS AND THE MYTH OF THE IDEAL SERIES 385

Sammelbände of Montano seems to vary.[50] This changed in 1684 when Giovanni Giacomo de' Rossi reprinted the popular books of prints as a collection called *Li Cinque Libri di Architettura*. The famed stocklist of the de' Rossi family, the *Indice delle Stampe intagliate*, offers the five books for purchase either individually or together.[51] De' Rossi made two important alterations to the collection: his name was now included on the title page for each of the five books and, if patrons acquired them all at once, a table of contents now preceded the sequence in Montano's editions.[52] By selling the books together with a table of contents, de' Rossi codified the way in which the *Sammelband* was to be assembled. This permitted Montano's fantastical temple designs, altar decorations, and church ornaments to be read together as an anthology of his work.

Sammelbände of pictures are noteworthy for the histories they reveal – the conditions of sale for books of prints, their use by early owners, and their handling by later users and institutions. Print collections, libraries, individual collectors, and print and book sellers have erased these histories by removing books of prints from their bindings (and often continue to do so), but in certain cases we can reconstruct the earlier lives of these *Sammelbände*.[53] One exemplar at the British Museum contains a handwritten table of contents by an early user on the flyleaf preceding the first plate. The list outlines five books and the number of plates within each edition.[54] The book today is altered considerably from this early user's moment. The *Sammelband* was rebound with the work by Michel Sweerts now missing six of its initial seventeen plates. Sweerts' and Paul van Somer's books as well as twenty-three ornamental and religious prints added to the assemblage are mounted onto separate sheets. Most remarkably, a book of twenty-four plates of beggars by Callot (also called "The Barons") was removed in its entirety from the *Sammelband*. The Callot book is not found in the British Museum or British Library catalogues – it likely has disappeared.

50 Compare the Getty Research Institute's volume (85–B12422) with that of the British Library (50.g.10.(1–5)).

51 Rossi Giovanni Giacomo de', *Aggiunta all'indice delle stampe intagliate in rame, al bulino all'acqua forte* (Rome, Giovanni Giacomo de' Rossi: 1686) 19.

52 Fowler, *Fowler Architectural Collection* 168. In his 1691 edition of *Li Cinque*, de' Rossi maintains the same arrangement as the first edition.

53 On the eighteenth and nineteenth century disbinding of *Sammelbände*, see Needham P., *The Printer & the Pardoner: an Unrecorded Indulgence Printed by William Caxton for the Hospital of St. Mary Rounceval, Charing Cross* (Washington: 1986) 17–19. On the relationship between *Sammelbände* and institutional practices, see Knight, *Bound to Read* 26–30.

54 The notation reads: 1) '24. for drawing by de Wit' 2) '24. fr. drawing. Beggars. by Callot.', 3) '12. of Flowers. by Lotharingus', 4) '17. Head. Originals by. Sweert.', and 5) '12. figures various. Paul van Somirs'. The British Museum, 1937,0802.1.1–82.

This example suggests the often-complex histories that can be unearthed through close examination of the materiality of a *Sammelband* of pictures. Alexandra Gillespie, in her study of fifteenth-century textual *Sammelbände*, expresses her interest in 'real and imagined volumes – in all the books that appear and disappear as we attend to the minute evidence and the evidentiary traditions of bibliographical history'.[55] When we consider the British Museum exemplar, we do not just examine the book as it is now, but as it was and could be. It is a rare case of a *Sammelband* of pictures containing evidence of ownership from a previous existence. In confronting *Sammelbände*, we encounter a history of substantial loss: books of prints are torn out of their covers as individual plates to sell for greater profit. The customizations that institutions, collectors, and sellers make to *Sammelbände* of books of prints frequently obscure the customizations of early owners – the book is so often 'a historic object with most of the traces of its history removed', as William Sherman notes.[56] We are commonly left with individually bound books that reflect how we expect an ideal series to look – independent works that represent an artist's vision entirely within its own boards.

3 Assembled in Parts

The British Museum *Sammelband* leads us to recognize the whole as part, but we must also consider the part as whole. The nineteenth-century view of the 'organically whole text' presumes that a book is always a finished product, but recent examinations into early modern book assembly have questioned this belief.[57] Books were commonly cut and pasted into new albums, as with the Little Gidding 'harmonies' that collaged new books out of the excerpts of prints and texts.[58] Commonplace books extracted quotations from cherished authors to form powerful information systems.[59] Miscellanies transcribed popular poetry alongside recipes, sermon notes, records of household finances,

55 Gillespie, "Poets, Printers" 200.
56 Sherman W.H., *Used Books: Marking Readers in Renaissance England* (Philadelphia: 2008) 164.
57 Palfrey S. – Stern T., *Shakespeare in Parts* (Oxford: 2007) 2.
58 For a recent account, see Gaudio M., *The Bible and the Printed Image in Early Modern England: Little Gidding and the Pursuit of Scriptural Harmony* (London: 2017).
59 Blair A., "Humanist Methods in Natural Philosophy: The Commonplace Book", *Journal of the History of Ideas* 53.4 (1992) 541–551.

CUSTOMIZED BOOKS OF PRINTS AND THE MYTH OF THE IDEAL SERIES 387

and other non-literary texts.[60] Juliet Fleming calls for us 'to stop thinking in wholes': a recognition of the fractured, combinatory nature of the early modern book challenges any construal of text as a total artefact.[61]

An ideal series is similarly conceived as a whole work, a complete representation of the artist that overlooks how contemporaries divided their bound pictures in constructing unique material forms. Any book of prints can be defined by what in the modernist view would only be a 'fragment'. Buyers could acquire however many plates they wished from a book of prints while printmakers often condensed the prints available within an existing edition. Salvator Rosa's *Figurine*, first produced in the late 1650s, was subject to frequent reprintings throughout the seventeenth and eighteenth centuries, often in segments of Rosa's initial grouping.[62] Georg Christoph Kilian's *Diversae positurae* (c. 1770), for instance, borrowed significantly from Rosa's initial creation, reversing the images and condensing the number of figures from sixty-two down to thirteen.[63] Excerpts of the *Figurine* could be individualized by makers. Rosa fashioned a fascinating example from the first edition that includes only twenty-five of his etchings as well as a title page with a written dedication to the collector Carlo de' Rossi. While there has been some debate as to whether de' Rossi received an 'incomplete' iteration, it did not seem to trouble him or Rosa: the work, which Rosa referred to as his *libretto* ('little book'), did not need to be finished for him to ink the frontispiece with a dedication, nor did de' Rossi require a complete example to add to his extensive collection of Rosa's art.[64] Rosa's decision to include certain prints from the publication defined the whole for de Rossi's iteration of the book. Customization did not detract from the book of prints but enhanced it.

'Fragments' of books of prints such as the Rosa example are frequently described as having something missing or wrong from an ideal series. This offers a narrow vision of the fragment as an incomplete entity that yearns for a prior existence, rather than recognizing the wholeness of the fragment itself.[65] Adam

60 Vine A., *Miscellaneous Order: Manuscript Culture and the Early Modern Organization of Knowledge* (Oxford: 2019) 7.

61 Fleming J., "The Renaissance Collage: Signcutting and Signsewing", *Journal of Medieval and Early Modern Studies* 45.3 (2015) 451.

62 On eighteenth century printings of the *Figurine*, see Sunderland J., "The Legend and Influence of Salvator Rosa in England in the Eighteenth Century", *The Burlington Magazine* 115 (1973) 787.

63 Rosa Salvator, *Diversae Positurae* (Augsburg, Georg Christoph Kilian: c.1770). Staats- und Stadtsbibliothek Augsburg, Kst 3244.

64 Wallace R.W., *The Etchings of Salvator Rosa* (Princeton: 1979) 16–17.

65 For an excellent overview of the 'fragment' as it relates to book history, see Bamford H., *Cultures of the Fragment: Uses of the Iberian Manuscript, 1100–1600* (Toronto: 2018) 3–20.

Smyth argues that a fragment looks forward, not backwards from the originating book: its power comes from its potential to generate new meanings beyond its initial form.[66] Books of prints produce many sorts of 'fragments', whether a plate excerpted from a complete series or a disassembled *Sammelband*. Any book after all becomes a 'fragment' behind glass in an exhibit.[67] Museums also produce scans of books of prints that frequently omit any material outside of the plate. It is critical to recognize these digital 'fragments' since they reinforce our own epistemologies, digitally removing knowledge on paper and cementing the image as the only part of a leaf worth observing.

Books of prints that vary in their number of plates are not the exception but the norm. It was common for users to form books of prints out of illustrated books. When purchasing prints for Villacerf, La Teulière, head of the French Academy in Rome, decided to buy the plates within a multi-volume illustrated book by Carlo Fontana first and then to acquire the text at a later point.[68] Printmakers would sometimes make the illustrations from a letterpress book available for purchase together.[69] The 1664 edition of Cesare Vecellio's famous costume book, the *Habiti antichi*, is a book of prints rather than a reprint of the illustrated book as it appeared in the first two editions – the woodcuts no longer include the explanatory text. In distinguishing itself from previous editions, the title page refers to the costume book as a 'raccolta di figvre' ('collection of figures') and a 'libro vtilissimo a Pittori, Diffegnatori, Scultori, Architetti, & ad ogni curioso, e peregrino ingegno' ('most useful book for painters, draughtsmen, sculptors, architects, and to anyone curious and of a unique intellect').[70] The 1664 edition presents itself as a book of prints, which emerges out of letterpress book production. Any illustrated book was a possible book of prints.

The book of prints has sometimes been interpreted as the less creative counterpart to the album, an individually made volume typically consisting of

66 Smyth A., "'Rend and teare in peeces': Textual Fragmentation in Seventeenth-Century England", *The Seventeenth Century* 17.1 (2004) 43.

67 Heather Bamford makes this important observation. See Bamford, *Cultures of the Fragment* 16.

68 La Teulière's letter of 18 May 1694 to La Teulière explains that he bought the plates separately, with the intention of buying the text later at a more reasonable price. See Montaiglon A. de, *Correspondence des Directeurs de l'Académie de France a Rome avec les Surintendants des Batiments*, 2 vols. (Paris: 1887–88) 2:22. See also Consagra F., *The De Rossi Family Print Publishing Shop: A Study in the History of the Print Industry in Seventeenth-Century Rome* (Ph.D. Dissertation, The Johns Hopkins University, 1993) 22.

69 For instance, see Fuhring, "The Stocklist" 308, nrs. 340–341.

70 Vecellio Cesare, *Habiti Antichi Ouero raccolta di figvre Delineate dal gran Titiano, e da Cefare Vecellio fuo fratello, diligentemente intagliate, conforme alle Nationi del Mondo* (Venice, Combi, La Noù: 1664) fol. *<2>r.

CUSTOMIZED BOOKS OF PRINTS AND THE MYTH OF THE IDEAL SERIES 389

pasted-in prints. According to this thinking, books of prints are fixed, 'whole' products produced solely in the printmaker's shop while albums were assembled in parts by early owners.[71] A book of prints housed at the Kupferstichkabinett in Berlin demonstrates the limitations of this binary. The work contains twenty-five printed dice games by Giuseppe Maria Mitelli. To my knowledge, there was never a book of printed dice games conceived by the artist; each of the prints in the book was printed individually and not as an edition. It is not arranged alphabetically, thematically, or by date of printing – the only structure comes from the pasted-in title page, which includes the handwritten inscription 'Li Giochi di Giuseppe Mitelli Tavole N: 25.' ('The Games of Giuseppe Mitelli Figures N: 25.').[72] The book is not a complete collection of the estimated thirty-three printed dice games by Mitelli, nor does it promise to be.[73] The prints must have been chosen and arranged because of a personal connection to its early owner. The strange codex forms a new whole out of existing parts. It was assembled outside of any control by Mitelli, demonstrating that users could make new books of prints without a prescribed order established by the printmaker.

Like albums, books of prints were subject to orderings and re-orderings, with users arranging fragments to construct unique creations. A *Sammelband* held at the British Library contains two books: Gabriel Bodenehr's *Grotesche capriciose* (c. 1725) and a book of 29 prints of assorted caricatures under the title *Proverbii verificati* (1718) by Johann Christoph Kolb.[74] The latter deviates considerably from the standard 25 plates within Kolb's edition.[75] The book begins with the title page of the *Proverbii*, followed by four of six plates from a small book of Latin proverbs published by Joseph Friedrich Leopold and engraved by

71 Consider Peter Parshall's distinction between bound series and albums in the print collection of Ferdinand, Archduke of Tyrol: 'Fuller attention is given to volumes which were actually compiled as albums rather than bound series of prints published as self-contained series. The individually constructed albums are symptomatic in more interesting ways of the strategies of organization underlying the collection as a whole'. See Parshall P., "The Print Collection of Ferdinand, Archduke of Tyrol", *Jahrbuch der Kunsthistorischen Sammlungen in Wien* 78 (1982) 145.

72 [*Book of Printed Dice Games*] (Bologna, Giuseppe Maria Mitelli.: n.d.). Kupferstichkabinett Berlin, R-Lipp Ti 2 mtl (Lipperheidesche Kostümbibliothek).

73 On the estimated number of printed games by Mitelli, see Dossena G., "I 33 (+18) Giochi del Mitelli", Lai P. – Menichelli A.M. (eds.), *Costume e Società nei giochi a stampa gi G.M. Mitelli* (Perugia: 1988) 17.

74 British Library, General Reference Collection 561*.e.37.(1–2.).

75 For an exemplar with 25 plates, see Kolb Johann Christoph, *Proverbii verificati. Per l'esperienza cotidiana. Come li megliorj e più piacevoli informatori di massime salutifere. In 25 Stampe leggiadre et espicationi dé verfi, al profito d'ogni uno ...* (Augsburg, Johann Kristoph Kolb (?): 1612). University of Illinois-Urbana-Champaign, Q. Emblems 0005.

Elias Baeck.[76] We then find plates 6 and 7 of the *Proverbii* and a second edition printed by Leopold and Baeck – a book of Callot figures designed by Johann Adam Müller. The volume concludes with 9 more plates from the *Proverbii* in the following order, as marked by their plate numbers: 19, 20, 24, 1, 4, 25, 15, 5, 22.

It is uncertain why these prints were included in the volume. Many of the plates resemble prints by Mitelli, who created the first edition of the *Proverbii* in 1678. They may have been collected together not only due to related subject matters but formal similarities too. It is also unclear why this sequence was chosen. The plate numbers of the *Proverbii* offer a reminder of the arrangement established by the 'complete' edition of Kolb's prints, revealing how an excerpt combined with other parts can form a new book out of an existing one. The exemplar breaks the orders imposed on the publications. It is for this reason that Roger Chartier refers to readers as 'rebellious and vagabond' against the controls placed on a book by its producer(s).[77] A unique volume is formed with and against its previous structures, challenging any notion of the book of prints as a fixed and total medium.

4 Parapicture

For many books of prints, evidence of use and assembly is found not only in the arrangement of the pictures, but the oft-forgotten materials surrounding them. I propose an inversion of Gérard Genette's use of 'paratext' to encompass the various elements surrounding the pictures in a book of prints, such as the letters to the reader, dedications, indices, and so forth. I call these elements the 'parapicture' of a book of prints. The term serves two functions. First, it problematizes Genette's relegation of pictures to a secondary role in the makeup of the book.[78] The book of prints demonstrates that pictures may serve as the 'main' part of a book and are not merely supplements to its text, as he conceived. Second, while Genette defines paratext to describe the materials that transform the immaterial text into the material book, I introduce the parapicture to describe the features around pictures that are omitted from most

76 There is also an unknown print published by François Guérard interspersed between the third and fourth of Baeck's prints.

77 Chartier R., *The Order of Books: Readers, Authors, and Libraries in Europe between the Fourteenth and Eighteenth Centuries*, trans. L.G. Cochrane (Stanford: 1994) viii.

78 Genette states that the inclusion of illustrations within a book was always the choice of its author, believing that writers must provide the pictures, commission them, or in some way 'accept their presence'. See Genette G., *Paratexts: Thresholds of Interpretation*, trans. J.E. Lewin (Cambridge: 1997) 406.

CUSTOMIZED BOOKS OF PRINTS AND THE MYTH OF THE IDEAL SERIES 391

accounts of books of prints.[79] The absence of these bookish parts dematerializes the medium and move it closer to an ideal series.

Looking *around* a book of prints offers important insights into how it was customized. Printmakers commonly tinkered with the tables of contents, changed the honoree in their dedications, and altered title pages to meet new demands. Standard paratexts in early modern printing are not always precisely analogous to parapictures in books of prints; the latter suggest unique ways of guiding a user through its plates. Signatures and catchwords, tips for the binder on how to assemble the pages together, do not usually occur in books of prints.[80] The printmaker supplied plate numbers and letters rather than signatures and page numbers to stipulate the internal ordering, although this was sometimes ignored as in the case of the *Proverbii*.[81] Instead of footnotes or printed notation in the margins, books of prints may include stamped letters within the image that act as keys, with further explications at the bottom of the plate or in supplementary letterpress. Introductory remarks and texts at the bottoms of plates were commonly reinscribed, revised, or translated for a new target audience, meaning the parapicture provides important clues on how books of prints were localized and brought up to date.

The parapicture also directs our attention to the topic of book use, a popular subject in book history that studies the multitude of ways in which contemporaries left evidence of their handling of books. While much of the history has been erased due to the mounting of plates and cleaning of leaves, we nevertheless find evidence of users marking their books of prints with doodles, statements of ownership, and responses to the pictures.[82] When tables of contents were not included, users of books of prints sometimes inscribed their own lists at the beginning or end of a book, as witnessed in the British Museum *Sammelband* above.[83] One example at the National Gallery of Art Library in Washington D.C. demonstrates the diverse ways in which books of prints were used. This iteration of Hans Vredeman de Vries' *Scenographiae, sive perspectivae* (1560) surrounds the prints with numerous architectural and figural drawings by early users Ioannes and Philips Vingboons, who signed their names on the

79 Ibid. 1.
80 Smith H. – Wilson L., "Introduction", Smith H. – Wilson L. (eds.), in *Renaissance Paratexts* (Cambridge – New York: 2011) 4.
81 See footnote 75 for the *Proverbii* example.
82 On nineteenth and twentieth century responses to early modern marginalia, see Sherman, *Used Books* 151–178.
83 See footnote 55 for the British Museum *Sammelband*.

dedication page.[84] One of the Vingboons brothers even appears to have wiped his brush on the verso of the fifth plate.[85] Although earlier scholarship stressed the 'goal-oriented' nature of book use in the period, the Vingboons' example suggests a more quotidian treatment of books of prints by their contemporary users.[86]

Jacopo Ligozzi's *Descrizione del Sacro Monte della Vernia* demonstrates how alterations to the parapictures could transform a publication. The *Descrizione*, printed twice in Florence (1612 and 1617) and later in Milan (1672), was a pictorial guidebook that simulated the experience of visiting the Franciscan site of La Verna. The *Descrizione* leads users on their virtual pilgrimage through its long, vertical plates with a plethora of parapictures.[87] What makes the *Descrizione* so striking is the degree to which contemporaries customized their parapictures and therefore their imagined pilgrimages to La Verna, as illustrated by the significant alterations made to two exemplars of the 1612 Florentine edition.

The first exemplar of the *Descrizione* is housed at the Biblioteca Nazionale Vittorio Emanuele III in Naples. Although much of the book remains untouched, the introductory material has been subject to significant upheaval. The standard frontispiece and dedication are not found in this iteration. In their place, we find a custom-made dedication and bookplate, both of which honour Ranuccio, Duke of Parma and Piacenza [Fig. 12.3]. The dedication by Paulo Henoch, a little-known printer residing in Florence, likens him to the architect Stasicrates with specific reference to his plan to transform Mount Athos into a portrait of Alexander the Great. The story was widely discussed in Antiquity, from Plutarch to Vitruvius.[88] Unlike Stasicrates, Henoch claims he succeeded in making an accurate rendering of Ranuccio in La Verna: 'ma quel che non si fece nel Monte Ato, si è fatto nel Monte Sacro di Alverna' ('but what

84 Vredeman de Vries Hans, *Scenographiae, sive perspectivae* [...] *pvlcherrimae viginti selectissimarvm fabricarvm* (Antwerp, Hieronymus Cock: 1560). National Gallery of Art Library (Washington D.C.), π1ᵃ.

85 Ibid. E1ᵇ.

86 Jardine L. – Grafton A., "'Studied for Action': how Gabriel Harvey read his Livy", *Past & Present* 129 (1990) 30–78. For an important revision of Jardine and Grafton's thesis, see Knight J.T., "'Furnished' for Action: Renaissance Books as Furniture", *Book History* 12 (2009) 38–41.

87 On virtual pilgrimage, see Rudy K., *Virtual Pilgrimages in the Convent: Imagining Jerusalem in the Late Middle Ages* (Turnhout: 2011).

88 Plutarch, *Plutarch's Lives*, trans. B. Perrin, 11 vols. (London: 1967) 7:425–427; and Vitruvius, *Vitruvius: Ten Books on Architecture*, trans. Rowland I.D. (New York: 1999) 33.

CUSTOMIZED BOOKS OF PRINTS AND THE MYTH OF THE IDEAL SERIES 393

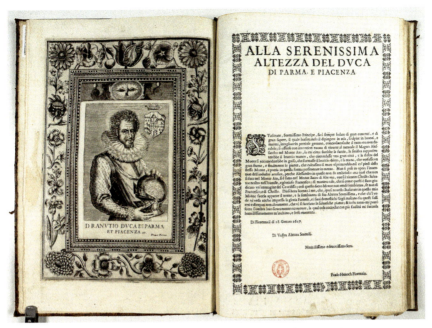

FIGURE 12.3 Paulo Henoch, *Alla Serenissima altezza del dvca di Parma e Piacenza*.
Letterpress, 1617. From: *Descrizione del Sacro Monte della Vernia* (Florence, Paulo Henoch (?): 1612/17)
IMAGE © BIBLIOTECA NAZIONALE "VITTORIO EMANUELE III"

was not done in Mount Athos, was done in the Sacred Mount of Alverna').[89] The user of this unique exemplar is intended to revel in Henoch's creation and the magnificence of Ranuccio: 'e che chi'l vede vi veda anche impressa la Gloria Farnese' ('and whoever sees [the mountain] will also see the Farnese glory impressed on it').[90] In this individualized iteration, La Verna is virtually remade in Ranuccio's image through the altered parapicture.

In the second example, at the New York Public Library, nearly all the letterpress, including the titles atop each page, has handwritten translations into contemporary Dutch added underneath the printed text [Fig. 12.4].[91] The translation seems to have been undertaken by at least three different hands, all belonging to seventeenth-century annotators. The motivations for such

89 Moroni Lino (?), *Descrizione del Sacro Monte della Vernia* (Florence, s.n.:1612/17). Biblioteca Nazionale Vittorio Emanuele III, n.u. s.7. a.da rosi (C) 1617 (Q). π2ᵃ. It is unclear whether Henoch published the entire copy or only the dedication.
90 Ibid.
91 Moroni Lino (?), *Descrizione del Sacro Monte della Vernia* (Florence, s.n.: 1612). New York Public Library, Spencer Coll. Ital. 1612 93–390. F1ᵇ.

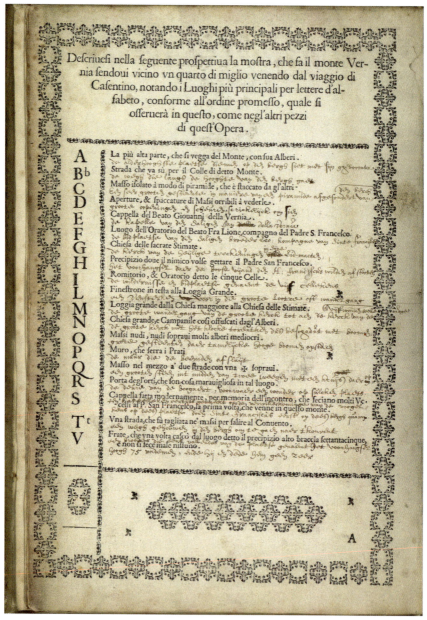

FIGURE 12.4 Lino Moroni (?), *Descriuesi nella seguente prospettiua la mostra* [...]. Letterpress, 1612. From: *Descrizione del Sacro Monte della Vernia* (Florence, s.n.: 1612)
PUBLIC DOMAIN. NEW YORK PUBLIC LIBRARY

CUSTOMIZED BOOKS OF PRINTS AND THE MYTH OF THE IDEAL SERIES 395

a unique undertaking are unclear, and no other evidence of provenance has been found. The NYPL's exemplar could have been brought back to the Low Countries and adapted for Dutch users, either before or after arrival in their homeland. The copy could have also been translated for a Dutch community residing in Italy, perhaps in Florence – the Ranuccio example and later Milanese edition suggest a pan-Italian interest in the publication. Dutch émigrés presumably would have possessed the linguistic skills to translate the text from Italian.

The act of translation, whether by expats or Dutch locals, imposes order on the book. Homi Bhabha suggests such translations are fraught with misrepresentations and function as 'staging[s] of cultural difference'.[92] Similarly, Heather Jackson notes that one of the rationales behind marginalia is to establish the reader's independence from the writer: 'conscious agreement and dissent alike contribute to the construction of identity'.[93] It is this very tussling between printmaker and user that lies behind the annotations of this copy, a desire to make the *Descrizione* their own. The NYPL's copy of the *Descrizione* is a site for contesting linguistic and cultural control, an attempt to localize the book of prints through its malleable surrounding features.

Parapictures form and perform senses of self. In the *Descrizione*, they reveal how contemporaries defined their identities in personalizing their book of prints – a pilgrimage into themselves as well as virtually to La Verna. Attending to the features around the plates is critical to moving past the ideal series and directing our attention towards the book of print's customizable material configurations. In doing so, it reveals how contemporaries made the book of prints as much as the book of prints made contemporaries.

5 Conclusion

Antony Griffiths describes the book of prints as existing in a 'no man's land' between various print and book media.[94] I have argued that recasting books of prints *as books* sheds new light on where they lived in early modernity, offering new possibilities for our understanding of pictures *in books* from the early modern period. Books of prints demonstrate the extended lives of book illustrations, from the movement of plates far beyond their initial loci to the

92 Bhabha H.K., *The Location of Culture* (London: 2004) 325.
93 Jackson H.J., *Marginalia: Readers Writing in Books* (New Haven: 2001) 87.
94 Griffiths, *Print before Photography* 175.

new books formed by printmakers through the merging of different groups of prints. They show that pictures within a book may be divided, enlarged, or combined with other book illustrations to generate novel codices. And books of prints reveal that the features around book illustrations offer critical evidence for how early modern users engaged with their pictures. This 'no man's land', this uninhabited space between our understanding of the book and print, in fact provides fruitful terrain for showing us what pictures do in the early modern book.

Bound pictures, however, navigate a 'no man's land' across the institutions in which they are held today, residing between print collections in museums and rare book libraries. They therefore have important ramifications for how these institutions record their objects. Within print collections, the print as the basic unit of cataloguing proves problematic for recording illustrated books in general and books of prints in particular, while digitization projects often reinforce such hierarchies of the individual print. Whereas in print collections a visitor is more likely to engage with pictures that are now mounted and placed in solander boxes, libraries often house larger collections of books of prints.[95] Yet as I have discussed elsewhere, libraries lack a standard for describing books of prints which makes it equally difficult to find volumes within their precincts.[96] Studying books of prints not only means looking beyond the printroom as the standard repository for print historical research, it also requires us to reconsider how these institutions structure our experiences of print media.

This paper has argued that art historical binaries for describing series of prints – finished and unfinished, whole and part, original and derivative, complete and incomplete – do not account for the diverse forms books of prints can take, then and now. I have proposed that book historical approaches can be reimagined to provide new insights into artefacts that are normally of interest to art historians alone. A series of prints does not happen to be bound together; book history teaches us that it is a formal decision that affects its meaning.[97] Nomenclature that describes a book of prints as a series obfuscates questions about its medial features, thereby limiting our understanding of these works as fixed artefacts that are best considered in their earliest setting and circumstances. When we attend to the materiality of the book of prints, we discover its intermedial nature. Books of prints overlap with albums of prints, illustrated

95 Stijnman, *Engraving and Etching* 339.
96 The Books of Prints Cataloguing Project, *Introduction*, https://booksofprints.omeka.net /intro [accessed 26 April 2022].
97 Here I reference the famous line by D.F. McKenzie: 'forms effect meaning'. See McKenzie D.F., *Bibliography and the Sociology of Texts* (London: 1986) 4.

books, and other bookish forms. Book history has largely overlooked how these media overlap and relegated printed pictures as secondary or even superfluous to the codex. Bound pictures must play a far greater role in defining the early modern book than presently conceived.

Bibliography

Bamford H., *Cultures of the Fragment: Uses of the Iberian Manuscript, 1100–1600* (Toronto: 2018).

Bhabha H.K., *The Location of Culture* (London: 2004).

Blair A., "Humanist Methods in Natural Philosophy: The Commonplace Book", *Journal of the History of Ideas* 53.4 (1992) 541–551.

[*Book of Printed Dice Games*] (Bologna, Giuseppe Maria Mitelli: n.d.). Kupferstichkabinett Berlin, R-Lipp Ti 2 mtl (Lipperheidesche Kostümbibliothek).

Bowers F., *Principles of Bibliographical Description* (Princeton: 1949).

British Museum, *Theatrum Pictorium*, https://www.britishmuseum.org/collection /object/P_A-8-1 (accessed 26 April 2022).

Chartier R., *The Order of Books: Readers, Authors, and Libraries in Europe between the Fourteenth and Eighteenth Centuries*, trans. L.G. Cochrane (Stanford: 1994).

Consagra F., *The De Rossi Family Print Publishing Shop: A Study in the History of the Print Industry in Seventeenth-Century Rome* (Ph.D. Dissertation, The Johns Hopkins University, 1993).

Dane J., "'Ideal Copy' versus 'Ideal Texts': The Application of Bibliographical Description to Facsimiles" *Papers of the Bibliographical Society of Canada* 33.1 (1995) 31–50.

Donati L., "Proposte per una datazione della Scuola perfetta: le series incisorie nelle raccolte romane", *Rivista dell'Istituto Nazionale d'Archaeologia e Storia dell'Arte* 57 (2002) 323–344.

Dossena G., "I 33 (+18) Giochi del Mitelli", Lai P. – Menichelli A.M. (eds.), *Costume e Società nei giochi a stampa gi G.M. Mitelli* (Perugia: 1988) 15–46.

Fleming J., "The Renaissance Collage: Signcutting and Signsewing", *Journal of Medieval and Early Modern Studies* 45.3 (2015).

Fowler L.H., *The Fowler Architectural Collection of the Johns Hopkins University* (Baltimore: 1961).

Fuhring P., "From Commerce to Fashion: the Architecture à la mode or an Ornament Encyclopedia of the Louis XIV Period", in Ouwerkerk A. (ed.), *Het Nederlandse binnenhuis gaat zich te buiten: internationale invloeden op de Nederlandse woationcultuur* (Leiden: 2007) 146–164.

Fuhring P., "Speculum diversarum insignium speculativum, à variis viris doctis ad inventarum, atque ab insignibus pictoribus ac sculptoribus delineatarum, 1638", in

Bass M. – Wyckoff E. (eds.), *Beyond Bosch: the Afterlife of a Renaissance Master in Print*, exh. cat., St Louis Art Museum (St Louis: 2015) 218–223.

Fuhring P., "The Stocklist of Joannes Galle, Print Publisher of Antwerp, and Print Sales from Old Copperplates in the Seventeenth Century", *Simiolus* 39.3 (2017) 225–313.

Galbraith S.K., "Spenser's First Folio: the Build-It-Yourself Edition", *Spenser Studies* 21.1 (2006) 21–49.

Gaudio M., *The Bible and the Printed Image in Early Modern England: Little Gidding and the Pursuit of Scriptural Harmony* (London: 2017).

Genette G., *Paratexts: Thresholds of Interpretation*, trans. J.E. Lewin (Cambridge: 1997).

Gillespie A., "Poets, Printers, and Early English *Sammelbände*" *Huntington Library Quarterly* 67.2 (2004) 189–214.

Grazia M. de, "The Essential Shakespeare and the Material Book", *Textual Practice* 2.1 (1988) 69–86.

Grazia M. de, *Shakespeare Verbatim: the Reproduction of Authenticity and the 1790 Apparatus* (Oxford: 1991) 49–93

Grazia M. de – Stallybrass P., "The Materiality of the Shakespearian Text", *Shakespeare Quarterly* 44.3 (1993) 255–83.

Greg W.W., *A Bibliography of the English Printed Drama to the Restoration* (1939–59), 4 vols. (London: 1962).

Greist A., *Learning to Draw, Drawing to Learn: Theory and Practice in Italian Printed Drawing Books, 1600–1700* (Ph.D. Dissertation, University of Pennsylvania, 2011).

Griffiths A., *The Print before Photography: An Introduction to European Printmaking 1550–1820* (London: 2016).

Haskell F., *The Painful Birth of the Art Book* (London: 1987).

Hass A., "Two Devotional Manuals by Albrecht Dürer: The 'Small Passion' and the 'Engraved Passion.' Iconography, Context and Spirituality", *Zeitschrift für Kunstgeschichte* 63 (2000) 169–230.

Hattori C. – Leutrat E. – Meyer V. (eds.), *À l'origine du Livre d'art: les Recueils d'estampes comme entreprise éditoriale en Europe, XVIe–XVIIIe siècle.* (Milan: 2010).

Heilmann M. – Nanobashvili N. – Pfisterer U. – Teutenberg T. (eds.), *Punkt, Punkt, Komma, Strich: Zeichenbücher in Europa, ca. 1525–1925* (Passau: 2014).

Iusco A.G., "Note all'INDICE del 1735 e alle Tavole Sinottiche", in Iusco A.G. (ed.), *Indice delle Stampe de' Rossi: Contributo alla storia di una Stamperia romana* (Rome: 1996) 373–511.

Kastan D.S., "Shakespeare and the Book" (Cambridge: 2001).

Knight J.T., "'Furnished' for Action: Renaissance Books as Furniture", *Book History* 12 (2009) 37–73.

Knight J.T., *Bound to Read: Compilations, Collections, and the Making of Renaissance Literature* (Philadelphia: 2013).

Jackson H.J., *Marginalia: Readers Writing in Books* (New Haven: 2001).

Jardine L. – Grafton A., "'Studied for Action': How Gabriel Harvey read his Livy", *Past & Present* 129 (1990) 30–78.

Klinge M., "David Teniers and the Theatre of Painting", in Vegelin van Claerbergen E. (ed.), *David Teniers and the Theatre of Painting*, exh. cat., Courtauld Institute of Art Gallery (London: 2006) 10–39.

Kolb Johann Christoph, *Proverbii verificati. Per l'esperienza cotidiana. Come li megliorj e più piacevoli informatori di massime salutifere. In 25 Stampe leggiadre et espicationi dé verfi, al profito d'ogni uno …* (Augsburg, Johann Kristoph Kolb (?): 1612). University of Illinois-Urbana-Champaign, Q. Emblems 0005.

Leca B., "An Art Book and its Viewers: The 'Recueil Crozat' and the Uses of Reproductive Engraving", *Eighteenth-Century Studies* 38.4 (2005) 623–649.

Lerer S., "Medieval Literature and Early Modern Readers: Cambridge University Library Sel. 5.51–5.63", *Papers of the Bibliographical Society of America* 97 (2003) 311–332.

Loewenstein J., *The Author's Due: Printing and the Prehistory of Copyright* (Chicago: 2002).

Marcus L., *Unediting the Renaissance: Shakespeare, Marlow, Milton* (London: 1996).

McGann J.J., *The Textual Condition* (Princeton: 1991).

McKitterick D. *Print, Manuscript and the Search for Order, 1450–1830* (Cambridge: 2003).

Montaiglon A. de, *Correspondence des Directeurs de l'Académie de France a Rome avec les Surintendants des Batiments*, 2 vols. (Paris: 1887–88).

Moroni Lino (?), *Descrizione del Sacro Monte della Vernia* (Florence, s.n.: 1612). New York Public Library, Spencer Coll. Ital. 1612 93–390.

Moroni Lino (?), *Descrizione del Sacro Monte della Vernia* (Florence, s.n.: 1612/17). Biblioteca Nazionale "Vittorio Emanuele III", n.u. s.7. a.da rosi (C) 1617 (Q).

Moxey K., "Visual Studies and the Iconic Turn", *Journal of Visual Culture* 7.2 (2008) 131–146.

Murphy A., *Shakespeare in Print: A History and Chronology of Shakespeare Publishing* (Cambridge: 2003; reprint ed., 2021) 258–290.

Nanobashvili N., *Das ABC des Zeichnens. Die Ausbildung von Künstlern und Dilettanti* (Petersberg: 2018).

Needham P., *The Printer & the Pardoner: an Unrecorded Indulgence Printed by William Caxton for the Hospital of St. Mary Rounceval, Charing Cross* (Washington: 1986)

Orgel S., "The Authentic Shakespeare", *Representations* 21 (1988) 1–25.

Orgel S., "What is a Text?", in Kastan D.S. – Stallybrass P. (eds.), *Staging the Renaissance: Reinterpretations of Elizabethan and Jacobean Drama* (New York – London: 1991) 83–87.

Palfrey S. – Stern T., *Shakespeare in Parts* (Oxford: 2007).

Palmer R. – Frangenberg T. (eds.), *The Rise of the Image: Essays on the History of the Illustrated Art Book* (Aldershot: 2003).

Parshall P., "The Print Collection of Ferdinand, Archduke of Tyrol", *Jahrbuch der Kunsthistorischen Sammlungen in Wien* 78 (1982) 139–190.

Parshall P., "Antonio Lafreri's 'Speculum Romanae Magnificentiae'", *Print Quarterly* 23.1 (2006) 3–28.

Pearson D., *English Bookbinding Styles, 1450–1800: a Handbook* (London – New Castle: 2005).

Plutarch, *Plutarch's Lives*, trans. B. Perrin, 11 vols. (London: 1967).

Pratt A.T., "Stab-Stitching and the Status of Early English Playbooks as Literature", *The Library* 16.3 (2015) 304–328.

Rosa Salvator, *Diversae Positurae* (Augsburg, Georg Christoph Kilian: *c.* 1770). Staats- und Stadtsbibliothek Augsburg, Kst 3244.

Rossi Giovanni Giacomo de', *Aggiunta all'indice delle stampe intagliate in rame, al bulino all'acqua forte* (Rome, Giovanni Giacomo de' Rossi: 1686).

Rudy K., *Virtual Pilgrimages in the Convent: Imagining Jerusalem in the Late Middle Ages* (Turnhout: 2011).

Savage N., *Early Printed Books, 1478–1840: Catalogue of the British Architectural Library, Early Imprints Collections* (London: 1994).

Schreurs A. (ed.), *Unter Minervas Schutz: Bildung durch Kunst in Joachim von Sandrarts Teutscher Academie* (Wolfenbüttel: 2012).

Sherman W.H., *Used Books: Marking Readers in Renaissance England* (Philadelphia 2008).

Smith H. – Wilson L., "Introduction", in Smith H. – Wilson L. (eds.), *Renaissance Paratexts* (Cambridge – New York: 2011) 1–14.

Smyth A., "'Rend and teare in peeces': Textual Fragmentation in Seventeenth-Century England", *The Seventeenth Century* 17.1 (2004) 36–52.

Stallybrass P. – Chartier R., "Reading and Authorship: the Circulation of Shakespeare 1590–1619", in Murphy A. (ed.), *A Concise Companion to Shakespeare and the Text* (Oxford: 2007) 35–56.

Stallybrass P., "Printing and the Manuscript Revolution", in Zelizer B. (ed.), *Explorations in Communication and History* (London – New York: 2008) 111–118.

Stijnman A., *Engraving and Etching 1400–2000: a History of the Development of Manual Intaglio Printmaking Processes* (London: 2012).

Sunderland J., "The Legend and Influence of Salvator Rosa in England in the Eighteenth Century", *The Burlington Magazine* 115 (1973) 785–789.

Tanselle T., "The Concept of Ideal Copy", *Studies in Bibliography* 33 (1980) 18–53.

The Books of Prints Cataloguing Project, *Introduction*, https://booksofprints.omeka .net/intro (accessed 26 April 2022)].

Vecellio Cesare, *Habiti Antichi Ouero raccolta di figvre delineate dal gran Titiano, e da Cefare Vecellio fuo fratello, diligentemente intagliate, conforme alle Nationi del Mondo* (Venice, Combi, La Noù: 1664).

Vine A., *Miscellaneous Order: Manuscript Culture and the Early Modern Organization of Knowledge* (Oxford: 2019).

Vitruvius, *Vitruvius: Ten Books on Architecture*, trans. Rowland I.D. (New York: 1999).

Vredeman de Vries Hans, *Scenographiae, sive perspectivae* [...] *pvlcherrimae viginti selectissimarvm fabricarvm* (Antwerp, Hieronymus Cock: 1560). National Gallery of Art Library (Washington D.C.).

Wallace R.W., *The Etchings of Salvator Rosa* (Princeton: 1979).

Werstine P., "Narratives About Printed Shakespeare Texts: 'Foul Papers' and 'Bad' Quartos", *Shakespeare Quarterly* 41 (1990) 65–86.

Yerkes C. – Minor H.H., *Piranesi Unbound* (Princeton – Oxford: 2020).

Zorach R., *The Virtual Tourist in Renaissance Rome: Printing and Collecting the Speculum Romanae magnificentiae* (Chicago: 2008).

CHAPTER 13

Customizing an Emblem Book as an *album amicorum*: Valentin Ludovicus' Entry in the *Stammbuch* of Christian Weigel

Mara R. Wade

The printed emblem book containing manuscript entries presents a special kind of customized book, a hybrid form which is the focus of my research into social practices of the emblem. Both the *album amicorum* and the emblem book are book genres from the first half of the sixteenth century. Very soon, they became literally interleaved with one another when additional blank pages were inserted between pages of printed emblem books to repurpose them as an albums, or *Stammbücher*. These interleaved pages then served as the place for signatories to make their entries. The greater share of the possessors and signers of *alba* were men, although women also owned and signed *Stammbücher*. Typically, the album owner presented his book to those he met on his study tour, and the person presented with the album entered words of friendship to document the encounter. Sometimes coats of arms or other images were included in the entry, thus paving the way for the development of emblem books as albums.

Within the social hierarchy of the *Stammbuch*, the highest-ranking persons made their entries in the front of the book, while fellow students and close family members made their entries near the back. Persons asked to sign the emblematic *Stammbuch* could therefore choose to make their entry near a specific emblem, although it had to be within their social range, so to speak. As was particularly the case with the albums belonging to young men such as Weigel, an otherwise unknown student from Silesia, traveling on their study tours, the emblem chosen often reflected the signatory's relationship to the owner, and provided some ethical advice to accompany the young man on his travels.

Often signatories into an emblematic *album amicorum* exploited the printed emblem to develop a new aggregate construct in which the manuscript entry entered into dialogue with the printed image and its associated texts. These new and often sophisticated assemblages consisted of printed and manuscript images and poetry, derived from classical or biblical sources, or of one's own invention. The entries were personalized, usually naming the book's owner, the signatory, and the date and place of signing the album. The texts were

© KONINKLIJKE BRILL NV, LEIDEN, 2024 | DOI:10.1163/9789004680562_014

usually multilingual with Latin and often included languages other than the native German of the album owner, as in the case presented here. In cases where the album entry engaged in a dialogue with the printed emblem, the scripted text generally went beyond annotating, commenting, or correcting, and instead employed strategies of emblem creation – that is, adaptation, variation, amplification, and refinement of ideas presented in the printed emblem. The handwritten entry often intersected with, and refocused or expanded, ethical tenets from the printed emblem, combining them with fluent personalized messages from a specific writer to the owner of the *Stammbuch*. The manuscript album entry thus opened the printed emblem to new meanings and interpretations. The emblem book as album was therefore a uniquely customized book that interpolated handwriting into print. The following essay presents a detailed analysis of such a manuscript amplification of a printed emblem. It focuses on an entry in an early seventeenth-century album made on top of a sixteenth-century printed emblem book. The emblem book is a copy of Achillis Bocchi, *Symbolicarum quæstionum, de universo genere, quas serio ludebat, libri quinque* (1574).[1]

1 Christian Weigel's Album

The *album amicorum* of Christian Weigel from Silesia is relatively unremarkable among early *Stammbücher*, in that little is known about the owner, and there are only a few entries.[2] Nevertheless it is highly significant for the research and analysis of customized books that newly imagine printed texts and images in the social practices of the emblem. At least two signatories of Weigel's album recognized the opportunity of engaging with the printed work through their own handwritten entries. One was made by the young German poet Martin Opitz (1597–1639), whose entry I have discussed elsewhere,[3] and

1 Bocchi Achillis, *Symbolicarum quæstionum, de universo genere, quas serio ludebat, libri quinque* (Bologna, apud Societatem Typographiæ Bononiensis: 1574). [Symbolic questions about the whole genre, which he played seriously, five books.]

2 Herzog August Bibliothek (HAB), Wolfenbüttel, Cod. Guelf. 225 Noviss. 8°. See Giermann R., *Die neueren Handschriften der Gruppe Novissimi: 1 Noviss. 2–100 Noviss. 2; 1 Noviss. 4–78 Noviss. 4; 1 Noviss. 8–235; Noviss. 8; 1 Noviss 12–19; Noviss. 12*, Kataloge der Herzog-August-Bibliothek Wolfenbüttel, 20 (Frankfurt am Main: 1992) 176.

3 Wade M.R., "Martin Opitz signiert ein Stammbuch. Multiple Autorschaft und 'andere Ästhetik' im emblematischen *album amicorum*", in Gropper S. – Pawlak A. –Wolkenhauer A. – Zirker A. (eds.), *Plurale Autorschaft: Ästhetik der Co-Kreativität in der Vormoderne. Andere Ästhetik – Koordinaten*, Vol. 2 (Berlin/Boston/Munich: de Gruyter, 2023), 97–122.

the other was made by a Silesian, Valentin Ludovicus (1576–1630), whose entry is the centre of the interpretation presented here.

The initials on the cover of the *Stammbuch* 'C.W.C.S.' indicate the owner's name and origins, 'Christian Weigel Carnoviensis Silesius', that is, from Jägerndorf in Silesia (Fig. 13.1).[4] Very little is known about this Christian Weigel. Given the context of his album, he was likely born slightly before 1600 and was a pupil at the gymnasium in Liegnitz. Several possible connections have been suggested by Seidel und Marschall in their edition of the Latin works of Martin Opitz, since the poet also signed this *Stammbuch*. As one possible relative, they offer a certain Ursula Weigel, daughter of a deceased pastor Georg Weigel in Haynau, for whom Opitz wrote an epithalamium, or a certain Johann Weigel, Bürgermeister and Senator in Liegnitz.[5] There was also an early Bürgermeister in Jägerndorf named Hans Weigel, who might have been a relative, perhaps a progenitor.[6] This particular Christian Weigel left few traces beyond his *Stammbuch*, now preserved at the Herzog August Bibliothek, Wolfenbüttel.[7] In addition to his initials, the volume's cover also bears the date 1613. In general, when dates are inscribed on the cover of an *album amicorum* as a *supra libros*, as in the case of Weigel's book, the date reflects its creation as a customized book, not the date of publication. This practice confirms the owner's awareness of creating a book for a special purpose. Therefore, this date – 1613 – is when the nearly forty-year-old book came into Weigel's possession, was interleaved with blank pages for use as an album, and received a special binding to accompany him on his student journeys.

The practice of interleaving a printed book with blank pages was done for a variety of purposes, such as providing an author with a working copy of his own printed work with space for additions, emendations, and supplementations, or offering intensive readers a place for marginalia.[8] In the case of the

4 Schulz-Behrend G., "Zwei Opitz-Autographen", *Wolfenbütteler Beiträge* 3 (1978) 91.

5 See Opitz M., *Lateinische Werke*, eds. V. Marschall – R. Seidel, Vol. I, 1614–1624 (Berlin: 2009) 276. See also Opitz M., *Briefwechsel und Lebenszeugnisse: Kritische Edition mit Übersetzung*, eds. K. Conermann – H. Bollbuck (Berlin: 2009) 163 and 216.

6 There was a Hans Weigel, 1564–1566, who was a *Ratsherr* [town councilor] in Jägerndorf. See Guzy S., "Vögte, Schöffen, Zechmeister und andere städtische Amtsträger in Jägerndorf 1564 bis 1570", *Zeitschrift für ostdeutsche Familienkunde* 61 (2013) 121–124.

7 Bocchi Achillis, *Symbolicarum quaestionum* [...] HAB, Stammbuch Christian Weigel, Cod. Geulf. 225 Noviss. 8°. See also, *Repertorium Album Amicorum*: https://raa.gf-franken.de/de /suche-nach-stammbuechern.html?permaLink=1613_weigel.

8 Brendecke A., "Durchschossene Exemplare. Über eine Schnittstelle zwischen Handschrift und Druck", *Archiv für Geschichte des Buchwesens* 59 (2005) 50–64. See also Feuerstein-Herz P., "Seitenwechsel. Handschrift und Druck in durchschossenen Buchexemplaren der frühen

CUSTOMIZING AN EMBLEM BOOK: LUDOVICUS IN WEIGEL'S *STAMMBUCH* 405

FIGURE 13.1 'C.W.C.S.' and '1613', Cover, Achillis Bocchi, *Symbolicarum quæstionum* (Bologna, apud Societatem Typographiæ Bononiensis: 1574); *Stammbuch* Christian Weigel. Cod. Guelf. 225 Noviss. 8
COURTESY OF THE HERZOG AUGUST BIBLIOTHEK (HAB), WOLFENBÜTTEL

interleaved emblem book the interfoliation was almost always done with the aim of repurposing it as an *album amicorum*. The fine binding of Weigel's book with the decorated cover and its embellishments, together with the chased gilt fore-edges, confirms the valuable place this splendid book was intended to have in the young man's personal library.[9] Weigel used the book until 1616; it has 18 entries from Liegnitz, Münsterberg, Breslau, and Prague, among others.[10] While the entries are few, they are noteworthy.

What makes Weigel's album interesting is that he customized a printed book, Bocchi's *Symbolicarum Quæstionum* (1574) as a *Stammbuch*. The lay-out of the customized book is consistent throughout [Fig. 13.2]. Each of Bocchi's emblems begins as a single opening, that is, motto and *pictura* on the left-hand side and *subscriptio* on the right. In some cases, the *subscriptiones* continue beyond a single opening. However, the basic unit is the opening, left and right. By making Bocchi's volume into a *Stammbuch*, Weigel quite literally opened the emblems for customization by interpolating blank pages between the two pages of the emblem opening. The emblem's own intermediality in its employment of visual and textual sources already suggests the genre's openness to (re-)combination with other forms. When customized in this fashion as a *Stammbuch*, the inserted blank page invited signatories to sign within a specific emblem and enter into dialog with it. In this manner the two genres of the emblem book and the *Stammbuch* converged to create the hybrid volume of the printed emblem book with manuscript album entries.

That a signatory often put a great deal of thought and consideration into his choice of emblem is attested by the entry made by Valentin Ludovicus the Younger, a poet laureate, a notary, and teacher at the ducal school at Liegnitz

 Neuzeit", *Kodex* 9 (2019) 9–26; Feuerstein-Herz P., "Weisse Seiten. Durchschoßene Bücher in alten Bibliotheken", *Zeitschrift für Ideengeschichte* 11 (2017) 101–114; and Beinert W., "Durchschießen", *Typolexikon* – 2001. (Article from 22. Juni 2018.) https://www.typolexikon.de/. Accessed 30 June 2022.

9 The spine once had other information written on the cover at the top. This information appears to have been later covered by a label, since removed. The condition of the spine suggests that the book was perhaps bound when new and then, rather than rebinding it, the binding was repurposed for Weigel and stamped with the insignia 'CWCS' and year. There are marks of later ownership in the front of the volume. On the front fly page at the top: 'Johanes Puff. Anno Domini den 12. April ist ein schwer tag geweßen ist' [sic]. Below on same page: 'Daß buhlen ist mir lieb, wer mich schildt der ist ein Dieb. Johaneß Frist'. These owners apparently did not use the volume as an album.

10 The catalogue entry for the printed book at the HAB lists the album entries. See Bocchi, *Symbolicarvm Qvæstionvm* 1574.

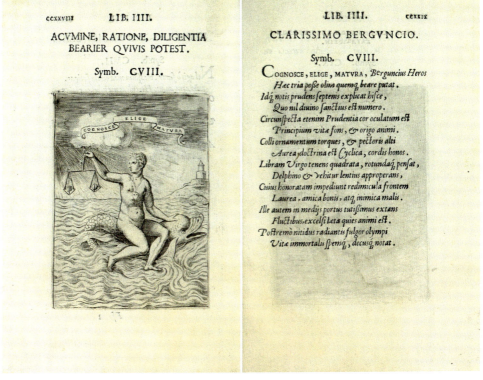

FIGURE 13.2 Emblem 108, Achillis Bocchi, *Symbolicarum quæstionum* (Bologna, apud Societatem Typographiæ Bononiensis: 1574). http://emblematica.library.illinois.edu/detail/emblem/E020865
COURTESY OF EMBLEMATICA ONLINE, UNIVERSITY OF ILLINOIS

[Figs. 13.3 & 13.4].[11] He signed the album on 31 October 1615 at "Symbolum CVIII", that is, Emblem 108.[12] Because the Wolfenbüttel copy cannot be digitized, for comparison I refer here to the copy from the University of Illinois at Urbana-Champaign – which is not customized as an album and which is freely available through *Emblematica Online*.[13] All manuscript images discussed in

11 He was educated at the school and later became a teacher there. See Kraffert A.K., *Geschichte des evangelischen Gymnasiums zu Liegnitz* (Liegnitz: 1869) 108.
12 Bocchi's emblems are divided into five "books," or parts, and Ludovicus signed in the second half of the volume, in the third book of five, see Bocchi, *Symbolicarum quaestionum* 228.
13 Call number: Emblems 096.1 B63a 1574; see http://emblematica.library.illinois.edu/detail/emblem/E020865.

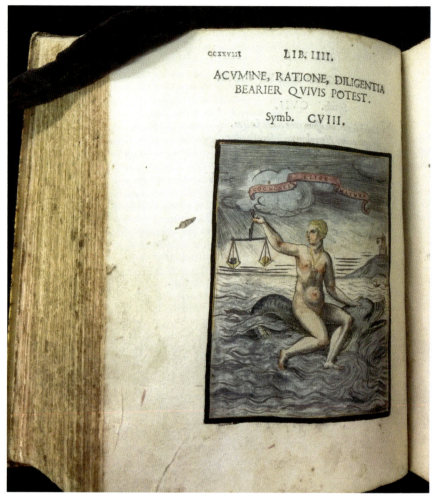

FIGURE 13.3 Emblem 108, Ludovicus entry, *pictura*, Bocchi, *Symbolicarum quæstionum; Stammbuch* Christian Weigel. Herzog August Bibliothek (HAB), Wolfenbüttel, Cod. Guelf. 225 Noviss. 8
COURTESY OF HAB, WOLFENBÜTTEL

this chapter were taken from the Wolfenbüttel copy, and I would like to thank the library here for allowing me to use these images.[14]

Weigel's album demonstrates how the signatory could create an entirely new textual environment for his chosen emblem. Ludovicus signed the album in his hometown of Liegnitz ("e Ligîs"); he wrote his carefully composed words

14 My special thanks are owing to Dr. Christian Heitzmann.

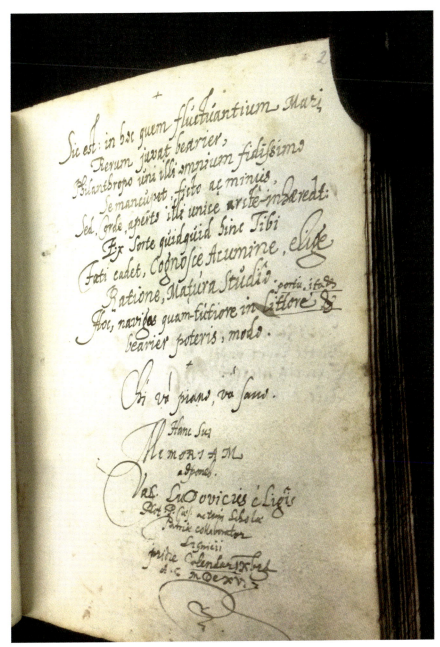

FIGURE 13.4 Emblem 108, Ludovicus entry, text, Bocchi, *Symbolicarum quæstionum; Stammbuch* Christian Weigel. Herzog August Bibliothek (HAB), Wolfenbüttel, Cod. Guelf. 225 Noviss. 8
COURTESY OF HAB, WOLFENBÜTTEL

in 1615.[15] The long entry in a fair hand is opposite Bocchi's *symbola* CVIII [108] 'Acvmine, ratione, diligentia bearier quivis potest' (Through keenness, reason, and diligence, anyone can become happy).[16] The image depicts a goddess, a conflation of Justice and Prudence, holding in her right hand scales, one pan with a round and one a square object. She sits astride a dolphin and wears a golden chain with a pedant of a heart with eyes on it. According to the epigram on the next printed page, she also wears a laurel wreath. The background depicts a safe harbour with a lighthouse and little boats at anchor below. The rays emitted from the heavens and the lamp extending from the lighthouse reflect the glory of Olympus and eternal life. The *pictura* has been professionally hand coloured, the blue of the skies and water offset by a red banderol with the printed motto, 'Cognosce elige matura' (Investigate, Choose, Advance). The rose colours highlighting Prudence's body closely associate her with the motto on the banderol. The emblem *pictura* is framed in black, the inner frame highlighted in gold; the Virtue's hair and necklace are also golden. The exquisitely executed colouring confirms that the signer carefully chose this emblem as his own and customized its message for the album owner.

In my experience in studying the emblematic *album amicorum*, the images are rarely adapted in any way; the picture remains the stable, if polyvalent, element. While the emblems in some books have been coloured, to showcase a single emblem with high quality colours in this way is unusual. That Valentin Ludovicus had the emblem coloured, making it the only such vividly enhanced image in the volume, attaches particular importance to Emblem 108 and attests to his desire to distinguish his entry from all others. Instead of giving the album to an artist to add his heraldic device, the signer gave it to an artist to colour this single image. The colours make this emblem stand out among all the emblems in this volume, compelling readers to ruminate over it. The motto is a device a young man could well apply in life: Know, choose, hasten to accomplish it. The words of the motto seem to be assigned respectively to 1) the Virtue Prudence – 'cognosce' (investigate, know), 2) the scale – 'elige' (choose), and 3) the dolphin – 'matura' (advance, hurry).

15 Bocchi, *Symbolicarum quaestionum* … 1574, Book III, Emblem CVIII (108). HAB: Stammbuch Christian Weigel, Cod. Guelf. 225 Noviss. 8°, 239–240. All further references to the Ludovicus entry are made from this opening.

16 The persistent link in Emblematica Online to Emblem 108 is: http://hdl.handle.net/10111/EmblemRegistry:E020865.

CUSTOMIZING AN EMBLEM BOOK: LUDOVICUS IN WEIGEL'S *STAMMBUCH* 411

The printed emblem epigram deserves our close attention [Fig. 13.2]:

CLARISSIMO BERGVNCIO
Symb[olum] 108

Cognosce, elige, matura, Berguncius Heros
 Haec tria posse olim quemque beare putat.
Idque notis prudens septenis explicat hisce,
 Quo nil diuino sanctius est numero.
Circunspecta etenim Prudentia cor oculatum est
 Principium vitae fons, et origo animi.
Colli ornamentum torques, et pectoris alti
 Aurea doctrina est Cyclica, cordis honos.
Libram Virgo tenens quadrata, rotundaque pensat,
 Delphino et vehitur lentius approperans,
Cuius honoratam impediunt redimicula frontem
 Laurea, amica bonis, atque inimica malis.
Ille autem in mediis portus tutissimus extans
 Fluctibus, excelsi laeta quies animi est.
Postremo nitidus radiantis fulgor olympi
 Vitae immortalis spemque, decusque notat.

[To most illustrious Berguncius.
Symbol 108

Investigate, choose, advance. Heroic Berguncius thinks that these three
 things can bring anyone happiness one day.
And the wise man explains it through these sevenfold signs,
Than which divine number nothing is more sacred.
For the heart endowed with eyes is circumspect Prudence, the beginning
 of life, the source and origin of the soul.
The ornament on the neck and high breast, a golden necklace, is encyclo-
 pedic learning, the honour of the heart.
The virgin holding the scale weighs out the square and the round, and
 hastening slowly[17] is carried on a dolphin;
her honoured brow is encircled by laurel fillets: [she is] a friend to the
 good and an enemy to the wicked.

17 "Lentius approperans" is reminiscent of the Italian aphorism in the other text: 'chi va
 piano'.

And that port, standing out most secure in the midst of the waves, is the happy peace of the elevated soul.
Finally, the shining brightness of radiant heaven signifies the hope and glory of undying life.][18]

The printed poem guides our interpretation of the complex image. Among the attributes of Prudence are circumspection and learning, as depicted in the golden chain with the pendant of eyes looking out from the heart. Circumspection inherently bears the meaning of 'looking around' and reinforces the concept of 'cognosce', or knowing keenness, as does the figure of the dolphin, whose attributes are swift intelligence and loyalty. The necklace and the golden chain reference the connectedness of things, and knowledge. The turbulent sea represents the events in life. The lantern at the harbour not only beckons to safety, it also stands for enlightenment, learning, and reflection. The tension between learning and reflection and choosing and advancing in a timely fashion to complete a decision is embodied in the central figure of Prudentia. She glances back at the scales with the sphere of possibility and the cube of knowledge, while the dolphin advances to the harbour of enlightenment. In a sense the present moment is delicately balanced, like the scales pictured here, between the past and that which is to come. Prudentia is depicted not with her usual mirror and snake, but with a pair of scales, which conflates her with Justitia. Prudence is the ability to make right decisions, and the scales indicate an expansion also into jurisprudence with the implication of correct legal decisions. This text is, in a sense, a juridical extrapolation of the well-known emblem 'Festina lente' ['Eile mit Weile', or make haste slowly] that is often portrayed by the anchor and dolphin as qualities balancing haste and slowness. The adage *Festina lente* was well known to contemporaries and would have resonated with readers of both the emblem and the album. The symbolic interplay and non-linear reading across the texts and images, both those visually present and those available in a well- stocked mind, significantly deepen the interpretation of the emblem.

Bocchi addressed this emblem to Berguncius, that is, Bernardino Francesco Bergonzi (1500–1561), who, having studied in Bologna, held from 1535 the chair of jurisprudence in Parma. In her magisterial study of the Bolognese poet, Anne

18 Dr. Jeremy Thompson, Bonn, expertly translated the Latin of both this emblem and the manuscript entry into English. I would like to thank him for his insights and exchanges concerning my arguments presented here. For a German translation, see Henkel A. – Schöne A., *Emblemata: Handbuch zur Sinnbildkunst des XVI. und XVII. Jahrhunderts* (Stuttgart: 1967) 1554.

Rolet dates Bocchi's elegiac distichs to Bergonzi to the years 1538–1542, when he was at the peak of his career and held important civic and court positions.[19] Rolet states that the image was Bergonzi's personal device and interprets the elements, starting with the three imperatives from the banderol, as parts of juridical decision making, the three actions of intelligent reasoning, reflection and choice, and expedient implementation of the decision.[20]

After having highlighted the emblem *pictura* by adding vibrant colour, Valentin Ludovicus customized Bocchi's emblem by supplementing the author's *subscriptio* with one of his own [Fig. 13.5]. His entry on the interleaved page makes a direct intervention in the compound reading of Bocchi's motto, *pictura*, and epigram, and inserts his own words between the printed pages

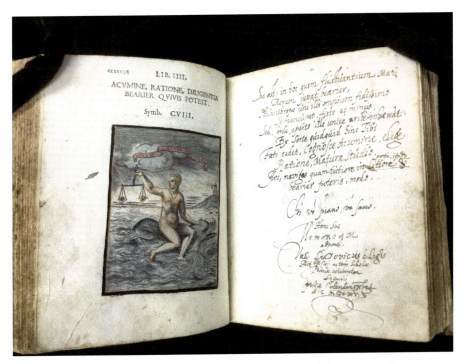

FIGURE 13.5 Emblem 108, Ludovicus entry, opening, Bocchi, *Symbolicarum quæstionum; Stammbuch* Christian Weigel. Herzog August Bibliothek (HAB), Wolfenbüttel, Cod. Guelf. 225 Noviss. 8
COURTESY OF HAB, WOLFENBÜTTEL

19 Rolet A., *Les Questions symboliques d'Achille Bocchi. Symbolicae quaestiones, 1555*. Vol. 2., *Traduction, annotation et commentarie* (Tours: 2015) 553–558.
20 Ibid. 553.

of emblem construct. His manuscript entry is a personalized Latin poem for Weigel, written in an elegant hand. When we read the new *subscriptio*, as Christian Weigel himself must have done, we need to locate it within the context of Bocchi's motto and *pictura*, including the banner with the words 'Cognosce Elige Matura', which immediately precede the new poem. With this new emblematic construct, Ludovicus confirms that he was familiar with reading and creating emblems, as demonstrated by his building out from an existing image and motto with his own epigram. That is to say, Bocchi's motto and *pictura* become part of the new emblem associated with Ludovicus' poetic manuscript entry.[21] His entry reads as follows:

ACUMINE, RATIONE, DILIGENTIA
 BEARIER QUIVIS POTEST
Symb[olum] CVIII.
[on the banner within the symbol:]
Cognosce / Elige / Matura
[The texts above are from the printed emblem and *pictura* and comprise
 the new emblem construct for which Ludovicus has composed a new
 epigram.]
Sic est: in hoc quem fluctuantium Mari,
 Rerum juvat bearier,
Philathropo uni illi omnium fidissimo
 Se mancupet, ficto ac minus,
Sed Corde aperto illi unice rite inhaereat:
 Ex Sorte quidquid hinc Tibi
Fati cadet, cognosce Acumine, elige
 Ratione, Matura Studio.
Hoc, navigas quam tutiore in littore et portu ita et
 Bearier poteris, modo.

Chi va piano, va sano.

Hanc sui
Memoriam
Adponeb[at]
Val. Ludovicus é Ligîs

21 He stresses the emblematic invention by stating in his signature, "This memento [is] one of his own."

CUSTOMIZING AN EMBLEM BOOK: LUDOVICUS IN WEIGEL'S *STAMMBUCH* 415

Not[arius] P[ublicus] Caes[areus], artium scholae
Patriae collaborator
Lignicii
Pridie Calendar[um] IXbris [Novembris]
A.D. MDCXV'.[22]

[Through keenness, reason, diligence,
 Anyone can come to happiness.[23]
Symbol 108

Investigate / Choose / Advance
So it is: whomsoever it pleases to come to happiness in this sea of fluctu-
 ating affairs,
let him subject himself to that one philanthropist, truest of all; and less
 to an illusion,
but, with an open heart, let him cling solely to him, as is right: whatever
 fate may by chance
befall you,[24] investigate with keenness, choose with reason, advance with
 purpose.[25]
In this way, how much safer is the port in which you are navigating, and
 thus you will be able to come to happiness.
He who goes gently, goes in health.
This memento,
one of his own,
was set down by
Valentin Ludwig of Liegnitz,

22 Bocchi, *Symbolarum* 1574, Book III, Emblem CVIII (108). Stammbuch Christian Weigel,
 HAB: Cod. Guelf. 225 Noviss. 8°.

23 The verb is related to the word 'beatitude', and it may also elicit connotations of salva-
 tion, such as become explicit in the first two distichs, with the reference to the turning
 seas of the world (a traditional metaphor with biblical roots) and the naming of the
 Philanthropus. The verbal form *bearier* is archaic, and hence erudite.

24 With 'tibi' the poem shifts in these lines from the moralizing third-person to the sec-
 ond person.

25 'Studio' [with purpose] is commonly associated with *diligentia*, the word one would
 expect to find, but replaced for being non-metrical. I would like to thank Dr. Jeremy
 Thompson for this insight.

imperial public notary, instructor in the school of arts
in his homeland,[26]
At Liegnitz
October 31st
AD 1615

The mix of languages, here Italian with the Latin, is typical of both emblems and album entries. We can assume that the Italian rhyme, 'Chi va piano, va sano', is Ludovicus' own motto. Ludovicus also deliberately amplifies the motto from the banner in the emblem *pictura* whose imperative scans in poetically balanced a triad of three words of three syllables each: 'cognosce, elige, matura'. He intertwines the words from the banderol with words from the emblem motto: 'Acumine' and 'Ratione'. Ludovicus appropriately adds 'Studio' to his advice to a young man on a study tour, with the resulting motto of his own: 'Cognosce Acumine, elige Ratione, Matura Studio'. In this manner, he admonishes Weigel to recognize the wise, to choose reason and understanding, and to hasten to his studies. Moreover, there are several verbs of motion (go, hurry) which underscore the idea of travel and the journeys which the young Weigel undertakes for his study.[27] The fugue-like textual variations on 'Cognosce, elige, matura' across the manuscript entries demand multiple, non-linear reading strategies. By creatively reworking the motto and paratexts of the printed emblem, Ludovicus shapes his manuscript entry to the printed emblem, while simultaneously customizing his message to Weigel, thereby intertwining the printed and manuscript messages.

The fact that Ludovicus includes his own motto in his entry also indicates that the wisdom he imparts in his admonitory passage is in dialogue with Bocchi's emblem. The motto printed on the *pictura*, 'Cognosce, Elige, Matura' aligns with Ludovicus' own Italian motto 'Chi va piano, va sano' (He who goes slowly, goes safely). Both can be broadly considered variants of 'Festina lente' (Make haste slowly). All three *motti* elaborate similar ideas in a fugue-like variation. The spectacular colouring of the image, the fine calligraphic hand of the entry, and the completion of the printed texts surrounding the *pictura* by the new handwritten ones create a new multidirectional emblematic construct intended for the album owner Christian Weigel. Through complex

26 The abbreviated title here is expanded on the basis of the database of early modern titles and professions: *Thesaurus Professionum*: https://www.online.uni-marburg.de /fpmr/thepro/rs.php. There may be a better, more conventional way of identifying him. *Collaborator scholae* is simply called at this database a 'Lehrer'.

27 Dr. Corinne Dzuidzia alerted me to the significance of the verbs of motion during the discussion of this paper when I presented it in Heidelberg in September 2021. I would like to thank her for this insight.

cognitive associations, the manuscript album entry orients itself to the thought from the printed page and develops an entirely new message intended specifically for Weigel. Ludovicus renews the meaning of the emblem, shifting it from Berguncius (Bergonzi), the scholar to whom Bocchi had dedicated his emblem, to Weigel, the owner of the album. The scholar's closing indicates his position as a notary public and teacher at the school in Liegnitz and confirms the date of 31 October 1615. Weigel kept his *Stammbuch* from 1613 through 1616, so Ludovicus was chronologically one of the last signatories in the volume.

2 Roman Ludwig's Entry in Weigel's *Stammbuch*

On the verso of Ludovicus' entry is the hand-coloured coat of arms and entry by Romanus Ludwig, also from Liegnitz, who served on the town council there [Fig. 13.6]. The motto 'Dominus providebit' and the date 1615 appear on a banner above an abbreviation 'ABCDEF' which is a cipher for 'Allein bei Christo die

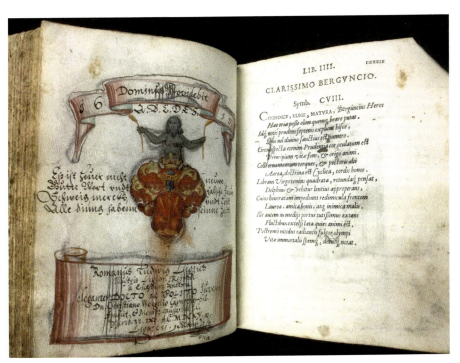

FIGURE 13.6 Emblem 108 verso, Roman Ludwig entry, opening, Bocchi, *Symbolicarum quæstionum; Stammbuch* Christian Weigel. Herzog August Bibliothek (HAB), Wolfenbüttel, Cod. Guelf. 225 Noviss. 8
COURTESY OF HAB, WOLFENBÜTTEL

ewige Freude', reflecting the polyglot practices of both emblems and albums. It was completely typical for the time for individuals to abbreviate their personal motto for inscription in *alba*, and also a practical way to save space on a page in a small book. The date is given more specifically in the scroll at the bottom of the page as 6 November 1615. The mottos, the year, and the dedication with Ludwig's his name in Latin are positioned above and below the coat of arms, respectively. These texts and the heraldic image constitute part of the identify formation and creation of *memoria* that occur in *Stammbücher*.

On either side of the heraldic device is a four-line rhyme in German:

> Es ist heuer nicht neuw,
> Gutte Wort undt falsche Treuw,
> schweig, merckh, und leidt
> Alle dinng habenn seinne Zeitt.

> (It is not at all new these days
> Nice words and false friends [literarally loyalty]
> Be silent, pay attention, and endure
> All things have their own time.)

His concluding attestation of friendship is fairly typical for the time:

> Romanus Ludwig Ligius
> Illustris Ligior. Reipubl.
> A quaestura senatoria.
> Eleganter DOCTO ac POLITO Iuveni
> Dn. Christiano Weigelio Carnovio-Sil.
> Amicit[iae] et memor[iae] caussa haec f.C.
> et scrib., VI. IXb. A.C. M.DCXV
> Lignicii. Manu Propria

> [Roman Ludwig of Liegnitz
> illustrious [citizen] of the Republic of Liegnitz,
> from the quaestorship of the senate,
> makes and writes these things as a souvenir of friendship
> for the finely learned and polite young man, Mr. Christian Weigel of
> Jägerndorf in Silesia,
> 6 November, AD 1615
> At Liegnitz in his own hand].[28]

28 I would like to thank Jeremy Thompson also for his translation of Roman Ludwig's entry.

CUSTOMIZING AN EMBLEM BOOK: LUDOVICUS IN WEIGEL'S *STAMMBUCH* 419

Ludwig's entry describes him as illustrious [citizen] of the Republic [City] of Liegnitz, from the 'quaestorship of the senate', that is, a financial officer of the town's treasury. Analogies can be drawn among the admonitions in the German poem to remain silent ('schweig'), observe ('merckh'), and endure ('leidt'), Bocchi's Latin 'cognosce, elige, matura', and Ludovicus' amplification as 'Cognosce Acumine, elige Ratione, Matura Studio'. It is striking, however, that Ludwig employs a very different strategy by placing his entry, motto, heraldic device, and words of friendship on a single page. Nevertheless, the spatial orientation of his image on the back of the entry by Valentin Ludovicus associates him with that text and simultaneously keeps his own contribution within the pages of Bocchi's Emblem 108. Through word associations across the motti Ludwig engages indirectly with Bocchi's emblem and Ludovicus' reworking of it into a multi-partite emblem. While in his German strophe Ludwig complements the Ludovicus entry by providing an echo of Bocchi's motto, he provides his own visual image in the form of his coat of arms. This version of Emblem 108 can now be interpreted as having (at least) five *motti*: Bergonzi's motto 'Cognosce elige, matura' on the banderol; Bocchi's 'Acumine, ratione, diligentia bearier quivis potest' printed above the *pictura*; and Ludovicus' own manuscript motto 'Chi vá piano, va sano' as well as his amplification as 'Cognosce Acumine, elige Ratione, Matura Studio', and finally Ludwig's 'schweig, merckh, leidt'. The several voices of the emblem mottos each articulate a variation of ethical advice for a young man on a study tour who is preparing for a legal career.

According to the logic of the *album amicorum*, whereby members of the same family or close friends often sign in clusters, it is telling that Roman Ludwig positioned his own vibrantly coloured device on the back of Valentin Ludovicus' elegant entry. The two entries are also connected by their dates and geographical location: only a week apart and in the same town, on 31 October and 6 November 1615 in the Silesian town of Liegnitz. Also a poet, Romanus Ludwig appears in 1614 as 'Lig. quaestoræ senatoriæ in patriæ adjunctus', that is, with a title similar to the one in his signature in Weigel's *Stammbuch*, in a publication together with Valentinus and Laurentius Ludovicus.[29] The proximity in the publication suggests familial connections among the three of

29 Garber K., *Handbuch des personalen Gelegenheitsschrifttums in europäischen Bibliotheken und Archiven* (Hildesheim: 2007), Vol. 19–20, Breslau Universitätsbibliothek, Abt. 4, Bestände aus Liegnitz, item 119. The famous humanist and theologian at Görlitz, Laurentius Ludovicus (1536–1594) is an unrelated man with this surname. See Absmeier C., 'Laurentius Ludovicus', *Schlesische Lebensbilder* 9 (2007) 135–143. On Laurentius Ludovicus (1574–1615), see Flood J., *Poets of the Holy Roman Empire: A Bio-bibliographical Handbook* (Berlin: 2011) 1216–1217. Für Valentin Ludovicus, see Flood 1217–1218.

them – Valentin Ludovicus, Laurentius Ludovicus, Roman Ludwig – and is further supported by the German and Latin versions of the apparently same name, Ludwig and Ludovicus. Roman Ludwig's entry reflects his vocation in the civic government and his advocation as a poet. Given Valentin Ludovicus' age of roughly forty when he signed and his seniority with respect to the placement of his entry, it can perhaps be assumed that he is the senior of those two signatories.

The printed Bocchi emblem with its motto, *pictura*, paratexts, and epigram, and the subsequent colouring of the emblem picture coupled with the elegant Latin manuscript entry by Valentin Ludovicus together create a multivalent emblematic ensemble that enriches and deepens the original meaning of Bocchi's emblem. In a further step the colourful coat of arms and handwritten German entry on the verso by Roman Ludwig extends the process of amplification. The Latin epigram of the printed emblem *subscriptio* dedicated to the Italian legal figure Bergonzi reflects both Ludovicus' and Ludwig's own civic positions and presumably their legal training. While there is next to nothing known about this Christian Weigel, a young man with a *Stammbuch* traveling to advance his studies, both Ludovicus and Ludwig indicate he has future potential. One can reasonably project that he aspired to a civic position in Silesia.

3 Conclusion

Since Elizabeth Eisenstein's pioneering work, print has been associated with modernism, innovation, and forward-facing developments.[30] Yet the addition of manuscripts into the printed emblem fundamentally changes how the emblem is read and understood. The supplementation of the printed emblem with the older technology of handwriting signals asynchronous, collaborative knowledge-making. The case study of Ludovicus's entry into Weigel's *Stammbuch* confirms a deep engagement with the emblem. Assembling the emblem book as album created a new form of learned sociability that documents a complex web of learning, friendship, family, and networks through polyvalent emblematic elements that are in dialogue with each other. The doubling of the genres (album and emblem) is a dynamic form of emblematic intervention, whereby the manuscript additions unleash entirely new interpretative potential.

The space and time of the learned emblem is created anew in this *Stammbuch*, attesting to a sophisticated cosmopolitan culture of learning and study with the printed emblem from which scholars can extrapolate new

30 Eisenstein Elizabeth, *The Printing Press as an Agent of Change* (Cambridge: 1979).

social, citational, and reading practices. The multiple temporal aspects of the emblem ensemble are striking. Bocchi's emblems were first published in 1555, the copy used here as an album was printed in 1574, the date of acquisition 1613 is recorded on the book's binding, and the several entries are dated from 1614–1616 with the focus in the present analysis on 1615. In terms of social networks, the founder of an informal Italian academy, the Accademia Bocchiana under the patronage of Cardinal Alessandro Farnese, Achille Bocchi dedicated his emblem to Berguncius. Forty years later Christian Weigel offered his album to an established poet, possibly his teacher, Valentin Ludovicus, who signed at Emblem 108. On the verso of his entry, Roman Ludwig inscribed himself. The myriad connections among the printed emblem and the handwritten entries further layer the reading experience. Furthermore, the place of the book's publication in Bologna, its acquisition in Jägerndorf, the entries from several places in Silesia and Prague, my reading of it in Wolfenbüttel and Illinois, your reading of it now also offer various data points for interpretation and analysis. The manuscript additions are significant both for the process of production – new texts in dialogue with each other – but also in their reception by the album owner and by all subsequent readers. At its most basic level the handwritten additions set into conversation a printed text from 1574 with a set of highly personalized annotations from 1615. These complementary texts resonate with readers to the present day.

The case study of Valentin Ludovicus's entry into Christian Weigel's *album amicorum* analysed here shows how the signatory created a dialogue between the printed emblem and his manuscript entry. These emblem-album constructs exemplify the workings of this hybrid customized genre and document social networks of learning. The opportunities for interpersonal communication expanded exponentially when the two genres of emblem book and *Stammbuch* coincided. The scholarly conversation around this single emblem, ignited nearly sixty years after the first publication of Bocchi's emblem, maintained humanistic discourses not only across time but also across wide geographical distances and national cultures.

Bibliography

Absmeier C., 'Laurentius Ludovicus', *Schlesische Lebensbilder* 9 (2007) 135–143.

Beinert W., "Durchschießen," *Typolexikon*—2001. (Article from 22. Juni 2018.) https://www.typolexikon.de/. Accessed 30 June 2022.

Bocchi Achillis. *Symbolicarum quæstionum, de universo genere, quas serio ludebat, libri quinque* (Bologna, apud Societatem Typographiæ Bononiensis: 1574). Available at: http://emblematica.library.illinois.edu/detail/book/achillisbocchiiboobocch.

Bocchi Achillis. *Symbolicarum quæstionum, de universo genere, quas serio ludebat, libri quinque* Bologna: apud Societatem Typographiæ Bononiensis (Bologna, apud Societatem Typographiæ Bononiensis: 1574). Catalogued as the manuscript, Stammbuch Christian Weigel, Cod. Guelf. 225 Noviss. 8°, Herzog August Bibliothek, Wolfenbüttel. (See also Weigel *Stammbuch*)

Brendecke A., "Durchschossene Exemplare. Über eine Schnittstelle zwischen Handschrift und Druck," *Archiv für Geschichte des Buchwesens* 59 (2005) 50–64.

Eisenstein E., *The Printing Press as an Agent of Change* (Cambridge: 1979).

Feuerstein-Herz P., "Seitenwechsel. Handschrift und Druck in durchschossenen Buchexemplaren der frühen Neuzeit," *Kodex* 9 (2019) 9–26.

Feuerstein-Herz P., "Weisse Seiten. Durchschoßene Bücher in alten Bibliotheken," *Zeitschrift für Ideengeschichte* 11 (2017) 101–114.

Flood J., *Poets of the Holy Roman Empire: A Bio-bibliographical Handbook* (Berlin: 2011).

Garber K., *Handbuch des personalen Gelegenheitsschrifttums in europäischen Bibliotheken und Archiven* (Hildesheim: 2007), Vol. 19–20, Breslau Universitätsbibliothek, Abt. 4, Bestände aus Liegnitz.

Giermann R., *Die neueren Handschriften der Gruppe Novissimi: 1 Noviss. 2–100 Noviss. 2; 1 Noviss. 4–78 Noviss. 4; 1 Noviss. 8–235; Noviss. 8; 1 Noviss 12–19; Noviss. 12.* Frankfurt am Main: Klostermann, 1992. (Kataloge der Herzog-August-Bibliothek Wolfenbüttel, 20).

Guzy S., "Vögte, Schöffen, Zechmeister und andere städtische Amtsträger in Jägerndorf 1564 bis 1570", *Zeitschrift für ostdeutsche Familienkunde* 61 (2013) 121–124.

Henkel A. – Schöne A., *Emblemata: Handbuch zur Sinnbildkunst des XVI. und XVII. Jahrhunderts* (Stuttgart: 1967).

Kraffert A.K., *Geschichte des evangelischen Gymnasiums zu Liegnitz* (Liegnitz: 1869).

Opitz M., *Lateinische Werke*, eds. V. Marschall – R. Seidel, Vol. 1, 1614–1624 (Berlin: 2009).

Opitz M., *Briefwechsel und Lebenszeugnisse: Kritische Edition mit Übersetzung*, ed. K. Conermann – H. Bollbuck (Berlin: 2009).

Rolet A., *Les Questions symboliques d'Achille Bocchi. Symbolicae quaestiones, 1555.* Vol. 2. *Traduction, annotation et commentarie* (Tours: 2015).

Schulz-Behrend G., "Zwei Opitz-Autographen", *Wolfenbütteler Beiträge* 3 (1978) 89–96.

Wade M.R., "Martin Opitz signiert ein Stammbuch. Multiple Autorschaft und 'andere Ästhetik' im emblematischen *album amicorum*", in Gropper S. – Pawlak A. – Wolkenhauer A. – Zirker A. (eds.), *Plurale Autorschaft: Ästhetik der Co-Kreativität in der Vormoderne. Andere Ästhetik – Koordinaten*, Vol. 2 (Berlin/Boston/München: de Gruyter, 2023), 97–122.

PART 5

Editorial Customisation

∴

CHAPTER 14

A Play of Continuity and Difference: A Book of Fortune-telling Adapted from the Kingdom of Poland to Southeastern Europe

Justyna Kiliańczyk-Zięba

It is an obvious notion that works translated, adapted, and appropriated from one language to another are a staple of early modern literature. It is less often recognised, however, that when texts were mediated across languages, cultures, and genres, their presentation (their visual form) could be – and indeed was – emulated and customised as well. Naturally, 'presentation' and 'form' are very broad terms. They may designate the physical properties of the writing materials, the layout conventions governing the display of the text and images on consecutive pages, as well as the organisation of the intellectual content within the volume. Whether in manuscript or in print, these constituents inform the appearance of a book, that is often defined as 'a text in a given form'.[1] They themselves are in turn determined by a convergence of various conditions – technical, economic, social, psychological, artistic etc. As these circumstances change in the processes of the transmission of texts and images, so does their presentation (their form), reception, and meaning.[2]

This study examines the history of changes in the presentation of a book of fortune-telling, *Fortuna albo Szczęście*, first printed in Krakow in 1532. While it was reissued in Poland well into the eighteenth century, *Fortuna* was also adapted by printers active around the areas of present-day Slovakia, Romania, and Hungary. At the same time, probably in 1660, one of the volumes printed in the Carpathian Basin was customised into a manuscript book in northern Croatia. In my essay, I will thus look at a book adapted and customised across time (from 1532 to the nineteenth century), space (from Poland to Croatia), language (Polish – Hungarian – Croatian), social milieux (from the Polish royal court into the wider world), and production technology (from print to manuscript). My material here will consist of volumes produced and circulated

1 Janssen F.A., *Technique and Design in the History of Printing* ('t Goy-Houten: 2004) 33.

2 McKenzie D.F., *Bibliography and the Sociology of Texts* (London: 1986). See also McKitterick D., "How Can We Tell If people Noticed Changes in Book Design? Early Editions of the *Imitatio Christi*", *Jaarboek voor nederlandse boekgeschiedenis* 19 (2012) 10–31.

© KONINKLIJKE BRILL NV, LEIDEN, 2024 | DOI:10.1163/9789004680562_015

in markets that, though smaller and less explored than those of France, the German lands, or Italy, supported a book culture no less interesting than that of the most developed contemporary European centres. The ensuing study comprises two sections. The first deals with the early stage of *Fortuna*'s publishing history in Poland. The second focuses on the transmission of the work and the customisation of its presentation in southeastern Europe. I will not scrutinise the text (or analyse the translation of Polish poems into Hungarian, that were in turn mediated into Croatian), but will instead concentrate on the physical form of the book: the broader issues of structure and visual appearance, and more specific questions of *mise en page* or layout, encompassing illustrations, letterforms, and format. I will ask what changed and what remained stable – and most importantly, why it did so – when *Fortuna* permeated geographical, chronological, language, and social boundaries.

1 The Fortunes of *Fortuna*

Fortuna is a collection of oracles that, while it might have been used for serious fortune-telling practices, was (as was customary in early modernity) conceived as a book of social conviviality, a book-game.[3] Books of fortune-telling, also called books of divination, books of fate, or books of fortune, were collections of oracles composed in prose or verse. As a distinct literary genre they flourished especially in medieval and early modern Europe, exploiting a tradition that reached back as far as antiquity and the religious practices of the ancient Greeks.[4] Collections of oracles, already eagerly copied and read in manuscript

3 Bolzoni L., *The Gallery of Memory: Literary and Iconographic Models in the Age of Printing Press* (Toronto: 2001). On books that were games see also Karr Schmidt S., *Interactive and Sculptural Printmaking in the Renaissance* (Leiden: 2018) 325–352.

4 For the history of the genre in antiquity and in Middle Ages, see Bolte J., "Zur Geschichte der Punktier- und Losbücher", *Jahrbuch für historische Volkskunde* 1 (1925) 185–214; Skeat T.C., "An Early Mediaeval 'Book of Fate': The Sortes XII Patriarcharum", *Mediaeval and Renaissance Studies* 3 (1954) 41–54; Braekman W.L. (ed.), *Fortune-telling by the Casting of Dice: A Middle English Poem and its Background* (Brussels: 1981); Eis G. (ed.), *Wahrsagetexte des Spätmittelalters aus Handschriften und Inkunabeln* (Berlin: 1956) 7–26. Recent literature includes: Lee Palmer A., "Lorenzo 'Spirito' Gualtieri's 'Libro delle Sorti' in Renaissance Perugia", *Sixteenth Century Journal* 47.3 (2016) 557–578; Kelly J., "*Predictive Play. Wheels of Fortune in the Early Modern Lottery Book*", in Levy A. (ed.), *Playthings in Early Modernity. Party Games, Word Games, Mind Games* (Kalamazoo: 2017) 145–166; Karr Schmidt S., "Convents, Condottieri, and Compulsive Gamblers. Hands-On Secrets of Lorenzo Spirito's 'Libro'", in Dekoninck R. – Guiderdoni A. – Melion W. (eds.), *Quid est secretum? Visual Representation of Secrets in Early Modern Europe, 1500–1700* (Leiden: 2020) 683–707.

A PLAY OF CONTINUITY AND DIFFERENCE: A BOOK OF FORTUNE-TELLING 427

form, quickly passed into print. The first printed book of fortune-telling was *Il libro delle sorti* by Lorenzo Spirito, published in 1482 in Perugia.[5] This book was an immediate success: by the end of the fifteenth century Spirito's work had been published in multiple editions in its original language and in French. In the sixteenth century dozens of editions followed, both in Italian and in other vernacular languages.[6] At the same time, *Il libro* served as a source of inspiration for later compilations. Many authors of early modern books of fortune-telling can rightly be believed to have been familiar with Spirito's work, even if their lottery books have a different structure, answer slightly different questions, and the *oracula* contained within are pronounced by different authorities. Most of the books of fortune-telling that were composed and published later than *Il libro* resonate, sometimes in a very subtle way, with the ideas outlined in Spirito's work. Spirito's followers include, among others, the Italians Sigismondo Fanti, author of *Triompho di Fortuna* (1527), and Francesco Marcolini, author of *Le ingeniose sorti intitulate giardino di pensieri* (1550), the Germans who compiled *Losbücher*, and Jörg Wickram, author of the collection *Kurzweil* (1539).

Distant echoes of the popular Italian collection (as well as those of the German *Losbücher*) can also be traced in the Polish book of fortune-telling composed by Stanisław z Bochnie (Gąsiorek, Kleryka) and printed in 1532 as *Fortuna albo Szczęście* in Krakow, in Hieronim Wietor's (Hieronymus Vietor's) workshop.[7] At the time, Krakow, where printing started as early as 1473, was the dominant book centre of the Kingdom of Poland and the most vibrant printing hub in its region of Europe.[8] Late fifteenth- and early sixteenth-century printed materials produced in the city document a variety of local printers' experience with publications addressed to different audiences, including those

5 Rosenstock A., *Das Losbuch des Lorenzo Spirito von 1482. Eine Spurensuche* (Weissenkorn: 2010).

6 Zollinger M., *Bibliographie der Spielbücher des 15. Bis 18. Jahrhunderts, Bd. 1: 1473–1700* (Stuttgart: 1996) 197–267.

7 On the author's life and poetic legacy see Kapełuś H., *Stanisław z Bochnie, kleryka królewski* (Wrocław: 1964); Stanisław z Bochnie Gąsiorek, *Fortuna abo Szczęście*, ed. J. Kiliańczyk-Zięba (Kraków: 2015).

8 Kawecka-Gryczowa A., "Kraków", in Kawecka-Gryczowa (ed.), *Drukarze dawnej Polski*, vol. 1: *Małopolska*, part 1: *Od XV do XVI wieku* (Wrocław: 1983) 105–115; Małecki J., "Rola Krakowa w handlu Europy Środkowej w XVI i XVII w.", *Zeszyty Naukowe Akademii Ekonomicznej w Krakowie* 70 (1974) 174–175; Pirożyński J., "Der Buchhandel in Polen in der Renaissance-Zeit", in Göpfert H.G. et al. (eds.), *Beiträge zur Geschichte des Buchwesens im konfessionellen Zeitalter* (Wiesbaden: 1985) 267–294; Jaglarz M., *Księgarstwo krakowskie XVI wieku* (Kraków: 2004); Żurkowa R., *Księgarstwo krakowskie w pierwszej połowie XVII wieku* (Kraków: 1992).

428 KILIAŃCZYK-ZIĘBA

who sought to read in Polish.[9] One of the earliest printers who attempted to satisfy the appetite for books entirely *in lingua vulgari Polonica* was Hieronim Wietor (died c. 1547), active in Krakow from 1518.[10] From 1520 onwards, Wietor printed a series of texts that adapted established bestsellers into Polish, such as *Rozmowy, ktore miał krol Salomon mądry z Marchołtem grubym a sprosnym* (The Dialogue of Salomon and Marcolf, 1521) or *Ezop* (Aesop, 1522). As a collection of over 440 amusing epigrams in the vernacular, *Fortuna* harmonised well with Wietor's Polish language output. But it also advanced the workshop's repertoire: whereas Marcholf's adventures or Aesop's fables were produced as humble, affordable octavos and quartos, *Fortuna* was designed as a profusely illustrated folio. Wietor dedicated the volume to Sigismund I (1467–1548), the Jagiellonian king of Poland and grand duke of Lithuania.

No copy of *Fortuna*'s first 1532 edition has survived to the present day, and we know this work only from unique copies of later reprints, dated 1561–1577, ca. 1649, and 1665 respectively.[11] Yet, as I have argued elsewhere, the copies of these editions can be analysed for evidence as to when (in 1532), where (in Krakow), and by whom (Hieronim Wietor) the *editio princeps* was issued, and what its design was.[12] At the same time the visual appearance and content of the surviving copies confirm that later editions of *Fortuna* reflected the structure and layout of the earlier imprints – the *editio princeps* included. Thus, acknowledging the necessary restrictions inherent in this approach, and for

9 Wydra W. – Rzepka W.R., "Niesamoistne drukowane teksty polskie sprzed roku 1521 i ich znaczenie dla historii drukarstwa i języka polskiego", in Grzeszczuk S. – Kawecka-Gryczowa A. (eds.), *Dawna książka i kultura. Materiały międzynarodowej sesji naukowej z okazji pięćsetlecia sztuki drukarskiej w Polsce* (Wrocław: 1975) 263–288. The discussion about the beginnings of printing in Polish and controversies raised by the subject are summarised by Bacewiczowa D., "Kasper Hochfeder", in Kawecka-Gryczowa (ed.), *Drukarze* 65–66.

10 Kiliańczyk-Zięba J., "In Platea Columbarum. The Printing House of Hieronim Wietor, Łazarz Andrysowic and Jan Januszowski in Renaissance Krakow", *Publishing History*, 67 (2010) 5–37. For details concerning the production of Wietor see Mańkowska A., Kawecka-Gryczowa A., "Wietor Hieronim", in Kawecka-Gryczowa (ed.), *Drukarze* 325–352.

11 Stanisław z Bochnie, *Fortuna albo Szczęście* ([Kraków] Łazarz Andrysowic, ca. 1561–1577 [1570]), copy at Die *Bayerische Staatsbibliothek, Munich, call no.* Res. 2 Phys.m.7; *Fortuna abo Szczęście* (Krakow, Walerian Piątkowski: ca. 1646–1652 [1649]), copy at the Biblioteka Narodowa, Warsaw, call no. XVII.4.3504. *Fortuna abo Szczęście* (Krakow: Dziedzice Stanisława Bertutowica, 1665), copy at Strahovska Knihovna v Klastere Premonstratu, Prague, call no. AG XII 25.

12 Kiliańczyk-Zięba J., "In Search of Lost Fortuna. Reconstructing the Publishing History of the Polish Book of Fortune-Telling", in Bruni F. – Pettegree A. (eds.), *Lost Books. Reconstructing the Print World of Pre-Industrial Europe* (Leiden: 2016) 120–143; Kiliańczyk-Zięba J., "Wydawnicze skamieliny. Późne edycje bestsellerów jako źródło informacji o kształcie wizualnym pierwszego wydania tekstu", *Terminus* 21.4 (2019) 401–436.

A PLAY OF CONTINUITY AND DIFFERENCE: A BOOK OF FORTUNE-TELLING

want of a better alternative, in the proposed study I will analyse the design of the item closest to the lost ultimate template, both chronologically and visually, as representative of *Fortuna albo Szczęście* as it was composed and printed in 1532: a volume, now residing in the Bayerische Staatsbibliothek, produced around 1570 (1561–77) not by Hieronim Wietor, but by the old master's apprentice and successor, Łazarz Andrysowic.[13]

2 Structure and Appearance

First let us browse through *Fortuna* – not so much to understand how it was supposed to be enjoyed, but more to acquaint ourselves with the structure of the work and the appearance of the edition.

The volume opens with a title page dominated by a monumental figure of "Fortuna-Occasio" [Fig. 14.1]. The prefatory material consists of a full-page depiction of a stationary wheel of fortune and heraldic woodcuts displayed along with a dedicatory epistle. These are followed by instructions explaining how to consult the lottery book and a list of the twenty-one queries *Fortuna* would answer, all of which concern various dilemmas of daily life (e.g., will I be rich? should I get married?). After this list of questions come over forty pages of woodcut charts, followed by, finally, 444 rhymed predictions that are divided among twelve Sybils. When *Fortuna*'s readers, who should perhaps rather be called users, wished to know, for example, if it they would be lucky in love, they would open the book-game to a page where a printed chart featured a rooster at centre [Fig. 14.2]. If the dice happened to reveal, say, two and two, the readers would be instructed 'go to the rabbit, town of Skąpe' [Fig. 14.3]. That meant that among a second set of charts, one was supposed to find a diagram with a rabbit and look there for the pertinent town's name. Locating it would mean getting yet another instruction: 'Sybil 7, poem 2'. The reader would then turn the book's pages, looking for the second one, by Sybil 7 (Kumana), among the humorous, ambiguous, or even insulting predictions: 'Witaj bracie, co tam słychasz, / A snadź po swej miłej wzdychasz, / Szaty sprawiasz, dajesz dosyć, / Jednak ona da inszym uprosić.' (Hello, brother, how are you doing? It seems

13 This book has been part of the Bavarian collection since at least the seventeenth century. It is already mentioned in a catalogue from 1650: 'Pollnisch getruckht Buech Fortuna intitulirt in schlecht Pergamen gebunden' (A book printed in Polish, entitled Fortuna, bound in bad parchment), cf. Kaltwasser F.G., *Bibliothek als Museum. Von der Renaissance bis heute, dargestellt am Beispiel der Bayerischen Staatsbibliothek* (Wiesbaden: 1999) 67.

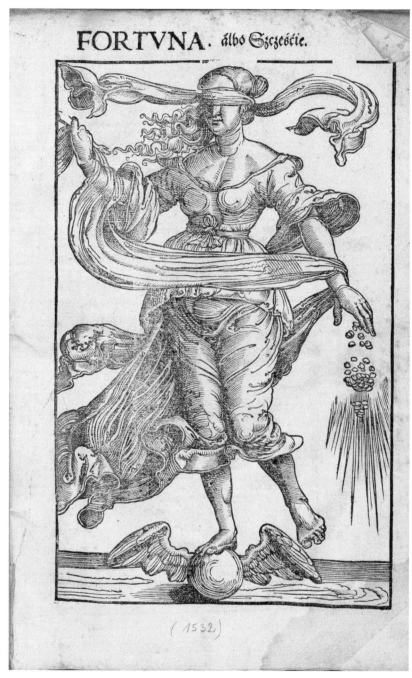

FIGURE 14.1 "Fortuna-Occasio". Woodcut illustration, ante 1532 (1531?). Title page of Stanisław z Bochnie, *Fortuna albo Szczęście* (Kraków, Łazarz Andrysowic: [post 1561]). Munich, Bayerische Staatsbibliothek, call no. Res. 2 Phys.m.7
IMAGE © BAYERISCHE STAATSBIBLIOTHEK

A PLAY OF CONTINUITY AND DIFFERENCE: A BOOK OF FORTUNE-TELLING 431

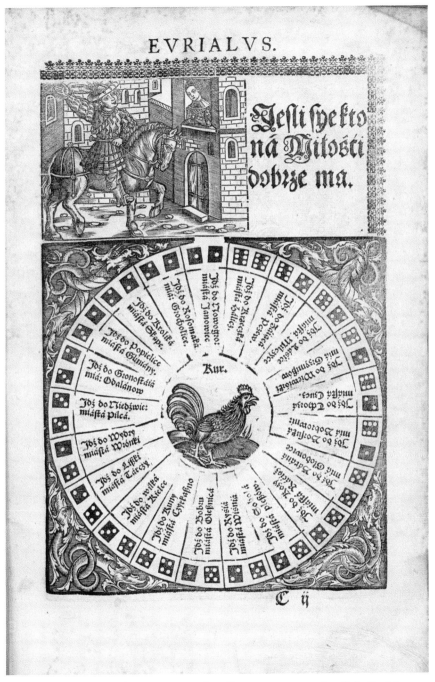

FIGURE 14.2 "Chart with a Rooster". Woodcut illustration, ante 1532 (1531?). In Stanisław z Bochnie, *Fortuna albo Szczęście* (Kraków, Łazarz Andrysowic: [post 1561]), fol. C ii r. Munich, Bayerische Staatsbibliothek, call no. Res. 2 Phys.m.7
IMAGE © BAYERISCHE STAATSBIBLIOTHEK

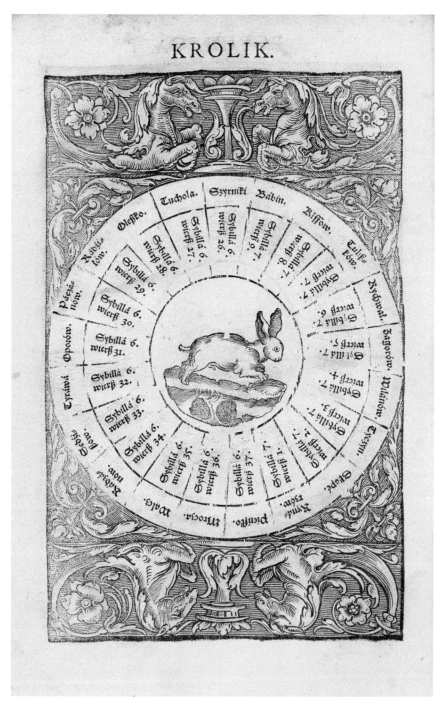

FIGURE 14.3 "Chart with a Rabbit". Woodcut illustration, ante 1532 (1531?). In Stanisław z Bochnie, *Fortuna albo Szczęście* (Kraków, Łazarz Andrysowic: [post 1561]), fol. D vi v. Munich, Bayerische Staatsbibliothek, call no. Res. 2 Phys.m.7
IMAGE © BAYERISCHE STAATSBIBLIOTHEK

A PLAY OF CONTINUITY AND DIFFERENCE: A BOOK OF FORTUNE-TELLING 433

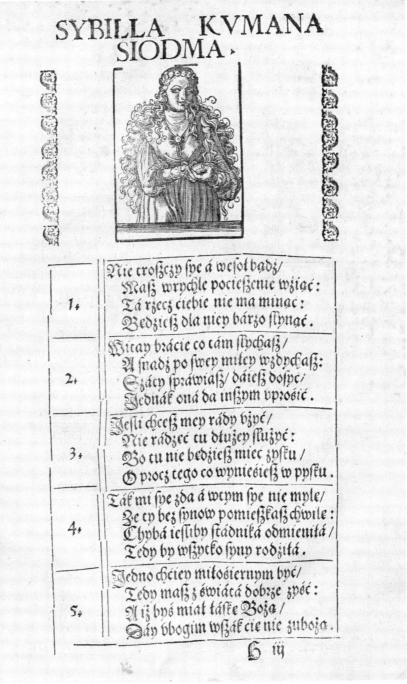

FIGURE 14.4 "Oracles of Sybilla Kumana". Woodcut illustration, ante 1532 (1531?). In Stanisław z Bochnie, *Fortuna albo Szczęście* (Kraków, Łazarz Andrysowic: [post 1561]), fol. H iii r. Munich, Bayerische Staatsbibliothek, call no. Res. 2 Phys.m.7
IMAGE © BAYERISCHE STAATSBIBLIOTHEK

you sigh from love, you buy clothes, and many other gifts for your lady. Yet she will be gracious to others) [Fig. 14.4.].

Such a composite organisation of the book's content was in absolute accord with the genre's tradition; a perplexing arrangement of tables, spheres, and clusters of text was a common trait of late medieval and early modern books of fate. Customarily, consulting a book of fortune-telling meant navigating one's way through a maze of diagrams, wandering among astral representations, mythological figures, talking animals, prophets, and philosophers. Prolonged searching for references and outcomes had its obvious function: it was intended to mystify the reader, to build suspense, and to keep the person posing a question (or more often the company sharing the pleasures and excitements of the game) in a state of uncertainty about the outcome.

3 Imitation of the Template

Investigating the earliest surviving copy of *Fortuna* suggests that in the initial decades of its publishing history in Poland, reprinting this work meant avoiding customisation, which was deemed redundant. This is first visible in the complex structure of the volume, and especially the organisation of its contents, wherein the 'clue and hunt format' remained unchanged.[14] This was the only reasonable decision for any printer who reissued the lottery book: in order for it to work properly, the printer had to reproduce the traditional order of the questions, the tips directing users to subsequent stages of the game, and the numerical relations between the charts and the oracles. Making any changes to this order would necessitate re-arranging journeys to over four hundred oracles – and this would cost time and money, and therefore was to be avoided.

Interestingly, however, the later copy of *Fortuna* also retained the prefatory material of the *editio princeps*: most notably the coat of arms of both the Kingdom of Poland and of Sigismund I, together with an old dedicatory epistle presenting the book-game to the king himself. Copying these elements neither helped speed up the production process of the subsequent edition, nor reduced the risk of making mistakes when preparing the form. Perhaps preserving the prefatory letter of a long-dead printer to a long-dead king served its own purposes, as part of a strategy for presenting the volume to the public. Even if not every copy of *Fortuna* was bound for noble hands, the dedication of the new edition suggests that initially this was the intended audience of the work. In other words, these older sections serve to elevate and consolidate the

14 Karr Schmidt, *Interactive* 328.

reputations of *Fortuna* and its printer. Also, pointing out the royal recipient of the *editio princeps* was an easy way to warn off potential critics, as books of fate were often regarded with suspicion both in Poland and across Europe. At the same time, readers familiar with Latin could also learn from Wietor's epistle that the fortune-telling in the volume was nothing but an innocent pastime and, moreover, that the author of the collection was himself a priest and chaplain of King Sigismund I the Jagiellon.[15]

When Łazarz Andrysowic prepared the reissue of *Fortuna*, an earlier copy (perhaps even a copy of the *editio princeps*) served as the printer's copy. It provided a model for organising the content of the volume, but also for its layout, giving precise instructions to the compositor regarding all the elements that constituted the book's typographical design. In the 1570 reissue, not only was the disposition of these elements imitated; woodblocks taken over from previous editions (especially those that were cut specifically for *Fortuna*, namely, "Fortuna-Occasio", series of birds and animals to be set in the centre of the charts, and a parade of the twelve Sibyls) were also used. This was possible because Łazarz Andrysowic had taken over Wietor's wokshop, and was in possession of the printing materials once owned by Hieronim.[16]

Obviously, printers would reuse old blocks to reduce the costs of an expensive project. It is less clear why Łazarz Andrysowic decided to retain *fraktur* as the text letterform, too. This was not a straightforward choice of typeface at the time when the surviving copy of *Fortuna* was produced, since by the second half of the sixteenth century printers, including Andrysowic, commonly used *schwabacher* for printing texts in Polish.[17] Using *schwabacher* to print the Sybils' predictions would certainly enhance the legibility of the epigrams and the pages as wholes, thus customising the book-game for new audiences. Yet Andrysowic chose to exploit the authority of the established tradition.[18] Not only were the book's structure, paratexts, and images taken over from the *editio princeps*, but also the typeface.

15 Janssen, *Technique* 85.

16 Kiliańczyk-Zięba, "In Platea Columbarum". For details concerning the history of the Łazarz workshop see Kawecka-Gryczowa A. – Mańkowska A., "Andrysowic Łazarz", in Kawecka-Gryczowa (ed.), *Drukarze* 124–137.

17 Piekarski K., *Książka w Polsce XV i XVI wieku* (Kraków: 1931) 12.

18 On the analogous traditional preferences of Italian printers see Grendler P.F., "*Form and Function* in Italian Renaissance Popular Books", *Renaissance Quarterly* 46.3 (1993) 451–485.

4 Customisation in Print

Towards the end of the sixteenth century *Fortuna* crossed the borders of Poland, becoming the model for fortune-telling books published in the Carpathian Basin.[19] This was not a surprise, as there had been a lively cultural and commercial exchange between the kingdoms of Poland and Hungary since the Middle Ages.[20] The Hungarian translation of the Polish *sortilegium* was printed first in Bárfta (now Bardejov in Slovakia), later in Kolosvár (now Cluj-Napoca in Romania), and finally in Buda (now the western part of Budapest).

The sixteenth century was a period of military turmoil and increasing political decay for the region. Battles with the Turks, internal struggles, and finally the defeat at Mohács (1526, when King Louis II of Hungary was killed) all contributed to the collapse of the Hungarian state. In 1541, the Turks captured Buda, and Hungary was divided into three parts: the fringes to the west and north came under Habsburg rule, the central territory, including the former capital of Buda, was incorporated into the Ottoman dominions, and the territory to the east became the principality of Transylvania. Continuing unrest slowed the economic development of the country and reduced the growth of the towns, which naturally also affected the book culture of the region.[21] Printing developed only in the territories not occupied by the Turks and on a small scale.[22] Before the end of the sixteenth century, ephemeral presses were active in numerous locations in the Carpathian Basin, but more stable workshops operated only in a handful of towns. The most productive of these was a workshop that opened around 1549 in Kolozsvár (today Cluj-Napoca in Romania) and evolved into a relatively prosperous enterprise after 1574, under

19 Kapełuś H., Ślaski J., "Polski druk popularny na Węgrzech. Z dziejów 'Fortuny'", *Rocznik Biblioteki Narodowej* 2 (1966) 297–317.

20 Both countries also gravitated towards each other because of political and dynastic ties. Most notably Louis II Jagiellon of Hungary was Sigismund I's nephew, while Izabela, the daughter of the Polish king was married to Jan Zápolya (János Szapolyai), from 1526 king and counter king of Hungary. On the mutually connected literatures of Poland and Hungary see Ślaski J., *Wokół literatury włoskiej, węgierskiej i polskiej w epoce Renesansu. Szkice komparatystyczne* (Warszawa: 1991) 13–37; Várnai D., *Wokół polskiej i węgierskiej literatury epoki renesansu* (Budapest: 2019).

21 See e.g., Monok I., *The Cultural Horizon of Aristocrats in the Hungarian Kingdom. Their Libraries and Erudition in the 16th and 17th Centuries*, trans. K. Vargha (Vienna: 2019).

22 For the history of early printing in the Hungarian state see e.g., Ecsedy J.V. – Pavercsik I., *A magyarországi könyvkiadás és kereskedelem 1800-ig* (Budapest: 1999). A useful summary in English is provided by Monok I., "Towns and Book Culture in Hungary at the End of the Fifteenth Century and during the Sixteenth Century", in Rial Costas B. (ed.), *Print Culture and Peripheries in Early Modern Europe: A Contribution to the History of Printing and the Book Trade in Small European and Spanish Cities* (Leiden: 2013) 171–200.

A PLAY OF CONTINUITY AND DIFFERENCE: A BOOK OF FORTUNE-TELLING 437

the management of Gáspár Heltai. In Bárfta (now Bardejov) right across the mountains and close to the border of the Kingdom of Poland, the workshop of David Gutgesell (later maintained by Jakob Klöss) operated from 1577. At the same time, books for local audiences were imported from Krakow and further abroad, via trade routes running from the Polish capital south to Istanbul (among others via Cluj-Napoca), and east to Ruthenia (among others via Bardejov).[23] Bookmen from both Poland and the trisected Hungary maintained lively contacts with each other. Importantly, it was in Krakow that the earliest books in Hungarian were printed by Hieronim Wietor and his successor Łazarz Andrysowic, both of whom were key players in the print history of *Fortuna* (Wietor printed the first edition, while Andrysowic printed the oldest surviving copy). Among the early jobbing printers active in the Hungarian territories were many who learned their trade in Krakow from Wietor and from Łazarz, who was a particularly skilled typesetter of Hungarian texts.[24]

The Hungarian book of fortune-telling that emulated (and customised) the Polish work has been preserved in individual copies of two different editions that were printed at the turn of the seventeenth century. Their presentation is a compelling example of how closely the processes of customisation and editing were related, especially for printers based in such places as the Carpatian Basin, where the market was relatively small and mostly peripheral. One of the publishing strategies they employed was to imitate the earlier success of books issued in larger centres of production (in the case of *Fortuna*, Krakow happened to be such a printing hub), by adapting and appropriating their contents as well as their visual design. Both copies are damaged, and each contains a different variant of the text. Hungarian historians refer to the earlier edition

23 Pieradzka K., *Handel Krakowa z Węgrami w XVI w.* (Kraków: 1955); Leśniak F., "Wymiana towarowa między miastami polskiego Podkarpacia a północno-węgierskimi (wschodnio-słowackimi) w XVI i pierwszej połowie XVII stulecia. Tovarová výmena medzi poľskými podkarpatskými a severouhorskými (východoslovenskými) mestami v 16. storočí a v prvej polovici 17. storočia", *Historické štúdie* 41 (2000) 49–67; Leśniak F., "Transgraniczna komunikacja miast podgórskich po obu stronach Karpat (do końca XVIII wieku)", in Karolczak K. – Kovaľ P. – Meus K. (eds.), *Miasto w Europie Środkowo-Wschodniej. Procesy modernizacyjne* (Kraków: 2016) 50–71.

24 Varjas B., "Początki węgierskiego drukarstwa i krakowskie druki w języku węgierskim", in Csapláros I. – Hopp L. – Reychman J. – Sziklay L. (eds.), *Studia z dziejów polsko-węgierskich stosunków literackich i kulturalnych* (Wrocław: 1969) 66–94; Borsa G., "Die polnisch-ungarischen Beziehungen auf dem Gebiete der Buchdruckerkunst im 16. Jahrhundert", in Csapláros I. (ed.), *Studia z dziejów polsko-węgierskich stosunków literackich* (Warszawa: 1978) 117–134; Ecsedy J.v., *Rola krakowskich drukarzy w kulturze węgierskiej* (Budapest: 2000); Ecsedy J.v., "Trading Printing Types: The Evidence of Imported Printing Material in Hungary in the Seventeenth Century", *Gutenberg-Jahrbuch* 82 (2007) 198–199.

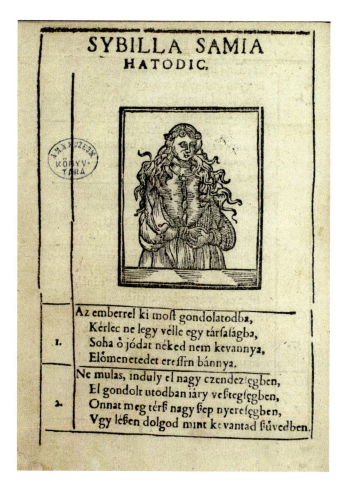

FIGURE 14.5
"Oracles of Sybilla Samia". Woodcut illustration, ante 1599. In *Fortuna* (Cluj-Napoca, The Heltai Press, ca 1599–1601). Budapest, Országos Széchényi Könyvtár, call no RMK I. 361b
IMAGE © ORSZÁGOS SZÉCHÉNYI KÖNYVTÁR

as *Fortuna*; it was produced in the years 1599–1610 in Cluj-Napoca, printed at the press of Heltai [Fig. 14.5].[25] The later edition, commonly called *Sybillák jövendölése* (*The Sibyls' Oracles*), but catalogued as *Fortuna*, was printed around 1616 in Bardejov by Jakob Klöss (Junior) [Fig. 14.6].[26] Neither of these copies

25 Copy in Országos Széchényi Könyvtár (National Széchényi Library), Budapest, call no. RMK I. 361b, Régi Magyarországi Nyomtatványok (RMNy) 916. On the Heltai workshop and its production see Czintos E., "A Woman Printer and Her Readers in Early Modern Transylvania", *The Journal of Early Modern Christianity* 3.2 (2016) 167–199.

26 Copy in Országos Széchényi Könyvtár (National Széchényi Library), Budapest, call no RMK I. 350, Régi Magyarországi Nyomtatványok (RMNy) 1097. Information about the Hungarian editions of *Fortuna* is given from Borsa G., *Hol és mikor nyomták az eddig ismert két legrégibb magyar sorsvetö könyvet?*, in Borsa G., *Könyvtörténeti írások I. A hazai nyomdászat 15–17 század* (Budapest: 1996) 295–300; Borsa G., "A 'Fortuna' sorsvetökönyv

A PLAY OF CONTINUITY AND DIFFERENCE: A BOOK OF FORTUNE-TELLING 439

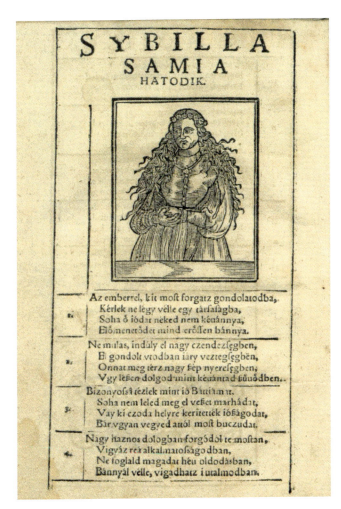

FIGURE 14.6
"Oracles of Sybilla Samia". Woodcut illustration, ca 1616. In *Fortuna* (Bardejov, Jakob Klöss (Junior), ca 1616). Budapest, Országos Széchényi Könyvtár, call no RMK I. 350
IMAGE © ORSZÁGOS SZÉCHÉNYI KÖNYVTÁR

represents the Hungarian book's *editio princeps* that must have been printed in Bardejov by Klöss before 1594. However, there can be little doubt that they adhere to the structure and layout of this lost template. The Cluj-Napoca edition is especially striking, because its printer followed the lost Bardejov-produced volume so closely that he even held on to the preface by Klöss, who repeated the same ideas expressed by Wietor in his Polish edition of 1532.

The overall structure of the volume adheres to the pattern crystalised in Krakow: the title page is still dominated by the "Fortuna-Occasio" woodcut

eredete és utóélete", in Borsa (ed.), *Könyvtörténeti írások* 301–306. Both articles previously appeared in *Magyar Könyvszemle*, in 1964 and 1966 respectively.

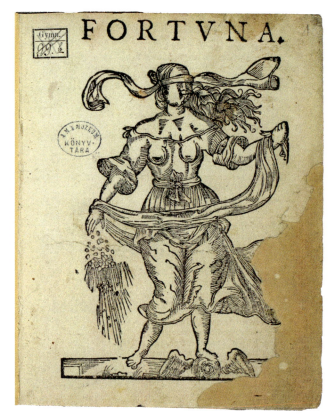

FIGURE 14.7
"Fortuna-Occasio".
Woodcut illustration,
ante 1599. Title page of
Fortuna (Cluj-Napoca,
The Heltai Press,
ca 1599–1601).
Budapest, Országos
Széchényi Könyvtár,
call no RMK I. 361b
IMAGE © ORSZÁGOS
SZÉCHÉNYI
KÖNYVTÁR

and displays only the work's title [Fig. 14.7], while the prefatory apparatus mirrors the placement and content of those present in the Polish *Fortuna* (except for the heraldic woodcuts). Most importantly, the method of fortune-telling remains the same: there is an instruction for the reader-players, along with twenty-one questions followed by two series of diagrams with dice casts, and the order of the answers announced by the twelve Sibyls remains intact. The design of the early Hungarian editions also clearly reveals that a copy imported from Krakow was their ultimate template. This is perhaps most manifest in the iconography of the full-page woodcuts (preserved only in the volume from Cluj-Napoca), one of which depicts "Fortuna-Occasio", another the "Wheel of Fortune". Yet, we can also see the imitation of the Polish model in the disposition of the typographical and woodcut material on the pages that provide answers to the game: the numbered oracles are separated by ruling and arranged in twelve groups, while the opening page of each group is headed by the portrait of a Sibyl. However, the Polish and Hungarian editions do not conform absolutely. The customisation of the template included: first, adapting

the folio into a quarto format; second, removing the generic portraits of mythical figures that were associated with life dilemmas in the Polish imprint; third, abandoning *fraktur* for *schwabacher*; and, last but not least, visibly lowering the quality of the woodcuts. No doubt all these transformations of the Krakow model were economically motivated. The choice of a smaller format was the most crucial decision – this meant that the book could be produced more cheaply and sold to wider audiences.

It is striking how the overall appearance of the Hungarian imprints of *Fortuna* is based on the play of continuity and difference that, in turn, was mostly dependant on the circumstances of the printers in the Carpathian Basin. They were active in a milieu of limited financial means, which did not allow them to design the book according to then-prevalent patterns, or pay for woodblocks inspired by new iconographical models and visual forms. They avoided any innovation that involved expenditure, modified their prototype only in ways that reduced the cost of production.

The Hungarian book of fortune-telling enjoyed considerable longevity. It was included in the publishing repertoire of the Buda printers, the Landerers, and in the nineteenth century it was still being printed by the Landerers' successor – Marton Bagó.[27] Again, both the layout and the overall structure of the book were retained, which included keeping intact the preface composed in the sixteenth century by the Bardejov printer. Admittedly, some innovations were introduced by the Buda printers, such as moving the "Fortuna-Occasio" woodcut to the verso of the first leaf, and replacing it with a 'regular' title page, framed by a broken border from Komárom (a town on the Danube now split between Hungary and Slovakia).

An examination of the Polish *Fortuna* and its subsequent customisations leaves no doubt about the enduring relevance of this Krakow book-game as an editorial project. A new title page might have emerged and prefatory material might have been partly removed, but the structure of the content in the lottery remained virtually unchanged. At the same time, the visual strategies adapted in the 1532 Krakow *editio princeps* of *Fortuna* informed the typographical design of all the editions that followed as the book-game crossed geographical and chronological barriers. Early woodcuts provided the template for recuts,

27 Borsa, "A Fortuna sorsvetőkönyv", informs us about copies of 6 editions from 1743–1849 (and two items printed in the opening decades of the 20th century) that are held in the National Széchényi Library in Budapest. Because these items are numbered (the 1743 edition as the 2nd, the 1757 as the 3rd, the 1790 as the 5th, the 1807 edition as the 6th, the 1817 edition as the 8th and the 1849 as the 15th), they indicate the former existence of editions that cannot be linked to existing copies. The Newberry Library in Chicago owns a copy produced in Buda in 1770 (call no Case BF1850. G37 1770).

and even the blackletter type long remained the letterform of choice for the main body of text in the volume.

Researchers' attention is drawn primarily to innovations introduced by the early printers and their search for new technical and visual solutions. However, *Fortuna*'s publishing history suggests that it is worth paying more attention to printed materials that document the conservatism of their producers, not least because they seem to throw light on the technical and economic challenges of the printing industry. The conservative choices of early printers may have had a variety of motivations, but it seems that the most important of these was pragmatism: by copying and petrifying tested solutions early modern printers made their workshop operations faster and less complicated; they limited the risk of costly mistakes by the compositors, saved their workers' time, and spared themselves from unnecessary expenditure. Apparently, when reeditions of *Fortuna* in Polish and the imprints of its Hungarian adaptation were produced, their printers' adherence to the traditional design of the volume was chiefly economically motivated. But later, as *Fortuna* was reprinted in the Carpathian Basin throughout the seventeenth, eighteenth, and even nineteenth centuries, this might have also been a conscious publishing strategy. Together with other characteristics of the materiality of copies (such as the poor-quality paper used to print them), the antiquated layout of the repeated imprints contributed to the obsolete appearance of the volumes. Such an appearance signalled the accessibility of the work to the audience – its relatively low price and entertaining content were attractive even to those who rarely bought books. As such, the traditional form of the Hungarian *Fortuna* can be seen as both a consequence and an indicator of the lowering social, monetary, and intellectual status of its readers.

5 From Print to Manuscript

In this context it is particularly interesting to see *Fortuna* re-emerge in the 1660s at a noble court – this time not as a specimen surviving from a print run of a few hundred copies, but as a manuscript, that is, a volume unique due to the very nature of its production process. *Sibila Katarine Zrinske*, as the manuscript is customarily called, was in all probability written and decorated in northern Croatia, perhaps shortly before 1664, for a countess who inscribed her name on the front pastedown in April 1670 with the inscription 'Groff Marques Frangipan Catarina Zrinska Grofficha manu propria'.[28]

28 Zvonimir B., *Sibila. Knjiga gatalica Zrinskoga dvora u Čakovcu* (Čakovec – Zagreb: 2007); Pelc M., *Sibila Katarine Zrinske* (Zagreb: 2017); and older literature quoted by both authors.

A PLAY OF CONTINUITY AND DIFFERENCE: A BOOK OF FORTUNE-TELLING 443

In the territory that, after the conquest of the southeastern Europe by the Turks, constituted 'reliquiae olim incliti regni Croatiae' and depended on foreign (Habsburg) protection, the members and supporters of Katarina's aristocratic family sought liberation from the Ottoman yoke on the one hand, and resisted Habsburg domination on the other. Katarina's husband Nikola Zrinski, her brother Petar Krst Frankopan, and the countess herself were the heart of an anti-Habsburg conspiracy. They eventually failed – the men were arrested in March 1670, imprisoned and, in April 1671, beheaded in Vienna Neustadt. Katarina – also incarcerated – died two years later, in 1673. Thus the *Sibila* with which Katarina had played at her court in Čackovec castle, having been inscribed with her name only weeks after her husband and brother were abducted by Leopold I's soldiers, was witness to Croatia's dramatic history. It is justly famous as one of the earliest collections of poetry in Croatian, created or at least read at the court that remained the most important centre of culture and literature within the country (until the confiscations and lootings that resulted from the downfall of the Zrinski-Frankopan conspiracy).[29]

As a book and a material object, *Sibila* demonstrates the possibility of the exchange and translatability between print and manuscript in the early modern era. Both the manuscript's structure (with its opening illustrations, list of 21 questions, spherical diagrams, and over four hundred oracles predicted by the twelve Sybils), as well as the visual organisation of successive pages were copied from a Hungarian imprint. This bibliographic lineage can be seen in a number of elements, especially in the full page illustrations [Fig. 14.8] and the arrangement of the pages featuring the Sybil figures and the four-verse poems [Fig. 14.9]. Just as in the printed copies of *Fortuna*, a generic portrait of a prophetess identified by her name occupies the upper half of the page, towering over the epigrams that are still separated by thin lines.

Yet, the printed template has also been manipulated and customised. In the first place this can be linked to the change of medium: in the Croatian book the text has not been typeset, but hand-written (in fine cursive script), while the woodcuts have been replaced by a watercolour decoration allowing for opulent images not possible in black and white. A mass-produced book for wide audiences was customised into a luxury item only available to an elite group of patrons. At the same time, the adaptive reuse of the prototype included recombining it with other sources, offering models more in accord with the baroque

29 About the text see Bartolić, *Sibila*; Lukács I., "Nejasna mjesta u *Sibili* Ane Katarine Zrinske", *Studia Slavica, Studia Slavica Hung.* 65.2 (2020) 275–297. About Zrinsky's libraries and text creation in their courts (also in Čakovec), see Hausner G. – Klaniczay T. – Kovács S.I. – Monok I. – Orlovszky G. (eds.), *Bibliotheca Ziniana története és állománya* (Budapest: 1991); Monok, *The Cultural Horizon* 57–70.

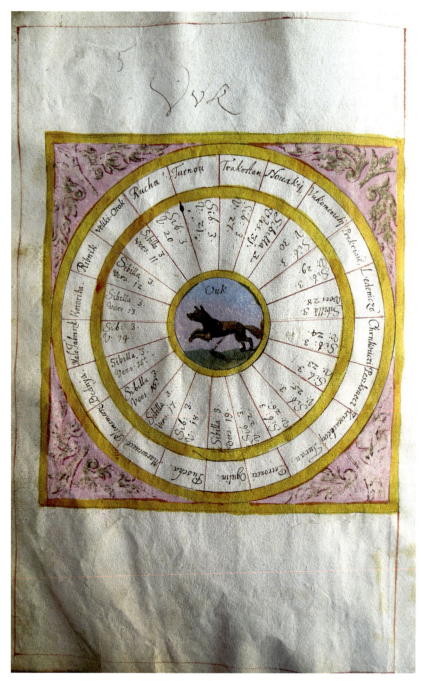

FIGURE 14.8 "Chart with a Wolf". Watercolour on paper, ante 1664. In *Sibila Katarine Zrinske* (northern Croatia, ante 1664). Zagreb, Knjižnica Zagrebačke nadbiskupije (Metropolitana), call no. MR 157
PHOTO COURTESY OF MILAN PELC

A PLAY OF CONTINUITY AND DIFFERENCE: A BOOK OF FORTUNE-TELLING 445

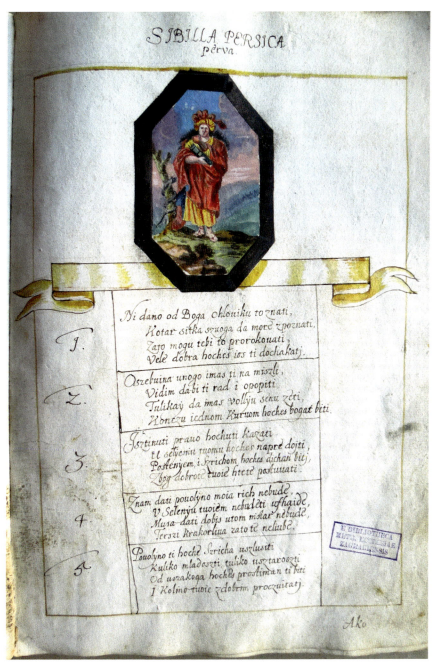

FIGURE 14.9 "Oracles of Sybilla Persica". Watercolour on paper, ante 1664. In *Sibila Katarine Zrinske* (northern Croatia, ante 1664). Zagreb, Knjižnica Zagrebačke nadbiskupije (Metropolitana), call no. MR 157
PHOTO COURTESY OF MILAN PELC

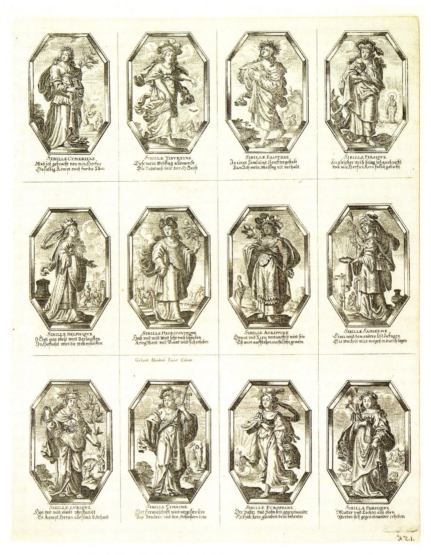

FIGURE 14.10 Gerhard Altzenbach, *Twelve Sybillen*. Engraving, 36.6 × 29.1 cm. Cologne, 1620–1672. Braunschweig, Herzog Anton Ulrich-Museum, call no Galtzenbach AB 3.14
IMAGE © HERZOG ANTON ULRICH-MUSEUM

taste of the period. Notably, the representations of Sybils (clumsy, but grander and more exuberant than the woodcut figures from the volumes printed in the Carpathian Basin) were modelled on a Cologne series of etchings originating from the workshop of Gerhard Altzenbach. Interestingly, the German

engravings in turn copied depictions by Gilles Rousselet and Abraham Bosse in a set of prints made from the designs of Claude Vignon from about 1630 [Fig. 14.10].[30] Thus, the model provided by the printed item whose ultimate source was a 1532 volume (typeset in *fraktur* and illustrated with late medi-aeval and Renaissance woodcuts) was modified to suite the taste of times, a new cultural setting, and the requirements of the aristocratic patrons paying for the work. As a result, the prototype was transformed into an aesthetically different object, even while the structure of the volume was kept almost intact and pages of the manuscript were governed by the same principles that deter-mined the layout of the printed book.

6 Conclusion

Fortuna, a humble work produced away from the better known emporia of early print and book culture in Europe, provides much material for studying the visual and material dimensions of the transmission of texts and images. *Fortuna*'s case demonstrates that when words and images presented as 'recorded forms' (to use Donald McKenzie's expression) were mediated across languages, cultures, geographical locations, and social milieux, their materi-ality (in general) and their visual presentation (in particular) were reframed and transformed, in ways that inevitably affected the status and use and of the customised work. At the same time, the fact that a printed book and a series of engravings were employed as models for a seventeenth-century manuscript volume provides an opportunity to explore the different methods applied, across media, to the production of texts and images in the early modern period. These methods prove to have co-existed in complex, connected ways.

Histories of the book often focus on innovation: bookmakers' incessant search for new technical and visual solutions. However, volumes that docu-ment the conservatism of early modern bookmen are also worth noting. As the history of *Fortuna* demonstrates, some book producers, especially those who issued sought-after (and typographically demanding) works, gravitated

30 Paas J.R., *The Altzenbachs of Cologne, Early Modern Print Publishers: Popular Prints of the XVIIth Century*, 2 vols. (Wiesbaden: 2020); Maria Bartko, "Artificium extra ideam: przed-stawieniowe wzorce cyklu obrazów Adolfa Boya", *Acta Universitatis Nicolai Copernici. Nauki Humanistyczno-Społeczne. Zabytkoznawstwo i Konserwatorstwo* 11 (1987) 29–45; Pacht-Bassani P. – Mignot C. (eds.), *Claude Vignon et son temps: Actes du colloque interna-tional de l'université de Tours, 28–29 janvier* (Paris: 1998). On Petar Zrinski's ownership of 'imagines Sibillarum', see Pelc, *Sibila* 78. I thank prof. Milan Pelc for pointing my attention to the Altzenbach's etching.

towards safe, tested solutions. Conservatism had an important place in practices of customisation.

Bibliography

Bacewiczowa D., "Kasper Hochfeder", in Kawecka-Gryczowa A. (ed.), *Drukarze dawnej Polski*, vol. 1: *Małopolska*, part 1: *Od XV do XVI wieku* (Wrocław: 1983) 62–68.

Bartko M., "Artificium extra ideam: przedstawieniowe wzorce cyklu obrazów Adolfa Boya", *Acta Universitatis Nicolai Copernici. Nauki Humanistyczno-Społeczne. Zabytkoznawstwo i Konserwatorstwo* 11 (1987) 29–45.

Bolte J., "Zur Geschichte der Punktier- und Losbücher", *Jahrbuch für historische Volkskunde* 1 (1925) 185–214.

Bolzoni L., *The Gallery of Memory: Literary and Iconographic Models in the Age of Printing Press* (Toronto: 2001).

Borsa G., "Hol és mikor nyomták az eddig ismert két legrégibb magyar sorsvetö könyvet?", in Borsa, *Könyvtörténeti írások I. A hazai nyomdászat 15–17 század* (Budapest: 1996) 295–300.

Borsa G., "A 'Fortuna' sorsvetökönyv eredete és utóélete", in Borsa, *Könyvtörténeti írások I. A hazai nyomdászat 15–17 század* (Budapest: 1996) 301–306.

Borsa G., "Die polnisch-ungarischen Beziehungen auf dem Gebiete der Buchdruckerkunst im 16. Jahrhundert", in Csapláros I. (ed.), *Studia z dziejów polsko-węgierskich stosunków literackich* (Warszawa: 1978) 117–134.

Braekman W.L. (ed.), *Fortune-telling by the Casting of Dice: A Middle English Poem and its Background* (Brussel: 1981).

Czintos E., "A Woman Printer and Her Readers in Early Modern Transylvania", *The Journal of Early Modern Christianity* 3.2 (2016), 167–199.

Ecsedy J.V., *Rola krakowskich drukarzy w kulturze węgierskiej* (Budapest: 2000).

Ecsedy J.V., "Trading Printing Types: The Evidence of Imported Printing Material in Hungary in the Seventeenth Century", *Gutenberg-Jahrbuch* 82 (2007) 189–204.

Eis G. (ed.), *Wahrsagetexte des Spätmittelalters aus Handschriften und Inkunabeln* (Berlin: 1956).

Grendler P.F., "Form and Function in Italian Renaissance Popular Books", *Renaissance Quarterly* 46. 3 (1993) 451–485.

Hausner G. – Klaniczay T. – Kovács S.I. – Monok I. – Orlovszky G. (eds.), *Bibliotheca Zriniana története és állománya* (Budapest: 1991).

Jaglarz M., *Księgarstwo krakowskie XVI wieku* (Kraków: 2004).

Janssen F.A., *Technique and Design in the History of Printing* (t Goy-Houten: 2004).

Kaltwasser F.G., *Bibliothek als Museum. Von der Renaissance bis heute, dargestellt am Beispiel der Bayerischen Staatsbibliothek* (Wiesbaden: 1999).

Kapełuś H., *Stanisław z Bochnie, kleryka królewski* (Wrocław: 1964).

Kapełuś H. – Ślaski J., "Polski druk popularny na Węgrzech. Z dziejów 'Fortuny'", *Rocznik Biblioteki Narodowej* 2 (1966) 297–317.

Karr Schmidt S., *Interactive and Sculptural Printmaking in the Renaissance* (Leiden – Boston: 2018).

Karr Schmidt S., "Convents, Condottieri, and Compulsive Gamblers. Hands-On Secrets of Lorenzo Spirito's 'Libro'", in Dekoninck R. – Guiderdoni A. – Melion W. (eds.), *Quid est secretum? Visual Representation of Secrets in Early Modern Europe, 1500–1700* (Leiden: 2020) 683–707.

Kawecka-Gryczowa A. – Mańkowska A., "Andrysowic Łazarz", in Kawecka-Gryczowa (ed.), *Drukarze dawnej Polski*, vol. 1: *Małopolska*, part 1: *Od XV do XVI wieku* (Wrocław: 1983) 124–137.

Kawecka-Gryczowa A., "Kraków", in Kawecka-Gryczowa (ed.), *Drukarze dawnej Polski* 105–115.

Kelly J., "Predictive Play. Wheels of Fortune *in the Early Modern Lottery Book*", in Levy A. (ed.), *Playthings in Early Modernity. Party Games, Word Games, Mind Games* (Kalamazoo: 2017) 145–166.

Kiliańczyk-Zięba J., "In Platea Columbarum. The Printing House of Hieronim Wietor, Łazarz Andrysowic and Jan Januszowski in Renaissance Krakow", *Publishing History* 67 (2010) 5–37.

Kiliańczyk-Zięba J., "In Search of Lost Fortuna. Reconstructing the Publishing History of the Polish Book of Fortune-Telling", in Bruni F. – Pettegree A. (eds.), *Lost Books. Reconstructing the Print World of Pre-Industrial Europe* (Leiden: 2016) 120–143.

Kiliańczyk-Zięba J., "Wydawnicze skamieliny. Późne edycje bestsellerów jako źródło informacji o kształcie wizualnym pierwszego wydania tekstu", *Terminus* 21.4 (2019) 401–436.

Lee Palmer A., "Lorenzo 'Spirito' Gualtieri's 'Libro delle Sorti' in Renaissance Perugia", *Sixteenth Century Journal* 47.3 (2016) 557–578.

Leśniak F., "Wymiana towarowa między miastami polskiego Podkarpacia a północno-węgierskimi (wschodnio-słowackimi) w XVI i pierwszej połowie XVII stulecia. Tovarová výmena medzi poľskými podkarpatskými a severouhorskými (východo-slovenskými) mestami v 16. storočí a v prvej polovici 17. storočia", *Historické štúdie* 41 (2000) 49–67.

Leśniak F., "Transgraniczna komunikacja miast podgórskich po obu stronach Karpat (do końca XVIII wieku)", in Karolczak K. – Kovaľ P. – Meus K. (eds.), *Miasto w Europie Środkowo-Wschodniej. Procesy modernizacyjne* (Kraków: 2016) 50–71.

Lukács I., "Nejasna mjesta u *Sibili* Ane Katarine Zrinske", *Studia Slavica, Studia Slavica Hung.* 65.2 (2020) 275–297.

McKenzie D.F., *Bibliography and the Sociology of Texts* (London: 1986).

McKitterick D., "How Can We Tell if People Noticed Changes in Book Design? Early Editions of the *Imitatio Christi*", *Jaarboek voor nederlandse boekgeschiedenis* 19 (2012) 10–31.

Małecki J., "Rola Krakowa w handlu Europy Środkowej w XVI i XVII w.", *Zeszyty Naukowe Akademii Ekonomicznej w Krakowie* 70 (1974) 173–188.

Monok I., *The Cultural Horizon of Aristocrats in the Hungarian Kingdom. Their Libraries and Erudition in the 16th and 17th Centuries*, trans. K. Vargha (Wien: 2019).

Ecsedy J.V. – Pavercsik I., *A magyarországi könyvkiadás és kereskedelem 1800-ig* (Budapest: 1999).

Monok I., "Towns and Book Culture in Hungary at the End of the Fifteenth Century and during the Sixteenth Century", in Rial Costas B. (ed.), *Print Culture and Peripheries in Early Modern Europe: A Contribution to the History of Printing and the Book Trade in Small European and Spanish Cities* (Leiden: 2013) 171–200.

Mańkowska A. – Kawecka-Gryczowa A., "Wietor Hieronim", in Kawecka-Gryczowa (ed.), *Drukarze* 325–352.

Paas J.R., *The Altzenbachs of Cologne, Early Modern Print Publishers: Popular Prints of the XVIIth Century* (Wiesbaden: 2020).

Pacht-Bassani P. – Mignot C. (eds.), *Claude Vignon et son temps: Actes du colloque international de l'université de Tours, 28–29 janvier* (Paris: 1998).

Pelc M., *Sibila Katarine Zrinske* (Zagreb: 2017).

Piekarski K., *Książka w Polsce XV i XVI wieku* (Kraków: 1931).

Pieradzka K., *Handel Krakowa z Węgrami w XVI w.* (Kraków: 1955).

Pirożyński J., "Der Buchhandel in Polen in der Renaissance-Zeit", in Göpfert H.G. et al. (eds.), *Beiträge zur Geschichte des Buchwesens im konfessionellen Zeitalter* (Wiesbaden: 1985) 267–294.

Rosenstock A., *Das Losbuch des Lorenzo Spirito von 1482. Eine Spurensuche* (Weissenkorn: 2010).

Skeat T.C., "An Early Mediaeval 'Book of Fate': The Sortes XII Patriarcharum", *Mediaeval and Renaissance Studies* 3 (1954) 41–54.

Ślaski J., *Wokół literatury włoskiej, węgierskiej i polskiej w epoce Renesansu. Szkice komparatystyczne* (Warszawa: 1991).

Stanisław z Bochnie Gąsiorek, *Fortuna abo Szczęście*, ed. J. Kiliańczyk-Zięba (Kraków: 2015).

Varjas B., "Początki węgierskiego drukarstwa i krakowskie druki w języku węgierskim", in Csapláros I. – Hopp L. – Reychman J. – Sziklay L. (eds.), *Studia z dziejów polsko-węgierskich stosunków literackich i kulturalnych* (Wrocław: 1969) 66–94.

Várnai D., *Wokół polskiej i węgierskiej literatury epoki renesansu* (Budapest: 2019).

Zvonimir B., *Sibila. Knjiga gatalica Zrinskoga dvora u Čakovcu* (Čakovec – Zagreb: 2007).

Wydra W. – Rzepka W.R., "Niesamoistne drukowane teksty polskie sprzed roku 1521 i ich znaczenie dla historii drukarstwa i języka polskiego", in Grzeszczuk S. – Kawecka-Gryczowa A. (eds.), *Dawna książka i kultura. Materiały międzynarodowej sesji naukowej z okazji pięćsetlecia sztuki drukarskiej w Polsce* (Wrocław: 1975) 263–288.

Zollinger M., *Bibliographie der Spielbücher des 15. Bis 18. Jahrhunderts, Bd. 1: 1473–1700* (Stuttgart: 1996).

Żurkowa R., *Księgarstwo krakowskie w pierwszej połowie XVII wieku* (Kraków: 1992).

CHAPTER 15

Shifting Perspectives: Changing Optical Theory in the Printed Works of Jean-François Niceron

Brent Purkaple

1　Introduction

The discipline of optics underwent drastic changes in the early modern period. In contrast to the uniform optical theory of the medieval period, known as *perspectivist* optics, early modern optical theory developed new ideas and explanations, and, as a result, it lacked widespread coherence or agreement as to the nature of the subject. The reason for this is that perspectivist optics ultimately explained cognition.[1] By the early modern period, however, the cognitive aspects of optics were questioned, and ultimately by the eighteenth century, optics was widely recognized as only the study of light. This transformation, known among contemporary historians as the change from *sight* (cognition) to that of *light*, provides a helpful reference point for the long-term changes with respect to the theory of optics.[2] As beneficial as this big picture is for the history of optics, the subtleties of the intervening transition are much less clear. Most studies consider the investigations of a particular individual, focusing on novelties, without attempting to situate that person's work more broadly within a history of transitional changes in optical theory.

Thinking about book customization can help to provide a more nuanced view. Book customization could take a variety of forms, one of which was the editing of subsequent editions of early modern books. By studying such transformations within one book on optics, what may be gleaned is a more complex understanding of how the discipline of optics underwent a decisive change. Such an understanding of the historical development of optics can go a long way toward circumventing the progressive narratives all too common within the history of science, especially the history of optics.

One such book that allows this analysis is the printed treatise on optics by Jean-François Niceron, a French Minim active during the first half of the seventeenth century. Niceron initially composed his book, *La perspective curieuse*,

1　Smith A.M., "Getting the Big Picture in Perspectivist Optics", *Isis* 72 (1981) 568–589.

2　Idem, *From Sight to Light: The Passage from Ancient to Modern Optics* (Chicago: 2014).

© KONINKLIJKE BRILL NV, LEIDEN, 2024 ｜ DOI:10.1163/9789004680562_016

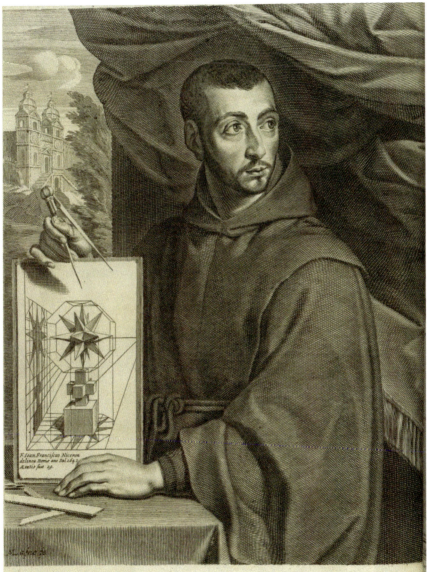

FIGURE 15.1 Michel Lasne, engraved portrait of Jean-François Niceron. In Niceron Jean-François, *La perspective curieuse* (Paris, François Langlois: 1652)
IMAGE COURTESY OF THE HISTORY OF SCIENCE COLLECTIONS, UNIVERSITY OF OKLAHOMA LIBRARIES

as a text to train artisans in the techniques of perspective. The book went through three editions, and is most familiar among contemporary historians for its anamorphic depictions, distorted images only made intelligible by viewing the images from an oblique angle or by locating a mirror beside them.[3] While the book focuses mainly on visual representation, it is noticeable that the text (in accordance with the expectations of perspectivist optics) locates its analysis within optical theory. Considering the way Niceron and his later editors customized the explanation of optical theory alongside that of perspective art, allows us to track the shifting explanation of optical theory as it was undergoing drastic changes in the seventeenth century. Attending to these changes opens a window onto the history of early modern optics, and shows how textual editing was linked to changing theories in the natural sciences, as well as book customization more broadly.

2 Jean-François Niceron

Jean-François Niceron was born in Paris on July 5, 1613. At the age of 19, he joined the Order of the Minims at the convent of Nigeon-Chaillot, and was soon after, in 1632, accepted into the convent of the Place Royal in Paris.[4] It was there that he studied mathematics, optics, and art as a student of the Minim Marin Mersenne.[5] During this time Niceron demonstrated his exceptional ability in art and mathematics; as a result, he was sent to the convent of Trinità dei Monti in Rome, shortly after joining the convent in Paris. He was ordained as a Minim in 1638, the same year his first book on optics was published.[6] In 1640, he returned to the Place Royale, where he remained for some time. He died in 1646, at the age of thirty-three, while traveling near Aix-en-Provence.[7]

In addition to publishing a book on optics, Niceron also completed several specimens of anamorphic art during the 1630s and 1640s, some of it in collaboration with the Minim Emmanuel Maignan, whom he met during his stay in Rome. Two noteworthy pieces, both now lost, were the large anamorphic frescoes in the Minim cloister of Place Royal: *St. John the Evangelist on the Island*

3 One of the best overviews is Rosa A.D., *Jean François Niceron: Prospettiva, Catottrica & Magia Artificiale* (Rome: 2013).
4 Whitmore P., *The Order of Minims in Seventeenth Century France* (The Hague: 1967) 155.
5 Dear P., *Mersenne and the Learning of the Schools* (Ithaca: 1988).
6 Hunter J.L. – Sharp J. – Raynaud D., "Introduction", in Hunter J.L. – Sharp J. – Raynaud D. (eds.), *Curious Perspective Being an English Translation of His 1652 Treatise 'La Perspective Curieuse' with A Mathematical and Historical Commentary* (Tempe: 2019) 12.
7 Whitmore, *The Order of Minims* 156.

CHANGING OPTICAL THEORY IN THE PRINTED WORKS OF NICERON

of Patmos and *Saint Mary Magdalene* at St. Baume. A print after the former appears in one of Niceron's optical works, where it gives a sense of how he adapted anamorphic images to monumental architectural settings.[8] In 1643, Niceron began a different anamorphosis on the interior wall of the same convent in Paris, showing the founder of the Minim Order, Saint Francis of Paola, from one position and, from another, the story of his perilous crossing of the Strait of Messina.[9] Due to Niceron's early death, this particular anamorphosis was finished by his confrere, Emmanuel Maignan. Still visible today in Rome, the anamorphosis was reproduced in Maignan's 1648 book on sundials, *Perspectiva horario*.

Among historians, Niceron stands as one of the most important French practitioners of perspective. His anamorphic techniques, which borrowed from the basic principles of perspective art, demonstrated a mathematical mastery that reinforced many of the fundamental rules of early modern perspective theory.[10] In developing his own techniques, he built upon the works of many contemporary artists, such as Salomon de Caus, Girard Desargues, and Jean-Louis Vaulezard. Vaulezard was particularly important, as he had devised a technique for correctly transforming a work of art into an anamorphic projection, visible only when a cylindrical mirror was placed within it. Niceron's own contribution to the technique was a simpler construction, which used a grid system to create the cylindrical anamorphosis than Vaulezard had explained.[11] The plate depicting this technique, shown in Figure 15.2, is the only two-page plate in both the first edition (1638) and third edition (1652).

During his lifetime, Jean-François Niceron produced one printed book on optics, *La perspective curieuse* (1638) and began work on a second, *Thaumaturgus opticus* (1646), which was published posthumously. Despite separate titles and different languages, the text and printed images of these two books indicate that they should be considered not separate books, but successive editions. Such a relationship between the two books was reinforced in 1652, when a second publication of *La perspective curieuse* was produced, incorporating images and text drawn from both the French first edition and the Latin second edition. The 1652 edition (also in French), was often bound alongside *L'Optique et la Catoptrique* (1651) by the French Minim Marin Mersenne. The two books were reprinted in a joint edition in 1663, using precisely the same texts as in 1651 and

8 Baltrušaitis J., *Anamorphic Art*, trans. W.J. Strachan (New York: 1977) 37–60.

9 Andersen K., *The Geometry of an Art: The History of the Mathematical Theory of Perspective from Alberti to Monge* (New York: 2007) 457.

10 Kemp M., *The Science of Art: Optical Themes in Western Art from Brunelleschi to Seurat* (New Haven: 1992) 211; Anderson, *The Geometry of Art* 401.

11 Ibid. 454.

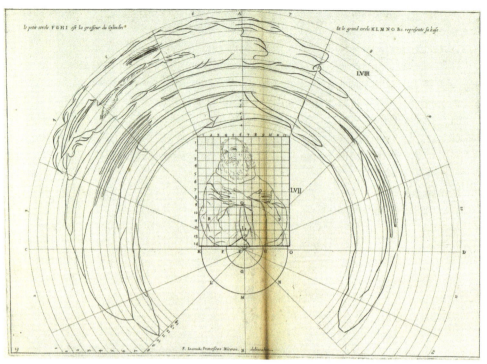

FIGURE 15.2 Engraving of cylindrical anamorphosis sketched by Jean-François Niceron. In Niceron Jean-François, *La perspective curieuse* (Paris, Pierre Billaine: 1638) plate 19. Source gallica.bnf.fr / Bibliothèque nationale de France

1652, with only a new title page stating that the 1663 volume is better understood as a reissue of the third edition. Similarly, the same printer also produced a second printing of the 1646 Latin edition, also without noticeable changes.[12]

These three editions – the 1638, 1646, and 1652 – all were produced at a time when the theory of optics was undergoing rapid change. New optical theories were being introduced and circulated that significantly altered the theory of perspectivist optics. By considering the textual transformations within these two books, it becomes apparent that the theory of optics included within the three editions was being purposefully altered, and thus customized, at the same time that Niceron's anamorphic techniques were published and popularized. Identifying the textual changes involved provides an important commentary on shifting scientific ideas during this critical period. The analysis is even more interesting in the case of Niceron, because he was alive only during the printing of the first edition. The second and third editions, as will be explained

12 Hunter – Sharp – Raynaud, "Introduction" 17–19.

CHANGING OPTICAL THEORY IN THE PRINTED WORKS OF NICERON

below, were likely overseen by two subsequent editors, Marin Mersenne and Gilles Personne de Roberval. What this means is that the changes introduced into the subsequent editions were not developed by Niceron himself, but by the later editors. Moreover, by carefully considering key changes in the subsequent editions, what will be shown is the way in which the act of early modern editing could be a form of customization.

3 Early Modern Optics

To understand the significance of the process of customization as applied in Niceron's book, it is important to locate his publication within the history of optics. For the most part, optics at the start of the seventeenth century was considered to be not merely the study of light, but more fundamentally, the study of sight, within which light played an important role.[13] As historian Sven Dupré reminds us, one must therefore be cautious about separating works on perspective art from the broader philosophical interest in perspectivist optics.[14] And, as Niceron and his subsequent editors reveal, the theory of optics could be an important component even in a book largely about perspective art.

The heritage of perspectivist optics within the early modern period is difficult to overstate. Formed from the ancient optical theories of Aristotle, Galen, and Euclid, the perspectivist tradition of optics came to fruition in the medieval period through the work of the Islamicate mathematician and astronomer, Ibn al-Haytham, and was later adapted in the West by Robert Grosseteste, Roger Bacon, Erasmus Witelo, and John Pecham. Historians have shown that perspectivist optics influenced such wide-ranging subject areas as theology, architecture, literature, art, and philosophy, as well as medicine, mathematics, and natural philosophy.[15] It is because perspectivist optics cut across so many areas, and because it had as its telos the explanation of cognition, that

13 Smith, *From Sight to Light*.

14 Dupré S., "The Historiography of Perspective and *reflexy-const* in Netherlandish Art", in Jorink E. – Ramakers B. (eds.), *Netherlands Yearbook for History of Art* (Leiden: 2011) 34–61; see also Raynaud D., *L'hypothèse d'Oxford. Essai sur les origines de la perspective* (Paris: 1998).

15 Tachau K.H., *Vision and Certitude in the Age of Ockham: Optics, Epistemology, and the Foundations of Semantics, 1250–1345* (Leiden: 1988); Pasnau R., *Theories of Cognition in the Later Middle Ages* (Cambridge: 1997); Akbari S.C., *Seeing Through the Veil: Optical Theory and Medieval Allegory* (Toronto: 2004); Denery D.G., *Seeing and Being Seen in the Later Medieval World: Optics, Theology, and Religious Life* (Cambridge: 2005); Brown P., *Chaucer and the Making of Optical Space* (Oxford: 2007).

perspectivist theory has been referred to as a 'paradigm' of knowledge within the western intellectual tradition.[16]

Perspectivist optical theory describes the visual world using four terms: *lux*, *lumen*, *color*, and *species*. Two of these terms, *lux* and *lumen*, are translated as 'light', but with two distinct meanings. According to perspectivist theory, most objects were self-luminous, and as a result radiated light (*lux*) from an infinite number of locations on the surface of the object. This radiation occurred through the movement of *color*, a quality of a visual object, which moved out from the object in a straight path. Vision occurred through the reception of the visual *species* through a medium made transparent by light (*lumen*). Visual sensation occurred as the *species* touched the surface of the eye, thereby transmitting the quality of *color* to the visual humor within the eye. At this point the *species* would traverse in a non-rectilinear path as it progressed to the back of the eye, through the optic nerve, and into the different chambers of the brain.[17]

Important changes were introduced to this basic theory during the early modern period. Light came to be considered a substance, and the *species* lost its relevance. Among the most important individuals contributing to this change was the astronomer and mathematician Johannes Kepler, who published a critique of perspectivist optical theory in 1604, *Ad Vitellionem paralipomena*, in which he argued that light was a physical-mathematical entity that projected 'pictures' on the retina of the eye, similar to a *camera obscura*. The significance of Kepler's optical theory was that he eliminated the need for the *lux* and *lumen* distinction and replaced the visual *species* with mere mechanical projections on the retina called 'pictures', thereby redefining the discipline of optics as the study of light apart from the cognitive aspects so important to the perspectivist tradition. The full philosophical and optical importance of Kepler's work was best recognized by René Descartes in *Le monde* (published posthumously in 1664) and *La dioptrique* (1637). In these works and others, Descartes utilized Kepler's theory of optics to demonstrate the new mechanical philosophy, which aimed to eliminate the scholastic foundations upon which perspectivist optics rested.[18]

It should be noted that the ideas of Kepler and Descartes were not universally accepted, especially by the perspectivists, and to an extent, represent only one deviation, albeit an important one, from perspectivist optics. This subtle

16 Smith A.M., "Saving the Appearances of the Appearances: The Foundations of Classical Geometrical Optics", *Archive for History of Exact Sciences* 24.2 (1981) 73–99; idem, *From Sight to Light* 2.

17 Idem, *From Sight to Light* 184–231.

18 Ibid., 322–416.

point will become more important below, when considering the way the ideas of Kepler and Descartes were edited into the text of Niceron. As noted below, while it is important to notice the way Niceron's text incorporates many of the conceptual developments of Kepler and Descartes, it is nevertheless equally important to maintain that these changes represent an intentional choice, as there was not a widespread consensus in the seventeenth century that their optical changes were correct.

Coeval with these theoretical developments in optics, the optical interests of Niceron led him to push the boundaries of perspective art to create optical illusions. One recent study has even argued that it was anamorphoses such as Niceron's that shaped the philosophical skepticism of Descartes, since anamorphosis reminded him that vision (and knowledge more broadly) was an embodied yet de-centered experience.[19] This particular historiographical trajectory, building on the pioneering work of Jurgis Baltrušaitis and Rosalie Colie, ultimately gave rise to Stuart Clark's interpretation of early modern anamorphosis. As Clark argues, anamorphoses enabled early modern thinkers to develop the idea that vision itself was a cultural phenomenon.[20] According to this line of reasoning, the cultural foundations of vision implicitly removed the explanation of vision from the discipline of optics in the seventeenth century.

These developments in the science of optics, which separated light from sight and examined the experimental effect of anamorphosis on cognition, raise the question: what evidence (if any) does Niceron's text provide for an engagement with optical theory? The prevailing interpretation has been that Niceron was basically not interested in the philosophical aspects of optical theory.[21] Yet, the text itself, and alterations in the subsequent editions, indicate otherwise. By taking note of these subtle changes, which on the surface appear to be mere editorial alterations but in fact were strategic customizations, it is possible to track the way in which shifting theories of light came to be edited into Niceron's original text. These changes indicate the way in which the projected readers of the book would have been interested in more than the images themselves, but would have also expected a theory of light based on the newest developments. And yet, because these theoretical changes were by no means widely agreed upon nor necessarily proven to be accurate by the middle of the seventeenth century as they were being introduced, the incorporation of

19 Massey L., *Picturing Space, Displacing Bodies: Anamorphosis in Early Modern Theories of Perspective* (University Park: 2007).

20 Baltrušaitis, *Anamorphic Art*; Colie R., *Paradoxia Epidemica the Renaissance Tradition of Paradox* (Princeton: 1966); Clark S., *Vanities of the Eye: Vision in Early Modern European Culture* (Oxford: 2007) 292.

21 Kemp, *The Science of Art* 211.

460 PURKAPLE

these changes should be seen as more than mere editorial shifts. They were in fact a customization.

4 *La perspective curieuse* (1638)

The 1638 edition of *La perspective curieuse* was printed when Niceron was twenty-five years old, the same year he was ordained as a Minim.[22] The title page states that the book subscribes to the normal tripartite division of optics: optics, catoptriques, and dioptriques. The Preface explains that Niceron intends to demonstrate the techniques behind various tricks of natural magic, justifying them as licit on account of their inherent popularity and interest. Yet, the explanation of optical tricks turns out to be a means to an end, since learning how to perform them allows the researcher better to grasp '[perspective] with ardor and learn it diligently'.[23] It is for this reason that a "Geometrical Introduction" explaining the basic principles of geometry precedes volume I; these principles are then utilized in the other four volumes.

As noted above, one of the well-known strengths of Niceron's book is his improved technique for creating an anamorphosis for a cylindrical mirror. Alongside this technique, two other optical tricks demonstrate the theatrical flair that he brought to bear in teaching optics. The first occurs in the fourth volume, on dioptrics. Niceron mentions many of the important advances in telescopes as used by Galileo, Kepler, Descartes, De Dominis, Fontana, and Torricelli. Consistent with his interest in presenting marvelous images, Niceron explains how to fit a polygonal glass or faceted crystal on the end of a telescope in order to distort the image viewed. When one looks through a telescope with such a lens, it reconfigures several constituent images into an entirely different image. In his example he depicts twelve Arabic Sultans who become reconfigured as Louis XIII when viewed through a telescope with such a lens.[24]

Similarly, in volume 3 he explains how to use a quadrangle to produce a disjointed reflected image on several blocks that only becomes recognizable when viewed against a planar mirror. In this particular experiment one creates an image upon triangular blocks, which can then be turned away from the viewer and then refashioned into a new image when projected against a

22 Niceron Jean-François, *La perspective curieuse* (Paris, Pierre Billaine: 1638).
23 Ibid., Preface: 'se la leur pourrois faire rechercher avec ardeur & s'en instruire avec diligence'.
24 Ibid., 105–107.

CHANGING OPTICAL THEORY IN THE PRINTED WORKS OF NICERON 461

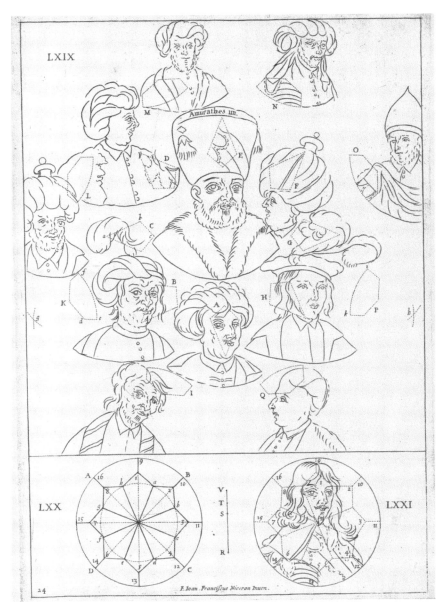

FIGURE 15.3 Engraving designed by Jean-François Niceron depicting Louis XIII seen using a faceted crystal. In Niceron Jean-François, *La perspective curieuse* (Paris, Pierre Billaine: 1638) plate 24. Source gallica.bnf.fr / Bibliothèque nationale de France

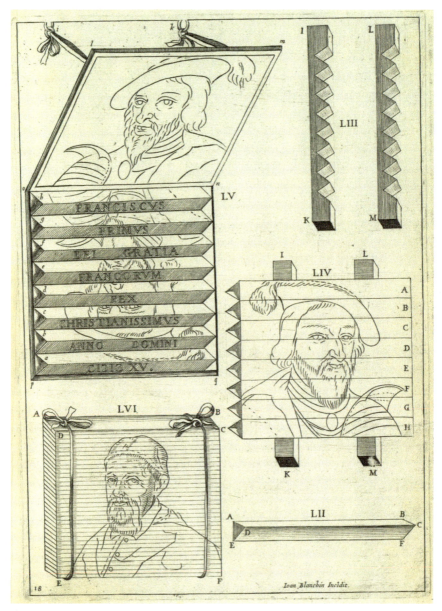

FIGURE 15.4 Jean Blanchin, engraving of quadrangle optical projection. In Niceron Jean-François, *La perspective curieuse* (Paris, Pierre Billaine: 1638) plate 18. Source gallica.bnf.fr / Bibliothèque nationale de France

CHANGING OPTICAL THEORY IN THE PRINTED WORKS OF NICERON 463

mirror positioned at an oblique angle. Niceron imagines how one might utilize this trick to project political or theological ideas, whether to praise great individuals, such as a king or prince, or to depict scenes from the Bible, such as the vision of the bones in *Ezekiel* or the Resurrection or Ascension of Jesus.[25] Although Niceron did not invent this trick, his incorporation of it into political and religious imagery reveals the degree to which he considered optical tricks to be functional; they can be utilized in public to exercise a rhetorical effect upon the people who view them.

The 1638 edition aims to be a practical book on optics; in teaching the mathematical foundations of perspective, Niceron capitalizes on the widespread interest in natural magic. Yet there are places in the book where Niceron clearly locates practical optics alongside (if not within) perspectivist optics. For instance, in the first part of the book, when explaining the geometrical foundations of optics, he explains that 'the *species* of the object passes to the eye of the observer'.[26] This statement, undeveloped as it is, nevertheless indicates that perspectivist optical theory underlies his pedagogical approach to optics.

It is interesting to note that the text demonstrates an awareness of recent optical developments, such as Descartes's *Dioptrique* (1637), which is listed among the authorities important for explaining the operation of the telescope. The text states, 'As for me, I consider it very difficult, if not impossible, to proceed geometrically, because concerning the nature and the principles of refraction, they are not well known to us'.[27] This concession on Niceron's part is important because it is within the *Dioptrique* that Descartes begins to establish the principle of refraction and its implications for the nature of light, all of which directly replaced perspectivist optical theory. So, while Niceron was aware of Descartes to some extent, he does not seem to have understood how Descartes's theory might alter the perspectivist theory.

When stepping back to consider the first edition, what is apparent is that perspectivist optical theory was assumed to coexist alongside the anamorphic and perspective techniques that Niceron expounded. As a consequence, one may assume that Niceron did not recognize any disjuncture between the traditional perspectivist optics and his optical illusions. Rather, he largely adopted

25 Ibid. 78–80.
26 Ibid. 12: 'l'espece de l'objet passant à l'oeil du regardant'.
27 Ibid. 102: 'Quant à moy ie tiens pour tres-difficile, qui ie ne die impossible, d'y proceder Geometriquement: car outre que la nature & les principes de la refraction, ne nous sont pas encore bien cognus'.

464 PURKAPLE

the theory of optics that was widely known and available at the time he composed the book. Contemporary historians might well wonder how the species was thought to function with respect to anamorphic projection or other optical tricks, but at least within the text itself, there is no concern to disconnect the theory of the species or other aspects of perspectivist optics from Niceron's practice of optical illusion.[28]

Turning now to the second edition, composed in Latin, what is important to note is the way the text incorporates further contemporary texts and ideas as a way to reinforce its explanations of perspectivist optics.

5 *Thaumaturgus opticus* (1646)

The *Thaumaturgus opticus*, published in 1646, was intended as a translation into Latin of the French first edition, with subtle improvements. Because Niceron died in 1646, it is almost certain that he did not complete the translation himself. This point is reinforced by the fact that the printing of *Thaumaturgus opticus* includes neither volumes 3 or 4. In comparing the first and second editions, only the "Geometrical Introduction", along with portions of volumes 1 and 2, need be considered.

Most scholars credit Marin Mersenne with getting the Latin text published, and he assisted in translating the text from French into Latin. Mersenne was a fellow Minim and teacher of Niceron, who became quite interested in optics at the end of the 1630s; he was likely responsible for the final stages of production. Indeed, Mersenne bequeathed to Gilles Personne de Roberval, a mid-seventeenth century French mathematician, a partially-completed French translation of the 1646 second edition shortly before Mersenne died in 1648. This second French text, largely translated from the Latin text, is the third edition of the book.[29]

Similar to the 1638 French edition, the Latin text of the 1646 edition identifies its contents as covering optics, catoptrics, and dioptrics. There are strong similarities between the table of contents of the 1646 edition and that of 1638, with some changes directed at providing a clearer and more systematic explanation. For instance, in the "Geometrical Introduction", the first edition contains several sequenced mathematical propositions, some of which become separated in the second edition. So, Proposition 2 is split into two separate

28 Clark, *Vanities of the Eye* 110.
29 Hunter – Sharp – Raynaud, "Introduction" 14–17.

CHANGING OPTICAL THEORY IN THE PRINTED WORKS OF NICERON 465

propositions – now numbered as Propositions 2 and 3 – and the curved and the straight line are handled in two distinct propositions.

There are many more significant changes in volume 1, some of which are clearly intended to supply a clearer explanation of optical theory. One of the best examples is the addition of an entire section explaining 'an optical experience'. In what follows, the text explains how a *camera obscura* may demonstrate important optical principles, not least of which is the analogy to the operations of the eye. The text refers to the recent work of the Jesuit Christoph Scheiner, who had popularized Kepler's comparison between the eye and the *camera obscura* in his *Oculus: Fundamentum opticum* (1619) and *Rosa Ursina* (1630). Yet, whereas Kepler had eliminated the visual *species*, Scheiner retained it.[30] Although the second edition acknowledges that Scheiner's explanation is difficult to follow, especially as regards the reversed image on the retina, it nevertheless relies on Scheiner to teach the basics of the perspectivist optical system: the species projects into the eye, is refracted on the crystalline lens, and eventually arrives at the retina.[31]

In order to avoid an overly close comparison between the camera obscura and the eye, the text also cites the early modern physician Vopiscus Fortunatus Plempius, who emphasized that the eye functions in a living person, and not merely as an inanimate object such as a camera obscura.[32] Thus, the camera obscura may analogically relate to the eye, but the fact that the camera obscura is not alive impedes the comparison. The text then describes how a camera is made and used and discusses the underlying mathematics, using the example of a pyramid to show how the device can aid in representing an object, as seen in Figure 15.5.

After this, the text concludes by stating that even though the image is reversed on the retina, 'the soul' (*animus*) is still able to perceive the object; this was a standard way of explaining the reversed retinal image remain intelligible.[33] As regards the explanation of the camera obscura, it is especially important to note that the understanding of vision has progressed from where it was in the 1638 edition. Whereas refraction was an enigma in the first edition,

30 Dupré S., "The Return of the Species: Jesuit Responses to Kepler's New Theory of Images", in De Boer W. – Göttler C., (eds.) *Religion and the Senses in Early Modern Europe* (Leiden: 2013) 473–487.

31 Niceron Jean-François, *Thaumaturgus opticus* (Paris, François Langlois: 1646) 16.

32 Vanagt K., "Early Modern Medical Thinking on Vision and the Camera Obscura. v.F. Plempius' Ophthalmographia", in Horstmanshoff H.F.J. – King, H. – Zittel C. (eds.), *Blood, Sweat, and Tears: The Changing Concepts of Physiology from Antiquity into Early Modern Europe* (Leiden: 2012) 569–593.

33 Niceron, *Thaumaturgus opticus* 18.

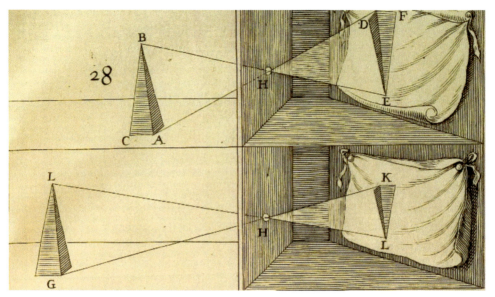

FIGURE 15.5 Engraving of camera obscura. In Niceron Jean-François, *Thaumaturgus opticus* (Paris, François Langlois: 1646) plate 2
MAX PLANCK INSTITUTE FOR THE HISTORY OF SCIENCE, LIBRARY

in this text it explains the operation of the eye, a difference likely traceable to Scheiner's and Plempius's texts.

Among the other important additions to the 1646 edition is a section titled: "What is the art of perspective"?[34] This is the only section unique to the 1646 edition, as it was not included in 1638 or 1652. Quite short, it aims to define perspective art, conceivably in relationship to optical theory; significantly, it follows immediately upon the explanation of the camera obscura. It is thus evident that the issue the text is addressing is the relationship between pictorial representation, mathematics, and visual knowledge – all issues conceptually related to the camera obscura.

The text states that 'Perspective is the art of representing things as they appear, so much so that the painter who deceives the eyes more is more excellent and is the first in optics'.[35] Explanations are then provided about the importance of visual rays, the visual pyramid, and how those may be utilized to create pictures with appropriate perspective. It is significant, then, that in this section the text also describes the movement of the 'scattered rays of the

34 Ibid. 22: 'Quid sit ars perspectivae'.
35 Ibid. 23: 'Perspectiva autem est ars repraesentandi prout apparent, adeo ut pictor ille sit excellentior & in perspectivis prior qui magis oculos fallit'.

CHANGING OPTICAL THEORY IN THE PRINTED WORKS OF NICERON 467

visual species in the aperture [of the camera obscura]'.[36] The term 'visual *species*' clearly evokes the perspectivist theory of optics, in which it is the qualities of an object that are the objects of perception. The text goes on to explain that the rays that intersect with the picture plane are 'the visible species [...] the true image of the object'.[37] The camera obscura, whose images are themselves a projection of perspective lines, is adduced to reinforce the reality of the visual *species* and hence to ratify perspectivist optical theory.

In this way, the text of the 1646 edition makes use of explanations very similar to those of the Jesuit Christoph Scheiner. In his *Pantographice* of 1631, Scheiner explains the operation of the pantograph, a device used to copy an image. Scheiner developed the instrument between 1610 and 1616, when he was an instructor of mathematics and Hebrew at Ingolstad.[38] To understand Scheiner's account of the pantograph, it is important to situate it in relation to his concurrent development of optical theory in the *Oculus* and *Rosa Ursina*. Interestingly enough, in the *Pantographice* Scheiner praises the device for its ability to recreate 'true images or optical species from visual objects'.[39] What Scheiner seems to be saying is that the pantograph is a tool whereby visual *species* can be copied and demonstrated; it can thus be seen to reinforce (and be reinforced by) the basics of perspectivist optics.[40]

To understand why the 1646 edition borrows from Scheiner in this section, it is necessary to recognize an important addition later on: the 'scenographum catholicum'. An instrument intended to reproduce the one by Cigoli that Niceron had seen in Rome, the device, illustrated in Fig. 15.6, functioned similarly to the pantograph in that it allowed the draftsman to reproduce geometrical figures.[41] Following the same line of reasoning from Scheiner's *Pantographice*, the 1646 edition states, 'For it is certain, as Scheiner says in *Pantographice*, that a plane intersects a visual pyramid or species, the same as [does] the picture of an object'.[42] It is not surprising, then, that the second edition, in its appendix

36 Ibid. 24: 'decussatos in foramine specierum visibilium radios'.

37 Ibid. 24: 'Species igitur visibilis in aere tanquam vera obiecti imago realiter versatur suique similem imaginem stabilem & permanentem in quocunque intersecante & proposito plano describendam artificibus propinat'.

38 Daxecker F., *The Physicist and Astronomer Christopher Scheiner: Biography, Letters, Works* (Innsbruck: 2004) 5–10.

39 Scheiner Christoph, *Pantographice, seu ars delineandi* (Rome, Ludovici Grignani: 1631) 31: 'verum etiam imagines seu species optices ab obiectis visibilibus'.

40 Further on this topic, see Purkaple B. *Confessionalized Optics: The Society of Jesus and Early Modern Optics* (Ph.D. dissertation, University of Oklahoma: 2022) 160–163.

41 Kemp, *The Science of Art* 210.

42 Niceron, *Thaumaturgus opticus* 23: 'Certum enim est, ut ait Scheinerus in pantographice, quod planum pyramidem visualem seu speciem intersecans eamdem tanquam picturam obiecti'.

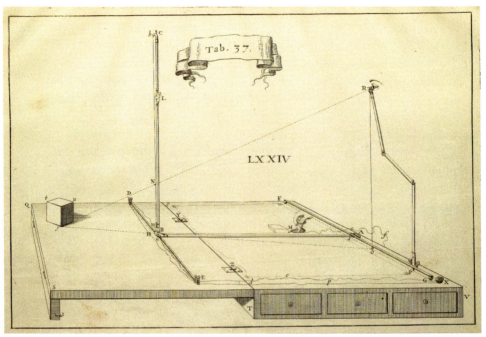

FIGURE 15.6 Engraving of 'scenographum catholicum'. In Niceron Jean-François, *Thaumaturgus opticus* (Paris, François Langlois: 1646) plate 37
MAX PLANCK INSTITUTE FOR THE HISTORY OF SCIENCE, LIBRARY

on light, which occurs immediately after the explanation of the perspective instrument, includes an analysis of light that borrows key terms from the theory of perspectivist optics. 'Light' (*lux*) is explained as the 'glittering quality' of a body, whereas '*lumen*' is the 'visible quality' that enables the object to be seen through a 'diaphanous medium', all language which conceptually borrows from perspectivist optics.[43] Just as Scheiner utilized the pantograph as a practical representation of the visual species, so also did the 1646 text recognize how instruments could instantiate perspectivist theory.

Based upon this analysis it is evident that the 1646 edition continues to situate the mechanics of perspective art within the theoretical framework of perspectivist optics. This is not to say that the work suddenly takes on a new focus, adopting perspectivist optical theory as its raison d'être, for this is still largely a work of practical optics. But the text clearly reinforces the perspectivist theory wherever it would make sense to talk about a theory of optics. In doing so, it establishes a theory of optics that integrates the pictorial and optical in

43 Ibid. 206.

CHANGING OPTICAL THEORY IN THE PRINTED WORKS OF NICERON 469

a similar fashion to Scheiner, which is not altogether surprising considering the widespread appeal of Scheiner's optical works and the fact that he was in Rome at the Collegio Romano at the same time as Niceron. Based upon these changes in the second edition, in which the perspectivist tradition was reinforced and expanded, it is all the more important to observe how noticeably the third edition shifts away from the second, and thus perspectivist theory.

6 *La perspective curieuse* (1652)

The 1652 edition of Niceron's book is a composite of the first and second editions, with important emendations that will be discussed below. It includes a French translation of the first two volumes of the 1646 Latin edition as well as the French of the 1638 edition in Volumes 3 and 4. Because it is a composite of both the first and second editions, the 1652 edition contains the most complete set of engravings, assembled from both sources.[44]

As already indicated, there is strong evidence that Marin Mersenne did most of the translation work, and that Gilles de Personne Roberval enabled its publication. One reason Mersenne is believed to have translated the text is that a few insertions traceable to him appear in the section explaining the nature of light. For instance, in the sub-section titled "Treatise on Light and Shadow", a translation of the appendix on light from the 1646 edition, the text states, 'I will also not speak of the nature or the essence of light, that is if it is a Peripatetic accident, or a very subtle substance, or only the movement of small atoms of which I have spoken elsewhere'.[45] Then, in the same section after Proposition 5, which explains whether light projects from a single point or from the totality of the body, the text states, 'I will speak about this difficulty in the *Optics*'.[46]

Because Niceron was a student of Mersenne and because it is known that during the 1630s and 1640s Mersenne focused extensively on optics, it is very probable that Mersenne inserted the text references to his own work on optics. This point is reinforced by the fact that the 1652 edition was printed by the same printer and was oftentimes bound with Mersenne's *Optique et Catoptrique*, first published posthumously in 1651.[47] The subsequent history of

44 There is a helpful table and brief analysis of the plates in the different editions in Hunter – Sharp – Raynaud, "Introduction" 32–34.

45 Niceron Jean-François, *Curious Perspective*, trans. Hunter J.L. – Sharp J. – Raynaud D. (Paris, François Langlois: 1652; translation, Tempe: 2019) 221.

46 Ibid. 223.

47 Hunter – Sharp – Raynaud, "Introduction" 17–20.

470 PURKAPLE

the texts also points toward Mersenne having played a prominent role. The third edition of *La perspective curieuse* was reprinted in 1663 and bound with Mersenne's optical work. Both texts entirely match; even typographical errors in the 1651 and 1652 editions were carried over.[48] The fact that the title page refers to both works indicates that, by this time, the books had come to be recognized as companion texts.

There are signs that the editor of the third edition, presumably Mersenne, altered the theory of optics within the text. This aspect is clearest in the section on light. For instance, whereas the second edition had explained light according to the Aristotelian distinction between *lux* and *lumen*, the text of the 1652 edition dismisses this subtle distinction. As Proposition 3 explains, it does so in part because of the limitations of the French language, which lacks the ability to distinguish between the two types of light.[49] But, as one reads further in the text, it becomes evident that the elimination of the Aristotelian distinction has to do with the introduction of an entirely new theory of light, one consistent with mid-seventeenth century theories, in which light itself was identified as a substance:

> If a body does not have pores, or small voids, where the atoms of light, or rays from the eye, can pass, but is entirely continuous in all its parts, and there is no penetration of the body, one cannot understand how light can pass through a diaphanous body, unless the body vibrates, and the impacts which are too rapid for us to see make the movement that we call light.[50]

The editor, presumably Mersenne, has shifted the optical framework within the text, and ultimately replaced perspectivist optics with a new theory. In fact, during the period from 1644 until his death in 1648, which overlapped with his editing of the 1646 edition of Niceron's text, Mersenne's understanding of light underwent a drastic reversal. Before 1644, he was a staunch defender of Aristotelian optics, but by 1648, he had adopted a new explanation of light, as seen in the quote above in which light is characterized as some sort of substance.[51] Such an interest in the theory of light may even be noticed in the way the propositions of this section are altered. Whereas the propositions on

48 Ibid. 19.
49 Niceron Jean-François, *La perspective curieuse* (Paris, François Langlois: 1652) 137.
50 Niceron, *Curious Perspective* 222.
51 Darrigol O., *A History of Optics from Greek Antiquity to the Nineteenth Century* (Oxford: 2012) 49.

light in the second edition were listed with minimal explanation, the third edition, as seen in the passage above, includes a much more detailed analysis. It is not inconsequential to notice, then, that by the time the 1652 edition of Niceron was published, the theory of optics that accompanies the perspective explanations was similar to what Mersenne included in his own *Optique*.[52]

It is striking that the newer optical theory coheres subtly with certain other elements of the treatise. For instance, the section titled "What is the art of perspective?", the only unique section in the 1646 edition, was left out of the 1652 edition. Consequently, there is no discussion of Scheiner or Plempius and their novel explanations of the eye and its relationship to the camera obscura or visual species. Based on the analysis above, which identified the defense of the visual *species* as a major aim of that section, its absence in 1652 is all the more intriguing. A theory of light, as quoted above, does not cohere with the visual species, and so this section in particular would have been difficult if not impossible to reconcile with an atomistic or wave theory of light. Furthermore, because the explanations of sight and light were distinct endeavors, no attempt was made in this edition to conceptualize the use of the pantograph and other perspective instruments.

One further aspect indicates that the third edition was changed to emend the optical theory of the previous editions. As noted, the second edition discussion of the camera obscura involves a digression on how the 'soul' interprets the visual *species*. In the third edition, the French translation introduces a subtle albeit important difference. It reads, 'we see them [the reversed images on the retina] upright, because we apply imagination to the places where we are stimulated'.[53] The use of the word 'imagination' is a significant textual change in the context of optical theory. When Kepler introduced his fundamental break from the perspectivist optical tradition in *Ad Vitellionem* (1604), he did so by explaining the visual process in a similar manner: 'An image (*imago*) is the vision of some object conjoined with an error of the faculties contributing to the sense of vision. Thus, the image is practically nothing in itself, and should rather be called imagination'.[54] While Kepler himself was not advocating a substantial view of light, his introduction of 'imagination' as a way to identify the essence of the visual *species* was an interpretative move which later readers, who advocated substantial theories of light, borrowed. So, in editing the third edition to cohere with newer theories of optics, the translation of 'spirit'

52 Cozzoli D., "The Development of Mersenne's Optics", *Perspectives on Science* 18.1 (2010) 20

53 Niceron, *Curious Perspective* 86.

54 Kepler J., *Paralipomena to Witelo whereby the optical part of astronomy is treated*, trans. W.H. Donahue (Santa Fe: 2000) 77.

(*animus*) to 'imagination' (*imagination*) may be seen as an intentional choice, providing the reader of the third edition with a theory of optics that made use of the most important theoretical developments of the time period. Such customizations, contrary to the perspectivist optics that had initially framed Niceron's 1638 edition, enabled the reader of the third edition to be informed on important shifts in optical theory.[55]

These subtle points reinforce the way in which the 1652 edition not only repurposed the previous texts, but intentionally customized them to adopt optical theory that was foreign to the first two editions.[56] Niceron's *La perspective curieuse* becomes not merely a text about the performance of natural magic and anamorphic depictions, but also a vehicle for the transmission of changing theories of optics. Moreover, the fact that Mersenne's book on optics was oftentimes bound with the 1652 edition of *La perspective curieuse* suggests that, at the same time its readers learned the techniques for conjuring illusions, they were also learning critical aspects of the changing theory of optics.

Before concluding, it is important to make one final point about the customization of Niceron's works within the shifting theories of optics. Based on the preceding analysis, it could reasonably be assumed that the optical illusions propagated in Niceron's work possessed an inherent tendency to counter or even eradicate perspectivist optics. When one looks at the reception of Niceron's images and techniques, it becomes evident that contemporary readers understood Niceron's texts and even reproduced the mechanics of his illusions, even while remaining wedded to the tenets of perspectivist optics. The Jesuits Mario Bettini, Athanasius Kircher, and Gaspar Schott are three clear examples of such applied reading.[57] For each of them, anamorphic projections did not entail the dismissal of perspectivist optics, but instead reinforced it. What this means is that Niceron's anamorphic representations were not connected to optical theory. Yet, what this also means is that the changes introduced into his works were not obvious or inherent to the theory of anamorphosis itself. They were customizations that provided an optical theory,

55 Niceron, *La perspective curieuse* (1652) 24.

56 In one instance, the text still uses the language of the 'species of the object' (*l'espece de l'obiet*) to describe the reflection of an image in a mirror. In this context, the language of species has negligible significance for how vision occurs. Niceron, *La perspective curieuse* (1652) 148.

57 Bettini Mario, "Apiarium v", in *Apiaria universae philosophiae mathematicae*, 2 vols. (Bologna, Johannes Baptista Ferronius: 1642) I 28–29; Kircher Athanaius, *Ars magna lucis et umbrae* (Rome, Hermann Scheus: 1646) 184; Schott Gaspar, *Magia universalis naturae et artis*, 4 vols. (Würzburg, Henricus Pigrin: 1657–1659) I 100–169.

CHANGING OPTICAL THEORY IN THE PRINTED WORKS OF NICERON 473

one version of 'sight' and 'light' among other competitors, at a time when there was no agreed upon explanation of optics.

7 Conclusion

Based upon the preceding analysis it should be clear that textual editing could play an important part in the customization of early modern books. Jean-François Niceron provides a perfect example. Surrounding his iconic anamorphic illustrations is a shifting optical theory. Whereas the first and second editions actively reinforce the tenets of perspectivist optics, the third edition explains optical theory in ways that would not cohere with perspectivist optics. By the third edition, optics was the study of 'light' with very little bearing upon 'sight'. As a consequence, the reader of the third edition would have been introduced to a novel theory of optics, one informed by the ideas of Kepler and Descartes. The important point to remember, however, is that the shifting optical theory in these texts represents more than the editorial task of updating optical theory. The fact that the Jesuits incorporated many of the same anamorphic projections, and yet maintained fidelity to perspectivist theory reinforces this point. Instead, the changes that were made introduced a particular theory of optics, one among others, customizing the reception of the work to fit those interested in situating anamorphic projections alongside the latest optical theories.

Bibliography

Akbari S.C., *Seeing Through the Veil: Optical Theory and Medieval Allegory* (Toronto: 2004).

Andersen K., *The Geometry of an Art: The History of the Mathematical Theory of Perspective from Alberti to Monge* (New York: 2007).

Baltrušaitis J., *Anamorphic Art*, trans. Strachan W.J. (New York: 1977).

Brown P., *Chaucer and the Making of Optical Space* (Oxford: 2007).

Clark S., *Vanities of the Eye: Vision in Early Modern European Culture* (Oxford: 2007).

Colie R., *Paradoxia Epidemica the Renaissance Tradition of Paradox* (Princeton: 1966).

Cozzoli D., "The Development of Mersenne's Optics", *Perspectives on Science* 18.1 (2010) 20.

Darrigol O., *A History of Optics from Greek Antiquity to the Nineteenth Century* (Oxford: 2012).

Daxecker F., *The Physicist and Astronomer Christopher Scheiner: Biography, Letters, Works* (Innsbruck: 2004).

Dear P., *Mersenne and the Learning of the Schools* (Ithaca: 1988).

Denery D.G., *Seeing and Being Seen in the Later Medieval World: Optics, Theology, and Religious Life* (Cambridge: 2005).

Dupré S., "The Historiography of Perspective and reflexy-const in Netherlandish Art", in Jorink E. – Ramakers B. (eds.), *Netherlands Yearbook for History of Art* (Leiden: 2011).

Dupré S., "The Return of the Species: Jesuit Responses to Kepler's New Theory of Images", in De Boer W. – Göttler C., (eds.) *Religion and the Senses in Early Modern Europe* (Leiden: 2013) 473–87.

Hunter J.L. – Sharp J. – Raynaud D., "Introduction", in *Curious Perspective Being an English Translation of His 1652 Treatise 'La Perspective Curieuse' with a mathematical and historical commentary* (Tempe: 2019).

Kemp M., *The Science of Art: Optical Themes in Western Art from Brunelleschi to Seurat* (New Haven: 1992).

Kepler J., *Optics*, trans. Donahue W.H. (Santa Fe: 2000).

Massey L., *Picturing Space, Displacing Bodies: Anamorphosis in Early Modern Theories of Perspective* (University Park: 2007).

Pasnau R., *Theories of Cognition in the Later Middle Ages* (Cambridge: 1997).

Purkaple B., *Confessionalized Optics: The Society of Jesus and Early Modern Optics* (Ph.D. dissertation, University of Oklahoma, 2022).

Raynaud D., *L'hypothèse D'Oxford. Essai sur les origines de la perspective* (Paris: 1998).

Rosa A.D., *Jean François Niceron: Prospettiva, catottrica & aagia artificiale* (Rome: 2013).

Smith A.M., "Getting the Big Picture in Perspectivist Optics", *Isis* 72 (1981) 568–589.

Smith A.M., *From Sight to Light: The Passage from Ancient to Modern Optics* (Chicago: 2014).

Smith A.M., "Saving the Appearances of the Appearances: The Foundations of Classical Geometrical Optics", *Archive for History of Exact Sciences* 24.2 (1981) 73–99.

Tachau K.H., *Vision and Certitude in the Age of Ockham: Optics, Epistemology, and the Foundations of Semantics, 1250–1345* (Leiden: 1988).

Vanagt K., "Early Modern Medical Thinking on Vision and the Camera Obscura. V.F. Plempius' Ophthalmographia", in Horstmanshoff H.F.J. – King, H. – Zittel C. (eds.), *Blood, Sweat, and Tears: The Changing Concepts of Physiology from Antiquity into Early Modern Europe* (Leiden: 2012) 569–593.

Whitmore P., *The Order of Minims in Seventeenth Century France* (The Hague: 1967).

CHAPTER 16

Venice as a Musical Commodity in Early Modern Germany: A Frontispiece Collage, *c.* 1638

Jason Rosenholtz-Witt

Housed in the Herzog August Bibliothek in Wolfenbüttel are several manuscript music partbooks, edited and curated from a variety of printed sources. One such manuscript at the center of this essay is the sole surviving partbook of what was once a set, compiled in Helmstedt in 1638: Cod. Guelf 323 Mus. Hdschr. It was carefully and deliberately designed to look and feel like a printed partbook, a process that included conscientious collaging from printed musical sources. The size and layout are similar to that visible in the sizeable output of the Venetian printing houses, including a detailed index arranged by number of voices. The manuscript bassus partbook comprises 130 pieces that include the bass voice, while the full index lists 221 compositions and their composers, information that would have been lost save for the prefatory index [Fig. 16.1].[1] The general musical style is representative of modern trends pouring out of Venetian publishing houses and popularized in German-speaking lands during the early seventeenth century, largely a small-scale genre as compared to previous decades of polychoral opulence. An example of the new style is represented by Italian composer Lodovico Viadana, heavily represented in the manuscript, with twenty-four individual works. Many, but not all, of these originated in Viadana's *Cento concerti ecclesiastici* (1602) and *Concerti ecclesiastici* (1607), both printed in Venice. Further cementing the manuscript to a Venetian aesthetic, the compiler of Cod. Guelf. 323 selected for its title page a device used by the Scotto Press in Venice, one of the most prolific music printers of the era. The result is a customized book, one that emblematically connects the contents of the manuscript with a Venetian musical ethos.

Printed music before 1600 rarely included detailed information for the reader. Customarily, prefatory material in music published during this era relied on rather formulaic and acclamatory prose addressed to a patron or public figure. Within this context, Viadana's lengthy preface to his 1602 *Cento*

1 The full 221-work index is reproduced in Appendix 7 of Rosenholtz-Witt J., *Musical Networks in Bergamo and the Borders of the Venetian Republic, 1580–1630* (Ph.D. dissertation, Northwestern University, 2020) 380–402.

© KONINKLIJKE BRILL NV, LEIDEN, 2024 | DOI:10.1163/9789004680562_017

FIGURE 16.1 Index, Cod. Guelf. 323 Mus. Hdschr, Wolfenbüttel, Herzog August Bibliothek

VENICE AS A MUSICAL COMMODITY IN EARLY MODERN GERMANY 477

concerti ecclesiastici stands out as something relatively novel.[2] The composer includes extraordinarily specific details regarding performance, instrumentation, and the desired effect of his *concerti*. Among other details, the preface includes the first didactic passages on performing the new Italian *basso continuo*, a term for an accompanying musical part that includes a bass line and indications for chordal harmony.[3] The years around 1600 are a watershed in the history of Western music largely owing to publications such as this, as well as Giulio Caccini's 1602 *Le nuove musiche* and its prefatory essay.[4] Characterized by a turn away from large-scale polychoral scoring – double-choir ensembles of at least eight parts – Viadana's *Cento concerti ecclesiastici* consists of small-scale motets for one to four voices along with *basso continuo*.

It is difficult to overstate the influence and importance of Viadana's collection, along with his 1607 *Concerti ecclesiastici*, also for one to four voices with *basso continuo*.[5] These publications would find especially fertile ground in German-speaking lands; of the composer's twenty-seven publications of music published between 1588–1619, fourteen saw multiple editions.[6] *Cento concerti ecclesiastici* and *Concerti ecclesiastici* went through seven and eight editions respectively, a prodigious number compared to most contemporaneous examples. Nicolaus Stein's publishing house in Frankfurt issued Viadana's works as early as 1609. Stein's 1613 reprint of *Cento concerti ecclesiastici* included a German translation of Viadana's lengthy preface to the performer. Stein embellished it somewhat, adding that Viadana was the inventor of the *basso*

2 Viadana Lodovico, *Cento concerti ecclesiastici, a una, a due, & a quattro voci. Con il basso continuo per sonar nell'organo* (Venice, Giacomo Vincenti: 1602). The volume underwent numerous reprints in multiple cities, but the only complete specimen of the original 1602 printing of which I am aware is held by the Biblioteka Jagiellońska in Krakow: PL-Kj, Mus.ant.pract. V 485.

3 For a lengthier discussion of this preface, as well as a full translation see the introduction in Viadana L., *Cento Concerti Ecclesiastici: Opera duodecima 1602*, ed. C. Gallico (Kassel: 1964). The term *basso continuo* refers to a group of instruments (or single instrument, such as an organ or viola da gamba) used to provide the bass line in a musical work, as well as to the notated line from which those instruments play. This practice was a marked shift in musical theoretical thought, as it implied a polarity between the melodic line and the bass.

4 Caccini Giulio, *Le nuove musiche* (Florence, li here di Marescotti: 1602).

5 Viadana Lodovico, *Concerti ecclesiastici a una, a due, & a qauttro voci, con il basso continuo per sonar nell'organo* (Venice, Giacomo Vincenti: 1607).

6 For full subsequent publication details of Viadana's oeuvre, see Appendix I in Mompellio F., *Lodovico Viadana; musicista fra due secoli, XVI–XVII* (Florence: 1967) 105–173. Mompellio's comprehensive appendix catalogues contemporary library holdings, as well, and is often a more reliable source for the later Viadana reprintings than The Répertoire International des Sources Musicales (RISM).

continuo, an erroneous attribution that persisted in music scholarship until the twentieth century.[7]

Venetian printers dominated the international music market, albeit with hefty competition from Antwerp, Lyon, and Paris, and it was not at all uncommon for composers from across the Italian peninsula to seek out one of Venice's presses to distribute their work.[8] The physical material then spread in all directions thanks to the printed book trade and found footholds in German-speaking lands partially through the Frankfurt book fair.[9] Commonly, a number of Italian imprints were bound together and sold in pre-packaged bundles [*Sämmelbände*]. The numbers of Venetian imprints were so vast that emerging musical stylistic trends came to be associated specifically with the city of Venice, regardless of any specific composer's origin or place of employment. Yet Viadana, the composer who above all became associated with the new Venetian style, was never himself active in Venice. The German reprints of *Cento concerti ecclesiastici* played an outsized role in the dissemination of the genre. Further cementing the association of the *concertato* motet with the city were didactic writings of Venetians such as Giovanni Bassano and Girolamo Dalla, and Venetian composers would continue to develop the *concertato* motet to a high level in the coming years.[10] Through such publications, the lineaments of what can erroneously be construed as a distinctly Venetian style spread both north and south of the Alps.

As Viadana states in his preface to *Cento concerti ecclesiastici*, the motets were designed to cater to the specific desiderata he encountered for years in the churches and chapels of Rome. Viadana, after all, was an itinerant cleric-musician. Having also worked at posts in Mantua, Cremona, Padua, and Fano, he wrote music that was both practical and utilitarian, curated for the particularities of these sacred institutions.[11] At these various locations, Viadana was struck by the dearth of readily available music composed at a high artistic level and affordable to perform on a daily basis. It was not every church that

7 Lang P.H., *Music in Western Civilization* (New York: 1941) 358. Lang refers to Viadana's *Cento concerti ecclesiastici* as the first publication to include thorough bass.

8 For more on the Venetian music presses, see Bernstein J., *Print Culture and Music in Sixteenth-Century Venice* (Oxford: 2001).

9 Rose, S., "The Mechanisms of the Music Trade in Central Germany, 1600–40", *Journal of the Royal Musical Association* 130/1 (2005) 1–37.

10 Roche J., *North Italian Church Music in the Age of Monteverdi* (Oxford: 1984) 49.

11 Lacunae in the sources make reconstructing Viadana's biography rather difficult. The best source for biographical information on Viadana, as well as a detailed account of his twenty-seven publications, remains Mompellio, *Lodovico Viadana; Musicista fra due secoli*.

VENICE AS A MUSICAL COMMODITY IN EARLY MODERN GERMANY 479

had the economic resources or personnel required to produce the polychoral repertoire typical of Venice's San Marco. The new small-scale style offered a solution to the predicament of small churches with small choirs unable to perform large-scale polyphony, a pragmatic stylistic shift that was readily adopted in German-speaking lands amid economic and social turbulence brought on by the Thirty Years War, which had depleted the coffers of local churches. The circulation of Italian imprints and foreign reprints allowed these innovations to spread more quickly than would have been possible in previous decades. Additionally, as an alternative to purchasing a vast amount of partbooks, the curation and customization of manuscripts for local use was one way to codify music for the day to day liturgical needs of specific institutions in a relatively economical manner. In this way, Viadana emerged as an example of a composer responsible for spreading a Venetian musical character without any specific association to the city; indeed, I would suggest that printers and scribes often relied on the musical reputation of well-known Venetian publishers to broadcast the quality of their goods, whether or not the product itself was 'Venetian' in any real sense. Venice, fetishized as a musical stamp of authority, was a significant factor in the commodification of music printing by publishers and purveyors of books. The traces of this phenomenon appears in libraries and archives throughout Europe, and one such customized manuscript source in Wolfenbüttel is a case in point.

Scholars of print and manuscript cultures are understandably limited by the surviving sources. The nature of music printing makes this even more problematic, as early modern music was not printed in scores that put all the parts together, but in small individual books known as partbooks, with each voice or instrument printed separately from the others. There are many cases of incomplete specimens – a missing soprano partbook here, a missing alto there – though scholars have long since understood the value of examining incomplete sources for their material aspects.[12] Nonetheless, it is rarely known where and when printed music was used in any given locale. To this end, I here carefully examine one incomplete manuscript partbook originating from lower Saxony, ca.1638, now housed in the Herzog August Bibliothek.[13] It originally belonged to the collection of St. Stephani in Helmstedt. The surviving manuscript, a single unbound partbook, is 20 × 17cm in landscape format, suggesting that it was crafted to visually resemble a printed partbook An investigation of this source and its contents reveals that this locality became increasingly

12 For an example of a scholar utilizing this technique, van Orden K., *Music, Authorship, and the Book in the First Century of Print* (Berkeley: 2014).

13 D-W Cod. Guelf 323 Mus. Hdschr.

dependent on printed Italian musical sources and specifically on Venetian musical products commodified and circulated in the marketplace. In addition, German-edited multi-composer collections supplemented Venetian-sourced volumes. However, two of the featured 'Venetian' composers in these documents had little to do with the city of Venice: the aforementioned Viadana and the Austrian-born, Regensburg-trained, Ljubljana-based composer, Isaac Posch. Through print and manuscript networks, the 'Venetian' style was internalized and imitated by composers such as Posch and copied by scribes in lower Saxony for performance in church.

The main impetus behind publishing, as explained by Viadana, was to provide suitable sacred music for smaller ensembles. One of the chief reasons why these works proved popular in Germany was that they required few performers and thus met the needs of the impoverished German chapels. This new way of writing sacred music, for one or two voices with continuo, was widely imitated, with composers active around Venice – such as Claudio Monteverdi and Alessandro Grandi, both of whom are represented in Cod. Guelf. 323 – becoming particularly proficient; they developed the style to a high degree, thereby cementing abroad the association of this style with Venice. Venetian music further found its way into the Wolfenbüttel manuscript mediated through non Venetian composers inspired by newly available imprints. Venetian music infiltrated Inner-Austria during the first three decades of the seventeenth century. Print was the medium through which it primarily spread, leading to the availability of works in cultural centers like the court in Graz, the cathedrals of Ljubljana and Gurk, and the parish church of Villach. One non-Venetian composer influenced by these developments was Isaac Posch, who settled in what is now Slovenia. As far as we know, he never made the relatively short trip to Venice, yet his three published collections display strong Venetian elements. Posch was a typical example of a musician working both for official Catholic ecclesiastical authorities and for the secular, Protestant elite. Despite zealous efforts to re-Catholicize the area, many aristocratic families in Carniola, Carinthia, and Styria remained largely faithful to Lutheran teachings, and this coexistence of official Catholic and private Protestant worship encouraged patrons to foster the new Italian style of *concertato* motets, ideal for private devotions and services at smaller churches, where only a limited number of singers was available.[14] The most important and influential model for these composers were Stein's editions of Viadana's *Cento concerti*

14 Kokole M., "Venetian Influence on the Production of Early Baroque Monodic Motets in the Inner-Austrian Provinces", *Musica e Storia* 8.2 (2000) 478.

ecclesiastici, issued between 1609 and 1626. Posch's solo motets stand out because they show the composer's familiarity with the cutting-edge *concertato* motet. There were twelve in his 1623 *Harmonia concertans*, and they represent the earliest extant Protestant sacred monody. Posch explicitly refers to Viadana as his model in the collection's preface, and the two books are arranged in a similar fashion.[15]

One key difference in Posch compared with his Venetian counterparts is a complete absence of Marian motets. This is hardly surprising, given that he was a Protestant composer. Instead, the majority of Posch's paraliturgical texts come from the *Song of Solomon* and were intended for private devotion. *Harmonia concertans* was published posthumously by Posch's wife and dedicated to Melchior Putz, a Carinthian Protestant nobleman. Simon Halbmayer, an important Protestant printer, published it in Nürnberg. Included in *Harmonia concertans* are twelve solo motets for a variety of voice types, seven of which are found in Cod. Guelf. 323. After comparing the manuscript to one of the three extant complete copies of *Harmonia concertans*, in Frankfurt, there is little doubt as to the print source for the Halberstadt scribe of Cod. Guelf. 323.[16]

The content of the Wolfenbüttel manuscript is unusual, in that it intermingles Catholic and Protestant composers as well as Latin and German motets. While this was certainly not normative, it was also not so rare as to appear idiosyncratic. Indeed, one of the scribe's print sources was *Fasciculus secundus* and *Fasciculus primus*, a cross-confessional collection in two volumes that overtly alludes to the Thirty Years War, printed in Goslar in 1637 and 1638 respectively [Fig. 16.2]. The title page mentions the long, sad war and encourages youths to practice music as a way of lifting the oppressive weight of the ongoing conflict [see Table 16.1]. Each composition concludes with a Latin couplet commenting on the music, almost like a textual antiphon. Some of these refer explicitly to the war, such as a setting of *Verleih uns Frieden*, a paraphrase of a text by Martin Luther based on the seventh-century hymn, *O pace, Domine* (Give us peace, O Lord, in our time). The ensuing Latin couplet is a plea to Jove for peace [Fig. 16.3].

15 See appendix L in Kokole M., *Isaac Posch: "didtus Eois Hesperiisque Plagis" – Praised in the Lands of Dawn and Sunset* (Frankfurt: 2009) 263.

16 The copy I consulted is part of a large, bound *Sammelband*: Frankfurt am Main, Stadt und Universitätsbibliothek, Goethe Universität, Mus W 55 Nr. 4.

TABLE 16.1 Full title page and English translation for the *Fasciculus* series title page

Geistlicher wolklingender CONCERTEN *Mit 2. und 3. Stimmen sampt dem Basso continuo pro Organis Aus den vornembsten und besten Componisten / von etlichen der edlen Music Liebhabern fleissig comportiret in der Kayserlichen Freyen Reichsstadt* NORTHAUSEN *und Bey jetzigen langweren-den traurigen Kriegs-Pressuren zu sonderli-cher recreation unterweilen in ehrlichen zusammenkunsten practiciret, Jetzo aber Undern Philomusis zu gefallen und der lieben Jugend In Hierosophia ad praxin Musicam accedenti zum besten Socialiter zum Druck verfertiget.*	Sacred melodius Concertos for 2 and 3 voices, with the *basso continuo* for Organ from the distinguished and best composers, diligently compiled by several of the noble music lovers in the Imperial free state of Nordhausen, sometimes practiced in genteel gather-ings as form of special recreation, to counteract the pressures of the present, long-lasting and sad war. Now put into print to please other music lovers [Philomusis] and to bring the beloved youth in schools to the practice of music.
Cum gratia & Privilegio Sereniss, Elect. Saxon.	With the thanks and favor of his Highness, the elector of Saxony.
Aut limos averte oculos, & com-prime linguam: Si potes, aut melius, Zoile, profer opus!	Either turn your eyes from the mud and hold your tongue: or better, if you are able, Zoilus, advance this work!

The music was compiled in Nordhausen, most likely by the local *Kantor* Andreas Oehme from the Collegium Musicum repertoire for the city.[17] The series evidently made it to Helmstedt, as nineteen compositions were cop-ied into Cod. Guelf. 323. Helmstedt was Protestant terrain and part of the principality of Braunschweig-Wolfenbüttel, bordering the Archbishopric of Magdeburg, also Protestant territory since 1524. Notably, Magdeburg was the site of one of the worst catastrophes of the Thirty Years War. Imperial forces besieged the city in 1631 after it declared for Sweden, eventually storming the walls. The result was the slaughter of over 20,000 of the city's 25,000 residents, and the burning of 1,700 of its 1,900 buildings.[18] A census taken the following year listed fewer than five hundred residents and most of the city remained

17 Engel H., *Musik in Thüringen* (Cologne: 1966).
18 Wilson P., *The Thirty Years War: Europe's Tragedy* (Cambridge, MA: 2009) 469.

FIGURE 16.2 Title page, *Fasciculus Secundus* (Goslar, 1637). Krakow, Biblioteka Jagiellońska, Mus.ant.pract. D 600

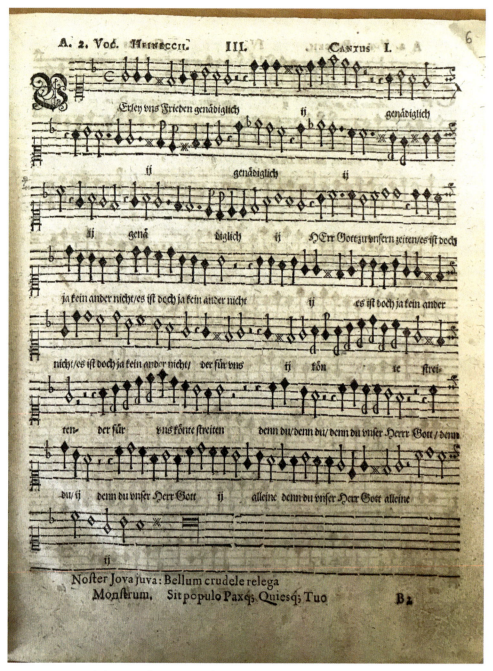

FIGURE 16.3 *Verleih uns Frieden*, in *Fasciculus Secundus* (Goslar: 1637). Cantus partbook. Krakow, Biblioteka Jagiellońska, Mus.ant.pract. D 600

rubble for nearly one hundred years.[19] A new verb entered the German lexicon, *Magdeburgisieren*, 'to make someplace a Magdeburg'.[20] Over two hundred pamphlets describing the city's fall appeared in 1632 alone.[21] This was a well-known event, and the two *Fasciculus* publications must be viewed in this context.

Nineteen *Fasciculus* compositions are included in Cod. Guelf. 323: five from *secundus* and fourteen from *primus* [see Table 16.2]. There is a conspicuous absence of Marian motets among the Italian works, which rely instead on psalms such as *O bone Jesu*, Monteverdi's contribution. *Jubilate Deo* from Psalm 100, set here by Giovanni Nicolò Mezzogori, calls for all lands to praise God with song. A German setting of the same psalm by Heinrich Grimm, *Jauchzet dem Herrn*, is also found in another Wolfenbüttel manuscript partbook.[22] Two other references on the title page help support a reading of these items as war-weary, cross-confessional compositions. Philomusis, translated in this context as 'music lover', was also the penname of sixteenth-century poet Jakob Locher, whose texts were used at the Nordhausen Gymnasium. Locher was a pupil of Conrad Celtes, German humanist and renowned founder of literary societies.[23] Hierosophia refers to Johannes Girbert, a grammatician and rector of the Gymnasium. Locher, best known for his translations of Horace, remained faithful to the Catholic Church even after the Reformation. It is of course possible that the *Fasiculus* series was printed at a time when printers thought they must add war references, although I consider it no accident that there are allusions to these two figures with connections to Nordhausen – one Catholic and one Protestant – on the title page of a collection incorporating such a fascinating mix of Catholic and Protestant composers. It certainly aligns with both the cross-confessional ethos and the musical style of the Helmstedt manuscript. Given this background, when the title page says, 'Now put into print to please other music lovers [Philomusis]', it may refer not just to other music lovers, but to those who – like Locher – have remained faithful to Catholic practice in Reformation Germany.

19 Wilson, *The Thirty Years War* 470.

20 Parker G., *Europe in Crisis 1598–1648* (Oxford: 2001) 161.

21 Wilson, *The Thirty Years War* 470.

22 Cod. Guelf. 324 Mus. Hdschr.

23 Tracy J., "Against the 'Barbarians': The Young Erasmus and His Humanist Contemporaries", *The Sixteenth Century Journal* 11.1 (1980) 5.

TABLE 16.2 Selections from *Fasciculus secundus* and *Fasciculus primus* included in Cod. Guelf. 323 Mus. Hdschr., with number of voices

Fasciculus secundus (1637)	*Fasciculus primus* (1638)
– Heinneccius, 'Lobet den Herrn' à2	– Johann Dilliger, 'O Herr hilff' à1
– Heinrich Grimm, 'Wie bin ich doch' à2	– Johann Krause, 'Herzlich lieb hab ich' à1; 'Domine Iesu Christe' à1
– Claudio Monteverdi, 'O bone Jesu' à2	– Lodovico Viadana, 'Domine Dominus noster' à1; 'O Domine Iesu Christe' à1;
– Johann Hermann Schein, 'Kom heiliger' à3	Dulcissime Iesu Christe' à1; 'Inclina Domine' à1
– Samuel Scheidt, 'Dancket dem Herrn' à3	– Melchior Franck, 'Das ist das ewige Leben' à1
	– Heinrich Baryphonius, 'Wir glauben' à1
	– Andreas Oehme, 'Wir glauben, pars 1' à1; 'Wir glauben, pars 2' à2
	– Giovanni Mezzogorri, 'Iubilate Deo omnis' à2
	– Daniel Selich, 'Wer unter dem Schirm' à2
	– Heinrich Schütz, 'Lobe den Herzen' à2
	– Giacomo Finetti, 'Domine inclina' à2

The most unusual and striking feature of the Wolfenbüttel manuscript is its title page. The compiler of this manuscript partbook cut out segments from two different printed books, one from an unknown source for the ornamental border which was then hand-colored, and one of a full frontispiece. An added 'Third Voice' [III Vox] was inked by hand to indicate voice type, as this originally would have formed one part of a full set [Fig. 16.4]. The incorporation of curated printed imagery, carefully collaged into a new context, broadcasts the status of the customized book as a Venetian commodity. The source of the frontispiece was one of the printer's devices used by the Scotto Press in Venice, one of the most prolific music printers of the era. A printer's device not only acted as advertisement for a music book, but also attested to the quality of its contents.[24] Scotto and his heirs used around twenty different devices, several of which adopted emblems specifically associated with Venetian

24 Bernstein, *Music Printing in Renaissance Venice* 79.

FIGURE 16.4 Cover page with collaged frontispiece, Cod. Guelf. 323 Mus. Hdschr., Wolfenbüttel, Herzog August Bibliothek

iconography, including the one used here.[25] Why was Scotto's very Venetian device chosen for this hybrid product? The reputation of the Scotto house beyond the confines of Venice was likely a factor.

While uncommon, the incorporation of printed material within a manuscript is not entirely without precedent. However, the study of hybrid material

25 Ibid.

such as this poses certain bureaucratic obstacles, as manuscripts and printed books are not only treated as distinct archival categories but are often studied in separate rooms on diffcrent floors of libraries.[26] I am inspired by a recent turn towards materiality in the history of book and print culture – in musicology, most notably Kate van Orden's monograph *Materilaities*, but also a recent special issue of *The Journal of Medieval and Early Modern Studies* on the topic of the Renaissance collage.[27] The contributors to this issue urge scholars to think about collaging as an intellectual gesture. Juliet Fleming points out that cutting and pasting has a long history, a refutation of the claim by art historical scholarship that this is a modern phenomenon.[28] The title page to Cod. Guelf. 323 is unmistakably a collage that goes a step beyond mere scribal copying. It is an epitome of tactile intertextuality, one that graphically connects the contents of this manuscript to Venice, transmitted and mediated without the direct intervention of *La Serenissima*. The Scotto frontispiece acts as an emblem of Venetian musical quality; the reader of this text is first confronted with imagery that a trained musician would instantly recognize. In the center of the Scotto Press device nests an anchor surrounded by a palm frond and an olive branch above the letters SOS, which stand for 'Signum Octaviani Scotto' [Fig. 16.5]. The banner reads, 'In tenebris fulget' (In darkness he shines), the 'he' referring to Scotto and his products or, in its new post-Magdeburg context, to music shining amid the darkness of war. The anchor and log joined together, specifically ascribed to Venetian iconography, symbolize stability on both sea and land, and allude to Venice's maritime power. The manuscript's curious materiality and its musical contents – curated from myriad printed materials and from a wide spectrum of geographies – epitomizes the early modern reality of musical mediation and circulation, comprised by a complex, multimedial, supraregional, and transnational network of communication.

Tracing networks of printed material allows us to see how quickly the new Italian musical styles spread throughout German-speaking lands, and how the scribes of the Wolfenbüttel manuscript relied on editors who had capitalized

26 Sherman W. – Wolfe H., "The Department of Hybrid Books: Thomas Milles between Manuscript and Print", *Journal of Medieval and Early Modern Studies* 45.3 (2015) 457–485. The authors address this reality, discussing their shared experience at the Cambridge University Library.

27 Fleming J. – Sherman W. – Smyth A. (eds.), "The Renaissance Collage: Toward a New History of Reading", *Journal of Medieval and Early Modern Studies* 45.3 (2015) 443–615.

28 Fleming J., "The Renaissance Collage: Signcutting and Signsewing", *Journal of Medieval and Early Modern Studies* 45.3 (2015) 443. Several essays in this special issue support this underlying point.

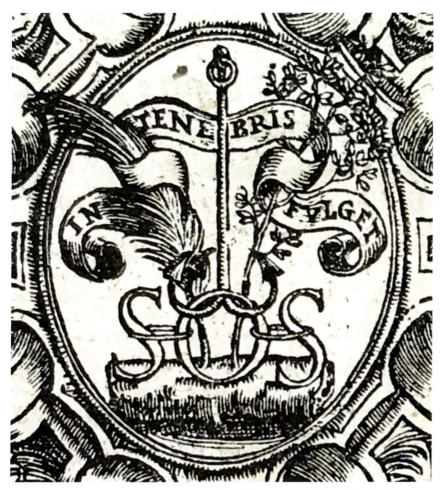

FIGURE 16.5 Detail, Scotto press device, Cod. Guelf. 323 Mus. Hdschr., Wolfenbüttel, Herzog August Bibliothek

on the cultural cachet of Venice. Venetian affiliation functioned as a commodity; it was advertised to sell musical wares, as evidenced by the manuscript's Venetian emblem, irrespective of the absence of purely Venetian musical content. A conception of Venice as commodifiable idea rather than fixed locale deepens our understanding of musical mediation and circulation outside of *La Serenissima* in the early seventeenth century. The fact that a German scribe in a war-torn locale took the time and trouble to craft and curate a customized partbook with Venetian emblems of musical excellence is remarkable evidence for the commodification of Venice in the music market.

Bibliography

Agee R., "A Venetian Music Printing Contract and Edition Size in the Sixteenth Century", *Studi Musicali* 15 (1986) 59–65.

Bernstein J., *Music Printing in Renaissance Venice: The Scotto Press (1539–1572)* (New York: 1998).

Bernstein J., *Print Culture and Music in Sixteenth-Century Venice* (Oxford: 2001).

Caccini Giulio, *Le nuove musiche* (Florence, li here di Marescotti: 1602).

Dobbs B., *A Seventeenth-Century Musiklehrbuch in Context: Heinrich Baryphonus and Heinrich Grimm's Pleiades Musicae* (Ph.D. Dissertation, University of North Texas, 2015).

Einstein A., "Italienische Musik und italienische Musiker am Kaiserhof und an den erzherzoglichen Höfen in Innsbruck und Graz", *Studien Zur Musikwissenschaft* 1 (1934) 3–52.

Eisenstein E., *The Printing Press as an Agent of Change* (Cambridge: 1979).

Engel H., *Musik in Thüringen* (Cologne: 1966).

Fasciculus Primus Geistlicher wolklingender Concerten Mit 2. und 3. Stimmen sampt dem Basso Continuo pro Organis (Goslar, Nicolas Dunkern: 1638).

Fasciculus Secundus Geistlicher wolklingender Concerten Mit 2. und 3. Stimmen sampt dem Basso Continuo pro Organis (Goslar, Nicolas Dunkern: 1637).

Fleming J., "The Renaissance Collage: Signcutting and Signsewing", *Journal of Medieval and Early Modern Studies* 45.3 (2015) 443–456.

Fleming J. et al (eds.), "Special Issue: The Renaissance Collage", *Journal of Medieval and Early Modern Studies* 45 (3) (2015).

Garbe D., *Das Musikalienrepertoire von St. Stephani zu Helmstedt: ein Bestand an Drucken und Handschriften Des 17. Jahrhunderts*, 2 vols., (Wiesbaden: 1998).

Hammond S.L., *Editing Music in Early Modern Germany* (Aldershot: 2007).

Kokole M., *Isaac Posch: "didtus Eois Hesperiisque Plagis" – Praised in the Lands of Dawn and Sunset* (Frankfurt: 2009).

Kokole M., "Venetian Influence on the Production of Early Baroque Monodic Motets in the Inner-Austrian Provinces", *Musica e Storia* 8.2 (2000) 477–507.

Lang P.H., *Music in Western Civilization* (New York: 1941).

Love H., *The Culture and Commerce of Texts: Scribal Publication in Seventeenth-Century England* (Amherst: 1993).

Mompellio F., *Lodovico Viadana; musicista fra due secoli, XVI–XVII* (Florence: 1967).

Parker G., *Europe in Crisis 1598–1648*, 2nd edition (Oxford: 2001).

Posch Isaac, *Harmonia concertans* (Nuremburg, Simon Halbmayer: 1623).

Roche J., "'Aus den berühmbsten italiänischen Autoribus': Dissemination North of the Alps of the Early Baroque Italian Sacred Repertory through Published Anthologies

and Reprints", in Leopold S. – Steinheuer J. (eds.), *Claudio Monteverdi und die Folgen: Bericht über das internationale Symposium, Detmold 1993* (Kassel: 1998) 13–50.

Roche J., *North Italian Church Music in the Age of Monteverdi* (Oxford: 1984).

Rose S., "The Mechanisms of the Music Trade in Central Germany, 1600–40", *Journal of the Royal Musical Association* 130/1 (2005) 1–37.

Rosenholtz-Witt J., *Musical Networks in Bergamo and the Borders of the Venetian Republic, 1580–1630* (Ph.D. dissertation, Northwestern University, 2020).

Saunders S., *Cross, Sword, and Lyre: Sacred Music at the Imperial Court of Ferdinand II of Habsburg* (Oxford: 1995).

Sherman W., "The Department of Hybrid Books: Thomas Milles between Manuscript and Print", *Journal of Medieval and Early Modern Studies* 45/3 (2015) 457–485.

Tracy J., "Against the 'Barbarians': The Young Erasmus and His Humanist Contemporaries", *The Sixteenth Century Journal* 11.1 (1980) 3–22.

Valentin C., *Geschichte der Musik in Frankfurt am Main vom Anfange des XIV. bis zum Anfange des XVIII. Jahrhunderts* (Frankfurt am Main: 1906).

Van Orden K., *Materialities: Books, Readers, and the Chanson in Sixteenth-Century Europe* (Oxford: 2015).

Van Orden K., *Music, Authorship, and the Book in the First Century of Print* (Berkeley: 2014).

Viadana Lodovico, *Cento concerti ecclesiastici, a una, a due, & a quattro voci. Con il basso continuo per sonar nell'organo* (Venice, Giacomo Vincenti: 1602).

Viadana Lodovico, *Cento Concerti Ecclesiastici: Opera duodecima 1602*, ed. C. Gallico (Kassel: 1964).

Viadana Lodovico, *Concerti ecclesiastici a una, a due, & a qauttro voci, con il basso continuo per sonar nell'organo* (Venice, Giacomo Vincenti: 1607).

Wollny P., "The Distribution and Reception of Claudio Monteverdi's Music in Seventeenth-Century Germany", in S. Leopold – J. Steinheuer, (eds.), *Claudio Monteverdi und die Folgen: Bericht über das internationale Symposium, Detmold 1993* (Kassel: 1998) 51–75.

Wilson P., *The Thirty Years War: Europe's Tragedy* (Cambridge, MA: 2009).

CHAPTER 17

Vaenius in Ireland: An Eighteenth-Century Customization of the *Emblemata Horatiana*

Simon McKeown

The late-Renaissance genre of the emblem offers a rich research field for those engaged with questions of literary customization.[1] Andrea Alciato (1492–1550), the Milanese lawyer and founder of the emblem genre, customized his condensed epigrams out of a plenitude of lore plundered from the *Anthologia Graeca*, Aesop, Virgil, Pausanius, Pliny, and other places, some of it ekphrastic descriptions of ancient monuments, statues, coins, or other artefacts.[2] This was also the practice of the many later emblematists who took inspiration from Alciato and his *Emblematum liber* of 1531, including the learned Flemish artist, Otto Vaenius (1556–1629).[3] Although Vaenius was author to no fewer than five emblem books, and of a further three para-emblematic texts, his reputation rests upon the fame and success of his great triumvirate published in the early 1600s: *Quinti Horati Flacci emblemata* (1607), more commonly known as the *Emblemata Horatiana*; *Amorum emblemata* (1608); and *Amoris divini emblemata* (1615), all published in Vaenius's native Antwerp.[4] Just as Alciato drew his ideas

1 Concerning the emblem, see, *inter alia*, Praz M., *Studies in Seventeenth-Century Imagery*, 2nd ed. (Rome: 1964); Manning J., *The Emblem* (London: 2002); and Daly P.M. (ed.), *Companion to Emblem Studies* (New York: 2008).

2 See Bässler A., *Die Umkehrung der Ekphrasis. Zur Ehtstehung von Alciatos* "Emblematum liber" *(1531)*, (Würzburg: 2012); and Cummings R., "Alciato's *Emblemata* as an Imaginary Museum", *Emblematica: An Interdisciplinary Journal for Emblem Studies* 10 (1996) 245–281.

3 The standard biography of Vaenius (who is often referred to in the literature under his Dutch name of Otto van Veen) remains Hofstede J.M., *Otto van Veen, der Lehrer des P.P. Rubens* (PhD dissertation, Albert-Ludwigs-Universität: Freiburg-im-Breisgau, 1959). Concerning Vaenius more widely, see also Hofstede J.M., "Zum Werke des Otto van Veen 1590–1600", *Bulletin Koninklijk Musea voor Schone Kunsten* 6 (1957) 127–174; and Haberditzl F.M., "Die Lehrer des P.P. Rubens", *Jahrbuch der Kunsthistorischen Sammlungen des Allerhöchsten Kaiserhauses* 27 (1908) 192–235. See also McKeown S., "Introduction: Otto Vaenius and his Emblem Books", in McKeown (ed.), *Otto Vaenius and his Emblem Books* (Glasgow: 2012) ix–xxxvi.

4 Vaenius Otto, *Quinti Horati Flacci emblemata* (Antwerp, O. Vaenius – H. Verdussen: 1607); Vaenius, *Amorum emblemata* (Antwerp, H. Swingenii: 1608); Vaenius, *Amoris divini emblemata* (Antwerp, M. Nutii – J. Meurii: 1615). Among the many studies of Vaenius's emblem corpus, see Praz M., *Studies in Seventeenth-Century Imagery, passim*; and the essays in McKeown (ed.), *Otto Vaenius and his Emblem Books*, notably Melion W.S., "Venus/

© KONINKLIJKE BRILL NV, LEIDEN, 2024 | DOI:10.1163/9789004680562_018

from a range of celebrated sources in ancient literature, so Vaenius looked to texts from the venerable past. As Margit Thøfner has demonstrated, the spiritual emblems of the *Amoris divini emblemata* depend upon aspects of Teresian mysticism.[5] And as Mario Praz and then Karel Porteman have duly noted, the *Amorum emblemata* could as well be named the 'emblemata Ovidiana' for the extent to which it recasts the key works of the *Ars amatoria*.[6] But neither of these works declares as unambiguously its dependence upon older sources than the *Emblemata Horatiana*, with its emblems fashioned out of the stuff and substance of Horace's *carmina*.[7] Gravitating towards Horatian texts with a

Venius: on the Artistic Identity of Otto van Veen and his Doctrine of the Image", 1–53. For studies of the *Amorum emblemata* and *Amoris divini emblemata*, see Buschhoff A., *Die Liebesemblematik des Otto van Veen. Die* Amorum emblemata *(1608) und die* Amoris divini emblemata *(1615)* (Bremen: 2004); Buschhoff A., "Zur gedancklichen Struktur der *Amoris divini emblemata* des Otto van Veen (Antwerpen, 1615)", in Manning J. – Porteman K. – Van Vaeck M. (eds.), *The Emblem Tradition and the Low Countries: Selected Papers of the Leuven International Emblem Conference, 18th–23rd August 1996* (Turnhout: 1999) 39–76; Boot P., "A Mirror to the Eyes of the Mind: Metaphor in Otto van Veen's *Amoris divini emblemata* (Antwerp, 1615)", in Dekoninck R. – Guiderdoné-Bruslé A. (eds.), *Emblemata sacra: The Rhetoric and Hermeneutics of Illustrated Sacred Discourse* (Turnhout: 2007) 291–304; Boot P., "Playing and Displaying Love: Theatricality in Otto van Veen's *Amoris divini emblemata* (Antwerp: 1615)", *Emblematica: An Interdisciplinary Journal for Emblem Studies* 16 (2008) 339–364; Boot P., "Similar or Dissimilar Loves: *Amoris divini emblemata* and its Relation to *Amorum emblemata*", in McKeown (ed.), *Otto Vaenius and his Emblem Books* 157–173; Montone T., "Cupid in the *Ourobouros*, the Disconsolate Alembic and other Matters: The *Amorum emblemata* (1608) from a New Perspective", in ibid. 55–72. On Vaenius's *Emblemata sive symbola*, see Vassilieva-Codognet O., "Coining Neo-Stoic Hieroglyphs: From Brussels Mint to *Emblemata sive symbola*", in ibid. 211–248; concerning his *Physicae et theologicae conclusiones*, see Dekoninck R. – Guiderdoni A., "Reasoning Pictures: Vaenius's *Physicae et theologicae conclusiones* (1621)", in ibid. 175–196; and Catellani A., "Emblematic and Graphic Processes in Vaenius's *Physicae et theologicae conclusiones* (1621): Semiotic Observations", in ibid. 197–210. Vaenius's other published work may be classified as 'para-emblematic': see, for example, his *Vita D. Thomae Aquinatis* (Antwerp, Sumptibus Othonis Vaeni: 1610); and *Historia septem infantium de Lara* (Antwerp, Philippus Lisaert: 1612). Concerning the first, see Melion, W.S., "Venus/Venius", in McKeown (ed.), *Otto Vaenius and his Emblem Books* 46–53; and the second, McKeown S., "An Unknown English Translation of Otto Vaenius's *Historia septem infantium de Lara* (British Library, 551.e.9): A Transcription and Introductory Note", in ibid. 107–156.

5 Thøfner M., "'Let Your Desire Be to See God': Teresian Mysticism and Otto van Veen's *Amoris divini emblemata*", *Emblematica: An Interdisciplinary Journal for Emblem Studies* 12 (2002) 83–103.

6 Praz M., *Studies in Seventeenth-Century Imagery* 100; Porteman K., "Introduction", in *Vaenius, O.*, Amorum emblemata (1608) (Aldershot: 1996) 3.

7 For commentary on his *Quinti Horati Flacci emblemata*, see Sabbe M., "Les *Emblemata Horatiana* d'Otto Venius", *De Gulden Passer* 13 (1935) 1–14; Gerards-Nelissen I., "Otto van Veen's *Emblemata Horatiana*", *Simiolus* 5 (1971) 20–63; Forster L., "Die *Emblemata*

marked Stoic emphasis, Vaenius plays a curatorial part, supporting the central passages from the Roman poet with *loci communes* drawn from other classical writers and augmenting the whole with 103 full-page quarto plates engraved to his designs and executed with virtuosic skill [Figs. 17.1A–17.1B].

Vaenius's original 1607 edition of the *Emblemata Horatiana* was followed by a second issue before the end of the same year, and a third in 1612.[8] Such was its popularity that it was deemed worthy of pirating, and in 1646 there appeared in Paris a version of Vaenius's emblems that we may consider to be an act of further customization.[9] This was *La doctrine des moeurs*, a lavishly produced book ascribed to Marin Le Roy, Sieur de Gomberville (1600–1674), with plates cut by the royal engraver Pierre Daret, who rendered Vaenius's images in reverse [Fig. 17.2]. As is well known, Gomberville expunged the name of Vaenius from the book, and brazenly claimed that Vaenius's distinctive, and by 1646 familiar engravings were in truth mysterious records of the lost paintings that once graced the *Stoa Poikile* of the Athenian Agora.[10] It was this version of Vaenius's emblems that Thomas Mannington Gibbs translated into English during the 1710s [Fig. 17.3]. It is possible that Gibbs may have undertaken the task without knowing of Gomberville's falsehood or of the book's true source in Vaenius. In any case, his English edition was first published in 1721 under the title *The Doctrine of Morality*, appearing again in 1726 with the same sheets but a new title-page declaring it to be *Moral Virtue Delineated*.[11] This change was not

 Horatiana des Otho Vaenius", *Wolfenbütteler Forschungen* 12 (1981) 117–128; McGrath, E., "Taking Horace at his Word: Two Abandoned Designs for Otto van Veen's *Emblemata Horatiana*", *Wallrof-Richartz Jahrbuch* 55 (1994) 115–126; Thøfner M., "Making a Chimera: Invention, Collaboration and the Production of Otto Vaenius's *Emblemata Horatiana*", in Adams A. – Van der Weij M. (eds.), *Emblems of the Low Countries: A Book Historical Perspective* (Glasgow: 2003) 17–44; Mayer R., "*Vivere secundem Horatium*: Otto Vaenius's *Emblemata Horatiana*", in Houghton L.B.T. – Wyke M., (eds.), *Perceptions of Horace: A Roman Poet and his Readers* (Cambridge: 2009) 200–218; and Enenkel K.A.E., *The Invention of the Emblem Book and the Transmission of Knowledge, ca.1510–1610* (Leiden – Boston: 2019) 365–438.

8 Concerning these editions, and the subsequent versions published in several languages, see Landwehr J., *Emblem Books in the Low Countries, 1554–1949: A Bibliography* (Utrecht: 1970) 678–692.

9 Gomberville M.L.R. de, *La doctrine des moeurs tirée de la philosophie des Stoiques: Representée en cent tableaux, expliquée en cent discours pour l'instruction de la jeunesse* (Paris, P. Daret – L. Sevestre: 1646).

10 Gomberville, *La doctrines des moeurs*, sig. A1r–A1v. For the customization of Vaenius's book by Gomberville, see Teyssandier B., "Les Métamorphoses de la Stoa: De la Galerie comme Architecture au Livre-Galerie", *Études Littéraires* 34.1–2 (2002) 1–34.

11 Gibbs T.M., *The Doctrine of Morality, or a View of Human Life According to the Stoick Philosophy* (London, J. Darby – A. Bettesworth – F. Fayram – J. Pemberton – J. Hooke – C. Rivington – F. Clay – J. Batley – E. Symon: 1721); and *Moral Virtue Delineated, or One Hundred and Three Short Lectures, both in French and English, on the Most Important Points*

VAENIUS IN IRELAND: CUSTOMISATION OF THE *EMBLEMATA HORATIANA* 495

sanctioned by Gibbs, and indeed he was fated to see neither issue of his work in print, dying in the last weeks of 1720, aged 25.

So how did his work come to light posthumously? Little is known of Gibbs, other than he was born around 1695, and educated first at Merchant Taylors' School, London, then Hart Hall, Oxford.[12] But his Last Will and Testament in the National Archives at Kew states that the young scholar bequeathed all his worldly goods to Penelope Aubin (*c.*1679–1738), a literary entrepreneur, actress, playwright, and author of both pious meditations and erotic romances.[13] The terms of Gibbs's relationship with Aubin are unknown, but what is not in doubt is that the energetic Aubin acquired a completed literary manuscript which she quickly turned to profit. How Aubin managed to secure Daret's original copperplates from the 1640s is a further mystery, but manage she did, and with evident alacrity, since Gibbs's customized edition of Vaenius was published with handsome results within a year of the young man's death.[14]

The work of publishing Gibbs's book fell to a syndicate of London printers, but one circumstance of its history has passed without scholarly comment, namely the intriguing fact that Penelope Aubin dedicated it to the principal female figure within the Irish peerage, Mary, Duchess of Ormonde (1664–1733) [Fig. 17.4].[15] Why did the enterprising Aubin hazard the fortunes of her expensively produced book to the whim of the duchess? Perhaps it was because the

 of Morality (London, J. Darby – A. Bettesworth – F. Fayram – J. Pemberton – J. Hooke – C. Rivington – F. Clay – J. Batley – E. Symon: 1726).

12 See Wilson H.B., *The History of Merchant-Taylors School, from its Foundation to the Present Time*, 2 vols. (London: 1812) II 963.

13 Will of Thomas Mannington Gibbs, Gentleman of Saint Clements Dames, Middlesex, 29th October 1720, National Archives, Kew, Prob. 11/576/295. Concerning Penelope Aubin, see, *inter alia*, Prescott S., "Penelope Aubin and the Doctrine of Morality: A Reassessment of the Pious Woman Novelist", *Women's Writing* 1.1 (1994) 99–112; Welham D., "Penelope Aubin, Short Biography", (Chawton: 2011); and Welham D., "The Particular Case of Penelope Aubin", *Journal for Eighteenth-Century Studies* 31.1 (2008) 63–76.

14 It is possible that Gibbs had already secured the plates, a circumstance that might have encouraged his effort at translation.

15 Mary was the second wife of James Butler, the 2nd Duke of Ormonde (1665–1745). Born Lady Mary Somerset, daughter of the Duke of Beaufort, she married her husband in 1685 when he was Earl of Ossory; three years later Butler succeeded to the ducal title of his grandfather. She was a correspondent of Jonathan Swift, and attracted literary tribute from authors in search of patronage, including John Dryden: see Ohlmeyer J. – Zwicker S., "John Dryden, the House of Ormond, and the Politics of Anglo-Irish Patronage", *The Historical Journal* 49.3 (2006) 677–706. Concerning Mary Butler and her husband, see Barnard T. – Fenlon J. (eds.), *The Dukes of Ormonde, 1610–1745* (Woodbridge: 2000), particularly 137–159. The anonymous *A Short Memorial, and Character, of that Most Noble and Illustrious Princess, Mary, Dutchess of Ormonde* (London, n.p.: 1735) may be discounted as a legitimate biographical source, having been penned by Edmund Curll, the notorious London printer who specialized in 'scandalous memoirs, [and] instant biographies of the

32 VIS INSTITVTIONIS.

*Lib.*1.
epiſt. 2.

Quo ſemel eſt imbuta recens, ſeruabit odorem
Teſta diu.

Plutarch. Alexander Rex cùm interrogaretur , vtrùm patrem mallet Philippum an Ari-
in Alex. ſtotelem: Magiſtrum, inquit: ille enim, vt eſſem; hic autem, vt præclarè inſtitutus
Maxim. eſſem, auctor fuit.
*Serm.*23.

Iuuenal
Sat. 14.

Nil dictu fœdum, viſuq, hæc limina tangat.
Intra quæ puer eſt: procul hinc procul inde puellæ
Lenonum, & cantus pernoctantis paraſiti.
Maxima debetur puero reuerentia, ſi quod
Turpe paras, nec tu pueri contemſeris annos:
Sed peccaturo obſiſtat tibi filius infans.

No de otra ſuerte, que el licor precioſo,
Por poco que aya eſtado en algun vaſo,
En el dexa gran tiempo ſu fragancia,
Aſſi de la niñez aquel gracioſo
Tiempo alegre, de engaños tan eſcaſo,
Eſta ſugeto à perdida ò ganancia,
Porque tiene tan fuerte conſonancia
Con la primer doctrina, que le dura
Haſta la ſepultura,
Que es ſimiente, y naſcida,
Creſce con el diſcurſo de la vida,
Y ymporta grandemente, que eſta ſea,
Tal, qual vno en la muerte la deſea.

Een pot na'tghene riertkt alt ſit
Wat men daer cerſt in heeft ghegoten :
De leeringh wert men ſelden quijt
Die men heeft in ſijn ieught ghenoten.
De ionckheyt lichtlijck pet inpzent/
Schout woozden vijl' ſijt repin van leuen
Na dat ern tacxken wert ghe-ent
Sal't goed of quade bzuchten gheuen.

Del primiero liquor che fu ripieno,
Serua ſempre l'odor e ſpira il vaſo.
Quello vitio ò virtù ritien non meno
L'huom , che in tenera età gli ſu perſuaſo,
Però da l'impudico ogn'atto oſceno
Lunge ſia, che'l fanciul non macchiâ caſo.
Imita lo ſcolare il precettore,
Che Aleſſandro antepoſe al Genitore.

La cruche ſent touſiours l'odeur,
Et le gouſt du premier breuuage:
Auſſy retinent touſiours le cœur
Les meurs appriſes en bas age.
Gardez vous bien d'outrager
Par quelque acte, ou mot leger,
La veuë & l'oreille tendre;
Qui eſt trop prompte à l'entendre.

Le vaſe fraiſ moulé recoit l'odeur entiere
Des premieres liqueurs dont il eſt abbreué:
Le ieune eſprit auſſy d'vn bon maiſtre eſleué
De ſes dogmes retient l'impreſſion premiere.

FIGURE 17.1A Cornelis Galle or Cornelis Galle (engravers) and Otto Vaenius (designer), "Vis
Institutionis". Sample of *loci communes*. From: Vaenius Otto, *Q. Horatii Flacci
emblemata* (Antwerp, P. Lisaert: 1612)
IMAGE BY KIND PERMISSION OF THE EMBLEM PROJECT UTRECHT

book in Gomberville's iteration strongly signalled its capacity for Stoic conso-
lation thought proper to divert, comfort, and fortify a lady who had suffered
heavily from Fortune's blows. The duchess's pre-eminence among the Irish

famous dead'. Curll was long embroiled in disputes with Alexander Pope. See Pope A.,
A Critical Edition of the Major Works, ed. P. Rogers (Oxford: 1993) 719.

FIGURE 17.1B Cornelis Galle or Cornelis Galle (engravers) and Otto Vaenius (designer), "Vis Institutionis". Engraving, 16.1 × 13.1 cm. From: Vaenius Otto, *Q. Horatii Flacci emblemata* (Antwerp, P. Lisaert: 1612)
IMAGE BY KIND PERMISSION OF THE EMBLEM PROJECT UTRECHT

aristocracy came to a dramatic end in 1715 when her husband, James Butler, the 2nd Duke of Ormonde, declared his allegiance to the exiled King James and supported the ill-fated Jacobite Uprising against the Hanoverian Succession.[16]

16 For an introduction to the ducal family and its pre-eminence amongst the Anglo-Irish aristocracy, see Barnard T.C., "The Dukes of Ormonde", in Barnard – Fenlon J. (eds.), *The*

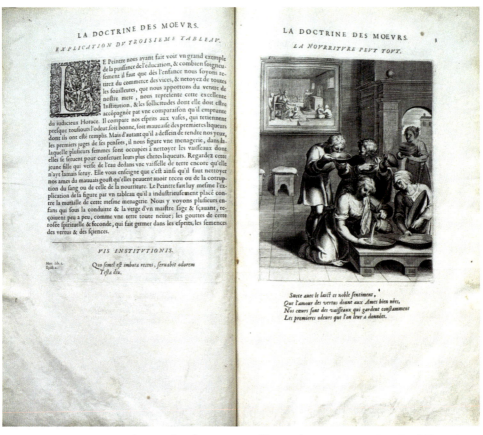

FIGURE 17.2 Pierre Daret (engraver) and Otto Vaenius (designer), "La Nourriture Peut Tout". Engraving, 18 × 14.5 cm. From: Le Roy, Marin, Sieur de Gomberville, *La doctrine des moeurs* (Paris, P. Daret – L. Sevestre: 1646)
IMAGE FROM A PRIVATE COLLECTION

Its failure saw Butler disgraced, attainted, his land and wealth forfeited, and his titles erased. He entertained little thought of sending for his wife to join him in his French or Spanish exile, and he never saw her again, turning instead to a life of dissipation and enervated political intrigue.[17] Left exposed by her husband's fall, the duchess cut a pitiable figure, harried by commissioners and bailiffs

Dukes of Ormonde 1–53. The ducal title is traditionally spelled as 'Ormond' up to the death of the 1st Duke (1688), then as 'Ormonde' thereafter.

17 Concerning the lamentable financial situation of the Ormondes even before the crisis of 1715, see Hayton D.W., *The Anglo-Irish Experience, 1680–1730: Religion, Identity, and Patriotism* (Woodbridge: 2012) 49–75.

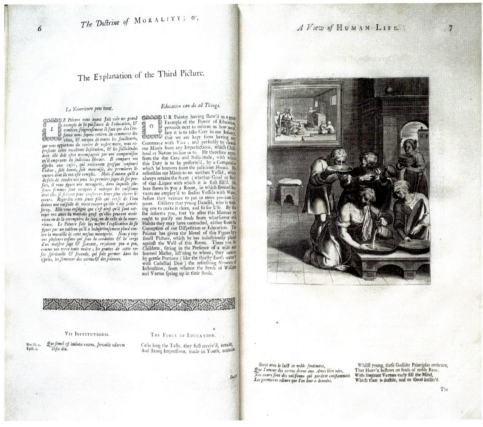

FIGURE 17.3 Pierre Daret (engraver) and Otto Vaenius (designer), "Education Can Do All Things". Engraving, 18 × 14.5 cm. From: Gibbs Thomas Mannington, *Moral Virtue Delineated* (London, J. Darby – A. Bettesworth – F. Fayram – J. Pemberton – J. Hooke – C. Rivington – F. Clay – J. Batley – E. Symon: 1726)
IMAGE FROM A PRIVATE COLLECTION

tasked with dividing up the Ormonde estate. Perhaps emblematic consolation was deemed welcome to the duchess because Aubin knew of her favour towards her chaplain, the Reverend Edmund Arwaker, an Irishman educated first at Kilkenny College, then at Trinity College, Dublin, both schools under the chancellorship of Ormonde.[18] Arwaker was author of several books, but is

18 Concerning Arwaker, see O'Donoghue D.J., *The Poets of Ireland: A Biographical and Bibliographical Dictionary of Irish Writers of English Verse* (Dublin – London: 1912) 13; and Leslie J.B., *Armagh Clergy and Parishes: Being an Account of the Clergy of the Church of Ireland in the Diocese of Armagh, from the Earliest Period, with Historical Notes of the Several Parishes, Churches, etc.* (Dundalk: 1911) 53. In "The Epistle Dedicatory" to the Duchess of Ormonde, Arwaker reminds his patroness that: 'Since I began my growth in

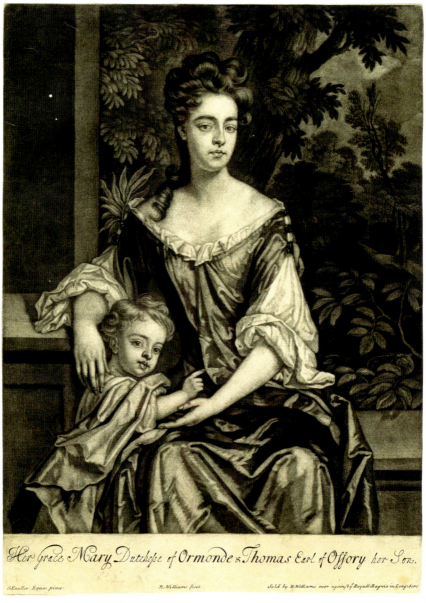

FIGURE 17.4 Robert Williams (engraver) and Godfrey Kneller (painter), "Portrait of Mary Butler, Duchess of Ormonde, with Thomas, Earl of Ossory," c.1693. Mezzotint, 34.3 × 25 cm
IMAGE BY KIND PERMISSION OF THE TRUSTEES OF THE BRITISH MUSEUM

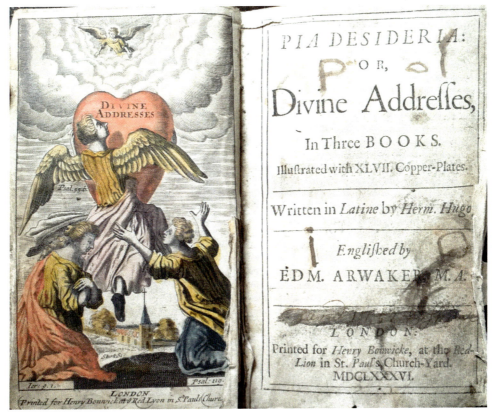

FIGURE 17.5 Edmund Arwaker, *Pia desideria: or, Divine Addresses in Three Books* (London, Henry Bonwicke: 1686), with a frontispiece by John Sturt (engraver) and Boëtius Bolswert (designer)
IMAGE FROM A PRIVATE COLLECTION

best remembered for his popular translation of Herman Hugo's *Pia desideria* [Fig. 17.5].[19] Arwaker's Anglican customization of one of the most influential of

a Seminary of Learning planted by the late Memorable Duke of Ormond, so I have continued it under the benign Influences of his Family, and the House of Beaufort, in Your Grace's Service; and to the Advantages I have received from that, owe All that I pretend to'. See Arwaker Edmund, *Thoughts Well Employ'd; or The Duty of Self-Observation, to Which are Added Pythagora's Golden Verses Made Christian* (London, T. Warren f. F. Saunders: 1697), sig. A3ᵛ. Kilkenny College was the principal school in the country, and its list of *alumni* from the late seventeenth century is remarkable, including in addition to Arwaker, Jonathan Swift, George Berkeley, William Congreve, and George Farquhar. Concerning the school, see Brown J., "Kilkenny College", *Transactions of the Kilkenny Archaeological Society* 1.2 (1850), 221–229.

19 See Dimler G.R., "Edmund Arwaker's Translation of the *Pia Desideria*: The Reception of a Continental Jesuit Emblem Book in Seventeenth-Century England", in Daly P.M. (ed.),

502 MCKEOWN

all Jesuit emblem books enjoyed sustained success, appearing in five editions, four revised by Arwaker between 1686 and 1712, and a fifth published in provincial York in 1727, customized so as to be 'fit for the use of schools'.[20]

The nexus between Mary Butler, Arwaker, Gibbs, Aubin, and Vaenius points to an Irish dimension seldom found in emblem studies. Scholars of early modern iconography have had scant cause to turn their attention in the direction of Ireland since the established bibliographical tools of the discipline – those of Praz, Heckscher and Sherman, Daly and Dimler, Black and Weston, or McGeary and Nashe – collectively fail to record a single instance of an emblem book published on Irish soil.[21] We may speculate on the probability that Francis Quarles began work on his *Emblemes* while resident in Dublin as secretary to James Ussher, Archbishop of Armagh.[22] We may also observe Dublin to have been the birthplace of Patrick Cary (c.1624–1657), son of Lord Falkland and author of emblems preserved in manuscript at Sir Walter Scott's library at Abbotsford.[23] And it has been a labour for scholars engaged in puzzling out the meaning and intentions of the mercurial Laurence Sterne to 'penetrate the moral' of the 'motly emblem of my work' blazoned in Volume III

> *The English Emblem and the Continental Tradition* (New York: 1988) 203–224. Less satisfactory is Raspa A., "Arwaker, Hugo's *Pia desideria* and Protestant Poetics", *Renaissance and Reformation/Renaissance et Reformé*, New Series 24.2 (2000) 63–74, where the author blunderingly refers to Arwaker as 'an English Protestant poet' from 'the then-British Armagh' (63, 66). As emphasized here, Arwaker was Irish, having been probably born in County Kilkenny. Armagh is today a city in Northern Ireland, part of the United Kingdom, and therefore British, at least in the eyes of its Unionist citizens; but in Arwaker's lifetime, Ireland had not entered into political union with Great Britain (which came in 1800 with the Act of Union), so Armagh was an unambiguously Irish city when Arwaker knew it.

20 Arwaker Edmund, *Pia desideria: or Divine Addresses* (London, H. Bonwicke: 1686); Arwaker, *Pia desideria: or, Divine Addresses. The Second Edition, with Alterations and Additions* (London, J.L.f.H. Bonwicke: 1690); Arwaker, *Pia desideria: or, Divine Addresses, in Three Books* (London, H. Bonwicke: 1702); Arwaker, *Pia desideria: or, Divine Addresses. The Fourth Edition, Corrected* (London, R. Bonwicke – J. Bonwicke: 1712); Arwaker, *Divine Entertainments in English and Latin. Selected from the Works of the Learned Hermanius Hugo* (York, T. Gent: 1727), prefatory matter.

21 Praz, M., *Studies in Seventeenth-Century Imagery*; Heckscher, W.S. – Sherman, A.B., *Emblem Books in the Princeton University Library: Short Title Catalogue* (Princeton, NJ: 1984); Daly, P.M. – Dimler, G.R., *Corpus librorum emblematum: The Jesuit Series*, 5 vols. (Montreal: 1997–2007); Black, H.M. – Weston, D., *A Short Title Catalogue of the Emblem Books and Related Works in the Stirling Maxwell Collection of Glasgow University Library* (Aldershot: 1988); McGeary, T. – Nash, N.F., *Emblem Books at the University of Illinois: A Bibliographic Catalogue* (Boston: 1993).

22 Quarles, Francis, *Emblemes* (London, G.M.: 1635). Concerning Quarles's Irish sojourn, see Höltgen, K.J., *Francis Quarles, 1592–1644* (Tübingen: 1978), 50–63.

23 See Cary, P., *The Poems of Patrick Cary*, Delany, V., (ed.) (Oxford: 1978).

of *The Life and Opinions of Tristram Shandy, Gentleman* of 1761.[24] Among these, Brigitte Friant-Kessler has pursued emblematic quarry further than others in eighteenth-century illustrations of the Tipperaryman's work.[25] But such intersections between Ireland and the emblem seem both tenuous and tangential, giving rise to the impression that searching for the trove of *emblemata Hibernica* presents a conundrum as puzzling as Sterne's inky page.[26] We must suppose that such emblem books as were read in Ireland came into readers' hands through the steady stream of printed material imported from Britain and the Continent; but since no attempt has been made to audit the presence of emblem books on the shelves of Ireland's historic libraries, our current outline of the emblematic presence in Ireland is as loosely drawn as the country's maps of the same era. Unlike in other European cultural territories, we do not find the dearth of native printed *emblemata* compensated for by extant applied emblematics in the Irish architectural heritage, sacred or secular. For these reasons, the footprint made by the emblem on Irish literary and cultural history is unusually light.

But the influence of Vaenius's *Emblemata Horatiana* in the built environments of places as widely cast as Brazil or Sweden testifies to its peculiar powers of penetration, and it seems that these forces even applied to Ireland.[27] There survives fragile evidence of an aborted attempt to publish an Irish edition of the *Emblemata Horatiana* in Dublin in 1785. This book – really, a part of a book – bears the letterpress title "The First Number of a Translation from the Italian of the Morals of Horace" printed on its paper wrappers.[28]

24 Sterne, Laurence, *The Life and Opinions of Tristram Shandy, Gentleman*, 9 vols. (London, D. Chamberlaine: 1761) III, chapter 36.

25 Friant-Kessler, B., "Figuring Shandean Tales: *Tristram Shandy* Illustrations and the Rhetoric of Emblems," in McKeown S., (ed.), *The International Emblem from Incunabula to the Internet: Selected Proceedings from the Eighth International Conference of the Society for Emblem Studies, 28th July-1st August, 2008, Winchester College* (Newcastle-upon-Tyne: 2010) 464–482.

26 Sterne, *Life and Opinions of Tristram Shandy* I, chapter 12.

27 For a survey of articles and studies documenting the influence of images from the *Emblemata Horatiana* upon material culture, see McKeown, "Introduction", in *Otto Vaenius and his Emblem Books* xxvi-xxvii.

28 Grattan Elizabeth (trans.). *The First Number of a Translation from the Italian of the Morals of Horace, with Notes from the Principal Greek and Latin Historians and Poets* (Dublin, D. Graisberry: 1785). The work also appears in catalogues, including the English Short Title Catalogue, as *La filosofia maestra della vita umana*, this title being adopted from the emblematic *inscriptio* heading the first page of the first number. Grattan's publication has been noted only in a short descriptive article by Doris O'Keefe published in the newsletter of the Friends of Trinity College Library some thirty years ago. See O'Keefe D., "A Dublin Edition of the 'Emblemata Horatiana'", *Long Room* 36 (1991) 35–40.

504 MCKEOWN

The work consists of ten full-page engravings closely modelled on the originals in Vaenius's book, but with dedications to prominent members of the Irish Ascendancy class. The designation 'number' applies to a printing of two emblem plates with their accompanying texts. On the back cover of the paper binding is a printed list of what are termed the "Conditions" of publishing which sets out the parameters of the undertaking. There we read that the intention has been to issue the book 'in Italian and English in one volume quarto, consisting of thirty numbers and sixty engravings'.[29] Very few copies have survived: printed as loose plates, they were not circulated as a bound book, but as a kind of proof quire towards the advertised larger volume. Of the handful of copies of this quire that have been identified, only that at the British Museum contains the full set of ten plates; the Trinity College, Dublin copy consists of eight plates, and that at the Gilbert Collection, Dublin City Library, of five.[30] Confirmation that the book was never formally or fully published comes from its absence from the ledger of the work's publisher, Daniel Graisberry of Back Lane, which documents his output between 1777 and 1785.[31] Nor is it found in the standard reference work for eighteenth-century Irish books, *A General Catalogue of Books in All Languages, Arts and Sciences, that have been Printed in Ireland and Published in Dublin*.[32]

Not the least of the points of interest surrounding this fragmentary emblem book is that the principal mover behind the enterprise, its author and its translator, was a woman, a certain Elizabeth Grattan. It is to be hoped that future research will unearth more information concerning the person and circumstances of Elizabeth Grattan. Our present state of knowledge is, alas, as fragmentary as her edition of Vaenius, but this much can be noted.[33] She was

29　Grattan (trans.), *First Number of a Translation*, back cover.

30　See British Museum, cat. nos. 1876, 0510, 994–1003; Trinity College Dublin, shelfmark OLS X-1–197; Dublin City Library, Pearse Street, shelfmark Gilbert Library: 14D (18). A librarian's hand of the nineteenth century has added to the letterpress title of the Trinity copy the emendation 'The First Four Numbers [...]'.

31　Graisberry enters his work done on the ten plates but makes no further mention of the project. See Kinane V. – Benson C., "Some Late Eighteenth- and Early Nineteenth-Century Dublin Printers' Account Books: The Graisberry Ledgers", in Isaac P. (ed.), *Six Centuries of the Provincial Book Trade in Britain: Papers Presented at the Eighth Seminar on the British Book Trade, Durham, July 1990* (Winchester: 1990) 139–150. Graisberry's publication of Grattan's book is noted by Mary Pollard: see Pollard M., *A Dictionary of Members of the Dublin Book Trade, 1550–1800* (London: 2000) 249.

32　*A General Catalogue of Books in All Languages, Arts and Sciences, that have been Printed in Ireland and Published in Dublin* (Dublin, George Draper: 1791).

33　The sparse biographical outline here derives from information in Montgomery-Massingbird H., *Burke's Irish Family Records* (London: 1976) 489.

born Elizabeth Warren around the year 1760 to a minor landowning family in County Dublin. In 1784 she married Colley Grattan, a relation of the celebrated politician, Henry Grattan. She lived with her husband at Clayton Lodge, Castle Carbery in County Kildare; both Lodge and Castle were burned down during the 1798 Rebellion. Elizabeth did not live to see these tumultuous events: between 1785 and 1791, she bore five children, but died in the delivery of the last, her son Thomas Colley Grattan.

Just after her marriage in 1784, Elizabeth established a school for twelve young ladies in which she tutored her charges in the learning of French and Italian. Her public notice of this enterprise survives printed inside the verso flyleaf of the paper wrapper, and lays her credentials before the Dublin public:

> Mrs Grattan, at the desire of many persons of fashion, distinguished by their knowledge of polite literature, has opened an academy for twelve young ladies, where they will be instructed in the idiom and grammar of the French and Italian languages. The approbation with which Mrs Grattan's translations from French and Italian authors have been received, is, she flatters herself, the strongest recommendation she can offer for her capability to teach them with fluency and elegance. Hours of attendance from eleven until two. Admittance one guinea a month, and one guinea entrance.[34]

A key strategy in the promotion of Elizabeth Grattan's academy was the publication of her translations of emblems from the *Emblemata Horatiana*, which, we must suppose, were among the translations for which Grattan had enjoyed such approbation. The project, as laid out in the "Conditions" printed on the back cover of the paper wrapper, entailed the publication of a book of sixty emblems in a quarto volume, with the plates to be newly cut by 'the first artists in London, Paris, and Dublin'.[35] Her business model was that subscribers to the work would pay two guineas, one up front to defray costs, and the second upon the delivery of the completed volume. It was possible, however, for subscribers to buy individual plates at a cost of two English shillings (Irish coinage being much debased at this historical point). But Grattan did not tackle the original Latin of Horace's texts; instead, as she writes in the "Advertisement", 'This work was originally compiled by Ottoneo Venio and was many years afterwards translated into Italian by Stefano Mulinari of Florence, and published

34 Grattan (trans.), *First Number of a Translation*, inner cover.
35 See O'Keefe, "A Dublin Edition" 36.

by him'.[36] She refers to the edition published in Florence in 1777 under the title *Q. Horati Flacci emblemata/Emblemi Di Q. Orazio Flacco* by Stefano Mulinari (*c*.1741–*c*.1790), an engraver of old master works who supplied Grand Tourists with images derived from Raphael, Ghirlandaio, Vasari, and others.[37] Most distinctively, Mulinari's edition of Vaenius was printed in a spectrum of coloured inks, making it a visually striking volume, even if the pastel hues of viridian, rose, and turquoise appear at odds with the tough moral tone of the *picturae* [Fig. 17.6]. It is possible that Grattan acquired this Florentine edition of Vaenius in Dublin. The city boasted a bookshop for foreign-language books, the *Cabinet Littéraire*, at College Green that was open from 7am to 11pm and which specialized in French and Italian books and journals.[38] The existence of such a shop testifies to the appetite in late eighteenth-century Dublin for literature from across the continent, an interest and taste that Grattan was evidently hoping to service with her academy.

Elizabeth Grattan's presentation of the emblems of Otto Vaenius amounts to more than a bilingual edition of the author's work, a new attempt upon the work undertaken by Mannington Gibbs decades earlier. Rather, it is a customization of elements of Vaenius's book intended for a specific audience and for a particular purpose. The late-humanist ethical teaching framed in Vaenius's texts and plates is not the true focus of the publication; instead, it is Grattan's tasteful and elegant performances in translation that we are invited to admire, and to see through them the level of refined accomplishment a young lady could aspire to under Grattan's tutelage. We gain a sense of her strategy for the volume by looking at the opening group of emblems in her selection. The first presents Grattan's version of Vaenius's "Vis Institutionis" which, via Mulinari's text "La Forza dell'Educazione", she renders as "The Force of Education" [Fig. 17.7].[39] Vaenius's plate shows servants scouring vessels that have held certain liquids, and noting that their odours linger even after cleaning: in the same way, the moral avers, we see the enduring effect of good and bad influences upon young minds. Among the texts that Grattan offers from the Italian is an anecdote from Plutarch in which 'Alexander the Great being asked, whether

36 Grattan (trans.), "Advertisement", in *First Number of a Translation*.

37 Vaenius Otto, *Q. Horati Flacci emblemata/Emblemi di Q. Orazio Flacco*, ed. Stefano Mulinari (Florence, S. Mulinari: 1777).

38 Kennedy M., "'Politicks, Coffee and News': The Dublin Book Trade in the Eighteenth Century", *Dublin Historical Record* 58.1 (2005) 80.

39 See Vaenius, *Quinti Horati Flacci emblemata* 32–33; Vaenius, *Q. Horati Flacci emblemata*, ed. Mulinari 26; and Grattan (trans.), *The First Number of a Translation from the Italian of the Morals of Horace* 3–4.

VAENIUS IN IRELAND: CUSTOMISATION OF THE *EMBLEMATA HORATIANA* 507

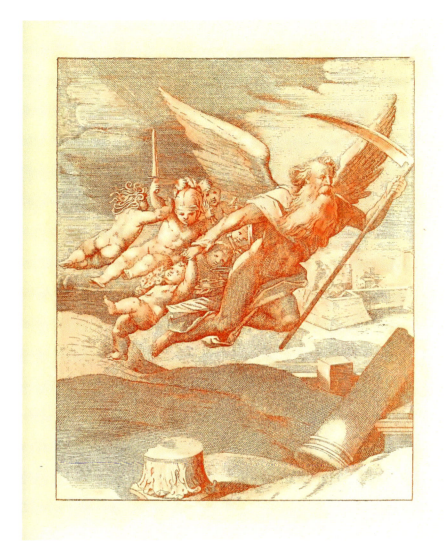

FIGURE 17.6 Stefano Mulinari (engraver) and Otto Vaenius (designer), "Tempora Mutantur, Et Nos Mutamus In Illis." Engraving, 17 × 13.8 cm. From: Otto Vaenius – Stefano Mulinari, *Q. Horati Flacci emblemata/Emblemi Di Q. Orazio Flacco* (Florence, S. Mulinari: 1777)
IMAGE BY KIND PERMISSION OF THE GETTY RESEARCH INSTITUTE, LOS ANGELES

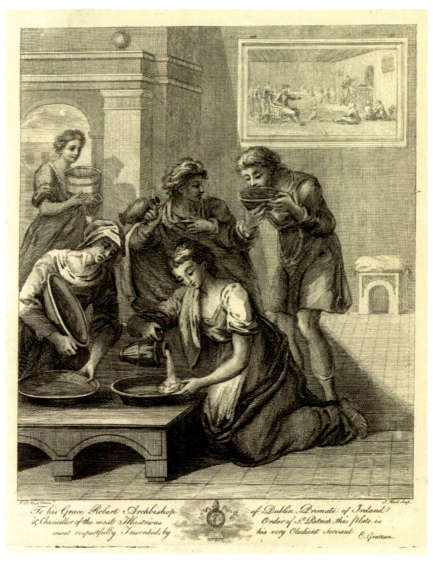

FIGURE 17.7 J. Ford (engraver) and F.R. West, Otto Vaenius, and Stefano Mulinari (designers), "La Forza dell'Educazione." Engraving, 17.7 × 14.8 cm. From: Elizabeth Grattan, *The First Number of a Translation from the Italian of the Morals of Horace, with Notes from the Principal Greek and Latin Historians and Poets* (Dublin, D. Graisberry: 1785)
IMAGE BY KIND PERMISSION OF THE TRUSTEES OF THE BRITISH MUSEUM

he was more pleased at having Philip for his Father, or Aristotle for his Tutor, answered, "I am better pleased at having Aristotle my Tutor, for although Philip gave me being, my Master has given me a good education".[40] This is supported by other texts, including Euripides's saw, 'In general the affections of men are placed in a greater degree on those from whom they have had their education, than on those who gave them being'.[41] Another emblem shows a man leaving behind him the things of childishness by banishing timidity and presenting himself before a group of philosophers [Fig. 17.8].[42] The lessons he will learn will support him in old age, figured by *Tempus*, and the enlightenment Philosophy brings is figured by the sunbeams streaming through the window. The subliminal implication infers that the young ladies who submit themselves to the tuition of Mrs. Grattan can expect to make the step from girlhood to adult understanding. But Grattan was evidently concerned to avoid the suggestion that her academy offered only stern Stoic teaching. In her translation of Mulinari's "Conviene Alternare Il Contegno Grave Con La Piacevolezza" (It is Necessary to Vary Serious Actions with Pleasure), Grattan offers Horace's advice that: 'You may at times introduce, in the most grave and serious conversations, some chearful expression that promotes laughter, for jests are pleasant things if seasonably used, and on proper occasions'.[43] The notion of 'occasion' is supported in the engraving by the allegorical figure of *Occasio* consigning a child dressed in the cap and bells of a fool's motley to the custody of Minerva [Fig. 17.9]. This little jester will bring levity to the lessons taught to the earnest child standing in the doorway of the Temple of Knowledge on the hill behind, just as Mrs. Grattan's wit will leaven and lift the atmosphere of learning in her academy.

We can readily see that Grattan prioritized, at least for these early samples of her proposed work, emblems that emphasized the necessity of elite education. But to add polish to her performance it was important that the visual components of the publication set the right tone of sophistication and elegance, hence her stated ambition to use 'the first artists of London, Paris, and Dublin'. In the event, the engravers of Paris were untroubled by the project, but Grattan

40 Grattan (trans.), *First Number of a Translation* 3: 'Alessandro Magno interrogato se egli gravida di aver per Padre Filippo, piuttosto che Aristotile, rispose: più il Maestro, poichè il Padre fu causa del mio essere, ma il Maestro ha procurato di bene educarmi'.

41 Ibid.: 'Per lo più l'educazione frag li Uomini risveglia maggiore amore, che la procreazione'.

42 See Vaenius, *Quinti Horati Flacci emblemata* 46–47; Vaenius, *Q. Horati Flacci emblemata*, ed. Mulinari 40; and Grattan (trans.), *First Number of a Translation* 1–2.

43 Horace, *Odes* 12, 4; Vaenius, *Quinti Horati Flacci emblemata* 66–67; Vaenius, *Q. Horati Flacci emblemata*, ed. Mulinari 60; and Grattan (trans.), *First Number of a Translation* 9–10.

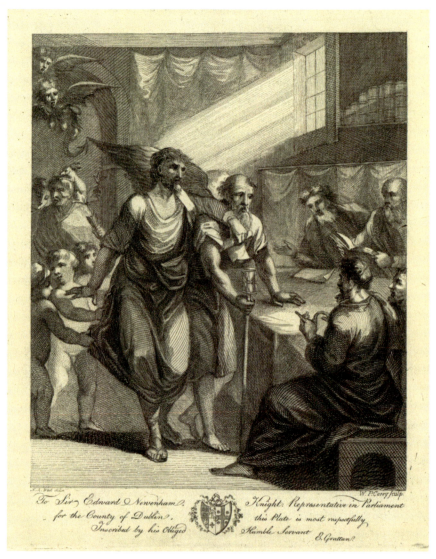

FIGURE 17.8 W.P. Carey (engraver) and F.R. West, Otto Vaenius, and Stefano Mulinari (designers), "La Filosofia Maestra della Vita Umana." Engraving, 18.1 × 14.8 cm. From: Elizabeth Grattan, *The First Number of a Translation from the Italian of the Morals of Horace, with Notes from the Principal Greek and Latin Historians and Poets* (Dublin, D. Graisberry: 1785)
IMAGE BY KIND PERMISSION OF THE TRUSTEES OF THE BRITISH MUSEUM

VAENIUS IN IRELAND: CUSTOMISATION OF THE *EMBLEMATA HORATIANA* 511

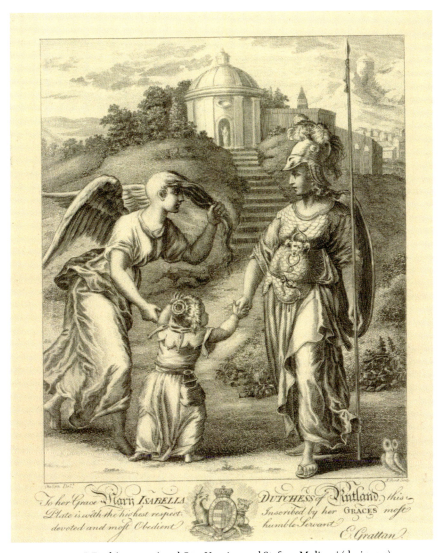

FIGURE 17.9 J. Ford (engraver) and Otto Vaenius, and Stefano Mulinari (designers), "Conviene Alternare Il Contegno Grave Con La Piacevolezza." Engraving, 18.8 × 14.8 cm. From: Elizabeth Grattan, *The First Number of a Translation from the Italian of the Morals of Horace, with Notes from the Principal Greek and Latin Historians and Poets* (Dublin, D. Graisberry: 1785)
IMAGE BY KIND PERMISSION OF THE TRUSTEES OF THE BRITISH MUSEUM

did secure the services of some notable artists and copper engravers. Her principal artist, responsible for preparing drawings for seven of the plates was Francis Robert West, son to Robert West, Principal of Dublin's Drawing School which had opened in 1740.[44] One intriguing notice of West's artistic interactions with Elizabeth Grattan's husband was recorded in a memoir of 1836 by the engraver J.D. Herbert. In it, he remembers being sent away from West's door because West had 'forty drawings to do for Colley Grattan'.[45] Might these have been sketches for the Dublin edition of Vaenius? Three of West's drawings were converted to copperplates by William Paulet Carey, a Dublin-born artist who gave up practice in 1793 to become an art critic in London, and as such, was the first to champion both Francis Chantrey and William Blake.[46] What is noticeable is that Carey's plates consistently reverse the images in Vaenius and Mulinari. In the case of the work of another engraver, James Ford, a former pupil of West's in the Drawing School, we find that five of his plates retain the orientation found in Vaenius, but another two are reversed. Three of the plates are not assigned to West, but to Vaenius and Mulinari, suggesting that Ford worked directly from images in the Italian edition of Vaenius's book. The quality of engraving is high across the series of plates and shows fidelity to the original compositions, although we may discern small adjustments to style that reflect the gulf in taste between Flemish graphic art from the early 1600s and work produced in the age of Reynolds and Gainsborough. These tweaks are never substantial: one such can be seen in the delineation of the head of the servant entering the room in "The Force of Education". Her physiognomy belongs not to Vaenius's aesthetic, but to that of Romney or Reynolds, or, more particularly, to that of Angelica Kauffmann.

A strong sense of Grattan's intended readership for her volume is provided by the list of subscribers appended to the volume. It is dominated by the names of the leading members of the Irish nobility, Irish Protestant churchmen, Irish politicians of all stamps from unionist to nationalist, and figures prominent on the Dublin literary scene. One emblem, "Nature Moderates All Things", is dedicated to Elizabeth Hastings, Countess of Moira, an advocate of female

44 An anonymous contributor to the *Monthly Pantheon* of April 1809 described how West became an artist 'owing more to the indefatigable exertions of his father, who grounded him in the rudiments of his art by dint of severity, than to any felicity of genius with which he was favoured by nature': see Strickland W.G., *A Dictionary of Irish Artists* (London: 1913) 516.

45 Herbert J.D., *Irish Varieties for the Last Fifty Years, written from Recollections* (London: 1836) 253.

46 "Carey, William Paulet", in *Dictionary of National Biography, Vol. 9* (London: 1885–1900) 78–79.

education and women's engagement in the public conversation [Fig. 17.10].[47] Other vocal supporters of education were Charles Manners, Duke of Rutland, and Mary Isabella, his duchess, dedicatees respectively of Grattan's emblems "Who is Rich? He Who Covets Nothing" and "Power is Subject to Greater Power" [Figs. 17.11–17.12].[48] Another figure of interest is Sir Edward Newenham, Member of Parliament for the County of Dublin, and recipient of "The Force of Education". He was a politically progressive and liberal figure, as understood from his friendly correspondence with George Washington and Benjamin Franklin. These were relationships in which he took much pride, as evidenced by the pavilion Newenham built in his garden at Belcamp Hall to enshrine busts of the American statesmen.[49] While his relationship with Washington was necessarily epistolary, his contact with Franklin was direct and in person, with the two men meeting in Paris in 1783 and striking up a friendship: it had been on this occasion that Franklin had presented Newenham with his portrait bust.[50] It was through this connection that Elizabeth Grattan was emboldened to approach Benjamin Franklin herself. Remarkably, among the correspondence of the great man is an unpublished letter from Grattan dated 8th June 1784, in which she asks Franklin to become patron of her emblem book. Written in French, she assures Franklin that:

> the people of this country regard you with admiration and matchless esteem, but none more so than Sir Edward Newenham, the true Patriot and Supporter of Liberty; It is upon his wishes that I do myself the honour to send you the example of a Work that has received the approbation of the leading *Literati* here. I have taken the liberty of praying for your protection as the highest honour that can crown my labours.[51]

47 Vaenius, *Quinti Horati Flacci emblemata* 42–43; Vaenius, *Q. Horati Flacci emblemata*, ed. Mulinari 36; and Grattan (trans.), *First Number of a Translation* 19–20. Concerning the cultural interests of Elizabeth Hastings, see Meaney G. – O'Dowd M. – Whelan B., "The Enlightenment and Reading, 1714–1820", in *Reading the Irish Woman: Studies in Cultural Encounters and Exchange, 1714–1960* (Liverpool: 2013) 25. Elizabeth Hastings was a correspondent of Sir Walter Scott's and a close friend of the novelist, Maria Edgeworth. Among her many contributions to Irish intellectual life was her archaeological report on a bog body published in the 1780s, the first such description to appear anywhere.

48 Vaenius, *Quinti Horati Flacci emblemata* 80–81, 78–79; Vaenius, *Q. Horati Flacci emblemata*, ed. Mulinari 74, 72; and Grattan (trans.), *First Number of a Translation* 17–18, 11–12.

49 See Coyle E.A., "Sir Edward Newenham: The Eighteenth-Century Dublin Radical", *Dublin Historical Record* 46.1 (1993) 20–21.

50 The bust was one of several terracotta casts taken from a portrait bust sculpted by Jean-Jacques Caffiéri. See Ehrlich P., "The Royal Academy of Sciences' Bust of Benjamin Franklin", *Antiques and Fine Art Magazine* 15.2 (2016) 144–153.

51 See Franklin B., *The Papers of Benjamin Franklin: March 1 through August 15, 1784, Vol. 42*, ed. E.R. Cohn (New Haven: 2017) 313–314: 'Monsieur, L'opinion que le Monde entretien si

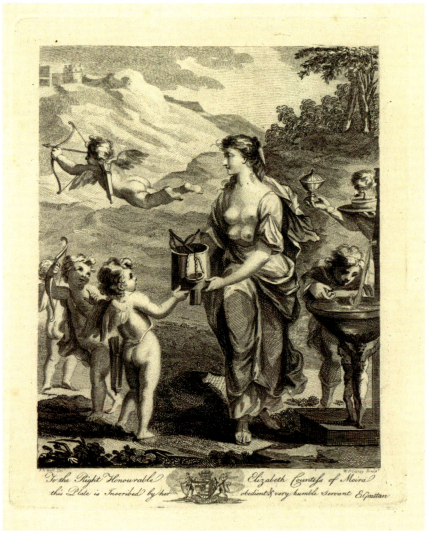

FIGURE 17.10 J. Ford (engraver) and F.R. West, Otto Vaenius, and Stefano Mulinari (designers), "La Natura Ottima Moderatrice." Engraving, 18.1 × 14.9 cm. From: Elizabeth Grattan, *The First Number of a Translation from the Italian of the Morals of Horace, with Notes from the Principal Greek and Latin Historians and Poets* (Dublin, D. Graisberry: 1785)
IMAGE BY KIND PERMISSION OF THE TRUSTEES OF THE BRITISH MUSEUM

VAENIUS IN IRELAND: CUSTOMISATION OF THE *EMBLEMATA HORATIANA* 515

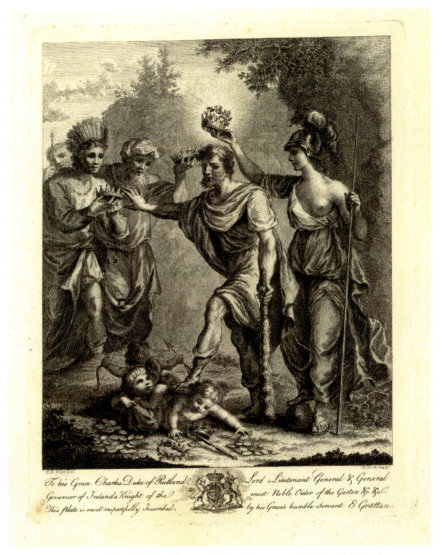

FIGURE 17.11 J. Ford (engraver) and F.R. West, Otto Vaenius, and Stefano Mulinari (designers), "Chi E Ricco? Chi Nulla Desidera." Engraving, 18 × 14 cm. From: Elizabeth Grattan, *The First Number of a Translation from the Italian of the Morals of Horace, with Notes from the Principal Greek and Latin Historians and Poets* (Dublin, D. Graisberry: 1785)
IMAGE BY KIND PERMISSION OF THE TRUSTEES OF THE BRITISH MUSEUM

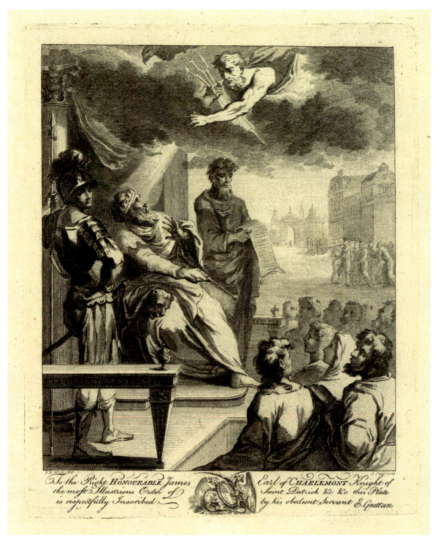

FIGURE 17.12 J. Ford (engraver) and F.R. West, Otto Vaenius, and Stefano Mulinari (designers), "La Potesta Soggetta Ad Altra Maggior Potesta." Engraving, 18 × 14.7 cm. From: Elizabeth Grattan, *The First Number of a Translation from the Italian of the Morals of Horace, with Notes from the Principal Greek and Latin Historians and Poets* (Dublin, D. Graisberry: 1785)
IMAGE BY KIND PERMISSION OF THE TRUSTEES OF THE BRITISH MUSEUM

VAENIUS IN IRELAND: CUSTOMISATION OF THE *EMBLEMATA HORATIANA* 517

Perhaps Grattan was encouraged to ask for Franklin's patronage knowing of his enthusiasm for emblems, notably his design of the "Join or Die!" serpent device, or of his fondness for Joachim Camerarius's *Emblemata*.[52] Whatever her hopes, they were to be disappointed: her petition seemingly went unanswered.

So, why did Elizabeth Grattan's more than competent work, customized from the *Emblemata Horatiana*, fail to make it to completion? Her textual work was irreproachable, the content grave, and the quality of the graphic work strong. As ever with emblem books, we must consider the economic disadvantages of this kind of publication. It is interesting to observe that even with the good will and down payments of over eighty subscribers – Franklin not among them – the book stalled. But other, more prosaic reasons explain why Grattan failed to deliver a fully realized Irish emblem book. The first was the death in December 1785 of her printer, Daniel Graisberry.[53] The second was the pressure of motherhood. It is likely that Elizabeth Grattan was already pregnant when her quire of ten emblems was ready for her inspection, and a further four children followed in the years between 1786 and 1791. It is melancholy to reflect that her youngest child, Thomas Colley Grattan, was never to know his mother who died as a result of his birth. He went on to be a notable man of letters, as well as a diplomat and raconteur.[54] For a decade in his middle years, he lived in the Low Countries, and became an authority in the British press on the newly established kingdom of Belgium. Among his other writings, he published a successful *History of the Netherlands* in 1830 that dealt not only with the political and confessional history of Flanders and Holland, but its artistic heritage, too. In his survey of the artists of the region, he singled out one

justement des vos talens comme Consellier d'Etat, et de votre Sapience comme un Ecolier, et si generalement connu qu'il ne'st point necessaire que je le repete.Les gens de ce païs vous regarde avec un admiration et un estime que rien ne peut egaler, mais personne plus que Sir Edward Newenham, le vrai Patriote et Soutien de la Liberte; ce'st à son desir que je me fais l'honneur de vous envoyer l'exemple d'un Oeuvrë qui à reçu l'approbation des premiers personnes du Literati ici. J'ai pris la libertè de prier votre protection comme le plus grand honneur qui puisse couronner mes travaux. J'ai l'honneur d'etre Monsieur avec le plus grand respect le très humble, et très obeissante Servante de votre Excellence, Elizabeth Grattan, Camden Street 37'. Concerning Franklin's affection for Camerarius's emblems, see Smith P.J., "Joachim Camerarius's Emblem Book on Birds (1596), with an Excursus on America's Great Seal," in Enenkel K.A.E. – Smith (eds.), *Emblems and the Natural World* (Leiden – Boston: 2017) 178–179.

52 Concerning the serpent device, see Cook K.S., "Benjamin Franklin and the Snake That Would Not Die", *The British Library Journal* 22 (1996) 88–111.

53 Mary Pollard notes that Graisberry died a few hours after the death of his mother. Pollard, *Dictionary of Members of the Dublin Book Trade* 249.

54 "Grattan, Thomas Colley", in *Dictionary of National Biography, Vol.* 22 (London: 1885–1900) 425–426.

name for special mention: 'Otto Venire, the master of Rubens [who] held most important employments'.[55] Perhaps Vaenius's name carried particular resonance for Grattan as a reminder of his mother, a woman whom he had never known, but who had bequeathed to him his literary inclinations and talents.

Bibliography

Anon. [Curll E.], *A Short Memorial and Character of that Most Noble and Illustrious Princess Mary Dutchess of Ormonde*. Np [London]. npub [E. Curll]: nd [1733–1735?].

Arwaker E., *Pia desideria: or Divine Addresses* [...] (London, H. Bonwicke: 1686).

Arwaker E., *Pia desideria: or, Divine Addresses* [...] *The Second Edition, with Alterations and Additions* (London, J.L.f.H. Bonwicke: 1690).

Arwaker E., *Pia desideria: or, Divine Addresses ... The Third Edition, Corrected.* (London, H. Bonwicke: 1702).

Arwaker E., *Pia desideria: or, Divine Addresses ... The Fourth Edition, Corrected* (London, R. Bonwicke – J. Bonwicke: 1712).

Arwaker E., *Divine Entertainments: in English and Latin. Selected from the Works of the Learned Hermanius Hugo; and translated by the Rev. Mr Edmund Arwaker, M.A.* (York, T. Gent: 1727).

Arwaker E., *Thoughts Well-Employ'd, or The Duty of Self-Observation: To which are Added Pythagoras's Golden Verses made Christian* (London, T. Warren f. F. Saunders: 1697).

Barnard T. – Fenlon J. (eds.), *The Dukes of Ormonde, 1610–1745* (Woodbridge: 2000).

Bässler A., *Die Umkehrung der Ekphrasis. Zur Ehtstehung von Alciatos* "Emblematum liber" *(1531)* (Würzburg: 2012).

Black H.M. – Weston D., *A Short Title Catalogue of the Emblem Books and Related Works in the Stirling Maxwell Collection of Glasgow University Library* (Aldershot: 1988).

Boot P., "A Mirror to the Eyes of the Mind. Metaphor in Otto van Veen's *Amoris divini Emblemata* (Antwerp, 1615)," in *Emblemata sacra: The Rhetoric and Hermeneutics of Illustrated Sacred Discourse*, Dekoninck R. – Guiderdoné-Bruslé A., (eds.) (Turnhout: 2007), 291–304.

Boot P., "Playing and Displaying Love. Theatricality in Otto van Veen's *Amoris divini emblemata* (Antwerp, 1615)," *Emblematica: An Interdisciplinary Journal for Emblem Studies* 16 (2008), 339–364.

Boot P., "Similar or Dissimilar Loves: *Amoris divini emblemata* and its Relation to *Amorum emblemata*," in *Otto Vaenius and his Emblem Books*, McKeown, S., (ed.) (Glasgow: 2012), 157–173.

55 Grattan T.C., *The History of the Netherlands*, 2nd ed. (Philadelphia: 1835) 227.

Briant-Kessler B., "Figuring Shandean Tales: Tristram Shandy Illustrations and the Rhetoric of Emblems," in *The International Emblem: From Incunabula to the Internet. Selected Proceedings of the Eighth International Conference of the Society for Emblem Studies, 28th July–1st August, 2008, Winchester College.* McKeown, S., (ed.) (Newcastle upon Tyne: 2010), 464–482.

Browne J., "Kilkenny College," *Transactions of the Kilkenny Archaeological Society* 1.2 (1850), 221–229.

Buschhoff A., *Die Liebesemblematik des Otto van Veen. Die* Amorum emblemata (*1608*) *und die* Amoris divini emblemata (*1615*) (Bremen: 2004).

Buschhoff A., "Zur gedancklichen Struktur der *Amoris divini emblemata* des Otto van Veen (Antwerpen, 1615)," in *The Emblem Tradition and the Low Countries: Selected Papers of the Leuven International Emblem Conference, 18th–23rd August 1996*, Manning J. – Porteman K. – Van Vaeck M. (eds.) (Turnhout: 1999), 39–76.

Cary P., *The Poems of Patrick Cary*. Delany, V. (ed.) (Oxford: 1978).

Catellani A., "Emblematic and Graphic Processes in Vaenius's *Physicae et theologicae conclusiones* (1621): Semiotic Observations," in *Otto Vaenius and his Emblem Books*, McKeown, S., (ed.) (Glasgow: 2012), 197–210.

Cook K.S., "Benjamin Franklin and the Snake That Would Not Die," *British Library Journal* 22 (1996), 88–111.

Coyle E.A., "Sir Edward Newenham: The Eighteenth-Century Dublin Radical," *Dublin Historical Record* 46.1 (1993), 20–21.

Cummings R., "Alciato's *Emblemata* as an Imaginary Museum," *Emblematica: An Interdisciplinary Journal for Emblem Studies* 10 (1996), 245–281.

Daly P.M. (ed.), *Companion to Emblem Studies* (New York: 2008).

Daly P.M. – Dimler G.R., *Corpus librorum emblematum: The Jesuit Series*, 5 vols. (Montreal: 1997–2007).

Dekoninck R. – Guiderdoni A., "Reasoning Pictures: Vaenius's *Physicae et theologicae conclusiones* (1621)," in *Otto Vaenius and his Emblem Books*, McKeown, S., (ed.) (Glasgow: 2012), 175–196.

Dimler G.R., "Edmund Arwaker's Translation of the *Pia Desideria*: The Reception of a Continental Jesuit Emblem Book in Seventeenth-Century England," in *The English Emblem and the Continental Tradition*. Daly, P.M., (ed.) (New York: 1988), 203–224.

Ehrlich P., "The Royal Academy of Sciences' Bust of Benjamin Franklin," *Antiques and Fine Art Magazine* 15.2 (2016), 144–153.

Enenkel K.A.E., *The Invention of the Emblem Book and the Transmission of Knowledge, ca. 1510–1610*. Brill's Studies in Intellectual History 295/Brill's Studies in Art, Art History, and Intellectual History 36 (Leiden – Boston: 2019).

Forster L., "Die *Emblemata Horatiana* des Otho Vaenius," *Wolfenbütteler Forschungen* 12 (1981), 117–128.

A General Catalogue of Books in All Languages, Arts and Sciences, that have been Printed in Ireland, and Published in Dublin: from the year 1700 to the Present Time (Dublin, G. Draper: 1791).

Gerards-Nelissen I., "Otto van Veen's *Emblemata Horatiana*," *Simiolus* 5 (1971), 20–63.

Grattan E., *The First Number of a Translation from the Italian of the Morals of Horace, with Notes from the Principal Greek and Latin Historians and Poets* (Dublin, D. Graisberry: 1785).

Grattan T.C., *The History of the Netherlands*, 2nd ed. (Philadelphia: 1835).

Haberditzl F.M., "Die Lehrer des P.P. Rubens," *Jahrbuch der Kunsthistorischen Sammlungen des Allerhöchsten Kaiserhauses* 27 (1908), 192–235.

Hayton D.W., *The Anglo-Irish Experience, 1680–1730: Religion, Identity, and Patriotism* (Woodbridge: 2012).

Heckscher W.S. – Sherman A.B., *Emblem Books in the Princeton University Library: Short Title Catalogue* (Princeton: 1984).

Herbert J.D., *Irish Varieties for the Last Fifty Years, written from Recollections* (London: 1836).

Hofstede J.M., *Otto van Veen, der Lehrer des P.P. Rubens*, diss. Albert-Ludwigs-Universität (Freiburg: 1959).

Hofstede J.M., "Zum Werke des Otto van Veen 1590–1600," *Bulletin Koninklijk Musea voor Schone Kunsten* 6 (1957), 127–174.

Höltgen K.J., *Francis Quarles, 1592–1644* (Tübingen: 1978).

Kennedy M., "'Politicks, Coffee and News': The Dublin Book Trade in the Eighteenth Century," *Dublin Historical Record* 58.1 (2005), 76–85.

Kinane V. – Benson C., "Some Late Eighteenth- and Early Nineteenth-Century Dublin Printers' Account Books: The Graisberry Ledgers," in *Six Centuries of the Provincial Book Trade in Britain: Papers Presented at the Eighth Seminar on the British Book Trade, Durham, July 1990*, Isaac, P. (ed.) (Winchester: 1990), 139–150.

Landwehr J., *Emblem Books in the Low Countries, 1554–1949: A Bibliography* (Utrecht, 1970).

Le Roy M., *La doctrine des moeurs* (Paris: P. Daret – L. Sevestre: 1646).

Le Roy M., *The Doctrine of Morality, or a View of Human Life, According to the Stoick Philosophy*. T.M. Gibbs (trans.) (London, J. Darby – A. Bettesworth – F. Fayram – J. Pemberton – J. Hooke – C. Rivington – F. Clay – J. Batley – E. Symon: 1721).

Le Roy M., *Moral Virtue Delineated*. T.M. Gibbs (trans.) (London, J. Darby – A. Bettesworth – F. Fayram – J. Pemberton – J. Hooke – C. Rivington – F. Clay – J. Batley – E. Symon: 1726).

Leslie J.B., *Armagh Clergy and Parishes: Being an Account of the Clergy of the Church of Ireland in the Diocese of Armagh, from the Earliest Period, with Historical Notes of the Several Parishes, Churches, etc.* (Dundalk: 1911).

McGeary T. – Nash N.F., *Emblem Books at the University of Illinois: A Bibliographic Catalogue* (Boston: 1993).

McGrath E., "Taking Horace at his Word: Two Abandoned Designs for Otto van Veen's *Emblemata Horatiana*," *Wallrof-Richartz Jahrbuch* 55 (1994), 115–126.

McKeown S. (ed.), *Otto Vaenius and his Emblem Books* (Glasgow: 2012).

McKeown S., "An Unknown English Translation of Otto Vaenius's *Historia septem infantium de Lara* (British Library, 551.e.9): A Transcription and Introductory Note," in *Otto Vaenius and his Emblem Books*, McKeown S. (ed.) (Glasgow: 2012), 107–156.

Manning J., *The Emblem* (London: 2002).

Mayer R., "*Vivere secundum Horatium*: Otto Vaenius' *Emblemata Horatiana*," in *Perceptions of Horace: A Roman Poet and his Readers*. Houghton L.B.T. – Wyke M. (eds.) (Cambridge: 2009), 200–218.

Meaney G. – O'Dowd M. – Whelan B., *Reading the Irish Woman: Studies in Cultural Encounters and Exchange, 1714–1960*. Reappraisals in Irish History 2 (Liverpool: 2013).

Melion W.S., "Venus/Venius: on the Artistic Identity of Otto van Veen and his Doctrine of the Image," in McKeown, S., (ed.), *Otto Vaenius and his Emblem Books* (Glasgow: 2012), 1–53.

Montgomery-Massingbird H., *Burke's Irish Family Records* (London: 1976).

Montone T., "Cupid in the *Ourobouros*, the Disconsolate Alembic and other Matters: The *Amorum emblemata* (1608) from a New Perspective," in *Otto Vaenius and his Emblem Books*, McKeown S. (ed.) (Glasgow: 2012), 55–72.

O'Donoghue D.J., *The Poets of Ireland: A Biographical and Bibliographical Dictionary of Irish Writers of English Verse* (Dublin – London: 1912).

Ohlmeyer J. – Zwicker S., "John Dryden, the House of Ormond, and the Politics of Anglo-Irish Patronage," *The Historical Journal* 49.3 (2006), 677–706.

O'Keefe D., "A Dublin Edition of the 'Emblemata Horatiana,'" *Long Room* 36 (1991), 35–40.

Pollard M., *A Dictionary of Members of the Dublin Book Trade, 1550–1800* (London: 2000).

Pope A., *A Critical Edition of the Major Works*, Rogers P. (ed.) (Oxford: 1993).

Praz M., *Studies in Seventeenth-Century Imagery*, 2nd ed. (Rome: 1964).

Prescott S., "Penelope Aubin and the Doctrine of Morality: A Reassessment of the Pious Woman Novelist," *Women's Writing* 1.1 (1994), 99–112.

Quarles F., *Emblemes* (London, G.M.: 1635).

Raspa A., "Arwaker, Hugo's *Pia Desideria* and Protestant Poetics," *Renaissance and Reformation/Renaissance et Réforme* New Series 24.2 (2000), 63–74.

Sabbe M., "Les *Emblemata Horatiana* d'Otto Venius," *De Gulden Passer* 13 (1935), 1–14.

Smith P.J., "Joachim Camerarius's Emblem Book on Birds (1596), with an Excursus on America's Great Seal," in *Emblems and the Natural World*. Enenkel K.A.E. – Smith P.J. (eds.). (Leiden – Boston: 2017), 149–183.

Sterne L., *The Life and Opinions of Tristram Shandy, Gentleman. Volume I* (London, D. Chamberlaine: 1760).

Sterne L., *The Life and Opinions of Tristram Shandy, Gentleman. Volume III* (London, D. Chamberlaine: 1761).

Strickland W.G., *A Dictionary of Irish Artists*. (London: 1913).

Teyssandier B., "Les Métamorphoses de la Stoa: De la Galerie comme Architecture au Livre-Galerie," *Études Littéraires* 34.1–2 (2002), 1–34.

Thøfner M., "'Let Your Desire Be to See God': Teresian Mysticism and Otto van Veen's *Amoris divini emblemata,*" *Emblematica: An Interdisciplinary Journal for Emblem Studies* 12 (2002), 83–103.

Thøfner M., "Making a Chimera: Invention, Collaboration and the Production of Otto Vaenius's *Emblemata Horatiana,*" in *Emblems of the Low Countries: A Book Historical Perspective*, Adams A. – Van der Weij M. (eds.) (Glasgow: 2003), 17–44.

Vaenius O., *Amoris divini emblemata*. (Antwerp, M. Nutii – J. Meurii: 1615).

Vaenius O., *Amorum emblemata*. (Antwerp, H. Swingenii: 1608).

Vaenius O., *Amorum emblemata (1608)*. Intro. K. Porteman. (Aldershot: 1996).

Vaenius O., *Historia septem infantium de Lara*. (Antwerp, P. Lisaert, 1612).

Vaenius O., *Qvinti Horati Flacci emblemata*. (Antwerp: O. Vaenius – H. Verdussen, 1607).

Vaenius O., *Q. Horati Flacci emblemata imaginibus in aes incises notisque illustrate studio Othoni Vaeni Batavolugdunensis. ...* (Florence, S. Mulinari: 1777).

Vaenius O., *Vita D. Thomae Aquinatis* (Antwerp, O. Vaenius: 1610).

Vassilieva-Codognet O., "Coining Neo-Stoic Hieroglyphs: From Brussels Mint to *Emblemata sive symbola,*" in *Otto Vaenius and his Emblem Books*, McKeown, S., (ed.) (Glasgow: 2012), 211–248.

Welham D., "Penelope Aubin, Short Biography" (Chawton: 2011).

Welham D., "The Particular Case of Penelope Aubin," *Journal for Eighteenth-Century Studies* 31.1 (2008), 63–76.

Wilson H.B., *The History of Merchant-Taylors School, from its Foundation to the Present Time*, 2 vols. (London: 1812).

PART 6

Visual Customisation

∵

CHAPTER 18

Frames, Screens and Urns: Customisation and Poetics in the 1495 Aldine *Theocritus* painted by Albrecht Dürer for Willibald Pirckheimer

Jakub Koguciuk

In 1495, Aldus Manutius published a volume of poetry in ancient Greek, containing the collected *Idylls* by Theocritus (ca. 300–after 260 BC), the original poems of the pastoral tradition.[1] The book was both a philological and a technological innovation. For the first time the *Idylls* were rendered as a complete collection in the original language, using movable type.[2] Due to his extensive network of philological experts, Aldus Manutius managed to obtain an edited version of the text to produce this volume. The same scholars likely influenced the visual appearance of the book, since their handwriting provided inspiration for the printed characters, mediating the transition from script to type.[3]

A copy of this edition, previously owned by the German humanist Willibald Pirckheimer, contains an image painted by Albrecht Dürer. Currently in the National Gallery of Art in Washington, D.C., the picture is not only unique in the corpus of Dürer's work as a fully developed painted landscape embedded a printed book, but also one-of-a-kind as the only illustration accompanying any copy the *Idylls* in the period.[4] The image engages in the pastoral mode of the

1 The colophon dates the printing to February 1495, which would be 1496 by modern reckoning, as the Venetian new year started on March 1st. See: *Incunabula Short Title Catalogue*, No. it00144000. *Gesamtkatalog der Wiegendrucke*, M45831.

2 An earlier edition, containing *Idylls* 1–18, was published in Milan by Bonus Accursius around 15 years earlier. For a list of manuscripts of the *Idylls* before printed circulation, see Gow A.S.F., *Theocritus, Edited with a Translation and Commentary* (Cambridge: 1952) xxxvi–xlviii. For the history of the early modern transmission of the poems, see als: Corfiati C., "Il fantasma di Teocrito", *Cahiers de recherches médiévales et humanistes*, 25 (2013) 295–326.; and Hubbard T., "'Simple Theocritus' from the 16th to the 18th Centuries", in Kyriakou P. – Sistakou E. – Rengakos A. (eds.), *Brill's Companion to Theocritus* (Leiden: 2021) 769–770.

3 Wilson N.G., *From Byzantium to Italy: Greek Studies in the Italian Renaissance* (London: 2017) 144–177; and Barker N., *Aldus Manutius and the Development of Greek Script and Type in the Fifteenth Century* (New York: 1992).

4 On the picture, see Ferrari S., *'Una luce per natura' – studi su Giorgione* (Padua: 2016) 20–22.; Bach F., "Albrecht Dürer: Figures of the Marginal", RES: *Anthropology and Aesthetics* 36 (1999) 79–99; Grasselli M. (ed.), *The Touch of the Artist: Master Drawings from the Woodner Collections*, exh. cat., National Gallery of Art (Washington, D.C.: 1995) 114.; Dumas A. – Stevens M.A.

© KONINKLIJKE BRILL NV, LEIDEN, 2024 | DOI:10.1163/9789004680562_019

text and turns the volume into a customised book. Dürer designed his image of two pastoral musicians in a landscape to activate the poetics of Theocritus.

1 Albrecht Dürer's Painting as Frame and Screen

The painting consists of two figures standing on each of the side margins on the first page [Fig. 18.1]. The one on the left is sitting under a tree, playing a viola, and the one on the right is playing a set of pipes. They are united in the lower section of the page by a landscape of remarkable variety. A number of animals – sheep, goat and a dog – populate a wooded valley surrounding a spring.

Before the Aldine edition, the *Idylls* by Theocritus circulated in Western Europe in a Latin translation, in relatively few manuscripts and partial printed editions, none of which was illustrated. The iconography of Dürer's picture, as much as it has a precedent, likely relates to images accompanying the text of the Latin follower of Theocritus: Virgil's *Eclogues*. In many editions of the *Eclogues*, in both manuscript and print, the opening folio contains a depiction of Tityrus and Meliboeus engaging in dialogue, as in the first poem of the Latin sequence.[5] Such figures were often re-purposed and re-identified in the visual tradition of the pastoral. Virgil followed the first *Idyll* specifically by opening his *Eclogues* with a dialogue. Dürer then used the visual tradition associated with Virgil, reaching back to the originary moment of pastoral in Theocritus and making that text relevant to contemporary concerns.

The essential iconography of the painting relates to the ownership of the book [Fig. 18.2]. The two coats-of-arms at either side represent the families of Pirckheimer, on the left, and his wife Crescentia Reiter, on the right.[6] However, the figures themselves likely stand for Pirckheimer and Albrecht Dürer himself. There are some essential similarities between the faces and the known

(eds.), *Woodner Collection: Master Drawings* (New York: 1990) 106 no. 58; Strauss W., *The Complete Drawings of Albrecht Dürer* (New York: 1974), Supplement 2, no. 1502/26. For the context within Pirckheimer's library, see Rosenthal E., "Dürers Buchmalereien für Pirckheimers Bibliothek", *Jahrbuch der Preuszischen Kunstsammlungen* 49 (1928) 1–54; and Rosenthal E.,"Dürers Buchmalereien für Pirckheimers Bibliothek: Ein Nachtrag", *Jahrbuch der Preuszischen Kunstsammlungen* 51 (1930) 175–178.

5 For an overview of the iconography of the Eclogues, see Guest E., *The Illustration of Virgil's 'Bucolics' and its Influence on Italian Renaissance Art* (Ph.D. dissertation, Rutgers, State University of New Jersey: 2005).

6 Merkl U., *Buchmalerei in Bayern in der erste Hälfte des 16. Jahrhunderts: Spätblüte und Endzeit einer Gattung* (Regensburg: 1999) 376.

CUSTOMISATION AND POETICS IN THE 1495 ALDINE *THEOCRITUS* 527

portraits of the two.[7] This replacement of the wife's image with that of a close friend speaks to the close relationship between the artist and the owner of the book.[8] Surviving letters and visual evidence suggest that Pirckheimer and Dürer had a close friendship. In related pastoral images and portraits of Pirckheimer, Dürer frankly alludes to erotic content, in the candid manner of a friend addressing a friend.[9] Dürer's Theocritan picture testifies to the complex close and creative relationship between the two friends.

The book belonged to a group of volumes in Pirckheimer's library decorated by Dürer. These illuminations, taken as a set, have been studied in the context of Pirckheimer's humanism and of his friendly ties with the artist.[10] In other volumes, the illuminations consist of isolated decorative motifs and depictions of coats-of-arms. None features a landscape. Dürer's customisation of Pirckheimer's copy of the *Idylls* stands apart, not only because it is more elaborate than any other such intervention but also due to the dialogue developed between the image and the text – a previously unaddressed aspect in studies of this object.

Pirckheimer may have acquired the book in Italy. He studied in Padua and Pavia between 1488 and 1495.[11] Among students who could afford them, Aldine editions of the classics were in vogue as they distributed ancient Latin and Greek works to a wider audience in print. Dürer's journeys to Italy, so pivotal for his development as a painter and his reputation as a famous artist, took place during the same years: the first likely in the 1490s and the second in the

7 For an overview of the known portraits of Pirckheimer in relation to the figure on the left, see Koguciuk J., *Pastoral and the Book: Jacopo Sannazaro and the Visual Arts in Renaissance Veneto, ca. 1460–1530* (Ph.D. dissertation, Yale University: 2019) 65–70.

8 A full discussion of the relationship between Dürer and Pirckheimer falls outside the scope of this paper. For a recent overview, see Schleif C., "11. Albrecht Dürer between Agnes Frey and Willibald Pirckheimer", in: Silver L. – Smith J.C. (eds.), *The Essential Dürer* (Philadelphia: 2011) 185–205.

9 On portraits of Pirckheimer combining pastoral themes and sexual content, see Ashcroft J. (ed.), *Albrecht Dürer: Documentary Biography: Dürer's Personal and Aesthetic Writings, Words on Pictures, Family, Legal and Business Documents, the Artist in the Writings of Contemporaries* (New Haven: 2017) 113; and Strauss, *Complete Drawings of Albrecht Dürer*, III 1371 no. 1513/24.

10 See Georgi K. – Eser T. – Grebe A. – Grossmann G. – Sauer C. (eds.), *Heilige und Hasen: Bücherschätze der Dürerzeit*, exh. cat., Germanisches Nationalmuseum (Nuremberg: 2008) 80–6; Mende M., "Dürer und der Meister der Celtis-Illustrationen. Paragone um 1500 in Nürnberg", in: Wiener C., (ed.), *Amor als Topograph. 500 Jahre Amores des Conrad Celtis. Ein Manifest des deutschen Humanismus* (Schweinfurt: 2002) 34–35; and Merkl, *Buchmalerei in Bayern in der erste Hälfte des 16. Jahrhunderts* 375–6.

11 On this period in Pirckheimer's life, see Holzberg N., *Willibald Pirckheimer: Griechischer Humanismus in Deutschland* (Munich: 1981) 41–49.

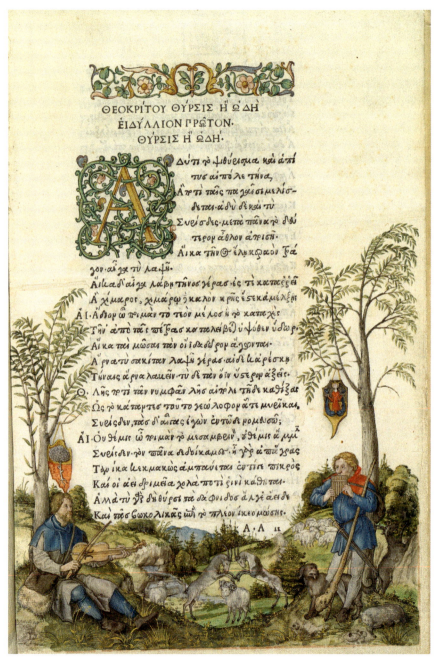

FIGURE 18.1 Albrecht Dürer, *A Pastoral Landscape with Shepherds Playing a Viola and Panpipes*. Painted illumination on a printed sheet, 31 × 20.3 cm. From: Theocritus, *Idylls and Other Texts*. (Venice, Aldus Manutius: 1495/6)
WASHINGTON, D.C., NATIONAL GALLERY OF ART. IMAGE IN THE PUBLIC DOMAIN (CREATIVE COMMONS ZERO)

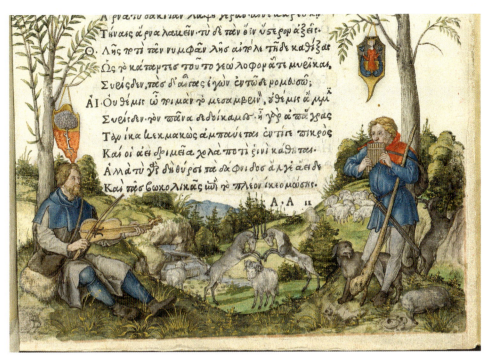

FIGURE 18.2 Albrecht Dürer, *A Pastoral Landscape with Shepherds Playing a Viola and Panpipes* (detail)
CREATIVE COMMONS ZERO

years 1505–1507.[12] Much of the primary evidence on Dürer's second Italian journey consists of ten surviving letters to Pirckheimer, who also provided a loan to fund the excursion. A large part of the correspondence concerns practical matters such as jewellery that Dürer wanted to purchase for Pirckheimer. Two letters of 1506 also reveal Pirckheimer's interest in Greek literature. In August, Dürer reported that a Venetian printer knew of no new Greek books published recently. In October, he again reported that no new books in Greek were available.[13] Pirckheimer's side of the correspondence has not survived, but we may presume that Dürer was responding here to repeated requests to procure Greek books. In 1504, Pirckheimer wrote to the humanist and poet

12 The first Italian journey is widely discussed in the scholarship, although direct documentary evidence exists only for the second trip. For an overview of the artistic evidence for the two journeys, see: Bartrum J. (ed.), *Albrecht Dürer and His Legacy*, exh. cat., British Museum (Princeton: 2002) 105–163. For a discussion of Dürer's stay in Italy claiming that the earlier journey did not occur, see: Luber K., *Albrecht Dürer and the Venetian Renaissance* (Cambridge: 2005) 40–77.
13 Ashcroft (ed.), *Albrecht Dürer: Documentary Biography*, no. 29.7–29.10, p. 168–174.

Konrad Celtis that he owned every Greek book printed in Italy so far.[14] The image in the Aldine Theocritus thus may be placed in the context of the Italian journeys of both Pirckheimer and Dürer.

The visual evidence suggests that Dürer painted the picture closer to his second than first Italian journey, at a significant remove from the volume's date of publication. Friedrich Teja Bach notes that similar figures of animals and shepherds appear in the drawing *Madonna with the Multitude of Animals*, currently in Berlin, and the woodcut *Joachim and the Angel*, both dated to 1503 [Fig. 18.3].[15] For the purposes of my argument, it is important to emphasise that the image, even while responding to the Theocritan text – in this sense 'reading' it – is distinct from the book it embellishes, an insertion into it that produces the poem as much as it is produced by it. Dürer's picture, in other words, must be seen both as an act of production as well as of reception,

If the object can be associated with Dürer's Italian period, it may be compared with his other works of art as well as with textual evidence that stems from his experience south of the Alps. Memorably, Dürer marvelled at the high status of painters in Renaissance Venice as he described his encounter with Giovanni Bellini.[16] In his self-portraiture, Dürer often employed visual strategies to assert a high status for his own artistic persona; from the expensive dress of the Madrid *Self-Portrait* of 1498, to the assertive gaze of the figure at the side of *Feast of the Rose Garlands*, to the monumental lyricism of the celebrated Munich *Self-Portrait*, Dürer continuously meditated on his own persona.[17]

In this context, the visual customization of Pirckheimer's volume may be seen as a special kind of double portrait. The association between Pirckheimer and Dürer stages a confrontation between the verbal and the visual, as well as invites comparison between scholarship and picturing, and their attendant conditions and circumstances. In its details, the image develops this theme in contradictory layers. The figure who stands for Pirckheimer plays a wind instrument, prohibiting the scholar from adding verbal poetry to his performance. The comparison brings to mind the myth of Apollo and Marsyas. In the version preserved by Diodorus Siculos, Apollo wins the musical contest with the satyr by adding voice to his music. Since Marsyas plays the pipes, he is

14 Holzberg, *Willibald Pirckheimer: Griechischer Humanismus in Deutschland* 88.

15 Bach, "Albrecht Dürer: Figures of the Marginal", 81–84. The drawing is in the collection of the Kupferstichkabinett, Sammlung der Zeichnungen und Druckgrafik Staatliche Museen zu Berlin – Preußicher Kulturbesitz, Berlin, KdZ 15387.

16 Ashcroft (ed.), *Albrecht Dürer: Documentary Biography* 139 no. 29.2.

17 On Dürer's experiments in self-portraiture in the period, see especially Koerner J., *The Moment of Self-Portraiture in German Renaissance Art* (Chicago: 1993) 80–160.

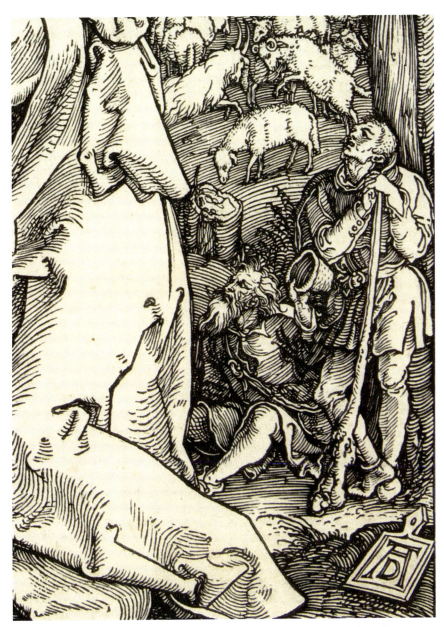

FIGURE 18.3 Albrecht Dürer, *Joachim and the Angel* (detail), ca. 1504. Woodcut, sheet: 29.4 × 21 cm. Yale University Art Gallery, 1956.16.2c

forced to concede.[18] Singing then brings music into the realm of literature, so it is paradoxical that Pirckheimer remains voiceless. Dürer's avatar holds a *viola da braccio*, which would allow for singing. However, even though Pirckheimer's voice may be silenced here, his panpipes carry a long tradition dating back to ancient mythological scenes. Dürer's viola was a contemporary instrument perceived as popular, folkloric, and suitable for outdoor performances.[19] A double portrait inserted in a book allows both the artists and the scholar to The image signals ownership in a basic sense, but it is also a comment on Dürer's reputation, or at least on his status in comparison to Pirckheimer's.

As an ensemble of text and image, the book can be compared to other Aldines in the period. Some of the owners of these books opted to have them illuminated. These hybrid products, combining the visual conventions of manuscripts and printed books, were in vogue in the Veneto at the beginning of the sixteenth century. In many cases, the illumination occupies the lower margin of the first page, and its principal function is to identify the owner through an inclusion of a coat-of-arms in a landscape setting. In an Aldine edition of the collected works of Ovid from 1502–1503 (currently at the John Rylands University Library in Manchester) Benedetto Bordon, the likely illuminator, employed a similar visual schema, developing the landscape to embellish the visual signifiers of ownership [Fig. 18.4].[20] Even as the printing press allowed for the mechanical reproduction of texts, the visual conventions and technologies of the manuscript book were still employed to customise, personalise, and embellish its printed counterpart. Durer's intervention can be seen as an elaboration upon the Bordonesque formula, in that he displays a coat-of-arms in a landscape setting on the book's first page.[21] However, Dürer goes beyond simply declaring the owner of the printed book; he also engages with the content of the poem in itself.

Dürer customised the printed book by placing his picture on the surface of the page, thereby superimposing his hand-made image onto the mechanically printed sheet. To do so, he carefully cut out and inserted a separate U-shaped

18 Diodorus Siculos, *Library of History*, III, 59.

19 I thank Dr. Jason Rosenholtz-Witt for pointing out the possible meanings behind these instruments in a comment during the Lovis Corinth Colloquium; he also guided me through the literature on the history of the viol. For the emergence of different types of viols in the period, see Woodfield I., *The Early History of the Viol* (Cambridge: 1984) 80–118.

20 For an example of an illuminated image inserted into a printed book, using separate sheets of paper, also attributed to Bordon and including a landscape, see Vecce C., "Arcadia at the Newberry", *I Tatti Studies in the Italian Renaissance* 17.2 (2014) 283–302.

21 On Venetian stylistic formulas for illuminating Aldines in the period, see Alexander J.J. (ed.), *The Painted Page: Italian Renaissance Book Illumination*, exh. cat., Royal Academy of Arts and the Morgan Library (New York: 1994) 35–46.

CUSTOMISATION AND POETICS IN THE 1495 ALDINE *THEOCRITUS* 533

FIGURE 18.4 Ovid, *Opera* (Venice, Aldus Manutius: 1502–1503. Manchester, The John Rylands University Library, Spencer 3366, (illumination attributed to Benedetto Bordon)
COPYRIGHT OF THE UNIVERSITY OF MANCHESTER

FIGURE 18.5 Albrecht Dürer, *A Pastoral Landscape with Shepherds Playing a Viola and Panpipes* (detail)
CREATIVE COMMONS ZERO

piece of paper in such a way that it surrounds the block of text, forming the lower, left, and right margins. There are clear seams, such as the horizontal line below the final verse on the first page [Fig. 18.5]. On the left and right margins, the illumination has been inserted using narrow patches.

The evidence of codicological customisation is particularly apparent in this case, as the reading of the book spatially encourages close looking. Cuts, seams, and connective patches do not break the illusion of the painting, but rather insist on the material qualities of this hybrid object. In the case of Dürer's large-scale paintings, a viewer may approach the painted surface in order to appreciate the finer details of technique and find the evidence of the artist's hand. Upon opening of the volume, a reader such as Pirckheimer would have been perfectly placed to look closely and appreciate the artistry

involved in customising this volume. In the leaves of the tree at the left margin, for instance, the intensity of word-image junctures draws attention to the divisions between the image and the page. The flat horizontal seam on top of the tree strongly designates the top edge or end of the image. Between the tree crown and the verses of the poem, a horizontal cut weaves in and out. In one detail, a branch fits in between the lines of the poem: the organic matter fills out the spaces between mechanically reproduced signs. Dürer's nature illusionistically enlivens the page, but also conditions the viewer to look closely at the mechanics of this book customisation [Fig. 18.6].

Visually, the image surrounds the poem on three sides, acting as a partial frame for the text. The two trees on either side fill the space of the margins, whereas the landscape enlivens the bas-de-page. Many of the natural motifs provide a visual counterpart to the main carrier of meaning in the text. In the two-dimensional space of the page, the image frames the poem by Theocritus. Like any other frame, it surrounds and defines an area of visual interest, and thereby emphasises that the text itself counts as the work of art, the principal area of focus.

In addition, the painting introduces a third dimension: the landscape develops the pastoral topography in space and allows the eye to wander into the illusionistic depths behind the surface of the lettering. Dürer's painting is a two-dimensional frame as much as it is a three-dimensional screen – a pictorial device for viewing the poem in projected space. The image is superimposed, so it is physically situated between the reader and the text itself. Dürer inserted it on the surface of the page so that the image would be seen first. This insertion turns the reader into a viewer. The book presents the poem not just in relation to the painting – in comparison to it – but also through the screen of the painting, in a three-dimensional sequence.

Recently, art historians have explored the use of screens in various visual configurations. In Gothic architecture, for example, screens were used to divide the sacred space between the area for the lay congregation and the inner sacrum for the clergy. However, recent scholarship, such as work by Jacqueline Jung, emphasises that such architectural interventions gave interiors a sense of coherence.[22] A screen may divide, but its placement, iconography, and style may also orient the viewer within and around space, giving it additional

22 For a recent discussion of Gothic screens, see Jung J., *The Gothic Screen: Space, Sculpture, and Community in the Cathedrals of France and Germany, Ca. 1200–1400* (Cambridge: 2012). For additional examples, see Gerstel S.E.J., *Thresholds of the Sacred: Architectural, Art Historical, Liturgical, and Theological Perspectives on Religious Screens, East and West* (Washington, D.C.: 2007).

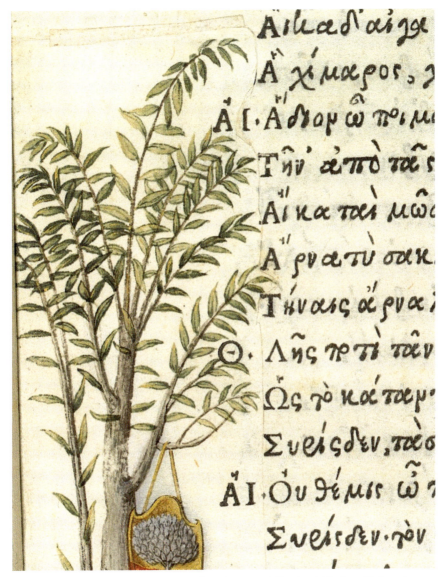

FIGURE 18.6 Albrecht Dürer, *A Pastoral Landscape with Shepherds Playing a Viola and Panpipes* (detail)
CREATIVE COMMONS ZERO

coherence. In Santa Maria Gloriosa di Frari in Venice, for instance, a fifteenth-century screen divides the church into two essential zones, but also allows for visual access to the later altarpiece painted by Titian [Fig. 18.7]. For a viewer standing close to the main entrance and directly at centre, the screen

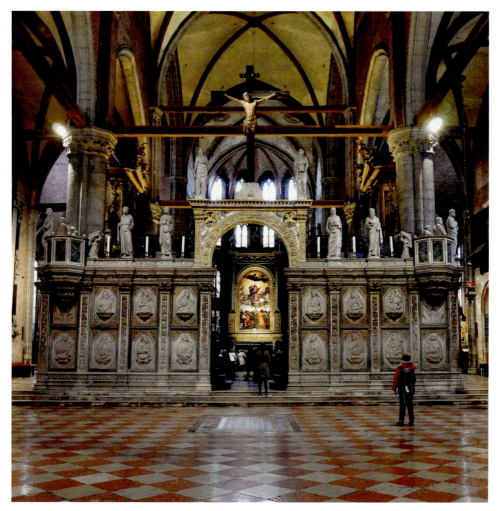

FIGURE 18.7 Choir screen at Santa Maria Gloriosa dei Frari, Venice, ca. 1475. Photo: "The Choir Screen" by Slices of Light (marked CC BY-NC-ND 2.0). Available at: https://flic.kr/p/2hPhQcn To view the terms, visit https://creativecommons.org/licenses/by-nd-nc/2.0/jp/?ref=openverse

establishes the painting as an area of spatial and visual focus. The screen divides the space but also unifies it, enhancing the sense of spatial coherence. It also acts as an aperture that places the altar in perspective. Similarly, Dürer places his image in front of the space of the text in order to provide an aperture for reading the poem. Indeed the painting, by leading the eye into the illusive depth of the landscape, pushes the text block away into space.

After Dürer created the image, he pasted it onto the first page and into the finished book to customise the volume for Pirckheimer, unlocking a range of

CUSTOMISATION AND POETICS IN THE 1495 ALDINE *THEOCRITUS* 537

visual juxtapositions and meanings. The painted page joins the printed page to play on the relationship between the humanist and the artist, but also to make a comment on the poem in itself. I want not to present a reading of the *Idyll*, as suggested by the material terms of this customisation. If the painting is a frame and a screen, it conditions the reading of the poem in visual terms. In his own poetics, Theocritus uses similar framing devices, exploring an analogous space of the pastoral.

2 The Opening Dialogue in *Idyll 1*

The first *Idyll* consists of a dialogue between the shepherd Thyrsis and the anonymous Goatherd. The Goatherd convinces Thyrsis to sing his famous lament of Daphnis. In reward, he is to receive a beautiful wooden cup. The object is first thoroughly described before being presented as a reward at the end of the performance. After the vessel is evoked in an elaborate ekphrasis, the performance by Thyrsis occupies most of the *Idyll*. The rest of the poem consists of the funerary and melancholic lament of Daphnis.

The introductory exchange between the two figures leads to the ekphrasis of the richly ornamented wooden cup, which then unlocks the performance by Thyrsis. In the final section, the cup is awarded to the singer. The idyll has a nesting structure: it is built as a set of nesting frames, with two figures engaging in dialogue at the start and the end. The cup is described first, but only presented later. The bulk of the poem juxtaposes the ekphrasis of the pastoral cup with the lament of Daphnis.[23] Two works of art are compared in two fictional exercises that originate in and depart from the encounter between the two shepherds. The opening exchange announces the major themes of this pastoral dialogue. Dürer's painting directly surrounds these germinal lines of the poem:

THYRSIS
A sweet thing is the whispered music of that pine by the springs, goatherd, and sweet is your piping, too; after Pan you will take the second prize. If he should choose the horned goat, you will have the she-goat, and if he has the she-goat as his prize, the kid falls to you. The flesh of a kid is good before you milk her.

23 For a discussion of the structure of the poem in terms of 'bucolic frames', see Segal C., *Poetry and Myth in Ancient Pastoral: Essays on Theocritus and Virgil* (Princeton: 1981) 31.; and Alpers P., *What Is Pastoral?* (Chicago – London: 1996) 144–145.

GOATHERD

Sweeter is the outpouring of your song, shepherd, than that cascade teeming down from the rock up above. If the Muses should take the sheep as their gift, you will have a stall-fed lamb, and if they would like to have a lamb, you will be next and take away the sheep.[24]

The two figures exchange praise of their respective poetic gifts. The terms of comparison are features of the natural world -- the sounds of trees and springs. Sheep and goat are introduced as potential rewards. The specificity of these rewards signals that we are entering a lower poetic register: the shepherds are so simple that they are only able to see poetry as equivalent in worth to particular animals. The Goatherd's response is a variation of the opening statement by Thyrsis. He returns his praise by reformulating the original lines.[25] The opening dialogue, just like the following juxtaposition between the ekphrasis and the lament by Thyrsis, introduces the theme of comparison and rivalry.[26]

The painting makes the thematic connections to the opening exchange clear. For instance, Dürer includes a detailed representation of the water spring, referred to by the Goatherd as a point of comparison for the talent of Thyrsis. More metaphorically, the theme of confrontation seems to be developed in the detail of a pair of sparring goats, their horns clinched, in the centre of the landscape. Friedrich Teja Bach notes the flatness of this episodic scene, as well as it stylistic distance from the other animals and plants populating and projecting from the landscape. In his reading, the goats are an heraldic symbolisation that brings to mind Dürer's famous monogram – the letter A over the letter D.[27] In this visual sign of confrontation, the artist may have inserted his persona as he gestured toward the structure of the opening of the poem.

Beyond such transformations of textual motives into visual details, more general poetic features also conditioned the making and the viewing of this image. If the first lines of the *Idyll* are viewed as an explanatory opening, it is striking to note what the poem does *not* contain: there is no introduction

24 Hopkinson N (ed.), *Theocritus. Moschus. Bion.* Loeb Classical Library 28 (Cambridge, 2015) 18–19.

25 For a recent overview of the philological parallels between these opening lines, see Payne P., *Theocritus and the Invention of Fiction* (Cambridge, 2007) 25–27. See also, in relation to Vergil, Alpers, *What is Pastoral?* 21–25.

26 In this foundational text of the pastoral tradition, various elements of the content and structure point to the centrality of the poetic contest as an idyllic form. See the etymological analysis of 'bucolicising' as 'competing in an exchange of extemporised verses', in Hunter R. (ed.), *Theocritus: A Selection* (New York: 1999) 6.

27 Bach, "Albrecht Dürer: Figures of the Marginal" 89.

of the two figures nor any description of setting. In other words, the text purposely does not orient the reader in the world of the first *Idyll*. The opening lines obscure the voice of the poet, as there is no lyrical 'I' guiding the reader through the dialogue. The exchange, then, is presented in direct speech, with the very first line of the poem being the first line spoken by Thyrsis. We are able to differentiate between the speakers through their initials on the left side of the poetic verses.

Literary critics of Theocritus have found various ways to describe the deictic effect of the two figures' emergence from direct speech and their setting. For George B. Walsh, 'landscape [in the poem] is variable and "nature" seems to change its meaning as a function of the speaker's rhetoric'. For Graham Zanker, Theocritus is tone-setting rather than scene-setting.[28] For Mark Payne, the surrounding landscape functions for the pastoral pair as the expression of their 'complementary desires'.[29] In all of these readings, the landscape setting is dynamically evoked in concert with the personalities of the figures. The dynamic revelation of both character and landscape contributes to the informal and impressionistic effect of the poem. Readers, eavesdropping on a dialogue, are expected to keep up with what is being said without being given many clues. In addition, the sense of dynamism and informality is reinforced through deictic expressions of familiarity: 'that pine' and 'that cascade' are referred to as if already known. They suggest a wider frame of reference, but there is no explanatory context for the demonstrative pronouns.[30] The language gestures beyond fragments, but without a way for the reader to build up an image of the spatial relationships among all the elements or a greater narrative structure that places the dialogue in context.

In the case of the Aldine edition from Pirckheimer's library, many of these gaps are filled in by the painting itself. The image sets the figures in space, situating them in relation to their surrounding circumstances, and visually describes them, in particular their facial features and details of their clothing. Thus, Dürer does not so much illustrate the poem as elaborate upon the conceptual space created by the text. The painting, in describing the figures and the landscape, places them in a setting, filling the Theocritean gaps of omission.

28 Zanker, *Modes of Viewing in Hellenistic Poetry and Art* 48.

29 Payne, *Theocritus and the Invention of Fiction* 27.

30 In an analogous reading, Ellen Zetzel Lambert claims that Theocritus is 'placing' rather than describing' the setting: 'Thyrsis and the Goatherd make their setting come alive for us less by describing objects rather than by pointing to them'. See: Lambert E., *Placing Sorrow: A Study of the Pastoral Elegy Convention from Theocritus to Milton* (Chapel Hill: 1976) 5.

As the poem is a mimetic dialogue, the reader gradually builds up mental images of the two idyllic characters. The pictorial image supplies an alternative route into the poem. By way of the painted figures positioned as if in front of the page, the eye finds itself dwelling on descriptive details, indices of character, as it scans each line of text from left to right. The two marginal figures created by Dürer thus punctuate or, better, bracket the experience of reading or mental oscillation required to follow the dialogic exchange in *Idyll* 1. The opening lines reveal the terms of comparison between Thyrsis and the Goatherd and insist on the pastoral setting, particulars of which are then described in the painting. The image does not develop details included by Theocritus; instead, Dürer took advantage of partial suggestions, indirect allusions and conceptual spaces in the poetic material to make an artistic intervention.

3 The Well-wrought Pastoral Vessel

The opening exchange sets the stage for the ekphrasis of the wooden cup, a much longer passage where the poem more explicitly negotiates with the visual.[31] The vessel is described by the anonymous Goatherd as an enticing award for the performance by Thyrsis. The cup is a two-handled kissubion (κισ-σύβιον), made of wood, and still smelling of perfumed wax. There are three images on it: a woman surrounded by two men quarrelling with each other, an old fisherman standing on a rock, and a boy with two foxes in a vineyard. In almost fifty lines the Goatherd shows Thyrsis how to lose himself in this object.

A lot here is left to the imagination. The ultimate meaning of the sequence of images is one of the great mysteries of this poem. The scenes are described as a series of impressions, rapidly evoked, one after another. Nevertheless, scholars have attempted to draw connections between the scenes. The triad of images may stand for the totality of human existence, much like the scenes from the shield of Achilles in the *Iliad*.[32] Perhaps Theocritus presents a version of the

31 As noted by Ruth Webb, the definition of ekphrasis as 'a description of a work of art' is a nineteenth-century construct and, hence, Theocritus would have likely not referred to this passage in *Idyll* 1 as such. For the origins of the concept in rhetorical manuals and the later history of the term, see Webb R., *Ekphrasis, Imagination and Persuasion in Ancient Rhetorical Theory and Practice* (Farnham: 2009) 13–61. Here, I use ekphrasis as a convenient term following modern literary usage.

32 On Theocritus and the Shield of Achilles, see Alpers, *What is Pastoral?* 140–145.; and Zanker, *Modes of Viewing in Hellenistic Poetry and Art* 14. For the cup as the 'bucolisation' of the Shield of Achilles, see Hunter (ed.), *Theocritus: A Selection* 76, with further references.

CUSTOMISATION AND POETICS IN THE 1495 ALDINE *THEOCRITUS* 541

three ages of man.[33] The characters depicted on the cup are described in small visual details, but in general, they depicts qualities of human life rather than connected narrative scenes.[34] In some manner, the ekphrasis seems to communicate Theocritus' literary program.[35] The pastoral poet is interested in self-absorbed figures, existing in snippets of daily life rather than grand narrative structures. He looks at the world obliquely, satisfied with partial appearances and unexplained contexts. This poem reveals the possibilities of reading pastoral images without searching for explanatory narrative meanings. In terms closer to the visual arts, this kind of verbal image-making might be considered anti-iconographic: the urn operates like a symbol, but is not constitutive of a visual sign susceptible to decoding.

As this object is described, it is important to emphasise that it is not actually shown to Thyrsis. As the description progresses, Thyrsis cannot verify the details against the vessel itself.[36] He is asked to imagine the award from the description provided, just like the reader of the poem. Theocritus uses devices such as this one to establish the sense of fictionality in the poem: the vessel is as imaginary to the readers as it is to Thyrsis and the Goatherd for the majority of the poem. The object stands for the possibilities of evocative visual description, but also for the unlocking of poetic performance. Just as in the case of the customised copy of the Dutch *New Testament* by Franciscus Costerus, analysed in this volume by Walter Melion, the image mediates between the reader and the text. The painting by Albrecht Dürer, physically mediating between the reader and the poem, performs an analogous function to the figure of the figured urn.

Analysing similar literary devices in other contexts, Cleanth Brooks has emphasised their role as vessels of cohesive meaning. In his *Well-wrought Urn: Studies in the Structure of Poetry* (1947), the American literary critic provided an influential reading of a number of poems that feature urns. The titular phrase comes from Brooks's first object of analysis, John Donne's poem "The Canonization". In each case, the vessel provides a key figure for Brooks's

33 For a recent summary of the possible meanings of the three images, see Payne, *Theocritus and the Invention of Fiction* 39.

34 Koopman N., *Ancient Greek Ekphrasis: Between Description and Narration: Five Linguistic and Narratological Case Studies* (Leiden: 2018) 202.

35 For a detailed philological analysis of the ekphrasis as programmatic, see Cairns F., "Theocritus' First Idyll: The Literary Programme", *Wiener Studien* 97 (1984) 95–105. See also Halperin D., *Before Pastoral: Theocritus and the Ancient Tradition of Bucolic Poetry* (New Haven: 1983) 167–189.

36 Koopman, *Ancient Greek Ekphrasis: Between Description and Narration: Five Linguistic and Narratological Case Studies* 185.

formalist analysis. In this classic text of literary New Criticism, Brooks offers a methodological paradigm for writing about poetry without excessive investigations of historical context. Gradually, as the argument develops, Brooks makes an explicit connection: the urn is the poem, the container of disparate thoughts.

In the case of the poem by John Donne, Brooks points out that the sonnet constitutes an exploration of what he calls 'the language of paradox'. The speaker brings together the language of romantic love with the distant discourse of spirituality. For Brooks, neither of these types of love dominates the other. Rather, the exploration of their coexistence leads to the essence of the poem, an exploration of paradox.[37] Finally, the lovers will co-exist after their death, together in a funerary urn. The object functions as a container for disparate meanings and brings a sense of resolution, all in one. In a close reading of John Keats's "Ode on a Grecian Urn", Brooks focuses on reconciling the poem with its enigmatic final line. The poem culminates in the proclamation that 'beauty is truth, truth beauty'. For many critics, the abstract equivalence seemed so out of place that it had to be explained away as an imperfection, a blemish in the smooth surface of the ode. Brooks instead reads the final line as harmonious with many paradoxes evident throughout the poem. For instance, Keats describes one of the scenes on the urn as a 'cold pastoral' – the idyllic scene contrasts with the harsh and unfeeling materiality of the object.[38] As a governing structure of the entire poem, the urn emphasises the fusion of such disparate motifs. The association between truth and beauty may be pursued in either direction, travelling across the edges of the Grecian urn. In both of these instances, urns are used as figures for unifying meanings and bringing together the intellectual strands comprised by self-contained poems.[39]

The iconography of the particular scenes in the Goatherd's cup remains mysterious, but regardless of the details, the vessel stands as a useful figure for Theocritean poetics. The cup brings to mind definition and containment: it is a structure of sorts that gives shape to various experiences and motives. It embraces a poem-within-a-poem, and insists that whatever is contained in it should be seen as a whole. The text consciously compares the cup to the lament of Thyrsis. Both constitute levels of fiction, containers for imagined worlds. The cup embraces a visual field without a clear beginning or end – the connections among pictures on its surface may be pursued in either direction.

37 Brooks C., *The Well Wrought Urn: Studies in the Structure of Poetry* (New York: 1947) 3–13.

38 Ibid. 151–167.

39 For an overview of Cleanth Brooks as a critic of poetry, see Simpson L., *The Possibilities of Order: Cleanth Brooks and His Work* (Baton Rouge: 1976) 128–150.

CUSTOMISATION AND POETICS IN THE 1495 ALDINE *THEOCRITUS*

And yet, the vessel suggests finitude: even if the images on it seem unfinished and mysterious, Theocritus designates them as contained and therefore finished. Brooks is a useful guide for the formal properties of urns and vessels as metaphorical constructs for intellectual containment. The poem by Theocritus and the painting by Dürer expand the boundaries of the imaginative spaces presented by the volume, but they also both employ stylistic devices to frame and contain. The word-image frames explore the possibilities of selection and wholeness. This juncture makes use of the form of the book itself as another container for artistic expression.[40]

In examining the book closely, it must have been clear to Pirckheimer, as it is to the viewer now, that some of the printed letters on the first page had been covered by Dürer. For instance, he painted over the signature of the first page of the first quire – 'AA' [Fig. 18.5]. Similarly, the Greek letters *alpha, jota*, and *theta*, which stand for the two speakers of the poem [Fig. 18.6], are on the painted side of the seam. In sum, the customisation of this Aldine edition consisted in creating the image and then inserting it onto the printed page, with some detailed adjustments. It is emblematic of this layered process that Dürer then inserted painted letters in order to replace signs crucial to the mechanics of the book. In instances such as these, the terms of the dialogue between the artist and the book reveal themselves as material signs. The names of the speakers play a crucial role in the *Idyll* as a dialogue. The signature of the first page is technically unnecessary, as it carries information useful for binding sheets into a quire, and the book as a collection of sheets is finished. However, Dürer preserved it, thereby emphasising that he was customising a printed volume.

Dürer's painting amplifies upon and emphasises the visual qualities of the poem. The word *idyll*, coined either by Theocritus himself or an early editor of his work, signalled the possibilities of such an intervention. The term comes from the more general Greek *eidos* (εἶδος) meaning 'that which is seen', 'shape', 'form'. The derivation of *idyll* from the act of seeing emphasises that pastoral was at its inception a visual phenomenon––the terms implies that its effects are to be admired as if by the sense of sight.[41] Hence the poem reveals its particular meanings through visual devices, such as the ekphrasis of the cup, but also is susceptible to visual commentary. The diminutive *eidolon* (εἴδωλον),

40 For a recent interpretation of Cleanth Brooks's formalism, emphasising the cohesive possibilities of metaphoric forms such as the urn, see Levine C., *Forms: Whole, Rhythm, Hierarchy, Network* (Princeton: 2015) 29–40.

41 See: Simon G., "Eidôlon / Eikôn / Phantasma / Emphasis / Tupos", in Cassin B. – Apter E. – Lezra J. – Wood M. (eds.), *Dictionary of Untranslatables* (Princeton: 2014) 245–249.

closer to the later literary term, additionally emphasises the fragmentary and informal quality of such mental images.

Both Theocritus and Dürer created 'little images' that play on each other in this customisation of one of Pirckheimer's prized books. Guided by Brooks, we may see the poem as well as the illumination as urns, performing the function of giving formal boundaries to artistic utterances. In other metaphors of containment, Dürer's image can also be seen either as frame or screen; in turn, either function, framing or screening, is well suited to the Theocritan poetics of the fragment. The illumination literally surrounds the text, contextualises by framing it, and also, since the image is pasted in, screens it. In this way, Dürer's picture calls attention to the poem's interest in its own framing. Conversely, the image can be seen as to respond to the idyll's pastoral poetics: like much of pastoral poetry that followed it, *Idyll* 1 presents fragments as visualisable works of art. This particular act of customisation, bridging the gap between printed books and manuscript images, employs pastoral poetics to decorate beyond markers of ownership. Dürer's pastoral landscape was made in a particularly fertile moment of intersection between the culture of manuscript and the culture of print. The volume is not merely assigned to the owner, but rather enveloped in multiple traces of agency: of the owner, the reader and the artist.

Bibliography

Alexander J.J. (ed.), *The Painted Page: Italian Renaissance Book Illumination*, exh. cat., Royal Academy of Arts and the Morgan Library (New York: 1994).

Alpers P., *What is Pastoral?* (Chicago – London: 1996).

Ashcroft J. (ed.), *Albrecht Dürer: Documentary Biography: Dürer's Personal and Aesthetic Writings, Words on Pictures, Family, Legal and Business Documents, the Artist in the Writings of Contemporaries.* (New Haven: 2017).

Bach F., "Albrecht Dürer: Figures of the Marginal", *RES: Anthropology and Aesthetics* 36 (1999) 79–99.

Barker N., *Aldus Manutius and the Development of Greek Script and Type in the Fifteenth Century* (New York: 1992).

Bartrum J. (ed.), *Albrecht Dürer and His Legacy*, exh. cat., British Museum (Princeton: 2002).

Brooks C., *The Well Wrought Urn: Studies in the Structure of Poetry* (New York: 1947).

Cairns F., "Theocritus' First Idyll: the Literary Programme", *Wiener Studien* 97 (1984) 89–113.

Cassin B. – Apter E. – Lezra J. – Wood M. (eds.), *Dictionary of Untranslatables* (Princeton: 2014).

Corfiati C., "Il fantasma di Teocrito", *Cahiers de recherches médiévales et humanistes* 25 (2013) 295–326.

Dumas A. – Stevens M.A. (eds.), *Woodner Collection: Master Drawings* (New York: 1990).

Ferrari S., *'Una luce per natura' – studi su Giorgione* (Padua: 2016).

Georgi K. – Eser T. – Grebe A. – Grossmann G. – Sauer C., *Heilige und Hasen: Bücherschätze der Dürerzeit*, exh. cat., Germanisches Nationalmuseum (Nuremberg: 2008).

Gerstel S.E.J., *Thresholds of the Sacred: Architectural, Art Historical, Liturgical, and Theological Perspectives on Religious Screens, East and West* (Washington, D.C.: 2007).

Gow A.S.F., (1952) *Theocritus, Edited with a Translation and Commentary* (Cambridge: 1952).

Grasselli M. (ed.), *The Touch of the Artist: Master Drawings from the Woodner Collections*, exh. cat., National Gallery of Art (Washington, D.C.: 1995).

Guest E., *The Illustration of Virgil's 'Bucolics' and its Influence on Italian Renaissance Art* (Ph.D. dissertation, Rutgers, State University of New Jersey: 2005).

Gutzwiller K., *Theocritus's Pastoral Analogies: The Formation of a Genre* (Madison: 1991).

Halperin D., *Before Pastoral: Theocritus and the Ancient Tradition of Bucolic Poetry* (New Haven: 1983).

Holzberg N., *Willibald Pirckheimer: Griechischer Humanismus in Deutschland* (Munich: 1981).

Hopkinson N. (ed), *Theocritus. Moschus. Bion.* Loeb Classical Library 28. (Cambridge, 2015).

Hunter R. (ed.), *Theocritus: A Selection.* (New York: 1999).

Jung J., *The Gothic Screen: Space, Sculpture, and Community in the Cathedrals of France and Germany, Ca. 1200–1400* (Cambridge: 2012).

Koerner J., *The Moment of Self-portraiture in German Renaissance Art* (Chicago: 1993).

Koguciuk J., *Pastoral and the Book: Jacopo Sannazaro and the Visual Arts in Renaissance Veneto, ca. 1460–1530* (Ph.D. dissertation, Yale University: 2019).

Koopman N., *Ancient Greek Ekphrasis: Between Description and Narration: Five Linguistic and Narratological Case Studies* (Leiden: 2018).

Kyriakou P. – Sistakou E. – Rengakos A. (eds.), *Brill's Companion to Theocritus.* (Leiden: 2021).

Lambert E., *Placing Sorrow: A Study of the Pastoral Elegy Convention from Theocritus to Milton.* (Chapel Hill: 1976).

Levine C., *Forms: Whole, Rhythm, Hierarchy, Network* (Princeton: 2015).

Luber K., *Albrecht Dürer and the Venetian Renaissance* (Cambridge: 2005).

Mende M., "Dürer und der Meister der Celtis-Illustrationen. Paragone um 1500 in Nürnberg", in Wiener C., (ed.), *Amor als Topograph. 500 Jahre Amores des Conrad Celtis. Ein Manifest des deutschen Humanismus* (Schweinfurt: 2002) 27–37.

Merkl U., *Buchmalerei in Bayern in der erste Hälfte des 16. Jahrhunderts: Spätblüte und Endzeit einer Gattung* (Regensburg: 1999).

Payne P., *Theocritus and the Invention of Fiction* (Cambridge, 2007).

Rosenthal E., "Dürers Buchmalereien für Pirckheimers Bibliothek", *Jahrbuch der Preuszischen Kunstsammlungen* 49 (1928) 1–54.

Rosenthal E., "Dürers Buchmalereien für Pirckheimers Bibliothek: Ein Nachtrag", *Jahrbuch der Preuszischen Kunstsammlungen* 51 (1930) 175–178.

Segal C., *Poetry and Myth in Ancient Pastoral: Essays on Theocritus and Virgil* (Princeton: 1981).

Silver L. – Smith J.C., *The Essential Dürer* (Philadelphia: 2011)

Simpson L., *The Possibilities of Order: Cleanth Brooks and His Work* (Baton Rouge: 1976).

Strauss W., *The Complete Drawings of Albrecht Dürer* (New York: 1974).

Vecce C., "Arcadia at the Newberry", *I Tatti Studies in the Italian Renaissance* 17.2 (2014) 283–302.

Walsh G.B., "Seeing and Feeling: Representation in Two Poems of Theocritus", *Classical Philology* 80.1 (1985) 1–19.

Webb R., *Ekphrasis, Imagination and Persuasion in Ancient Rhetorical Theory and Practice* (Farnham: 2009).

Wilson N.G., *From Byzantium to Italy: Greek Studies in the Italian Renaissance* (London: 2017).

Woodfield I., *The Early History of the Viol* (Cambridge: 1984).

Zanker G., *Modes of Viewing in Hellenistic Poetry and Art* (Madison: 2004).

CHAPTER 19

Compiled Compositions: The *Kattendijke Chronicle* (*c.* 1491–1493) and Late Medieval Book Design

Anna Dlabačová

The *Kattendijke Chronicle*, a late fifteenth-century manuscript nowadays kept at the Royal Library in The Hague, contains illustrations that combine elements taken from woodcuts and/or engravings, which are enhanced through drawn and painted components, and through the addition of colouring. These mixed-media images are fascinating for several reasons – they can help us reach a better understanding of the ways images were designed (or indeed altered, or customized) to fit a text in the late fifteenth century. While the *Kattendijke Chronicle* has been extensively studied, the images that were once pasted in but are now largely lost have not been explored systematically, nor have the methods behind the design process of these images. By examining the material assembly of images, I hope to reach an understanding of how the creation of composite images was rooted in the physical engagement with pictorial material in the early age of print.

After introducing the *Kattendijke Chronicle*, its contents, and origins, I will discuss the patterns in the way compositions were compiled and the strategies and techniques employed to create customized images to accompany the text. I have clustered these strategies into three, partly overlapping categories: altering the scale, refiguring individuals, and compiling a new, customized composition. In the final section I aim to explore the wider implications of the patterns and practices underlying the design process we can discern in the *Chronicle* for the rationale behind the design of late medieval books, their illustrations – especially woodcuts – as well as their study and appreciation.

I argue that the 'image editing' or 'image compositing' technique that we are confronted with in various images throughout the *Chronicle*, and that can be studied through the approach of 'image philology', must have been an indispensable part of late medieval book design, primarily when designing (woodcut) images for a particular text. The *Kattendijke Chronicle*, even though a particular case that appears to be a highly customized book, can and should be seen as an important exemplar of how images for a particular book were conceived and designed through image editing or compositing. The *Chronicle* can provide new insights into the fundamental principles of analogue image

© KONINKLIJKE BRILL NV, LEIDEN, 2024 | DOI:10.1163/9789004680562_020

design. Beyond its relevance for late medieval historiography and the history of heraldry, the *Kattendijke Chronicle* is thus an important object for the history of the book – or more broadly, the history of media in general.

1 The *Kattendijke Chronicle*

The *Kattendijke Chronicle*, first introduced to scholarship by Karin Tilmans in 1994, derives its name from its seventeenth-century owner, Johan Huyssen of Kattendijke (1566–1634).[1] It was Johans Huyssens's explicit wish that the manuscript should remain a family possession. In the 1990s his descendants made the manuscript available to a small team of researchers, which in 2005 resulted in an edition with an in-depth introduction by, amongst others, Wim van Anrooij, Jos Biemans and Antheun Janse, who focused on textual, heraldic and codicological aspects of the manuscript, and explored the profile of the author of the *Chronicle*.[2] The latter worked in Holland (possibly Haarlem) and completed the book in or shortly after 1491. Van Anrooij, Biemans, and Janse regard him as the mastermind behind the whole manuscript and characterize him as a layman (*not* a professional intellectual) and a talented bookmaker. They hold him responsible for the text, the layout, and the images, although he collaborated with an artist who painted the coats of arms and coloured the illustrations.[3]

1 The *Kattendijke Chronicle* is conserved at The Hague, National Library of the Netherlands, KW 1900 A 008. The manuscript is digitally available via https://commons.wikimedia.org/wiki/Kattendijkekroniek. See Tilmans K., "De Kattendijke-kroniek: een unieke kopij-manuscript uit Haarlem", in Hermans J.M.M. – van der Hoek K. (eds.), *Boeken in de late Middeleeuwen. Verslag van de Groningse Codicologendagen 1992* (Groningen: 1994) 188–211. For a more recent introduction see Tilmans K., "De Johan Huyssen van Kattendijke-kroniek. Geschiedenis en belang van de uitgave", in Janse A. – Biesheuvel I. – Van Anrooij W. – Biemans J.A.A.M. – Ekkart R.E.O. – Ridderikhoff C.M. – Tilmans K. (eds.), *Johan Huyssen van Kattendijke-kroniek. Die historie of die cronicke van Hollant, van Zeelant ende van Vrieslant ende van den Stichte van Utrecht*, Rijks Geschiedkundige Publicatiën uitgegeven door het Instituut voor Nederlandse Geschiedenis, Kleine serie 102 (The Hague: 2005) XI–XIX, esp. XII; see also Janse A., "Kattendijke-kroniek", in G. Dunphy (ed.), *The Encyclopedia of the Medieval Chronicle* (Leiden – Boston: 2010) 960–961.

2 Janse et al. (eds.), *Johan Huyssen van Kattendijke-kroniek* LXI–CLIII.

3 Van Anrooij W. – Biemans J.A.A.M. – Janse A., "Karakteristiek van de auteur", in ibid. CXL–CLII; Tilmans, "De Johan Huyssen van Kattendijke-kroniek", in ibid. XVIII. On the dating and localization, see also Biemans J.A.A.M., "Codicologische beschrijving van het Kattendijke-handschrift", in ibid. LXXXVI. For a profile of the author, see Ebels-Hoving B., "'Kattendyke', een goed verpakte surprise", *Bijdragen en Mededelingen betreffende de Geschiedenis der Nederlanden* 122 (2007) 1–14.

The text, which tells the (mythical) history of the world and Holland, Zeeland, and Utrecht up to 1478, is a compilation of at least six fifteenth-century sources, mainly chronicles that already circulated in both manuscript and print.[4] They include the Dutch translation of the *Fasciculus temporum* printed in 1480 by Johann Veldener in Utrecht, the so-called *Gouds kroniekje* or *Little Gouda Chronicle* (*Chronike of Historie van Hollant, van Zeelant ende Vriesland ende van den sticht van Utrecht*), published by Gerard Leeu in 1478, and the two historical novels written by Raoul Lefèvre in the 1460s and published in Dutch by Jacob Bellaert at Haarlem between 1484 and 1485: *L'histoire de Jason* (*Historie van den vromen ridder Jason*) and *Le Recueil des histoires de Troyes* (*Vergaderinge der historien van Troyen*).[5] Original passages in the *Chronicle* are scarce. Most of the text is the result of two methods of textual compilation that Antheun Janse has aptly described as coarse threadwork ('grove rijgwerk') and finer interlacement ('fijner vlechtwerk'). In the latter the author uses multiple sources at the same time and interweaves them into a 'new' text; while in the former the author uses substantial passages from existing texts as building blocks to create a new narrative.[6] Similar strategies and patterns of compilation can be observed in the many images that originally accompanied the text. I will return to this observation in the final section of this essay.

Based on his codicological analysis, Biemans concludes that the copying of the text, the design of the layout, and illustration of the book took place simultaneously.[7] Van Anrooij argues for the same concurrent genesis of text and image based on the layout of the manuscript, which must be an autograph. Before writing the text, the author applied the contours of the heraldic weapons using a stencil. According to Van Anrooij, the leading principle in the illustrational program is the heraldry, together with the so-called 'genealogical circles' that visualize the genealogic course of history described in the text. He places the manuscript in the tradition of armorials, as epitomized in the *Fasciculus temporum*. The latter was a source of inspiration for the *Kattendijke*-author both for the text and the visual presentation.[8]

4 Tilmans, "De Johan Huyssen van Kattendijke-kroniek" XVI–XVII; Janse A., "De Kattendijke-kroniek als historiografische bron", in idem et al. (eds.), *Johan Huyssen van Kattendijke-kroniek* CXX–CXXXIX.

5 Ibid. CXXIV–CXXXII.

6 Ibid. CXXXII–CXXXIV.

7 Tilmans, "De Johan Huyssen van Kattendijke-kroniek" XV; Biemans, "Codicologische beschrijving van het Kattendijke-handschrift" LXIX.

8 Tilmans, "De Johan Huyssen van Kattendijke-kroniek" XV–XVI; Van Anrooij W., "Illustraties in de Kattendijke-kroniek", in *Johan Huyssen van Kattendijke-kroniek* XCV, XCVII–XCIX. See CIV–CV for an example of the text following the curves of the stencil. The text therefore must be secondary to the stencils, and hence the coats of arms. The latter were part of the original design.

FIGURE 19.1 "David of Burgundy", in the *Kattendijke Chronicle*. The Hague, National Library of the Netherlands, KW 1900 A 008, fol. 530v. Folio size 200 × 140 mm
PUBLIC DOMAIN. WIKIMEDIA COMMONS

The codex contains 144 images in total. One hundred of these images are considered heraldic and present either a secular ruler with his or her banner or one of the fifty-five bishops of Utrecht. The final bishop portrayed is David of Burgundy [Fig. 19.1]. The remaining forty-four images depict battles, cities, and various other scenes related to the narrative.[9] Some of the printed images

9 See the overview in Janse A., "Overzicht niet-heraldische afbeeldingen", in Janse et al. (eds.), *Johan Huyssen van Kattendijke-kroniek* cxv–cxix.

THE *KATTENDIJKE CHRONICLE* AND LATE MEDIEVAL BOOK DESIGN

were pasted in whole or only slightly trimmed, others were assembled from pasted in parts. Both Biemans and Van Anrooij postulate that it was likely the scribe who 'prepared' (i.e., cut and pasted) the images.[10] At a later stage, after the lay-out of the page had been defined and the images pasted onto the page, the painter, who was also responsible for the heraldic shields and banners, coloured them.[11] Before they were coloured, some images were first touched up with 'pen drawings' of meaningful details such as a banner or a miter that carried implications for the meaning of the image; others were tweaked by adding less significant details (e.g., waves, part of a landscape, or a gothic-style frame).[12] It remains unclear who exactly was responsible for these drawn additions – the scribe or the painter?

The origins of most of the woodcut images still *in situ* in the manuscript have been traced by Tilmans, Van Anrooij, and Janse, who identify one incunable edition as the main source: the *Historie van hertoghe Godevaert van Boloen* (History of Duke Godfrey of Bouillon), printed at Gouda in Holland around 1486–1487 and narrating the First Crusade to the Holy Land by Godfrey of Bouillon.[13] Another incunable edition, the dialogic recension of Ludolph of Saxony's *Vita Christi* published by Gerard Leeu in 1487 in Antwerp, was identified as the source of one of the images.[14] Unfortunately, the lion's share of the pasted-in images has been lost. Who removed the pasted-in elements and when remain unclear.[15] The image of Emperor Louis, son of Lothar, is an illustrative example of the many now-lost images [Fig. 19.2]. In its absence,

10 Van Anrooij, "Illustraties in de Kattendijke-kroniek" XCV; Biemans, "Codicologische beschrijving van het Kattendijke-handschrift" LXIX.

11 Van Anrooij, "Illustraties in de Kattendijke-kroniek" XCV–XCVI and especially CXIII for a summary of the order of the activities in creating the *Chronicle*; Van Anrooij – Biemans – Janse, "Karakteristiek van de auteur" CXLIV.

12 Van Anrooij, "Illustraties in de Kattendijke-kroniek" XCVI, CVI.

13 The identification is discussed in Tilmans, "De Kattendijke-kroniek: een unieke kopij-manuscript uit Haarlem" 191–192; Tilmans K., "De Trojaanse mythe voorbij. Of: Waarom de Kattendijke-kroniek alleen door Bockenberg opgemerkt werd", *It Beaken* 56 (1994), themanummer *Mythe en geschiedschrijving in Nederland en Friesland* 188–211; Van Anrooij, "Illustraties in de Kattendijke-kroniek" CVI–CVII. See also the overview compiled by Janse, "Overzicht niet-heraldische afbeeldingen" CXV–CXIX. Boloyne Godefrey of, *Historie van hertoghe Godevaert van Boloen* ([Gouda, Printer of Godevaert van Boloen (Collaciebroeders?): about 1486–87]). Cf. Kok I., *Woodcuts in Incunabula printed in the Low Countries*, vol. 1 (Houten: 2013), nos. 187.1–26 (these woodcuts appear in this edition only and were cut especially for the edition of *Historie*).

14 First identified by Tilmans, "De Kattendijke-kroniek: een unieke kopij-manuscript uit Haarlem" 190–191. Saxonia Ludolphus de, *Tboeck vanden leven Jhesu Christi* (Antwerp, Gerard Leeu: 3 Nov. 1487). Cf. Kok, *Woodcuts in Incunabula*, vol. 1 nos. 85.1–111.

15 Tilmans, "De Johan Huyssen van Kattendijke-kroniek" LXXXV. Van Anrooij, "Illustraties in de Kattendijke-kroniek" XCVI.

FIGURE 19.2 "Emperor Louis", in The Hague, National Library of the Netherlands, KW 1900 A 008, fol. 152v. Folio size 200 × 140 mm
PUBLIC DOMAIN. WIKIMEDIA COMMONS

a precious piece of information has been revealed: the author inscribed the subject matter of the images before they were pasted in (in this case 'keyser lodewijck' [Emperor Louis]).[16] I believe that these inscriptions served as instructions for the person who created the images; contrary to what has been assumed in the scholarly literature, I argue that someone other than the scribe

16 These inscriptions are described in Van Anrooij, "Illustraties in de Kattendijke-kroniek" XCVI; and Biemans, "Codicologische beschrijving" LXXX.

THE *KATTENDIJKE CHRONICLE* AND LATE MEDIEVAL BOOK DESIGN 553

and author produced the images. A designer-editor was likely responsible for the images. I will elaborate on this in the final section.

Although most of the pasted-in images have been lost, there are several ways to reconstruct the images as well as the actual design process. The remnants and the contours of now-lost images can be used to determine which image was originally pasted in – as I will show below, even tiny remains can be revealing and can lead to an identification. Woodcut images taken from books have not only left behind contours, but also some of the text printed on their verso side (in reverse).[17] Tracing the text can effectively lead to the woodcut used in the image and can, moreover, point to the exact place in the source book from which that image was lifted. The latter can be relevant in instances where the book that functioned as an image bank contained two or more impressions of the same woodblock. In instances where images are still (partially) *in situ*, an examination of the cutting lines and the pasting process can help reveal the compositional procedure. The examination of said cutting lines will be further explored in relation to the first image-editing strategy employed in the *Kattendijke Chronicle*: the altering of the size of an image.

2 Changing the Scale

The image that illustrates the description of kings and princes coming to Troy to assist King Priam against the Greeks, may at first sight look like an unaltered woodcut that was simply pasted into the manuscript [Fig. 19.3a].[18] On closer inspection, however, several cutting lines are clearly discernible: they run, for example, along the bottom of the city walls and along the contours of some of the human figures [Fig. 19.3b]. Originally, the woodblock portrayed the Christians standing in the city of Jerusalem, conquered by them, and observing the signs in heaven.[19] When the image in the *Chronicle* is placed next to its original, made for the *Historie van hertoghe Godevaert van Boloen*, published in 1486–87, it is still rather difficult to distinguish what has been altered exactly, except for the fact that the size of the image has been reduced [Fig. 19.4].[20] Moreover, the quality of the editing work already shines through in the slightly

17 Van Anrooij, "Illustraties in de Kattendijke-kroniek" CVI–CVII.

18 The Hague, National Library of the Netherlands, KW 1900 A 008, fol. 48v.

19 Boloyne, *Historie van hertoghe Godevaert van Boloen*, fol. p3v; cf. Kok, *Woodcuts in Incunabula*, vol. 1 no. 187.25, 'The Christians in Jerusalem seeing signs in heaven'.

20 Janse, "Overzicht niet-heraldische afbeeldingen" CXVI, no. 12, mentions that the woodcut has been altered through cutting and that the 'back and figures within the walls [were] cut loose'.

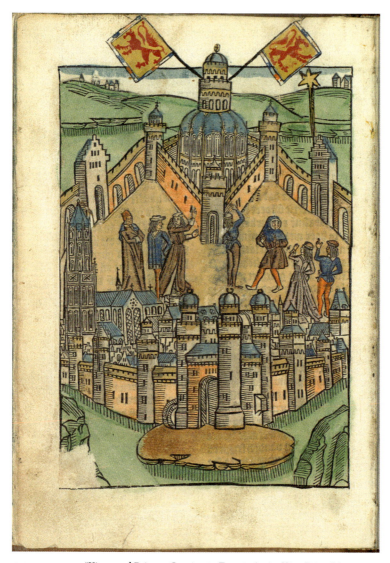

FIGURE 19.3A "Kings and Princes Coming to Troy to Assist King Priam", in The Hague, National Library of the Netherlands, KW 1900 A 008, fol. 48v. Folio size 200 × 140 mm
PUBLIC DOMAIN. WIKIMEDIA COMMONS

altered proportions of the composition, which delicately change the perspective of the viewer and reduce the amount of dead space in the image.

To reduce the image, the designer-editor went to great lengths to retain most of the original elements of the image; he also amplified the original. A close analysis of the cutting lines allows for a reconstruction of the process of

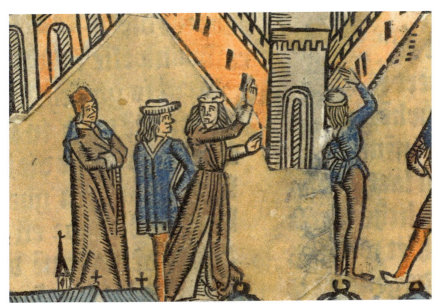

FIGURE 19.3B Detail of "Kings and Princes Coming to Troy to Assist King Priam", in The Hague, National Library of the Netherlands, KW 1900 A 008, fol. 48v. Folio size 200 × 140 mm
PUBLIC DOMAIN. WIKIMEDIA COMMONS

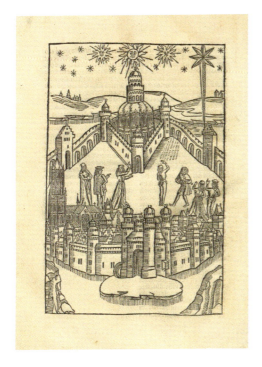

FIGURE 19.4
"Christians in Jerusalem Seeing Signs in Heaven", in *Historie van hertoghe Godevaert van Boloen* ([Gouda, Printer of Godevaert van Boloen (Collaciebroeders?): about 1486–87]). Woodcut. Leiden, University Library, shelf mark THYSIA 2259A, fol. p3v
PUBLIC DOMAIN

 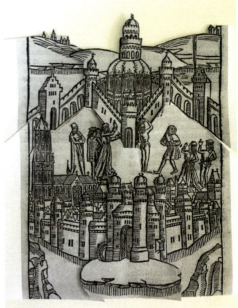

FIGURE 19.5A–B Reconstruction of the cutting and pasting process using a modern printout of the woodcut from the *Historie van hertoghe Godevaert van Boloen* ([Gouda, Printer of Godevaert van Boloen (Collaciebroeders?): about 1486–87])

image-editing [Fig. 19.5a–b]. At the top, the editor cut along the contours of the hills and buildings, preserving the dome. At the bottom, he trimmed off a few millimeters. He did not simply pare the sides of the image to make it fit into the manuscript. Instead, he dissected the image into six parts, always cutting along the contours of figures, buildings, or elements in the landscape. He probably retained the top section for later use – the stars and sun could come in handy when compositing another image – and discarded the bottom section. The six core parts of the image were then reassembled: the two upper side pieces were partially slid under the central structure; the two bottom sidepieces were placed against the underside of the city walls. To top it off, the gate building and the pointing figure attached at its top left were placed back into position at the bottom center of the image.

Without violating the composition or omitting any of the figures, the editor managed to create a smaller image that fit into the manuscript. Through the removal of excessive dead space, which effected a slight shift in the viewer's perspective, the edited image even seems to improve on the original. The colouring added to the edited image, along with the banners and the star (top right) carefully drawn by hand, aid in creating a cohesive whole.

THE *KATTENDIJKE CHRONICLE* AND LATE MEDIEVAL BOOK DESIGN 557

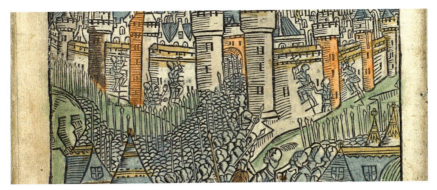

FIGURE 19.6 Detail of "Troy under Siege", in The Hague, National Library of the
Netherlands, KW 1900 A 008, fol. 55v
PUBLIC DOMAIN. WIKIMEDIA COMMONS

Similar techniques, less intricate but still effective, were employed to change the scale of other images still *in situ*. For the image that illustrates the account of Troy under siege, a woodcut from the same edition of the *Historie van hertoghe Godevaert van Boloen* was utilized, this time a scene that originally depicted the Christians taking over Jerusalem.[21] The banners added at the top, outside the frame, have already been noted, but the image itself, in particular its sense of scale, was altered as well by trimming at the left side, the bottom, and the top. By cutting away the top, the image editor excised the original caption identifying the city portrayed as Jerusalem ("Jherusalem"). The remains of the caption were covered over with paint of a blue hue. To further reduce the height of the woodcut without losing any of the details, the editor dissected the image in half, cutting roughly along the line formed by the spearheads of the approaching army. The moat, where the least action took place, was also removed. This 'image surgery' was performed so skillfully that the modification is barely noticeable. Zooming in at the cutting line shows that the intervention resulted in a remarkable smooth transition between the two segments: some of the lines in the woodcut even appear to connect to each other [Fig. 19.6].

The same technique proved effective when changing the height of the image that accompanies the enumeration of sovereigns of Rome (kings, emperors, popes).[22] The editor made clever use of the open space in the middle of the

21 The Hague, National Library of the Netherlands, KW 1900 A 008, fol. 55v. Cf. Boloyne, *Historie van hertoghe Godevaert van Boloen*, fol. k2r. Also see Kok, *Woodcuts in Incunabula*, vol. 1 no. 187.22, 'Jerusalem taken by the Christians, assault on the temple of Solomon'. Janse, "Overzicht niet-heraldische afbeeldingen" CXVI, no. 14, in this case does not record the alterations through cutting.
22 The Hague, National Library of the Netherlands, KW 1900 A 008, fol. 70v; Janse, "Overzicht niet-heraldische afbeeldingen" CXVII, no. 17.

original image which, in *Historie van hertoghe Godevaert van Boloen*, formerly illustrated Pope Urban II preaching a Crusade to the Holy Land in Clermont.[23] By removing the excess open space, the image editor succeeded in reducing the size of the image without losing any significant details, and brought the crowd and the group of men surrounding the pope closer to each other. Here, a closer look at the cutting line clearly demonstrates that colouring was only added after completion of the image surgery: the red of the cardinal's cape, for example, spills over onto the fence behind him.

The same technique proved equally useful when reducing the width of an image. It was applied to a woodcut that originally accompanied the story of Bohemond meeting the leader of the army of Antioch in *Historie van hertoghe Godevaert van Boloen*.[24] In the *Kattendijke Chronicle*, the image is scaled back in width by reducing the space between the two central figures, who are now not only standing closer to each other but also transformed into Brutus and Cormeus, the founders of Britain and Cornwall, respectively.[25] In this case the image editor also had to trim the sides of the image to make it fit within the dimensions of the text column. By removing excess space in the middle of the images, however, he managed to trim the sides without losing any of the figures. The metamorphosis we see in these two figures was not unique to this image; indeed, we can distinguish it as the second editing strategy.

3 Refiguring Individuals

The image editor often cut out individual figures to recast them in an entirely different role. This editing practice can be encountered most often in the heraldic images that portray a worldly ruler accompanied by a banner bearer. Most of the figures in the heraldic miniatures are unfortunately now lost.[26] Nevertheless, small remnants of them have been preserved, such as the spur of the horseman who represented Dirc III, Count of Holland, and these are helpful in tracing the image.[27] The small fragment of the woodcut, together with the contours of the horse's legs and the tip of the horseman's sword, point

23 Boloyne, *Historie van hertoghe Godevaert van Boloen*, fol. [*]1r; cf. Kok, *Woodcuts in Incunabula*, vol. 1 no. 187.1, 'Pope Urban II preaching a Crusade to the Holy Land in Clermont'.

24 Boloyne, *Historie van hertoghe Godevaert van Boloen*, fol. h<5>v; cf. Kok, *Woodcuts in Incunabula*, vol. 1 no. 187.21, 'Boemont proposing to the army that they proclaim him King of Antioch'.

25 The Hague, National Library of the Netherlands, KW 1900 A 008, fol. 89v; Janse, "Overzicht niet-heraldische afbeeldingen" cxvii, no. 20.

26 These images are discussed extensively in Van Anrooij, "Illustraties in de Kattendijke-kroniek".

27 The Hague, National Library of the Netherlands, KW 1900 A 008, fol. 173v.

THE *KATTENDIJKE CHRONICLE* AND LATE MEDIEVAL BOOK DESIGN 559

to a woodcut that originally illustrated the allegorical account of the figure of the knight in a Dutch translation of *De ludo scachorum, Boek dat men hiet dat scaecspel* by Jacobus de Cessolis, published at Delft on 14 February 1483 by Jacob Jacobszoon van der Meer [Figs. 19.7a & 19.7b].[28] Intriguingly, this image was used repeatedly by the image editor of the *Kattendijke Chronicle*: the knight was recast in different roles at least seven times, which indicates that the image editor had several copies of this woodcut at his disposal.[29]

The 2005 study of the manuscript pointed to the fact that some woodcuts from other books appear in the *Chronicle* without any text on their verso. As a possible explanation, Van Anrooij suggested two options: the compiler either had single sheet prints of the woodcut at his disposal, or he might have borrowed the actual block from 'a colleague', using it to produce his own impressions.[30] The former suggestion implies that some printers used their woodblocks – primarily made to illustrate books – to make single sheet prints of images that could be used for decorative purposes and as illustrations in manuscripts. This appears quite likely, since single-leaf prints – woodcuts and engravings – were used with some frequency in fifteenth-century handwritten books.[31] Some engravings were purposefully made to be pasted into books. In her seminal study, Ursula Weekes demonstrated that cycles of religious images, both engravings and woodcuts, were produced between 1450 and 1470/1500 in the Rhine-Maas region with an eye to their application in handwritten books. These 'ready-made' images were either pasted into manuscripts without any significant alteration or printed in the form of a booklet to which text could be added.[32] In her 2019 study *Image, Knife and Gluepot*, Kathryn Rudy discussed

28 Cessolis Jacobus de, *De ludo scachorum* [Dutch] *Boek dat men hiet dat scaecspel* (Delft, Jacob Jacobszoon van der Meer: 14 Feb. 1483) fol. e<5>v; cf. Kok, *Woodcuts in Incunabula*, vol. 1 no. 33.4 'The knight: A knight on horseback'.

29 The Hague, National Library of the Netherlands, KW 1900 A 008. The woodcut was originally also pasted in on fols. 131r, 184v, 209v, 225v, 247v, 263r, and possibly on fol. 301v.

30 Van Anrooij, "Illustraties in de Kattendijke-kroniek" CVII. Janse, "Overzicht niet-heraldische afbeeldingen" CXVII, no. 19. However, some of these woodcuts could have been cut from a later edition where, for example, the main woodcut used for the image on fol. 86v (Kok, *Woodcuts in Incunabula*, vol. 1 no. 85.27) was printed on a folio that was largely left blank on the verso: Saxonia Ludolphus de, *Tboeck vanden leven Jhesu Christi* (Antwerp, Claes Leeu: 20 Nov. 1488) fol. m3r–v.

31 Studies on this phenomenon include Schmidt P., *Gedruckte Bilder in Handgeschriebenen Büchern: zum Gebrauch von Druckgraphik im 15. Jahrhundert* (Cologne: 2003); Areford D.S., *The Viewer and the Printed Image in Late Medieval Europe, Visual Culture in Early Modernity* (Farnham – Burlington: 2010); Petev T., "A Group of Hybrid Books of Hours Illustrated with Woodcuts", in Hindman S. – Marrow J.H. (eds.), *Books of Hours Reconsidered* (London: 2013) 391–408.

32 Weekes U., *Early Engravers and Their Public. The Master of the Berlin Passion and Manuscripts from Convents in the Rhine-Maas Region, c. 1450–1500* (Turnhout: 2004); Van

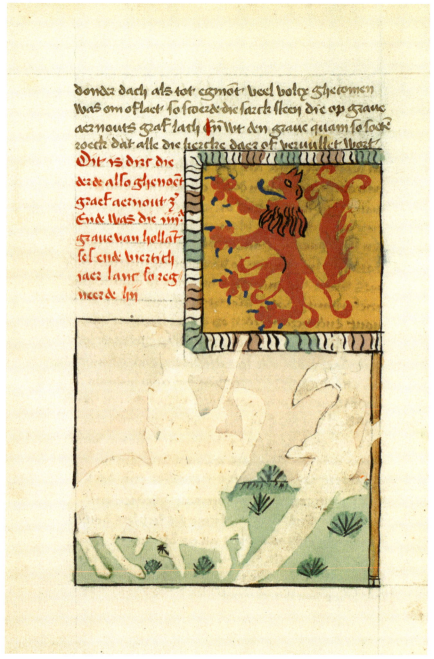

FIGURE 19.7A "Dirc III, Count of Holland", The Hague, National Library of the Netherlands, KW 1900 A 008, fol. 173v. Folio size 200 × 140 mm
PUBLIC DOMAIN. WIKIMEDIA COMMONS

FIGURE 19.7B "Knight", in *De ludo scachorum* in Dutch (Delft, Jacob Jacobszoon van der Meer: 14 Feb. 1483). Woodcut. Oxford, Bodleian Library, shelf mark Auct. 2Q 5.7, fol. e<5>v
© BODLEIAN LIBRARIES, UNIVERSITY OF OXFORD

the use of small engravings trimmed for the adornment of manuscripts by the Beghards in Maastricht around 1500. She describes the 'silhouetting' of figures, mainly saints, from engravings and their pasting into manuscripts as an integral part of handwritten book production, something that took place simultaneously to the writing of the text.[33] Silhouetting allowed for full recontextualization and a change of meaning, for example altering the identity of a given saint.[34] The image editor of the *Kattendijke Chronicle* implemented this technique regularly, both on woodcuts and engravings.

In fact, Dirc's banner bearer was not cut from a woodcut but from an engraving. The use of engravings in the *Chronicle* has hitherto gone unnoticed but was integral to the workflow of the manuscript's image editor.[35] He often combined elements of woodcuts with cutouts of engravings. Many of the banner-bearing animals in the *Chronicle* originally appeared as part of a full deck of playing cards by the Master of the Playing Cards, probably made between 1430 and 1450 and largely copied by anonymous engravers whom Max Lehrs grouped under the 'School of the Master of the Playing Cards'.[36] These later cards include designs now lost from the original deck as well as cards inspired by the work of Master E.S.[37] He and the Master of the Berlin Passion produced their own suits of cards and series of animals, respectively.[38] The cards and

Anrooij, "Illustraties in de Kattendijke-kroniek" XCV. On the phenomenon of pre-printed booklets in which image preceded text, see also Renger M.O., "The Cologne Ars Moriendi: Text and Illustration in Transition", in Hermans J.M.M. – van der Hoek K. (eds.), *Boeken in de late Middeleeuwen. Verslag van de Groningse Codicologendagen 1992* (Groningen: 1994) 125–140.

33 Rudy K.M., *Image, Knife, and Gluepot: Early Assemblage in Manuscript and Print* (Oxford: 2019) 20, 59–65.

34 Ibid., esp. 60–62.

35 Engravings were likely used on the following folios: The Hague, National Library of the Netherlands, KW 1900 A 008, fols. 79v, 84r, 97v, 101v, 107v, 111v, 116v, 126v, 144r, 149v, 152v, 153v, 173v, 180r, 181v, 203v, 209v, 216v, 225v, 263r, 293v, 301v, 311v, 320r, 321v, 350v, 382v, 514v, 537v, 558v.

36 Lehrs M., *Geschichte und kritischer Katalog des deutschen, niederländischen, und französischen Kupferstichs im XV Jahrhundert*, vol. 1 (Vienna: 1908) 97–148, nos. 42–106, Tafeln nos. 7–23 (Master of the Playing Cards) and 168–207, nos. 20–85 (School of the Master of the Playing Cards); Van Buren A.H. – Edmunds S., "Playing Cards and Manuscripts: Some Widely Disseminated Fifteenth-Century Model Sheets", *The Art Bulletin* 56 (1974) 12–30; Lehmann-Haupt H., *Gutenberg and the Master of the Playing Cards* (New Haven: 1966).

37 Lehrs, *Geschichte und kritischer Katalog* vol. 1, 149.

38 Ibid., vol. 2 (Vienna: 1910) 315–355, nos. 226–282 (Master E.S.); vol. 3 (Vienna: 1915) 120–129, nos. 82–101. Hollstein F.W.H., *Dutch and Flemish Etchings, Engravings and Woodcuts, ca. 1450–1700. Vol. XII: Masters and Monogrammists of the 15th century* (Amsterdam: [1955]) L.82–101.

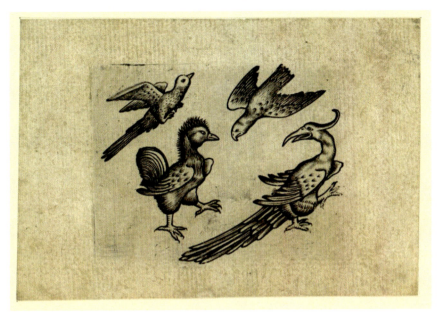

FIGURE 19.8 Anonymous Master (School of the Master of the Playing Cards), "Four of Birds". Copper engraving, plate 6.9 × ca. 9.2 cm, sheet 9.6 × 14.1 cm. Vienna, Albertina, inv. no. DG1926/639
PUBLIC DOMAIN

series also served as model sheets, and motifs from these engravings were widely copied in manuscript painting.[39]

Due to the fact that most engravings in the *Chronicle* are no longer in place and the ubiquity of the images, it is difficult to establish the exact copy used in the *Chronicle*. Moreover, the image editor likely made use of (copies of) engravings that are no longer attested anywhere else. Dirc's banner bearer, in any case, has an intriguing contour that points to a bird on the "Four of Birds" by an anonymous master from the School of the Master of the Playing Cards, possibly the Master of the Dutuit Mount of Olives.[40] The bird on the bottom right of the card, described by Lehrs as 'ein beschopfter Vogel mit langem Schnabel und sehr langem Schwanz' (a crested bird with a long beak and a very long tail) neatly fits the contours of Dirc's banner bearer [Fig. 19.8].[41]

39 Van Buren – Edmunds, "Playing Cards and Manuscripts" 18–23; Lehmann-Haupt H., *Gutenberg and the Master of the Playing Cards* (New Haven: 1966); Marrow J., "A Book of Hours from the Circle of the Master of the Berlin Passion: Notes on the Relationship between Fifteenth-Century Manuscript Illumination and Printmaking in the Rhenish Lowlands", *The Art Bulletin* 60 (1978) 590–616, esp. 603 (borrowing of a bird's head).
40 Lehrs, *Geschichte und kritischer Katalog* vol. 1, 187, no. 60, "Vogel-vier".
41 Ibid.

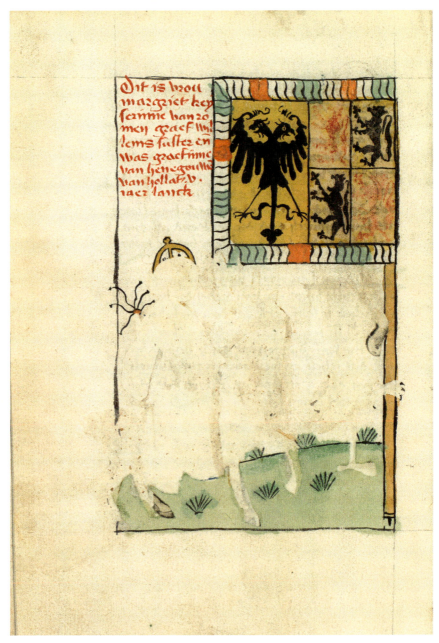

FIGURE 19.9A "Margaret II of Hainault and Banner Bearer" in The Hague, National Library of the Netherlands, KW 1900 A 008, fol. 311v. Folio size 200 × 140 mm
PUBLIC DOMAIN. WIKIMEDIA COMMONS

FIGURE 19.9B
Detail of "Margaret II of Hainault and Banner Bearer" in The Hague, National Library of the Netherlands, KW 1900 A 008, fol. 311v. Folio size 200 × 140 mm
PUBLIC DOMAIN. WIKIMEDIA COMMONS

Engraved birds appear frequently as banner bearers in the *Chronicle*, but their stance was often adjusted to help them fulfill their new role. In the heraldic miniature that portrays Margaret II of Hainault, the banner bearer's silhouette, especially its lower part, is clearly recognizable as that of a bird.[42] Only a small remnant of the engraving has been preserved in the position where the animal's neck or head should be [Figs. 19.9a & 19.9b]. The fragment matches the neck of the bird at the top left of the card of "Eight of Birds" from the same suite of cards as the bird accompanying Dirc III [Fig. 19.10].[43] The contours of the bird (a stork), in particular the position of its head do not seem to align. This can be explained as follows: the image editor adjusted the stance of the bird

42 The Hague, National Library of the Netherlands, KW 1900 A 008, fol. 311v.
43 Lehrs, *Geschichte und kritischer Katalog* vol. 1, 189, no. 65, "Vogel-acht".

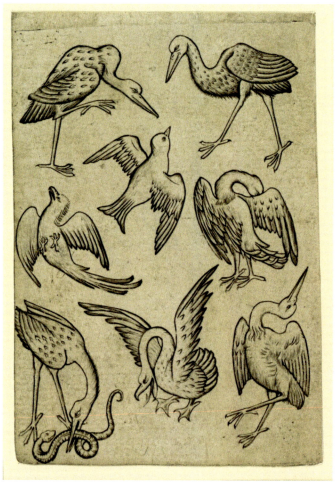

FIGURE 19.10 Anonymous Master (School of the Master of the Playing Cards), "Eight of Birds". Copper engraving, plate 13.5 × 9.9 cm. Vienna, Albertina, inv. no. DG1926/645
PUBLIC DOMAIN

by first decapitating it, then pasted in the neck and head, topping it off with the bird's body and legs, and tilting both parts to achieve the desired position [Fig. 19.11]. Something similar happened to the ostrich that served as the banner bearer for another Count of Holland, Floris II.[44] The contours are not very

44 The Hague, National Library of the Netherlands, KW 1900 A 008, fol. 189v.

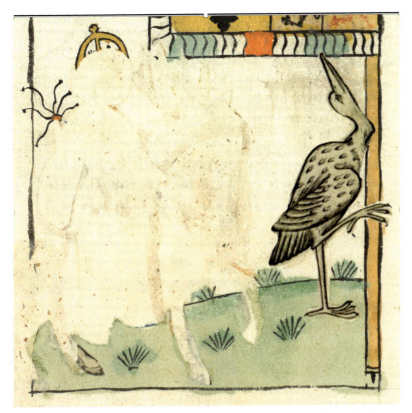

FIGURE 19.11 Reconstruction of "Margaret II of Hainault's Banner Bearer", in The Hague, National Library of the Netherlands, KW 1900 A 008, fol. 311v and Vienna, Albertina, inv. no. DG1926/645
PUBLIC DOMAIN

clear, but the silhouette of the horseshoe in the bird's beak is distinguishable.[45] The ostrich, likely cut from an engraved *Swan, Stork, and Ostrich* ascribed to the Master of the Berlin Passion, was not beheaded, but its leg was amputated and repositioned horizontally against the banner's pole to help it fulfill its new task [Figs. 19.12a & 19.b].[46] Images were thus not only moved into a new context; the image editor let the figures themselves move as well.

45 Especially in an enlarged version which can be consulted online via https://commons.wikimedia.org/wiki/Kattendijkekroniek.

46 Lehrs, *Geschichte und kritischer Katalog* vol. 3, 124, no. 91, "Schwan, Storch und Strausz"; Hollstein, *Dutch and Flemish Etchings, Engravings and Woodcuts* vol. XII, 107, L. 91. The image editor used other birds from this print as well: the stork originally accompanied Dirc, Count of Holland, as his banner bearer (The Hague, National Library of the Netherlands, KW 1900 A 008, fol. 163r).

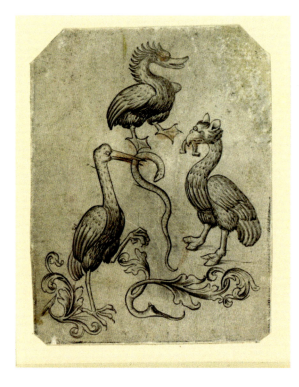

FIGURE 19.12A
Master of the Berlin Passion, *A Swan, a Stork, and an Ostrich*. Copper engraving, sheet 8.7 × 6.9 cm. Vienna, Albertina, inv. no. DG1926/832
PUBLIC DOMAIN

The contours and small remains in some of the images in the manuscript, moreover, point to the use of other animals (bears, lions) as banner bearers, as well as an angel.[47] In the case of Count Willem V of Holland the image editor cut a monkey, still in place in the *Chronicle*, from yet another playing card, likely a copy (in reverse) after "Six of Beasts" from the *Small Deck of Cards* by Master E.S. [Fig. 19.13 & 19.14].[48] The kneeling monkey, originally holding a guenon by a leash and its left ear, now actively grabs the pole of the banner.

47 Ibid., fol. 321v. Cf. Lehrs, *Geschichte und kritischer Katalog* vol. 2, 316, no. 227, "Tier-sechs". Other animals as banner bearers were inserted elsewhere, e.g., fol. 222v (bear, image lost), fols. 232v, 263r (lion, image lost), and fol. 301v (remains of tail and animal leg with a hoof, possibly a fawn or goat?). The stance of this animal was likely manipulated in a way similar to the birds discussed above. The angel was used on fol. 84r, as mentioned in Van Anrooij, "Illustraties in de Kattendijke-kroniek" CIII.
48 The Hague, National Library of the Netherlands, KW 1900 A 008, fol. 321v. Cf., Lehrs, *Geschichte und kritischer Katalog* vol. 2, 316, no. 227, "Tier-sechs". Other animals as banner bearers were inserted on fol. 222v (bear, image lost) and fols. 232v, 263r (lion, image lost).

THE *KATTENDIJKE CHRONICLE* AND LATE MEDIEVAL BOOK DESIGN 569

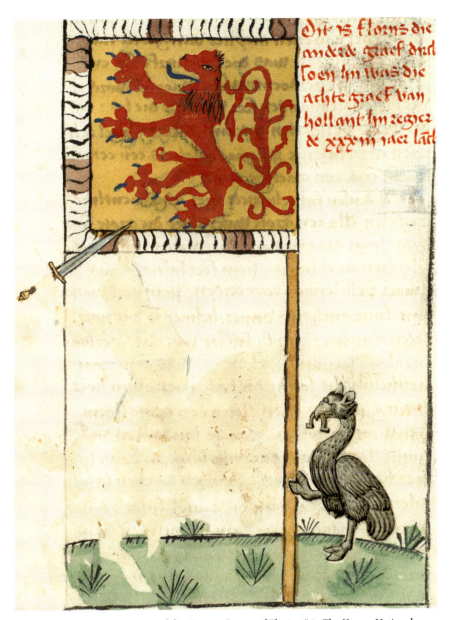

FIGURE 19.12B Reconstruction of the "Banner Bearer of Floris II", in The Hague, National Library of the Netherlands, KW 1900 A 008, fol. 189v and Vienna, Albertina, inv. no. DG1926/832
PUBLIC DOMAIN

FIGURE 19.13 Master E.S., retouched by Israhel van Meckenem, *Six of Beasts*. Copper engraving, plate 9.7 × 6.7 cm. Vienna, Albertina, inv. no. DG1926/792
PUBLIC DOMAIN

Engravings were also used for the depictions of the rulers themselves. The image of Emperor Nero on horseback, which has been preserved almost entirely, testifies to this, as do minute fragments of secular and religious rulers portrayed in other heraldic miniatures.[49]

49 I have been unable to identify the source of these images. They might well have been cut from prints that are no longer extant, which would make the manuscript the unique witness to these prints. The image of Nero can be found on fol. 101v; other rulers for whom the image editor certainly used an engraving (based on remaining fragments) can be found on fols. 126v (Charles Martel), 144r (Louis the Pious), 149v (Lothar), 153v (Charles the Bold; engraved hand loose but still in ms.), 293v (Jacobus van Oesterhoren, 44th bishop of

THE *KATTENDIJKE CHRONICLE* AND LATE MEDIEVAL BOOK DESIGN

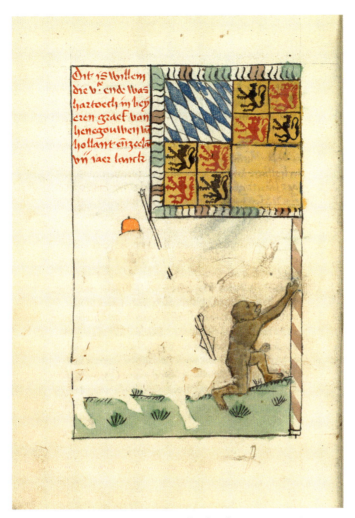

FIGURE 19.14 "Count Willem V of Holland with Banner Bearer", in The Hague, National Library of the Netherlands, KW 1900 A 008, fol. 321v. Folio size 200 × 140 mm
PUBLIC DOMAIN. WIKIMEDIA COMMONS

Banner bearers were not only cropped out of engravings. They were also silhouetted from impressions of woodcuts. As a rule, in these instances, the identity of the human figures changed completely. The creature holding up

Utrecht), 311v (Lady Margaret, empress of Rome), 350v (Duke Aelbrecht of Bavaria), 382v (Willem VI, duke of Bavaria), 537v (Charles the Bold, Duke of Burgundy), and 558v (Mary of Burgundy).

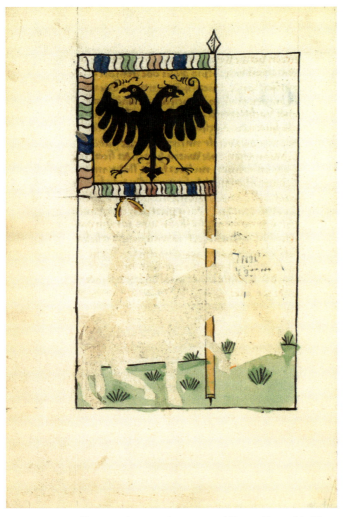

FIGURE 19.15 "Emperor Octavian Augustus and Banner Bearer", in The Hague, National Library of the Netherlands, KW 1900 A 008, fol. 101v. Folio size 200 × 140 mm
PUBLIC DOMAIN. WIKIMEDIA COMMONS

Octavius Augustus' banner is clearly a human figure, and the textual remains suggest that a woodcut was taken from a book [Fig. 19.15].[50] The contours point to the woman of Samaria in a woodcut originally cut for the Delft 1488 edition of *Tboeck van den leven Jhesu Christi* (Book on the Life of Christ), a Middle

50 The Hague, National Library of the Netherlands, KW 1900 A 008, fol. 101v.

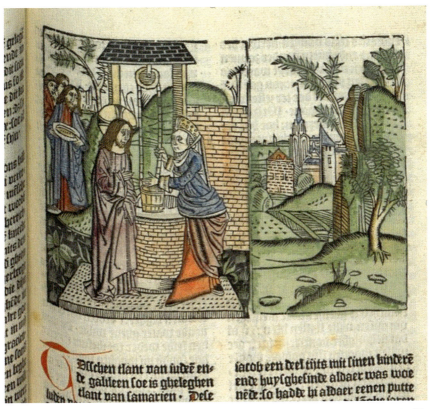

FIGURE 19.16 "Christ and the Woman of Samaria", in *Tboeck vanden leven Jhesu Christi* (Delft, [Christiaen Snellaert]: 22 May 1488). Woodcut, hand coloured. Nijmegen, University Library, shelf mark Inc 40 nr.1, fol. r1r
PUBLIC DOMAIN

Dutch dialogic recension of Ludolph of Saxony's *Vita Christi* [Fig. 19.16].[51] In the *Kattendijke Chronicle* the woman of Samaria is no longer drawing water from the well and offering it to Christ; instead, her stance made her suitable to hold up the banner. The remains of the toe of the right shoe of the banner bearer of Dirc II, Count of Holland, as well as his contours, allow for an identification with a soldier from the scene of "Christ disrobed" from the same woodcut series [Fig. 19.17 & 19.18].[52] Note that the banner bearer's right hand,

51 Kok, *Woodcuts in Incunabula*, vol. 1 no. 37.17.
52 The Hague, National Library of the Netherlands, KW 1900 A 008, fol. 167v. Cf. Kok, *Woodcuts in Incunabula*, vol. 1 no. 37.36.

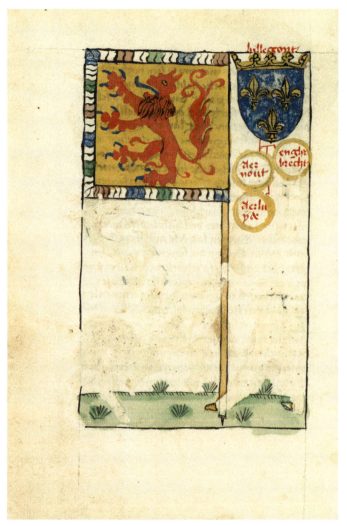

FIGURE 19.17 "Dirc II, Count of Holland", in The Hague, National Library of the Netherlands, KW 1900 A 008, fol. 167v. Folio size 200 × 140 mm
PUBLIC DOMAIN. WIKIMEDIA COMMONS

including the weapon held in that hand, originally belonged to another soldier within the group, standing right behind the soldier who is refigured as banner bearer in the *Chronicle* [Fig. 19.19]. Again, the latter's posture made him a good match for the task of holding up the banner. The toe of his left shoe was drawn in by hand and therefore differs in shape from the original in the woodcut.

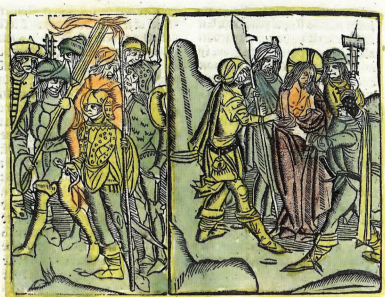

FIGURE 19.18 "Christ Disrobed", in *Tboeck vanden leven Jhesu Christi* (Delft, [Christiaen Snellaert]: 22 May 1488). Woodcut, hand coloured. Liège, University Library, shelf mark XV.B228, fol. gg1v
PUBLIC DOMAIN

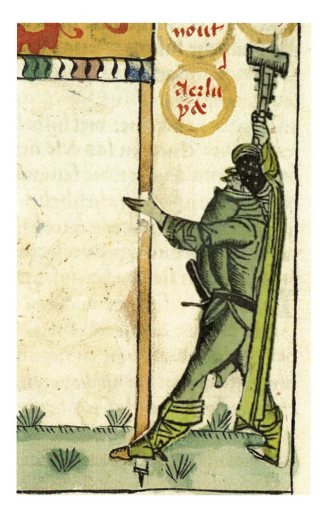

FIGURE 19.19
Reconstruction of "Dirc II's Banner Bearer", The Hague, National Library of the Netherlands, KW 1900 A 008, fol. 167v and Liège, University Library, shelf mark XV.B228, fol. gg1v
PUBLIC DOMAIN

Finally, the banner bearer of Duke Philip the Good was not lifted from a woodcut with a religious scene. The contours point to the brother of the King of France in an image from the series cut for the *Historie van hertoghe Godevaert van Boloen*, showing a meeting between him and Godfrey of Bouillon at Constantinople.[53] To make the brother of the King of France fit into his new position as the Duke of Burgundy's banner bearer, his crown was removed and replaced with a simple red cap [Fig. 19.20].

53 The Hague, National Library of the Netherlands, KW 1900 A 008, fol. 514v. Cf. Kok, *Woodcuts in Incunabula*, vol. 1 no. 187.5.

THE *KATTENDIJKE CHRONICLE* AND LATE MEDIEVAL BOOK DESIGN 577

FIGURE 19.20 Reconstruction of "Philip of Burgundy's Banner Bearer", in The Hague, National Library of the Netherlands, KW 1900 A 008, fol. 514v and figure cut from *Historie van hertoghe Godevaert van Boloen* ([Gouda, Printer of Godevaert van Boloen (Collaciebroeders?): about 1486–87]). Woodcut. Leiden, University Library, shelf mark THYSIA 2259A, fol. k2r
PUBLIC DOMAIN

4 Creating a New Composition

The two editing strategies I have discussed above, i.e., adjusting scale and refiguring individuals, were also be combined by the image editor of the *Kattendijke Chronicle* in the creation of entirely new compositions. These images show considerable variation in subject matter. Four examples will have to suffice here.

The image of the city of Rome, for example, placed at the start of the passage recounting the Eternal City's foundation, is made up of three different woodcuts (one of them in two impressions), all from the same woodcut series: the above-mentioned series made for the *Historie van hertoghe Godevaert van Boloen*.[54] One woodcut (originally the Prince of Persia's mother pleading with her son before Antioch) provided the central section of the city in front and a dwelling in the rear section at right.[55] Another woodcut that originally portrayed the "Siege of Antioch" supplied the central part in the back, as well as the series of buildings at left, which were taken from another impression of the same woodblock.[56] This explains why some of the towers in the background of the cityscape are repeated. The image was completed with two small remains of a woodcut that originally illustrated the story of the Christian delegation to the Prince of Persia at Antioch.[57] A narrow building was placed in front at right, and a small series of buildings was inserted in the rear row. Two banners drawn in by hand completed the image of Rome.

Due to similarities in style and format, it seems to have been relatively easy to compose a coherent image with woodcuts from a single series. Other images in the *Kattendijke Chronicle*, however, effectively combine elements from woodcuts from disparate series. The image that portrays a ship at sea with the exiled Queen Albina and her sisters, who according to legend eventually reached Albion (now Britain), consists of four different woodcuts from four different series.[58] The ship and the major part of the company come from a woodcut of Christ preaching with the Parable of the Sower in the background, originally designed and cut for the first edition of the aforementioned dialogic *Tboeck*

54 The Hague, National Library of the Netherlands, KW 1900 A 008, fol. 68v.
55 Kok, *Woodcuts in Incunabula*, vol. 1 no. 187.17.
56 Kok, *Woodcuts in Incunabula*, vol. 1 no. 187.11. In the *Kattendijke Chronicle*, this same woodcut was also used on fols. 15r (Siege of Troy) and 23v (idem).
57 Ibid., vol. 1 no. 187.19. The main part of this woodcut was used on fol. 52r (Athenor and Aenaes making an agreement) of the *Chronicle*.
58 The Hague, National Library of the Netherlands, KW 1900 A 008, fol. 86v. I have discussed this particular image in Dlabačová A., "Medieval Photoshop", *Leiden Medievalists Blog* (18 February 2022), https://leidenmedievalistsblog.nl/articles/medieval-photoshop. The text of this paragraph is partly based on this blogpost. Images are available online.

THE *KATTENDIJKE CHRONICLE* AND LATE MEDIEVAL BOOK DESIGN 579

van den leven Jhesu Christi (Boeck vanden leven Ihesu Christi), printed by Gerard Leeu in Antwerp in 1487.[59] Originally, the ship carried Christ and his apostles. In the *Chronicle* they had to make room for the crowd that initially occupied the shore and was now placed inside the ship. To fill the ship further – the legend has it that Albina had no less than thirty sisters – two female heads were lifted from a woodcut of the "Marriage of Mary and Joseph" that belonged to an important woodcut series used by Gerard Leeu in many of his editions of devotional texts.[60] There was space for one more sister, and she was lifted from a woodcut of the "Presentation of the Christ Child at the Temple", originally created for the 1488 Delft edition of the *Tboeck van den leven Jhesu Christi*.[61] The shore was lifted from one of the woodcuts initially made to illustrate the story of Godfrey of Bouillon.[62] Finally, the additional waves between the woodcuts were drawn in by hand, and the new image was coloured.

In some of the new compositions, elements from woodcuts from different series appear side by side excerpts from engravings, as is the case in the image of the "Forest without Mercy" (*Woud zonder Genade*), thought to have been situated in the northern part of the Netherlands (Holland) [Fig. 19.21].[63] Within this image, I have been able to trace two trees only, both from a series of woodcuts made for a devotional text, *Van die gheestlike kintscheÿt Ihesu ghemoraliseert* (On Jesus's Spiritual Childhood Moralized), in which the personified Soul embarks on a hunt for her dear Christ [fig. 19.22].[64] Despite similar trees occurring in several of the other woodcuts made for this text (and even in several other woodcut series), none of the extant images seems to fit the other trees used by the *Chronicle*'s image editor.[65] The group of soldiers in the lower left

59 Kok, *Woodcuts in Incunabula*, vol. 1 no. 85.27. This woodcut was previously identified by Tilmans, "De Kattendijke-kroniek: een unieke kopij-manuscript uit Haarlem" 191–192. See also Van Anrooij, "Illustraties in de Kattendijke-kroniek" CVII and Janse, "Overzicht niet-heraldische afbeeldingen" no. 19.

60 Kok, *Woodcuts in Incunabula*, vol. 1 no. 74.7. On this woodcut series, see also Dlabačová A., "Religious Practice and Experimental Book Production. Text and Image in an Alternative Layman's 'Book of Hours' in Print and Manuscript", *Journal of Historians of Netherlandish Art* 9(2) (Summer 2017) DOI: 10.5092/jhna.2017.9.2.2.

61 Kok, *Woodcuts in Incunabula*, vol. 1 no. 37.9.

62 Ibid., vol. 1 no. 187.10; Janse, "Overzicht niet-heraldische afbeeldingen" no. 19.

63 The Hague, National Library of the Netherlands, KW 1900 A 008, fol. 111v.

64 Kok, *Woodcuts in Incunabula*, vol. 1 nos. 89.20 and 89.29. On this text and its woodcuts, see also Dlabačová A., "Drawn Corrections and Pictorial Instability in Devotional Books from the Workshop of Gerard Leeu", in Della Rocca de Candal G. – Grafton A. – Sachet P. (eds.), *Printing and Misprinting: A Companion to Mistakes and In-House Corrections in Renaissance Europe* (1450–1650) (Oxford: 2023) 431–445.

65 Similar trees occur in, for example, Kok, *Woodcuts in Incunabula*, vol. 1 nos. 92.4 and 92.5, as well as in nos. 87.1–87.12. I believe that the trees used by the image editor may have

FIGURE 19.21 "Forest without Mercy", in The Hague, National Library of the Netherlands, KW 1900 A 008, fol. 111v. Folio size 200 × 140 mm
PUBLIC DOMAIN. WIKIMEDIA COMMONS

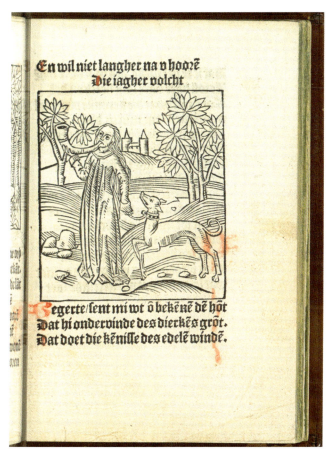

FIGURE 19.22 "The Soul with a Hound on a Leash", in *Van die gheestlike Kintscheÿt ihesu ghemoraliseert* (Antwerp, Gerard Leeu: 16 Feb. 1488). Woodcut. The trees on the top right were cut and pasted behind the remains of dragon-like figure (engraving) in the bottom half of the *Forest without Mercy* (Fig. 19.21). Washington D.C., LoC, Incun. 1488 .V3, fol. h2r. Library of Congress, Rare Book and Special Collections Division

corner of the image comes from the woodcut series created for the *Historie van hertoghe Godevaert van Boloen* and originally showed a group of Christian soldiers returning to camp from Antioch with their booty.[66] The origins of the other elements out of which the image was composed – the engravings of the

been lifted from woodcuts made for the *Historie van Reynaert die vos*, published by Gerard Leeu in Antwerp between 1487 and 1490. Only three of a total of about 31 woodcuts survive: see Kok, *Woodcuts in Incunabula*, vol. 1, nos. 84.1–3.

66 Ibid., vol. 1 no. 187.15. In the *Chronicle* the soldiers are accompanied by a horse, which I was unable to trace.

dragon-like figure below and of the three dogs and two deer that now dominate the image – remain obscure for now. Nevertheless, the image is a fascinating example of how pictorial elements from several sources produced in various techniques could skillfully be brought together to form a unity.

One final feature involved in the process of creating new compositions that deserves attention is the strategic use of 'drawn elements' to connect the components taken from woodcuts and engravings. A simple example has already been discussed above, i.e., the addition of waves drawn by hand between the shore and the ship carrying the exiled Queen Albina and her sisters.[67] Drawn elements could also be used to add items necessary for the depiction of a scene but not readily available in a printed image. An illustrative example is the image depicting the "Miracle of Loosduinen" [Fig. 19.23].[68] According to the miracle story, Lady Margaret, daughter of Floris IV, Count of Holland, was visited by a poor woman with young twins who begged her for alms. Margaret reasoned that since according to popular belief twins cannot come from the same father the woman must have led an immoral life and was thus unworthy of any charity. The poor women then prayed to God that he might give Margaret as many children as could be born from her in a single year. Her prayers were answered, and Margaret gave birth to no fewer than 365 children.[69]

The *Kattendijke Chronicle* recounts a slightly different version of the story that confuses Margaret with her mother Machteld and mentions a different number of children: 314. The children were all christened at once by the bishop of Utrecht, Otto of Holland, but as soon as they were baptized, they passed away and were buried in the monastery at Loosduinen.[70] What remains of the image that precedes the text in the manuscript are the two baptismal fonts, filled with the faces of Machteld's numerous children. The contours of the figures on both sides of the fonts, partly covering them, point to a source woodcut of the "Circumcision" that originated in Delft and was created, like several of the images discussed above, to illustrate the 1488 edition of *Tboeck van den leven Jhesu Christi* [Fig. 19.24].[71] The scale of the image was altered by separating the two groups of figures; through the addition of the baptismal fonts, Mary and the Christ Child were refigured as Lady Machteld and one of her babies (Christ's halo having been removed) and the priest as the bishop

67 The Hague, National Library of the Netherlands, KW 1900 A 008, fol. 86v.

68 Ibid. fol. 226v.

69 Groffen D., "Holland, Margaretha van", in *Digitaal Vrouwenlexicon van Nederland*. URL: http://resources.huygens.knaw.nl/vrouwenlexicon/lemmata/data/Henneberg, Margaretha van [27/03/2019].

70 *Chronicle*, fol. 227r–v.

71 Kok, *Woodcuts in Incunabula*, vol. 1 no. 37.7.

THE *KATTENDIJKE CHRONICLE* AND LATE MEDIEVAL BOOK DESIGN 583

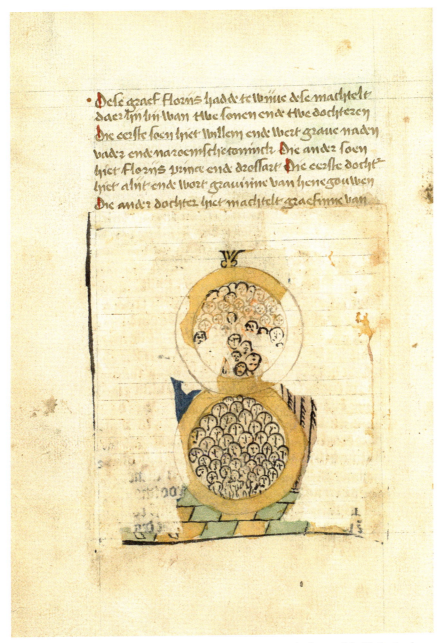

FIGURE 19.23 "Miracle of Loosduinen", in The Hague, National Library of the Netherlands, KW 1900 A 008, fol. 226v. Folio size 200 × 140 mm
PUBLIC DOMAIN. WIKIMEDIA COMMONS

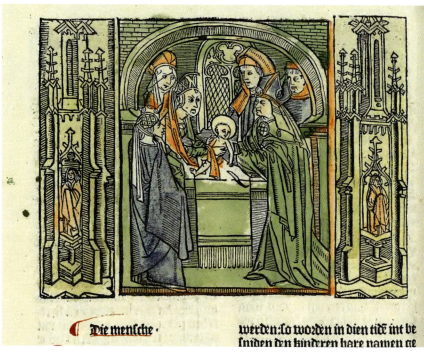

FIGURE 19.24 "Circumcision", in *Tboeck vanden leven Jhesu Christi* (Delft, [Christiaen Snellaert]: 22 May 1488). Woodcut, hand coloured. Liège, University Library, shelf mark XV.B228, fol. e3v
PUBLIC DOMAIN

of Utrecht, no longer taking Christ from Mary but reaching for one of the 314 babies. It remains unclear how his hands were added: they do not seem to have been drawn in, but rather pasted in, which indicates that they were taken from another woodcut or engraving.[72]

5 Image Philology, Moveable Figures, and the Appreciation of Woodcuts

Close study of the compilatory images in the *Kattendijke Chronicle* and investigation of their sources – an endeavor that I would like to label 'image

72 Alternatively, the priest may have been lifted from a different woodcut altogether, but because the shape of his robe fits the contours in the manuscript, this seems unlikely.

THE *KATTENDIJKE CHRONICLE* AND LATE MEDIEVAL BOOK DESIGN

philology' – allows for interlocking hypotheses concerning the methodology of the image editor who contributed to the *Chronicle* and his particular work environment, the design of woodcut series likely created in close proximity to the *Chronicle*, and, more generally, the design principles underlying images in the early age of print.

First, regarding the production context of the *Kattendijke Chronicle*, the image philology conducted above clearly shows that the designer of the images had a wide range of printed materials at his disposal. In addition to the images from two incunabula editions that had already been identified (see above), I was able to identify images from another nine different woodcut series (see Table 19.1). Moreover, the images that remain unidentified point to the fact that the image editor utilized woodcuts from other series as well. Chief examples of the latter are the woodcuts used to portray the fifty-five bishops of Utrecht. For their portraits, the image editor employed prints from three different woodblocks, from which he lifted the bishops; he altered these sources, cutting away certain details, and drew in additional features and frames by hand.[73] There is one exception: for the 44th bishop of Utrecht, Jacobus of Oesterhoren, the image editor used an engraving.[74] Part of one of the backgrounds trimmed off when silhouetting the bishops was then added to the image of Emperor Louis [see Fig. 19.2]. This shows that the staff held by the figure of a pope in one of the three woodcuts was systematically altered by the image editor; initially it depicted a papal *ferula* ending in a cross and not a curl.[75] The reuse of this detail from the trimmings also demonstrates that the image designer kept, and likely carefully filed away, any potentially useful parts of images he had cut up.

73 Van Anrooij, "Illustraties in de Kattendijke-kroniek" CVII–CIX. Van Anrooij distinguishes four 'types', but impressions of the same woodcut were used for types 1 and 2. See also Tilmans, "De Kattendijke-kroniek: een unieke kopij-manuscript uit Haarlem" 193, and idem, "De Trojaanse mythe voorbij" 210, n. 28. The first time these woodcuts occur (I refer to instances in which the woodcuts have been preserved) in The Hague, National Library of the Netherlands, KW 1900 A 008 is on fols. 129v, 134v and 141v. I would like to thank Sandy Wilkinson (University College Dublin) who ran the 'bishop-woodcuts' through *Ornamento*, the database of printed images that he has been developing (see https://ornamento.ucd.ie/), which uses image-recognition (e-mail from Sandy Wilkinson, d.d. 6 March 2022).

74 The Hague, National Library of the Netherlands, KW 1900 A 008, fol. 293v. Only a small fragment (the crosier) has been preserved.

75 Woodcut that first occurs on fol. 129v. See Van Anrooij, "Illustraties in de Kattendijke-kroniek" CVIII, Figs. 41 & 42.

586

DLABAČOVÁ

TABLE 19.1 Identified woodcuts used in the *Kattendijke Chronicle*[76]

Kok series no.	Place & Printer	Year and edition of first appearance
33	Delft, Jacob Jacobszoon van der Meer	1483 Jacobus de Cessolis, *De ludo scachorum* [Dutch] *Boek dat men hiet dat scaecspel*
37	Delft, Jacob Jacobszoon van der Meer	1486–8 *Epistelen ende evangelien* (1486) and *Tboeck vanden leven Jhesu Christi* (1488)
46	Delft, Jacob Jacobszoon van der Meer or Christiaen Snellaert	1488 *Tboeck vanden leven Jhesu Christi*
74	Gouda, Gerard Leeu	1482 *Dat liden ende die passie* and *Leven ende Passie Ons Heren*
80	Antwerp, Gerard Leeu	1486 Johannes de Garlandia, *Composita verborum* [Latin and Dutch]
85	Antwerp, Gerard Leeu	1487 *Tboeck vanden leven Jhesu Christi*
89	Antwerp, Gerard Leeu	1488 *Van die gheestlike Kintscheÿt ihesu ghemoraliseert*
166	Haarlem, Jacob Bellaert	1486 Guillaume de Deguilleville, *Le Pèlerinage de la vie humaine* [Dutch]
168	Antwerp, Gerard Leeu	1487 *Paris et Vienne*

76 Kok series numbers come from *Woodcuts in Incunabula*. Note that the table includes the printer who had the woodcut series made and/or first used the woodcuts, as well as the edition(s) in which the woodcuts first appeared. Since many woodcuts were reused, e.g. Kok, *Woodcuts in Incunabula* vol. 1, series no. 85, it is more than likely that the image designer cut them from later editions (possibly issued by a different printer). Cf. also note 29 above.

THE *KATTENDIJKE CHRONICLE* AND LATE MEDIEVAL BOOK DESIGN

TABLE 19.1 Identified woodcuts used in the *Kattendijke Chronicle (cont.)*

Kok series no.	Place & Printer	Year and edition of first appearance
187	Gouda, Printer of Godevaert van Boloen (Collaciebroeders?)	1486–89 *Historie van hertoghe Godevaert van Boloen*
188	Gouda, Printer of Godevaert van Boloen (Collaciebroeders?)	1486–89 *Historie van hertoghe Godevaert van Boloen*

As already noted above, the image editor complemented the substantial variety of woodcuts he had at his disposal along with engravings. The ones I have been able to identify are birds and other animals that were cut from widely disseminated playing cards, but the image editor also cut horsemen from engravings.[77] The range of printed materials used in the *Kattendijke Chronicle* is thus rather impressive. The designer-editor must have been well connected to the print trade in engravings as well as books. The woodcut series from which he obtained his material indicate that his network covered a specific circle of Netherlandish printers: those who worked or had worked in Holland in the 1480s, particularly along the axis of the towns of Delft, Gouda, and Haarlem. These observations fit well with the dating of the manuscript since all the woodcut series were in use before 1491, as well as with the place of origin of the manuscript suggested by Van Anrooij, Biemans, and Janse, i.e., Holland, possibly Haarlem.[78]

The fact that the image editor had so much pictorial material at his disposal, and his remarkable attention to detail and the quality of his compositions (some edited images even seem to surpass the original), suggest that he worked within a professional setting, possibly in the entourage of a printer. In an earlier article Tilmans proposed that the manuscript served as a printer's copy for the Haarlem printer Jacob Bellaert, and that the images were in fact designs for new woodcuts, which might have been intended for Yolande of Lalaing

77 See note 47 above for a list of images for which the image editor likely used horsemen cut from engravings.

78 Van Anrooij – Biemans – Janse, "Karakteristiek van de auteur" CXLV–CXLIX.

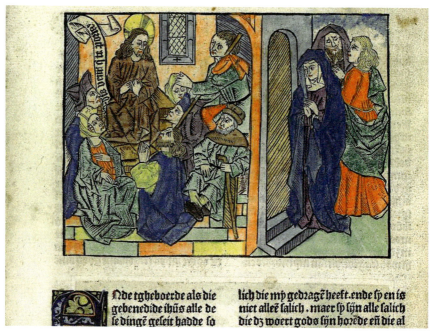

FIGURE 19.25 "Christ preaching and a woman in the crowd raising her voice", in *Tboeck vanden leven Jhesu Christi* (Antwerp, Gerard Leeu: 3 Nov. 1487). Woodcut, hand coloured. Liège, University Library, XV.C164, fol. v2r
PUBLIC DOMAIN

(1422–1497).[79] While Tilmans argument might not hold, the entourage of a printer does not seem far-fetched as a possible setting wherein the *Chronicle* originated; indeed, the images seem to exemplify a practice of analogue image editing. This practice must have been more widespread, and the principle upon which it was based – moveability of pictorial elements – appears to underlie the form and function of many of the woodcuts in fifteenth-century printed books, including those that the image editor of the *Chronicle* integrated into his designs.

A woodcut of "Christ preaching and a woman in the crowd raising her voice", for example, from the same series from which the ship in the image of Albina and her sisters was taken, offers a striking illustration [Fig. 19.25].[80] The seated

79 Tilmans, "De Johan Huyssen van Kattendijke-kroniek" esp. 183–184, 192, 195, 197, but see Van Anrooij – Biemans – Janse, "Karakteristiek van de auteur" cxlv–cxlvi, who refute this argument.
80 Kok, *Woodcuts in Incunabula* vol 1 no. 85.37. I discuss this example in Dlabačová, "Medieval Photoshop".

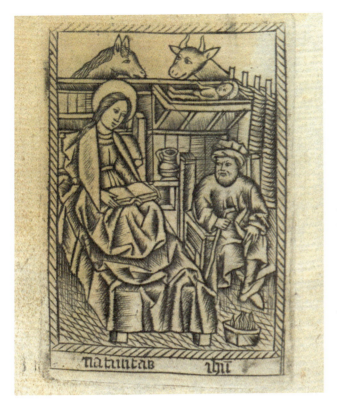

FIGURE 19.26
Master of the
Ten Thousand
Martyrs, *Nativity*, in
Prayerbook, Dutch,
after c. 1485, paper,
ca. 130 × 90 mm.
Copper engraving.
Vienna,
Österreichische
Nationalbibliothek,
Ms. Series
Nova 12909, fol. 17v
PUBLIC DOMAIN

male figure in the lower right corner of the room, who seems to meet Christ's gaze, is in fact the same figure who represents Joseph in a Nativity scene that was widespread in engravings and woodcuts [Fig. 19.26].[81] In the image for *Tboeck*, he is included as an anonymous bystander.

Awareness of the compositing techniques that we have encountered in the *Kattendijke Chronicle* – where the design process, reconstructed through image philology, almost seems to evolve right before our eyes – facilitates a new way of looking at woodcut images. Slight inconsistencies in crowds of people, figures that might have a somewhat odd position or seem somehow to float, or that might seem different in style, become noticeable and might point to analogue image editing as an important part the creation of the composition. In the case of the woodcut of "Christ preaching and a woman in the crowd raising her voice", the figure to the right of Christ, pointing toward him, holding a wooden staff, and hovering over Joseph, appears to be a re-contextualized shepherd from an Adoration scene. Even though I was unable to identify a

81 Dlabačová, "Religious Practice and Experimental Book Production" 32–33.

source print, awareness of the compilatory techniques used in the *Kattendijke Chronicle* makes it possible to discern how the final result, the woodcut, was produced: the designer must have looked for figures to fill the room around Christ and lifted figures from woodcuts and engraving in his stack of images.

The key woodcut series used for the images in the *Kattendijke Chronicle*, the series originally created for the *Historie van hertoghe Godevaert van Boloen*, also contains several recurring figures. One of them is a male figure that we encounter at the crowning of Godfrey as King of Jerusalem (first figure on the left), the crowning of his brother Baldwin (now carrying a sword but without a feather in his head gear), at the deathbed of Godfrey's brother (idem), and at the meeting between Godfrey and the King of France before the gates of Constantinople.[82] The same figure also appears in two older woodcut series from Haarlem, designed by the Master of Bellaert to illustrate the Dutch translations of Raoul Lefèvre's *L'historie de Jason* (*Historie van den vromen ridder Jason*) and *Le Recueil des histoires de Troyes* (*Vergaderinge der historien van Troyen*) published by Jacob Bellaert betwen 1484 and 1485, both of which were textual sources used by the author of the *Kattendijke Chronicle*.[83] In one of the woodcuts commissioned by Bellaert for the history of Jason, the figure that appears multiple times in the Godfrey of Bouillon series is holding a torch; in the Troy series he appears in a composition closely related to the two coronation scenes in the Godfrey of Bouillon series.[84]

Another attendee at Godfrey's coronation, the male figure on the far right sporting a hat, his leg visible through the slit in his robe – also present at Pope Urban II's sermon at Clermont (at the front on the far right) – makes his appearance in the Jason-series, too, as no less a person than Jason himself [Figs. 19.27 & 19.28].[85] In the Troy series, he appears in the same coronation composition as the figure mentioned above.[86] Without a feather in his hat and wearing an additional undergarment, 'Jason' also made his appearance in 1484 as one of the twenty-four elders in Bellaert's edition of the *Boeck des gulden throens*, the Dutch translation of Otto of Passau's *Die vierundzwanzig Alten, oder Der goldne Thron*.[87] Animal figures from these woodcuts could also be moved and customized

82 Kok *Woodcuts in Incunabula*, vol. 1 nos. 187.23, 187.24, 187.26 and 187.5. In the latter image the figure is partly hidden behind Godfrey's robes.
83 Janse, "De Kattendijke-kroniek als historiografische bron" CXXV; Van Anrooij – Biemans – Janse, "Karakteristiek van de auteur" CXLVIII.
84 Kok 2013, *Woodcuts in Incunabula*, vol. 1 nos. 160.14 and 162.2.
85 Ibid., vol. 1 nos. 187.23 and 187.1, and 160.2 and 160.9 in the Jason series.
86 Ibid., vol. 1 no. 162.2.
87 Ibid., vol. 1 no. 159.3. Another one of the Elders (no. 159.4) appears (in reverse) as King Melliseus in the Troy series (no. 162.4).

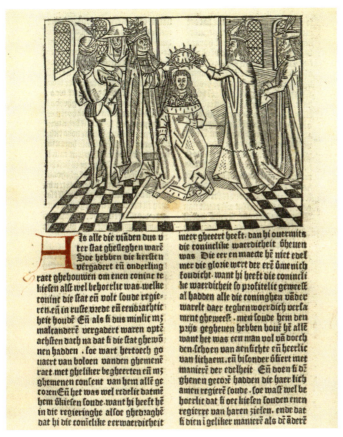

FIGURE 19.27 "Godfrey Crowned King of Jerusalem", in *Historie van hertoghe Godevaert van Boloen* ([Gouda, Printer of Godevaert van Boloen (Collaciebroeders?): about 1486–87]). Woodcut. Leiden, University Library, shelf mark THYSIA 2259A, fol. k5v
PUBLIC DOMAIN

in different contexts. For example, a pair of bulls appears in both the Jason and Godfrey of Bouillon series: in the Jason series they stand behind the dragon being slain by Jason on the island of Colchis; in the Godfrey of Bouillon series they are part of the loot the Christian soldiers take back to camp.[88]

The woodcut series made for Bellaert's editions of Lefèvre's texts in Dutch are closely related. Lotte Hellinga has observed that 'many of the architectural

88 Ibid., vol. 1, nos. 160.15 and 187.15.

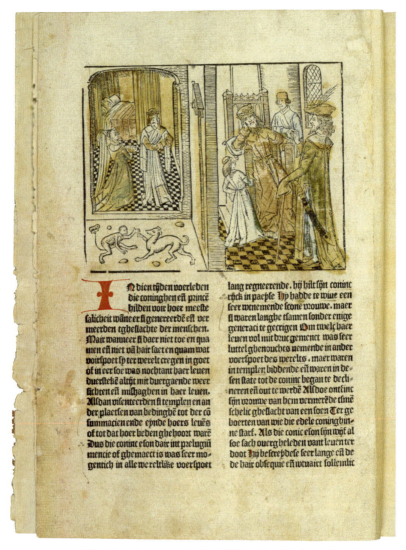

FIGURE 19.28 "King Eson Announces his Last Will", in Raoul Lefèvre, *Historie van den vromen ridder Jason* (Haarlem, Jacob Bellaert: [about 1483–85]). Woodcut, hand coloured. Washington, Library of Congress, fol. a2v. Library of Congress, Rare Book and Special Collections Division
PUBLIC DOMAIN

elements and human figures in the Jason woodcuts recur' in the Troy series.[89] Yet another woodcut series, first issued in an edition by Leeu (*Paris et Vienne*),

89 Hellinga L., "The History of Jason: From Manuscripts for the Burgundian Court to Printed Books for Readers in the Towns of Holland", in Hellinga L., *Texts in Transit: Manuscript to Proof and Print in the Fifteenth Century* (Leiden: 2014) 359. Kok, *Woodcuts in Incunabula*,

THE *KATTENDIJKE CHRONICLE* AND LATE MEDIEVAL BOOK DESIGN

but deriving from Bellaert, also contains woodcuts copied from the Jason series.[90] Intriguingly, a woodcut from this series also appears in the *Kattendijke Chronicle*.[91] The woodcuts for the history of Jason were possibly inspired by the drawings of the so-called Jason Master in the manuscript used by Bellaert as a printer's copy for his edition. Hellinga situates the Jason Master in Gouda and connects him to the design of woodcuts used by Gerard Leeu, whose business was closely tied to Bellaert's before his move to Antwerp in 1484.[92] Furthermore, as Ina Kok has observed, one of the woodcuts made to illustrate the history of Godfrey of Bouillon (Gouda, 1486–1487) was cut after a woodcut from the Jason series; she concludes that 'examining the exact relationship between these various series' would be worthwhile.[93] The similarities noted above between the Bellaert Master's woodcuts for the histories of Jason and Troy and the woodcuts made for the history of Godfrey of Bouillon, show that this is indeed the case. They have hitherto gone unnoticed because they concern moveable figures that are often subtly reshaped and refigured to fit a new context. They not only testify to an additional connection between Haarlem and Gouda after Leeu moved to Antwerp, but also confirm that the editing strategies employed by the image editor of the *Kattendijke Chronicle* were widespread in the design of woodcuts.

In the 2005 edition of the *Kattendijke Chronicle*, Van Anrooij described the re-use of existing images as a rare 'collage technique' that reveals the particular care with which images were reworked: they were carefully cut out and combined with details from other woodcuts. At the same time, this very same technique allowed Van Anrooij to conclude that 'the maker was an amateur'.[94] He especially values the heraldic images – in his view they are executed 'adequately' and even betray a certain degree of accomplishment – as well as the

vol. 1 nos. 162.1–25. On p. 376 she describes two examples of woodcuts cut for *Le Recueil des histoires de Troyes* that were partly copied after the Jason woodcuts (nos. 162.3 and 162.4) and mentions that '[a] closer study of these woodcuts might reveal more similarities'.

90 Ibid., vol. 1 nos. 168.1–25, 230–235.

91 Ibid., vol. 1 no. 168.19. The Hague, National Library of the Netherlands, KW 1900 A 008, fol. 35r. Woodcut now largely lost.

92 Hellinga, "The History of Jason" 316 and esp. 331–332. On the possible relationship between the Master Jason drawings and the woodcuts in Bellaert's edition, see also Nieuwstraten R., "Overlevering en verandering: de pentekeningen van de Jasonmeester en de houtsneden van de Meester van Bellaert in de Historie van Jason", in Hermans J.M.M. – van der Hoek K. (eds.), *Boeken in de late Middeleeuwen. Verslag van de Groningse Codicologendagen 1992* (Groningen: 1994) 111–124.

93 Kok, *Woodcuts in Incunabula*, vol. 1, no. 187.6 (the building of Constantinople) was cut after no. 160.11.

94 Van Anrooij, "Illustraties in de Kattendijke-kroniek" XCVI: 'Deze collagetechniek is zeldzaam en toont dat aan de afbeeldingen met zorg is gewerkt. Ze illustreert echter tevens dat de maker een amateur was'. Also see ibid. CVI.

two initials decorated with stylistically refined penwork. He contrasts these elements with the woodcut images that, as he puts it, consist of 'collages of small things pasted together which in the manuscript were touched up or smeared into whole. The way this was done shows the need to make the most of it, but at the same time illustrates the lack of professionalism'.[95]

I believe that there are good reasons to reconsider this assessment. While we might tend to associate cutting out, pasting, and colouring images with kindergarten, analogue image editing must have been an essential part of late medieval professional book design. These techniques profoundly affected the nature, composition, and style of early woodcuts. The practices of analogue image editing found in the *Kattendijke Chronicle* give an indication of how the designs of related woodcut series with recurring pictorial elements material-ized: cutting and pasting might well have been a common procedure in the workplace of the Bellaert Master and other artists. After the introduction of print, images became more broadly and cheaply available, allowing for the highly physical design process of image compositing that we encounter in the *Chronicle*. Apart from freehand copying, tracing, and pouncing, cutting and pasting seems to have become another compositional technique and method of relocating pictorial elements into new compositions.[96] It is important to keep in mind that pictorial elements were moveable not only in the sense that they could be recontextualized in a new image, but also in the sense that they themselves could move in the hands of the artist.

Since the image editor at work in the *Chronicle* seems to have engaged in a professional practice that required a specific set of skills, it is likely that con-trary to what was argued in the standard edition of the *Chronicle*, the author (and scribe) was not himself responsible for the images.[97] It seems plausible that the words he left in the blank spaces reserved for the images, describ-ing their subjects, served as instructions for another person who was charged with producing the images. This might have been the same person classi-fied as 'the painter' in the 2005 edition, who also coloured the images and painted the heraldic weapons and banners. It was likely the same person who

95 Ibid. XCVI: 'Daartegenover staan de ingeplakte houtsneden of collages van kleine plaksels die in het handschrift werden bijgetekend of tot een geheel gesmeerd. De manier waarop dit gebeurde toont de behoefte er iets van te maken, maar illustreert tevens het gebrek aan professionaliteit'.

96 See, for example, Van Buren – Edmunds, "Playing Cards and Manuscripts" 22 on methods to transfer motifs from the engraved playing cards to manuscripts.

97 Van Anrooij – Biemans – Janse, "Karakteristiek van de auteur" CXLIV; Tilmans, "De Johan Huyssen van Kattendijke-kroniek", XVIII.

THE *KATTENDIJKE CHRONICLE* AND LATE MEDIEVAL BOOK DESIGN 595

enhanced the images with drawn additions since they are part and parcel of the new composition.[98] An excellent example is the image of the "Miracle of Loosduinen", discussed above.

The *Kattendijke Chronicle* is a unique source for the study of (customized) image design, and the wider implications of the techniques and strategies employed by its illustrator are considerable for our understanding of book and image design in the late medieval period, particularly for the period after the introduction of print. Compilation and reuse play an important role in both textual and visual culture in the late medieval period. The principles underlying image compositing are, for example, similar to those found in many late medieval texts, including the *Kattendijke Chronicle*: smaller or larger portions of different existing texts were brought together, intertwined with newly composed, complementary texts. It is up to the philologist to untangle the strands and distinguish the sources of a text. Image philology applies a parallel approach to images that were intended to be viewed as new, independent compositions, but were composed out of pre-existing images. It shows how images could travel, move (change their stance), and end up in a new image. The strategies of textual compilation described by Janse as 'coarse threadwork' and 'fine interlacement' are closely analogous to some of the image editing techniques: constituent elements of printed images were repositioned, or small subsections were intricately combined to create altogether new compositions.[99]

The mobility of pictorial elements susceptible to customization was also essential to the very nature of the woodblocks themselves. Woodblocks were often intended to be combined with other woodblocks, in ways that would alter their size and meaning.[100] The woodblocks meant to create these composite woodcuts thus had a built-in customization option. A telling example are the woodblocks used to print the images that mark the start of each of the expositions by the twenty-four Elders in the 1480 Utrecht edition of *Dat boeck des gulden throens*, published by the Printer with the Monogram.[101] Each

98 Cf. note 11 above.

99 Tilmans, "De Johan Huyssen van Kattendijke-kroniek" XVII; Janse, "De Kattendijke-kroniek als historiografische bron" CXXXII–CXXXIV.

100 An excellent example of a woodcut series produced according to this principle comes from Bellaert's workshop and was commissioned for the Dutch translation of Jacobus de Theramo's *Consolatio peccatorum* (published 15 February 1484): Kok, *Woodcuts in Incunabula*, vol. 1, nos. 157.1–32. Some woodcuts in the series made for the history of Godfrey of Bouillon also required sidepieces and were to a certain degree customizable: Kok, *Woodcuts in Incunabula*, vol. 1 nos. 187.2–4, 187.13–14.

101 Passau Otto von, *Dat boeck des gulden throens* (Utrecht, [Printer with the Monogram], 30 Mar. 1480).

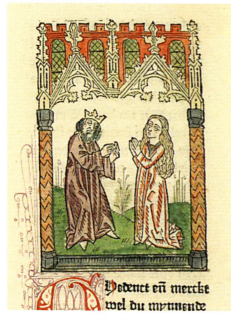 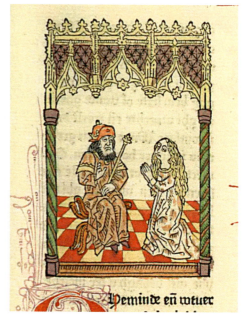

FIGURE 19.29A–B "The Elder and the Soul", in Otto von Passau, *Dat boeck des gulden throens* (Utrecht, [Printer with the Monogram], 30 Mar. 1480). Woodcut, hand coloured. Utrecht, University Library, shelf mark E fol 153 (Rariora) dl 1, fols. 9v and 18r

of the images depicting an Elder who instructs the Soul is made up of three small woodblocks: an architectural frame, an Elder, and the Soul. The woodcut series consists of six Elders (instructing while standing, seated, or walking), five Souls (standing or kneeling, always with hands folded), and four architectural borders. For each image these pictorial elements could be combined and thus refigured into a new composition.[102] The empty space within the frame inspired colourists of individual copies of the edition to further customize the setting in which the Elders exhort the Soul: they placed the figures in an outdoor location by adding a low brick wall and greenery or a set of hills, or suggested an indoor space by adding a tiled floor [Figs. 19.29a & b].[103] Such practices and the compositional principles that underlie them would have been all too familiar to the image editor of the *Kattendijke Chronicle*.

102 Kok, *Woodcuts in Incunabula*, vol. 1, nos. 117.2–16. Kok notes that '[a]lthough obviously a wide range of variations was possible, three combinations were used twice […]'.

103 Passau Otto von, *Dat boeck des gulden throens*, copy Utrecht, University Library, shelf mark E fol 153 (Rariora) dl 1, for example fols. 9v, 30r and 18r.

6 Conclusion

The *Kattendijke Chronicle* is a unique manuscript that allows us to see how a new composition was compiled through the physical process of analogue image editing; the *Chronicle* places this process before our eyes. As such, it helps us uncover patterns in the editing process: the alterations made to the scale of images, the refiguring of individuals, and the creation of entirely new compositions. Knowledge and awareness of the strategies and techniques employed by the image editor of the *Kattendijke Chronicle* can lead to a better understanding of the design processes underlying the compositions found in woodcuts. Conversely, an improved understanding of the methods of compositing can advance our appreciation of late medieval book design, especially of book illustration. Moreover, this type of research might bring new connections and dependencies to light. Printers did not just trade or copy existing woodblocks; figures and other pictorial elements in the impressions travelled in their own right, and could literally move into new compositions.

What I would like to call 'image editing' or 'image compositing' rather than a 'collage technique' must have been an essential part of late medieval book design, specifically when designing customized images for a particular text. In the process, no distinction was made between genres – figures from religious images could easily be appropriated to a secular scene.[104] Moveable figures were neither religious nor secular in themselves; their meaning was defined in the context of the book and in relation to the text. The principles of compiling compositions were thus not restricted to a specific genre or production technique, but travelled across various texts and media, as did the images themselves. If a pictorial element suited the purpose, a compositor could use images from various genres, as well as prints made in various techniques, placing them side by side. As I hope to have shown in the last section of this essay, image philology can lead to a more profound, historically grounded appreciation of the strategies employed by woodcut designers, allowing us to see different aspects of woodcut prints that might have gone previously unnoticed.

Bibliography

Areford D.S., *The Viewer and the Printed Image in Late Medieval Europe, Visual Culture in Early Modernity* (Farnham – Burlington: 2010).

104 Cf. Van Anrooij, "Illustraties in de Kattendijke-kroniek" xcv–xcvi, who separates religious from secular images.

Biemans J.A.A.M., "Codicologische beschrijving van het Kattendijke-handschrift", in *Johan Huyssen van Kattendijke-kroniek. Die historie of die cronicke van Hollant, van Zeelant ende van Vrieslant ende van den Stichte van Utrecht*, eds. Janse A. – Biesheuvel I. – Van Anrooij W. – Biemans – Ekkart R.E.O. – Ridderikhoff C.M. – Tilmans K. (eds.), Rijks Geschiedkundige Publicatiën uitgegeven door het Instituut voor Nederlandse Geschiedenis, Kleine serie 102 (The Hague: 2005) LXI–XCIV.

Boloyne Godefrey of, *Historie van hertoghe Godevaert van Boloen* ([Gouda, Printer of Godevaert van Boloen (Collaciebroeders?): about 1486–87]).

Dlabačová A., "Drawn Corrections and Pictorial Instability in Devotional Books from the Workshop of Gerard Leeu (d. 1492)", in Della Rocca de Candal G. – Grafton A. – Sachet P. (eds.), *Printing and Misprinting: A Companion to Typos and Corrections in Renaissance Europe* (Oxford: forthcoming).

Dlabačová A., "Medieval Photoshop", *Leiden Medievalists Blog* (18 February 2022), https://leidenmedievalistsblog.nl/articles/medieval-photoshop.

Dlabačová A., "Religious Practice and Experimental Book Production. Text and Image in an Alternative Layman's 'Book of Hours' in Print and Manuscript", *Journal of Historians of Netherlandish Art* 9(2) (Summer 2017) DOI: 10.5092/jhna.2017.9.2.2.

Ebels-Hoving B., "'Kattendyke', een goed verpakte surprise", *Bijdragen en Mededelingen betreffende de Geschiedenis der Nederlanden* 122 (2007) 1–14.

Groffen D., "Holland, Margaretha van", in *Digitaal Vrouwenlexicon van Nederland*. URL: http://resources.huygens.knaw.nl/vrouwenlexicon/lemmata/data/Henneberg, Margaretha van [27/03/2019].

Hellinga L., "The History of Jason: From Manuscripts for the Burgundian Court to Printed Books for Readers in the Towns of Holland", in Hellinga L., *Texts in Transit: Manuscript to Proof and Print in the Fifteenth Century* (Leiden: 2014) 304–365.

Hollstein F.W.H., *Dutch and Flemish etchings, engravings and woodcuts, ca. 1450–1700. Vol. XII: Masters and monogrammists of the 15th century* (Amsterdam: [1955]).

Janse A., "Overzicht niet-heraldische afbeeldingen", in *Johan Huyssen van Kattendijke-kroniek. Die historie of die cronicke van Hollant, van Zeelant ende van Vrieslant ende van den Stichte van Utrecht*, idem et al. (eds.), Rijks Geschiedkundige Publicatiën uitgegeven door het Instituut voor Nederlandse Geschiedenis, Kleine serie 102 (The Hague: 2005) CXV–CXIX.

Janse A., "De Kattendijke-kroniek als historiografische bron", in idem et al. (eds.) *Johan Huyssen van Kattendijke-kroniek* CXX–CXXXIX.

Janse A., 'Kattendijke-kroniek', in Dunphy G. (ed.), *The Encyclopedia of the Medieval Chronicle* (Leiden – Boston: 2010) 960–961.

Kok I., *Woodcuts in Incunabula printed in the Low Countries*, 4 vols. (Houten: 2013).

Lehmann-Haupt H., *Gutenberg and the Master of the Playing Cards* (New Haven: 1966).

Lehrs M., *Geschichte und kritischer Katalog des deutschen, niederländischen, und französischen Kupferstichs im XV Jahrhundert*, 9 vols. (Vienna: 1908–1934).

THE *KATTENDIJKE CHRONICLE* AND LATE MEDIEVAL BOOK DESIGN 599

Marrow J., "A Book of Hours from the Circle of the Master of the Berlin Passion: Notes on the Relationship between Fifteenth-Century Manuscript Illumination and Print-making in the Rhenish Lowlands", *The Art Bulletin* 60 (1978) 590–616.

Nieuwstarten R., "Overlevering en verandering: de pentekeningen van de Jasonmeester en de houtsneden van de Meester van Bellaert in de Historie van Jason", in Hermans J.M.M. – van der Hoek K. (eds.), *Boeken in de late Middeleeuwen. Verslag van de Groningse Codicologendagen 1992* (Groningen: 1994) 111–124.

Passau Otto von, *Dat boeck des gulden throens* (Utrecht, [Printer with the Monogram]: 30 Mar. 1480).

Petev T., "A Group of Hybrid Books of Hours Illustrated with Woodcuts", in Hindman S. – Marrow J.H. (eds.), *Books of Hours Reconsidered* (London: 2013) 391–408.

Renger M.O., "The Cologne Ars Moriendi: Text and Illustration in Transition", in Hermans J.M.M. – van der Hoek K. (eds.), *Boeken in de late Middeleeuwen. Verslag van de Groningse Codicologendagen 1992* (Groningen: 1994) 125–140.

Rudy K.M., *Image, Knife, and Gluepot. Early Assemblage in Manuscript and Print* (Oxford: 2019).

Saxonia Ludolphus de, *Tboeck vanden leven Jhesu Christi* (Antwerp, Gerard Leeu: 3 Nov. 1487).

Schmidt P., *Gedruckte Bilder in Handgeschriebenen Büchern: zum Gebrauch von Druckgraphik im 15. Jahrhundert* (Cologne: 2003).

Tilmans K., "De Kattendijke-kroniek: een unieke kopij-manuscript uit Haarlem", in Hermans J.M.M. – van der Hoek K. (eds.), *Boeken in de late Middeleeuwen. Verslag van de Groningse Codicologendagen 1992* (Groningen: 1994) 188–211.

Tilmans K., "De Trojaanse mythe voorbij. Of: Waarom de Kattendijke-kroniek alleen door Bockenberg opgemerkt werd", *It Beaken* 56 (1994), themanummer *Mythe en geschiedschrijving in Nederland en Friesland* 188–211.

Tilmans K., "De Johan Huyssen van Kattendijke-kroniek. Geschiedenis en belang van de uitgave", in Janse et al. (eds.), *Johan Huyssen van Kattendijke-kroniek* XI–XIX.

Van Anrooij W., "Illustraties in de Kattendijke-kroniek", in Janse et al. (eds.), *Johan Huyssen van Kattendijke-kroniek* XCV–CXIII.

Van Anrooij W. – Biemans J.A.A.M. – Janse A., "Karakteristiek van de auteur", in Janse et al. (eds.), *Johan Huyssen van Kattendijke-kroniek* CXL–CLII.

Van Buren A.H. – Edmunds S., "Playing Cards and Manuscripts: Some Widely Disseminated Fifteenth-Century Model Sheets", *The Art Bulletin* 56 (1974) 12–30.

Weekes U., *Early Engravers and their public. The Master of the Berlin Passion and manuscripts from convents in the Rhine-Maas region, c. 1450–1500* (Turnhout: 2004).

CHAPTER 20

Interpolated Prints as Exegetical Meditative Glosses in a Customized Copy of Franciscus Costerus's Dutch *New Testament*

Walter S. Melion

Issued in 1614 for the express purpose of re-evangelising the United Provinces, Franciscus Costerus, s.j.'s *Het Nieu Testament onses Heeren Iesu Christ, met korte uytlegginghen* (The New Testatment of our Lord, with Short Explanations) (Antwerp, Joachim Trognaesius: 1614) consists of a Dutch translation of the New Testament, mainly adapted from the Moerentorf Bible of 1599 [Fig. 20.1]; the Gospels, Acts, Epistles, and Apocalypse are supplemented by numerous marginal glosses referring to parallel scriptural texts from the Old and New Testaments, and by an extensive interpretative apparatus that underscores the scriptural warrant for key points of Roman Catholic doctrine [Fig. 20.2].[1]

1 The full title gives prominence to Costerus, identifying him as author of the annotations and member of the Society of Jesus: *Het Nieu Testament onses Heeren Iesu Christi, met korte uytlegghinghen door Franciscum Costerum, Priester der Societeyt Iesu.* Two editions of *Het Nieu Testament* appeared in close succession, the A-edition, issued by Trognaesius, and the B-edition, pirated from the A, on which see Agten E., "Costerus en Van den Leemputte: twee katholieke bijbelvertalingen uit de eerste helft van de zeventiende eeuw", in Gillaerts P. et al. (eds.), *De Bijbel in de Lage Landen: elf eeuwen van vertalen* (Heerenveen: 2015) 395–400; and eadem, *The Catholic Church and the Dutch Bible: From the Council of Trent to the Jansenist Controversy, 1564–1733*, Brill's Series in Church History 80 (Leiden: 2020) 135–141. The B-edition, likely published in the North Netherlands, barely departs from the A. Costerus's New Testament updates the version in the *Moerentorfbijbel*, published by Jan Moretus in 1599, which derives in turn from Nicolaus van Winghe's Dutch translation of the Latin Vulgate edition of Johannes Henten; on the *Moerentorfbijbel*, see Rosier B.A., *The Bible in Print*, 2 vols. (Leiden: 1997) 1:49–50; Imhof D., *Jan Moretus and the Continuation of the Plantin Press: A Bibliography of the Works Published and Printed by Jan Moretus 1 in Antwerp (1589–1610)*, 2 vols., Bibliotheca Bibliographica Neerlandica 3 (Leiden: 2014) 1:90–91; and Agten, *Catholic Church and Dutch Bible*, 133–135, 144–146. On Van Winghe's recension, published by Bartholomeus van Grave in 1548, see François W., "De Leuvense Bijbel (1548) en de katholieke bijbelvertalingen van de tweede helft van de zestiende eeuw", in Gillaerts et al. (eds.), *Bijbel in de Lage Landen* 266–294. The copy of *Het Nieu Testament* discussed in this essay comes from the A-edition. On Costerus, see Poncelet A., s.j., *Histoire del a Compagnie de Jésus dans les anciens Pays-Bas*, 2 vols. (Brussels: 1927–1928) 1:166–168, 187–190, 262–266; Hardeman R., s.j., *F. Costerus (1532–1619), Vlaamsche apostel en volksredenaar* (Alken: 1933); Andriessen J., s.j., *Nationaal biografisch woordenboek van België* (Brussels: 1964-), vol. 1,

© KONINKLIJKE BRILL NV, LEIDEN, 2024 | DOI:10.1163/9789004680562_021

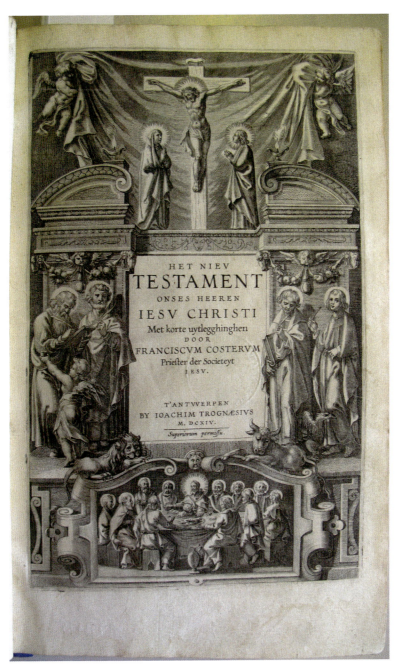

FIGURE 20.1 *Het Nieu Testament onses Heeren Iesu Christi, met korte uytlegghinghen door Franciscum Costerum, Priester der Societeyt Iesu* (Antwerp, Ioachim Trognaesius: 1614), title-page. Engraving, in folio
MAURITS SABBEBIBLIOTHEEK, KATHOLIEKE UNIVERSITEIT, LEUVEN

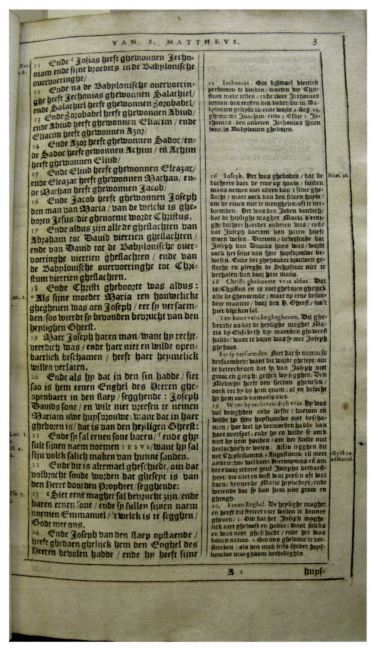

FIGURE 20.2 Matthew 3:11–24, with scriptural glosses in the narrow outer margins at left and far right and Costerus's glosses in the wide column at right, from Costerus Franciscus, s.J., *Het Nieu Testament onses Heeren Iesu Christi* (Antwerp, Ioachim Trognaesius: 1614) 3
MAURITS SABBEBIBLIOTHEEK, KATHOLIEKE UNIVERSITEIT, LEUVEN

A CUSTOMISED COPY OF COSTERUS'S DUTCH *NEW TESTAMENT* 603

Whereas the scriptural citations cluster along a narrow columnar band at the left or right of each page, the prose commentary inhabits the wider band adjacent to the numbered scriptural verses. Costerus construed his explanations as pictures of a sort: for example, with reference to Matthew 6:22–23 and Augustine's reading of this passage (*De sermone domini in monte* 2.13.45), he argues that discerning the true meaning of Scripture is like looking at images; if one's eyes are healthy, and one's vision is clear, then the body will be as if illuminated by the images the eyes behold. Similarly, if one's reading ('meyninghe') of Scripture is true, unsullied by false opinions and heresies, then all one's works, having been guided by the Gospel, will be as true ('goedt') as these true images. And conversely, if one's eyes are impure or blind, then the rest of one's body, for want of organs of sight, will abide in great obscurity ('verduystertheyt'). Likewise, one's reading of Scripture will be neither good nor righteous, and one's works will be false ('quaedt').[2]

At some point after its publication, probably at mid-century, judging from the many prints issued by engraver-publishers such as Maarten van den Eenden, Cornelis Galle the Younger, Gaspar Huybrechts, and Alexander Voet the Elder, the owner of the copy of Costerus's book (now in the Maurits Sabbebibliotheek of the Katholieke Universiteit, Leuven), inspired by this analogy between seeing and reading, added a second tier of visual glosses, interspersing small devotional prints and cropped excerpts from larger prints amongst the marginal comments at right [Fig. 20.3].[3] Two kinds of image were

cols. 333–341; and Polgár L., *Biblographie sur l'histoire de la Compagnie de Jésus 1901–1980*, 3 vols. (Rome: 1981–1990), 3:526–527, 526–527, nos. 5318–5334.

2 Costerus, *Het Nieu Testament* 14: "'Het licht uwes lichaems'. Dat is: Ghelijck d'ooghe, die het licht des lichaems is, als sy suyver is, het gantsch lichaem verlicht; maer is sy onsuyver ende blindt, soo is daer groote verduystertheyt in alle d'andere leden, die uyt henselven niet en sien: alsoo als uwe meyninghe goedt ende oprecht is, soo zijn uwe wercken oock goedt, die in hen-selven niet quaedt en zijn; is sy quaedt, soo zijn die oock quaedt. Daerom en dooghen d'aelmoessen, bidden, ende vasten niet, uyt hooverdije ghedaen. Augustinus'. N.B. All citations from *Het Nieu Testament* come from the A-edition in the Maurits Sabbebibliotheek. For the text of the A-edition, see https://books.google.nl/books?id=6tcomEfl-2AC&printsec =frontcover&hl=nl&source=gbs_ge_summary_r&cad=0#v=onepage&q&f=false (accessed 1 July 2022). For the text of the B-edition, see https://www.google.com/books/edition /Het_Nieu_Testament_Met_korte_uytlegghing/xwlmAAAAcAAJ?hl=en&gbpv=1 (accessed 1 July 2022). Scriptural citations follow Costerus's translation, which closely harmonises with the Douay-Rheims edition of the Vulgate (http://www.drbo.org/).

3 On Maarten van den Eenden (Enden) (1605–1673/74), engraver and first publisher of Anthony van Dyck's *Iconography* and brother-in-law of Pieter de Jode II, see Rombouts P. – Lerius T. van, *De liggeren en andere historische archieven der Antwerpsche Sint Lucasgilde*, 2 vols. (Amsterdam: 1961) 2:15, 18, 142, 175, 313; Thieme U. – Becker F., *Allgemeines Lexikon der bildenden Künstler: von der Antike bis zur Gegenwart*, 37 vols. (Leipzig: 1907–1950) 10:514; Heurck E. van, *Les images de dévotion Anversoises du XVIe au XIXe siècle* (Antwerp: 1930) 57; Duverger E., *Antwerpse kunstinventarissen uit de zeventiende eeuw*, 13 vols. (Brussels:

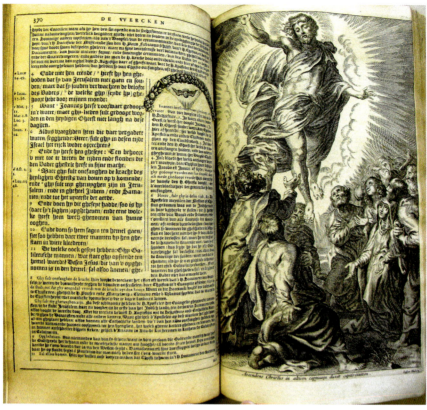

FIGURE 20.3 Acts 1:4–11, with cut and pasted-in *Garland and Holy Spirit*, and sewn-in *Ascension* by Gaspar Huybrechts, from *Het Nieu Testament onses Heeren Iesu Christi* (Antwerp, Ioachim Trognaesius: 1614) 370–371. Engraving, inserted in folio

MAURITS SABBEBIBLIOTHEEK, KATHOLIEKE UNIVERSITEIT, LEUVEN

1984–2004) 3:417–412 no. 845, 4:271–272 no. 1065, 5:399–400 no. 1478; Depauw G. – Luijten G., *Antoon van Dyck en de prentkunst*, exh. cat., Museum Plantin-Moretus, Antwerp / Stedelijk Prentenkabinet, Antwerp; Rijksmuseum, Amsterdam (Antwerp: 1999) 370–371; Beyer A. et al., *Allgemeines Künstlerlexikon: die bildenden Künstler aller Zeiten und Völker* (Munich: 1992–), vol. 33:529; and Diels A., *The Shadow of Rubens: Print Publishing in 17th-Century Antwerp. Prints by the History Painters Abraham van Diepenbeck, Cornelis Schut, and Erasmus Quellinus II* (London: 2009) passim. On Cornelis Galle II the Younger (1615–1678), engraver-publisher, son of Cornelis Galle the Elder and father of Cornelis Galle III, see Rombouts – Van Lerius, *Liggeren* 2:passim; Thieme – Becker, *Allgemeines Lexikon* 13:106; Van Heurck, *imayes de dévotion* 58; Hollstein F.W.H. et al., *Dutch and Flemish Etchings, Engravings, and Woodcuts, ca. 1450–1700*, 72 vols. (Amsterdam: 1940–2010) 7:62–72; Duverger E., *Antwerpse kunstinventarissen uit de zeventiende eeuw*, 13 vols. (Brussels: 1984–2004) 8:211–212 no. 2413; Beyer et al., *Allgemeines Künstlerlexikon*, vol. 48:8; Verheggen E.M.F., *Beelden voor passie en hartstocht:*

A CUSTOMISED COPY OF COSTERUS'S DUTCH *NEW TESTAMENT* 605

intercalated: small-scale prints, anonymously engraved for the most part, were cropped and pasted directly into the spaces above or below the marginal glosses, where they correlate to the immediately adjacent annotations whose exegetical function they variously inflect [Fig. 20.4]; full-page prints, ranging from quarto- to folio-size, were bound in between the relevant pages whose scriptural verses and glosses they elucidate [Fig. 20.5]. More often than not, the finer workmanship of the larger prints commands attention, and attentive viewing becomes a kind of asymptotic referent for close reading of the correlative verses and glosses. But the small prints, even when crudely worked, also capture the viewer's interest by virtue of their miniature size, which compels close viewing. The full-page inserts spread their nets widely, usually referring to multiple annotations ranged on the pages before and after; the images

bid- en devotieprenten in de Noordelijke Nederlanden, 17de-18de eeuw (Zutphen: 2006) 189, 278; Diels, *Shadow of Rubens*, passim; Bowen K.L., "Declining Wages for the Printing of Book Illustrations: Arrangements between the Galle Family of Printmakers and the Managers of the 'Officina Plantiniana' in Seventeenth-Century Antwerp", *Bijdragen tot de geschiedenis, bijzonderlijk van het aloude Hertogdom Brabant* 87 (2004) 63–85; eadem, "Workshop Practices in Antwerp: The Galles", *Print Quarterly* 26 (2009) 123–142; Bowen K. – Imhof D., "Exchanges between Friends and Relatives, Artists, and their Patrons: The Correspondence between Cornelis Galle I and II and Balthasar Moretus", *Monte Artium: Journal of the Royal Library of Belgium* 3 (2010) 88–113. On Gaspar Huybrechts (Gasparus Huberti) (1619–1684), engraver and prolific print-publisher, see Rombouts – Van Lerius, *Liggeren* 2:214, 241, 297, 331, 334, 339, 359, 361, 390, 412, 499, 502, 515; Wurzbach A. von, *Niederländisches Künstler-Lexikon auf Grund archivalischer Forschungen bearbeitet*, 3 vols. (Vienna: 1906–1911) 1:731; Thieme – Becker, *Allgemeines Lexikon* 18:196–197; Van Heurck, *Images de devotion* 67; Jacobs J.H.M., "Vroomheid in prenten: de prentjesverzameling in het Museum voor Religieuze Kunst", in Liebergen L. van – Rooijakkers G.W.J. (eds.), *Volksdevotie: beelden van religieuze volkscultuur in Noord-Brabant* (Uden: 1990) 112–118; Thijs, *Antwerpen* 23, 34, 39, 106, 151; Duverger, *Antwerpse kunstinventarissen* 5:249 no. 3651, 8:211–212 no. 2413, 9:376–377 no. 2940, 11:132–133 no. 3555, 249–255 no. 3651; Verheggen, *Beelden voor passie* 136, 167, 248–249, 257; and Lemmens F. – Thijs A.K.L., "Van 'cunst' tot populair beeldmateriaal. Van Merlen: twee eeuwen prentenproductie te Antwerpen (1600-circa 1830)", in Pauwels H. et al., *Liber memorialis Erik Duverger: bijdragen tot de kunstgeschiedenis van de Nederlanden* (Wetteren: 2006) 91–129. On Alexander Voet (1608–1609), an engraver-publisher based in Antwerp whose print publishing business numbered sixty to seventy employees in 1665, including illuminators, printers, and engravers, see, Rombout – Van Lerius, *Liggeren* 1:664, 2:passim; Van Heurck, *Images de devotion* 58; Thieme – Becker, *Allgemeines Lexikon* 34:471; Duverger, *Antwerpse kunstinventarissen* 3:358–360 no. 805, 417–420 no. 845, 7:80 no. 1957, 8:211–212 no. 2413, 11:144 no. 3569, 164 no. 3581, 249 no. 3651, 325–237 no. 3717, 351–354 no. 3739, 420–422 no. 3784, 531–536 nos. 3889–3890, 569–579 no. 3918, 12:22–24 no. 3945, 58–60 no. 3972; Hollstein et al., *Dutch and Flemish Etchings, Engravings, and Woodcuts* 42:7–48; Jacobs, "Vroomheid in prenten", in Liebergen – Rooijakkers (eds.), *Volksdevotie* 112–128; Thijs A.K.L., *Antwerpen: internationaal uitgeverscentrum van devotieprenten, 17de-18de eeuw*, Miscellanea neerlandica 7 (Leuven: 1993), passim; Verheggen, *Beelden voor passie*, passim; and Lemmens – Thijs, "Van 'cunst' tot populair beeldmateriaal", in Pauwels et al., *Liber memorialis*, 91–130, esp. 114–115.

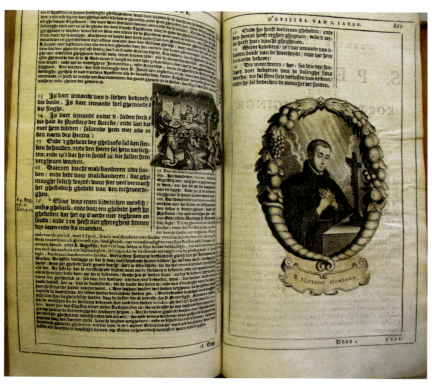

FIGURE 20.4 James 5:13–20, with cut and pasted-in *Death of a Sick Man, with Monks, Lay People, and the Devil at his Bedside,* and cut and pasted-in *Saint Aloysius Gonzaga in Prayer,* from *Het Nieu Testament onses Heeren Iesu Christi* (Antwerp, Ioachim Trognaesius: 1614) 866–867. Engraving, inserted in folio
MAURITS SABBEBIBLIOTHEEK, KATHOLIEKE UNIVERSITEIT, LEUVEN

become a point of mutual reference for these glosses, concatenating them, so that a sequence of pages becomes a thematic network, a notional gathering centred on a shared theme.

The book's owner, as we shall see, may have been a person, male or female, affiliated with the Jesuits, either as a patron, student, or congregant, or alternatively, a member of the order, or, a third possibility, a corporate entity – say, a group of teachers at one of the order's houses of study, or the residents of a novitiate house. Costerus, in his dedication to the pious reader, envisions multiple readerships: having ascribed the impetus for his Dutch New Testament to his superiors in the Society, fellow Jesuits whom he characterises as learned, he then avers that the book will be profitable, first, to full-fledged Catholics, sure of their faith but desirous of patristic arguments wherewith to counter heresies; second, to those in whom the prevalence of heresies has introduced

A CUSTOMISED COPY OF COSTERUS'S DUTCH *NEW TESTAMENT* 607

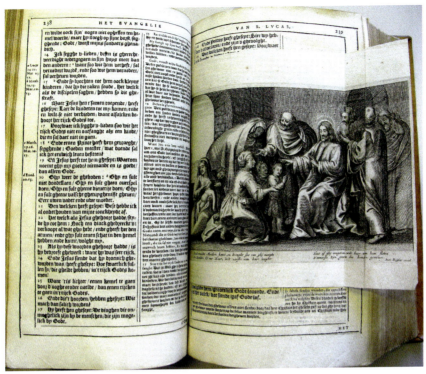

FIGURE 20.5 Luke 18:14–27, with sewn-in *Suffer the Children to Come unto Me*, from *Het Nieu Testament onses Heeren Iesu Christi* (Antwerp, Ioachim Trognaesius: 1614) 238–239. Engraving, inserted in folio
MAURITS SABBEBIBLIOTHEEK, KATHOLIEKE UNIVERSITEIT, LEUVEN

doubts, and who wish to be assured of the foundations of their faith; and third, to heretics themselves, who will discover how the unified doctrine of the Roman Church has the power to curtail their falsehoods [Fig. 20.6].[4] With these functions in mind, my chapter highlights the care and ingenuity with which the devotional prints were placed, examines their triple function *in contextu* – exegetical, meditative, and controversialist – and explicates the visual-verbal hermeneutic that animates this richly customised book.[5]

4 Costerus, "Tot den Godtvruchtighen leser", in *Het Nieu Testament*, fol. **3 r–v (B-edition).
5 By inserting devotional prints to comment on the relation between the Gospels and Costerus's glosses, the book's owner aligned it in format, and to some extent in function, with a type of prayerbook popular in the Low Countries; modeled on illuminated breviaries, missals, and books of hours, these prayerbooks consisted of printed images – engravings or woodcuts – pasted, sewn, or bound into a manuscript *liber precum* or *gebedenboek*. Just as the language of the prayers was adapted to respond to the adjacent images, so conversely,

TOT DEN
GODTVRVCHTIGHEN
LESER.

Oor de begheerte van Christene ende gheleerde persoonen, ende namelick van mijn' Ouerste in onse Societeyt, hebbe ick gheschreuen korte uytlegghinghen op het gheheel nieu Testament, die profijtelick moghen vvesen in den eersten den volstandighen Catholijcken, die teghen d'opvverpinghe der ketteren het vvaerachtich verstandt der Schrifture na d'uytlegghinghe der ouder Vaderen hier sullen vinden, als sy van de ketttersche nieuvve verdichte verstanden hooren: ten anderen den tvvijfelachtighen, die den oprechten sin begheeren ende soecken: ten derden den herdtneckighen ketteren, der vvelcker loghenachtighen mondt hier mede klaerlick ghestopt vvordt, als sy d'eendrachtighe leeringhe der heyligher Kercke met de Schrifture bevestight sien; ende daer teghen niet inhouden, maer in alles daer mede ouereenkomen: vvant het gheschil tusschen ons ende onse ketttersche vernieuvvers en is niet gheleghen in de Schrifture, (soo den heylighen Hilarius vvel seght) maer in't verstandt dat sy na hun goedtduncken versinnen; maer vvy het oudt, van de heylighe Kercke ons ouerghegheuen, bevvaren: van de vvelcke ghelijck vvy den text der Schrifturen ontsanghen hebben, alsoo hebben vvy oock den oprechten sin daer mede ontsanghen. Desen Catholijcken sin sult ghy in desen mijnen boeck met Godts gratie hebben: dien ick v rade vvel t'ouerleggen, ende met de leeringhe der heyligher Kercke te voeghen; op dat ghy den ouderdom van beyde mooght ghevvaer vvorden, ende v van alle nieuvvicheydt der ketteren vvachten: vvant in't ghene dat Godt ende sijn heylich vvoordt aengaet, en moet men gheene nieuvvicheydt bijbrenghen, noch op sijn eyghen duncken staen; maer het oudt vvel begrijpen, bevvaren, ende bevestighen. Dat oudt is, komt van Godt: de nieuvvicheydt is der menschen dichtinghe, ende daerom voor suspect te houden; ghelijck selfs de ketters die voor sulcks houden, aenghesien dat sy by de leeringhe ende uytlegghinghe hunner mede-ketteren niet en blijuen, maer iet nieus, dat hen aenstaet, versinnen. Hier af komt het dat niemandt en vvilt Caluinist oft Lutheraen ghenoemt vvorden, dat is, in alles volghende d'uytlegghinghe van Caluijn oft Luther; maer Euangelisch oft Gherefor-

** 3 meert,

FIGURE 20.6 "Tot den Godtvruchtighen leser", from *Het Nieu Testament onses Heeren Iesu Christi* (Antwerp, Ioachim Trognaesius: 1614), fol. **3 recto

A CUSTOMISED COPY OF COSTERUS'S DUTCH *NEW TESTAMENT*

Costerus, in his prefatory remarks addressed to the States General of Holland, Zeeland, and their sister provinces, justifies his glossate New Testament on several grounds. Comparing it to earlier publications such as the "[Acht] Catholijcke propositien teghen alle nieuwe sectarisen" (Eight Catholic Propositions in Opposition to All New Sectarians) in *Schildt der Catholijcken, teghen de ketterijen* (Shield of Catholics against Heresies) (1591), he avows that the explanatory annotations are designed to prove that Roman Catholic doctrine, rooted as it is in extra-scriptural traditions sanctified by the Fathers and authorised by the Church, in no way contravenes the canonical Scriptures; rather, these traditions, as vindicated by his comments, fully complement and amplify the teachings distilled throughout the New Testament, in the manner of a well-argued gloss.[6] Against the enemies of the Roman Church who claim that she

the presence of the adjacent texts led to adjustments in the ways the images were read. In this copy of *Het Nieu Testament*, the conjunction of scriptural texts, exegetical annotations, and devotional images likewise constitutes a verbal-visual apparatus in which the mutual implications of the texts and images invite close reading. Indeed, the book in its amended form could easily be utilised as a series of image-based spiritual exercises. Early versions of the type of prayerbook on which the amendments to *Het Nieu Testament* appear to have been modeled first appeared in the late fifteenth century; see Weeks U., *Early Engravers and their Public: The Master of the Berlin Passion and Manuscripts from Convents in the Rhine-Maas Region* (Turnhout: 2004) 101–185. For later examples of such multimedia prayerbooks, in which interpolated prints alter the ways that sacred texts were read and meditative spiritual exercises were practiced, see Melion W.S., "Convent and *cubiculum cordis*: The Incarnational Thematic of Materiality in the Cistercian Prayerbook of Martin Boschman (1610)", in Melion – Wandel L.P. (eds.), *Image and Incarnation: The Early Modern Doctrine of the Pictorial Image, 1400–1700*, Intersections: Interdisciplinary Studies in Early Modern Culture 39 (Leiden – Boston: 2015) 413–458; idem, "*Libellus piarum precum* (1575): Iterations of the Five Holy Wounds in an Early Jesuit Prayerbook", in De Boer W. –. Enenkel K.A.E – Melion (eds.), *Jesuit Image Theory*, (Leiden – Boston: 2016) 189–253; and idem, "'Eyes Enlivened and Heart Softened': The Visual Rhetoric of Suffering in *Gebedenboek Ruusbroecgenootschap* HS 452", in Graham H. –Kilroy-Ewbank L.G. (eds.), *Visualizing Sensuous Suffering and Affective Pain in Early Modern Europe and the Spanish Americas*, Brill's Studies on Art, Art History, and Intellectual History (Leiden – Boston: 2018) 269–312. The use of prints as integral embellishments of prayerbooks is traceable to an earlier development – the use of portable illuminations in Books of Hours – on which, see Rudy K., *Postcard on Parchment: The Social Lives of Medieval Books* (New Haven – London: 2015) 75–223. Useful in thinking through the kinds of active readership posited by systems of interpolated images, in/through an 'operative chain' consisting on the one hand of cultural artefacts and technologies, on the other of 'culturally determined procedures', is Manuwald H., "How to Read the 'Andachtsbüchlein' aus der Sammlung Bouhier (Montpellier BU Médecine, H 396). On Cultural Techniques Related to a Fourteenth-Century Devotional Manuscript", in Stead E. (ed.), *Reading Books and Prints as Cultural Objects*, New Directions in Book History (Cham: 2018) 57–80.

6 Costerus, "Aen d'edele moghende ende machtighe Heeren de Staten van de Genunieerde Provincien van Hollandt, Zeelandt, etc.", in *Het Nieu Testament*, fols. *3r–v (B-edition). Cf. Costerus Franciscus, s.j., *Schildt der Catholijcken, teghen de Ketterijen: inhoudende de*

diverges from Scripture by cleaving to practices explicitly licensed nowhere in the Bible, Costerus rejoins that these practices originate in unbroken apostolic and patristic traditions founded by Christ himself through the action of the Holy Spirit. Implicitly relying on John 21:25 – 'But there are also many other things which Jesus did, which, if they were written every one, the world itself, I think, would not be able to contain the books that should be written' – he states that much of what Christ taught the apostles was left unwritten, and nor did he command them to record everything they saw and heard. Moreover, the traditions upheld by the Church can also be defended biblically, either because they contravene nothing expressly stated in the Bible, or because they can be found to have an exegetical warrant, if not a literal one, by recourse to patristic exegesis. For instance, according to the Church Fathers – Tertullian and Basil, to name but two – the term *consubstantiale* ('van eender nature', of one nature), though it does not appear in the New Testament, has an apostolic pedigree extending back to the founding of the Church, a lineage so authoritative that it can be seen as rooted in the blood shed by Peter and Paul to establish the Roman Church: 'The other thing the aforesaid olden teachers say is that with respect to questions or doubts about the Church, or to novelties, one must send the doubters to the ancient Church founded by the apostles; and namely, to Rome where Saint Peter and Saint Paul (so says Tertullian) left their entire doctrine, pouring it forth with their blood'.[7]

The Trinitarian doctrine of co-existence in the same substance can also be derived from patristic exegesis, demonstrates Costerus, when he avers shortly thereafter, on the basis of Romans 12:6 – 'And having different gifts according to the grace that is given us, [as] prophecy, to be used according to the rule of faith' – and 1 Corinthians 14:3 – 'But he that prophesieth speaketh to men unto edification, and exhortation, and comfort' – that exegesis of Scripture, when it follows the usage of the Fathers, has a force equal to that of prophetic utterance. As he puts it: 'Further, we hold fast to the interpretation of the Holy Fathers, and the teaching of the Holy Church; thus Saint Paul counsels

 principaelste gheschillen, die in onsen tijden opgheresen zijn in t'geloove, met een oprechte verclaeringe der selver (Antwerp, By de Weduwe C. Plantijn en Jan Mourentorf: 1591), fols. f3v–f6r.

7 Costerus, *Het Nieu Testament*, fol. *3v: 'Het ander dat de voorseyde oude Leeraers segghen, is, dat men in alle Kerckelicke questien, oft twijfelinghen, oft oock nieuwicheden, dese twijfelaers sal senden tot d'oude Kercken van de H. Apostelen ghefondeert; ende namelick te Roomen daer Sinte Peeter ende Sinte Pauwels (seght Tertullianus) met hun bloedt hunne gantsche leeringhe uytghestort ende ghelaten hebben'. Costerus implicitly alludes to the doctrine of consubtantiality defended by Basil in *De spiritu sancto* and by Tertullian in *Adversus Praxeam*.

A CUSTOMISED COPY OF COSTERUS'S DUTCH *NEW TESTAMENT* 611

us that prophecy, that is, scriptural interpretation, is like unto faith'.[8] Costerus undoubtedly has in mind Paul's close readings of the prophets to recount the life and death of Christ in Hebrews 1:5–13, 5:5–6, 7:17–21, 8:8–12, and 10:5–16. He adds that it is useless to contradict heresy by reference to Scripture, since heretics willfully misread the Bible: instead, one must adduce the Fathers, closely emulating their works as do contemporary exegetes such as Alphonsus Salmeron, Cardinals Toletus and Bellarmine, Ruardus Tapper, Cornelius Jansen, and Joannes Maldonatus.[9]

If Costerus authorises his anti-heretical exegetical apparatus by anchoring his glosses in the scriptural writings of Augustine, Ambrose, Gregory, Jerome, Basil, Tertullian, and the other Fathers, he does so to defend two traditions of the Church in particular: the cult of saints and the cult of images. He views the two practices – the veneration of saints and of images – as virtually identical, in that saints are revered as representatives of God, and holy images as representations of God and his saints. As the halt, lame, and sick sought to be healed by the shadow of Saint Peter, in Acts 5:15–16, venerating him by way of the image he cast, howsoever imperfect the likeness, so images of the saints are venerated in the way the name of Jesus is honored: it is Jesus himself, not the breath that gives voice to the Holy Name, whom one worships, and likewise, it is not the image but the person portrayed who is reverenced.

> I answer that we invoke the saints not as gods, but as God's servants, desiring their prayers as did Saint Paul when he wrote [in *Romans* 15:30–33: 'I beseech you therefore, brethren, through our Lord Jesus Christ, and by the charity of the Holy Ghost, that you help me in your prayers for me to God']. Honoring and praying to images (*beelden*), we do not take them for gods (as the pagans were wont to do), but honor the saints therein, as did those who sought to lie in the shadow of Saint Peter in order to be healed: for a shadow is nothing more than an imperfect image. And we honor Christ in this fashion: just as kneeling when we hear the name Jesus, we worship the person of Jesus, whose name is thus signified, not the breath that transmits the word Jesus. So, too, we honor the saints whom the images signify. What can be said against this, inasmuch as the Fathers of

8 Ibid., fol. *4r: 'Voordt houden wy ons aen d'uytlegghinghe der H. Vaderen, ende aen de leeringhe der H. Kercke; soo ons S. Pauwels vermaent *dat de prophecije*, dat is, d'uytlegghinghe der Schrifture, *den gheloove ghelijck zy*'.

9 Ibid., fol. *4v.

old, for more than 1,200 years, even back to the apostles, have taught and written about it in this wise, as they had it from their forefathers?[10]

When s/he appended pictorial images to align with Costerus's glosses, the visual exegete who customised their copy of *Het Nieu Testament* was operating within a patristic frame of reference, using representational means approved by the Fathers, to defend the scriptural foundations of the Roman Church's age-old traditions (Figs. 20.3, 20.4, & 20.5). Following Costerus, s/he was engaging in an activity inspired by the Spirit, walking in the footsteps of the prophets whose pronouncements had foreseen the life, death, and triumph of Christ and of his Church. The interpolated *beelden*, in addition to commenting on the annotations and affiliated biblical verses, exemplify the Catholic commitment to images as secondary sources of primary subjects – God the Father, Son, and Holy Spirit, the Virgin, the angels and saints – fit be worshipped, reverenced, or venerated. But, as Costerus indicates at the close of his prefatory remarks, s/he was also doing something more specific – fashioning a counter-image of the Jesuit order whose true image had been defaced and despoiled by its heretical detractors. Costerus addresses the Reformed leaders of the States General:

> I know well that in your lands no order is more hated, censured, or defamed by so many slanderous broadsides than we Jesuits, who are painted more hideously than the devil himself: yet, whoever knows us, and daily treats with us, can ascribe to us nothing but virtue and honor. They confess openly about us that one can speak neither of indulgence in eating and drinking, nor of unchastity (for our Rule, which we strive to fulfill, enjoins angelic purity upon us), or of disputes, hatred and envy, discord, enmity, etc.; on the contrary, we inculcate youths with every virtue, spiritual and temporal, and with learning, both the poor and the rich, to the fullest extent of our capacity. They see the great concord and love

10 Ibid., fol. *5r: 'Ick andwoorde dat wy de Heylighen niet en aenroepen als Goden, maer als Godts dienaers; begheerende hunne ghebeden, ghelijck S. Pauwels der ghener daer hy aen schreef. Ende eerende de beelden en aenbidden wy die niet voor Goden, (ghelijck de Heydenen plegen) maer wy eeren de Heylighen daer in, ghelijck de ghene die in S. Peeters schaduwe sochten te ligghen, om van hem alsoo gesondt te worden; want eene schaduwe en is niet anders dan een onvolmaeckt beeldt. Ende wy eeren daer Christum oock mede; ghelijck wy oock doen knielende voor den naem Iesus, als wy dien hooren noemen: want ghelijck wy den windt niet en aenbidden, die dat woort Iesus voert; maer den persoon Iesum; die door dien name beteeckent wordt; alsoo eeren wy in de beelden die Heylighen, die daer mede beteeckent worden. Wat is hier teghen te seggen, als d'oude Vaders over 1200. iaren, ende voorder tot d'Apostelen, het selve ons hier af ende van diergelijcke gheleert ende gheschreven hebben, dat sy van hunne voorvaders ontfanghen hadden'?

A CUSTOMISED COPY OF COSTERUS'S DUTCH *NEW TESTAMENT* 613

amongst us, and that so many incline toward this condition that there are not enough places for all of them, even though about thirty Colleges now exist in the Netherlands.[11]

The book's owner responded to these polite yet provocative remarks by appending beatific images of Saint Ignatius of Loyola, co-founder of the Society, and Saint Francis Xavier, one of his foremost followers, at the close of the Gospel of Matthew [Fig. 20.7].[12] The oval format of the two portrait prints jibes with that of the icon they flank, which depicts Mary sewing a garment for the boy Jesus; while she labours on his behalf, he labours on hers, holding a book, presumably the Bible, and using it to instruct her. The implication is that Ignatius, who displays an open book with the Society's motto, 'For the greater glory of God', an allusion to its vocation of labouring for the Lord, and Francis Xavier, whose lily alludes to his Marian purity, maintained during years of arduous missionary activity in Asia, are close imitators of both the Virgin and child: they apply their hands, minds, and hearts to the task of promulgating the gospel of Christ.

11 Costerus plays upon the verb *schilderen*, ironically accusing anti-Jesuit Dutch iconoclasts of having fashioned a false image of the Society of Jesus; see ibid., fols. **1v–**2r: 'Ick wete wel dat in uwe landen gheene vergaderinghe alsoo ghehaet, gheblameert, ende met soo veel laster-boeckskens befaemt en wordt, als wy Iesuiten; die leelicker gheschildert worden dan den duyvel selfs: maer die ons kennen ende daghelicks met ons handelen, en weten van ons niet anders dan deughdt ende eere te segghen: sy belijden openlick, dat men by ons niet en weet te spreken van overdaedt in't eten ende drincken, noch van onkuyscheyt, (want ons wordt in onsen Reghel bevolen Enghelsche reynicheydt, die wy oock porren na te volghen) noch van kijvagien, hact ende nijdt, twist, tweedracht, etc. maer dat men de ionckheyt in alle deughden ende geleertheydt onderwijst, ende den volcke soo wel den armen als den rijcken, in't gheestelick ende tijdelick, na onse macht behelpich is: sy sien groote eendrachticheyt ende liefde onder malckanderen; die-der so veel tot desen staet beweeght, dat men voor alle gheene plaetse en vint, hoe wel nu in Nederlandt omtrent dertich Collegien sijn'. Costerus then adds that he has lived as a Jesuit for more than sixty years, doing his best to unmask heresy and striving like a shepherd to return errant Catholics to the sheepfold of Christ: 'Ick, die nu meer dan sestich iaren in desen staet leve, en hebbe in onse Societeyt noyt iet anders ghevonden dan goedtheydt, Godtvruchticheydt, gheleertheydt, ende grooten yver in eenen-ieghelicken, om de verdoolde schapen in den waerachtighe schaeps-stal Christi te brenghen, ende het bedroch der ongheloovighe in't openbaer te toonen'.

12 Ibid. 100–101. Also see the discussion *infra* of the preface to the canonical epistles of Saints James, Peter, John, and Jude, "Van de Catholiicke oft Canoniicke Brieven", in ibid. 844–845, embellished with prints of *Blessed Aloysius Gonzaga, s.j. in Prayer* and the *Communion of Blessed Stanislaus Kostka*, with *Blessed Franciscus Borgia, s.j. Receiving the Sacred Heart and Offering his Heart in the Presence of the Trinity, Mary, and Saints Ignatius and Francis Xavier* (Fig. 20.8).

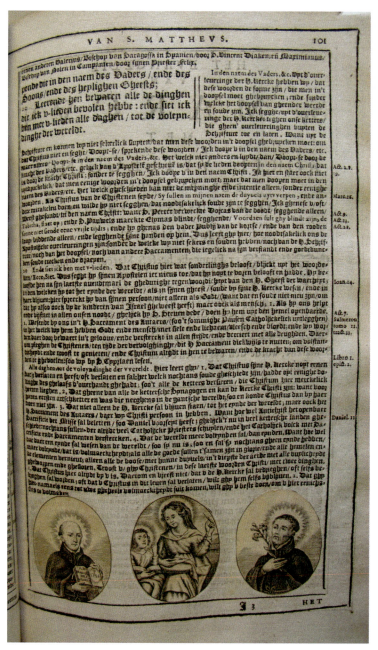

FIGURE 20.7　Matthew 28:17–20, with cut and pasted-in *Saints Ignatius and Francis Xavier Flanking the Virgin and Child*, from *Het Nieu Testament onses Heeren Iesu Christi* (Antwerp, Ioachim Trognaesius: 1614) 100–101. Engraving, inserted in folio
MAURITS SABBEBIBLIOTHEEK, KATHOLIEKE UNIVERSITEIT, LEUVEN

A CUSTOMISED COPY OF COSTERUS'S DUTCH *NEW TESTAMENT* 615

Positioned directly after annotation 20, which qualifies Matthew 28:20 –
'Teaching them to observe all things whatsoever I have commanded you. And
behold I am with you all days, even to the consummation of the world' – the
virtual triptych precisely correlates to Costerus's topical reading of the final
sentence, not least to his emphasis on its opening word, 'Ecce' (Behold). He
points out that Christ is imparting new information, asking the apostles to
visualise something they have not heard previously: whereas at the Last Supper
he promised that he would be with them in spirit, present in and through the
Holy Ghost, until the end of the world, now he pledges that he will accom-
pany them jointly in the spirit *and* the flesh, both as God and as man, fully
attentive to their every need, in the way he showed himself to Saint Stephen
at the moment of his martyrdom. The instrument that guarantees his total
presence, simultaneously as soul and body, is the Eucharist, whereby every
good Christian is preserved in faith, strengthened in adversity, ornamented
with virtues, and consoled in spirit, as Saint Cyprian affirms (*Epistola* 1.2).
Furthermore, continues Costerus, Christ assures his followers that as long as
the Church exists, he shall never desert it, in contradistinction to whatever the
heretics assert about his abandonment of the Roman Church and residence in
their allegedly reformed temples or, better, 'synagogues'; for how could he fulfill
his promise to be eternally with the Church he founded, if that church, being
newly coined, is, temporally speaking, a mere novelty. Even in those places –
i.e., the Northern Netherlands – where the public celebration of the Catholic
Eucharist is forbidden, he will remain present through the clandestine activi-
ties of concealed priests ('nochtans sullen-der altijdt veel Catholijcke Priesters
schuylen'), sworn to uphold the liturgy and combat the Anti-Christ. Confident
in their ministers, all adherents of the true faith must continually strive to per-
fect themselves, even while awaiting the transcendent life to come; Costerus
urges them to remain sure in the knowledge that the world is fated not merely
to end but to be consummated when, with Christ's coming, it finally achieves
true perfection ('gheheele volmaecktheydt').[13]

The inserted prints, seen in light of annotation 20, identify Ignatius, Francis
Xavier, and their fellow Jesuits as executors of the apostolic command issued
by Christ. Responsive to the apostrophic 'Ecce', they swivel left and right
respectively, as if turning to gaze at Jesus, in imitation of the Virgin. That he is
shown as a child beside Mary evokes the mystery of the Incarnation, his dual
nature as God made flesh: his boyhood underscores his vulnerable humanity,
whereas his action of teaching from the book of Scripture insists on his divinity.
Combined with the pendant portraits of Ignatius and Francis Xavier, he thus
perfectly illustrates Costerus's assertion that Christ is ever present to his true

13 Ibid. 101.

ministers, whom he promises to accompany until the final end of the world. The reference to hidden priests who celebrate the liturgy in places where it is banned, pointedly calls to mind the Jesuit investment in the *Missio Hollandica*, focussed on saving souls in the United Provinces. In short, the Society of Jesus is portrayed as heir to the message of Matthew 28:20 as elucidated by Costerus. On the model of Saint Stephen, they are seen to embody fervent belief in the presence of Christ, whose promise to keep them company, bodily and spiritually, is fulfilled not only during the sacrifice of the Mass, but also wherever and whenever they strive to spread the Gospel:

> Here he speaks about his own person, not only as God (for that would be nothing new, since as such he had accompanied the children of Israel), but also as man: first, given that he assists and stands by us in our every need, as he did for Saint Stephen when from heaven he revealed himself to him; second, being with us in the Holy Sacrament of the altar (as certain Catholic Popes have explained), wherein we have him as God and man, soul and body, flesh and blood, being thereby preserved in faith, fortified in battle, and adorned with every virtue.[14]

Portraits of the next generation of Jesuit saints make an appearance at another crucial spot, later in the book – this time at the end of the preface to the "Catholic or Canonical Epistles", i.e., the seven letters written by Saints James, Peter, John, and Jude, not to specific congregations but more generally [Fig. 20.8]. The term 'canonical', explains Costerus, designates the polemical force of these letters, which were written to contest the heresy, advanced in pseudo-apostolic epistles, that faith alone was enough to secure salvation. Citing 2 Peter 1:10–11 – 'Wherefore, brethren, labour the more, that by good works you may make sure your calling and election' – and paraphrasing Augustine's *De fide et operibus* (cap. 14), Costerus propounds an apostolic and patristic defense of the doctrine of good works:

> Saint Augustine writes that at the time of the apostles, there were some who found cause for falsely interpreting Saint Paul's letters (as Saint Peter also professes), and namely, concerning the sufficiency of faith (for they

14 Ibid.: 'Hier spreeckt hy van sijnen persoon, niet alleen als Godt, (want dat en soude niet nieu zijn, om dat hy alsoo oock by de kinderen van Israel gheweest heeft) maer oock als mensch: 1. Als hy ons helpt ende bijstaet in allen onsen noodt, ghelijck hy S. Steven dede, doen hy hem uyt den hemel openbaerde. 2. Wesende by ons int H. Sacrament des Autaers, (soo't sommighe Pausen Catholijckelick uytlegghen) in het welck wy hem hebben Godt ende mensch, met siele ende lichaem, vleesch ende bloedt; ende wy worden daer door bewaert in't geloove, ende versterckt in allen strijdt, ende verciert met alle deughden'.

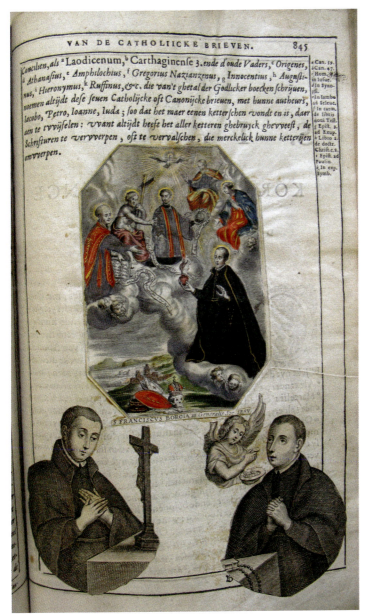

FIGURE 20.8 "Van de Catholiicke oft canoniicke brieven", with cut and pasted-in *Blesseds Aloysius Gonzaga and Stanislaus Kostka*, and *Francis Borgia Kneeling before the Trinity, the Virgin, and Saints Ignatius and Francis Xavier*, from *Het Nieu Testament onses Heeren Iesu Christi* (Antwerp, Ioachim Trognaesius: 1614) 844–845. Engraving, inserted in folio
MAURITS SABBEBIBLIOTHEEK, KATHOLIEKE UNIVERSITEIT, LEUVEN

took it from his words and doctrine, as our heretics also do, that good works are not necessary for salvation, but that it is enough to believe in Christ); the four apostles, James, Peter, John, and Judas, wrote these letters against the heretics, wherein they expressly teach the necessity of good works with faith.[15]

Our visual exegete this time cut and pasted prints of three further Jesuits – Saint Francis Borgia, and the Blessed Aloysius Gonzaga and Stanislaus Kostka – who are thereby characterised as defenders, in the lives they led as members of the Society, of the integral doctrine of faith and works. They are also implicitly enshrined within an apostolic canon of orthodox churchmen. Gonzaga and Kostka are portrayed with their chief attributes: the former gazing at the crucifix he clutched before he died, the latter receiving Holy Communion from an angel sent by Saint Barbara. Francis Borgia, the Society's third Father General, is shown kneeling before Christ, whom he offers his heart, in accordance with *Proverbs* 23:26, inscribed on the banderole between them: 'My son, give me thy heart, [and let thy eyes keep my ways]'.[16] Ignatius, quoting 1 *Corinthians* 12:31, invites Borgia to accept the way of life he proffers: 'And I shew unto you yet a more excellent way'.[17] He displays an open book inscribed 'Constitutions of the Society of Jesus', and bearing a line from *Luke* 10:28: 'This do: and thou shalt live'.[18] Francis Xavier, holding the orb of the world, cites *John* 12:19 to declare his aspiration of converting all peoples: 'Behold, the whole world is gone after him'.[19] Together, the three prints asseverate that these holy men, like the Society they represent, epitomize the power of good works to defend the faith against heretical encroachments of every kind. Their inspiring lives, in the effect they have on devotees, are analogized to the 'upright and Catholic' ('oprechte ende Catholijcke') letters sent by their apostolic forebears properly to evangelise the world.[20]

15 Ibid. 844: 'Sint' Augustijn schrijft dat daer ten tijde der Apostelen sommighe waren die uyt S. Pauwels brieven oorsake van dolinghen namen, (het welck oock S. Peeter bekent) ende namelick van de ghenoechsaemheydt des gheloofs, (want sy namen uyt sijne woorden ende leeringhen, soo oock onse ketters doen, dat de goede wercken ter salicheydt niet van noode en waren; maer dat het ghenoech was in Christum te ghelooven) ende dat vier Apostelen, Jacobus, Petrus, Ioannes, ende Judas, teghen die ketters dese brieven gheschreven hebben; daer sy ons uytdruckelick leeren de noodtsakelickheydt der goeder wercken met het gheloove'. Cf. *De fide et operibus*, in *Corpus scriptorum ecclesiasticorum latinorum 31 (sect. V pars III): Sancti Aureli Augustini opera*, ed. J. Zycha (Vienna: 1887) 61 64.

16 'Praebe fili mi cor tuum mihi'.

17 'Adhuc excellentior[e]m viam vobis demonstro'.

18 'Hoc fac, et vives'.

19 'Ecce, mundus totus post eum abyt'.

20 Costerus, *Het Nieu Testament* 844.

A CUSTOMISED COPY OF COSTERUS'S DUTCH *NEW TESTAMENT*

The book's owner often introduced images to call attention to and elaborate upon a point Costerus makes in the margin: s/he occasionally does this by triangulating between an annotation and a related but unannotated verse. Take the cut-out images of Christ the Judge, enthroned in heaven, and a kneeling votary, his arms crossed in homage to the wounds of Christ, on page 71 (Fig. 20.9). The collaged prints illustrate Matthew 23:22: 'And he that sweareth by heaven sweareth by the throne of God and by him that sitteth thereon'. They also connect to annotation 18, which expounds the reprobative admonition of Christ, directed against the scribes and Pharisees, whose hypocrisy he attacks in Matthew 23:18: 'And whosoever shall swear by the altar, it is nothing; but whosoever shall swear by the gift that is upon it is a debtor'. On the contrary, as he goes on to state in verses 19–20, since the altar sanctifies the gift, to swear by it is to swear by 'all things that are upon it'. The votary's cruciform gesture, though it chiefly functions in concert with Matthew's reference to taking an oath upon the throne of God, also implies, by counter-example, that the other kinds of oath-taking, deprecated by the scribes and Pharisees, are in fact likewise sworn in the Lord's name, for the altar is his, and the temple in which the altar stands is his habitation. But the meaning of the image in this context is more complex, for it equally serves to complement Costerus's annotation: he reads verse 18 as a justification of the cult of saints and, implicitly, of the representational logic that undergirds the cult of relics and of images.

> To swear by creatures, to the extent they appertain to God, is to swear by God, their Creator and indweller ('inwoonder'). Thus the heretics speak falsely when they say that one may show spiritual honour to no one other than God: for we invoke the saints in heaven and the places [they lived], their clothes and appurtenances, with reference to God whom they sanctified.[21]

The images of the votary kneeling before the enthroned Christ emphasise that it is he, the Lord himself, toward whom any prayer or oath is ultimately directed, whether by the mediation of a holy place or holy relic. The fact that two separate cut-outs were used to make this case, which is to say, two distinct images, constitutes an implied defense of images, in that the votary can be construed as praying or oath-taking before an image of Christ enthroned.

21 Ibid. 71: 'By de creaturen sweeren, soo sy Godt aengaen, is by Godt sweren, als by haren schepper oft haren inwoonder. Dus segghen onse ketters qualick, dat men niemanden, dan Godt alleen, en mach gheestelicke eere bewijsen: want den Heylighen des hemels, ende der heyligher plaetsen, kleederen, oft instrumenten bewijsen wy die, ten aensiene Godts, die-se heylight'.

FIGURE 20.9 Matthew 23:16–29, with cut and pasted-in *Christ the Judge* and *Kneeling Votary*, from *Het Nieu Testament onses Heeren Iesu Christi* (Antwerp, Ioachim Trognaesius: 1614) 71. Engraving, inserted in folio
MAURITS SABBEBIBLIOTHEEK, KATHOLIEKE UNIVERSITEIT, LEUVEN

A CUSTOMISED COPY OF COSTERUS'S DUTCH *NEW TESTAMENT* 621

Viewed in tandem with annotation 18, the paired prints attest that holy signifiers, whether they be saints, relics, or pictures, lead ultimately to one signified – Christ – who is the source by whom they are made holy.

Elsewhere in the book, prints are interposed to produce a contrastive effect. The image of God the Father on page 72 clearly aligns with Matthew 23:34 [Fig. 20.10]: 'Therefore behold I send to you prophets and wise men and scribes: and some of them you will put to death and crucify: and some you will scourge in your synagogues and persecute from city to city'. God's downcast eyes and benedictory gesture indicate that he is the source of these prophets, whom he sends forth as a blessing, howsoever his people Israel malign and maltreat them. The image is also positioned in relation to annotations 29, 34, and 35, which dwell on the malevolence of Israel's forefathers who silenced and murdered the messengers sent by the Father for their benefit and correction. Forefathers and the Father are counterposed, and by the same token, though prophetically, the sons of these wicked forefathers and the only-begotten Son of the Father, who in a similar fashion will be put to death. Annotation 29, in actual fact, comments as well on verses 30–32, stressing that the scribes and Pharisees truly follow in the footsteps of their malevolent fathers; according to Costerus, this is why Jesus ironically commands: 'Fill ye up then the measure of your fathers'. And when they respond, in verse 30, that had they lived in the days of their fathers, they would not have partaken in the blood of the prophets, he again reproves them, prophesying his death at their hands: 'Thus he says: 'Fill ye up [...]. That is: you shall kill the one your fathers could not, since they died before him. Thus explains [Thomas] Cajetanus, in conformity with Saint Chrysostomus'.[22] Annotation 34 drives home this point, listing the many apostles martyred in Christ's wake: Stephen, James, Simeon, Cleophas, and others. And he concludes this train of thought with the protracted annotation on verse 35: 'That upon you may come all the just blood that hath been shed upon the earth'. Costerus points out that God, although he refrains from punishing children for their fathers' crimes, makes an exception when a people's communal body, its misdeeds continuing unabated from generation to generation, becomes so polluted that the collective weight of sin engulfs and overwhelms them all. The image of God the Father, revisited from this perspective, is less benign than remorseless, the inexorable God of judgement:

> Christ here predicts the total destruction of the Jewish Synagogue: which they deserved, lacking charity, on the one hand because their iniquity

22 Ibid. 72: 'Dus seght hy: *Vervult ghy oock uwer vaderen mate.* Dat is: Ghy sult dooden die uwe vaders niet en habben konnen dooden; om dat sy selfs te voren doodt waren. Alsoo leght Caietanus dit uyt, conformelick met Sinte Chrysostomus'.

FIGURE 20.10 Matthew 23:30–35, with cut and pasted-in *God the Father*, from *Het Nieu Testament onses Heeren Iesu Christi* (Antwerp, Ioachim Trognaesius: 1614) 72. Engraving, inserted in folio
MAURITS SABBEBIBLIOTHEEK, KATHOLIEKE UNIVERSITEIT, LEUVEN

A CUSTOMISED COPY OF COSTERUS'S DUTCH *NEW TESTAMENT* 623

lasted so long, on the other hand because having killed Christ their God, their sins were more unspeakable that all that came before. In saying that they would bear the burden of their foregathers' sins, Christ wished them to know that their punishment would take account of the sins of their ancestors. For since the community that becomes worse and worse, is worst at the last: so it shall be exterminated and repudiated by God, suffering totally for all the transgressions it has committed.[23]

If God the Father's character appears to change as one progresses through verses 18–35, and through annotations 18, 24, 25, 29, 34, and 35, his mediating presence, as supplied by the image, yet joins them into a *catena* – an exegetical chain – that signals how the Father and the Son speak with one voice, and how the God of the Old Testament and of the New become pitiless when a sinful community fails to relent, its sins persisting without pause.

The majority of prints have been interjected discretely: they function singly or in clusters of two or three in close proximity. However, a significant minority cohere into larger clusters extending over several pages, whence they sometimes also refer retrospectively to complementary passages from earlier annotations. One such sequence connects the second half of Mark 15, on the Passion, to the opening verses of Mark 16, on the Resurrection. The serial cluster begins with a small image on page 152 of the crucified Christ closely watched by Mary and John, whose reverent attitudes contrast with those of the two Pharisees who condemn Christ in the full-page *Ecce Homo* interpolated as a facing page [Fig. 20.11]. The Pharisees are shown looking at him from exactly the same position and angle of view as Mary and John, but with contempt rather than devotion; one of them even displays the cross onto which he demands that Christ be nailed. The ironic juxtaposition of the two prints, the small oval immediately above annotation 21, the large *Ecce Homo* beside it, emphatically calls attention to the distinction Costerus draws between Christian empathy and Pharisaic inhumanity in the linked annotations 21 and 25. Annotation 21 qualifies verse 21 on Simon of Cyrene, father of Alexander and Rufus, who was drafted to assist Christ carry the cross; annotation 25 amplifies verse 25 on the

23 Ibid.: 'Dat Christus hier de gantsche destructie der Jodscher Synagoghe voorseght: die sy sonder bermherticheydt verdienden: eensdeels, om dat hunne boosheydt so langh geduert hadde; eensdeels oock, om dat de sonden van dese Joden onsprekelick meerder waren, die Christum hunnen Godt doodden, dan alle de voorgaende. Als Christus dan hen seght, dat dese de sonden van hunne voorvaders sullen draghen; wilt hy te kennen geven, dat in hunne straffinghe oock sullen aengesien worden de sonden der voorvaderen. Want ghemerckt dat die ghemeynte altijdt argher ende argher geworden is, ende nu in't laetste alderarchst: so sal sy uytgeroeyt worden, ende van Godt verworpen; volkomelick lijdende voor al't ghene dat sy tot noch toe misdaen heeft'.

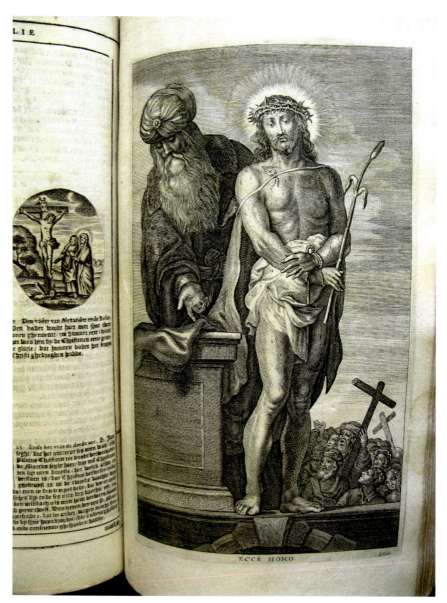

FIGURE 20.11 Mark 15:12–17, with cut and pasted-in *Crucifixion with Mary and John*, and sewn-in *Ecce Homo* by Alexander Voet, from *Het Nieu Testament onses Heeren Iesu Christi* (Antwerp, Ioachim Trognaesius: 1614) 152–153. Engraving, inserted in folio
MAURITS SABBEBIBLIOTHEEK, KATHOLIEKE UNIVERSITEIT, LEUVEN

A CUSTOMISED COPY OF COSTERUS'S DUTCH *NEW TESTAMENT* 625

hour when Christ was crucified.[24] Together the two annotations, like the two images, oppose respect for Jesus and hatred of him. Mark makes a point of mentioning Alexander and Rufus, speculates Costerus, because sharing the burden of the cross was thought by Christ's followers to be a signal honour, the dignity of which passed from Simon to his sons, who themselves became eager Christians. On the contrary, Christ's crucifiers did everything they could to hasten the hour of his death upon the cross:

> Saint John says that it was around the sixth hour when Pilate condemned Christ to death; and Mark says here that he was crucified at the third hour: which is to say that Christ was condemned and crucified during the day's second watch, consisting of three hours; or during the third hour, when prayers were offered in the temple, called *Tertia* in our Hours, or Terce [...]; thus, between the third and sixth hour of the day, or (by our reckoning) between nine and noon. It was midday, therefore, not quite twelve, approaching eleven, when men crucified him. And so we learn from Saint Mark that they very much hastened to crucify Christ: first, in order that he might not die underway from exhaustion; second, lest Pilate, by way of his wife (who was otherwise inclined) should revoke his judgement spoken against his will and conscience.[25]

The emphasis on time and duration as symptoms of malice aforethought, played up by opposition to Simon, Alexander, and Rufus's embrace of the cross, is further heightened by the next full-page image, which portrays Christ's sixth to ninth hours on the cross, when darkness covered the whole earth (Mark 15:33) [Fig. 20.12]. Engraved by Alexander Voet, the print turns Jesus and the cross toward the viewer, so that his eyes directly meet ours; the conspicuous inscription 'King of the Jews', in Hebrew, Greek, and Latin (Mark 15:26),

24 Ibid., 152.
25 Ibid.: 'S. Jan seght, dat het omtrent ses uren was, als Pilatus Christum ter doodt verwees; ende Marcus seght hier, dat men Christum ten dry uren kruyste: het welck alsoo te verstaen is, dat Christus verwesen ende ghekruyst is in de tweede wachte des daechs, die dry uren begreep; oft in de derde ure des ghebedts dat men in den tempel dede, die wy in onse Ghetijden noemen *Tertia*, oft Tierce [...]; dat is, tusschen dry ende ses uren des daechs, oft (na onse uren) tusschen negen ende twelf. Het ghingh dan omtrent den middach, als men hem verwees; want het was omtrent elf uren: als men hem nu kruyste, en was't noch geene twelf. Dus leeren wy uyt S. Marcus, dat-se hen seer gehaest hebben om Christum te kruyssen, vreesende 1. Dat hy onder wegen mocht sterven van flauwicheyt. 2. Dat by avendturen Pilatus, komende by zijne huysvrouwe, (die anders gesint was) zijnen sententie soude herroepen, die hy teghen zijnen danck ende conscientie ghesproken hadde'.

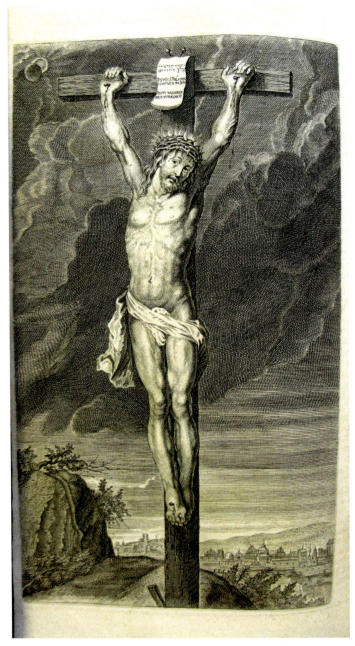

FIGURE 20.12 Mark 15:28–41, with sewn-in *Crucifixion, Sixth to Ninth Hours*, from *Het Nieu Testament onses Heeren Iesu Christi* (Antwerp, Ioachim Trognaesius: 1614) 152–153. Engraving, inserted in folio
MAURITS SABBEBIBLIOTHEEK, KATHOLIEKE UNIVERSITEIT, LEUVEN

A CUSTOMISED COPY OF COSTERUS'S DUTCH *NEW TESTAMENT* 627

likewise implicates us, forcing the question of which side we take – that of Simon and his sons, or of the scribes and Pharisees who hastily but surely plotted the Lord's murder: the former would read the text literally, the latter, cynically and contemptuously.

The full-page *Crucifixion* faces page 153, where two additional images of Christ on the cross accompany annotation 39 and, additionally, correlate to annotations 43 and 45 on page 154 [Fig. 20.13]. The image above, in depicting Jesus flanked by angels who worship the Holy Blood, alludes to his divinity, while the image below, showing him already dead, his side pierced by Longinus, testifies to his human mortality. The paired images thus illustrate the argument of annotation 39: asking why Mark 15:39 – 'And the centurion [...] said: Truly this man was the Son of God' – differs from Luke 23:47 – 'Truly this was a just man' – Costerus answers that the centurion must have said both things, thereby simultaneously signifying the absolute humanity of Christ and his absolute divinity ('beteeckenende Christi suyvere menschelicke nature, ende oock sijne Godtheydt').[26] Annotation 44 elaborates upon this point, remarking that Pilate, who knew that death by crucifixion could be agonisingly slow, marveled at the quick death of Christ; he could not have known, supposes Costerus, the terrible torments Jesus suffered before he was crucified, torments intended to curtail his natural life ('hem naturelick het leven nemen').[27] He then adds, by reference to John 10:17–18 – 'No man taketh [my life] away from me: but I lay it down of myself, and I have power to lay it down: and I have power to take it up again' – that no man could destroy the soul of Christ, which he alone had the power to unloose. This reference to his divine control over life and death turns on Costerus's reading of the gerund *uytlatende* – 'crying out' – in association with verbal phrase *gheest ghevende* – 'giving the spirit up, out', or alternatively, 'forth' – in Mark 15:37: 'And Jesus, having cried out with a loud voice, gave up the ghost'. Costerus merges the two terms, using 'uytlaten' to mean 'give forth from out of himself', in the manner speech is let out, discharged, or exsufflated: '[It must needs be true] that noone could forcibly take from him his soul, which he could discharge as he wished'.[28] On this account, the two small *Crucifixion* scenes are entirely consonant with the argument of annotations 39 and 44 that Jesus died, being mortal in the flesh, and yet, as God, exercised full control over his death. Similarly, as the full-page *Ecce Homo* calls upon the beholder to acknowledge the suffering humanity of Christ, so *Longinus Piercing the Side of Christ* and the full-page *Crucifixion*, viewed through the lens of annotation 44, call upon the beholder

26 Ibid. 153.
27 Ibid. 154
28 Ibid.

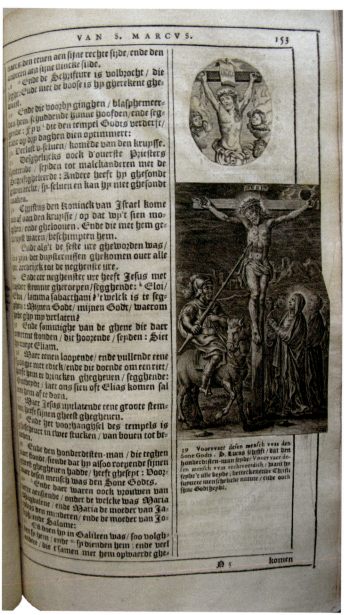

FIGURE 20.13 Mark 15:28–41, with cut and pasted-in *Crucified Christ Flanked by Angels* and *Centurion / Longinus Piercing the Side of Christ*, from *Het Nieu Testament onses Heeren Iesu Christi, met korte uytlegghinghen door Franciscum Costerum, Priester der Societeyt Iesu* (Antwerp, Ioachim Trognaesius: 1614) 153. Engraving, inserted in folio
MAURITS SABBEBIBLIOTHEEK, KATHOLIEKE UNIVERSITEIT, LEUVEN

A CUSTOMISED COPY OF COSTERUS'S DUTCH *NEW TESTAMENT* 629

to acknowledge the divine nature of Christ, discernible in the Lord's death [Figs. 20.12 & 20.13].

In counterpoint with Costerus's Matthean annotations, another coherent sequence of images, extending from midway through Luke 22 to the close of Luke 23, demonstrates how the Passion of Christ is to be imprinted upon the heart and interiorised contemplatively. The image-cluster begins on page 254 with a small oval of the *Agony in the Garden*, and concludes on page 260 with a half-length oval miniature of *Christ Crucified* and, facing it on an interpolated sheet, a rectangular image of the *Virgin of Sorrows Mourning the Entombment* [Figs. 20.14 & 20.15]. The *Agony in the Garden* accompanies Luke 22:41, 43, and 44 and their associated annotations, which in turn grow out of two preliminary annotations – 37 and 38 – that contrast Jesus's profound foreknowledge of the imminent Passion with the apostles' failure to understand, let alone empathise with his anticipatory suffering [Fig. 20.14]. Annotation 37 explains that Luke 22:37 – 'For I say to you that this that is written must yet be fulfilled in me. "And with the wicked was he reckoned"'. – presages the murderous persecution of Christ and his followers, soon to follow in fulfillment of Isaiah 53:12 and other prophecies of the Crucifixion.[29] Annotation 38 emphasises how complete was the apostles' failure to comprehend: when he warns them that they shall have to buy a sword, they take him only literally, not realising that he is also speaking allegorically of the violence they will soon encounter as Christians: 'The apostles had not understood Christ's meaning: for they thought that he wanted them to defend themselves with swords. Christ seeing their gaucheness, did not answer their words, instead saying, "It is enough": as one is wont to do when something gross is tendered that merits no response'.[30] Annotation 41 now draws a moral from this somber story. Finding no comfort in his disciples, Jesus withdraws into private prayer, setting an example for all good Christians who find themselves sorely oppressed by circumstances: 'The oppression of heart was so great that he left his disciples, retiring into prayer, there to obtain a measure of consolation not forthcoming from them: and teaching that oppressed hearts, giving themselves over to prayer, should pour forth their sorrows before God'.[31] The angel that came to comfort him, adds annotation 43, took the form of a man and addressed Christ outwardly, not inwardly, using spoken words

29 Ibid. 253.

30 Ibid.: 'D'Apostelen en hadden Christi meyninghe niet verstaen: want sy peysden dat Christus nu rapieren begheerde, om daer mede beschermt te worden. Christus, hunne plompheydt siende, en andwoorde op hunne woorden niet; maer seyde, *'Tis ghenoech*: ghelijck wy pleghen, als ons iet grofs voorghehouden wordt, dat gheen andwoorde weerdt en is'.

31 Ibid. 254: 'De droefheydt sijns herten was soo groot, dat sy hem van sijne discipelen aftrock tot het ghebede; om daer door eenighen troost te verkrijghen, dien hy by sijne

FIGURE 20.14 Luke 22:41–55, with cut and pasted-in *Agony in the Garden*, from *Het Nieu Testament onses Heeren Iesu Christi* (Antwerp: Ioachim Trognaesius, 1614) 254. Engraving, inserted in folio
MAURITS SABBEBIBLIOTHEEK, KATHOLIEKE UNIVERSITEIT, LEUVEN

FIGURE 20.15 Luke 22:44–56, with cut and pasted-in *Christ Crucified* and *Virgin of Sorrow Mourning the Entombment*, from *Het Nieu Testament onses Heeren Iesu Christi* (Antwerp, Ioachim Trognaesius: 1614) 260–261. Engraving, inserted in folio
MAURITS SABBEBIBLIOTHEEK, KATHOLIEKE UNIVERSITEIT, LEUVEN

to impress upon him the will of the Father, in order to deceive the devil into thinking that Christ was only mortal, not divine. But the human trappings of this prayerful exchange have a further exemplary function – to accentuate the empathetic mercy of Christ who answers to our every need, having taken upon himself the vesture of needful flesh: the scriptural phrase, 'being in an agony', signifies that 'he felt great oppression of heart, having assumed it on our behalf, gaining compassion through the [co-]experience of our oppression'.[32] Hence,

discipelen niet en vondt: leerende dat bedruckte herten hen sullen tot bidden begeven, ende hunne droefheydt voor Godt uytstorten'.

32 Ibid.: 'In groote benautheydt des herten; die hy voor ons heeft willen aennemen, om door experientie met onse benautheydt compassie te hebben'.

concludes annotation 44, the 'drops of blood trickling down upon the ground', the 'profusion of which was so great that his clothes could not contain it'.[33]

Annotations 41, 42, and 44, and preliminary annotations 37 and 38, thus constitute a call to prayer on the model of Christ, whose contemplative prayer of entreaty is presented as an antidote to the object-centred literalness of the apostles. Between pages 254 and 255, the full-page image of the penitent Peter illustrating Luke 22:61–62 – 'And the Lord turning looked on Peter. [...] And Peter going out, wept bitterly' – further connects to the theme of supplicatory prayer, in that it recalls the argument of annotation 32, Costerus's reading of Luke 22:32: 'But I have prayer for thee, [Peter,] that thy faith fail not: and thou, being once converted, confirm thy brethren' [Fig. 20.16]. Costerus claims that Jesus, who is always 'hear[d] for his reverence' [*Hebrews* 5:7], was informing Peter that he had prayed to preserve the 'constancy of the holy Christian and Catholic faith' ('volstandicheydt in't H. Christen ende Catholijck geloove'), not only in him but also in every Pope who would eventually succeed to his high office.[34] Seen in light of this annotation and in relation to the prior print of the *Agony in the Garden*, the full-page image of Peter weeping after his betrayal of Jesus, his arms crossed in empathetic suffering with Christ, the papal keys lying beside him, can be interpreted as an exemplum of papal imitation of the Lord's contemplative prayer of entreaty [Figs. 20.14 & 20.16]. As Christ prayed for constancy of spirit when he knelt in the garden (and for the constancy of Peter, when praying for him beforehand), so now Peter likewise prays to be renewed in constancy, after having faltered, and also, as the keys imply, for the preservation of the constant spirit of his papal successors. His compressed corkscrew pose embodies the notion, distilled in annotation 61, that he was reacting to Jesus who turned round to look at him at the instant Peter denied knowing him a third time: '"The Lord turned himself round". He looked at him with spiritual eyes, wherewith he illuminated his heart'.[35] His distinctive pose also evokes Peter's liminal state of mind (and soul): 'being once converted' ('wanneer ghy bekeert zijt', from *bekeren*, 'to turn, convert'), as Luke 22:32 puts it, and now stricken by remorse, he now turns once again to Christ; in actual fact, this constitutes the closing message of annotation 32, which distinguishes between two senses of the term *bekeert*:

> The little word *bekeert*, or *conversus* (converted), can be explained in two ways. First, when you turn yourself toward your brothers, you fortify

33 Ibid.: 'Hier wordt beteeckent eene seer groote menichte van bloedt; dat in de kleederen niet en bleef'.

34 Ibid. 252.

35 Ibid. 255: '"Den Heere hem omkeerende". Hy aenschoude hem met geestelicke ooghen, daer hy sijn herte mede verlichtede'.

A CUSTOMISED COPY OF COSTERUS'S DUTCH *NEW TESTAMENT* 633

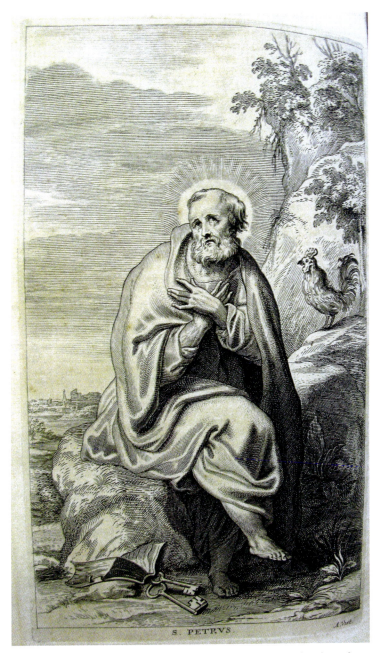

FIGURE 20.16 Luke 22:56–69, with sewn-in *Penitent Saint Peter* by Alexander Voet, from *Het Nieu Testament onses Heeren Iesu Christi* (Antwerp, Ioachim Trognaesius: 1614) 254–255. Engraving, inserted in folio
MAURITS SABBEBIBLIOTHEEK, KATHOLIEKE UNIVERSITEIT, LEUVEN

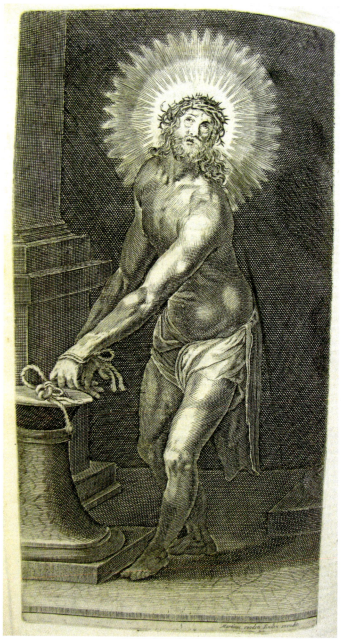

FIGURE 20.17 Luke 22:11–26, with sewn-in *Christ Bound to the Column* by Maarten van den Eenden, from *Het Nieu Testament onses Heeren Iesu Christi* (Antwerp, Ioachim Trognaesius: 1614) 256–257. Engraving, inserted in folio
MAURITS SABBEBIBLIOTHEEK, KATHOLIEKE
UNIVERSITEIT, LEUVEN

A CUSTOMISED COPY OF COSTERUS'S DUTCH *NEW TESTAMENT* 635

them in faith, as if Christ were saying: If you or your successors espy some error or inconstancy of faith in [your fellow] Christians, at once turn toward them, teach and fortify them, so that they remain firm in faith. Second, when you turn away from the sin that you shall commit this night by denying me, know that your duty is to strengthen your brothers' faith, and to teach them. Accordingly, we learn from the glosses of the old Teachers and the Councils that the Popes who succeeded Saint Peter and his immediate successors had it as their duty [...] to preserve the Holy Church in the Catholic faith, elucidating it, resolving doubts, clarifying the truth, and extirpating all heresies.[36]

That Peter is indeed [re]turning to Christ becomes evident from the relation between this print and the full-page print of *Christ Bound to the Column* that follows immediately thereafter, between pages 256 and 257 [Fig. 20.17]. Peter's pose is a reversed, condensed, seated version of Christ's: this indicates his strong meditative attachment to the suffering of his Lord, which fills his mind, heart, and spirit, and as a result, is expressed bodily as well as spiritually [Fig. 20.16]. More to the point, the upward gaze of both Peter and Christ indicates that they are praying, training their thoughts heavenward, in allusion to such scriptural passages as Luke 22:42 – 'but yet not my will, but thine be done' (from the Agony in the Garden) – and John 19:11: 'Thou shouldst not have any power against me, unless it were given thee from above' (spoken to Pilate) [Figs. 20.16 & 20.17]. The presence of Peter's chief attribute, the papal keys, implies that his prayer, howsoever private, is also exemplary, enacted in his capacity as Pope, to teach his flock how to convert themselves from inconstancy to constancy by means of penitential prayer. In this fashion, the two senses of *bekeert* – turning others, turning oneself – are shown to be imbricated.

The two cut-and-pasted prints on page 257 (above, a small image of *Christ Scourged and Bleeding from many Wounds*; below, an image of the *Virgin of Sorrows Meeting Christ on the Road to Calvary*), respectively illustrate Pilate's twice-issued provisional judgement of Jesus in Luke 23:16 and 23:22 – 'I will

36 Ibid. 252–253: 'Dat woordeken *bekeert*, oft *conversus*, kan men op twee manieren uytleg-ghen. 1. Als ghy u tot uwe broeders bekeert hebt, versterckt-se in't gheloove, als oft hy seyde: als ghy, oft uwe nakomelinghen, eenighe dolinghe oft onghestapeltheydt by de Christenen in't gheloove sult vernemen, keert u terstondt daer na, ende onderwijst-se ende versterckt-se, dat sy in't gheloove vast blijven. 2. Als ghy u van de sonde, die ghy desen nacht doen sult in my te loochenen sult bekeert hebben, soo weet dat u officie is, uwe broeders oock in't geloove te verstercken ende t'onderwijsen. Dus leeren wy, na d'uytlegginge der ouder Leeraren ende Concilien, dat S. Peeters ende sijnder nakomelin-gen, Pausen van Roomen, officie is [...] het Catholijck gheloove in de H. Kercke te bewaren ende uyt te legghen, de twijfelinghen te resolveren, de waerheydt te verklaren, ende alle ketterijen uyt te roeyen'.

chastise him therefore and release him' – and the great number of Jesus's followers who kept pace with him on the road to Calvary, as reported in Luke 23:27 [Fig. 20.18]: 'And there followed him a great multitude of people and of women, who bewailed and lamented him'. I use the term 'illustrate' loosely, since neither print exactly corresponds with the passages from Luke: rather, both are meditative distillations of Luke's Passion narrative. The former image puts Christ's wounded body on display, using an archway to highlight it; the latter interpolates the Virgin of Sorrows into the Calvary scene, so that Mary's heightened sorrow stands proxy for that of Christ's other followers. The presence of Mary recalls Costerus's assertion, in annotation 9 of Mark 16, that 'no one loved Jesus more than she, nor was closer to him, or desired his advent with greater desire, or suffered more with him during his holy Passion, or was more worthy to be consoled by him'.[37] The print abstracts Mary and Jesus from their circumstances, condensing their meeting into a heartfelt exchange of gazes.

Annotation 24 of Luke 23 dispatches the reader-viewer to John 19:1–17, where 'the flagellation, crowning with thorns, and all that followed' are more fully chronicled than in Luke.[38] There the opening annotations 2, 3, and 4 closely coordinate with the message of the *Virgin of Sorrows Meeting Christ*, calling attention to the maternal devotion she epitomises, by supplying antitheses to her surpassing love of Jesus [Fig. 20.18]. The soldiers, states annotation 2, crowned Christ with thorns gratuitously, not at Pilate's command, hoping to ingratiate the scribes and Pharisees.[39] According to annotation 3, they then paid him mock homage, in the manner of ambassadors sent from afar to honour a king.[40] And annotation 4, referring to John 19:4 – 'Pilate therefore went forth again and saith to them: Behold, I bring him forth unto you, that you may know that I find no cause in him' – conjectures that he had Jesus scourged, dreadfully wounding his every limb, in hopes of appeasing his hateful accusers and ultimately saving him from death.[41] Pilate, having inadvertently converted Christ into a living image of Isaiah 53:3, fulfilled this great prophecy of the Passion: 'Despised and the most abject of men, a man of sorrows and acquainted with infirmity; and his look was as it were hidden and despised'. But compared to what ensued once Jesus was released to his captors, Pilate's actions appear motivated by nothing less than charity: 'And in order that

37 Ibid. 155: 'Want niemandt en beminde Christum so seer, niemandt en was hem nader dan sijne moeder: niemandt en hadde meerder verlanghen na sijne komste, niemandt en hadde met hem in sijne H. Passie meer gheleden'.

38 Ibid. 257: 'Hier moet voorgaen het ghene dat S. Jan schrijft van de gheesselinghe, ende van de doornen-kroone, met het ghene dat daer na volght'.

39 Ibid. 355.

40 Ibid.

41 Ibid.

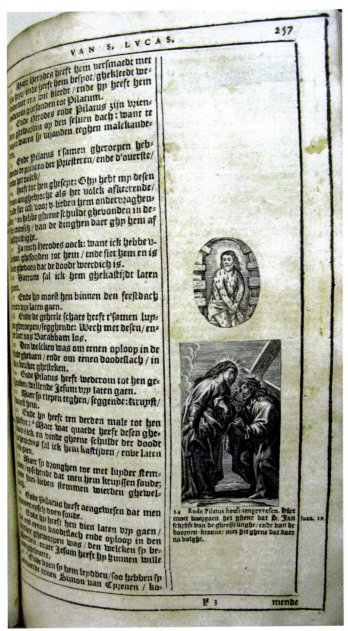

FIGURE 20.18 Luke 22:11–26, with cut and pasted-in *Christ Scourged and Bleeding from many Wounds* and *Virgin of Sorrows Meeting Christ on the Road to Calvary*, from *Het Nieu Testament onses Heeren Iesu Christi* (Antwerp, Ioachim Trognaesius: 1614) 257. Engraving, inserted in folio
MAURITS SABBEBIBLIOTHEEK, KATHOLIEKE UNIVERSITEIT, LEUVEN

they should recognise him [as the Isaian Man of Sorrows], Pilate said, "See this man"; as if he wished to say: "He is a man, after all, and no beast; for this reason, impose no further cruelty upon him, than that which you now see".[42] The charity of Pilate, when compared with that shown by Mary, functions as a harbinger of her incalculable compassion. By the same token, the brutality and cynicism of his tormentors, who attempt to hide the beauty of his face, and to deform it, magnify the tenderness and candour of Mary's face-to-face encounter with Christ, and her clear-eyed gaze. The sword piercing her heart makes it quite clear that she is the Virgin of Sorrows, prophesied in Luke 2:35, associated with the five sorrowful decades of Rosary, and here presented as an allegorical epitome of affective reflection on the Passion and, more expressly, of meditative espousal of Christ's burdensome cross.

The small cut-and-pasted print of an angel displaying the Holy Face, on page 258, just above annotation 28 of Luke 23, supports this reading of *Virgin of Sorrows Meeting Christ* on page 257 [Fig. 20.19]. Seen in relation to it, *Angel Exhibiting the Sudarium* intimates that Mary has prayerfully imprinted the face of her son upon her mind, heart, and soul, in the fashion of Veronica, who driven by fervent devotion, knelt down to impress his face upon her veil [Figs. 20.18 & 20.19]. Annotation 28, one of the longest in *Het Nieu Testament*, takes up this analogy, arguing that all devout Catholics must imitate Mary and the women who mourned Christ by making common cause with him. Self-mortifying compassion is the devotional instrument whereby they bound themselves to him. Costerus builds his case in three stages. First, he attacks the heretical argument that Christ's Passion, and in particular, the events memorialised during Holy Week, need not be commemorated with sorrow, fasting, and acts of contrition, and furthermore, that since they were the cause of our salvation, they should stir nothing but joy in us, and license the enjoyment of pleasures of all kinds. After all, Christ commands the holy women in Luke 23:28, '[...] weep not over me'.

Costerus rejoins that on the contrary one must meditate upon four aspects of the Passion, in imitation of the Virgin, who suffered with Christ as intensely – nay, more intensely – that mothers were wont to do when their sons were circumcised. The reference to the rite of circumcision evokes the sensation of sorrow felt by Mary at the first shedding of her son's blood, a threshold of suffering, as Costerus later avers in his reading of Luke 23:31 – 'For if in the green wood they do these things, what shall be done in the dry'? – that was infinitely

42 Ibid.: 'Ende op dat sy hem kennen souden, ende beweeght worden, seyde Pilatus: "Siet desen mensch". Als oft hy segghen wilde: 'Tis doch eenen mensch, ende geene beeste; daerom en toont gheene meerdere wreedtheydt aen hem, dan ghy nu siet'.

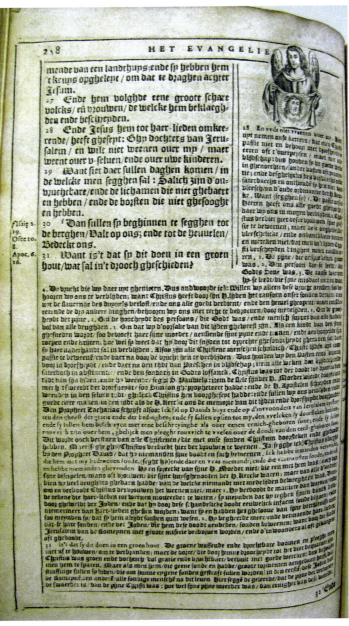

FIGURE 20.19 Luke 22:27–31, with cut and pasted-in *Angel Exhibiting the Sudarium*, from *Het Nieu Testament onses Heeren Iesu Christi* (Antwerp, Ioachim Trognaesius: 1614) 258. Engraving, inserted in folio
MAURITS SABBEBIBLIOTHEEK, KATHOLIEKE UNIVERSITEIT, LEUVEN

magnified during the Passion: 'Here say the theologians, that the pain of those damned [to hell] is graver than was the pain of Christ, whose pain was greater than any in this world'.[43] The first aspect to be considered is the enormity of Christ's pain, so great as to be veritably unspeakable. The second is the nature of him who thus suffered – the Son of God. The third is the cause – human sin. The fourth is the fruit of his torment – human salvation. In sum, concludes Costerus:

> Were we to pay heed solely to this fruit, it would behoove us to rejoice [...]: but considering the other three things, we ought rightly to sorrow with compassion. First, for the greatness of his pain. Second, for the majesty of his person, who was God and man, free from all sin, replete with all virtue. Third, for the cause of his suffering. For when a child is circumcised by the stone, his mother grieves, seeing his pain and tears, and hearing his calls and cries, even when she knows that through this circumcision he shall attain to righteous well-being, wherein she will rejoice. Consequently, it is incumbent upon all Christian persons compassionately to bewail the suffering of Christ, thereafter to rejoice in its fruit. [...]. Christ was sorrowful even unto death at the time of his Passion [Matthew 26:38], and he wept, says Saint Paul [Hebrews 5:7]; likewise the soul of his holy Mother was pierced through by the sword of sorrow, as Simeon had prophesied. And the holy Apostles cried and wept [John 16:20] at the same time, as Christ had foretold: and should we rejoice, and make good cheer, at the time when the holy Church represents to us the memory of [his] pain and sorrow?[44]

43 Ibid. 258: 'Hier seggen de geleerde, dat de pijne der verdoemde swaerder is, dan de pijne Christi was: hoe wel sijne pijne meerder was, dan eenigher van dese wereldt'.

44 Ibid.: 'Willen wy alleen dese vrucht aensien, soo behooren wy ones te verblijden [...]: maer considerende de dry andere dinghen, behooren wy ons met recht te bedroeven, door medelijden. 1. Om de grootheydt der pijne. 2. Om de hoochheydt des persoons, die Godt was, ende mensch suyver van alle sonden, vol van alle deughden. 3. Om dat wy d'oorsake van dit lijden geweest zijn. Als een kindt van den steen ghesneden wordt, soo bedroeft haer zijne moeder, aensiende zijne pijne ende tranen, ende aenhoorende zijn roepen ende krijten [...]. Alsoo zijn alle Christene menschen schuldich, Christi lijden uyt compassie te beweenen, ende daer na door de vrucht hen te verblijden. [...] Christus was tot der doot toe droef in den tijt van zijn lijden; ende hy weende, seght S. Pauwels: item de siele zijnder H. Moeder wierdt doorsteken met het sweerdt der droefheydt, so Simeon ghepropheteert hadde: ende de H. Apostelen schreyden ende weenden in den selven tijt, ghelijck Christus hen voorgeseyt hadde: ende sullen wy ons verblijden, ende goede ciere maken, in den tijt als de H. Kercke ons de memorie van dit lijden ende droefheydt voorhoudt'?

A CUSTOMISED COPY OF COSTERUS'S DUTCH *NEW TESTAMENT* 641

Quoting Zechariah 12:10, Costerus answers that sorrowful prayer is the only acceptable response to such thoughts: 'And I will pour out upon the house of David, and upon the inhabitants of Jerusalem, the spirit of grace, and of prayers: and they shall look upon me, whom they have pierced: and they shall mourn for him as one mourneth for an only son, and they shall grieve over him, as the manner is to grieve for the death of the firstborn'.[45] Costerus then exalts the Virgin for her prayerful communion with Christ, which models that of the disciples and holy women who followed after him and were intimate members of his Church family. Through their prayers of mourning, they offer an antidote to the words of Christ prophesied by David in Psalm 68:21, his prediction of the Passion: 'And I looked for one that would grieve together with me, but there was none: and for one that would comfort me, and I found none'.[46]

With regard to Jesus's admonition, 'Daughters of Jerusalem, weep not over me', Costerus asseverates in annotation 28 that Christ was offering a specific corrective: they were shedding tears for the wrong reasons – because they presumed that his reputation was being irremediably defamed, because they thought they would never see him again, and because they did not know that there was a better cause for lamentation, the imminent destruction of Jerusalem, fast approaching.[47] By contrast, implies Costerus, the Virgin's tears, shed in the knowledge of all these things, are fully justified.[48] The book's owner, to stress this point, inserted the image of the *Angel Exhibiting the Sudarium* [Fig. 20.19]: the grief felt by every true Christian who dwells on the Passion and all it portends, should issue, like Mary's sorrow, from an image of Jesus indelibly imprinted in the manner of Veronica's veil. This verbal-visual argument is further exemplified by the full-page print of the *Carrying of the Cross*, engraved and / or published by Gaspar Huybrechts, and inserted opposite page 258 [Fig. 20.20]. Inscribed with an excerpt from John 19:17 – 'And bearing his own cross, he went forth to the place which is called Calvary' – it depicts the Virgin kneeling in the place where one might expect to find Veronica, her hands clasped in fervent prayer, tears streaming from her eyes, as Jesus turns

45 Ibid.: '"Ic sal op Davids huys en op d'inwooders van Ierusalem uytstorten den gheest der gratie ende der bedinghen; ende sy sullen opsien tot my, den welcken sy doorsteken hebben, ende sy sullen hem beschreyen met eene beschreyinghe als over eenen eenich-gheboren sone; ende sy sullen rouwich sijn over hem, ghelijck men pleeght rouwich te wesen over de doot van een eerst-gheboren sone"'.

46 Ibid.: 'Ick hebbe iemanden verwacht, die hem met my bedroeven soude, (seght hy) ende daer en was niemandt; ende die vertroosten soude, ende ic en hebbe niemanden ghevonden'.

47 Ibid.

48 Ibid.: 'Hy en spreeckt van zijne H. Moeder niet, die een met hem was'.

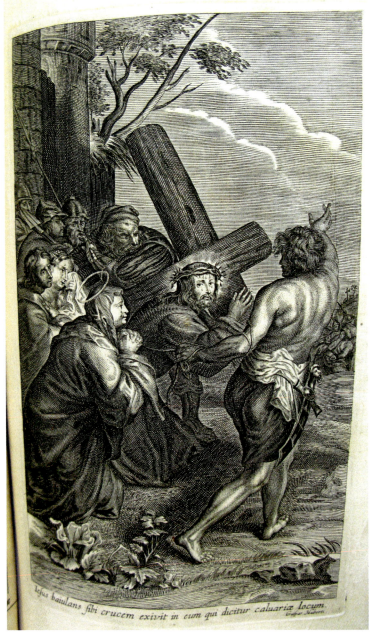

FIGURE 20.20 Luke 22:27–31, with sewn-in *Carrying of the Cross* by Gaspar Huybrechts, from *Het Nieu Testament onses Heeren Iesu Christ* (Antwerp, Ioachim Trognaesius: 1614) 258–259. Engraving, inserted in folio
MAURITS SABBEBIBLIOTHEEK, KATHOLIEKE UNIVERSITEIT, LEUVEN

A CUSTOMISED COPY OF COSTERUS'S DUTCH *NEW TESTAMENT* 643

back toward her. As his head swivels, his eyes catch ours, as if he were about to deliver to us the message warning the holy women to weep more judiciously, elucidated in annotation 31. Within the context of the text-image apparatus we have just been exploring, his look invites us to imitate Mary, to join her in praying forlornly and with remorse, and to prepare virtually to shoulder his heavy burden and to alleviate his great misery.

Pasted onto the back of the *Carrying of the Cross* is a hybrid scene of the same subject, which comprises many elements of the full-page print but combines them with the figure of the Virgin of Sorrows [Fig. 20.21]. Opposite it, the book's owner inserted a full-page image of the *Holy Face with the Crown of Thorns*, inscribed 'Behold the face of your Christ', again engraved and / or published by Gaspar Huybrechts [Fig. 20.22]. Typical of such meta-images of the sudarium, the face of Christ reads as imprinted and yet independent of the cloth: it projects forward, entirely free of contingent folds, and the blood dripping from the wounds left by the crown of thorns, like the bloody tears, have a weight and density similar to the bloody drops dripping from the crown itself, half obscured by the Holy Face. Although the print clearly alludes to the sudarium, it does not precisely illustrate it, since the puncture marks left by the crown of thorns, but not the crown itself, are pictured. Rather, this is a kind of semi-allegorical image that even while alluding to the holy relic, actually depicts the manner of Christ's imprinting upon the heart of the compassionate votary, who in this case is none other than the Virgin herself. The inscription, by using the familiar 'tui', prompts the viewer to associate her- or himself with the Virgin, whose son this is. The juxtaposition of the two prints – face-to-face, one might say – underscores the complementarity of Christ's gaze, cast toward Mary in the one, toward us in the other. This is to say that the appeal to return his gaze, to meditate him while he beholds us, can be analogised to the exchange of glances passing between the Virgin and Christ, or, more precisely, between Christ and the Virgin of Sorrows who exemplifies meditative immersion in the Passion. Situated within this analogical network, she can be seen to stand for the pensive viewer who reciprocates Christ's gaze, dwelling at length upon its significance.

The Lucan sequence we have been tracking climaxes with a more purely symbolic rendition of the Crucifixion that mobilises imagery from the Canticle to prompt reflection on the nature of contemplative union with Christ on the cross [Fig. 20.23]. Three kinds of image have predominated up till now: narrative scenes illustrating scriptural events, such as the *Carrying of the Cross* [Fig. 20.20]; scriptural scenes that feature an allegorical intercalation, such as the *Virgin of Sorrows Meeting Christ on the Road to Calvary* [Fig. 20.21]; and portrayed objects indexically linked, as relics, to the Passion, such as the *Holy Face with the Crown of Thorns* [Fig. 20.22]. Like the embedded references to the

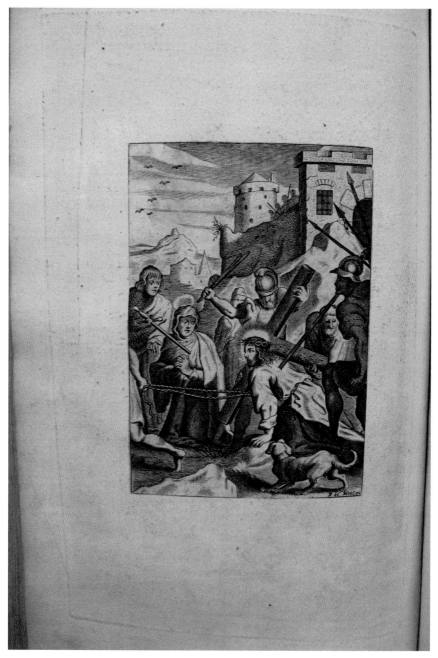

FIGURE 20.21 Luke 22:27–31, with cut and pasted-in *Carrying of the Cross with Virgin of Sorrows*, from *Het Nieu Testament onses Heeren Iesu Christi* (Antwerp, Ioachim Trognaesius: 1614) 258–259. Engraving, inserted in folio
MAURITS SABBEBIBLIOTHEEK, KATHOLIEKE UNIVERSITEIT, LEUVEN

A CUSTOMISED COPY OF COSTERUS'S DUTCH *NEW TESTAMENT* 645

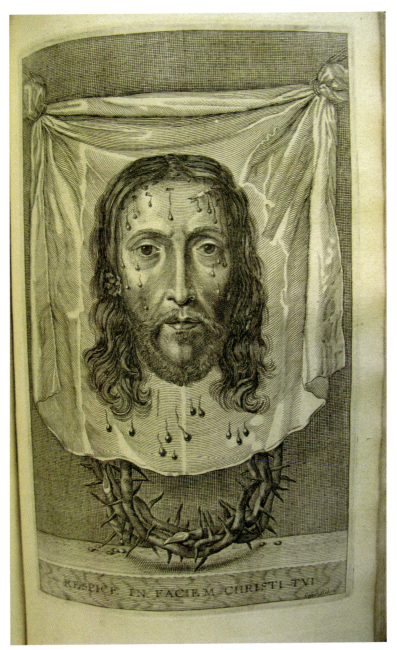

FIGURE 20.22 Luke 22:27–31, with sewn-in *Holy Face with the Crown of Thorns* by Gaspar Huybrechts, from *Het Nieu Testament onses Heeren Iesu Christi* (Antwerp, Ioachim Trognaesius: 1614) 258–259. Engraving, inserted in folio
MAURITS SABBEBIBLIOTHEEK, KATHOLIEKE UNIVERSITEIT, LEUVEN

Virgin of Sorrows, the images of relics allude to Mary's prayerful relationship with Christ: they stand for the imprinted images of his Passion that she carries within her mind, heart, and spirit, and by extension, they exhort the reader-viewer to imitate her in meditating such images, if s/he wishes to share in Jesus's suffering. However, even the *Carrying of the Cross* participates in what can be read as a stepwise meditative progression from external to internal experience, for as we have seen, it shows Mary praying ardently, her eyes fixed on Christ, and besides, is grouped with two images of the sudarium – *Angel Exhibiting the Sudarium*, en face, and the *Holy Face*, interpolated as the next folio recto – that betoken her heartfelt devotion [Figs. 20.19, 20.20, & 20.22]. The movement toward inwardness reaches its apogee in the *Symbolic Crucifixion* [Fig. 20.23].

The image showcases the crucified Christ, his body hanging dead from the cross, flanked by the *arma Christi*. In an allusion to the Resurrection, the cross rises from the open tomb, but it also appears to emerge from the aorta of the Lord's wounded heart. Fluttering above the heart, a banderole quotes from Canticle 4:9 – 'Thou has wounded my heart, my sister, my spouse'; the brief epigraph declares that the self-sacrifice of Christ was motivated by his compassionate love of humankind, but it concurrently ascribes blame, charging sinful humankind with having necessitated this willing sacrifice. Beside the wound left by the spear that pierced Christ's side, a second inscription, taken from Psalm 131:13–14, and spoken in his voice, reveals that the heart jointly belongs to the faithful votary, whom his blood has wed eternally to himself: '[For the Lord hath chosen Sion: he hath chosen it for his dwelling.] This is my rest for ever and ever: [here I will dwell, for I have chosen it]'. The empathetic heart that suffers so fully with Christ that it assimilates his side-wound is likened by the two inscriptions first, to his bride's heart, and then to that of his people Sion, whose salvation he has secured. Nestled within the heart is the crowned figure of *Ecclesia*, the Church as bride of Christ, mystically born from his heart's blood; she jointly personifies the Christian soul elevated to heavenly glory through her sacramental participation in the Lord's sacrifice on her behalf. Below, the inscription from Canticle 3:11 (misidentified 'Cant. 2. Cap.') celebrates the nuptials of the bridegroom and bride, Christ and the Church, Jesus and the votary: 'Go forth, ye daughters of Sion, and see king Solomon in the diadem wherewith his mother crowned him [in the day of his espousals, and in the day of the joy of his heart]'.

Because this intricate image, inserted after page 258, faces two further cut-and-pasted prints of the Virgin of Sorrows, on page 259, it can be construed in a third way – as a nuptial allegory of the Marian heart and its loving assimilation into the sacred heart of Christ [Figs. 20.23 & 20.24]. In the topmost Marian image, she stands on a rocky ridge atop Golgotha, at some

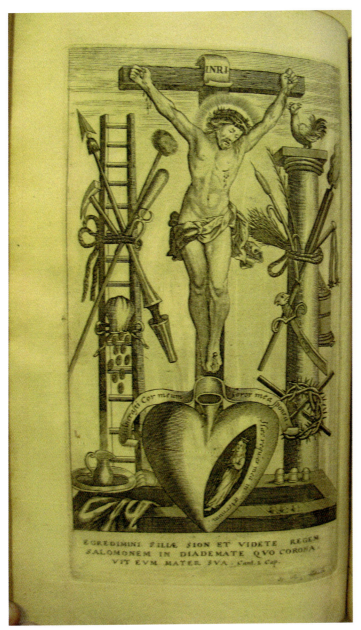

FIGURE 20.23 Luke 22:32–43, with sewn-in *Crucified Christ with Arma Christi and Ecclesia Lodged in the Sacred Heart*, from *Het Nieu Testament onses Heeren Iesu Christi* (Antwerp, Ioachim Trognaesius: 1614) 258–259. Engraving, inserted in folio
MAURITS SABBEBIBLIOTHEEK, KATHOLIEKE UNIVERSITEIT, LEUVEN

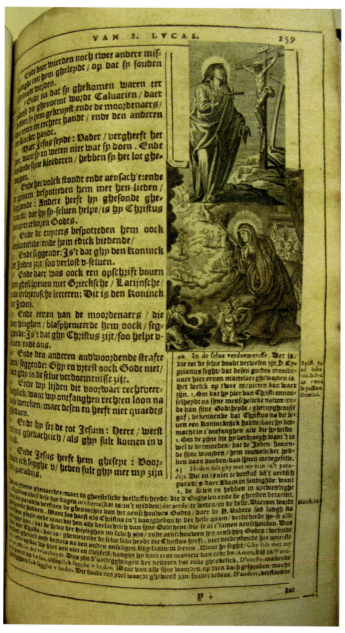

FIGURE 20.24 Luke 22;32–43, with cut and pasted-in *Virgin of Sorrows Gazes at the Crucified Christ* and *Virgin of Sorrows Meditates on the Passion*, from Het Nieu Testament onses Heeren Iesu Christi (Antwerp, Ioachim Trognaesius: 1614) 259. Engraving, inserted in folio
MAURITS SABBEBIBLIOTHEEK, KATHOLIEKE UNIVERSITEIT, LEUVEN

A CUSTOMISED COPY OF COSTERUS'S DUTCH *NEW TESTAMENT* 649

distance from Christ crucified on the summit. Gazing intently at him, with the left hand, palm held outward, she signifies that in her relation to Jesus, she is entirely open-handed, i.e., ready and willing to take his every kind and degree of suffering upon herself. With the right hand, she gestures toward her heart, indicating that she brings him there, to the source and seat of her nearly infinite capacity for co-suffering. Below, the second image portrays her kneeling in prayer, angels round about, and meditating on the five sorrowful mysteries of the Rosary – the Agony in the Garden, the Flagellation, the Crowning with Thorns, the Carrying of the Cross, and the Crucifixion – visible in the distance. Both prints evince her ability interiorly to transfer the external events she sees either at first hand or in her mind's eye. If the repository for these transferred things, their affective home, is her heart, the *Symbolic Crucifixion* allegorically maps what she there makes of them: they become the spiritual measure of her contemplative union with Christ, into whose mystical bride compassion has fully converted her [Figs. 20.23 & 20.24].

Annotation 40 implicitly compares her to the good thief, whose empathy toward Christ transformed him into a martyr for the faith. Citing Saint Cyprian's *Epistola* 73 *ad Jubaianum* and *Sermo de coena et passione Domini*, Costerus commends him in terms that apply equally, if not more, to Mary:

> Saint Cyprian says that the good murderer became a martyr in this place, which can be said to hold true in two ways: first, because he gave witness to the innocence of Christ according to his human and divine nature, confessing that he possessed a kingdom whereto he could invite all whom he would, after this life; second, because of the pain he endured, which the Jews presumably made more grievous than that of his fellow murderer, after hearing his words.[49]

Annotation 43, which reflects on his reward, can likewise be applied, by an implied analogy adduced through the proliferation of Marian images, to the Virgin. The paradise granted him in Luke 23:43, states Costerus, was not earthly ('van't aerdsch paradijs') but spiritual, like that bestowed on the Fathers in purgatory, who patiently awaited the coming of Christ.[50] The terminology

49 Ibid. 259: 'S. Cyprianus seght, dat desen goeden moordenaer hier eenen martelaer gheworden is. Het welck op twee manieren kan waer zijn. 1. Om dat hy hier van Christi onnooselheydt na sijne menschelicke nature, ende van sijne Godheydt, ghetuyghenisse gaf; bekennende dat Christus na dit leven een Koninckrijck hadde, daer hy vermocht in t'ontfanghen alle die hy wilde. 2. Om de pijne die hy verdroegh; want 't is wel te vermoeden, dat de Joden, hoorende sijne woorden, hem rouwelicker hebben doen dooden, dan sijnen medegeselle'.

50 Ibid.

650 MELION

Costerus uses to describe the paradise of the soul, especially the phrase 'in't herte' (in the heart), derives from contemplative usage and appertains to unitive conjunction between the soul and Christ; only the most adept votary, or martyrs, can attain this highest stage of spiritual experience. Obtained through the practice of mystical devotion, it occurs when the immediacy of affective communion with the divine replaces the discursive, analytical process of meditation. Costerus's exegesis of the clause, 'This day thou shalt be with me in paradise', can be read as an allegory of this kind of contemplative prayer:

> This is not to be understood as the earthly paradise wherein Adam sinned: for firstly, souls take no pleasure in terrestrial gardens, but rather in spiritual delights that accord with the angels and the spirits; secondly, Christ remained three days in the heart (that is, in the midst) of the earth, namely, in hell. Consequently, this paradise is to be construed as the pleasure of seeing God, wherefor the Fathers yearned at such length. For as soon as Christ came to the forecourt of hell, he shed his light upon them in glory, making them participants in his Godhead, at which they gazed all together. In view of this, learn here that the souls of the saints are forthwith saved; they look upon the countenance of God, being with Christ, that is, enjoying that salvation he possesses, not awaiting final judgment (as the heretical followers of the unholy Vigilantius teach).[51]

With regard to Jesus's promise to the good thief – 'This day thou shalt be with me in paradise' – Costerus then adds that it is sometimes read in connection with Paul's exegesis of Psalm 94 in Hebrews 3:6–11, specifically verse 6: 'But Christ, as the Son in his own house: which house are we, if we hold fast the confidence and glory of hope unto the end'.[52] In the end, Costerus reads the passage differently, siding with Saint Ambrose who argued in *Sermo 8 in psalmum*

51 Ibid.: 'Dit en is niet te verstaen van't aerdsch paradijs, daer Adam in sondighde: want 1. De sielen en hebben in uytwendighe hoven gheene ghenoechte, maer in gheestelicke wellusticheydt, die d'Enghelen ende de gheesten betaemt. 2. Christus bleef dese dry dagen *in't herte* (dat is, in't midden) *der aerde*: te weten, in de helle. Daerom wort door dit paradijs verstaen de ghenoechte van het aenschouwen Gods, daer de H. Vaders so langh na ghehaeckt hadden. Want so haest als Christus in't voorgheborcht der helle quam, verlichtede hy-se alle met sijne glorie, ende maeckte hen alle deelachtich van sijne Godtheyt, die-se al t'samen aenschouden. Dus leert ghy hier, dat de sielen der Heylighen nu salich zijn, ende aenschouwen het aenschijn Gods: wesende daer met Christo, dat is, ghenietende de selve salicheydt die Christus heeft; niet verbeydende het uyterste oordeel, ghelijck onse ketters na den ouden onsaligen Vigilantium leeren'.
52 Ibid.: 'D'andere, verstaende dat woordeken, *heden*, voor allen den tijdt tot het uyterste oordeel, ghelijck't S. Pauwels in den Psalm uytleght'.

A CUSTOMISED COPY OF COSTERUS'S DUTCH *NEW TESTAMENT* 651

118 that the penitent thief was instantly saved;[53] but his reference to *Psalm* 94 is significant, since verse 8 – 'Today if you shall hear his voice, harden not your hearts, as in the provocation; in the day of temptation in the desert' – provides the basis for his explication of Christ's encounter with the good thief in annotations 40 and 43, which the visual exegete, through her / his pasting-in of the *Symbolic Crucifixion* together with a slew of Marian images, converted into a Marian allegory [Figs. 20.24 & 20.25]. Like the good thief, though in a higher degree, Mary's porous heart was entirely open to the Passion: utterly soft, hard in no part, it became her son's 'own house', and as such, it can be thought instantly to have achieved contemplative union with him. In the language of the mystics, taken from Psalm 131, she has been chosen 'for [the Lord's] dwelling'; and in the words of the Canticle, her spousal heart and his have been 'wounded' together. Above and beyond these points of agreement, the topmost image, on page 259, of Mary staring into the face of Jesus, perfectly corresponds with Canticle 4:9's allusion to the reciprocally wounding eyes of the bride and bridegroom [Fig. 20.24].

Two final paired prints, the small torso-length *Crucified Christ* on page 260 and the adjacent *Virgin of Sorrows Mourning the Entombment of Christ*, pasted onto an inserted sheet that constitutes the other half of this opening, supply a coda to the series of images on the empathetic Virgin as an epitome of interiorised prayer [Fig. 20.15]. Doleful and withdrawn, with head veiled, eyes closed, and hands folded in prayer, Mary contemplates the death of Jesus, viewing him spiritually not corporeally, while John, Nicodemus, and Joseph of Arimathea lay the lifeless body in the sepulchre. Positioned in the upper left quadrant of the sheet, her head inclined downward, she stands just above and to the right of *Christ Crucified*: her line of sight, were her eyes opened, would intersect with the upward-turned eyes of Christ, and this suggests that she is thinking not only upon the Entombment, but also upon the Crucifixion. Annotation 46, coordinated with *Christ Crucified*, reveals in greater detail what this image purportedly portrays, and collaterally, what the Virgin must be calling to mind – namely, that Jesus, when he announced his death by crying out 'with a loud voice', 'Father, into thy hands I commend my spirit', revealed that he exercised some measure of control over his violent death: by resolutely transmitting his spirit, he embraced death as an offertory, willingly not involuntarily

53 Ibid. 260: 'Daer tegen is het ghene dat S. Ambrosius wel seght: "hy belooft dat toekomende was, maer dat toekomende en stelt hy niet eenen dach uyt; want Christus wilde terstondt sijne belofte volbrenghen". Hy andwoorde den moordenaer na zijne begheerte; die was, dat hy sijns ghedachtich wesen soude, soo haest als hy in sijn rijck soude komen, het welck gheschiedde terstondt na sijne doodt'. In fact, the passage from Ambrose comes not from *Expositio in psalmum XVIII* but from *Expositio Evangelii secundum Lucam* X.121; see *Patrologia latina* 15.1530 (col. 1834).

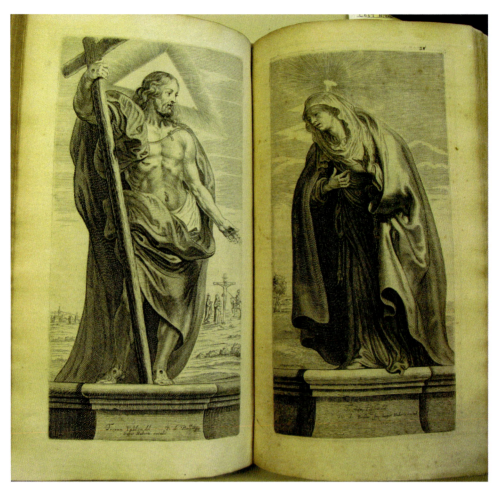

FIGURE 20.25 John 20:29–31, with sewn-in *Effigy of the Risen Christ* and *Effigy of the Virgin* (*Apparition of Jesus to Mary*), by Pieter de Bailliu after Theodoor van Thulden, from *Het Nieu Testament onses Heeren Iesu Christi* (Antwerp, Ioachim Trognaesius: 1614) 364–365. Engraving, inserted in folio
MAURITS SABBEBIBLIOTHEEK, KATHOLIEKE UNIVERSITEIT, LEUVEN

('vrijelick sendende sijne siele in de handen sijns Vaders').[54] Below *Christ Crucified*, aligned with Mary's downward gaze in *Virgin of Sorrows*, annotation 51 jointly attaches to verse 51 on Joseph of Arimathea. In describing him as a good Jew, righteously awaiting the kingdom of God, Costerus imputes this same watchful attitude to Mary; but whereas Joseph actually carries Christ's corpse and deposits it in the tomb, she, standing at some distance, cultivates

54 Ibid.

A CUSTOMISED COPY OF COSTERUS'S DUTCH *NEW TESTAMENT* 653

righteousness interiorly, bearing his person from within: "'Who also himself looked for [the kingdom of God]": Not the temporal kingdom of carnal Jewry but the spiritual kingdom of Christ, in his Holy Church'.[55]

Throughout *Het Nieu Testament*, especially in the annotations parsing Mark 16 and John 20 in light of the Resurrection, a great mystery directly witnessed by no one but fully attested by the many *teeckenen* (perceptible signs) that followed in its wake, Costerus ruminates on the nature of such signs.[56] He characterises them not only as testaments to the ineffable truths they make discernible by representational means, but also as catalysts to faithful testimony: they enable the processes of *toonen* (showing forth), *openlick seyden* (speaking openly), *kennen geven* (making known) through which the mysteries of faith are propagated and circulate more widely.[57] Many of the interpolated prints, both in what they show and in their material status as inserted images (either pasted in or sewn into the binding), make apparent their semiotic status as mediative instruments of attestation. Take the folio-size pair of prints interposed between pages 364 and 365, at the close of John 20 (Fig. 20.25). Engraved by Pieter de Bailliu after Theodoor van Thulden, and published by Gaspar Huybrechts, these full-page inserts depict the encounter between the newly risen Christ and the Virgin who appear fully alive and yet also purport to be statues set upon socles, before a continuous landscape that stretches across the two plates. In this way, Jesus and Mary, whose exchange is predicated on the Resurrection of Christ, insistently represent it at one remove, in the purposive manner of a signifying referent: indeed, adduced as explicitly pictorial-sculptural *teeckenen* of this great mystery, they can be said doubly to mediate access to it – through their meeting, as also through their meeting in effigy.

55 Ibid.: "'Den welcken ooc selfs verwachtede". Niet het tijdelick rijc, dat de vleeschelicke Jode verwanteden, maer het gheestelick rijck Christi in sijne H. Kercke'.

56 See, for example, the annotation on Mark 16:17, focusing on the phrase 'Ende dese teeckenen', in ibid. 156–157, and the annotation on John 20:5, in ibid. 360, which explains that John, when he saw Christ's discarded linen shroud lying in the tomb, straightway believed in the Resurrection.

57 On *toonen*, see, for instance, the annotation on John 18:22, in ibid. 353, where he ruminates that when Malchus struck Christ in the house of Caiaphas, he did so to make a show of the fact that Jesus had not converted him; Costerus then cites Saint Cyril, who identified the man not as Malchus but as the minister who avouched the power of the Lord's preaching, in John 7:46, but now wanted emphatically to show his repudiation of Christ. On *openlick seyden*, see the annotation on John 18:31, in ibid. 354, where Costerus impugns the Pharisees who wished for Pilate to crucify Jesus but would not openly say what they were secretly plotting. On *kennen geven*, see the annotation on John 19:30, in ibid. 358, which states that when Christ said from the cross, 'It is consummated', he did not mean that the work of our salvation was now at an end, but instead wished to make known that every prophecy of the Passion had been fulfilled.

654 MELION

Moreover, in addition to drawing attention to Mary and Jesus as living signs of the Resurrection, the pendant prints also allude to the apocryphal nature of their encounter: as images of effigies that seem alive, Christ and the Virgin can be seen to enact a scene at once entirely plausible and yet irrefragably factitious; staged as a work of art, their joint meeting serves to epitomise the ostensive functions of representational *teeckenen*.

The person who intercalated the paired prints was most likely responding to Ludolphus of Saxony's *Vita Christi* and Ignatius of Loyola's *Exercitia spiritualia*, in which the apocryphal episode is intimately associated with meditation upon the mystery of the Resurrection.[58] By representing Jesus and Mary as pendant sculptures, the prints invite the reader-viewer frankly to acknowledge that s/he is dealing with manufactured images. This acknowledgement comports with the meditative sources that were the portrayed scene's primary sources: Ludolphus and Ignatius, in their spiritual exercises, empower the exercitant actively to fabricate her / his own *imagines agentes* (mental images, artificially produced from memory). If s/he is to reform her-/himself, s/he must engage fully and knowingly in the task – the spiritual artifice – of meditative image-making; this entails visualizing scenes from the life of Christ in the form of meditative schemata set out in the two treatises, while calling upon the assistance of a spiritual advisor, whenever possible. Simply put, the self-evidently representational status of Van Thulden and De Bailliu's *Jesus* and *Mary* bears comparison with the pointedly image-based exercises upon which Ludolphus and Ignatius build their respective meditations on the meeting between the risen Christ and the Virgin.

Whereas many of the images in *Het Nieu Testament* are positioned beside the glosses they annotate, in chapters 18–20 of John, as elsewhere, clusters of annotations centering on certain themes – *ghetuygenisse* (testimony), *bewijs* (demonstration), and *teeckenen* (signs), for instance – connect to clusters of images, often interjected as sequences of folios before or after the texts they qualify.[59] This is true of *Mary* and *Jesus*, which provide a visual gloss on other

58 See Ludolphus de Saxonia, "Quomodo Dominus Iesus apparuit matri suae", in *Vita Christi Domini servatoris nostri* (Paris, Michael Sonnius: 1580), fols. 450r–452r; and Ignatius de Loyola, "Quarta hebdomada. Contemplatio prima. Quomodo Iesus Dominus, post resurrectionem apparuit sanctae Matri Suae", in *Exercitia spiritualia* (Rome, Antonius Bladus: 1548), fol. I iiii verso-I v recto. On the iconography of this apocryphal *apparitio Christi*, see Breckenridge J.D., "*Et prima vidit*: The Iconography of the Appearance of Christ to his Mother", *The Art Bulletin* 39 (1957) 9–32; and Bø R.M., "The Resurrected Christ Appearing to His Mother in Late Medieval Netherlandish Altarpieces", *Konsthistorisk tidskrift* 89 (2020) 1–16.

59 On the interconnected themes of *ghetuygenisse* (testimony, in the sense of bearing witness) and *bewesen* (proof, in the sense of adducing evidence), see, for example, the

A CUSTOMISED COPY OF COSTERUS'S DUTCH *NEW TESTAMENT* 655

complementary annotations in John 20 [Fig. 20.25]. To cite an example, in annotation 5 on John 20:5 – 'And when [Peter] stooped down, he saw the linen cloths lying' – Costerus, invoking the parallel passage in Mark 16:7, inquires whether Peter, when he saw the cloths formerly draped on the Lord's face and body, instantly believed in the Resurrection, as did John. Did he rightly read the signs, in other words? His answer is no: because the evangelist 'could not see into Peter's heart', John 20:5 does not explicitly concur, but *Mark* 16, in stating that the angels expressly commanded the women to return and announce to Peter that the Lord was risen, strongly implies that he had yet to be swayed.[60] He must thus have been less sensitive to visual signs than John or the women. Annotation 21 on John 20:21–22 – 'As the Father hath sent me, I also send you. When he had said this, he breathed on them: and he said to them, Receive the Holy Ghost' – reflects upon the significance of the ceremony of casting breath. This was a sign, avows Costerus, that the power to forgive sins, which Jesus was about the bestow, would be conferred through the agency of the Holy Spirit: '[...] here is signified not only the grace of justifying, but also the power to absolve sins, which is a great gift of the Holy Spirit, alone given to priests at their consecration'.[61] Likewise, annotation 23 on the passage – 'Whose sins you shall forgive, they are forgiven them' – explains that the word *vergheven* (forgive) is itself a sign of every consecrated priest's power to reconcile sinners, converting them from enemies into friends of God. Compounded with Christ's refusal to specify which sins, or how many, the conferral of sacramental power encompasses every kind and degree of sin, and as well, every variety of reparatory satisfaction imposed by any priest consecrated within the unbroken line of succession extending from Peter and his fellow apostles to the present. The sacrament, to be efficacious, must incorporate certain external, apprehensible signs ('uytwendich teecken') mandated by the Lord: words of confession, words of contrition, and words of absolution, that respectively reveal the sins to be evaluated, the necessary contrition of the person confessing them, and finally, that person's reconciliation with God. In turn, the episcopal ritual of breathing

extensive annotation on John 19:34, in ibid. 359, as it relates to 1 John 5:6, on the sacramental testimony, baptismal and eucharistic, by water and by blood, to the humanity and divinity of Christ. *Teeckenen* are evidentiary signs constitutive of the closely related processes of *toonen, openlick seyden*, and *kennen geven*, on which see note 57 *supra*.

60 Costerus, *Het Nieu Testament* 360: 'Daerom seght S. Jan dat hy dese teeckenen siende ghe-loofde: niet dat het lichaem daer niet en was, want dat sach hy; maer dat het verresen was, so hy't Christum dickwijls had hooren voorsegghen. Oft Petrus oock geloofde, en seght hy niet; want hy sijn herte niet en sach'.

61 Ibid. 362: '[...] en wordt hier niet beteeckent alleen de gratie der rechtveerdichmakinghe, maer de macht om de sonden te vergheven: de welcke is eene groote gave des H. Geests, ende sy wort allen Priesteren in hunne wijinghe ghegeven'.

656 MELION

upon new priests during the consecration ceremony, is a re-enactment of the sign first enacted by Christ to represent Penance as an essential though secondary part of the priestly office, corollary to the celebration of the Eucharist.[62]

The annotations about the prevalence of *teeckenen* in John 20 conclude by assaying the evangelist's unequivocal endorsement of signs in verses 30–31: 'Many other signs ('teeckenen') also did Jesus in the sight of his disciples, which are not written in this book. But these are written, that you may believe that Jesus is the Christ, the Son of God, and that believing, you may have life in his name'. John is distinguishing, says Costerus, between his Gospel, which was written primarily to attest the divinity of Christ, and the synoptic Gospels, which describe many other miracles performed by him. Everything so described can be visualised on faith, but such matters have a lesser importance than the Lord's divinity, for it is a key doctrine of the faith: without professing it, along with the eleven other points of doctrine summarised in the *Symbolum* (Apostles' Creed), one cannot claim to be a Christian. The *teeckenen* John records and describes, the Resurrection above all, as the chief sign of the divinity of Christ, along with the corollary signs that corroborate this great mystery, are thus the sine qua non without faith in which, one cannot be saved ('sonder het welck niemandt en kan salich worden').[63] With regard to the other matters, significant as they are, one need only refrain from obstinately denying them; on the contrary, the truth of the Resurrection, known after the fact by way of the signs left in its wake, must be embraced thoroughly.[64]

Inserted into John 20, three sets of pendant images illustrate the power of these signs: in addition to *Mary* and *Jesus*, at the close of the chapter, two

62 Ibid. 362–363: 'Dat in't woordeken, *vergheven*, beteeckent wordt de macht niet alleen van Godts woordt te preken, ende door sermoonen den mensch tot leedtwesen te verwecken; noch ooc om te toonen oft te verklaren dat-se vergheven zijn, gelijck de Priesters der ouder wet de melaetsche suyverden, (seght S. Chrysostomus) maer om selfs de sonden te vergheven. [...] Dat het een uytwendich teecken zy: het welck hier zijn 1. De woorden der absolutie die den Priester spreeckt: want Christus wilt dat men de sonden niet met ghepeysen alleen, maer oock met uytsprake verghve; op dat het den sondaer mach weten. 2. De teeckenen des biechters die sijne sonden verhaelt, ende sijn berou toont, als bequaem om vergiffenisse te ghenieten'.

63 Ibid.

64 The *Gospel of John*, states Costerus, affirms the divinity of Christ, offering incontrovertible proofs thereof, the Resurrection above all: see ibid. 364: 'S. Jan heeft sijn Evanghelie gheschreven om te bewijsen, teghen Cerinthum ende d'Ebioniten, dat Christus niet alleen mensch is, maer oock Godt. [...] Dat hier S. Jan niet en spreeckt van al dat men noodtsakelick moet ghelooven, maer alleen van't gheloove der Godtheydt Christi'. Regarding the articles of faith taken from elsewhere in Scripture and from the traditions of the Church, Costerus adds: 'welcke dinghen en is niemandt schuldich al uytdruckelick te ghelooven; maer 'tis ghenoech dat men daer niet teghen obstinatelick en wilt houden'.

A CUSTOMISED COPY OF COSTERUS'S DUTCH *NEW TESTAMENT*　　　　657

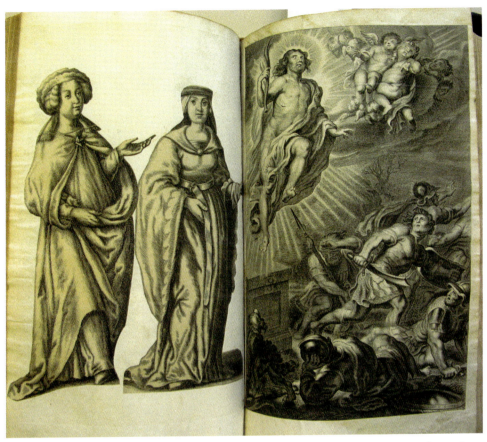

FIGURE 20.26　John 20:1–13, cut and pasted-in *Salome and Mary of James / Joanna and Mary of James Bear Witness to the Resurrection* and sewn-in *Resurrection*, from *Het Nieu Testament onses Heeren Iesu Christi* (Antwerp, Ioachim Trognaesius: 1614) 360–361. Engraving, inserted in folio
MAURITS SABBEBIBLIOTHEEK, KATHOLIEKE UNIVERSITEIT, LEUVEN

further pairs are placed at the start [Figs. 20.25, 20.26, 20.27]. The first of the openings consists of cut-out images of two holy women, presumably Salome and Mary of James (Mark 16:1) or Joanna and Mary of James (Luke 24:10), who gesture across the book gutter toward a full-page *Resurrection* [Fig. 20.26]; these are the women who, finding the tomb empty, were met by an angelic man (Mark 16) or by two heavenly youths in shining apparel (Luke 24) who announced that Christ was risen. Fortified by these signs, they rushed back to Jerusalem, convinced of the Resurrection. Ingeniously cut and pasted, the two figures, perhaps excerpted from a Burgundian chronicle, point toward the mystery they did not actually witness but now deictically evince and wholeheartedly embrace on the basis of signs seen and heard. The next opening

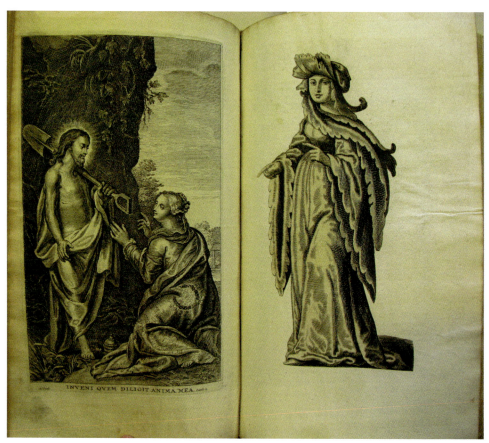

FIGURE 20.27 John 20:1–13, sewn-in *Apparition of the Risen Christ to the Magdalene*, and cut and pasted-in *Mary Magdalene*, from *Het Nieu Testament onses Heeren Iesu Christi* (Antwerp, Ioachim Trognaesius: 1614) 360–361. Engraving, inserted in folio
MAURITS SABBEBIBLIOTHEEK, KATHOLIEKE UNIVERSITEIT, LEUVEN

consists of the cut-out figure of a woman, very richly dressed, who plays the part of the Magdalene [Fig. 20.27]: she points toward the great *teecken*, Christ in the guise of a gardener (John 20), whereby she came to know that he had risen. Like the two women of the previous opening, she can be thought not only to call attention to an actual event – the Resurrection, the apparition of Christ in the garden – but also to printed image of that event, as if she were an embodied manicule, a *teecken* that bears witness to a further pictorial *teecken*. The holy women and the Magdalene thus present themselves as lively indeed living signs of the mystery whose existence their testimony allows us to construe as true and representable [Figs. 20.26 & 20.27]. By the same token, in *Mary and Jesus*, the Virgin submits to the power of the mystery she beholds in

A CUSTOMISED COPY OF COSTERUS'S DUTCH *NEW TESTAMENT* 659

and through an apparition of the risen Christ; their encounter is entirely comprised by images alluding to the power of *teeckenen* visually to convey the truth of the Resurrection [Fig. 20.25]. Underlying these readings of the term *teecken* is its usage in workshop parlance and art theoretical discourse, wherein the verb *teyckenen* signifies 'to delineate', *teyckening* is an image made up of lines, and *teyckenconst* is the art of portraying people or things with lines.[65] Implicit in the term, then, is a reference to linear images, more specifically, to the evidentiary value of the kinds of prints, executed in contour lines, hatches, and cross-hatching, that populate this copy of *Het Nieu Testament*. In this context, they can be appreciated as specimens of *teyckening* that lay bare the signifying function of the scriptural proof-*teeckenen* of the Resurrection discussed in Costerus's annotations.

The emphasis on bearing witness to Christ in the annotations accompanying John 18 and 19 lays the groundwork for the defence of *teeckenen* as wellsprings of faith in the Resurrection, advanced by the three pairs of prints inserted into John 20. Numerous full-page images of the Passion punctuate John 18 and 19, serving to exemplify how testimony to Jesus was by turns given or withheld, and how Christ himself testified, through his words and deeds, to the major prophecies of the Passion now being fulfilled. Take annotation 9 and its correspondent images: above, a small cut-out of Christ with the chalice, a condensed allusion to the Agony in the Garden; facing it, engraved by Voet, a more elaborate folio-size version of the same scene, this time with the angel who came to fortify Christ [Fig. 20.28]. One hand held at his heart, Jesus expresses his resolve to do the will of the Father (cf. Matthew 26:39, Mark 14:36, Luke 22:42); with his other hand, he gestures toward the sleeping apostles who exemplify the maxim, 'The spirit indeed is willing, but the flesh is weak' (cf. Matthew 26:41, Mark 14:38), having failed to heed his admonition, 'Arise, pray: lest you enter into temptation' (cf. Matthew 26:41, Mark 14:38, Luke 22:46). The same gesture fixes more distantly on the men who come to arrest him, and as such, pertains to his statement: 'Behold the hour is at hand: and the Son of man shall be betrayed into the hands of sinners' (cf. Matthew 26:45, Mark 14:21). Annotation 9, on John 18:9 – 'That the word might be fulfilled which he said: Of them whom thou hast given me, I have not lost any one' – argues that the

65 On the various meanings of *teecken* and *teyckening* – in Latin, 'signare, designare, insignire, notare, annotare, denotare' – and on their close association with the motions of the hand, see Plantin Christopher – Killiaan Cornelis et al., *Thesaurus Theutonicae linguae. Schat der Neder-duytscher spraken* (Antwerp, Christopher Plantin: 1573), fols. Ff 3 verso-Ff 4 recto; and Mander Karel van, "Van het teyckenen, oft Teycken-const", in *Het Schilder-Boeck: Den Grondt der Edel vry Schilder-const* (Haarlem, Paschier van Wesbusch: 1604), fols. 8r–10r.

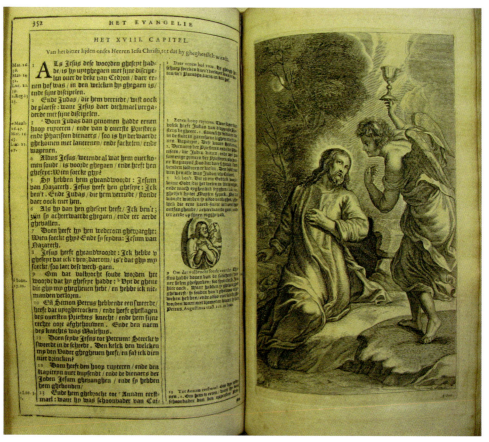

FIGURE 20.28 John 18:1–13, cut and pasted-in *Agony in the Garden,* and sewn-in *Agony in the Garden* by Alexander Voet, from *Het Nieu Testament onses Heeren Iesu Christi* (Antwerp, Ioachim Trognaesius: 1614) 352–353. Engraving, inserted in folio
MAURITS SABBEBIBLIOTHEEK, KATHOLIEKE UNIVERSITEIT, LEUVEN

evangelist is testifying to the fulfillment of the pledge made in John 17:12: 'Those whom thou gavest me have I kept: and none of them is lost'. Costerus opines that it was to keep this promise, which concerned the apostles' spiritual welfare first and foremost, that Christ told the arresting soldiers to let his companions 'go their way' (John 18:8): '"That it might be fulfilled": Christ had spoken before about the salvation of their souls: in like manner, Saint John speaks here. For had they been arrested, they would have wavered in faith, and ceased to be sanctified; for none of them was more devout that Peter [who betrayed Christ]'.[66] The proximity to annotation 9 of the two images of Christ's

66 Costerus, *Het Nieu Testament* 352: '"Om dat volbrocht soude worden". Christus hadde boven van de salicheydt hunner sielen ghesproken: soo spreeckt S. Jan hier oock. Wat

A CUSTOMISED COPY OF COSTERUS'S DUTCH *NEW TESTAMENT* 661

prayer of entreaty connects them to the lengthy prayer of promise recorded in John 17:15–26: the latter can be deemed to testify to the former, and the Lord's attentiveness to his sleeping men in the large *Agony in the Garden* becomes a further manifestation of his express wish to protect his followers from spiritual harm [Fig. 20.28].

Costerus develops the theme of testimony in annotation 15, on John 18:15, about the two disciples who followed Christ to the courtyard of Caiaphas's house, after his arrest: 'But Simon Peter followed Jesus: and so did another disciple. And that disciple was known to the high priest and went in with Jesus into the court of the high priest'. The sorrowful image of Peter pasted just below evokes the bitter regret he felt after failing to bear witness to Christ, in John 18:25–27, when the servants and ministers of the high priest accosted him (cf. Matthew 26:75, Mark 14:72, Luke 23:62) [Fig. 20.29]. Peter's penitence is visually counterposed to Costerus's account of the other disciple, whom he presumes to have been Joseph of Arimathea or Nicodemus, known to their fellow Jews as crypto-Christians ('bedeckten ende onbekenden Christen'), who kept faith with Christ by covertly following after him, but refrained from bearing witness fully.[67] Both he and Peter are contrasted with Jesus, who openly professed the Gospel, everywhere evincing its truth, according to annotation 20, on John 18:20: 'Jesus answered [the high priest]: I have spoken openly to the world'. Costerus writes: 'Christ here answers that he taught before the whole world, also in the presence of those who sat there [...]: so that men should impute no wrong to him'.[68] By contrast, his accusers begin their interrogation, in John 8:19, not by making an accusation but by posing questions about his doctrine and disciples, since they have nothing substantive to attest against him. Annotation 22, on John 18:22 – 'And when he had said these things, one of the servants standing by gave Jesus a blow' – describes another kind of oppositional testimony: Costerus conjectures that the person who struck him must have been Malchus, whom he had miraculously healed, but who now wished publicly to bear witness against the Lord; he strikes a blow violently to declare his refusal to be converted ('hier mede wilde toonen dat hy niet bekeert en was').[69] Costerus appends the alternative hypothesis of Saint Cyril that the man may have been one of the ministers sent by the 'rulers and Pharisees', in John 7:32–34,

 hadden sy ghevanghen gheweest, sy souden van't gheloove afgeweken hebben, ende also niet salich ghewoorden: want niet vromer en waren sy dan Petrus'. He cites Augustine's *Tractatus 112 in Iohannis evangelium* as his source.

67 Costerus, *Het Nieu Testament* 353.

68 Ibid.: 'Hier op andwoordt Christus dat hy sijne leeringhe voor de gantschen werelt ghedaen hadde, oock in de teghenwoordicheydt der gener die daer saten [...]: op dat men van hen gheen quaet vermoeden en soude hebben'.

69 Ibid.

FIGURE 20.29
John 18:14–23, cut and pasted-in *Penitent Saint Peter*, from *Het Nieu Testament onses Heeren Iesu Christi* (Antwerp, Ioachim Trognaesius: 1614) 353. Engraving, inserted in folio
MAURITS
SABBEBIBLIOTHEEK,
KATHOLIEKE
UNIVERSITEIT, LEUVEN

to apprehend Christ; having returned empty-handed and reported admiringly, 'Never did man speak like this man', they too wish emphatically to show that they remain unconverted ('hier door wilde toonen dat hy niet omgheset en was').[70] Annotation 23, on John 18:23 – 'Jesus answered him: If I have spoken evil, give testimony of the evil' – asks why Jesus did not turn the other cheek, as he had counseled the apostles during the Sermon on the Mount, in Luke 6:29.

70 Ibid.: 'S. Cyrillus meynt dat het was eenen van de ghene die uytghesonden waren om Christum te vanghen […]'. See Cyril of Alexandria, *Commentary on John* XI.xviii.10.

A CUSTOMISED COPY OF COSTERUS'S DUTCH *NEW TESTAMENT* 663

Costerus speculates that the Lord refused to invite a second blow, in order to demonstrate his complete innocence: being innocent, he deserved no ill treatment. Moreover, by his silence he hoped to prick the conscience of the man who had attacked him so gratuitously, causing the malefactor to acknowledge that no 'testimony of evil' could be given ('om de conscientie van desen dienaer tot berou van dit ongelijck te beroeren').[71] According to annotation 31, on John 18:31–32 – 'The Jews therefore said to [Pilate]: It is not lawful for us to put any man to death. That the word of Jesus might be fulfilled, which he said, signifying what death he should die' – the evangelist recalls Jesus's prophecy of his Passion and death, in Matthew 20:18–19: 'And [they] shall deliver him to the Gentiles to be mocked, and scourged, and crucified'. The deeds these words of testimony foretold are now coming to pass: 'For he had formerly said not only by whom he would be killed, that is, by the Gentiles, but also what sort of death he would suffer, namely, death by the cross'.[72]

Two full-page prints by Gaspar Huybrechts of *Christ before Caiaphas* and *Christ before Pontius Pilate* attach to and expand upon this densely layered sequence of references to various kinds and degrees of testimony [Figs. 20.30 & 20.31]. The first of the two harmonises John 18:22 with Matthew 26:59–65: a helmeted soldier, his gauntlet raised, prepares to strike Christ, who stares silently downward, having just certified (in Matthew 26:63–64) that he is indeed the Christ, Son of the living God, whose innocence, authority, and power of judgement the many false witnesses brought in by the priests and council can neither impugn nor contravene [Fig. 20.30]: 'And the high priest said to him: [...] tell us if thou be the Christ the Son of God. Jesus saith to him: thou hast said it. Nevertheless I say to you, hereafter you shall see the son of man sitting on the right hand of the power of God and coming in the clouds of heaven'. The stillness of Jesus, his withdrawn stance, and downcast eyes correlate to the argument of annotation 23 that the Lord's silence was both compunctious and evidential. The high priest, Christ's presumptive judge, tears his garment, in illustration of Matthew 26:65: 'Then the high priest rent his garments, saying: He hath blasphemed'. The network of annotations frames this gesture ironically, accusing Caiaphas and his servants of bearing false witness against Jesus, whose true testimony clashes with their injudicious claim that he is a blasphemer. On the contrary, it is Caiaphas who has blasphemed. This is the

71 Ibid.: 'om al swijghende niet schijnen te belijden dat hy den slach verdient hadde, ende also om sijne sonden was lijdende, die noyt de minste faute en dede'.

72 Ibid. 354: 'Want hy hadde te voren geseyt, niet alleen van wien hy soude ghedoodt worden, te weten, van de Heydenen; maer oock wat doodt hy lijden soude, te weten, de doodt des kruys'.

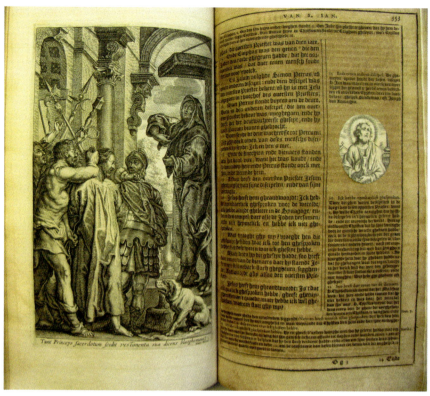

FIGURE 20.30 John 18:14–23, sewn-in *Christ before Caiaphas* by Gaspar Huybrechts, from *Het Nieu Testament onses Heeren Iesu Christi* (Antwerp, Ioachim Trognaesius: 1614) 352–353. Engraving, inserted in folio
MAURITS SABBEBIBLIOTHEEK, KATHOLIEKE UNIVERSITEIT, LEUVEN

moment when he sends Jesus on to Pilate to be judged and ultimately crucified: the situation in which the Christ finds himself can thereby be educed from annotation 31, which emphasises, as noted above, that his oracle concerning the Crucifixion is about to be fulfilled.

Christ before Pilate is so similar in composition and detail to *Christ before Caiaphas* that it draws attention to the one element of the picture that differs conspicuously – the figure of Pilate [Figs. 20.30 & 20.31]. The exchange between Christ and Pilate constitutes the chief subject of Costerus's annotations 36 and 37, the penultimate glosses in John 18. Both annotations respond to Christ's key statement in John 18:36–37: '[…] and for this came I into the world: that I should give testimony to the truth'. His downcast eyes and humble demeanour are perfectly attuned to the content of the testimony he offered Pilate before again falling silent, as annotation 36 explains:

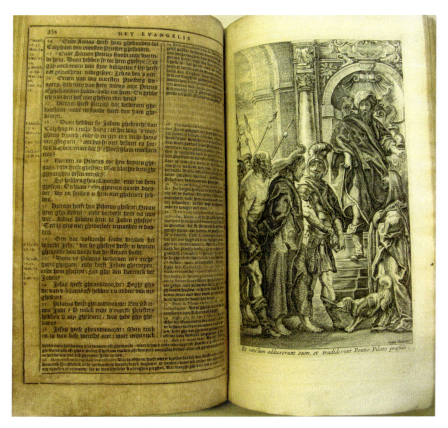

FIGURE 20.31 John 18:24–36, sewn-in *Christ before Pontius Pilate* by Gaspar Huybrechts, from *Het Nieu Testament onses Heeren Iesu Christi* (Antwerp, Ioachim Trognaesius: 1614) 354–355. Engraving, inserted in folio
MAURITS SABBEBIBLIOTHEEK, KATHOLIEKE UNIVERSITEIT, LEUVEN

'My kingdom is not of this world'. That is, you need not fear that I desire to take power over a temporal and terrestrial kingdom from an emperor or king: for I did not come to reign temporally, as human kings are wont to do, as may be seen from the fact that I have gathered no servants to assist and protect my person, and shield me from my enemies: for had I raised them up, they would have prevented my capture by the Jews.[73]

73 Ibid. 354–355: "'Mijn rijck en is van dese wereldt niet". Dat is: Ghy en hoeft niet te vreesen dat ick den Keyser oft eenighen Koninck zijn tijdelick ende uytwendich koninckrijck begheere te nemen: want ick en ben niet ghekomen om tijdelick te regneren, soo de menschelicke Koninghen pleghen. Dat mooght ghy daer aen mercken, om dat ick noyt knechten vergadert en hebbe, die my souden dienen, mijn lijf bewaren, ende van mijne vijanden beschermen: want hadde ick sulcke opghelicht, sy en souden my van de Joden niet laten vanghen hebben'.

Costerus observes in annotation 37 that only a heart desirous of knowing, hearing, and believing Christ could have grasped the import of his speech, freely delivered before Pilate ('want alle die de waerheydt uyt der herten begheeren te kennen, die hooren ende ghelooven wat ick segghe').[74] The governor's prominence in *Christ before Pilate*, heightened by comparison with *Christ before Caiaphas*, is precisely analogous with Costerus's conviction, set forth in the opening annotations on John 19, that Pilate, incipiently aware of the truth of Christ's words, had the makings of such a heart. Evidence of this can be found in his attempt to stage a spectacle – albeit a cruel one – that would highlight the innocence of Jesus and even solicit compassion for him. With reference to John 19:1–5, in which Pilate has Jesus scourged, crowned with thorns, and dressed in purple, before showing him to the people, annotation 4 states: 'Through the despoilment of Christ ('door Christi mismaecktheyt'), he meant to mollify the Jews so that they might let him go: wherefrom we may learn how gruesomely and appallingly his body was beaten, in accordance with the prophecy of Isaiah [53:2]: "There is no beauty in him, nor comeliness: and we have seen him, and there was no sightliness, that we should be desirous of him"'.[75] When Pilate shortly afterward declares to the people, 'Behold the Man' (in John 19:5), he is issuing a coded plea on Christ's behalf: 'As if he wished to say: Yet is he a man, no beast, and for this reason let no further cruelty be shown him, other than that you now see'.[76] By contrast with Pilate's futile effort to attest his innocence, the people, stirred up by their leaders, once again bear false witness: even while purposefully neglecting to cite the many miracles that had given ample proof of his divinity, they accuse Christ of blasphemy for calling himself the Son of God.

The book's owner responded to Costerus's remarks by inserting the image of Pilate rising from the governor's throne to mark Christ's presence [Fig. 20.31]; he gestures toward the right edge of the picture, as if directing the viewer's gaze to the triad of interpolated prints that directly follow, between pages 354 and 355: Huybrechts's *Flagellation*, Voet's *Christ Kneels to Retrieve his Robe after the Scourging at the Pillar*, and Huybrechts's *Christ Mocked and Crowned with Thorns* [Figs. 20.32, 20.33, & 20.34]. The three episodes illustrate successive

74 Ibid. 355.

75 Ibid.: 'Hy meynde dat de Joden door Christi mismaecktheyt souden vermorwt worden om hem te laten gaen: daer wy moghen uyt leeren dat hy seer eyselick en grouwelick het gantsch lichaem door gheslaghen was; na de prophecije Isaie: "He en heeft gene gedaente noch schoonheydt; ende wy hebben hem ghesien, ende daer en was geene aenschouwen"'.

76 Ibid.: 'Als oft hy segghen wilde: "Tis doch eenen mensch, ende geene beeste; daerom en toont gheene meerdere wreedtheydt aen hem, dan ghy nu siet".

A CUSTOMISED COPY OF COSTERUS'S DUTCH *NEW TESTAMENT* 667

stages of the Passion engineered by Pilate to 'despoil' Christ's body, herewith to solicit sympathy for his *mismaecktheyt*.[77] The scene of Christ, exhausted and bloody, crawling toward his robe functions like a heartfelt plea to the beholder [Fig. 20.33]: as Pilate strove to soften the people's hearts by converting Jesus into a pitiable spectacle, so this abject image of the Isaian Man of Sorrows is deployed to arouse the viewer's compassion. Pilate then appears a second time in Huybrechts's *Ecce Homo*, where he repeats and in a sense completes the gesture of showing seen earlier in *Christ before Pilate* [Figs. 20.31 & 20.35]. But this time Pilate's hand directs the viewer's gaze toward the cross, held aloft by a soldier standing below the podium on which Pilate displays Christ; cropped by the right edge of the picture, the cross leads to Huybrechts's *Carrying of the Cross*, between pages 356 and 357 [Fig. 20.36], and Huybrechts's *Crucifixion*, *Deposition*, and *Entombment*, between pages 358 and 359 [Figs.20.37, 20.38, & 20.39]. This subset of images correlates to a change in the argument of Costerus's annotations: whereas previously he endeavoured at least partly to exonerate Pilate, annotations 10–11 instead reveal how and why he lacked the courage of his convictions.

These are the wages of bearing witness timidly and exercising one's free will fearfully, not for good but for ill, asserts Costerus in annotation 10, on John 19:10: 'Pilate therefore saith to him: […] knowest thou not that I have power to crucify thee'? Speaking ironically, he contrasts this would-be defender of Christ with Lutheran and Reformed heretics who privilege the doctrine of predestination above the Roman Catholic emphasis on good works as salvific and agential instruments of free will.

> Pilate was more learned than our heretics: for he admitted to having the power, and also the freedom of will, either to crucify Christ or let him go, something our heretics deny. For not only did he have the authority, whereby he might justly have refrained from crucifying him, but also his own free will, whereby he unjustly crucified him, as Ambrose comments.[78]

77 Read in tandem, annotations 6 and 8 on John 19, in ibid. 355–356, argue that Pilate, though he treated Jesus unjustly in having him scourged, did so to make of him a pitiable spectacle, thereby to solicit the people's compassion: 'ende op dat sy hem kennen souden, ende beweeght worden, seyde Pilatus: "Siet desen mensch"'.

78 Ibid. 356: 'Pilatus was geleerder dan onse ketters: want hy bekende in hem-selven de macht Christum te kruyssen ende te laten gaen, ende also sijnen vrijen wille; dien onse ketters loochenen. Want niet alleen en hadde hy d'authoriteyt, daer hy hem met recht niet en mocht mede kruyssen; maer ooc sijnen eyghenen wille, daer hy hem teghen recht mede ghekruyst heeft, so S. Ambrosius noteert'. See Ambrose, *Expositio Evangelii secundum Lucam* x.97–99, in Patrologia Latina 15:1525 (cols. 1828–1829).

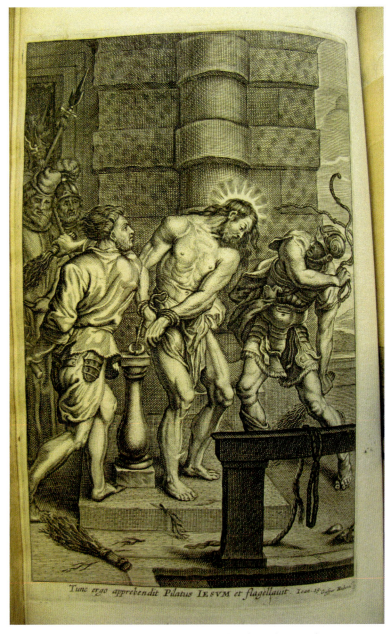

FIGURE 20.32 John 19:1–6, sewn-in *Flagellation* by Alexander Voet, from *Het Nieu Testament onses Heeren Iesu Christi* (Antwerp, Ioachim Trognaesius: 1614) 354–355. Engraving, inserted in folio
MAURITS SABBEBIBLIOTHEEK, KATHOLIEKE UNIVERSITEIT, LEUVEN

A CUSTOMISED COPY OF COSTERUS'S DUTCH *NEW TESTAMENT* 669

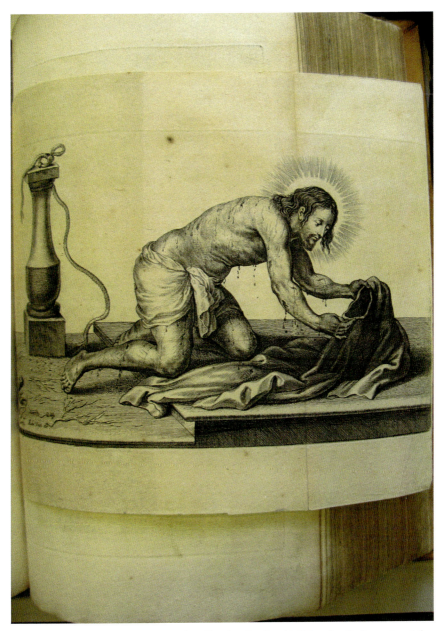

FIGURE 20.33 John 19:1–6, sewn-in *Christ Kneels to Retrieve his Robe after the Scourging at the Pillar* by Alexander Voet, from *Het Nieu Testament onses Heeren Iesu Christi* (Antwerp, Ioachim Trognaesius: 1614) 354–355. Engraving, inserted in folio
MAURITS SABBEBIBLIOTHEEK, KATHOLIEKE UNIVERSITEIT, LEUVEN

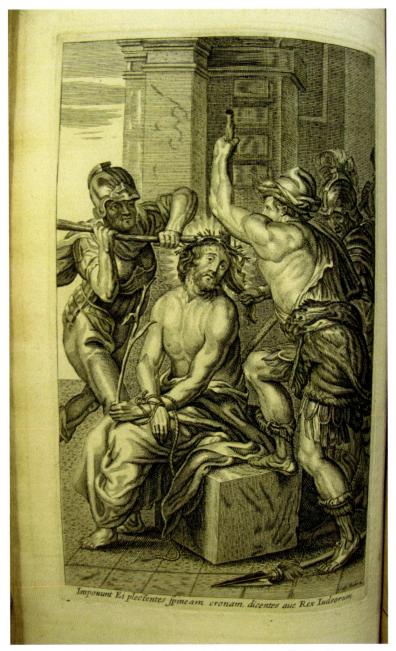

FIGURE 20.34 *Christ Mocked and Crowned with Thorns*, from *Het Nieu Testament onses Heeren Iesu Christi* (Antwerp, Ioachim Trognaesius: 1614) 354-355. Engraving, inserted in folio
MAURITS SABBEBIBLIOTHEEK, KATHOLIEKE UNIVERSITEIT, LEUVEN

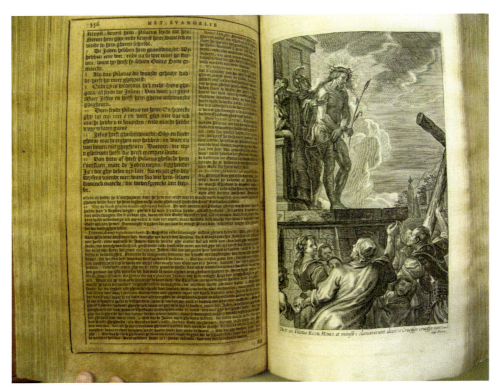

FIGURE 20.35 John 19:7–12, sewn-in *Ecce Homo* by Gaspar Huybrechts, from *Het Nieu Testament onses Heeren Iesu Christi* (Antwerp, Ioachim Trognaesius: 1614) 356–357. Engraving, inserted in folio
MAURITS SABBEBIBLIOTHEEK, KATHOLIEKE UNIVERSITEIT, LEUVEN

Knowing he could save Jesus, Pilate yet chose to condemn him: why, asks Costerus, and to what effect? Annotation 11 points out that he surely heard and understood Christ's avowal of his divinely mandated power over life and death; Pilate exercised power over him only by the will of God, as clearly stated in John 19:11: 'Thou shouldst not have any power against me, unless it were given thee from above. Therefore, he that hath delivered me to thee, hath the greater sin'.[79] Pilate undoubtedly sinned when he sent Christ to his death, but there were extenuating circumstances: first, because though he caused Jesus to be crucified, unlike the scribes and Pharisees he pitied rather than hated him, and was driven more by fear of imperial sanction and the people's displeasure;

79 Ibid.: 'Ick en ben u naturelick niet onderworpen, so d'andere zijn; want ick ben Godt, Oversten van alle creaturen: maer door mijns Vaders wille onderwerpe ick my onder u, niet uyt noodt, maer willens'.

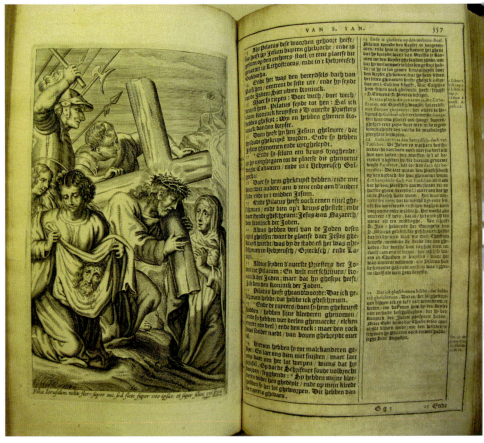

FIGURE 20.36　John 19:13–24, sewn-in *Carrying of the Cross* by Gaspar Huybrechts, from *Het Nieu Testament onses Heeren Iesu Christi* (Antwerp, Ioachim Trognaesius: 1614) 356–357. Engraving, inserted in folio
MAURITS SABBEBIBLIOTHEEK, KATHOLIEKE UNIVERSITEIT, LEUVEN

second, because it was God's will that Christ be crucified as a sin-offering; third, because Pilate knew nothing of the prophecies of the Messiah divinely ordained by the Father as his people's Saviour. For these and other reasons, Costerus considers it plausible that Christ, when he diverted blame from Pilate, mainly laying it upon the shoulders of the scribes, Pharisees, and other local leaders, was assuring him that his sin, howsoever grievous, could ultimately be forgiven: 'He did not say "your sin", but rather, "the sin of them that delivered me to thee", in order to give him hope of forgiveness. For when he afterward saw some of the men converted who had crucified Christ out of ill-will, it was granted him, who had committed a lesser sin, to trust in the acquisition of

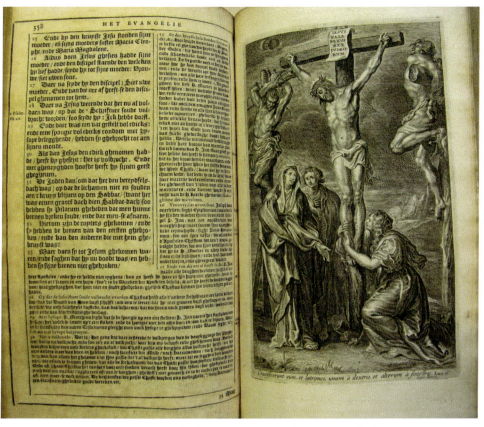

FIGURE 20.37 John 19:25–33, sewn-in *Crucifixion* by Gaspar Huybrechts, from *Het Nieu Testament onses Heeren Iesu Christi* (Antwerp, Ioachim Trognaesius: 1614) 358–359. Engraving, inserted in folio
MAURITS SABBEBIBLIOTHEEK, KATHOLIEKE UNIVERSITEIT, LEUVEN

remission'.[80] The sequence of full-page images bracketed by *Christ before Pilate* and the *Entombment,* due to its placement beside the annotations on Pilate, can be interpreted as an extended meditation on Pilate's actions and motives, as they relate to the nature of the witness he bore, both for and against Jesus [Figs. 20.31–20.39]. Pilate, viewed through the lens of the associated images and annotations on testimony, establishes an outermost threshold of sin, making

80 Ibid.: 'Hy en seght niet, *uwe sonde*; maer, *de sonde der gener die my u ghelevert hebben*: om hem eenighe hope van verghiffenisse te gheven. Want als hy namaels sommige bekeert sach, die Christum uyt quaedtheydt hadden doen kruyssen, mocht hy oock betrouwen verghiffenisse te verkrijghen; die mindere sonde ghedaen hadde'.

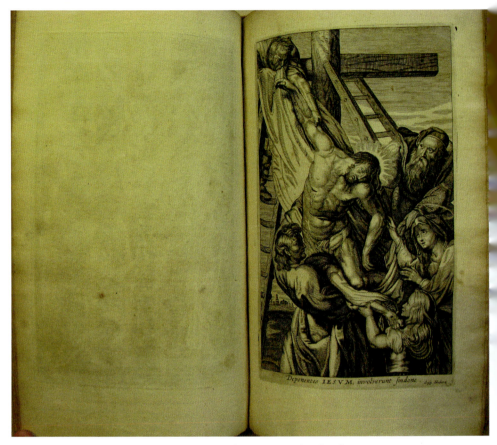

FIGURE 20.38 John 19:25–33, sewn in *Deposition* by Gaspar Huybrechts, from *Het Nieu Testament onses Heeren Iesu Christi* (Antwerp, Ioachim Trognaesius: 1614) 358–359. Engraving, inserted in folio
MAURITS SABBEBIBLIOTHEEK, KATHOLIEKE UNIVERSITEIT, LEUVEN

known, even if inadvertently, which grievous sins may be forgiven, and which are irredeemable (the ones committed by Christ's remorseless accusers). He thus stands as witness in another sense – to the saving power of Christ's death upon the cross.

The annotations that most closely connect to the *Carrying of the Cross*, *Crucifixion*, *Deposition*, and *Entombment* – annotations 25–37 on pages 358–359 – focus on the Virgin and John, who likewise occupy pride of place amongst the watchful followers of Christ [Figs. 20.36, 20.37, 20.38, 20.39].[81] All four prints

81 Gaspar Huybrechts published the *Crucifixion*, *Deposition* (based on Lucas Vorsterman's print after Rubens), and *Entombment*; the *Carrying of the Cross* was published anonymously.

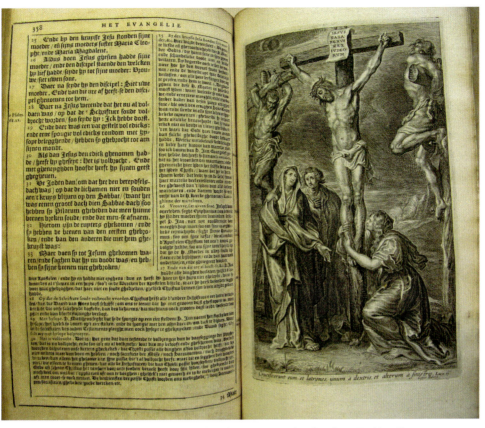

FIGURE 20.37 John 19:25–33, scwn-in *Crucifixion* by Gaspar Huybrechts, from *Het Nieu Testament onses Heeren Iesu Christi* (Antwerp, Ioachim Trognaesius: 1614) 358–359. Engraving, inserted in folio
MAURITS SABBEBIBLIOTHEEK, KATHOLIEKE UNIVERSITEIT, LEUVEN

remission'.[80] The sequence of full-page images bracketed by *Christ before Pilate* and the *Entombment*, due to its placement beside the annotations on Pilate, can be interpreted as an extended meditation on Pilate's actions and motives, as they relate to the nature of the witness he bore, both for and against Jesus [Figs. 20.31–20.39]. Pilate, viewed through the lens of the associated images and annotations on testimony, establishes an outermost threshold of sin, making

80 Ibid.: 'Hy en seght niet, *uwe sonde*; maer, *de sonde der gener die my u ghelevert hebben*: om hem eenighe hope van verghiffenisse te gheven. Want als hy namaels sommige bekeert sach, die Christum uyt quaedtheydt hadden doen kruyssen, mocht hy oock betrouwen verghiffenisse te verkrijghen; die mindere sonde ghedaen hadde'.

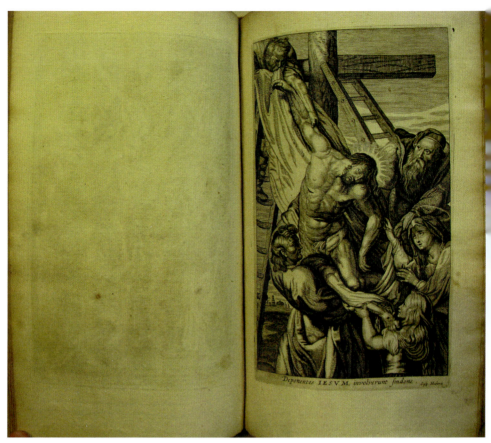

FIGURE 20.38 John 19:25–33, sewn in *Deposition* by Gaspar Huybrechts, from *Het Nieu Testament onses Heeren Iesu Christi* (Antwerp, Ioachim Trognaesius: 1614) 358–359. Engraving, inserted in folio
MAURITS SABBEBIBLIOTHEEK, KATHOLIEKE UNIVERSITEIT, LEUVEN

known, even if inadvertently, which grievous sins may be forgiven, and which are irredeemable (the ones committed by Christ's remorseless accusers). He thus stands as witness in another sense – to the saving power of Christ's death upon the cross.

The annotations that most closely connect to the *Carrying of the Cross*, *Crucifixion*, *Deposition*, and *Entombment* – annotations 25–37 on pages 358–359 – focus on the Virgin and John, who likewise occupy pride of place amongst the watchful followers of Christ [Figs. 20.36, 20.37, 20.38, 20.39].[81] All four prints

81 Gaspar Huybrechts published the *Crucifixion*, *Deposition* (based on Lucas Vorsterman's print after Rubens), and *Entombment*; the *Carrying of the Cross* was published anonymously.

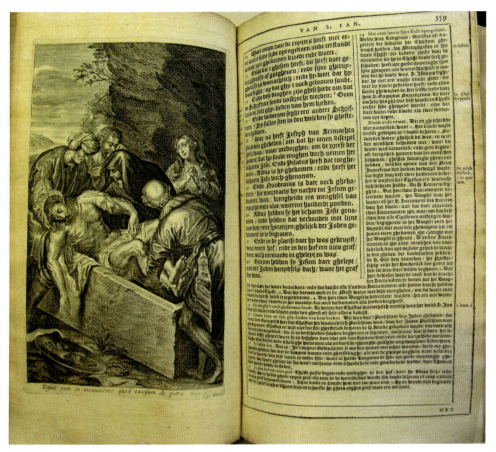

FIGURE 20.39 John 19:34–42, sewn-in *Entombment* by Gaspar Huybrechts, from *Het Nieu Testament onses Heeren Iesu Christi* (Antwerp, Ioachim Trognaesius: 1614) 358–359. Engraving, inserted in folio
MAURITS SABBEBIBLIOTHEEK, KATHOLIEKE UNIVERSITEIT, LEUVEN

feature Mary as her son's chief mourner, uniquely privileged to look directly at his face. In the *Crucifixion*, John accompanies Mary, imitating her gaze, though in the form of a sidelong glance, and in the *Deposition*, he bears the main weight of Christ's body, enabling Mary to reach out and touch her son [Figs. 20.37 & 20.38]. Mary and Jesus are the only two figures who sport a halo, his more radiant than hers, in the *Crucifixion* and *Deposition*, and this shared mark of sanctity correlates to the argument of annotation 25 that she alone suffered martyrdom with Christ, sharing in his every torment, not bodily but spiritually. So great was her suffering, asserts Costerus, that she would have succumbed had God not kept her alive during the violent death of Jesus. The

Gospel of John is cited as the source that most fully attests the miracle of her God-given endurance, and enshrines the witness she stalwartly bore at every moment of the Passion, above all during the final moments of Christ's death on the cross: 'Whose miraculous preservation in no wise precludes her crown of martyrdom, as I have argued above on the basis of Saint John the Evangelist. Thus she, too, possesses the *aureolam*, that is, the little crown of the martyrs: howbeit her suffering was different from Christ's (for what he bore in body, she bore in soul), yet was her martyrdom greater and more excellent than that suffered by every other martyr'.[82] With reference to John 19:25 – 'Now there stood by the cross of Jesus, his mother [...]' – Costerus affirms that more than an eyewitness, she kept faith with such prophecies of the saving Passion as Psalm 68, which famously concludes: 'For God will save Sion'. Unwavering in her conviction that the Passion was needful, she gives ample warrant of the redemptive value of her son's undue suffering: 'She desired as well to see the manner of his triumph over the devil, and how he should free the world from slavery, that she might meditate [these things] all the days of her life, and praise them'.[83]

As Mary is seen to verify the prophets, so John, who alone amongst the apostles stood watch by the cross ('die alleen van d'Apostelen Christum tot aen't kruys gevolght hadde'), is praised, in annotation 26, for verifying the scriptural circumstances of the Crucifixion.[84] Annotation 28 on John 19:28 – 'Afterwards, Jesus knowing that all things were now accomplished, that the scripture might be fulfilled, said: I thirst' – makes much of the evangelist's efforts to view the Crucifixion through the filter of Psalm 68:22, which prophesies the Crucified's spiritual thirst for the salvation of humankind.[85] John takes pains to show how the event conformed to its prognostic. Similarly, annotation 29 on John 19:29 – 'And they, putting a sponge full of vinegar about hyssop, put it

82 Ibid. 358: 'Welcke mirakeleuse bewaringhe en belet hare kroone van martelie niet; so ick boven van S. Jan Evangelist geseyt hebbe. So heeft sy dan oock *aureolam*, dat is, het kroonken der martelaren: ende ghemerckt haer lijden het selfste was met het lijden Christi (want dat hy in het lichaem leedt, dat leedt sy in de siele) soo is haer martelie veel excellenter ende meerder gheweest dan 't lijden van alle andere martelaers'.

83 Ibid.: 'Sy begeerde oock te sien de maniere hoe hy den duyvel soude verwinnen, ende de wereldt uyt sijne slavernije verlossen, om alle hare leefdagen daer op te peysen, ende hem te loven'.

84 Ibid.

85 Ibid.: 'Christus heeft alle d'andere Schrifturen eer laten vervullen, dan die David van sijnen dorst schrijft: om ons te leeren dat hy met grooten dorst ghestorven is: meer der siele, die onse dalicheyt dorstede; dan des lichaems, dat nochtans oock grooten dorst leedt, wesende van pijne ende van bloedtstortinghe verdort'.

A CUSTOMISED COPY OF COSTERUS'S DUTCH *NEW TESTAMENT* 677

to his mouth' – reads this passage as the fulfillment of Psalm 50:9.[86] Costerus situates the joint witness of Mary and John on a gradient rising toward the evidentiary intention of Christ himself, who took care, moment by moment, to stage the Passion as the completion of all scriptural prophecies foretelling the redemption of sin. If he bodies forth the truth of these prophecies, Mary and John are finally characterised as collateral guarantors of this same truth, made discernible to them by, in, and through Christ, the author of faith. Needless to say, the faith at issue is the one true faith entrusted to the Holy Roman Church, as Costerus stresses in annotation 30:

> 'It is consummated'. Namely, whatsoever oracles of the prophets remained to be fulfilled, were now accomplished; and now has all been fulfilled which was promised and written about me. On the basis of these words, our heretics foolishly contend that the Passion of Christ having brought all things to completion, nothing more is required besides faith in his Passion which has perfected everything – not the sacrifice of the Mass, not the Sacraments, not virtuous works. But these words [of John] do not say this: they state only that all the scriptural prophecies of Christ's Passion have been fulfilled. And although Christ through his suffering paid the ransom for our sins, much still is requisite for us to apply and impart: just as medecine must not merely be made, but also taken. The merits of Christ's Passion are conferred on us through Sacraments, sacrifices, prayers, good works, etc.[87]

Three of the prints – the *Crucifixion, Deposition*, and *Entombment* – depict droplets of blood and water trickling from the heart wound of Christ [Figs. 20.37, 20.38, & 20.39]. This must be one of the reasons why they were

86 Ibid.: 'Want in de sacrificien des ouden Testaments pleeght men oock hysope te ghebruycken: ende David seght, "Ghy sult my met hysope besproeyen"'.

87 Ibid.: '"Het is volbrocht". Dat is: Het gene dat daer resteerde te volbrengen van de voorsegginge der Propheten, dat is nu volbrocht; ende so is't nu al volbrocht, wat van my belooft ende gheschreven was. Uyt dese woorden disputeren onse ketters gheckelick, dat Christi passie alle dinghen also volbrocht heeft, dat wy niet anders meer van doen en hebben, noch sacrificie der Misse, noch Sacramenten, noch deughdelicke wercken, dan alleen het gheloove van sijne passie, die't al volbrocht heeft: maer dit en segghen dese woorden niet, die alleen te kennen gheven, dat alle de Schrifturen, die van Christi passie voorseyden, volbrocht zijn. Ende oft schoon Christus het ransoen voor onse sonden betaelt heeft door zijn lijden, so ghebreeckt daer noch veel om ons dat t'appliceren oft aen te voeghen: ghelijck't niet genoech en is de medecijne te maken, oft men moet-se oock nemen. De verdiensten der passie Christi worden ons medegedeylt door Sacramenten, sacrificien, ghebeden, goede wercken, etc.'

inserted just before Annotation 34 on John 19:34 – 'But one of the soldiers with a spear opened his side: and immediately there came out blood and water' – which elaborates upon the sacramental meaning of these vestiges of the Passion, by reference to Innocent III's decretal on the Eucharist, "In quadam [...]", from *De celebratione missarum*. Costerus affirms that the blood and water, more than humoral proofs of Christ's bodily humanity, respectively signify Baptism and the Eucharist, more precisely, the complementarity of these two sacraments. When Longinus pierced Christ's side, he not only avouched his death, but also displayed the efficient cause of all sacramental efficacy – the Lord's redeeming blood. More than this, he disclosed the signifying relation between water and blood, the former of which follows upon the latter as its image, its subsequent baptismal sign ('dat het Doopsel, hier door het water beteeckent').[88] When the priest mixes water and wine during the consecration rite, he represents the mingled blood and water poured out by Christ ('om dit water ende bloet in den H. kelck te representeren'), and causes the representational process recursively to double back upon itself.[89] As Costerus puts it, two Baptisms are being represented: if wine signifies the shedding of blood whereby all sins were forgiven, water complementarily signifies the purifying function of the Holy Blood which baptised the sinful world, cleansing it of its transgressions: 'Herein two Baptisms are signified, the one with water, the other with blood in the torment that forgives all sin fully'.[90] Water represents the blood of Christ, shed in suffering, and baptism by water represents the baptism by blood upon which the sacramental efficacy of Baptism and the Eucharist alike is premised. The representational character of the printed images, their ontology as images, constitutes a material analogy to the concrete signifiers wine and water and their representational properties.

Costerus's exegetical engagement with the thematic of testimony, discussed earlier apropos the accounts of the mystery of the Resurrection in Mark 16 and John 20, ultimately derives from John 19:35 – 'And he that saw it hath given testimony: and his testimony is true. And he knoweth that he saith true: that you also may believe' – which is adduced to underscore the evangelist's practice of testimonial semantics as an expression of steadfast fidelity to Christ. Annotation 35 argues that John here summarises the meaning of the Passion by invoking the prior mystery of the Incarnation, and thereby acknowledges the mutually constitutive relation of both mysteries: "'So that you also may

88 Ibid. 359.

89 Ibid.

90 Ibid.: 'Dat hier twee Doopsels beteeckent worden: het een met water, het ander door't bloedt in het martelie, dat oock volkomelick alle sonden vergheeft'.

A CUSTOMISED COPY OF COSTERUS'S DUTCH *NEW TESTAMENT* 679

believe". Namely, that Christ was a true man, as John demonstrates through this water and blood, as he elsewhere [demonstrates] the spirit and soul [of Christ]'.[91] The further allusion is to 1 John 5:6: 'This is he that came by water and blood, Jesus Christ: not by water only, but by water and blood. And it is the spirit that testifieth that Christ is the truth'. Annotation 36 on John 19:36 – 'For these things were done that the scripture might be fulfilled: "You shall not break a bone of him"' – adds that when John confesses Jesus to be the true Paschal lamb, he does so to signify the unity of the Church, united by and in his paschal body, whose integrity, whole and undivided, no fractious heretics can sunder: 'Christ wishes his spiritual body the Church not to be fractured: which very ungodly heretics will to do by tearing it to pieces'.[92] On the contrary, states annotation 37 on John 19:37 – '"They shall look on him whom they pierced"' – when the Lord returns to judge the world, immediately before he passes final judgment, all without exception, without division, shall be gathered to look upon his wounds.[93] Viewed in light of annotation 37, the wounded body of Christ displayed in the *Crucifixion, Deposition*, and *Entombment* as an object of devotion to Mary and John in the first place, and then to Mary Magdalene, Joseph of Arimathea, and Nicodemus, becomes an allusion to the Church whose congregants resolutely cleave to one another in Christ [Figs. 20.37, 20.38, & 20.39].

Interspersed throughout John 18 and 19, the Johannine sequence of prints I have been discussing exemplifies the close correlation between text and image that the book's owner strove regularly to cultivate. S/he selected collatable images responsive in one way or another to the proximate scriptural passages and annotations beside which they were placed. The images inflect the meaning of the texts, and conversely, the texts have purchase on the images. Take the *Christ before Pilate* [Fig. 20.31]: the inscription from Matthew 27:2 – 'And they brought him bound and delivered him to Pontius Pilate the governor' – identifies the scene as the initial encounter between Jesus and Pilate, during which he refused to answer the governor's questions, nor to acknowledge the 'great testimonies [...] allege[d] against him'. Obscured by shadow but also silhouetted against the more brightly lit soldier and henchman flanking and manhandling him, he appears both conspicuous and inconspicuous simultaneously, a cipher to Pilate and yet the object of his full attention. Christ's

91 Ibid.: "'Op dat ghy't oock ghelooven soudt". Te weten, dat Christus waerachtich mensch was: het welck S. Jan door dit water ende bloedt, ende den gheest oft siele, elders bewijst'.

92 Ibid.: 'Christus en wilt niet dat sijn gheestelick lichaem de H. Kercke gebroken worde: dus doen alle ketters seer ongodlick, die-se in verscheyden stucken begeeren te scheuren'.

93 Ibid.: "'Sy sullen sien". Dat is: In't oordeel Godts sullen-se my sien komen met mijne wonden, die sy my ghegheven hebben'.

downward glance betokens his unresponsive silence. These pictorial devices, along with a few others – the barking dog and hooded high priest confronting him from the right – indicate that he is the centre of attention, but the centre of gravity shifts from him to the other protagonists, to Pilate most notably, when the picture as a whole is viewed together with the adjacent annotations on John 18. As we have seen, the annotations reflect upon Pilate's reaction to Jesus as *teecken*, upon his halting attempts to proclaim the Lord's innocence, and upon the dire effects of his timid, fearful, and ultimately ineffectual testimony. Inscribed with an extract from John 19:5 & 6, the following print, *Ecce Homo*, positions Pilate at the left periphery, where he forms a counterweight to the soldier carrying the cross at the lower right. Christ takes centre stage, but the annotations instead direct the reader to focus on Pilate, and insist on the opposition between his forgivable sin of punishing and condemning Jesus, and the unforgivable sin of the scribes and Pharisees, committed with malice aforethought. The picture was likely chosen because it so perfectly accommodates this reading: Christ becomes the hinge around which the contrasting dyad of Pilate and the soldier pivots.

The four full-size prints of the Passion – *Carrying of the Cross, Crucifixion, Deposition*, and *Entombment* – undergo the same process of inflection [Figs. 20.36, 20.37, 20.38, & 20.39]. Here attention shifts from Christ to the Virgin and secondarily to John, but also to their fellow mourners – Veronica, Mary Magdalene, Joseph of Arimathea, and Nicodemus – whom annotations 34 and 37 characterise as congregants representative of the Church, and united by their participation in the sacraments of Baptism and the Eucharist. As such, they stand for us, and indeed, in all four images, their position in relation to Christ coincides with our vantage point, i.e., the point of view from which we look into the image. Above all, we are asked to think of ourselves as epigones of Mary in her relation to Jesus. The images, seen in this way, function like case-studies that reflect back upon the annotations, inflecting them just as they are inflected by them. In the *Carrying of the Cross*, for instance, Mary gazes intently at the face of Jesus, turned fully toward her, while Veronica displays the Holy Face on the *sudarium*, imprinted frontally, as if from Mary's viewpoint [Fig. 20.36]. The analogy between Mary's gaze and Veronica's veil redounds upon the exegetical theme of the Virgin's co-martyrdom, as enunciated by Costerus: her co-suffering is shown to have been a kind of empathetic imprinting of Christ's image, transmitted from eyes to heart. Positioned head-on, the veronica solicits a like response from the reader-viewer who is urged to engage with John's Passion narrative and Costerus's glosses with a fervor imitative of Mary's. In the *Crucifixion*, consonance of gesture and pose is expressive of Mary's intense compassion: her head inclines toward Jesus as his tilts toward

her, and her arms open wide in imitation of his arms stretched out on the cross (Fig. 20.37). In the *Deposition*, she reaches out to take him into her arms, and in the *Entombment*, she grasps his left arm, assisting Nicodemus and Joseph of Arimathea to lower him into the tomb [Figs. 20.38 & 20.39]; bending down, shrouded, she appears ready to lay herself with Jesus, joining him in the sepulchre. The four prints mark stages in her experience of co-martyrdom, extending from sight to touch, from visceral torment to virtual death. Together they reveal precisely how and to what degree she imitated Christ, with an affective intensity and narrative specificity that exceed the remit of Costerus's theological glosses. This set of four images, in concert with the other gatherings of cut, pasted, and / or bound prints discussed in this article, reveals the degree to which the person who illustrated *Het Nieu Testament* ex post facto strove not only to exemplify but also to elaborate upon the book's exegetical apparatus, thereby fully adapting it, on the model of Ludolphus's *Vita Christi* and Ignatius's *Exercitia spiritualia*, to the uses of meditative devotion.

Bibliography

Agten E., "Costerus en Van den Leemputte: twee katholieke bijbelvertalingen uit de eerste helft van de zeventiende eeuw", in Gillaerts P. et al. (eds.), *De Bijbel in de Lage Landen: elf eeuwen van vertalen* (Heerenveen: 2015) 395–400.

Eadem, *The Catholic Church and the Dutch Bible: From the Council of Trent to the Jansenist Controversy, 1564–1733*, Brill's Series in Church History 80 (Leiden: 2020).

Andriessen J., s.j., *Nationaal biografisch woordenboek van België* (Brussels: 1964–), vol. 1, cols. 333–341.

Beyer A. et al., *Allgemeines Künstlerlexikon: die bildenden Künstler aller Zeiten und Völker* (Munich: 1992–), vol. 33:529.

Bowen K.L., "Declining Wages for the Printing of Book Illustrations: Arrangements between the Galle Family of Printmakers and the Managers of the 'Officina Plantiniana' in Seventeenth-Century Antwerp", *Bijdragen tot de geschiedenis, bijzonderlijk van het aloude Hertogdom Brabant* 87 (2004) 63–85.

Bowen K.L., "Workshop Practices in Antwerp: The Galles", *Print Quarterly* 26 (2009) 123–142.

Bowen K. – Imhof D., "Exchanges between Friends and Relatives, Artists, and their Patrons: The Correspondence between Cornelis Galle I and II and Balthasar Moretus", *Monte Artium: Journal of the Royal Library of Belgium* 3 (2010) 88–113.

Bø R.M., "The Resurrected Christ Appearing to His Mother in Late Medieval Netherlandish Altarpieces", *Konsthistorisk tidskrift* 89 (2020) 1–16.

Breckenridge J.D., "*Et prima vidit*: The Iconography of the Appearance of Christ to his Mother", *The Art Bulletin* 39 (1957) 9–32.

Costerus Franciscus, s.j., *Het Nieu Testament onses Heeren Iesu Christi, met korte uytleg-ghinghen door Franciscum Costerum, Priester der Societeyt Iesu* (Antwerp, Joachim Trognaesius: 1614).

Depauw G. – Luijten G., *Antoon van Dyck en de prentkunst*, exh. cat., Museum Plantin-Moretus, Antwerp / Stedelijk Prentenkabinet, Antwerp; Rijksmuseum, Amsterdam (Antwerp: 1999).

Diels A., *The Shadow of Rubens: Print Publishing in 17th-Century Antwerp. Prints by the History Painters Abraham van Diepenbeck, Cornelis Schut, and Erasmus Quellinus II* (London: 2009).

Duverger E., *Antwerpse kunstinventarissen uit de zeventiende eeuw*, 13 vols. (Brussels: 1984–2004).

François W., "De Leuvense Bijbel (1548) en de katholieke bijbelvertalingen van de tweede helft van de zestiende eeuw", in Gillaerts et al. (eds.), *Bijbel in de Lage Landen* 266–294.

Hardeman R., s.j., *F. Costerus (1532–1619), Vlaamsche apostel en volksredenaar* (Alken: 1933).

Heurck E. van, *Les images de dévotion Anversoises du XVIᵉ au XIXᵉ siècle* (Antwerp: 1930).

Hollstein F.W.H. et al., *Dutch and Flemish Etchings, Engravings, and Woodcuts, ca. 1450–1700*, 72 vols. (Amsterdam: 1940–2010) 7:62–72, 42:7–48.

Ignatius de Loyola, "Quarta hebdomada. Contemplatio prima. Quomodo Iesus Dominus, post resurrectionem apparuit sanctae Matri Suae", in *Exercitia spiritualia* (Rome, Antonius Bladus: 1548).

Imhof D., *Jan Moretus and the Continuation of the Plantin Press: A Bibliography of the Works Published and Printed by Jan Moretus I in Antwerp (1589–1610)*, 2 vols., Bibliotheca Bibliographica Neerlandica 3 (Leiden: 2014).

Jacobs J.H.M., "Vroomheid in prenten: de prentjesverzameling in het Museum voor Religieuze Kunst", in Liebergen L. van – Rooijakkers G.W.J. (eds.), *Volksdevotie: beelden van religieuze volkscultuur in Noord-Brabant* (Uden: 1990) 112–118.

Lemmens F. – Thijs A.K.L., "Van 'cunst' tot populair beeldmateriaal. Van Merlen: twee eeuwen prentenproductie te Antwerpen (1600–circa 1830)", in Pauwels H. et al., *Liber memorialis Erik Duverger: bijdragen tot de kunstgeschiedenis van de Nederlanden* (Wetteren: 2006) 91–129.

Ludolphus de Saxonia, "Quomodo Dominus Iesus apparuit matri suae", in *Vita Christi Domini servatoris nostril* (Paris, Michael Sonnius: 1580).

Manuwald H., "How to Read the 'Andachtsbüchlein' aus der Sammlung Bouhier (Montpellier BU Médecine, H 396). On Cultural Techniques Related to a Fourteenth-Century Devotional Manuscript", in E. Stead (ed.), *Reading Books and Prints as Cultural Objects* (Basingstoke: 2018) 57–79.

Melion W.S., "Convent and *cubiculum cordis*: The Incarnational Thematic of Materiality in the Cistercian Prayerbook of Martin Boschman (1610)", in Melion – Wandel L.P. (eds.), *Image and Incarnation: The Early Modern Doctrine of the Pictorial Image, 1400–1700*, Intersections: Interdisciplinary Studies in Early Modern Culture 39 (Leiden – Boston: 2015) 413–458.

Melion W.S., "*Libellus piarum precum* (1575): Iterations of the Five Holy Wounds in an Early Jesuit Prayerbook", in De Boer W. – Enenkel K.A.E. – Melion W.S. (eds.), *Jesuit Image Theory* (Leiden – Boston: 2016) 189–253.

Melion W.S., "'Eyes Enlivened and Heart Softened': The Visual Rhetoric of Suffering in *Gebedenboek Ruusbroecgenootschap* HS 452", in Graham H. – Kilroy-Ewbank L.G. (eds.), *Visualizing Sensuous Suffering and Affective Pain in Early Modern Europe and the Spanish Americas*, Brill's Studies on Art, Art History, and Intellectual History (Leiden – Boston: 2018) 269–312.

Polgár L., *Biblographie sur l'histoire de la Compagnie de Jésus 1901–1980*, 3 vols. (Rome: 1981–1990) 526–527, nos. 5318–5334.

Poncelet A., s.j., *Histoire del a Compagnie de Jésus dans les anciens Pays-Bas*, 2 vols. (Brussels: 1927–1928).

Rombouts P. – Lerius T. van, *De liggeren en andere historische archieven der Antwerpsche Sint Lucasgilde*, 2 vols. (Amsterdam: 1961).

Rosier B.A., *The Bible in Print*, 2 vols. (Leiden: 1997) 1:49–50.

Rudy K., *Postcards on Parchment: The Social Lives of Medieval Books* (New Haven – London: 2015).

Stead E., *Reading Books and Prints as Cultural Objects* (Cham: 2018).

Thieme U. – Becker F., *Allgemeines Lexikon der bildenden Künstler: von der Antike bis zur Geyenwart*, 37 vols. (Leipzig: 1907–1950) 10:514, 13:106, 18:196–197, 34:471.

Thijs A.K.L., *Antwerpen: internationaal uitgeverscentrum van devotieprenten, 17de–18de eeuw*, Miscellanea neerlandica 7 (Leuven: 1993).

Verheggen E.M.F., *Beelden voor passie en hartstocht: bid- en devotieprenten in de Noordelijke Nederlanden, 17de–18de eeuw* (Zutphen: 2006).

Weeks U., *Early Engravers and their Public: The Master of the Berlin Passion and Manuscripts from Convents in the Rhine-Maas Region* (Turnhout: 2004).

Wurzbach A. von, *Niederländisches Künstler-Lexikon auf Grund archivalischer Forschungen bearbeitet*, 3 vols. (Vienna: 1906–1911) 1:731.

CHAPTER 21

'By the Genius of the Indians': The Customization of Nieremberg's *De la Diferencia* in Guarani (Loreto, Juan Bautista Neumann et alii: 1705)

Pedro Leal

ore ára jeguaka ra'y

We are the sons of the diadem of time[1]

∵

1 Introduction

Amongst the Guarani, when an individual is born, *mokõi gwyra* (the two birds) land on their shoulders. These invisible birds protect a person's *ayvu* – the voice-soul – for the individual's entire lifespan so that when someone dies by natural causes, the birds take the soul back to the sky. However, they can be scared away when the individual experiences traumatic events: evil spells, acts of violence, scenes of horror. And if they fly away, the person enters a state of voicelessness, known as *ñemyrõ*, a place of profound sorrow and nonconformity which causes some Guarani to contemplate *jejuvy*, ritual suicide by hanging. Without the birds, the spirit of the dead person remains in this world as a fearsome ghost, *angué*.

1 Adapted from Chamorro G., *Kurusu ñe'engatu: Palabras que la historia no podría olvidar* (Asuncion: 1995) 35. I would like to thank Fabián Vega and Samira Perucchi Moretto for reading this manuscript; Guillaume Candela, Eduardo Neumann and Pauliane Amaral for sharing sources and discussing some of the hypotheses included here; Scott Hendrickson for giving me access to pertinent documentation at the Archivum Romanum Societatis Iesu; and Viviana Melloni de Mallol, director of the Museo Colonial e Histórico de Luján (Argentina), for allowing me to study and use the images in their copy of the Guarani *De la Diferencia*.

© KONINKLIJKE BRILL NV, LEIDEN, 2024 | DOI:10.1163/9789004680562_022

The colonial regime certainly impacted the frequency of *jejuvy*.[2] In 1603, Hernán Arias de Saavedra, Governor of Rio de la Plata and Paraguay, issued a decree which stated that in some regions more than a third of the Indigenous population had perished because of the cruel treatment they received:

> The *encomenderos* treat the Indians worse than they treat slaves, and as such many Indians are sold and bought by one *encomendero* from another. Some [Indians] are killed by whipping, while women die or burst from [carrying] heavy loads. Other women and their children are forced to work in their farms. They sleep in the fields, where they give birth and raise their children bitten by poisonous vermin. Many of them hang themselves, and others are left to die without eating. Others take poisonous herbs, and there are mothers who kill their children after birth, saying that they do so to set them free from the [forced] work to which they are subject. The Indians have a great hatred for the word 'Christian', and they consider the Spaniards to be deceivers, so they don't believe anything they are taught.[3]

Arias de Saavedra's account of the horrific treatment meted out against Indigenous peoples – and its ultimate consequences – does not depict an isolated event. There are innumerable known episodes of Guarani individuals

2 The crimes that continue to be committed against the Guarani peoples in today's Brazil have very dire consequences: the suicide rate amongst the Guarani is nineteen times higher than the national average, according to Survival International, and young adults under the age of 30 accounted for 85% of the suicides (Survival International, "Guarani suicides"). Moreover, 95% of these suicides result from the practice of *jejuvy* (Staliano P. – Mondardo M.L. – Lopes R.C., "Where and How the Guarani and Kaiowá Commit Suicide in Mato Grosso do Sul: Confinement, Jejuvy and Tekoha", *Psicologia: Ciência e Profissão* 39 (2019) 9–21; see also: Coloma C. – Hoffman J.S. – Crosby A., "Suicide among Guaraní Kaiowá and Nandeva youth in Mato Grosso do Sul, Brazil", *Archives of Suicide Research* 10.2 (2006) 191–207.

3 '[the *encomenderos*] tratan [the Indians] peor que esclavos y como tales se hallan muchos vendidos y comprados de unos encomenderos a otros y algunos muertos en azote, y mujeres que mueren u revientan con las pesadas cargas, y a otras y a sus hijos les hacen servir en sus granjerías, y duermen en los campos, y allí paren y crían mordidos de sabandijas ponzoñosas, y muchos se ahorcan y otros se dejan morir sin comer, y otros toman yerbas venenosas, y que hay madres que matan a sus hijos, en pariéndoles, diciendo que lo hacen para librarlos de los trabajos que ellos padecen, y que han concebido los indios muy grande odio al nombre cristiano y tienen a los españoles por engañadores y no creen en cosas que les enseñan' (Arias de Saavedra Hernán, *Ordenanzas para el buen gobierno del Río de la Plata hecho por Hernán Arias de Saavedra, Gobernador de dicha provincia, insertandose en elllos la doctrina y buen tratamiento que se ha de dar á los indios, Fecho en la ciudad de la Asunción del Paraguay, 29 de noviembre de 1603* [Archivo General de Indias, 74-4-12]).

686 LEAL

taking their own lives,[4] but one of the entries in Ruiz de Montoya's famous thesaurus of the Guarani language is very representative of how the custom was regarded and treated in the Jesuit Missions of the Paraguayan province:

> Oyêiubĭbae nitỹmbábi Tûpâ ópe, ytĭapĭpeheitĭgipĭ âmôngatú, los que se ahorcan no son enterrados en la Iglesia, sino arrojados al muladar.

> Those who hang [*jejuvy*] themselves are not buried in the church, but thrown in the midden[5]

The practice of *jejuvy* was certainly a major issue, not only for the colonial establishment in the Rio de la Plata region, but also for the spread of Christianity amongst the Guarani. This socio-religious phenomenon posed an existential threat on two fronts: it contravened the regime's temporal interest in perpetuating Guarani forced labor, and the Church's mission of saving souls, given the core Christian doctrine that suicide is a mortal sin entailing the eternal damnation of the soul. From a cold, rhetorical standpoint, performing a *jejuvy* was equivalent to a final and irrefutable argument, as no other proposition could reverse the Guarani's utmost act of negation.

Arias de Saavedra's conclusion that the Indigenous people had developed 'a great hatred for the word Christian', assume that the Spaniards are liars, and don't believe in their teachings' unravels a logical contradiction – if the colonizers were taken as liars, based on widespread evidence of violence, what could they say to convince the Guarani to endure *ñemyrõ* and renounce *jejuvy*? I would argue that, by the end of the seventeenth century, the Jesuits had built a rhetorical repertoire sophisticated enough to confront this inherently colonial paradox: and a book would be chosen as the stage for this spiritual dispute.

In this essay, I present a new study on the Guarani edition of Juan Eusebio Nieremberg's *De la Diferencia entre lo Temporal y Eterno* (1705). I show how the two extant copies of this book are the product of a complex process of

4 The acts of *jejuvy* caused a great impression on Martín González, dubbed the 'Bartolomé de las Casas of Paraguay'. In two of his letters, he expressed his concerns about women that 'hang themselves' (Martín González, *Abusos del Capitan Vergara en el Parana, Asunción, June 25, 1556*. Archivo Historico Nacional [Paraguay]) or that 'get desperate with ropes' in the woods (Martín González, *Carta de Martín González, Madrid, May 3, 1575*. Archivo General de Indias, Charcas, 143). These moving accounts were recently published in Candela G., *Entre la pluma y la cruz el clérigo Martín González y la desconocida historia de su defensa de los indios del Paraguay: documentos inéditos (1543–1575)* (Asuncion: 2018).

5 Montoya Antonio Ruiz de, *Tesoro de la lengua Guarani* (Madrid, Juan Sanchez: 1639) fol. 199r.

NIEREMBERG'S *DE LA DIFERENCIA* IN GUARANI 687

customization that bears no parallel in the history of the book in the early Americas.[6] The essay is divided into three intimately connected parts.

In the introduction, I demonstrate how Guarani visual and writing practices were influenced by print culture to such a degree that their 'copies of prints' were used in lieu of a publication house. This prepared the ground for the introduction of a press in the Guarani mission of Loreto in 1696.

The second section, "Customizing the Images", details how the Guarani created the 43 plates that accompany the extant copies of *De la Diferencia*. By 'decoupling' and 'adapting' images from hitherto unknown iconographic sources, the Guarani artists created new images that were interpolated into the text and produced new emblematic meanings. I also show how the various modes of image customization at play in the Guarani *De la Diferencia* are embedded in a 'Guarani-Jesuit image theory' that confronts notions of 'copy' and 'originality' in the cultural history of the Americas.

The third section, "Customizing the Book," demonstrates how the extant copies of the Guarani *De la Diferencia* were customized further with the addition of prints that were originally created for other editorial projects. Building on the previous section, I analyze the marginal annotations (that connect the Guarani plates with the text of *De la Diferencia*) and the materiality of the book in order to recreate the entire editorial process that led to its publication in 1705, and its further customization at a later date.

Lastly, in my afterword, I briefly reflect on the local and global impact of the Guarani *De la Diferencia*.

1.1 Aiquatiá Hâângába: *Drawing the Print*

Although print culture can be understood as the impact of a press and its products on a particular society, it is reasonable to say that in the Paraguayan province of the seventeenth century this notion also operated beyond the boundaries of materiality. The Jesuits had been trying to establish a printing house in their Paraguayan missions since the 1620s,[7] but even before the establishment of a typographic press, which took place only in 1696, the Guarani

6 Nieremberg Juan Eusebio, *De la Diferencia entre lo Temporal y Eterno / crisol de desengaños; com la me- / moria de la eternidade, postrimerias hu- / manas, y principales mistérios divinos / por el / P. Iuan Eusebio Nieremberg / de la Compañia de / Iesus / y traducidos en lengua Guarani / por el padre / Joseph Serrano / de la misma compañia / dedicado a la magestad del / Espiritu Santo / com Licencia del Exelentissimo / señor / D. Melchor Lasso de la Ve- / ga Porto Carrero / Virrey, Governador, y Capitan general de Peru* (Loreto, Juan Bautista Neumann et alii: 1705).

7 Furlong G., *Orígenes del Arte Tipográfico en América. Especialmente en la República Argentina* (Buenos Aires: 1947) 127.

688 LEAL

were already experienced in the particulars of print culture, manifested in at least three interconnected domains: language, learning, and practice.

1.1.1 Language

In his *Arte, y bocobulario de la lengua guarani*, Ruiz de Montoya incorporates a vocabulary of terms related to prints:

> Print/Engraving. *Hâângába*
> A Print/Engraving of God. *Tûpâ râângába*
> A Print/Engraving of the saints. *Tûpâ boyâ râângába*
> Printing. *Ahâângá quatiá. Aiquatiá hâângába*
>
> Estampa. *Hâângába*
> Estampa de Dios. *Tûpâ râângába*
> Estampa de santos. *Tûpâ boyâ râângába*
> Estampar. *Ahâângá quatiá. Aiquatiá hâângába*[8]

Beyond any doubt, at that point, prints were already being used systematically as a tool for proselytism – together with other linguistic devices, evidence of which will be discussed later in this paper. But what I consider surprising here is the coinage of a Guarani word for the verb 'to print' (*Ahâângá quatiá. Aiquatiá hâângába*), instead of reliance on a Spanish term, six decades before the construction of a press. The existence of such a term can only be justified by one or more of the following prerequisites: the prior existence a) of a woodcut press, for which there is little, if any, material evidence,[9] b) of the process of creating printed images amongst the Guarani, and/or c) of the allied process of

8 Montoya Antonio Ruiz de, *Arte, y Bocobulario de la lengua Guarani* (Madrid, Juan Sanchez: 1640) 369. Although my objective here is to emphasize the existence of the verb 'to print' before the advent of a press amongst the Guarani, Montoya's early terminology was an attempt to create a common language in the Jesuit *reducciones*, in which many foreign concepts were translated into Guarani. Later stages of the development of this contact language indicate that the notion of printing underwent an interesting transformation. In his 1722 edition of Montoya's *Vocabulario de la lengua Guarani*, Paolo Restivo still gives *haangaba* as 'print' (estampa) and even 'image' ('Tupã raangaba, Ymagen di Dios'). However, the verb 'to print' is rendered both as *ahaanga qutia* [sic] and *amoce quatia*. See Montoya Antonio Ruiz de, *Vocabulario de la lengua Guarani* (Santa Maria la Mayor, [s.n.]: 1722) 307. I thank Fabián Vega for bringing this important point to my attention.
9 Furlong (*Orígenes del Arte Tipográfico en América* 129) reproduced fragments of syllabary and catechism, printed with woodcut blocks, allegedly created in Paraguay before the establishment of the typographic press. This document, however, was not printed in the *misiones*, and was produced much later.

NIEREMBERG'S *DE LA DIFERENCIA* IN GUARANI 689

copying prints by hand, which could be confirmed by an etymological analysis of the expression *aiquatiá hâângába*, where the verb *aiquatiá* usually stands for 'to write' or 'to draw' and *hâângába* can be translated as 'image' amongst other things (see § 2.5 "Towards a Guarani-Jesuit Theory of Image", below).

1.1.2 Learning

From the start of the Jesuit missions in the Province of Paraguay, young Guarani were educated under the *Ratio Studiorum*, the set Jesuit curriculum. But of particular interest here is the fact that students were trained to write both with cursives and block letters, as a priest attested in the annual letters, between 1615 and 1637:

> [There are schools [classes] to read in their language, in Spanish and in Latin; and to write in cursive [*letras de mano*] and block letters [*letras de molde*]. [...] These [Indigenous students] from the schools are the ones who, becoming adults, manage the village.[10]

These children would grow not only to manage the missions, but many would become teachers in this or other missions, further developing their local expertise. As late as 1771, José Cardiel would write that the schools

> [...] had their Indigenous teachers; and some [students] learn to read with notable ability, and they read a foreign language better than we [the priests] do. They also have an exceptionally good letter [i.e., handwriting].[11]

The curricular emphasis on the continuous practice of printlike scripting had a clear social purpose: the creation of a specialized labor force capable of substituting for the output of a press in order to meet the demands of a complex administrative and educational system, which at its peak, in 1732, had a population of over 141,000 individuals.[12]

10 Leonardt C. *Cartas anuas de la provincia del Paraguay, Chile y Tucumán, de la compañia de Jesús* (1615–1637) (Buenos Aires: 1929) II 37.

11 Cardiel José, *Breve relación de las misiones del Paraguay* (1777) (Buenos Aires: 1996) II 557.

12 Jackson, R.H, "Una mirada a los patrones demográficos de las misiones jesuitas de Paraguay" *Fronteras de la Historia* 9 (2004) 162.

690 LEAL

1.1.3 Practice

Symptomatically, there are innumerable accounts of the Guarani people making perfect 'reproductions' of printed texts and images by hand. All the Jesuit chroniclers who wrote at length about the Paraguayan province mention this phenomenon. Francisco Xarque, for instance, states that the Guarani:

> Quickly read any handwriting, even if it is in a foreign language: those who write manage to imitate with their quill the best letters, in such way that they can copy a Missal printed in Antwerp, with such perfection that one needs very close attention to distinguish which one was written by the hand of Indian. In the same way, they can copy [pericopes from] Sacred [Scripture], used in Masses, as printed in Rome, with many images from the Passion and the Saints, everything drawn with their quills, as if they were typographic characters [como se fuera de molde]. In this way, *the misioneros partially overcome the lack of a press in all that Province* (my emphasis).[13]

Antonio Sepp, who lived in the Jesuit missions between 1691 and 1733, held a very similar opinion:

> Here there are some missals written by hand by the Indians, and they are not different from an Antwerp print. Many priests have been fooled by this, and mistook a handwritten [Missal] for another, printed in Cicero [i.e., with Roman characters].[14]

Here one can clearly identify echoes of the classical Greek topos of the ideal of art as a perfect imitation of nature, capable of deceiving the human senses, the greatest example of which is the story of Zeuxis and Parrhasius, as recorded by Pliny in his *Historia Naturalis* (35.36). José Manuel Peramás, in his account of the expulsion of the Jesuits from the Paraguayan province, not only reports the phenomenon – in terms very close to those used by Sepp – but recounts an anecdote similar to that of the Greek painters:

> What they do is to copy and imitate prints, with results so similar to the original, that it is necessary to be very careful to distinguish one from the another; and sometimes one cannot make the distinction, as happened

13 Xarque Francisco, *Insignes misioneros de la Compañia de Jesus en la Provincia del Paraguay. Estado presente de sus Missiones en Tucuman, Paraguay, y Rio de la Plata* (Pamplona, Juan Micon: 1687) 343.

14 Sepp Antonio, *Relación de un viaje a las Misiones Jesuíticas* (1696) (Buenos Aires: 1971) 71.

in the following case. When the General Captain of Buenos Ayres came to visit the *misiones* and saw many curiosities of the Indians, the priests gathered some mezzotints [*estampas de humo*] from Germany, and told his Excellency [the captain] to choose one to his liking so that the Indians could make a copy [*traslado*]; his Excellency chose one, [and] the priest called an Indian and told him: 'Take it, N.; and in such time bring me another one like this, [made] with the quill'. The Indian took it and made it in such a way that, putting both in the hands of the General Captain, the priest asked his Excellency to see which was the original, but his Excellency did not know which was which and was stunned.[15]

For a fair comparison, however, there are important distinctions to be made between Parrhasius and the Guarani anonymous artist: the Indigenous artist had a few hours to work, and, unlike painting, there is no room for mistakes when working with a quill. Moreover, in the Guarani case, one is not speaking

FIGURE 21.1 Preface page from Nicolás del Techo, *Historia Provinciae Paraquariae Societatis Iesu* [p. 8], late 17th century
IMAGE © BIBLIOTECA NACIONAL DE ESPAÑA

15 José Manuel Peramás (1768) apud Ribera, A.L. "El grabado en las misiones guaraníticas" in Academia Nacional de Bellas Artes (ed.), *Historia General del Arte en la Argentina* (Buenos Aires: 1983) II 96.

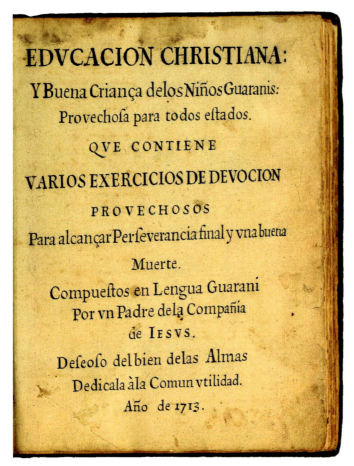

FIGURE 21.2
Spanish titlepage from *Edvcacion Christiana: y buena criança de los niños guaranis*, 1713
IMAGE © THE JOHN CARTER BROWN LIBRARY

of the artistic ability of one specific artist but about the development of a social phenomenon, a cultural paradigm that would last almost two centuries.

One might be inclined to think that this remarkable ability is another myth around the Jesuit-Guarani missions, which have been lauded by Jesuits and other scholars as 'ideal cities'. However, whereas the *misiones* are now mostly ruins, there is vast and compelling evidence of the print script of the Guarani. To demonstrate this, I will refer to two extant manuscripts that used the Guarani print script in Latin, Spanish, and Guarani: Nicolás del Techo's *Historia Provinciae Paraquariae Societatis Iesu* and *Edvcacion Christiana: y buena criança de los niños guaranis* [Figs. 21.1–21.3].[16]

16 Techo Nicolás del, *Historia Provinciae Paraquariae Societatis Iesu* (Biblioteca Nacional de España, ms. 5931, after 1650); *Edvcacion Christiana: y buena criança de los niños guaranis: provechosa para todos estados: Qve contiene varios exercicios de devocion provechosos*

FIGURE 21.3 Guarani titlepage from *Edvcacion Christiana: y buena criança de los niños guaranis,* 1713
IMAGE © THE JOHN CARTER BROWN LIBRARY

The process of creating print-like manuscripts included the use of images and clear notions of composition, that further underlines the close proximity between print culture and Guarani writing practices. Looking closer into this practice in relation to print culture, it is clear that they retained a very intimate bond, almost a sort of symbiosis: whereas printing could be perceived as the process of remediating manuscript into print, the Guarani would remediate[17] prints into something that, as a final product, often could not be distinguished from a print, and that would have the same social purpose of a print in that culture. This is one of the reasons why I think that the Guarani phenomenon

para alcançar perceverancia final y vna buena muerte. ([Loreto:] 1713) (John Carter Brown Library, Codex Ind 45).

17 Remediation should be understood here as the process of translating information from one medium to another (from print to painting, for example).

differs significantly from certain aspects of late medieval and Renaissance copying, in which the medium of the source and the product were the same (manuscripts), and the product could surpass the visual qualities of the source. In other words, the Guarani valued the elegance of an exact copy, the sober aesthetics of prints, rather than the embellishments of late medieval and Renaissance illumination.[18]

In essence, because of the Jesuits' need for a press in the Paraguayan province, Guarani were initially trained by foreigners to recreate prints by hand. But the perfection of this art is the result of an autonomous cultural transmission, an Indigenous praxis in which Guarani teachers would train Guarani students, who reached levels of ability beyond the Jesuits themselves. The scale of this Guarani practice, the quality of its results, and the social apparatus that enabled its existence have no parallel in other cultures, and it is so intrinsically related to print culture (and to the Guarani missions), that I would suggest that this phenomenon can only be satisfactorily named by the expression that the Guarani used for it, *Aiquatiá hââ ngába*: they printed before the press.

1.2 An Indigenous Press, a Bibliographic Puzzle

Those familiar with early printing in the Americas are aware that the editorial project there obeyed the logics of local demand. For instance, in the first works printed in Mexico or in Peru one can notice two main groups of publications: devotional treatises, such as catechisms, doctrines, and manuals, along with grammars of Indigenous languages, produced to support the politics of conversion. In the Jesuit Province of Paraguay, this trend reigned supreme. The Jesuits had been trying to establish a printing house in the Paraguayan missions since 1620, as is well documented,[19] but this project was only accomplished in 1696 thanks to the efforts of two central figures, José Serrano, who was then the rector of the College of Buenos Ayres, and Juan Bautista Neumann, who had just arrived in the Paraguayan province.

18 This is the case for books, of course. The Guarani also had a vibrant visual culture before and after the arrival of the Jesuits.

19 For an introduction and extensive bibliography: Krüger R. "La imprenta misionera jesuítico-guaraní y el primer libro rioplatense, Martirologio Romano, de 1700", *Cuadernos de Teología* 29 (2010) 1–26; Wilde G., "Adaptaciones y apropiaciones en una cultura textual de frontera: Impresos misionales del Paraguay jesuítico",*História Unisinos* 18.2 (2014) 270–286; Vega F.R. – Wilde G., "La dimensión bibliográfica de la reducción reducción lingüística. La producción textual jesuítica en guaraní a través de los inventarios de bibliotecas", *Nuevo Mundo Mundos Nuevos* (September 2018), https://doi.org/10.4000/nuevo mundo.73946 (accessed 27 March 2023).

NIEREMBERG'S *DE LA DIFERENCIA* IN GUARANI 695

The press was initially installed in the Nuestra Señora de Loreto Mission (commonly referred as Loreto), at that time one of the three largest *reducciones*. Neumann, working with the Guarani, built the typographic press *ab initio*, with local materials and at no cost to the Jesuits or the missions: an 'Indigenous' press, in all senses.[20] The wood was taken from the forest, metal parts forged, and even the types were cast[21] in the mission. The only imported material was paper, which was extremely expensive, and one of the reasons for the downfall of the Guarani press in 1727.

Following Furlong, scholars agree that the three first books published by the Guarani press were: Dionisio Vázquez's translation of the *Martirologio Romano* (published in 1709, but dated 1700 incorrectly by Furlong),[22] of which only one fragmentary copy is known; José Serrano's Guarani version of Pedro de Ribadeneira's *Flos sanctorum* (n.d.), which Serrano began to translate in the exact year that the press was established (1696); and finally, Serrano's translation of Juan Bautista Nieremberg's *De la Diferencia entre lo Temporal y Eterno* (Loreto, 1705) of which only two 'complete' copies are extant.

Furlong's hypothesis was based solely on Antonio Sepp's testimony. In his *Continuatio laborum apostolicorum* (Ingolstadt, Johann Andreas de la Haye: 1709), dedicated to the years 1694–1701, Sepp states that:

> Indeed, this very year ['hoc ipso [...] anno'], Father Juan Bautista Neumann, from the Bohemian province, brought to public light, in printed characters, the *Martirologio Romano*, which many *reducciones* needed. And although the impression of the letters is uneven, they are nevertheless readable. (p. 161).[23]

20 Furlong G., *Misiones y sus pueblos de guaraníes* (Buenos Aires: 1962) 567.

21 Josefina Plá reviewed the bibliography on the material used for the types and agrees with Furlong that the types were casted with an alloy of lead and tin (*El Barroco Hispano-Guarani* [Asuncion: 1975] 12). José Carlos Balmaceda, however, sides with Toribio Medina and other historical accounts to suggest that the types used in the Guarani *De la Diferencia* were new, and cast in tin (Balmaceda J.C., "El Origen de la Imprenta Argentina: introducción al estudio del 'incunable' Guarani impreso en Loreto", in *Isabel I y la Imprenta: consecuencias materiales, en el mundo cultural, de esta revolución tecnológica* (Madrid: 2004) 1–29). I agree with the latter.

22 See Furlong, *Misiones y sus pueblos de guaraníes* 569; and Krüger R. "La imprenta misionera jesuítico-guaraní y el primer libro rioplatense, Martirologio Romano, de 1700", *Cuadernos de Teología* 29 (2010) 1–26.

23 'Hoc ipso namque anno P. Joann. Bapt. Neumann, ex Provincia Boëmiæ, Martyrologium Romanum, quo hucusque plurimæ Reductiones carebant, typis impressum, luci publicæ exposuit, et licèt impressioni Europææ (sic) inæquales sunt litteræ, sunt tamen legibiles' (Sepp Antonio, *Continuatio laborum apostolicorum* [Ingolstadt, Johann Andreas de la Haye: 1709] 161).

Even though the Latin edition of *Continuatio* was published in 1709, as the last year in Sepp's narrative is 1701, Furlong assumed that he was speaking of the previous year, therefore 1700. However, Sepp's account was also published in 1710, in German. And in that edition, the same passage starts with 'a year ago' ('Dass vor einem Jahre [...]'). How is it possible that Sepp gives two different dates for the same episode? Since no actual date is given in that passage, I would suggest that the temporal deictic ('hoc ipso ... anno'), stressed by the ablative pronoun (*ipso*), refers to the year in which the *Continuatio* was published: 1709. In fact, the German edition, published in 1710, noticed this intention and adequately refers to the previous year: 1709. And, according to Furlong, the date given by contemporary sources for the publication of *Martirologio Romano* is again 1709. It is arguable that Furlong was misled by the German translation of *Continuatio*, which diverges considerably from the Latin original.[24]

Around 1695, if not slightly before, José Serrano was reprimanded by the Provincial of Paraguay, Lauro Núñez. Nuñez argued that Serrano needed prior permission to translate *Flos sanctorum*. In search of clarification – and clearly demonstrating his strong political connections within the Society of Jesus – Serrano complained to the Superior General, Tirso González, who wrote back to Núñez in January 1696:

> Father José Serrano sends me a piece of paper that Your Reverence wrote to him, in which you order that he stop the translation that he was making of the *Flos sanctorum* in the Guarani language, general [language] of the Indians, because that could not be done without a license from the General, according to the Rule 6. For me, it is greatly edifying the attention that Your Reference gives to any shadow [of doubt] about the rule; but you have been far too scrupulous on this matter; the same norm that

24 Sepp Antonio, *Continuation oder Fortsetzung der Beschreibung der Denckwürdigeren Paraquarischen Sachen* (Ingolstadt, Johann Andreas de la Haye: 1710). For example, in the Latin version of *Continuatio*, the *Martirologio Romano* is described as necessary for the *reducciones*, as it was an important reference work. In the German version, the printing press itself is listed as the requisite, perhaps due to a mistranslation of 'typis impressum'. Furlong notes this discrepancy between the two editions (Furlong, *Orígenes del Arte Tipográfico en América* 136). However, even if this discrepancy is ignored and we assume that Sepp learned of a *Martirologio Romano* being 'printed' in Loreto in 1700, that does not mean that the book was necessarily 'published'. From a bibliographic perspective, there are critical differences and implications between these two categories.

NIEREMBERG'S *DE LA DIFERENCIA* IN GUARANI 697

applies to printing composite books [i.e., proof copies], also applies to printing a translated book: it is not necessary to obtain a license from the General or from anyone else, nor to compose it [i.e. prepare it for publication], nor to translate it. I praise Father Serrano for the translation of Father Juan Eusebio Nieremberg's *De la Diferencia entre lo Temporal y Eterno*, and Father Rivadeneira's *Flos sanctorum*, because I think it is very useful for the Indians who, knowing how to read, will be able to enjoy these books. I would be delighted to send movable types [*letras de imprenta*] and someone with knowledge of printing, so that these books could be printed there, but we cannot find anyone artful.[25]

This letter provides a wealth of information, but for now I will focus on two central particulars: first, the letter shows that by the time it was written, Serrano was working on his translation of *Flos sanctorum* – a large work, originally published in three large tomes,[26] which Serrano was still translating in 1699.[27] At that point, the translation of *De la Diferencia* had already been concluded (in 1693), and it therefore makes sense that *De la Diferencia* would be the first work in the queue to be printed in Loreto, when Juan Bautista Neumann arrived.

Second, the *Martirologio Romano* is not even mentioned by González, and the suggestion that it was published before the proper authorization, without further supporting evidence, is problematic.

Moreover, even before the translation of *Flos sanctorum* was concluded, Serrano had already obtained all necessary permissions to publish *De la Diferencia*: the permission (*parecer*) by Diego de Orduña and the religious license by Simón de León in 1696; and permission by Francisco de Castañeda in

25 Apud Furlong, *Orígenes del Arte Tipográfico en America* 138.

26 Ribadeneyra Pedro de, *Flos sanctorum* (Madrid, Luis Sanchez: 1599). Thomas Brignon estimates that Serrano translated the original work in 3 tomes, or approximately 2,000 pages ("Du copiste invisible à l'auteur de premier ordre. La traduction collaborative de textes religieux en guarani dans les réductions jésuites du Paraguay", *Sociocriticism* 33 [2018] 312). I dissent, as such a volume would require an excess of paper – a project too expensive and impractical for the Guarani press. Instead, I think that for the Guarani edition of *Flos sanctorum*, Serrano would probably have used an epitomized version, such as the one printed by Luis Sanchez in Madrid in 1604 (with 232 pages in double columns).

27 As attested in a letter from Tirso González to Simón de Leon (the successor of Lauro Núñez as Provincial of Paraguay): 'Father Serrano says that his translation of Father Rivadeneira's *Flos Sanctorum* is well advanced, and because this book will also be very useful to the Indians, when the translation is finished, I want it to be revised and sent so it can be printed' (Furlong, *Orígenes del Arte Tipográfico en América* 138).

1697. In order to obtain official approval, a proof copy was printed for submission to the Superior General of the Society of Jesus, Tirso González. This proof was sent to Rome around 1700,[28] together with Bernardino Cerbin's approval, the latter written in Guarani print script [Fig. 21.4].

I recently discovered that the unbound leaves of *De la Diferencia* in Guarani, which are currently kept at the Archivum Romanum Societatis Iesu (about six pages), are not remnants of a different copy of the '1705 edition', as previously believed by scholars, but part of a first state, most likely a proof copy. This can easily be observed by comparing the page 4 at the Archivum Romanum Societatis Iesu (first state) with the same page in the 1705 edition at the Museo Colonial e Histórico de Luján [Figs. 21.5–21.6]. The two pages are almost identical, but there are some crucial differences: the Archivum Romanum Societatis Iesu first state has a smaller decorated capital 'C', which is never used in the 1705 edition; the entire line reading 'capitulo segundo' was reset; the decorated capital 'T' was reset to improve layout justification; 'Agustin' (left column, line 18) becomes 'Aguſtin' (with a long 'S'); 'tupã' (left column, line 28) becomes 'Tupã' (God); '*in sæculum et insæculum sæculi*' (Italic, right column, line 20) becomes 'in sæculum et insæculum sæculi' (normal characters); and there are additional minor changes.

The existence of a first state of *De la Diferencia* hiding in plain sight shows that the editorial history of the Guarani press may be more complex than previously imagined, trapped in the complexities of book production. The convoluted editorial process of *De la Diferencia* lasted until at least 1703, when Melchor Portocarrero, the Viceroy of Peru, granted the final publishing license.[29] Portocarrero was very specific about the permission to publish 'books in the Guarani language', a criterion that includes *De la Diferencia* and the *Flos sanctorum*, but that certainly excludes the *Martirologio Romano*.

28 The date coincides with Serrano's move to Loreto (1700–1701) and with the official travel of Francisco Burgés and Nicolás de Saba, procurators of the Paraguayan province, to Rome in August 1700 (Furlong, *Misiones y sus pueblos de guaraníes* 572).

29 Portocarrero y Laso de la Veja Melchor Antonio, *Licencia acordada por el Virrey del Peru de Imprimir libros en lengua guarani, en las misiones del Tucumán. 1703* (Biblioteca Nacional [Brazil], Manuscritos 508 (22) Ânnuas, Doc. n.º 530).

NIEREMBERG'S *DE LA DIFERENCIA* IN GUARANI

FIGURE 21.4 Bernardino de Cerbín's approbation, Archivum Romanum Societatis Iesu, 1700, VL Paraquaria 01.1

IMAGE © ARCHIVUM ROMANUM SOCIETATIS IESU

CAPITVLO SEGVNDO

TEco apĭreỹ rehe poromomaendu ahaba ymbaractebe raco açereco ñemomarãgatu haguãma

FIGURE 21.5 First state, c. 1700, page 4 from Juan Eusebio Nieremberg, *De la Diferencia* (Doctrinas [Loreto, Juan Bautista Neumann]: 1705)
IMAGE © ARCHIVUM ROMANUM SOCIETATIS IESU

CAP. 2.

quie ỹbĭpeguara mbaẽ tetĩrongatu yareteramo Tūpã ñandeyara omoĩnga ramoyepe, hecórã upe ndeỹ obahẽmo range, haẽ yepi omaẽ maẽ nūnga oicobone; Atibĭbĭỹramo oico nāngã cobaẽteco ĭbĭpeguara raĭhuparau, teco ypĭcopĭetebaẽ ybapeguã rehe ndoñemomaẽndua moãi, cobẽ̈ teco apĭreĩ ybapeguara rehe oiepĭamongetaĩramo, oĩmoã moã aũ có ỹbĭ oyepea

yepeah aguetãmbeteramo heco rehe. Cotenãnga S. Gregorio marãngatu ñeèngue. Ayporãmi abe ayaçoiabo nunga ỹbapegua, haẽ ỹbĭpegua reco, peẽme ymboiequaabo, Tũpã rerobiaha marãngatu ñande reçapebaramo, Santos marãngatu ñeẽngue, cobaẽ yiabai etebaẽ peẽme ymboiequaahaguamari, yporubo, haẽ Filosophos yaba ñeèngue pĭpe rānō cheremimombeũramã ymboyehubo coĩte

CAPITVLO SEGVNDO

TEco apĭreỹrehe poromomaenduahaba ymbaraetebe raco açereco ñemomarãngatu haguama

eco apĭreĩ rehe açe maẽnduahaba mbae tubicha bicha eteỹ, heyraco S. Agustin, haẽ haete niã ymarãngatubae upe poromoãngapĭhĭihabeteramohecóni, emōnã abe teraco ypochĭbae upe poromongĭhĭyehabeteramo heconi ranō. Cobae poromōmaẽnduahaba nãnga mbae tubichabaẽ apohaguāmã ri açe omōngĭreĩ, ỹbĭpegua guauraureco aĩbĭ mboyequaapa ranō. Ayporãmbari tenico añi pĭrumbota Tũpã rerobiaha marãngatu poroeçapebaẽ cheraperã mboyequaahabamo herecobo, ỹbĭporeco poriahubĩ mombeguabo, emōnã abe tenãngaỹbapeguareco ñandemaẽnduapabamo oicotibaẽrãngue ymombeubo ranō. Cotenãngã Santo Profeta marãngatu Dauid rececue, haẽ raco acoi ãngaipa apohaguerabe teco apĭreĩ rehe oiepĭamongeta pabeĩ oĩnagaramō, oñembohopa hopa

pa oquihĭye guaçu racĭ agui oyequĭỹ yequĭỹbo nũnga: Emōnã abe teraco Santo marãngatu teco ỹbapeguarani oyepoquaahaguamãn oñemōngĭreĩ. Cobaẽ rehe raco psalmos tetĭrongatu pĭpe co teco apĭreỹ omboyoapĭapĭ potarã na oyabo: in sæculum et insæculum sæculi. Cotenãngã yepiguaramã, emōnã abe rānō amōamōmẽ co teco apĭreĩ recoubicha mboyequaahaguamãri, psalmos oyapō, acoi tecopucu ỹbĭpeguaparire oubaẽ rãma mboyequaapa. Cobaẽteco apĭreỹ rehe tenaco araramo, pĭtũnãmoabẽ oyepĭamōngeri oicobo, cobaẽ teco apĭreĩ rehe Tũpã upe oçapuca pucai henoĩta, opĭtĭbohaguamari oyerure rurebo, cobae teco apĭreĩ rehe poromomaenduahaba ha yĭtĭtĭhaba omocãñĭcañĭ nũnga ychugui; Emōnã abe co temĭmoã marãngatu mbaraete teco omoãnamba mambi ymboabuçupãbo, ymopĭreĩ pĭtũ nũnga herecoboranō: Cobaẽ temĭmo ã marãngatu ỹbĭpegua reco oriori a ombo

FIGURE 21.6 Second state, page 4 from Juan Eusebio Nieremberg, *De la Diferencia* (Doctrinas [Loreto, Juan Bautista Neumann]: 1705)
IMAGE © MUSEO COLONIAL E HISTÓRICO DE LUJÁN

1.3 *Nieremberg's* De la Diferencia entre lo Temporal y Eterno

Nieremberg's *De la Diferencia* was originally published in Madrid in 1640; it became increasingly popular, with over seventy-five editions.[30] The work consists of five books exploring the temporality of human life, in contrast with the eternity of the soul. In Nieremberg's words, perhaps the most 'notable difference between the Eternal and the Temporal, is that one is the end, and the other, the medium. And this [difference] is the ultimate purpose for which man was created' (p. 540). Each chapter deals with a very specific problem: for instance, 'How effective it is to consider eternity in order to change one's life' (Book 1, chapter 2); 'Why the end of the temporal life is terrible' (2.4); 'How miserable is the temporal life' (3.7); 'On the greatness of eternal things' (4.1); 'How happy are those who renounce all temporal possessions to ensure eternal ones' (5.7).

As the extended title announces, the treatise is a 'melting pot of disillusions' ('crisol de desengaños'), which are manifested in a plethora of anecdotes and *paradeigmata*. As one would expect from an erudite Jesuit, the work is supplemented by two indexes: one for Latin authorities and another for biblical passages. The influence of Ignatius of Loyola's *Spiritual Exercises*[31] goes beyond the sensorial appeal of the text and materializes itself in the preliminary matter, with a 'warning on the most important meditations in this work', in which Nieremberg establishes a direct correspondence between his text and Loyola's exercises.

In terms of style, Nieremberg's prose resembles that of Thomas à Kempis' *De imitatione Christi*, which the Jesuit translated into Spanish.[32] For a baroque spiritual treatise, the text is very accessible and explicative, and often unapologetically repetitive, as befits its didactic character.

30 Nieremberg Juan Eusebio, *De la Diferencia entre lo temporal y lo eterno. Crisol de desengaños, con la memoria de la eternidad, postrimerias humanas, y principales misterios diuinos* (Madrid, Francisco de Robles – Juan Antonio Bonet: 1640). For an introductory text about Juan Eusebio Nieremberg, see Hendrickson S., *Jesuit Polymath of Madrid: The Literary Enterprise of Juan Eusebio Nieremberg (1595–1658)* (Leiden: 2015). On the relationship between Nieremberg and the Americas, see Ledezma, D. "Una legitimación imaginativa del Nuevo Mundo: la 'Historia naturae, maxime peregrinae' del jesuita Juan Eusebio Nieremberg", in Ledezma D. – Millones Figueroa L. (eds.) *El saber de los jesuitas, historias naturales y el nuevo mundo* (Madrid: 2005) 53–84.

31 Loyola Ignatius of, *Exercitia Spiritualia* (Rome, Antonio Bladio: 1548).

32 Kempis Thomas à, *Los IV. libros de la Imitacion de Christo, y menosprecio del mundo: compuestos en latin por el venerable Tomas de Kempis, canonigo reglar de san Agustin, y traduzidos nuevamente en español por el P. Juan Eusebio Nieremberg, de la compañia de Jesus* (Antwerp, Officina Plantiniana: 1656).

NIEREMBERG'S *DE LA DIFERENCIA* IN GUARANI

The first illustrated edition would only appear in 1684, as an octavo printed in Antwerp by Hieronymus Verdussen.[33] The book contains an engraved frontispiece and eleven full-page copperplates engraved by Gaspar Bouttats. At least one of these engravings (453) is an amalgamation of the nine hell plates from Jeremias Drexel's *Infernus, damnatorum carcer et rogus* (Antwerp, Jan Cnobbaert: 1631). Another known source is Boëtius à Bolswert's *Allegory of the World* (1616),[34] which illustrates a parable wrongly attributed to John Damascene, deriving instead from the legend of Barlaam and Josaphat; a plate that Bouttats recreated in full. Bouttats also recreates an emblem by Otto Vaenius, "Mortis formido" (Dread of Death), from *Quinti Horatij Flacci emblemata*, which represents the episode of the Sword of Damocles [Fig. 21.7–21.12].[35]

In his illustrations, Gaspar Bouttats condenses various meaningful scenes described by Nieremberg into a single, complex plate, a compositional strategy that became very common in other Jesuit illustrated books after the publication of Jerome Nadal's *Evangelicae historiae imagines* (Antwerp, Society of Jesus: 1593), where not only the foreground images carried meaning but also those in the background. In point of fact, condensing scenes – and meaning – was a widespread cultural paradigm in the seventeenth century, probably influenced by three correlated phenomena: the widespread adoption of copperplate *intaglio* (which allows the engraver to incise finer lines, thus allowing for an increase in the number of figures per plate); the concentration of visual meaning used in book frontispieces and allegorical prints; and, no less importantly, the extreme accumulation of images used in the decoration of early-modern festivals, and consequently, *fête* books. Furthermore, the aesthetic influence of Antoine Girard's *Les peintures sacrées sur la Bible* (Paris, Antoine Sommaville: 1653) over Bouttat's illustrations for *De la Diferencia* is striking, and is yet to be appreciated fully.

Shortly after its publication in 1684, Hieronymus Verdussen's edition reached José Serrano in the Paraguayan province; he began to translate it, as already mentioned, in 1693. Gaspar Bouttats' prints illustrating this particular edition – an editorial novelty – would serve as the basis for the engravings of the Guarani

33 Nieremberg Juan Eusebio, *De la Diferencia entre lo temporal y lo eterno. Crisol de desenga-ños, con la memoria de la eternidad, postrimerias humanas, y principales misterios diuinos* (Antwerp, Hieronymus Verdussen, 1684).

34 During the preparation of this essay, I identified Bolswert's hitherto unknown source, a French engraving with a very similar *disegno* (Wellcome Library no. 5742i). I use the term *disegno* throughout this essay to refer to the originating design after which copies in the manner of prints were then executed.

35 Vaenius Otto, *Quinti Horatij Flacci Emblemata* (Antwerp, Hieronymus Verdussen: 1607) 75. The reference to the sword of Damocles derives from an anecdote recounted by Cicero (*Tusculanae Disputationes*, 5.61).

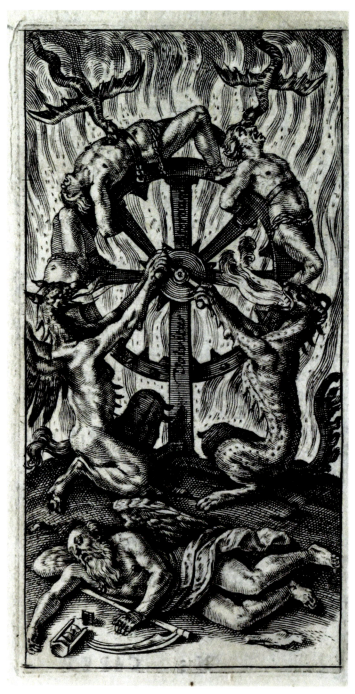

FIGURE 21.7 Plate 9 from Jeremias Drexel's *Infernus, damnatorum carcer et rogus* (Monaco, Cornelius Leysser: 1631) 182
IMAGE © GETTY RESEARCH INSTITUTE

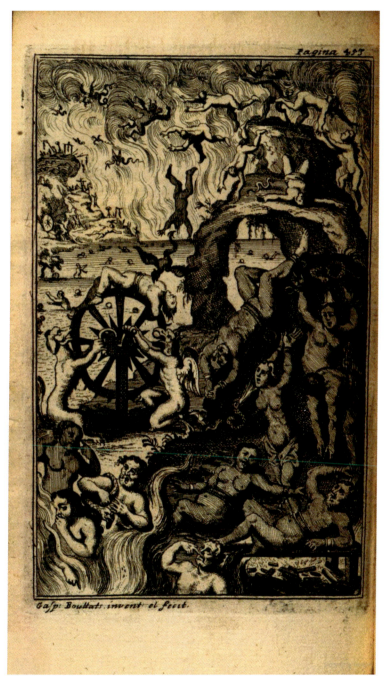

FIGURE 21.8 Gaspar Bouttats, plate 453 from Juan Eusebio Nieremberg's *De la Diferencia* (Antwerp, Verdussen: 1684)
IMAGE © MUSEO COLONIAL E HISTORICO DE LUJÁN

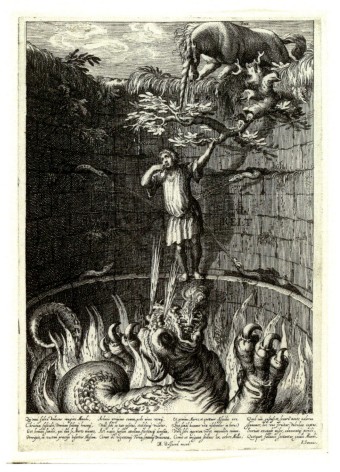

FIGURE 21.9 Boetius à Bolswert, "Image of the World". Engraving. 1616
IMAGE © RIJKSMUSEUM

recreation of this book [Fig. 21.13]. The Guarani edition was published as an in-folio (28 × 18.4 cm), with 438 pages.[36] The text is divided in two columns of 41 lines (45, in Book 2). The page title, the prefatory matter – permissions, dedication to Tirso González and to the Holy Spirit – and the chapter titles are in Spanish, but the remaining text is in Guarani. The edition does not include the learned appendices from the previous editions, and the pagination is reinitiated in every chapter.

36 José Carlos Balmaceda was the first scholar to publish the exact measurements of this book, in his "El Origen de la Imprenta Argentina" 9. Based on a meticulous analysis of the book, Balmaceda notices that the original paper probably measured 31.5 × 43 cm, before its sides were guillotined.

NIEREMBERG'S *DE LA DIFERENCIA* IN GUARANI 707

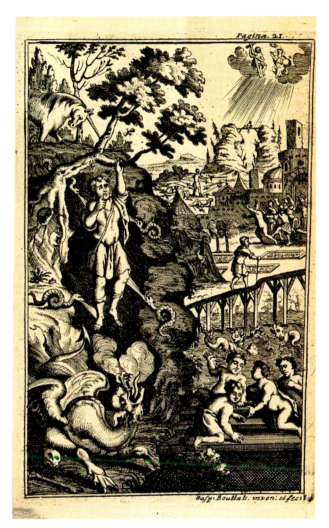

FIGURE 21.10 Gaspar Bouttats, plate 21 from Juan Eusebio Nieremberg's *De la Diferencia* (Antwerp, Verdussen: 1684)
IMAGE © MUSEO COLONIAL E HISTORICO DE LUJÁN

Finally, different from Verdussen's edition, which contains an illustrated frontispiece and eleven full-page plates, the Guarani edition contains 43 full-page plates,[37] 67 initials with iconographic motifs, and 2 vignettes, all engraved in

37 There is only one known copy with 43 full-page engravings, which belongs to a private collection in Buenos Aires, Argentina. The copy examined in this essay, belonging to the library of the Museo Colonial e Histórico de Luján (Buenos Aires Province, Argentina), contains 42 full-page plates. The missing plate is a full-page engraving of the Immaculate Conception.

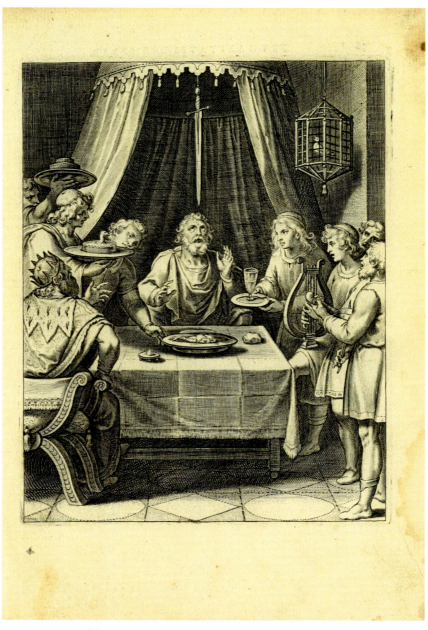

FIGURE 21.11 Emblem *Mortis Formido* from Otto Vaenius, *Quinti Horatij Flacci Emblemata* (Antwerp, Phillipe Lisaert: 1612) 75
IMAGE © GETTY RESEARCH INSTITUTE

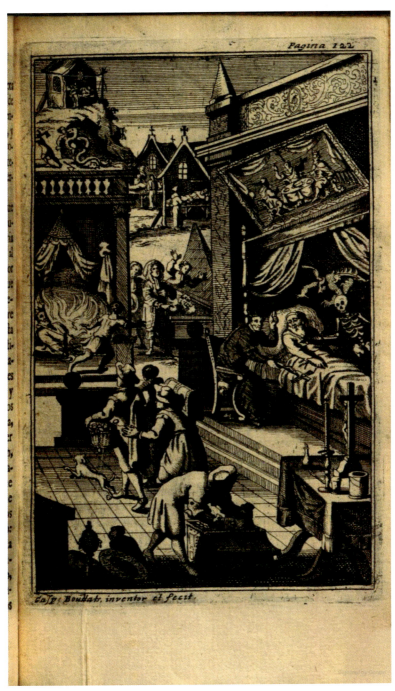

FIGURE 21.12 Gaspar Bouttats, plate 122 from Juan Eusebio Nieremberg's *De la Diferencia* (Antwerp, Verdussen: 1684)
IMAGE © LYON PUBLIC LIBRARY

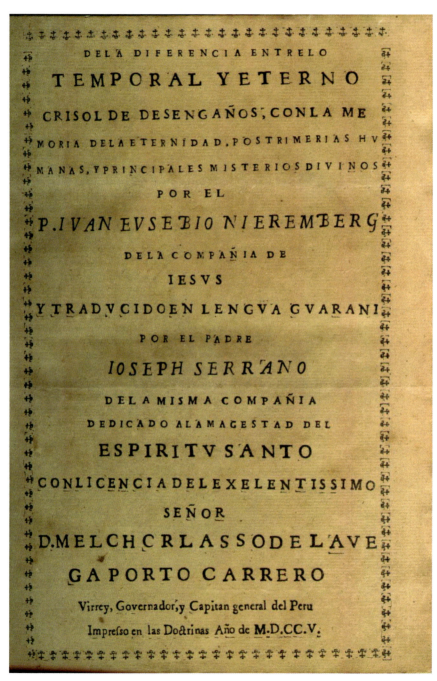

FIGURE 21.13 Titlepage, Guarani edition of Juan Eusebio Nieremberg's *De la Diferencia* (Loreto, Juan Bautista Neumann et alii: 1705)
IMAGE © MUSEO COLONIAL E HISTÓRICO DE LUJÁN

copper. Rather than being numbered in sequence, the plates are numbered by hand according to their position in the book (e.g., plate 6 is positioned immediately after page 6).[38] Although this method makes external references to the plates cumbersome, it would have allowed the editors to add new plates to the book after printing the first state. Similar to Bouttats' illustrations, most of the Guarani plates contain a diversity of scenes – frequently numbered by hand. At the same time, marginal annotations, printed or handwritten, create a link between a specific textual passage and its corresponding illustration within a given plate.

2 Customizing the Images

The profusion of illustrations in the Guarani *De la Diferencia* has captured the attention of numerous scholars, as it contains many more illustrations than its base edition (Antwerp: 1684). However, only a few studies have correctly identified the iconographic sources of the Guarani images. Ironically, these studies are not necessarily motivated by a desire to understand the 'original' meaning of the images, as their meanings can be easily identified in the text of *De la Diferencia* associated with them. Instead, scholars have undertaken iconographic analyses of the Guarani plates for other reasons, including attempts to understand the Guarani creative process and the circulation of books and prints in the Paraguayan province.

Understanding how the Guarani customized images from various sources to 'emblematize' *De la Diferencia* serves new purposes, such as revealing the intellectual work behind this form of composition and unearthing the ruins of an ambitious editorial project with no parallel in the history of the book in the Americas.

The Guarani plates can be divided into four main groups based on their iconographic and literary sources. These groups will be discussed in detail below: full-plates customized after Bouttats, partial customizations after Bouttats, full-plate customizations after other sources, and partial customizations after other sources.

38 Throughout this paper, I number the plates of the Guarani edition by order (1–43), followed by their positioning (chapter and page). Therefore, plate 17 (2.2.) is the 17th plate in this edition, and it is placed in book 2, after page 2. For more on numbering the plates, see § 3.1. "Marginal Annotations", below.

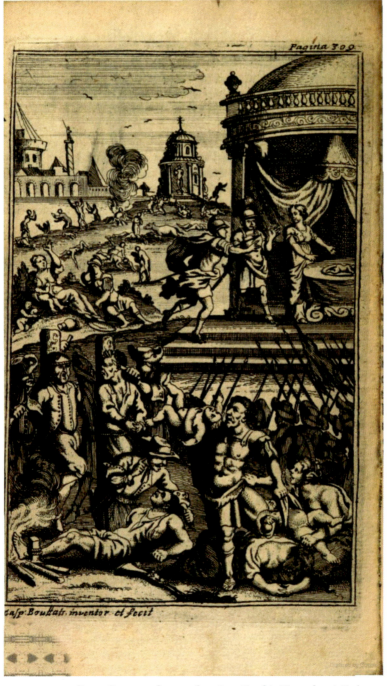

FIGURE 21.14 Gaspar Bouttats, plate 309 from Juan Eusebio Nieremberg's *De la Diferencia* (Antwerp, Verdussen: 1684)
IMAGE © LYON PUBLIC LIBRARY

NIEREMBERG'S *DE LA DIFERENCIA* IN GUARANI

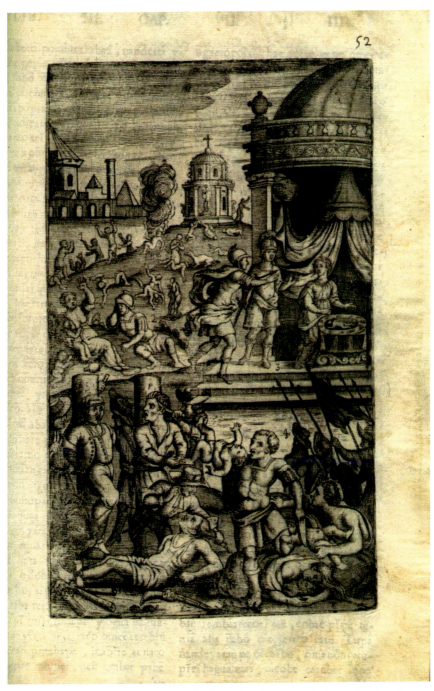

FIGURE 21.15 Juan Yaparí (attributed to), plate 31 from Juan Eusebio Nieremberg's *De la Diferencia* (Doctrinas [Loreto, Juan Bautista Neumann]: 1705)
IMAGE © MUSEO COLONIAL E HISTÓRICO DE LUJÁN

2.1 Full-Plate Customizations after Bouttats

Rodolfo Trostiné was the first scholar correctly to identify Verdussen's 1684 edition as the source of the Guarani version.[39] He looked at earlier editions of *De la Diferencia* and found that some of Gaspar Bouttats' engravings had been recreated in full by the Guarani artists. The Guarani artists customized six full plates from Bouttats (Guarani plates 28, 30, 31, 32, 33, 42). In four cases, the Guarani *disegno* was inverted, so that the print is not mirrored [Figs. 21.14–21.15]. The visual resemblance in the example shown here is remarkable, especially when one takes into consideration that the inverted *disegno* was amplified (from *octavo* to *quarto*) before it was engraved.

The close visual proximity between Bouttats' work and the Guarani full-plate customizations certainly facilitated the process of iconographic identification. However, there are two pieces of evidence that scholars have overlooked, which are of great interest here. First, two important full-page plates by Gaspar Bouttats – the frontispiece and the initial engraving – are absent from the Guarani book. Second, the full plates customized from Bouttats are some of the best-executed plates in the book and are almost in sequence, concentrated in the middle of the work: one at the end of Book 2, all the plates in Book 3, the first plate of Book 4, and then the very last plate in the book.

2.2 Partial Customizations after Bouttats

Apart from the six full-page customizations, the plates in the Guarani edition are sometimes only partially based on the Antwerp edition's *disegni*. Individual figures from Bouttats' plates are 'decoupled' and rearranged into new plates, as if they were typographic clichés or movable types that could be reconfigured to create new compositions. I have already mentioned how the Guarani image-making (*aiquatiá hâângába*) favors the aesthetics of prints, but here the process of decoupling brings the Guarani images closer to the logic of printing. At least three effects can be identified through this mode of image customization:

39 Trostiné R., "El arte del grabado en la Argentina durante el período hispânico", *Estudios* 81 (1949) 298–309; *Estudios* 82 (1949) 142.

NIEREMBERG'S *DE LA DIFERENCIA* IN GUARANI 715

2.2.1 Simplification

Plate III of the Antwerp *De la Diferencia* is very busy, with many figures arranged in an intricate perspective, connected through complex architectural design. Rather than reproducing Bouttats' entire *disegno*, the Guarani artist created a new plate, 17 (2.4), in which the number of figures is reduced, and the scenes are rearranged into a basic yet elegant composition [see Figs. 21.16–21.17].

However, although there is a relative decrease of visual elements, there is no loss in terms of iconographic information: the scenes from Bouttats' plate III not used in the Guarani plate 17 (2.4) are used elsewhere in the book (such as the 'disarmed soldiers' customized into plate 16, 2.2.; or the 'killing soldier' scene, moved to plate 6, 1.12).

2.2.2 Amplification and Meaning

The process of decoupling images gives the Guarani an opportunity to produce new meanings by redimensioning and rearranging. For instance, in the upper left corner of Bouttats' plate 122, there is an almost imperceptible scene of a man being constricted by a snake while another figure, also holding an axe, walks away from the scene. Whereas the scene is very small in the original plate, it is amplified about ten times in the Guarani composition, and brought to the foreground of a new plate [Figs. 21.18–21.19]. Together with this amplification, there is an increase in the number of visual details, and in all, a new semantic charge is added to the figure. The Guarani feared not only the dangerous species of snakes in the region – such as the *jiboia* (*Boa constrictor*) – but also *moñaî*, the mythical serpent. This dread is present elsewhere in the actual translation of *De la Diferencia*, as Thomas Brignon observed so well: '[The] deformed dragon, that breathed fire through its eyes' ('un disforme Dragon, que echava fuego por los ojos') becomes a 'mboi guaçu moñaî rami, gueça rupi tata mocêbo', 'a big serpent like *moñaî*, spouting fire through the eyes that belonged to it'.[40]

Thanks to this re-dimensioning, the serpent in Guarani plate 23 becomes part of a thematic visual narrative of dragon/*moñaî*, created by the serpents that appear in other plates, taken from different sources (plate 1, as an ouroboros; plate 5, 1.6; plate 6, 1.2; and 8, 1.34), and often designed in a menacing context.

40 Brignon T., "De la Différence entre l'Âne et le Jaguar: la traduction en guarani d'un traité ascétique illustré, entre adaptation linguistique et visuelle (missions jésuites du Paraguay – 1705)", *Textimage: revue d'étude du dialogue texte-image* (2018) 3.

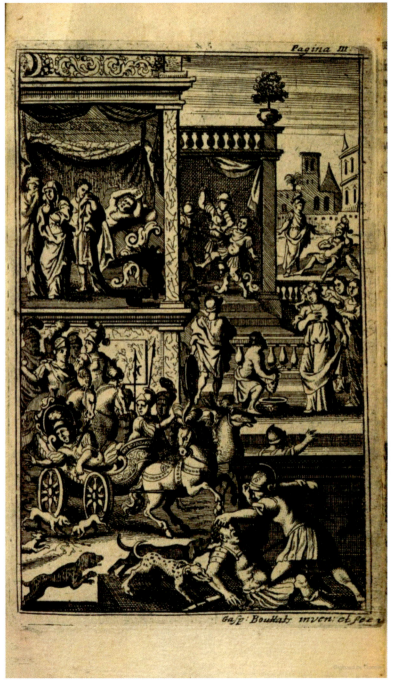

FIGURE 21.16 Gaspar Bouttats, plate iii from Juan Eusebio Nieremberg's *De la Diferencia* (Antwerp, Verdussen: 1684)
IMAGE © LYON PUBLIC LIBRARY

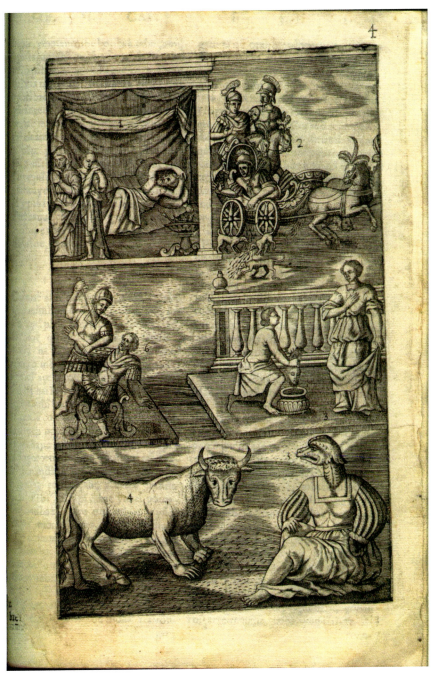

FIGURE 21.17 Plate 17 from Juan Eusebio Nieremberg's *De la Diferencia* (Loreto, Juan Bautista Neumann et alii: 1705)
IMAGE © MUSEO COLONIAL E HISTÓRICO DE LUJÁN

FIGURE 21.18
Gaspar Bouttats, plate 122 (detail) from Juan Eusebio Nieremberg's *De la Diferencia* (Antwerp, Verdussen: 1684)
IMAGE © LYON PUBLIC LIBRARY

FIGURE 21.19 Plate 23 from Juan Eusebio Nieremberg's *De la Diferencia* (Loreto, Juan Bautista Neumann et alii: 1705)
IMAGE © MUSEO COLONIAL E HISTÓRICO DE LUJÁN

NIEREMBERG'S *DE LA DIFERENCIA* IN GUARANI

2.2.3 Multiplication of Plates

The last effect of the 'decoupling' method is a consequence of Bouttats' plates being understood as a treasure trove of iconographic references for the creation of new plates in the Guarani edition. This allowed Guarani artists to disassemble Bouttats' plates into new plates that were then enriched with images taken from other sources. The most extreme example of this process is Bouttats' plate 122 [Figs. 21.12 & 21.18], which loaned figures to no less than 5 of the Guarani plates: 18, 19, 21, 23 and 24 [Fig. 21.20].

The impulse to multiply plates, far from being an accident of production, was crucial to the method/mode of customization exemplified in the Guarani *De la Diferencia*. Characteristic of this and other Jesuit politico-editorial projects, this method/mode created new opportunities for the display the image-making skills of the Guarani artists.

2.3 *Full-Plate Customizations after Other Sources*

In the Guarani edition, there are at least twelve full-page plates inspired by prints from sources other than Bouttats (plates 2, 15, 34–41, 43). Technically speaking, the engravings customized in full are amongst the highest quality plates in the Loreto edition, as one can confirm by comparison of the Guarani plate 2 with the frontispiece from Francisco Aguado's *Sumo Sacramento de la fe* (Madrid, Franco Martinez: 1640), engraved by Maria Eugenia de Beer [Figs. 21.21–21.22].

But another example warrants special attention here: the eight gruesome engravings showing the different punishments of the damned in hell (Guarani plates 34–41). The source of the motifs has been known for a while: in 1949, Rodolfo Trostiné had already noticed that the same motifs appear in a 1785 edition of Giovanni Pietro Pinamonti's *L'Inferno aperto al cristiano perche non v'entri* in Puebla de los Angeles, with prints by the Novohispano engraver Manuel de Villavicencio. Trostiné deduced correctly that both works probably derived from an earlier edition of Pinamonti.[41]

Fernando Miguel Gil recently identified this possible source (Bologna, Heirs of Antonio Pisarri: 1689), the *disegni* of which served as inspiration for the prints re-elaborated and included in the Guarani book.[42] Pinamonti's work

41 Trostiné, "El arte del grabado en la Argentina" 11.

42 Pinamonti Giovanni Pietro, *L'Inferno aperto al cristiano perche non v'entri* (Bologna, heirs of Antonio Pisarri: 1689). See Gil F.M., "El ciclo del Añaretâ (infierno) en los grabados del De la diferencia entre lo temporal y lo eterno de Nieremberg, traducido al guaraní e impreso en las reducciones del Paraguay (1705)", *IHS. Antiguos Jesuitas en Iberoamérica* 7.1 (2019) 4–26.

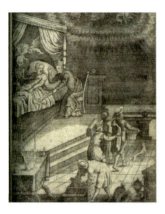
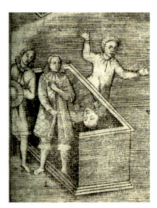
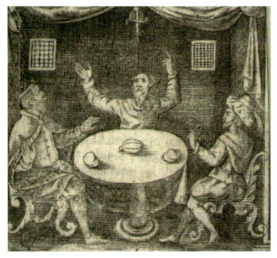

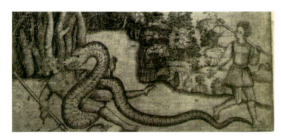

FIGURE 21.20 Detail from plates 18 (2.8); 19 (2.12); 21 (2.20), 23 (2.30), 24 (2.44), from Juan Eusebio Nieremberg's *De la Diferencia* (Loreto, Juan Bautista Neumann et alii: 1705)

IMAGE © MUSEO COLONIAL E HISTÓRICO DE LUJÁN

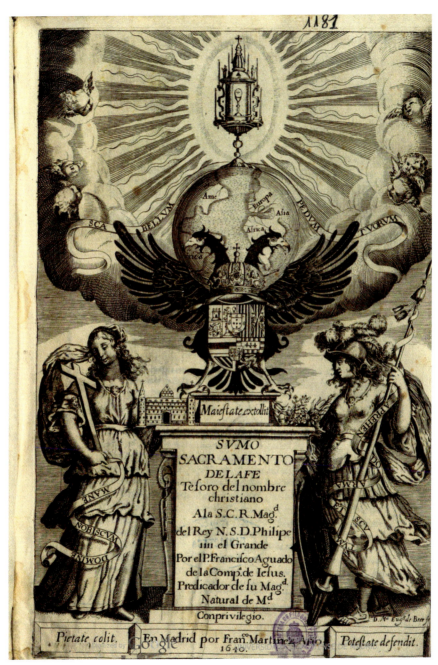

FIGURE 21.21 Maria Eugenia de Beer, frontispiece for Francisco Aguado's *Sumo Sacramento de la fe* (Madrid, Franco Martinez: 1640)
IMAGE © UNIVERSIDAD COMPLUTENSE DE MADRID

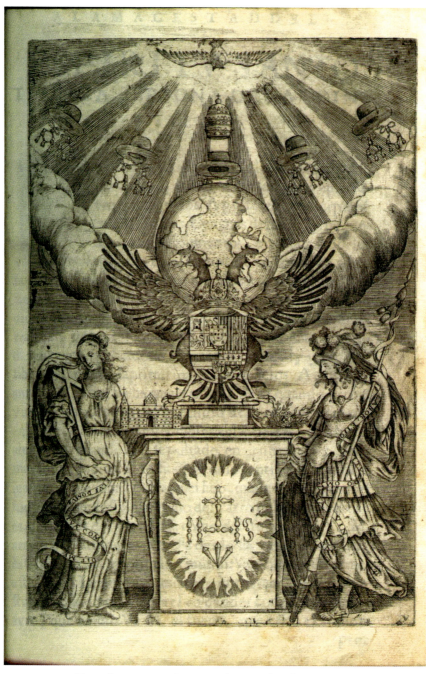

FIGURE 21.22 Plate 2 from Juan Eusebio Nieremberg's *De la Diferencia* (Loreto, Juan Bautista Neumann et alii: 1705)
IMAGE © MUSEO COLONIAL E HISTÓRICO DE LUJÁN

was very popular in Latin America during the seventeenth and eighteenth centuries – so much so, that thanks to its emotional qualities, capable of moving observers into tears, these illustrations were frequently used as a visual source for dramatic paintings that molded the imaginary of hell throughout the colonial period [Figs. 21.23–21.24].[43]

It is noteworthy that, unlike all the other iconographic sources discussed in this essay, the illustrations from Pinamonti's 1689 edition were fully customized and used in their entirety in the Guarani edition of *De la Diferencia* – even the frontispiece. Furthermore, these plates are grouped together in sequence (Guarani plates 34–41) and constitute almost all the plates used to illustrate Book 4.

2.4 *Partial Customizations after Other Sources*

Identifying iconography in *De la Diferencia* is most challenging when the figures or scenes are taken from sources other than the Verdussen edition. These elements do not belong to the source work and cannot be easily identified visually, as they are not full-page plates and have been further adapted by Guarani artists. In this section, I present newly identified iconographic sources for *De la Diferencia*. These sources shed light not only on the creative process of the Guarani artists, but also on the circulation and accessibility of non-religious books in the Paraguayan missions.

2.4.1 Customizing the Occasion

Guarani plate 13 (1.60) contains four scenes: *Occasio* [Occasion], standing on a wheel, with a razor in her right hand and a forelock over her brow; a woman sitting on a tomb, her hair in her hands; an unspecified female figure rejecting

43 This can be demonstrated by an account from roughly the same period, taken from a Jesuit house of spiritual exercises in Lima. Baltasar de Moncada reports that a corridor decorated with painted emblems, created under his supervision after *Inferno Aperto*, causes 'such great horror and astonishment, that just by entering this area and looking [these images], [people] soak themselves in their copious and bitter tears; others, upon entering the corridor, are taken by such horror, that they run away without being able to look at [the images of *Inferno aperto*]' (Moncada Baltasar de, *Descripcion de la casa fabricada en Lima, Corte del Perù, para que las señoras ilustres de ella, y las demàs mugeres devotas, y las que desean servir à Dios Nuestro Señor, puedan tener en total retiro, y con toda abstraccion, y direccion necessaria los exercicios de San Ignacio de Loyola* [Seville, Joseph Padrino: 1757] 76–77).

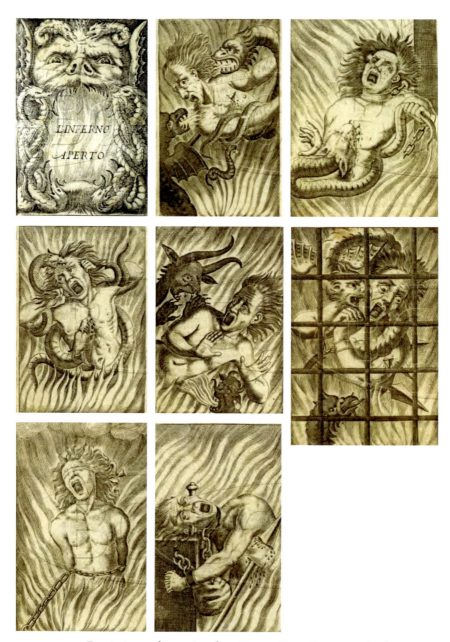

FIGURE 21.23　Frontispiece and engravings from Giovanni Pietro Pinamonti's *L'Inferno aperto al cristiano perche non v'entri* (Bologne, heirs of Antonio Pisarri: 1689)

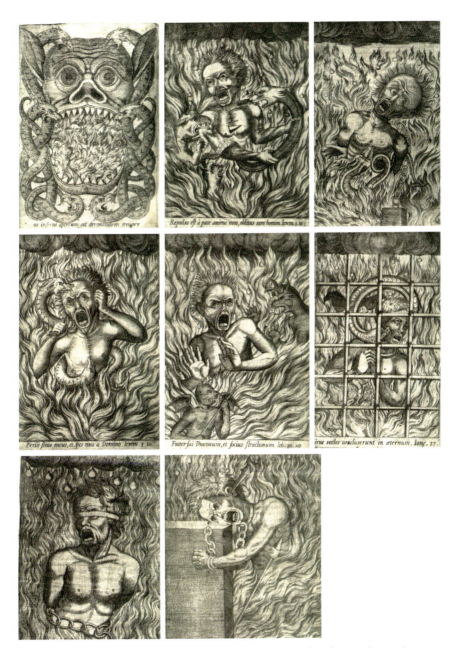

FIGURE 21.24 Plates 34–41 from Juan Eusebio Nieremberg's *De la Diferencia* (Loreto, Juan Bautista Neumann et alii: 1705)
IMAGE © MUSEO COLONIAL E HISTÓRICO DE LUJÁN

726 LEAL

temporal riches on the ground; and the figure of Time/Saturn standing on a globe, with a long scythe and wings on his arms and legs.

Occasio is depicted in one of Andrea Alciato's most famous emblems, *In occasionem*, so I searched dozens of different editions of Alciato's work in search for the exact source of the Guarani *Occasio*,[44] but I could not find any occurrence of *Occasio* with her face completely covered.[45] However, having worked in a *variorum* edition of Alciato,[46] I was confident that I could find the next figure, Virtue sitting on the tomb of Ajax: the exact same *disegno* occurs in the emblem *In Victoriam dolo partam* ("On Victory won by deceit", emblem 48). This woodcut was created by Bernard Salomon and published for the first time in Jean de Tournes' 1547 Lyon edition of Alciato's *Emblematum liber*.[47]

The correspondence between the Guarani *disegno* and its source, *In Victoriam dolo partam*, allowed me to treat this connection as an iconographic 'anchor', as I call figures identified with a high level of confidence, which belong to iconographic repertoires that may be used as the source for other *disegni* (in this case, in the Guarani *De la Diferencia*). Based on this information, I revised the other figures in the same Guarani plate and was able to match

44 This task was made much easier thanks to digital collections such as *Alciato at Glasgow*, *Emblematica Online*, and *Arkyves*. As far as I know, the first scholar to associate the Guarani *De la Diferencia* with Alciato was Ricardo González in his article "Textos e imágenes para la salvación: La edición misionera de la diferencia entre lo temporal y eterno", *Artcultura*, 11[18], 2009, 137–158). On page 145, he presents the *pictura* of Alciato's emblem *Reverentiam in matrimonio require* ("Respect is required in marriage"), from Alciato Andrea, *Emblematum liber* (Augsburg, Heinrich Steyner: 1531) as a possible source for Guarani plate 8 (1.34). I disagree with this identification because the Guarani plates are in fact inspired by the Bernard Salomon woodcuts (see below), and which have a very different design. Furthermore, the serpent in Guarani plate 8 is more similar to the serpents in emblems 24 and 35 from Antoine de Bourgogne's *Lingua Vitia et Remedia* (Antwerp, Jan Cnobbaert: 1631), which are used elsewhere by the Guarani artists, or to the two serpents in Schmidel Ulrich, *Vierte Schiffart. Warhafftige Historien einer wunderbaren Schiffart, welche Ulrich Schmidel von Straubing, von Anno 1534. biss Anno 1554 in Americam oder Newenwelt, bey Brasilia und Rio della Plata gethan* (Nuremberg, Levinus Hulsius: 1599), after 17.

45 Occasio has her face fully covered by her hair in David Jan, *Occasio arrepta neglecta huius commoda illius incommoda* (Antwerp, Officina Plantiniana: 1605), but other attributes in the Guarani figure were missing.

46 Alciato Andrea, *The Variorum Edition of Alciato's Emblemata*, ed. M. Tung – P.G. Leal (Glasgow: 2015).

47 Alciato Andrea, *Emblematum libri duo* (Lyon, Jean de Tournes and Guillaume Gazeau: 1547) 11. For reference, here I will use the 1556 Lyon edition, that contains the same woodcuts.

NIEREMBERG'S *DE LA DIFERENCIA* IN GUARANI

the Guarani *Occasio* with the emblem *In Occasionem* ("On the Occasion", emblem 122);[48] moreover, the female figure on the lower left side derives from the *disegno* of Venus in the emblem *Ferè simile ex Theocrito*, though she was given new attributes ("More or less the same, from Theocritus", emblem 113) [Figs. 21.25–21.26].[49] However, the design of Saturn was customized from another emblematic source used in Guarani's *De la Diferencia* – Otto Vaenius' *Quinti Horatij Flacci emblemata*, specifically the emblem *Tempora mutantur, et nos mutamur in illis* ("Times are changed, and we too are changed in them", pp. 176–177).[50]

Despite the correct identification of iconographic sources of *Occasio*, Venus, and Saturn, it was necessary to discover the reason why they 'deviate' from their sources: why *Occasio* had her face covered; why Venus had gifts at her feet; and why Saturn had winged hands and feet, and not on his shoulders. The answer lies in the text of *De la Diferencia* that accompanies these images, which deserves to be quoted in full:

> Knowing the importance of the occasion, the Ancients disguised her as a Goddess, to declare the great fortune that she brings to those who take advantage of her. They would put her on [top] of a wheel that would be moving around constantly, and they would [represent] her with wings on her feet, to denote her speed when she passes by. One could not see her face, because she had it covered with her long hair, which on the front was very full, and stretched out. For it is difficult to know when she is coming, but when she is present, one has somewhere to latch on. However, the back of her head was flat and bald, because once she turns away, one cannot detain her [by pulling her hair]. To signify the feeling that [Occasion] presses upon those that she leaves behind, which is regret, Ausonius said that Occasion was followed by Metanea, that is penance. Metanea was the only thing left behind when Occasion passed by: because when Occasion passes by, great is the sadness amongst those who could not cease her. Others represented the same Occasion holding many gifts in her hands, and goods, because she carries many of those. But she is accompanied by

48 Alciato, *Emblematum libri duo* 91.

49 Alciato, *Emblematum libri duo* 93.

50 Vaenius was previously known as the source of Guarani plate 21; but I also identify him as a potential source for Guarani plate 20, customized after Vaenius' emblem *Crapula ingenium offuscat* ("Drunkenness obfuscates intelligence", Otto Vaenius *Quinti Horatij Flacci emblemata* 40–41).

FIGURE 21.25 Emblems 48, 122 and 113 from Andrea Alciato's *Emblematum libri duo* (Lyon, Jean de Tournes: 1547)

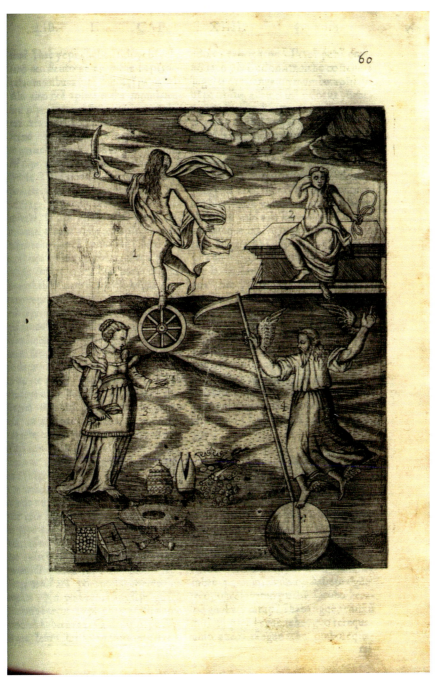

FIGURE 21.26 Plate 13 from Juan Eusebio Nieremberg's *De la Diferencia* (Loreto, Juan Bautista Neumann et alii: 1705)
IMAGE © MUSEO COLONIAL E HISTÓRICO DE LUJÁN

swift Time dressed as a pilgrim, who guides her. He has four – not two – wings, thus representing the haste with which he goes by.[51]

The Guarani *Occasio* has its face covered by her hair because the text of *De la Diferencia* required it; and Virtue, tearing her hair in despair beside the tomb of Ajax – as described in the *subscriptio* of Alciato's emblem *In Victoriam dolo partam* – becomes Metanea, the personification of *metanoia* (based on the concept of 'repentance' in Christian theology, used throughout the New Testament).[52] This proves beyond doubt that the Guarani artists not only had access to an edition of Alciato, but were able to read and interpret its complex epigrams in Latin, finding the correct correspondence between *In Victoriam dolo partam* and the notion of *metanoia*.[53]

51 'Conociendo los Antiguos ['Philosophos', in the Guarani translation] la importancia de la ocasion, la fingieron Diosa, para declarar los grandes bienes que trae à los que se aprovechavan della, cuya imagen adoravan en esta misteriosa figura. Ponianla sobre una rueda q[ue] se estava continuamente moviendo al rededor, y con alas en los pies, para denotar la velocidad con que se passa, no se le veìa el rostro, porque le tenia cubierto con el cabello largo, que por la parte anterior tenia muy poblado, y tendido; porque es dificil de conocer quando viene, pero quando està presente, tiene donde assirse; mas por la parte posterior de la cabeça estava rasa, y calva; porq[ue] en bolviendo las espaldas, no tiene de donde la puedan detener. Ausonio, para significar el efeto, que dexa à los que la dexaron passar, que es el arrepentimiento, añadiò que tenia detràs de si à Metanea, que es la penitencia, la qual solamente quedava en passandose la ocasion: porque es grande el pesar que dexa, por no averse logrado. Otros figuraron à la misma ocasion, teniendo las manos ocupadas de grandes dones, y bienes, por los muchos que traen consigo; pero acompañada del tiempo muy veloz, en habito de peregrino, que no solo con dos, pero con quatro alas la guiava, por la prisa con que se passa' (Nieremberg, *De la Diferencia* [1684] 97); cf. Nieremberg, *De la Diferencia* (1705) 59.

52 The *subscriptio* reads: 'I, Virtue, bedew with tears the tomb of Ajax, tearing, alas, in my grief my whitening hairs. This was all it needed – that I should be worsted with a Greek as judge, and that guile should appear to have the better cause'. (Emblem 46, translation from the *Alciato at Glasgow* website). This emblem is one of Alciato's many 'recreations' after epigrams from the *Anthologia Graeca*: ἅδ ἐγὼ ἁ τλάμων Ἀρετὰ παρὰ τῷδε κάθημαι / Αἴαντος τύμβῳ κειραμένα πλοκάμους, / θυμὸν ἄχει μεγάλῳ βεβολημένα, εἰ παρ Ἀχαιοῖς / ἁ δολόφρων Ἀπάτα κρέσσον ἐμεῦ δύναται. (Here sit I, miserable Virtue, tearing my hair by this tomb of Ajax, suffering with heavy sorrow as devious Fraud has more power over the Accadians than I.) (*Anthologia Graeca*, 7.145)

53 The Guarani in the missions possessed a sophisticated knowledge of Latin that should not be overlooked. For example, Nicolás Yapuguay was not only able to read in Latin but also skilled in rhetoric. For more information on this important topic, see Vega, F.R. – Wilde, G. "(Des)clasificando la cultura escrita guaraní. Un enigmático documento trilingüe de las misiones jesuíticas del Paraguay" *Archivos virtuales de la alteridad americana*, 9.1 (2019) 1–36.

NIEREMBERG'S *DE LA DIFERENCIA* IN GUARANI 731

In one single plate, therefore, there are at least three customization strategies at play: the recreation of the source with the same meaning, but adapting its *disegno* to the text of *De la Diferencia* (the first *Occasio* and Time); the use of the same *disegno* from the source, thanks to the correct interpretation of the source's meaning (Virtue > Metanea); and, finally, the recreation of the *disegno*, with a new meaning based on the text of *De la Diferencia* (Venus > the second *Occasio*).

A further survey on the potential uses of Alciato in the Guarani *De la Diferencia* revealed that Bernard Salomon's woodcuts for *Emblematum libri duo* were a main source of inspiration, appearing on no less than seventeen occasions.[54] One of the Guarani engravings, plate 11, was created entirely after multiple emblems from Alciato – and it was precisely the example chosen by José Serrano to be sent to Rome. Although this is not the occasion to comment on every individual finding, it is worth mentioning that Alciato's emblems are not used only because of their suitable *disegno* but also because they offer insightful and sophisticated commentaries on the Guarani plates, to anyone familiar with these emblems. A case in point is the young woman hit by a roof tile in the Guarani plate 18 (2.2), from Alciato emblem 158 (*Semper presto esse infortunia*, "Misfortune is always ready").

This finding is particularly revealing if one takes into consideration what is known about book circulation in the Jesuit missions. Although the composition of emblems is included in the Jesuit's *Ratio studiorum*, used in the *reducciones*, Alciato's *Emblemata* is not a religious work, and was not held in the library of the Candelaria mission, according to its surviving inventories.

2.4.2 Customizing the Devil

Previous studies have noted the influence of Jerome Nadal's *Evangelicae historiae imagines* on at least three Guarani plates (plate 9, 1.38, twice; plate 12, 1.58; plate 18, 2.8).[55] Departing from these findings, I reevaluated the presence of Nadal's work and was able to bring this number up to thirteen matches.[56] The systematic way in which Nadal was customized opened a new line of investigation for potential sources: Jesuit illustrated books, a vast genre of text-image

54 Plates 10, 11 (7 times), 13 (4 times), 14 (3 times) and possibly 29.

55 Almerindo Ojeda (*Project on the Engraved Sources of Spanish Colonial Art*, available at colonialart.org) attributes these identifications to Bailey G.A. *Art on the Jesuit missions in Asia and Latin America, 1542–1773* (Toronto: 1999).

56 With different levels of confidence: elements from Guarani plates 8, 14, 19, 20, 23, 24, 26, 27. These matches will be revisited in a future publication.

compositions.[57] But it was an unassuming little devil that helped me identify Antoine Sucquet's *Via vitae aeternae* (Antwerp, Martinus Nutius: 1620) as one of the iconographic 'anchors' of the Guarani *De la Diferencia* [Fig. 21.27].

In the illustrations for Sucquet's *Via vitae aeternae*, again designed by Gaspar Bouttats, the figure of a painter is frequently used to produce a very particular form of *mise en abyme*, in which the painting is a metaphor for the spiritual process of meditation, the *representatio* by means of which the *exemplum* is pictured into one's heart.[58]

As happened with the other images studied here, the Guarani artist worked very carefully to recreate even minute details of the core figures but customized its attributes so that they would fit into a new scene and interpretation: in Sucquet (plate after p. 428) the devil 'breaks the fourth wall' of the painter, as a reminder that the meditative process of *representatio* is not final – instead, one must contemplate (*contemplatio*) the entire context in which the *representatio* is being produced – to escape damnation.[59] Sucquet's accompanying text (*annotatio*) offers a clarification:

> Pay attention to the examples of the Saints and their sayings, with regards to N., by the virtue of your purposes [...][60] B. Hence, avert the sin that leads you astray. Consider what is felt, written, and worshiped by virtue.[61]

In the Guarani plate, however, the figure is no longer a painter, but an anonymous man in flames, being dragged down and beaten by monstrous figures,

57 For a rich introduction to this subject, see De Boer – Enenkel – Melion (eds.), *Jesuit Image Theory* (Leiden: 2016) and Daly P.M. – Dimler G.R., *The Jesuit Emblem in European Context* (Philadelphia: 2016). For a bibliography, see Daly P.M. – Dimler G.R., *Corpus Librorum Emblematum: The Jesuit Series*, 5 vols (Montreal: 1997–2007). The scholarship awaits with great anticipation Walter Melion's upcoming book *Imago veridica: The Form, Function, and Argument of Joannes David, s.j.'s Four Latin Emblem Books*. The revaluation of the presence of Jesuit illustrated books in the Guarani *De la Diferencia* allowed me to challenge imprecise attributions to Sebastián Izquierdo's *Praxis exercitiorum spiritualium* (Roma, Lazzari Varese: 1678), previously identified as the sources for two Guarani plates (Guarani plate 10, 1.44; and plate 29, 2.88). The correct source for plate 10 is the first illustrated edition of Ignatius of Loyola's *Spiritual Exercises* (*Esercitii Spirituali*, [Rome, heirs of Manelfo Manelfi: 1649]); and plate 29 is customized after Antoine Sucquet's *Via vitae aeternae* (Antwerp, Martinus Nutius: 1620).

58 Sucquet dedicates an entire chapter to explaining his method of meditation and contemplation (*Via vitae aeternae* 344–357).

59 On this image, see the Sucquet chapter of Melion, W. *The Meditative Art: Studies in the Northern Devotional Print*, 1550–1625 (Philadelphia: 2010) 151–187.

60 In the original, 'Attende exempla Sanctorum et dicta eorum de N. virtute tibi proposita'.

61 In the original, 'Peccatum hinc te abstrahens detestare. Expende quid de ea virtute seserint, scripserint, ut eam coluerint'.

NIEREMBERG'S *DE LA DIFERENCIA* IN GUARANI 733

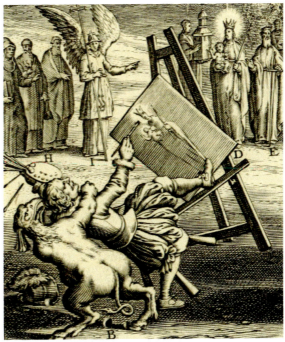

FIGURE 21.27 Plate 23 from Juan Eusebio Nieremberg's *De la Diferencia* (Loreto, Juan Bautista Neumann et alii: 1705). Detail from Figure 21.19 (Image © Museo Colonial e Histórico de Luján); and Boetius a Bolswert, eighteenth image [*decimaoctava imago*] from Antoine Sucquet's *Via Vitae Aeternae* (Antwerp, Martinus Nutius: 1620). Detail
IMAGE © GETTY RESEARCH INSTITUTE

including Sucquet's little devil. The corresponding text from Nieremberg is a metaphor for the scene of a man who is constricted by a serpent in the same plate (as mentioned above, see Fig. 21.23):

> How would that man feel, with no hope of being rescued from a merciless enemy, while he is bitten a thousand times and eaten little by little? Having no hope of temporal life, and being unable to escape the power of a snake, is such a regrettable thing! What stupor and astonishment should it not cause when, at God's judgment, there is a sinner without remedy, nor hope of escaping the power of the infernal dragon that will seize his soul and take him to the depths of the abyss?[62]

Furthermore, in the Guarani text, the violent figures surrounding the human are no longer devils, but referred to as the *anguéra* (ghosts).[63] Although the general structure of the scene is preserved (for instance, the *disegno* of the devil is recreated in detail, dragging down a human figure), the scene is customized not only to Nieremberg's text, but to the Guarani translation of it. An expanded comparative analysis of Sucquet's *Via vitae aeternae* indicates that Bolswert's engravings were used on at least eight occasions in the Guarani *De la Diferencia* (in plates 1, 7, 19, 20, 21, 23, 24, 25).

2.4.3 Customizing the Emperor

In the upper part of Guarani plate 22 (2.26), a figure dressed as an emperor stands before another figure, who kneels and offers some sort of gift. The corresponding passage in the Antwerp *De la Diferencia* reads as follows:

> According to John the Merciful, on the day an Emperor was crowned, the Ancients would present him with various pieces of marble – through the hands of their finest Architects – so that the Emperor could choose his favorite [stone] to build his sepulcher. This meant that his Empire would

62 'Como estaria aquel hombre en poder de un enemigo, que no sabia usar de misericordia, y no teniendo èl esperança de quien le socorriesse, dandole mil dentelladas, y comiendosele à bocados? Pues sino tener esperança de la vida temporal, y estar sin remedio de salir del poder de una culebra, es cosa tan lamentable; que pasmo, y assombro no ha de causar quando en aquel punto del juizio de Dios estè un pecador sin remedio, ni esperança de librarse, en poder del dragon infernal, que assirà à su alma, y llevarà à la cueva del abismo?' (Nieremberg, *De la Diferencia*, 1684, 152).

63 I identified the remaining *anguéra* around the central figure with the ones from De Bry Theodor, *Americae Tertia Pars* (Frankfurt, Theodor de Bry: 1592) 239.

NIEREMBERG'S *DE LA DIFERENCIA* IN GUARANI 735

be so short-lived, that it was necessary to start building his sepulcher immediately, so it would be ready before the end of his life.[64]

In his passage, which Nieremberg attributes to John the Merciful himself, was in fact narrated in Leontius' *Life of John the Almsgiver* (chapter 19). There are no illustrated editions of Leontius' work, with which to supplement Nieremberg's text, but one discrepancy between the *disegno* and the text is immediately apparent: the emperor is not dressed *a l'antica*, as one would expect, but in a familiar, recognizable sixteenth-century fashion, that of Charles v.[65]

The emperor sports a beard, an imperial crown, armor, and a cape. He is old (as signaled by his walking stick and the way he leans on another figure's shoulder). These easily identifiable elements constitute a very specific 'iconographic cluster'. Another point of interest is the figure kneeling before him, on a cushion, which indicates that figure's high social status. Apropos the main events of Charles v's life, this scene could be seen as a representation of the abdication of the emperor in Brussels, in 1555, which became the subject of many contemporary and later prints.[66] The exact source of the Guarani plate was Prudencio de Sandoval's *Historia de los Hechos del Emperador Carlos v* (Antwerp, Verdussen: 1681, volume 2, after p. 592); the Guarani plate derives, once again, from a print by Gaspar Bouttats [Figs. 21.28–21.29].

In the process of customization, the Guarani artist recreated Bouttat's print, including the background: the throne, the baldachin (ornamented with the Jesuit monogram and not the double-headed eagle), and the ornate door in the background are all present in the Guarani print. The new elements – the carved marble and the sepulcher – are customized because of Nieremberg's text. But the figure of an emperor is used to recreate another emperor, producing a macrocosmic synecdoche.

This process is very different from the customization of another Emperor in the Guarani *De la Diferencia*. The scene in question appears at the bottom of

64 'El día en que coronaban al Emperador, acostumbraban los antiguos (según refiere San Juan Eleemosinario) presentarle en manos de los Arquitectos mas primos de aquél tiempo, unos pedazos de diferentes mármoles para que escogiesse dellos el que mas le contentase para fabricar su sepulcro, dándole a entender que avía de durar tan poco su Imperio, que era menester comenzar luego su sepulcro para que se acabasse antes que se le acabasse la vida' (Nieremberg, *De la Diferencia*, 1684, 145).

65 Cf., amongst others, the portrait of Charles v included in Vallée Jacques de la, *Histoire pleine de merveille sur la mort de tres devote dame, madame, Catherine de Harlay, dame de la Mailleraye* (Paris, Étienne Richer: 1616).

66 E.g. Frans Hogenberg's *Abdication of Charles v*, 1570 (British Museum, 1869,0612.486); engravings from Eytzinger Michael *De Leone Belgico* (Cologne, Gerardus Campensis: 1583); amongst others.

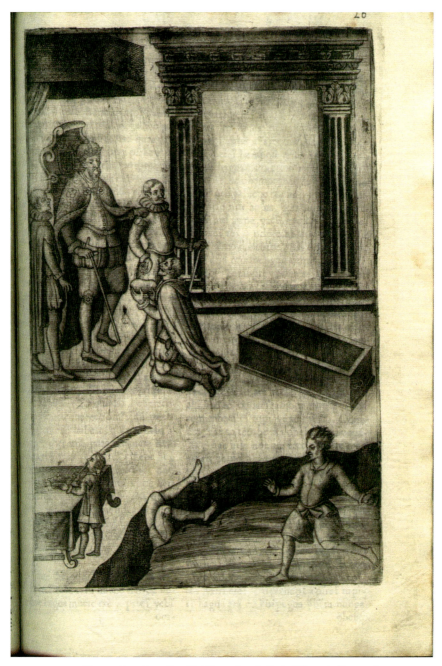

FIGURE 21.28 Plate 22 from Juan Eusebio Nieremberg's *De la Diferencia* (Loreto, Juan Bautista Neumann et alii: 1705. Detail
IMAGE © MUSEO COLONIAL E HISTÓRICO DE LUJÁN

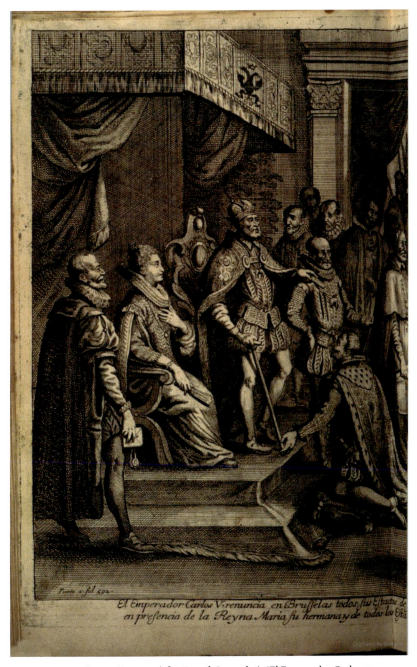

FIGURE 21.29 Gaspar Bouttats (after Joseph Lamorlet), "El Emperador Carlos V. renuncia en Brusselas todos sus Estados de Flandes [...]". Detail. Engraving from Prudencio de Sandoval's *Historia de los Hechos del Emperador Carlos V* (Antwerp, Verdussen: 1681)
IMAGE © UNIVERSIDAD COMPLUTENSE DE MADRID

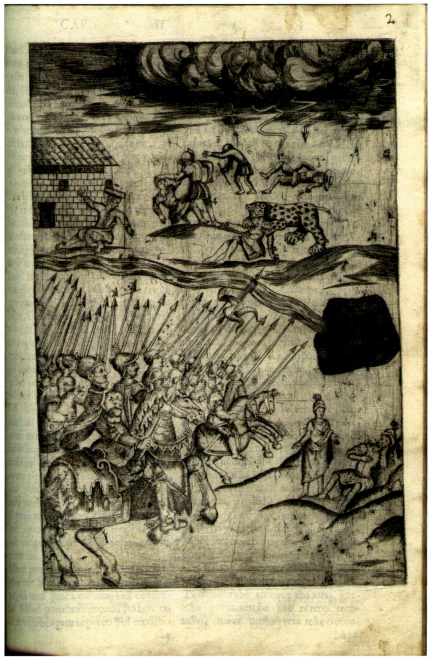

FIGURE 21.30 Plate 16 from Nieremberg's *De la Diferencia*. Detail. (Doctrinas [Loreto, Juan Bautista Neumann]: 1705)
IMAGE © MUSEO COLONIAL E HISTÓRICO DE LUJÁN

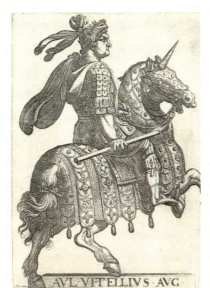 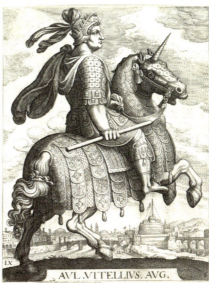

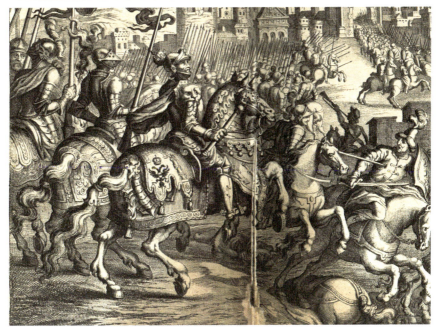

FIGURE 21.31 Antonio Tempesta, "Aul[us] Vitellius Aug[ustus]", engraving from the series *The First Twelve Roman Caesars* (1596) (Image © Metropolitan Museum); Mathäus Merien, "Aul[us] Vitellius Aug[ustus]" after Tempesta (1616) (Image © Metropolitan Museum); Gaspar Bouttats after Joseph Lamorlet, engraving from Prudencio de Sandoval's *Historia de los Hechos del Emperador Carlos v*. Detail. (Antwerp, Verdussen: 1681) (Image © Universidad Complutense de Madrid)

740 LEAL

Guarani plate 16 (2.2), in which cavalry advances against two unarmed men. The corresponding text in *De la Diferencia* reads:

> Who, being naked and disarmed against many enemies, would laugh and be happy? Surrounded by so many enemies is man, and many are the pathways that can lead to his death.[67]

Recreated after Bouttats, the two men – clearly not naked – are taken from the Antwerp 1684 edition of *De la Diferencia* (plate iii, upper right side). But the horsemen were inspired by Prudencio de Sandoval's *Historia de los Hechos del Emperador Carlos V* (Antwerp, Verdussen: 1681, I after p. 206). And again, the engraving was made by Gaspar Bouttats, but this time designed by Joseph Lamorlet, who in was inspired by the ninth plate of Matthäus Merian's *The First Twelve Roman Caesars* (1610–1650) or Merian's own source, Antonio Tempesta [Figs. 21.30–21.31].

In this densely woven fabric of customizations, Tempesta designed the Roman Emperor Aulus Vitellius; Merian recreated it; Lamonert converted Emperor Aulus Vitellius into Emperor Charles V, at the Siege of Tunis in 1535; Bouttats engraved Lamorlet work; and the Guarani artist transformed the image of Charles V into that of an 'enemy'. The Guarani customization inherits further negative connotations, thus cementing its new meaning, because the horseman is dressed as a Roman soldier – frequently identified in Nadal's *Evangelicae historiae imagines* and even in the Antwerp *De la Diferencia* as one of Christ's tormentors.

2.5 *Towards a Guarani-Jesuit Theory of Image*

The iconographic study on which this essay is based identified over 60 new matches between the Guarani images and a variety of sources, in comparison with the 21 hitherto known identifications.[68] Although there is still much to be done, this means that every plate in the Guarani *De la Diferencia* can be identified with at least one iconographic source. This information directly affects our expectations of 'originality' in the Guarani *De la Diferencia*.

A recurrent concern amongst cultural historians of the colonial Americas – particularly manifested in the study of the Guarani *De la Diferencia* – is the

67 'Quien, estando desnudo, y sin armas entre muchos enemigos, pudiera reirse, y estar contento? Entre tantos enemigos està el hombre, como son los caminos por donde puede suceder la muerte' (Nieremberg, *De la Diferencia*, 1684, 137).

68 Based on four known sources, as documented in Almerindo Ojeda's *Project on the Engraved Sources of Spanish Colonial Art*.

dichotomy between 'original' and 'copy'. For reasons beyond the scope of this essay, in these contexts 'copy' is often understood to refer to artistic products that use other works as a model, and, within a context of colonial occupation, this would indicate a subaltern activity that results in a derivative and less important work of art (if not a 'craftwork'). In fact, 'copy' and 'reproduction' are frequently referred to as an intrinsic characteristic of 'colonial art', as a quick survey of the literature reveals.[69] Since the 1970s, scholars have been trying to identify the iconographic sources (mainly prints) of artworks produced in the Americas. This scholarly effort is oftentimes heavily descriptive, but nonetheless important for understanding visual culture in the Americas, and how ideas traveled and were conveyed through images.[70]

In contrast, 'original' – as Furlong used the term – is understood as a quality of artistic products not directly inspired by other artworks: they are not based on models, and therefore are 'pure', 'creative', 'unique'. Under the aegis of colonialism, this 'originality' would signify the efforts of Indigenous artists subversively to convey their own aesthetics, ideas, and identity.

The clash between 'original' and 'copy' is another facet of what Carolyn Dean and Dana Leibsohn have already described very well:

> As scholars, we seem to have been trained to sniff out purity and to thus purify colonial culture: people either come to this material from European studies with skills and desires to distinguish the purely European from the purely New World (i.e., derivative or impure), or come from pre-Hispanic studies, where desires and skills for seeing what is truly indigenous (beneath some veil of European style or media) have been well honed. Yet both of these approaches value, in different ways, purity.[71]

This anxiety emerges from the habit of analyzing colonial realities on the basis of their complex if not conflicting products, which are seen in isolation (such as the Guarani plates themselves), with a set of expectations alien to the

69 A good starting point for this discussion is Ojeda, A. "El Grabado Como Fuente del Arte Colonial: Estado de la Cuestión", in Ojeda A. et alii (eds.), *Project on the Engraved Sources of Spanish Colonial Art* (2005–2022). Available at: https://colonialart.org/essays /el-grabado-como-fuente-del-arte-colon. Also see: (PESSCA). Available at: https://colo nialart.org/essays/el-grabado-como-fuente-del-arte-colonial-estado-de-la-cuestion.

70 The *Project on the Engraved Sources of Spanish Colonial Art* is a collaborative database connecting artworks produced in the Americas with printed models used in their creation.

71 Dean, C. – Leibsohn, D., "Hybridity and Its Discontents: Considering Visual Culture in Colonial Spanish America", *Colonial Latin American Review* 12 (2003) 26. Although I agree with the authors' excellent characterization of this phenomenon, but disagree with their conclusions.

culture[s] that created these products. Let me be more specific: 'originality' as the highest artistic ideal is a Romantic fetish, radically different from the status of art in the long European Renaissance, and even more so in relation to the cultures of the Americas.

Despite the vast evidence that European artists, and particularly engravers, created their works of art in imitative or emulative reference to other artworks, scholars rarely question the originality of Gaspar Bouttats, Matthäus Merian, Theodor de Bry, the Wierix family, the Sadeler family, and so on. As a matter of fact, in the course of identifying the iconographic sources of the Guarani plates, I realized that the visual models at play, the Jesuit illustrated book sources, were far more numerous and intricate than I had anticipated. A great deal remains to be mapped at the level of iconographic motifs. It bears repeating that in European artistic culture, the process of remediation of iconographic motifs by means of various material and print media was a norm. It was also a cultural habitus deeply anchored in methods of cultural transmission (e.g., learning how to draw implied copying, and learning how to engrave required precise reproduction of drawings); *inventio*, understood as novelty, was not necessarily the only – or main – criterion of artistry.

Over the course of the seventeenth century, the Jesuits consolidated their own visual culture: this included the creation of emblems and hieroglyphs, as formalized in the *Ratio studiorum*.[72] The Society also sponsored the production of emblems to decorate the festivals held at their colleges and missions, including the Paraguayan province,[73] and published iconographic repertoires (such as Nadal's *Evangelicae historiae imagines*) and emblem books (some already discussed here), treatises on religious paintings[74] (such as Louis Richeome's *La Peinture Spirituelle* [Lyon, Pierre Rigaud: 1611] and Antoine Girard's *Les peintures sacrées sur la Bible* [Paris, Antoine Sommaville: 1653]), and comprehensive works on the theory of images. The purpose of this entire apparatus was not necessarily to advocate for 'originality' or 'creativity': rather, images had

72 Society of Jesus, *Ratio atque Institutio studiorum*. See Item 12, in the Rhetoric curriculum: 'For the sake of erudition, other and more recondite subjects may be introduced on the weekly holidays in place of the historical work, for example, hieroglyphics, emblems, questions of poetic technique, epigrams, epitaphs, odes, elegies, epics, tragedies, the Roman and Athenian senate, the military system of the two countries, their gardens, dress, dining customs, triumphs, the sibyls, and other kindred subjects, but in moderation' (translated in Farrell A., "The Jesuit Ratio Studiorum of 1599", in *Conference of Major Superiors of Jesuits 133* [Washington: 1970]).

73 Maeder, E.J.A. (ed). "Cartas Anuas de la Província Jesuítica del Paraguay (1641 a 1643)", *Resistencia* 11 (1996) 136–142.

74 Amongst others, Richeome Louis, *La Peinture Spirituelle* (Lyon, Pierre Rigaud: 1611) and Girard Antoine, *Les peintures sacrées sur la Bible* (Paris, Antoine Sommaville: 1653).

clearly delimited spiritual, pedagogical, and propagandistic purposes, heavily charged with meaning, as instruments for devotion for the use of priests who were not primarily artists. The virtue of these images resided in their faithful conveyance of Catholic dogma, their efficacious stirring of emotions, and their utility as instruments of conversion.

With respect to visual culture in the Americas during the early modern period, I have discussed in prior studies what I call the 'pictorial dispute' between the iconographic approaches of the Franciscans and the Jesuits:[75] from the perspective of cultural transmission, whereas the Franciscans attempted to create a common visual language from the ruins of the local scripts, manifested in Testerian manuscripts and colonial codices (creating new cultural traits and their associated codes), the Jesuits tended to overwhelm Indigenous cultures, bringing not only their own vetted images (cultural traits), but also rules for their use (cultural codes, such as the *Ratio studiorum*, iconographic repertoires, etc.). The Jesuits also established institutions (cultural complexes, such as missions, churches, schools, presses) necessary to secure the controlled retransmission of these traits and codes.

When this entire cultural pattern (complex > code > trait) collides with the Guarani cosmovision, a very particular idea of the image emerges. As regards the delicate intricacies of Guarani philology, before contact with the Europeans the Guarani had two central words for 'image': *quatiá* and *ãng*.[76] Originally, *quatiá* probably corresponded to the kind of image that is produced by humans, as represented in the Guarani's rich pottery tradition. Based on Montoya, one can easily notice that the word acquired many new meanings by metonymic transfer: such as 'writing, painting, drawing, paper, letter,

75 See Leal P.G. "Os Hieróglifos do Novo Mundo: das escritas indígenas à chegada dos *jeroglíficos* hispânicos", in Leal – García Arranz J.J. (eds.), *Jeroglíficos en la Edad Moderna* (A Coruña, 2020) 257–330; Leal P.G., "To the New World, on the Ship of Theseus: An Introductory Essay to Emblems in Colonial Ibero-America", in Leal – Amaral, Jr. R. (eds.), *Emblems in Colonial Ibero-America* (Glasgow: 2017) 1–54.

76 A field of study brilliantly inaugurated by Bartolomeu Melià (see Melià B., *La création d'un langage chrétien dans les reductions des Guarani au Paraguay* (Ph.D. dissertation, Université de Strasbourg: 1969) and *La lengua Guaraní en el Paraguay Colonial* (Asuncion: 2002); for a brief introduction, see Melià B., "La lengua transformada: el guaraní en las Misiones Jesuíticas", in Wilde, B. (ed.). *Saberes de la conversión. Jesuitas, indígenas e imperios coloniales en las fronteras de la cristiandad* (Buenos Aires: 2011) 81–98. Also see: Thun H., "La hispanización del guaraní jesuítico en 'lo espiritual' y en 'lo temporal'. Primera parte: El debate metalingüístico", in Stehl T. (ed.), *Kenntnis und Wandel der Sprachen. Beiträge zur Potsdamer Ehrenpromotion für Helmut Lüdtke* (Tubingen: 2008) 217–240; and "La hispanización del guaraní jesuítico en 'lo espiritual' y en 'lo temporal'. Segunda parte: Los procedimientos" in Wolf D. – Symeonidis H. (eds.), *Geschichte und Aktualität der deutschprachigen Guaraní-Philologie* (Berlin: 2008) 141–169.

book'.[77] *Ãng* corresponded to what one could call a 'natural image', which had an indexical, dependent relationship with another entity in the physical and spiritual world.[78] At that historical stage, *ãng* encompassed the meanings of 'signal', 'imitation', and 'shadow'. In fact, the terrifying Guarani ghosts, *anguéra* (sing., *angué*), are a combination of *ãng* (shadow) and -*kue*, a nominal suffix indicating the past (the absence of a previous state[79]), meaning the shadow of something that is no longer there.

Upon the arrival of the Jesuits in the province of Paraguay, they attempted to translate the Guarani culture, reframing it with reference to concepts familiar to Christians. In 1594, before the foundation of the *reducciones*, the Jesuit Alonso de Barzana contended:

> This entire nation [the Guarani] is very inclined to religion, be it the true or false [faith]. If the Christians had given them a good example, or if the sorcerers had not deceived them, they would not only be Christians, but devout Christians. They know about the immortality of the soul, and they fear greatly the *anguéra*, which are the souls that come out of the body. They say that [the *anguéra*] go around scaring [people] and causing evil.[80]

In those initial contacts, *anguéra* are already being translated as 'souls coming out from the body'. Later, Montoya would refer to *ãng* as 'soul out of the body, and phantom'[81] and 'soul of the deceased'.[82] It is perceptible that between Barzana and Montoya, the translation of *ãng* (along with its orthography) was still relatively fluid and tentative – subject to a long process of normalization.

77 Montoya, *Tesoro de la lengua Guarani*, fol. 329v ("*Quatiá*").

78 Montoya, *Tesoro de la lengua Guarani*, fols. 35r ("*ang*") and 135v ("*Hãã*, Prueba, señal, medida, imitacion, contrahazer, imagen, retrato, ensaye, tentacion, semejança"); cf. Montoya, *Arte, y Bocobulario*, fol. 153r ("Alma, *Ang*") and 198r ("Sombra, *ãng*"). I say 'corresponded' because, over time, this word acquired new meanings.

79 Cf. *Akãngue* (from *aka*, head, and -*kue*): a decapitated head of a person or animal, i.e., 'something that used to be a head' (Estigarribia, *A Grammar of Paraguayan Guarani* 122).

80 'Es toda esta naçión [the Guarani] muy inclinada a riligión, verdadera o falsa, y si los cristianos los hubieran dado vuen ejemplo y diversos echiceros no los ubieran engañado, no sólo fueran cristianos sino devotos. Conoscen toda la inmortalidad del alma y temen mucho las anguéra, que son las almas salidas de los cuerpos, y dicen que andan espantando y aziendo mal' (Barzana (1594) apud Society of Jesus, *Monumenta Peruana* 589–590).

81 Montoya, *Tesoro de la lengua Guarani*, fol. 38v ('*Angûera*. c.d. ãng. y cûera, praeterito, alma fuera del cuerpo, y fantasma').

82 Montoya, *Arte, y Bocobulario* 153 ('Alma de difunto, *Anguêra*').

NIEREMBERG'S *DE LA DIFERENCIA* IN GUARANI 745

By the end of the century, José Serrano and his Indigenous collaborators[83] were translating 'devils' as *anguéra* in the Guarani *De la Diferencia*.

The process of translating Christian theology into Guarani not only impacted the Guarani language spoken in the missions but also Christian concepts, the reception of which underwent a significant transformation. This is perfectly demonstrated in a Guarani translation of *Genesis* 1:27 ('So God created man in his own image'), in the *Tesoro de la Lengua Guarani*: '*Gûããngãmo Tupã ñande ãnga oyapó*, hizo Dio nuestra **alma** a su **imagen** y semejança' (bold letters mine).[84] There, the root *ãng* is used in the same phrase to translate both 'soul' and 'image'.

Another example of this transformation is in the word *rããngába* (as already mentioned, derived from *ãng*): in Montoya's *Tesoro de la Lengua Guarani* (1639), it corresponds to 'image', 'portrait', 'imitation' ('*Tupãcy rããngába*, Imagen de Nuestra Señora', 135r),[85] and one year later, in Montoya's *Arte y bocobulario*, the same word in exactly the same context is translated as 'print' ('*Tupã rããngába*, Estampa de Dios').[86] And how should this image or print ('*rããngába*') be received or treated in the missions? This was also codified in the doctrinal lessons of the Jesuits. As Ruiz de Montoya asserts in his *Catecismo de la lengua Guarani*:

> What reverence do we owe to the images of god (*Tûpãrããngába*) and of the saints (*Santas raàngábaabé*)? / The same that we owe to the saints they represent.[87]

Despite their semantic differences, from a linguistic perspective, both *quatiá* and *ãng* could have been used to translate and adapt the idea of 'image/engraving' in Guarani. *Quatiá* would have emphasized the human process of producing an image (similar to 'drawing' or 'painting');[88] *ãng*, however, is evidentiary.

83 For the participation of the Guarani in the process of translation at the Jesuit missions in Paraguay, see Brignon, "Du copiste invisible à l'auteur de premier ordre".

84 Montoya, *Tesoro de la lengua Guarani* fol. 135r.

85 Montoya, *Tesoro de la lengua Guarani* fol. 135r.

86 Montoya, *Arte, y Bocobulario* 369.

87 'Marãnûngápe Tûpãrããngába Santas raàngábaabé ñamboyerobia raene? / Que reuerencia deuemos à las Imagenes de Dios, y de los Santos? / Hetê ñamboyerobiã ñãbeîngatú, haãngába ñãm boyerobiãne. / La misma que dariamos à los mismos Santos q[ue] representan' (Montoya Antonio Ruiz de, *Catecismo de la lengua Guarani* (Madrid, Diego Diaz de la Carrera: 1640, 81).

88 Cf. Montoya, *Tesoro de la lengua Guarani*, fol. 329v ('Ayquatiá, escriuir, pintar').

It implies not the process of producing an image but its pre-existence: the image is a being itself, and the semiotic index of being.[89]

My working hypothesis is that *ãng* was chosen to translate 'image' (especially in the sense of 'prints') in the missionary context because it inherently signified something about which Jesuit image theory energetically speculated: the power of *enargeia* (*evidentia*).[90] The use of highly intellectualized yet affective images to induce the exercise of *meditatio* was at the core of Jesuit theology. However, whereas in Jesuit visual culture *enargeia* is a quality that images can be crafted to attain in a higher or lesser degree, amongst the Guarani *ãng* was evidentiary in itself.

Amongst the visual strategies used by Guarani artists, there is a case that is exceptionally revealing of how the Guarani regarded the engravings that they had at their disposal, not only as a model but also source of factual information. In the lower part of the Guarani plate 24 (2.44), a group of men approach the city of Jerusalem. The text of *De la Diferencia* associated with this scene refers to *Zephaniah* 1:12 ('And it shall come to pass at that time, that I will search Jerusalem with candles'). To engrave this passage, the Guarani artist used Nadal's *Evangelicae historiae imagines*, plate 87, showing the entry of Jesus into Jerusalem [Figs. 21.32].

It is disputable whether the figure holding the candle in the Guarani scene is Jesus[91] or Zephaniah. But beyond any doubt the Guarani artist recreated Jerusalem as originally designed by Hieronymus Wierix. Any of the various cities that appear as *fatti* in the many sources consulted in composing the Guarani plates could have been used to create a view of Jerusalem, but the artist decided to find an image that, he believed, represented the actual city of Jerusalem – even while changing the perspective of the city to bring it closer to the approaching figures and match the description of the scene.

89 In its verbal form, 'Ahãa, prouar, medir, señalar' (Montoya, *Tesoro de la lengua Guarani*, fol. 135v).

90 For an extensive discussion on *enargeia*, see Plett H.F., *Enargeia in Classical Antiquity and the Early Modern Age* (Leiden: 2012).

91 As suggested by Fernando Gil in his introduction to the facsimile edition of the Guarani *De la Diferencia* (Gil F.M., "De la diferencia entre lo temporal y eterno. Crisol de desengaños con la memoria de la eternidad, postrimerías humanas y principales misterios divinos, de Juan Eusebio Nieremberg s.j. Introducción", in Nieremberg,J.E., *De la diferencia entre lo temporal y eterno, primera edición facsimilar en conmemoración al Bicentenario de la Revolución de Mayo* [Buenos Aires: 2010] lvii). If the figure in question were intended to be understood as Jesus, that would imply a fascinating process of interpretation by the artist. However, another iconographic problem would emerge: as the Bible (and Wierix's plate from Nadal's *Evangelicae historiae imagines*) indicates, Jesus enters Jerusalem on a donkey.

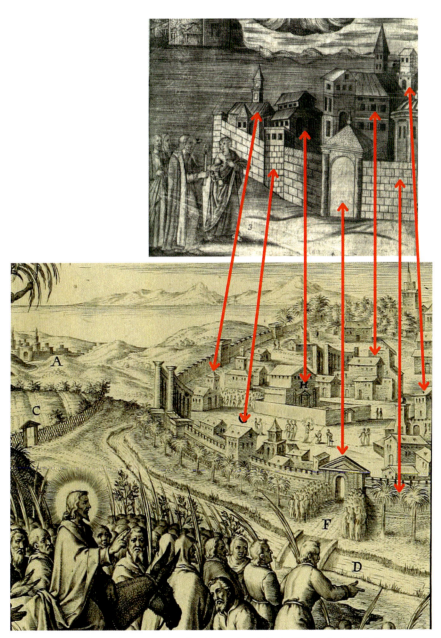

FIGURE 21.32 Plate 24 from Juan Eusebio Nieremberg's *De la Diferencia*. Detail. (Loreto, Juan Bautista Neumann et alii: 1705) (Image © Museo Colonial e Histórico de Luján); and Hieronymus Wierix (engraver), *Ingressus solemnis in ciuitatem*, plate 87 from Jeronimo Nadal's *Evangelicae Historiae Imagines*, Antwerp, 1593. The arrows are mine and indicate 'points of interest' for comparison

It becomes clear, then, that in the production of *De la Diferencia*, the Guarani artists are not merely copying models but also treating the visual sources made available to them (and vetted by the Jesuits) as first-hand testimony of a reality their eyes had not seen, which catechisms instructed them to venerate as such. *Aiquatiá hâângába* – 'drawing a print' – was a spiritual exercise, and the level of artistry that the Guarani displayed in these plates can only be explained as an intentional achievement, resulting from an inter-generational, quasi monastic dedication to the craft.[92]

The elegance of the Guarani language was frequently praised by the Jesuit canon.[93] And if there is any truth to this thesis, the word *hâângába* would epitomize the Guarani's poetic vocation, if compared to the foreign concept that it translated (such as 'estampa' or 'print'). After all, what is a print's ink, if not the shadow of a carved plate?

3 Indigenous Agency and Authorship

In his dedication of the Guarani *De la Diferencia* to Tirso González, José Serrano highlights the Indigenous labor that produced the illustrations in this edition:

> The printing [of this book] and the many plates that illustrate it were the work of the finger of God, the more remarkable as a few poor Indians, new to the faith, were the instrument [of their confection], without the direction of European masters, [thereby] to ascertain that everything is a favor from the heaven, which wanted to teach these poor [Indians] the truths of the faith, through such unexpected medium.[94]

It was the scholarship around this book that questioned Indigenous artistic agency in the Guarani *De la Diferencia*: the Jesuits were seen as responsible for the conception, i.e., invention of the plates; Juan Bautista Neumann was

92 *Aiquatiá hâângába* did not preclude the Guarani from creating new designs and artworks. One must also consider that their environment and resources (including the use of paper) were subject to the scrutiny of the Jesuits and, ultimately, of the Holy Office.

93 See Rodriguez Y., "Spanish-Guarani Diglossia in Colonial Paraguay: A Language Undertaking", in Weber B. (ed.), *The Linguistic Heritage of Colonial Practice* (Berlin: 2019) 159.

94 '[...] la ymprenta, Como las muchas laminas para su realze an sido obra del dedo de Dios, tanto mas admirable, quanto los ynstrumentos son vnos pobres yndios nuebos en la fee, y sin la direccion de los Maestros de la Europa, paraque Conste, que todo es favor del cielo, que quiso Con medio tan ynopinadoenseñar aestos pobres las verdades dela fee' (Nieremberg, *De la Diferencia*, 1705, vi).

NIEREMBERG'S *DE LA DIFERENCIA* IN GUARANI

held to be the author of the *disegni*; in sum, the Guarani artists were thought to have been involved only in the *intaglio* of the copperplates. All of these assumptions were made *a posteriori*, without supporting evidence, and despite José Serrano's own words about the absence of European masters or teachers ('maestros').

The only mark of authorship in the Guarani plates is inscribed at the bottom of plate 4, which contains a portrait of Tirso González above a clock, its pointer in the form of a finger indicating the twelfth hour, beside the motto 'haec digitus dei est' (this is the finger of god). The plate is signed: 'Ioan.yapari sculps' (Juan Yapari engraved it). Josefina Plá suggests that this signature 'acknowledges the work of the burin, but not that of an original designer'.[95] However, the truth could not be more different, as Yapari probably worked from a printed source [Fig. 21.33]. The signature, fortunately, is not the only way to identify the authorship of these engravings. In the process of analyzing the Guarani plates, I set a score for the different *intaglio* techniques (line, contour, linear hatching, cross-hatching, contoured hatching) wherever applicable, and ordered the plates according to their overall score. As a result, I was able to identify at least four major groups of characteristics that indicate the work of four potential authors (A, B, C, and D), and consequently, the intaglio of at least sixteen plates can be attributed to Juan Yapari (group A) with a high level of certainty. These results, however, are limited to the process of *intaglio*. In other words, Yapari may have designed other plates, which were engraved by other artists with different levels of experience (and vice-versa).

But there is circumstantial evidence of the creative authorship of the Guarani plates, and once again, the loose folios of *De la Diferencia* kept at the Archivum Romanum Societatis Iesu provide a wealth of unexplored information. At the time these documents were sent to Rome, it was an archival best practice to write contextualizing notes on the back of documents preserved at the ARSI. Hence, it is of no surprise to find on the verso of Bernardino de Cerbín's approbation [Fig. 21.34] two handwritten notes – one in Latin, the other in Italian (which would remain visible when the paper was folded as a letter):

[Latin]
Indi qui fuerant barbari, ita a Missionarijs societatis, per poliuntur ut ita scribant.

95 Plá, *El Barroco Hispano Guarani* 134.

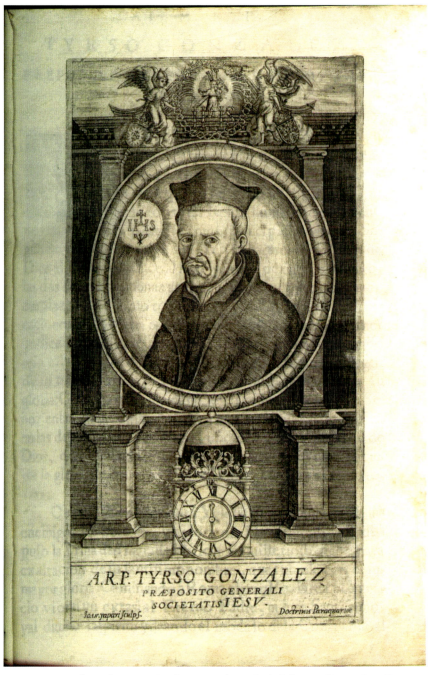

FIGURE 21.33 Plate 4 from Juan Eusebio Nieremberg's *De la Diferencia* (Loreto, Juan Bautista Neumann et alii: 1705)
IMAGE © MUSEO COLONIAL E HISTÓRICO DE LUJÁN

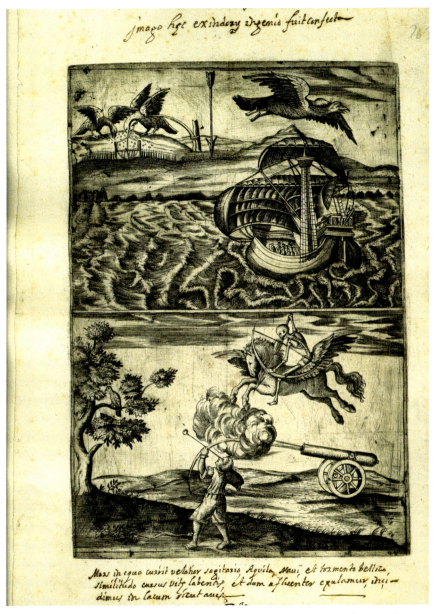

FIGURE 21.34 Juan Yapari (attributed to), plate 11 from Juan Eusebio Nieremberg's *De la Diferencia* (Loreto, Juan Bautista Neumann et alii: 1705)
IMAGE © ARCHIVUM ROMANUM SOCIETATIS IESU

The Indians, who were barbarians, would go to the missionaries of the society in order to refine [themselves] and this is how they would write.

[Italian]
Paraquariae et Chilensis / Anno 1700 / Modo di scrivere ed intagliare in Paese insegnato [da?] gl'indiani de i nostri lato.

[Province of] Paraguay and Chile / year 1700 / Way of writing and engraving in the country taught [by?] the Indians [that are] on our side.

These texts are the residue of the discourse that accompanied these documents to Rome, preparing them to be received by the keepers of Archivum Romanum Societatis Iesu, where it was understood that the Guarani were responsible for the print script in the manuscript, and for the engraving as well. The engraving in question is one of the sixteen that I attributed to Juan Yapari – a first state of the Guarani plate 11. It is almost identical to the second state (from the Luján copy), except for two manuscript annotations, one below and another above the engraving, which unambiguously attributes to Guarani artists the conceptual authorship of this plate: 'Haec imago ex indorum ingenio fuit confecta' (This image was made by the genius of the indians).

The existence of this plate proves that before 1700 – perhaps before other plates were even made – it had been decided that the Guarani *De la Diferencia* would include more illustrations than the 1684 Antwerp edition, as a way to showcase the Guarani's pictorial abilities. Moreover, it was also decided that the plates would not be drawn exclusively from Gaspar Bouttats's engravings, but also from other sources, such as Bernard Salomon's woodcuts for Andrea Alciato's *Emblemata*, as demonstrated here.

4 Customizing the Book

There is a causal relationship between the authorship of the Guarani *De la Diferencia* and the phenomenon of *aiquatiá hâângába*, which can be outlined in this way: Jesuits introduced cultural traits (prints, typography, the aesthetics of prints), codes (iconographic repertoires, notions of Jesuit image theory, practices of learning by copying) and complexes (schools, workshops) that, in contact with the Guarani own cultural traits (the idea of *quatiá* and *ãng* before the presence of the Jesuits), formed a new cultural code (*aiquatiá hâângába*) – an Indigenous form of image customization, developed and culturally transmitted by Indigenous artists who conformed their drawings to the aesthetics of printed images which they construed as evidentiary; these print-like drawings

NIEREMBERG'S *DE LA DIFERENCIA* IN GUARANI 753

operated socially in lieu of a press. From a political perspective, *aiquatiá hâângába* enabled the introduction of the press in the Paraguayan missions by giving the Jesuits like José Serrano a powerful argument in favor of using the Guarani's abilities as a propaganda tool. The advent of a new cultural complex (the press) allowed the use of the modes of image customization – created as expressions of *aiquatiá hâângába* – to be introduced in the process of illustrating a book.

Amongst other motivations, the ambitious editorial project of the Guarani *De la Diferencia* was conceived to showcase *aiquatiá hâângába*, the Indigenous artistic achievements, thus technically rivalling the production of European presses. But something happened in the process of publishing the Guarani *De la Diferencia* that triggered another layer in the customization to this cultural artifact: the customization of the book, which can be traced thanks to the evidence left in the way that the plates were interpolated, and by a secret kept by the paper used to publish this work.

4.1 *Marginal Annotations as Evidence of Customization*

In the Guarani edition, the plates are numbered (by hand) according to the number of the previous page (therefore, plate 34 appears immediately after page 34), and the verso of the plates is blank. As the page numbers are reinitiated in every chapter, it becomes very difficult to follow the plate sequence – as plate '88' (i.e., chapter 2, plate 88) appears before plate '12' (i.e., chapter 3, plate 12). This complex page numbering system, however, has its advantages: it allowed for the inclusion of new plates after the text was printed.

Different from the Antwerp edition of 1684, the Guarani version is full of *annotationes* linking the text with the images – in what can be perceived as a process of emblematization.[96] In the copy examined here, almost every plate contains a small numeric annotation next to a scene within the plate.[97] This number is included in the annotations in the margins of the printed text.[98] The marginal annotations were printed, corrected (by hand), or handwritten;

96 Different from Nadal's *Evangelicae historiae imagines* or Jan David's emblems, which use letters to link scenes with the text, the Guarani edition uses a combination of numbers and letters. The text from Nieremberg (to which a scene is associated) usually contains a visual description of the scene (*ekphrasis*) and a moral or theological interpretation of the scene: two essential components of the *subscriptiones* in emblem books.

97 There are differences in the indexation of the images (i.e., the annotations inside the images) between the two 'complete' copies of the Guarani *De la Diferencia*: for instance, the scene of a deathbed in plate 9 (1.38) is numbered '1' in Luján's copy, and numbered '2 in the private collector's copy.

98 For example, in chapter 2, p. 49, the marginal annotation 'ᵃ 60.1' indicates that the text after the note '(ᵇ)' (column 2, line 25) corresponds to scene 1 of plate 60 (i.e., the allegory of *Occasio*). See Fig. 21.26.

they are sometimes absent. By examining these annotations one can obtain an extraordinary insight into the different stages of the book's composition.

4.1.1 Printed Annotation

By logical inference, the printed annotations in the margins of the text indicate scenes or plates that were planned – if not drawn or engraved – before the corresponding pages were printed, and what should be the relative positioning of these plates. Only Guarani plates 14 (1.62) and 27 (2.62) have annotations in print, without further correction and handwritten additions. The last printed annotation corresponds to plate 27 (2.62). This is a good indication that the remaining plates were neither planned nor drawn before the text was printed.

4.1.2 Corrected Annotation

There are many occurrences of printed marginal annotations that were then corrected by hand. This correction may indicate a change in the image indexing (i.e., the handwritten numbers corresponding to each scene inside a plate) or even a change in the relative position of the plate in the book. For instance, plate 5 (1.6) was originally expected to be inserted after page 10 (and not after page 6). The existence of annotations for plates 5 and 7 (1.14), both taken from Bouttats' plate 21, indicates that before the book was printed, it had already been decided that Bouttats' engravings would be 'disassembled' into new plates. Not surprisingly, partial plates after Bouttats were consistently drawn and engraved by the best artists in the Guarani workshop.

4.1.3 Handwritten Annotation

Handwritten annotations may indicate that the scenes were indexed after the corresponding text (along with marginal annotations) was printed, as seems to be the case with plate 11 (1.46), which had already been engraved when the first state of the Guarani *De la Diferencia* was issued (c. 1700). However, there are six plates with only handwritten annotations, which may imply that they were conceived later, and only then indexed in relation to the text.

4.1.4 No Annotation

Of the forty-two plates examined here, fifteen have no annotation connecting them with the text. The first four (plates 1–4) are in the preliminary matter and are not supposed to illustrate specific parts of the text. However, there are cases in which the absence of *annotationes* is telling, and they can be divided in three groups of full-page plates: one after Hieronymous Wierix (plate 15, 1.68); three after Bouttats (plates 32, 4.68; 33, 4.64; and 42, 5.66); and eight after Pinamonti's *Inferno aperto* (see Fig. 21.23, above). Collating this information

NIEREMBERG'S *DE LA DIFERENCIA* IN GUARANI 755

with the attribution of authorship, one can see that all these plates were engraved by the two most skillful engravers from the Guarani workshop. In fact, all full-plate engravings after Bouttats (6 in total) are products of authors A/B and have no matching printed annotation.

Finally, the hell scenes after Pinamonti's *Inferno Aperto* constitute the only series of prints that were recreated in full by the Guarani artists. In other words, all eight engravings produced for *Inferno aperto* are present in the Guarani *De la Diferencia*. As a result, there are more full-plate engravings after *Inferno aperto* than after the 1684 edition of *De la Diferencia*, by Bouttats. These infernal engravings loosely illustrate Book 4, chapters 8–12, of *De la Diferencia*, which is dedicated to the punishments of sinners in hell, but there are no ekphrastic passages in Nieremberg's text matching these plates.

4.2 *The Paper Trail*

In 2004, José Carlos Balmaceda published a detailed study of the paper used in the Guarani *De la Diferencia*. His research revealed that this work was printed almost entirely on Genoese paper, with the exception of the titlepage, which carried a 'Brittania' watermark indicating its English origin. However, since this specific watermark did not appear until 1706 or later, Balmaceda suggested for the first time that the frontispiece of the Guarani *De la Diferencia* may not be original.[99]

Four additional pieces of information settle this question beyond doubt. First, an analysis of the typography of the titlepage reveals that the fleuron used to frame the page was not used elsewhere in the book. The only other place where it appears is in a Loreto press of 1721, in the frontispiece of the *Manuale ad usum* published under the direction of Paolo Restivo.[100] The same fleuron is used in subsequent publications brought to light by Restivo, such as Antonio Ruiz de Montoya's *Vocabulario de la Lengua Guarani* (Santa Maria la Mayor: 1722) and *Arte de la Lengua Guarani* (Santa Maria la Mayor: 1726).[101] In fact, the overall composition of the titlepage of the Guarani *De la Diferencia*

99 Balmaceda, "El origen de la imprenta Argentina" 18.

100 *Manuale ad usum Patrum Societatis Iesu qui in Reductionibus Paraquariae versantur ex Rituali Romano ac Toletano decerptum* (Loreto, Society of Jesus: 1721).

101 Montoya, *Vocabulario de la Lengua Guarani*, 1722; Montoya, *Arte de la Lengua Guarani*, 1724. For comparison, Antonio Garriga's *Instruccion Practica* published in Loreto in 1713, uses stars to decorate the titlepage, the fleuron is not to be found anywhere else (Garriga Antonio, *Instruccion practica para ordenar santamente la vidà; que ofrece el P. Antonio Garriga de la Compania de Iesus. Como brebe memorial, y recuerdo à los que hazen los exercicios espirituales de S. Ignacio de Loyola fundador de la misma Compañia* [Loreto, Society of Jesus: 1713]).

has many problems with typographic alignment, kerning, and even typos, which shows that it bears a closer resemblance to the later works published under Restivo than to the core of the Guarani *De la Diferencia* itself.

The second piece of information comes from the process of customizing images for this book. It is unreasonable to assume that the Guarani artists would make extensive use of Bouttats' plates for the Antwerp 1684 edition and then ignore both its rich frontispiece and first plate. Moreover, it cannot even be argued that these plates were missing from the copy of the Antwerp 1684 edition that the Guarani artists had at their disposal, because the city view from the frontispiece is customized in Guarani plate 7 (1.14).

Third, I conducted a brief comparative analysis between the paper used in the Guarani *De la Diferencia* and later publications from Paraguayan presses. The results are revealing: Garriga's *Instruccion Practica* (published in Loreto in 1713), an *octavo* (14 cm), was printed on an undetermined paper that partially matches Balmaceda's description of the title page for the Guarani *De la Diferencia*.[102] For the next known publication, *Manuale ad usum* (published in Loreto in 1721), a *quarto* (17 cm), the Genoese paper was again used, but it ran out during the printing process and was subsequently replaced with a lower-quality paper that had similar characteristics to the English paper discussed by Balmaceda. Future publications under Paolo Restivo, such as Antonio Ruiz de Montoya's *Vocabulario de la Lengua Guarani* (Santa Maria la Mayor: 1722) and *Arte de la Lengua Guarani* (Santa Maria la Mayor: 1726), use the same paper as Garriga's *Instruccion Practica*. This means that up until 1721, the title-page of the Guarani *De la Diferencia* could have been published on the higher-quality Genoese paper, which would have been consistent with the rest of the book.

Finally, there is the mystery of Guarani plate 43, which is missing from the Luján copy examined for this essay.[103] I was able to identify the source of this image thanks to a facsimile of the plate, which unfortunately cannot be reproduced here. It comes from the frontispiece of Antonio Ruiz de Montoya's *Arte, y bocobulario de la lengua guarani* (Madrid, Juan Sanchez: 1640), and depicts the Immaculate Conception. This print is stylistically distinct from the other

102 The paper has a regular surface with '8 thick corondels every 25 mm and 7 points per cm' (Balmaceda, "El Origen de la Imprenta Argentina" 18). The paper used in Antonio Garriga's *Instruccion practica*, however, has two identifiable filigrees: that of a grape (found in French papers from the late seventeenth century) and the monogram P♡B inside a cartouche. Although I could not find this precise combination of letters in specialized databases, the motif is also present in French paper used in Spain.

103 The only surviving copy of this print is bound in the volume of the Guarani *De la Diferencia* in a private collection in Argentina.

plates in the Guarani *De la Diferencia*.[104] A private communication suggests it was printed on English paper, but I could not confirm this finding. Since there are no marginal annotations in the Guarani *De la Diferencia* that refer to this print, I would suggest that the *Immaculate Conception* was customized to illustrate the Guarani reedition of Montoya's work (which came to light in 1724, as indicated above).

This analysis of the paper, though not definitive, provides yet another strong piece of evidence to support the customization of the extant copies of the Guarani *De la Diferencia*.

4.3 *Reconstructing the Book Customization*

A comparative analysis of bibliographical, textual, authorial, and iconographic information about the Guarani *De la Diferencia* discussed in this essay has laid the foundation for reconstructing the processes of editing and customization discernible in this book.

The book was translated between 1684–1696 by José Serrano and anonymized Indigenous collaborators. An early proof of the initial pages was printed around 1700 and sent to Rome, where six pages still survive, at the Archivum Romanum Societatis Iesu. It is possible that the typeset tray of these initial pages was kept intact so that the pages could be corrected at a later stage. The textual core of the book was certainly printed by late 1701 and early 1702. This is because Juan Bautista Neumann, who was responsible for the press, went on an expedition up the Pilcomayo River (Ysyry Araguay, in Guarani). He returned in 1703, fell ill, and died on 5 January 1704 in Asunción.

From the very beginning a decision was made that the Guarani *De la Diferencia* would have more images than the source, the Antwerp edition of 1684. The engraved page sent to Rome (plate 11) indicates that the images customized for this project would include materials customized from different sources, such as Alciato. At the time of Neumann's death, the text folios were printed, but many plates remained to be finished, as the project of 'decoupling' Bouttat's plates was yet to be completed. This can be easily observed in the graph below, which shows a considerable reduction in the number of plates per book:[105]

104 The engraving of the *Immaculate Conception* bears a closer proximity to the work of another indigenous artist: Tomás Tilcara, and his famous print of *Saint John Nepomucene*, engraved in the mission of San Ignacio Miní in 1728.

105 Preliminary matter, 4 plates; book 1, 11 plates; book 2, 14 plates; book 3, 3 plates; book 4, 9 plates (8 of which are recreated after Pinamonti's *Inferno aperto*); book 5, 1 plate.

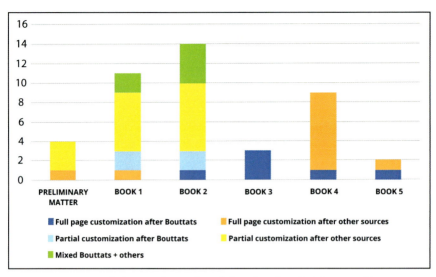

FIGURE 21.35 A graph showing the number of plates based on their iconographic group

This graph provides a wealth of information to understand how the plates were interpolated into the Guarani book. In the first part of the book (from the preliminary matters to chapter 2), there is a frequent use of plate customization through decoupling, as envisioned in the editorial project.

However, right before the end of chapter 2, something drastic happened, and the editorial project was halted. This can be deduced from the abrupt end of the decoupling process used to produce new plates. Moreover, from a technical perspective, it is clear that the production of some of the plates from book 2 was rushed; they were left unfinished by less experienced engravers, as well as by some of the workshop's best artists.[106]

This phenomenon coincides exactly with the death of Neumann. To complete the work, it was determined that the remaining plates by Bouttats would be customized in full (see Fig. 21.35, in dark blue in the graph), instead of 'disassembling' them and creating new prints, which would require more work and significantly delay the publication; and the best artists in the workshop were selected to engrave the plates. A few copies were bound in time to be sent to Tirso González – a staunch supporter of the Guarani press – who was terminally ill and died in October 1705. But I would suggest that these copies did not have any of the full plates produced after other sources (in dark yellow,

106 Amongst the least experienced artists were the ones who executed Guarani plates 16 (2.2); 20 (2.18); 29 (2.88); and, unfinished by a more skilled engraver, Guarani plate 22 (2.26).

in the graph above). The only exception would be the one used in the preliminary matter.

The project of the Guarani *De la Diferencia* was put on hold, and the book remained unbound while it waited for its full set of prints, which were was never brought to completion. As time passed, the press turned its attention to less ambitious projects, such as the *Martirologio Romano* (printed in 1709, and extant only in a partial copy) and Garrido's *Intruccion Practica*, which was published in 1713, the year in which José Serrano passed away.

After these episodes, and faced with a lack of supplies (especially paper), the Loreto press ceased operations until, I would suggest, the intervention of Paolo Restivo, who became the Superior of the Guarani missions between 1719 until 1721. With his permission and during his tenure, the Loreto press published the *Manuale ad usum* (1721) with the remaining sheets of Genoese paper.

My hypothesis is that Restivo became familiar with the remaining copies of the Guarani *De la Diferencia* in Loreto and decided to bind them. It was during this critical moment that the book was customized with engravings originally made for other purposes: the plate after Hieronymus Wierix (15, 1.68); the *Immaculate Conception* (plate 43), possibly made to illustrate the Guarani edition of Antonio Ruiz de Montoya's *Vocabulario de la Lengua Guarani* (Santa Maria la Mayor, 1722); and all the engravings from Pinamonti's *Inferno aperto*. These prints were used to embellish the new books, allowing for prints to be distributed more evenly across the volume and increasing the number of high-quality plates (thus securing the propagandistic value of the Guarani *De la Diferencia*).

Strong evidence for this hypothesis comes from the fact that these plates were not planned in the initial editorial project. They have no marginal annotations connecting them to the places where they should be bound, and, more importantly, they have no direct connection with the text where they were finally interpolated.

Subject to further archival research, I would suggest that the plates designed after Pinamonti's *Inferno aperto* were engraved to be published in a Guarani (Chiquito or Spanish) edition of the same title, to be issued by the Guarani press. As mentioned earlier, the additional plates are not closely tied to the texts they supposedly illustrate. The 'emblematic' effect, which characterizes the other plates in the Guarani *De la Diferencia*, is completely absent. Additionally, a Guarani translation of *Inferno aperto* would be the natural sequel to *De la Diferencia* in conceptual terms. Through interpolation into the Guarani edition, the supplementary prints provide a vivid, powerful impression of the punishments of the soul in hell. For this reason, I argue that the Guarani *De la*

Diferencia is a customized book sophisticated by the interpolation of prints that originated in the ruins of an editorial project.

To consolidate these customized copies, a new titlepage was required. It is likely that the original Guarani edition of *De la Diferencia* had a frontispiece and an initial print customized after Bouttats. However, these plates may have been lost after being used to print individual sheets, or even destroyed due to the challenging humidity of the Rio de la Plata basin. In this scenario, the same artists involved in printing the *Manuale ad usum* (1721) were probably commissioned to create a new titlepage. As the stock of Genoese paper had run out, the titlepage was printed on English paper, with the same fleuron that was used for the frontispiece of the *Manuale*.

Such were the vicissitudes and idiosyncrasies of this editorial project that the Guarani *De la Diferencia* should be culturally regarded not as a single book, but as a book with two *anguéra*: the extant customized copies; the incomplete book that was actually published around 1705; and the shreds of editorial projects that never came to light, including José Serrano's original project for the Guarani *De la Diferencia*, complete with all its image customizations, and a hypothetical edition of Pinamonti's *Inferno aperto*.

5 Afterword

Books such as Nieremberg's *De la Diferencia*, Ribadeneyra's *Flos sanctorum*, Vasquez's translation of the *Martirologio Romano*, and Pinamonti's *Inferno aperto* are all deeply connected by a transversal thematic line: the suffering and vanity of the temporal life, in relation to the eternal rewards or punishments of the afterlife. Together they fulfill the Jesuit priests' continuous need of *paradeigmata* for their sermons, and on the other hand, these books were accessible enough to be read directly by the Guarani in the *reducciones*.

At the same time, the process of normalizing the Guarani language in order to consolidate a missionary dialect required the production and circulation of books that were more narrative than catechisms, and the Guarani press was fitted to this purpose. Generally speaking, at least four major forces are at play in this context: first, the early grammatization the Guarani language undertaken by Antonio Ruiz de Montoya. Second, the subsequent revisions and updates of early grammatical works.[107] Third, the publication of books in Guarani under the auspices of José Serrano and then Paolo Restivo, such as *De la Diferencia*

107 Such as the manuscript *Phrases Selectas* from 1687 (of which two copies are known, one in the Museo Mitre in Buenos Aires, ms. 14/4/41; and the other at the Museo Colonial y

and the *Flos sanctorum*. And fourth, the production of religious works that flourished in Guarani and paved the way for the production of works authored by the Guarani themselves, in particular by the *Cacique* Nicolás Yapuguay.[108]

It is in this wider socio-historical context that Nieremberg's *De la Diferencia* was recreated rather than simply translated. The constant use of *ekphrasis* and *exempla* in the original provided a fertile ground for Guarani autonomous artistry. José Serrano certainly saw an opportunity to showcase a Guarani edition of *De la Diferencia* as a piece of propaganda, not only to present the Paraguayan missions as a model for the rest of the Society of Jesus but also as a model for the Catholic Church.[109] The Guarani *De la Diferencia*, a book 'created after models', would then itself be promoted as a model.

Since the early sixteenth century, paintings after printed models had been used in the Americas as a catechetical tool by the Franciscans, whose efforts resulted from a combination of intuition and necessity. With the arrival of the Jesuits, however, this practice was transformed in what I call a phenomenon of 'mass remediation': images from Jesuit illustrated and emblematic books were systematically painted on canvas, in fresco, and on festival decorations, and these media created a consistent – and coherent – visual language, with carefully crafted iconographic motifs that had a common purpose: to convert,

Histórico de Luján, ms. 091=873.241 CDJ), and Paolo Restivo 'actualizations' of Montoya's works, already discussed in this essay.

108 The 1710s saw the emergence of many religious manuscripts written in Guarani, such as the already mentioned *Edvcacion Christiana* (John Carter Brown Library, Codex Ind 45, 1713), and *Quatia ymomocoînda tecobe pahabarehe poromboéha. Cunumbuçu reta upe yquabeêmbĭ Angaipa hegui* ñepĭçĭrõ *hâguâ* (Archivo General de la Nación, Buenos Aires, Colección Biblioteca Nacional, 91. 1715). Nicolás Yapuguay was allowed to published his works under his own name, but many other Indigenous writers were also known: 'the Jesuit Josep Peramás mentions an Indian called Vázquez, from Loreto, the author of notable sermons. In the *reducción* of Corpus Christi there was also an Indian, called Melchor, who wrote a work of an historical nature, and in San Francisco Javier another one composed a *Historia* of that village' (Wilde G., "Adaptaciones y apropiaciones en una cultura textual de frontera: Impresos misionales del Paraguay jesuítico," *História Unisinos* 18.2 [2014] 297). On the Guarani appropriation of writing culture, see Eduardo Neumann's pioneering *Letra de Indios: cultura escrita, comunicação e memória indígena nas Reduções do Paraguai* (São Bernardo do Campo: 2015).

109 The Paraguayan Jesuits sent a missal, produced by Guarani artists to the Pope; it was received with great admiration by the Vatican. See Sepp A., *Jardín de flores paracuario*, ed. W. Hoffmann (Buenos Aires: 1974) III 180–181: 'Les parece una bagatela imitar una impresión de Colonia, Amberes o Amsterdam con la pluma. Hace pocos años que se obsequió a Su Santidad el Papa con un misal entero, escrito por un indio, que causó sorpresa en el vaticano'.

to teach, to build a common imaginary.[110] These European books 'irradiated' the Americas with the Jesuit imagery.

The advent of the Guarani *De la Diferencia* subverts this cultural pattern as this book itself became a source of irradiation: its images were reused in the material culture of the Guarani; the book was read by the Guarani in the missions, without mediators; its plates (initials and vignettes) were used in new publications from the Guarani press, and to create new artworks; and so on. By disrupting the colonial cultural flux (Europe > America), this book could well be regarded as the pinnacle of Jesuit culture in the Americas. But this achievement did not rely exclusively on Jesuit initiative: it owes deeply to the agency and social practices of the Guarani and their Indigenous, neophyte press.

As for the content of *De la Diferencia*, it can be said that what it came to mean to the Guarani exceeded what the original text expressed. In his book, Nieremberg addresses the despair of the temporal life, a topic to which the Guarani could certainly relate as they lived between the sword of Portuguese slave-capturers and the cross of acculturation in the *reducciones*. Throughout the book there are innumerable references to profound sadness and despair, for instance, the episode in the life of Ezra:

> When the Jews left their captivity in Babylon, Saint Ezra learned of the great sins that they had committed by communicating with the Gentiles. Such was the emotion that gripped [Ezra] that he ripped off his clothes, he pulled out his beard, and tore out his hair. He remained in great affliction and sadness, without eating or drinking, praying to the Lord and weeping for the sins of the people.[111]

The solution proposed in the text for this feeling of *ñemyrõ* – an experience of unsettling, similar to that evoked in the passage by Hernán Arias de Saavedra, cited at the start of this essay – is not *jejuvy*[112] but penitence, permeated by the hope for salvation at the Final Judgment. Even the terrifying *anguéra* are treated in an unexpected way: Nieremberg's original frequently uses 'shadow'

110 See Leal, "Os Hieróglifos do Novo Mundo", and Leal, "To the New World, on the Ship of Theseus".

111 'Aviendo salido los Judios del cautiverio de Babilonia, supo el Santo Esdras grandes pecados, que avian cometido por la comunicacion con los Gentiles. Con el sentimiento que desto tuvo, rasgose las vestiduras, arrancavase la barba, y mesavase los cabellos, perseverando con gran affliccion, y tristeza, sin comer, ni beber, rogando al Señor, y llorando por los pecados del pueblo' (Nieremberg, *De la Diferencia*, 1684, 597).

112 Death and suicide by hanging is another frequent topic in *De la Diferencia*, appearing at least eleven times, and it also informs the plates.

NIEREMBERG'S *DE LA DIFERENCIA* IN GUARANI 763

as a metaphor on at least 30 occasions, and in fact has many chapters dedicated to this subject. In one of these passages, he states:

> It is so true that the shadow is an image, that it shows everything in reverse: whoever stands between a statue and its shadow will see that whatever is in the right hand of the statue will be represented by the shadow in the left hand; whatever is in the left hand of the statue will be represented [by the shadow] in the right hand. In the same way, time is an image of eternity, and shows its properties in reverse.[113]

One can only strive to grasp how Guarani speakers in the *reducciones* interpreted the text and its images: the temporal (*ára*) is a 'shadow' (i.e., *ãng*) of the eternal, with its inverted qualities. In the same way, *ãng* is the shadow of a human, and becomes *angué* when there is rupture in the existential nexus between shadow and human, because of *jejuvy*. In Guarani, this uncanny passage synthesizes a latent theory of images that finds harmony in the Indigenous cosmovision: as already discussed here, *rããngába* is a kind of *ãng*, and shares its qualities. The evidence is that just like a shadow (*ãng*), *rããngába* is the reverse image of a sculpture (i.e., of the carved plate, 'sculpted' by the engraver). Consequently, *rããngába* must be a faithful recreation of it, to avoid disrupting the mystical connection between an image and what it makes visible.

The Guarani text *De la Diferencia* was customized for both local and global purposes. Locally, it directly addressed the concept of *jejuvy* (the violent end of temporal life) and modeled a syncretic belief system, in which the *anguéra* were Christianized into devils, without losing their indigenous qualities. Globally, *aiquatiá hâãngába* was used as a rhetorical and propagandistic tool that established a short-lived new institution amongst the Guarani capable of transmitting, producing, and irradiating their own images, and in consequence disruptive of relations of colonial power on the cultural stage.

Ara teco apĭreĩ ãng, haè haãngabamo heconi.[114]

113 'Assi como la sombra de tal suerte es imagen, que tiene todas las cosas al revès: porque quien se pusiere entre la estatua, y su sombra echarà de ver, que lo que està à mano derecha de la estatua, lo representa la sombra à la izquierda; y lo que està à mano izquierda, lo tiene ella à mano derecha. Assi el tiempo de tal manera es imagen de la eternidad, que tiene todas sus propiedades al revès' (Nieremberg, *De la Diferencia*, 1684, 110).

114 'Time is an image, or shadow of eternity' (Nieremberg, *De la Diferencia*, 1705, 1.65).

Bibliography

Aguado Francisco, *Sumo Sacramento de la fe* (Madrid, Franco Martinez: 1640).

Alciato Andrea, *Emblematum liber* (Augsburg, Heinrich Steyner: 1531).

Alciato Andrea, *Emblematum libri duo* (Lyon, Jean de Tournes and Guillaume Gazeau: 1547).

Alciato Andrea, *The Variorum Edition of Alciato's Emblemata*, ed. M. Tung – P.G. Leal (Glasgow: 2015).

Arias de Saavedra Hernán, *Ordenanzas para el buen gobierno del Río de la Plata hecho por Hernán Arias de Saavedra, Gobernador de dicha provincia, insertandose en elllos la doctrina y buen tratamiento que se ha de dar á los indios, Fecho en la ciudad de la Asunción del Paraguay, 29 de noviembre de 1603* (Archivo General de Indias, 74-4-12).

Bailey G.A., *Art on the Jesuit missions in Asia and Latin America, 1542–1773* (Toronto: 1999).

Balmaceda J.C., "El Origen de la Imprenta Argentina: introducción al estudio del 'incunable' Guarani impreso en Loreto" in *Isabel I y la Imprenta: consecuencias materiales, en el mundo cultural, de esta revolución tecnológica* (Madrid: 2004) 1–29.

Barzana Alonso de, in Society of Jesus, *Monumenta Peruana* V, Archivum Romanum Societatis Iesu (Rome: 1970) 589–590.

Boidin C. – Cerno L. – Vega F.R., "'This Book Is Your Book': Jesuit Editorial Policy and Individual Indigenous Reading in Eighteenth-Century Paraguay", *Ethnohistory* 67.2 (2020) 247–267.

Bourgogne Antoine de, *Lingua Vitia et Remedia* (Antwerp, Jan Cnobbaert: 1631).

Brignon T., "De la Différence entre l'Âne et le Jaguar: la traduction en guarani d'un traité ascétique illustré, entre adaptation linguistique et visuelle (missions jésuites du Paraguay – 1705)", *Textimage: revue d'étude du dialogue texte-image* (2018) 1–6.

Brignon T., "Du copiste invisible à l'auteur de premier ordre. La traduction collaborative de textes religieux en guarani dans les réductions jésuites du Paraguay", *Sociocriticism* 33 (2018) 299–338.

Candela G., *Entre la pluma y la cruz el clérigo Martín González y la desconocida historia de su defensa de los indios del Paraguay: documentos inéditos (1543–1575)* (Asuncion, 2018).

Cardiel José, *Breve relación de las misiones del Paraguay* (1777) (Buenos Aires: 1996).

Cerbín Bernardino de, *Aprovacion del D.or D. Ioseph Bernardino Cerbin [...]* (1700 Archivum Romanum Societatis Iesu, VL Paraquaria 01.1).

Chamorro G., *Kurusu ñe'engatu: Palabras que la historia no podría olvidar* (Asuncion: 1995).

Chamorro G., *Teología Guaraní* (Quito: 2004).

Coloma C. – Hoffman J.S. – Crosby A., "Suicide among Guaraní Kaiowá and Nandeva youth in Mato Grosso do Sul, Brazil", *Archives of Suicide Research* 10.2 (2006) 191–207.

Daly P.M. – Dimler G.R., *The Jesuit Emblem in European Context* (Philadelphia: 2016).

Daly P.M. – Dimler G.R., *Corpus Librorum Emblematum: The Jesuit Series*, 5 vols (Montreal: 1997–2007).

David Jan, *Duodecim Specula* (Antwerp, Officina Plantiniana: 1610).

David Jan, *Occasio Arrepta Neglecta Huius Commoda Illius incommoda* (Antwerp, Officina Plantiniana: 1605).

David Jan, *Typus Occasionis* (Antwerp, Theodor Galle: 1603).

David Jan, *Veridicus Christianus* (Antwerp, Officina Plantiniana: 1601).

De Boer, W. – Enenkel K.A.E. – Melion W. (eds.), *Jesuit Image Theory* (Leiden: 2016).

De Bry Theodor, *Americae Tertia Pars* (Frankfurt, Theodor de Bry: 1592).

Dean C. – Leibsohn, D., "Hybridity and Its Discontents: Considering Visual Culture in Colonial Spanish America", *Colonial Latin American Review* 12 (2003) 5–35.

Drexel Jeremias, *De aeternitate considerationes* (Monaco, Raphael Sadeler: 1631).

Drexel Jeremias, *Infernus, damnatorum carcer et rogus* (Amsterdam, Bernard Gualteri: 1632).

Drexel Jeremias, *Infernus, damnatorum carcer et rogus* (Monaco, Cornelius Leysser: 1631).

Edvcacion Christiana: y buena criança de los niños guaranis: provechosa para todos estados: Qve contiene varios exercicios de devocion provechosos para alcançar perceverancia final y vna buena muerte. ([Loreto:] 1713) (John Carter Brown Library, Codex Ind 45).

Estigarribia B., *A Grammar of Paraguayan Guarani* (London: 2020).

Eytzinger Michael, *De Leone Belgico* (Cologne, Gerardus Campensis: 1583).

Fabrici S., "Un antiguo libro en Guaraní: De la diferencia entre lo temporal y eterno de Juan Eusebio Nieremberg (impreso en las doctrinas, 1705):, *Incipit* 3 (1983) 173–183.

Farrell A., "The Jesuit Ratio Studiorum of 1599", in *Conference of Major Superiors of Jesuits 133* (Washington: 1970).

Fausto C., "Se Deus fosse Jaguar: canibalismo e cristianismo entre os Guarani (séculos XVI–XX), *Mana* 11.2 (2005) 385–418.

Furlong G., *José Manuel Peramás y su Diario del destierro, 1768* (Buenos Aires: 1952).

Furlong G., *Misiones y sus pueblos de guaraníes* (Buenos Aires: 1962).

Furlong G., *Orígenes del Arte Tipográfico en América. Especialmente en la República Argentina* (Buenos Aires: 1947).

Garriga Antonio, *Instruccion practica para ordenar santamente la vidà; que ofrece el P. Antonio Garriga de la Compania de Iesus. Como brebe memorial, y recuerdo à los que hazen los exercicios espirituales de S. Ignacio de Loyola fundador de la misma Compañia* (Loreto, 1713).

Gil F.M., "El ciclo del Añaretâ (infierno) en los grabados del De la diferencia entre lo temporal y lo eterno de Nieremberg, traducido al guaraní e impreso en las reducciones del Paraguay (1705)", *IHS. Antiguos Jesuitas en Iberoamérica* 7.1 (2019) 4–26.

Gil F.M., "De la diferencia entre lo temporal y eterno. Crisol de desengaños con la memoria de la eternidad, postrimerías humanas y principales misterios divinos, de Juan Eusebio Nieremberg s.j. Introducción" in Nieremberg, Juan Eusebio, *De la diferencia entre lo temporal y eterno, primera edición facsimilar en conmemoración al Bicentenario de la Revolución de Mayo* (Buenos Aires: 2010).

Girard Antoine, *Les peintures sacrées sur la Bible* (Paris, Antoine Sommaville: 1653).

González R., "Textos e imágenes para la salvación: La edición misionera de la diferencia entre lo temporal y eterno", *Artcultura*, 11(18) (2009) 137–158.

Hendrickson S., "Early Guaraní Printing: Nieremberg's *De la diferencia* and the Global Dissemination of Seventeenth-Century Spanish Asceticism", *Journal of Jesuit Studies*, volume 5, issue 4 (2018) 589–609.

Hendrickson S., *Jesuit Polymath of Madrid: The Literary Enterprise of Juan Eusebio Nieremberg (1595–1658)* (Leiden: 2015).

Insolera L.S., "Le illustrazioni per gli Esercizi Spirituali intorno al 1600", *Archivum Historicum Societatis Iesu* 60 (1991) 161–217.

Iparraguirre I., "Un escritor ascético olvidado: El Padre Juan Eusebio Nieremberg (1595–1658)," *Estudios eclesiásticos* 32 (1958) 427–48.

Izquierdo Sebastián, *Praxis exercitiorum spiritualium* (Roma, Lazzari Varese: 1678).

Jackson R.H., "Una mirada a los patrones demográficos de las misiones jesuitas de Paraguay" *Fronteras de la Historia* 9 (2004) 129–178.

Jacob Masen, *Dux viae ad vitam puram, piam, perfectam* (Trier, Christoph Wilhelm Reulandt: 1667).

Kempis Thomas à, *Los IV. libros de la Imitacion de Christo, y menosprecio del mundo: compuestos en latin por el venerable Tomas de Kempis, canonigo reglar de san Agustin, y traduzidos nuevamente en español por el P. Juan Eusebio Nieremberg, de la compañia de Jesus* (Antwerp, Officina Plantiniana: 1656).

Krüger R., "La imprenta misionera jesuítico-guaraní y el primer libro rioplatense, Martirologio Romano, de 1700", *Cuadernos de Teología* 29 (2010) 1–26.

Leal P.G., "Os Hieróglifos do Novo Mundo: das escritas indígenas à chegada dos *jeroglíficos* hispânicos" in Leal P.G. – García Arranz J.J. (eds.), *Jeroglíficos en la Edad Moderna* (A Coruña: 2020) 257–330.

Leal P.G., "To the New World, on the Ship of Theseus: An Introductory Essay to Emblems in Colonial Ibero-America" in Leal P.G. with Amaral Jr. R. (eds.), *Emblems in Colonial Ibero-America* (Glasgow, 2017) 1–54.

Leal P.G., with Amaral, Jr. R. (eds.), *Emblems in Colonial Ibero-America* (Glasgow: 2017).

Ledezma D., "Una legitimación imaginativa del Nuevo Mundo: la 'Historia naturae, maxime peregrinae' del jesuita Juan Eusebio Nieremberg", in Ledezma D. – Millones Figueroa L. (eds.) *El saber de los jesuitas, historias naturales y el nuevo mundo* (Madrid: 2005) 53–84.

Leonardt C., *Cartas anuas de la provincia del Paraguay, Chile y Tucumán, de la compañía de Jesús (1615–1637)* (Buenos Aires: 1929).

López S.S., "Lectura iconográfica de la versión guaraní del libro del padre Nieremberg, De la diferencia entre lo temporal y eterno", *Boletín del Museo e Instituto Camón Aznar*, 48, (1992) 309–328.

Loyola Ignatius of, *Esercitii Spirituali* (Rome, heirs of Manelfo Manelfi: 1649).

Loyola Ignatius of, *Exercitia Spiritualia* (Rome, Antonio Bladio: 1548).

Maeder E.J.A., "El Martirologio Romano. Hallazgo del primer libro impreso en el Río de la Plata. Idéa Viva", *Gaceta de Cultura* 9 (2001) 17–18; 46–47.

Maeder E.J.A. (ed), "Cartas Anuas de la Província Jesuítica del Paraguay (1641 a 1643)", *Resistencia* 11 (1996) 1–170.

Manuale ad usum Patrum Societatis Iesu qui in Reductionibus Paraquariae versantur ex Rituali Romano ac Toletano decerptum (Loreto, Society of Jesus: 1721).

Melià B., *La lengua Guaraní en el Paraguay Colonial* (Asuncion: 2002).

Melià B., "La lengua transformada: el guaraní en las Misiones Jesuíticas" in Wilde B. (ed.). *Saberes de la conversión. Jesuitas, indígenas e imperios coloniales en las fronteras de la cristiandad* (Buenos Aires: 2011) 81–98.

Melià B., *La création d'un langage chrétien dans les reductions des Guarani au Paraguay* (Ph.D. dissertation, Université de Strasbourg: 1969).

Melion W., *The Meditative Art: Studies in the Northern Devotional Print*, 1550–1625 (Philadelphia: 2010).

Moncada Baltasar de, *Descripcion de la casa fabricada en Lima, Corte del Perù, para que las señoras ilustres de ella, y las demàs mugeres devotas, y las que desean servir à Dios Nuestro Señor, puedan tener en total retiro, y con toda abstraccion, y direccion necessaria los exercicios de San Ignacio de Loyola* (Seville, Joseph Padrino: 1757).

Montoya Antonio Ruiz de, *Arte, y Bocobulario de la lengua Guarani* (Madrid, Juan Sanchez: 1640).

Montoya Antonio Ruiz de, *Tesoro de la lengua Guarani* (Madrid, Juan Sanchez: 1639).

Montoya Antonio Ruiz de, *Catecismo de la lengua Guarani* (Madrid, Diego Diaz de la Carrera: 1640).

Montoya Antonio Ruiz de, *Vocabulario de la lengua Guarani* (Santa Maria la Mayor [s.n.]: 1722).

Nadal Jerome, *Evangelicae historiae imagines* (Antwerp, Martin Nutius: 1593).

Neumann E., *Letra de Indios: cultura escrita, comunicação e memória indígena nas Reduções do Paraguai* (São Bernardo do Campo: 2015).

Nieremberg Juan Eusebio, *De la Diferencia entre lo Temporal y Eterno / crisol de desengaños; com la me- / moria de la eternidade, postrimerias hu- / manas, y principales mistérios divinos / por el / P. Iuan Eusebio Nieremberg / de la Compañia de / Iesus / y traducidos em lengua Guarani / por el padre / Joseph Serrano / de la misma companhia / dedicado a la magestadad del / Espiritu Santo / com Licencia del Exelentissimo / señor / D. Melchor Lasso de la Ve- / ga Porto Carrero / Virrey, Governador, y Capitan general de Peru* (Loreto, Juan Bautista Neumann et alii: 1705).

Nieremberg Juan Eusebio, *De la Diferencia entre lo temporal y lo eterno. Crisol de desengaños, con la memoria de la eternidad, postrimerias humanas, y principales misterios diuinos* (Madrid, Francisco de Robles – Juan Antonio Bonet, 1640).

Nieremberg Juan Eusebio, *De la Diferencia entre lo temporal y lo eterno. Crisol de desengaños, con la memoria de la eternidad, postrimerias humanas, y principales misterios diuinos* (Antwerp, Hieronymus Verdussen, 1684).

Obermeier F., "Der argentinische Erstdruck Nierembergs *De la diferencia* in Guarani im Kontext der Bilderzyklen in Lateinamerika im 18. Jahrhundert", ART-Dok (2006) 1–66.

Ojeda A., "El Grabado Como Fuente del Arte Colonial: Estado de la Cuestión" in Ojeda A. et alii (ed.), *Project on the Engraved Sources of Spanish Colonial Art* (2005–2022). Available at: https://colonialart.org/essays/el-grabado-como-fuente-del-arte-colon.

Ojeda A. et alii, *Project for the Engraved Sources of Spanish Colonial Art* (2005–2022), https://colonialart.org.

Portocarrero y Laso de la Veja Melchor Antonio, *Licencia acordada por el Virrey del Peru de Imprimir libros en lengua guarani, en las misiones del Tucumán. 1703* (Biblioteca Nacional [Brazil], Manuscritos 508 (22) Ânnuas, Doc. n.º 530).

Pinamonti Giovanni Pietro, *L'Inferno aperto al cristiano perche non v'entri* (Bologna, heirs of Antonio Pisarri: 1689).

Plá J., *El Barroco Hispano Guarani* (Asuncion: 1975).

Plett H.F., *Enargeia in Classical Antiquity and the Early Modern Age* (Leiden: 2012).

Quatia ymomocoînda tecobe pahabarehe poromboéha. Cunumbuçu reta upe yquabeêmbĭ Angaipa hegui ñepĭçĭrô *hâguâ* (Archivo General de la Nación, Buenos Aires, Colección Biblioteca Nacional, 91. 1715).

Ribadeneyra Pedro de, *Flos sanctorum* (Madrid, Luis Sanchez: 1599).

Ribera A.L., "El grabado en las misiones guaraníticas" in Academia Nacional de Bellas Artes (ed.), *Historia General del Arte en la Argentina* (Buenos Aires: 1983) II 95–106.

Richeome Louis, *La Peinture Spirituelle* (Lyon, Pierre Rigaud: 1611).

Ripa Cesare, *Iconologia* (Rome, heirs of Giovanni Gigliotti: 1593).

Rodriguez Y., "Spanish-Guarani Diglossia in Dolonial Paraguay: A Language Undertaking", in Weber B. (ed.), *The Linguistic Heritage of Colonial Practice* (Berlin: 2019) 153–168.

Sandoval Prudencio de, *Historia de los Hechos del Emperador Carlos V* (Antwerp: Hieronymus Verdussen, 1681).

Schmidel Ulrich, *Vierte Schiffart. Warhafftige Historien einer wunderbaren Schiffart, welche Ulrich Schmidel von Straubing, von Anno 1534. biss Anno 1554 in Americam oder Newenwelt, bey Brasilia und Rio della Plata gethan* (Nuremberg, Levinus Hulsius: 1599, after p. 17).

Izquierdo Sebastián, *Praxis exercitiorum spiritualium* (Roma, Varese: 1678).

Sepp Antonio, *Continuatio laborum apostolicorum* (Ingolstadt, Johann Andreas de la Haye: 1709).

Sepp Antonio, *Continuation oder Fortsetzung der Beschreibung der Denckwürdigeren Paraquarischen Sachen* (Ingolstadt, Johann Andreas de la Haye: 1710).

Sepp A., *Jardín de flores paracuario*, ed. W. Hoffmann (Buenos Aires: 1974).

Sepp A., *Relación de un viaje a las Misiones Jesuíticas* (1696) (Buenos Aires: 1971).

Society of Jesus, *Ratio atque Institutio Studiorum Societatis Iesu* (Naples, Tarquinio Longo, 1598, issued in 1599).

Staliano P. – Mondardo M.L. – Lopes R.C., "Where and How the Guarani and Kaiowá Commit Suicide in Mato Grosso do Sul: Confinement, Jejuvy and Tekoha". *Psicologia: Ciência e Profissão* 39 (2019).

Sucquet Antoine, *Via vitae aeternae* (Antwerp, Martin Nutius, 1620).

Survival International, "Guarani suicides – how mankind's divorce from nature impacts on the psyche", *Survival International* (2018).

Techo Nicolás del, *Historia Provinciae Paraquariae Societatis Iesu* (Biblioteca Nacional de España, ms. 5931, after 1650).

Thun H., "La hispanización del guaraní jesuítico en 'lo espiritual' y en 'lo temporal'. Primera parte: El debate metalingüístico" in Stehl T. (ed.), *Kenntnis und Wandel der Sprachen. Beiträge zur Potsdamer Ehrenpromotion für Helmut Lüdtke* (Tubingen: 2008) 217–240.

Thun H., "La hispanización del guaraní jesuítico en 'lo espiritual' y en 'lo temporal'. Segunda parte: Los procedimientos" in Wolf D. – Symeonidis H. (eds.), *Geschichte und Aktualität der deutschprachigen Guaraní-Philologie* (Berlin: 2008) 141–169.

Trelles M.R., "Único ejemplar. Traducción al guaraní de una obra de Nieremberg", *Revista patriótica del pasado argentino*", 4 (1890) 16–38.

Trinkellius Zacharias Ignatius, *Divinatorium viae et vitae aeternae* (Vienna, Joannis Jacobi Kürner: 1663).

Trostiné R., "El arte del grabado en la Argentina durante el período hispánico", *Estudios* 81 (1949) 298–309; *Estudios* 82 (1949) 465–490.

Vaenius Otto, *Quinti Horatij Flacci emblemata* (Antwerp, Hieronymus Verdussen: 1607).

Vaenius Otto, *Quinti Horatij Flacci emblemata* (Antwerp, Phillipe Lisaert: 1612).

Vallée Jacques de la, *Histoire pleine de merveille sur la mort de tres devote dame, madame, Catherine de Harlay, dame de la Mailleraye* (Paris, Étienne Richer: 1616).

Vazquez Dionisio (trans.), *Martirologio Romano* (Mexico, Antonio Francisco de Zafra: 1678).

Vega F.R., "La dimensión bibliográfica de la reducción lingüística. La producción textual jesuítica en guaraní a través de los inventarios de bibliotecas", *Nuevo Mundo mundos nuevos; Nuevo mundo Mundos Nuevos* 12 (2018) 1–37.

Vega F.R. – Wilde G., "(Des)clasificando la cultura escrita guaraní. Un enigmático documento trilingüe de las misiones jesuíticas del Paraguay" *Archivos virtuales de la alteridad americana*, 9(1) (2019) 1–36.

Wilde G., "Adaptaciones y apropiaciones en una cultura textual de frontera: Impresos misionales del Paraguay jesuítico," *História Unisinos* 18.2 (2014): 270–286.

Xarque Francisco, *Insignes misioneros de la Compañia de Jesus en la Provincia del Paraguay. Estado presente de sus Missiones en Tucuman, Paraguay, y Rio de la Plata* (Pamplona, Juan Micon: 1687).

Yapuguay Nicolás, *Explicacion de el catechismo en lengua guarani* (Santa Maria Mayor: 1724).

Yapuguay Nicolás, *Sermones y exemplos en lengua guarani* (San Francisco Xavier: 1727).

Index Nominum

Acuña y de Herrera, Fernando de (Viceroy of Sicily) 305
Adria, Gian Giacomo 317
Adso of Montier-en-Der 85
Aesop 428
Aguado, Francisco s.j. 719
Albert of Austria (Archduke of the Spanish Netherlands) 362
Alciato, Andrea 28–29, 325, 337–338, 368, 492, 726, 730–731, 752, 757
Alcuin 103, 108
Alexander the Great 88*n*43, 392, 506
Alexander VI (Pope) 102
Altzenbach, Gerhard 446, 447*n*30
Ambrose, Aurelius of Milan 611, 670
Andrysowic, Łazarz 428*n*10, 429, 435, 437
Anglicus, Bartholomeus 151
Anonymous German poet 331, 334, 336, 340, 342, 345, 350–352, 355, 358, 360, 367–368
Anselm of Canterbury, Saint 212
Anshelm, Thomas 93, 99–104, 106, 113
Apelles 99*n*15, 105
Apian, Peter 144–145
Aretio, Claudio Mario 315*n*67, 323
Arias de Saavedra, Hernán (Governor of Rio de la Plata) 685–686, 762
Aristotle 102, 252–253, 457, 509
Arwaker, Edmund 499, 501*n*18, 502
Athanasius, Saint, Bishop of Alexandria 281, 472
Aubin, Penelope 495
Aubert, David 182
Augustijnken 200, 201
Augustine, Aurelius of Hippo 52, 603, 616, 661*n*66
Augustus (Roman Emperor) 572
Augustus of Saxony (Elector) 127
Aurelius Victor 298*m*18
Aytta, Hector van 26, 28

Bacon, Roger, o.f.m. 457
Baeck, Elias 390
Bagó, Marton 441
Baldwin I (King of Jerusalem) 590
Baptista, Juan 472*n*57

Barbara, Saint 212, 289*n*1, 618
Bartoli, Pietro Santi 372*n*1, 380–381
Barzana, Alonso de, s.j. 744
Basil of Caesarea 610-611
Beccadelli, Antonio 291, 300, 313, 315
Bede (Beda Venerabilis) 97, 106–107, 199, 201, 203
Bellaert, Jacob 549, 586–587, 590–591, 593–594, 595*n*100
Bellarmine, Robert, s.j. 611
Berengaudus 75
Bergonzi, Bernardino Francesco 412–413, 417, 419–420
Berguncius. See Bergonzi
Beringhen, Henricus de 231*m*10, 232, 233*n*15, 235, 244
Berthold of Nuremburg 107
Bettini, Mario, s.j. 472
Billaine, Pierre 460*n*22
Bitti, Democrito Bernardo 266–269, 272, 273*n*37
Blake, William 512
Blanchin, Jean 462
Bocchi, Achillis 403, 404*n*7, 406, 407*m*12, 410, 412–414, 415*n*22, 416–421
Bodenehr, Gabriel 389
Bolswert, Boetius à 34, 703, 734
Bordon, Benedetto 532
Bosse, Abraham 447
Bouillon, Godfrey of 551, 576, 579, 590–591, 593, 595*n*100
Bouts, Dirc 69
Bouttats, Gaspar 703, 711, 714, 717, 719, 732, 735, 740, 742, 752, 754–756, 758, 760
Bracomonte, Diego 266
Brant, Sebastian 100–102, 105–106, 113*n*52
Breu, Jörg 143–144
Blyenburch, Cornelis à 25, 28
Breydenbach, Bernard von 68, 151, 153, 159
Brilli, Pedro 258
Brizio, Francesco 381
Broeck, Chrispijn van den 349
Bry, Theodor de 734*n*63, 742, 765
Burgés, Francisco, s.j. 698*n*28
Burgkmair, Hans 277, 280–281, 282*n*48, 283
Burgundy, David of (bishop of Utrecht) 550

772 INDEX NOMINUM

Butler, James, 2nd Duke of Ormonde
495n15, 497–498, 502
Butler, Mary, Duchess of Ormonde 495n15,
502

Caccini, Giulio 477
Callot, Jacques 384–385, 390
Camerarius, Joachim 517
Canto, Francisco de 283n52
Carafa, Oliviero 302, 304
Cardiel, José, S.J. 689
Carey, William Paulet 512
Carracci, Agostino 23–24, 381
Carracci, Annibale 23–24
Cartari, Vincenzo 340n28, 344
Cary, Lucius, Viscount Falkland 502
Cary, Patrick 502
Castañeda, Francisco de, S.J. 697
Catherine of Alexandria, Saint 208, 212, 303
Catullus 306–307
Caus, Salomon de 455
Caxton, William 69
Celtes, Conrad 485
Celtis, Conrad 118
Celtis, Konrad 530
Cerbin, José Bernardino (commissar of the
Holy Office, Governor of the Paraguayan
Bishopric) 698, 749
Cessolis, Jacobus de 559, 586
Chantrey, Francis 512
Charles v (Holy Roman Emperor) 740
Charles v of France (King) 125n67
Christian II (Elector Duke) 128
Christina (Queen of Sweden) 124
Christopher, Saint 4, 206
Ciamberlano, Luca 381
Cicero, Marcus Tullius 181, 181n32, 301, 305,
312, 690, 703n35
Cigoli (Ludovico Cardi) 467
Claudianus, Claudius 356
Cocles. See Rocca, Barolommeo della; Cocles,
Barptolomaeus; Cocles, Bartholomeus
Collett, John 30, 34
Colocasio, Vincenzo 296n15
Constantine (Roman Emperor) 104–105,
295, 358
Cordova, Juan de 262, 265n27

Costerus, Franciscus, S.J. 541, 600, 603, 606,
607n5, 609–613, 615–616, 618n20, 619,
621, 623, 625, 627, 629, 632, 636, 638,
640–641, 649–650, 652–653, 655–656,
659–661, 663–664, 666–667, 671–672,
675–678, 680
Cromberger, Juan 249–250, 258n13
Crozat, Pierre 375
Cruz, Juan de la 250, 264
Cyril of Alexandria 653n57, 661

d'Este, Alessandro (Cardinal) 128, 421, 480
d'Este, Isabella 125n68
Damocles 703
Daret, Pierre 494–495, 520
David, Johannes (Jan) S.J. 15, 17–20, 753n96
de Beer, Maria Eugenia 719
de' Medici, Cosimo (the Elder) 125
de' Medici, Lorenzo 125
de' Medici, Piero 125
Dente da Ravenna, Marco 346
Desargues, Girard 455
Descartes, René 458–459, 463, 473
Diomedes 97
Dirc II (Count of Holland) 558, 573
Dirc III (Count of Holland) 565
Dominis, Marco Antonio de (Archbishop)
460
Donatus 97, 611
Donne, John 541–542
Drexel, Jeremias, S.J. 703–704
Duodo, Piero (Venetian ambassador) 128
Dürer, Albrecht 118, 380, 525–526, 541

Eberhard of Friuli (Margrave) 109n47
Eckhart, Meister 197, 201
Eenden, Maarten van den 603
Elector of Saxony 118, 482
El Greco (Theotokópoulos, Doménicos)
24, 25
Emmerick, Jan van 6
Empedocles 309
Erasmus 29, 98, 250, 457
Erasmus, Desiderius 250
Ernest (Archduke of Austria) 122
Espinosa, Antonio 254, 258–259, 262
Euclid 457

INDEX NOMINUM

Euripides 509
Eytzinger, Michael 735*n*66

Fabius Maximus Verrucosus, Quintus 347
Fanti, Sigismondo 427
Ferdinand III (Roman Emperor) 362
Feria, Pedro de 250
Fernández de Santaella, Rodrigo 293, 309
Ferrante, Carlo 384
Ferrar, Nicholas 30, 34
Ferronius, Johannes Baptista 472*n*57
Feyerabend, Sigmund 25, 28, 29*n*45, 37, 39,
 337–338, 368
Figueroa, María de 258
Filarete (Antonio di Pietro Averlino) 125–126
Floris II (Count of Holland) 566
Floris IV (Count of Holland) 582
Fontana, Carlo 388, 460
Fontana, Francesco 460
Ford, James 512
Franklin, Benjamin 513, 517
Frankopan, Petar Krst 443
Fröschl, Daniel 128

Gainsborough, Thomas 512
Galen 457
Galilei, Galileo 460
Galle, Cornelis II 20, 603
Galle, Philip 346
Gallinarius, Johannes 100, 102–103
Gallus, Jodocus (Jost Hahn) 100, 102
Gazeau, Guillaume 726*n*47, 764
George, Saint 205–206, 208
Gerardus de Lisa 292, 300*n*19, 324
Gerson, Jean 200, 218
Gesner, Conrad 342
Ghent, Henry of 7, 191, 197, 229*n*8, 239, 247
Ghirlandaio, Domenico 24, 506
Gibbs, Thomas Mannington 494–495, 502,
 506
Giraldi, Lilio Gregorio 344
Girard, Antoine, s.j. 703, 742
Girbert, Johannes 485
Gilberti, Maturino 253
Goltzius, Hendrik 350
González, Tirso, s.j. (Superior General of the
 Society of Jesus) 696–698, 706, 748–749,
 758

Graisberry, Daniel 503*n*28, 504, 517
Grandi, Alessandro 480
Grattan, Colley 505, 512, 517
Grattan, Elizabeth 420, 503*n*28, 504–506,
 512–513, 517
Grattan, Henry 505
Grattan, Thomas Colley 505, 517
Gregory I, Pope 266*n*28
Gregory IV (Pope) 108*n*47
Gregory the Great 108
Gresemundus, Theodore Dietrich (the
 Younger) 100, 102
Grignani, Ludovici 467*n*39
Grimm, Heinrich 102*n*27, 145*n*16, 485–486
Grosseteste, Robert O.F.M. 457
Guaman Poma de Ayala, Felipe 264*n*24, 270
Gutgesell, David 437
Gutiérrez, Jeronimo 258

Habsburg (Family) 28*n*44, 129, 361, 369,
 436, 443
Halbmayer, Simon 481, 490
Hastings, Elizabeth, Countess of Moira
 512–513
Haytham, Ibn al 457
Held, Jeremias 337, 340, 703
Heltai, Gáspár 437–438
Henoch, Paulo 392–393
Henriet, Israël 384
Henry of Louvain. *See* Heinric vander Calsteren
Herbert, James Dowling 512
Hicro (Tyrant of Syracuse) 301
Hogenberg, Frans 735*n*66
Horace (Quintus Horatius Flaccus) 301*n*24,
 305, 326, 327*n*5, 329, 331, 337–338,
 340, 341*n*32, 346*n*40, 349, 354, 358*n*58,
 359*n*62, 362–363, 365–366, 485, 493,
 503, 505, 509
Hrotsvitha of Gandersheim 118, 121
Hugo, Herman, s.j. 501
Huybrechts, Gaspar (Gaspar Huberti) 603,
 605*n*3, 641, 643, 653, 663, 666–667, 675

Ignatius of Loyola, s.j. (Íñigo López de Oñaz
 y Loyola) 613, 654, 702, 732*n*57
Ignatius of Loyola, Saint 613
Isidore of Seville 97
Izquierdo, Sebastián, s.j. 732*n*57

774 INDEX NOMINUM

Jacobus of Oesterhoren (bishop of
 Utrecht) 570*n*49, 585
James II of Great Britain 497
Jansen, Cornelius 611
Jean de Berry (Duke of Berry and
 Auvergne) 178
Jerome (Saint) 10, 312
Jerome, Eusebius Sophronius 611
John Damascene, Saint 703

Kattendijke, Johan Huyssen of 548
Kauffmann, Angelica 512
Keats, John 542
Keinbös, Nikolaus 99, 101*n*20, 102, 105–106
Kempen, Thomas von 43, 50, 59
Kempis, Thomas à 702
Kepler, Johannes 458–460, 465, 471, 473
Kilian, Georg Christoph 387*n*63, 400
Kircher, Athanasius, s.J. 472
Klöss, Jakob 437
Klöss, Jakob (Junior) 438–439
Kolb, Johann Christoph 389–390

Lafreri, Antonio 382
Lalaing, Yolande of 588
Lampsonius, Domenicus 367
Langlois, François 465*n*31, 469*n*45, 470*n*49
Lascaris, Constantine 295
Lasne, Michel 453
Le Fevre, Jehan 325
Le Roy, Marin 494
le Voleur, Colart 174, 176
Leeu, Gerard 549, 551, 559*n*30, 579, 581*n*65,
 586, 592–593, 599
Lefèvre, Raoul 549, 590–591
Lentulus 277, 279–280
León, Simon de, s.J. (Provincial of the
 Paraguayan province) 697
Leopold Wilhelm (Archduke of
 Austria) 372
Leopold, Joseph Friedrich 389
Ligozzi, Jacopo 392
Limbourg brothers 178
Livy (Livius, Titus) 26, 28
Locher, Jakob 485
Lopes Davalos, Diego 254
Loredan, Andrea di Bernardino 292, 298
Loredan, Andrea di Francesco 292, 298
Loredan, Andrea di Nicolo 292, 298

Louis II (Emperor of the Romans) 551–552
Louis II (king of Hungary) 436
Louis the Pious (Emperor) 106
Louis XIII (King of France) 460
Lowne, Matthew 382, 412
Ludolphus de Saxonia 551*n*14, 559*n*30, 654,
 681
Ludovicus, Laurentius 419–420
Ludovicus, Valentin 404, 406, 407*n*12, 408,
 410, 413–414, 416–417, 419–421
Ludwig, Roman 417–421
Luther, Martin 100, 481
Lyra, Nicholas of 195

Machteld of Brabant 582
Maecenas 365–366
Maerlant, Jacob van 197–198
Magd[alena], sister 231
Magnus, Albertus 197, 229*n*6
Maignan, Emmanuel O.M. 454–455
Maldonatus, Joannes 611
Manlius, Arnold 28, 29
Manners, Charles, Duke of Rutland 513
Manners, Mary Isabella, Duchess of
 Rutland 513
Mannoet, Amant 200
Manutius, Aldus 8, 525
Marcolini, Francesco 427
Marcus Aurelius (Roman Emperor) 358
Margaret II of Hainault 565
Margaret of Holland (daughter of Floris IV)
 582
Mariette, Pierre 384
Martin of Tours, Saint 208
Masen, Jacob, s.J. 766
Master E.S. 562, 568
Master of Bellaert 590
Master of the Berlin Passion 562, 567
Master of the Dutuit Mount of Olives 563
Master of the Playing Cards 562–563
Matham, Jacob 350
Maurus, Hrabanus (Archbishop) 92, 96*n*5,
 98*n*12, 99*n*13, 104*n*33, 105*n*36, 106*n*40,
 132
Maximilian I of Bavaria (Duke) 128
Maximilian III (Archduke, Grand Master of
 the Teutonic Knights and Regent of the
 Tyrol) 128
Meer, Jacob Jacobszoon van der 559, 586

INDEX NOMINUM

Mehmed II (Ottoman Sultan) 291, 300
Melanchthon, Philipp 103n31
Melchor (Guarani writer) 698
Merian, Matthäus 740, 742
Mersenne, Marin O.M. 454, 455, 457, 464, 469–472
Mezzogori, Giovanni Nicolò 485
Mirabellius, Ioannes 343
Mitelli, Giuseppe Maria 389–390, 397
Mogrovejo, Toribio Alonso de 259
Molina, Alonso de 254, 262–264
Mongitore, Antonino 304n32, 317n80
Montano, Benito Arias 9
Montano, Giovanni Battista 384
Montecatini, Antonio (Ambassador from Ferrara) 125
Monteverdi, Claudio 480, 486
Montoya, Ruiz de, S.J. 686, 688, 743–745, 746n89, 755n101, 756–757, 759–760
Mulinari, Stefano 505–506, 509, 512, 513nn47–48
Münster, Sebastian 153, 406
Murúa, Martín de 264, 270
Mutianus, Conradus (Konrad Mutian) 117

Nadal, Jéronimo (Jerome) 312, 703, 731
Nero (Roman Emperor) 570
Neumann, Juan Bautista, S.J. 694–695, 697, 748, 757–758
Newenham, Edward 513, 517n51
Niceron, Jean-François, O.M. 452, 454–455, 460n22, 465n31, 469n45, 473
Nieremberg, Juan Eusebio, S.J. 686, 697, 702n30, 703n33
Noot, Thomas van der 229
Núñez, Lauro S.J. (Provincial of the Paraguayan province) 696, 697n27

Ocharte, Pedro 250, 254, 258, 262–265
Oehme, Andreas 482, 486
Oña, Pedro de 269
Ondegardo, Polo de 260
Opitz, Martin 403–404
Optatian (Publilius Optatianus Porfyrius) 92n3
Orduña, Diego de, S.J. 697
Oré, Luís Jerónimo de 270, 274n39, 283
Otgar of Mainz (Archbishop) 109
Otto I (Emperor) 118

Otto of Holland (bishop of Utrecht) 582
Ovid 305, 354, 358n59, 532

Pablos, Juan 249–250, 253–254, 258, 260
Palumbo, Francesco 296
Paradin, Claude 25, 26
Parisio, Cataldo 314n65
Parrhasius 105, 690–691
Passau, Otto of 138, 590, 595n101
Pausanius 492
Pecham, Robert O.F.M. 457
Peeters, Jacobus 372, 374
Peraldus, Guillermus 200
Peramás, José Manuel, S.J. 690, 691n15
Perrier, François 381
Persius 301n24, 303n26, 353
Petri, sister Kath[arina] 153, 231
Phalaris (Tyrant of Agrigento) 301
Philip II 260n20
Philip the Good (Duke of Burgundy) 5, 169–170, 172, 576
Piccolomini-Ammannati, Jacopo 300, 310–311, 319
Pigrin, Henricus 472n57
Pinamonti, Giovanni Pietro S.J. 719, 725, 754–755, 759–760
Piranesi, Giovanni Battista 380
Pirckheimer, Willibald 525–527, 529–530, 532–533, 536, 539, 543–544
Pius II (Pope, Enea Silvio Piccolomini) 303
Plannck, Stephan 310
Plempius, Vopiscus Fortunatus 465, 466, 471
Pliny the Elder (Gaius Plinius Secundus) 300, 303, 315, 319, 492, 690
Pliny the Younger 292, 294, 298, 300
Plutarch 392, 506
Pontano, Giovanni Gioviano 290–293, 305–307, 309, 313, 315, 318
Portocarrero, Melchor (Viceroy of Peru) 698
Posch, Isaac 480–481
Posthius, Johann 25
Priscian (Priscianus Caesariensis) 97, 312
Putz, Melchior 481

Quarles, Francis 502
Quintilian (Marcus Fabius Quintilianus) 312

INDEX NOMINUM

Ranuccio I (Duke of Parma and Piacenza) 392

Raphael of Urbino 506

Regiomontanus, Johannes 144

Reuchlin, Johannes 99, 101–105, 117

Reynbout, sister Eliz[abeth] 231

Rhenanus, Beatus 117

Ribadeneira, Pedro de, s.j. 695

Ricardo, Antonio 249, 254, 258–260, 262–270, 272, 273n37, 274, 276–277, 280–284

Richeome, Louis, s.j. 742

Ripa, Cesare 768

Ripelin of Strassbourg, Hugo 85, 200

Roberval, Gilles Personne de 457, 464, 469

Rolevinck, Werner 68

Rosa, Salvator 387nn62–63

Rossi, Carlo de' 387

Rossi, Giovanni Giacomo de' 385

Rousselet, Gilles 447

Rubens, Peter Paul 518

Rudolf II (Holy Roman Emperor) 94, 122, 127–128, 129n83

Rughalm, Benedictus 138

Rughalm, Wolfgangus 138

Ruusbroec, Jan van 199–200

Saba, Nicolás, s.j. 698n28

Salmeron, Alphonsus, s.j. 611

Salomon, Bernard 340, 726, 731, 752

Sambucus, Ioannes 370, 391, 618n15

Sandoval, Prudencio 735, 740

Sandrart, Johann Jacob von 381

Sangallo, Antonio da 381

Savonarola, Girolamo 324

Saxony, Ludolph of 551, 573

Schedel, Hartmann 117, 141, 153, 229

Scheiner, Christoph s.j. 465–469, 471

Scheus, Hermann 472n57

Schifaldo, Tommaso 290, 292, 296, 305, 313–314, 319

Schön, Erhard 162

Schongauer, Martin 69

Schott, Gaspar, s.j. 472

Schott, Johann 145n19

Schrotbanck, Hans 113

Scott, Walter 502, 513n47

Scotto, Ottaviano 488

Seneca Lucius Annaeus, the Younger 305, 330

Sepp, Antonio, s.j. 690, 695–696, 761n109

Serenus of Marseilles 266n28

Serrano, José, s.j. (Provincial of the Paraguayan province) 694–696, 703, 731, 745, 748–749, 753, 757, 759–761

Shakespeare, William 378

Sigismund I (king of Poland) 428, 434, 435, 436n20

Simler, Georg 100, 103

Snellaert, Christiaen 586

Solis, Virgil 25, 338, 340

Somer, Paul van 385

Sorg, Anton 43, 59–60

Soria, Giovanni Battista 384

Spenser, Edmund 382

Spirito, Lorenzo 427, 428n11

Stanisław z Bochnie (Gąsiorek, Kleryka) 427

Stasicrates (Dinocrates of Rhodes) 392

Stein, Nicolaus 477

Sterne, Laurence 502

Steyner, Heinrich 325, 726n44

Stobaeus Joannes 342

Stradanus, Johannes 380

Suarès, Joseph Marie 381

Sucquet, Antoine, s.j. 732, 734

Swart van Groningen, Jan 229

Sweerts, Michel 385

Sylvius, Petrus 227n2, 228, 243–244

Tapper, Ruardus 611

Techo, Nicolás del, s.j. 692

Tempesta, Antonio 340, 740

Terence 121

Tergoes, Anthonis Jansen van 328–329

Tertullian, Quintus Septimius Florens 610

Teulière, Matthieu de la 388

Thau, Johann von 25

Theocritus 525–526, 534, 537, 539–541, 543–544, 727

Themar, Adam Werner von 102

Thucydides 302–303

Thulden, Theodoor van 653–654

Tibullus, Albius 358

Toletus, Franciscus, s.j., Cardina (Francisco de Toledo) 611

INDEX NOMINUM

Tomasello, Leonte 307
Torricelli, Evangelista 460
Tournes, Jean de 726
Trinkellius, Zacharias Ignatius, s.j. 769
Trithemius, Johannes (Abbot) (Johann Heidenberg) 102, 108

Urban II (Pope) 558, 590
Ussher, James 502

Vaenius, Otho (Otto van Veen) 326, 327n5, 328, 330–331, 335, 337–338, 340, 343–344, 346, 348–354, 356n55, 357–359, 361–363, 365–368, 370, 492–495, 502, 504, 506, 512, 703, 727
Valerius Maximus 301
Valla, Lorenzo 303, 311–312, 317
Vallée, Jacques de la 735n65
Varthema, Ludovico de 143–144
Vasari, Giorgio 22–25, 506
Vaulezard, Jean-Louis 455
Vázquez (Guarani writer) 761n108
Vázquez, Dionisio, s.j. 695
Vecellio, Cesare 388
Veldener, Johann 549
Vera Cruz, Alonso de la 252
Verdussen, Hieronymus 326n4, 492n4, 522, 703, 707, 714, 723, 735, 740
Viadana, Lodovico 475, 477–481, 486
Vignon, Claude 125, 343n35, 447
Villacerf, Édouard Colbert de 388
Vincent de Beauvais 100
Vingboons, Ioannes 391–392
Vingboons, Philips 391–392
Virgil (Publius Vergilius Maro) 354, 359, 361, 492, 526
Vitellius, Aulus (Roman Emperor) 740
Vliederhoven, Gerard van 218
Voet, Alexander 603, 605n3, 625, 659, 666
Vorsterman, Willem 227n2, 228–229, 246
Vries, Hans Vredeman de 391, 392n84

Washington, George 513
Wauquelin, Jean 171

Wechel, Chrestien 325, 338n28
Wechtlin, Hans 145, 147
Wederden, Johannes van 193
Weigel, Christian 402–404, 406, 408, 410n15, 414, 415n22, 416–421
Weigel, Georg 404
Weigel, Hans 404n6
Weigel, Johann 404
Weigel, Ursula 404
Weset, Johannes von 108n45
Westernach, Johann von (Secretary to Archduke Ernest of Austria) 122–124
West, Francis Robert 512
West, Robert 512
Weyden, Rogier van de 69
Wickram, Jörg 427
Wierix, Hieronymus 746, 754, 759
Wierix, Johannes 349
Wietor, Hieronim (Hieronymus Vietor) 427–429, 435, 437, 439
Willem V (Duke of Bavaria) 571n49
Willem V (Count of Holland) 568
Wimpfeling, Jakob 93, 98–100, 102–110, 113, 117–118, 121–122, 132
Witelo, Erasmus 457

Xarque, Francisco, s.j. 690

Yapari, Juan 749, 752
Yapuguay, Nicolás (Cacique) 730n53, 761

Zacchia, Laudivio 300–301
Zainer, Günther 60
Zayas, Gabriel de 9
Zephaniah 746
Zesen, Philipp von 328–329, 340, 356, 361–362, 370
Zeuxis 105, 690
Zizo, Cesare 290–293, 296, 298, 300, 304–305, 309, 311, 313–315, 317–319
Zrinska, Katarina 442–443
Zrinski, Nikola 443, 447
Zumárraga, Juan 249–250

Printed in the United States
by Baker & Taylor Publisher Services